The Encyclopedia of Sculpture

Volume Three

Board of Advisers

The Encyclopedia of Sculpture

Volume Three

P–Z

Index

Antonia Boström, editor

Fitzroy Dearborn
New York • London

P

MICHAEL PACHER ca. 1435–1498
Austrian or German

Michael Pacher was an Austrian or German artist who maintained a workshop in Tyrol. A contract for his famous St. Wolfgang altar is dated 1471, but he likely did not intend to work on this project until he completed work on the Gries altar, which began that same year. The patron, Benedict Eck, Abbot of Mondsee, may have wished to secure the St. Wolfgang contract early since Pacher's work was already in high demand.

Art historians have remarked on two essential characteristics of Pacher's work. First, although Pacher was regarded as a talented painter, his most famous and mature works also show his outstanding skill as a sculptor of wood. Second, Pacher was keenly aware of contemporary directions in artistic expression. Most important among these were the bold figure style from the Lower Rhine and the Burgundian Netherlands and artistic developments in Italy, especially Padua. As a result scholars often dissect his paintings and sculptures according to his northern (Germanic) and southern (Italian) features. The active flourishes of drapery in his sculpted figures and the use of elaborate Gothic ornamentation (such as highly detailed tracery, baldachins, pinnacles, and finials) reflect Germanic sensibilities, while the calm expressions of Pacher's figures convey a quiet solemnity associated with art of the quattrocento. Late-20th-century scholarship also considered Pacher's ability to create a theatrical setting in which sculpture, architecture, and painting ingeniously combine into a singular whole (see Koller, 1998).

Pacher's earliest documented work (ca. 1462) is the high altar for the Church of S. Lorenzo in Pusteria, Italy, in which he already synthesized Germanic and Italian elements. Pacher continued this direction with the Gries altar, an early work that survives only in parts, for the parish church of Gries in Austria. The painted panels are thought to be by another master, but the central shrine, depicting the *Coronation of the Virgin*, is a fine example of Pacher's early work. The wooden sculptures, placed in a shallow architectural setting, form a less dimensional and less theatrical scene than is found in Pacher's later works. Nevertheless, active surfaces of drapery folds cover the figures and reflect the dynamic sculpture of Nicholas Gerhaert. The contract for the Gries altar specified that Pacher follow the nearby works of Hans von Judenburg; to what extent this requirement altered Pacher's own innovation remains unclear.

Pacher created his most famous work, the St. Wolfgang altar, for the pilgrimage Church of St. Wolfgang in St. Wolfgang, Austria. The contract for the altar survives, but no sketch is extant. The altar presents three transformations that reveal a complex iconographic program. In its closed state the altar displays four painted panels with scenes from the *Life of St. Wolfgang*. Once these four panels are opened, eight more panels exhibit scenes from the *Life of Christ*. Opening these eight panels reveals four more panels representing scenes from the *Life of the Virgin*, along with the sculpted central shrine. The central shrine depicts the *Coronation of the Virgin with SS. Wolfgang and Benedict*. The pinnacle, which is visible during all three transformations, contains sculpted figures representing *Christ as God the Father* and the *Crucifixion*.

In total, the St. Wolfgang altar holds an impressive 71 carved and painted figures and 24 painted panels.

As a painter Pacher demonstrated his complete understanding of mathematical perspective common to Italy by the first half of the 15th century. Research of those painted panels depicting interior settings suggests that he established the horizon and orthogonal lines on the panels first and then drew the figures freehand (according to contemporary Italian practice). Indeed, such interior scenes have strong parallels to Italian works in Padua, especially the works of Andrea Mantegna. In the same manner that perspective gives dramatic effect to the painted panels, careful placement of sculpted figures demonstrates Pacher's ability to create a three-dimensional theatrical setting. This placement contrasts with the earlier Gries altar, which is generally flatter. The ornamental details of the St. Wolfgang altar are also more deeply carved and illusionistic than in the Gries altar. Additionally, in the central shrine of the St. Wolfgang altar, the figures of *Christ* and the *Virgin* reflect the changing light of the choir while the dark shadows in the background provide a contrasting negative space. This cadence of shadows adds a rhythm of light and dark akin to Italian fresco painting. At the same time, the realistic aged faces of *SS. Wolfgang and Benedict* reveal the influence of Pacher's German-speaking contemporaries, particularly the sculptor Hans Multscher and the painter Konrad Witz.

Pacher's outstanding skill, demonstrated in his acumen to devise geometrically complex architectural ornamentation and his use of mathematical perspective, combined with his synthesis of Italian art and fidelity to the artistic practices in German-speaking regions make him one of the most important German artists of the 15th century.

KEVIN MCMANAMY

Biography

Born in either Austria or Germany, *ca.* 1435. Perhaps related to Friedrich Pacher. Apprenticeship likely during 1450s, but little known of training; may have been a master artisan by 1462, certainly by 1467; maintained workshop in city of Bruneck (present-day Brunico, Italy), and recorded as master and citizen in that city; house at Marktgasse 25 still stands today; most documents record him as a painter (*maler, pictor*); succeeded by his son Hans Pacher. Died in Salzburg, Austria, 1498.

Selected Works

ca. 1462 High altar; wood and painted panel; Church of San Lorenzo, Pusteria, Italy
1471–75 Gries altar; wood; Gries Parish Church, Gries, Austria
1471–81 St. Wolfgang altar; pine, lime wood; Church of St. Wolfgang, St. Wolfgang im Salzkammergut, Austria

Further Reading

Baxandall, Michael, *The Limewood Sculptors of Renaissance Germany*, New Haven, Connecticut: Yale University Press, 1980
Koller, Manfred, *Der Flügelaltar von Michael Pacher in St. Wolfgang*, Vienna: Böhlau, 1998
Müller, Theodor, *Sculpture in the Netherlands, Germany, France, and Spain: 1400 to 1500*, Baltimore, Maryland: Penguin, 1966
Müller, Theodor, *Gotische Skulptur in Tirol*, Bozen, Austria: Athesia, and Innsbruck, Austria: Tyrolia, 1976
Rasmo, Nicolò, *Michele Pacher*, Milan: Electa, 1969; as *Michael Pacher*, translated by Philip Waley, London: Phaidon, 1971
Stampfer, Helmut, and Hubert Waldner, *Michael Pacher in Bozen-Gries: Der Flügelaltar in der Alten Pfarrkirche*, Bozen, Austria: Athesia, 1980

St. Wolfgang Altar
© Foto Marburg / Art Resource, NY

AUGUSTIN PAJOU 1730–1809 *French*

Like so many artists of the 18th century, the Parisian Augustin Pajou was born into a family of artists. Out

of this artistic milieu, he quickly became the complete Enlightenment artist: draftsman, notably to the Académie des Inscriptions; successful sculptor, who would have been first sculptor to the king had such a title existed; teacher and active member of the Académie Royale; and close friend to his fellow academicians Hubert Robert and Adelaide Labille-Guiard and to such luminaries as Denis Diderot's daughter, Angélique de Vandeul. The sculptor, who later became perhaps the leading Neoclassicist, began his artistic training early. At the age of 14, Pajou entered the studio of Jean-Baptiste II Lemoyne, from whom he learned his graceful style and with whom he always remained close; Pajou's terracotta portrait bust of his former teacher, exhibited in the Salon of 1759, received praise from Diderot and others.

Pajou made rapid progress, winning the Prix de Rome in sculpture in 1748 and, at the age of 18, entering the École Royale des Élèves Protégés as part of its inaugural class. Lenormant de Tournehem, *directeur des bâtiments* (*director of buildings*) and Charles-Antoine Coypel, *directeur de l'académie*, founded the school in 1748, in order to provide young students with further artistic and intellectual training before going to the French Academy in Rome. The training in history and literature was to provide students with the necessary source material to absorb the ancient glories of Rome and to produce works in the edifying grand manner the government desired. In 1750 Pajou demonstrated his assimilation and admiration of the ancients that became the hallmark of his style. He exhibited at the school a work based on the ancient poet Anacreon, *Anacreon Plucking a Feather from Cupid's Wings*.

Upon his return from Rome, Pajou was accepted as *agréé* (admitted) to the Académie Royale in Paris in 1759. In his first Salon exhibition of the same year, he showed the commissioned funerary monument *Anastasia Ivanova, Princess of Hesse-Homburg, in the Guise of Minerva Consecrating the Ribbon of the Order of Saint Catherine on the Altar of Immortality*, based on sketches of ancient cameos of Minerva that Pajou had made during his Roman studies. Although the work was coolly received at the time because of its rigorous Neoclassicism, critics now believe that this fairly austere statement would have been influential in later years had it not been brought to Russia. In contrast, his *morceau de réception* (a piece submitted as part of the requirement for membership into the Academy), *Pluto Holding Cerberus Chained*, displayed in the Salon of 1761, combined an ancient subject with the *terribilità* (immense force [of art]) of Italian masters and was critically acclaimed. By 1765 the periodical *Mercure de France* proclaimed, "This artist, who is already well known and already deserves to be, gives new proof of his development with every exhibition."

In addition to his rapid academic and critical success, Pajou quickly gained royal commissions. He oversaw the rushed completion of the decorations of the opera house at Versailles for the wedding of the future Louis XVI and Marie-Antoinette. In the Salon of 1767, he presented four royal busts, including the posthumous portrait *Louis de France*, depicting the dauphin who had died in 1765. The works were criticized at the time as "dull" and "ignoble," but although Pajou's royal portraits have been considered the weakest of his works, they brought him the financial security and acclaim necessary for his highly successful career as the preeminent royal sculptor. Indeed, it was within the realm of portraiture that Pajou particularly excelled. Having exhibited his first portrait bust in the Salon of 1759, he exhibited at least one in each of the next 20 salons.

Sculpted portraits often were intended to carry moral content *directeur des bâtiments* Charles Claude de La Billarderie's Great Men of France project, in which four statues of illustrious Frenchmen would be commissioned for each salon, is an example. As a sign of his favored status, Pajou was given first choice of subjects and exhibited his *René Descartes* at the Salon of 1777. Pajou ultimately produced four subjects— more than any other sculptor—for the prestigious Great Men of France series, following his *Descartes* with the better-received depictions *Jacques-Génigne Bossuet, Blaise Pascal*, and *Henri de la Tour d'Auvergne, Maréchal de Turenne*. Similarly marking the sculptor's status as the royal favorite, when Louis XV felt the need to make amends for a perceived snub to the philosopher-scientist Georges-Louis Leclerc, comte de Buffon, he requested that Pajou create Leclerc's monument.

A comparison of two works completed within a year of each other, the portrait bust of *Hubert Robert* and *Psyche Abandoned*, illustrates Pajou's range as a sculptor. His portrait of Robert presents one of the sculptor's closest friends as intelligent and alert. Robert's head is turned and mouth slightly open, as if Pajou had captured a particular moment. The artist displayed his skill in the carving of the locks of hair and the folds of Robert's apparently somewhat disheveled attire. Despite the similar skill in its production, *Psyche Abandoned* stands in direct contrast to this personal statement. *Psyche Abandoned* was a royal commission and has been considered Pajou's attempt both to prove his preeminence as a sculptor and, in its matching of cool antiquity with anatomic correctness, to provide a statement—one that would ultimately be rejected—on the aspirations of the Neoclassical style.

Pajou fled to Montpellier during the French Revolution but later returned to Paris. Following a career based on royal and courtly patronage, he produced

works to commemorate the reign of Napoléon I. In 1801 he presented his *Julius Caesar* for Napoléon's Gallery of the Consuls in the Palais des Tuileries, the sculptor's Neoclassical manner now appreciated by a new regime. He received the Chevalier of the Legion of Honor in 1805 but the following year was evicted from his apartments in the Louvre. When Pajou died in 1809, he had not worked for several years. With late-20th-century scholarship there has been renewed interest in Pajou.

DENISE AMY BAXTER

See also **Lemoyne, Jean-Baptiste II**

Biography

Born probably in Paris, France, 19 December 1730. Son of Martin, a minor sculptor of wood as were grandfathers and great uncle. Began studies with Jean-Baptiste Lemoyne, 1744; won Prix de Rome, 1748; one of first students at École Royale des Élèves Protégés and pensionnaire at the French Academy in Rome, 1752–56; became *agréé* (admitted) of Académie Royale, 1759, *académicien*, 1760, *adjoint à professeur*, 1762, professor, 1766; appointed draftsman to Académie des Inscriptions and keeper of modern sculpture in royal collections, 1772; appointed treasurer of the Académie Royale, 1781, and rector, 1792; only sculptor to be a member of the commission for the Musée Centrale des Arts de la République; member of the Institut de France upon its creation and received the Chevalier of the Legion of Honor, 1805; evicted from Louvre, along with other artists, because of the political regime, 1806. Died in Paris, France, 8 May 1809.

Selected Works

1750 *Anacreon Plucking a Feather from Cupid's Wings*; terracotta; Musée du Louvre, Paris, France

1759 *Anastasia Ivanova, Princess of Hesse-Homburg, in the Guise of Minerva, Consecrating the Ribbon of the Order of Saint Catherine on the Altar of Immortality*; marble; Hermitage, St. Petersburg, Russia

1759 *Jean-Baptiste II Lemoyne*; terracotta; Musée des Beaux-Arts, Nantes, France

1760 *Pluto Holding Cerberus Chained* (also known as *Pluto Keeping Cerberus in Chains*); marble; Musée du Louvre, Paris, France

1767 *Louis de France*; marble (untraced)

1768–70 *Youth, Health, Plenty, Peace, Apollo, and Venus*; marble; opera house, Château, Versailles, Yvelines, France

1773 *Georges-Louis Leclerc, Comte de Buffon*; marble; Musée du Louvre, Paris, France

1773 *Madame Du Barry*; marble; Musée du Louvre, Paris, France

1773–76 *Monument to Buffon*; marble; Musée National d'Histoire Naturelle, Paris, France

1777 *René Descartes*; marble; Institut de France, Paris, France

1779 *Jacques-Génigne Bossuet*; marble; Institut de France, Paris, France

1781 *Blaise Pascal*; marble; Musée du Louvre, Paris, France

1783 *Henri de la Tour d'Auvergne, Maréchal de Turenne*; marble; Musée National du Château, Versailles, France

1789 *Hubert Robert*; terracotta; École Nationale Supérieure des Beaux-Arts, Paris, France

1790 *Psyche Abandoned*; marble; Musée du Louvre, Paris, France

1800–01 *Julius Caesar*; marble; Sénat, Palais du Luxembourg, Paris, France

Further Reading

Beaulieu, Michèle, "Oeuvres inédites et procédés de travail d'un sculpteur de la seconde moitié du XVIIIᵉ siècle: Augustin Pajou," *Bulletin de la Société de l'histoire de l'art français* (1979)

Chaussard, Pierre-Jean-Baptiste, "Notice inédite et historique sur la vie et les ouvrages de M. Augustin Pajou, statuaire, membre de l'Institut de France et de la Légion d'honneur," in *Le Pausanias français: État des arts du dessin en France, à l'ouverture du XIXᵉ siècle: Salon de 1806*, Paris: Buisson, 1806; reprint, 1988

Draper, James David, and Guilhem Scherf, *Augustin Pajou: Royal Sculptor, 1730–1809*, New York: Metropolitan Museum of Art, and Paris: Réunion des Musées Nationaux, 1997

Draper, James David, and Guilhem Scherf, *Augustin Pajou, dessinateur en Italie, 1752–1756*, Nogent-Le-Roi, France: Librarie des Arts et Métiers-Éditions Jacques Laget, 1997

Levey, Michael, *Painting and Sculpture in France, 1700–1789*, New Haven, Connecticut: Yale University Press, 1993

West, Alison, *From Pigalle to Préault: Neoclassicism and the Sublime in French Sculpture, 1760–1840*, Cambridge and New York: Cambridge University Press, 1998

PSYCHE ABANDONED

Augustin Pajou (1730–1809)

1790

marble

h. 177 cm

Musée du Louvre, Paris, France

In 1895 Louis Gonse asserted, "All that can be said of Pajou can be summed up in one phrase: exquisite

grace. Even when he tries to heighten the emotional level, even when he becomes violent or tender, Pajou remains graceful." In 1972 Michael Levey explained that "any excitement engendered by great events is banished in Pajou's work, in which the mood is quiescent, tending to lapse into the sentimental and particularly into the inert." Both these related qualities, grace and its perhaps subsequent inertia, are exemplified in the sculpture by which Augustin Pajou is best known, *Psyche Abandoned*, a work that problematically combines Neoclassical idealism and attention to naturalistic detail.

The sources for Pajou's Roman mythological subject range from Apuleius's 2nd-century *Golden Ass* to Jean de La Fontaine's *Les Amours de Psyché et Cupidon* (The Loves of Cupid and Psyche; 1669). Offended by the great beauty of the princess Psyche, Venus sends her son, Cupid, to punish her. Cupid, however, falls in love and continues visiting Psyche in darkness, concealing his identity. Fearing that her suitor might be a monster, Psyche, carrying a lamp and a dagger, attempts to discover his identity as he sleeps. While she marvels at Cupid's beauty, a drop of oil from the lamp falls on his shoulder and awakens him to her deceit. Venus discovers their love and punishes them both.

Pajou received the important government commission in 1783 for the large sum of 15,000 *livres* to create a pendant of his own device for Edmé Bouchardon's highly praised *Cupid Carving a Bow out of the Club of Hercules* (1750). Pajou indicated in a letter to the *Directeur des Bâtiments* (Director of Buildings) Charles Claude de La Billarderie, comte d'Angivillier, of the same year that he was "resolved to spare neither time nor expense in order to bring this figure to the perfection of which I am capable."

While creating his pendant, Pajou had ample access to the work by Bouchardon, which was then housed in the Salle des Antiques, of which Pajou was curator. In addition to the antique sources for his subject, Pajou studied 17th-century Italian sculpture in the royal collection, Mannerist paintings of similar subjects, and a live model. The moment Pajou chose to depict is that of the dejected, abandoned Psyche, whose identity is barely decipherable through the attributes of the butterfly, symbol of Psyche and the soul, the dagger, and the lamp—whose incriminating oil still runs—on the base of the sculpture. Even the generality of its composition, in which the seated figure of Psyche forces a frontal view reminiscent of the antique while the sculpture is fully finished in the round, alludes to the divide between the ideals of Neoclassicism and the contemporary.

Pajou first exhibited *Psyche Abandoned* as a plaster cast at the Paris Salon of 1785. As a life-size sculpture commissioned by the crown, the work was positioned at the exhibition's entrance. It remained there for only five days before the curate of Saint-Germain l'Auxerrois, who complained of the impropriety of this nearly inexplicable, completely nude woman, convinced d'Angivillier to have it removed. Although the work was a great success when shown in Pajou's own studio, in close proximity to the Salon, and the curate himself suffered the adverse effects of public opinion, his reaction to the combination of the real and the ideal embodied in Pajou's *Psyche* was shared by the generally mixed critical responses to the work. One critic praised the *Psyche* as superb; another expressed amazement that the figure, "although perfectly naked, was actually quite modest." Others, however, questioned Pajou's choice of staying close to his model, rather than relying on the ideal, complaining that *Psyche* did "not have an antique character," that "she has a French face," or more explicitly, that "I've seen a *Psyche* who looks like a chorus girl from the Opera."

The plaster is now lost, so it can no longer be ascertained how the final marble differs, but when exhibited

Psyche Abandoned
© Erich Lessing / Art Resource, NY

in 1791, it garnered almost universal praise: "We lack words to render all the praise that is heaped daily upon this Psyche." But even in this Revolutionary Salon there were voices of complaint: "It is a good work as an imitation of life, but it is not Psyche." In the work, Pajou combined a naturalistic form, based on a contemporary French model, with psychological realism of sorrow, loosely based on the models for expressions of sorrow by Charles le Brun. Embodied in the recognizable form of "a chorus girl," the work bridges the gap between the sculpture's audience and the mythological content. As one contemporary critic has explained it, in Pajou's *Psyche* "the realm of myth approaches the daily modern world." It is this proximity that allows for some to find the work chaste while others had it removed from the Salon; some to find her superb while others could claim that it is "not Psyche." The most telling critique of the work, however, may be that taken from the sculptor's obituary in the *Journal de l'Empire*, 29 July 1809:

> The work that most contributed to M. Pajou's fame is the statue of Psyche. [She is depicted at] an age that most consider slightly past the age she should have been. Remove the lamp and the dagger that indicate the situation, and one could just as easily take this tearful woman for Ariadne. . . . The overly pronounced expression mars the effect of her head, which itself is lacking in beauty; her hair is poorly styled and too voluminous. Otherwise, the statue is pleasant and well modeled, generous in its design, carefully crafted down to its slightest accessories, which are all in good taste.

Pajou had experimented with his own interpretation of Neoclassicism as an integration of the ideal and the real through which it might be possible to bring myth to life. Yet while the *Psyche* has been considered "graceful" or "in good taste," this lukewarm praise makes clear that Pajou's reconceptualization of the style was hardly unanimously well received.

DENISE AMY BAXTER

Further Reading

Bresc-Bautier, Geneviève, *Sculpture française XVIIIᵉ siècle*, Paris: Éditions de la Réunion des Musées Nationaux, 1980
Johnson, McAllister W., "Visits to the Salon and Sculptors' Ateliers during the Ancien Régime," *Gazette des Beaux-Arts* (1992)

PALLAGO, CARLO DI CESARE

See **Carlo di Cesare del Palagio**

EDUARDO PAOLOZZI 1924– *British*

Eduardo Paolozzi is known internationally for his sculpture that often ironically questions humankind's dependence on technology and the uncertain benefits of science. Yet he has described himself as a sculptor who is not obsessed with making sculpture. As a member of the Independent Group in London in the early 1950s, Paolozzi contributed influentially to the development of Pop art and in the next decade to the history of screen printing. He has since made animated films, ceramics, and tapestry; written poetry and novels; designed for other media, including exhibitions and the theater; and had a long and distinguished career as a teacher, including at the Akademie der Bildenden Künste, Munich, where for ten years he was a professor of sculpture. Such is his experience of working with architects that he describes anything he makes that occupies space, whether the decoration of a shopping mall or the design of a landscape outdoors, as "social sculpture." In 1960 he defined his artistic process as the "metamorphosis of quite ordinary things into something wonderful and extraordinary," thus associating himself and his sculpture with the legacy of Surrealism, which has remained a powerful influence.

Paolozzi strongly identified with the cinema and street culture of 1930s Scotland, in which he grew up. Through his Italian heritage, he grasped at an early age the social and cultural implications of European Modernism before his unsatisfying experience in art school and the army, when he discovered Amédée Ozenfant's book *Foundations of Modern Art* (1928), which drove him to seek out its major exponents in post–World War II Paris. There in 1947 he met Jean (Hans) Arp, Constantin Brancusi, and Alberto Giacometti, who was making figurative sculpture for an exhibition in New York the following year. Paolozzi was equally impressed by Giacometti's Surrealist sculpture of the 1930s. When he returned to London, he adapted its motifs for fountains in concrete and steel, which were commissioned for the Festival of Britain of 1951, and for a prize-winning entry for the competition, *Monument to the Unknown Political Prisoner* of 1953.

Mr. Cruikshank was the first sculpture Paolozzi modeled after a ready-made machine—a wooden simulator developed by scientists to measure irradiation of the human skull—which he cut into sections and then recast; this was a formative process for the development of his sculpture. The sculpture he exhibited at the XXVI Venice Biennale in 1952 was interpreted as existentialist, and its "brutalism" was perceived as being in strong opposition to the smooth biomorphic forms of Henry Moore's work. By 1956 Paolozzi had developed a style of figurative sculpture that, like Pablo Picasso's later sculpture and Jean Dubuffet's painting, exploited the process of metamorphic bricolage by impressing ready-made, obsolete mechanical objects into sheets of wet plaster from which wax and bronze sculpture was cast. Some of his life-size figures made in

this way assumed a wobbly robotic appearance derived from science fiction imagery; others were ironically named after Classical deities or Christian saints, such as *St. Sebastian II.* Paolozzi described this type of sculpture, which was exhibited in the 1959 *New Images of Man* exhibition at the Museum of Modern Art, New York City, as the "metamorphosis of rubbish."

In the following decade, Paolozzi substituted animal and human metaphors for technology and the machine. Such sculptures welded from aluminum elements—some were totemic and geometric, in the form of twin towers, or resembled computer consoles, whereas others were tubular and evoked the ancient Roman *Laocoön* group—were extemporized on the factory floor of an engineering workshop and reflect the industrial aesthetic of David Smith. In 1964 Paolozzi began to paint his sculpture in the colors of his screen print series *As Is When*, which takes as its subject Ludwig Wittgenstein's philosophical investigation into how language describes objects and experience; the prints and sculpture, including *Wittgenstein at Casino*, were shown together at the Museum of Modern Art in the fall of that year. Paolozzi's frequent exhibitions of sculpture in New York City in the 1960s, at Betty Parsons Gallery and the Pace Gallery, included a series of highly polished, chrome-plated works, some of which relate to Minimalism.

Hamlet in a Japanese Manner, which exists in three movable sections, is the largest of Paolozzi's polychrome sculptures. It was first displayed—painted—in the exhibition "Sculpture in the Open Air" (20 May–30 September 1966; Battersea Park, London); the illustration in the catalogue shows the piece marked for painting. It was repainted for the artist's exhibition at the Tate Gallery, London, in 1971; in 1976 the sculptor stripped it back to the base metal and lent it to the Fitzwilliam Museum in Cambridge, England. As Paolozzi wrote of the work in 1982, "My original reason for painting *Hamlet* was to relate it to my collages while taking it one step further. By walking around the sculpture the changing and overlapping colored forms created a surprising juxtaposition pointing to a theatrical idea" (see Spencer, 2000). The work was purchased by the Art Gallery and Museum in Glasgow, Scotland, in 1982; in 1996 it was restored to its original painting by a team of conservators from the Tate Gallery and computer animation experts from the company Channel 20–20, coordinated by the British Council, for the exhibition *A Century of British Sculpture* in Paris in the summer of 1996.

In the 1970s Paolozzi made a major contribution to low-relief sculpture. Building on the Modernist tradition of Arp in Europe and of Louise Nevelson in the United States, Paolozzi created an abstract geometric style of fretsaw-cut relief sculpture in wood and plaster

Self Portrait as Hephaestus with a Strange Machine (detail) © Humphrey Evan; Cordaiy Photo Library / CORBIS, and (2003) Artists Rights Society (ARS), New York, and DACS, London

for casting in metals and resins that could be adapted for architecture, thus anticipating the reemergence of sculptural decoration for buildings in the Postmodern era. The most notable examples are the aluminum doors Paolozzi designed in Scotland for the Hunterian Art Gallery at Glasgow University and the nine-panel ceiling for Cleish Castle, Kinross-shire, now relocated in the Dean Gallery, Edinburgh.

On his appointment as professor of sculpture in Munich in 1981, Paolozzi was attracted to the fragmented Greek sculpture in the Glyptothek. The sliced and fragmented heads that resulted from this study are still being developed and have been extended to include figural sculpture for which the limbs are intercut with mechanical inserts, as in the double-life-size *Self Portrait as Hephaestus with a Strange Machine* in High Holborn, London.

Major public sculpture by Paolozzi can be found in the three European cities with which he is closely associated. In London he devised an extensive decora-

tive scheme of figurative imagery in bright mosaic for the Tottenham Court Road underground station. For the forecourt of the new British Library in London, he was commissioned to make the bronze sculpture *Newton*. In Edinburgh there are two monumental bronze figure groups consisting of an arrangement of a fragmented head, feet, and hands: *The Wealth of Nations*, for the Royal Bank of Scotland, and *The Manuscript of Montecassino*, which is outside St. Mary's Roman Catholic Cathedral. Sculpture in Munich includes *For Leonardo*, a cast-iron work based on computerized imagery, which is situated on the lawn outside the Alte Pinakothek. Other major works of social sculpture in Germany include the redevelopment of the Rheingarten in Cologne, a landscape that consists of 26 elements in stone, metal, and water. A major collection of Paolozzi's work in all media, together with a reconstruction of his London studio and the 27-foot-tall figure *Vulcan* in welded stainless steel, is permanently installed in the Dean Gallery.

ROBIN SPENCER

Biography

Born in Leith, Edinburgh, Scotland, 7 March 1924. Attended evening and day classes at Edinburgh College of Art, 1941–43; also attended Slade School of Fine Art, Oxford and London, to study sculpture under A.H. Gerrard, 1944–47; founding member of the Independent Group, Institute of Contemporary Arts, London, 1952; part-time tutor in textile design at St. Martin's School of Art, 1949–55; studied sculpture at the Central School of Art, 1955–58, and ceramics at the Royal College of Art, London, 1968–79; visiting professor, Hochschule für Bildenden Künste, Hamburg, 1960–62, and University of California, Berkeley, 1968; professor of ceramics, Fachhochschule, Cologne, 1977–81, and professor of sculpture, Akademie der Bildenden Künste, Munich, 1981–91; appointed Her Majesty the Queen's Sculptor in Ordinary for Scotland, 1986; trustee of the National Portrait Gallery, London, 1988–95; visiting professor, Royal College of Art, 1989. Prizes and awards include Noma and William Copley Foundation Award, 1956; David E. Bright Foundation Award for Best Sculptor under 45, 1960; Watson F. Blair Prize, Chicago, 1961; first prize for sculpture, Carnegie International Exhibition, Pittsburgh, 1967; Goethe Medal and *Cavaliere Officiale del Ordine al Merito della Repubblica Italiana*, 1991. Lives and works in London, since 1960.

Selected Works

1950s *Mr. Cruikshank*; bronze; Dean Gallery, Edinburgh, Scotland

1951 *Fountain* for Festival of Britain; concrete, open steel (destroyed)

1952 *Monument to the Unknown Political Prisoner*; plaster; private collection

1957 *St. Sebastian II*; bronze; Solomon R. Guggenheim Museum, New York City, United States

1963–64 *Wittgenstein at Casino*; painted aluminium; Leeds City Art Gallery, England

1966/71/ *Hamlet in a Japanese Manner* (restored, 76 1996); aluminium (previously painted); Art Gallery and Museum, Glasgow, Scotland

1971–76 *Thunder, Lightning, Flies, and Jack Kennedy*; mixed media; Galleria d'Arte Contemporanea, Milan, Italy

1976–77 *Hunterian Art Gallery Doors*; aluminium; Glasgow University, Scotland

1978–79 *Camera*; bronze; European Patent Office, Munich, Germany

1981–86 *Rheingarten*; stone, metal, water; Cologne, Germany

1986 *For Leonardo*; cast iron; Munich, Germany

1987 *Self Portrait as Hephaestus with a Strange Machine*; bronze; High Holborn, London, England

1990 *The Manuscript of Montecassino*; bronze; Picardy Place, Edinburgh, Scotland

1993 *The Wealth of Nations*; bronze; Royal Bank of Scotland, South Gyle, Edinburgh, Scotland

1999 *Vulcan*; stainless steel; Dean Gallery, Edinburgh, Scotland

Further Reading

Kirkpatrick, Diane, "Eduardo Paolozzi: A Study of the Artist's Art, 1946–1968," Ph.D. diss., University of Michigan, 1969

Kirkpatrick, Diane, *Eduardo Paolozzi*, London: Studio Vista, 1970

Konnertz, Winifried, *Eduardo Paolozzi*, Cologne, Germany: DuMont, 1984

Middleton, Michael, *Eduardo*, London: Methuen, 1963

Paolozzi, Eduardo, *Metafisikal Translations*, London: Kelpra Studio, 1962

Paolozzi, Eduardo, *The Metallization of a Dream*, London: Lion and Unicorn Press, 1963

Paolozzi, Eduardo, *Kex*, London: Percy Lund Humphries, 1966

Paolozzi, Eduardo, *Abba Zaba*, London: Hansjorg Mayer, 1970

Paolozzi, Eduardo, *Lost Magic Kingdoms and Six Paper Moons from Nahuatl*, London: British Museum Publications, 1985

Pearson, Fiona, *Paolozzi*, Edinburgh: National Galleries of Scotland, 1999

Robbins, David, editor, *The Independent Group: Postwar Britain and the Aesthetics of Plenty*, Cambridge, Massachusetts: MIT Press, 1990

Spencer, Robin, *Eduardo Paolozzi, Recurring Themes*, London: Trefoil Books, 1984

Spencer, Robin, editor, *Eduardo Paolozzi, Writings and Inter-views*, Oxford: Oxford University Press, 2000
Whitford, Frank, *Eduardo Paolozzi*, London: Tate Gallery, 1971

PAPIER MÂCHÉ

The ancient technique of papier mâché originated in China and spread to Persia as a natural consequence of the invention of paper and its subsequent spread from the 2nd century CE onward. In China and Japan, papier mâché was used for making armor, but its primary use in the East has been for the making of masks and festival objects. In the West, the medium has been used for a wide range of arts and crafts, including festival masks, small decorative and useful objects, furniture, theatrical sets, sculptural models, and finished works of sculpture. It is also an extremely popular medium for children's art.

Papier mâché (literally, the French term for "chewed paper") consists of paper combined with a binder. It can be worked in three primary ways. In pulp form, the paper pulp is pressed into molds and allowed to dry. The paper can also be applied in layers of strips or sheets that have been soaked in a binding solution. Finally, papier mâché pulp can be modeled in a way similar to the working of clay. When applied in layers, the forms can be built up over solid objects from which the dried forms are cut free and reassembled using more papier mâché. Layers can also be applied over armatures of wood, cardboard, or wire.

Papier mâché's wide use owes much to the simplicity of the technique and the ready availability of the necessary materials and tools. Historically, there has been an abundance of formulas for binding mediums. The varied list of ingredients in pulp papier mâché has included animal glues, casein glue, wheat and flour pastes, wallpaper paste, polyvinyl acetate glues, and epoxy. Plaster of Paris, whiting, borax, pumice, and asbestos have been added to some mixtures to increase the final object's resistance to fire. Oxyquinoline sulfate, salicylic acid, formaldehyde, carbolic acid, tobacco juice, garlic, wormwood, wintergreen oil, and carnation oil have also been added as preservatives—something not necessary when using modern glues and pastes. Other additives used to change the texture or consistency of the pulp, or to lower the cost, include clay, sawdust, ashes, flour, crayon, and ground soapstone.

The choice of the paper is of a greater concern when using the layering method and depends to a significant extent on artist preference and the type of object being made. A wide range, including tissue paper, newspapers, and packing papers, can be employed. The addition of more glue to the binding solution can strengthen weak papers. Papier mâché objects may be painted with oil paints, but casein, tempera, and acrylic paints are far more common. Clear varnishes, enamels, lacquers, or shellac may also be used. If the work is made of newspaper or plain white paper, it will likely be painted. The artist may, however, choose colored papers, with the intent of later applying only a clear finish.

In Japan papier mâché has proved to be one of the most stable materials for making the heads of *gosho* dolls. It is applied over wood, cut apart, and reassembled before the artist spreads on several layers of *gofun*, made from pulverized oyster shell mixed with rice paste. Each coat is burnished to a porcelain-like finish. In the West, sculptors used papier mâché—known as *cartapesta* in Italian—during the Renaissance much in the way that they used terracotta for making working models and reproductions. Donatello and Jacopo Sansovino were among the artists who produced works in this medium Gianlorenzo Bernini and Alessandro Algardi also produced papier mâché *bozzetti*. By the 17th century, artists were using the medium for original and finished works. It also became widely used at this time in France for stage sets.

In Spain and Mexico, the use of papier mâché in festivals dates back centuries. Each March, on the last night of the fiesta of Las Fallas in Valencia, Spain, hundreds of largely papier mâché figures are set afire in the streets. In Mexico on the Saturday morning before Easter, thousands of papier mâché effigies of Judas are burned, and gifts fly from the flaming figures as the firecrackers with which they are strung explode.

During the second half of the 20th century, papier mâché again emerged among artists as a medium for finished sculpture. Claes Oldenburg used newspaper soaked in wheat paste over a wire armature to construct several papier mâché sculptures in the late 1950s, including *Empire (Papa) Ray Gun*, *Elephant Mask*, and *Street Head, I ("Big Head"; "Gong")*. In the two latter works, the choice of the medium may have been related to traditional uses of papier mâché for masks in other cultures. Oldenburg was also drawn to children's art as source material, and he favored wood and paper because of their organic qualities.

Sculptors have continued to use papier mâché, either alone or in combination with other media. Liza Lou constructed *Back Yard* (1995–97), comprising a picnic table, barbecue grill, lawnmower, hose, trees, flowers, laundry, and flamingoes, primarily of papier mâché covered with 30 million glass beads. Suzan Woodruff's *Burning Woman Project* (1999) contained a life-size papier mâché effigy of the artist. At the close of the exhibition, and in a way reminiscent of the festivals of Spain and Mexico, the effigy was ritualistically burned to symbolize the release from the physical form

of the body and liberation for the female body and spirit.

JEFFREY D. HAMILTON

Further Reading

Causey, Andrew, *Sculpture since 1945*, Oxford: Oxford University Press, 1998

Dambrot, Shana Nys, "Suzan Woodruff at Highways Gallery," *Artweek* 30 (December 1999)

Johnson, Ellen H., *Claes Oldenburg*, London: Penguin, 1971

Kuykendall, Karen, *Art and Design in Papier-Mâché*, New York: Hearthside Press, 1968

Meilach, Dona Z., *Papier-Mâché Artistry*, New York: Crown, 1971

Mertel, Timothy, "Gosho-Ningyo: Palace Dolls from the Ayervais Collection," *Arts of Asia* 26 (July/August 1996)

Meyer, Helga, *The Contemporary Craft of Papier Maché: Techniques, Projects, Inspirations*, Asheville, North Carolina: Lark Books, 1996

Penny, Nicholas, *The Materials of Sculpture*, New Haven, Connecticut: Yale University Press, 1993

Rich, Jack C., *The Materials and Methods of Sculpture*, New York: Oxford University Press, 1947; reprint, New York: Dover, 1988

Rose, Barbara, *Claes Oldenburg*, New York: Museum of Modern Art, 1969

Rush, Peter, *Papier Mâché*, New York: Farrar Straus and Giroux, and London: Pan, 1980

Schjeldahl, Peter, and Marcia Tucker, *Liza Lou*, Santa Monica, California: Smart Art Press, 1998

Toller, Jane, *Papier-Mâché in Great Britain and America*, Newton, Massachusetts: Branford, and London: Bell, 1962

Walkling, Gillian, "Papier Mâché," *Connoisseur* 204/821 (July 1980)

Wittkower, Rudolf, *Sculpture: Processes and Principles*, New York: Harper and Row, and London: Allen Lane, 1977

PARLER FAMILY German

The Parlers were a highly talented and prolific family of architects, sculptors, woodcarvers, and reliquary designers. Originally from Germany, they worked in several 14th-century centers, most notably in Prague, and their artistic influence spread throughout Central Europe, from the Rhineland to Austria and Poland. In the closing stages of the 14th century, the sculptural style of some members of the family and their workshop gave impetus to the development of the so-called *schöne Stil* (beautiful style).

The name of the family derives from the German word for a foreman (*Polier*, from the French *parleur*) and was not uncommon among medieval masons. This has often made the identification of the genuine members of the family difficult. Moreover, not all the Parlers used that name, but most seem to have used the identical mason's mark of a shield with a twice broken staff. Klezel has identified two different branches of the Parler family (see Thieme Becker, and Vollmer 1932). One evolved from Heinrich Parler (*fl.*

1330s–71), foreman at Cologne Cathedral and master of works at Holy Cross Minster in Schwäbisch Gmünd. The second branch was active in Ulm in the last quarter of the 14th century. Schock-Werner rejects Klezel's identification of some individual members of the family and modifies his numerical system used to differentiate them (see Schock-Werner, 1996). Only a few of the Parlers have been attributed with specific works of sculpture.

Peter Parler 1332/33–1399

Best documented is the work of Peter Parler, chief architect to Emperor Charles IV (*r.* 1347–78). An inscription above Peter's portrait bust in the triforium of Prague Cathedral identifies him as the son of Heinrich Parler, who worked with his father in Schwäbisch Gmünd. It is certain that Peter also worked alongside Heinrich in Nuremberg in the early 1350s at Church of Our Lady, where he has been credited with sculptures on the exterior facade of the western narthex. In 1356, at the age of 23, he was brought to Prague by Charles IV and put in charge of completing the cathedral choir (which had been begun by Matthias of Arras). The inscription further identifies him as the architect of the All Saints Chapel (1378–87) in Prague Castle, the stone Charles Bridge across the Vltava River, and the choir of St. Bartholomew's Church in Kolín, Bohemia, as well as the carver of the choir stalls (1386) for Prague Cathedral. Although Peter's style both as an architect and a sculptor seems to draw on a variety of sources, it is not known whether he traveled outside Germany during his *Lehrjahre* (apprenticeship years) or if he later accompanied Charles IV on his journeys to Italy and France.

Peter's activities as a sculptor were mostly connected with the rich sculptural program of Prague Cathedral. The weekly accounts for the cathedral recorded a large sum of money (900 groschen) paid to Peter in August 1377 for the effigy of Otakar I (*King Otakar I*), one of the six new tombs commissioned by Charles IV in honor of his predecessors on the Bohemian throne. Because of its documented attribution, the effigy is a fundamental work in Peter's sculptural oeuvre and an important example of his style, with its tendency toward monumentality, abstract linearism, and dramatic expressiveness. The same qualities characterize the effigy *King Otakar II*, which has been attributed on a stylistic basis directly to Peter rather than his workshop. Nevertheless, the large number of works—which included 21 busts on the interior and 10 on the exterior of the triforium, many carved consoles, capitals, and bosses, as well as numerous decorative masks—demanded the involvement of a large number of sculptors and stonecarvers, among whom were

probably two of Peter's sons and a nephew. Although attributing any individual work to Peter alone has often proved difficult, it is beyond doubt that he remained in overall charge of the workshop until 1392. Among the triforium busts of the Luxembourg family and the members of the court, Peter has been credited with those of Charles IV, Elizabeth Premyslovná, Anna of Pfalz, and John of Luxembourg (all 1374–80) and with his own *Self-Portrait* (see Legner, 1978). The busts are characterized by their high quality and finish, and the subtle modeling of the heads both captures the individual features of their subjects and strives to idealize them. Their presence in the triforium, which is unparalleled on this scale in Gothic art, links up iconographically with the position of the Bohemian rulers' tombs in the radiating chapels below. The different temporal spheres suggested by the dynastic program of the choir found their approximation in the style used by Peter and his workshop. The dignified pathos of the effigies, resembling Old Testament prophets and epitomizing Bohemia's past, is supplanted on the triforium level by the immediacy of the Luxembourg dynasty busts, emphasized by their fashionable attire, an engaging gaze, and varied, lively expressions.

Heinrich von Gmünd *ca.* 1354–after 1387

Another surviving work in Prague Cathedral clearly associated with the Parler family is the statue titled *St. Wenceslas*. The richly polychromed, two-meter-high statue of the saint presently stands on a plinth above the altar of the St. Wenceslas Chapel in the southwest corner of the choir, although it was probably originally intended for the canopied buttress on the exterior of the chapel. The base of the statue clearly displays the Parler mark, and the accounts for April 1373 mention 30 groschen paid to "Heinrich," probably Peter Parler's nephew Heinrich von Gmünd, for the five days, work on the statue. Heinrich's short involvement with the statue has prompted suggestions that its true author was Peter Parler himself, with Heinrich as his collaborator (see Hlobil, 1994).

Nevertheless, Heinrich von Gmünd was one of the most important and influential sculptors in the Parler family. Son of Peter Parler's brother, architect Johann von Gmünd (*fl.* Basel, Switzerland, 1356), Heinrich was probably trained at Schwäbisch Gmünd and perhaps at Freiburg, where his father worked on the new choir of the cathedral. After his employment in the Prague Cathedral workshop, he worked on Cologne Cathedral's St. Peter's Portal with Michael of Savoy (*d.* 1384/85), Peter Parler's son-in-law, although the precise chronology of Heinrich's presence there has been questioned. Between 1381 and 1387 Heinrich settled in Brno, Moravia, and worked as a court sculptor

to Jobst of Luxembourg, margrave of Moravia, where he probably created the refined *Pietàs* in St. Thomas's Church. He has also been associated with a series of *Pietà* in Wrocław, Poland (Muzeum Narodowe [National Museum]) and Klosterneuburg, Austria (Stiftesmuseum) and, more famously, with the superb female bust console bearing the Parler mark in the Schnütgen-Museum in Cologne. His delicate and sensitive style marked a shift in central European sculpture of the 1380s, toward the softer forms of the *schöne Stil* (Beautiful Style), and heralded the creation of a popular type of the Virgin and Child known as the *Schöne Madonna*.

ZOË OPACIC

Heinrich Parler *fl.* 1330s–1371

Biography
Probably born in Germany, early 14th century. Became active in Germany, 1330s; founded a renowned 14th-century dynasty of architects and sculptors; master of the works at Holy Cross Minster, Schwäbisch Gmünd, Germany, where he is credited with the nave; worked with his son Peter on the nave of the Church of Our Lady in Nuremberg; has also been linked with the work on the choir of Augsburg Cathedral, where some of the south portal sculpture bears the Parler mason mark. Died probably in Schwäbisch Gmünd, Germany, late 1370s.

Selected Works

1330s/ 1351– 1370s	Nave of the Holy Cross Minster, Schwäbisch Gmünd, Germany
1350s	Nave of the Church of Our Lady, Nuremberg, Germany
1356	Sculpture for choir; stone; Augsburg Cathedral, Germany (attributed)

Peter Parler 1332/33–1399

Biography
Born in Cologne or Schwäbisch Gmünd, Germany, 1332 or 1333. Son of Heinrich Parler, and brother to the architects Johann von Gmünd and Michael Parler. Trained as an architect and sculptor alongside his father at Schwäbisch Gmünd and Nuremberg, and probably spent time in the Rhineland; arrived in Prague as chief architect to Emperor Charles IV, 1356; in charge of building the choir of Prague Cathedral, where he set up a large workshop employing several members of his family; although linked with later work at Schwäbisch Gmünd, spent most of his working life in

Bohemia. Died in Prague, Bohemia (now Czech Republic), 13 July 1399.

Selected Works

1352	Sculptures; stone; Church of Our Lady, Nuremberg, Germany
1356–99	Tomb effigies *King Otakar I and King Otakar II* (attributed) and some of the triforium busts; limestone; choir, Prague Cathedral, Czech Republic
from 1357	Bridge over Vltava River (present-day Charles Bridge); stone; Prague, Czech Republic
from 1360	Choir; stone; St. Bartholomew's Church, Kolín, Czech Republic
ca. 1374–80	Busts of Charles IV, Elizabeth Premyslovna, Anna of Pfalz, and John of Luxembourg; limestone; triforium, Prague Cathedral, Czech Republic
ca. 1374–80	*Self-Portrait*; limestone; Prague Cathedral, Czech Republic

Heinrich von Gmünd *ca.* 1354–after 1387

Biography

Born *ca.* 1354, location unknown. Son of Johann von Gmünd; nephew to Peter Parler. Trained in Schwäbisch Gmünd, Germany, and perhaps alongside his father in Freiburg, Germany; worked, probably as a sculptor, for Prague Cathedral, until 1378; together with Peter Parler's son-in-law Michael of Savoy has been credited with the work on St. Peter's Portal (the south portal) of the west front of Cologne Cathedral, 1378–81; settled in Brno, Moravia, 1381, and worked as court sculptor to Jobst of Luxembourg, margrave of Moravia, 1381–87. Died in shortly after 1387, location unknown.

Selected Works

1373	*St. Wenceslas*; polychromed limestone; St. Wenceslas Chapel, Prague Cathedral, Czech Republic
1378–81	Sculpture for St. Peter's Portal (with Michael of Savoy); Cologne Cathedral, Germany (attributed)
ca. 1385	*Pietà*; limestone; St. Thomas's Church, Brno, Czech Republic (attributed)
ca. 1390	Female bust consol; limestone; Schnütgen-Museum, Cologne, Germany (attributed)
ca. 1390	*Pietà*; Stiftesmuseum, Klosterneuburg, Austria (attributed)

Further Reading

Benesovská, Klará, *Petr Parlér: Svatovítská katedrála, 1356–1399*, Prague: Správa Prazského Hradu, 1999; as *Peter Parler and St. Vitus's Cathedral, 1356–1399*, Prague: Prague Castle Administration, 1999

Hlobil, Ivo, "Gotické soha̧rství," in *Katedrála sv. Víta v Praze*, edited by Anezka Merhautová and Klára Benesovská, Prague: Academia, 1994

Legner, Anton, editor, *Die Parler und der schöne Stil, 1350–1400* (exhib. cat.), 5 vols., Cologne, Germany: Museen der Stadt Köln, 1978

Opitz, Josef, *Die Plastik in Böhmen zur Zeit der Luxemburger*, Prague: Stenc, 1936

Schock-Werner, Barbara, "Parler," in *The Dictionary of Art*, edited by Jane Turner, New York: Grove, and London: Macmillan, 1996

Thieme, Ulrich, Felix Becker, and Hans Vollmer, editors, *Allgemeines Lexikon der bildenden Künstler von der Antike bis zur Gegenwart*, 37 vols., Leipzig: Engelmann, 1932; reprint, Leipzig: Seemann, 1978

FILIPPO PARODI 1630–1702 *Italian*

Filippo Parodi played a chief role in the Genoese Baroque era, a role assigned to him already in contemporary biographies. He was trained as a woodcarver in his father's workshop, and sources indicate that he twice spent a long period of time in Rome, studying in Gianlorenzo Bernini's workshop. These stays in Rome, each one six years long, are difficult to date with any accuracy, but they are confirmed by the stylistic features of Parodi's works. Based on his documented Genoese works and on the contemporary sources, his first trip may have been in the 1660s (*ca.* 1661–67), and the second one in the 1670s (*ca.* 1674–77).

Parodi's second stay in Rome was particularly important for shaping his role in bringing Roman Baroque trends, principally those of Bernini, mostly on Pierre Puget's model, to Genoa. The main innovations that Parodi adopted were the conception of the autonomy of the figure sculpture from the architectural frame and, at the same time, the conception of an interrelationship between the figure sculpture and the entire decorative context.

Parodi also contributed to the renewal of the high altar structure. Such a structure was conceived as an autonomous sculptural monument, in which the figures are the focus and the whole creates a great scenographic effect, mainly in representing mystical visions or other religious miracles. One of the best examples of this effect by Parodi is the *Immaculate Conception* (1698) for the Church of San Luca in Genoa, where such scenographic elements as putti and clouds surround and expand the movement of the single statue.

An astonishing example of Parodi's work in the area of monumental decoration is the Cappella del Tesoro (1689–97) in the Basilica of Sant' Antonio in Padua. Here, Parodi directed the architectural work and designed and almost completely realized the rich sculptural decoration. The large chapel has a circular shape,

and on the curved wall in front of the entrance archway is the monumental Reliquary. It takes up a large part of the wall with three ample niches, which are flanked by statues of *Angels* bearing candlesticks and in which are marble cabinets containing ancient reliquaries. The whole architectural monument is crowned by many stucco statues of music-making *Angels* standing on the upper cornice and by a stucco group of *Saint Anthony of Padua in Glory*. On the ground level the whole is protected by a curved balustrade, at the extremities of which are two statues of saints. It also includes four monumental statues of Virtues. The whole has an extraordinary sumptuous effect through the use of materials and the virtuosity in the execution of the statues, particularly in the figures of *Humility* and *Penitence*.

Pierre Puget introduced an innovative method of marble carving to Genoa, which was continued by Parodi and his workshop, particularly Parodi's pupils Giacomo Antonio Ponsonelli and Domenico di Antonmaria Parodi. This new quality of marble carving aimed to exalt the different degrees of luminosity of the material, with pictorial effects and with a virtuoso search for a surface definition with rich refinement. Parodi's training and continued activity in woodcarving resonates in a peculiar feature of his marble carving: technical experimentation in the choice of instruments for each part of a work. This aspect is particularly evident in the handling of drapery, with his predilection for reiterated and deeply engraved creases, resulting in remarkable chiaroscuro effects. An amazing example of this in marble sculpture is in the funerary monument to Francesco Morosini; in wood carving it is exemplified in the *Pietà* in the Church of San Luca in Genoa. Parodi's predilection for the virtuoso execution of naturalistic details is traceable to his mastery of wood carving.

Remarkable also in Parodi's works is the search, mainly in the faces of his figures, for an emotive expressiveness, often very sensitive, tender, and languishing, such as in the *Hyacinth*. This interest also results in a more charged expressiveness in the works from Parodi's last years of activity, marked by a more dynamic and complex composition, as well as by a dramatic use of chiaroscuro contrasts. One of the most extraordinary achievements of this activity is the garden sculpture group of *Adonis Imprisoned by Cupid*.

Parodi's mature work in wood carving is interesting also for his concern in designing and executing objects for everyday use and for furniture such as frames and for figural basements for candlesticks. Parodi updated these works, which belong to the sector of applied arts, to the major directions in monumental decorative and sculptural trends. One such example is the wooden frame *The Judgment of Paris*. Probably originally used for a looking glass, it serves now as the frame for a portrait of *Maria Mancini* attributed to Pierre Mignard. In this case Parodi conceived the frame as an integration either of the image reflected or of the painting. Indeed, the myth represented in the frame correlates both to the image and the painting, portraying the beautiful woman in *The Judgment of Paris* as the winning Venus chosen by the shepherd. Thus, Parodi expressed a conventional panegyristic conceit by a composition of carved figures in direct relationship with the image or the painting for which the frame had been conceived. This is a striking example of the general aim of Parodi's art, to combine the different techniques into a unity, also a principal concern in Baroque art as a whole.

The remarkable production of garden sculpture by Parodi, mentioned by contemporary sources but now lost, demonstrates another aspect of this concern. In this case the sculpture must integrate itself in a naturalistic context. It should be noted that a number of sculptural portraits of Genoese aristocracy and garden sculptures by Parodi are known only from early documentary sources and are presently untraced.

One of the main features of Parodi's work was his capacity to integrate innovations from sculpture and from painting. A recurring topic of critical essays on the artist concerns the relation between Parodi's style and the style of contemporary Genoese painting, such as works by Domenico Piola and Gregorio de' Ferrari.

Choir candlestick sculpture with cherubs
© Araldo de Luca / CORBIS

FILIPPO PARODI 1630–1702

Indeed, there are documented cases of collaboration between Parodi and contemporary Genoese painters, such as Piola, in the production of polychrome wood sculptures.

FRANCESCA PELLEGRINO

See also **Puget, Pierre**

Biography

Born in Genoa, Italy, 1630. Son of Giovanni Battista Parodi, a woodcarver; father to two fresco painters. Worked primarily as woodcarver in early career, then concentrated on marble sculpture; first documented in 1670s; influenced by sculptor Pierre Puget in Genoa, 1661–67; completed important works in the Veneto, Italy; worked in Venice, *ca.* 1678 and 1687; worked in Padua, 1685 and 1689; workshop included Genoese sculptors Angiolo Rossi, Domenico di Antonmaria Parodi (not related), and Giacomo Antonio Ponsonelli. Died in Genoa, Italy, 22 July 1702.

Selected Works

late 1660s	*Seasons* (four allegorical figures); gilded wood; Villa Durazzo-Faraggiana, Albisola, near Savona, Italy
late 1660s	Two statues of *Telamon*; stone; Palazzo Brignole, Piazza della Meridiana, Genoa, Italy
late 1660s	*Virgin and Child*; marble; Church of San Carlo, Genoa, Italy
early 1670s	*Immaculate Conception*; marble; Conservatorio, Church of the Brignoline, Marassi, near Genoa, Italy
early 1670s	*The Judgment of Paris*; gilded wood; Galleria Nazionale di Palazzo Spinola, Genoa, Italy
ca. 1678–83	*Fame*, *Charity*, and *Time*, for funerary monument to Francesco Morosini; marble, painted stucco; Church of San Nicolò da Tolentino, Venice, Italy
ca. 1680	*Dead Christ* (with Domenico Piola); wood, polychromy; Monastero delle Teresiane, Savona, Italy
ca. 1680	*Lucretia*; marble; Ca' Rezzonico, Venice, Italy
ca. 1680	*Narcissus*, *Hyacinth*, *Clitia*, and *Flora*; marble, gold; Palazzo Reale, Genoa, Italy
ca. 1680s	*Adonis Imprisoned by Cupid*; marble; Galleria Nazionale di Palazzo Spinola, Genoa, Italy
1689–97	Sculptural decoration of the Cappella del Tesoro (with pupil Filippo Roncaioli): allegorical figures of *Humility*, *Penitence*,

Charity, and *Faith*; marble; *Saint Francis* and *Saint Bonaventura*; marble; *Saint Anthony of Padua in Glory*; stucco; *Angels*; stucco, white and polychrome marbles; Basilica of Sant'Antonio, Padua, Italy

early 1690s	*Immaculate Conception*; marble; Church of Santa Maria della Cella, Genoa, Italy
after 1692	*Ecstasy of Santa Marta*; polychrome marbles; high altar, Church of Santa Marta, Genoa, Italy
1698	*Immaculate Conception*; marble; high altar, Church of San Luca, Genoa, Italy

Further Reading

Boccardo, Piero, et al., "Il Seicento: Artisti e committenti nel segno del Barocco," in *La scultura a Genova e in Liguria*, vol. 2, Genoa, Italy: Pagano, 1989

Bresc-Bautier, Geneviève, et al., *Pierre Puget (Marsiglia 1620–1694): Un artista francese e la cultura barocca a Genova* (exhib. cat.), Milan: Electa, 1995

Davis, Charles, "Shapes of Mourning: Sculpture by Alessandro Vittoria, Agostino Rubini, and Others," in *Renaissance Studies in Honour of Craig Hugh Smyth*, edited by Andrew Morrogh et al., vol. 2, Florence: Giunti Barbera, 1985

Den Broeden, Frederick, "A Bust of Flora Attributed to Filippo Parodi," *Worcester Art Museum Bulletin* 2 (1973)

Ferrari, Oreste, "Parodi, Filippo," in *The Dictionary of Art*, edited by Jane Turner, New York: Grove, and London: Macmillan, 1996

Magnani, Lauro, and Daniele Maternati, "Filippo Parodi," in *Genova nell' età Barocca* (exhib. cat.), edited by Ezia Gavazza and Giovanna Rotondi Terminiello, Genoa, Italy: Nuova Alfa, 1992

Wittkower, Rudolf, *Art and Architecture in Italy, 1600–1750*, London and Baltimore, Maryland: Penguin, 1958; 6th edition, 3 vols., revised by Joseph Connors and Jennifer Montagu, New Haven, Connecticut: Yale University Press, 1999

PARTHENON *Athens, Greece, 447–432 BCE*

The Parthenon, the crowning monument of Athens's Golden Age, was constructed in the relatively short time from 447 to 432 BCE. Dedicated to Athena Parthenos (Virgin), this most prestigious Classical Greek temple stands today, in splendid ruin but with its glory undiminished, on the Acropolis, the high, naturally fortified plateau that in Preclassical Antiquity was simply the *polis* (city). It was built on a site occupied by one or more earlier temples, the most recent an unfinished "Parthenon" destroyed by the Persians during their sacks of the city in 480/479 BCE; the present building's plan probably incorporated some parts that remained from the aborted building.

The names of the men who were most closely associated with the Parthenon's creation are known, unlike the names of the builders of most Classical buildings.

Its architects were Iktinos and Kallikrates. The overseer of its sculptural decoration and the sole creator of its colossal gold-and-ivory cult statue was Pheidias. The man whose inspired patronage resulted in the building program on the acropolis and whose inspired politics presided over Athens's most fabled years was a military man, Perikles. His funeral oration on the dead of the first year of the Peloponnesian War, as recorded by the historian of that war, Thucydides, remains the best literary conceptualization of those years when Athens reigned as the tribute-collecting head of a confederacy of Greek city-states united in their efforts to prevent another Persian invasion—a phenomenon that is referred to somewhat controversially as the Athenian Empire and to which is owed the financing of the Periklean building program that included the Parthenon. The Athens that was called the "education of Hellas" in Perikles' funeral oration in 430 BCE was one whose twilight, sadly, was imminent. Devastated and demoralized, Athens would lose the war to the Spartans in 404 BCE; Perikles himself had died of the plague in 429 BCE.

The Parthenon is an unabashedly Athenocentric visual statement. It is made entirely of local Pentelic marble. It is the largest of Doric temples, yet its scale is still human, not divine, as is the case in most Egyptian temples. Although it can be said to be the paragon of Doric architecture, it is by no means the paradigm (that would be the canonical Temple of Zeus at Olympia). For a Doric building, it contains a surprising number of features more properly associated with the Ionic order—in particular, with the grandiose Ionic temples built by the eastern Greek kings and tyrants of the Archaic Period (for example, the earliest Temple of Artemis at Ephesus).

The scale of the building is Ionic. It contains an exceptional eight columns across the front, rather than the canonical six. Its back room, known in Antiquity as the Parthenon and which gives its name to the entire building, contains four freestanding Ionic columns at its center. Unlike other Doric buildings that are distinguished by their spareness, the Parthenon is embellished with decoration to its limits, characteristic of an Ionic building. Both of its pediments and all of its metopes were filled with sculpture. Most unorthodox of all, it contains the unprecedented feature of a continuous Ionic figural frieze running around the top of the exterior *cella* (the temple building proper, as distinct from its colonnade) walls.

The Parthenon is famous for its so-called optical refinements, described at great length (but without mentioning the Parthenon specifically) by the Roman architect Vitruvius in his *De Architectura* (1st century BCE) the only intact architectural treatise that we have from Antiquity. These refinements consist of a series

Battle between Lapiths and Centaurs (Centaur carrying away a woman), south metope, the Parthenon
© Alinari / Art Resource, NY

of customized features such as the deliberate curving, swelling, and tapering of the contours of most of its members, whose cumulative result is a visual sensation that the entire building pulses like a living organism, and the enlargement of its corner columns so that the integrity of their mass and profile are preserved when viewed against the backdrop of the relentless Mediterranean sun.

Much is known about the construction of the Parthenon because of the survival of a series of yearly inscribed building accounts that were kept, recording exactly what was done, by whom, with what materials, and for how much, among other practical matters. Between what we know from the building accounts and what we can surmise from other evidence, the following order is suggested for the completion of the various components of the Parthenon's sculptural decoration: the metopes were the earliest; then the frieze; the statue was dedicated in 438 BCE; and the pedimental figures were in place by 432 BCE.

The 92 metopes are fragmentary, with those of the south being in the best condition. As with all of the Parthenon's sculptural decoration, the preserved remains can be supplemented by a valuable series of drawings made by the artist Jacques Carrey, who accompanied the French ambassador on a visit to Athens in 1674, just before the shelling of the building by the

The Ergastines, a fragment of the frieze of the Panatheneans, the Parthenon
© Erich Lessing / Art Resource, NY

Venetians in 1687 that left the Parthenon in its present state of destruction. The metopes are rendered in high relief, with some figures nearly in the round. The metopes to the south show the battle between lapiths and centaurs (centauromachy), the same subject that had been featured in the west pediment of the Temple of Zeus at Olympia and that was a perennial favorite of Greek artists in all media. The metope to the west displayed the battle between Greeks and Amazons (Amazonomachy), the east, the battle between gods and giants (gigantomachy), and the extremely fragmentary north, the Trojan War, although the last is not certain.

All these subjects may have been thought of as mythological precursors of the most recent real-life struggle between Greeks (read "civilization") and barbarians—the Persian Wars—in which Athens had played the starring role and had subsequently emerged as the acknowledged military and cultural leader of all Greece. The style of the metopes is distinctly early, showing multiple variations on a rather simple theme consisting of tensed, muscular equine body displayed against that of man in a chiastic (X-shaped) arrangement. The various anatomies are masterfully carved, yet still limited by the Early Classical idiom.

Athenocentrism becomes even more overt in the iconography of the pediments. The figures in the round are carved fully, front and back. The east pediment showed the birth of Athena. We may never be entirely certain of the exact composition or even of the identification or the arrangement of the fragmentary figures that we do possess. One prevailing theory has Zeus seated on a throne and a tiny, fully grown, fully armed Athena emerging from his head. The other (more likely) theory has the two deities side by side, equal

in scale and power. The west pediment showed the contest between Athena and Poseidon for rulership of Athens. (The olive tree that won Athena the honor still grows—so it is claimed—on the acropolis near the Erechtheum, begun a few years after the completion of the Parthenon, and Poseidon's trident marks can still be seen through an opening in the floor of the north porch of the Erechtheum.) In this case, although the remains are even more scarce, two powerful, fragmentary torsos prove that the central group consisted of the two deities confronting one another in dramatic chiasm. The distinctive sculptural style displayed in all of the draped figures from the Parthenon pediments became perhaps the most influential of all Greek art; what is sometimes referred to as the "wet look" in drapery—in actuality, an expressionistic, chiaroscuric handling of what had been a static element until the Parthenon, resulting in some of the most active, energetic surfaces in the history of marble sculpture—dominated the Late Classical style and led directly to such Hellenistic works as *Nike of Samothrace*, which dates from the 3rd to 2nd century BCE.

Most controversial has been the Parthenon frieze, to some the masterpiece and epitome of Classical low relief carving. Its subject has been identified since the 18th century as the Panatheniac procession held every four years in honor of Athena at which her "ancient image" (housed not in the Parthenon but in another, still unidentified building) received a new dress, a *peplos* freshly embroidered with the story of the Gigantomachy (as in Euripides' *Hecuba*). The transmission of that garment is depicted in a scene directly over the front (east) door of the temple. The fact that some of the elements of the procession as known from numerous literary sources are missing has, however, left room for continual reinterpretations of the iconography of the frieze. No iconographical element of the frieze—the cavalcade, the offering-bearers, the maidens, the eponymous heroes, the pantheon of seated gods, and especially the *peplos* scene sandwiched between the two groups of deities—has been immune from controversy.

Other apparent incongruities in the frieze have given rise to a variety of explanations. The issues of space, time, and the more pragmatic one of viewing have occupied the attention of many scholars. The vignettelike sequences (appropriate, perhaps, for a frieze viewed through a colonnade) in which the narrative unfolds might be compared with literary *ekphrasis*, the archetype of which is the description of Achilles' shield in book 18 of Homer's *Iliad*. The figures on the frieze occupy space that is indefinable, immeasurable, basically undifferentiated, and sometimes downright irrational, having been assigned by and thus answerable only to the artist's discretion. Like the Parthenon

itself, its sculptured frieze is full of optical refinements that may be identified, given names, and catalogued, but whose overall effect is nearly impossible to articulate. And because of its placement directly under the ceiling of the colonnade, whether anyone was able to appreciate the frieze as fully as today's museum visitor can remains a question.

The colossal *chryselephantine* (sculptures of wood, ivory, and gold that suggest drapery over flesh) cult statue of *Athena Parthenos*—the *raison d'être* of the Parthenon and of which not a trace remains—was created entirely by Pheidias, without the help of assistants. Although we do not know for certain where and how to detect the master's hand in the rest of the Parthenon's sculptural program, literary sources tell us that because of the intrinsic value of the materials for this statue, only one person, the artist himself, was entrusted with them. The gold, sometimes thought to have represented the entire wealth of the Delian League over which Athens exerted control, was weighed before the artist entered his studio and again when he emerged from his day's work. Pheidias twice found himself in legal trouble over the making of the statue, once when he incurred the jealousy of the people for portraying himself and his patron, Perikles, among the Greeks in the Amazonomachy that decorated the exterior of the Parthenos's shield, and again when he was accused, unfairly, of embezzling some of the gold, which led to a trial and possibly to the artist's imprisonment.

The statue's awesome appearance has been re-created with virtual certainty from ancient copies and literary accounts. The figure stood nearly 12 meters high, wore a triple-crested helmet, and was draped with a snaky-edged aegis decorated with a gorgon's head. It held a life-size golden Nike (Victory) in its right hand and with its left clasped a spear and a shield carved with figural imagery inside and out, with a huge snake curled within. It stood on a base decorated with a scene of the birth of Pandora. A reflecting pool in front mirrored the image, effectively doubling its size, and prevented the ivory from cracking.

The post-Classical history of the Parthenon and its sculptures is one of neglect and despoliation, salvation as a Christian church and a mosque, wanton destruction and more despoliation (the continued presence in the British Museum of what are known as Lord Elgin's marbles, taken from the Parthenon in the early 19th century while Greece was still under Ottoman rule, remains a hotly debated international ethics issue), restoration, and, finally, preservation and conservation. In the late 20th century there was a ten-year-long restoration project that featured the most up-to-date materials and methods. The few sculptures that had remained *in situ* were removed for safekeeping in the Acropolis Museum. For all those who revere Western civilization

and its monumental achievement, the Parthenon stands alone, an unparalleled reminder of the mental and physical capabilities of mere mortals—mortals who turned the tables on the gods by creating the gods in their own likeness, mortals who so reveled in their very humanity that they dared to attribute human qualities and behaviors to their immortals.

MARY STIEBER

See also **Chryselephantine Sculpture; Greece, Ancient;** *Nike of Samothrace***; Pheidias; Temple of Zeus, Olympia**

Further Readings

Berger, Ernst, editor, *Parthenon-Kongress Basel*, Mainz, Germany: Von Zabern, 1984

Boardman, John, *Greek Sculpture: The Classical Period*, London and New York: Thames and Hudson, 1985

Boardman, John, *The Parthenon and Its Sculptures*, Austin: University of Texas Press, and London: Thames and Hudson, 1985

Bowie, Theodore Robert, and Diether Thimme, *The Carrey Drawings of the Parthenon Sculptures*, Bloomington: Indiana University Press, 1971

Brommer, Frank, *Die Parthenon-Skulpturen: Metopen, Fries, Giebel, Kultbild*, Mainz, Germany: Von Zabern, 1979; as *The Sculptures of the Parthenon: Metopes, Frieze, Pediments, Cult-Statue*, translated by Mary Whittal, London: Thames and Hudson, 1979

Bruno, Vincent J., editor, *The Parthenon*, New York and London: Norton, 1974

Cook, B.F., *The Elgin Marbles*, London: British Museum, and Cambridge: Harvard University Press, 1984

Hurwit, Jeffrey M., *The Athenian Acropolis: History, Mythology, and Archaeology from the Neolithic Era to the Present*, Cambridge and New York: Cambridge University Press, 1999

Jenkins, Ian, *The Parthenon Frieze*, Austin: University of Texas Press, and London: British Museum Press, 1994

Leipen, Neda, *Athena Parthenos: A Reconstruction*, Toronto: Royal Ontario Museum, 1971

Michaelis, Adolf Theodor Friedrich, *Der Parthenon*, Leipzig: Breitkopf und Härtel, 1870–71

Robertson, Martin, *The Parthenon Frieze*, New York: Oxford University Press, and London: Phaidon, 1975

PATINATION AND GILDING

Although the term *patina* is associated primarily with bronze, the metal traditionally and most closely associated with sculpture, most metals take a patina. Rust on a car, for example, may be a corrosion problem to the owner, but it is also a patina of dark reds and rich browns. Silver tarnishes gray-blue to black, lead oxidizes to a delicate dove gray, copper to bright green, and so on. Patination is essentially a form of corrosion. Various minerals that come into contact with the metal surface react electrolytically when moisture is present and combine with oxygen to produce colored oxides.

Metal surfaces also combine with oxygen when subjected to heat. These reactions may happen accidentally, for example, when sculptures have been lost in shipwrecks; incidentally, when sculptures have become buried; during the manufacturing process or in day-to-day use; or intentionally, when the sculptor exploits the phenomenon by artificial patination.

In order to produce an artificial patina the metal must come into contact with chemicals that will react with it, given the proper conditions, in a controlled manner. Many variables may affect the process: some chemical solutions work if they are painted or sponged over the surface cold; others require a hot surface; some must be brushed vigorously with a stiff or wire brush. In addition, the metal may need to be immersed into the solution for a period of time, buried in a mixture of wood dust and the solution, wreathed in fumes from the boiling solution, wrapped in saturated cloths, or subjected to the solution's application in spray or paste form. Initially, the patinator applies an artificial patina to the surface of a bronze at a foundry or in the sculptor's studio, for which an extensive palette of colors is available. The patina is an integral part of the sculpture; it affects and enhances the form and the surface texture. In creating the sculpture, the sculptor must be aware of the effect of the applied patina. For example, a patinating compound will react differently on a polished surface compared with its effect on a rough, textured surface. The skilled patinator may emphasize the form by visually deepening hollows with a cold, dark, dense color and raise highlights with a light, warm color. The variables are infinite; one can apply different patinating solutions—which can range from simple salt and vinegar, which produces a dark green on bronze, to complex combinations of highly toxic chemicals, acids, and alkalis in volatile solutions—over ground colors, the patina can be selectively cut back to reveal the glow of the underlying bronze, or it can be adjusted with pigments, powdered graphite, or gold dust mixed into wax or lacquer. No single definitive means exists for arriving at the sculptor's patina.

Sculptors need to be knowledgeable in the craft of patination in order to make a sculpture look a certain way, knowing and accepting that time can also bring about change. The Castle Fine Art Foundry in Wrexham (Powys, Wales), for example, created a particularly gorgeous patina of greens with subtle flashes of rich red for Harry Everington's The Crusader (2000) at Witley Court (Worcestershire, England). The sculpture is unwaxed because Everington wanted the work to change and develop.

Evidence suggests that the use of artificial patination began relatively early in the history of metalworking. By the 12th century CE, Chinese metalworkers referred to surviving ancient bronzes from the Shang and Chou dynasties (1523–249 BCE), which by then had acquired natural patinas that the metalworkers reproduced and developed with artificial patination.

In Japan the craft of fine metalworking and patinating was elevated to an art form. Artists made objects in sophisticated alloys, frequently inlaid with or combined with other alloys or metals and given varied textures to achieve maximum effect from patination.

By the 8th century BCE, Greek sculptors who had learned the techniques from the Egyptians established the art of making bronze sculpture in the European Classical world. Greek public and architectural sculptures were often painted, but later, both in Greece and in the Roman Empire, there developed an appreciation of patinas, sometimes induced, sometimes allowed to form naturally, and sometimes adjusted by a coating of oil or resin.

The distillation of mercury in China led to the discovery of fire gilding, an extremely dangerous process by which an amalgam of mercury and gold was made into a paste and painted onto the cleaned surface of the parent metal. By this means, artists could decorate selected areas precisely with gold. The metal was heated and the mercury vaporized, leaving the gold firmly adhered.

The Romans had learned the Chinese technique of fire gilding but also used leaf gilding, producing a similar effect, but by a very different process. The gilder beats the gold into leaves of tissue thinness, reduced to such an extent that it becomes semitransparent and needs a colored undercoat—reds to lend richness or yellows to add brightness. The gold is then stuck to the surface to be gilded with a "size," paint or lacquer that becomes tacky before it dries completely. The gilder has to judge the point of optimum adhesion and then applies the gold leaves, finally burnishing it to achieve maximum contact before the size matures.

After the fall of the Roman Empire, the understanding of the chemistry associated with metals developed as a derivative of alchemy. Although it was a muddled mix of science, myth, and magic, artists learned much along the way about mineral pigments, alloying, and coloring metal, which laid the groundwork for developments in patinas in 15th-century Italy.

During the Renaissance, connoisseur collectors avidly acquired Classical antiquities, which in turn influenced sculptors of the day. Like the Chinese metalworkers before them, they also valued the naturally acquired patina of age and set about reproducing and developing such patinas. The 16th-century art historian Giorgio Vasari describes how bronze was colored using oil, colored varnishes, and vinegar (see Vasari, 1907). All the techniques that Vasari discusses were

used, sometimes in combination, and some sculptors developed their own distinctive identifying patinas.

The mid 19th century in the rich industrialized countries of Europe saw an increased demand for sculpture—made possible by technological advances in the metalworking industries—and a renewed acceptance of polychromy on sculpture and advances in artificial patination. Sculptors, metalworkers, and metallurgists worked together to expand the available palette; in addition, Japanese techniques were introduced. A contemporary commentator described green patinas that could be made to appear new or old depending on the colors applied to the high points. Pale silver grays also existed, as well as patinas of random red flecks that created the impression of poppies in a cornfield and others that gave the impression of red wallflowers against green foliage. Despite the introduction of new materials in sculpture and changes in aesthetics in the 20th century, patinating skills have been preserved and a huge palette is still available to the sculptor who works in bronze.

ANDREW NAYLOR

See also **Metal Casting; Polychromy**

Further Reading

Blühm, Andreas, et al., *The Colour of Sculpture, 1840–1910*, Zwolle, The Netherlands: Waanders, 1996
Hughes, Richard, and Michael Rowe, *The Colouring, Bronzing, and Patination of Metals*, London: Crafts Council, 1982; New York: Reinhold, 1983
Mattusch, Carol C., *Classical Bronzes: The Art and Craft of Greek and Roman Statuary*, Ithaca, New York: Cornell University Press, 1996
Mitten, David Gordon, and Suzannah F. Doeringer, *Master Bronzes from the Classical World*, Mainz, Germany: Von Zabern, and Cambridge, Massachusetts: Fogg Art Museum, 1967
Vasari, Giorgio, *Vasari on Technique*, translated by Louisa S. Maclehose, edited by Gerard Baldwin Brown, New York: Dutton, and London: Dent, 1907; reprint, New York: Dover, 1960

PERFORMANCE ART

Performance art is a diverse practice that encompasses many genres of the visual arts, such as sculpture, painting, film, video, and photography, as well as more theatrically based disciplines of poetry, music, and dance. Performance art moves within concepts of real time; often artists perform in front of an audience, but it can also be a solitary, private event. Performance draws on notions of ritual, action, and gesture to convey themes that generally center on ephemeral expressions of ideas, the artist's body, sociopolitical statements, and an exploration of space and time. Because performance art is transient and often takes place outside the art museum, it defies the premise of conventional art-making practices and survives after the event through photographic or film documentation. Writers, artists, and philosophers such as Lucy Lippard, RoseLee Goldberg, Lea Vergine, and Amelia Jones have written extensively on performance art, developing the understanding of the use of the artist's body in art.

Performance art became a widely explored genre during the 1960s and 1970s. Precedents for performance art can be found, however, in the work of the Italian Futurists, the Swiss Cabaret Voltaire, the German Dadaists, Marcel Duchamp, the Surrealists, and the Bauhaus. Performance has long been considered a way of bringing to life the many formal and conceptual ideas on which the making of art is based.

Futurists, Dadaists, and Surrealists in the first decades of the 20th century engaged in performance activity as a radical means to attack aesthetic and social norms. These avant-garde movements staged provocative performances based on chance and nonintentional actions that forced otherwise passive audiences to react. One such precedent to performance art is French playwright Alfred Jarry's *Ubu Roi* (1896), in which the satirical and sordid content of the play enraged the public and generated riots.

Established in 1933, Black Mountain College in North Carolina attracted a community of artists and students due to its diverse curriculum and experimental focus on performance. Collaborative energy at the college increased in momentum during the 1940s with the introduction of musician John Cage and dancer-choreographer Merce Cunningham to the teaching program. They believed that one could incorporate everyday sound and movement into the choreographed or composed sequence rather than solely relying on rhythm or narrative. Cage was influenced by Zen Buddhism, Futurist manifestos such as Luigi Russolo's *The Art of Noises* (1935), and Marcel Duchamp's Dada gestures; he based his compositions on notions of fluency, interchangeability, indeterminacy, and "nonintentional" music. In 1952 Cage's experimentation led to the silent work *4'33"*, which the score describes as "a piece in three movements during which no sounds are intentionally produced" (see Goldberg, 1978).

Untitled Event (1952) at Black Mountain College set a precedent for many of the performance actions that would take place during the 1960s. The event offered new unlimited possibilities for future collaborations between artists, such as the collaboration of Robert Rauschenberg with the Judson Dance Group in New York City during the 1960s, in which Rauschenberg's costumes and sets reflected the Minimalist tendencies in dance theory and practice at that time.

American performance artist Allan Kaprow collaborated with John Cage in 1956 and, along with other

young artists such as Jim Dine, Al Hansen, and Claes Oldenburg, conducted performances that were an extension of everyday life. Kaprow's *18 Happenings in 6 Parts* (1959) at the Reuben Gallery, New York City, carried the idea of complete participation into the public arena and was the first official Happening. Happenings became popular events during the 1960s and 1970s with the Gutai Group, the Fluxus movement, and artists such as Oldenburg, Rauschenberg, Roy Lichtenstein, and Joseph Beuys developing the idea in other avant-gardist centers around the world.

The French artist Yves Klein extended the idea of the body as a prime repository of meaning through his famous *Leap into the Void* (1960) and *Anthropométries of the Blue Period* (1960). Klein believed that the body is the center of spiritual and sensorial energy. The *Anthropométries of the Blue Period* involved the application of paint directly onto the bodies of naked women who were then dragged across the surface of white paper on the floor. The Italian artist Piero Manzoni also engaged with the body in a performative manner, literally signing people to create living works of art in *Living Sculpture* (1961) and selling inflated balloons in *Artist's Breath* (1961).

The English artists Gilbert Proesch and George Passmore performed as living sculptures in London during the late 1960s and 1970s. Dressed in suits and silver-painted faces, the artists silently mimed the words to the Victorian song *Underneath the Arches* (1969) to crowds of hippies. In 1970 they conducted the performance seven hours a day for five days at the Nigel Greenwood Gallery, London, and subsequently in 1991 at the Sonnabend Gallery, New York.

American performance artist Carolee Schneemann, through such performances as *Eye Body* (1963), *Meat Joy* (1964), *Interior Scroll* (1975), and *Up to and Including Her Limits* (1976), deployed her body in her work as a gestural extension of painterly constructions and as a way of challenging formal patriarchal assumptions within art-world hierarchies. In *Eye Body*, Schneemann, her face and body marked with strokes of paint, established her body as visual material within a haptic setting of large panels, broken mirrors, and motorized parts. Her feminist performance work moves within the genre of Body art, which is "antiformalist in impulse, opening up the circuits of desire informing artistic production and reception" (see Jones, 1998).

Performance art during the 1960s and 1970s opened parameters for women artists to transcend given artistic structures, offering a means to collaborate and to produce performances that critiqued not only hegemonic art-world discourse but also gender politics. Other women to make an impact through body-oriented performance art included Yayoi Kusama, Shigeko Ku-bota, Karen Finley, Hannah Wilke, Suzanne Lacy, and Ana Mendeita.

The breaking down of the boundaries of art and life informed performance art practice in the 1970s and 1980s, with artists creating visual bodily ciphers through gesture and ritual. Joseph Beuys, Bruce Nauman, Vito Acconci, and Dennis Oppenheim all conducted performances that "examined boundaries between the body and its environment, social limitations and the interior and exterior of the body" (see Warr and Jones, 2000). These gestures commented on a myriad of conditions such as race, class, gender, and environmental and political issues. Beuys's expanded idea of art was to incorporate all creativity within what he termed "social sculpture." His performances *Eurasia* (1967) and *I Like America and America Likes Me* (1974) conveyed the idea of the artist as a teacher and shaman, able to heal the world's "vast wound" through ritual. In *How to Explain Pictures to a Dead Hare* (1963) at Galerie Schmela, Düsseldorf, Beuys poured gold and honey over his head and cradled a dead hare in his arms. He carried the hare over to paintings hung on the walls of the gallery and explained their origins and concepts since "a hare comprehends more than many human beings with their stubborn rationalism" (see Warr and Jones, 2000). Beuys's use of material as signifiers for greater understanding of the corporeal and spiritual worlds—his desire to address the alienation people experience living in an age of global uncertainty translated through numerous actions—influenced many subsequent performance artists.

Viennese Actionists in Germany, including Gina Pane, Chris Burden, Valie Export, Mike Parr, Bob Flanagan, Annie Sprinkle, and Marina Abramovic, engaged with what is considered to be ritualistic and transgressive Body art. For instance, Herman Nitsch's *Orgies Mysteries Theater* (1984) "incorporated ritual sacrifice of animals and destruction as a vehicle for purging and catharsis" (see Warr and Jones, 2000). Pushing the boundaries of the artist's body and, indeed, the limits of accepted artistic behavior, transgressive performance artists incorporate deliberate risk, danger, and pain to protest the complacency they see inherent in Western society and to research through identity-seeking rites, such as Abramovic's *Rhythm O* (1974), the dynamics of corporeal and psychological exchange.

Beginning in the late 1960s, Australian and New Zealand artists started using the multidisciplinary performance premise. Stelarc from Australia suspended himself in space by meat hooks inserted into his skin in *Event for Stretched Skin* (1976) and investigated the use of technology interacting with the body, as in his prosthetic "third hand" designed and produced for him by Japanese robotic engineers. Leading New Zealand

sculptor Andrew Drummond began his career as a performance artist during the 1970s after contact with Beuys in Canada. Drummond's actions centered on the transformative potential of material to heal an environment in the South Island of New Zealand under threat of pollution, as in the private performance *Filter Action* (1980). Dressed in white, the artist metaphorically investigated the filtering benefits of an animal kidney into the estuary through a series of intricate gestures that included spitting a kidney into the mud.

Performance art in the 1990s and beyond has continued to raise questions about the nature of art and identity, questioning the relationship between artist and spectator in often highly politicized terms. The performance artist Orlan broadcast her performance *Omnipresence* live via satellite from a New York gallery in 1993 to 15 sites worldwide. This and other of Orlan's "performance-operations" are elaborate events whereby the artist undergoes facial surgery during the broadcast in order to remold herself in the images of famous idealized beauties depicted in paintings and sculpture across the ages. Vanessa Beecroft subverts the exchange of the gaze by commandeering a given classification of person, young vulnerable women or military men, to pose for long lengths of time. In *VB 39, US NAVY* (1999) at the Museum of Contemporary Art, San Diego, for example, self-controlled uniformed navy SEALs silently confronted the collective gaze of the audience imposed upon them by the artist.

In 1998 the Museum of Contemporary Art, Los Angeles, organized a major exhibition examining action and the artist's body as sculptural material. *Out of Actions: Between Performance and the Object, 1949 to 1979*, comprised of substantial photodocumentation of artists' work during that period, examined the process and circumstances leading to performance art's ongoing and dynamic influence on how art is produced and viewed.

JENNIFER HAY

See also **Beuys, Joseph; Dine, James Lewis; Duchamp, Marcel; Klein, Yves; Manzoni, Piero; Oldenburg, Claes; Segal, George; Surrealist Sculpture**

Further Reading

Armstrong, Elizabeth, and Joan Rothfuss, *In the Spirit of Fluxus*, Minneapolis, Minnesota: Walker Art Center, 1993
Goldberg, RoseLee, *Performance: Live Art, 1909 to the Present*, New York: Abrams, 1978; London: Thames and Hudson, 1979; revised and enlarged edition, as *Performance Art: From Futurism to the Present*, New York: Abrams, and London: Thames and Hudson, 1988
Jones, Amelia, *Body Art/Performing the Subject*, Minneapolis: University of Minnesota Press, 1998
Lippard, Lucy, *Six Years: The Dematerialization of the Art Object*, London: Studio Vista, and New York: Praeger, 1973
Marsh, Anne, *Body and Self: Performance Art in Australia, 1969–92*, South Melbourne, Victoria, and New York: Oxford University Press, 1993
McEvilley, Thomas, "Art in the Dark," *Artforum* (Summer 1983)
Rush, Michael, *New Media in Late 20th-Century Art*, New York: Thames and Hudson, 1999
Schimmel, Paul, editor, *Out of Actions: Between Performance and the Object, 1949–1979*, Los Angeles: Museum of Contemporary Art, and London and New York: Thames and Hudson, 1998
Schneemann, Carolee, *More than Meat Joy: Complete Performance Works and Selected Writings*, New Paltz, New York: Documentext, 1979; 2nd edition, Kingston, New York: Documentext/McPherson, 1997
Tisdall, Caroline, *Joseph Beuys*, New York and London: Thames and Hudson, and New York: Guggenheim Museum, 1979
Vergine, Lea, *Body Art and Performance: The Body as Language*, Milan: Skira Editore, 2000
Warr, Tracey, and Amelia Jones, *The Artist's Body*, London: Phaidon, 2000

PERGAMON ALTAR (GREAT ALTAR OF PERGAMON)

Anonymous
166–156 BCE
marble
h. of frieze 2.3 m; h. of monument 42 m
Staatliche Museen, Berlin, Germany

The Great Altar of Pergamon is one of the most important and well-preserved original monuments of Hellenistic art. Its marvelously detailed and beautifully carved gigantomachy (battle between gods and giants) frieze, which decorates the altar's podium, is a spectacular example of the Hellenistic Baroque style. The Telephos frieze, which decorates the inner wall of the altar court and tells the life story of the mythical founder of Pergamon, uses many innovative pictorial devices, such as continuous narrative, developed for and borrowed from Hellenistic monumental painting. The Great Altar of Pergamon was dedicated in the first half of the 2nd century BCE, probably by the Pergamene king Eumenes II after the Peace of Apamea in 188 BCE, a victory that secured Attalid power. The sculpture from this monument not only provides important evidence for the style and technique of Hellenistic sculpture but also gives us a crucial fixed point for assessing and dating other less well documented examples. The fine preservation, virtuoso carving, secure provenance, and known date make the Great Altar of Pergamon central to the study of Hellenistic art.

The altar consists of a monumental stepped platform and a tall, sculpted podium topped by an Ionic colonnade. A grand stairway set between the podium's two projecting wings leads up to the altar proper, accessible

through a double columnar screen. This sacrificial altar is set in the middle of a court that is enclosed by a second, smaller Ionic colonnade, whose back wall is decorated with the Telephos frieze. The most recent reconstruction shows the altar literally covered in sculptural decoration: life-size draped statues stand in between each of the Ionic columns on the facade, four-horse chariots decorate the roofline, and statues are even placed on top of the sacrificial altar (see Hoepfner in Dreyfus and Schraudolph, 1996). Altars were, in fact, transformed and monumentalized in the Hellenistic period through the incorporation of design elements usually associated with Classical temple architecture, such as colonnades, relief sculpture, and freestanding statues. The Great Altar of Pergamon is simply the largest and best preserved example of this new trend in Hellenistic altar architecture.

The altar's colossal gigantomachy frieze is 2.3 meters high and 110 meters long and is almost completely preserved. The figures, which originally numbered about 100, are carved in extremely high relief so as to be nearly three-dimensional. They fill the entire height of the frieze in a thundering mass of limbs, wings, and scaly snake and fish legs. The divine and monstrous figures twist and turn in space; some confront and threaten the viewer, and some even invade real space by spilling out onto the steps of the monumental staircase. In one detail, for example, Artemis, dressed in a knee-length sleeveless tunic and short boots, and armed with a bow and quiver, strides vigorously forward to attack a young helmeted and armed giant. In her haste, she steps on the chest of a dead giant lying on the ground beneath her. Artemis's horned, lionlike dog assists his mistress by sinking his teeth into the head of a large snake-legged giant, who tries to defend himself by poking out the dog's eye. This giant's contorted face, thick wild hairlocks, and underarm hair signify his status as uncivilized and barbarous.

The particulars of the figures—feathers, scales, skins, hair, clothing, attributes, weapons—are elaborately carved in precise detail. Such virtuoso technique and lavish attention to details were usually reserved in the Hellenistic period for bronze statuary and are highly unusual in architectural relief sculpture. Also unusual in this context is the inscribing of the names of those who carved the relief; sculptor's signatures

Overall view of the Great Altar, from Pergamon
© Erich Lessing / Art Resource, NY

are usually only found in association with freestanding statues. The names of 16 sculptors are preserved, inscribed on the molding below the section of the frieze for which they were responsible. The names of the gods and giants are similarly recorded. The care and attention invested in carving and finishing the frieze, as well as the thoughtful planning of the program, with all the figures helpfully identified for the viewers, show the elevated aesthetic importance given to this frieze. The ambitiousness of the project and its unusually high aesthetic value rival, perhaps deliberately, that of the sculptures of the Parthenon. That is, while the subject of the frieze—the mythical battle between the gods and giants—surely functions on one level as a reference to the victory of the Attalids over the Gauls, it was also closely associated in this period with both mythical and historical Athenian victories over invading barbarian hordes. The use of this subject on the Great Altar, then, surely also framed Pergamon as a new Athens by elevating its military achievements to the level of the Athenian victory at Marathon. This desire on the part of Pergamon to cast itself as the new defender of Greek civilization and culture is also expressed in other Pergamene building projects, such as the Sanctuary of Athena Polias, located on the terrace above the Great Altar.

The Telephos frieze presents a stark contrast to the tumultuous tenor of the gigantomachy frieze. The Telephos frieze, which ran around the inner wall of the altar court, is 1.58 meters high and about 80–90 meters long. It is much less well preserved than the gigantomachy frieze, with sections originally left unfinished in Antiquity. The figures are carved in low relief, with details of setting and location carefully delineated. Rocks, hills, and trees denote outdoor locations; pillars, curtains, and thrones indicate indoor settings. In contrast to the gigantomachy frieze, whose subject, depicted at a single moment in time, is easily understood, the story of the Telephos frieze, told in narrative time that is both continuous and episodic, is complex and difficult to decipher in places. With no helpful inscriptions to identify the figures, which may have numbered over 200, and with its sometimes abrupt changes in time and place, the viewer must follow the story carefully in order to understand what is happening.

The basic outlines of the story, nonetheless, are clear. The frieze illustrates the life of Telephos, from his birth in Arcadia—the offspring of Hercules and Auge—to his death in Pergamon. In between are depicted his many adventures, including his arrival in Mysia, the region in which Pergamon is located, his wounding by Achilles, and his trip to the court of Agamemnon in Argos to find a cure for his wound. In one detail, four women set up a cult to Athena, one of many

such cult scenes included on the frieze. This scene surely depicts the founding of the cult of Athena at Pergamon by Auge. The women, dressed in their finest clothing and carrying sacred vessels and fillets, approach and decorate the cult statue of the goddess that stands on the pedestal at the left of the scene. The cult is located outdoors, as indicated by the leaves in the upper right corner. Here we also see an unfinished section of the frieze—a rectangular raised section of stone with a rough surface finish that was never brought down to the smooth level of the background. The story of Telephos as presented in the frieze seems to be an Attalid invention, combining several different strands of myth to create a new, more complete, and more coherent narrative. With his connections both to Greece and the prestigious Trojan cycle, Telephos offered the Attalids the perfect mythical founder for their dynasty.

Most of the fragments of sculpture and architecture from the Great Altar were discovered by Carl Humann, a German engineer, and Alexander Conze, archaeologist and director of the sculpture collection of the Royal Berlin Museums, during excavations carried out at Pergamon from 1878 to 1886. The finds were shipped to Germany, and the altar was reconstructed in the Altes Museum in the center of Berlin, 1901–08. The Great Altar is now the centerpiece of the Pergamon Museum in Berlin, a museum specifically built to display the spectacular finds from the site. German archaeologists continue their work on the site to the present day.

SHEILA DILLON

Further Reading

Dreyfus, Renée, and Ellen Schraudolph, editors, *Pergamon: The Telephos Frieze from the Great Altar* (exhib. cat.), 2 vols., San Francisco: Fine Arts Museum of San Francisco, 1996

Pollitt, J.J., *Art in the Hellenistic Age*, Cambridge and New York: Cambridge University Press, 1986

Schmidt, Evamarie, *Der grosse Altar zu Pergamon*, Leipzig: Seeman, 1961; as *The Great Altar of Pergamon*, Leipzig: VEB Edition, 1962; Boston: Boston Book and Art Shop, and London: Owen, 1965

Smith, R.R.R., "The Hellenistic Period," in *The Oxford History of Classical Art*, edited by J. Boardman, Oxford and New York: Oxford University Press, 1993

Smith, R.R.R., *Hellenistic Sculpture: A Handbook*, New York: Thames and Hudson, 1991

Spivey, Nigel, *Understanding Greek Sculpture: Ancient Meanings, Modern Readings*, New York: Thames and Hudson, 1996

Stewart, Andrew, *Greek Sculpture: An Exploration*, 2 vols., New Haven, Connecticut: Yale University Press, 1990

Stewart, Andrew, "Narration and Allusion in the Hellenistic Baroque," in *Narrative and Event in Ancient Art*, edited by Peter J. Holliday, Cambridge and New York: Cambridge University Press, 1993

BALTHASAR PERMOSER 1651–1732

German

Balthasar Permoser's earliest known works were created in Italy. They were small-scale ivory carvings and monumental stone figures. Even as a young artist, he demonstrated his virtuosity in the two different areas of sculpting he had learned. Permoser was trained as a woodcarver in Salzburg and in stone sculpture in Vienna. Later in life, he demonstrated his brilliance in both areas concurrently.

Permoser received some considerable commissions in Italy; most prominent among these are the sculptures for the Theatine Church of S. Michele e Gaetano in Florence. Along with the statue of St. Gaetano, the two allegories over the main entrance of the church are especially impressive. The richly dynamic female figures are wrapped in picturesquely flowing robes. It is clear here that Permoser was drawn to the Roman High Baroque—for example, to Gianlorenzo Bernini's tomb for Pope Urban VIII (1627–47) in St. Peter's Basilica in Rome. Before he moved from Rome to Florence, he must have studied Bernini's works; Bernini's influence can be recognized even in Permoser's late work (such as *Apollo* for the Dresden Zwinger; 1715).

Of the documented works from his time in Italy, many have disappeared; those remaining are ivory carvings that Permoser created on commission from the Medici family. In a richly detailed *Calvary*, Permoser depicted the figures under the cross in opulently billowing robes. They also exhibit an expressive drama indicative of Permoser's German origins.

The sculptor had achieved such a high degree of renown in Italy that he was called to Dresden to be a court sculptor, arriving there in 1690. During his first years in Dresden, he mostly produced small-scale carved sculptures, along with the outdoor figures for the *Grosser Garten* (*Great Garden*). Shortly after his arrival, the goldsmith Johann Melchior Dinglinger was summoned to Dresden, and they collaborated several times. They created the first Moor figurines from ebony (before 1700) and the magnificent chalcedony bowl *Diane's Bath* (before 1704) with Permoser's ivory figure of the goddess. Again and again, these two leading artists of the Dresden court produced works together; of note is the *Moor with Emerald Druse* created about 1724. This is a stately figure in ebony that appears lively and natural despite the rich decorations in gold and precious stones.

Several of Permoser's famous ivory works were presumably created during his first years in Dresden; for example, the series of the *Four Seasons* in the Grünes Gewölbe in Dresden, consisting of two female figures—Spring/Flora and Summer/Ceres—and two male figures—Autumn/Bacchus and Winter/Vulcan.

Balthasar Permoser, *Winter* (*Vulcan*)
Photo reproduced with kind permission of the Earl and Countess of Harewood, and the Trustees of Harewood House Trust, England courtesy Harewood House, Leeds, England

The abundantly dynamic and painstakingly decorated figures are variously characterized. The draping is not as detailed as it was in the ivory works of Permoser's early Italian phase. This tendency continued in the second series of the Seasons, which were dated 1695 by the artist. The folds in the robes of the women figures were formed in a relatively firm and angular manner. Permoser also went even further in the individual characterization within this group; he placed a haggard, freezing Vulcan—an extraordinarily expressive figure—opposite a youthful Bacchus invigorated by wine.

Permoser's most popular ivory work was the *Hercules and Omphale* group, of which there were four replicas. In the depicted scene, the hero of Antiquity helps Omphale with her spinning. Here the sense of humor of the sculptor is expressed, and contemporaries

characterized him as an original, but also a proud and sensitive, artist.

The body of Permoser's works is exceptional in that he achieved the same intensity on a small scale as he did on a monumental scale. Among the sculptures that were displayed outside, however, many have been destroyed or damaged. Thus, it is especially difficult today to decide which among his extensive range of sculptures were from his own hands and which were created by the members of his workshop. The quality of Permoser's stone sculpture can best be seen in the excellently preserved figures of the tomb of Electress Anna-Sophie of Saxony in Freiberg Cathedral, especially in the marble statue of *Abundantia*. The female figure, with a Classical dignity in her bearing, is wrapped in opulent garments and is further marked by a cornucopia, crowns, and a laurel wreath in her hair. Permoser succeeded in conveying an impressive Baroque presence, but at the same time, he executed his carvings in a detailed and extremely fine manner. Various tender blossoms are depicted, and finely pleated material is set off with the heavier draping. In the figure of *Abundantia*, the sculptor proved himself to be a master of larger forms as well as of detail.

The same can be said of one of Permoser's most ambitious works, the *Apotheosis of Prince Eugene*. This monument, however, seems overblown, pathetic, and impersonal from today's perspective. In 1722/23, an *Apotheosis of Augustus the Strong*—Permoser's most important patron—was created employing a comparable scheme (destroyed).

Permoser's style began with the Roman High Baroque and developed in new directions with various commissions. In his sculptural decorations for the Dresden Zwinger, his major work, he arrived at a proto-Rococo style. Both of the wood sculptures of the church fathers St. Augustine and St. Ambrose in the Roman Catholic Hofkirche in Dresden, however, even anticipated Neoclassicism. Broad drapery calmly contains the figures; this impression is strengthened by the uniformly white painting.

That the artist had a strong personality is shown most clearly, perhaps, in the three versions of the *Christ at the Column* from his final productive years. Figures in which human suffering is expressed were among Permoser's most impressive earlier creations (crucifixes and various versions of *Winter* or the *Damned Soul*). The late expressive Christ figures show emaciated bodies in tortured positions. The third version of *Christ at the Column* exhibits a self-portrait of the then 77-year-old artist above an inscription, and therefore can be understood to be his personal legacy.

URSEL BERGER

See also **Ivory Sculpture: Renaissance–Modern; Germany: Baroque–Neoclassical**

Biography

Born in Kammer, near Otting, Chiemgau, Bavaria, Germany, 13 August 1651. Trained in Salzburg as woodcarver and in Vienna as stonemason; moved to Rome, 1674–75, then Florence, *ca.* 1677, where he received commissions from ducal residence; returned to Germany and became court sculptor in Dresden, 1690; several trips to southern Germany, Austria, and Italy; active for Saxon court and other nobility and members of the bourgeoisie. Died in Dresden, Germany, 18 February 1732.

Selected Works

1685–89	*Hope, Poverty of Spirit*, and *St. Gaetano*; marble; Church of S. Michele e Gaetano, Florence, Italy
ca. 1685	*Triumph of the cross*; ivory, painted wood, gilt metal; Kunstgewerbemuseum (in former Grassi Mus.), Leipzig, Germany
1686	*Calvary*; ivory; Museo degli Argenti, Florence, Italy
ca. 1690–95	*Four Seasons*; ivory; Grünes Gewölbe, Dresden, Germany
1695	*Four Seasons*; ivory; Herzog Anton Ulrich Museum, Brunswick, Germany; Harewood House, Leeds, England
after 1700	*Hercules and Omphale*; ivory; Grünes Gewölbe, Dresden, Germany
1703–12	*Abundantia*, for tomb of Electress Anna-Sophie of Saxony, Germany; marble; Freiberg Cathedral, Germany
ca. 1704	Bust of Duke Anton Ulrich; alabaster; Herzog Anton Ulrich Museum, Brunswick, Germany
1711–19	Sculptures for the Dresden Zwinger: *Apollo* and *Minerva*; marble; Skulpturensammlung der Staatlichen Kunstsammlungen, Dresden, Germany *Three Nymphs*; sandstone; Zwinger, Bath of Nymphs *Ceres*; sandstone; Zwinger, Crown Gate *Vulcan*; sandstone; Zwinger, Lapidarium (copy at the Crown Gate) *Hercules Saxoniae*; destroyed (copy at Zwinger, Rampart Pavilion) Three satyr herms; destroyed (copies at Zwinger, Rampart Pavilion)
1712	Angel with the tools of suffering; wood; pulpit, Cathedral, Dresden, Germany
ca. 1715	*Damned Soul*; marble; Museum der bildenden Künste, Leipzig, Germany
1720–21	*Apotheosis of Prince Eugene*; marble; Lower Belvedere, Vienna, Austria

1721–28 *Christ at the Column*; marble; versions in
 Skulpurensammlung der Staatlichen
 Kunstsammlungen, Dresden, Germany (on
 loan to the Dresden Cathedral);
 Schlosskapelle, Moritzburg, Germany
1722–23 *Apotheosis of Augustus the Strong*; marble
 (destroyed)
ca. 1724 *Moor with Emerald Druse*; ebony, gold-
 plated silver, precious stones; Grünes
 Gewölbe, Dresden, Germany
1724–25 *St. Augustine* and *St. Ambrose*; wood;
 Dresden Cathedral, Germany

Further Reading

Asche, Sigfried, *Balthasar Permoser: Leben und Werk*, Berlin: Deutscher Verlag für Kunstwissenschaft, 1978

Beschorner, Hans, *Permoser-Studien*, Dresden: Bertha von Baensch Stiftung, 1913

Helas, Volker, "Permoser, Balthasar," in *The Dictionary of Art*, edited by Jane Turner, New York: Grove, and London: Macmillan, 1996

Kunst des Barock in der Toskana: Studien zur Kunst unter den letzten Medici, Munich: Bruckmann, 1976

Michalski, Ernst, *Balthasar Permoser*, Frankfurt: Iris-Verlag, 1927

Schmidt, Eike D., "Ein dokumentierter Kalvarienberg aus Elfenbein von Balthasar Permoser in Florenz," *Pantheon* 55 (1997)

Stephan, Bärbel, *Balthasar Permoser hat's gemacht: Der Hofbildhauer in Sachsen*, Dresden: Skulpturen sammlung, 2001

SCULPTURES FOR THE DRESDEN ZWINGER

Balthasar Permoser (1651–1732)

1711–1719

marble, sandstone

Dresden Zwinger, Dresden, Germany;

Skulpurensammlung der Staatlichen

Kunstsammlungen, Dresden, Germany (surviving examples; many others destroyed)

At the behest of Augustus the Strong, the planning began for the so-called Zwinger in Dresden in 1709. It was erected on the grounds of the defensive fortifications west of the palace, from whence comes the name *Zwinger* ("cage" or "pen"). The architect, Matthäus Daniel Pöppelmann, was originally meant only to carry out plans for an orangery and terrace. Beginning in 1711, he developed an architectural ensemble consisting of several wings, a design that was then provisionally completed in 1719 for the celebrations of the crown prince's wedding. The orangery, surrounded by galleries and pavilions, had by then become the grounds for courtly festivals.

Whereas the Zwinger architect's involvement is well documented, this is not the case for the work of the head sculptor, Balthasar Permoser. It cannot, however, be doubted that he was included in the design process. The experienced court sculptor presumably possessed a rank equal to that of the architect, who was 11 years younger and still had little practice.

In contrast to Pöppelmann's other buildings, the architectural design of the Zwinger is extraordinarily plastic, such that the sculptures are not merely decorative but are closely integrated into the structure and organization of the building. This becomes especially clear when the most distinguished parts of the ensemble—the *Kronentor* (*Crown Gate*) and Rampart Pavilion—are compared with the first design sketches in which the traditional partitioning of columns was foreseen in front of the wall architecture.

In the Rampart Pavilion, herms carry the entablature. These are not bearers in rigid postures, but rather vitally dynamic satyrs that evoke a cheerful atmosphere. The upper floor of this central pavilion seems to be swinging back and forth: instead of a ledge running throughout, there are sprightly plastic figures. Because the architecture and sculpture are formed from the same sandstone, an indissoluble connection arises between them, anticipating the Rococo style.

The hundreds of figures, masks, vases, and other ornamental details could have been carried out only in a large workshop in such a relatively short time. Among the many masons, however, were a few important young sculptors working on the Zwinger under Permoser's direction. Individual statues have been attributed to Johann Joachim Kretzschmar, Paul Heermann, Benjamin Thomae, Johann Christian Kirchner, and Paul Egell.

Permoser's work on the Zwinger apparently consisted of the conception of the overall plastic design, the distribution and supervision of the sculptural work, and the execution of several distinguished sculptures of his own. The first were presumably *Apollo* and *Minerva*, which are dated to 1715/16. The statues were originally placed in a grotto room whose interior has not been preserved. Today they are found in the sculpture collection of the Staatliche Kunstsammlungen in Dresden. Unlike the figures outside, they were not made of sandstone but of colorful Saxon marble. The influence of the Roman High Baroque on Permoser can be seen in these imposing works.

The Rampart Pavilion is crowned by the mighty *Hercules Saxonicus* with a globe. This figure, which was destroyed during World War II and reconstructed according to an old plaster cast, was signed by Permoser. It symbolizes Augustus the Strong's virtues as a ruler. Among the characteristic satyr-herms in the Rampart Pavilion, three were likewise made by Permoser himself. After being severely damaged in the war, they had to be almost entirely reconstructed. In

old photographs, their individual and lively shapes can be seen, expressed in the various gestures, physiognomies, and grimaces in which the sculptor's preference for drastic depictions is evident.

For the satyr consoles in front of the arcades to the one side of the Rampart Pavilion, Permoser presumably created a prototype that the workshop then varied; a similar procedure was likely used to craft the satyr masks. The cheerful festival space is defined by the many satyrs on the interior facades of the Zwinger; the rich flower and fruit decoration next to them refers back to the original design for the orangery.

Next to the Rampart Pavilion there is a nymphaeum (bath of nymphs) that is especially richly furnished with sculptures. A basin, a wall cascade, and the grotto architecture lend the nymphs' bath its character. Niches containing statues of the nymphs are set into the high surrounding walls. These female figures are among the most beautiful sculptural works there, and they are also better preserved than most others. Graceful female shapes are depicted climbing out of the bath, wrapping themselves in towels, or wringing water out of their hair. Three of the statues were made by Permoser, whereas the others are attributed to Egell, Kirchner, and Thomae.

Large figures of divinities are in niches at the *Crown Gate*; of these, *Ceres* and *Vulcan* are attributed to Permoser on the basis of stylistic grounds. Both of the statues—the bearded and freezing *Vulcan* and the *Ceres* bearing sickle and grains—are similar to the corresponding figures in the *Four Seasons* series made of ivory (*ca.* 1690–95; Grünes Gewölbe, Dresden). The *Ceres* has an especially festive appearance: the artfully executed bundles and wreaths of grain stalks, which are just as detailed as the finely folded clothing, lend this female figure a sprightly air of ease. *Ceres* is thus the ideal sculpture to grace one of the most beautiful festival spaces of the European Baroque.

Some of the original material of the sculptures was lost even before the severe destruction in World War II. During the most comprehensive restoration of the Zwinger's sculptures in the early 20th century (1911–33), a total of 251 sculptures and 394 decorative carvings were reproduced under the direction of the sculptor Georg Wrba. Some of these were copies made of damaged originals, but others were new creations for the decorative pieces and figures that had been missing in the original—for example, several female statues for the nymphaeum. At the time, the artisans were trying to complete the Baroque design.

Neither the destruction nor the later additions changed the festive character of the Dresden Zwinger. Pöppelmann and Permoser's *Gesamtkunstwerk* (total work of art) has retained its enchanting effect up to the present day.

URSEL BERGER

Further Reading

Asche, Sigfried, *Balthasar Permoser und die Barockskulptur des Dresdner Zwingers*, Frankfurt: Weidlich, 1966

Hempel, Eberhard, *Der Zwinger zu Dresden: Grundzuge und Schicksal seiner künstlerischen Gestaltung*, Berlin: Deutscher Verein für Kunstwissenschaft, 1961

Kirsten, Michael, *Dresden, der Zwinger*, Leipzig: Seemann, 1991

Kloss, Günter, *Georg Wrba (1872–1939): Ein Bildhauer zwischen Historismus und Moderne*, Petersberg, Germany: Imhof Verlag, 1998

Marx, Harald, editor, *Matthäus Daniel Pöppelmann, der Architekt des Dresdner Zwingers*, Leipzig: Seemann Verlag, 1989

Stephan, Bärbel, *Balthasar Permoser hat's gemacht: Der Hofbildhauer in Sachsen*, Dresden: Skulpturen sammlung, 2001

GEORG PETEL *ca.* 1601/1602–*ca.* 1634
German

Georg Petel grew up in an artistic atmosphere in his native city of Weilheim, a center of sculpture in the Late Renaissance and the Early Baroque periods. After his father, a cabinetmaker, died young, the sculptor Bartholomäus Steinle became his guardian and teacher. The Weilheim sculptors were characterized by a craft tradition dominated by an old-fashioned style. The young Petel escaped this influence by moving to the Bavarian residential city of Munich and then traveling to the progressive foreign centers of artistic production. In the Netherlands he visited Antwerp where the painter Peter Paul Rubens was active; they became friends. In Rome, Petel studied Antique and High Baroque sculpture.

Petel financed his travels by making ivory carvings that he could carry out along the way. He was able to sell his works in Paris and Genoa. The earliest masterpiece known to be by Petel, a magnificent Crucifix, has been preserved in the Pallavicino collection in Genoa. The slender Christ figure, the character of whose skin is varied and whose loincloth is finely folded, looks upward with a pained expression on his face. This impressive work leaves the quality of the smaller, dry carving executed in the workshops of Petel's native Weilheim far behind.

During his years as a journeyman, around 1624, Petel made his first ivory carvings for Rubens: the *Three Graces*. Only bronze castings of this work have survived and are direct reproductions of Rubens's paintings. *Venus with Cupid* is a magnificent female nude in a calm standing posture with a vibrant putto. The sculpture, which is presumably based on drawings by Rubens, translates the painter's Baroque body types into plastic form. The sensuous impression is strengthened by the finely worked and shimmering ivory. Rubens's example remained the dominant factor in Petel's style. Some years later he took up typical Rubens motifs once again, in a tankard (*pokal*) with a bacchanal scene (Städtisches Museum, Augsburg) and in the

1265

stunningly beautiful *Salt-Cellar with Triumph of Venus*. Picturesque scenes decorate these precious containers as reliefs.

Not only the sensuously cheerful world of Rubens's paintings, however, is represented in Petel's work. In stark opposition is his *Flagellation of Christ*. In a dramatic scene, the antagonists are shown in darkly stained pear wood with striding movements, faces torn by hatred. The Christ figure, made of white ivory, stands out from them. The beautiful masculine body is paralyzed by pain, the mouth is opened wide, and the eyes are turned up. Such an expressive manner of depiction draws upon the German sculptural tradition.

In contrast with Rubens, religious depictions dominated Petel's work. This may have been the effect of the Counter Reformation and the Thirty Years' War on the culture. After his move to Augsburg in 1625, Petel worked mostly for churches, although several contracts either came from the Fugger family or were mediated by them. His principal theme was the crucifixion of Christ. In ivory statuettes as well as in life-size wood sculptures, he depicted Christ as a well-formed male body; twice he followed the so-called Jansenist type with arms stretched upward, which was preferred by Rubens. Although the faces are shown distorted by pain in the early ivory crucifixes, the great Augsburg figures bear an expression of mild suffering.

In the figure of *St. Sebastian*, which Petel depicted several times, he did not emphasize the pain, but rather the beauty of the figure resigned to his fate as a martyr. This is evident in the masterly ivory figure and both of the wood sculptures in Augsburg (St. Moritz) and Aislingen. Finally, in the *Ecce Homo*, the dignified bodily presence and the muted suffering are emphasized by the wood sculpture's original polychromy. Whereas most of Petel's large statues have lost their original polychromy, this detail was rediscovered in the figure underneath later applications and restored. The flesh color is extremely delicate; it changes to pink or blue-green, and thus recalls Rubens's paintings.

Petel was, above all, a carver, in both small and large scale; he did, however, also produce models for a few bronze sculptures. The large figure of *Neptune*, whose depiction as an older man is not very idealistic but still has a sweeping dynamism, is dated around 1627–30. Petel's major work in bronze is the *Crucifixion with Mary Magdalen* in the Neumünster in Regensburg. It consists of a large crucifix, similar to the wood sculptures in Augsburg, and the splendid figure of Mary Magdalen. The latter kneels at the base of the cross, which she embraces with her right arm. The woman's misery is expressed vividly in her countenance and gestures. Because of the splendid garments and the free, waving hair, however, the figure exhibits a sensuous Baroque aura.

In 1632 the Thirty Years' War expanded to Augsburg; the Swedish troops under Gustav II Adolf occupied the city. Although Petel was Roman Catholic, he was commissioned to make a portrait of the king, the commander of the Protestant army. A second casting of the bust bears the designation *ad vivi*, but because of the brevity of Gustav II Adolf's stay in Augsburg there could not have been enough time for him to sit for the bust. The portrait depiction seems rather indebted to graphic sources. The rigid posture, the stylized face, and the dry depiction of the heavily bejeweled robe do not match the quality of Petel's other works. The terracotta bust of his friend Rubens, created the following year, in 1633, makes an entirely different impression. Here the rich robe is depicted as loose, and the beautiful head with its impressively alert face is turned slightly to the side. The bust is a vitally rendered homage to the sculptor's great exemplar.

Despite his early death, Petel created a unique body of work; there was nothing comparable to it at the time in Germany. He was a Baroque sculptor with an international reputation and international connections. His admiration of Rubens, the most successful painter of the time, opened up new paths for him stylistically. The sculptor from the Bavarian provinces was able to exploit this source of inspiration successfully in his own profession. He carved sensuously beautiful images of people that are convincing, on the one hand, because of the great impression they make and the lively and dynamic quality of the compositions, and, on the other hand, because of their exquisitely crafted execution.

URSEL BERGER

See also **Germany: Baroque–Neoclassical**

Biography

Born in Weilheim, Bavaria, Germany, *ca.* 1601/02. Son of a cabinetmaker; trained under Bartholomäus Steinle, 1615–18. Traveled via Munich to the Netherlands with detour to Paris; made acquaintance of Peter Paul Rubens in Antwerp; traveled further to Rome and Genoa, where he received commissions; returned to Germany, 1623–24; traveled possibly a second time to the Netherlands; became master and received right to establish shop in Augsburg, 1625; numerous church commissions followed; traveled to Antwerp to see Rubens, 1628 and 1633. Died in Augusburg, Germany, *ca.* 1634.

Selected Works

ca. 1623 Crucifix; ivory; Pallavicino collection, Genoa, Italy

ca. 1624 *Venus with Cupid*; ivory; Ashmolean Museum, Oxford, England

ca. 1625/26 *Flagellation of Christ*; pear wood, ivory; Bayerisches Nationalmuseum, Munich, Germany

ca. 1627/28 *St. Sebastian*; linden wood; St. Moritz, Augsburg, Germany

ca. 1627–30 *Neptune*; bronze; Residenz, Munich, Germany

1628 *Salt-Cellar with Triumph of Venus*; ivory; Royal Palace, Stockholm, Sweden

ca. 1628 *Crucifix*; ivory; Nationalhistoriske Museum, Hillerød, Frederiksborg, Sweden

ca. 1629–30 *St. Sebastian*; linden wood; St. Sebastian Chapel, Aislingen, Germany

ca. 1630 *Crucifix with Mary Magdalen*; bronze; Niedermünster, Regensburg, Germany

ca. 1630/31 *St. Sebastian*; ivory; Bayerisches Nationalmuseum, Munich, Germany

ca. 1630/31 *Ecce Homo*; limewood; Cathedral, Augsburg, Germany

1632 Bust of Gustav II Adolf; bronze; Royal Palace, Stockholm, Sweden; variant: Stockholm Nationalmuseum, Sweden

1632/33 *Salvator Mundi*; limewood; altar, St. Moritz, Augsburg, Germany

1633 Bust of Peter Paul Rubens; terracotta; Museum voor Schone Kunsten, Antwerp, Belgium

Further Reading

Arndt, Karl, "Studien zu Georg Petel," *Jahrbuch der Berliner Museen* (1967)

Feuchtmayer, Karl, et al., *Georg Petel, 1601/2–1634*, Berlin: Deutscher Verlag für Kunstwissenschaft, 1973

Müller, Theodor, and Alfred Schädler, editor, *Georg Petel, 1601–1634* (exhib. cat.), Munich: Hirmer Verlag, 1964

Sauermost, Heinz-Jürgen, *Die Weilheimer: Grosse Künstler aus dem Zentrum des Pfaffenwinkels*, Munich: Süddeutscher Verlag, 1988

Schädler, Alfred, *Georg Petel (1601/02–1634): Barockbildhauer zu Augsburg*, Munich: Schnell and Steiner, 1985

ANTOINE PEVSNER 1884–1962 *Russian, active in France*

The brothers Antoine Pevsner and Naum Gabo shared an interest in copper refining that led them to engineering careers, which they quickly abandoned because of their artistic temperaments. After having completed his studies at the Academy of Fine Arts in Kiev, where the experience of academic painting keenly disappointed him, Pevsner tried to find other means of expression, in contrast to academic sterility and different from the medieval art practiced in Kiev by his contemporaries Mikhail Vrubel and Léon Bakst. He discovered Rus-

sian painters through the modern French paintings of the collectors Ivan Morosov and Sergevei Shchukine Pevsner left the academy in 1910 and founded "The Jack of Diamond" (*Bubnovy Valet*), which included Cezannists and primitivists, as well as Futurists and Cubists.

Having continued his studies at the Academy of Arts in St. Petersburg, Pevsner left inspired by the French artists' freedom of expression and bold conceptions. He arrived in Paris just at the moment of the Salon des Indépendants. The Cubists in particular affected him, and after a year back home, he returned to Paris, this time determined to work with the Cubists. He was drawn to their conception of applying strongly drawn lines, adopting the style of Byzantine art.

On a trip during World War I to visit his younger brother Gabo, who had studied science and was creating sculpture, Pevsner took another decisive step that compelled him to study more profoundly "the rocking motion of the figure indicated by a sequence of lives behind it, suggesting the contemporary interests of Fernand Léger and Marcel Duchamp." Pevsner returned to Russia where he decided to continue, with his colleagues, in transforming art to focus on the originality of the Russian tendencies of the period.

Obtaining an official post as professor in 1917 at the Moscow Art Academy, whose staff also included Vladimir Tatlin and Kazimir Malevich, to whom he was close, Pevsner hoped to solve what Cubists had left unsolved, being impressed with the Malevich Suprematist system: "The artist is no longer bound to the canvas but also able to shift his compositions into space." This new approach gave him further liberty

World
Photo by Christian Bahier et Philippe Migeat. © Musée National d'Art Moderne, Centre Georges Pompidou, Paris, France and Réunion des Musées Nationaux / Art Resource, New York, and Artists Rights Society (ARS), New York, and ADAGP, Paris

in experimenting with pigment as an independent and tangible substance. In addition, he used color to separate planes still further; that is, he constructed his paintings with forms of material substance that move in space. This was the beginning of his conception about works as construction.

While in Moscow, Pevsner exhibited with his brother, in open opposition to the official use of art as political propaganda. Pevsner participated in January 1923 in the Constructivist Exhibition and in 1924, for the first time, at the Galerie Percier, with Gabo.

During the 1920s the VkhuTeMas ideas of art began to crystallize, and every member of the group chose their mode of expression. Sympathetic to Tatlin's use of actual materials built into space, Pevsner and Gabo took an independent stand, as outlined in their *Realist Manifesto*: "Space and time are two elements which exclusively fill real life (reality)." Meetings with Marcel Duchamp and with Cubists and Dadaists—which concerned construction and motion and freedom of invention of materials and methods—and a meeting with Katherine Dreier, the founder of *Société Anonyme* in Berlin, convinced him to leave Moscow, resettle in Paris, and work on strengthening his previous attempts in construction. He worked on a series of relief constructions in which he eliminated any element of perspective (e.g., *Bust*, 1924–25). *Torso* (1923–24) exploited light through the various densities and directions of planes.

Through its complexity created by a particular synthesis of plans, *Marcel Duchamp* marked for Pevsner an important passage to another period of creation and to a more open and more personal vision of his Cubist-Constructivist conception. Settling in Paris in October 1923, when artists manifested a great interest in the machine and mechanics, and where the various arts became interconnected, Pevsner actively associated with this metamorphosis. With his brother he created a series of constructions, in which brass and bronze were cut and joined in flat sections held together by screws. It was a period of important works such as *Dancer* and *Abstraction* (1927), for which he used machine forms. *Construction for an Airport* displays a mechanic's loving care of his instruments and pays frank tribute to technology.

After May 1930, when he became a French citizen, Pevsner actively took part in the exhibitions and meetings of French Cubists associated with the *Section d'Or* exhibitions and the group called Abstraction-création: Art non-figuratif. He began multiple developments of his ideas on metal construction from machine forms, which he entitled "projection into space" or "developable surface." These constructions comprise a cone or a cylinder that can be affixed flush onto a flat plane without cutting.

In comparison with Gabo, who generally used transparent materials, Pevsner preferred bronze, which, disembodied by light, relates the construction to natural atmospheric events. He repeatedly used certain symbolic forms, for example, the radiation of a cell into form, as in *World Construction*. He also used the "V" sign, a universal sign of liberation and victory, enriching it with a pulsating rhythm as in the *Developable Column of Victory*. He orchestrated forms into a complex movement full of "emotion" of poetic spatial dynamics, as in the *Column of Peace* (1954) and *Twined Column* (1947), on which he had been working for 40 years. In addition, he studied the problem of top-weight and duplication of forms, of equilibrium and space constructions. After a great period of artistic activity in France, Pevsner died in Paris in 1962.

DOÏNA LEMNY

See also **Constructivism; Duchamp, Marcel; Gabo, Naum; Modernism; Tatlin, Vladimir Yevgrafovich**

Biography

Born in Klimovitchi, Russia, 30 January 1884. Studied at the School of Art, Kiev, 1902–09; visited Paris, 1910, then continued his studies at the Academy of Arts, St. Petersburg; in 1913, while in Paris, met Amadeo Modigliani and regularly spent time with Alexander Archipenko; returned to Bryansk, 1914, then settled in Moscow same year; left Russia for Oslo, 1915; in Oslo with his brother Naum Gabo, 1915–17; appointed professor at the Moscow Art Academy with Gabo, Tatlin, and Malevich, 1917; with Gabo wrote the *Realist Manifesto*, the theoretical and definitive foundation of Constructivism, 1920; left Moscow for Berlin, 1923, where he participated in the Constructivist exhibition, then went to Paris; exhibited with Gabo at the Galerie Percier in Paris, 1924; took part in several exhibitions in New York, at the Little Review Gallery and at the International Exhibition of Modern Art, assembled by *Société Anonyme*, at the Brooklyn Museum, 1926; became a French citizen, 1930; cofounder of the Paris *Abstraction: Creation Art non-figuratif group*, 1931; exhibited at the Kunsthalle in Basel, 1934; active member of the Salon des Réalités Nouvelles, beginning in 1946; became vice president of the *Salon des Réalités Nouvelles*, 1953, and won a second prize in the Unknown Political Prisoner Competition. Died in Paris, France, 12 April 1962.

Selected Works

1923 *Mask*; wood, plastic; private collection
1926 *Marcel Duchamp*; zinc, celluloid on wood; Yale University Art Gallery, New Haven, Connecticut, United States

1927–29 *Dancer*; bronze, celluloid; Yale University Art Gallery, New Haven, Connecticut, United States

1929 *Construction in Space (Project for a Fountain)*; brass, glass; Kunstmuseum Basel, Switzerland

1937 *Construction for an Airport*; bronze, brass; Stedelijk Museum, Amsterdam, the Netherlands

1942 *Developable Column*; brass; Museum of Modern Art, New York City, United States

1947 *World*; bronze; Musée Nationale d'Art Moderne, Centre Georges Pompidou, Paris, France

1947 *Dynamic Construction*; bronze; Musée Nationale d'Art Moderne, Centre Georges Pompidou, Paris, France

1949 *Germe*; brass; Musée Nationale d'Art Moderne, Centre Georges Pompidou, Paris, France

1954 *The Column of Peace*; bronze; Musée Nationale d'Art Moderne, Centre Georges Pompidou, Paris, France

1955–56 *Monument to the Unknown Prisoner*; bronze; Musée Nationale d'Art Moderne, Centre Georges Pompidou, Paris, France

1957 *Phoenix*; bronze; private collection, Walter Bechtler, Zollikon, Switzerland

1959 *Spectral Vision*; brass, bronze; Musée Nationale d'Art Moderne, Centre Georges Pompidou, Paris, France

Further Reading

Art concret (exhib. cat.), Paris: Galerie Drouin, 1945

Barr, Alfred H., Jr., *Cubism and Abstract Art*, New York: Museum of Modern Art, 1936

Barr, Alfred H., Jr., *Art in Our Time*, New York: Museum of Modern Art, 1939

Burnham, Jack, *Beyond Modern Sculpture: The Effects of Science and Technology on the Sculpture of This Century*, New York: Braziller, 1968

Dreier, Katherine S., *Modern Art*, New York: Museum of Modern Art, 1946

Duchamp, Marcel, et al., *Antoine Pevsner*, Paris: Drouin, 1947

Francastel, Pierre, *Les sculpteurs célèbres*, Paris: Mazenod, 1954

Giedion-Welcker, Carola, *Moderne Plastik*, Zurich: Girsberger, 1937; as *Modern Plastic Art: Elements of Reality, Volume, and Disintegration*, translated by Philip Morton Shand; revised and enlarged edition, as *Contemporary Sculpture*, New York: Wittenborn, 1960

Hammer, Martin, and Christina Lodder, *Constructing Modernity: The Art and Career of Naum Gabo*, New Haven, Connecticut: Yale University Press, 2000

Marcadé, Jean-Claude, editor, *Pevsner, 1884–1962*, Paris: Art Édition, 1995

Read, Herbert Edward, *Art Now: An Introduction to the Theory of Modern Painting and Sculpture*, New York: Harcourt Brace, and London: Faber, 1933; 5th edition, London: Faber, 1968

Rickey, George, *Constructivism: Origins and Evolution*, New York: Braziller, 1967; revised edition, 1995

Ritchie, Andrew Carnduff, *Sculpture of the Twentieth Century*, New York: Museum of Modern Art, 1952

Wartmann, Wilhelm, *Antoine Pevsner, Georges Vantongerloo, Max Bill* (exhib. cat.), Zurich: Kunsthaus, Zurich 1949

PHEIDIAS *fl. ca.* 465–425 BCE *Athenian*

The most renowned artist of Antiquity, Pheidias (Phidias) the son of Charmides, reputedly began his career as a painter. Ancient authors variously report that he was trained by Hageladas and/or Hegias, but details of his career, like those of other ancient artists, are unreliable, although the literary record is considerably richer. None of his work survives, but ancient copies and representations in other media, as well the descriptions of Greek and Latin writers, allow a glimpse of some of his creations.

The bronze group dedicated by the Athenians along the Sacred Way in the Sanctuary of Apollo at Delphi in commemoration of their victory over the Persians at Marathon in 490 BCE is Pheidias's earliest attested project. Probably produced in about 465 BCE at the instigation of Kimon, son of the victorious general Miltiades, only the stone foundations of this multifigure composition survive. Described by Pausanias in the mid 2nd century CE, the monument featured some 16 life-size statues, including images of Athena and Apollo, Theseus, the Eponymous heroes and other legendary Athenians, and Miltiades. Modern attempts to identify Roman copies or fortuitous survivals (e.g., the Riace bronzes) remain unconvincing.

Pheidias won other major commissions from the Athenian state soon thereafter. He produced the monumental bronze figure of Athena (*Athena Promachos*) on the acropolis in about 460–450 BCE. Inscriptions list the expenses for the statue, which included workmen's wages and the cost of the metal, clay for the molds, coal and firewood, and so on. Armed but at ease, this image of the goddess also commemorated the Athenian victory in the Persian Wars and stood as a landmark visible from the sea. Numerous authors subsequently praised the work, which came to be featured on Roman coins. Scholars have identified fragments of its base on the Acropolis, but the statue itself was apparently removed to Constantinople, where it was destroyed in the 13th century.

Pheidias produced another Athena, the *Athena Lemnia*, between about 451 and 446 BCE. Commissioned by Athenian settlers sent to the island of Lemnos, it too stood on the Acropolis. Some ancient critics, including

Pausanias, Lucian, and Himerios, considered it to be the most beautiful of his works. Adolph Furtwängler recognized the type in Roman marble copies in the late 19th century, but his identification has since been challenged (see Hartswick, 1983).

Ancient literary sources associate Pheidias closely with Pericles and often name the sculptor as the genius behind the Parthenon project. Plutarch (*Life of Pericles*, 1st century CE) called Pheidias the "overseer of everything," although such an office did not exist in democratic Athens. Although are iconographic and stylistic links between the Parthenon's architectural sculptures and the monumental *Athena Parthenos*—the gold, ivory, and marble statue Pheidias created for its interior—indicate that he had a hand in the overall design of the temple, Pheidias likely spent most of his time from 447 to 438 BCE occupied with the production of the *chryselephantine* image (sculptures of wood, ivory, and gold that suggest drapery over flesh).

Although the literary tradition is garbled, Pheidias was prosecuted, perhaps as part of an attack on Pericles, for peculation and/or impiety soon after completion of the *Athena Parthenos*. He fled to Olympia, where he produced his acknowledged masterpiece, the *chryselephantine Zeus*, which came to be ranked among the Seven Wonders of the Ancient World, and which was described in considerable detail by Pausanias and other ancient authors. Like the *Athena Parthenos*, subsidiary iconographic decoration overloaded the *Zeus* at Olympia, including images of the *Slaughter of the Niobids* on the god's throne and *Birth of Aphrodite* on the statue's base. However, the majesty of the statue and the splendor of its materials, rather than the details, struck awe into those fortunate enough to see it. Excavation of Pheidias's workshop at Olympia has demonstrated that the statue consisted of glass, obsidian, ebony, and horn, as well as gold, ivory, and hard stones mentioned by ancient authors. Archaeologists have also recovered molds, tools, and even a cup inscribed with the artist's name. Excavation of the temple itself confirms Pausanias's account of a shallow, marble-lined pool installed in front of the statue, which served not only to reflect the divine image, but also to regulate the humidity and thus preserve the ivory. A similar pool was cut into the floor of the Parthenon.

Ancient authors widely praised the calm grandeur of Pheidias's statues of the Olympian gods, and modern scholars credit him with the invention of the Classical style in sculpture. Pliny the Elder (*Natural History*, 1st century CE) commends him for revealing the potential of sculpture in bronze, but the sculptor received highest acclaim for his monumental *chryselephantine* figures. These large-scale multimedia projects served as the training ground for numerous artisans, and talented pupils—including Agorakritos, Alkamenes, Kolotes, Pa-

naions, and Mys—spread his influence. Other artists widely copied his statues and their subsidiary ornaments in the round and represented them on coins, gems, reliefs, and other media. Numerous works by others have been misattributed to him, both in antiquity and in modern times. Frequently invoked by ancient authors as the consummate artist, he was also the subject of scurrilous tales. His reputation survived the Middle Ages, when he was considered something of a magician, and until the anti-Classicism of the 20th century his name was synonymous with supreme creative achievement.

KENNETH D.S. LAPATIN

See also **Chryselephantine Sculpture; Greece, Ancient; Temple of Zeus, Olympia**

Biography

Born in Greece (city unknown), *ca.* early 5th century BCE. Said to have been trained by Hageladas and/or Hegias; eventually employed by the Athenian state on various commissions, although the precise dates of most of these remain debatable. Date and circumstances of his death also highly problematic: one ancient source says he died in prison; another says he was executed; a third writes of his exile.

Selected Works

ca. 465 BCE	Marathon Dedication at Delphi, Greece; bronze (lost)
ca. 460–450 BCE	*Athena Promachos*, for the Acropolis, Athens, Greece; bronze (lost)
ca. 451–446 BCE	*Athena Lemnia*, for the Acropolis, Athens, Greece; bronze (lost)
probably *ca.* 450 BCE	*Athena Areia*, at Pellene, Greece; marble and wood (lost)
probably *ca.* 450 BCE	*Athena Areia*, at Plataia, Greece; marble and wood (lost)
ca. 447–438 BCE	*Athena Parthenos*, for the Parthenon, Athens, Greece; ivory, gold, marble, wood, precious and semiprecious stones (lost)
after 438 BCE	*Aphrodite Ourania*, at Elis, Greece; gold and ivory (lost)
year unknown	*Zeus*, at Olympia, Greece; glass, obsidian, ebony, horn, gold, ivory, hard stones (lost)
year unknown	*Amazon*, at Ephesos, Athens, Greece (lost)
year unknown	*Anadoumenos* (youth binding his hair), at Olympia, Greece; bronze (lost)
year unknown	*Aphrodite Ourania*, at Athens, Greece; marble (lost)

year *Apollo Parnopios*, for the Acropolis, unknown Athens, Greece; bronze (lost)
year *Hermes Pronaos*, at Thebes, Greece; unknown marble (lost)

Further Reading

Boardman, John, *Greek Sculpture: The Classical Period: A Handbook*, London and New York: Thames and Hudson, 1985

Delivorrias, Angelos, "Fidia," in *Enciclopedia dell'arte antica classica e orientale, Secondo supplemento, 1971–1994*, vol. 2, Rome: Istituto dell'Enciclopedia Italiana, 1994

Harrison, Evelyn B., "Pheidias," in *Personal Styles in Greek Sculpture*, edited by J.J. Pollitt and Olga Palagia, Cambridge and New York: Cambridge University Press, 1996

Hartswick, K.J., "The *Athena Lemnia* Reconsidered," *American Journal of Archaeology* 87 (1983)

Höcker, Christoph, and Lambert Schneider, *Phidias*, Hamburg, Germany: Rowohlt Taschenbuch Verlag, 1993

Hurwit, Jeffrey M., *The Athenian Acropolis: History, Mythology, and Archaeology from the Neolithic Era to the Present*, Cambridge and New York: Cambridge University Press, 1999

Lapatin, Kenneth D.S., "Pheidias Elephantourgos," *American Journal of Archaeology* 101 (1997)

Lapatin, Kenneth D.S., *Chryselephantine Statuary in the Ancient Mediterranean World*, Oxford: Oxford University Press, 2001.

Mallwitz, Alfred, and Wolfgang Schiering, *Die Werkstatt des Pheidias in Olympia*, 2 vols. in 3, Berlin and New York: De Gruyter, 1964–91

Overbeck, Johannes Adolf, *Die antiken Schriftquellen zur Geschichte der bildenden Künste bei den Griechen*, Leipzig: Verlag von Wilhelm Engelmann, 1868; reprint, Hildesheim, Germany: Olms, 1959

Ridgway, Brunilde Sismondo, *Fifth-Century Styles in Greek Sculpture*, Princeton, New Jersey: Princeton University Press, 1981

Stewart, Andrew F., *Greek Sculpture: An Exploration*, New Haven, Connecticut: Yale University Press, 1990

ATHENA PARTHENOS

Pheidias (fl. ca. 465–425 BCE)

446–438 BCE

ivory, gold, marble, wood, precious and semiprecious stones

h. 13 m

Destroyed 3rd–4th century BCE. Fragments and/or copies in Vatican Museums, Rome, Italy; British Museum, London, England; Aphrodisias Museum, Aphrodisias, Turkey; Archaeological Museum, Peiraeus, Greece; Art Institute of Chicago, Illinois, United States; Pergamon Museum, Berlin, Germany; Ny Carlsberg Glypothek, Copenhagen, Denmark

The *Athena Parthenos* represented Pheidias's greatest achievement of the democratic regime of Pericles (462–429 BCE) and the artistic embodiment of the Periclean state. The first of the artist's colossal chryselephantine statues (sculptures of wood, ivory, and gold that suggest drapery over flesh), it stood about 13 meters high. Fire destroyed the statue in the 3rd or 4th century BCE, but its general appearance is well known from several reduced copies and literary sources such as Pausanias (*Description of Greece*) and Pliny the Elder (*Natural History*).

The goddess stood on a marble base. The figure's face, arms, hands, and feet were of ivory, while the garments were of gold. On her helmet was the image of the Sphinx and on either side of it were griffins in relief. The head of Medusa in ivory appeared on her breast. In her outstretched right hand stood a flying *Victory* figure approximately 1.8 meters high. A column supported her outstretched right hand, in which the *Victory* stood. Her left hand rested on a shield, with a serpent (*Erichthonios*) coiled inside the convex side. A spear rested against the figure's left hand. A gilded *Amazonomachy* (battle between Theseus and the Amazons) in relief covered the concave portion of the

Athena Parthenos
© Alinari / Art Resource, NY

shield, while a painted *Gigantomachy* decorated the convex inner side. Pheidias wove a *Centauromachy* into the design of her sandals.

Several reduced versions of the *Amazonomachy* survive (Vatican Museums, Rome; British Museum, London; a Roman copy in the Archaeological Museum, Patras; and a sarcophagus in the Aphrodisias Museum, Turkey). In addition, individual groups of figures, copied to scale, survive on marble slabs from the 2nd century CE (Archaeological Museum, Peiraeus; Art Institute of Chicago, Illinois; Pergamon Museum, Berlin; Ny Carlsberg Glypothek, Copenhagen). A red-figure calyx crater from about 400 CE in the Museo Archaeologico, Naples, preserves a portion of the *Gigantomachy*. *The Birth of Pandora* was carved onto the base. Details of the composition survive on an unfinished statuette in the National Archaeological Museum in Athens.

Pheidias fashioned the statue's hair, drapery, and weapons out of over a ton of gold. Therefore, the *Athena Parthenos* served both as the Athenian financial reserve and as a visible manifestation of the wealth of the imperial city.

STRATTON GREEN

Further Reading

Borbein, A.H., "Phidias-Fragen," in *Festschrift für Nikolaus Himmelmann*, edited by Hans-Ulrich Cain, Hanns Gabelmann, and Dieter Salzmann, Mainz, Germany: Von Zabern, 1989

Furtwängler, Adolf, *Masterpieces of Greek Sculpture: A Series of Essays on the History of Art*, edited by Eugénie Sellers, London: Heinemann, and New York: Scribner, 1895; reprint, Chicago: Argonaut, 1964

Himmelmann, N., "Pheidias und die Parthenon-Skulpturen," in *Bonner Festgabe: Johannes Straub zum 65. Geburtstag am 18. Oktober 1977*, edited by Adolf Lippold and William Schneemelcher, Bonn, Germany: Rheinland-Verlag, 1977

Leipen, Neda, *The Athena Parthenos: A Reconstruction*, Toronto: Royal Ontario Museum, 1971

Pollitt, Jerome Jordan, *Art and Experience in Classical Greece*, Cambridge: Cambridge University Press, 1972

Robertson, Martin, *A History of Greek Art*, 2 vols., London: Cambridge University Press, 1975; abridged edition, as *A Shorter History of Greek Art*, Cambridge and New York: Cambridge University Press, 1981

Schiering, Wolfgang, and Alfred Mallwitz, *Die Werkstatt des Pheidias in Olympia*, Berlin: De Gruyter, 1964

Stewart, Andrew F., *Greek Sculpture: An Exploration*, New Haven, Connecticut: Yale University Press, 1990

PABLO PICASSO 1881–1973 *Spanish, active in France*

Pablo Picasso's contribution to the plastic arts of the 20th century is, without a doubt, of exceptional importance: he experimented with all mediums and explored every technique, laying the foundation for contemporary sculpture. In 1902, in Barcelona Picasso modeled his first promising sculpture, *Seated Woman* (Musée Picasso, Paris). This bronze work was plainly influenced by Paul Gauguin, whose *Vase in the Form of the Head of a Woman* (1889; Collection E. Reves, Roquebrune, France) was probably admired by Picasso at the 1900 Exposition Universelle. The subject of the sculpture is, on the other hand, present in his contemporaneous paintings: the canvases of his Blue Period are, in fact, populated by numerous seated or crouched women. Following a few years later are two interesting sculptural portraits—a fairly frequent genre of Picasso's—completed after his move to Paris in 1904: *The Madman* (1905; Musée Picasso), initially conceived as a portrait of his friend, the poet Max Jacob, and *Head of a Woman (Fernande)* of 1906, which represents the face of Fernande Olivier, Picasso's companion at the time. In these works, in which the blurred and vibrant figures recall the idea of the unfinished, it is possible to recognize the influence of Medardo Rosso and Auguste Rodin (see Spies, 1983).

In 1906–07 Picasso experimented with the little-used technique of woodcarving, the use of which reminds one again of Gauguin, and Picasso, in this same period, associated with Francisco "Paco" Durio, a sculptor in Gauguin's circle. Works such as *Standing Nude* (1907; Musée Picasso) or *Figure* (1907; Musée Picasso) are characterized by an explicit primitivism, as much in the woodcarvings—the wood is more rough-hewn than sculpted—as in the strokes of the figures often underlined by violent chromatic interventions. Picasso was profoundly impressed not only by pre-Roman Iberian art, but also by objects at the ethnographic museum at the Trocadéro in Paris. In the same period, he painted *Les Demoiselles d'Avignon* (The Young Women of Avignon; 1907), a crucial work for the beginning of Cubism. In this extraordinarily creative period, Picasso's painting and sculpture were tightly linked, and, in fact, Picasso conceived them to be one: "It would be enough to cut and then reassemble these paintings according to color to find oneself in the presence of a 'sculpture' " (see Gonzalez, 1936). This conviction brought Picasso to conceive compositions of all kinds, midway between painting and sculpture. These are the *tableaux-reliefs*, works in which the relief appears in a still markedly pictorial context (such as *Glass, Pipe, Ace of Spades, and Dice*; 1914; Musée Picasso).

In addition, Picasso created true assemblages utilizing the most heterogeneous materials: pieces of wood, tin, string, and iron wire placed together almost as if to form bas-reliefs. These constructions, used above all for the theme of the guitar, allowed for multiple and simultaneous representations (such as *Guitar and Violin*). The most significant work of this period is, without question, *Glass of Absinthe*, where the Cubist

play of the collage completely conquers the three dimensions. On the other hand, *Head of a Woman (Fernande)* of 1909—another portrait of Fernande where the rhythmic juxtaposition of fullness and emptiness reaches a disconcerting strength and dynamism—is the only work of the Cubist period that confronts the viewer with a canonical format and genre.

Picasso's sculptural activity was interrupted until 1928, when, thanks to the technical support of his friend Julio González, he began to work with metal. Certain works in iron wire owe their existence to this collaboration, such as *Figure* (1928; Musée Picasso) and, on a monumental scale, *Woman in the Garden*, in which pieces of iron, sheet metal, and found objects were soldered together and, to give unity to the composition, painted white. Picasso's taste for collage is seen in other works from this period, such as the *Head of a Woman* (1929–30; Musée Picasso), a curious character born of the daring use of a colander and several found objects.

With his acquisition of Château de Boisgeloup in 1930, sculpture leapt to the center of Picasso's interests. Numerous designs of this period explicitly attest to this, such as the etchings of the so-called Vollard series, which represent a sculptor at work in his atelier. In the stables of his new residence, transformed into a sculpture workshop, Picasso carved small wooden figures (*Standing Woman*; 1930; Musée Picasso); modeled in plaster and then cast in bronze large heads and busts (*Head of a Woman*; 1931; Musée Picasso); and realized—assembling imprints of diverse objects that were chosen for their shape or grain—curious plaster characters (*Woman in the Leaves* and *The Orator*).

At the beginning of the 1940s, Picasso modeled figures and animals in plaster (*The Crouching Cat*; 1943; private collection; copies in bronze, Musée Picasso) and, with discarded objects, organic fragments, and whatever else he could find, constructed remarkable sculptural inventions. One sees, for example, the renowned *Head of a Bull* built from a saddle, bicycle handlebars, and molten bronze. In addition, he created a demanding work entirely modeled in clay and then cast in plaster, *The Man on a Sheep*. Preceded by a series of drawings—a common practice for Picasso—*The Man on a Sheep* is a work that, relative to World War II, is full of symbolic implications. Picasso gave a bronze version of the work to the town of Vallauris, France, where he settled in 1949. The works of this period accomplish daring metamorphoses: found objects assembled and cast in plaster become animals (*The Goat*) and human figures (*Little Girl Jumping Rope*; 1950; Musée Picasso). In addition, in 1956 Picasso gave life—again gathering and assembling the most disparate objects—to a sculptural group, *The Bathers*, which was composed of six elongated and geometric human forms.

Picasso's last sculptures, created in the 1960s, are works in sketched and cut sheet metal. For this production, Picasso availed himself of the technical support of the workers of the Prejger workshop, a factory in Vallauris. The first works of this kind are of feminine figures (*Head of a Woman*; 1957; Musée Picasso) and are often conceived as prototypes of monumental works. One sees this, for example, in *Woman with Open Arms* (1961; Musée Picasso), which, cut initially as a page in an album, later became a large figure in metal (Saint-Hilaire, Essonne, France).

Through Carl Nesjar, a Norwegian, Picasso familiarized himself with cement sculpture. Starting with small figures in cut cardboard—designed for Edouard Manet's monumental *Déjeuner sur l'Herbe* (Lunch on the Grass)—he realized *Seated Woman* (1962) and *Woman in the Bath* in cement, on a grand scale, in the garden of Moderna Museet in Stockholm.

Finally, Picasso's ceramic production should not be overlooked. From 1947 and for the next 20 years, Picasso eagerly collaborated with the potters of Vallauris (particularly with the Madoura workshop), creating about 4,000 one-of-a-kind pieces, including vases (*Vase-Woman*; 1949; Musée Picasso), zoomorphic figures (*Dove Made of Eggs*; 1953; Musée Picasso) and several sculptural forms (*Head of a Woman*; 1948–49; private collection).

In spite of this extraordinary plastic production, the figure of Picasso the sculptor has long been overshadowed by Picasso the painter, and only now has his sculptural activity been freed from the ancillary role to which it was so long relegated.

LUCIA CARDONE

See also **Assemblage; France: 20th Century–Contemporary; Gauguin, Paul; González, Julio; Matisse, Henri (-Emile-Benoît); Modernism; Rodin, Auguste**

Biography

Born in Málaga, Spain, 25 October 1881. Enrolled in the School of Fine Arts (also known as La Llotja, Barcelona, 1895; opted not to attend Royal Academy of San Fernando, Madrid, 1897; created first sculpture in Barcelona, 1902; moved to Paris, 1904; met Guillaume Apollinaire, Gertrude and Leo Stein, and Henri Matisse; initially concentrated on woodcarving and modeling in clay or wax, 1904–09; created mostly assemblages, 1909–*ca.* 1915; began producing metal sculptures with help of Julio González, 1928; acquired Château de Boisgeloup, Normandy, France, 1930, where he set up a sculpture workshop; became friendly with Jean-Paul Sartre, Simone de Beauvoir, and Paul Eluard; nominated director of the Museo del Prado, Madrid, 1935; began a 20-year career of creating

gelo's figures do. Elements like the turn of a head or an arm that is led back to the body appear to be more harmonizing than dynamic. Also, the forcefulness of the mostly powerful statues of his teacher Tribolo does not appear in Pierino's work; instead, Pierino's statues make his pronounced feeling for graceful movement and balance apparent.

Pierino at first began his apprenticeship in the workshop of Baccio Bandinelli. After only a brief period he must have changed to Tribolo's workshop, for as early as 1545, we can stylistically detect his collaboration on the fountains of the Villa Medici in Castello. Independent of these works, Pierino created by mid 1547, among other things, a *Bacchus* (bought by Bongianni Capponi for his Florentine palace, now lost), a *Flagellation*, a *Putto with a Fish*, a *Putto with a Mask*, and a small relief showing *Pan with Daphnis*. Already these early works demonstrate Pierino's large sculptural talent, his interest in mimicry, and his feeling for harmonic movements and delicate surfaces.

According to Vasari, Pierino must have worked for Francesco Bandini and Cardinal Niccolò Ridolfi during his stay in Rome. Both of these men were in personal touch with Michelangelo, so a meeting between the young artist and the great master does not appear unlikely. All the works created by Pierino in Rome, including a small wax copy of Michelangelo's *Moses* and two Antique completions, are now lost.

In the early part of 1548, Pierino moved to Pisa, where Luca Martini was the head of the ducal magistracy for the sewerage system. This is where his most important works were created. Among these, the relief *The Death of Count Ugolino and His Sons* achieved great fame in the subsequent centuries. The relief is founded on verses 1–90, canto XXXIII, of Dante's *Inferno* (1314). Pierino did not illustrate the canto, however, but instead separated the episode from its context, which is based on an event in the history of Pisa. He generalized the historic event and tried by using artistic means to awaken compassion in the viewer; hereby, he most definitely intended to compete with the poet.

Another relief, *Pisa Restored*, shows the allegorical restoration of Pisa by Cosimo I de' Medici. In form and content, the sculpture is strongly based on Antique reliefs and cameos. Disposition, gesture, and clothes of the figures are also based on Antique models; for example, the gesture of *restitutio* (raising up) is traced to imperial coins. The allegory arose from Martini's initiative and was most probably intended to encourage the erection of a statue of Cosimo I in Pisa, as well as simultaneously recommending Pierino as the sculptor.

Through Martini's negotiations, Pierino received a commission from Cosimo I for the *Dovizia*. This statue reinterprets in a modern way an older model, also titled *Dovizia* (an allegory of wealth), by Donatello (1433 or 1434; formerly in the Mercato Vecchio, Florence), which at that point was still in existence.

The *River God* is one of the most important statues of Pierino's sculptural work. Like *Pisa Restored* and *The Death of Count Ugolino and His Sons*, the statue was created for Martini, who then gave it to Duchess Eleonora da Toledo, Cosimo I's consort, who in turn gave it to her brother Don Garzia da Toledo for his Neapolitan garden. The figural movement of the youth, the vase held inclined, and the three putti organized around the middle of the block and the stand, which was worked to an irregular oval, clearly show Pierino's effort to create a figure that could be viewed from various sides. That the secondary figures hereby vary by their gestures the movement and expression of the main figure as well as maintain a certain independence again leads back to Michelangelo's work, such as the *Bacchus* (ca. 1496–98; Museo Nazionale del Bargello, Florence).

The *Samson Conquers a Philistine* is also conceptionally indebted to Michelangelo's sculptures, such as his *bozzetto* (small-scale preparatory study) (Casa Buonarroti, Florence) and the *Victory* (1532–34; Palazzo Vecchio, Florence). Here, however, the strong spatial compositions of Michelangelo, which further contain multiple viewing points, are simplified to a frontal principal viewing point. The representation of the actual event itself, the triumph, is thereby forced into the background by the presentation of the beautiful heroic nude. The *Samson-Philistine* group stood for a brief time in front of Martini's house in Pisa before it was moved in 1592 to the first courtyard of the Palazzo Vecchio in Florence.

Shortly before his death, Pierino began to work on the tomb of Baldassare Turini in Pescia, which was completed by Raffaello da Montelupo (1505–66). The left of the two monumental mourning genies was most probably begun by Pierino. The large, sensual youthful nudes are modeled on the *ignudi* (nude youths) of the ceiling of the Sistine Chapel (Vatican City) and have found no successor, as is typical for much of Pierino's work.

Pierino was unable to achieve artistic independence in his brief period of creativity, and concrete models and artistic influences were always clearly visible. With the support of his patron, he was able to confront in a short time all of the current sculptural tasks (history reliefs, sculptures with multiple viewing points, multiple figure groups, and little bronzes like the *Pomona* and *Bacchus* at Venice), and he thus created works that belong in their elegance to those of the highest quality of his time.

BRITTA KUSCH

Biography

Born in Vinci, Italy, end of 1529 or beginning of 1530. Nephew of Leonardo da Vinci. Began his apprenticeship as sculptor and goldsmith with Baccio Bandinelli, *ca.* 1542; studied under Niccolò Tribolo until 1547; visited Rome, 1547–48; lived and worked in Pisa, from early 1548, in the house of courtier Luca d'Agnolo Martini dell'Ala (Luca Martini), who acted as his patron; traveled to Genoa with Luca Martini, 1552, where he became ill. Died in Pisa, Italy, 1553.

Selected Works

1542–45 *Putti Holding a Coat of Arms*; stone; Victoria and Albert Museum, London, England

1542–45 *Pan and Daphnis*; marble; Museo Nazionale del Bargello, Florence, Italy

1542–45 *Putto with a Fish*; marble; Grotta di Madama, gardens of Boboli, Florence, Italy

1542–45 *Putto with a Mask*; marble; Galleria e Museo Medioevale e Moderno, Arezzo, Italy

mid 1540s *Bacchus*; grey-stone (lost)

mid 1540s *Flagellation*; marble (lost)

1545–47 Two fountains (collaboration); marble; Villa Medici, Castello (near Florence), Italy

ca. 1547 *Pomona* and *Bacchus*; bronze with inscribed base; Museo della Ca' d'Oro, Venice, Italy

1548 *River God*; marble; Musée du Louvre, Paris, France

1548–50 Tomb for Matteo Corte (collaboration); marble; Camposanto, Italy

1548–50 *The Death of Count Ugolino and His Sons*; numerous versions in different materials: wax and terracotta; Ashmolean Museum, Oxford, England; bronze; Chatsworth, Derbyshire, England; terracotta; private collection in the Palazzo Antinori, Florence, Italy

1548–50 *Dovizia*; travertine or stone; Piazza Cairoli, Pisa, Italy

1550–52 *Samson Conquers a Philistine*; marble; Palazzo Vecchio, Florence, Italy

ca. 1552 *Madonna with Child, St. John, Elisabeth, and Zacharias*, in Museo Nazionale del Bargello, Florence, Italy; marble (stolen during World War II, now lost)

ca. 1552 *Pisa Restored*; marble; Vatican Museums, Rome, Italy

1552 Tomb of Baldassare Turini (with Raffaello da Montelupo); marble; Pescia Cathedral, Pescia, Italy

Further Reading

Cianchi, Marco, editor, *Pierino da Vinci*, Florence: Becocci, 1995 (the best introduction to Pierino's life and work)

Cianchi, Marco, "Pierino da Vinci: His Life and Works in Brief," *Italian History and Culture* 1 (1995)

Kusch, Britta, "Pierino da Vinci," Ph.D. diss., University of Münster, 2000

Middeldorf, Ulrich, "Additions to the Work of Pierino da Vinci," *The Burlington Magazine* 53 (1928)

Middeldorf, Ulrich, "Notes on Italian Bronzes: Drawings and a Tripod by Pierino da Vinci," *The Burlington Magazine* 73 (1938)

Poeschke, Joachim, *Die Skulptur der Renaissance in Italien*, vol. 2, *Michelangelo und seine Zeit*, Munich: Hirmer, 1992; as *Michelangelo and His World: Sculpture of the Italian Renaissance*, translated by Russell Stockman, New York: Abrams, 1996

Vasari, Giorgio, *Le vite de più eccellenti architetti, pittori, e scultori italiani*, 3 vols., Florence: Torrentino, 1550; 2nd edition, Florence: Florence: Apresso i Giunti, 1568; as *Lives of the Painters, Sculptors, and Architects*, 2 vols., translated by Gaston du C. de Vere (1912), edited by David Ekserdjian, New York: Knopf, and London: Campbell, 1996

PIETÀ

A pietà is the representation of the Virgin Mary grieving as she holds the body of Christ on her lap. A genuinely Western invention without antecedents in Classical or Byzantine art, this representation began to appear around 1300 in every genre of pictorial art. Nonetheless, in central, northern, and western Europe, the pietà was predominantly intended as a subject for sculpture. This not only led to genre-specific religious practices but also provided a continual source of new inspirations for the development of the sculptural arts, which sought solutions to the inherent problems of the figural group. In the Medieval period, the pietà acquired great importance as a pictorial composition that touched on a complex, core expression of Christian doctrine and principles of piety. The contrast within the medium of sculpture of a naked, dead man and a living, clothed woman in a situation of emotional shock laid the foundation for the archetypal character of the pietà, which evokes a physical and emotional response in the viewer. As in the generalization of this theme in 20th-century art, the worship of the pietà in the Roman Catholic Church, even beyond confessional limits, is rooted in the context of motherhood, war, and death.

Scholarship on the pietà is closely connected with art historical discussion surrounding devotional images, and it was introduced into art history in the 1920s

Claus Sluter) from 8 August 1390, which describes "a picture of Our Lady, who is holding Our Lord in her arms" for the capital room of the Carthusian monastery in Champmol. Beginning around 1450, pietà wall groups in stone, which depicted Christ in an unusual, sliding, recumbent position, appeared in Burgundy and western Switzerland. The highest quality example of this type is in the Liebieghaus in Frankfurt am Main. In Spain and England, the pietà is not traceable before 1430. The southern Netherlands area (Belgium) is the only western European region in possession of a large supply of pietàs from the 15th and 16th centuries. The early pietà is represented in a few examples beginning around 1340/50 (Eglise de la Visitation, Bellaire; see Ziegler, 1992).

Pietà sculptors of the 15th and 16th centuries from Germany and the Netherlands strove for new, more natural formulations for the grouping of a clad and a nude figure, which corresponded to a general tendency in the art of that time. For example, the Upper Bavarian Master of Rabenden positioned the body of Christ in a plausible manner: Mary embraces Christ's upper body tightly (Cleveland Museum of Art, Cleveland, Ohio). Around 1500, pietàs featuring Christ lying on the floor appeared in Germany and were probably inspired by Dutch painting, such as the work of Rogier van der Weyden. In the case of the pietà in Goslar (ca. 1510–15; St. Jakob's Church) by the master "HW" who was active in Saxony, the body of Christ lies on the floor, raised only at the torso and arms, and is surrounded by Mary's cloak to form a unifying gesture of uplifting protection that encompasses the entire group. The anatomically detailed representation of the tense and wrenched body is an intense reminder of Christ's suffering and death.

Michelangelo seems to have stumbled upon the theme of the pietà, which had been frequently depicted in Italy in painting but hardly in sculpture, through Cardinal Bilhères de Lagraulas, the French client for the pietà in St. Peter's Basilica, Rome (1489–99). This work set new standards for the naturalness of the pietà group and the ideal of Mary's youthful beauty. As with his later pietàs, the interest for Michelangelo lay in the relationship between Mary and Christ, for which purpose he created new forms of expression for their physical proximity. The body of Christ is buried deep in Mary's lap, and her gaze rests on the center of his body. Late in his life, Michelangelo turned the pietà into a progressive experiment, which was also fueled by his personal confrontation with death. The gestation history of his three unfinished sculptural pietàs—the pietà in Florence (ca. 1550–55; Museo dell'Opera del Duomo), the *Palestrina Pietà* (ca. 1555; Gallería dell'Accademia, Florence), and the *Rondanini Pietà* (two versions dated 1552–53 and 1555–64; Museo del

Castello Sforzesco, Milan)—are characterized by interruptions and changes of plan. His continual search for new solutions was fraught with conflict and climaxed in the demolition of the Florentine pietà: Michelangelo destroyed Christ's left leg, which was draped over Mary's hip. This larger-than-life-size group, which incorporated Joseph of Arimathea as an implied self-portrait as well as Mary Magdalene, was intended to serve as his own funerary monument. Steinberg's iconographical interpretation of the leg draped over the hip attempts to establish the pietà as a "mystical wedding," since the above gesture was a common symbol for the act of sexual intercourse in mythological images of the 16th century (see Steinberg, 1989). This thesis met adamant rejection in the field of art history; however, in light of the connection of the pietà with the Song of Solomon, its plausibility is growing. Michelangelo's Florentine pietà alienates the viewer not only because of the pagan origin of the gesture, but also because the body is in a contrived position where it drapes over the figure that supports it. This singularly complicated interpretation, justified in terms of Mannerism, penetrates deeply into the spiritual content of the pietà. Nonetheless, the predictable lack of appreciation on the part of his contemporaries may have aroused Michelangelo's frustration and led to the destruction of the work.

The pietà remained an important theme in Catholic art in Europe during the 17th and 18th centuries. Already at the forefront of the Reformation and reinforced during the Counter Reformation, an elevation of the medieval pietà was taking root. Ludwig Juppe integrated the beautiful pietà in Marburg into the predella of the altar of Mary (1517–18). Beginning in the 17th century, the medieval pietà was presented as a statue with miraculous power, accentuated by cloth vestments and a crown and baldachin (mission church, Telgte, Germany; Cistercian monastery, St. Marienstern, Germany).

A characteristic function of the pietà was a public focal point for devotion, such as in the display in Vorhallen, on church facades, or on roadside *Bildstöckeln* (wayside shrines), or, to a lesser extent, as a funerary monument. Frequently masterful works in wood, ivory, or terracotta (such as one by Anton Raphael Donner from 1721 in the Schloss Münchengrätz) were produced for private use.

The unusual use of the pietà as a monumental top to a main altar led to innovative solutions during the Baroque period, witnessed in works by Nicolas Coustou (1712–28; high altar of the Cathedral of Notre-Dame, Paris) and Anton Raphael Donner (1740–41; Gurk Cathedral). The pietà groups in polychromed wood by Franz Ignaz Günther are far removed from the traditional schemata and thus represent the func-

tional use of the pietà in the 18th century. His high-relief group in Kircheiselfing in St. Rupertus (1758) was placed in front of a painted Passion landscape. Günther's free conception of the emotional figural group enabled him to add regional symbolic motifs on the pietà in Weyarn (1764; Cloister Church of Sts. Peter and Paul), which was also designed as a processional sculpture. In the free sculptural pietà in Nenningen (1774; Lauerstein cemetery chapel), Günther combined the essential elements of the emotional relationship between Christ and Mary in a balanced triangular composition.

The life-size pietà of white marble by the Classical sculptor (Theodor) Wilhelm Achtermann (1841–49; destroyed in World War II, but fragments survive in the Domkammer of the Cathedral of St. Paul in Münster) in the Münster Cathedral was significant in the sense of the Nazarene artistic ideal. The pietà motif experienced a resurgence in German warrior monuments for World War I, often in an effort to continue the iconographical tradition. Even when the mother of the soldier and her dead son took the place of Mary and Christ, the belief in Christian salvation remained, as in Ernst Barlach's monument for Stralsund in which the group of figures assumes the contours of a memorial cross. Käthe Kollwitz set an entirely new direction for the pietà with her small statue known as *Pietà*, which was meant to be understood as a reflection and *bilanz* (conclusion) of the life course of a mother and artist marked by loss and influenced by war and the Nazi era.

The adaptation of Kollwitz's sculpture at the center of "a place of remembrance and memory of the victims of war and tyranny" in Berlin's *Neue Wache* monument enclosure requires some scrutiny, especially considering that the small and private model has been transformed into a large-scale monument. A tendency to overexpose Kollwitz's artistic intentions puts the act of remembering in danger of losing its meaning through sentimentalization.

ULRIKE HEINRICHS-SCHREIBER

See also **Daucher Family; Günther, Franz Ignaz; Kollwitz, Käthe; Michelangelo (Buonarroti); Parler Family; Polychromy**

Further Reading

Dobrzeniecki, Tadeusz, "Medieval Sources of the Pietà," *Bulletin du Musée national de Varsovie* 8 (1967)
Finke, Jutta, "Das Vesperbild in der süddeutschen Plastik des 17. und 18. Jahrhunderts," Ph.D. diss., University of Munich, 1985
Grossmann, Dieter, *"Stabat Mater": Maria unter dem Kreuz in der Kunst um 1400* (exhib. cat.), Salzburg: Salzburg Cathedral, 1970
Heinrichs-Schreiber, Ulrike, *Die Skulpturen des 14. bis 17. Jahrhunderts*, edited by Michael Eissenhauer, Coburg, Germany: Kunstsammlungen der Veste Coburg, 1998
Krönig, Wolfgang, "Rheinische Vesperbilder aus Leder und ihr Umkreis," *Wallraf-Richartz-Jahrbuch* 24 (1962)
Michler, Jürgen, "Neue Funde und Beiträge zur Entstehung der Pietà am Bodensee," *Jahrbuch der Staatlichen Kunstsammlungen in Baden-Württemberg* 29 (1992)
Probst, Volker G., *Bilder vom Tode: Eine Studie zum deutschen Kriegerdenkmal in der Weimarer Republik am Beispiel des Pietà-Motives und seiner profanierten Varianten*, Hamburg, Germany: Wayasbah, 1986
Schawe, Martin, "Fasciculus Myrrhae—Pietà und Hoheslied," *Jahrbuch des Zentralinstituts für Kunstgeschichte* 6/7 (1989/90)
Steinberg, Leo, "Animadversion: Michelangelo's Florentine Pietà: The Missing Leg Twenty Years After," *Art Bulletin* 71 (1989)
Wenk, Silke, "Die 'Mutter mit totem Sohn' in der Mitte Berlins: Eine Studie zur aktuellen Wirkung einer Skulptur von Käthe Kollwitz," in *Schmerz und Schuld* (exhib. cat.), Berlin: Gebrüder Mann, 1995
Ziegler, Joanna E., *Sculpture of Compassion: The Pietà and the Beguines in the Southern Low Countries, ca. 1300–ca. 1600*, Brussels: Institut Historique Belge de Rome and Turnhout, Belgium: Diffusion Brepols, 1992

PIETRA DURA AND OTHER HARD STONE CARVING

In the language of art, the term *pietra dura* (hard stone) describes a wide range of prized stones that may be opaque, opalescent, or, more rarely, crystalline. These hard stones are sometimes monochrome, but more commonly they have decorative markings and shadings and have always been admired for their wide range of fascinating and splendid colors, which acquire great and long-lasting luster after being polished. These stones are resistant to the wear of time; they are also resistant to being worked by artists, who must equip themselves with special tools and particular skills in order to utilize their creative ideas. Beauty, durability, and technical virtuosity are the very qualities that have made works in hard stone particularly appreciated by commissioners and collectors from the earliest times to the present day.

In order to evaluate the "hardness" (resistance to scratching) of a stone, German scientist Friedrich Mohs established the Mohs scale in 1816, and it is still a fairly empirical reference based on the ability of one stone to cut another. The diamond, at ten degrees, is the highest on the Mohs Scale, and the lowest is talc; true hard stones fall between six and seven degrees. Although in everyday parlance and artistic and financial assessments minerals such as lapis lazuli and malachite are referred to as hard stones, they are only between four and five degrees on the Mohs scale. However, the stones most frequently used for cameos

sibly from the 1st century BCE) that once belonged to Lorenzo the Magnificent; it is a large sardonyx cup carved on the exterior with a gorgon's head and on

long believed to date from Classical times have now been ascribed to Renaissance artists who were perfect and deliberate emulators of the early masters. Although

and carvings, variegated quartzes, register at seven degrees of hardness.

Variegated quartzes include well-known crystalline stones, such as rock crystal or hyaline quartz, and can ~~be found clear as glass or with rainbow reflections that~~

doned in the 5th century CE after heavy exploitation during the Imperial Roman period.

The techniques for working hard stones involved two different procedures according to whether two-dimensional works, such as a Florentine mosaic, or

PIETRA DURA AND OTHER HARD STONE CARVING

hard-stone examples by early humanist artists have been lost, including the famous cornelian cut by Lorenzo Ghiberti, there remain a few but important carvings by Giovanni delle Corniole, one of the most acclaimed artists of the late 15th century, including his agate cameo with the *Portrait of Lorenzo the Magnificent* (Museo degli Argenti, Florence). The stonecarver Pier Maria Serbaldi of Pescia also worked in Lorenzo's court, carving small porphyry sculptures whose workmanship was perfected during the 16th century until, at the time of Cosimo I, large-scale works were produced, such as the *Justice* facing the Church of Santa Trinità that was sculpted by Francesco Ferrucci del Tadda, the first artist in a family that eventually specialized in porphyry sculpture.

During the Cinquecento, towns in the Veneto also became renowned for their glyptics, benefiting from their well-established tradition of cutting rock crystal. Among the various artists was Valerio Belli from Vicenza whose most famous work is his *Casket* (1537; Museo degli Argenti, Florence), made for Pope Clement VII with 25 pieces of crystal that have deeply engraved scenes from the life of Christ. Another city in northern Italy that achieved an international reputation for its stone carving was Milan, where numerous art workshops specialized in working hard stone, particularly vases, and their fanciful shapes embellished with gold decorations attracted patrons and collectors throughout the century. These Milanese workshops supplied the elite of Europe with vases, and sovereigns drew the most skillful Milanese craftsmen to their courts. In this way, Jacopo da Trezzo entered the service of Philip II of Spain, and the Miseroni brothers established a stone-carving workshop in the 1580s at the court of Rudolph II of Habsburg in Prague.

The Caroni and Gaffurri workshops established by Francesco I de' Medici in Florence in the 1570s were also Milanese, and their presence was a determining factor in the creation of the precocious technical skills of the grand duke's workshop, which specialized in carved stone works. Officially founded by Ferdinando I in 1588, it continued to be active for three centuries. Besides the prevailing specialization in inlay work, carvings in the form of cameos, small sculptures, and mosaic reliefs were also produced. Artists who excelled in this field during the Baroque period include Giuseppe Antonio Torricelli, who worked for many years for Cosimo III de' Medici; Francesco Mugnai, who moved in the early 1700s to the court of the landgrave of Hesse-Cassel; and Francesco Ghinghi, who entered the service of Charles of Bourbon in 1737 after the fall of the Medici dynasty.

Vases and vessels in hard stone also appeared in France during the 16th century and in the Germanic

Bohemian area where the outstanding artists were Caspar Lehmann from Prague and his pupil Georg Schwanardt; Schwanardt invented the diamond cutter for rock crystal. However, rock crystal soon lost favor because of the invention of the much cheaper glass.

During the 18th century, Neoclassical taste was responsible for glyptics becoming almost exclusively used for antique-style cameos and gems that were often mounted to form elegant sets of jewelry. Remarkable work in stone engraving and carving was produced by the family workshop of Pichler from the South Tyrol region, which specialized in imitating the antique. The German Johann Lorenz de Biberach, who worked in the middle decades of the 18th century, achieved international fame and was the chosen portraitist of European sovereigns and princes, as well as being an extremely skillful imitator of the antique. An indication of the popularity of cameos during the empire period is revealed by their presence on Napoléon's imperial crown, commissioned expressly for this purpose from the goldsmith. This fashion persisted even during the restoration, although the Classical themes gradually gave way to portraits and ideas drawn from the *pompier* style of painting, which is well represented by the sardonyx cameo *Napoléon I's Apotheosis* (Musée d'Orsay, Paris), carved by Adolphe Davide and commissioned by Napoléon III.

At the end of the 19th century, the advent of new technologies and the mass production of artifacts led to the gradual decline of the highly skilled and intricate craft of carving hard stones by hand. The Opificio delle Pietre Dure in Florence continues to train craftsmen in the art of *pietra dura* carving, both the reproduction

Anonymous, Pietra Dura Cabinet, 1620
Founders Society Purchase, Robert H. Tannahill Foundation Fund; gifts from Mr. and Mrs. Trent McMath, Mrs. Allan Shelden, Mrs. William Clay Ford, Robert H. Tannahill, Mrs. Ralph Harman Booth, John Lord Booth, Mr. and Mrs. Edgar B. Whitcomb, Mr. and Mrs. James S. Whitcomb, K. T. Keller, Virginia Booth Vogel, and City of Detroit, by exchange
© 1994 Detroit Institute of Arts

of historical designs and the restoration of historical carvings.

ANNA MARIA GIUSTI

See also **Gems, Engraved (Intaglios and Cameos)**

Further Reading

Boardmann, John, *Greek Gems and Finger Rings, Early Bronze Age to Late Classical*, London: Thames and Hudson, and New York: Abrams, 1970

Butters, Suzanne B., *The Triumph of Vulcan: Sculptors' Tools, Porphyry, and the Prince in Ducal Florence*, 2 vols., Florence: Olschky, 1996

Dake, H.C., *The Art of Gem Cutting*, 7th edition, Baldwin Park, California: Gem Guides, 1987

Giusti, Anna Maria, *Pietre Dura: Hardstone in Furniture and Decoration*, London: Wilson, 1992

Hayward, J.F., *Virtuoso Goldsmiths and the Triumph of Mannerism, 1540–1620*, London: Sotheby Park, 1976

Weinstein, Michael, *Precious and Semi-precious Stones*, London: Pitman, 1944

JEAN-BAPTISTE PIGALLE 1714–1785

French

"Truth to nature" was the motto that the academician and aesthetic theorist Toussaint-Bernard Emeric-David used to establish Jean-Baptiste Pigalle's seminal place in the history of 18th-century art. To his mind, Pigalle's commitment to truth telling in form—to art's mimetic power—had freed sculpture from the perceived decadence and frivolity of the Rococo style and had led it down the road to progress. Emeric-David's view, on which art historians still rely to characterize Pigalle's uniqueness as a sculptor, placed the artist's oeuvre as the source of inspiration for a first generation of French Neoclassical sculptors (including Pierre Julien, Siméon-Louis Boizot, and Jean-Guillaume Moitte, all of whom counted among his students). More important, it mounted an explicit defense of a particular aspect of Pigalle's approach, which on more than a few occasions had prompted surprise, even disgust, in the critics of his generation: a veracity pushed to its absolute limits. This veracity surfaced in controversial works such as *Voltaire Nude*, in which Pigalle treated the great philosopher's aged anatomy—sagging skin, brittle bones, and emaciated chest—with brutal honesty. It likewise produced a morbid effect in the tomb of Claude Henri, Comte d'Harcourt, where the viewer confronts a nightmarish emergence from the tomb of the dead count's face and torso. But if visual truth was Pigalle's main contribution to the directions sculpture could take at the end of the Enlightenment, it was by no means his only contribution. Over the course of a long and highly successful career, he explored almost all sculptural genres (decorative interior sculpture, the portrait bust, the classical nude, garden sculpture, religious art, and the public monument), and his works encompassed every artistic style to which his century bore witness (Baroque exuberance, Rococo sensuality, and Neoclassical restraint). Such a creative scope attests to an admirably wide range of skills.

Pigalle had no formal education to speak of, but he nonetheless had direct access to artists whose studios neighbored those of the craftsmen and artisans who were part of his familial heritage and entourage. He thus benefited from apprenticeships with two sculptors of considerable standing: Robert Le Lorrain, whose works decorated the royal residences of Versailles and Marly and who oversaw his initial training; and the young Jean-Baptiste II Lemoyne, winner of the Royal Academy of Fine Art's coveted Rome prize and a supremely gifted teacher, whose influence is discernible in Pigalle's first signed and dated work, *Head of a Triton*. It seems likely that Pigalle paired those years of apprenticeship with rigorous training at the Royal Academy. Nonetheless, the academy dealt him his first professional blow. In 1735 he competed for the Rome prize only to see it go to Guillaume II Coustou. Winning would have provided an extended stay at the French Academy in Rome, the opportunity to study firsthand Classical and Renaissance masterpieces, and an inside track to gaining academic status and securing royal commissions. Pigalle's response to failure was admirable determination. He paid his own way to Italy, and with special permission from the Duc d'Antin, he obtained an affiliation with the French Academy in Rome. He also submitted prize-winning works to the Academy of Saint Luke's competition.

Historical records leave little trace of Pigalle's activities in Italy, however, and lessons learned from his stay seemingly translated into a mature handling of anatomy and *contrapposto* (a natural pose with the weight of one leg, the shoulder, and hips counterbalancing one another) rather than into subject matter and composition in the work that made the young sculptor famous upon his return to Paris. The statuette of *Mercury Attaching His Winged Sandals*, whose pictorial source was a 17th-century engraving, was Pigalle's *morceau de réception* (a piece submitted as part of the requirement for membership) for the Royal Academy in 1741, the year he was *agréé* (admitted). The Salon exhibited a plaster version to great acclaim a year later along with its pendant, the *Venus*. The marble version, today in the Musée du Louvre, was officially received as his reception piece in 1744. For art critics and academicians alike, the *Mercury* announced a master's touch. Louis XV financed two over-life-size marble versions of the *Mercury and Venus* (1748) to send to Frederick II, King of Prussia, to decorate the garden

Voltaire Nude
© Giraudon / Art Resource, NY

episode by stressing that portrait busts and bare-breasted female allegories occupy an altogether different realm from that of the politically charged monument. Giving weight to the former view, two major commissions immediately followed the Pompadour sculptures, which kept Pigalle busy for much of the rest of his career: the tomb of Maurice, marshal of Saxony and the monument to Louis XV in Reims. The latter, the idea for which was approved and to some extent controlled by the king's cultural administration, was in fact a municipally sponsored project dating from 1755.

Pigalle took ten years to complete the royal effigy and its accompanying figures, the seated Citizen so admired by Denis Diderot and the female allegory of Good Government leading a lion by the mane. Pigalle's composition resulted in a major reassessment of public sculpture's meaning, and it is in a work such as this one that viewers can perhaps discern most clearly why Emeric-David sought to celebrate Pigalle's legacy. In the Reims Monument, Pigalle replaced the militaristic notion of a despotic leader on his pedestal looming above the vanquished in chains—the idea of kingship's power and inviolability that Louis XIV had manipulated into image in a variety of ways a century before—with a philosophical program based on the notion of enlightened royal benevolence. Public art, in other words, could evoke both power and munificence, could juxtapose kingship and the body of the people. Although not quite a revolutionary agenda, it must nevertheless rank among the most significant of Pigalle's contributions in the revision he made of sculpture and its possibilities.

ERIKA NAGINSKI

Biography

Born in Porte Saint-Martin, Paris, France, 26 January 1714. Son of a master carpenter. Apprenticed in studio of Robert Le Lorrain until 1735; apprenticed briefly under Jean-Baptiste II Lemoyne, who introduced him to Jean-Jacques Caffiéri and Augustin Pajou; also studied at Royal Academy during this time; financed own way to Italy, where he distinguished himself at Academy of Saint Luke; returned to Paris, where reception piece for Royal Academy was accepted, 4 November 1741; became full member, 30 July 1744, and professor, 1752; favored by Madame de Pompadour, whose patronage facilitated success; major commissions in early and mid 1750s secured place as sculptor of large-scale commemorative works, the completion of which occupied most of his career; awarded Order of Saint-Michel, 8 May 1769; traveled to Berlin, Potsdam, and Dresden, 1776; named chancellor of Royal Academy, 8 January 1785. Circle of friends included prominent critics, connoisseurs, and artists, such as Denis Diderot, l'abbé Louis

of Schloss Sanssouci, a sure sign that the beginnings of Pigalle's official career were auspicious. His mythological pair now represented to the rest of Europe the achievements of the French school at midcentury.

Success at the Salon and international repute coincided with a series of commissions in the early 1750s from Louis XV's mistress, Jeanne-Antoinette Poisson, Marquise de Pompadour (commonly referred to as Madame de Pompadour). Works such as the finely executed bust of Madame de Pompadour, *Marquise de Pompadour as Friendship*, and *Love Embracing Friendship* all exhibit the formal delicacy, playful subtexts, and lighthearted sensuality of the so-called Pompadour style associated with Louis XV's reign. But whether her protection and interventions were directly instrumental in bringing Pigalle to the king's attention as the sculptor of choice for state-sponsored public art remains a matter of debate. Whereas some scholars see here a means of emphasizing the crucial impact of women patrons in the 18th century, others downplay the

Gougenot, and painter Jean-Baptiste-Siméon Chardin. Died in Paris, France, 21 August 1785.

Selected Works

1735 *Head of a Triton*; terracotta; Staatliche Museen, Berlin, Germany

1742 *Vase with the Attributes of Autumn*; marble; Metropolitan Museum of Art, New York City, United States

1744 *Mercury Attaching His Winged Sandals*; marble; Musée du Louvre, Paris, France

1745–48 *Virgin and Child*, for Church of Les Invalides, Paris, France; marble; Church of Saint Eustache, Paris, France

1748 *Venus*; marble; Staatliche Museen, Berlin, Germany

1749 *Child with a Birdcage*; marble; Musée du Louvre, Paris, France

1751 Bust of Madame de Pompadour; marble; Metropolitan Museum of Art, New York City, United States

1753 *Christ*; plaster; Musée Boucher-de-Perthes, Abbeville, France; marble (untraced)

1753 *Marquise de Pompadour as Friendship*; marble; Musée du Louvre, Paris, France

1753–76 Tomb of Maurice, marshal of Saxony; marble, bronze; Church of Saint Thomas, Strasbourg, France

1755–65 Reims Monument (also called Monument to Louis XV); bronze; Reims, France

1758 *Love Embracing Friendship*; marble; Musée du Louvre, Paris, France

1767 *Georges Gougenot and His Wife*; marble; Musée du Louvre, Paris, France

1770 Tomb of Claude Henri, Comte d'Harcourt; marble; Cathedral of Notre Dame, Paris, France

1774 *Abundance*; marble; private collection, Paris, France

1776 *Self-Portrait*; terracotta; Musée du Louvre, Paris, France

1776 *Voltaire Nude*; marble; Musée du Louvre, Paris, France

1777 *Denis Diderot*; bronze; Musée du Louvre, Paris, France

1785 *Young Girl with a Thorn in Her Foot* (unfinished); marble; Musée Jacquemart-André, Paris, France

Further Reading

Bailey, Colin B., "The Abbé Terray: An Enlightened Patron of Modern Sculpture," *The Burlington Magazine* 135 (1993)

Beyer, Victor, *La place royale de Reims et le monument de Pigalle*, Paris: Société française d'archéologie, 1980

Colton, Judith, "Pigalle's Voltaire: Realist Manifesto or Tribute *all'antica?*" *Studies on Voltaire and the Eighteenth Century* 193 (1980)

Gaborit, Jean-René, *Jean-Baptiste Pigalle (1714–1785): Sculptures des Musée de Louvre*, Paris: Réunion des Musées Nationaux, 1985

Goodman, Dena, "Pigalle's *Voltaire nu*: The Republic of Letters Represents Itself to the World," *Representations* 16 (1986)

Guicharnaud, Hélène, "Un collectionneur parisien ami de Grueze et de Pigalle, l'abbé Louis Gougenot, 1724–1767," *Gazette des beaux-arts* 134 (1999)

Janson, Horst W., "Observations on Nudity in Neoclassical Art," in *Stil und Überlieferung in der Kunst des Abendlandes*, vol. 1, Berlin: Mann, 1967

Lami, Stanislas, "Pigalle (Jean-Baptiste)," in *Dictionnaire des sculpteurs de l'école française au dixhuitième siècle*, by Lami, vol. 2, Paris: Champion, 1911; reprint, Nendeln, Liechtenstein: Kraus, 1970

Levey, Michael, "The Pose of Pigalle's Mercury," *The Burlington Magazine* 106 (1964)

Licht, Fred, "Friendship," in *Art the Ape of Nature: Studies in Honor of H.W. Janson*, edited by Moshe Barasch, Lucy Freeman Sandler, and Patricia Egan, New York: Abrams, and Englewood Cliffs, New Jersey: Prentice Hall, 1981

Réau, Louis, *J.-B. Pigalle*, Paris: Tisné, 1950

West, Alison, *From Pigalle to Préault: Neoclassicism and the Sublime in French Sculpture, 1760–1840*, Cambridge and New York: Cambridge University Press, 1998

Zuchold, G. H., "Friedrich der Grosse and die Götter der Antike. Das ikonographische und ikonologische Programm der Skulpturen an der Grossen Fontäne im Park von Sanssouci," in *Berlin in Geschichte und Gegenwart: Jahrbuch des Landesarchives Berlin* (1987)

TOMB OF MAURICE, MARÉCHAL DE SAXE (MAURICE OF SAXONY)
Jean-Baptiste Pigalle (1714–1785)
1753–1776
marble, bronze
Church of Saint Thomas, Strasbourg, France

In 1756, when the art critic Denis Diderot saw the model for the tomb of Maurice, marshal of Saxony (known as Maurice of Saxony), he predicted that it would yield one of Europe's most beautiful works of sculpture. Prosper Tarbé reiterated these thoughts over a century later, claiming in his classic monograph devoted to Jean-Baptiste Pigalle and his oeuvre that the sculptor's efforts had resulted in the triumph of French national art. Modern viewers may be tempted to agree: Pigalle's tomb, which stages an encounter between a portrait statue of the deceased and a lively cast of allegories, is ambitious both in its aesthetic and iconographic aims. The work physically dwarfs the choir of Strasbourg's Church of St. Thomas, where it was erected in 1776. In addition, it belongs to an artistic genre, that of tomb sculpture, which in the 18th century continued to pay tribute to Baroque precedents by relying for its effects on the theatrical potential of visual

forms. Like Louis François Roubiliac, Jean-Baptiste II Lemoyne, and the Slodtz family before him, Pigalle conceived of funerary art in dramaturgical terms; sculpted figures not only personified memorable traits and events but also interacted as if performing in a play. Yet the rhetorical bombast of Diderot's and Tarbé's assessments of Pigalle's work might seem excessive, particularly when one considers that, for all its promise to deliver an enduring public image of Louis XV's most famous field marshal, the sculptural group was relegated to relative obscurity in France's collective memory as well as in the annals of art history. Why, one wonders, would a national memorial to a French military hero end up in a Protestant church near the German border?

On initial reflection the answer is straightforward. The tomb commemorates Arminius-Maurice, Count of Saxony, who was neither French nor Catholic. This illegitimate son of Augustus the Strong, king of Poland and elector of Saxony, was Lutheran—a fact that proved vexing, after he died on 30 November 1750 in his residence of Chambord, for the Catholic king who wanted to honor his faithful servant's military prowess at the front. That there was good reason to honor him went unquestioned. Maurice of Saxony received his military commission from Louis XV in 1720 and then became commander-in-chief of the royal armies, leading his troops to hard-won victory over the British and Dutch at Fontenoy in 1745. Louis XV did not miss the occasion to capitalize on a superlative example of devotion to the state—and on the possibility that it might restore dignity to a royal house whose political inviolability was being increasingly tested over the course of the Enlightenment by the social philosophies of Voltaire and Jean-Jacques Rousseau. The sculpture, in other words, was ideologically inscribed from the start, construed as a representation of French kingship's stability and might. But because of Maurice of Saxony's Protestant beliefs, his commemorative image could not possibly have found place alongside those of illustrious predecessors such as Marshal Turenne, which were housed in France's royal necropolis, the Benedictine abbey Church at Saint-Denis, near Paris. Attending to ecclesiastical propriety meant looking elsewhere. Louis XV's solution was a Protestant house of worship in a city tied, geographically and historically, to Maurice of Saxony's homeland and cultural roots.

If the tomb's installation site (a church interior as opposed to an open-air location) highlights a religious purpose, the visual program Pigalle devised to describe Maurice of Saxony's intrepidity in death also suggests another purpose. The symbolic meaning and spatial arrangement of the sculpted elements underscore a patriotic and therefore potentially secular message as well, one that ran far afield of the fear of God's last judgment that funerary sculpture traditionally sought to inspire in the devout viewer. The tomb's curious combination of the sacred and profane may well be its most remarkable aspect. Its centerpiece is the marble effigy of the marshal himself, striking a defiant pose as he descends toward a tomb whose open cover is pointed to by Death. This draped skeleton, armed with the requisite hourglass indicating that the final moment has come, is the single religious note in a group otherwise entirely composed of pagan and historical motifs. To the marshal's right, an animated menagerie emblematizes defeated foes: a toppled leopard for England's vanquished troops, a roaring lion for the retreating Dutch, and a screeching eagle for the Austrian Empire intimidated by France's show of military strength. To the marshal's left, a seated female allegory of France and a cherubic figure of Love dramatize their sorrow with tears and gestures of restraint. An anatomically impressive Hercules, mournfully propped up by his club, is a Classical pendant to the Christian symbol of Death. The whole is set against a pyramid, an architectural sign of immortality.

The archival documents and critical reactions surrounding the royal commission clearly indicate that a secular message was present in all of this. Pigalle had secured the commission in 1753 after submitting two preparatory sketches to the marquis of Marigny, director of royal buildings and Louis XV's arbiter of cultural affairs. The project became Pigalle's main enterprise for two decades; to his mind the final product would cement his reputation as France's preeminent maker of public art. If he thought so, it was because of the attention the work continued to receive in the intellectual world of enlightened connoisseurs both in Paris and abroad. Was this a funerary sculpture or a national monument? Did it encourage religious sentiment or patriotic pride? Could the image of church and state—God and king—really be confused in this way? Critics argued heatedly over the tomb's meaning when the model was first exhibited in the sculptor's studio in 1756, and their pamphlets served as published testimony to the sculpture's broader importance for France's collective memory. An even more notable register of that importance, however, was a second moment of critical reception after 1770, when the controversial issue of the sculpture's final destination resurfaced in artistic, political, and philosophical circles. Prompted by appeals made to Marigny and his successor by critics, scientists, and artists, Pigalle campaigned to no avail to keep the work in Paris rather than consign it to the provinces. In the end his campaign and the public debate that had fueled it for over two decades are the most noteworthy historical measures of this tomb's unique cultural significance. Pigalle's was

a memorial that revealed just how disconcerting a conflation of church and state could be; and as the Enlightenment moved to its revolutionary end, that conflation would indeed prove impossible to sustain.

ERIKA NAGINSKI

Further Reading

Beyer, Victor, "Le recueil Werner-Boudhors et la pompe funèbre du Maréchal de Saxe," *Bulletin de la Société de l'histoire de l'art français* (1976)

Beyer, Victor, *Le mausolée du Maréchal de Saxe*, Strausbourg, France : Hirlé, 1994

Furcy-Raynaud, Marc, "Le tombeau du Maréchal de Saxe," in *Inventaire des sculptures exécutées au XVIIIe siècle pour la direction des bâtiments du roi (1720–1790)*, Paris: Colin: 1927

Hüttinger, Eduard, "Pigalles Grabmal des Maréchal de Saxe," in *Studi di storia dell'arte in onore di Antonio Morassi*, Venice: Alfieri, 1971

Rocheblave, Samuel, *Le mausolée du Maréchal de Saxe*, Paris: Alcan, 1901

Vander Veken, Laurence, "Représentation et conception de la mort dans le monument funéraire du maréchal de Saxe de Jean-Baptiste Pigalle," *Annales d'histoire de l'art et d'archéologie* 21 (1999)

White, Jon Ewbank Manchip, *Marshal of France: The Life and Times of Maurice, Comte de Saxe, 1696–1750*, London: Hamish Hamilton, 1962

GERMAIN PILON *ca.* 1525–1590 *French*

Germain Pilon, the greatest French sculptor of the 16th century, was without peer for commissions originating in the Valois court. He was sculptor to Catherine de' Medici and to her sons, Kings François II, Charles IX, and Henri III. His sculptures in marble, bronze, terracotta, and alabaster fuse the Mannerist influences of Francesco Primaticcio's work with traditional French types to produce a highly complex idiom marked by compellingly repeated, sweeping, knife-edged vertical folds of copious draperies.

Pilon was born in Paris about 1525, but his earliest works (before 1558) remain unidentified. It is generally agreed that he learned his art from his father, André Pilon, who was also a sculptor and with whom Germain is documented as collaborating in 1557. André Pilon's sculptures have not been identified and are assumed lost. The earliest known surviving documented work by Germain is among four marble putti that remain of 16 ordered by Philibert de l'Orme in 1558 for alterations to the tomb of François I in the Basilica of Saint-Denis, near Paris, a commission that was shared equally with Ponce Jacquio. The putto in the Musée National de la Renaissance (Écouen) customarily is believed to be the only surviving example by Pilon. Three others were used for the monument to the heart of François II in Saint-Denis; the putto on

the leading point of the monument might be Pilon's, and the Écouen putto may instead be Ponce's.

When Henri II died in 1559, completion of the tomb of François I and the new tomb of Henri II and Catherine de' Medici fell to Primaticcio. The reliefs under the arched canopy of the tomb of François I were attributed to Pilon by Alexandre Lenoir, who set up the Museum of French Monuments in the wake of the French Revolution, early in the 19th century. Although Lenoir's judgment has been repeatedly questioned, his attribution to Pilon can be sustained by virtue of the exceptional quality of all but two of the reliefs. The dimpled draperies of the evangelists in the four corner panels, in particular, point directly to Pilon's most well-known sculpture, the exquisite *Monument to the Heart of Henri II* (originally in the Church of the Célestins, Paris), popularly called the *Three Graces*, of which the design is often associated with an engraving of a perfume burner traditionally ascribed to Raphael. There is, however, no clear proof of a direct relationship between the print and the sculpture.

Pilon's maturity is shown in the tomb of Henri II and Catherine de' Medici for the Valois Chapel (now destroyed) at Saint-Denis, from the mid 1560s, which Pilon executed to Primaticcio's design in conjunction with at least two other sculptors, including Ponce. No longer was Pilon's sculpture only an experiment in surface treatment, but rather it became an essay in great plastic force: the influence of Michelangelo (two of whose *Slaves*, ca. 1513, were already in France) can be seen in the *Risen Christ*, which was commissioned to complement the tomb.

Although Michelangelo's influence can also be observed in Pilon's marble figures of St. Peter and St. Paul, it is absent from the *Virgin and Child*, for which the apostles were commissioned as accompanying figures. Instead, the *Virgin* follows a traditional 14th-century formula; this may account in part for its remarkable popularity in the region around Le Mans where a number of terracotta variants continued to be produced for about 50 years after Pilon's death and where his family had ties.

In 1572 an inventory was taken of the sculptures executed for the Valois Chapel. By this time Pilon was called *sculpteur du Roy* (sculptor to the king) and was commissioned to work on the decorations for the entry of Charles IX into Paris. He also secured the commission for monumental terracotta sculptures (destroyed) that would ornament the Horloge du Palais, the great clock of the Palais de Justice in Paris. In 1572 Charles IX established a new position (*controlleur général . . . des effigies*) for oversight of the images on French coins, and the king appointed Pilon to this post.

Although a grand figure of a horse, said to have been a commission of Charles IX, was in Pilon's studio

Monument for the Heart of Henry II of France, 1560–63; Musée du Louvre, Paris
© Giraudon / Art Resource, NY

at the time of his death, the greatest proportion of his work was in tomb sculpture. The reclining figure of Valentine Balbiani, whose winsome beauty contrasts breathtakingly with the horrible pathos of the brilliantly carved low relief of her cadaver, is one of the key works of the 1570s by Pilon. These sculptures remain from Balbiani's ornately polychromed wall monument originally in the Church of Sainte Catherine-du-Val-des-Écoliers (destroyed), which was commissioned by her husband, René de Birague, chancellor of France. Birague's bronze *priant* (praying figure) was commissioned for the same church and was also part of an elaborate funerary monument. (Pilon's mas-

terful bronze relief *Lamentation* in the Louvre is generally considered to have been an element of the monument, but its location within the church has not been identified.) The realism of Birague's face, which Pilon had earlier rendered in a gilt bronze medallion, was once heightened by lifelike polychromy, which is now lost. Birague's small figure is nearly overwhelmed by cascades of sumptuous draperies that are marked by Pilon's distinctive treatment of uninterrupted, numerous vertical folds. The Birague monument remains one of approximately 15 funerary monuments, nearly all of them destroyed, awarded to Pilon during the reign of Henri III and the most fecund period of his career.

During the 1580s work on the Valois Chapel and its sculptures continued despite desperate sectarian civil wars that tore France apart. Pilon created a marble *Virgin of Sorrows* and marble Effigies of Henri II and Catherine de' Medici for it. The rigidity and repetitive ornamental vocabulary of the effigies have been criticized, but these are characteristics of traditional parade effigies of deceased monarchs. Pilon's sculptures must be understood as marble renderings of such wax figures. The richness of Pilon's imagination is immediately apparent, particularly in the complex draperies that curl around the effigies' feet.

A terracotta *Virgin of Sorrows*, logically assumed to be a finished model for the marble commissioned for Saint-Denis, reveals Pilon's genius and the spiritual intensity of his late work. Although possibly derived from Michelangelo's 1497–99 *Pietà* (a plaster cast of which had been ordered by François I), the *Virgin of Sorrows* is composed like the tapering flame preferred in Mannerism instead of the stable pyramidal shapes of the Renaissance. The elegiac spirituality of the *Virgin of Sorrows*, whose influence was spread through prints and later derivatives, makes it a supreme example of the art of sculpture. A gray and white marble *Saint Francis in Ecstasy*, commissioned by Henri III possibly for the Valois Chapel (now in the Church of Saint-Jean-des-Arméniens, Paris), embodies the mystic fervor of the last Valois king.

The *Diana with a Stag* from the château of Anet (*ca.* 1550; Musée du Louvre, Paris) has often been called one of Pilon's early sculptures. This attribution cannot be sustained. The heavily restored *Diana* shows few characteristics of his early work. Similarly, a series of medallions of the last members of the Valois dynasty has also been attributed to Pilon. Derived directly from François Clouet's portraits, they have limited technical similarity with the medallion securely attributed to Pilon, that of Birague (an ungilded example is also in the British Museum, London). A sculptor of Pilon's creativity would not normally have slavishly followed the designs of another artist or have rendered the images with such reduced plasticity.

MARY L. LEVKOFF

Biography

Born in Paris, France, ca. 1525. Son of the sculptor André Pilon. Probably trained by his father and is known to have collaborated with him in 1557; noted for tomb and monument sculpture, mostly in Paris, from 1558; known as *sculpteur du Roy* (sculptor to the king) by 1572, and began work on sculptures for official buildings in Paris, including terracotta ornaments for the great clock of the Palais de Justice; named *controlleur général . . . des effigies*, a position that was to guarantee the quality of images on French coinage; King Henri III gave him a residence on the Île de la Cité, Paris, 1588. His sons Raphael Pilon (1559–90) and Germain Pilon the Younger (1571–?) also became sculptors. Died in Paris, France, 1590.

Selected Works

ca. 1558 *Putto*; marble; Basilica of Saint-Denis, Saint-Denis, France

ca. 1560 Canopy reliefs for tomb of François I; marble; Basilica of Saint-Denis, Saint-Denis, France

ca. 1559–80 Tomb of Henri II and Catherine de' Medici: *priants* (praying figures) of Henri II and Catherine de' Medici, bronze; *gisants* (recumbent figures) of Henri II and Catherine de' Medici, marble; *Justice* and *Fortitude*, bronze; *Faith* and *Religion* (formerly called *Hope*), marble; Basilica of Saint-Denis, Saint-Denis, France

1561–65 *Monument for the Heart of Henri II* (popularly known as the *Three Graces*); marble and bronze; Musée du Louvre, Paris, France

ca. 1565–70 Portrait bust of Charles IX; bronze; Wallace Collection, London, England

ca. 1570 *Virgin and Child, Saint Peter*, and *Saint Paul*; marble; Church of Notre-Dame-de-la-Couture, Le Mans, France

1570s *Lamentation*; bronze; Musée du Louvre, Paris, France

ca. 1572 Monumental sculptures for the Horloge du Palais (Clock of the Palais), Palais de Justice, Paris, France; terracotta (destroyed)

ca. 1572 *Risen Christ*; marble; Musée du Louvre, Paris, France

1574–77 Figures from the tomb of Valentine Balbiani; marble; Musée du Louvre, Paris, France

1576 Medallion of René de Birague; gilt bronze; Cabinet des Médailles, Bibliothèque Nationale de France, Paris, France

ca. 1583 Effigies of Henri II and Catherine de' Medici; marble on bronze mattresses (restorations of destroyed bronzes); Basilica of Saint-Denis, Saint-Denis, France

ca. 1583–86 *Saint Francis in Ecstasy*; gray and white marble with bronze; Church of Saint-Jean-des-Arméniens, Paris, France

1585 Tomb of René de Birague; painted bronze and marble; remains in Musée du Louvre, Paris, France

ca. 1586 *Virgin of Sorrows*; terracotta; Musée du Louvre, Paris, France; marble: Church of Saint-Paul-Saint-Louis, Paris, France

1587 Tomb of Joseph Foulon, Sainte-Geneviève, Paris, France; bronze (destroyed)

Further Reading

Bresc-Bautier, Geneviève, editor, *Germain Pilon et les sculpteurs français de la Renaissance*, Paris: Documentation Française, 1993

Ciprut, Édouard-Jacques, "Nouveaux documents sur Germain Pilon," *Gazette des Beaux-Arts* 73 (May–June 1969)

Ciprut, Édouard-Jacques, "Chronologie nouvelle de la vie et des oeuvres de Germain Pilon," *Gazette des Beaux-Arts* 74 (December 1969)

Coyecque, Ernest, "Au domicile mortuaire de Germain Pilon," *Humanisme et Renaissance* 7 (1940)

Grodecki, Catherine, "Les marchés de Germain Pilon pour la chapelle funéraire et les tombeaux des Birague en l'église Sainte-Catherine-du-Val-des-Écoliers," *Révue de l'art* 54 (1981)

TOMB OF HENRI II AND CATHERINE DE' MEDICI

German Pilon (ca. 1525–1590)
ca. 1559–1580
marble, bronze
Gisants (reclining figures), priants (praying figures), and Virtues: approximately life-size; h.(of white marble reliefs) approximately 1 m; h. (of 16 red marble reliefs) 35 cm Basilica of Saint-Denis, Saint-Denis, France

The tomb of Henri II and Catherine de' Medici is the jewel of the French Renaissance. Through it Germain Pilon's place in history is customarily identified. The tomb was intended as the centerpiece of the Valois Chapel, a rotunda attached to the basilica of Saint-Denis (the traditional resting place of the bodies of the kings of France), which was commissioned by Catherine de' Medici. Its plan was based on ancient Roman mausoleums.

The harmoniously composed, richly toned, two-tiered monument comprising bronze *priants* (praying figures) of Henri II and Catherine de' Medici, marble *gisants* (recumbent figures) of their nude bodies, bronze allegorical figures of the four Cardinal Virtues, four white marble allegorical reliefs, and decorative red marble reliefs of grimacing grotesque heads in the base that supports marble Corinthian columns and pilasters is not exactly in the form in which it was originally designed. In particular, the bronze Virtues stood on corner supports that were not at oblique angles to the body of the tomb, the white marble reliefs were set in a different sequence, and the king and queen's pulpits were lost, as were the black marble support of the *gisants* and the black marble plinth on which the entire monument rested. The Valois Chapel was never completed: in severe disrepair even in the 17th century, it was demolished in 1719. The tomb, then installed in the basilica, was dismembered in the wake of the French Revolution. Its elements were saved from destruction in 1794. The tomb was erected in its present form in the 19th century.

The monument was commissioned from Francesco Primaticcio in 1559 by François II upon the death of his father, Henri II, who died as the result of a jousting accident. It is logically assumed that Primaticcio was chosen because he was the preferred sculptor of the influential Guise family and the child-king's mother, Catherine de' Medici. Primaticcio selected artists to execute his design. Pilon was one of several sculptors who collaborated on the monument: Benoît Boucher was responsible for casting bronze; Domenico Barbieri for a terracotta model of Henri II's *priant*; Laurent Regnauldin for wax models of bronze reliefs (presumably never cast); and Frémyn Roussel for the relief customarily called *Charity*. Ponce Jacquio did the bronze Virtues *Temperance* and *Prudence*, which for many years were mistakenly attributed to Pilon. Jacquio and Roussel prepared a model of the tomb, and Girolamo della Robbia carved a *gisant* of Catherine de' Medici (not used; now in the Musée du Louvre, Paris, France). Various other sculptors carved decorative elements.

Pilon's bronzes on this tomb set a rarely equaled standard of beauty in European sculpture. The sumptuous, detailed costumes of his *priants* surge with vitality; the king's figure has a robustness that was unprecedented in sculptures of the same type. This has been credited to the Italian influence of both Primaticcio and Barbieri, but Pilon's own inventiveness should not be ignored in this regard. The contrast of Jacquio's Virtues, which seem somewhat static and interchangeable, with Pilon's *Justice* and *Fortitude*, demonstrates Pilon's genius. The different characters of *Fortitude* and *Justice* have been distinctly rendered. The drapery of *Fortitude*, diagonally patterned in numerous fine folds, enhances the energy of the figure; *Justice* is elegantly patrician. Their forms and attitudes seem like specific representations of their characters defined by Cicero (*De Officiis* I: 61–65): *Fortitude* does not flinch before vicissitudes, nor does she surrender to vagaries of luck. *Justice* is the most splendid: Pilon rendered her as a regal figure. Indeed, *Justice* is in the position of honor, below the right hand of the king.

The white marble reliefs show the participation of at least three sculptors, but their compositions were clearly derived from Primaticcio's designs. Traditionally considered representations of the three theological virtues, with Good Works added for the fourth panel (presumably because the Roman Catholic Church increasingly emphasized good works in response to Protestant assertions that justification was predetermined), the reliefs might instead be interpreted as Faith (now at the head of the tomb) combined with two forms of Charity (the only subject defined in the surviving documents)—providing food and water (Matthew 25: 35)—and Religion, which is represented by a reclining female figure holding the model of a small church. It is likely that the elegant *Faith* and *Religion* are by Pilon, who carved the compellingly beautiful, almost Classically perfect *gisants* of the dead king and queen.

The absence of military imagery in Henri II's tomb marks a departure from its immediate forerunners, the monuments to Louis XII and François I in Saint-Denis. This may have been the choice of Catherine de' Medici, whose failed attempts to reconcile Catholics and Protestants would only be successfully realized by her son-in-law, Henri IV. The subject of the tomb of Henri II is instead completely tied to Catholic faith and the Resurrection, which would have been represented in the Valois Chapel by Pilon's superb *Risen Christ* (Louvre), had only the Medici queen's hopes for her soon-to-be-extinct dynasty and her adopted country been realized.

MARY L. LEVKOFF

Further Reading

De Boislisle, Arthur, "La sépulture des Valois à Saint-Denis," *Mémories de d'histoire de Paris et de l'Île-de-France* 3 (1876)

Lersch, Thomas, "Die Grabkapelle der Valois in Saint Denis," Ph.D. diss., University of Munich, 1995

Levkoff, Mary, "Remarques sur les tombeaux de François Ier et de Henri II," *Henri II et les arts*, edited by J. Fritsch, Paris: La Documentation Française, 2003

Thirion, Jacques, "Observations sur les sculptures de la Chapelle des Valois," *Zeitschrift für Kunstgeschichte* 36 (1975)

PISANELLO (ANTONIO DI PUCCIO PISANO) ca. 1395–1455 *Italian*

Pisanello was among the most celebrated artists of his day. His skill as a painter, deeply rooted in the Interna-

tional Gothic style, earned him extensive commissions in fresco and on panel throughout the Italian peninsula during the first half of the quattrocento. A surprisingly large number of his drawings from live models survive, many of animals, displaying an uncommonly sensitive naturalistic concern (primarily in the Vallardi Codex, Musée du Louvre, Paris). Despite his success in painting, it is Pisanello's landmark introduction of the modern portrait medal (1438) that has come to define the modern perception of the artist and his importance to Renaissance style. By combining and transposing imperial and late medieval medallion and numismatic sources, Pisanello essentially invented and perfected an art form that not only described but embodied many of the primary concerns of 15th-century Italian culture. By the middle of the 15th century, portrait medals, by various artists, had become a standard and highly effective vehicle of personal and political propaganda throughout Italy. Pisanello ironically represents both the end of an era (one that included sometime collaborator Gentile da Fabriano) and the anticipation of High Renaissance ideals and achievements.

In 1438 the ecumenical council met in Ferrara, aiming to unify the Eastern and Western Churches. The penultimate Byzantine emperor, John VIII Paleologus, and his retinue of 700 were to be guests of Pope Eugenius IV and Niccolò III d'Este (the council retreated to Florence in 1439 owing to the plague and the threat of war). Pisanello was in Ferrara to witness the event, and although the pageantry would necessarily have been of great interest to a Late Gothic painter such as Pisanello, it is not known what inspired the artist to capture the emperor's likeness on a commemorative bronze disk, combined with a narrative reverse. Leon Battista Alberti, the celebrated humanist and architect, may have been in Ferrara at the time and either shown or discussed his bronze relief self-portrait *all'antica* (after the antique) with Pisanello. The obverse of John VIII's medal has the bearded emperor's bust facing right in a tall, pointed hat and surrounded by a Greek inscription. The reverse shows the emperor on horseback, praying to a cross in a rocky landscape, again surrounded by a Greek inscription, and the artist's signature in Latin. The immediate success of Pisanello's medal for John VIII can be effectively gauged by the succession of medallic commissions for elite clientele over the next 12 years.

Between 1439 and 1442, Pisanello fashioned medals for Gianfrancesco I, Marquess of Ferrara; Filippo Maria Visconti and Francesco I Sforza, Dukes of Milan; and the condottiere Niccolò Piccinino. The humanist Prince Leonello d'Este employed Pisanello at Ferrara in the mid 1440s; Pisanello produced for him, probably in 1443, five medals of uniform size. Also for Leonello, Pisanello cast a larger medal to commem-

orate the prince's marriage in April 1444 to Maria of Aragon, daughter of King Alfonso of Naples. One of the most appealing medals of the Renaissance, the reverse shows Cupid (or Love), to the right, teaching a lion (Leonello), tail between its legs, to sing. Filling out the composition are an eagle (an Este heraldic device), and a stela showing the date and a mast with a billowing sail.

Pisanello fashioned medals for Sigismondo Malatesta, Lord of Rimini, and his more studious younger brother Domenico (called Novella Malatesta) later in 1444 and 1445. One of the reverses to Sigismondo's medals depicts the controversial ruler in full armor amid various heraldic devices; the other shows an armored equestrian. The reverse to his medal for Novella Malatesta shows Domenico, on his knees in full armor, clutching a full-length crucifix, with his horse to his left in Pisanello's familiar rocky backdrop. Domenico is said to have made a vow to build a hospital dedicated to the Holy Crucifix if he escaped from Milanese troops, a vow he honored in 1452.

Pisanello also cast a medal for Vittorino da Feltre, one of the most influential humanist teachers of the 15th century. Vittorino's school in Mantua became an important locus for humanist education, attracting students not only from the Gonzaga family, but throughout the peninsula and including the young Federigo da Montefeltro, later Duke of Urbino. The obverse shows the unshaven educator facing left, wearing a *berretto* (a peaked cap) and a simple high-necked tunic. On the reverse, a pelican nourishes its young with its own blood, following the medieval bestiary tradition, an elegantly appropriate description of Vittorino's role in "nourishing" the Gonzaga children.

Pisanello cast medals for Belloto Cumano, Ludovico II Gonzaga, and Pier Candido Decembrio in the late 1440s, and most notably for Cecilia Gonzaga, one of Vittorino's star pupils. Cecilia chose the solitude and chastity of conventual life to continue her Classical studies and poetry. The marvelously sensitive reverse to her medal may be Pisanello's best. In the now-familiar rocky landscape and under a crescent moon, a half-naked virgin, presumably Cecilia, sits to the left. At her feet and also facing left rests a goatlike unicorn, which, according to medieval tradition, could only be subdued by a woman of chastity and innocence. A study of the goat that may have inspired this work, apparently drawn from life, survives in the Vallardi Codex. A stela to the right records the artist's name and date and compositionally balances the figure of Chastity/Innocence. Lead specimens of this medal are particularly elegant in capturing the velvety luminescence and mood of the reverse composition's setting.

In 1448–49 Pisanello moved south to Naples at the request of Alfonso V of Aragon and cast three medals

PISANELLO (ANTONIO DI PUCCIO PISANO) *ca.* 1395–1455

of the king; several sketches for these medals survive in the Vallardi Codex. At about the same time (probably in 1449–50), Pisanello made an exquisite medal for Don Iñigo de Avalos, master chamberlain of Naples and close companion of Alfonso. This latter medal arguably constitutes the artist's best medallic portrait, although the handling and precise meaning of the reverse is less certain. The portrait shows the young chamberlain facing right and wearing a fur-trimmed coat and, on his head, a hood (*chaperon*) fixed to a large padded ring (*bourrelet*). The reverse holds a globe with a starry sky above; a sea below frames a mountainous landscape with buildings. Above the compressed globe are the Avalos arms flanked by what may be roses. It has been suggested that the composition refers to the famous shield fashioned by Mulciber for Achilles as described in Homer's *Iliad*.

There is no record of Pisanello after 1450, and he died some time between 14 July and 31 October 1455, probably in Rome (see Woods-Marsden, 1988).

ARNE R. FLATEN

Biography

Probably born in Pisa, Italy *ca.* 1395. Family moved to Verona, 1404; employed as painter, Gonzaga court in Mantua, 1424–26, and by Filippo Maria Visconti in Milan later in that decade; worked in Rome for Pope Eugenius IV, 1430s and 1440s; again in Gonzaga court, Mantua; and for the Este court at Ferrara; in Ferrara for the arrival of Byzantine emperor John VIII Paleologus, 1438, and created the first modern portrait medal, presumably as a tribute; created medals for Sigismondo and Domenico Malatesta at Rimini, 1445, and painted a series of frescoes based on Arthurian legend, *ca.* 1447–48, for the Ducal Palace in Mantua; summoned in 1448 to Naples and the court of King Alfonso V of Aragon. Died probably in Rome, Italy, 1455.

Selected Works

Unless otherwise noted, all works listed below are medals. Most survive in multiple locations, though only one location is provided below; for a more comprehensive account, see Hill, 1905.

1438　*John VIII Paleologus, Emperor of Byzantium*; bronze; Staatliche Museen Berlin, Germany
1441–42　*Gianfrancesco I, Marquess of Ferrara*; bronze; British Museum, London, England
1441–42　*Filippo Maria Visconti, Duke of Milan*; bronze; Victoria and Albert Museum, London, England
1441–42　*Francesco I Sforza, Duke of Milan*; bronze; Victoria and Albert Museum, London, England
1444　*Marriage Medal for Leonello d'Este*; bronze; National Gallery of Art, Washington, D.C., United States
1445　*Domenico Novella Malatesta*; bronze; Museo Nazionale del Bargello, Florence, Italy
1445　*Sigismondo Malatesta*; bronze; Museo Nazionale del Bargello, Florence, Italy
1446–47　*Vittorino da Feltre*; bronze; Morganroth Collection, University of California, Santa Barbara, United States
1447　*Cecilia Gonzaga*; lead; National Gallery of Art, Washington, D.C., United States
1447–48　*Ludovico III Gonzaga*; bronze; Gulbenkian Museum, Lisbon, Spain
1447–48　*Pier Candido Decembrio*; bronze; lead cast: British Museum, London
1448–49　Medals for Alfonso V of Aragon; bronze; Museo Nazionale del Bargello, Florence, Italy
1449–50　*Don Iñigo de Avalos*; bronze; National Gallery of Art, Washington, D.C., United States
late 1440s　*Belloto Cumano*; bronze; Brera, Milan, Italy

Further Reading

Chiarelli, Renzo, *L'opera completa del Pisanello*, Milan: Rizzoli, 1972
Cordellier, Dominique, and Bernadette Py, editors, *Pisanello*, Paris: La Documentation Française, 1998
Degenhart, Bernhard, *Pisanello*, Turin, Italy: Chiantore, 1945
Hill, George Francis, *Pisanello*, New York: Scribner, and London: Duckworth, 1905
Hill, George Francis, *Drawings by Pisanello*, Paris and Brussels: Van Oest, 1929; reprint, New York: Dover, 1965
Paccagnini, Giovanni, *Pisanello: Il ciclo cavalleresco di Mantova*, Milan: Electa, 1972; as *Pisanello*, translated by Jane Carroll, London: Phaidon Press, 1973
Puppi, Lionello, editor, *Pisanello: Una poetica dell'inatteso*, Milan: Silvana, 1996; as *Pisanello*, translated by Odile Ménégaux and Daniel Arasse, Paris: Hazan, 1996
Scher, Stephen, editor, *The Currency of Fame: Portrait Medals of the Renaissance*, New York: Abrams, and London: Thames and Hudson, 1994
Sindona, Enio, *Pisanello*, Milan: Istituto Editoriale Italiano, 1961; as *Pisanello*, translated by John Ross, New York: Abrams, 1961
Woods-Marsden, Joanna, *The Gonzaga of Mantua and Pisanello's Arthurian Frescoes*, Princeton, New Jersey: Princeton University Press, 1988

ANDREA PISANO *ca.* 1295–1348/1349
Italian

Andrea Pisano (Andrea da Pontedera) is universally recognized as one of the greatest 14th-century sculp-

tors. Starting in the 16th century with Giorgio Vasari, who described him as a sculptor, architect, and goldsmith, Pisano has been the subject of myriad studies that have established a certain amount of biographical information about him, particularly for the period during which he worked in Florence.

Pisano was born in Pontedera (near Pisa). He was the son of the notary public Ugolino di Nino. The inscription on his only known signed works—the bronze reliefs on the southern doors of the Baptistery in Florence—reads "Andreas Ugolini Nini di Pisis me fecit AD MCCCXXX" (Made by Andrea, son of Ugolino di Nino from Pisa, 1330). This date is the first sure piece of information concerning his life and works. Given the importance of the commission, it would probably have gone to someone who was already well known, so he is likely to have been at least 30 at the time. Accordingly, he is normally assumed to have been born toward the end of the 13th century.

The consensus among art historians is that the *Reliquary of the Cross* at the cathedral in Massa Marittima is one of Andrea's earliest works. Its inscription mentions four Pisan goldsmiths, including an "Andreas." It is hardly surprising that Andrea was working as a goldsmith in the early years of his career; in the Middle Ages the sculptor's and goldsmith's crafts often overlapped. In Florentine documents dating from 1330 to 1336, Andrea is described only as a goldsmith, leading to the hypothesis that he trained with the Pistoia goldsmith Andrea di Jacopo d'Ognabene or at least was familiar with Sienese art. This familiarity can be seen in two other early works in polychrome wood, both representing the *Virgin of the Annunciation*. Moreover, the relief style Andrea used in the Baptistery panels—whereby the figures are set against a flat background—was common in early-14th-century Sienese sculpture and gold work. Surviving documents attest to each step in the work on the Baptistery portal: the Florentine goldsmith Piero di Jacopo designed and executed the framework, and Andrea started modeling the 28 panels in January 1330, completing this stage in October 1331. The wax models were then cast in bronze, and, after laborious cleaning and polishing, the castings were mounted and the doors installed. The portal was unveiled on 24 June 1336, the feast day of St. John the Baptist. The reliefs depict 20 scenes from the life of St. John and, on the lowest row, eight Virtues symbolizing the foundations of his life. A Gothic frame shows the influence of Giotto; the figures in relief and the architectural background provide the sense of space. The strong similarities between Andrea's scenes and those painted by Giotto in the Peruzzi Chapel (Church of Santa Croce, Florence) testify to the closeness between Andrea's creative sensibility and Giotto's.

As soon as he was appointed master of the cathedral works in Florence, Giotto designed the cathedral's new bell tower. Construction began in 1334, and Giotto continued to oversee the work until his death in 1337. According to Antonio Pucci, a contemporary chronicler, thereafter Andrea Pisano supervised the project. After completing the Baptistery doors he served as master of the cathedral works until 1341. The whole lower third of the bell tower corresponds to the period in which these two artists directed the work. The reliefs inside the hexagonal frame decorating the two orders of the base in particular show how Andrea was moving closer to Giotto. These reliefs are the first stone sculptures known to have been carved by Andrea. In the lower order the reliefs on the west side show scenes from Genesis, while those on the other sides depict the inventors of the trades and the arts (*artes mechanicae*), including sculpture. On the upper part of the base are the series of seven planets, seven Virtues, seven liberal arts, and seven sacraments. Giotto almost certainly designed the scenes from Genesis and the inventors of the arts and trades; the dynamic construction and the monumentality of the figures support this hypothesis. But the panels appear to have been inspired in part by ancient sculpture; for instance, the *Agricultura* panel recalls an ancient model at the monumental cemetery (the *camposanto*) in Pisa, which has led art historians to conclude that Andrea probably worked on their design as well as their execution. At one time scholars thought that all the 14th-century statues and reliefs on the bell tower were the work of a single sculptor, Andrea Pisano (and his workshop). It now seems more likely that various sculptors worked on the project and that Giotto, as master of the works, chose Andrea to carve the 21 reliefs on the base. At least 18 of these hexagons are unanimously attributed to Andrea and his assistants (among them, his son Nino): *Creation of Adam*, *Creation of Eve*, *Labours of Adam and Eve*, *Jabal*, *Jubal*, *Tubalcain*, *Equitation*, *Lanificium*, *Daedalus*, *Medicina*, *Phroneus*, *Theatrica*, *Navigatio*, *Hercules*, *Agricultura*, *Architectura*, *Pictura*, and *Sculptura*. Andrea also carved the *Virgin and Child* set in the lunette above the northern portal of the bell tower, as well as other sculptures in the niches.

Between 1334 and 1340 the wool guild (which controlled the cathedral works) commissioned Andrea to sculpt a *Saint Stephen* (*ca.* 1340) for the Church of Orsanmichele, Florence (now at the Museo dell'Opera del Duomo, Florence). This period is probably when he (alone or with helpers) carved a *Redeemer* and a female saint (Museo dell'Opera del Duomo, Florence) that exhibit a still more delicate Classical monumentality.

In 1341 Andrea was forced to leave the Florence cathedral works, apparently because he had tried to

depart from Giotto's design for the bell tower. Numerous works testify to his return to Pisa, where he opened his own workshop with his sons Nino and Tommaso. The tomb of Simone Saltarelli and a relief depicting *St. Martin* and the beggar are among the most significant examples of Andrea's sculptures, on which his assistants worked more or less freely. Another work from Andrea's workshop is a *Virgin and Child* made to replace a statue that had fallen from the heights of the facade of Cathedral of Pisa. From 1344 to 1348 the workshop worked on the external and internal decoration of the Church of Santa Maria della Spina in Pisa; outstanding pieces from this endeavor include a *Virgin and Child* and a *Madonna and Child*, also called *Madonna del Latte*.

In 1347 Andrea left Pisa for Orvieto, where he was appointed master of the cathedral works, but his workshop continued to operate in Pisa. A *Majesty* group he had begun in Pisa and shipped to Orvieto in 1348 is the only work in Orvieto unanimously attributed to him. Since a 1349 document names Nino Pisano as the master of the cathedral works, historians conclude that Andrea must have already died at the time or had at least stopped working. Nino remained only a few months in Orvieto, the time necessary to complete the works his father had begun.

LORENZO CARLETTI

See also **Pisano, Nino**

Biography

Born in Pontedera, near Pisa, Italy, *ca.* 1295. Father of artists Nino and Tommaso Pisano. Began as a goldsmith; only documented works are reliefs on the bronze doors of Florence Baptistry's southern portal, signed, in part, "Andreas Ugolino Nini de Pisis" (Andrea, son of Ugolino di Nino from Pisa) and dated 1330; worked with son Nino on Florence's new bell tower under Giotto's influence and artistic leadership; master of Florence cathedral works, 1337–41; according to contemporary account, dismissed because he wished to alter Giotto's plans; returned to Pisa and worked in different media, primarily stone and wood; appointed Master of Orvieto cathedral works, 1347. Died probably in Orvieto, Italy, 1348/49.

Selected Works

ca. 1320 *Reliquary of the Cross*; silver; Cathedral of Massa Marittima, Italy

ca. 1320 *Virgin of the Annunciation* (two examples); wood; Museo Nazionale di San Matteo, Pisa, Italy

ca. 1330 Crucifix; polychromed wood; Church of St. Andrew, Palaia, Pisa, Italy

1330–36 South doors of Florence Baptistery: scenes from the life of St. John the Baptist and figures of the *Virtues*, for east portal; bronze; south portal, Baptistery, Florence, Italy

1334–41 *Creation of Adam, Creation of Eve, Labours of Adam and Eve, Jabal, Tubalcain, Equitation, Lanificium, Daedalus, Navigatio, Hercules, Agricultura, Sculptura, Rhetorica, Geometrica, Virgin and Child,* and *Solomon,* for campanile (bell tower), Florence Cathedral, Italy; marble; Museo dell'Opera del Duomo, Florence, Italy

1341–45 *St. Martin*; marble; Church of S. Martino, Pisa, Italy (attributed)

1341–45 Tomb of Simone Saltarelli (with Nino Pisano); marble; Church of S. Caterina, Pisa, Italy

1343–47 *Virgin and Child, St. Peter,* and *St. John the Baptist*; marble; Church of Santa Maria della Spina, Pisa, Italy (attributed)

ca. 1345 *Virgin and Child*; marble; facade, Cathedral of Pisa, Italy

1345–50 *Madonna and Child* (also called *Madonna del Latte*) (additional work by Nino Pisano); polychromed and gilded marble; Museo Nazionale e Civico di S Matteo, Pisa, Italy (attributed)

1347–48 *Virgin and Child*; marble; Museo dell'Opera del Duomo, Orvieto, Italy (attributed)

Further Reading

Burresi, Mariagiulia, editor, *Sacre passioni : scultura lignea a Pisa dal XII al XV secolo*, Milan: Motta, 2000

Burresi, Mariagiulia, Antonino Caleca, and Aurelio Amendola, *Andrea, Nino e Tommaso scultori pisani*, Milan: Electa, 1983

Carletti, Lorenzo, and Cristiano Giometti, *Scultura lignea Pisana*, Milan: Motta, 2001

Castelnuovo, Enrico, *Andrea Pisano*, Milan: Fratelli Fabbri, 1966

Falk, Ilse, *Studien zu Andrea Pisano*, Hamburg, Germany: Niemann und Moschinski, 1940

Kreytenberg, Gert, *Andrea Pisano und die toskanische Skulptur des 14. Jahrhunderts*, Munich: Bruckmann, 1984

Moskowitz, Anita Fiderer, *The Sculpture of Andrea and Nino Pisano*, Cambridge and New York: Cambridge University Press, 1986

Pope-Hennessy, John, "Andrea da Pontedera," in *Encyclopedia of World Art*, New York: McGraw-Hill, 1959–87

Pope-Hennessy, John, *An Introduction to Italian Sculpture*, 3 vols., London: Phaidon, 1963; 4th edition, London: Phaidon, 1996; see especially vol. 1, *Italian Gothic Sculpture*

Toesca, Ilaria, *Andrea e Nino Pisani*, Florence: Sansoni, 1950

Valentiner, Wilhelm Reinhold, "Andrea Pisano as Marble Sculptor," *The Art Quarterly* 10 (1947)

SOUTH DOORS OF FLORENCE BAPTISTERY

Andrea Pisano (ca. 1295–1348/49)
1330–1336
bronze with gilded details
h. 4.86 m; h. of each panel 48.2 cm
Baptistery, Florence, Italy

The set of bronze doors for the Florentine Baptistery executed under the direction of Andrea Pisano (Andrea da Pontedera) were commissioned about 1330 and installed in 1336. They were intended to be a demonstration of Florentine wealth, power, taste, and piety. As part of a tradition that goes back at least to the ancient Roman bronze doors of the Pantheon, the Baptistery doors were probably also in part a response to the figurated Romanesque bronze doors—signed by Bonanus of Pisa and dated 1180—of the cathedral in Pisa, one of Florence's traditional rivals. Pisano's doors were commissioned by the Arte di Calimala, the Florentine guild in charge of the Baptistery; here, too, rivalry may have played a role, for the doors were begun at the same time that the Arte della Lana (Wool Guild), the guild in charge of the adjacent cathedral, was proceeding with work on the nearby campanile (bell tower).

The new, fashionable Gothic style of the Florentine doors and their scale, refined detail, subtle technique, and gilded decoration must have made them among the most impressive works of Gothic art in Italy. These large doors are so superbly crafted that they have survived centuries of exposure on one of Florence's main piazzas with virtually no damage; although some of the gilding has worn away and a few figures have been smoothed by the touch of many hands, the only other damage is a crack caused by the banging of the doors during the tumultuous flood of the Arno River on 4 November 1966. Today, however, they are threatened by atmospheric pollution, although this is somewhat alleviated by the elimination of most traffic in the Baptistery area.

Originally placed in the portal on the east side of the Baptistery, the doors were later moved to the south when the cycle of three sets of doors was completed with two sets by Lorenzo Ghiberti; the first of these, completed in 1424, was Gothic in style, whereas the second set, in a fully developed Renaissance style, was completed in 1452. The doors reiterate on the exterior of the Baptistery the themes of the three mosaic narratives that wrap around the interior vault: the Old Testament, the life of St. John the Baptist, and the life of Christ.

The design of Pisano's doors includes 20 scenes from the life of St. John the Baptist in five tiers, and eight figures of Virtues on the lowest two tiers. The civic and political nature of the Baptistery is suggested in the choice of this saint for the first set of doors to be commissioned; St. John the Baptist is the city's most highly visible patron saint, and his image appears on the gold florin, which by the 1330s was widely recognized as the most important and stable monetary unit in Europe. The use of lions' heads in the framing of the doors is another reference to Florence, where the lion was a popular civic symbol. Although the fire gilding of figures and selected details clarifies the narratives and adds further decoration, it was probably most important as an indication of Florentine wealth; it may also have been a specific reference to the gold florin and the Florentines' prestige as bankers.

The decorative totality of the doors is based on the French Gothic motif of the quatrefoil, which is repeated 28 times. The borders around the quatrefoils have Florentine lions at the corners between a running motif of alternating flowers and diamonds. The circular petals of the flowers and the points of the diamonds are a play on the shape of the quatrefoil, giving the doors further unity. The compositions of the individual narrative scenes are influenced by their surrounding quatrefoils, but the solutions are distinct, with the figures or elements such as landscape responding or react-

South doors of Florence Baptistery
© Alinari / Art Resource, NY

GIOVANNI PISANO *ca. 1250–ca.1314*

narrative and powerfully leads the viewer through the account.

RITA TEKIPPE

See also **Pisano, Nicola**

Biography

Born in Pisa, Italy, mid 13th century. Son and pupil of sculptor Nicola Pisano. First known from Nicola's contract for Siena pulpit, which suggests he was a teenager, 1265; worked on Perugia fountain, 1277–78; documented in Pisa, 1284, and then as returning to Siena, September, 1825; connected with work on the facade of the Siena Cathedral, 1287, and headmaster of the project, 1290; last known from Siena Council tax immunity records in 1314. Buried in Siena, Italy.

Selected Works

1278	Figures of two eagles; marble, bronze; lower basin, Great Fountain, Perugia, Italy
1287–97?	Facade; marble; Siena Cathedral, Italy
after 1297	*Virgin and Child*; fragments: Camposanto, Pisa, Italy
1298–1301	*Pulpit*; marble, porphyry; Church of Sant'Andrea, Pistoia, Italy
ca. 1298	*Virgin and Child*; ivory; Museo dell'Opera del Duomo, Pisa, Italy
1300	Crucifix; polychromed wood; Church of Sant'Andrea, Pistoia, Italy
1300?	*Madonna and Child*; marble; Museo dell'Opera del Duomo, Pisa, Italy
1302–10	Pulpit; marble; Pisa Cathedral, Italy
1305?	Crucifix; polychromed wood; Museo dell'Opera del Duomo, Siena, Italy
1312	Tomb of Margaret of Luxemburg, for the Church of S. Francesco do Castelletto, Genoa, Italy; fragments: Galleria di Palazzo Bianco (Civica Galleria), Genoa, Italy
ca. 1313	*Virgin and Child*, for tympanum, Porta di S. Ranieri, Pisa Cathedral, Italy; fragments: Museo dell'Opera del Duomo, Pisa, Italy

Further Reading

Ayrton, Michael, *Giovanni Pisano: Sculptor*, London: Thames and Hudson, and New York: Weybright and Talley, 1969

Bober, Phyllis Pray, and Ruth Rubinstein, *Renaissance Artists and Antique Sculpture*, London: Miller, and Oxford: Oxford University Press, 1986

Busch, Harald, and Bernd Lohse, editors, *Gotische Plastik in Europa*, Frankfurt: Umschau, 1962; as *Gothic Sculpture,* translated by Peter George, London: Batsford, and New York: Macmillan, 1963

Crichton, George Henderson, *Romanesque Sculpture in Italy*, London: Routledge and Paul, 1954

Keller, Harald, *Giovanni Pisano*, Vienna: Schroll, 1942

Pope-Hennessy, John Wyndham, *Introduction to Italian Sculpture*, 3 vols., London: Phaidon, 1963; 4th edition, 1996; see especially vol. 1, *Italian Gothic Sculpture*

Sanpaolesi, Piero, *La facciata della Cattedrale di Pisa*, Florence: La Nuova Italia, 1957

Weinberger, Martin, "Giovanni Pisano," *The Burlington Magazine* 70 (1937)

White, John, *Art and Architecture in Italy, 1250–1400*, London and Baltimore, Maryland: Penguin, 1966; 3rd edition, New Haven, Connecticut: Yale University Press, 1993

Williamson, Paul, *Gothic Sculpture, 1140–1300*, New Haven, Connecticut: Yale University Press, 1995

PULPIT, SANT' ANDREA

Giovanni Pisano (ca. 1250–ca. 1314)

1298–1301

marble, porphyry

h. 4.55 m

Church of Sant'Andrea, Pistoia, Italy

Giovanni Pisano's Sant'Andrea pulpit in Pistoia expresses human, emotion-laden spirituality with overtones of the prophetic and the apocalyptic. Like most medieval church sculpture, it reflects contemporary theology (drawing on Franciscan and Dominican thought), emphasizes preaching, and encourages personal religiosity. Christ is represented as a man and in relation to man. Diverging from his father Nicola Pisano's reliance on serene antiquities, Giovanni expanded his expressive range by combining deeper carving with energetic composition. Seeking new solutions, he perhaps investigated different antique monuments, such as the *Jonah Sarcophagus* for conflated narratives and the *Sarcophagus of the Two Brothers* for figures freed from the background, as well as later European and Byzantine art. From new forms and styles, Giovanni chose more concrete and particular portrayals (see Larner, 1971) from animated French and German Gothic cathedral sculpture and portable works for his figure types and emotional eloquence, which was better suited to the anxiety of the era (see Ayrton, 1969). And Giovanni deferred to none of his fellow artists as superior, as the inscription carved beneath the basket tells us: "Giovanni carved it who performed no empty works. Born of Nicola, but blessed with greater science, Pisa gave him birth and endowed him with mastery greater than any seen before" (see White, 1966).

The iconography of the pulpit probably reflects local liturgical practice and preaching that accentuated the pulpit as a site for reading the Epistles and Gospels

(see Glass, 1987). Narratives invite response by engaging emotions—tender bonding of mother and child, pain and horror of violent physical attack—while stimulating the mind with scriptural messages and evoking multilevel attention with mind, heart, and soul. Rendering a sense of "urgency of human communication . . . (through) . . . tremendously potent gesture forward. . . . Giovanni . . . put the whole body into the expression, . . . with implications of . . . contradictions, troubles and worries inside the head" (see Moore, 1969). References to communication—speaking, listening, gesturing, and responding—recur throughout narrative panels and figural elements. Giovanni enhanced these messages by making fuller use of human forms, simplifying and abstracting depiction, and dynamically grouping conflated, complex narrative incidents with interactive statuary between. Lower level figures interrelate and refer to carvings above by posture, gesture, and gaze, strengthening a sense of coordinated overall composition.

The first panels present the Annunciation and Nativity stories with anecdote and innovation. Profound compositional changes differentiate depictions from related works on Nicola's pulpits. Quiet moments of human activity and dynamic effects of concerted movement emphasize interrelationships. Arms and legs establish rhythmic patterns, which was an unprecedented innovation. Dramatic, expressive distortion and linear gestures and forms characterize Giovanni's genius for leading the eye through pictorial elements, establishing psychological and emotional connections and reflecting his era in theoretical, theological, and practical, human ways, visually linking prophets to sibyls, antique prophecies to New Testament events, and exaggerating such responses as maternal terror in the Massacre of the Innocents and the tender care of the Virgin Mary and the midwives for the infant Christ Child.

The stories of the three Magi accentuate Christ as world savior and sovereign (see Schiller, 1971). Giovanni deemphasized lavish gifts, innovatively giving visual form to Pseudo-Bonaventura's *Meditations on the Life of Christ*: "then, full of reverence and piety, they kissed His feet" (see Ragusa and Green, 1961). There is a loving connection between the kneeling Magus (the crown respectfully removed and hung on his arm) and the Christ Child holding the gift on his lap. Other written sources for imagery are Psalm 45: 11, Matthew 2, and the Apocrypha. Another unprecedented treatment illustrates Voragine's *Golden Legend* description of the Magi's journey as guided by a child-faced star (see Mâle, 1958).

Three remaining panels relate single stories. The *Massacre of the Innocents* depicts emotional reaction to horrors perpetrated by Herod, attesting to the local experience of sack during recurrent factional wars in Pistoia (see Ayrton, 1969). Energetic chisel use lends added dimensions through frenzied, highly dramatic marks; the carving, which was left unpolished with very little finish, enhances the turbulence and brutality (see White, 1966). Gesture and struggle create a linear staccato orchestrated to lead the eye through powerful action and reaction, writhing postures, and emotion-filled gazes. The *Crucifixion* panel, which is less innovative, still presents expressive interpretation and emotional faces and forms. The corpus of Christ shows graphic suffering, the face tremendous anguish. The *Last Judgment*, also less dynamic, is still much less static than its predecessors in Pisa and Siena.

Upper angles bear images of St. Stephen (see White, 1966), the first deacon and the first martyr, the apocalyptic Christ, the prophet Jeremiah, the Angel with Evangelist Symbols, and Writers of the Canonical Epistles. The latter two had precedents on pulpit corners in nearby San Giovanni Fuorcivitas, by Fra Guglielmo, who was also Nicola's assistant. On the final angle are angels blowing trumpets with exquisite corporeality, their bellies and cheeks filled with air.

Below are 12 prophets in spandrels and six sibyls on angles. In coeval theology, sibyls from Antiquity joined Old Testament prophets in the prefiguration of New Testament events. Prophets were scholars of Mosaic law, whereas sibyls worked intuitively (see Ayrton, 1969), like late medieval female mystics. Each sibyl, with an angel whispering into her ear, claims her space while dynamically relating to surrounding carvings. Giovanni pushed the expressive limits of physical posture with bodies twisted in space, depicting an alertness felt throughout the figure: for instance, an alarmed head turned in astonishment, a hand raised to breast in surprise, humility, and intuition. All the sibyls and prophets bear scrolls, originally inscribed with words announcing scroll bearers as instruments and voices of God (see Mâle, 1958).

Finally, two lecterns completed the work (now removed, perhaps in the Metropolitan Museum of Art, New York City, and in Berlin-Dahlem; see Ayrton, 1969). One may have been positioned above the angel with evangelist symbols, since John's eagle emblem is missing there. The other shows Christ suffering and worn, his head hanging on his breast, a similar figure to that on the cross in the Crucifixion panel.

Giovanni's work manifests the spiritual sentiment of his times. The aforementioned inscription tells us he "performed no empty works." The complex pictorial message of the pulpit is compelling, reflecting that he was attuned to broad human experience ranging from mystical rapture to the concrete realities of everyday life. This monument far surpasses the work of his con-

temporaries, indeed of his fellow artists for several generations before and after.

RITA TEKIPPE

See also **Pulpit**

Further Reading

Ayrton, Michael, *Giovanni Pisano: Sculptor*, London: Thames and Hudson, and New York: Weybright and Talley, 1969

Glass, Dorothy, "Pseudo-Augustine, Prophets, and Pulpits in Campania," *Dumbarton Oaks Papers* 41 (1987)

Herlihy, David, *Medieval and Renaissance Pistoia: The Social History of an Italian Town, 1200–1430*, New Haven, Connecticut: Yale University Press, 1967

Larner, John, *Culture and Society in Italy, 1290–1420*, New York: Scribner, and London: Batsford, 1971

Lesnick, Daniel R., *Preaching in Medieval Florence: The Social World of Franciscan and Dominican Spirituality*, Athens: University of Georgia Press, 1989

Mâle, Émile, *L'art religieux du XIIIe siècle en France: Étude sur l'iconographie du Moyen Âge et sur ses sources d'inspiration*, Paris: Leroux, 1898; as *The Gothic Image: Religious Art in France of the Thirteenth Century*, translated by Dora Nussey, New York: Harper and Row, 1958

Moore, Henry, introduction to *Giovanni Pisano: Sculptor*, by Michael Ayrton, London: Thames and Hudson, and New York: Weybright and Talley, 1969

Ragusa, Isa, and Rosalie B. Green, editors, *Meditations on the Life of Christ: An Illustrated Manuscript of the 14th Century*, Princeton, New Jersey: Princeton University Press, 1961

Schiller, Gertrud, *Ikonographie der Christlichen Kunst*, 5 vols., Gütersloh, Germany: Mohn, 1966–91; as *Iconography of Christian Art*, 2 vols., translated by Janet Seligman, Greenwich, Connecticut: New York Graphic Society, and London: Lund Humphries, 1971

Seidel, Max, *Giovanni Pisano: Il pulpito di Pistoia*, Florence: Sadea/Sansoni, 1965

White, John, *Art and Architecture in Italy, 1250–1400*, London and Baltimore, Maryland: Penguin, 1966; 3rd edition, New Haven, Connecticut: Yale University Press, 1993

NICOLA PISANO ca. 1220–BEFORE 1284
Italian

During the third quarter of the 13th century, the Italian sculptor Nicola Pisano created a distinctive sculptural language by introducing into the Italian Romanesque both the Classicism of ancient Rome and the Gothic style of contemporary France. In fashioning this new sculptural language, he effectively founded the Tuscan school of sculpture that would reach its culmination in Michelangelo.

Despite his name, which means Nicola (Niccolò) of Pisa, he was almost certainly born in Apulia in southern Italy, and it is now generally accepted that he was also trained there. At this time, the region of Apulia was ruled by the Holy Roman Emperor Frederick II (*r.* 1220–50), whose court there was one of the outstanding cultural centers of the age.

Nicola's training would certainly have introduced him to a wide range of styles and techniques and, in particular, to the use of Classical models—Frederick's taste for the Classical was inspired by his need to legitimize his imperial claims.

Nicola probably moved to Tuscany in the early or mid 1240s; we know that his son, Giovanni, was born in Pisa in the late 1240s. Pisa was then the leading city of Tuscany, its wealth and culture founded on its extensive maritime trade; it had a strong sculptural tradition, which was based largely on the Romanesque of Tuscany and Lombardy but also included works drawn from the Byzantine tradition. Moreover, its sympathies were firmly with the Ghibelline (imperial) cause, and so it would have been a natural destination for an Apulian artist.

Nicola's first major work was a pulpit for the Pisa Baptistery, signed and dated 1260. He must already have had a high reputation to receive such an important commission, although no major works prior to this have been identified. This is all the more surprising given the pulpit's originality and complete assurance—a comparison with a pulpit by Guido da Como in the Church of S. Bartolomeo in Pistoia, completed only ten years earlier, clearly illustrates how innovative Nicola's Pisa pulpit was in both sculptural and architectural terms.

Nicola's pulpit is a freestanding structure with a six-sided platform; the use of a polygonal form was in itself an innovation in Tuscany. On the five panels of white marble that form the sides of the platform (the sixth side provides access), Nicola depicted scenes from the life of Christ, and it is here that his striking Classicism is most evident. Given his training in Frederican Apulia, a pronounced Classicism would have been a natural development for Nicola, and there is good reason to believe that it would have been encouraged by the Pisan authorities, who were keen to establish their city's pedigree. This search for a Classical past would soon play a key role in the development of Italian humanism. Nicola's Classicism, however, is interfused with Romanesque and, above all, Gothic elements, this blending of styles animated by the growing "naturalism" of his age—in both religious and intellectual life, there was now an increasingly keen interest in this world as well as the next. Among the more imaginative artists and patrons, this interest led to a desire to create not mere conventional religious symbols, but believable images of real life—images with which worshipers could more readily identify. This change in attitude and perception is clearly seen in Nicola's work. In contemporary (Romanesque) reliefs, rather flat, hieratic figures are generally arranged schematically along the frontal plane. In Nicola's Classical

reliefs, by contrast, are boldly defined figures, convincing in both physique, gesture, and expression, moving and acting in a deeper, more coherent space.

The Pisa Baptistery pulpit doubtless established Nicola as an important sculptor, and during the 1260s his assistants (working to his designs) carved reliefs for the facade of Lucca Cathedral and constructed a shrine to St. Dominic for the Church of S. Domenico in Bologna. Nicola himself seems to have been employed mainly on rebuilding the upper section of the Pisa baptistery. Giorgio Vasari records in his *Lives of the Painters, Sculptors, and Architects* that Nicola was a celebrated architect, although no buildings have yet been firmly attributed to him (see Vasari, 1550).

In 1265 Nicola was commissioned to create a pulpit for Siena Cathedral, which he completed in 1268. In broad terms, this is a work similar to the pulpit in Pisa: both are freestanding polygonal pulpits decorated with large narrative panels and resting on columns linked by trefoil arches. There are important differences, however. This platform is eight-sided, so there are seven reliefs, which are separated not by small columns (as in Pisa), but by standing figures. The result is a greater fluency in the narrative and a greater sense of overall coherence. In fact, two of the panels form a single scene: the *Last Judgment* has the Saved on one panel and the Damned on another, with Christ in Judgement being the corner figure linking them. There are also subtle changes in iconography; for example, the spandrels now contain images not only of the prophets and Evangelists, but also of Sibyls, another indication of the desire to integrate Classical and Christian culture.

The most important difference, however, is the dramatic change in style. There are still Classical elements (some figures are even modeled on Roman works in Siena), but on the whole, there has been a decided move to the Gothic style. The figures are smaller and more numerous, the emotion more intense, the rhythms fluid and dynamic. The figure of Christ in the *Crucifixion*, which in Pisa has the calm dignity of a *Christus triumphans*, is here unmistakably a *Christus patiens*, the agony of death all too visible.

This adoption of the Gothic style is usually explained by the greater participation of his son, Giovanni, who in his own works was to develop an ornately Gothic style of great emotional intensity. It may also be important that the man who drew up the contract for the pulpit, Fra Melano, the cathedral's clerk of works, was a Cistercian and so was probably familiar with developments in France.

Father and son also worked closely on Nicola's last major work, a large public fountain (*Fontana Maggiore*) in Perugia, built as an expression of the city's civic pride and political (Guelf—allied to the pope) loyalties. The fountain was constructed in 1277–78.

The two large lower polygonal basins of the Perugia fountain are of marble and display reliefs (first basin) and standing figures (second) representing the liberal arts, the Labors of the Months (with the signs of the zodiac), biblical figures, heraldic animals, fables, saints, city dignitaries, and personifications of various regions and cities. Like the pulpits, the fountain as a whole reveals a subtle interplay of forms, ratios, and iconography. Many of these images are based on French (Gothic) prototypes, and although the carving (now weatherworn) is seldom as bold or as dramatic as that on the pulpits, it is usually elegant and expressive. The third (round) basin, of bronze, is surmounted by three bronze caryatids, graceful Classical figures that, standing back to back, support a vessel from which water flows.

In its characteristic merging of both Classical and Gothic influences, and in its elaborate iconography, which draws on a wide range of Christian and pagan sources, the Perugia fountain is a compendium of medieval culture reminiscent of the encyclopedic *Speculum majus* of Vincent of Beauvais (*ca.* 1190–1264).

Nicola's remarkable advances in figural style, composition, and carving technique effectively established a new school of Italian sculpture. His immediate beneficiaries were the two major sculptors of the next generation: his son, Giovanni Pisano, and Arnolfo di Cambio, both of whom worked as his assistants.

CHRIS MURRAY

Biography

Born in Apulia, southern Italy, *ca.* 1220. His documented career covers the period 1258–78, when he worked in northern Italy; his name first occurs in the will of Guidobono Bigarelli (brother of Pisan sculptor Guido da Como), dated April 1258; probably moved to Pisa in Tuscany in early 1240s; first authenticated work, pulpit for Pisa Baptistery, completed 1259/60; his workshop carved reliefs for the facade of Lucca Cathedral, *ca.* 1260–65, and a shrine to St. Dominic in the Church of S. Domenico, Bologna, 1264–68; during the same period Nicola is known to have been extending the upper sections of the Pisa Baptistery; began a pulpit for Siena Cathedral in 1265 (contract dated 29 September), completed in 1268; two contracts drawn up in Siena on 12 May 1266 refer to him as Nicola de Apulia (from Apulia); in Perugia (Umbria) worked on the *Fontana Maggiore* (Large Fountain), on which he was assisted by his son Giovanni as well as Arnolfo di Cambio and others, 1277–78. Died probably in Pisa, Italy, before 1284.

Selected Works

1259/60 Pulpit; marble; Baptistery, Pisa, Italy
1265–68 Pulpit; marble; Siena Cathedral, Italy
1277–78 *Fontana Maggiore*; marble, bronze;
Perugia, Italy

Further Reading

Avery, Charles, *Florentine Renaissance Sculpture*, London: John Murray, and New York: Harper and Row, 1970

Ayrton, Michael, *Giovanni Pisano: Sculptor*, London: Thames and Hudson, and New York: Weybright and Talley, 1969

Barasch, Moshe, "A Silenus Surviving in Nicola Pisano," in *Imago Hominis: Studies in the Language of Art*, Vienna: IRSA, and New York: New York University Press, 1991

Crichton, George Henderson, and Elsie Robertson Crichton, *Nicola Pisano and the Revival of Sculpture in Italy*, Cambridge: Cambridge University Press, 1938

Greenhalgh, Michael, *The Classical Tradition in Art*, New York: Harper, and London: Duckworth, 1978

Polzer, J., "The Lucca Reliefs and Nicola Pisano," *Art Bulletin* 46 (1964)

Pope-Hennessy, John, *An Introduction to Italian Sculpture*, 3 vols., London: Phaidon, 1963; 4th edition, 1996; see especially vol. 1, *Italian Gothic Sculpture*

Seymour, C., "Invention and Revival in Nicola Pisano's 'Heroic Style,'" *Studies in Western Art* 1 (1963)

Vasari, Giorgio, *Le vite de più eccellenti architetti, pittori, e scultori italiani*, 3 vols., Florence: Torrentino, 1550; 2nd edition, Florence: Florence: Apresso i Giunti, 1568; as *Lives of the Painters, Sculptors, and Architects*, 2 vols., translated by Gaston du C. de Vere (1912), edited by David Ekserdjian, New York: Knopf, and London: Campbell, 1996

White, John, *Art and Architecture in Italy, 1250 to 1400*, London and Baltimore, Maryland: Penguin, 1966; 3rd edition, New Haven, Connecticut: Yale University Press, 1993

PULPIT, PISA BAPTISTERY

Nicola Pisano (ca. 1220–Before 1284)

completed 1259–1260

marble

h. 4.71 m

Pisa, Italy

The pulpit Nicola Pisano created for the Pisa Baptistery was probably part of an extensive program of improvement: a polygonal font by Guido da Como had been set in place in 1250, and on completion of the pulpit, Nicola began extending the upper section of the building. An important and ambitious work, the pulpit was probably commissioned by the new archbishop of Pisa, Federico Visconti who served (*ca.* 1254–77), and it is safe to assume that the archbishop would have been responsible for its iconography (some scholars have even claimed that the key to the pulpit can be found in Visconti's sermon *Civitas Dei, Domus Dei*).

Largely because of the preaching zeal of two of the new religious orders—the Dominicans (founded 1216) and the Franciscans (founded 1209)—pulpits assumed a greater architectural and iconographic significance in Italy during the 13th century, with their sculptures in effect becoming visual aids, the sermons exhorting an imaginative participation in biblical events that was facilitated by vividly carved images. The pulpit Nicola created for the Pisa Baptistery marked the high point of this development.

Although it grew directly out of a Romanesque tradition, the Pisa Baptistery pulpit is best known for employing Classical and Gothic models. The form Nicola used—a freestanding polygonal structure, in this case six-sided—was rare in Tuscany and was almost certainly chosen for aesthetic reasons: a round baptistery whose central feature was now an eight-sided font. But the forms and proportions employed would also have been seen as reflecting the sacred geometry that was an integral part of Medieval and later Renaissance thinking. Although this aspect of the pulpit is still to be fully explored, it is safe to assume, for example, that the circle formed by the baptistery will have been taken to represent perfection (and therefore God), the eight sides of the font the Resurrection (it was on the eighth day after his entry into Jerusalem that Christ rose from the dead), and the six sides of the pulpit the Creation (the number of days God took to create the world). Form and iconography, in other words, were almost certainly meant to work in harmony.

The six-sided platform of the pulpit is supported by one central and six corner columns, essentially Corinthian with foliated Gothic capitals, a borrowing from the French Gothic style recently brought to Italy by the Cistercians. Three of the corner columns rest on naturalistic lions, symbols of the Church either protecting Christians or devouring their enemies. At the base of the central column sit stylized animals and a curious male figure, grinning toothlessly, who probably represents unregenerate nature. (In Nicola's next pulpit, in Siena, these figures are replaced by representations of the Liberal Arts and Philosophy.)

Linking the corner columns are trefoil arches, also clearly derived from French Gothic; in their spandrels are figures of relevant prophets and (under the *Crucifixion* and the *Last Judgment*) the four Evangelists. Standing at the corners above the capitals are single figures (the Virtues) carved in three-quarter relief: Charity, Fortitude, Prudence, Chastity (represented by St. John the Baptist, a key figure in a baptistery), Temperance, and Faith (as there are no identifying inscriptions with these figures, interpretations differ).

Although the overall impression of the pulpit is Gothic, there are also unmistakable Classical allusions—the architecture of round arches flanked by columns and supporting large narrative panels is a clear

Pulpit, Baptistery, Pisa
© Alinari / Art Resource, NY

echo of the Roman triumphal arch, notably the Arch of Constantine (312 CE) in Rome.

Nicola's Classicism is most pronounced in the relief panels, particularly the first three. The five panels depict the *Nativity*, *Annunciation*, and *Annunciation to the Shepherds* (combined in a single panel), the *Adoration of the Magi*, the *Presentation in the Temple*, the *Crucifixion*, and the *Last Judgment*. Significantly, some of the incidents in these scenes are taken from the many legends and saints' lives that would soon be collected by a contemporary, Jacobus de Voragine, to form the *Legenda Aurea* (Golden Legend). The proliferation of such stories—and the influence of St. Francis of Assisi (1181/82–1226)—represents a humanizing of religion, with a greater emphasis being placed on experiencing the sacred in everyday life. Similarly, the rediscovery of Aristotle's works in the 12th century had brought about a transformation in Western thinking, the result being a greater interest in the natural world and in the particular rather than the universal.

In developing a Classicism that would express these new ideas and attitudes, Nicola was able to turn to models ready at hand, principally the so-called Phaedra Sarcophagus (2nd century CE), which then stood in front of Pisa Cathedral. In the *Adoration of the Magi*, for example, the Virgin Mary (based incongruously on

an image of the incestuous Phaedra) is an aristocratic Roman matron, complete with Greco-Roman head-dress and hairstyle, shown receiving dignitaries. Even the Magi's horses, curiously wild for such a calm scene, are taken directly from the sarcophagus. This source also provided the corner figure of Fortitude, which, though traditionally represented as a woman, is here a fine nude Hercules, vigorous and unashamed. A confident and finely modeled classical male nude standing in *contrapposto* (a natural pose with of one leg, the shoulder, and hips, counterbalancing one another), he is one of the first heroic nudes of the Middle Ages, showing not the slightest signs of the sense of sin or shame typical of nudes in medieval art, and is a direct forerunner of Michelangelo's *David*.

Another important borrowing is the figure of the High Priest in the *Presentation in the Temple*, taken this time from a Roman copy of a Neo-Attic krater in the nearby Camposanto (Pisa's main cemetery). This krater was significant because it was thought to have been a gift to Pisa from the first Roman emperor, Augustus (*ca.* 27 BCE–14 CE); a Ghibelline city, Pisa was keen to display both its present loyalty to the imperial cause (the Hohenstaufen dynasty) and its own Classical past.

Nicola's figures are obviously meant to have a Classical gravitas. Clearly defined, even when they overlap, they have a strong individual presence, their features clear-cut and expressive, their actions dignified, their gaze alert and intelligent. The folds in their Roman dress are deep and emphatic; this not only helps to give the bodies a sense of weight and form, but also creates strong linear rhythms that both animate and unify the compositions. By contrast, the *Last Judgment* and the *Crucifixion* panels, restless and crowded, may well have been based on French or Byzantine ivories; their Gothic style would become even more evident in Nicola's next pulpit, in Siena.

All the reliefs display a subtle and imaginative interplay of forms that reveals how closely and perceptively Nicola studied Roman reliefs; he was not, like so many other medieval sculptors, simply borrowing motifs. They also show his skill in carving techniques, both in broad effects and in the rendering of detail; it is clear that he took full advantage of sharper, more accurate chisels made possible by recent improvements in the tempering of metal. He made extensive use of the drill to sharpen focus and often undercut the figures deeply, not merely to give them greater definition but also to accentuate the patterns of light and shadow across the surface. Faint traces of pigment suggest that originally the panels were also painted.

By drawing together into a harmonious yet dynamic unity a wide range of elements—iconographic as well as formal—Nicola's pulpit in the Pisa Baptistery can

be seen as an outstanding expression of two concepts long central to Medieval aesthetics, *proportio et claritas* (proportion and clarity). By embodying a new sculptural language remarkable for its expressive, intellectual, and formal range, the Pisa pulpit can also be seen as a clear anticipation of the Renaissance.

CHRIS MURRAY

See also **Pulpit**

Further Reading

Angiola, Eloise M., "Nicola Pisano, Federico Visconti, and the Classical Style in Pisa," *Art Bulletin* 59 (March 1977)
Herlihy, David, *Pisa in the Early Renaissance: A Study of Urban Growth*, New Haven, Connecticut: Yale University Press, 1958
Smith, Christine, *The Baptistery of Pisa*, New York: Garland, 1978
Weinberger, M. "Nicola Pisano and the Tradition of Tuscan Pulpits," *Gazette des Beaux-Arts* 1 (1960)

NINO PISANO *ca.* 1315–1368 *Italian*

Following the medieval tradition in which the trade of a sculptor was not distinguished from that of a goldsmith, Nino Pisano was both a goldsmith and a sculptor and began to learn the rudiments of his craft in the workshop of his father Andrea Pisano, as well as with his brother Tommaso. Nevertheless, the reconstruction of Nino's biography and artwork is made more difficult by the meagerness of documentary evidence and by a body of signed work that consists of only three sculptures.

Evidence of Nino appears for the first time in Orvieto in 1349 where he was mentioned in two documents dated 22 October and 17 November. These documents indicate that he served as master of the cathedral works after his own father, who died around 1348 or 1349, had previously occupied this role. Nino probably began working as a sculptor in his own right at his father's Pisan workshop, which thrived between 1343 and 1347. Critics today almost unanimously recognize the hand and style of Nino in some parts of the tomb of Simone Saltarelli in the Church of S. Caterina in Pisa, identifiable in the figure of the angel to the right of the Madonna and in the effigy of the deceased, even if we cannot exclude the possibility that Nino worked on other parts of the monument in collaboration with and under the attentive control of his father. After leaving Orvieto about 1350, Nino returned to Pisa, and in 1358 he worked on a now-lost silver antependium for the cathedral. The last document, which also provides the approximate date of his death, is from 5 December 1368, when 20 florins were paid by the city of Pisa to his son Andrea for the tomb of the doge

Giovanni dell'Agnello (which at that time was on the facade of the Church of San Francesco in Pisa, but is now destroyed) that Nino had finished before his death.

There are three works autographed by Nino that can be placed in this time period: the *Holy Bishop* at the Church of S. Francesco in Oristano, the *Virgin and Child* at the Church of Santa Maria Novella in Florence, and the *Virgin and Child between the Saints Peter and Paul and Two Angels* at the tomb of Doge Marco Cornaro at the Church of Santi Giovanni e Paolo in Venice. Through an attentive stylistic analysis an attempt to reconstruct the chronological sequence of these sculptures is possible. The first to be sculpted was probably the *Holy Bishop* in Oristano, a figure that, for its hints of the school of Giotto and the elegant but restrained torsion of the body, still shows definite ties to the work of Andrea Pisano. This affiliation with his father's style began to grow weaker in the *Virgin and Child* at the tomb of Doge Marco Cornaro and weaker still in the Florentine *Virgin and Child* in which the elegance eclipses the corporeal *gravitas*, and the curves of the drapery create an abstract decorative pattern that no longer reflects the subordinate forms of the body, manifesting Nino's growing assimilation of the styles of French Gothic sculpture. The same researched counterpoint, which preserves the type of face characterized by the subtle and pungent features that are typical of Nino's faces, can also be found in the marble *Virgin and Child* at The Detroit Institute of Arts and in the wooden retable also representing the *Virgin and Child* (Pisa, Museo Nationale di San Matteo), known as the "Madonna dei Vetturini" (Madonna of the Carriage Drivers). In his sculptures of the *Virgin and Child*, Nino surpassed the hieratic interpretation of the typical twosome of the Tuscan figurative

Carved sepulchre for an archbishop's burial vault, Pisa, Italy
© Massimo Listri / CORBIS

tradition and, taking as a model the prototypes of Parisian workshops of the first half of the 14th century, he interpreted the relationship between mother and child with extreme delicacy and intimacy. This delicateness also was accentuated by an extremely refined technique of smoothing the marble, which obtained results of such high quality that they were noted by Giorgio Vasari: "Nino began to overcome the hardness of the rock and adapted it to the liveliness of flesh, shining it with a good polishing."

Further information on the catalogue of works attributed to Nino was furnished by Vasari. In the first edition of *Lives of the Painters, Sculptors, and Architects* in 1550, Vasari lingers only briefly on Nino in the margins of the life of Andrea Pisano, but in the second edition in 1568, the historiographer pauses for a longer time on Nino, assigning to him three other works in addition to the *Virgin and Child* in the Church of Santa Maria Novella: the *Madonna with Child* in the Church of Santa Maria della Spina in Pisa, the *Madonna with Child* in the Museo Nazionale e Civico di S. Matteo in Pisa, and the group of the *Annunciation* at the Church of S. Caterina, also in Pisa. Although these Pisan sculptures show mutual stylistic connections, their affinity to the works signed by Nino prove to be weak and the difficulty in retracing their paternity is also highlighted by the divergent positions of critics. For example, the group of the *Annunciation* at S. Caterina is assigned to Nino by Gert Kreytenberg (1984) and Mariagiulia Burresi (1983), but was then refuted by Moskowitz, who saw in these sculptures the hand of another independent sculptor who absorbed the lessons of Andrea and Nino, blending them with those of Alberto Arnoldi (see Moskowitz, 1986). This oscillation of critical judgment is inevitably reflected in the number of works attributed to Nino, which is relatively scanty in Moskowitz and reaches about 50 works in Kreytenberg, whereas Burresi singled out 11 collaborative works by Andrea and Nino.

Among the major works that can be attributed to Nino, there are two monuments that are very similar in their structures; these are the tombs of Archbishops Giovanni Scherlatti and Francesco Moricotti now in the Museo dell'Opera del Duomo in Pisa. In a highly detailed document from February 1362, the executors of Scherlatti's will asked Nino to carve a deposit of Carrara marble to be finished within 15 months of the stipulation of the contract: he had to decorate a sarcophagus with three relief panels representing Christ in pietà, the Virgin Mary, and St. John the Baptist each flanked by two angels. The effigy of the archbishop accompanied by two angels was to lie on top of the sarcophagus. On the sides of the sepulcher, which was covered by a multilobed marble arch, the figures of Sts. Peter and Paul were to be placed. The Moricotti

monument, commissioned before the archbishop left Pisa in 1368, presents the same structure except for the relief-sculpted figures on the panels of the sepulcher: Christ blessing in the center, an unidentified saint, and an unknown martyr. Originally placed on the wall of the cathedral's sanctuary, the two monuments were moved various times around the church, and in 1829 they were transferred to the *camposanto monumentale*. On this occasion the front stones were mounted erroneously so that the figure of Archbishop Scherlatti was lying on Moricotti's sepulcher and vice versa. In 1986, on the occasion of moving the tombs to their present location, the error was corrected and the figures were reconnected to their original fronts. On the basis of documentary data and stylistic analysis, there seem to be five other sculptures from the early 1360s originally belonging to these monuments: a statue of *St. Peter*; one of *St. Paul* and an *Angel*, presumably a part of Scherlatti's tomb; one of *St. Francis*; and a *Holy Bishop*, part of the tomb of Maricotti.

CRISTIANO GIOMETTI

See also **Pisano, Andrea**

Biography

Born *ca.* 1315, location of birth known. Son of sculptor and goldsmith Andrea Pisano; brother Tommaso a sculptor. Active in father's workshop by 1343; recorded in Orvieto as master of the cathedral works, 1349; documented in Pisa to work as goldsmith for cathedral, 1358; contracted to build monument to Archbishop Giovanni Scherlatti, 1362. Died in Pisa, Italy, before 8 December 1368.

Selected Works

ca. 1341–45	Tomb of Simone Saltarelli (with Andrea Pisano and workshop); marble; Church of S. Caterina, Pisa, Italy
ca. 1343–47	*Holy Bishop*; marble with traces of polychromy and gilding; Church of S. Francesco, Oristano, Italy
ca. 1343–47	*Madonna with Child* (with Andrea Pisano and workshop); marble with traces of polychromy and gilding; Church of Santa Maria della Spina, Pisa, Italy
ca. 1343–47	*Virgin and Child between the Saints Peter and Paul and Two Angels*; marble with traces of polychromy and gilding; over tomb of Doge Marco Cornaro, Church of Santi Giovanni e Paolo, Venice, Italy
ca. 1347–48	*Virgin and Child*; marble; Church of Santa Maria Novella, Florence, Italy
ca.	*Annunciation*; polychromed and gilded

Middeldorf, Ulrich, and Oswald Goetz, *Medals and Plaquettes from the Sigmund Morgenroth Collection*, Chicago: Art Institute of Chicago, 1944

Pope-Hennessy, John, *Renaissance Bronzes from the Samuel H. Kress Collection: Reliefs, Plaquettes, Statuettes, Utensils, and Mortars*, London: Phaidon Press, 1965

Rossi, Francesco, editor, *Placchette, sec. XV–XIX: Catalogo*, Vicenza, Italy: Pozza, 1974

Weber, Ingrid S., *Deutsche, niederländische, und französische Renaissanceplaketten, 1500–1650*, 2 vols., Munich: Bruckmann, 1975

PLASTER

See **Stucco (Lime Plaster)**

PLASTER CAST

A plaster cast is a reproduction of the form, volume, and surface of a three-dimensional object and is created by pouring the liquid form of gypsum plaster, or plaster of Paris, into a mold taken directly from the object. As the plaster crystallizes, it expands to fill the details of the mold and quickly sets as a uniform, solid mass. Plaster casts may be made with piece molds (in which each part of the object is cast by a separate mold), but more often plaster casts are created with single-use or waste molds (the mold must be destroyed in order to reveal the cast).

Because plaster is easy to produce, dries quickly, and is readily available and inexpensive, sculptors frequently use it to make casts for use as models or reproductions. When dry, however, plaster is brittle and highly absorbent, making casts difficult to transport and vulnerable to water and dirt. The low tensile strength of plaster often requires metal rods to form an interior armature in the casts.

The earliest uses of plaster occurred in the civilizations of the ancient Near East and Mediterranean. The first known plaster casts are reproductions of human heads or wax heads found among the artist's models in the studio of the main sculptor at the court of the Egyptian pharaoh Akhenaton (*ca.* 1340 BCE). Plaster casts may have been in use in Egypt as early as 2400 BCE as material for death masks made before mummification. During Greek and Roman Antiquity, the impetus for creating plaster casts came with the growing interest in portraiture, the custom of death masks, and the popularity of reproducing copies of famous statues in marble and bronze. In the 1st century CE, Pliny the Elder in his *Natural History* credited the ancient Greeks for inventing the technique of piece molding—naming sculptor Lysistratus of the fourth century BCE as the first artist to make plaster molds from statues and human faces for use in making wax and clay casts—and for the reproduction of statues in stone using the pointing process.

According to 16th-century art historian Giorgio Vasari, the sculptor Andrea del Verrocchio (1435–88) either invented or was the first to rediscover how plaster was made, as well as the method of making casts. Owing to beliefs that ancient art was superior in style and composition, artists commonly used plaster casts of ancient sculpture as models and teaching aids in their workshops by at least the 15th century. Vasari noted that during the 1440s, the painter Andrea Mantegna studied casts after ancient sculpture in the studio of his teacher, Francesco Squarcione. A treatise on painting published in 1586 by Giovanni Battista Armenini advocates the benefits of learning how to draw by studying casts of famous ancient sculpture in Rome. In 1665 Gianlorenzo Bernini remarked that all students of art should study casts of the best works from ancient Rome before learning to draw from nature; by the 18th century, Étienne-Maurice Falconet praised casts as better than the originals. Cast collections were available in the art schools at the Accademia di San Luca in Rome by 1598 and in the academy in Milan by 1620.

By 1684 the French Academy in Rome, sponsored by Louis XIV, had amassed more than 100 plaster casts of ancient statues. The casts were created for art schools in France and for use as models in producing marble copies for the king's palace at Versailles. Art academies in Sweden, Poland, Germany, Holland, and England soon followed suit. In 1803 the U.S. ambassador to Paris commissioned a set of casts of ancient sculpture in the Musée du Louvre for the New York Society of Fine Arts; in 1805 the Pennsylvania Academy of the Fine Arts acquired its own set of study casts.

Art collectors and connoisseurs also acquired and displayed their own plaster casts. During the Renaissance, for example, Francis I of France employed Italian artist Francesco Primaticcio to gather plaster molds of famous statues in Rome in order to produce bronze casts to decorate his palace at Fontainebleau. The 17th-century Spanish artist Diego Velázquez traveled to Rome to purchase a set of plaster casts for the Spanish royal family.

Increased appearances of the most famous statues of ancient Rome in the form of prints and plaster casts elsewhere in Europe produced a general appreciation for these statues. During the 18th century, cast galleries in Venice and Mannheim (present-day Germany) became popular attractions for wealthy travelers touring Europe. Casts displayed in galleries and museums allowed viewers to compare and discuss works not seen together in reality, and for those without the resources for travel, the casts allowed viewers to experience masterpieces in three dimensions. By 1700 foreign crafts-

men in England had established a commercial trade for making plaster casts of famous works to sell to a growing number of collectors who wished to display an assortment of great masterpieces.

By the 19th century, most large European museums housed their own casting studios and employed their own craftsmen, called *formatore*, Italian experts who specialized in the production of plaster molds and casts. Later, private firms such as Brucciani in London and Caproni in Boston arose to supply the increasing consumer market for plaster casts. These firms opened large galleries as public showrooms for their products and published catalogues from which customers could purchase casts after ancient, medieval, and Renaissance sculptural or architectural works, offered in a variety of sizes and prices.

During the late 19th century, attitudes toward the plaster cast began to change. Beliefs in the primacy of the aesthetic value of the original work of art and a genuine imprint of the artist's genius, together with fears concerning damage to the original sculpture in the mold-making process, led to a shift in the appreciation and production of plaster casts. Many museums and art academies expelled casts from their collections in the early decades of the 20th century.

Plaster casts have been the subject of late-20th-century scholarship, which sees them as useful archaeological and art-historical tools. Casts often give a record of the original statue prior to changes resulting from later restorations or deterioration. They may also show the style and working methods of restorers, who were often sculptors themselves. Because sculptors have frequently used casts as working models or records of finished pieces, casts are sometimes all that remain of lost originals. Furthermore, plaster casts can serve as tangible records of aesthetic taste over a period of centuries, the cultural devotion to Antiquity in the West, and the development of the canon of sculpture in the history of art.

KATHERINE BENTZ

See also **Bernini, Gianlorenzo; Falconet, Étienne-Maurice; Metal Casting; Modeling; Pointing; Primaticcio, Francesco; Segal, George; Stone; Stucco (Lime Plaster); Verrocchio, Andrea del**

Further Reading

Baker, Malcolm, *The Cast Courts*, London: Victoria and Albert Museum, 1982

Baker, Malcolm, "A Glory to the Museum: The Casting of the 'Pórtico de la Gloria,'" *Victoria and Albert Album* 1 (1982)

Haskell, Francis, and Nicholas Penny, *Taste and the Antique: The Lure of Classical Sculpture, 1500–1900*, New Haven, Connecticut: Yale University Press, 1981

Mills, John W., *The Technique of Casting for Sculpture*, London: Batsford, and New York: Reinhold, 1967; revised edition, London: Batsford, 1990

Mills, John W., *The Encyclopedia of Sculpture Techniques*, New York: Watson Guptill, 1989; London: Batsford, 1990

P.P. Caproni and Brother, *Catalogue of Plaster Cast Reproductions from Antique, Mediaeval, and Modern Sculpture*, Boston: P.P. Caproni and Brother, 1894

Penny, Nicholas, *The Materials of Sculpture*, New Haven, Connecticut: Yale University Press, 1993

Rich, Jack C., *The Materials and Methods of Sculpture*, New York: Oxford University Press, 1947

Vasari, Giorgio, *Vasari on Technique*, translated by Louisa S. Maclehose, edited by Gerard Baldwin Brown, New York: Dutton, and London: Dent, 1907; reprint, New York: Dover, 1960

POINTING

The pointing process, or pointing off, is a technique used to copy sculpture. With pointing one can enlarge or reduce a three-dimensional model (usually clay or plaster) or reproduce the same-size object in a block of stone. The phrase is often used rather loosely; pointing can refer to a very mechanical method of copying that exactly reproduces the original, or it can mean a more general process of taking measurements from a model while still applying the direct carving technique.

The mechanical method by which measurements are transferred involves locating three fixed points first on the model and then on the unworked block of stone. By use of these points on the model as references, one can accurately measure any fourth point. In order to transfer this measurement to the marble block, the block must be drilled to the depth that corresponds to the measurement and the excess marble removed. This is repeated as many times as necessary to accurately copy the model. If the model is full-scale, then the process is simple and direct; if the model is smaller, the measurements taken from it must be converted.

A history of the methods used to measure and copy begins with the Greco-Roman period. The Greeks developed increasingly sophisticated methods of measuring from models. By the 5th century BCE, sculptors developed a method that probably used a series of fixed cords stretched from the head to the feet of the statue to take more accurate measurements. For original Greek statues to be accurately copied for Roman patrons, a more advanced use of plumb lines was developed, and the process of translating measurements from the model to the marble became more mechanical. Evidence suggests that this method, perhaps initiated by the 1st century BCE artists Pasiteles and Arkesilaos, continued for approximately 3rd centuries.

The theoretical treatises of Lorenzo Ghiberti (late 1440s) and Leon Battista Alberti (*ca.* 1430/1440) describe methods for measuring, although not specifi-

cally for transferring compositions. The first documented evidence of experimenting with techniques for the precise purpose of transferring a composition is not found until the end of the 15th century with Leonardo da Vinci. It is unlikely, however, that more than half of a century would have passed with no further interest in the problem, particularly considering the caliber of artists in the intervening years. Indeed, it has been suggested that Desiderio da Settignano, Agostino di Duccio, and Benedetto da Maiano were likewise exploring systems of measurement.

Leonardo's experiments took place in the 1490s during his work on the Francesco Sforza equestrian monument. With the aid of a sketch, Leonardo described a box pierced with a number of holes that was placed over the model. Rods were then inserted into the holes and pushed in until they touched the model. The depth of the rods was marked and the box was lifted off and then placed around the marble block. By using the marked rods as guides, the sculptor would have an idea how far to cut into the marble. This procedure does not provide a method of proportional enlargement; rather, it implies that the model is the same size as the intended marble, and it probably requires that the sculpture be relatively small as well.

Giorgio Vasari described a process of using carpenter's squares to take continual measurements of a full-scale model and the marble in order to copy the model. Other 16th-century artists who mention methods for measuring, enlarging, or both, are Pomponio Gaurico and Benvenuto Cellini.

Extant clay models from the 17th century reveal empirical evidence of measuring techniques. Gianlorenzo Bernini may have been one of the first to use an incised scale on a model to aid in the measuring and subsequent enlarging from the small-scale model to the full-scale marble. The artist could use a compass to take measurements from the model and apply them to the incised scale. The measurements were proportionally transferred to an enlarged scale, which were in turn applied to the marble with a larger compass.

By the 18th century pointing had become a standard aspect of workshop procedure. One method involved drawing a net of horizontal and vertical lines on both the model and the marble block, much as painters squared a drawing for transfer. Other techniques such as Antonio Canova's became vogue. Canova used a system (largely carried out by assistants) that involved placing wooden rectangular frames with plumb lines over the full-scale model and the marble block and pointing off by using large calipers to translate distances between points.

The invention of even more sophisticated devices in the 19th century, such as the Collas machine, further mechanized the technique. Invented by the French engineer Achille Collas in 1836, this machine provided a method for fast mechanical enlargements and reductions on the basis of fixed mathematical proportions. One arm of this machine is attached to a tracing needle, while the second arm is fixed to a cutting stylus. As the needle follows the lines of the model, the stylus cuts the blank surface of the copy. Auguste Rodin's assistants often made enlargements or reductions of his original models using this device.

This indirect method of carving the final sculpture from the artist's clay or plaster model, which could be carried out entirely by assistants, was considered necessary due to the large number of commissions taken on by the master. In the 20th century, however, techniques such as these were increasingly rejected for direct carving, as witnessed in the works of Henry Moore.

JEANNINE A. O'GRODY

Francesco Carradori (1747–1827), etching of a sculptor measuring for pointing
© Victoria & Albert Museum, London / Art Resource, NY

Further Reading

Cellini, Benvenuto, *The Treatises of Benvenuto Cellini on Goldsmithing and Sculpture*, translated by C.R. Ashbee, London: Arnold, 1898; reprint, New York: Dover, 1967

Honour, Hugh, "Canova's Sculptural Practice," in *Canova*, edited by Guiseppe Pavanello and Giandomenico Romanelli, Venice: Marsilio, 1992

Lanteri, Eduoard, *Modelling: A Guide for Teachers and Students*, London: Chapman and Hall, 1911

Lavin, Irving, "Bozzetti and Modelli: Notes on Sculptural Practice from the Early Renaissance through Bernini," in *Stil und Überlieferung in der Kunst des Abendlandes*, Berlin: Mann, 1967

Radke, Gary M. "Benedetto da Maiano and the Use of Full-Scale Preparatory Models in the Quattrocento," in *Verrocchio and Late Quattrocento Italian Sculpture*, edited by Steven Bule, Alan Phipps Darr, and Fiorella Superbi Gioffredi, Florence: Le Lettere, 1992

Rockwell, Peter, *The Art of Stoneworking: A Reference Guide*, Cambridge: Cambridge University Press, 1993

Sigel, Anthony B., "The Clay Modeling Techniques of Gian Lorenzo Bernini," *Harvard University Art Museums Bulletin* 6 (1999)

Vasari, Giorgio, *Vasari on Technique*, translated by Louisa S. Maclehose, edited by Gerard Baldwin Brown, New York: Dutton, and London: Dent, 1907; reprint, New York: Dover, 1960

Wasserman, Jeanne L., editor, *Metamorphoses in Nineteenth-Century Sculpture*, Cambridge, Massachusetts: Fogg Art Museum, 1975

Wittkower, Rudolf, *Sculpture: Processes and Principles*, London: Allen Lane, and New York: Harper and Row, 1977

POLAND

The development of sculpture in Poland during the premodern period is linked to the growth of the Roman Catholic Church and consolidation of political power under the monarchy. Adoption of Christianity as a state-sanctioned religion by King Mieszko I in 966 initiated a period of rapid development of sculpture associated with religious architecture. In the 11th century, sculptural decorations, frequently of symbolic character, began appearing in the context of Romanesque monastic structures and churches (e.g., carved stone capitals at the Benedictine abbey in Tyniec, *ca.* 1000). By the mid 12th century, monumental stone figural sculpture (such as *St. John the Baptist*, the portal of Wrocław Cathedral, 1160–70, Archdiocese Museum, Wrocław) and sophisticated sculptural objects (for example, bronze doors of the cathedrals in Płock, 1152–56, and Gniezno, *ca.* 1180) were being commissioned from foreign workshops.

The influence of German Gothic on Polish architectural sculpture can be first observed by the middle of the 13th century (Wrocław Cathedral, 1244–72). The strong dynastic ties with Hungary during the reign of King Casimir III the Great (1333–70), which also marked the beginnings of an organized guild system and a spur in church construction, contributed to an influx of foreign craftsmen and sculptors and rapid refinement of Gothic forms. Noteworthy is the development of local artistic centers in Silesia, Lesser Poland, and Pomerania, which began producing a stylistically distinct body of works (such as Gniezno Cathedral, 1342, and Collegiate Church at Wiślica, after 1350). Common use of wood contributed to increased production of votive figures, crucifixes, sculptural groups, and winged altarpieces. The arrival of Veit Stoss (1447–1533) in Kraćow from Nuremberg to undertake a commission for a carved, polychrome main altarpiece for the Church of St. Mary (1477–98) also played a significant role in influencing local production, in particular in Silesia region (such as altars from parish churches in Świdnica, 1492, and Gosciszowice, 1505).

Although Gothic endured as a vital influence through the 16th century, patronage of the Jagiellon dynasty played an important role in introducing Italian Renaissance conventions to Poland. The extensive remodeling of the royal residence, the Wawel Castle, during the reign of King Sigismund I (1506–48), which brought northern Italian artists and craftsmen to Kraków, provided the main impetus for this development. One of the most outstanding examples of sculptural groups dating from this period can be found in the Sigismund Chapel at Wawel Cathedral (1517–33), which was executed by the workshop of Bartolomeo Berrecci (1480–1537), a northern Italian architect and sculptor who arrived at the Kraków court in 1516. The chapel's richly articulated yet Classically restrained, sculptural program provided an important model for new stylistic norms associated with the Italian Renaissance and was repeatedly emulated throughout the country. Other prominent Italian artists active in Kraćow during this period were Giovanni Cini (1519–65; canopy over the tomb of Vladislav Jagiellon at the Wawel Cathedral, 1519–48), Bernardino Zanobi de Gianotis (?–1541; tombstone of Bishop Konarski at the Wawel Cathedral, 1521), Giovanni Maria Mosca Padovano (1493–1574; tomb of Bishop Gamrat at the Wawel Cathedral, 1545–47), and Santi Gucci (1530–1600; tomb of Kryski family at Dorobin, 1572–76). At the end of the 16th and the beginning of the 17th centuries, the influence of Netherlandish artists can be observed in works of local artists such as Jan Michałowicz z Urzędowa (1530–83; tombs of Bishop Izbieński at the Poznań Cathedral, 1557, and Bishop Zebrzydowski at the Wawel Cathedral, 1562–63).

The royal court's move from Kraków to Warsaw at the beginning of the 17th century ushered in a period of vigorous development in Polish sculpture. Although royal commissions continued to play an important role, the growth of aristocratic fortunes in the 17th and 18th centuries began to create new sources of patronage. The rivalry between the wealthiest nobles and their efforts to compete with the royal court gave rise to an unprecedented demand for works. The founding of several new religious orders also provided an impetus for construction of new churches and major renovations of existing structures. Although foreign artists continued to be sought for major commissions, native sculptors gradually began emerging into prominence. Baroque sculpture influenced by both Italian and northern and central European examples dominated sculptural decoration of churches through the end of the 17th and the beginning of the 18th centuries (for example, Church of St. Anna, *ca.* 1700, and St. Peter and Paul in Kraców, 1619–33; architectural decoration

Other prominent commissions completed by Pollaiuolo were his silver plaques depicting scenes from the life of St. John the Baptist, the patron saint of Florence. In his silver relief of the *Birth of John the Baptist* for the silver altar of the Baptistery of Florence, Pollaiuolo places the figures in a perspective setting. One of the midwives supports a basket of towels on her head with her right hand and carries a pitcher in her left. Her figure is based on an antique prototype and appears also in paintings by Sandro Botticelli, Domenico Ghirlandaio, and Raphael.

The 27 embroideries depicting the life of John the Baptist (*ca.* 1469–80; Museo dell'Opera del Duomo, Florence, Italy) for liturgical vestments reveal Pollaiuolo's compelling narrative powers. His depictions of the Visitation, the Baptist preaching, the Dance of Salomé, and the Arrest, Imprisonment, and Beheading of the Baptist were subjects repeated later in the work of Andrea del Sarto, Jacopino del Conte, Santi di Tito, and Michelangelo Merisi da Caravaggio.

The artist's drawings include those of male models, equestrian figures, profile views of women, narrative scenes, and compositional studies. Always innovative, Pollaiuolo expanded the possibilities for interior modeling in his famous engraving *Battle of Ten Nude Men* by adding zigzag and cross-hatching to the standard studio repertory of parallel hatching. This print demonstrated his interest in human anatomy and was a masterpiece in the medium as the largest engraving produced in the 15th century from a single plate. It is Pollaiuolo's only signed engraving and the first Italian plate incised by a master artist.

Pollaiuolo's grandest commissions were the two papal tombs for Sixtus IV della Rovere and Innocent VIII. The first was extraordinary for being a free-standing monument completely of bronze. The recumbent effigy of Sixtus IV appears as if lying in state, its convincing naturalism stemming from Pollaiuolo's use of a death mask. Immediately adjacent to the pope's body are seven personifications in relief of the Theological and Cardinal Virtues, with the register below serving as a base containing personifications of the Liberal Arts, including the figure of Perspective holding an astrolabe and oak branches, the latter of which alludes to the della Rovere family. The personification of Music seated at an organ is quite lively in design; an angel positioned behind the pipes works the bellows.

Pollaiuolo's tomb for Innocent VIII is a more conventional wall tomb but contains two images of the pope, one as a recumbent effigy and the other as a seated figure with his right arm raised in an animated gesture of blessing and the left hand holding a relic of the Holy Lance used by Longinus to pierce the side of Christ. This was a gift from the Sultan Bejazet. Pollaiuolo's design established the canon for later papal tombs, including those of the Baroque period in St. Peter's Basilica, Rome, for its combination of liturgical and prelatial elements of costume.

Both tombs had been moved from their original locations in St. Peter's Basilica to Donato Bramante's new structure. This created problems in the reconstruction of Innocent's tomb; a drawing of about 1535 by the Dutch painter Martin van Heemskerck indicates the seated figure of the pope below the reclining effigy, which has been inverted in its present installation. Since St. Peter's Basilica was ordered to be dismantled at this date by Pope Paul III, it is not clear if Heemskerck's drawing records Innocent's monument before its move, after its reinstallation in the new basilica, or in some transitional phase.

EDWARD J. OLSZEWSKI

Biography

Born in Florence, Italy, *ca.* 1432. Brother of painter Piero Pollaiuolo. Trained as a goldsmith; after 1460 studio became one of the busiest in Florence, from which he produced sculptures, paintings, graphic arts, and design fabrics; recorded as a member of the silkweaver's guild, the *Arte della Seta*, as a goldsmith, 1466, and a member of the Company of Saint Luke in 1473 as a painter; moved to Rome in 1484, where in the 14 years before his death he installed two papal tombs. Died in Rome, Italy, *ca.* 4 February 1498.

Selected Works

1468	*Bust of a Young Warrior*; painted terracotta; Museo Nazionale del Bargello, Florence, Italy
1470s	*Hercules*; bronze; Bodemuseum, Berlin, Germany
1470s	*Hercules*; bronze; Frick Collection, New York City, United States
1470s	*Judith*; bronze; The Detroit Institute of Arts, Michigan, United States
ca. 1470–75	*Ten Battling Nude Men*; engraving on paper; Cleveland Museum of Art, Ohio, United States
1475	*Hercules and Antaeus*; bronze; Museo Nazionale del Bargello, Florence, Italy
1477	*Birth of John the Baptist*; silver; Museo dell'Opera del Duomo, Florence, Italy
1484–93	Tomb of Pope Sixtus IV; bronze; St. Peter's Basilica, Rome, Italy
1493–98	Tomb of Pope Innocent VIII; bronze and marble; St. Peter's Basilica, Rome, Italy

Further Reading

Emison, Patricia, "The Word Made Naked in Pollauiolo's Battle of the Nudes," *Art History* 13 (1990)

Ettlinger, Leopold, *Antonio and Piero Pollaiuolo: Complete Edition with a Critical Catalogue*, Oxford: Phaidon, and New York: Dutton, 1978

Ettlinger, Leopold, "Pollaiuolo's Tomb of Sixtus IV," *Journal of the Warburg and Courtauld Institutes* 16 (1953)

Fusco, Laurie, "Antonio Pollaiuolo," in *Early Italian Engravings from the National Gallery of Art*, Washington, D.C.: National Gallery, 1973

Fusco, Laurie, "Antonio Pollaiuolo's Use of the Antique," *Journal of the Warburg and Courtauld Institutes* 42 (1979)

Fusco, Laurie, "The Use of Sculptural Models by Painters in Fifteenth-Century Italy," *Art Bulletin* 64/2 (1982)

Italian Renaissance Sculpture in the Time of Donatello (exhib. cat.), Detroit, Michigan: The Detroit Institute of Arts, 1985

Jacobsen, Michael, "A Note on the Iconography of Hercules and Antaeus in Quattrocento Florence," *SOURCE: Notes in the History of Art* 1/1 (1981)

Olszewski, Edward, "Framing the Moral Lesson in Pollaiuolo's *Hercules and Antaeus*," in *Wege zum Mythos, Ikonographische Repertorien zur Rezeption des Antiken Mythos in Europa*, edited by G. Huber-Rebenich III, Berlin: Gebr. Mann Verlag, 2001

Richards, Louise, "Antonio Pollaiuolo: Battle of the Naked Men," *Bulletin of the Cleveland Museum of Art* 55 (1968)

Rubin, Patricia Lee, and Alison Wright, "The Pollaiuolo Brothers," in *Renaissance Florence: The Art of the 1470s*, London: National Gallery Publications, distributed by New Haven: Yale University Press, 1999

Saalman, Howard, "Concerning Michelangelo's Early Projects for the Tomb of Julius II," *Studies in the History of Art* 33 (1992) (refers to Pollaiuolo's tomb of Sixtus IV as a model of a free-standing tomb)

Wright, Alison, "Piero de'Medici and the Pollaiuolo," in *Piero de'Medici "il Gottoso" (1416–1469): Kunst im Dienste der Mediceer; Art in the Service of the Medici*, edited by Andreas Beyer and Bruce Boucher, Berlin: Akademie Verlag, 1993

Wright, Alison, "Antonio Pollaiuolo, *Maestro di Disegno*," in *Florentine Drawing at the Time of Lorenzo the Magnificent*, edited by Elizabeth Cropper, Bologna, Italy: Nuova Alfa Editoriale, 1994

Wright, Alison, "The Myth of Hercules," in *Lorenzo il Magnifico e il suo mondo*, edited by Gian Carlo Garfagnini, Florence: Olschki, 1994

Wright, Alison, "Dimensional Tension in the Work of Antonio Pollaiuolo," in *The Sculpted Object, 1400–1700*, edited by Stuart Currie and Peta Motture, Aldershot, Hampshire: Scolar Press, and Brookfield, Vermont: Ashgate, 1997

HERCULES AND ANTAEUS

Antonio Pollaiuolo (ca. 1432–1498)

1475–1480

bronze

h. 45 cm

Museo Nazionale del Bargello, Florence, Italy

Antonio Pollaiuolo's bronze group *Hercules and Antaeus* was mentioned in the Medici inventory of 1495 as in the apartment of Giuliano de' Medici. The triangular base rests on the backs of three tortoises, providing further evidence of its Medici origins; the tortoise alludes to the Medici motto, *festina lente* (make haste slowly), which was also the motto of the Roman emperor Augustus. Andrea del Verrocchio's tomb for Piero and Giovanni de' Medici in San Lorenzo is also supported on the backs of tortoises.

Pollaiuolo's choice of a triangular base was his creative means for introducing the statuette as an object in the round. That he intended his sculpture to be viewed from all angles is evident from his treatment of the faces of his two opponents. The head of Hercules is buried in the chest of Antaeus, whereas the face of Antaeus is raised to the sky as he howls in anguish in his struggle against the death grip of Hercules. Whether held in hand or resting on a tabletop, the bronze demands rotation by the viewer or circulation around it, either action ultimately resulting in frustration as no clear view of the figures emerges. Thus Pollaiuolo is able to capture the revolving struggle of a pair of wrestlers, to engage the viewer's attention, and to incorporate a sense of time in what is in essence a static art form.

That Pollaiuolo was fully aware of these issues is indicated in his little painting of the same subject in the Galleria degli Uffizi, in which he turns the face of Hercules toward the viewer in his private *paragone*, or comparison of sculpture with painting, admitting the liberties allowed the painter in pursuit of illusionism. But the limitations of painting are also made evi-

Hercules and Antaeus
© Arte & Immagini srl / CORBIS

dent by the sculpture, which the viewer can walk around, whereas the painted images allow no such multiple views. To compensate somewhat, Pollaiuolo provides more information on the flat surface of the painting than would be possible in nature—for example, by showing the top, side, and bottom of Hercules's left foot (an approach described as "pivotal presentation").

Pollaiuolo's sculpture depicts a story from mythology. The monster Antaeus inhabited a cave on the Libyan coast and devoured all who ventured near, and it was Hercules' task to kill him. As they engaged in struggle, the mighty Hercules found it easy to throw Antaeus to the ground, but each time he did so, Antaeus arose with renewed strength, revived by his earth mother, Gaia. Hercules finally realized what was taking place and triumphed by crushing his foe to death, the moment represented by Pollaiuolo in his sculpture.

Pollaiuolo exploits the great tensile strength of bronze as Antaeus squirms and kicks, extending his legs and opening his arms to push away from Hercules. The break in the back of Hercules (which also appears in the painting) might suggest a carelessness on the part of Pollaiuolo in his handling of the human form, although we know from his engraving of *Battle of Ten Nude Men* that he had an intense interest in human anatomy. The narrative of *Hercules and Antaeus* informs us, however, that there are three antagonists involved in this struggle. Gaia, the earth mother of Antaeus, pushes up to counter the downward pressure of her son against the head of Hercules, creating the vise-like compression that causes the break in the small of Hercules's back and simultaneously alerting the viewer to the presence of this third antagonist, the very ground on which Hercules stands.

Hercules had been a model of virtue for the Florentines since the 12th century and was appropriated as a personal emblem by the Medici family. Hercules' repetitive action in throwing Antaeus to the ground fit the Thomistic definition of virtue as a good habit, inspiring similar habituated practices on the part of the sculpture's owner (and its viewers). Hercules was also protector of Venus's golden apples of the Hesperides, and the statuette thus indirectly alludes to the *palle* or spheres that were part of the Medici arms. The bronze reveals Pollaiuolo's commitment to representations of the male nude in action, to spontaneity and change, to an interest in growth, and to form as a function of motion.

EDWARD J. OLSZEWSKI

Further Reading

Ettlinger, Leopold, "Hercules Florentinus," *Mitteilungen des Kunsthistorischen Institutes in Florenz* 16 (1972)

Jacobsen, Michael, "A Note on the Iconography of Hercules and Antaeus in Quattrocento Florence," *SOURCE: Notes in the History of Art* 1/1 (1981)

Olszewski, Edward, "Framing the Moral Lesson in Pollaiuolo's *Hercules and Antaeus*," in *Wege zum Mythos, Ikonographische Repertorien zur Rezeption des Antiken Mythos in Europa*, edited by G. Huber-Rebenich III, Berlin: Gebr. Mann Verlag, 2001

Wright, Alison, "The Myth of Hercules," in *Lorenzo il Magnifico e il suo mondo: Convegno internazionale di studi*, edited by Gian Carlo Garfagnini, Florence: Olschki, 1994

POLYCHROMY

Polychromy is the application of paint and other colored materials to the surface of a sculpture for decorative, practical, or ritual purposes. Artists have been painting three-dimensional objects from the earliest periods. Painted decoration is found on nearly every type of material used by sculptors, from wood and stone to ivory, stucco, terracotta, papier mâché, metal, and plastics. Polychromy is fragile and easily damaged by the environment; consequently, it rarely survives intact, and our understanding of the technique is often based on reconstruction from fragments of color.

Many of the earliest decorative methods fall more properly under the rubric of inlay. Elaborate inlaying techniques in hard stone were familiar to the ancient Sumerians (*ca.* 3500–2000 BCE) as well as the pre-Columbian cultures (*ca.* 2000 BCE–1521 CE) of Central and South America. Bronze sculpture in the ancient world often bore inlaid eyes or lips in metals such as copper or silver, creating subtle contrasts in skin tones. Other objects that one might characterize as painted are actually stained, dyed, or rubbed with a colorant. Materials such as blood, nut oils, and earth applied in a ritual context in some societies may be confused with paint coatings, particularly after aging or restoration treatments. Properly speaking, paint consists of a colorant (pigment) suspended in a liquid carrier (medium). The pigment determines the color of the paint, and the medium, which binds the individual pigment particles together, affects the drying speed and relative gloss of the paint. Almost any material that can keep its color when finely ground and dispersed in a medium can be and has been used as a pigment. This means that one occasionally finds unexpected and highly limited occurrences of a colorant, for instance the use of purple fluorite on 15th- and 16th-century sculpture in northern Europe. More commonly, however, artists employed a rather restricted number of reliable pigments adapted from plant, animal, or mineral sources. The same holds for paint media, which were limited to materials that either dry when the liquid carrier evaporates its volatile component (animal glues, plant gums), harden by exposure to oxygen (linseed oil, egg tempera), or solidify

by cooling (wax, bitumen). Until fairly recently, the sources of many pigments and in particular organic binders were usually local, with important exceptions being highly coveted materials such as ultramarine (lapis lazuli), which came from Afghanistan and was exported throughout medieval Europe. After the expansion of trade routes at the end of the Middle Ages and the realization of the commercial potential of non-native plants and animals, the palette of colors and media available to the painter of sculpture broadened. The greatest change, however, came with the manufacture in the 19th and 20th centuries of a host of inexpensive, synthetic binders and artificial pigments. The new pigments rivaled the natural mineral, plant, and animal examples in color and covering power and exceeded them in affordability. As a result, artists worldwide rapidly assimilated these new materials into their working methods. The pigments either gave a new color to an indigenous palette, such as artificial ultramarine in Sepik River Culture carvings in Papua New Guinea, or began to replace traditional colorants, as happened in the mid 19th century with the adoption of commercial oil paints by Yoruba woodcarvers in West Africa.

The techniques of polychromy on sculpture often paralleled those of two-dimensional painting in the same culture. Artists sometimes applied paint on sculpture to the substrate after it had been primed with sealants like glues or resins. This step helped prevent the migration of medium into a porous substrate. Ground layers, composed of minerals such as gypsum, calcite, or kaolin and an adhesive, served as smooth supports for the final painting and were essential for painting on wood when no trace of the underlying cellular structure was desired. The ground layers themselves could be pigmented to affect the color of the final coat and, in some cultures, were stamped or carved to imitate details such as hair, veins, or textile patterns. Appliqués cut from parchment, metal, shell, and paper also played an important role in the decoration of painted sculpture. The artist could transfer the richness and sheen of metal to sculpture by applying foil or leaf in various techniques. The paint itself may have been a single coat or a complex system of opaque and translucent layers. More durable paints such as linseed oil are often found on sculpture sited in an exterior location.

Application methods of paint on sculpture vary widely, depending on local custom. The ritual kachina objects of the Acoma Indians in New Mexico were reportedly colored in the early 20th century by spraying paint from premixed balls that the artisans held in their mouths; these objects could be glazed with cow's milk applied in the same manner. Paint could also be daubed on with the fingers or transferred with stamps made from a variety of materials, as seen in some Afri-

can cultures. Asmat woodcarvers in New Guinea in the mid 20th century used wads of fern leaves or twigs to apply color. The more widespread method of applying paint, however, involved a brush. The ancient Egyptians made simple brushes by chewing the ends of reeds and sharpening the point. In more recent times, brushes have been made from feathers or animal hair held in place and inserted into a wooden handle.

Figurines modeled from unbaked clay that were embellished with white, red, and black paint depicting jewelry, clothing, or tattoos are known from prehistoric Mesopotamia as early as the end of the 7th millennium BCE. Terracotta figurines, as well as stone sculptures, were also decorated with paint that left most of the substrate material visible while attempting simple imitations of body decoration. Color was an integral part of ancient Egyptian artistic expression, as attested by numerous excavated examples of fully polychromed artifacts such as faience figurines, miniature tomb sculpture, and painted linen and plaster, or *cartonnage*, mummy cases. The dry environment of Egypt accounts for the good state of preservation of excavated material, so that we have a fair notion of how painted objects originally appeared. Most limestone sculpture, particularly from the Old Kingdom (*ca.* 2575–2150 BCE), was entirely covered with paint or gilding, approximating stylized but lifelike effects. Even large-scale stone sculpture carved from hard, colored stones such as dark gray granodiorite or pink granite was fully polychromed, although it appears that by the Middle Kingdom (*ca.* 2008–1630 BCE) paint on these substrates was restricted to details such as the eyes, headdresses, or beards. Egyptian polychromy reached its most impressive heights with limestone tomb decoration of the New Kingdom, especially in private tombs of the 18th and 19th dynasties (*ca.* 1540–1190 BCE), where artists painted extremely low-relief carvings naturalistically, often with great finesse. Assyrian gypsum alabaster relief sculptures from the 1st millennium BCE were also polychromed, although long burial has removed most of the color. Remains of red, blue, white, and black pigments, often in significant amounts, may indicate that these reliefs were extensively painted.

Excavated material from the Greek and Roman world only rarely preserves large passages of original paint. The marble figures of the 3rd millennium BCE from the Cycladic Islands, much prized in the modern era for their clean, white abstractions of the human form, are now known to have been partially painted in Antiquity. Centuries of burial have removed the red, blue, and perhaps black patterns and shapes (some naturalistic, some decorative or symbolic) so that only traces can be detected under magnification. Evidence of polychromy from the Archaic period in Greece and

Cyprus is relatively abundant. Traces of elaborate embroidery patterns are still visible on the Acropolis Peplos Kore (*ca.* 530 BCE; Acropolis Museum, Athens), for example. In the Classical period (*ca.* 500–323 BCE), it appears that relief sculpture, in particular grave stelae, was more intricately painted than were freestanding figures. The great *chryselephantine* sculptures (sculptures of wood, ivory, and gold that suggest drapery over flesh) of the Late Classical period are known only through literary reference, but their painted and sculpted ornaments must have matched the colorful interior of temple architecture. During the 5th century BCE, artists achieved realistic imitations of skin tones with paint on marble, while sometimes leaving robes unpainted to allow the white of the marble to furnish another color. The tendency to reserve portions of the stone sculpture unpainted continued into the Hellenistic period, with gilded patterns applied to white marble sculpture, as well as in sarcophagus decoration. The so-called Alexander Sarcophagus (Istanbul; end of the 4th century BCE) is partially polychromed in tones of yellows, violets, and reds; the artist created an especially illusionistic effect by painting highlights in the eyes of the figures. Small-scale terracotta images (4th to 3rd centuries BCE), called Tanagra figurines after the city where many were found, were also painted in pastel colors with pigments such as cinnabar, madder lake, Egyptian blue, and azurite mixed with white. An important document for the painting of Roman marble sculpture during the early empire is the *Augustus Prima Porta* (*ca.* 19 BCE), a cuirassed figure of the first emperor that at its discovery in 1863, still preserved traces of an extensive and nuanced polychromy. Wall paintings that include images of sculpture suggest that artists singled out cult, garden, and fountain statuary in particular for comprehensive painted decoration; other images, such as portrait busts, were only partially painted. Perhaps the best-preserved Roman polychromy is found on late imperial sarcophagi (3rd century BCE), for which artists often combined bright colors such as blue, red, and yellow with a lavish use of gold leaf.

Although illusion of life was a goal of the ancient painters, perhaps the most elaborate attempts at material illusion in polychromy were made on wooden sculpture in Western Europe during the Middle Ages. The monumental *Volto Santo* of Sansepolcro in Italy, whose wooden form dates between 599 and 765 CE, still bears traces of its first polychromy, with a deep blue tunic and red cuffs with yellow borders. However, it retains far more of its splendid 12th-century repainting, which included elaborate painted scrollwork in imitation of embroidery and lifelike flesh tones. This tendency toward creating naturalistic effects in paint and metal developed further in the later Middle Ages.

Artists lavishly gilded garments, often contrasting a burnished gold leaf outer side with a matte blue or glossy red lining. They painted red or green transparent glazes over silver leaf to create a rich, enamel-like effect. Tin leaf found an important role in the manufacture of prefabricated imitations of costly Italian cut silks called press brocades, which painters applied as low-relief decorations. Artists also incorporated objects such as animal horns and leather horse harnesses into the sculptural ensemble to impart added verisimilitude, as is seen on the *St. George* group (consecrated 1489) by Bernt Notke in Stockholm. Perhaps the most daring attempts at illusionism were made in painting faces. By exploiting the translucency, gloss, and malleability of oil paint, artists could create extraordinarily lifelike expressions. Painters subtly blended the stubble of beards into chins and depicted tendrils of hair in paint, spilling onto foreheads. Artists even plastically rendered facial hair by impressing the forms into the still-soft paint with the wooden end of the brush. Sculptures in Spain continued to explore this tendency to exact imitation of life, long after northern Europe had abandoned polychromy for monochrome surfaces, adding glass eyes, real hair and fingernails, and clothing to sculpture to make the images startlingly lifelike. This tradition was carried into the New World and adapted in Central and South America to create images of saints, called *Santos*, using indigenous and imported artists' materials. During the 17th and 18th centuries in Europe, artists abandoned such complex and varied polychromies in favor of monochrome, gilded or silvered surfaces or subtle pastel shades. Extraordinary efforts were made in paint to create the illusion of alabaster, bronze, marble, or hard stone surfaces on wooden or stucco figures.

In the area of architectural sculpture, scientific examination has revealed that even the earliest buildings and the sculptures built into them were more colorful than they appear today. Catastrophic change followed by centuries of burial, exposure to the elements, or campaigns of rebuilding are some of the forces that have altered the original appearance of architecture, so that often only fragments of paint survive that indicate the intended brilliance of the sculptural program. Prehistoric levels at Çatal Hüyük in eastern Turkey contain remains of painted, high-relief plaster wall sculpture from the 7th millennium BCE. Archaeological excavation has also revealed splendidly preserved polychrome temple complexes and painted, low-relief limestone wall carvings in rock-cut tombs in sites as disparate as Teotihuacán, Mexico (1st century BCE through 7th century CE), and Thebes, Egypt (*ca.* 1540–1190 BCE). Paint on architectural sculpture often conformed to convention or to a pattern of two or three colors, rather than attempting to imitate nature. Al-

though little color is visible today on monuments in Greece or Rome, early travelers to Classical sites often reported traces of polychromy on architectural sculpture, such as the remains of blue paint seen on the backgrounds of the friezes of the Parthenon (447–432 BCE) and the Hephaisteion (*ca.* 450–445 BCE; Temple of Hephaistos) in Athens. It is clear both from ancient literary sources and the archaeological record that Greek architectural sculpture was brightly painted. A polychromatic effect was created in imperial Rome by the contrast of colored and white marble in architecture.

In medieval Europe, artists often painted church interiors monochromatically, with polychromy restricted to wall paintings and sculptural elements, as at Cologne Cathedral, Germany. At Exeter Cathedral in southwest England, where the early-14th-century polychromy is well preserved, artists picked out limestone architectural elements such as roof bosses and corbels in gold leaf and red, green, and blue pigments over a priming layer of lead white mixed with red lead. Half-columns along the aisles in Exeter Cathedral appear to have been painted in imitation of Purbeck marble, the material used for the columns along the main arcades. Colorful decoration was not limited to church interiors. Sculpture placed in protected areas of the exterior, such as portals and porches, was often painted as much for decorative purposes as to provide a superficial coating to protect the underlying stone from the harsh conditions of an outdoor environment. The late-13th-century Majestic Portal of the Collegiate Church of Toro, Spain, is a rare example of a well-preserved exterior polychromy. At least seven separate renewals of the paint scheme that covered and protected the original oil paint layers account in part for its extraordinary condition.

The moist tropical climate of the equatorial regions is highly detrimental to wooden sculpture, so examples older than the 18th century from these latitudes are relatively rare. It is therefore difficult to discuss the historical tradition of polychromy in the tropics, but a few remarks may be ventured. West African Yoruba polychromed wood carvings of the early 20th century may reflect a much older tradition and are startling in their wide range of color and gloss. Although the selection of colors appears at times to be highly arbitrary, red assumed a significant role in the African palette, and artists obtained a wide variety of tones from different sources, including earth, tree bark, sorghum, and millet leaves. Fang masks from Gabon were also painted in gum-bound, chalky whites, black, and earth tones.

Wooden sculpture from the Indian subcontinent exists from at least the 8th century, but no painted examples are known from before the 16th century. Sculpture from more recent times has been described with three main types of decoration: painted, inlaid, and shellac-based work. It is evident that polychrome wood sculpture in India was periodically repainted, as has been observed in Europe. More evidence survives for polychromed stone from the Indian subcontinent. Artists carved Gandharan sculpture (1st through 3rd centuries CE) from dark, greenish-gray schist that was covered with gold leaf, often over a red ground layer. As in West African sculpture, North Indian Buddhist sculpture frequently employed red, which furthermore was often associated with life and auspicious events. Painted stone relief sculpture had backgrounds in red on a white ground, with the figures and other details picked out in other colors.

Following Indian custom, Chinese cave sculpture depicting figures from Buddhist mythology was carved from the "living rock" and fully painted, such as the carvings on Mt. Baoding, Sichuan Province, around 1200 CE. Terracotta tomb figures also bear evidence of paint layers. Not every Chinese sculpture was polychromed, however; marble Ming Dynasty (1368–1644) tomb figures, for example, were apparently left unpainted. An early technique of finishing Japanese figural sculpture used a local material, called lacquer or *urushi*, prized for its tough finish and beauty. A paste of lacquer, incense powder, clay, or sawdust was applied to the unfinished sculpture and then carved with the final details of the form. On top of these layers artists applied a clay ground and layers of polychromy, often including elaborate designs made by the overlay of thin strips of cut gold leaf (*kirikane*) or sprinkled gold dust. The bodies of Buddhist sculpture were usually painted in flesh tones, but certain deities were painted red, yellow, or blue according to sutra regulation. Sculptures of the 10th through the 12th centuries are sometimes distinguished by the insertion of eyes, with pupils painted in black on the reverse and paper inserts imitating the white of the eye, into the hollow cavity of the head. This must have made a startling effect when seen in the gloom of a temple. Artists in Japan also practiced partial polychromy for some Heian-period sculpture (9th through 12th centuries), in which the eyes and lips were tinted with color, but the balance of the figure is monochromatic, following the style of unpainted images carved in aromatic sandalwood.

A strong backlash against polychromy has occurred at various points in history, especially in Europe. Before the Protestant iconoclasm of the early 16th century evaporated the market for large-scale religious sculpture, there was a brief period when monochrome surfaces were favored for wooden retable figures in southern Germany. In the 18th century, the canon of taste developed by Johann Joachim Winckelmann (*Gesch-*

ichte der Kunst des Altertums [History of the Art of Antiquity; 1763–68]), which regarded plastic form as paramount, included the belief that white was the appropriate color for sculpture. This attitude prevailed into the 19th century despite mounting archaeological evidence to the contrary. Sadly, many sculptures were stripped in this period of their original polychrome decoration to conform to this ideology of purity. As a result, countless original surfaces on antique marbles, medieval wooden figures, and even 19th-century sculpture were lost. Gradually this aesthetic lost its appeal as important publications of excavated antiquities proved that the ancient world was brightly colored, and polychromy was picked up as an artistic alternative, appearing first in architectural proposals of the 1830s. By midcentury, carefully crafted replicas of antique sculpture were made, such as the *chryselephantine Athena Parthenos* created by Charles Simart, which set the stage for a revival of polychromed works. John Gibson, in particular, developed an influential style that extended beyond the application of color to edges of garments or attributes to include coloring the entire figure. His most famous example of this style is *Tinted Venus* (1851–56), lightly colored with pigmented wax. Subsequent practitioners, such as Edgar Degas, Jean-Léon Gérôme, and Max Klinger, more fully exploited the potential of color in creating realism in sculpture.

The 20th century saw a periodic return to color with artists who incorporated paint or colored materials into their work. Alexander Calder, for example, influenced by the bright palette of Joan Miró, painted his famous mobiles and stabiles in flat and saturated colors. The fading or flaking of these sculptures has led to many being repainted in recent years. In the 1960s Jean Dubuffet began a series of polychromed Styrofoam or polyester objects he termed *L'Hourloupe*, which inspired a later generation of artists, including Niki de Saint Phalle. Anthony Caro, under the influence of American Abstract Expressionism, created large steel constructions painted in vivid colors that emphasized their separation from nature. The opposite tack was explored with the superrealist nudes of Reg Butler and John de Andrea in the 1970s, Duane Hanson's urban/suburban figures outfitted with polyester wardrobes of the same decade, and by Jeff Koons's self-portraits with his then wife Cicciolina in the 1990s.

MICHELE MARINCOLA

Further Reading

Bascon, William, "A Yoruba Master Carver: Duga of Meko," in *The Traditional Artist in African Societies*, edited by Warren L. d'Azevedo, Bloomington: Indiana University Press, 1973

Blühm, Andreas, editor, *The Colour of Sculpture, 1840–1910* (exhib. cat.), Zwolle, The Netherlands: Waanders, 1996
Die Farbe der Antike (exhib. cat.), Munich: Glyptothek, 2001
Hansen, Eric F., et al., editors, "Matte Paint: Its History and Technology, Analysis, Properties, and Conservation Treatment with Special Emphasis on Ethnographic Objects," *Art and Archaeology Technical Abstracts* 30 (1993)
Hendrix, Elizabeth, "Painted Ladies of the Early Bronze Age," in *Appearance and Reality: Recent Studies in Conservation*, New York: Metropolitan Museum of Art, 1998
Hulbert, Anna, "English Fourteenth-Century Interior Polychromy: Manuscript Sources and Workshop Practice at Exeter Cathedral," in *Painting Techniques: History, Materials, and Studio Practice*, edited by Ashok Roy and Perry Smith, London: International Institute for Conservation of Historic and Artistic Works, 1998
Katz, Melissa R., "The Mediaeval Polychromy of the Majestic West Portal of Toro, Spain: Insight into Workshop Activities of Late Medieval Painters and Polychromers," in *Painting Techniques: History, Materials, and Studio Practice*, edited by Ashok Roy and Perry Smith, London: International Institute for Conservation of Historic and Artistic Works, 1998
Kumar, Krishna, "The Evidence of White-Wash, Plaster, and Pigment on North Indian Sculpture with Special Reference to Sarnath," *Artibus Asiae* 45/2–3 (1984)
Kyotaro, Nishikawa, and Yoshimichi Emoto, "Colouring Technique and Repair Methods for Wooden Cultural Properties," in *International Symposium on the Conservation and Restoration of Cultural Property: Conservation of Wood*, Tokyo: Organizing Committee of International Symposium on the Conservation and Restoration of Cultural Property, 1978
Kyotaro, Nishikawa, and Emily J. Sano, *The Great Age of Japanese Buddhist Sculpture, A.D. 600–1300*, Fort Worth, Texas: Kimbell Museum, and New York: Japan Society, 1982
Penny, Nicholas, *The Materials of Sculpture*, New Haven, Connecticut: Yale University Press, 1993
Reuterswärd, Patrik, *Studien zur Polychromie der Plastik*, Stockholm: Almqvist and Wiksell, 1958
Reuterswärd, Patrik, *Studien zur Polychromie der Plastik: Griechenland und Rom*, Stockholm: Svenska Bokförlaget, 1960
Schleicher, Barbara, "Il restauro: Interventi, osservazioni, tecniche, indagini scientifiche," in *Il Volto Santo di Sansepolcro: Un grande capolavoro medievale rivelato dal restauro*, edited by Anna Maria Maetzke, Milan: Silvana, 1994
Taubert, Johannes, *Farbige Skulpturen: Bedeutung, Fassung, Restaurierung*, Munich: Callwey, 1978

POLYEUKTOS EARLY 3rd CENTURY
BCE *Greek*

Little is known about the artist Polyeuktos, except that he created what is surely one of the most striking and innovative portrait statues of Classical Antiquity—that of the Athenian orator Demosthenes. This statue, dedicated in 280/279 BCE, was made of bronze, so Polyeuktos was certainly a bronze worker, as were most of the leading portraitists of his day. His original bronze statue, however, no longer survives. Because of Demosthenes' continued popularity in the Roman period, many marble versions of Polyeuktos's statue were made (for instance, one in the Ny Carlsberg Glyptotek,

Copenhagen). It is through these later creations that one can glimpse his artistic genius and innovation. Despite Pliny the Elder's (1st century CE) polemical statement that the art of sculpture died in 296 BCE, only to be reborn again in 156 BCE, the early 3rd century BCE was an extremely creative and dynamic period for portrait sculptors working in Athens. The sculptors of Hellenistic Athens invented the genre of individualized, naturalistic portraiture, so central to Western art and one of their most distinctive achievements. Polyeuktos was surely in the forefront of this stylistic innovation. Although no works by Polyeuktos other than *Demosthenes* are known, this statue certainly had a profound effect on Greek portraiture, introducing a new range of expressive power through the skillful and sensitive characterization of physiognomy, dress, pose, and gesture.

Forty-two years after the death of the great Athenian orator Demosthenes, the people of Athens set up a bronze portrait statue of him in the agora, or marketplace, of Athens. The portrait statue depicts the orator standing with both feet flat on the ground and facing squarely forward. The hands are clasped in front, and the head is turned slightly to the side, the gaze downcast. The mantle is draped in an offhand, inelegant manner: a thick twist of folds is pulled across the body just below the chest, and one end is slung over the left shoulder to hang down straight in front. The material of the mantle appears thin and worn and seems to have little body. This plain, unadorned style of self-presentation is further emphasized through the lack of an undertunic, a short-sleeved garment that was, by the time of this statue, a standard component of full Greek civic dress. The portrait head is a brilliantly conceived study of individualized physiognomy and personal psychology. The strongly furrowed brow and firmly shut mouth impart an air of intense concentration; the downcast gaze and intertwined fingers suggest introspection, reflection, and restraint. The head and body work together here to construct a marvelously complex and nuanced characterization of Demosthenes, the staunch, but ultimately unsuccessful, defender of Athenian democracy against Macedonian imperialism. Not only is this statue one of the great works of Hellenistic art, but it is also a pivotal image in the history of Greek portraiture.

This statue of *Demosthenes* is unusually well documented; we know more about it than perhaps any other ancient portrait statue. It was set up in 280 or 279 BCE in the middle of the Athenian agora next to a plane tree and near the *Altar of the Twelve Gods*. The statue of the goddess Peace (Eirene) holding Wealth (Ploutos) and the portraits of Lycurgus of Athens and Callias stood nearby, as did the monument of the *Eponymous Heroes*. The statue, therefore, stood in a place of great honor. The portrait was commissioned by Demochares, Demosthenes' nephew and a leading democratic politician, decreed by the council and the people of Athens, and made of bronze by the sculptor Polyeuktos. On the base of the statue was inscribed the following epigram: "O Demosthenes, had your power been equal to your foresight, then would the Macedonian Ares never have enslaved the Greeks." Although the original bronze statue itself does not survive, the head is preserved in more than 50 Roman-period versions, whereas the body is preserved in three. These later examples provide a wealth of detailed information from which one can reconstruct the appearance of the original portrait with a great degree of certainty.

Demosthenes' four-square stance and plainly draped mantle were clearly meant to make a strong visual contrast with the more elegantly posed and suavely dressed portrait statue of the orator Aeschines, Demosthenes' archrival and a Macedonian sympathizer. *Demosthenes'* pensive and humble appearance also would have provided a visual commentary on the self-assured, swaggering statues of the Hellenistic rulers, whose outside intervention in Athenian democratic politics he had fought so hard to resist. The intensely frowning countenance, thoughtful attitude, and simple dress of this portrait statue are elements drawn from images of Greek philosophers, which signified intellectual energy, mental concentration, and an ascetic lifestyle. The beard and lack of undertunic of *Demosthenes* would also have made the statue appear decidedly old-fashioned in comparison to portraits of contemporary individuals, who by the early 3rd century BCE mostly seem to have been clean shaven, following the fashion set by Alexander the Great, and who were also always shown wearing full civic dress of both tunic and mantle.

With its introspective attitude and contemplative pose, signified by the furrowed brow, downcast eyes, and clasped hands, this portrait explores the way in which intense mental concentration and intellectual activity physically transform the body. When one spends a great deal of time and effort thinking, this statue says, one neglects to attend to such minor and superficial details as a properly draped mantle or an artful and elegant pose. This inattention to outward appearance as a sign of intellectual vigor is further developed and given brilliant expression in the portrait statues of Hellenistic philosophers. The self-presentation of an orator before the crowd—and this is surely where we should imagine that Demosthenes as depicted in his statue is standing—played a crucial role in his ability to persuade the audience. Pose, gesture, clothing, phrasing, and voice all contributed to the success or failure of rhetorical performance. Demosthenes was not known as a brilliantly polished public speaker. This statue,

however, celebrates this lack of poise and polish by suggesting that artifice and elegance undermine plain, honest, and thoughtful speech. Set up during a brief period when Athens was once again under democratic control, the statue of Demosthenes was meant to remind its viewers of traditional democratic values and to recall a time when the city charted its own destiny. That this statue in some way embodied the incorruptibility of Demosthenes is suggested by a charming story told by Plutarch in his *Life of Demosthenes*, written in the 2nd century CE. In this story, a soldier hides his money in the statue's clasped hands. When he later returns, he finds the gold still safely hidden beneath some leaves blown down from the nearby plane tree and is prompted to comment on Demosthenes' legendary honesty.

SHEILA DILLON

See also **Greece, Ancient**

Biography

There is virtually no known definitive information on the artist's life. All that is known for certain about Polyeuktos is that he created the bronze portrait statue of the Athenian orator Demosthenes, *ca.* 280 BCE, which once stood in the marketplace in Athens.

Selected Works

ca. 280 BCE *Demosthenes*, originally at Athens; bronze (lost); marble version: Ny Carlsberg Glyptotek, Copenhagen, Denmark

Further Reading

Lippold, G., "Polyeuktos," in *Pauly's Real-Encyclopädie der Altertumswissenschaft*, edited by August Friedrich Pauly and Georg Wissowa, vol. 21, Stuttgart, Germany: Druckenmüller, 1952

Overbeck, Johannes A., compiler, *Die antiken Schriftquellen zur Geschichte der bildenden Künste bei der Griechen*, Leipzig: Engelmann, 1868; reprint, Hildesheim, Germany, and New York: Olms, 1971

Pollitt, J.J., *The Art of Greece, 1400–31 B.C.: Sources and Documents*, Englewood Cliffs, New Jersey: Prentice-Hall, 1965; 2nd edition, as *The Art of Ancient Greece: Sources and Documents*, New York: Cambridge University Press, 1990

Pollitt, J.J., *Art in the Hellenistic Age*, Cambridge and New York: Cambridge University Press, 1986

Richter, Gisela M.A., *The Portraits of the Greeks*, 3 vols., London: Phaidon Press, 1965; see especially vol. 2

Ridgway, Brunilde Sismondo, *Hellenistic Sculpture*, Madison: University of Wisconsin Press, and Bristol, Avon: Bristol Classical Press, 1990–; see especially vol. 1

Smith, R.R.R., *Hellenistic Sculpture: A Handbook*, New York: Thames and Hudson, 1991

Smith, R.R.R., "The Hellenistic Period," in *The Oxford History of Classical Art*, edited by J. Boardman, Oxford and New York: Oxford University Press, 1993

Stewart, Andrew F., *Greek Sculpture: An Exploration*, New Haven, Connecticut: Yale University Press, 1990

Zanker, Paul, *The Mask of Socrates: The Image of the Intellectual in Antiquity*, Berkeley: University of California Press, 1995

POLYKLEITOS *ca.* 480–*ca.* 400 BCE *Greek*

One of the outstanding sculptors of Classical Antiquity, Polykleitos (Polyclitus), a little younger but the equal of Pheidias, was born in Argos and worked as skillfully in bronze as he did in marble, gold, or ivory. The dating to about 440–435 BCE of *Doryphoros*, his most celebrated work, fixes the time of his birth as prior to the middle of the 5th century BCE, whereas the statue *Aphrodite* dedicated by the Spartans to the sanctuary of Apollo at Amyklai following their victory over the Athenians at Aegospotamoi in 405 BCE establishes the duration of his active life. Consequently, as Pliny the Elder suggests in *Natural History* (77 CE), the tradition that the artist was at the height of his powers during the 90th Olympiad, that is, between 420 and 417 BCE, must correspond with his creation of the gold and ivory statue *Hera* (last quarter of the 5th century BCE) in the later temple of her Argive sanctuary, rebuilt immediately after the destruction by fire of her earlier sanctuary in 423 BCE, according to Pausanias. It would seem, therefore, that Polykleitos continued to work at an advanced age, doubtless with the assistance of his many pupils and associates who prolonged the tradition of his workshop throughout the 4th century BCE.

The artist's extraordinary fame in Antiquity is not matched by the few works for which he is remembered; of these, not one original has survived. Even fewer are those recognized in Roman copies, but they are sufficient to uphold the conviction that his art expresses the Peloponnesian ideal as completely as Pheidias's art expresses the Athenian. On the other hand, according to the aesthetic appreciation of various written sources, the two sculptors have this in common: the creation of a wondrous gold and ivory statue. In about 430 BCE, both artists participated in a contest announced by the priesthood of Artemis Ephesia for the commission of a series of bronze statues of Amazons who, according to the myth, were the founders of the goddess's sanctuary. On Pliny's evidence, the prize was awarded to Polykleitos. Present-day visual preferences, however, would be more hesitant to pick the *Sciarra* sculptural type, which, in the wake of exhaustive research and the no more generally acceptable rejection of the *Capitoline* type, is held to be Polykleitan as opposed to that of the *Mattei*, which is almost unanimously attributed to Pheidias.

Most Polykleitan statues were erected in temples and shrines in the Peloponnese with the exception of

Amazon of Ephesus, a *Hermes* transferred from its unknown original location to the Thracian Lysimachia, of works with no certain provenance, and of all those looted by the Romans. The bronze *Aphrodite* of Amyklai was recently identified in the copies of the famous *Hera Borghese*, one of the most lusty and wanton representations of the goddess of love, dating to the end of the 5th century BCE. It seems that contrary to what was previously maintained, the unique copy of a bust in Thessaloníki replicates the gold and ivory *Hera* of Argos. So far, according to Pausanias, no copies have been identified of the bronze *Hecate* in Argos, of the marble statue *Zeus Meilichios* once in the same city, or of a marble composition, perhaps a cult image group, of Apollo, Leto, and Artemis in the sanctuary of Artemis Orthia on Mount Lykoni beside the road to Tegea. It is the same with the six undoubtedly bronze statues of Olympic victors. Inscribed marble bases for the statues of Kyniskos, Pythokles, and Aristion were found during the excavations in Olympia. However, no surviving sculptural type can be ascribed to them. Part of a head, including the hair, of a bronze athlete, patently in the style of Polykleitos but condemned to anonymity, has also been found there. Two female statues of Kanephoroi eventually found their way to Messene in southern Italy, perhaps from Argos, whereas a group of unknown provenance showing two boys playing knucklebones, possibly the *Apoxyomenos* (scraper) and the *Apopternizon* (*talo incessens*, a knucklebone thrower), and perhaps *Herakles Agetor*, ended up in Rome. It could be held with greater likelihood that it was in Rome that Cicero saw a composition of Herakles and the *Lernaian Hydra*. However, it is impossible to identify any of these statues with the undoubtedly Polykleitan creations of the *Diskophoros* at Wellesley College (Massachusetts), the Boboli *Hermes*, the Rome-Copenhagen *Herakles*, the Westmacott *Ephebe*, and the Dresden *Youth*, which were rescued from the oblivion of copyist tradition by the unflagging persistence of archaeological research.

It is still uncertain where the original bronze *Diadoumenos*, so well known from several copies and mentioned only by Pliny, was standing about 420 BCE. The interpretation of the youth depicted with his arms raised as he ties a ribbon in his hair is also problematic; it is difficult to argue whether it portrays a god, a hero, or a mortal. The same ambiguity shrouds the enigmatic identity of *Doryphoros*, which, according to the abundant evidence of written sources and the large number of surviving copies, was the most renowned of the artist's works. Its bronze original is generally believed to have portrayed Achilles and to have stood in Argos, where its nearly contemporary reflection on a relief has been found. It was in this creation that Polykleitos applied his theoretical notions about the relationship of the parts to the whole, that is, the proportions of the standards of harmony that compose the beauty of the human body. He laid down these ideas in a treatise titled the *Canon*, from which there are echoes, if not quotations, in later writings and ancient medical texts, especially Galen's (2nd century CE). Judging from the copies of the work, the rhythmic treatment of a *contrapposto* (a natural pose with the weight of one leg, the shoulder, and hips counterbalancing one another) relieves the solidity and ruggedness of physical vigor. This is achieved by the diagonal elaboration along the basic axes, the tilt of the head toward the weight-bearing limb, and the relaxed limb drawn back and to the side, in contrast with the Pheidian model in which the soles of both feet are fully in contact with the ground.

It is surprising that there is no mention in written sources of any Polykleitan work in Athens, where the most important artists of the Classical period had been brought together to implement Pericles's monumental vision for the Acropolis. True, Pliny (N.H. 34.56) mentions the portrait of the crippled engineer Artemon, who was known as Periphoretos because he oversaw the execution of his projects while being carried around in a litter. However, archaeological research has thrown doubt on the authenticity of this information. But the influence wrought by Polykleitos on Athenian sculpture is evident both in the Parthenon frieze and in many of the most important statues produced following the completion of the Parthenon, as well as in the marvellous original *Youth from Eleusis* (early 4th century BCE), which remodels the Westmacott *Ephebe*. It would be difficult to posit a more commanding presence of his work in Athens on the sole evidence of a mention in Ailianos and an oblique reference by Plato, or on the theory that the figure *Doryphoros* might represent Theseus, in which case the possibility of it having been commissioned by the Athenians would explain the frequency with which it was copied in neo-Attic workshops. Greater support would be found in Xenophon's testimony, if indeed the sculptor whom he represents as conversing with Socrates was only inadvertently named Kleiton by the copyists of his text. Judging from evidence in the written sources and the undoubtedly identified roman copies, Polykleitos's works were marked by a compact structure and a subtle movement. The rhythmic tenor governing his statues is sensed even in the composition of the hair and the ethos marking the physiognomy of his figures, which was considered to be equal to that of Pheidias, reflects the contribution of the Peloponnesian tradition in the hammering of the classical ideal.

ANGELOS DELIVORRIAS

See also **Greece, Ancient; Pheidias**

Biography

Born in Argos, Peloponnese, Greece, *ca.* 480 BCE. In Antiquity his fame rivaled that of Pheidias; worked primarily on statues for Peloponnesian temples and shrines; said by Pliny the Elder to have been at the height of his powers during the 90th Olympiad (420–417 BCE); none of his works has survived, but they are known through many copies; created his best-known work, *Doryphoros*, *ca.* 440–435 BCE. Died in Greece, *ca.* 400 BCE.

Selected Works

ca. 450–*ca.* 440 BCE	*Diskophoros* (Discus Bearer); bronze (lost); Roman copy in marble (1st century CE): Wellesley College Museum, Massachusetts, United States
ca. 440–*ca.* 435 BCE	*Doryphoros* (Spear Bearer) at Argos, Peloponnese; bronze (lost); Roman copy in marble (1st century BCE): Minneapolis Institute of Art, Minnesota, United States
ca. 430 BCE	*Amazon of Ephesus*; bronze (lost); Roman copy in marble (1st century BCE–1st century CE): Metropolitan Museum of Art, New York City, United States
ca. 430 BCE	*Hermes*; bronze (lost); Roman copy in bronze (late 1st century BCE–1st century CE): Musée du Petit Palais, Paris, France
ca. 423–*ca.* 419 BCE	*Diadoumenos* (Youth Binding His Hair); bronze (lost); Roman copy in marble from Delos (early 1st century BCE): National Archaeological Museum, Athens, Greece
after 405 BCE	*Aphrodite*, at Amyklai, Peloponnese; bronze (lost); Roman copy in marble (1st century BCE), so-called Hera Borghese: Ny Carlsberg Glyptothek, Copenhagen, Denmark
year unknown	*Hera*, for the Heraion, near Argos; gold, ivory (lost); Roman copy in marble of the corps (1st century CE): Museum of Fine Arts, Boston, United States; Roman copy in marble of the head: Archaeological Museum, Thessaloníki, Greece

Further Reading

Amandry, Pierre, "À propos de Polyclète: statues d' Olympioniques et carrière de sculpteurs," in *Charites: Studien zur Altertumswissenschaft*, edited by Konrad Schauenburg, Bonn: Athenäum-Verlag, 1957

Beck, Herbert, and Peter C. Bol, editors, *Polykletforschungen*, Berlin: Mann, 1993

Borbein, A.H., "Policleto," in *Enciclopedia dell'Arte Antica Classica e Orientale*, supplement 4, Rome: Istituto della Enciclopedia italiana, 1996

Lorenz, Thuri, *Polyklet*, Wiesbaden, Germany: Steiner, 1972

Moon, Warren G., editor, *Polykleitos, the Doryphoros and Tradition*, Madison: University of Wisconsin Press, 1995

Pollitt, J.J., *The Art of Greece, 1400–31 B.C.: Sources and Documents*, Englewood Cliffs, New Jersey: Prentice-Hall, 1965; 2nd edition, as *The Art of Ancient Greece: Sources and Documents*, New York: Cambridge University Press, 1990

Richter, Gisela M.A., *The Sculpture and Sculptors of the Greeks*, New Haven, Connecticut: Yale University Press, and London: Oxford University Press, 1929; 4th edition, New Haven, Connecticut: Yale University Press, 1970

Ridgway, Brunilde Sismondo, *Fifth Century Styles in Greek Sculpture*, Princeton, New Jersey: Princeton University Press, 1981

Stewart, Andrew F., *Greek Sculpture: An Exploration*, New Haven, Connecticut: Yale University Press, 1990

Vermeule, Cornelius Clarkson, *Polykleitos*, Boston: Museum of Fine Arts, 1969

Von Steuben, Hans, *Der Kanon des Polyklet: Doryphoros und Amazone*, Tübingen, Germany: Wasmuth, 1973

DORYPHOROS (SPEAR BEARER)

ca. 440–435 BCE

bronze original; marble copies

h. 183 cm–198 cm

original lost; copies in Minneapolis Institute of Arts, Minnesota, United States; Galleria degli Uffizi, Florence, Italy; Vatican City; Museo Archeologico Nazionale, Naples, Italy

Since Quintilian (1st century CE) characterized the *Doryphoros* of Polykleitos as the work that sculptors used as their fundamental model, the statue is very likely identical with the *Canon* of Polykleitos, which Pliny the Elder described as the statue from which the sculptors derived "as though from a law, the very principles of their art." The *Canon* of Polykleitos was also lauded by Lucian (*De Saltatione*, *De Morte Peregrini*) and Tzetzes (*Chiliades*) as an exemplary and definitive work. According to Galen (*De Temperamentis*, *De Placitis Hippocratis et Platonis*), *Canon* was also the title of a tract by Polykleitos on the laws of sculpture. The text has not been preserved, but citations and comments by Galen, Chrysippus, Plutarch, and others indicate that the work dealt extensively with the laws of symmetry and proportions. The *Doryphoros* was evidently considered to be the work in which Polykleitos exemplified the rules of art. For that reason, he at some point transferred the title of his book to the statue, which had formerly been known under the name of *Doryphoros*.

Doryphoroi were also traditional subjects for other Classical sculptors, such as Kresilas or Aristodemos. Thus the name is not specific but would seem rather to have been a general term for a statutory schema, the significance of which could not be explained until recently. In Classical literature, armed warriors, in par-

ticular bodyguards and members of the guard, were called *Doryphoroi* (spear carriers). Because Pliny speaks of *hastam tenentes*, commonly referred to as *effigies Achilleae*, the belief arose that the *Doryphoros* was, in fact, a depiction of Achilles. However, the discovery in Messene of a torso in the style of the *Doryphoros*, yet belonging to a statue of Theseus, required a reworking of this theory. Unfortunately, the head of the statue is missing, so it cannot be determined whether it too was in the style of the *Doryphoros*. Nonetheless, the allusion to Achilles is highly unlikely, for it is unclear why the spear carriers displayed in palaces should go under the general name of "Achilleas" whereas the most famous among them, namely that of Polykleitos, should retain only the marker of the spear motif. The general retention of the name *Doryphoros* leads rather to the conclusion that the original name held no meaning for later generations. The spear could indicate that an honorary statue of a successful warrior, perhaps of a victorious strategist, stood behind the *Doryphoros*. In this instance one would expect, as with the portrait of *Pericles*, a warrior in a helmet.

A different direction is suggested by the swollen ear of the statue, a characteristic detail of the *Doryphoros* not found on any other Polykleitian statue but one normally found on statues of pugilists and *pankratiasts*. Hence the *Doryphoros* could have been erected as a victory statue of an athlete, whose name was replaced by its characteristic motif once the statue had been removed from its place of origin and thereby robbed of its function. Against this theory is the fact that a *dory* (spear), as opposed to the *acontion* (javelin), was not a piece of sporting equipment but a strictly military weapon. By combining military and athletic features, the statue embodies the very essence of manly restraint in a decidedly youthful manner.

At a height of about two meters, the *Doryphoros* is manifestly over-life-size. Portrayed is a young man (according to Pliny, a *viriliter puer*, or manly boy). The right leg is forward, stepping full onto the sole, and supports the weight of the body; the left arm bears that of the spear. Similarly, complementary elements of movement are found not only in the relation between the downward right slant of the shoulders and the *contrapposto* (a natural pose with the weight of one leg, the shoulder, and hips counterbalancing one another) of the hips but in the entire composition of the figure. This manner of composition developed by Polykleitos is called *chiasmus*, after the form of the Greek letter chi (X). The laws of *chiasmus*, the response to every action or form with its opposite, determine not only the stance and construction of the figure but also details, such as the shape of the hair. Here, two locks of hair over the middle of the forehead are predominant and together create a tonglike motif. Running toward

the outward points of these "tongs" are other locks of hair, which, for their part, produce a forklike motif; these are followed in turn by another "tong," and so forth. This formal precision confirms above all the precept preserved as a quote from the *Canon* of Polykleitos that the relation of one finger to another, and of all fingers to the palm of the hand and to wrist, and of these to the elbow, and of the forearm to the upper arm, and of everything to every other thing, leads to *Symmetria* (Chrysippus, cited by Galen).

As early as the 18th century, attempts were made to determine through measurements the system of proportions on which the *Doryphoros* was based. These attempts typically grew out of the expectation that the measurements would concur in principle with the rules established by Vitruvius (1st century BCE). This approach at first did not produce any convincing results. Examinations of recent years, however, have pointed in a new direction. In addition to the Classical units of measurement based on finger breadth (inch), foot length (foot), or forearm length (cubit), Polykleitos also based measurements on thirds, fourths, fifths, and so on, of the entire figure. In the latter case, he would

Doryphorus (Spear Bearer), Museo Archeologico Nazionale, Naples
© Alinari / Art Resource, NY

1327

calculate the dimensions of individual sections in part on the basis of the concept of the finished work standing upright, the height of which a statue with its weight shifted on one leg simply does not attain, or of the somewhat smaller figure of the statue with its weight shifted on one leg.

No other Classical masterpiece has had an impact on succeeding generations comparable to that of the *Doryphoros*. Even Cicero informed Lysippus that he considered the *Doryphoros* of Polykleitos to be his teacher. During the period of late Hellenism, the reception of the *Doryphoros* continued to gain strength, and in Roman art there is scarcely a revered pictorial statue that does not allude to it, either in the design of the posture or in the formation of the details—for example, the shape of the trunk—or in the inscriptions.

PETER C. BOL

See also **Greece, Ancient**

Further Reading

Beck, Herbert, Peter Bol, and Maraike Bückling, editors, *Polyklet: Der Bildhauer der griechischen Klassik* (exhib. cat.), Mainz, Germany: Von Zabern, 1990
Berger, Ernst, Brigitte Müller-Huber, and Lukas Thommen, *Der Entwurf des Künstlers: Bildhauerkanon in der Antike und Neuzeit*, Basel: Antikenmuseum und Sammlung Ludwig, 1992
Moon, Warren G., editor, *Polykleitos, the Doryphoros, and Tradition*, Madison: University of Wisconsin Press, 1995
Steuben, Hans von, *Der Kanon des Polyklet: Doryphoros und Amazone*, Tübingen, Germany: Wasmuth, 1973

POLYNESIA

Polynesia is a cultural region that includes a diversity of peoples living in the South Pacific Ocean. These cultures are primarily bounded within what is referred to as the Polynesian triangle, with each side measuring about 8,000 kilometers. The legendary Easter Island (Rapa Nui), where giant stone figures (*moai*) dominate the landscape of the tiny island, defines the eastern point of the triangle. The Hawaiian Islands, now a part of the United States, are located at the northern point; situated at the southernmost point is the largest land mass in Polynesia: New Zealand. In New Zealand the indigenous Maori people, like native Hawaiians, are now a minority in their own land. Both Maori and Hawaiians struggle to maintain their unique heritage while asserting their individual cultural identities.

Until the 16th century the Western world knew virtually nothing about the existence of these islands, and not until the late 18th century did Captain James Cook accurately chart the region, encouraging further exploration. The impact of explorers, missionaries, and other travelers had a profound effect on Polynesian culture,

as many new ideas were incorporated and many traditions were altered, repressed, or abandoned. Owing to the extreme changes that occurred with this colossal foreign impact, especially with the introduction and acceptance of the Christian religion, it is best to consider Polynesian art within two general divisions: traditional and contemporary. Traditional refers to art closely tied to Polynesian culture before the onset of radical societal changes, while contemporary encompasses art deeply rooted in a Western-influenced tradition. Many forms of traditional Polynesian art remain vital and relevant in the region, especially the arts of tattoo and body decoration, weaving and bark cloth, and some forms of woodcarving. While contemporary Polynesian art often consciously draws on earlier forms to reinforce cultural identity and to comment on personal and social issues of struggle, power, and politics, it is strongly aligned with Western heritage and artistic traditions. Contemporary Polynesian art makes use of introduced media and techniques and innovates at a far more accelerated pace; however, it is clearly a continuation of the Polynesian aesthetic tradition.

Before the influence of the West, traditional Polynesian societies were highly stratified, with complex social and political systems linking rank with spiritual power (*mana*). The highest classes inherited their rank and were often considered descendants of gods. However, in most societies other factors, including intellectual ability, success in warfare, and personal charisma, could enable a person to increase one's status, but usually to a far lesser degree than achieved through genealogical rank. In Polynesia traditional artworks functioned as visual symbols of status, rank, and wealth, as well as items of spiritual devotion. Artists were often priests, as the production of art involved complex religious procedures that endowed the artwork with *mana*. Over time and through use in spiritual devotion, many of these sculptures continued to accrue *mana*, becoming more valued and more powerful and operating more effectively in the earthly realm by virtue of strengthened spiritual ties. Thus artists carefully composed sculptural designs that were designed to endure, becoming potent entities that could benefit the human realm for many generations. The creativity of Polynesian artists took form in a variety of materials, including feathers, plant fibers, flowers, seeds, wood, stone, bone, human and animal teeth and hair, marine ivory, and shell. Polynesians believed that many of these materials contained great amounts of spiritual power, which was articulated and enhanced during the artistic process. Until foreigners introduced metal, artists fashioned objects with tools made from available materials, such as stone, bone, and teeth. Metal tools enabled the artist to express indigenous aesthetics with greater

ease, encouraging additional carved detail and accuracy. While men dominated carving in wood, stone, and bone, women tended to control the production and distribution of basketry and bark cloth, although there are exceptions to this general rule.

Primary characteristics of traditional Polynesian sculpture include a strong emphasis on the human figure, although some representations of flora and fauna, such as leaves, lizards, centipedes, birds, sea turtles, and sharks, also occur. The human form tends to be realistically depicted in a standing posture with slightly bent knees and arms hanging at the side or resting on a gently swelling belly. The head and face receive prominence by greater embellishment or a head proportionately larger than the body. Janus (back-to-back) figures occur in many island groups. The spine is often pronounced, as it relates to an understanding of genealogical position and the Polynesian cosmological concept of descent as articulated in the visual arts. More abstracted images of the human figure also represent concepts of genealogical descent; these images tend to be clustered in series or repetitions that have meanings similar to the human backbone, as high-status individuals and entire lineages clearly declared their ability to trace descent from divine origins.

Particular aesthetic intentions regarding color and surface design further enhanced the balanced, and often restrained, depiction of the human form. Most sculpture is monochrome; artists rarely use pigments to embellish sculptural forms. If pigments are used to create a surface design, artists prefer very dark colors, applied sparingly to create repetitive geometric motifs, while maintaining a controlled contrast between decorated and undecorated areas. This crisp delineation gives a strong graphic quality to many three-dimensional forms. The surface of nonfigural sculpture, such as weapons, is often incised with intricate and repetitive geometric motifs applied to the entire surface in carefully defined divisions. Surface design appears to be conceived as a two-dimensional graphic pattern that is subsequently wrapped around the sculptural form. Finally, to create and maintain a smooth texture and shiny surface, sculptural objects were kept oiled and polished. Since most figurative sculpture was directly linked to traditional Polynesian religions, the overwhelming acceptance of Christianity in the 19th century obliterated the need for these art forms. Today, the limited revival of figurative wood carving lacks spiritual associations and is primarily geared to a tourist market.

The characteristics of traditional sculpture also apply to living sculpture, or body decoration, an important category of Polynesian art practiced throughout the region. Pre-Christian Polynesia treated humans and sculptures in comparable ways, perhaps because they were viewed to function similarly: both humans and sculptures could serve as important links to the spiritual realm, links that could benefit those living in the earthly realm. Artists created designs and ornaments to be placed on the body, in the form of tattoo, body paint, and a variety of accoutrements, to enhance this spiritual connection. Body decoration could also protect the wearer by virtue of design or the spiritual properties of the material itself, as well as announce genealogical status and social achievement. While the body was dressed in a multitude of styles throughout Polynesia, some of the more common practices included wrapping the body in mats or decorated bark cloth, painting the body with black, white, red, and yellow pigments, and oiling the skin to make it glisten. Artists created necklaces, ear ornaments, hair combs, and knee, ankle, wrist, and elbow ornaments in a variety of inventive, and often dramatic, combinations that included shell, stone, bone, feathers, leaves, seeds, coconut fiber, and human and animal hair. Perhaps most important was the elaborate art of tattoo. As with surface decoration in the other arts, tattoo designs were complex geometric patterns contained within divisional zones that were wrapped around the figure, creating strong compositions that successfully exploited the sharp contrast between skin and dark blue/black pigment. Body decoration remains an important artistic form in Polynesia, primarily relating to family position and cultural identity rather than the spiritual dimensions of the pre-Christian past.

Natural resources vary greatly among the Polynesian islands. Many envision the islands of the South Pacific as lush tropical paradises; however, Easter Island is a far cry from that romantic vision. Located 3,700 kilometers west of Chile, Easter Island, so called because the Dutch explorer Roggeveen landed there on Easter Sunday 1722, is one of the most isolated cultures in existence. It consists of one island measuring 165 square kilometers, with no coral reefs and no deepwater harbors. Early in their history the islanders deforested the island through slash-and-burn agriculture and the massive use of logs to move and erect the more than 800 large stone ancestral figures (*moai*) scattered around the tiny island. Placed in groupings on ceremonial platforms (*ahu*), the stone *moai* have carved eye sockets that allowed the insertion of white coral and red scoria eyes for ceremonial activation. Once the forests were depleted, artists relied on driftwood and smaller pieces of wood from bushes to create figures on a much smaller scale. Many of these wood figures merge human, lizard, and avian characteristics; artists may have been capturing the physical process of spirit transformation, an important religious concept on the island. To enhance the dynamic tension of physical transformation, many artists successfully exploited

the potential of twisted curving branches to convey the impression of metamorphosis. In addition to large-scale stone sculptures and smaller wooden sculptures, artists also placed nearly 4,000 bas-relief petroglyph (rock carving) compositions on surfaces throughout Easter Island, depicting anthropomorphic and zoomorphic forms relating to a variety of cosmological and genealogical concerns. Whether in wood or stone, the style of Easter Island anthropomorphic sculpture remains constant, with a strong emphasis on the head with round or elliptical inlaid eyes, strong overhanging brows, thin horizontal lips, and elongated earlobes.

In stark contrast to Easter Island, New Zealand (Aotearoa) has an abundance of forested areas that furnished Maori carvers with ample wood to create large and ornately decorated architectural structures, including communal meeting houses, the houses of chiefs, and some food-storage buildings. These structures honor and embody the presence of important ancestors, with the ridgepole indicating the backbone, the rafters the ribs, and the slanting facade boards the arms. Representations of ancestors dominate the corpus of Maori sculpture, defining their place in the historical record of the community and their role in Maori cosmology. Ancestors continue to play an important role in many Polynesian societies, as lineage helps define a person's place in the world. Compared with the more rigid linear and geometric design tendencies of the rest of Polynesia, Maori art has a distinctive curvilinear style as entwined figures create intricate and complex compositions. This curvilinear motif may relate to the growing fern frond, which suggests growth and regeneration, appropriate references for ancestral figures and the importance of genealogical procreation and succession, as well as the role of ancestors in providing for their human progeny. Also unique to Maori figurative sculpture is the elaborate surface treatment; intricate curvilinear surface decoration, sometimes highlighted with red, white, and black pigments, covers most figures. Figures with three or four clawlike fingers, a motif that may simply indicate a figure's divinity, are also common. Many figures have a protruding tongue, suggesting an abundance of *mana*, aggressive tendencies, and the important role of oratory. Placed at the front of a canoe, elaborately carved prows feature a forward-thrusting head with outstretched tongue to help guide the canoe and protect its passengers in times of peace and war. Sterns sweep dramatically upward from the rear of the canoe and, like the prow, contain intricate openwork scrolling surrounding ancestral figures. Artists created finely finished clubs made from wood, bone, and stone to protect the bearer both spiritually and physically. Small-scale stonework remains prevalent in New Zealand, with the *hei tiki* (*hei* means neck, and *tiki* refers to anything in the shape of a human)

epitomizing the skill of the Maori stone carvers. Fashioned from greenstone, the *hei tiki* embodies the *mana* of many people, as it passes through the generations, absorbing the spiritual power of each wearer. Worn around the neck, the *hei tiki* continues to provide a deep and powerful genealogical presence in the proceedings of important events.

In the pre-Christian past Hawaii was the most socially stratified of all Polynesian cultures, stressing genealogical standing to an even greater degree than the Maori. Hawaiians considered those of the highest rank as living gods. Supple feathered cloaks and helmets sculpted in plant fibers with attached red, yellow, and black feathers protected these divine beings while glorifying their position to all viewers. Master artists working in plant fibers wove basketry heads with long necks over 60 centimeters high and covered with valuable feathers that were used as receptacles for the highest gods. These feathered images have eyes created from pearl shell and seeds and dog teeth placed in an open grimacing mouth, creating a powerful anthropomorphic sculpture. Many feather images contain attached human hair, a spiritually potent material. Boldly carved wooden figures (*ki'i akua*) used by the ruling class often reached a height of 180 centimeters or more and, when ritually activated, could contain the presence of major deities for state occasions. Hawaiians often used smaller figures (*ki'i aumakua*), usually under 60 centimeters tall, as receptacles for lesser ancestral spirits who could assist their living family. Hawaiian artists also created spears, bowls (some inlaid with teeth or shells), and intricately carved drums. As in many Polynesian groups, petroglyphs were widely prevalent, depicting groups of figures and motifs in a variety of locations that may have functioned as historical records or marked significant or sacred areas.

Of the many islands and cultural groups in Western Polynesia, Tonga, Samoa, and Fiji were traditionally the most prolific art producers and share many artistic traits, likely due to the lively trade between the islands. These Western Polynesian groups placed a strong emphasis on weapons, bowls, flywhisk handles (symbols of authority), and headrests, while figurative carvings were relatively rare. Finely crafted Western Polynesian weapons took a variety of forms, ranging from short throwing clubs to massive two-handed clubs. Artists created many clubs with elaborate and detailed surface incising organized within a primary grid system filled with geometric patterns shared with tattoo and bark-cloth decoration. Precious and spiritually potent marine ivory shaped into anthropomorphic and geometric forms (stars, crescents, and circles) was often inlaid into the surfaces of clubs. In addition to weapons, artists made finely carved bowls for food preparation and serving, oil dishes, and for the mixing of the ceremon-

ial drink *kava*. In Fiji some bowls took the form of humans, turtles, and birds. The precise attention to sculptural design and surface decoration created aesthetically pleasing objects that were spiritually enhanced by the ritual process of artistic design and creation, as well as through ceremonial use. *Kava* bowls remain an important form created by Western Polynesian carvers for use during ceremonial and social events.

The primary artistic cultures of Eastern Polynesia include the Society Islands, Marquesas Islands, Cook Islands, and Austral Islands. Large-scale figurative sculptures in wood and stone were placed on ceremonial complexes so that sacred ancestors and deities could enter them and thus participate in ritual events. Smaller-scale figures were also common, many of which were depicted back-to-back. Drums, some quite large, were used in ceremonial areas to honor and call spiritual entities into an arena. Characteristic of Polynesian art, intricate carving enhanced the effectiveness of the object, and drums were no exception. Sharkskin membranes tightly lashed with coconut fiber covered ornately carved bodies, often containing repetitive motifs referring to genealogical succession. Additional forms made by regional artists included fans with exquisitely carved handles in wood and ivory with finely woven coconut fiber blades, as well as elegant food containers and pounders, bowls, stools, neck rests, and clubs. Artists throughout the area also created petroglyphs and canoe-prow figurative ornaments. Figurative sculpture in the Society Islands can be placed into two broad categories: ancestor and lesser gods created in wood or stone (*ti'i*) and national gods woven with coconut fiber into cylindrical forms with slight anthropomorphic features (*to'o*). *Ti'i* figures tend to have rounded heads, pointed thrusting chins, and almost-expressionless faces. Contained within the *ti'i* figures is a piece of wood, and when activation was required red feathers were attached to the outside. Throughout Polynesia red and yellow are the colors most closely associated with sacred and elevated status. Unique to the Marquesas Islands was an emphasis on Janus heads displaying the Marquesan style of shallow surface carving to create round eyes, arched brows, broad nose, horizontal mouth, elaborate double-scroll ears, and, if included, cylindrical body. Cook Islands' figures have large high-domed heads, exaggerated crescent-shaped eyes and brows, a chin that seems to rest on the chest, and an emphasized and articulated navel and phallus. Some of the Cook Islands' wood figures are painted to different degrees with geometric motifs that echo surface carvings found on drums and adze handles, as well as painted designs on bark cloth. Freestanding figures are rare in the Austral Islands, but anthropo-

morphic motifs in stacked dancelike poses feature prominently on drums, flywhisk handles, and spears.

While conversion to Christianity and subsequent colonialism radically changed the traditional arts of Polynesia, art production continues to be vibrant and vital; traditional forms of body adornment, basketry, and bark cloth decoration remain strongly woven into the social and artistic fabric of Polynesian culture. Today, Polynesian artists have expanded their range of media to include Western-inspired techniques, often inventively combined with traditional forms and materials. As large Polynesian communities continue to develop in New Zealand and the Western United States, the ebb and flow of artistic trends and visions will no doubt continue to transform and strengthen the enduring power and relevance of Polynesian art.

TERI SOWELL

Further Reading

Cox, J. Halley, and William H. Davenport, *Hawaiian Sculpture*, Honolulu: University of Hawaii Press, 1974; revised edition, 1988

Kaeppler, Adrienne L., Christian Kaufmann, and Douglas Newton, *Oceanic Art*, New York: Abrams, 1997

Sowell, Teri L., *Worn with Pride: Celebrating Samoan Artistic Heritage*, Oceanside, California: Oceanside Museum of Art, 2000

Starzecka, D.C., and Janet M. Davidson, *Maori Art and Culture*, Chicago: Art Media Resources, and London: British Museum Press, 1996; 2nd edition, London: British Museum Press, 1998

St. Cartmail, Keith, *The Art of Tonga*, Honolulu: University of Hawaii Press, 1997

Van Tilburg, JoAnne, *Easter Island: Archaeology, Ecology, and Culture*, Washington, D.C.: Smithsonian Institution Press, and London: British Museum Press, 1994

PORPHYRY

True porphyry is an igneous rock, dark purplish-red in color, speckled with feldspar. Although some scholars describe certain stones as green, gray, or black porphyry, the derivation of the material's name from its color indicates that the term is reserved for the purple rock appropriated for images and architectural elements associated with deities and royalty. From the Ptolemaic period until abandonment of the quarries at Mon Porphyrites (now Jabal Abu Dukhan) in Egypt during the late Roman Empire (mid 4th century CE), its excavation and sculpting into objects and architectural members remained under imperial control. Prized for its regal color and its rarity, it was reserved for applications with significant imperial connotations. Its density, hardness, and consequent resistance to being worked rendered it both impractical for widespread use and highly esteemed as a material with a royal message.

References to this stone that appear in pre-Ptolemaic writings involve red granite rather than this material. Its popularity waxed and waned over the centuries from its first documented use under the Ptolemies, 2nd century BCE, to the decline of quarry operations at the end of the Roman Empire. Ptolemaic kings instigated the use of purple as a royal color, and later revivals of taste for the material may be associated with such emperors as Nero and Hadrian, who demonstrated an affinity for the Hellenistic past in art and architecture, emulating the use of various luxury stones and the Egyptian penchant for royal extravagance. Initial use for powerful portraiture and architectural members expanded to service for mosaics, elaborate furnishings and decorative items, commemorative monuments, jewelry, statuary, and sarcophagi. Its reputation as a sumptuous material led artists to destroy objects made of porphyry in order to refabricate the material for different purposes and to remove these objects to new contexts, making the task of reconstructing the history of the material's use complex in many instances and impossible in others, although its ongoing importance has left a historical paper trail. Many works had a considerable afterlife through reuse in later eras for regal and ecclesiastical purposes.

Remarkable works from disparate periods testify to the high esteem for this material in contexts of significant political and religious messages. Indicative of opulence and status, it was used for inscribed stelae (150 BCE, Thera) for columns and pilasters in Alexandria and Rome. Nero's fondness for it led him to choose (as did Septimus Severus) porphyry for the urn (1st century CE) in which his ashes would be deposited and for other imperial works. From Trajan's time forward, porphyry appeared increasingly in artistic statements of royal authority, through architectural components and sculptural objects. Exemplary are mixed-stone images of Dacian soldiers (in Paris and Rome), a type that appeared in various materials, and imperial portraits from Hadrianic to Diocletian times, some in an archaistic "Egyptian" style that led early scholars to erroneously attribute them to Egyptian eras.

Porphyry had been prized for sarcophagi beginning in the Ptolemaic period, and rulers, aristocrats, and church leaders later claimed many early burial containers for reuse. Among the most notable were the undated pre-Christian tomb from Alexandria used for Emperor Julian in Constantinople, the Engelsburg tomb for Pope Innocent II (Hadrian's 2nd century tomb), and the 4th century Helena sarcophagus in which Pope Anastasius IV was entombed in the Basilica of San Giovanni in Laterano, Rome, in the 12th century (now in the Vatican Museums and heavily reworked). This latter tomb, beautifully carved with battle scenes, deities, and imperial garlands, and the tomb

of Constanza, with its harvesting putti set forth in vine scrolls, as well as related works (statues, fonts, basins, and columns) described as Constantinopolitan treasures in Late Antiquity and throughout the Byzantine eras, indicate a revival of interest in porphyry in the Diocletian and Constantinian eras.

Rulers and church leaders energetically cultivated the material's association with court ceremony for palace and church, for throne and altar, and for tomb and baptismal font. In 435 CE Theodosius encouraged arrogation of such materials from pagan temples to further assert Christian transcendence. The Byzantine Empire emphatically reinforced the strong regal associations, especially with the construction of a birthing room in the palace, of which the walls and floor were lined with porphyry slabs, giving the concept of being "born to the purple" a literal interpretation.

Perhaps the best-known work in porphyry is the group of Tetrarchs at the Basilica of San Marco in Venice, brought there from Constantinople, a collective portrait of rulers of the late Roman Empire, from the early 4th century. The predilection of Constantinian-era rulers and churchmen for the material led to its selection for numerous architectural and artistic works

Four Tetrarchs (Emperors Diocletian, Maximum, Valerian, Constance), 4th century, San Marco, Venice
The Conway Library, Courtauld Institute of Art

east and west. Notable were the great porphyry column erected in the middle of the Constantinople forum, as base for the statue of Constantine as Sol, brought from Rome (perhaps a Diocletian work), and centerpiece of a capital replete with porphyry imperial monuments, with pagan and Christian messages, to adorn the new eastern capital.

Its hardness rendered this stone invulnerable to available metal tools, therefore difficult to cut, carve, and polish. In the centuries after Antiquity, techniques for working it were lost, particularly since the labor-intensive operations, involving such large captive workforces as prisoners and soldiers, were no longer practical. Fine carving and finishing became possible again when the Renaissance sculptor Francesco del Tadda of Fiesole devised new means of sculpting large-scale pieces such as the Palazzo Vecchio fountain basin and for carving Medici family portraits. Apparent rediscovery of lost means for tempering metal and for labor-intensive use of abrasives such as emery remained a trade secret, and widespread dissemination of means for handling porphyry remained to be found in modern metal technology and power tools.

RITA TEKIPPE

Further Reading

Bianchi Bandinelli, Ranuccio, *Rome, la fin de l'art antique*, translated by Jean-Charles Picard and Évelyne Picard, Paris: Gallimard, 1970; as *Rome: The Late Empire: Roman Art, AD 200–400*, translated by Peter Green, New York: Braziller, and London: Thames and Hudson, 1971

Butters, Suzanne B., *The Triumph of Vulcan: Sculptors' Tools, Porphyry, and the Prince in Ducal Florence*, 2 vols., Florence: Olschki, 1996

Delbrück, Richard, *Antike Porphyrwerke*, Berlin: De Gruyter, 1932

Fowden, Garth, "Constantine's Porphyry Column: The Earliest Literary Allusion," *Journal of Roman Studies* 81 (1991)

Napoleone, Caterina, "Marble Cosmesis, Cosmati Pavements in Rome," *FMR* 89 (1997)

Peacock, D.P.S., "Passio sanctorum quattuor coronatorum: A Petrological Approach," *Antiquity* 69 (June 1995)

Peacock, D.P.S., "Charlemagne's Black Stones: The Re-Use of Roman Columns in Early Medieval Europe," *Antiquity* 71 (September 1997)

Penny, Nicholas, *The Materials of Sculpture*, New Haven, Connecticut: Yale University Press, 1993

GUGLIELMO DELLA PORTA *fl.* 1532–1577 *Italian*

Guglielmo della Porta's early career as a sculptor most likely dates from his association in the 1520s with the Milan Cathedral, where the Genoese sculptor Gian Giacomo della Porta, who was either Guglielmo's father or uncle, was a member of the stonemason's lodge. Guglielmo collaborated with Gian Giacomo and Nic-

colo da Corte in 1532 on a baldachin for the Chapel of St. John the Baptist in Genoa Cathedral. Guglielmo's contributions consisted of several reliefs on the socles. He also collaborated with them on the tomb of Giuliano Cybo in Genoa Cathedral from 1533, for which he carved the figures of Cybo and Abraham. Guglielmo may have worked with Perino del Vaga at the Palazzo Doria in Genoa and joined him again in Rome, where Giorgio Vasari reported him as early as 1537. His stucco decorations for Perino in the Massimi Chapel of the Church of Trinità dei Monti in Rome have been lost.

In 1547 Guglielmo restored the antique Farnese *Hercules* (Museo Nazionale Archeologica, Naples), which had been discovered by Cardinal Alessandro Farnese in 1540. Alessandro's father, Pope Paul III, appointed Guglielmo *Piombatore Apostolico*, succeeding Sebastiano del Piombo as holder of the papal seal for official documents. He was also commissioned to install a tomb for Bishop Francesco de Salis. Guglielmo never completed this work, and the effigy of the bishop was sent to Spain, where it was incorporated into the tomb of Archbishop Lodovico de Torre in the Cathedral of Malaga. The base of the de Salis tomb later became part of the tomb of Paul III for St. Peter's Basilica, Rome.

After 1544 Guglielmo produced several bronze and marble busts of the Farnese pope (such as a bronze version in Hamburg and three marble versions in Naples), followed within three years by the commission for the tomb of Paul III. This was temporarily erected in the nave of St. Peter's Basilica in 1575 but was then installed in a reconstructed format in the niche of a crossing pier before 1588. In 1628 it was moved again, eventually to serve as a pendant to Gianlorenzo Bernini's tomb of Pope Urban VIII (1627–47) in the choir of the basilica. In this installation, the bronze figure of the seated pope was accompanied by reclining personifications of Fidelity and Prudence in marble. The allegories of Roman Peace and Public Wealth were removed to the Palazzo Farnese in Rome, where they were installed on the *piano nobile* (primary living quarters on second floor above ground floor) flanking a fireplace by Giacomo Vignola.

It was only after his arrival in Rome that Guglielmo began to work in bronze. His numerous bronze sculptures, which reside in collections throughout the United States and Europe, include crucifixes, religious scenes in relief, and a cycle of 16 mythological plaques based on the writings of Ovid. Specific items include a *Bacchanalian Feast* and a *Judgment of Paris*. These compositions captured the fancy of later generations of sculptors and were copied into the 18th century.

Guglielmo's white marble bust of Paul III in Naples is associated with a payment of 23 December 1546

and is thought to be that recorded in Cardinal Farnese's possession in 1568. Relief personifications of Abundance, Peace, Victory, and Justice and reliefs of *Moses and the Laws* and *Moses and the Dead Egyptians* decorate the copy of this bust and are set into the *giallo antico* (yellow marble) cope, fastened by a magnificent *giallo antico* morse. Guglielmo was also a prolific draftsman, a rare interest for a sculptor. Two of his sketchbooks are preserved in Düsseldorf. They show figures drawn in long, whiplike lines, revealing the decorative influence of Perino del Vaga on his drawing style.

Guglielmo may have provided designs for other Roman tombs, such as the tomb of Cardinal Paolo Cesi (*d.* 1537) and the tomb of Cardinal Federigo Cesi (*d.* 1565), both in the Basilica of Santa Maria Maggiore, Rome, the tomb of Cardinal Gregorio Magalotto (*d.* 1538) in the Church of Santa Cecilia in Trastevere, and the tomb of Bernardino Elvino (*d.* 1548) in the Church of Santa Maria del Popolo. The tomb for Cardinal Paolo Cesi shows the recumbent effigy wearing his miter and reclining on the sarcophagus on his right elbow, a pose favored for recumbent effigies by Andrea Sansovino and Michelangelo and ultimately derived from Etruscan tombs. The figure of Cardinal Cesi is framed by veined marble columns supporting a triangular pediment. A pair of infants supports his family arms above the peak of the gable. A backdrop of richly veined marble adds to the coloristic profusion of the monument.

Among Guglielmo's lost works are 14 scenes from the *Life of Christ*, which were to have been part of a grand circular structure containing an equestrian monument for Holy Roman Emperor Charles V. The commission originated in 1551 during the papacy of Pope Julius III, but the reliefs were diverted to a door project for Pius IV, which was also abandoned. A partial reconstruction of the scheme can be inferred from drawings in Guglielmo's Düsseldorf sketchbooks.

EDWARD J. OLSZEWSKI

Biography

Born in Porlezza, Italy, early 16th century. Son or nephew of Genoese sculptor Gian Giacomo della Porta; signed himself as "of Milan" (*Mediolanensis*). Worked with Gian Giacomo in Genoa, 1532; moved to Rome, before 1546, where he joined Perino del Vaga on a project in the Church of Trinità dei Monti; in the service of the Farnese family, 1547, and appointed keeper of the papal seal by Paul III; completed the Vatican tomb for the Farnese pope, Paul III, before 1577. Died in Rome, Italy, January 1577.

Selected Works

1534	Tomb of Giuliano Cybo; marble figures of Cybo and Abraham; Genoa Cathedral, Italy
1544	Bust of Pope Paul III; marble; Museo Nazionale di Capodimonte, Naples, Italy
1544	Bust of Pope Paul III; bronze; Museum der Kunst, Hamburg, Germany
after 1545	*Bacchanalian Feast*; bronze; Metropolitan Museum of Art, New York City, United States
after 1545	*Judgment of Paris*; bronze; Kunsthistorisches Museum, Vienna, Austria
1549–75	Tomb of Pope Paul III Farnese; bronze and marble; St. Peter's Basilica, Rome, Italy
1551–?	Fourteen scenes from the *Life of Christ*; bronze (lost)

Further Reading

Barbour, Daphne, and Lisha Glinsman, "An Investigation of Renaissance Casting Practices as a Means for Identifying Forgeries," *Studies in the History of Art* 41 (1993)

Der Glanz der Farnese: Kunst und Sammelleidenschaft in der Renaissance (exhib. cat.), Munich and New York: Prestal, 1995

Gramberg, Werner, *Die Düsseldorfer Skizzenbücher des Guglielmo della Porta*, 3 vols., Berlin: Mann, 1964

Gramberg, Werner, "Die Hamburge Bronzebuste Pauls III Farnese von Guglielmo della Porta," in *Festschrift für Erich Meyer zum sechzigsten Geburtstag*, edited by Werner Gramberg et al., Hamburg, Germany: Hauswedell, 1959

Kruft, Hanno Walter, "Porta, della: Guglielmo della Porta," in *The Dictionary of Art*, edited by Jane Turner, New York: Grove, and London: Macmillan, 1996

Pope-Hennessy, John, *An Introduction to Italian Sculpture*, 3 vols., London: Phaidon, 1963; 4th edition, 1996; see especially vol. 3, *Italian High Renaissance and Baroque Sculpture*

Riebesell, Christina, "Eine Herkulesstatuette des Guglielmo della Porta," in *Ars Naturam Adiuvans: Festschrift für Matthias Winner*, edited by Victoria von Flemming and Sebastian Schütze, Mainz, Germany: Von Zabern, 1996

TOMB OF POPE PAUL III FARNESE

Guglielmo della Porta (fl. 1532–1577)
1549–1575
bronze and marble
h. 19.62 m
St. Peter's Basilica, Rome, Italy

Guglielmo della Porta's tomb in St. Peter's Basilica, Rome, for Pope Paul III Farnese has a complicated

history and holds a transitional position in the history of funerary monuments in the Renaissance and Baroque periods in Italy. It takes its cues from Michelangelo Buonarroti's tombs of members of the Medici family in the New Sacristy of the Church of San Lorenzo in Florence in the reclining allegories placed below a seated effigy. The monument was eventually positioned in the choir of the Vatican basilica as a companion piece to Bernini's more recent tomb of Urban VIII in 1628. Guglielmo's model dictated the arrangement of a bronze papal effigy over marble allegories.

The tomb commission was placed on 17 November 1549 after Pope Paul III died, providing Guglielmo with a sum of 10,000 ducats. By 1555, 8,042 ducats had been spent on the figures alone, and the final cost of the monument came to 26,500 ducats.

The pope had already selected the base for the monument from Guglielmo's unfinished tomb for Bishop de Salis with its reliefs and scrolls in bronze. The pope's illegitimate son Cardinal Alessandro Farnese took responsibility for the project, minting a medal to commemorate its completion in the Holy Year of 1575. Supervision of project details had been delegated to

Tomb of Pope Paul III Farnese
© Alinari / Art Resource, NY

the humanist Annibale Caro and Antonio da Capodistria 25 years before. Guglielmo prepared a wooden model, which he presented to them on 5 August 1551. This showed a freestanding tomb with the papal sarcophagus placed within a structure supported by eight terms. There were also eight reclining allegories and a bronze figure of Paul III at the top. The latter is recorded as already cast in the autumn of 1552. Guglielmo wanted to add statues of the Four Seasons as well, but Caro rejected the idea.

The first marble allegory, Fidelity (often identified as Justice or Equanimity), was carved by April of 1554. Giorgio Vasari described it as a nude figure, to which Teodoro della Porta added drapery in 1594. A strap across the figure's torso contains Guglielmo's signature. The central figure of the pope was placed on a bronze base with putti at each corner and reliefs of Hope and Faith to the left and Temperance and Fortitude at the right. The four marble allegories were supported by two consoles at the front and two at the back. Vasari mentioned a relief with river gods, but this is the only reference that we have on this subject.

Vasari and Michelangelo offered their opinions on the project, Michelangelo discouraging the tomb's placement in the nave of the basilica in favor of a niche setting. By November 1553 the pope's statue had been set in an arcade of the new tribune, but after the death of Michelangelo in 1564 and of Caro two years later, Pope Gregory XIII approved its installation in the right side aisle as a freestanding construction. Some time later, about 1587, it was moved to the pier presently containing François du Quesnoy's marble statue of St. Andrew. The pairs of allegories here were displayed one above the other. In 1628 the monument was moved to its present site in the choir as a pendant to Bernini's planned tomb for Urban VIII. Prudence and Fidelity were retained for the final composition, each precariously balanced on a scroll bracket. Prudence at the right holds her mirror of self-knowledge almost as a heraldic pendant to the key of Fidelity opposite, the key signifying locked secrets. The mirror also allows Prudence to look backward, suggesting an evaluation of the past to gauge the future. (Prudence was identified by Thomas Aquinas as the chief of the cardinal virtues.) Guglielmo's reliefs of Faith and Fortitude have been lost, as have two of the putti. His allegories of Public Wealth and Roman Peace did not accompany the final installation but were taken to the Palazzo Farnese, where they were positioned flanking a fireplace by Giacomo Vignola on the *piano nobile* (primary living quarters on second floor above ground floor). A study for the Farnese tomb exists among Guglielmo's drawings in Düsseldorf.

EDWARD J. OLSZEWSKI

Further Reading

Gramberg, Werner, "Guglielmo della Portas Grabmal für Paul III Farnese in S. Pietro in Vaticano," *Römisches Jahrbuch für Kunstgeschichte* 21 (1984)

Thoenes, Christof, "Peregi Naturae Cursum: Zum Grabmals Pauls III," in *Festschrift für Hartmut Biermann*, edited by Christoph Andreas, Maraike Bückling, and Roland Durn, Weinheim, Germany: VCH, Acta Humaniora, 1990

PORTRAIT

Introduction

The standard concept of a portrait is the reproduction of a single individual, living or deceased. The fundamental aim of this operation is to reproduce some resemblance to the model. In cultures historically concerned with physiognomic and psychological research, this reproduction has been mainly focused on the human face, where the main elements of individual identification, personal character, and human expression are represented.

The portrait is a universal subject of figurative representation, exploited in every medium. Many scholars and practitioners have found in sculpture, however, a great advantage over the pictorial, as the three-dimensional quality of sculpture makes more concretely manifest the portrayed individual. This has been particularly true of funerary occasions, where sculpture has been used as a means to simultaneously make present and immortalize the dead.

In considering the potential advantages and disadvantages of sculpture as a medium for portraiture, one must account for its tendency to oversimplify physiognomic features. This should not imply that realism in sculpture portraits is impossible; on the contrary, chief examples by Antonio Pollaiuolo and Jean-Baptiste Pigalle are marked by great technical virtuosity. Nevertheless, the sculptural technique favors simplified and nonanalytical forms with large uniform surfaces, so idealization tends to overwhelm realism as a result.

A specific problem of realistic representation is characterizing and bringing to life the figure's eyes. This challenge was resolved in ancient art with polychromy—the insertion of materials of different colors (silver or ivory)—in the eye socket, or with the piercing of the figure's eyeballs. This latter technique was revived in 17th-century Baroque sculpture, such as Gianlorenzo Bernini's marble bust of Cardinal Scipione Borghese (1632).

Further difficulty arises, particularly with common sculptural mediums like marble and stone (especially porphyry), in the representation of costumes, so important in painted portraits. Here, sculpture is necessarily disadvantaged by the unyielding quality of the materials in realizing details and differentiating surfaces. The 16th and 17th centuries saw great sophistication in realizing sumptuous and richly refined costumes in painting, as well as technical advances in the handling of surfaces of marble and bronze in sculpture, such as Benvenuto Cellini's bronze bust of Duke Cosimo I de' Medici (1545–48) and Alessandro Algardi's marble bust of Cardinal Laudivio Zacchia (1626). The use of polychromatic marbles, a technique borrowed from ancient Rome, was revived during this period.

Perhaps because of these technical problems, the genre of realistic or idealized self-portraiture appears as one of the fields that is more limited in sculpture. Fine examples, however, came from Lorenzo Ghiberti, Baccio Bandinelli, Louis-François Roubiliac, and Antonio Canova.

The sculptural portrait can take on one of many forms: head only, bust to the shoulders, bust to the chest, half figure, three-quarters figure, or full-length figure. It is only in the relief, however, that the form chosen by the artist helps determine the vantage point of the observer. The bas-relief, for example, offers a profile view, whereas the sculpture in the round offers multiple points of view.

Because of this dimensional access to the work on the part of the viewer, formal limits are more difficult to evade than they are in painting. One of the primary challenges in the development of the bust genre, for example, was how to allude to the presence of the rest of the body, particularly of the arms of the figure. This problem was solved by Bernini in his busts with the body suggested by skillfully arranged drapery and rotation of the head.

The historical development of portraiture in sculpture can be synthesized by first considering the general conception of the portrait—the problem of physical resemblance—and the relationship between realism and idealism. This relationship is very complex, considering the specific functions of portraits and the anthropological and social context of their production.

Sculptural portraits can be found, although in minimal forms, in some primitive cultures of Africa, North America, Mesoamerica, and Melanesia, where they held mostly ritual functions and were realized in wood, stone, and terracotta. Sculptural portraits were also produced in ancient and preindustrial India, China, and Japan for funerary, ritual, and commemorative uses, realized in stone, wood, lacquer, and various metals in numismatics (coins or other forms of currency), in the round, and in relief carving. Sculpted portraiture was highly limited in the late ancient world, but it was of far greater importance in earlier ancient cultures (Mesopotamia, ancient Egypt, ancient Greece, and

Etruscan and Persian [today Iran] civilizations), where it was used for funerary and commemorative functions.

Physical resemblance became pertinent somewhat in Egyptian, Hellenistic Greek, Roman, and modern European art; these cultures were concerned with portraiture in every medium. Identification of the portrayed person, however, was independent from his or her physical resemblance.

Symbolic portraiture, which is quite different from the modern idea of a portrait, was particularly important to primitive cultures. Symbolic traits of the portrayed person were expressed with size and attitude of the figure, his or her attributes, and inscriptions. This indifference toward physical resemblance is evident by the practice of reemployment of the same images to represent different personages with a simple change of inscriptions.

FRANCESCA PELLEGRINO

PORTRAIT: ANCIENT ROME

Preserved portrait sculpture from the Roman Republic and Roman Empire depicts individuals in bust, statue, or herm format; in the round or in relief; and in media that range from bronze to cameo. The production of portrait sculpture, especially marble portraits, flourished in this period to an extent that has never been matched. Portraits had an essential function in both daily life and in the funerary realm. They were the standard way to commemorate individuals of both sexes and at all social levels. Moreover, most portraits made during the Roman Empire can be closely dated because the portraits of the emperors and their family members, which were copied endlessly for propaganda, provide a secure chronological framework of trends in fashion and appropriate self-representation.

The widespread diffusion of portraits in the Roman period is due to their important role in both the private sphere of the family and the public political arena. The literary record of the period reflects the Romans' significant adoration for the customs and behavior of their forefathers (*mos maiorum*). This overwhelming devotion produced a tradition that was influential in regard to portraiture. In the homes of the elite, the *imagines maiorum* (the images of the forefathers) were displayed with labels noting names and accomplishments. These *imagines*, perhaps originally made of wax, were certainly portraits and were likely to have been masks or busts. Intended to evoke a sense of a specific individual as well as his virtue, the *imagines* functioned as a visual prop that aimed both to instill in young men a desire to emulate their illustrious ancestors and to impress the visiting public with one's clearly established connections. Publicity of one's ancestors was important because the family name and its renown

were decisive factors for a young man. On the strength of these, he would be elected to his initial public post, from which his career could then develop.

The world of government careers in Rome was highly competitive, especially during the republic. Only about 20 young men, almost all of senatorial rank, were chosen every year to enter the lowest level of government as a quaestor. As one progressed upward in the ranks, the yearly number elected decreased markedly; for instance, at the outset of the empire, only about 8 men were annually elected to the desirable praetorian positions that would qualify them for important senatorial and imperial posts. During the empire a similar competition developed among men of the equestrian order. This difficult and prestigious world of the *cursus honorum*, the path of career positions, caused individuals to be proud of the accomplishments of their family members and led to the need to publicize these accomplishments. The so-called *Togatus Barberini* demonstrates exactly this type of family pride. The statue shows a togate man (whose head is a restoration) holding two busts, presumably the depictions of two of his illustrious forefathers.

A second use of the *imagines maiorum* that promoted portraiture and at least pseudoveristic reproduction was their public presentation in funeral ceremonies. Public funerals at Rome, initially for all elite and then almost exclusively for the imperial family during the empire, featured a parade of these images, each of which represented an ancestor of the family. On arrival in the forum, the individuals with the images of the ancestors would sit in a row on the platform as the living male relatives gave the eulogy. After the eulogy, the speaker would then say a few words about each of the seated ancestors. The images without doubt presented a realistic physical appearance for the ancestors and again had both a self-assertive and an educational role.

This tradition of the ancestral image enhanced two concepts, public statues and funerary honors, which—already established in the Greek world—flourished and developed during the Roman period. Portrait statues erected in public places were considered among the highest honors for a man because they had to be granted by a public organization. They provided a way for the community and not just the family to honor an individual who had contributed to the community's glory, generally either by bringing it status by means of his own fame or by improving its appearance or well-being by means of monetary donations. The purpose was no different from the purpose of the ancestral portraits; the audience was merely larger. Rather than to spur family members to greatness and to assert the place of the family in the community, it was often to spur the members of the entire society onward and to

assert the position of the community in the empire. By the 2nd century CE, such honors had become standard practice, with a standard visual vocabulary, and were almost a requirement for any outstanding individual and his or her family. The established format of the honor consisted of a portrait head, a statue body, and an inscribed base that identified the individual by name and by deed. In general, the repertoire of the statue body was limited; for instance, in the case of men, they were represented as nude, or as wearing a toga, cuirass, or a himation. These provided easily legible associations with public roles (Roman official, military, Greek, senatorial, etc.). The portrait head allowed for greater freedom because it, just as the individual's name, was specific to only one person. The social range and contribution of the honored individuals were wide. They included local government officials, any individual who erected or repaired a public building, priests and priestesses, young children of elite families, and even performers such as actors and boxers. The type of statue (gilded bronze, marble, or equestrian), the size of the statue (under-life-size, life-size, over-life-size, or colossal), and the location (forum, building facade, public portico, or sanctuary) corresponded to the status and contribution of the honored. The most

Bust of the ancient Greek philosopher Metrodorus (Roman copy), Hall of Philosophers, Palazzo Nuovo, Capitoline Museum, Rome
© Massimo Listri / CORBIS

prestigious statues were gilded bronze and colossal and had central locations. A statue in the Forum in Rome, for instance, was a greater honor than a statue in the forum of a small municipality or even than a statue in another location in the city of Rome.

Funerary monuments, which lined the streets leading out of every city, also featured abundant sculpted portraiture in the form of life-size reliefs or statues, busts in relief or in the round, and small-scale relief figures on elaborate sarcophagi. Such sculpture might have been placed either on the facade of a tomb or within it. The forms of funerary portraiture were dictated by burial forms—trends in inhumation as opposed to cremation—and by restrictions on the space available and the size permissible for monuments. For instance, late republican monuments tended to be large, with life-size sculpture on the exterior facades, whereas elaborate sarcophagi appear from the mid 2nd century onward. The motivation for portraiture on funerary monuments was again familial pride and an assertion of self-identity, as well as the human desire never to forget or be forgotten. Freedmen's tombs of the late republican and early Imperial periods often featured a series of busts in relief, sometimes each in a separate niche, that seem to be based on the elite man's display of his *imagines maiorum* in his house. These freedmen, having proudly achieved new status and money, appear to call attention to who they were and what they achieved by use of the same visual devices employed by their former masters. The appearance of portraiture on funerary monuments is a tradition still upheld in the Western world, where photographs of dead individuals are commonplace.

For most people the words "Roman portraiture" bring to mind images of the emperors and the vast series of studies, beginning in the mid 19th century, that have attempted to identify various extant portraits with imperial names. Imperial portraiture had a prominent position during the Roman Empire and deservedly plays an important role in the modern perception of Roman portraiture. The identification of sculpted portraits in the round with emperors depends mainly on numismatic evidence and secondarily on imperial portraits preserved with inscriptions. Extant coins and medallions feature portraits of individuals (who during the empire were all imperial family members) and written legends that identify the portrait. Thus comparisons of the coin portraits, although they show only a profile, with portraits in the round are the principal means by which to identify imperial portraits. From studies of these coins, the sculpted portraits associated with them, and the portraits labeled by inscriptions, it has emerged that the portrait of every imperial family member, no matter what the medium, was based on at least one well-distributed model. The faithful copying of the

model is attested by replica portraits with widely disparate provenances. The model, called by scholars the "official type," was assuredly produced by the imperial circle and disseminated throughout the provinces of the empire in order to obtain a certain cohesion and allegiance to the same concept in distant lands. Every town of the empire, no matter how small or how remote, erected some monument to some member of the imperial family as testimony of its loyalty and participation in the glory of the empire. The fact that the imperial family member would look the same in every city was undeniably important.

This is not to say that every copy of a given model of an emperor was exactly the same. This would be impossible given the countless number of sculptors employed, the variety of the media (bronze, marble, relief, coin, cameo, and so forth), and the variety of the size of the portraits (a few centimeters to over twice life size). The copyists aimed for recognition and seem to have always attempted to reproduce the important details of physiognomy—for instance, old or young, small-eyed or big-eared—and the most striking details of the arrangement of the hair, such as bearded or not and widow's peak or central part. The copying sculptor's particular concern for repeating the arrangement of the locks of hair, especially those over the brow, has enabled modern scholars to identify the subject of a portrait when only the representation of a few locks of hair are preserved.

Some emperors had more than one portrait model. It has been hypothesized that these different models were created in conjunction with important historical or familial events. For instance, a young man's accession to emperor might constitute the reason for one portrait model to be made, and his marriage might provide an occasion for another model. Similarly for a woman, the birth of every child might be reason for the creation of a new official type. Marcus Aurelius stands out as the emperor with the most complete and comprehensible series of official portrait types and motivations. In 139 CE when as a teenage boy he was adopted as the grandson of the Emperor Hadrian, a portrait model showing a glorious soft-cheeked youth with thick tousled locks and heavy-lidded eyes was produced. In 145 CE when as a 24-year-old he married the Emperor Antoninus Pius's daughter Faustina, a new portrait model, which showed the same physiognomy but shorter hair and a light beard, was issued. In 160 or 161 CE, to coincide with his first consulship or actual accession to the throne, a completely adult portrait was devised in which he was shown with a full beard. Subsequently, possibly in relation either to the commencement of his sole rule at the death of his coruler Lucius Verus or at the promotion of his son, Commodus, a last portrait type showing Marcus Aure-

lius as a yet older man was devised. In it, his hair is brushed straight back over the forehead and the beard is very long.

Despite the clarity of the general process and the modern ability to reconstruct the official portrait types, the study of imperial Roman portraiture is not without problems. The resemblance between members of the same imperial family, especially those of the Julio-Claudian clan, makes certain portraits difficult to identify; for example, the portraits of Germanicus, an adopted son of Augustus, are at times difficult to distinguish from portraits of Germanicus's sons. In addition, certain portraits appear in several replicas but remain unidentifiable because they never appear on coins with legends and are not preserved with an inscription; a particularly appealing portrait of an adolescent girl whose face is framed by small pin curls remains known only as the Leptis-Malta type. Conversely, certain 3rd-century emperors, especially those of the second half of the 3rd century, appear on coins but cannot be securely identified with a portrait in the round. A further potential problem is that sculptors at times mixed elements of two different official portrait types of the same individual. The resulting product confuses the modern viewer who, generally deprived of the inscription, bases his or her identification on the arrangement of the hair over the brow. Also, it is possible that some portraits that were originally intended to portray an emperor did not follow any official type. Unless these portraits are found with an inscription, modern archaeologists cannot identify them.

Another problematic aspect of imperial portraiture concerns emperors who after their death were publicly judged to have been unworthy. These emperors officially suffered a *damnatio memoriae*, a condemnation of their memory, which in practical terms means that their name and face were removed from every public monument and context. The emperors Caligula, Nero, and Domitian are prime examples of rulers who were justly considered improper. Geta, the younger brother of Caracalla, whose existence infringed on Caracalla's possibility to be sole emperor, provides a more undeserving example of *damnatio*. Frequently, rather than removal of a statue of such an emperor, his face was simply recarved to resemble the next emperor. This resulted in a series of strange portraits that feature, for example, the transformation of Caligula into Claudius, Nero into Titus, and Domitian into Nerva.

The imperial portraits are of great significance because they give us a firmly dated sequence for the evolution of technical aspects and aspects of self-representation. More precisely, this means one can trace developments in the techniques of rendering and changes in the format of busts, as well as follow fashion hairstyles and general attitudes of self-representa-

tion. The multilevel framework provided by the imperial portraits allows us reliably to date numerous unidentified portraits of private individuals.

Two points must be kept in mind. First, imperial portraits generally represent the most socially acceptable mode of self-representation and probably the height of metropolitan fashion. This is not, however, the only possible form of self-representation. There were, of course, people of the older or younger generations who preferred a look that may have been considered old-fashioned or cutting-edge, as well as individuals belonging to different cultural circles who chose alternative looks. Several beardless male portraits from the Antonine period (when all emperors wore beards) provide examples of men who continued to follow a conservative fashion. Similarly, 2nd-century portraits of heroically styled long-haired and long-bearded young men from the Greek east follow Hellenic traditions. In these cases, the imperial portraits provide a backdrop of elite social norms against which distinctive personal choices can be compared.

Second, it is necessary to understand the imperial family's odd position in regard to new fashion. To some extent, the family both followed and set the fashions. Because the imperial family needed the support of the established aristocracy, it would not unnecessarily shock the conservative nobility in Rome with unapproved fashions. Consequently, it is likely that they closely followed metropolitan fashion with the younger, as well as the female, members of the family often closer to the cutting-edge trends in Rome. In turn, the dissemination of their portraits shaped local fashions far from Rome. Thus, for example, bearded portraits certainly existed before the accession of Hadrian, the first bearded emperor; undoubtedly, before his accession Hadrian himself wore a beard during the reign of the beardless Trajan. Moreover, upon Hadrian's accession all men in Rome did not immediately grow beards. Yet the next generation, inundated with the imperial image, probably with few exceptions did wear beards.

Because of the importance of the framework created by the sequence of imperial portraits, portrait studies divide the Roman period as pre-imperial and then by imperial dynasty, so one speaks generally of republican, Augustan and Julio-Claudian, Flavian, Trajanic, Hadrianic, Antonine, Severan, Tetrarchic, and Constaninian portraits. Although each period has defining characteristics that merit review, it should be stressed that these divisions are in many senses modern.

The republican period portraiture is often described as veristic, or true to life. The period is characterized by unflattering portraits with accentuated signs of age and often a sense of dynamic energy. Deep creases, visible bone structure, contracted brows, and toothless and pursed mouths are common and are associated with the rigorous values of the early Romans—frugality, discipline, and stern rigidity. There was, however, considerable variation in these realistic quasicaricatures. The portraits of figures such as Caesar and Pompey provide examples. Caesar is a balding man with a bulbous brow and a gaunt face, whereas Pompey has short, cropped hair, small eyes set in an oddly shaped head, and a vertical tuft of hair over the center of the brow, perhaps an allusion to the anastole of Alexander the Great. The first portrait type of the young Augustus (Octavian) follows the principles of these portraits. It differs from its contemporaries primarily in that, created to depict a 21-year-old man, it shows youth rather than seasoned middle-aged experience.

The ensuing and most famous portrait type of Augustus is known as the Prima Porta type because it occurs on the famous portrait statue of Augustus found at Prima Porta. Probably created around 27 BCE, it depicted Rome's first emperor at age 36 and correspondingly showed no distinct signs of age. It marks a significant new trend in Roman portraiture—that is, a calm and detached sitter. The portrait type, which exists in more copies than any other ancient portrait, appears to have been successful. After some 60 years of political strife, the handsome, composed portrait of a confident, mature, but not old, man likely carried appeal. This change in self-presentation seems to be the visual counterpart of Augustus's political program that subtly sought to break away from the traditions of the republic and to institute a new age of peace and prosperity. Among portraits of Roman emperors, it is exceptional because it was never updated to show Augustus's increasing age. In fact, because of the lack of signs of age and its serene expression, modern scholars have labeled it Classical in reference to ideal images created in 5th-century Greece and have compared it to Polykleitos's *Doryphoros*.

The subsequent emperors of the Julio-Claudian family followed the path set by Augustus. They maintained likenesses that are recognizable as individuals but that avoid signs of old age. No portrait of Livia, Augustus's wife, was ever issued showing her as an old woman; the same holds true for the emperor Tiberius. The first official portrait type of Claudius, which was created when he was 51, featured only modest signs of age. The last portrait type of Nero diverges most greatly from all other images of the family in that it shows a particularly fat young man with a fanciful, modish hairstyle and an upturned glance. All three of these characteristics—ample physique, long hair, and a lofty gaze—appear to derive from the portraits of Hellenistic kings.

The first Flavian emperor, Vespasian, was already 60 when he came to power. His official portrait type

stands in contrast to that of Nero in that it shows an old man whose signs of age—for instance, the toothless mouth and crow's-feet around the eyes—are emphasized. His image is frequently interpreted as a conscious return to the republican past and veristic sculpture, which was adopted in order to separate him from the failures of Nero, the last classicizing Julio-Claudian. The stylistic definition of this type of image, however, is modern, and in Antiquity it was the content of the portrait that was important. Rather than a young, spoiled, fashionable, and perhaps regal man, Vespasian appeared to be old, experienced, hardworking, and traditional. The portraits of his young or middle-aged sons and successors, Titus and Domitian, do not strikingly differ from their Julio-Claudian predecessors (with the exception of the last portrait type of Nero).

For that matter, the Trajanic period did not bring change in the conception of the emperor. Trajan remains an individual with composure. He is shown as mature but without an age that the modern world, used as it is to counting birthdays, can readily pinpoint. It is women's portraits in this period that are striking with their elaborate, tall, frontal *toupet* arrangements that copied the shape of a diadem, which were in vogue.

The Hadrianic period introduces three new details. Above all, Hadrian is the first emperor whose official type shows him wearing a beard. Moreover, his hair, combed forward from the crown of the head, curls three-dimensionally at its ends. Finally, the posthumous marble portraits of Hadrian's beloved companion Antinous, who drowned in the Nile in 130, are the first precisely datable portraits that feature indentations on the eyeball to denote the pupil. Some portraits of Hadrian and all later imperial portraits feature this, as well as an engraved line delineating the iris.

Further technical innovations, motivated by changing hair and beard styles, characterize the Antonine period. Deep drill work was used to depict the full-bodied aspect of copious curling hair, and the skin surface was rendered with a high polish that makes the marble appear soft. The combination of these elements gives portraits of this period a strong chiaroscuro effect. In addition, a heavy upper eyelid, which was apparently a physiognomical detail of Marcus Aurelius, became a repeated detail in many portraits of the period. The well-known bust portrait of Marcus's son and successor, Commodus, in the guise of Hercules is a fine example of the virtuoso handling of marble that is characteristic of the middle to late 2nd century. It also illustrates the large size possible for portrait busts; the potential size of busts grew throughout the 2nd century until it reached its final stage during the Antonine period.

After the execution of Commodus and the rule of two short-lived emperors, Septimius Severus established himself and a Severan dynasty in 193. His wife, Julia Domna, is the first imperial woman to be shown wearing a wig. This fashion led to another innovative marble technique visible in some female portraits. The head was carved in white marble and the hair, or wig, was carved in a darker marble and added on. Septimius's elder son Caracalla, known to have been a favorite of the military, succeeded him, and it is his first official portrait type as sole emperor that marks a decisive change in the attitude of the Roman emperor. He appears with a brow that contracts forcefully above the bridge of the nose, a vigorous twist of the head, and a very short beard. The portrait gives him the air of a ferocious man of action. The portrait and the change have been interpreted in conjunction with Caracalla's vicious nature and his close connection to the army. They are deemed to have been unacceptable to the conservative Roman senate because no subsequent Severan imperial image repeats this forceful vitality. One wonders how much of the image's failure, such as in the case of the fourth portrait type of Nero, depended on its intrinsic characteristics and how much depended on the fact that the particular emperor had become offensive.

In the period of Caracalla's successors, male hairstyles changed once again and correspondingly a new technique, the so-called *a penna*, or feather technique for rendering hair, was developed. In this technique the hair was not given volume that stood off the scalp. Individual locks were engraved with their end points particularly well defined. These locks were arranged in overlapping layers almost as if they were scales. The final effect was of extremely short-cropped hair that had a lively surface. The early portrait type of Severus Alexander (*ca.* 222 CE) is the first datable example of this technique.

It was not until the successors of the Severan dynasty, a series of short-lived emperors elected by the military, that portraits depicting an emotional expression returned. The period from 235 to 284 was an infelicitous one for the empire, which struggled militarily, economically, and politically. The portrait of Philip the Arab, emperor from 244 to 249, exemplifies the imperial portraits of that era. The portrait depicting a short-haired man with a short beard features deep vertical furrows that rise from the inner corners of the eyebrows and deep nasolabial folds. This knitted brow and set mouth were intended to convey concern and determination, much-needed characteristics in the difficult 3rd century. Given the period in history, however, many scholars of Roman portraiture have misinterpreted the expression of this portrait and others like it as anxiety.

There is one moment during this period in which an emperor seems to have rejected this type of emotional self-representation and returned to the serene expression of the 1st- and 2nd-century emperors. This moment heralds the second portrait type for Gallienus, dated 261–68 and called the "Gallienic renaissance." Nearly contemporaneously, Postumus (260–74), a self-proclaimed emperor who for several years ruled his own empire in Gaul within the Roman Empire, portrayed himself on coins (and probably also in other media) in the style of the Antonine emperors.

At the end of the 3rd century, the empire had a momentary political restabilization under Diocletian, who eventually established a rule by four emperors known as the Tetrarchy. In this system there were two Augusti, one for the east and one for the west. Each Augustus had his own Caesar. It was a complete break from the old imperial system and entirely dismissed the senate. In this attempt to create a new unshakable system, theoretically the individual ruler himself was not as important (he could retire, for instance) as the position. For this system to work, absolute trust and harmony needed to exist between the individuals in the four positions. The sculptural record from this economically poor period is limited because monuments were generally not created from scratch. More commonly, existing monuments were reused: pieces from different past monuments were reassembled with existing portraits, then recut with new inscriptions added. The marble portraits that do exist feature men with large eyes, short hair, stippled beards, and simplified features in blocklike heads. Two remarkable groups of porphyry portraits of the Tetrarchs, now in Venice and the Vatican, correspond to our fundamental conception of the tetrarchic system. In both examples, all four members are shown together, each with the same nonspecific facial features. They clasp each other and wear military garb. The only distinctions between the Venice and Vatican groups is that in the Venice group, the four rulers wear animal-skin hats as opposed to laurel crowns and that two of the four are beardless. Both examples appear crudely rendered, although it should be noted that porphyry, which seems to have been popular for imperial statuary at the end of the 3rd and into the 4th century, is hard and thus difficult to carve.

The tetrarchy did not last because the harmony between its members was impossible to maintain. Constantine, the son of a Tetrarchic Caesar, emerged finally as the sole ruler and became the first Christian emperor; his accession marks the end of the pagan Roman Empire. His portrait and the portraits of his family members are far removed from the concept of the individual that dominated Roman portraiture while meaningful political competition existed in the senate and amid the equestrian order. Constantine's image,

following the development of the 3rd century, features pronounced eyes in a blocklike face that simplifies the modeled surface of human anatomy. His particular traits are a large, hawklike nose, a clean-shaven visage, and hair that falls in medium-length locks from the crown forward. These locks are evenly cut across the brow. Notwithstanding these features, the portrait is essentially an abstract of the complicated organic portraits of the Roman Republic and the 1st and 2nd centuries of the Roman Empire. It does not present an individual *primus inter pares* (first among equals), as Augustus claimed to be, rendered with the utmost realism, but rather presents a stiff schematic depiction of a human man who, through the size of the rendition, the presence of a crown, or both, was recognizable as the emperor.

Although Roman portraiture technically was derived from the portraiture that existed in the preceding Greek world, it stands out from that of all other historic periods. Above all, it is preserved in remarkably large numbers that exceed the output of any other historic period. This is both because marble was generally used in preference to other materials and because portrait sculpture was an integral and common practice in all zones of life—daily and funerary, urban and rural, public and private—on all social levels. Roman-period portraits, especially those made during the Empire, have been prized and collected in the Western world since the Renaissance. Particularly, the truly Roman tradition of portrait busts has been emulated in Renaissance and modern Europe. Today, Roman portrait sculpture is evaluated more scientifically than aesthetically and is rigorously interpreted in its historical context. This sculpture inarguably offers an extensive and exciting visual insight into the world of the Roman Republic and the Roman Empire.

JULIA LENAGHAN

Further Reading

Bergmann, Marianne, *Studien zum römischen Porträt des 3. Jahrhunderts n. Chr.*, Bonn: Habelt, 1977

Bonacasa, Nicola, and Giovanni Rizza, *Ritratto ufficiale e ritratto privato*, Rome: Consiglio Nazionale delle Ricerche, 1988

Boschung, Dietrich, "Die Bildnistypen der iulisch-claudischen Kaiserfamilie: ein kritischer Forschungsbericht," *Journal of Roman Archaeology* 6 (1993)

Eck, Werner, "Senatorial Self-Representation: Developments in the Augustan Period," in *Caesar Augustus: Seven Aspects*, edited by Fergus Millar and Erich Segal, Oxford: Clarendon Press, 1984

Fittschen, Klaus, "Courtly Portraits of Women in the Era of the Adoptive Emperors (98–80) and Their Reception in Roman Society," in *I, Claudia: Women in Ancient Rome*, edited by Diane E.E. Kleiner and Susan B. Matheson, New Haven, Connecticut: Yale University Press, 1996

Fittschen, Klaus, and Paul Zanker, *Katalog der Porträts in den Capitolischen Museen und den anderen kommunalen Sammlungen der Stadt Rom*, vols. 1 and 3, Mainz, Germany: Von Zabern, 1983–85; 2nd edition, 1994

Giuliani, Luca, *Bildnis und Botschaft: Hermeneutische Untersuchungen zur Bildniskunst der römischen Republik*, Frankfurt: Suhrkamp, 1986

Kleiner, Diana E.E., *Roman Sculpture*, New Haven, Connecticut: Yale University Press, 1992

Lahusen, Götz, *Untersuchungen zur Ehrenstatuen in Rom: Literarische und Epigraphische Zeugnisse*, Rome: Bretschneider, 1983

Lahusen, Götz, "Zur Funktion und Rezeption des römischen Ahnenbildes," *Mitteilungen des Deutschen Archäologischen Instituts: Römische Abteilung* 92 (1985)

"Ritratto," in *Enciclopedia dell'arte antica classica e orientale*, vol. 7, Rome: Istituto della Enciclopedia Italiana, 1965

Smith, R.R.R., "Roman Portraits: Honours, Empresses, and Late Emperors," *Journal of Roman Studies* 75 (1985)

Smith, R.R.R., "Typology and Diversity in the Portraits of Augustus," *Journal of Roman Archaeology* 9 (1986)

Smith, R.R.R., *Hellenistic Royal Portraits*, Oxford: Clarendon Press, and New York: Oxford University Press, 1988

Smith, R.R.R., "Cultural Choice and Political Identity in Honorific Portrait Statues in the Greek East in the Second Century AD," *Journal of Roman Studies* 88 (1998)

Wood, Susan, *Roman Portrait Sculpture, 217–260 A.D.: The Transformation of the Artistic Tradition*, Leiden: Brill, 1986

Zanker, Paul, *Provinzielle Kaiserporträts: Zur Rezeption der Selbstdarstellung des Princeps*, Munich: Bayerische Akademie der Wissenschaften, 1983

PORTRAIT: OTHER THAN ANCIENT ROME

Gothic–Baroque

During the Middle Ages in Europe, considerable portrait production was realized in marble, various stones, polychromed wood, bronze and other metals, and ivory in numismatics, in the round, and in relief. It was limited to important persons and was generally reserved for public or funerary purposes. The two primary types of sculpted portraiture were *gisants* (reclining figures) and public portraits of personages, which were usually attached or affiliated with public buildings (such as the 13th-century figures in the western choir of Naumburg Cathedral, Germany).

Most important for the history of portraits was the funerary *gisant*, which was used by the ancient Etruscans and became widespread—beginning in France during the 12th century—throughout Europe in the 14th century. Shifts in sculptural approaches regarding likeness are evident within these funerary works. In medieval Europe, portraiture was reserved almost exclusively for portraying the dead, although an important transition occurred around the second half of the 13th century: subjects were represented not as idealized youths experiencing eternal life, but rather as they appeared on their deathbeds, at the age of their deaths and with realistic physiognomic characteristics. Wax or plaster masks were molded after the dead or living model and later refined in the same material (such as in the mid-14th-century BCE series of portraits of Tell el-'Amârna from ancient Egypt) or precisely reproduced in marble or bronze, with the result of extreme verism. This technique, which was also used in ancient Rome, is documented in European art only from the 15th century, but it seems almost certain that it had been used before. By about 1460, the practice was generalized as typical of Italian Renaissance portraits of men, an example of which is Antonio Rossellino's bust of Giovanni Chellini (1456; Victoria and Albert Museum, London).

The degree of idealization was most persistent within female portraiture during the Renaissance, as in Francesco Laurana's bust of Isabella of Aragon (*ca.* 1470; Kunsthistorisches Museum, Vienna). Masks were generally not used.

By the 15th century in Italy, a great flourishing of sculptural portraiture occurred in marble, various metals, and painted terracotta in the round and relief, but most of all in the bust form. In northern Europe, portraiture was still intended primarily for funerary purposes, usually realized in full-length figures and busts.

There was also a revival of portraits on medals, an ancient genre, during the Italian Renaissance, as evidenced by the work of Pisanello (Antonio di Puccio Pisano) around 1438. His bronze portrait medals of Gianfrancesco I Gonzaga and John VIII Paleologus, emperor of Byzantium, are representative examples. Italian artists of the 16th century continued the major trends of 15th-century Italy, especially the creation of marble and bronze busts, such as Alessandro Vittoria's marble bust of Giulio Contarini (Church of Santa Maria del Giglio, Venice). Full-length statues of members of the highest social hierarchy were also employed in funerary and celebratory monuments, as in Leone Leoni's tomb of Emperor Charles V and his family at the Monastery of S. Lorenzo el Real, Escorial, Madrid. In addition, a great revival occurred, especially within Florentine workshops (Giambologna's equestrian statue of Duke Cosimo I de' Medici in the Piazza della Signoria, Florence; 1587–93), of the equestrian monument as a public portrait, which was an ancient Roman typology with precedents in the 13th and 14th centuries (equestrian statue of Mastino II della Scala, at the Church of Santa Maria Antica, Verona, Italy). This revival was sparked by Donatello's equestrian monument titled *Gattamelata* (1447–53; Piazza del Santo, Padua, Italy) created during the 15th century. These Italian explorations were also pursued and increased

within major European courts, such as those found in Fountainebleau and Prague.

Painting exerted repercussions within the field of sculptured portraiture, the most striking of which was the rendering of surface details of faces and costumes. Sculpture induces a simplification of features, favoring simplified forms with large uniform surfaces; therefore, idealization is more apparent in sculpture than in painting, and major examples of realism (such as Antonio Pollaiuolo's late-15th-century tomb of Pope Sixtus IV in St. Peter's Basilica, Rome) feature tremendous technical virtuosity. The more difficult a medium is to manipulate (such as marble and porphyry), the greater the difficulty in reproducing a true, recognizable identity with the sculpture. The easier the material, the easier the task.

The detailed representation of costumes, which was so important in painted portraiture as a symbol of social wealth and power, was terribly difficult in sculpture. However, during the 16th and 17th centuries strenuous technical research explored the possibilities of emulating the realism of painting with regard to sumptuous and richly defined costumes. Benvenuto Cellini and Alessandro Algardi displayed virtuoso handling of the surfaces of marble and bronze. The use of different materials—as with polychromy, a technique already common in ancient Rome—also aided in detailing.

In addition, Bernini's innovations had a decisive impact on developments in sculpture; he changed the traditions of funerary monuments by portraying the dead in the act of praying, in lively relationships with real settings, and with spectators (such as the tomb of Gabriele Fonseca (*ca.* 1668–75; Church of San Lorenzo in Lucina, Rome). He also changed papal funerary monuments by using gesture as a means of rhetorical expression. Most important for portraiture, however, he sculpted busts with far more lively facial expressions and attitudes.

Bernini resolved two major problems plaguing realism in sculpture versus that in painting: how to characterize and to enliven the figure's eyes and how to evade the material limits of the portrait's format. Looking to examples in ancient art, Bernini pierced the eyeballs to portray pupils. For the limits of format, a major problem in the bust genre became how to allude to the presence of the rest of the body, particularly the figure's arms. Bernini resolved this difficulty by infusing his busts with horizontal movement suggested by skillfully arranged drapery and the turning of the figure's head (such as the bust of Louis XIV [1665]; Château, Versailles, France).

Neoclassical–Contemporary

During the Napoleonic age of the early 19th century, enormous production of official portraiture took the form of busts, medals, narrative reliefs, statuettes, and colossal statues, which were generally Neoclassical in style and often sculpted of bronze. An interesting kind of idealization developed in portraiture during this time: the subject was depicted as a mythological or allegorical figure. It is a typology that had an earlier precedent (for example, Leone Leoni's 16th-century *Charles V and Fury Restrained* in the Museo del Prado, Madrid), but it developed mostly in 17th- and 18th-century European courts in full-length statues of various dimensions, carved in marble (such as Antoine Coysevox's 1710 statue of Marie-Adélaïde de Savoie, Duchess of Burgundy, as *Diana the Huntress* in the Musée du Louvre, Paris), painted terracotta, various metals, and wood. Great attention was given to costumes and attributes. Generally, only the head had a real likeness to the model, whereas the body was absolutely idealized. During the Neoclassical age, and particularly in the Napoleonic circle, this typology developed remarkably, as seen in Antonio Canova's *Paolina Borghese Bonaparte as Venus Victorious* (1804–08; Galleria Borghese, Villa Borghese, Rome). Nudity, for

Jacob Epstein, Jacob Kramer, 1921, Tate Gallery, London
© Tate Gallery, London / Art Resource, NY

reasons of the social concepts of decorum at that time, became an issue for which there were two solutions: total idealization (as in Canova's *Napoleon as Pacifying Mars* in the Accademia di Belle Arti di Brera, Milan) and total verism (Jean-Baptise Pigalle's *Voltaire Nude* completed in 1776; Musée du Louvre, Paris). Both approaches prompted polemical reactions from the public and critics.

The importance of the political value assigned to portraits of state leaders must be stressed. Sculpted portraits in numismatics and public statue-portraits of sovereigns were disseminated throughout their lands. As a consequence, destruction of these works generally followed violent changes of political regimes. Many Neoclassical works met this fate during the political restoration in Europe following the fall of the Napoleonic empire.

Earlier, in 18th-century Europe, private portraiture had increased, especially in France, England, and Germany. This type of production became especially conspicuous during the 19th century, when there developed a remarkable growth of artistic patronage. This was owing to the democratization of society and popular education. In 19th-century Europe, as public monuments of leaders became widespread, portraiture among historical personages of various social and professional categories also gained popularity. This is reflected in Jean-Léon Gérôme's 1895 bust of Sarah Bernhardt, depicting the famous actress and sculptor.

Interest in physiognomic and psychological characteristics came to the fore in 18th- and 19th-century European bust portraiture. A phenomenon concerning the interest for peculiar features became part of a new form of idealizing portraiture, which was exploited by European Romanticists. Perfect physical beauty was no longer emphasized; rather, spiritual and individual characteristics of the model, such as a broad forehead and the intensity of look, took on great importance, as is seen in David d'Angers's plaster *Portrait of Chateaubriand* (1830; Musée des Beaux-Arts, Paris).

Artists such as Auguste Rodin began experimenting with portraiture at the end of the 19th century, infusing the genre with expressive and new formal concerns (for example, in his work portraying the head of novelist Honoré de Balzac from 1898; Ashmolean Museum, Oxford, England). With Rodin, the infraction of all traditional typologies of the genre in format, materials, and modeling opened. This continued to be the chief trend in avant-garde portrait production during the first half of the 20th century; the primary aim became an expressionistic characterization that almost completely lost any semblance of the human shape (for instance, Alberto Giacometti's *Bust of Annette IV* from the 1950s; private collection).

American hyperrealism revived sculptural portraiture in the second half of the 20th century with the use of new synthetic materials such as polyester resin with acrylic painting and polychrome glass fiber and the application of real hair, clothes, and accessories. Often, the sculpture was contextualized in a realistic setting. Hyperrealism solved one of the major, centuries-old concerns of sculpted portraiture: the attempt at extreme likeness. This extreme realism presented a shift in the purpose of the portrait: rather than being a depiction of the subject, the hyperrealistic works molded from live models served as social critique (for example, Duane Hanson's *Tourists* from 1970; Hewlitt Bay Park, New York).

Portraiture is a universal approach to figurative representation that over time has been attempted with every technique. Although portraiture exists in other artistic genres, it is the three-dimensionality of sculpture that gives an advantage over the pictorial, because it provides a greater presence of the portrayed person with a much greater power of suggestion, an aspect that has been always stressed by the critics, both ancient and modern.

FRANCESCA PELLEGRINO

See also **Algardi, Alessandro; Bernini, Gianlorenzo; Canora, Antonio; Cellini, Benvenuto; David d'Angers; Gérôme, Jean-Léon; Giacometti, Alberto; Laurana, Francesco; Leoni Family; Pigalle, Jean-Baptiste; Pisanello (Antonio di Puccio Pisano); Pollaiuolo, Antonio; Rodin, Auguste; Rossellino Family; Sarcophagus; Tomb Sculpture; Vittoria, Alessandro**

Further Reading

Caroli, Flavio, editor, *L'anima e il volto: Ritratto e fisiognomica da Leonardo a Bacon*, Milan: Electa, 1998

Janson, Horst Woldemar, *19th-Century Sculpture*, edited by Phyllis Freeman, London: Thames and Hudson, 1985

Lavin, I., "On the Sources and Meaning of the Renaissance Portrait Bust," *Art Quarterly* 33 (1970)

Penny, Nicholas, "Bust," in *The Dictionary of Art*, edited by Jane Turner, New York: Grove, and London: Macmillan, 1996

Pope-Hennessy, John, *An Introduction to Italian Sculpture*, 3 vols., London: Phaidon, 1963; 4th edition, 1996; see especially vol. 2, *Italian Renaissance Sculpture*, and vol. 3, *Italian High Renaissance and Baroque Sculpture*

Scher, Stephen K., editor, *The Currency of Fame: Portrait Medals of the Renaissance* (exhib. cat.), New York: Abrams, and London: Thames and Hudson, 1994

Schuyler, Jane, *Florentine Busts: Sculpted Portraiture in the Fifteenth Century*, New York: Garland, 1976

La sculpture: Histoire d'un art, 4 vols., Geneva: Skira, 1987–91

Wittkower, Rudolf, *Sculpture: Processes and Principles*, New York: Harper and Row, and London: Allen Lane, 1977

POSTMODERNISM

What makes Postmodern sculpture distinct from the concerns and conditions of modern sculpture is a matter of often contentious aesthetic, historical, and theoretical debates. Generally speaking, Postmodernism emerged with a shift in European and American sculpture in the 1960s that continues in the contemporary era. In the visual arts Postmodern thought and criticism appeared first in the field of architecture, namely with Robert Venturi's influential text *Learning from Las Vegas* (1972), which put forth an intellectual critique of Modernism rooted in an ironic acceptance of kitsch and the vernacular in the development of a more pluralist, populist style. Here, the Postmodern aesthetic functioned as a questioning of the very tenets and codes of the Modern within architecture as a discipline. Some of the characteristics of Postmodern architecture included a reworking of historical architectural styles such as Neoclassicism, Neo-Baroque or Beaux Arts, and Art Deco, pastiche, and the embrace of kitsch, that is, "low" or pop culture as exemplified by the effulgence of Las Vegas casinos and roadscapes.

While much of Postmodernism in art and architecture is based on establishing Postmodernism's difference from Modernism, the complexity of that relationship must necessarily consider what of the Modern era remains relevant to the Postmodern in terms of language, form, and meaning. The growing pertinence and reputation of Postmodern thought in art and art history developed primarily outside the discipline, in, for instance, the seminal studies of cultural anthropologist Claude Lévi-Strauss (1963) and the philosophers Michel Foucault (1966), Jean François Lyotard (1984), and Jacques Derrida (1970), the latter of whom is credited with the invention of Deconstruction, a school of philosophy that suggests that all human knowledge—the social sciences, philosophy, medicine, art and literature—derives from systematic or structuralist paradigms that are fluid rather than fixed in time and space. In a paper given in 1966, "Structure, Sign and Play in the Discourse of the Human Sciences," Derrida stated that a chiasmatic event has occurred within history that has ruptured the Modern understanding of philosophical structures. Whereas historically Western philosophy had accepted that certain structures (or concepts) such as Truth and Beauty were stable and already in existence, Derrida argued that these "centers" were not existent or established truths, but rather, cultural constructs around which structures (and ideologies) were built. This realization provided the impulse or "event" for a self-critical questioning of the nature of structuralism.

As early as 1939, the German-American art historian and essayist Erwin Panofsky (1892–1968) drew the basic distinction between *iconography*, which concerns itself with the subject matter or meaning of works of art, and *iconology*, the study of their intrinsic meanings that required a kind of cultural de-coding. Panofsky's early description of what Postmodern thinkers and semiologists would later term sign systems was reworked in an influential essay by the French philosopher Roland Barthes called "Mythologies" in 1957. Briefly, Barthes argued that various expressions of art and literature could be read, like a text, using a system of interpretable icons, or images, but that these icons were, in the words of Derrida, subject to "free play" and therefore dependent upon a shifting system of multiple meanings.

Some of the earliest evidence of Postmodern ideas or theories can be found in the art of American Minimalist and Postminimalist sculptors, the Italian *arte povera* artists, and other European Conceptualists. For example, in 1967 art historian and critic Michael Fried virulently defended modern sculpture against the new and challenging three-dimensional work that came to be known as Minimalism. Fried claimed that, unlike the modern sculptures of David Smith and Anthony Caro, the Minimalism of Donald Judd, Robert Morris, Carl Andre and others attained a "condition of non-art" (see Fried, 1967). Fried called the new work "theatrical" and "literalist," meaning that it exhibited qualities of theater that he argued were contradictory to the experience of Modern sculpture. Because Minimalism introduced a nascent role for the viewer in the experience of the art object (rather than exist as a pure object autonomous from the viewer) sculpture had deteriorated into something else other than art. (Installation artists would eventually further exploit this tendency to achieve pronounced effects of spectacle.) Although Fried did not use the term *Postmodern*, he stressed Minimalism's difference from Modern sculpture. Fried's concept of a rupture in Modernist thinking, however, was not meant as an embrace of the new avant-garde but as a negation of such a shift in aesthetics.

Postminimalism and Land art or Earthworks of the late 1960s, particularly those by Americans Walter De Maria, Michael Heizer, Richard Serra, and Robert Smithson rejected the established, gallery-oriented forms of modern sculpture. Because their transient and ephemeral works could not be contained within the museum space, the works functioned as a critique of the qualities and conditions that had heretofore come to represent the modern in sculpture: its purity of form, originality of thought and process, and autonomy (from the viewer and even the artist). Large-scale outdoor works such as Smithson's *Spiral Jetty* (1969–70) or Heizer's *Double Negative* (1969–70) break with modern sculpture in the creation of what American art historian Rosalind Krauss termed an "expanded field" that renegotiated the limits of sculptural space. The blurring of sculpture with the concepts and forms of

Eva Hesse, *Tori*, 1969
© Philadelphia Museum of Art / CORBIS. Reproduced with the permission of The Estate of Eva Hesse, Galerie Hauser and Wirth, Zürich, Switzerland

both architecture and landscape resulted in another kind of divide from the Modern in sculpture, according to Krauss. These are works that not only exceed the space of the museum, but also can only be "represented" through photography or film, and those types of representation function as merely simulacra, or secondary imitations of the "real" or actual experience with the work of art.

Concurrently in the 1960s and 1970s in Europe, the Conceptual work of Joseph Beuys and Hans Haacke in West Germany, Yves Klein and Daniel Buren in France, and the Italian *arte povera* sculptors such as Jannis Kounellis and Mario Merz devised related anti-formalist strategies that questioned the stability of modern structures in art, in part by embracing unorthodox materials such as fat, food, and waste products that denoted an element of the abject through decay and deformation rather than the preciousness that was usually associated with sculptural works of art.

Since the 1970s contemporary Postmodern sculpture has advanced the argument that modern notions of authenticity and originality no longer hold. The American Marxist literary critic Frederic Jameson's discussion of the role of originality in the Postmodern age centers on a critique of capitalism (see Jameson, 1991). In other words, the multiple or the copy evinced first in 1917 with Marcel Duchamp's readymade sculptures, and later, with Andy Warhol's *Brillo Boxes*, films, and silkscreen prints, suggested that using technological forms of reproduction resulted in not one original, but rather, a series of copies, each being as "authentic" as the next. While Duchamp might have been the first 20th-century artist to imply

that the signature of artist gave credence to the work of art, contemporary sculptors such as Jeff Koons (1955–), Haim Steinbach (1944–), and Felix Gonzales-Torres (1957–96) have in similar ways critiqued the ideology of the original in their serial and mass-produced work. Again, Krauss argued that the cult of originality that had characterized much of Modern art is indeed revealed in Postmodern critiques to be a myth, and that the media of photography, film, and other forms of mechanical reproduction had opened up a new age of image-making that was no longer dependent upon modern truths such as artistic originality and even genius.

Returning to Derrida, the Postmodern critic might suggest that Duchamp's *Fountain* (a mass-produced urinal of which the artist "made" several versions between 1917 and 1964) or the multiples of Jasper Johns or Andy Warhol connote a death of intrinsic value or meaning in the work of art. Rather than function as an iconic sign (invested with what Panofsky would term iconography *and* iconology), the readymade or the *Brillo Box* stands as a mere indicator or index of what is arbitrary in sign systems to begin with. If the artist's signature is simply a code word for the work of art's aura or authenticity, then where do considerations such as the quality and beauty of the forms, the craftsmanship, and the historical value or significance of the artwork fit into the analysis? One Postmodern argument might interrogate the intrinsic value of "quality" or "beauty" in the work of art to begin with. Derrida developed a notion of what was termed the "center" of a work of art and what was outside of, or supplemental, to that center. He suggested that the concept of the center was troublesome in that it assumes that the center is the origin of all things within a structuralist system or discipline, making it irreplaceable and giving the center what he called "full presence." The German cultural critic Walter Benjamin had argued for a similar irreplacability when he defined the work of art as having a special, even mystical *aura* in his 1935 essay "The Work of Art in the Age of Mechanical Reproduction." While the art object's aura might seem to be inherent to the work itself, Benjamin suggested that it was revealed to be a complex construction of ideology and aesthetics that was cocreated by the artist and the culture in which the work of art existed.

Critical to much of Postmodernism in art were the vital debates that the American and European feminist movements brought to the fields of art, film, literature and philosophy in the 1970s. In particular, postwar sculptors as diverse as Louise Bourgeois, Lynda Benglis, Lee Bontecou, Ann Hamilton, Eva Hesse, Mona Hatoum, Rebecca Horn, Maya Lin, Ana Mendieta, and Kiki Smith challenged Modernist tenets of sculpture in their divergent and radical uses of icono-

graphies of the female body, including psychology, sexuality, maternity, and gender. Feminist artwork reinforced the critique of representation that Duchamp had first posited in 1917 by bringing to the debate a consideration of how institutional power was coaligned with patriarchal sources of power in society at large, whether in art history, medicine, science, philosophy, literature, or pop culture. Feminist artists and critics such as Mary Kelly, Lucy Lippard and Arlene Raven among others were quick to contest the presumed authority of a masculine artistic subject, voice and vision in their work that focused instead on an ethos of collaboration and decentering.

LYNN M. SOMERS

See also **Andre, Carl; Assemblage; Beuys, Joseph; Bourgeois, Louise; Caro, Anthony; Duchamp, Marcel; Hamilton, Ann; Heizer, Michael; Hesse, Eva; Horn, Rebecca; Installation; Judd, Donald; Klein, Yves; Koons, Jeff; Kounellis, Jannis; Lin, Maya; Merz, Mario; Modernism; Morris, Robert; Performance Art; Serra, Richard; Smith, David; Smith, Kiki; Smithson, Robert**

Further Reading

Barthes, Roland, *Mythologies*, Paris: Éditions du Seuil, 1957

Derrida, Jacques, "Structure, Sign and Play in the Discourse of the Human Sciences," *The Structuralist Controversy: The Languages of Criticism and the Sciences of Man*, edited by Richard Macksey and Eugenio Donato, Baltimore, Maryland: The Johns Hopkins University Press, 1970 (from a lecture presented in 1966)

Foucault, Michel, *The Order of Things: An Archeology of the Human Sciences*, New York: Pantheon, 1970 (first published in Paris, 1966)

Fried, Michael, "Art and Objecthood," *Artforum* (Summer 1967)

Jameson, Frederic, *Postmodernism, or, The Cultural Logic of Late Capitalism*, Durham, North Carolina: Duke University Press, 1991

Kelly, Mary, "Re-viewing Modernist Criticism," in *Art after Modernism: Rethinking Representation*, edited by Brian Wallis, New York: The New Museum of Contemporary Art, 1984

Krauss, Rosalind E., *The Originality of the Avant-Garde and Other Modernist Myths*, Cambridge, Massachusetts: MIT Press, 1985

Lévi-Strauss, Claude, *Structural Anthropology*, New York: Basic Books, 1963

Lippard, Lucy, *From the Center: Feminist Essays on Women's Art*, New York: Dutton, 1976

Lyotard, Jean François, *The Postmodern Condition: A Report on Knowledge*, translated by Geoff Bennington and Brian Massumi, Minneapolis: University of Minnesota Press, 1984

Panofsky, Erwin, *Studies in Iconology: Humanistic Themes in the Art of the Renaissance*, New York: Oxford University Press, 1939

Raven, Arlene, *Crossing Over: Feminism and Art of Social Concern*, Ann Arbor, Michigan: UMI Press, 1988

Venturi, Robert, Denise Scott Brown, and Steven Izenour, *Learning from Las Vegas: The Forgotten Symbolism of Architectural Form*, Cambridge, Massachusetts: MIT Press, 1977

JANE POUPELET 1874–1932 *French*

In the art establishment of the 1920s, Jane Poupelet was considered one of the major sculptors who, in the spirit of Auguste Rodin, rejuvenated sculptural practice by concentrating on the specificity of media and the formal qualities of the sculptural object. The nudes she designed in the period 1906–12 also won Poupelet an international female audience. It is from these two perspectives—that of official culture and that of a women's audience specific to the first quarter of the 20th century in Paris—that her oeuvre has been assessed.

Poupelet's career was launched in 1904 with *Funeral of a Child in Dordogne*, a serial sculpture depicting a rural procession with a central female figure, whose thoughtful attitude evoked contemporary discussion of the social function of maternity. In 1905 her study of ancient classical art in Italy confirmed Poupelet's decision to develop a Neoclassical style by reformulating the nonnarrative female nude. Thus, *Woman at Her Toilet* proceeded from an attempt to unify the intellectual and the physical dimensions of femininity. The sculptural technique acknowledges the substantive presence of the muscular body seen particularly in the expanse of thigh pressing against the plinth. The posture, one leg folded against the breast and the arms in front of the genitalia, ensures that from any viewpoint certain sections of female anatomy escape the beholder's grasp. Poupelet represented the sexual dimension as guarded and presumably within the control of the female subject. With the stability and self-containment of its formal structure, the work conveys a sense of poise and inner concentration. In other figures, Poupelet dealt with an imagery of physical exercises. *Woman Mirroring Herself in the Water* reverses the myth of Narcissus by showing a female figure in the posture of a runner preparing for a race; she is part of the public world of action rather than the private world of contemplation, the latter being a more typical iconographical trope of the female subject. *Before the Wave* features a woman as a diver, enjoying the free and energetic movement of her body.

Formal concerns were also conceptual issues. Through tension, resilience, and awkwardness of construct, Poupelet's sculptures challenged the tradition of erotic art. Influenced by contemporary issues in the French feminist movement, her female nudes offered a positive image of women as self-contained and endowed with some of the muscular body and the intellectual power women needed to act effectively in the public sphere.

World War I deeply affected Poupelet. She and the American sculptor Anna Coleman Ladd worked in collaboration with military hospitals crafting prostheses for soldiers who had suffered severe facial disfigurement, a practice Poupelet continued at the Val-de-Grâce Hospital until 1920. The experience of war left Poupelet uncertain as to the purpose of art practice; her one certainty rested with the decision not to put her Neoclassical nude at the service of nationalist ideologies.

The sculptures Poupelet designed in the 1920s all convey an aura of grief and mental suffering. *Sleeping Woman* was conceptualized as a monument to women. It features a woman lying on her side, stretched across the flat surface of a tomblike rectangular block, eyes closed, and hands joined in a position of prayer. *Meditation* challenges the ideologies developed around Rodin's *The Thinker* (*ca.* 1880) by showing the seated female figure, the palm of her hand pressing the front of the lowered head, her hair tied in several knots, like the secretion of pain. Poupelet's final work, *Imploration*, disquietingly combines elements of the other two compositions in a headless figure.

Poupelet's public image in the 1920s was fashioned around the recasting of prewar designs, in particular *Bather* and *Torso of Seated Woman*, a reworking of her 1913 *Seated Woman*, the head and the arms severed. Poupelet's career in the United States had been promoted by a network of professional women, including sculptor Janet Scudder, who negotiated the sale of *Woman at Her Toilet* to the Metropolitan Museum of Art, New York City, in 1913.

A separate aspect of Poupelet's career was the sculpture of domestic and farm animals displaying compact surfaces and geometric designs. Drawn from her interest in Greek, Egyptian, and Oriental sculp-

tures, most of these were designed between 1906 and 1910. They were subsequently recast, partly for her American clients, such as the industrialist George Porter, whose bequest to the Art Institute of Chicago included her *Rabbit*, *Cat*, *Donkey*, *Cock*, and *Goose*.

After 1923 Poupelet dedicated much of her work to the medium of drawing, experimenting with diverse techniques, from the continuous outline evolved from the use of tracing paper to ink wash in the Chinese tradition, dividing her subjects between the female nude and animals observed on her farm in Dordogne. Her interest turned to the female body affected by maternity and the aging process. An active exhibition policy promoted these drawings through Galerie Bernier in Paris and Montross Gallery in New York City.

Poupelet maintained an independent practice with a studio in Montparnasse, held positions of administrative responsibilities in the French establishment, and enjoyed the apparent freedom to decide what her art practice should be like. Specializing in small-scale works enabled her to keep much of the process of sculpture in her control. She did her own chiseling and developed unique techniques for bronze patina. Her official career was supported by critics, such as Louis Vauxcelles, who believed formalism did not need to lead to abstraction. To her female audience, and in the perspective of women's struggle to achieve recognition in the field of culture, Poupelet's career set a model to follow. Poupelet's practice had made it possible to articulate the relationship between the intellectual and the corporeal in the consciousness of women.

CLAUDINE MITCHELL

Biography

Born in Saint-Paul-Lizonne, Dordogne, France, 19 April 1874. Studied at the École des Beaux-Arts, Bordeaux (teaching diploma in drawing); moved to Paris independently of her family, 1896; rejected academic ethos of Académie Julian, studied instead under sculptor Lucien Schnegg; visited the western Mediterranean on a state scholarship, 1905; invited to exhibit with Rodin as member of Societé Nouvelle at Galerie Gorges Petit, Paris, 1909–14; independent studio in Montparnasse, Paris; exhibited with several associations of Women Artists: Les Quelques, Les Unes Internationales, Le Lyceum, and the American Association of Women Painters and Sculptors, New York City; belonged to associations of professional women militating for political rights and access to education and employment; during World War I worked for the Bureau for Reconstruction and Reeducation of the American Red Cross, Paris; health permanently damaged; recipient of Whitney Hoff award, 1911, and American Women Painters and Sculptors prize, 1918; made Sociétaire,

Woman at Her Toilet
The Conway Library, Courtauld Institute of Art

1910; elected president of Salon de la Societé Nationale des Beaux-Arts, 1921; founding member, Salon des Tuileries, Paris, 1923; Chevalier of the Legion of Honor, 1928. Underwent lung surgery in Paris, summer 1932. Died in or near Paris, France, 18 November 1932.

Selected Works

1904	*Funeral of a Child in Dordogne*; plaster; Musée du Périgord, Périgueux, France
1906–ca. 10	*Cat*; bronze; Art Institute of Chicago, Illinois, United States
1907	*Peasant and Cow*; bronze; Art Institute of Chicago, Illinois, United States
ca. 1908	*Cock*; bronze; Musée Nationale d'Art Moderne, Centre Georges Pompidou, Paris, France; cast: Art Institute of Chicago, Illinois, United States
1908	*Head of a Young Woman*; plaster; Art Institute of Chicago, Illinois, United States
1909	*Woman at Her Toilet*; tinted plaster; private collection; bronze version: 1910, Musée des Beaux-Arts et de la Dentelle, Calais, France; additional casts: 1913, Metropolitan Museum of Art, New York City, United States; 1921, Art Institute of Chicago, Illinois, United States
ca. 1909	*Donkey*; bronze; Musée d'Art et d'Industrie, Roubaix, France; casts: date unknown, Musée du Périgord, Périgueux, France; 1921, Art Institute of Chicago, Illinois, United States
ca. 1909	*Rabbit*; bronze; Musée des Beaux-Arts et de la Dentelle, Calais, France; cast: date unknown, Art Institute of Chicago, Illinois, United States
1910	*Woman Mirroring Herself in the Water*; plaster; private collection
1912	*Before the Wave*; bronze; private collection
1912–13	*Bather*; plaster; private collection; bronze; casts: 1917–21, Art Institute of Chicago, Illinois, United States; Musée du Périgord, Périgueux, France
1921	*Woman Torso*; bronze; Brooklyn Museum, New York, United States
1923	*Goose*; bronze; Art Institute of Chicago, Illinois, United States
1923	*Sleeping Woman*; plaster; private collection
1924	*Meditation*; bronze; private collection
1928	*Imploration*; bronze; Musée Nationale d'Art Moderne, Centre Georges Pompidou, Paris, France (on loan to the French Embassy, London, England)

Further Reading

Gaudichon, Bruno, "Poupelet, Jane: Femme à sa toilette," in *La sculpture au XXe siècle dans les musée du nord et du pas de Calais* (exhib. cat.), Calais: Musée des Beaux-Arts de Calais, 1992

Gaudichon, Bruno, "Jane Poupelet," in *Les sculpteurs et l'animal dans l'art du XXe siècle* (exhib. cat.), Paris: Monnaie de Paris, 1999

Hamelin, Elizabeth, "Jane Poupelet, Sculptor," *Brooklyn Museum Quarterly* 20/3 (1933)

Kunstler, Charles, *Jane Poupelet*, Paris: Crès, 1930

Mitchell, Claudine, "Facing Horror: Work, Sculptural Practice, and the Great War," in *Work and the Image*, edited by Valerie Mainz and Griselda Pollock, vol. 2, Aldershot, Hampshire, and Burlington, Vermont: Ashgate, 2000

Mitchell, Claudine, *Inventaires des plâtres du Studio Jane Poupelet*, Mont-de-Marsan, France: Musée Despiau-Wlérick, 1992

Wapler, Vincent, "Jane Poupelet sculpteur," Master's thesis, Université de Lille, 1973

HIRAM POWERS 1805–1873 *United States, active in Italy*

The most prominent member of the trio of pioneering American Neoclassical sculptors that included Horatio Greenough and Thomas Crawford, Hiram Powers enjoyed international prestige as a successor to Antonio Canova and Bertel Thorvaldsen. After seeing a plaster cast of Jean-Antoine Houdon's *Washington* (1779) at the Western Museum in Cincinnati, Ohio, where he worked as a waxworks impresario, he decided to become a sculptor.

Largely self-taught, in 1834 Powers set off for Washington, D.C., with letters of introduction from a wealthy Cincinnati backer, Nicholas Longworth. In 1835 Powers modeled a vividly realistic clay portrait bust of President Andrew Jackson that brought him immediate acclaim. Other subjects, all modeled between 1835 and 1838, included Chief Justice John Marshall, former president John Quincy Adams, and the statesmen John C. Calhoun and Daniel Webster. Further portrait commissions followed in Washington, D.C., New York, and Boston over the next three years.

In 1837 Powers moved his family to Florence, Italy, where he could obtain marble, training in stone carving, and skilled assistants. He became close to Horatio Greenough, whose bust, modeled in 1838, is one of Powers's masterpieces. Before long, Powers's studio was a fashionable stop on the grand tour, bringing a steady stream of portrait commissions despite the sculptor's cantankerous personality. He relied on precise measurements with calipers to achieve his striking likenesses and used the theories of physiognomy and phrenology to help plumb his sitters' characters. Physiognomy taught him to accentuate certain features in accordance with a widely understood language of fa-

cial expression, and phrenology provided tools for his analysis of temperament. By subtly reinforcing the overhang of a brow, for example, Powers enhanced the interpretive quality of his portraits.

Aspiring to render more elevated themes, Powers modeled his first full-length statue, *Eve Tempted*, in 1842. Later that year he turned to contemporary subjects: *Fisherboy* (1841), who listens to a conch shell, recalls François Rude's *Neopolitan Fisherboy Playing with a Tortoise* (1831–33) in its exploration of genre.

Powers's most renowned genre work, *The Greek Slave*, represents a beautiful young Christian captive being sold in a Turkish slave market during the Greek Wars of Independence. The face of the female nude, standing in *contrapposto* (a natural pose with the weight of one leg, the shoulder, and hips counterbalancing one another), wrists shackled, expresses fear, faith, and resignation. *The Greek Slave* was seen by more people than any other 19th-century sculpture. One of the six full-scale versions was exhibited in London in 1845, again at the Crystal Palace, London, in 1851, and in Paris in 1855. Another version traveled to at least 12 U.S. cities between 1847 and 1858. The work elicited a flood of engravings, photographs, copies, poems, critiques, and panegyrics. Its cool Néo-Grec profiles and alluring marble surfaces delighted connoisseurs and revealed the beauty of sculpture itself to a vast neophyte audience. So that his work could vie with the best antique and modern sculptures, Powers felt that *The Greek Slave* should be nude, notwithstanding any puritanical aversion viewers in the United States might harbor. He had found a rationale for a morally elevated appreciation of the human body in the religious precepts of Emanuel Swedenborg; for Powers, physical beauty imaged the ideal Swedenborgian "spiritual body" (the soul). In pamphlets that accompanied *The Greek Slave*'s exhibition tour, Powers explained that the figure's nakedness was, though realistic and certainly quite against her will, also intrinsically pure because of her Christian piety. Nonetheless, the sculpture's underlying eroticism (and subtext of sadomasochistic bondage) no doubt contributed to its sensational success in repressed Victorian society. Politics also boosted its popularity: sympathy for the Greek cause ran deeply in the United States, and furthermore, the controversy over Southern slavery led inevitably to an interpretation of *The Greek Slave* as an abolitionist statement. The statue made Powers the most celebrated American artist at midcentury and created a widespread audience for sculpture in the United States.

Having created the most famous marble sculpture by any American, Powers had set himself an impossible standard for subsequent work. He produced five more full-length female figures, all idealized Neoclassical nudes of very high quality but less originality. He began *America* as "a republican Liberty" figure expressing his

The Greek Slave
Photo reproduced by kind permission of Lord Barnard and the Photographic Survey, Courtauld Institute of Art

sympathies with Europe's 1848 revolutions, but he altered the piece in the 1850s to express his antisecessionist views. *California*, a nude Indian woman holding a divining rod, is an allegory of the fickleness of fortune and appearances during the Gold Rush.

Destitute in his youth, Powers eventually made a highly profitable business out of sculpture. His oeuvre consists of only 14 full-length statues, 14 ideal busts, scores of replicas (for example, 103 busts of *The Greek Slave*), and close to 200 portrait busts. He charged very high prices—$400 for his best-selling ideal bust, *Proserpina*, and $4,000 each for the six replicas of *The Greek Slave*. He never attempted multifigured compositions or reliefs; whether this evidenced admirable business acumen or a failure of creative energy has been debated.

In 1859 Powers received a long-desired federal art commission for two full-length figures, *Benjamin*

Franklin and *Thomas Jefferson*, for the Capitol in Washington, D.C. He created highly realistic portrayals in contemporary dress, having learned from his first rendition of a standing modern figure, *John C. Calhoun*, ordered for the Charleston, South Carolina, city hall in 1842, that putting his compatriots in Roman togas made everyone uncomfortable. His largest such sculpture, the approximately 2.4-meter-high *Daniel Webster*, is a rare essay in bronze.

The most distinctive feature of Powers's work is an extraordinary refinement of surface. Though static in pose, his marbles are enlivened by their richness of textural differentiation. This quality stems in part from his technical innovations. In about 1840 he discovered Seravezza marble, which he considered more flawless and finely grained than Carrara marble. In finishing his sculptures, he employed a special rolling tool to mimic the porosity of skin. In around 1850 he also developed an unusual method of modeling directly with plaster (rather than clay), which he then carved, reducing the distortions that normally resulted from translating a clay model into plaster. The mechanically gifted sculptor also invented, and patented, a special perforated file for carving plaster, still in wide use today, and a punching machine to manufacture the files. He also invented a pointing machine and a pneumatic drill to accelerate sculptural processes.

Although today we value Powers's naturalist portraiture just as highly as his laboriously perfected ideal works, in his own time, his importance lay in demonstrating to his compatriots that sculpture went beyond portraiture, that it could engage the highest moral content.

Lynne D. Ambrosini

See also **Crawford, Thomas; Greenough, Horatio**

Biography

Born in Woodstock, Vermont, United States, 29 July 1805. Moved with family to Cincinnati, Ohio, 1818; self-supporting by 1820; apprenticed in Luman Watson's clock factory, 1823–ca. 1826, then as inventor and waxwork fabricator at Joseph Dorfeuille's Western Museum, Cincinnati, ca. 1826–32; instructed in drawing, modeling, and casting by Frederick Eckstein, Academy of Fine Arts, Cincinnati, 1828; worked as sculptor of portrait busts in Washington, D.C., 1834–37, with three sojourns in Boston and other travel on eastern seaboard; moved to Florence, Italy, October 1837; settled in Via dei Fornaci, 1839; visited Rome in 1846, 1861, and 1871; trips to London in 1862, 1863, and 1871; honorary member, National Academy of Design, New York City, 1837; honorary associate professor, Florence Royal Academy of Fine Arts, 1841; honorary master of arts,

University of Vermont, 1841; Order of the Rose, Emperor of Brazil, 1873; built villa outside Porta Romana, Florence, 1868; accident with head injuries, 1870; lung problems and declining health, 1872. Died in Florence, Italy, 27 June 1873.

Selected Works

The largest single repository of Powers's works is the Smithsonian Institution, Washington, D.C., because of its 1967 purchase of the artist's studio, which still contained approximately 300 marbles and models and 20,000 manuscript sheets of documents.

1835 Bust portrait of Andrew Jackson; clay (lost); marble: 1839, Metropolitan Museum of Art, New York City, United States

1839 *Proserpina*; marble; Pitti, Florence, Italy

1842 *Eve Tempted*; plaster; National Museum of American Art, Washington, D.C., United States; marble versions: 1849 (lost); 1873, National Museum of American Art, Washington, D.C., United States

1844 Bust of Anna H. Barker Ward; marble; Corcoran Gallery of Art, Washington, D.C., United States

1844 *The Greek Slave*; marble; Collection of Lord Barnard, Raby Castle, Darlington, England; other versions: Newark Museum, New Jersey, United States; Corcoran Gallery of Art, Washington, D.C., United States; Brooklyn Museum, New York City, United States; Yale University Art Gallery, New Haven, Connecticut, United States; also numerous smaller versions and busts in existence

1849 *America*; plaster; National Museum of American Art, Washington, D.C., United States

1850 *John C. Calhoun*, for city hall, Charleston, South Carolina; marble (destroyed during Civil War)

1858 *California*; marble; Metropolitan Museum of Art, New York City, United States

1858 *Daniel Webster*; bronze; Massachusetts State House, Boston, Massachusetts, United States

1859 *Horatio Greenough*; marble; Museum of Fine Arts, Boston, Massachusetts, United States

1862 *Benjamin Franklin*; marble; U.S. Capitol, Washington, D.C., United States

1869 *Henry Wadsworth Longfellow*; marble; Fogg Art Museum, Cambridge, Massachusetts, United States

Further Reading

Clark, Henry Nichols Blake, *A Marble Quarry: The James H. Ricau Collection of Sculpture at the Chrysler Museum of Art*, New York: Hudson Hills Press, 1997

Colbert, Charles, "Each Little Hillock Hath a Tongue—Phrenology and the Art of Hiram Powers," *Art Bulletin* 68 (June 1986)

Crane, Sylvia E., *White Silence: Greenough, Powers, and Crawford, American Sculptors in Nineteenth-Century Italy*, Coral Gables, Florida: University of Miami Press, 1972

Crawford, John S., "Physiognomy in Classical and American Portrait Busts," *American Art Journal* 9 (May 1977)

Fryd, Vivien Green, "Hiram Powers's *America*: Triumphant as Liberty and in Unity," *American Art Journal* 18/2 (1986)

Gardner, Albert Ten Eyck, compiler, *American Sculpture: A Catalogue of the Collection of the Metropolitan Museum of Art*, New York: Metropolitan Museum of Art, 1965

Gerdts, William H., *American Neo-Classic Sculpture: The Marble Resurrection*, New York: Viking Press, 1973

Gerdts, William H., and Samuel A. Robertson, "The Greek Slave," *The Museum* (new series) 17/1 and 2 (winter/spring 1965)

Green, Vivien, "Hiram Powers's *Greek Slave*: Emblem of Freedom," *American Art Journal* 14/4 (1982)

Greenthal, Kathryn, Paula M. Kozol, and Jan Seidler Ramirez, *American Figurative Sculpture in the Museum of Fine Arts, Boston*, Boston: Museum of Fine Arts, 1986

Hyman, Linda, "*The Greek Slave* by Hiram Powers: High Art as Popular Culture," *Art Journal* 35/3 (1976)

Powers, Hiram, "Letter by Hiram Powers," *Virginia Historical Register* 4 (1851)

Powers, Hiram, "Letter from Hiram Powers to Sampson Powers," *Literary World* (March 1851)

Powers, Hiram, "Powers on Color in Sculpture," *Crayon* 1, no. 10 (1855)

Powers, Hiram, "Perception of Likeness," *Crayon* 1/10 (1855)

Powers, Hiram, "Letter from Hiram Powers—-The New Method of Modelling in Plaster for Sculpture," *Putnam's Monthly Magazine* 2 (August 1853)

Powers, Hiram, "The Process of Sculpture," *Cosmopolitan Art Journal* 2 (December 1857)

Powers, Hiram, "Letters of Hiram Powers to Nicholas Longworth," *Historical and Philosophical Society of Ohio Quarterly* 1 (April-June 1906)

Reynolds, Donald M., "The 'Unveiled Soul': Hiram Powers's Embodiment of the Ideal," *Art Bulletin* 59 (September 1977)

Wunder, Richard P., *Hiram Powers, Vermont Sculptor, 1805–1873*, 2 vols., Newark, Delaware: University of Delaware Press, and London and Cranbury, New Jersey: Associated University Presses, 1989–91

JAMES (JEAN-JACQUES) PRADIER
1790–1852 *Swiss, active in France*

Although James (Jean-Jacques) Pradier accomplished the rare feat of making sculpture popular with the public at the Paris Salon, he remained one of the most controversial sculptors of the 19th century. Laden with honors and royal patronage, Pradier nevertheless was regarded with some wariness by his academic colleagues and was often frustrated in his pursuit of major public commissions. Critics of conservative and avant-garde persua-sions attacked his work in equal measure. Often grouped with the Romantics, Pradier in fact was hostile to the violence and anti-Classicism of their work. This complex and contradictory figure created a highly individual body of work in a career spanning nearly 40 years.

Pradier's earliest life-size figures, such as *Son of Niobe*, differ in content from his mature works but already reveal his superb facility in depicting flesh in marble. His *Bacchante* is the first example of what was to become Pradier's primary subject: the female nude figure in an elaborate, often erotic pose. The sculptor's early training as a metal engraver in his native Geneva is evident in the linearism of the highly sophisticated coiffures of these nude figures, recalling those seen in female figures by Michelangelo's Mannerist followers.

The works that Pradier exhibited at the Salon after his return from the French Academy in Rome in 1819 soon established his reputation, leading quickly to his appointment to the Académie des Beaux-Arts and the École des Beaux-Arts. His monument to Jean, Duc de Berry, depicting the assassinated prince as an expiring, seminude figure, led to numerous commissions for further royal monuments and portraits. Pradier also worked for his native city, providing several portraits of his compatriot the philosopher Jean-Jacques Rousseau (after whom the sculptor was named), including an outdoor life-size bronze. Pradier was unsuccessful in obtaining a commission for the pedimental relief of the Church of the Madeleine, Paris, but he did design four enormous stone spandrel reliefs titled *Personifications of Fame* for the Arc de Triomphe in Paris.

In his principal marble figures, Pradier sought to emulate ancient Greek sculpture in both style and content. Works such as *Satyr and Bacchante*, which was shown at the 1834 Salon, were nevertheless considered scandalously erotic, and indeed, they exhibited a degree of realism quite different from the idealization of most antique sculpture. The great poet and critic Charles Baudelaire, in the essay "Why Sculpture Is Boring" in his *Salon of 1846*, attacked Pradier relentlessly: "An excellent proof of the pitiable state of sculpture today is the fact that M. Pradier is its king. . . . His talent is cold and academic. He has spent his life fattening up a small stock of antique torsos and equipping them with the coiffures of kept women" (see Baudelaire, 1965). This conflict between classicizing and "modern" realistic tendencies, widespread in early 19th-century art, is seldom fully resolved in Pradier's monumental works.

By 1840 Pradier was involved in producing editions of statuettes, usually of nude or seminude female figures. These small sculptures, ignored by the critics and not taken very seriously by Pradier himself, are among the artist's most original works. Freed from the need to present noble, classicizing subjects, Pradier depicts highly realistic vignettes of contemporary life: women

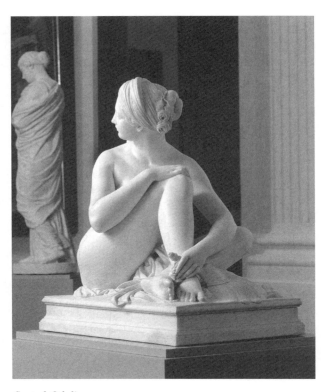

Seated Odalisque
© R.G. Ojeda, Réunion des Musées Nationaux / Art
Resource, NY

taking off their chemises or stockings or, most strikingly, a half-dressed laundress with her iron. These intimate works come out of a French tradition of small erotic sculptures dating back to the Rococo, but they have a modernity that sets them apart. Pradier also produced such genre subjects on a monumental scale: his life-size marble *Seated Odalisque*, virtually unique in subject and pose, is one of the most remarkable nude figures in 19th-century sculpture.

In the marble figures of his last years, Pradier alternated between classicizing sobriety and overt eroticism. He spent much of his time with a commission for 12 severe female *Victories* for the tomb of Napoléon I at the Hôtel des Invalides, Paris. At the Salon, Pradier was more adventurous, becoming one of the first modern sculptors to apply polychrome additions to marble (*Phryne*). He also experimented with the ancient technique of chryselephantine sculpture (sculpture of wood, ivory, and gold that suggests drapery over flesh): in collaboration with the goldsmith F.D. Froment-Meurice he produced a statuette of *Leda and the Swan* in ivory, silver, and turquoise (*ca.* 1849–51). Other life-size marble figures had bronze attachments, despite the disapproval of purist critics.

After 1847 Pradier's position as the leading sculptor of the female nude was challenged by the rising noto-riety of a younger artist, Auguste Clésinger. The blatant eroticism of Clésinger's *Woman Bitten by a Snake*, which created a sensation at the Salon of 1847, may have prodded the older sculptor to be more daring in his exhibition works. Pradier's *Nyssia* depicts the wife of King Candaules as she is spied upon while undressed. With her arms raised as she plaits her hair, *Nyssia* is perhaps the most openly sensual of Pradier's life-size nude figures. As if to atone for such liberties and to assure critics of his seriousness, Pradier produced a demurely seated, somewhat inexpressive *Sappho* that proved to be his last major marble for the Paris Salon (1852).

Despite Clésinger's greater subsequent reputation, Pradier remains the most gifted 19th-century sculptor of the female nude. The success of Pradier's large marble exhibition pieces was often compromised by the conflict between the sculptor's innate realism and his desire to conform to Classicizing models. When able to give free reign to his naturalistic, erotic bent, as in his genre statuettes or in large works such as *Seated Odalisque*, Pradier revealed himself to be one of the most progressive sculptors of his time.

DONALD A. ROSENTHAL

Biography

Born in Geneva, Switzerland, 23 May 1790. Studied at municipal drawing school in Geneva and trained in decorative engraving on metal; worked with older brother Charles-Simon, an engraver in Paris, from 1807; studied at École des Beaux-Arts, Paris, 1811; subsequently in atelier of sculptor François-Frédéric, Baron Lemot; won the Grand Prix de Rome, 1813; exhibited for first time at Paris Salon, 1819, obtaining gold medal; member of Académie des Beaux-Arts and professor of sculpture at École des Beaux-Arts, 1827; member of the Legion of Honor, 1828, and officier, 1834; numerous commissions from Bourbon and later from Orléans royal families; some public commissions; highest awards at Salon of 1848 (for *Nyssia*) and the London international exhibition of 1851 (for *Phryne*). Died in Bougival, France, 4 June 1852.

Selected Works

1817–22 *Son of Niobe*; marble; Musée du Louvre, Paris, France
1819 *Bacchante*; marble; Musée des Beaux-Arts de Rouen, France
1821–24 Monument to Jean, Duc de Berry; marble; Cathedral of St. Louis, Versailles, France
1824 *Psyche*; marble; Musée du Louvre, Paris, France

1828–31 *Personifications of Fame*; marble; Arc de Triomphe, Paris, France

1830–35 *Jean-Jacques Rousseau*; bronze; Geneva, Switzerland

1834 *Satyr and Bacchante*; marble; Musée du Louvre, Paris, France

1841 *Seated Odalisque*; marble; Musée des Beaux-Arts, Lyon, France

1843–52 Twelve *Victories*, for tomb of Napoléon I; marble; Hôtel des Invalides, Paris, France

1845 *Phryne*; marble with polychrome additions; version: Musée des Beaux-Arts, Grenoble, France

1848 *Nyssia*; marble; Musée Fabre, Montpellier, France

1852 *Sappho*; marble; Musée d'Orsay, Paris, France

Further Reading

Baudelaire, Charles, *Art in Paris, 1845–1862: Salons and Other Exhibitions*, translated and edited by Jonathan Mayne, London: Phaidon, 1965

De Caso, Jacques, *Statues de chair: Sculptures de James Pradier (1790–1852)* (exhib. cat.), Geneva: Musée d'Art et d'Histoire, 1985

Janson, Horst W., "Jean-Jacques, Called James, Pradier," in *The Romantics to Rodin* (exhib. cat.), edited by Peter Fusco and Horst W. Janson, Los Angeles: Los Angeles County Museum of Art, and New York: G. Braziller, 1980

Lami, Stanislas, *Dictionnaire des sculpteurs de l'école française au dix-neuvième siècle*, 4 vols., Paris: Champion, 1914–21; reprint, Nendeln, Liechtenstein: Kraus, 1970; see, especially, vol. 4

Pradier, James, *Correspondance*, edited by Douglas Siler, Geneva: Droz, 1984

Ward-Jackson, Philip, "Pradier, James," in *The Dictionary of Art*, edited by Jane Turner, New York: Grove, and London: Macmillan, 1996

West, Alison, *From Pigalle to Préault*, Cambridge and New York: Cambridge University Press, 1998

PRAXITELES *ca.* 395 BCE–*ca.* 326 BCE
Greek

Praxiteles is the most famous ancient Greek sculptor of statues of deities after Pheidias and the greatest artist of 4th-century BCE Athens. Some configurations are peculiar to his art: figures of sinuous teenagers, in an S-shaped curve and with smoothed surfaces, representing the deities of the sensual life, such as Eros, Aphrodite, Dionysus, and the Satyrs. Moreover, his art became the symbol of the world of the courtesan during a period when this institution of Greek society was admired. Another salient feature of his art was the expression of subjective feelings, especially of love.

Praxiteles' formal conception of sculpture, as well as the fortune of his workshop, was indebted to the Athenian bronze sculptor Cephisodotus the Elder, who was active about 390–365 BCE. Cephisodotos, who was well established by the 370s, was Praxiteles' master and most probably also his father. Cephisodotos's sister married Phocion, a politician and pupil of Plato; through this marriage, his family must also have established ties with the political leadership of Athens as well as with the world of the Academy.

The general Timotheus, who reestablished Athenian hegemony with the Panhellenic Peace of 374, commissioned from Cephisodotus a bronze sculptural group of Peace holding the baby Ploutus (Wealth). This group, known through copies, constitutes an example of the allegorical culture of Athens and of a mentality dominated by abstract concepts, typical of the golden period of Attic philosophy and oratory. Moreover, it suggests a precious and flowery conception of art, typical of a moment of self-confidence for the Athenians. Praxiteles' earliest works also celebrate the booming imperialistic policy of Athens in the late 370s. Some of the groups he made for the Eleusinian sanctuaries probably date to the early 360s. Other early works of Praxiteles reveal that he had become the beloved master of sculptures intended for the theater.

During the 360s Praxiteles began to specialize in marble sculpture, in keeping with the growing taste for sculpture with a marble surface and with the idea that marble sculpture was a revelation of what already exists within the marble, a concept consistent with Plato's condemnation of imitation in the visual arts.

In the 360s Praxiteles began to study how to carve sinuous figures in S-shaped curves, a technique he used to suggest a world of remote and incredible beauty, a goal in keeping with the growing individualistic and hedonistic mentality of Late Classical society, as well as with Plato's theory that true forms exist only in heaven. Praxiteles' art is considered great because he expressed the need to evade the narrow environment of the city-state. His *Archer Eros*, known through the copies of the Farnese/Steinhaeuser type (named for the best copy), expresses the need to define internal emotions rather than external materialistic situations. The *Pouring Satyr*, recognizable in the Dresden/Palermo type (whose best copies can be found at Dresden and Palermo), defines a world characterized by grace, kindness, beauty, and youth. In this period of crisis for the ideals of the city-state, more than in any other period of ancient society, exceptional artists such as Praxiteles were allowed to express their emotions. Praxiteles evidences, more than any contemporary artist, this moment of unusual freedom enjoyed by the artist.

Around 365 Praxiteles expressed his love for the exceptional courtesan Phryne in a sculptural group dedicated at Thespiae, *Triad of Eros, Phryne, and Aphrodite at Thespiae*; Eros was on the viewer's left,

Phryne in the center, and Aphrodite to the right. This group no longer exists. Phryne was seen as the most suitable representative for realizing in sculptural form the Platonic ideals of absolute beauty and love. The *Eros*, which can be identified in the Centocelle type (the best copy of which comes from Centocelle, near Rome), was represented as a sad figure, the personification of the Platonic ideal of suffering for love. *Aphrodite*, identifiable in the Arles type (the best copy of which comes from Arles, in southern France), was seminaked. Her smooth surfaces, rendered with a never-ending play of light and shade, suggested a world of sensual and fabulous beauty.

In the late 360s Praxiteles, emboldened by his success, became more daring and carved Aphrodite in all her beauty, naked. This statue was purchased by the Cnidians and was afterward known as the *Cnidian Aphrodite*; it became one of the most famous statues of the ancient world. Her sensual appeal and smoothed surfaces were consistent with the idea of sculptural creation as the manifestation of a dream, explaining the success of this masterpiece.

The fame of the *Cnidian Aphrodite* established the reputation of its master throughout the Greek world. Works of Praxiteles' mature years (*ca.* 365–350 BCE) were set up in many centers throughout Greece and Asia Minor. His *Resting Satyr*, known through more than 100 copies, shows an accentuated S-shaped curve. Such a study in the leaning figure, coupled with the placement of the figure of the satyr in the forest, became an emblem of a remote Arcadia, for which a search in the city would be in vain. Praxiteles' *Apollo Sauroktonos*, or "lizard slayer" (*ca.* 355 BCE), known through copies, was also a leaning figure. Apollo's teenage appearance and playful attitude indicate the importance of youth as a value associated with the ideals of beauty and love.

Praxiteles' late works are characterized by the accentuation of the rendering of the surfaces through plays of light and shade, making the image inconsistent and dreamlike. These works also fulfilled a taste for elegant figures that would excite the hedonistic gratification of the viewer.

Praxiteles' style permeated the Greek world and became the Athenian style par excellence. The *Slabs of Mantinea with the Contest between Apollo and Marsyas in the Presence of the Muses* depicts its subject with a variety of gracious styles. The *Hermes Carrying the Baby Dionysus* is another important work by Praxiteles. In this work, Hermes rests on a tree trunk. He holds the baby Dionysus with his left arm, and his right arm is raised. The position of Hermes reveals the predilection in Praxiteles' late days for S-shaped figures resting on vertical supports and for surfaces of statues characterized by soft styles. The *Eubouleus*,

known through both the original bust and copies, was rendered in an accentuated impressionistic style. The Petworth/Leconfield *Aphrodite* is typical of Praxiteles' late style, with its surface play of light and shade.

Praxiteles' sculptural technique and style lived on through the work of his sons, Cephisodotus the Younger and Timarchus, and that of other followers. His legacy contributed greatly to the art of the Hellenistic period, and more broadly to the power of the sculptor to realize in sculpture the dreams of an idealized world, an influence that was felt well into Late Antiquity.

ANTONIO CORSO

See also **Greece, Ancient**

Biography

Born in Athens, Greece, probably in the deme of Sybridae, *ca.* 395 BCE. Most likely son of the bronze sculptor Cephisodotus the Elder. Worked as a sculptor, 375–334 BCE, usually in workshop in Athens, where works sold to delegates of remote cities; became one of 300 richest men in Athens; obliged to pay public dues; said to have been praised by Plato for the *Cnidian Aphrodite*, with two epigrams; honored by the Cnidians with citizenship of their city after creation of the *Aphrodite*; two sons also sculptors: Cephisodotus the Younger and Timarchus; appears to have retired after 334. Died in Athens, Greece, *ca.* 326 BCE.

Selected Works

ca. 375 BCE	*Acanthus Column*; Pentelic marble; Archaeological Museum, Delphi, Greece (attribution and date controversial)
ca. 365 BCE	*Archer Eros*; bronze (lost); best copy: Farnese/Steinhaeuser *Eros*; Musée du Louvre, Paris, France
ca. 365 BCE	*Dionysus*; bronze (lost); best copy: *Sambon Dionysus*; Musée du Louvre, Paris, France
ca. 365 BCE	*Pouring Satyr*; bronze (lost); best copy: Albertinum, Dresden, Germany
ca. 365 BCE	*Triad of Eros, Phryne, and Aphrodite at Thespiae*; Parian marble (lost); best copies: *Arles Aphrodite*; Musée du Louvre, Paris, France; *Centocelle Eros*; Vatican Museums, Rome, Italy
364–361 BCE	*Cnidian Aphrodite*; Parian marble (lost); best copy: *Belvedere Aphrodite*, Vatican Museums, Rome, Italy
ca. early 360s BCE	*Choregic Monument with Dionysus and Two Victories*; Pentelic marble; National Archaeological Museum, Athens, Greece

early *Resting Satyr*; bronze (lost); best copy:
350s BCE Musée du Louvre, Paris, France

ca. 350 *Apollo Sauroktonos*; bronze (lost); best
BCE copy: Musée du Louvre, Paris, France

ca. 350 *Eros of Parion*; marble (probably Parian)
BCE (lost); closest variation: Archaeological
 Museum, Cos, Greece

ca. 345 *Slabs of Mantinea with the Contest*
BCE *between Apollo and Marsyas in the*
 Presence of the Muses; Pentelic marble;
 National Archaeological Museum, Athens,
 Greece

ca. 340– *Hermes Carrying the Baby Dionysus*;
330 BCE Parian marble; Archaeological Museum,
 Olympia, Greece

ca. 340 *Eubouleus*; Pentelic marble; National
BCE Archaeological Museum, Athens, Greece

336– *Phryne at Delphi*; bronze (lost); best copy:
335 BCE *Townley Aphrodite*; British Museum,
 London, England

334 BCE Petworth/Leconfield *Aphrodite*; Parian
or later marble; Petworth House, Petworth, Sussex,
 England

Further Reading

Ajootian, Aileen, "Praxiteles," *Yale Classical Studies* 30 (1996)
Closuit, Léonard, *L'Aphrodite de Cnide: Étude typologique des principales répliques antiques de l'Aphrodite de Cnide de Praxitèle*, Martigny, France: Closuit, 1978
Corso, Antonio, *Prassitele: Fonti epigrafiche e letterarie: Vita e opere*, 3 vols., Rome: De Luca, 1988–92
Corso, Antonio, "The Cnidian Aphrodite," in *Sculptors and Sculpture of Caria and the Dodecannese*, edited by Ian Jenkins and Geoffrey B. Waywell, London: British Museum Press, 1997
Corso, Antonio, "The Monument of Phryne at Delphi," *Numismatica e antichità classiche* 26 (1997)
Corso, Antonio, "Love as Suffering: The Eros of Thespiae of Praxiteles," *Bulletin of the Institute of Classical Studies* 42 (1997–98)
Havelock, Christine Mitchell, *The Aphrodite of Knidos and Her Successors: A Historical Review of the Female Nude in Greek Art*, Ann Arbor: University of Michigan Press, 1995
Kraus, Theodor, *Die Aphrodite von Knidos*, Bremen, Germany: Dorn Verlag, 1957
Stewart, Andrew, "A Cast of the Leconfield Head in Paris," *Revue archéologique* (1977)

HERMES CARRYING THE BABY DIONYSUS

Praxiteles (ca. 395 BCE–326 BCE)
ca. 340–330 BCE
Parian marble
h. 2.13 m; h. of base 1.43 m
Archaeological Museum, Olympia, Greece

The Greek writer Pausanias, writing around 175 CE, gave a list of the offerings standing in the temple of Hera of Olympia. He noted a "Hermes in stone . . . bearing the baby Dionysus, and the art is of Praxiteles."

In 1877 the German archaeologists excavating Olympia found, at the point where Pausanias himself had seen it, the base and a large part of *Hermes Carrying the Baby Dionysus* in a good state of preservation. The legs from the knees downward were missing (they have since been restored), as were the right arm of Hermes and the left arm of Dionysus. Hermes' right foot survived.

This mythical episode represented Hermes delivering, by order of Zeus, the child Dionysus to the cave of Nysa so as to save him from the wrath of Hera, Zeus's wife. Hera was jealous of the love between Zeus and Semele, Dionysus's parents. Hermes is represented taking a break from his journey, resting on a tree trunk. His right arm is raised, and in his hand he originally held an object upon which Dionysus gazes. Late figurative reconstructions of the same episode suggest that Hermes was showing Dionysus a bunch of grapes. Dionysus, revealing his nature, fixes his attention on the grapes, and raises his hands to take them.

The attribution of this group to Praxiteles is supported by many considerations. First, Pausanias mentions it as a work by Praxiteles, and Pliny states that Cephisodotus the Elder, who was most probably Praxiteles's father, sculpted a *Hermes Carrying the Baby Dionysus*, which suggests that this was a traditional theme of this workshop. Second, a similar group is represented on a coin from the Arcadian city of Pheneos, close to Olympia, dated between 362 and 330 BCE. Hermes holds the child Arkas (a personification of the Arcadian League), an indication of the prevalence of such iconography near Olympia during the period of Praxiteles' activity. Third, Pausanias lists the offerings standing in the temple of Hera from the cult statues to the entrance. This topographical sequence is also chronological, with the dedications closer to the cult statues being the most ancient and the most recent being nearer to the entrance. It seems the dedicators put their statues in the free intercolumns, the closest available at the time to the cult statues, resulting in a kind of stratigraphy of the sculptures dedicated in this temple. In the "layer" of Hermes, in front of this statue, stood a statue of Cleon of Sikyon, a contemporary of Praxiteles, active around 380–330 BCE.

Later representations of an adult male figure carrying Dionysus were crafted in the same style as the Olympian group. In particular, the representation on the wall painting in the Casa del Naviglio in Pompeii resembles this group, suggesting it was a copy. This implies that the latter was considered a famous masterpiece and further supports the view of it as the work of a great master.

Hermes Carrying the Baby Dionysus
© Alinari / Art Resource, NY

A fragment of a statue of an adult male figure draping his mantle on a tree trunk, dating to the 1st century BCE, has been found in the northern Italian city of Verona and seems to be a variation of the Olympian group. This statue bears an inscription declaring it to be a work of Praxiteles, suggesting it was a loose copy of the Olympian *Hermes* and strengthening, of course, the attribution of the latter to this sculptor. The rhythm of *Hermes* also is close to those of other works by Praxiteles, with an S-shaped figure resting on a vertical support located beside it—for example, the *Resting Satyr* and the *Apollo Sauroctonus*.

The anatomy of *Hermes* is close to those of other works by Praxiteles, and the style of *Dionysus* is similar to that of the baby Ploutus carried by Cephisodotus's *Peace*, suggesting the attribution of both statues to the same workshop, with a gap of a few decades between them.

The soft style of *Hermes* can be recognized in other works attributed to the late production of Praxiteles. The best examples are the *Eubouleus* and the Petworth/Leconfield *Aphrodite*. *Hermes* thus appears to belong to the later part of Praxiteles's career, around 340–330 BCE. *Hermes Carrying the Child Dionysus* is of such high quality that whoever carved it was one of the greatest experts in human anatomy and drapery of all the Greek sculptors whose works have survived. This observation reinforces its attribution as an original to Praxiteles.

Several objections have been raised against this attribution and in favor of this group as a Hellenistic creation or as a Roman copy. However, these objections have been fully answered by scholars who support the attribution to Praxiteles. In particular, the style of *Hermes'* sandal, with an indentation in the sole between the big toe and the small ones, is wrongly deemed not to have appeared before the 2nd century BCE. This indentation appears in the foot of a statue in the Mausoleum of Halicarnassus dated to around 350 BCE.

As for the patron of the group, we note that Hermes was the patron god of the Arcadians and Dionysus of the city of Elis, and that Late Classical societies preferred allegorical representations. As the Arcadian League restored oligarchic rule in Elis in 343 BCE, it has been suggested that this group is a votive offering of the Eleans as a token of gratitude. The probability that the iconography of Hermes holding the baby Arkas mentioned above was adopted for the Olympian group strengthens this possibility.

The Olympian group was probably a minor work of Praxiteles, as only Pausanias, among the surviving works by ancient writers, mentions it, but it has acquired great importance in modern times, as it is one of the very few surviving masterpieces of the great sculptors of Classical Greece and thus now stands as the best example of the Late Praxitelean style, characterized by the continual plays of light and shade on the surfaces of the statues.

ANTONIO CORSO

Further Reading

Adam, Sheila, *The Technique of Greek Sculpture in the Archaic and Classical Periods*, London: British School of Archaeology at Athens, 1966

Ajootian, Aileen, "A Roman Table Support at Ancient Corinth," *Hesperia* 69 (2000)

Antonsson, Oscar, *The Praxiteles Marble Group in Olympia*, translated by Axel Poignant, Stockholm: Victors Pettersons Bokindustri, 1937

Blümel, Carl, *Der Hermes eines Praxiteles*, Baden-Baden, Germany: Klein, 1948

Carpenter, Rhys, "Two Postscripts to the Hermes Controversy," *American Journal of Archaeology* 58 (1954)

Cook, Robert, "The Aberdeen Head and the Hermes of Olympia," in *Festschrift für Frank Brommer*, edited by Ursula Höckmann and Antje Krug, Mainz, Germany: Von Zabern, 1977

Corso, Antonio, "The Hermes of Praxiteles," *Numismatica e antichità classiche* 25 (1996)

Moormann, Eric, *La pittura parietale romana come fonte di conoscenza per la scultura antica*, Assen, The Netherlands, and Wolfeboro, New Hampshire: Van Gorcum, 1988

Morrow, Katherine Dohan, *Greek Footwear and the Dating of Sculpture*, Madison: University of Wisconsin Press, 1985

Richter, Gisela, "The Hermes of Praxiteles," *American Journal of Archaeology* 35 (1931)

Waywell, Geoffrey, *The Free-Standing Sculptures of the Mausoleum at Halicarnassus in the British Museum*, London: British Museum Publications, 1978

Wycherley, Richard, "Pausanias and Praxiteles," *Hesperia* Supplement 20 (1982)

PRECIOUS METALS

Gold and silver, the noblest of metals, have been the materials employed for the production of precious objects since metalsmiths of the ancient world discovered their unique properties. Archaic cultures such as Mesopotamia and Egypt and the pre-Columbian peoples of Mesoamerica made wide use of gold, prized both for its durability and its unchanging color and radiance, to make personal ornaments, vessels, and precious objects. It appealed to the senses and the spirituality of most societies, and most inhabitants of the pre-Christian world equated it with the sun. Cultures have always associated gold with gods or higher powers: the Aztecs called it *teocuitatl* (feces of the sun god), the ancient Chinese linked it with the principle of yang, and to Christians it symbolized the light of heaven.

Early craftsmen found gold readily available in nature throughout the ancient world in two forms: mixed as veins with the parent rock (usually quartz) or as nuggets or dust in alluvial deposits. Archaic communities could easily sift or gather alluvial gold, left behind in crevices or stream beds as the parent rock eroded by natural processes of wind and water, without the use of sophisticated technologies. Deposits were located throughout northern Africa, in the Nile River valley of Egypt, in Nubia, Iberia, and in Macedonia. As early as the 2nd century BCE, the Greek author Agatharchides described Egyptian mining techniques, recording their methods for crushing gold-bearing quartz in water and extracting it by running it through troughs—an early sluice method. One method of extracting all the gold from water may have been to strain it through a sheepskin—the possible origin of the legend of the Golden Fleece.

In contrast to the ease with which gold could be obtained, silver mining required a higher degree of technological expertise. Because one can only obtain it by extracting it from veins lodged in rock deposits in mountainous areas or from naturally occurring alloys, silver was more valuable than gold in archaic times, and artisans used it only in small quantities for the most precious objects. Silver could be separated from lead sulfide or galena by the process of cupellation, but those deposits, found in Asia Minor and the mountains of Afghanistan, were not easily accessible, and the process left traces of impurities in the metal. Symbol of the moon in many Mediterranean cultures and twin yin to the yang of gold in ancient China, silver was believed to have protective powers. Citizens of the Roman Empire buried small statues of silver along its borders to ward off barbarian invaders, and various cultures have traditionally used silver to ward off demons, vampires, and witches.

Although most gold and silver objects found in the tombs and archaeological sites of the ancient world are either pieces of jewelry or hollowware designed for ritual or household use, archaeologists have unearthed a small percentage of objects that function purely as sculpture. The earliest examples of gold work were unearthed in the royal tombs of Ur; those examples consist of simple jewelry trimmed from flat sheets of gold. True examples of three-dimensional gold sculpture were first found in the tombs of Egypt, small statuettes of cast gold representing various gods that were incorporated into pendants dating to the Middle Kingdom (2400 BCE). Funerary masks also served a purely sculptural function, created as portraits of the dead. Examples of these masks range from the most spectacular, the *Gold Mask of Tutankhamen* (*ca.* 1350 BCE), to a *Gold Burial Mask from Mycenae* (1600 BCE), to gold and jade masks found in the pre-Columbian burial sites of Central and South America.

Pre-Columbian cultures developed common techniques of metalworking, extrapolated from Bronze Age technologies. Artisans would first work pure gold, an extremely soft and ductile material, by hammering it into thin sheets, then cutting out from it simple forms for ornaments. From this skill developed the technique of repoussé (the method of producing relief metal by hammering and punching chiefly from behind). Artisans then developed various ways of achieving a desired form, from hammering the sheet gold over an already-carved wooden form to setting it into a container of sand or pitch for support and forming it from the back using punches of different shapes and sizes. Craftsmen sometimes joined these hollow forms by riveting or soft soldering to create a sculptural form, such as the 23-centimeter *Standing Figure* fabricated in the 1st to 5th centuries by the Tolita-Tumaco peoples who lived in what is now Ecuador and Colombia. However, most small solid-gold sculptural elements were cast using the lost-wax method. The earliest example of this method is a Falcon amulet found in a Fourth Dynasty (*ca.* 2613–2494) Egyptian tomb. The third technique used in ancient precious metal sculpture was gilding or gold leaf. The quantity of gold or silver required to produce a solid sculptural object was so great that in order to conserve material artisans ham-

mered sheets of metal until they were quite thin and pliable and could be applied to sculptures made of wood. Pheidias created the monumental statue of *Athena Parthenos* (446–438 BCE), once located in the sanctuary of the Parthenon, of ivory and removable gold plates over a wood core. His masterwork, *Zeus*, described as seven times life size and clad in golden robes, may have been constructed in the same way, but both works are lost.

Small-scale works made to serve a religious or protective purpose were the most conventional form of precious metal sculpture from ancient through medieval cultures. Romans cast small amuletic statues of gold and silver, some of which they incorporated into jewelry. The cultures of Celtic Britain, Scythia, and Thrace employed animal and naturalistic forms combined with flowing lines to form gold and silver funerary objects, such as the *Deer's Head Rhyton of Rozovets*, a horn-shaped silver drinking vessel dating to 400 BCE. Around the 6th century BCE, the Scythians created sculptural works from motifs based on animals: stags, horses, bears, wolves, eagles, and fish. Archaeologists have excavated many extraordinary small gold figural sculptures from Scythian tombs and graves in sites ranging from the Black Sea to central Siberia.

The archaic civilizations of India also cast small images of their gods in gold, which they may have incorporated into jewelry in the Hellenistic style. A more common practice in India, which continues today, is to dress temple statues in real gold jewelry for ceremonial occasions. Each deity wears a particular set of required ornaments, kept in vaults and brought out only on feast days. These ornaments are considered to hold such power that, the closer the proximity of the viewer, the greater the benefit; private viewings are therefore arranged for a donation to the temple. For everyday wear some statues have repousséed silver body coverings that simulate the special ornaments.

Precious-metal sculpture did not develop among most non-Western cultures to the degree it did in the West. The Chinese and Japanese both developed advanced techniques in metalworking but used these skills to create jewelry, shrine elements, or decoration for weapons. Most Asian sculpture is cast from bronze or copper alloy and then gilded to emulate the look of a solid precious metal sculpture. A few rare examples of silver deity sculptures, such as a *Seated Maitreya* (*ca.* 1850; now located in the Hermitage in St. Petersburg), were made in Mongolia in Dolonnor style in the 18th and 19th centuries. Artists used gilt bronze for the balance of sculptures created throughout China, Mongolia, Southeast Asia, and Japan, with one notable exception, the *Sukhothai Traimit Golden Buddha.* Located in Bangkok, Thailand, in the Wat Traimit, it is the largest golden Buddha in the world and may be the largest precious-metal sculpture in existence. Approximately 700 years old, it was created of pure gold during the Sukhothai period. The sculpture, 3.7 meters in diameter and 4.6 meters high, weighs approximately 5 tons. Originally, plaster covered the Buddha to conceal it from an enemy invasion. When the temple it was housed in was deserted in the 1930s, a new Wat was built for it; during the move the plaster cracked and the golden Buddha inside was discovered. The temple still displays a part of the plaster covering in its outer foyer.

As in Asia, cultures in Africa did not produce gold and silver sculpture. Many African cultures created jewelry from the gold that was scattered throughout the continent, but artists almost always constructed larger-scale sculptural objects from formed sheet gold or silver attached to a wooden core. One such object, a headrest, was found in the lost city of Mapungubwe. Located in South Africa, the ruins of this 1000-year-old city were discovered in the 1930s and continue to be excavated by the University of Pretoria. Discovered in a gravesite were the remains of a headrest, dating to the 12th century, which had been covered in solid gold plates. The Dahomey nation, now modern Benin, also created objects of wood sheathed in a gold-foil covering.

Surprisingly, the most notable traders in gold in all of Africa, the Akan and Ashante peoples of the former Gold Coast, now Ghana, whose alluvial gold deposits rivaled those of South Africa, did not produce precious-metal sculpture. Talented metalsmiths and the acknowledged masters of lost-wax casting in West Africa, the artisans of these areas cast gold for small ritual objects or regalia or for jewelry applications. Just as the Egyptians and Greeks used small three-dimensional forms in jewelry, the Ashante produced small animal forms such as scorpions, elephants, or twinned crocodiles to adorn finger rings, reflecting the system of proverbs on which their cultural philosophy is based.

Although the West produced thousands of works in gold and silver designed for both religious and secular use during the Late Roman, Carolingian, Ottonian, and Byzantine periods, no significant works of precious-metal sculpture emerged. The style of flat representation of the figure associated with medieval art precluded the production of three-dimensional sculpture in gold and silver. While hollow forms were made of precious metals, artists decorated the forms with flat scenes worked in cloisonné and champlevé enamel. One of the few examples of Romanesque precious-metal sculpture, the 12th-century reliquary of *Sainte Foy*, located in the Cathedral Treasury at Conques, France, is constructed, like its archaic counterparts, of gold and precious gems over a core of wood. Another exquisite example, the *Shrine of the Magi*, commis-

sioned from Nicholas of Verdun in Cologne in 1181 and constructed of gold, silver, and gilded bronze, still contains a wooden core. The figural representations, executed in such high relief as to be nearly three-dimensional, ushered in a new, more naturalistic era in figural representation that would be continued into sculpture during the Gothic period. Breaking away from the stiff body positions of the Romanesque canon, Nicolas of Verdun wrought figures with expressive posture and individual personality for the first time since the Late Roman period. This trend continued in the north with goldsmiths and sculptors of Germany and France, who produced genuine sculptures in solid gold and silver.

The Gothic sculptor produced works for the Church or the court, the only institutions with the available wealth to commission works in precious metals. French goldsmiths, who were trained as sculptors, created reliquaries of solid gilded silver to hold the artifacts of Charlemagne. Charles IV commissioned in the mid 14th century the Chapel Reliquary of Charlemagne, which contains a leg bone of the emperor. Some scholars contend that this style, distinguished by its three-dimensional naturalistic figures framed by fantastic architectural elements, persisted in Germany and the north well into the 18th century.

The goldsmiths' guilds of the 14th and 15th centuries played a crucial role in standardizing both the quality of technique and the content of the precious metal used in such sculptures. Both England and France legislated standards for the hallmarking of all forms of precious metal production, and for the first time goldsmiths kept records disclosing the process of creating a precious-metal sculpture. One highlight of the era was the exploration of different techniques of surface embellishment—niello, enameling, engraving, and gilding. While the great reliquaries were unarguably the outstanding pieces of the period, artists also created secular works for the courts of Burgundy and France. These examples of Gothic table sculpture all had a common purpose, to hold the silverware of a great lord or as table fountains for dispensing wine or water. One such *Table Fountain* of gilt silver (*ca.* 1350) is in the form of a Gothic tower, complete with gargoyle heads through which the liquid would spill. Most of these grand table pieces date from the 14th century; the 15th century saw a widespread lack of available silver.

In contrast, the 16th century ushered in a spirit of competition between the courts of Italy, France, and England for the production of status objects fabricated from precious metals. A taste for the exotic brought about the fashion of mounting curiosities in fittings of gilded silver or gold, and artists mounted a profusion of coconut and nautilus shells in fantastic standing cup forms. During the second half of the 16th century, the

Mannerist period, sculptors Benvenuto Cellini and Wenzel Jamnitzer produced some of history's finest examples of gold and silver sculpture. In relation to precious-metal sculpture, the term *Mannerism* describes a form in which emotion is expressed through both color and the exaggeration of the human figure. Francis I called upon Cellini to work in Paris, where the artist produced the only known example of his goldsmithing, a saltcellar (1540–43), a symbolic composition featuring allegorical figures of the Earth and the Sea in cast gold. Jamnitzer was the most famous of goldsmiths in Nuremburg, a city that boasted the greatest number of gold- and silversmiths in northern Europe. At the height of his career in the mid 16th century, he produced the *Merckel Centerpiece*. The most spectacular of his surviving works, it is a monumental pedestal—one meter high—in the form of an allegorical representation of Mother Earth, who carries a basket of fruits and flowers on her head that forms the wide bowl of the centerpiece.

The late 16th century saw a new trend for fantastic drinking vessels in the shape of birds, beasts, and human figures. These vessels often featured two-part bodies with hollow heads, which could be removed and used as a small cup. A popular form in the north, these types of cups are still reproduced today. Antwerp and London were also centers of production of precious-metal sculpture. Of the surviving examples of plate produced in these cities, only one example of a sculptural figure exists today, one of a pair of *Heraldic Leopards* in gilded silver, 97 centimeters tall, created in 1600 for the Tudor court in London.

During the 17th century the creation of nonfunctional sculptural figures gradually declined. Some exceptions include an *Equestrian Figure of Charles I*, made by David Schwestermüller in the 1640s, and state gifts such as Melchior Dinglinger's *Court of Aurangzeb* (*ca.* 1701–08). The overall trend was toward the incorporation of three-dimensional human or animal figures into the pedestals or finials of functional hollowware. This hybrid of figural sculpture as support for a variety of bowls, candelabrum, or presentation cups continued throughout the 18th and early 19th centuries, reflecting the changing motifs of Neoclassicism and Empire influences. By the mid 19th century the production of silver-plated wares was prevalent in both Europe and the Americas, and modern factory-production methods replaced the era of the goldsmiths guild. Factories that spat out silver plate for the new middle classes did not encourage the production of gold and silver sculpture.

The turn of the 20th century and the Arts and Crafts movement in Europe and the United States revived the arts of metalworking in the older hand wrought traditions and with them, the creation of precious metal

sculpture. From Gabriel Hermling in Cologne came the silver *Father Rhine Centerpiece* at the turn of the century, and from the Netherlands, Fritz von Miller's *Viking Ship* (1914), also in silver. The advent of new trends in modern art saw Salvador Dalí and Alexander Calder working in precious metals, but only in small-scale jewelry applications. Contemporary jewelers are once again pushing the limits of precious metal sculpture, a movement that began in the 1970s as the art-jewelry community moved into an experimental phase. Large nonfunctional works and nonwearable body ornaments blurred the line between traditional jewelry and abstract sculptural form, a phase that continues as Postmodern sculptors, metalsmiths, and jewelers both return to the traditional figure in precious metal sculpture and continue to explore the boundary between traditional jewelry and sculptural form.

KAREN YORK

See also **Bronze and Other Copper Alloys; Carolingian Sculpture; Cellini, Benvenuto; Egypt, Ancient; Mesoamerica; Near East, Ancient; Nicholas of Verdun; Ottonian Sculpture; Pheidias; Reliquary Sculpture**

Further Reading

Berger, Patricia Ann, and Terese Tse Bartholomew, *Mongolia: The Legacy of Chinggis Khan*, San Francisco: Asian Art Museum of San Francisco, and London: Thames and Hudson, 1995

Cherry, John F., *Goldsmiths*, Toronto and Buffalo, New York: University of Toronto Press, 1992

Clark, Grahame, *Symbols of Excellence: Precious Materials as Expressions of Status*, Cambridge and New York: Cambridge University Press, 1986

Schadt, Hermann, *Goldschmiedekunst: 5000 Jahre Schmuck und Gerat*, Stuttgart, Germany: Arnoldsche, 1996; as *Goldsmiths' Art: 5000 Years of Jewelry and Hollowware*, translated by Ann Potter Schadt, Stuttgart, Germany: Arnoldsche, 1996

Tait, Hugh, editor, *Jewelry, 7000 Years: An International History and Illustrated Survey from the Collections of the British Museum*, New York: Abrams, 1987

Truman, Charles, editor, *Sotheby's Concise Encyclopedia of Silver*, London: Conran Octopus, 1993

BARTHÉLEMY PRIEUR *ca.* 1536–1611
French

It is not known with which sculptor Barthélemy Prieur spent his years of apprenticeship. Like Ponce Jacquio, Prieur came from Champagne, and the two of them lived together in Rome during the 1550s. His oeuvre would later reveal the formative influence of his study of antique sculpture and the works of his Roman contemporaries, especially the successors of Michelangelo. He created the earliest of his known works as the

court sculptor for Duke Emanuele Filiberto in Turin, where he stayed from 1564 to 1568. When Prieur departed, he left only the model behind for the monumental bronze coat-of-arms on the newly constructed citadel of Turin. The cousin of his Turin patron, Madeleine de Savoie, widow of the powerful Constable Anne de Montmorency, gave him his first commission when he had just arrived in Paris in 1571. The constable's architect, Jean Bullant, provided the design of the monument for the constable's heart, which was supposed to be erected next to that of his lord, King Henry II, in the Eglise des Célestins. Bullant—who knew the architecture of Antiquity well—lent the heart monument a glorifying character by adopting the form of an antique column monument surrounded by three bronze figures: *Peace, Justice,* and *Felicity. Peace* and *Felicity* came from Prieur's hands, whereas the statue of *Justice* was created by Martin Lefort. Prieur's bronzes are robed figures based on antique models, with hairstyles and footwear *à l'antique* (after the antique). Powerful female bodies show through the drapery, which is depicted as moving but still seems rigid, and into which sharp folds are modeled. The impression of hardness and lack of sensuality is emphasized by the perfect smoothness of the heavily worked-over metallic surface.

Prieur's Antique (or Classicizing) style corresponded so much to the intentions of the architect, Bullant, that he entrusted the sculptor in 1573 with three further bronzes—the figures of the antique provinces of Gaul—for a new monument for the heart of Henry II. The models were the provinces in mourning depicted on Roman coins. However, this work was not completed.

Bullant engaged Prieur for a third spectacular project, which was begun in 1576: the two-storied tomb of the Constable Anne de Montmorency and the patron Madeleine de Savoie. An aedicule formed by coupled columns on a semicircular ground plan is covered by a half dome. The marble figures of the constable in armor and his wife in her widow's costume rest below. Both of the kneeling figures were cast in bronze and placed to the right and left sides of the cupola on additional columns. The tomb was destroyed during the French Revolution, and the bronzes were melted down. The marble figures are in the Musée du Louvre in Paris. The depiction of the recumbent figures followed a tradition upheld since the Middle Ages. They thereby conform to the series of older gravestones in the family tomb in the Church of St. Martin in Montmorency. Prieur's work as a stone sculptor exhibits less freedom than his bronze works. Nevertheless, he lightened the blocklike figures by carefully differentiating between the textures of the various materials, enlivening the mass of stone through his subtle

treatment of the surface, for example in the folding hems of garments.

A clear discrepancy between his bronze and stone works can also be felt in the wall epitaph that he designed and executed between 1582 and 1585 for the *premier président du parlement* Christophe de Thou. The architectural frame contained an oval niche with the bust of de Thou above a sarcophagus. Figures of *Prudence* and *Justice* in high relief recline against the oval. A large plaque below the sarcophagus displays the tomb's inscription. Two youths in gestures of mourning rest on the two semicircular halves of the plaque's gable. The bust carved from multicolored marble shows Prieur to be a portraitist who was able to characterize the subject's individuality concisely, while at the same time allowing liveliness and spirit to shine through in its features. The two Virtues, in their flowing drapery *à l'antique*, lack the elegance of the bronzes from Anne de Montmorency's heart monument. The bronze youths, by contrast, which follow Michelangelo's *Day* and *Night* in the Medici Chapel in Florence, are slim, muscular figures evincing an elegant sense of movement. The expressive faces reflecting pain and sadness are framed by an energetically modeled mass of animated curls. The barely worked-over bronze surface reproduces the freshness and lively modeling of the wax model. These figures provide evidence that Prieur was certainly familiar with the stucco decoration from the middle of the 16th century in Rome, for instance that of the Sala Regia in the Vatican.

That the bronzes were not finely polished and chased can possibly be explained by the fact that Prieur, as a Huguenot, suddenly had to close down his atelier after the Traité de Nemours in 1585 and flee to Sedan. His friend and fellow Huguenot the ceramic artist Bernard Palissy was already there. Prieur quickly established an atelier there just as Palissy had done. He carried out larger commissions in stone, such as a richly sculpted fireplace for the Palace of Sy, now lost, in 1589. It can be presumed, however, that his activity was limited mainly to producing greater numbers of small bronzes, a number of which he had already created in Paris. Prieur is the only French sculptor of the 16th century who applied himself in this genre. This probably led Henry IV to name him court sculptor in 1591, even before the reestablishment of the kingdom. Henry IV took advantage of the possibility to reproduce a model in several versions by putting it into the service of royal propaganda. A statue of *Henry IV on a Leaping Horse*, defeating his enemies, presumably refers to Henry IV's final victory over the Catholic League, which was achieved in 1594 with his march into Paris. Starting in 1600, after Henry IV's marriage to Marie de' Medici, whole series of small-scale busts

Genius from the Funerary Monument of Christophe de Thou © Musée du Louvre, Paris, and Archivo Iconografico, S.A. / CORBIS

of the king and queen, depicted in antique or contemporary costumes, were produced in the sculptor's workshop. The pair of busts, *France* and *Navarre*, also refer to dynastic issues.

Among the royal portraits, the signed statuette pair of *Henry IV* and *Marie de' Medici* as *Jupiter and Juno* is of a higher class. The ruler appears in heroic nakedness, whereas his wife is presented in an antique robe with bared breasts. The portrait heads of Marie and Henry stand in a strange contrast to these, as the facial features of the royal couple are rendered in a sober, entirely unheroic manner, reflecting the contemporary image of the monarchs.

The posthumous inventory of Prieur's works from 1611 lists numerous small bronzes, not all of which have been identified. His production includes figures from antique mythology, depictions of animals, and genre figures. A cavalier-and-maiden pair and a group of dainty female figures carrying out their toilet, such as *Woman Combing Her Hair*, as well as a few statuettes of men, such as *Man with a Child on His Shoulder* (*ca.* 1600), have been attributed to Prieur on stylistic grounds. These were favored collector's items and therefore were often reproduced and recast. The bronzes of animals include groups such as *Lion Devouring a Doe* and another of a lion attacking a horse, as well as individual animals. Prieur's bronze works were unusual in late 16th-century France. The possibility that the impulse for these works came from having known Giambologna's workshop in Florence cannot be excluded.

Even as the king's sculptor, Prieur still worked on private commissions. In 1602 Jacques-Auguste de Thou had him carve the burial statue of his wife Marie de Barbançon-Cani in marble. The great, never-com-

tween stucco and painting flaunted in the Queen's Chamber gave way to a balance between the two media. Primaticcio placed the sculptures around the paintings without forcing the space; their calm and elegant poses give the ornamentation a gentler rhythm and simplify its reading. The sculptures seem to be approaching sculpture in the round, as opposed to bas-relief, and his female figures, which recall Parmigianino's *Virgins* at the Steccata Church in Parma, gain in sensuality and naturalness.

The perfect balance achieved by Primaticcio in the Chambre de la Duchesse d'Estampes makes the destruction in 1738 of his largest and most important undertaking, the Gallerie d'Ulysse, all the more lamentable. The surviving drawings and etchings of the gallery, which occupied him from 1541 until his death, suggest that Primaticcio's language had matured and he was now capable of more freely using his sources, from Giulio to Raphael and Parmigianino, through meditation on Correggio's illusionism and with his own personal interpretation of Michelangelo's style as translated into ornamental terms.

The affinities between Primaticcio's decorations and others conceived in Italy contemporaneously (e.g., Alessandro Vittoria's Hall of the Gods at Palazzo Thiene in Vicenza) can aid speculations about his work in the Gallerie d'Ulysse. Here, he rendered the combination of stucco and painting on a huge scale (the hall was some 150 meters long) in an exuberant and innovative ensemble capable of becoming an unsurpassed model for this type of decoration.

While attending to this prestigious commission, Primaticcio also worked on other projects, as well as occasionally for other patrons, such as the ballroom with frescos by Niccolò dell'Abbate, the *Cave of the Pines*, a design for the de Guise tomb, a series of rooms in the castle of Meudon, and a design for Henry II's tomb, commissioned by the sovereign's widow, Catherine de' Médici.

Primaticcio's style is marked by refined and never banal gracefulness, full of ideas from Raphael, Giulio, and Parmigianino but also capable of taking up the challenge of Michelangelo and of the ancient models. In this way he met Francis I's expectations perfectly. His versatility and ability to combine different sources of inspiration also account for the high repute in which he was held in France for many years.

MADDALENA SPAGNOLO

See also **Michelangelo (Buonarroti); Stucco (Lime Plaster)**

Biography

Born in Bologna, Italy, 1504/05. Also known as "il Bologna," for his hometown. Worked as painter, decorator, sculptor, and architect; according to Giorgio Vasari, trained with two middling local painters, Innocenzo da Imola and Bagnacavallo; probably in Venice, perhaps as art expert and dealer, 1524; one of many artists working on decoration of Palazzo del Te in Mantua under Giulio Romano, 1526–31; went to France, entered service of King Francis I, 1531; remained in France, except for some journeys, until his death; traveled to Flanders to bring designs by Giulio Romano to the local tapestry works, 1532; traveled to Rome with Giacomo Vignola to buy medals, paintings, and antiquities for King Francis, 1540; appointed abbot of St. Martin de Troyes, 1544; King Francis sent to Rome to petition Michelangelo for making casts of his sculptures, 1546; went to Ferrara and Milan, where he met sculptor and art collector Leone Leoni, 1550; returned to Bologna, where he met Vasari and drew up last will, 1563. Died in Paris, France, 15 September 1570.

Selected Works

1528–31 *Mars*; stucco; Palazzo del Te, Mantua, Italy (attributed)
1528–31 Sculpted frame; stucco; Chambre de la Reine, Château de Fontainebleau, France
1541–44 Sculpted frames; stucco; Chambre de la Duchesse d'Etampes, Château de Fontainebleau, France
1541–70 Sculpted frames for the Gallerie d'Ulysse, Château de Fontainebleau, France; stucco (destroyed)
1543 *Cave of the Pines*; Château de Fontainebleau, France

Further Reading

Béguin, Sylvie, Jean Guillaume, and Alain Roy, *La Galerie d'Ulysse à Fontainebleau*, Paris: Presses Universitaires de France, 1985

Blunt, Anthony, *Art and Architecture in France: 1500–1700*, London and Baltimore: Penguin, 1953; 5th edition, revised by Richard Beresford, New Haven, Connecticut: Yale University Press, 1999

Dimier, Louis, *Le Primatice*, Paris: Michel, 1928

Haskell, Francis, and Nicholas Penny, *Taste and the Antique: The Lure of Classical Sculpture, 1500–1900*, New Haven, Connecticut: Yale University Press, 1981

Romani, Vittoria, *Primaticcio, Tibaldi e la questione delle cose del cielo*, Padua, Italy: Bertoncello Artigrafiche, 1997

Vasari, Giorgio, *Le vite de' più eccellenti architetti, pittori e scultori italiani*, 2nd edition, 3 vols., Florence: Apresso i Giunti, 1568; as *Lives of the Painters, Sculptors, and Architects*, 2 vols., translated by Gaston du C. de Vere (1912), edited by David Ekserdjian, New York: Knopf, and London: Campbell, 1996

PUBLIC SCULPTURE

As is the case with the more inclusive category of "public art," there is no definition of "public sculpture" that is universally accepted. Whereas some scholars argue for a public art that begins with prehistoric cave paintings, others believe that it did not exist until the 1960s. This wide divergence of opinion is owed in part to the equally unsettled view of the properties necessary for something to be classified as being public. Is it enough for a sculpture merely to be in a public place? If that were the case, all sculptures in museums could be considered public art. Is it necessary that the work was conceived and funded as a public sculpture, or can a work of art later become public? Are corporate-funded sculptures as public as sculptures funded by governments? Is a work of art truly public if it addresses only a fragment of the population? These are but a few of the concerns raised in the debate over what should be classified as public sculpture. For the present purposes, a broad definition of public sculpture, in terms of chronology and other criteria, will serve to elucidate many of these issues.

Public sculptures have historically served a limited set of purposes, and they have taken a number of general forms. At various times works have been created with the intention of helping to construct national or local identities; validate or enhance the authority of a ruler; memorialize a particular person (or animal), group of persons, or event; raise the status of a city in the eyes of others; provide a pleasing environment; improve the citizenry, either by exposure to art or to specific questions a work might raise; increase opportunities for artists; or generate increased economic activity and further development. To perform these functions, public sculptures have assumed the forms of mythical and allegorical figures, representations of actual or generalized persons or groups, equestrian monuments, fountains, as well as autonomous, often abstract, works of art. The traditional sites of public sculpture range from city squares and parks to government and civic buildings, commercial buildings and their grounds, and even religious structures.

The origins of public sculpture can be traced to the first great civilizations, particularly those of the ancient Near East and ancient Egypt. The colossal *lamassu* (winged, human-headed bulls) served as important symbols of Assyrian rulers' power and as protectors of the king from potential enemies. Egyptian pharaohs also celebrated their conquests and perpetuated their authority through monumental sculptures, such as those of Ramses II at Abu Simbel and the Great Sphinx at Giza.

At other times public sculpture has been most prominently associated with religious architecture. Some of the most visible sculpture of ancient Greece adorned the exteriors of temples. The most famous were, and remain, the friezes and pediment sculptures of the Parthenon in Athens, dating to just after the middle of the fifth century BCE. Other kinds of public sculptures existed as well in ancient Greece and were described by Greek and Roman authors. In addition to such gigantic statues as the 32-meter-tall *Colossus of Rhodes*, smaller public statues commonly stood in Greek agorae (marketplaces). The first known of such civic sculptures was the *Tyrannicides*, a life-size bronze pair of aristocrats celebrated for their assassination of Hipparchos in 509 BCE and as the founders of Athenian democracy. In the Roman Republic and the Roman Empire, the fora (marketplaces) of cities served as one of the primary sites for public sculptures. The colonnades of the Forum of Augustus were lined with portrait statues, including all of the ancestors of Augustus from Aeneas forward. The sculptures helped shape the public's perception of the history of Rome as largely a result of the accomplishments of the Julian family. In the early second century, the Forum of Trajan made use of most of the common forms of Roman public sculpture in an architectural setting that glorified the emperor's triumphs in battle. One entered through a triumphal arch with sculptural group featuring Trajan driving a chariot and being crowned by Victory. Above the columns of the forum's porticoes, statues of bound Dacians further impressed the emperor's success in battle upon the viewer; and in the center of the forum stood a larger-than-life-size equestrian statue of Trajan in gilded bronze. Behind the Basilica Ulpia was the *Column of Trajan*, its spiral narrative frieze detailing the deeds of the emperor, whose heroic nude statue adorned the top the column. The column statue, equestrian statue, and triumphal arch, along with sculptural fountains, are forms of public sculpture that would be fully exploited again during the Renaissance and for centuries would remain popular forms throughout the Western world for creating and reinforcing civic and national identities.

Like the temple sculptures of ancient Greece, the sculptures on the exteriors of Romanesque and especially Gothic churches were public in the sense that they were highly visible to all of a community's population and, like the buildings they adorned, possessed powerful civic and religious significance. Facade and portal sculptures, such as those of the west tympanum of Autun's Cathedral, Autun, France, could at times serve to strike the fear of God into the hearts of all who entered; or, like those on the Royal Portal of Chartres Cathedral, they could instruct or offer the hope of salvation. Elsewhere, as in the 14th-century depiction of Hercules, the mythical founder of Florence, on the bell-tower of Florence Cathedral, Italy, civic, and even

pagan, personages could be displayed on ecclesiastical architecture.

During the Renaissance, public sculpture on the scale of the ancient world—and with a similar purpose—returned. The Renaissance was a time of rediscovery of the arts of ancient Greece and Rome, but the power of public sculpture to influence citizens and embody civic ideals—a power understood in Antiquity—was also revived. Florence, anxious to assert itself as a Christian successor to ancient Rome, erected a number of sculptures in prominent public locations beginning in the early 15th century. Donatello's column statue *Dovizia*, a personification of Abundance, served to remind citizens visiting the Mercato Vecchio of the generosity of their virtuous government. Donatello's *St. Mark* (1411–13) and *St. George* (1415–17) were among a group of figures, including Nanni di Banco's *Quattro Santi Coronati* (1409–17) and works by Lorenzo Ghiberti, that graced the exterior of the Church of Orsanmichele in a way that emphasized the placement of sculpture relative to the architecture to a greater degree than had been the case during the Gothic period. Florence's greatest collection of public sculpture, including works by Donatello, Cellini, and Michelangelo's *David*, was erected in the Piazza della Signoria. In some instances the sculptures represented the ideals of the Florentine Republic, and in others they served the purposes of the ruling Medici family. Much of Florence's public sculpture was a response to events in Rome, where in 1480 six ancient statues were donated to the Capitoline, and other ancient sculptures would follow on the Capitoline Hill, including the equestrian statue of Marcus Aurelius, placed on a new plinth in the center of the piazza by Michelangelo in 1538.

During the 17th and 18th centuries, commemoration, memorialization, and the promotion of civic or religious virtues were the primary forces behind most public sculptures. The development of the urban square meant that there could be numerous venues ideally suited for public sculpture within European cities. Fountains, such as Bernini's *Triton Fountain* (1642–43) in the Piazza Barberini in Rome were a popular form for public sculpture. Also prevalent were commemorative columns and equestrian statues. In 1674 Caius Gabriel Cibber carved an allegorical panel of Charles II directing Architecture and Science to assist the City of London. The panel adorns the base of *The Monument*, a memorial column erected near the site where the Great Fire of London had broken out in 1666. Even in 18th-century America, the legacy of Rome was felt in such works as the equestrian statue of George III commissioned in 1766 from the London sculptor Joseph Wilton. The statue, featuring the king in Roman dress, was set up on Bowling Green in New York City in 1770; and after years of public desecration, it was toppled by a mob of American patriots in July 1776.

One of the most active periods in the history of public sculpture began around the middle of the 19th century and continued well into the 20th. The growth of cities and the popularity of grand urban plans led to a demand for public sculptures to adorn new boulevards and city squares. War, nationalism, and revolution played an important role in the proliferation of statues and monuments at this time; and their effects can be seen in the tremendous number of public statues and memorials devoted to figures such as Queen Victoria, Bismarck, and Lenin, as well as in the many memorials to events and participants in the American Civil War and World War I. Urbanization also meant new buildings, including museums, department stores, theaters, and train stations, many of which were adorned with statues or friezes. Even Auguste Rodin, whose public sculptures include such well-known works as his *Monument to Balzac* and *The Burghers of Calais*, contributed sculptures to the facade of the new Hôtel de Ville, built in Paris between 1873 and 1893.

From its inception until the middle of the 20th century, public sculpture was overwhelmingly figural. Works portrayed actual persons, mythical heroes, gods, or allegorical human or animal forms. The rise of modernism in the 1950s and 1960s, however, led to a conviction that public art could also be abstract and should be autonomous, or divorced from its social context. One of the earliest such works was commissioned from Pablo Picasso in 1967 by the city of Chicago, Illinois. To those responsible for commissioning the work, Picasso—despite the fact that he had never been to Chicago and lacked any affiliation with the city—was seen as the ideal choice because of his fame among nearly all sectors of the public. The "Chicago Picasso," as it has come to be known, was to be located in the plaza of the Chicago Civic Center. The goal was to create a landmark to which the city of Chicago would be linked, in the way the Eiffel Tower and Paris are inseparable and the Empire State Building and Statue of Liberty are joined to New York City. To a degree the work has been moderately successful in being identified with the city and has even been used as a civic logo.

In 1967 the National Endowment for the Arts initiated its Art in Public Places program with the commissioning of *La Grande Vitesse* from Alexander Calder for Grand Rapids, Michigan. Calder had never been to the city that was hiring him to create a new identity for it, and he did not even visit the site before the work was installed at the Civic Center in Grand Rapids, Michigan. These examples point to one of the major problems encountered in many of the public sculpture

commissions of the 1960s and 1970s: the works were museum or gallery works—often on a much larger scale—that had been placed in public, usually outdoor, spaces.

A massive, modernist, abstract work that was controversial in its placement, despite the fact that the artist took great pains to produce a sculpture for a specific location, was Richard Serra's *Tilted Arc*, which was commissioned by the General Services Administration in 1979 as part of its Art in Architecture program for installation in New York City's Federal Plaza. Serra purposely built the sculpture to block the views from the courthouse to the street and to cut across the entire plaza. At 36.6 meters in length, *Tilted Arc* was considered by much of the public to be an ugly imposition upon a public space that they wished to traverse, unimpeded, on a regular basis. After a court battle, the work was removed in 1989. *Tilted Arc* demonstrates the limits of what the public and those in positions of authority will accept in the face of an artist's personal vision for a public place.

Cincinnati Gateway (1988) by Andrew Leicester represented a very different kind of public sculpture that began to assert itself during the 1980s and 1990s. Unlike Picasso and Calder, Leicester won a competition to create a civic sculpture for the entrance to Cincinnati's Bicentennial Commons at Sawyer Point; and once he had been chosen, Leicester spent considerable time in Cincinnati researching the city and soliciting the input of citizens and art students. His proposal, however, was not accepted without controversy, mainly owing to his inclusion of bronze flying pigs (representing the historical importance of the meat-packing industry in the city) atop four representations of riverboat smokestacks. Many citizens felt that in his concentration on the commercial aspects of the city, Leicester neglected the more genteel benefits that resulted from such enterprise and ignored the place of women and minorities in Cincinnati's history, as well as the city's prominent role in abolishing slavery. Despite the controversy, Leicester's *Gateway* was quite inclusive as a record of a place, including many references to the site's history long before it was settled as the city of Cincinnati.

One of the most visited monuments in the world is Maya Lin's Vietnam Veterans Memorial (1982) on the Mall in Washington, D.C. Despite its popularity after completion, many criticized the V-shaped, polished black stone monument before construction began for not sufficiently exalting the sacrifice made by those who gave their lives in the conflict and for not explicitly honoring those who returned from the war. The monument, which formally resembles a minimalist sculpture, was not complete in the eyes of some until a bronze figural group of three soldiers by Frederick Hart was placed nearby in 1984, which attests to the prevailing figurative tradition in monument design.

The two world wars and their legacies played a major role in shaping much of the public sculpture of 20th-century Europe. Yevgeny Vuchetich's *Memorial to the Fallen Soviet Heroes* (1947–49) is a war memorial on a grand scale. Set within a tree-enclosed area in Berlin's Treptow Park, the work consists of a statue of a grieving mother separated by a vast Russian military cemetery from a figure of a massive sword-wielding Russian soldier holding a German child. The sculpture and cemetery not only honored the Soviet dead but also served to remind Berliners of the Russian sacrifice on their behalf.

Whereas permanence has traditionally been one of the goals for public sculpture, the 1980s saw the rise of the "counter-monument," a work that was usually meant to be short-term and to engage its audience in thoughtful debate and, sometimes, physical action.

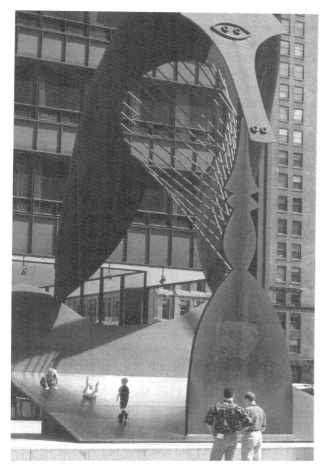

Pablo Picasso sculpture at Richard Daley Plaza, Chicago, Illinois, United States
© Kelly-Mooney Photography / CORBIS, and Artists Rights Society (ARS), New York

Puget returned to France in 1667 seeking royal commissions. Although he never obtained a foothold in Paris, he was appointed the director of the Arsenal in Marseille. His elaborate carvings for majestic vessels such as *le Monarque, le Paris*, and *L'Ile de France* are known mainly through documents and drawings. When Colbert cut back decorative work on naval vessels, Puget obtained a commission from him to carve two works of his own choice for the king from three large blocks of Carrara marble that had been abandoned at the docks in Toulon. One resulted in Puget's chef d'oeuvre, the *Milo of Croton*, which was placed in the park of Versailles in 1683 to universal acclaim. The work impressed Louvois, Colbert's successor, and Puget planned a series of grand projects for Louis XIV. Of these, his *Perseus Freeing Andromeda*, a richly carved group full of dramatic contrasts—female helplessness and masculine virility, sinuous contours and angular extremities, and sparkling highlights against dark recesses—reached Versailles in 1684 to wide approval, despite its Italianate ebullience. His bronze *Abduction of Helen* continues the compositional complexities of the *Perseus Freeing Andromeda*.

Although French taste was clearly changing, other of Puget's projects did not flourish. His majestic architectural design for a royal entrance to the port of Marseille, with an equestrian statue of Louis XIV, exists only in preparatory drawings and related relief portraits, while the king rejected outright his expressive relief of *St. Carlo Borromeo Praying for the Victims of the Plague in Milan*. A more spectacular, although more spatially restrained, relief, the massive *Alexander and Diogenes*, remained unfinished at Puget's death and did not reach Paris until 1697. The work was not installed and was put into store in the Louvre during the following year. This deeply cut work, full of movement, with the principal figures carved in particularly high relief, caused Puget enormous technical problems; it was eventually assembled from three large pieces of marble, still with bridges in place to secure the more fragile areas, such as the outstretched hand of Diogenes.

Even when his work was acknowledged by court patronage, Puget appears to have betrayed his own chances of public success and recognition, offending the etiquette of the court with his importunate, ambitious demands. The subject matter for figures that Puget selected for the king either imply a rebuke to a ruler (*Alexander and Diogenes*) or define weakness and poor judgment in a heroic character (*Milo of Croton*) and cannot have been popular with a ruler who supported an art of unambiguous allegorical propaganda in the service of the state. Puget's powerful, intense, flawed, and unidealized heroes sat uneasily beside the sophisticated works of François Girardon

and Antoine Coysevox, whose Classicizing productions fit better into the orchestrated schemes of the court painter Charles Le Brun.

Puget created his best and last works at Marseille and Toulon, sculpting intensely moving figures from materials of the highest quality and especially stimulated by grand projects. His technical understanding of materials was unparalleled in 17th-century France, and one can clearly trace his vigorous handling of point, chisel, and drill on the backs and unfinished areas of his works.

J. Patricia Campbell

Biography

Born in or near Marseille, France, *ca.* 16 October 1620. Apprenticed to Jean Roman, master carpenter and woodcarver for the Arsenal, Marseille, 1634; moved to Italy, 1638, and studied in Tuscan studios; returned to Marseille, *ca.* 1643; joined brother Gaspard in Toulon, France, 1645; worked until 1656 with Nicolas Levrey, master sculptor at the Arsenal; visited Rome to copy antiquities, 1646; worked in Paris, 1659; Nicolas Fouquet (minister of Louis XIV) served as patron in Paris, 1659–61; visited Carrara, Italy, to select marble, 1660; studied the work of Van Dyck in Genoa; maintained a studio with Van Dyck's best pupil, Christophe Veyrierin Genoa, 1661–67; returned to France, 1667; employed as director of the Studio of Sculptures of the Arsenal, Toulon, under François Girardon, 1667; appointed director of the decorative workshop at the Arsenal in 1668; received several commissions from the Lomellini family in Genoa; audience with Louis XIV at Fontainebleau, 1668; received important open commission from the king, 1670. Son François (born December 1651) became an assistant. Died in Marseille, France, 2 December 1694.

Selected Works

1648–49 Fountain for Port Saint-Lazare; stone; Toulon, France

1657 Carved portal (*Atlantes*), for Hôtel-de-Ville, Toulon, France; Calissane stone; Musée Naval, Toulon, France

1659 *Hercules Crushing the Hydra of Lerna*; Pageot marble; Musée des Beaux-Arts de Rouen, France

1661–62 *Hercules Resting* (also known as *Hercule Gaulois*); Carrara marble; Musée du Louvre, Paris, France

1662–63 *Head of Christ* (also known as *Salvator Mundi*); marble; Musée des Beaux-Arts, Marseille, France

1664–68 *Saint Sebastian*; marble; Church of Santa Maria Assunta di Carignano, Genoa, Italy

1665 *Assumption of the Virgin*; marble; Staatliche Museen, Berlin, Germany

1670–94 *Alexander and Diogenes*; Carrara marble; Musée du Louvre, Paris, France

ca. 1671–82 *Milo of Croton*; Carrara marble; Musée du Louvre, Paris, France

1675–84 *Perseus Freeing Andromeda*; Carrara marble; Musée du Louvre, Paris, France

1683–86 *Abduction of Helen*; bronze; The Detroit Institute of Arts, Michigan, United States

1686–87 *Louis XIV on a Charger*; marble; Musée des Beaux-Arts, Marseille, France

1688–94 *St. Carlo Borromeo Praying for the Victims of the Plague in Milan*; marble; Musée des Beaux-Arts, Marseille, France

1692–93 *Faun*; marble; Musée des Beaux-Arts, Marseille, France

Further Reading

Alibert, François Paul, *Pierre Puget*, Paris: Les Éditions Rieder, 1930

Auquier, Philippe, *Pierre Puget*, Paris: Laurens, 1928

Bieber, Margaret, *Laocoön: The Influence of the Group since Its Rediscovery*, New York: Columbia University Press, 1942; revised edition, Detroit, Michigan: Wayne State University Press, 1967

Blunt, Anthony, *Art and Architecture in France, 1500–1700*, London and Baltimore, Maryland: Penguin, 1953; 5th edition, revised by Richard Beresford, New Haven, Connecticut: Yale University Press, 1999

Brion, Marcel, *Pierre Puget*, Paris: Plon, 1930

Herding, Klaus, *Pierre Puget, das bildnerische Werk*, Berlin: Mann, 1970

Souchal, François, *French Sculptors of the 17th and 18th Centuries: The Reign of Louis XIV*, vols. 1–3, Oxford: Cassirer, 1977–87, and vol. 4, London: Faber and Faber, 1993; see especially vol. 3

Vial, Marie-Paule, and Luc Georget, *Pierre Puget: Peintre, sculpteur, architecte, 1620–1694*, Marseille, France: Musées de Marseille, and Paris: Réunion des Musées Nationaux, 1994

Walton, Guy, "Some Unnoticed Works by Pierre Puget," *Art Bulletin* 47 (1965)

MILO OF CROTON

Pierre Puget (1620–1694) ca. 1671–1682

Carrara marble

h. 2.7 m

Musée du Louvre, Paris, France

The French minister Jean-Baptiste Colbert recognized from the first that Pierre Puget was not temperamentally suited to collaborative work on his grand schemes for Louis XIV at Versailles. Nonetheless, he eventually permitted Puget in 1670 to produce statues from three blocks of marble abandoned at the port of Toulon. In 1682 Puget finally negotiated through his son François a contract with Colbert of payment for 8,000 livres for the *Milo of Croton* with pedestal and a huge relief of *Alexander and Diogenes*. The *Milo* was shipped from Marseille to Havre de Grace via Toulon and placed in the gardens at Versailles in the summer of 1683. Mounted on an exceptionally high pedestal, in the prime position opposite the entrance to the Grand Allée Royale, it immediately drew all eyes. Louvois, Colbert's successor, and the court painter Charles Le Brun wrote to congratulate Puget on the beauty of his work; Queen Marie-Thérèse was moved by the suffering expressed by the figure of *Milo*. Viewers widely remarked on the successful representation of the pathos of the human condition through energy, rage, and despair, and the king, after some hesitation, gave it his approval.

The design of the subject of *Milo of Croton* is first known through two pen-and-sepia wash drawings studies dated about 1670/71, one at Dijon (Musée des Beaux Arts) and the other, closer to the final arrangement, at Rennes (Musée des Beaux Arts). A terracotta model, now in a private collection, probably preceded work on the block of Carrara marble, which had been transferred to Marseille and which Puget eventually completed and signed in 1682. A small bronze reduction in Baltimore, Maryland (Museum of Arts), and a terracotta head of *Milo* in the Musée du Louvre collection, Paris, probably came from Puget's workshop. Originally placed outdoors at Versailles, the statue was moved to Paris in 1799; it is currently located in the Louvre.

To the Classical world Milo of Croton was synonymous with extraordinary physical power. In the late 6th century BCE, the Greeks revered him during his lifetime for his wisdom but especially for his immense strength, both as a military hero and as an athlete. The most renowned wrestler in Antiquity, he remained unbeaten over more than a quarter of a century in 32 events in the Olympic games. After he led the Crotoniate army to victory over the Sybarites in southern Italy about 510 BCE, his adulation reached a peak. In middle age he tested his declining strength by trying to split a tree trunk with his bare hands. A wedge that he had inserted in the gap fell out, and the trunk sprang back, trapping his hand. His reduced strength proved insufficient to reopen the split; alone, and without assistance, he was eventually devoured by wolves. The tragic theme of a hero unable to accept the ravages of age figures in the writings of many Classical authors, and Puget had a version of this story in his library. Milo became the exemplar of the suffering hero, but he can also be seen as a foolish man, a hero whose wisdom,

understanding, and judgment about his diminishing physical powers was also failing. One can thus read his inability to adjust to his altered condition as a warning to aging rulers.

In interpreting the anguish and despair of the lonely dying hero, Puget based *Milo*'s expression on the Hellenistic *Laocoön* group. This Classical sculpture preoccupied art historians and was the center of much discussion throughout 17th- and 18th-century Europe. Puget's hero expresses his psychological state, with his head jerked back in agony and toes clenched with pain, fully realizing his plight. It is unclear how the sculptor came to this unusual and challenging subject, although he may have seen Pordenone's painting of *Milo Attacked by Lions* (*ca.* 1520–35) when in Rome; Pordenone replaced the wolves, which most Classical writers describe as devouring Milo, with nobler lions. Few earlier versions of the theme in either painting or sculpture existed that Puget could have used as models.

Milo of Croton
© Giraudon / Art Resource, NY

At the time it was placed at Versailles, the sculpture heralded the fullest expression of the Baroque in France: monumental, multifaceted, and technically brilliant—a theatrical expression of suffering, death, and destiny. The tension and movement of the pose, the *contrapposto* (a natural pose with the weight of one leg, the shoulder, and hips counterbalancing one another) of the figure, and the variety of viewpoints from which the narrative can be read reveal a deep understanding of Italian high Baroque sculpture. A wide range of textures, for which Puget selected different-sized gouges, points, chisels, and rasps, enriches the group's pictorial effect. Despite some repaired breaks and the effects of a century of weather at Versailles, the contrasting textures of whipcord veins, jutting bones, drapery, bark, curling mane, and rough hair remain sharp and effective.

Puget's *Milo* became the French reference work in academic teaching for French sculptors for the following two centuries. François Rude and other sculptors used the *Milo* in allegories and histories for grand decorative schemes for palaces and public buildings to represent the entire achievement of France in the arts. Generations of artists at the French Academy, including Antoine-Louis Barye, Paul Cézanne, and Alfred Martin, studied Puget's work through the original or through casts. Numerous young sculptors in the 18th and 19th centuries, including Edmé Dumont, Johan-Heinrich Von Dannecker, Louis Desprez, and, most famously, Étienne-Maurice Falconet, reexamined the theme. Painters such as Hubert Robert featured the statue in their works as a nostalgic symbol of the past greatness of France, while others perpetuated Puget's triumph throughout the 18th century in depictions of the statue's unveiling at Versailles. Small bronze replicas proliferated, and European academies bought high-quality casts of the *Milo* for study. Even as late as 1960 students in standard antique drawing classes of Edinburgh College of Art copied a plaster cast of *Milo* as an exemplar of human suffering.

J. PATRICIA CAMPBELL

Further Reading

Bresc-Bautier, Geneviève, et al., *Pierre Puget*, Milan: Electra, 1995

Francastel, Pierre, *La sculpture de Versailles*, Paris: Morancé, 1930; reprint, Paris: La Haye, 1970

Reff, T., "Puget's Fortune in France," in *Essays in the History of Art Presented to Rudolf Wittkower*, edited by Douglas Fraser, Howard Hibbard, and Milton J. Lewine, London: Phaidon, 1967

Walton, Guy, "The Sculptures of Pierre Puget," Ph.D. diss., New York University, 1967

PULPIT

A pulpit is a raised platform or lectern used for delivering homilies or making other religious transmissions

in the Western church. Most pulpits were located in the nave of the church to the southern side of the altar, although positions in the choir were also common. Some pulpits were attached to the church's exterior, accessible through stairs within the church walls. In Italy the term *pulpit* also refers to a type of ambo (a raised structure used for gospel and epistle readings) developed by the 12th century, which consists of a casket supported by columns and accessed by a single set of stairs.

Today, we usually distinguish the pulpit from the ambo by its architectural form as well as by its liturgical function (delivering the sermon). Pulpits possess a rectangular, polygonal, or circular casket set on a single column or a group of columns. It is reached by a single steep set of stairs. Alternatively, the casket is attached to a wall, a choir screen, or a pilaster. The casket is often richly decorated with relief sculpture, painted narratives, stone inlay, or architectural ornament. In Italy pulpits were usually made of marble; in northern Europe they were more frequently made of wood, especially after the Reformation. Common biblical themes include scenes from Genesis, the infancy of Christ, and Christ's Passion. The narratives are often combined with symbolic elements such as the tetramorph (four winged animals envisioned by Ezechiel and interpreted as symbols for the four evangelists), the seven liberal arts, the doctors of the Romon Catholic Church, or precise references to the church's dedicatory saint.

From the point of view of sculptural decoration, the most spectacular pulpits were the pulpit-ambos produced in Italy during the 12th through the 15th centuries. The 12th-century pulpits that survive are square or rectangular in form, resting on four (or more) columns or two columns and the choir screen. In terms of the quantity of sculptural decoration and intricacy of its iconography, the 12th century may be considered transitional, forming a bridge between the simpler ambo and the complicated narrative programs common in the 13th century.

Exactly why the Italian pulpit-ambo took on this particular architectural form is not known, although it is probably connected to changes in liturgical practice. One striking feature that distinguishes even the earliest of these pulpit-ambos from their ambo predecessors is the diminished importance of the staircase. A prominent feature of the ambo, the pulpit staircase is comparatively smaller, steeper in grade, and often partially or completely hidden from view. This suggests that the ritual climbing and descent of the staircase—so important in early Christian and Byzantine liturgical practice—was no longer valued to the same degree. Paradoxically, a possible source of inspiration for the Italian pulpit-ambo form exists in Byzantine ambos,

whose platforms sometimes stood on sets of columns, as in the churches of Hagia Sofia, Constantinople, and St. Apollinare Nuovo, Ravenna. A more humble source for this kind of raised structure may have been the portable wooden caskets set on stones used for preaching by the mendicant orders (Dominicans and Franciscans) whose numbers and prominence increased over the 13th and 14th centuries.

It is probably not coincidental that one of the earliest Italian pulpit-ambos (*ca.* 1130, reassembled in the 13th century) exists in the Church of St. Ambrogio, Milan. Of the early church fathers, St. Ambrose of Milan was one of the few who was known for occasionally preaching from the ambo (the early Christian church did not require sermons as part of its liturgy). Placed on the north side of the nave, this pulpit combines the liturgical functions of both the gospel and the epistle ambos (as did the earliest ambos). The rectangular casket rests on 12 columns and possesses sculptural reliefs on its archivolts and on the decorative band between the archivolts and the casket. These reliefs depict animal and foliate motifs and crouching figures who seem to support the casket on their shoulders. The caryatid motif continues in the figural supports for the lectern:

Pulpit from La Trinità della Cava dei Tirrenti, 13th Century, Salerno, Italy
The Conway Library, Courtauld Institute of Art

1375

PULPIT

One of the most magnificent post-Reformation pulpits was executed by Hans Hoffmann for the cathedral at Trier (1570–72). Carved in sandstone, it is octagonal in form and includes an impressive archway marking the entrance of the stairs. Seated statues of the four evangelists and standing allegories and prophets surround its base. The side walls of its stairs represent two narrative scenes: Christ's Sermon on the Mount and the Last Judgment. The emphasis on preaching iconography continues through the Baroque and Rococo periods (e.g., St. Andrew's Church, Antwerp; Peterskirche, Vienna, 1716), as do themes of temptation (Brussels Cathedral, 1699), conversion (St. Rombout's Church, Mechelen, 1721), and Christ's Passion. Balthasar Permoser's Rococo cloudburst, with angels holding symbols of the Passion, for the Hofkirche, Dresden (1712), represents the last phase of elaborate sculptural pulpits, many of which had moved to a more exalted central position over the altar. Thereafter, and especially in the 20th century, the size and complexity of the pulpit was drastically reduced to reflect a renewed desire for intimate religious services.

MAIA WELLINGTON GAHTAN

See also **Ambo; Benedetto da Maiano; Donatello (Donato di Betto Bardi); Guido da Como; Pisano, Giovani; Pisano, Nicola**

Further Reading

Ames-Lewis, Francis, "Pulpits," in *Tuscan Marble Carving, 1250–1350: Sculpture and Civic Pride*, Aldershot, Hampshire, and Brookfield, Vermont: Ashgate, 1997

Baracchini, Clara, and Maria Teresa Filieri, "I pulpiti," and "Raccontare col marmo: Gugliemo e i suoi seguaci," in *Niveo de marmore: L'uso artistico del marmo di Carrara dall'XI al XV secolo* (exhib. cat.), edited by Enrico Castelnuovo, Genoa: Colombo, 1992

Butterfield, Andrew, "Documents for the Pulpits of San Lorenzo," *Mitteilungen des Kunsthistorischen Institutes in Florenz* 38 (1994)

Caleca, Antonino, "I pergami," in *Niveo de marmore: L'uso artistico del marmo di Carrara dall'XI al XV secolo* (exhib. cat.), edited by Enrico Castelnuovo, Genoa: Colombo, 1992

Cox, J. Charles, *Pulpits, Lecterns, and Organs in English Churches*, Oxford: Oxford University Press, 1915

Glass, Dorothy F., "Pseudo-Augustine, Prophets, and Pulpits in Campania," *Dumbarton Oaks Papers* 41 (1987)

Kockelbergh, Iris, "Pulpit," in *The Dictionary of Art*, edited by Jane Turner, New York: Grove, and London: Macmillan, 1996

Lamberini, Daniela, editor, *Pulpiti medievali toscani: Storia e restauri di micro-architetture*, Florence: Olschki, 1999

Morselli, Piero, "Corpus of Tuscan Pulpits, 1400–1550," Ph.D. diss., University of Pittsburgh, 1979

Poscharsky, Peter, *Die Kanzel: Erscheinungsform im Protestantismus bis zum Ende des Barocks*, Gütersloh, Germany: Gütersloher Verlagshaus, 1963

Tavenor-Perry, J., "The Ambons of Ravello and Salerno," *The Burlington Magazine* 9 (1906)

Tavenor-Perry, J., "Some Square Ambones in Northern Italy," *The Burlington Magazine* 16 (1909–10)

Weinberger, Martin, "Nicola Pisano and the Tradition of Tuscan Pulpits," *Gazette des Beaux-Arts* 55 (1960)

QUELLINUS (QUELLIN) FAMILY
Netherlandish

Erasmus I Quellinus (Quellin) *ca. 1580–1640*

Little remains of the work of Erasmus I Quellinus. He carved the traditional Renaissance oak pulpit for the St. Elisabeth Hospital in Antwerp. From archival sources it is known that he sculpted freestanding statues and a marble "altar garden" (which is no longer extant) for the St. Antonius Chapel in the Church of St. Jacob in Antwerp. He is chiefly remembered for the artistic training of his son, Artus I, who was to become one of the greatest sculptors of the 17th century.

Artus (Arnoldus) I Quellinus (Quellien, Quellin) 1609–1668

After training with his father (Erasmus I), Artus I Quellinus went on the classic trip to Italy (1634). In Rome, he worked in the studio of François du Quesnoy, whose influence was strong. Both closely studied the antique, and their works reflect this expertise. In 1639 Artus I was back in Antwerp; in the following year, he became a master in the guild of St. Luke and took over the studio of his father, where his brother-in-law, Peeter I Verbrugghen, was also active. This workshop contained a remarkable level of activity judging by who worked or was trained in it: his cousin Artus (Arnoldus) II, Guillielmus Kerricx, Gabriel Grupello, and probably Louis (Ludovicus) Willemssens.

In the early work of Artus I (during his first Antwerp period, 1639–44/45), Peter Paul Rubens's influence is clearly noticeable in works such as *Virgin and Child with Saints Anne and Joseph* in Antwerp's Church of St. Paul. The *Ara Coeli Madonna* (Madonna of the Heavenly Altar) in the Cathedral of Brussels proves how Artus I translated Rubens's style in sculpture.

Artus I's most important project was the sculptural decoration on the inside and outside of the new town hall of Amsterdam (now the Royal Palace), which was designed by the Haarlem architect Jacob van Campen. Artus I mainly stayed in the northern Netherlands from about 1650 to 1665, while he was working on this significant commission. He designed—often after compositions by van Campen, which he translated into sculptural language—and sculpted freestanding high and low reliefs, as well as numerous ornaments, in marble. These were stylistically and iconographically influenced by Rubens and Classical Antiquity, but also by van Campen's Classicism. An army of assistants collaborated on this masterpiece, which is often cited as the eighth wonder of the world: the most reputed assistants were Rombout Verhulst, Artus II Quellinus, Bartholomeus Eggers, and probably Gabriel Grupello. One of the greatest achievements is doubtlessly the four nude caryatids for the Vierschaar (Tribunal), or public high court: the human nudes tremble with sensuality and restrained emotion. Particularly successful are also the pediment reliefs on the east and west facades and the monumental figures on the corners of the building. On the east facade, the city Virgin is seated

enthroned, surrounded by river gods; on the west facade, the personification of the city of Amsterdam is honored by the four continents. Here, also, the nude figures are rendered in an extremely plastic way, with voluptuous forms that are accentuated with the well-thought-out play of light and shadow. The composition is all movement and life.

In 1655 Artus I bought a house in Antwerp and two country houses in Hoboken (near Antwerp). It was only in 1664 that he requested from the city of Antwerp to be granted the same privileges that he enjoyed in Amsterdam, such as an allowance for housing and an exemption from all professional, civic, and church obligations laid down by the St. Luke's guild, and city council. A year later he finally settled in his native city.

During his stay in Amsterdam, Artus I accepted a number of diverse commissions, such as the *Fountain of Pallas* for Kleve, Germany, and a tomb monument to Field Marshal Otto von Sparr in the Marienkirche in Berlin, Germany. He also received commissions from his native country, such as for the statues of St. Ignatius Loyola and St. Francis Xavier for the Jesuit church (now the Church of St. Carolus-Borromeus) in

Thomas Quellinus, commemorative monument of Baron Constantin Marselis and Sophie E. Marselis (Marselis-Carisius-Rodsteen family chapel and tomb)
The Conway Library, Courtauld Institute of Art

Artus (Arnoldus) I Quellinus, *Apollo and the Python*
Courtesy of The Royal Palace, Amsterdam, the Netherlands

Antwerp and the remarkable statue *Saint Peter* for the epitaph to Pieter Saboth in the Church of St. Andries of the same city. The tormented facial expression and the tensed muscles in the arms that clasp the tree trunk reflect the doubting of the apostle who has just betrayed Christ. The portrait bust of Andries de Graeff, now in the Rijksmuseum, Amsterdam, is also a remarkable achievement. Artus I's last work from his Amsterdam period is the portrait bust of Johan de Witt, pensionary of Holland, a masterpiece of realistic and psychological characterization.

The most important commission from Artus I's second Antwerp period is the bust of Don Luis de Benavides, marquess of Caracena, and governor-general of the Spanish Netherlands. This work displays deep psychological insight into the sitter.

Artus I formed a school of sculptors who were to play an important role in the evolution of the Baroque style in both the southern and northern Netherlands. His style was powerful and his rendering of the human nude was pioneering. His female figures received exuberant shapes sculpted as from life. These underline

QUELLINUS (QUELLIN) FAMILY

his knowledge of anatomy. Moreover, he achieved a deeper understanding and rendering of the human psychology than virtually any other sculptor. Indeed, he was one of the greatest Flemish sculptors of the Baroque period.

Artus (Arnoldus) II Quellinus 1625–1700

It is not clear where Artus II Quellinus received his training. Most probably he perfected his skill in the studio of his cousin Artus I in Antwerp. Artus II became master in the Antwerp guild of St. Luke in 1650 and joined his cousin in Amsterdam about 1652 to help him on the decoration of the town hall. He returned to Antwerp at the end of 1654. Only in 1663 did he officially become a citizen of the city of Antwerp. In 1667 he obtained the commission for the pulpit of the Church of St. Walburga in Bruges, Belgium, where Father Willem Hesius probably helped him devise the iconographic program. This pulpit with only one supporting figure, representing Hope, immediately displays a more theatrical style than his cousin Artus I's works, a style in which he replaces the fully plastic forms with asymmetric and graceful figures.

His niche figure of *Saint Rose of Lima*, in Antwerp's Church of St. Paulus, is sensitive and delicate. Its contrasting heavy folds and tender, meditating facial expression make it one of the most touching creations of the Antwerp Baroque style.

Artus II obtained an impressive list of commissions for tomb monuments. The praying effigy of the Abbess Anna Catharina de Lamboy, now in the Church of Onze-Lieve-Vrouw, Hasselt, Belgium, displays the sculptor's usual gracefulness. The rendering of the facial expression bears witness to the high level of his naturalism. Nevertheless, Artus II's masterpiece is without doubt the tomb monument to Bishop Marius Ambrosius Capello in the Cathedral of Antwerp. The tomb is of the semireclining type, with Capello lying on his left side and his hands in prayer. The portrait is chiseled with remarkable realism, and the lace of his stole and pluvial evidences Artus II's virtuosity in carving the marble. Artus II's figure *God the Father* on the rood loft of the Church of St. Salvator in Bruges is impressive in its composition, dynamism, and play of light and shadow. One of his most remarkable creations is the high altar of the Church of St. Jacob in Antwerp, executed together with Guilliclmus and Willem Kerricx as well as Willemssen. The sculpted image of the *Glorification of Saint James* on this high altar replaces the traditional painted altarpiece. The flowing drapery, the twisted styling, and the moving expressions characterize Artus II's late Baroque style.

Important to the diffusion of the Flemish late Baroque style in Denmark was the commission that Artus II secured for the erection of the tomb monument to Field Marshal Hans Schack in Copenhagen. The definitive contract for the monument was signed on 4 February 1687. It was only in 1689 that Thomas Quellinus, Artus II's son and collaborator, was to finish this military tomb monument in the Church of the Holy Trinity. Unfortunately, this work was heavily damaged during the fire of Copenhagen in 1728.

Artus (Arnold) III Quellinus 1653–ca. 1686

Artus III Quellinus, the eldest son of Artus II, enjoyed his training in the workshop of his father. From the 1680s he was settled in London. He often collaborated with Grinling Gibbons, who essentially specialized in decorative woodcarving, whereas Artus III excelled over him in the carving of stone and marble. In 1681 they formed a "copartnership," which they dissolved in 1683 after a quarrel. During these years, the two artists realized the marble altarpiece (destroyed) for James II's Roman Catholic chapel at Whitehall Palace in London. Of this only a few fragments and two kneeling angels remain. The Ferrers Monument in the Church of St. Editha, Tamworth, Staffordshire, England was also the product of their collaboration.

Artus III executed a number of tomb monuments, such as that to Thomas Thynne of Longleat in Westminster Abbey in London. In a moving relief, the sculptor represented the murder of Thynne on Pall Mall in London. The tomb monument to Archbishop Richard Sterne in York Minster is also by Artus III. He executed the remarkable marble statue *Sir John Cutler* for the Grocers' Hall in London and a series of statues for the second Royal Exchange, among which is *Charles II*; a terracotta model is preserved in Sir John Soane's Museum in London.

Artus III remained faithful to the Flemish tradition and was seen as too theatrical in England. His naturalistic style was too affected for the English taste.

Thomas Quellinus 1661–ca. 1709

Like his brother Artus III, Thomas Quellinus received his sculptural training in his father's workshop. He joined Artus III in London and remained there until 1688. He then traveled to Copenhagen to work on his father's commission for the tomb monument to Field Marshal Hans Schack. He settled there as an independent sculptor and ran a workshop with mostly Flemish assistants, specializing in tomb monuments for well-to-do Danish and northern German patrons. He also executed the high altar of the Marienkirche in Lübeck, Germany, which was partly realized in Antwerp and partly in Copenhagen. His most renowned work is the

QUELLINUS (QUELLIN) FAMILY

Gabriels, Juliane, *Artus Quellien, de Oude, "Kunstryck belthouwer,"* Antwerp: De Sikkel, 1930

Gibson, Katharine, "The Emergence of Grinling Gibbons as a 'Statuary,' " *Apollo* 90 (1999)

La sculpture au siècle de Rubens dans les Pays-Bas méridionaux de la principauté de Liège (exhib. cat.), Brussels: Musée d'Art Ancien, 1977

Stewart, J. Douglas, "Some Unrecorded Gibbons Monuments," *The Burlington Magazine* 108 (March 1963)

Stewart, J. Douglas, "New Light on the Early Career of Grinling Gibbons," *The Burlington Magazine* 118 (July 1976)

Thorlacius-Ussing, Viggo, *Billedhuggeren Thomas Quellinus*, Copenhagen: Koppel, 1926

Van de Velde, Carl, "Rubens, de gebroeders Quellien en de beelden van St.-Ignatius en St.-Franciscus in het koor van de Jezuïetenkerk te Antwerpen," in *Rubens and His World*, edited by Roger Adolf d'Hulst, Antwerp: Gulden Cabinet, 1985

Vlieghe, Hans, "Quellinus," in *The Dictionary of Art*, edited by Jane Turner, vol. 25, New York: Grove, and London: Macmillan, 1996

Whinney, Margaret, *Sculpture in Britain, 1530–1830*, London and Baltimore: Penguin, 1964; 2nd edition, revised by John Physick, London and New York: Penguin, 1988

QUESNOY, FRANÇOIS DU,

see **du Quesnoy, François**

R

RADOVAN 13TH CENTURY *Dalmatian* (*present-day Croatia*)

A Dalmatian sculptor of great talent, Radovan is inextricably associated with one particular work of art: the west portal of Trogir Cathedral (in present-day Croatia). The portal is one of the most outstanding 13th-century monuments in Dalmatia. Its complex program, which skillfully binds together the elements of late Romanesque and Early Gothic sculpture, was probably the creation of more than one artist, executed over a period of time. Nevertheless, Radovan was undoubtedly the chief sculptor, as the inscription on the lintel above the door proclaims. The inscription dates the work to 1240, the time of Bishop Treguano of Tuscany, Italy, and describes Radovan as the best in his art, "as testified by his reliefs and statues" ("Raduanum cunctis hac arte preclarum ut patet ex ipsis sculpturis et ex anagliphis").

The older and most accomplished parts of the portal have usually been attributed to Radovan alone. They include most of the carving on the main tympanum, especially the *Nativity Scene*; some of the inner archivolt reliefs (the *Annunciation*, the *Adoration of the Magi*, and the *Dream of Joseph*); the two carved colonnettes (small columns) flanking the door with intertwined floral and figural motifs; and the whole of the right-hand jamb (*Labors of the Summer Months*) and the two top reliefs of the left (*Labors of the Winter Months*). The Passion scenes on the outer architrave and the rest of the jamb carvings, including the figures of apostles, have been attributed to the workshop or followers. The atlantes and the large figures of Adam and Eve have also been attributed to Radovan's assistants, although the latter attribution is not unproblematic (see Fiskovic, 1965).

Despite the necessary division of labor and a slight chronological disparity, the large sculptural program of the Trogir portal displays a remarkable unity of concept and design. Its central theme focuses on the importance of Christ's incarnation and sacrifice for the salvation of humankind. The primordial sin, epitomized by the naked figures of Adam and Eve flanking the main entrance into the cathedral, is redeemed through the miracle of the *Nativity Scene* above the portal. The apostles on the jambs bear witness to Christ's teaching and Passion, whereas the writhing figures in the foliage, and the *Labors of the Months* and zodiac signs adjacent to them, symbolize the order imposed on disorder within the Christian universe. Abundant inscriptions on the tympanum help elucidate the visual narrative to those able to read Latin. Furthermore, they seem to fix precisely each object and character of that narrative, glossing its every detail. The freestanding lions (also attributed to Radovan) below the figures of Adam and Eve may have originally been intended to support a porch. The portal shows signs of several later alterations.

The analysis of Radovan's style has proved an equally complex task. Broadly speaking, his work stems from an older tradition of north Italian sculpture, exemplified by Wiligelmo's and Niccolò's achievements in the previous century. At the same time, Radovan's sculpture displays signs of many different influences, tempting scholars to propose speculative itineraries for the artist until his arrival in Trogir. Some

Lion, Eve, and bas reliefs on facade portal, Cathedral of Trogir
© Ruggero Vanni / CORBIS

lonnettes and the carefully observed genre scenes of the *Labors of the Months* to the theatrical solemnity of the *Nativity Scene* on the tympanum, nestled between the pastoral idyll of the *Annunciation to the Shepherds* and the three progressing *Magi*. The figures of the monthly labors, engrossed in their seasonal domestic activities, display many local features, such as the garments and the types of tools and instruments used. Radovan's draperies are soft and delineate the anatomy of the figures. The sculptor's wide and detailed knowledge of fantastical, wild, and domestic animals may have been enriched through contact with illuminated manuscripts.

The portal of Trogir Cathedral is the only work safely attributed to Radovan. Apart from his possible involvement with the workshop of San Marco in Venice in the 1230s, he was probably also responsible for the two oculi on either side of the Trogir portal, as well as the ciborium and the pulpit inside the cathedral. The ciborium and pulpit are not decorated with sculpture, but their finely chiseled capitals and the pronounced classicizing character of the columns and arches are reminiscent of Radovan's style. It is thought that his work may have been permanently interrupted by the devastating Tartar invasion of the kingdom of Hungary and Croatia in 1242, although some of his followers continued the work on the portal. Radovan's followers seem also to have been employed on the tympanum of the Church of St. John in Trogir. Radovan's own subsequent fate and career remain obscure.

ZOË OPAČIĆ

Biography

Date and place of birth unknown, although likely to have been born in Dalmatia (present-day Croatia). May have spent his early active years in the various centers in Italy, including Venice; in Trogir worked on cathedral portal, 1240s; some evidence that work there was interrupted, possibly owing to political turmoil. Nothing is known about the artist after this date.

Selected Works

1230s Figures on inner arch of main portal; stone; Basilica of San Marco, Venice, Italy (attributed)
1240s West portal, including *Nativity Scene, Annunciation, Adoration of the Magi, Dream of Joseph, Labors of the Summer Months, Labors of the Winter Months* (only upper two), and floral and figural motifs; limestone; Trogir Cathedral, Croatia

aspects of the portal's iconography (such as the dress and posture of the Virgin Annunciate) are undoubtedly echoes of Byzantine tradition, still much in evidence in Dalmatia at that time. Nevertheless, the closest parallel to Radovan's work has been found in the sculpture of Benedetto Antelami (especially at Parma Cathedral) and at the Basilica of San Marco in Venice. The link with Venice is seen as particularly relevant for the artist's years of apprenticeship. A close similarity of the figures on the inner arch of San Marco's main portal to those on the colonnettes of Trogir Cathedral suggests his direct involvement. Other sources are found as far afield as Amiens, Chartres, and Laon in France.

Despite these numerous stylistic strands, Radovan's contribution is not merely an exercise in skilled eclecticism. His strongly individual artistic personality is clearly apparent in his work. Although there is no great variety in the facial type of his figures, his rich carvings show a great expressive power and a close observation of nature. The rhythm of his sculpture changes from the animated vigor of the fighting beasts on the co-

1240s Sculptured oculi, ciborium, and pulpit; limestone and marble; Trogir Cathedral, Croatia

Further Reading

Babić, Ivo, et al., *Trogir's Cultural Treasure*, Zagreb: Turist-komerc, 1987

Babić, Ivo, editor, *Majstor Radovan i njegovo doba: Zbornik radova medjunarodnog znanstvenog skupa održanog u Trogiru 26–30 rujna 1990. godine*, Trogir, Croatia: Muzej Grada, 1994p

Demus, Otto, "Bemerkungen zu meister Radovan in San Marco," *Jahrbuch der Österreichischen Byzantinistik* 38 (1988)

Fisković, Cvito, *Radovan*, Zagreb: Izdavacko Poduzece, 1965

Goss, Vladimir, "Parma-Venice-Trogir: Hypothetical Peregrinations of a Thirteenth-Century Adriatic Sculptor," *Arte Veneta* 34 (1980)

Karaman, Ljubo, *Portal majstora Radovana u Trogiru*, Zagreb: Jugoslavenska Akademija Znanosti i Umjetnosti, 1938

RAINER OF HUY *fl.* 1107–1144 *French*

Active between 1107 and 1144, the goldsmith Rainer of Huy is mentioned once in a late source called *La Chronique Liégeoise*, which was written in 1402. A passage of that chronicle, which paleographers believe was composed about 1280, assigns the creation of the Liège baptismal font to a certain "Renerus aurifaber Hoyensis." In 1125 Rainer (*Reinerus aurifaber*) subscribed to a charter in favor of one of the altars of the *collegiale* (collegiate church) of Notre-Dame in Huy by Albero I, bishop of Liège. In the obituary of Neufmoustier, a small village near Huy, composed about 1150, the death of a *Reinerus aurifex* is commemorated on 4 December. Although medieval textual sources give artists' names that are not easily linkable to actual works of art, unless they are signed, it is in any case assumed by all authors that the three sources here discussed describe one and the same Rainer. Thus, if the information given by the *Chronique Liégeoise* is correct, this would make Rainer the author of a *unicum* (unique work) in medieval art history: the baptismal font of Liège. The font, which is barely comparable to any other of its kind—as the 1119 *Chronicon Rythmicum Leodiense* declared ("arte vix comparabili")—is remarkable not only for its technique and its style but also for its iconography. A series of small bronze crucifixes, two of which have been attributed to Rainer of Huy (see Usener, 1933; Euw, 1982), are the only other works of art that can be attached to Rainer's activity in the Meuse region, whereas some of the reliefs of the Châsse of St. Hadelinus at the Church of St. Martin in Visé have been attributed to a direct disciple trained in his workshop. The censer kept at the Musée des Beaux-Arts in Lille, although signed by a certain Reinerus, is not from the master's hand and should be dated from about 1160.

The baptismal font reached the Church of St. Bartholomew in Liège in 1804 after the destruction of its former location, the church of Notre-Dame "aux Fonts," during the Revolution in 1796. The *Chronicon rythmicum Leodiense* provides precious information on the date of its creation. For the year 1118, one can learn that the abbot of Notre-Dame, Hillinus, ordered the font to be made. This text also gives information about its technique and iconography, notably about its now-lost cover that was decorated with apostle and prophet figures. The font was cast in one piece, vat and reliefs together, using the technique of *cire perdue* (lost wax) casting. The metal used was brass, which is an alloy of copper and calamine (zinc carbonate). Although scientific analysis has shown that the lead present in the alloy does not originate from the Meuse region but more probably from Spain or Sardinia, it does not exclude a local origin for the baptismal font since the necessary material could have been brought by commercial exchanges. And we know for certain that about 1100 the diocese of Liège presented all the economical and technical conditions required for the production of such a piece (see Kupper, 1994).

Today the cylindrical vat stands on ten oxen; formerly there were twelve, arranged in groups of three to form four bases disposed at the cardinal points. According to the inscription that runs on the vat's lower edge, the oxen's feet certainly plunged into the Jordan's waters: " + Bissenis bobus pastorum forma notatur quos et apostolice commendat gratia vite + + officiiq[ue] gradus quo fluminis impetus huius + letificat sanctam purgatis civibus urbem +." An undulating line functioning as the ground line ripples around the vat's surface on which the scenes unroll, separated from each other (except for the last two episodes) by a tree that also serves as a landscape mark. The inscriptions running on the vat's brim comment on each scene, whereas on the field, short *tituli* identify the protagonists represented and biblical quotations reproduce their speech.

Following a chronological order, the preaching of St. John the Baptist to four publicans, or tax collectors, comes first (Luke 3:12, 3:14). Then follows their baptism. In accordance with Luke's Gospel, these first two scenes are followed by the *Baptism of Christ* (Luke 3: 21). The composition is rigorously constructed along a median axis emphasized by the frontal figure of Christ half immersed in the Jordan's waters. He is flanked by St. John the Baptist at his right and two angels at his left. The bust of God the Father emerging from heaven and the Holy Ghost in the form of a dove are above each other along this same axis. The next two scenes are inserted in the same field bordered by

two trees. They are treated as if the one were the mirror image of the other, although with a rotation. A common inscription qualifies both scenes, stressing their symmetry: "Hic fidei f[o]ns est petrus hos lavat hosq[ue] iohannes." The first scene illustrates Acts 10: 1–48, which relates the conversion of the centurion Cornelius and his baptism by St. Peter, after which follows the legendary baptism of Crato the philosopher by St. John the Evangelist. The legend comes from Pseudo-Obadiah's *Historiae Apostolicae*, a text written at the end of the 6th century that was eventually included in Jacopo da Voragine's *Golden Legend* in the 13th century. In the baptismal font, iconography strictly combines with epigraphy to translate a strong theological conception whose roots are to be found not, as has been brilliantly shown by Reudenbach, in Rupert of Deutz's *De Sancta Trinitate et Operibus Eius*—composed at Liège between 1114 and 1116— but in Beda Venerabilis's (the Venerable Bede's) *De Templo* (see Reudenbach, 1984).

Conceived as the antitype of the Brazen Sea (1 Kings 7: 25), the font stands at the convergent point of two typologies, namely baptism and church mission. The inscriptions on the vat's brim and the different scenes depicted clearly announce faith in the Holy Trinity and proclaim conversion and baptism for all peoples, here typified by the baptism of the Jews and the heathens Cornelius and Crato, in order to establish the Christian Church on earth.

Rainer's intent to leave the vat's background free is important; even the carved inscriptions are hardly visible so that no detail shall unbalance the field's unity. The field indeed plays its own role as a space into which the characters evolve as if on a stage (see Usener, 1933). Rainer's figures show by their physiognomy, dress, poses, and gestures a very large repertory of expressions that have always been qualified as Antique or Classical. The reliefs of the Liège baptismal font bear an undeniable resemblance to the art of modeling of Antiquity, but as has been shown (see Usener, 1933), his style derived from the Carolingo-Ottonian repertory of forms provided by early 11th-century ivories from Liège. But this alone could not explain the revival of the beginning of the 12th century. The properly Late Antique influence most probably also comes through reliefs and small-scale sculptures such as Roman provincial bronze statuettes from the 4th and 5th centuries (see Lapierre, 1982). Rainer's classicism was deeply influential in the Meuse region and had repercussions on the art of Godefroid of Huy and of Nicolas of Verdun later in the 12th century.

PIERRE ALAIN MARIAUX

See also **Baptismal Font**

Biography

Born in the late 11th century, location unknown. Active as a goldsmith and sculptor in the Meuse region (in what is now Belgium) in the early 12th century; subscribed to a charter for one of the altars of the *collegiale* (collegiate church) of Notre-Dame in Huy, Belgium, 1125. Died in Neufmoustier, Belgium, *ca.* 1150.

Selected Works

1107–18 Baptismal font; brass; Church of St. Bartholomew, Liège, Belgium

ca. 1100–1120 *Christ's Transfiguration*; ivory; Bibliothèque de l'Arsenal, Paris, France (attributed)

ca. 1100–1125 Crucifix; bronze; Schnütgen-Museum, Cologne, Germany (attributed)

ca. 1120–30 Crucifix; bronze; Schnütgen-Museum, Cologne, Germany (attributed)

ca. 1140–50 Châsse of St. Hadelinus (shrine); Church of St. Martin, Visé, Belgium (attributed)

ca. 1160–65 Censer; Musée des Beaux-Arts, Lille, France (attribution disputed)

Further Reading

Collon-Gevaert, Suzanne, Jean Lejeune, and Jacques Stiennon, *Art roman dans la Vallée de la Meuse aux XIe, XIIe et XIIIe siècles*, Brussels: L'Arcade, 1962; as *A Treasury of Romanesque Art: Metalwork, Illuminations, and Sculpture from the Valley of the Meuse*, translated by Susan Waterston, London and New York: Phaidon, 1972

Euw, Anton von, "Ein Beitrag zu Reiner von Huy," in *Clio et son regard: Mélanges d'histoire, d'histoire de l'art et d'archéologie offerts à Jacques Stiennon à l'occasion de ses vingt-cinq ans d'enseignement à l'Université de Liège*, edited by Rita Lejeune and Joseph Deckers, Liège, Belgium: Mardaga, 1982

Jean-Louis Kupper, "Les Fonts baptismaux de l'église Notre-Dame à Liège: Le point de vue d'un historien," in *Productions et échanges artistiques en Lotharingie médiévale: Actes des 7es journées lotharingiennes*, edited by Jean Schroeder, Luxembourg: Imprimerie Linden, 1994

Lapierre, Marie Rose, "A propos des fonts baptismaux de Saint-Barthélémy: Plastique païenne et symbolisme biblique," in *Clio et son regard: Mélanges d'histoire, d'histoire de l'art et d'archéologie offerts à Jacques Stiennon à l'occasion de ses vingt-cinq ans d'enseignement à l'Université de Liège*, edited by Rita Lejeune and Joseph Deckers, Liège, Belgium: Mardaga, 1982

Reudenbach, Bruno, *Das Taufbecken des Reiner von Huy in Lüttich*, Wiesbaden, Germany: Reichert, 1984

Usener, Karl Hermann, "Reiner von Huy und seine künstlerische Nachfolge: Ein Beitrag zur Geschichte der Goldschmiedeplastik des Maastales im 12. Jahrhundert," *Marburger Jahrbuch für Kunstwissenschaft* 7 (1933)

BARTOLOMEO CARLO RASTRELLI *ca.*
1675–1744 *Italian, active in Russia*

Bartolomeo Carlo Rastrelli belonged to that group of Italian artists who traveled to various countries in search of commissions and work. He found a second homeland in Russia and essentially became the first Western sculptor to produce successful work there.

There is almost no information concerning Rastrelli's youth. He was a student of Giovanni Battista Foggini in Florence. Around 1700, after a brief stay in Rome, he moved to France. From 1703 to 1707 he worked on the monumental tomb of Simone Armaud, marquis de Pomponne, for the Church of St. Merri in Paris (the work was destroyed during the French Revolution). Judging from the evidence, the tomb was created in the style of the High Baroque using multicolored marble and gilt bronze. Rastrelli planned other tombs in the same style; apparently none was realized (the drawings reside in the National Library in Warsaw, Poland). Rastrelli's first signed and dated works have only recently come to light: *A Woman's Portrait* and a statuette of the reclining Mary Magdalene. Although these works are testimony to the sculptor's good professional training, they say little about his creative individuality.

On 19 October 1715, Rastrelli signed a contract for three years with Jean de Forth, Peter the Great's agent in Paris. At the end of March of the following year, Rastrelli arrived in St. Petersburg, which had only recently become the new capital of Russia.

Rastrelli's activity in Russia began with a reworking of the plans for the royal residence at Strel'na. However, the arrival of the French architect Jean Baptiste Alexandre Le Blond drove him from all architectural work: from that point on, he worked only as a sculptor. It is possible that he completed some projects in cooperation with his son, Francesco Bartolomeo Rastrelli, who began his artistic activity quite early.

Rastrelli's first assignment as a sculptor was the preparation of two marble statues for the decoration of fountains. However, Peter the Great refused this project. Later, Rastrelli worked exclusively in metals—bronze and lead. Around 1716–17, he completed a portrait of Aleksandr Menshikov in bronze. The effective composition of this bust wholly recalls the tradition of the Florentine Baroque, which probably is borrowed from one of the busts of Giovacchino Fortini.

Most likely during this time, Rastrelli began work on an image of Peter the Great, who became one of the main themes of his career. Aside from mounted works in various materials (among which is a 1719 portrait of the czar in wax), he worked on a triumphal column, similar to the Roman Column of Trajan (106–13 CE), that was to have been crowned with a figure

Empress Anna Ivanovna with Her Black Page
© The State Russian Museum

of the czar and placed above an equestrian monument to Peter the Great. For this column, Rastrelli executed a series of bronze reliefs portraying various episodes from the czar's life. The most expressive and effective of these is a bronze portrait of Peter the Great that was created between 1723 and 1729 (Hermitage, St. Petersburg). Presenting the ruler in the armor and fluttering cape customary to Florentine sculpture, Rastrelli showed the czar full of motion and energy, which wholly corresponds to the exceptional personality of the subject.

After Peter's death in January 1725, Rastrelli executed a seated figure of the czar in wax using real hair and documentary precision *(Wax Person)*. He may also have made a medal (1725/26; Hermitage, St. Petersburg) for Catherine I's accession to the throne. Later he worked on a projected mausoleum for the czar, but because of political reasons, this work was never realized.

Only with Empress Anna's coming to power did Rastrelli return to his position as official court sculptor. A bronze bust of an unidentified person from 1732, which several authors have mistakenly seen as a self-portrait of the artist, belongs to this period. Another work of this period is one of Rastrelli's masterpieces, the bronze group *Empress Anna Ivanovna with Her Black Page*. The monumental figure of the empress is executed with great precision and care to detail, which only serves to strengthen the impression of awesome power emanating from her countenance. The significance of the autocrat is emphasized by the small figure of the boy servant holding the royal regalia. This work may be compared with Spanish sculpture of the 16th century, and it seems purposely archaic.

Rastrelli worked extensively on the ornamentation of the royal residence at Peterhof. His first works for

CHRISTIAN DANIEL RAUCH 1777–1857

series of years, been . . . one of the most distinguished sculptors in Germany. . . . his industry has been no less notable than his genius."

Although Rauch remained based in Berlin throughout his career, he undertook several important commissions in Bavaria. These included the bronze monument to King Maximilian I Joseph, unveiled in Munich in 1835, and the six marble *Geniuses of Fame* executed for King Ludwig I's Walhalla, which opened in 1842.

Rauch's career reached its zenith with his equestrian statue of Frederick the Great, finished in 1851 and originally placed on the Unter den Linden in Berlin. Contemporaries lauded the bronze monument as the sculptor's supreme achievement, and it remains Rauch's best-known piece. After Frederick the Great's death in 1786, numerous proposals for a commemorative sculpture were debated, including several by Rauch's mentor Schadow. The controversy over whether the monarch should be depicted in timeless or historic costume was finally resolved in 1836, and Rauch was awarded the commission. He followed Schadow's plan for an equestrian statue in historically accurate dress, and he added an elaborate base. The upper level of the base depicts scenes from the king's life in relief, and four allegories adorn the corners. The lower level includes equestrian statues of Frederick's generals at the corners and shows cultural heroes from Frederick's reign.

At his death in 1857, Rauch was the most admired sculptor in Germany; his style had become the benchmark for excellence in academic sculpture. His dominant position in Berlin's sculptural circles continued until the end of the 19th century through his numerous pupils, including Ernst Rietschel, Friedrich Drake, and August Kiss. The majority of his work has stayed in Germany, including many pieces of *in situ* outdoor sculpture, and most scholarship on Rauch remains untranslated.

Scholarship in English has appeared on Elisabet Ney, a pupil of Rauch's. The German-born Ney studied with Rauch during the last years of his life. She later immigrated to the United States, bringing many of Rauch's tenets to her sculpting practice in Texas. Recent books on Ney provide information in English about the central role Rauch played as a sculptor and teacher in 19th-century Germany.

EVA BOWERMAN

See also **Canova, Antonio; Ney, Elisabet; Schadow, Johann Gottfried; Thorvaldsen, Bertel**

Biography

Born in Arolsen, Germany, 2 January 1777. Son of a chamberlain in the principality of Waldeck; brother of Friedrich the castellan at Schloss Sanssoucci, Potsdam, until 1797; with Wilhelmine Schulze, fathered two illegitimate daughters, Agnes (born 1804) and Doris (born 1812), whom Rauch adopted and later raised; apprenticed to the court sculptor, Friedrich Valentin, in Helsen, 1790–94; entered studio of Christian Ruhl at Cassel and attended Landgräfliche Akademie, 1795; royal service, 1797–1804; during this time followed evening class at Berlin Academy under Johann Gottfried Schadow; studied in Rome, 1804–11; worked in Berlin and Italy (Rome and Carrara) before settling in Berlin, 1818; opened studio in Berlin and became professor at Academy of Art, 1819. Member of various academies and artists' associations in Germany and abroad (e.g., Carrara, Rome, Munich, Paris, and Vienna). Died in Dresden, Germany, 3 December 1857.

Selected Works

1802 *Recumbent Endymion*; plaster (untraced)

1805–10 *Queen Louise as Juno Ludovisi*; marble; Schloss Sanssouci, Potsdam, Germany

1810–18 Relief of *Jason*; marble (unfinished); Nationalgalerie, Berlin, Germany

1810–26 *Adelheid von Humboldt as Psyche*; marble; Schloss Tegel, Berlin, Germany

1811–15 Sarcophagus of Queen Louise of Prussia; marble; mausoleum, Schloss Charlottenburg, Berlin, Germany; version, 1812–27; Friedrich-Werdersche Kirche, Berlin, Germany

1816–22 Monument to General Scharnhorst, for Schinkel's Neue Wache; marble; Unter den Linden, Berlin, Germany

1819–26 Monument to General Blücher; bronze; Unter den Linden, Berlin, Germany

1820 *A-Tempo Bust of Goethe*; marble; Museum der Bildenden Künste, Leipzig, Germany

1821–25 Statues of *Genius for Belle-Alliance* and *Genius for Paris* (also known as the *Martial Geniuses*); iron, bronze; Kreuzberg Monument, Berlin, Germany

1826–35 Monument to King Maximilian I Joseph; bronze; Max-Joseph-Platz, Munich, Germany

1828–40 Monument to Albrecht Dürer; bronze; Albrecht-Dürer-Platz, Nuremberg, Germany

1832–42 *Geniuses of Fame*; marble; Walhalla, near Regensburg, Germany

ca. Equestrian statue of Frederick the Great;
1836–51 bronze; Unter den Linden, Berlin, Germany

Further Reading

Art Journal, n.s., 5 (1853)

Avery, Charles, "Neo-Classical Portraits by Pistrucci and Rauch," in *Studies in European Sculpture*, London: Christie, 1981

Bloch, Peter, Sibylle Einholz, and Jutta von Simson, editors, *Ethos und Pathos: Die Berliner Bildhauerschule, 1786–1914* (exhib. cat.), Berlin: Mann, 1990

Cheney, Ednah Dow Littlehale, *Life of Christian Daniel Rauch of Berlin, Germany*, Boston: Lee and Shepard, 1893

Cutrer, Emily Fourmy, *The Art of the Woman: The Life and Work of Elisabet Ney*, Lincoln: University of Nebraska Press, 1988

Eggers, Friedrich, and Karl Eggers, *Christian Daniel Rauch*, 5 vols., Berlin: Fontane, 1873–91

Goar, Marjory, *Marble Dust: The Life of Elisabet Ney: An Interpretation*, edited by Thomas Goar, Austin, Texas: Eakins Press, 1984

Mackowsky, Hans, "Rauch, Christian Daniel," in *Allgemeines Lexikon der bildenden Künstler von der Antike bis zur Gegenwart*, edited by Ulrich Thieme, Felix Becker, and Hans Vollmer, vol. 28, Leipzig: Engelmann, 1934; reprint, Leipzig: Seemann, 1978

Post, Chandler Rathfon, *A History of European and American Sculpture from the Early Christian Period to the Present Day*, 2 vols., Cambridge, Massachusetts: Harvard University Press, 1921; reprint, New York: Cooper Square, 1969; see especially vol. 2

Rosenblum, Robert, and Horst Woldemar Janson, *19th-Century Art*, New York: Abrams, 1984; as *Art of the Nineteenth Century: Painting and Sculpture*, London: Thames and Hudson, 1984

Simson, Jutta von, *Christian Daniel Rauch: Oeuvre-Katalog*, Berlin: Mann, 1996

Simson, Jutta von, "Rauch, Christian Daniel," in *The Dictionary of Art*, edited by Jane Turner, New York: Grove, and London: Macmillan, 1996

RAVENNA, SEVERO DA

See **Severo da Ravenna**

VINNIE REAM 1847–1914 *United States*

Vinnie Ream was one of a group of women sculptors referred to by Henry James as the "white, marmorean flock." She emerged in the second generation of American sculpture. Although Ream is less well known today than her contemporaries, Harriet Hosmer and Edmonia Lewis, she bolstered her talent as a sculptor with a skillful manipulation of the press, becoming a celebrity in her day as much for her vivacious personality as for her work. Although several of her contemporaries had roots in New England, Ream grew up on the Western frontier. Born in Madison, Wisconsin, in 1847, she attended the Christian College in Columbia, Missouri. James R. Rollins, a trustee of the school, noticed her talent for art and music and encouraged

her to continue her studies. Her family moved to Washington, D.C., during the Civil War. At the age of 15 Ream began working as a postal clerk to supplement her family's income. During this period Ream was introduced to the sculptor Clark Mills by her Missouri mentor Rollins, who was by then a United States congressman. Shortly thereafter she became apprenticed to Mills, devoting all her spare time to sculpture. While studying with Mills she produced small ideal works as well as several portrait busts, most notably that of Congressman Thaddeus Stevens.

By all accounts Ream was pretty, charming, and ambitious. Although her family was neither wealthy nor distinguished, her coquettish appeal allowed Ream to become the darling of several influential politicians. According to one account, a senatorial introduction provided her the opportunity to sculpt Abraham Lincoln just prior to his death. With little work to her credit and still in her teens, Ream was allowed daily sittings with the president in the White House. From

Photograph (*ca.* 1870) of Vinnie Ream at work on Abraham Lincoln bust
© CORBIS

1600), a son of Archduke Ferdinand of Tyrol. Reichle's assignment was to create 44 clay figures of Andreas's Habsburg ancestors—both historic and fictional—to be placed in the niches of the courtyard in the planned Residenz, complemented by crests and devices. This grandiose plan was not completed during the cardinal's lifetime; by 1601 Reichle had completed over 38 figures and 44 crests. Because the courtyard was never completed according to plan, the successor had the figures, along with six statues added by Reichle in 1607, gilded and put on display in the hall. Finally, in the 19th century, 24 of the statues were colored bronze and set on display in the courtyard. Others are now in the east wing of the Brixen Residenz, two in the Museum Ferdinandeum, and one in the Maximilianmuseum in Augsburg.

The Brixen project could hardly have avoided becoming monotonous, particularly as Reichle apparently had to work with someone else's dull model. The figures often seem heavy and awkwardly posed. They are also quite uniform, despite the great variety of "portraits"; the faces have large blocklike straight noses, sharply defined eyebrows, and enlarged but empty eyes. Surprisingly, Reichle did not correct the figures of his model to conform to Giambologna's figural ideal and Florentine Mannerism. The figures achieve their pathos through their sheer massiveness and rich ornamentation, very much in the taste of the German late Renaissance. Evidently, this was in accord with the patron's wishes. The cardinal's successor ordered the remaining figures from Reichle; other pieces from his Brixen period were either lost or never produced, such as terracotta statues of St. Andreas, St. George, and St. Catherine for the high altar of Brixen Cathedral or for a fountain ornamented with multiple figures.

In 1601 Reichle returned to Florence, where he worked under the bronze caster Domenico Portigiani on three new bronze portals for the Cathedral of Pisa, after the originals had been destroyed in a fire in 1595. After Giambologna had turned down the assignment, Portigiani gathered together all of Giambologna's well-known assistants to work on the project collectively. Reichle completed the *Nativity*. For this relief Reichle employed Giambologna's structural schemata, such as an arcade suggesting spatial depth. But he also added numerous naturalistic details, including landscape in the background. Although the resulting work's perspective is not entirely consistent, the overall impression of the piece compensates for the strongly modeled individual figures.

After a short stay in Brixen, where he marriried, Reichle returned to Augsburg in 1603, where he remained until 1607. His Augsburg pieces show him at the peak of his abilities. Here, he received assignments for magnificent works of sculpture, such as the bronze group *Archangel Michael Vanquishing Lucifer* on the facade of the arsenal and the monumental bronze figures for the altar of the Holy Cross in the Church of Saints Ulrich and Afra. Reichle had been called to Augsburg to decorate the arsenal, recently built by Elias Holl, with the *Archangel Michael* bronze group. With this project the city was continuing its series of bronze monuments, such as the Augustus Fountain (1589–1594) by Gerhard, and the Mercury Fountain in 1599 and Hercules Fountain in 1603 by Adriaen de Vries. The massive group of the *Archangel Michael*, who defeats the devil with his sword, with monumental putti alongside bearing weapons and flags, has become Reichle's masterpiece.

Reichle's second greatest work in Augsburg is the bronze Crucifixion group in the Church of Saints Ulrich and Afra, commissioned by Abbot Johannes Merk in 1605. Reichle's Crucifixion, originally set up in the middle of the nave, was part of a comprehensive renovation of the interior of the church, for which the choir and the nave were furnished with terracotta statues in niches, after the example of the Church of St. Michael in Munich.

Reichle's figures of *Mary Magdalene* and the *Christ on the Cross* emulate the group in the Church of St. Michael, which had been displayed there as a cross altar since 1602. Compared with Reichle's earlier *Mary Magdalene* in Munich, the Augsburg *Mary Magdalene* has a more voluminous form, probably following Reichle's own sense of form, which no longer had to adhere to Friedrich Sustris's model. The mourning figures of Mary and John in the Augsburg group achieve pathos with their sweeping forms, as well as through their sumptuously formed garments, seen from the rear. As with many of Reichle's works, and in common with other artists of his generation, this work seems to incorporate earlier stylistic phases than those of his teachers. Here, for instance, he was perhaps drawing on the formal possibilities of the Dürer era. Of the 32 over–life-size terracotta saints' figures that were displayed in the wall niches of the Church of Saints Ulrich and Afra, only five heads and one torso have survived the destruction of the series in 1873. Their attribution to Reichle has remained questionable.

Reichle also crowned the renovated Siegelhaus in Augsburg, the official municipal building for imports, with a bronze eagle. A surviving sheet with conceptual sketches for the monumental eagle signed by Reichle and dated 1605 illuminates his graphic ability as well. In the generous modeling, intended to be viewed from a distance, the eagle anticipates the forms of the Baroque period.

With the erection of the *Archangel Michael* group in 1607, Reichle's projects in Augsburg were com-

pleted. He returned to Brixen to furnish the remaining figures of the Habsburg cycle. He devoted the last 30 years of his life to projects other than sculpture, although not from a lack of assignments—King Christian IV of Denmark offered him the assignments for a bronze fountain for Frederiksborg Castle and other pieces. In 1610 Reichle was discussed as a potential sculptor for the Market Fountain in Danzig. The artist, however, expressed the desire to remain in Brixen for the rest of his life and requested a permanent position there, emphasizing his abilities as an engineer, architect, and master builder.

Only a single sculptural work has been preserved from the Brixen period after 1608: a small tomb relief of the *Descent from the Cross* made for a friend (Liebfrauenkirche, Bruneck, South Tyrol). The composition toward the top is reminiscent of a painting by Federico Barocci in Perugia; nonetheless, Reichle's difficulty with spatial structuring once again reveals itself in this relief, whereas his massive individual figures appear self-contained.

Repeated attempts have been made to assign small bronzes to Reichle. Nonetheless, as yet only one piece has proved stylistically convincing: a Venus Callipygos in Oxford (Ashmolean Museum).

DOROTHEA DIEMER

See also **Francavilla, Pietro; Giambologna; Gerhard, Hubert; Vries, Adriaen de**

Biography

Born in Schongau, Upper Bavaria, Germany, *ca.* 1565/70. Son of probably a cabinetmaker who worked for the courts in Munich and Innsbruck. Recorded as an apprentice in Hubert Gerhard's studio in Munich, 1586; documented as an assistant to Giambologna, Florence, 1587/88–94/95; worked for Duke William V of Bavaria, 1595; employed by Cardinal-Prince-Bishop Andreas von Habsburg of Brixen, Austria (now Bressanone, Italy), 1596–1601; received commissions for large bronze pieces in Augsburg, Germany, 1603–07; returned to Brixen, 1607, and was active there primarily as an engineer and architect. Died in Brixen (now Bressanone), Italy, 1642.

Selected Works

1595	*Mary Magdalene*, collapsed at the foot of the Cross; bronze; Church of St. Michael, Munich, Germany
1596–1607	Forty-four statues of Habsburg forefathers; terracotta; Archbishop's Palace, Bressanone, Italy; one example: Maximilianmuseum, Augsburg, Germany; two other examples: Museum Ferdinandeum, Innsbruck, Austria
1601	*Nativity* relief; bronze; west portal, Cathedral of Pisa, Italy
1603–07	*Archangel Michael Vanquishing Lucifer*; bronze; Armory, Augsburg, Germany
1605	Adler; bronze; Maximilianmuseum, Augsburg, Germany
1605	*Christ on the Cross, with Mary Magdalene, the Virgin Mary, and Saint John Mourning*; bronze; Church of Saints Ulrich und Afra, Augsburg, Germany

Further Reading

Baer, Wolfram, Hanno-Walter Kruft, and Bernd Roeck, editors, *Elias Holl und das Augsburger Rathaus* (exhib. cat.), Regensburg, Germany: Pustet, 1985

Diemer, Dorothea, "Quellen und Untersuchungen zum Stiftergrab Herzog Wilhelms V. von Bayern und der Renata von Lothringen in der Münchner Michaelskirche," in *Quellen und Studien zur Kunstpolitik der Wittelsbacher vom 16. bis zum 18. Jahrhundert*, edited by Hubert Glaser, Munich: Hirmer, 1980

Diemer, Dorothea, "Reichle, Hans," in *The Dictionary of Art*, edited by Jane Turner, New York: Grove, and London: Macmillan, 1996

Kriegbaum, Friedrich, "Hans Reichle," *Jarhbuch der Kunsthistorischen Sammlungen in Wien*, n.s., 5 (1931)

Welt im Umbruch: Augsburg zwischen Renaissance und Barock (exhib. cat.), 3 vols., Augsburg, Germany: Augsburger Druck- und Verlagshaus, 1980–81

ARCHANGEL MICHAEL VANQUISHING LUCIFER
Hans Reichle (ca. 1565/1570–1642)
1603–07
bronze
h. 4.27 m
Augsburg Arsenal, Augsburg, Germany

Hans Reichle's highly dramatic bronze group, over 4 meters high, of the Archangel Michael slaying Satan with a flaming sword, seconded by no-less-monumental putti bearing attributes of war such as banners and trophies, is among the chief works of early Baroque sculpture in Germany. Although still indebted to Florentine Late Mannerism in certain movements and motifs, Reichle brought so much unbridled power into the portrayal that the theatrical scene achieves a thoroughly Baroque pathos.

On 30 December 1603 Reichle signed a contract with the city councilors of Augsburg to sculpt the bronze group of the Archangel Michael triumphing over Lucifer for the facade of the city's arsenal. In 1602 the city architect, Elias Holl, had received the

sions of painting with the discipline of making real shapes. A painter may obscure a troublesome area with pigmented shadow, but the bas-relief sculptor must use real shadows to render pictorial effects.

Flattened relief, or *rilievo schiacciato* (relief sculpture emphasizing light and shadow through carving methods), is a sophisticated subcategory of bas-relief perfected during the Renaissance that uses subtle gradations of plane to falsify relationships in a way that suggests atmospheric perspective. Donatello's astounding marble relief of *Saint George and the Dragon* (1415–17) at Orsanmichele, Florence, and his *Feast of Herod* (*ca.* 1423–29) in the Baptistery of Siena Cathedral are outstanding examples of *rilievo schiacciato*, a virtuoso technique practiced by relatively few sculptors.

Related to bas-relief is sunken relief, a carving made entirely below the surface. The artist removes no background material but rather raises an image within a crisply engraved contour line. Sunken relief was common in ancient Egypt.

Early bas-relief sculptures depicted isolated individuals. A carved line showed where someone stood on the earth. Any implied movement was always to the right or left along the plane of relief. Typical subjects included ritual processions of gods or men. Egyptian and Mesopotamian relief conventions include carving the frontal eye on a profile head, with frontal shoulders blending through transitional hips into profile legs. Many Egyptian bas-reliefs show a figure with two left or two right hands.

Eventually, artists overlapped figures for the illusion of greater depth. Background heads peeked over the shoulders of the main characters; later, artists incorporated scenic elements. Some artworks blend low, high, and middle relief to mimic complex spatial relationships. With action no longer restricted to the plane of relief, subjects were shown moving out toward the viewer or deeper into the scene. Narrative sculpture was born when the same god or hero appeared over again in separate panels depicting different episodes of a story. Narrative relief sculpture became an important expression of cultural or religious identity. For example, sculpted stations of the cross on church walls unite Roman Catholics with a unifying narrative that cuts across languages and centuries.

Evidence exists of modeled high-relief clay animals on rock shelves within caves nearly 30,000 to 40,000 years ago. Scholars believe that Paleolithic artists raised decorative relief on weapons, tools, and other articles made of perishable materials, such as soft wood, for thousands of years before they carved more enduring horn, bone, and cave walls. Until metal tools became available in the first millennium BCE, relief sculptors used hard rocks to chip softer rock into im-

ages that were refined by painstakingly rubbing them with sand. Petroglyphs that are 25,000 years old have been found in southern Africa. Sicily's Cave of Addaura is decorated with incised outlines of 25-centimeter people and animals captured in motion some 12,000 to 17,000 years ago. An artist of the same period enhanced natural swells on the rock wall of La Madeleine Cave in France to create a life-size bas-relief of a recumbent woman.

The ancient civilizations of Egypt and Mesopotamia made permanent records of their achievements and beliefs in clay, limestone, granite, diorite, and marble. Egyptians were particularly ambitious builders, with a surfeit of limestone available. They planned so many architectural decorations for their temples, palaces, and tombs that they seldom had the time to chip away all of the background stone from around the relief figures of their rulers and gods, thus creating the tradition of sunken relief carving as a labor-saving device. They made many true relief sculptures as well, both high and low, including the awesome facade of the Abu Simbel temple (1240 BCE), with its four repetitive, approximately 20-meter-high relief sculptures of Ramses II carved directly into the rock cliff.

The ancient Egyptians saw continuity between this life and the afterlife, between one ruler and his successors, between one year's flooding of the Nile and the thousands that came before it, and their art reflected this worldview. The forms and conventions of Egyptian sculpture that coalesced around 4000 BCE remained essentially unchanged until their conquest by Greeks more than 3,000 years later. Scribes, priests, and commoners might be captured in portrait; however, the individual personality of each pharaoh was always subsumed into one idealized likeness. This tradition continued for thousands of years until the remarkable Akhenaton founded a new religion and a new art canon. A beautiful relief from 1360 BCE in the Cairo Museum shows Akhenaton and his family as recognizable individuals receiving the blessings of the sun. The great Egyptian relief tradition and Akhenaton's fascinating variant have influenced virtually every Western school of art to the present day.

The peoples of the Middle East showed a reverence for monumental relief sculpture that is surprising in a part of the world often lacking in permanent building material. Stone was transported over great distances to create such bas-reliefs as the remarkably advanced Akkadian victory stela of Naram-Sin erected at Sippar then moved to Susa (Mesopotamia; *ca.* 2200 BCE), now in the Musée du Louvre in Paris. This sculpture is unique among early works in its attempt to create a picture by showing the sky, a mountain, and trees along with the triumphant king and his army. Regional relief sculpture celebrated the sacred and the secular in Mes-

opotamia: on a diorite stela from about 1750 BCE, the Babylonian king Hammurabi confronts the sun god Shamash the Just with his famous law code.

High-relief Hittite lions from 1400 BCE inspired awe, fear, and respect in visitors to the Anatolian citadel at Hattusa (Bogazköy), which they guarded. Hittite low relief was born and matured between 1250 and 1220 BCE at one site, Yazilikaya, where one can trace the entire progression of development from perfunctory sunken-relief figures to multiplane figures with overlapping forms. Hittites refined their art for 30 years, using the same working method of modern architectural sculpture—master sculptors provided their assistants with models to guide the stone carving. Whereas modern technicians use pneumatic power tools, the Hittites used crude pointing hammers and abrasives. Hittites mastered the profile eye, but like their Egyptian counterparts, Hittite bas-reliefs attempt no depth greater than a single figure.

In Mesopotamia, the Assyrians, the next great imperial Near Eastern power, left behind some of the most admired of ancient relief sculptures. All Assyrian art glorified the king and his mastery of powerful animals, subjugation of rival kings, and fellowship with gods. A remarkable series of panels in the Brooklyn Museum in New York city show Ashurnasirpal (r. 883–859 BCE), the self-styled King of the World, in the company of winged genies, bestowing fertility upon the plants of the field. Ornate beards, wings, and fringes contrast with the simply massed planes of garments and the boldly delineated muscles of arm and calf. Some detail straddles the fence separating incised line drawing from relief without sacrificing any artistry.

Hunt scenes from 650 BCE Nineveh and Nimrud, now in the British Museum, London, rank with the finest relief art of all time. One panel shows enraged lions assailed by arrows the moment they are released from their cages. The wounded lioness in a second panel, pierced through her back with arrows, drags her useless hind legs in a last, pathetic effort to kill the huntsman. In a third, a lion leaps on the shoulders of a startled horse, but the unruffled King of the World Ashurbanipal (r. ca. 669–626 BCE)—not to be confused with Ashurnasirpal—displays his mastery by shoving a spear down the roaring lion's maw. An inscription on a fourth panel reads, "I am Ashurbanipal, king of hosts, king of Assyria, whom Ashur and Belit have endowed with might. Against the lions I slew, I directed the mighty bow of Ishtar."

At the city gates of Dur Sharrukin (Khorsabad), founded by Sargon II (r. 721–705 BCE), a pair of great stone creatures humbled all new arrivals. These guardian creatures, now in the Metropolitan Museum of Art in New York City, give the impression of being carved in the round, owing to clever innovations of the Assyr-

ian relief artist. From the front, each *mezzo-rilievo* carving of a human head sits atop the shoulders and legs of a powerful bas-relief animal. No stone has been excavated from beneath the body. Each side view carved in bas-relief has a surprising sense of movement. The Assyrian sculptor was bold enough to place a fifth relief leg in the walking position.

The Assyrian Empire that fell to the Scythians and Medes was replaced with a new imperial power at Babylon, which reached its zenith around 575 BCE, when Nebuchadnezzar adorned the city with gorgeously colored relief sculptures made of glazed brick. The Ishtar gate in Berlin's Staatliche Museen is a particularly fine example of Babylonian relief art.

Persians conquered and ruled the old Babylonian, Assyrian, Hittite, Mede, and Egyptian kingdoms between 612 and 331 BCE, blending the many native traditions they found into a tastefully restrained, courtly art that suited their refined culture. The dominant influence on Persian bas-relief was Assyrian art softened by two surprising touches: shoulders and pectoral muscles can be detected through clothes, which themselves fall into complex and harmonious pleats. This could only have come to Persian art through the influence of Ionian Greeks at the northwest frontier of the empire.

Lands near the Aegean Sea have a tradition of relief sculpture that goes back to 2000 BCE and the mysterious Minoans of Crete. Carvings traced to 1500 BCE are of such quality that an ongoing development of many centuries' duration can be assumed. The leaping goat on a limestone vase and the singing harvesters on a steatite vase—both treasures of Crete's Archaeological Museum in Iráklion—demonstrate confident handling of forms and movement, the latter vase even making early use of overlapping bodies, depth of space, perspective, and pictorial elements.

On mainland Greece, Mycenaean mercenary warriors who had served in Egypt brought home both their gold payment and an appreciation for Egyptian art. Imitative Mycenaeans combined Egyptian gold and Egyptian art, becoming skilled goldsmiths who hammered complex relief creations in jewelry, weapons, masks, and vessels. The Vaphio cups, from about 1500 BCE, in the National Archaeological Museum at Athens, are sophisticated *repoussé* compositions of the highest quality. On one, a foreshortened bullock trapped in a net convincingly twists toward the viewer, while his airborne rear quarters are held suspended in the groaning ropes.

Invasions plummeted Mycenae into a dark age. The Greek culture that raised itself in the 8th century BCE memorialized a dimly remembered heroic Mycenaean past in a relief art that had lost 1,200 years of progressive refinement—they blended geometric motifs with rudimentary figuration. Native artists of the 7th century BCE

an appreciation and respect for these relief works that continues to this day.

Relief sculptors from all art historical periods have had their successors. Artists from the 20th century had the freedom to draw upon every idiom of the past while creating daring new forms of its own. Today's relief sculptures—which are often manifested as multimedia installations—can be categorized as Abstract Expressionist, Futurist, Minimalist, Constructivist, Surrealist, Functionalist, Postmodernist, assembled, and deconstructed.

STEPHEN MIRABELLA

See also **Algardi, Alessandro; Bernini, Gianlorenzo; Bernini, Pietro; Berruguete, Alonso; Carpeaux, Jean-Baptiste; Cellini, Benvenuto; David d'Angers; Donatello (Donato di Betto Bardi); Doors; Du Broeucq, Jacques; Egypt, Ancient; Ghiberti, Lorenzo; Giambologna; Greece, Ancient; India; Michelangelo (Buonarroti); Near East, Ancient; Pradier, James (Jean-Jacques); Primaticcio, Francesco ("il Bologna"); Puget, Pierre; Rude, François; Sarcophagus; Sluter, Claus; Vela, Vincenzo; Vigarny, Felipe**

Further Reading

Alexander, Robert L., *The Sculpture and Sculptors of Yazilikaya*, Newark: University of Delaware Press, 1986

Dreyfus, Renee, and Ellen Schraudolph, *Pergamon: The Telephos Frieze from the Great Altar*, San Francisco: Fine Arts Museum of San Francisco, 1996

Friis Johansen, Knud, *The Attic Grave-Reliefs of the Classical Period*, Copenhagen: Munksgaard, 1951

Gardner, Helen, *Art through the Ages*, New York: Harcourt Brace, 1926; 11th edition, as *Gardner's Art through the Ages*, 2 vols., by Fred S. Kleiner, Christin J. Mamiya, and Richard G. Tansey, Fort Worth, Texas: Harcourt College Publishers, 2001

Grigson, Geoffrey, *Art Treasures of the British Museum*, New York: Abrams, and London: Thames and Hudson, 1957

Janson, Horst Woldemar, *History of Art*, Englewood Cliffs, New Jersey: Prentice-Hall, 1969; 6th edition, New York: Prentice-Hall and Abrams, 2000

Kowalczyk, Georg, and August Köster, *Decorative Sculpture*, New York: Weyhe, and London: Benn, 1927

Lullies, Reinhard, *Griechische Plastik von der Anfängen bis zum Ausgang des Hellenismus*, Munich: Hirmer, 1956; as *Greek Sculpture*, translated by Michael Bullock, New York: Abrams, and London: Thames and Hudson, 1960

Mehta, Rustam Jehangir, *Masterpieces of Indian Sculpture*, Bombay: Taraporevela, 1968

Paley, Samuel Michael, *King of the World: Ashur-nasir-pal II of Assyria, 883–859 B.C.*, New York: Brooklyn Museum, 1976

Penny, Nicholas, *The Materials of Sculpture*, New Haven, Connecticut: Yale University Press, 1993

Rayner, Edwin, *Famous Statues and Their Stories*, New York: Grossett and Dunlap, 1936

Rogers, Leonard Robert, *Relief Sculpture*, London and New York: Oxford University Press, 1974

Rothschild, Lincoln, *Sculpture through the Ages*, New York: Whittlesey House, and London: McGraw-Hill, 1942

Sculpture: From the Renaissance to the Present Day: From the Fifteenth to the Twentieth Century, Cologne, Germany, and New York: Taschen, 1999

Sullivan, Michael, *The Cave Temples of Maichishan*, Berkeley: University of California Press, and London: Faber, 1969

Verhelst, Wilbert, *Sculpture: Tools, Materials, and Techniques*, Englewood Cliffs, New Jersey: Prentice-Hall, 1973; 2nd edition, 1988

RELIQUARY SCULPTURE

Sculpture created to enshrine the relics of saints is among the most significant, distinctive, and enduring accomplishments of Western Christian art. From the time of Charlemagne to the eve of the Reformation—in marked contrast to reliquaries in the Byzantine world, which enshrined saints' bones in a manner that mimicked their profile and made the relic itself visible—reliquaries in western Europe often assumed highly inventive, three-dimensional images of the saint. In this essay, sculptural reliquaries will be defined as three-dimensional figural images in precious metal or wood that contained physical remains of the saints or objects associated with them; discussion will focus on bust- or head-shaped reliquaries, individual statuettes, and reliquaries in which statuettes are central elements. Because of space constraints, it will not treat sculptural reliquaries in the form of other parts of the body, sculpture that uses aspects of the cult of relics as its subject, or the less prevalent, less innovative reliquary sculpture produced after the Reformation.

Beginning with the earliest Christian authors, relics were highly valued. Eusebius's 2nd-century account of the martyrdom of St. Polycarp, which refers to his bones being "more valuable than precious stones and more to be esteemed than gold," eloquently expresses Christian attitudes toward their martyred dead. Because of their preciousness, these relics were often preserved in containers of costly materials. But as a consequence of their intrinsic material value, reliquaries were often destroyed during war, revolution, times of religious upheaval or economic difficulty, or because of changes of taste. Recognition of the importance of reliquary sculpture, as of the importance of reliquaries in the history of art in general, has traditionally been hampered by the paucity of surviving examples in comparison to monumental stone sculpture.

Most reliquary sculpture of the Middle Ages is the work of unknown artists. Some can be localized or even attributed to a particular master on the basis of stylistic comparisons to monumental sculpture. Increasingly, Late Gothic and Renaissance examples in precious metal can be securely localized by a hallmark or assigned to an artist by virtue of a contract or inscription. A history of reliquary sculpture must necessarily rely both on extant examples and documentary sources

that provide information concerning lost works, including inventories, pilgrims' badges, drawings, and engravings.

The first indisputable examples of the marriage of a relic with sculpture date from the Carolingian period. Carolingian reliquary sculpture took three principal forms: bust reliquaries, life-size images of the crucified Christ, and images of the Virgin and Child.

Boson, King of Burgundy, brother-in-law and vassal of Charles the Bald, commissioned the earliest documented reliquary bust to house the skull of St. Maurice, legendary leader of the Theban legion. The form of this late 9th-century reliquary, which was destroyed during the French Revolution, can be partially reconstructed from two sketches and a description made in 1612 by the French antiquarian Nicolas Fabri de Peiresc. These indicate that the reliquary was originally a bust-length image covered with sheets of metal and ornamented with jewels and bells. Similarly, a 10th-century inventory of the Cathedral of Clermont-Ferrand includes the *caput* (head) of a saint, probably Lawrence, the church's patron, that was clearly a three-dimensional bust, since it held a scepter and palm of martyrdom. Also in the diocese of Clermont, a precious image (*imagine*) of St. Pourçain was made on the occasion of the translation of his relics in 945 for the monastery that he founded. A 10th-century image (*imago*) of St. Martial, first bishop of Limoges, enshrined his head after 973. Most early examples of bust reliquaries are concentrated in central France; there is no documentation outside this region to suggest so early a pattern of devotion. Indeed, it was cited as a regional practice by Bernard of Angers in his *Miracles of Saint Foy*, written about his experience of the golden image reliquary for the skull of St. Foy created after the relics were brought to Conques in 864–75.

The earliest records of monumental crucifixes also date to the 9th century. There was a crucifix at Auxerre (813–23), in Le Mans (*ca.* 835), and at St.-Sauveur in Brittany (869). It is not always clear from references whether these contained relics, but a crucifix sheathed in gold and silver clearly containing a relic of the cross (*in qua particula Crucis Domini condita erat*) was installed in the Cathedral of Narbonne around 890 by Theodard. Research indicates that nearly half of 10th-century German crucifixes, such as the one given by Archbishop Gero of Cologne (970), contained relics.

Documentary evidence indicates that some early images of the Virgin and Child contained relics, notably one created for the Cathedral of Clermont-Ferrand around 946. The relics were often concealed. In the wake of a fire at Vézelay in the mid 12th century, a restorer happened upon relics contained within an image of the Virgin and Child including a lock of hair of the Immaculate Virgin, a swatch of her tunic, bones

of the blessed John the Baptist, a bit of the thumb of St. James, and a fragment of the scarlet robe that Jesus wore at his Passion.

In surviving examples, the presence of a relic within a sculpture often remains an open question. In the case of the *Virgin* from the Auvergne in the Metropolitan Museum of Art, New York City, a relic might be inferred from the existence of a hidden cavity in the chest. However, X rays have been unable to confirm the existence of a relic, and only invasive intervention would prove conclusive.

In England, an image of the Virgin was ordered by Abbot Fabritius of Abingdon, and an image at Ghent was made for Abbot Arnould to house relics brought from Constantinople. By 1171, an inventory of Winchester Cathedral included the head (*caput*) of St. Justus, decorated with gold and precious stones, which enshrined the skull that the cathedral had received as a gift from King Ethelstan in 924. These works are representative of the diffusion of these principal types of reliquary sculpture in Europe during the Romanesque period.

Although through the 12th century the sculpture concealed the relic within it, as in the case of the Virgin at Vézelay or the statue of St. Foy, reliquary sculpture from the 13th century made the relic (or part of the relic) visible following the dictates of the Fourth Lateran Council. Until early in the 13th century, most sculptural reliquaries were created by fixing sheets of silver or gold over a wood core that was carved. Some, like the bust of St. Cesarius at Maurs, used both polychromy, to simulate flesh and hair, and metal sheathing, to suggest luxurious vestments.

To accommodate changes in practice, to repair works damaged in use, and for numerous other reasons, reliquary sculpture was frequently restored, embellished, or even replaced altogether. The first image of St. Martial, patron of Limoges, was made after 952 and adapted as a reliquary in 973. This was replaced by other reliquaries at the end of the 12th century and the beginning of the 14th. Later, in 1380, a new bust of St. Martial was fabricated on the order of Pope Gregory XI, a native of the Limousin, only to be melted down during the French Revolution. The head reliquary of St. Valerie at Chambon-sur-Vouèze (Creuse) from the 15th century replaces an image mentioned in a text by Geoffreoy de Vigeois. A belt and gems were added to the image of St. Foy at Conques in the 14th century, and an aperture was created to cover a relic set in her stomach.

Beginning with the 13th century, documentary evidence increasingly suggests a wide geographic distribution and proliferation of sculptural reliquaries. In addition to busts, there was sculpture set into reliquaries that

RELIQUARY SCULPTURE

In the Cathedral of Reims, a gold and enameled reliquary of St. Ursula depicts the virgin martyr and her companions gathered on one of the ships that they used for their pilgrimage. Given by Henry III in 1572, the reliquary may originally have been made for Anne of Brittany in 1501. Finally, Notre-Dame Cathedral, Rouen preserves a silver- and copper-gilt and enamel reliquary of the Resurrection. Given by Henry II on the day of his coronation in 1547 and bearing his arms and those of Catherine de' Medici, it is a virtuoso sculpture in precious metal—the reliquary equivalent of Benvenuto Cellini's saltcellar in Vienna; it deserves to be similarly celebrated.

BARBARA DRAKE BOEHM

See also **Gerhaert von Leiden, Nikolaus;** *Goldenes Rössl* **(***Golden Horse***) of Altötting; Virgin and Child of Jeanne d'Evreux**

Further Reading

Baumstark, Reinhold, editor, and Renate Eikelmann, *Das goldene Roessl: Ein Meisterwerk der Pariser Hofkunst um 1400* (exhib. cat.), Munich: Hirmer, and Bayerische Nationalmuseum, 1995

Boehm, Barbara Drake, "Medieval Head Reliquaries of the Massif Central," Ph.D. diss., New York University, 1990

Braun, Joseph, *Die Reliquiare des christlichen Kultes und ihre Entwicklung*, Freiburg im Breisgau, Germany: Herder, 1940

Dahl, Ellert, "Heavenly Images: The Statue of St. Foy of Conques and the Significance of the Medieval 'Cult-Image' in the West," *Acta ad Archaeologiam et Artium Historiam Pertinentia* 8 (1978)

Forsyth, Ilene H., *The Throne of Wisdom: Wood Sculptures of the Madonna in Romanesque France*, Princeton, New Jersey: Princeton University Press, 1972

Halm, Philipp Maria, and Rudolf Berliner, editors, *Das Hallesche Heiltum: Man. Aschaffenb. 14*, Berlin: Deutscher Verein für Kunstwissenschaft, 1931

Holladay, Joan, "Relics, Reliquaries, and Religious Women: Visualizing the Holy Virgins of Cologne," *Studies in Iconography* 18 (1997)

Hubert, Jean, and Marie-Clotilde Hubert, "Piété chrétienne ou paganisme? Les statues-reliquaires de l'Europe carolingienne," in *Cristianizzazione ed organizzazione ecclesiastica delle campagne nell'alto Medioevo*, Settimane di studio del Centro italiano di studi sull'alto Medioevo, 28, Spoleto, Italy: Presso la Sede del Centro, 1982

Keller, Harald, "Zur Entstehung der sakralen Vollskulptur in der ottonischen Zeit," in *Festschrift für Hans Jantzen*, Berlin: Gebr. Mann, 1951

Kovacs, Eva, *Kopfreliquiare des Mittelalters*, Leipzig: Insel-Verlag, and Budapest: Corvina-Verlag, 1964

Lavin, Irvin, "On the Sources and Meaning of the Renaissance Portrait Bust," *Art Quarterly* 33 (Autumn 1970)

Legner, Anton, *Reliquien in Kunst und Kult: Zwischen Antike und Aufklärung*, Darmstadt, Germany: Wissenschaftliche Buchgesselschaft, 1995

Les trésors des églises de France (exhib. cat.), Paris: Caisse Nationale des Monuments Historiques, 1965

Lüdke, Dietmar, *Die Statuetten er gotischen Goldschmiede: Studien zu den "autonomen" und vollrunden Bildwerken der Goldschmiedeplastik und den Statuettenreliquiaren in Europa zwischen 1230 und 1530*, 2 vols., Munich: Tuduv-Verlagsgesellschaft, 1983

Montgomery, Scott B., "The Use and Perception of Reliquary Busts in the Late Middle Ages," Ph.D. diss., Rutgers University, 1996

Moskowitz, Anita, "Donatello's Reliquary Bust of Saint Rossore," *Art Bulletin* 63 (1981)

Sheingorn, Pamela, editor and translator, *The Book of Sainte Foy*, Philadelphia: University of Pennsylvania Press, 1995

Souchal, François, "Les bustes reliquaires et la sculpture," *Gazette des Beaux-Arts* 67 (1966)

Taburet-Delahaye, Elisabeth, "L'Orfèvrerie," in *Art et société en France au 15ème siècle*, edited by Christiane Prigent, Paris: Maisonneuve and Larose, 1999

FREDERIC REMINGTON 1861–1909
United States

Although Frederic Remington produced only 22 small bronzes and one life-size bronze, he was highly influential for his promotion of Western subject matter, ability to express physical energy and movement, and reintroduction of the lost-wax (*cire perdue*) technique to American art.

Remington was born and continued to live in upstate New York for most of his life. His father was a former cavalry officer and newspaper proprietor in Canton, New York. Remington was deeply involved in constructing a masculine, and specifically American, identity in his art and life. In 1878 he enrolled in the Yale College of Art and played first-string forward on the university's famous football team. At Yale he was instructed by John Ferguson Weir, known for his dramatic paintings of industrial workers, and John Henry Niemeyer, who led drawing classes in which Remington studied from plaster casts of Classical statues. Remington may have been introduced to sculpture by Niemeyer, who, following the model of the École des Beaux-Arts, Paris, added sculpture to the Yale curriculum in 1879.

With his father's death in 1880, Remington dropped out of Yale and traveled to Montana for artistic inspiration. Having married in 1884, he tried his hand as a salesman and saloon owner in Kansas City, Missouri, then moved to Brooklyn, New York, in 1885 to become a full-time illustrator. He soon achieved national renown for his illustrations in *Harper's Weekly*, *St. Nicholas*, *Outing*, and *Century Illustrated Magazine*. He also wrote several novels and excelled at painting, including *A Dash for the Timber*, which was exhibited at the National Academy of Design to rave reviews in 1889. In 1890 he bought a home in New Rochelle, New York, to provide space for his studio and contain his growing collection of Western Americana—which included costumes, weapons, and stuffed animals. Remington viewed the West as territory belonging to

white men, rarely disputing the subjugation of American Indians despite his relatively dignified portrayal of them. He also expressed bigoted views about immigrants from non-northern European and non-Protestant backgrounds. His friends included such influential figures as Theodore Roosevelt, the dramatist August Thomas, the painter Childe Hassam, and the sculptors Augustus Saint-Gaudens and Frederick MacMonnies.

Remington had long exhibited an interest in sculpture, but he did not begin his first model until 1894, when he met the academically trained sculptor Frederick Wellington Ruckstull, who was working in New Rochelle. Ruckstull's three-month mentorship provided Remington's only sustained training in the medium. However, he became infatuated with the tactility of the sculptural process and the permanence of bronze sculpture over canvas and paper. His first and most popular sculpture, *The Bronco Buster*, was initially sand cast at the Henry-Bonnard Bronze Company. Because of a fire at Henry-Bonnard, all of Remington's post–1898 work and subsequent casts of earlier work were made at the newly opened Roman Bronze Works, the first American foundry dedicated to the lost-wax (*cire perdue*) process. Experimenting with the recently revived lost-wax technique, Remington altered individual castings of his pieces by directly reworking each wax positive with a brush dipped in hot wax. For instance, in some later versions of *The Bronco Buster*, the rider wears woolly chaps with a richer texture than the original smooth leather ones, and the horse's anatomy acquired a more impressionistic quality through visible brush strokes. For *The Norther*, Remington depicted the windblown hide and jacket of a pony and rider with incredible detail, including icicles on the pony's long hair. Remington's specialization in technically challenging, highly detailed 20- to 30-inch-high bronzes revealed the limitations of sand casting and helped popularize the lost-wax technique in America at the turn of the 20th century.

In *The Wounded Bunkie*, Remington first experimented with innovative and visually exciting ways to anchor his mounted figures to the base, in this case supporting the two riders and their galloping horses on two hooves that barely touch the ground. *The Cheyenne* went even further, representing a horse and rider at full speed with all four hooves off the ground, supported only by a buffalo skin cloak that unfurls behind the pair. *The Cheyenne* is also distinguished by a mustard-yellow coloration that reflects the influence of Saint-Gaudens's use of unusual patinas. Remington's *Coming Through the Rye* depicts four cowboys on horseback in such close formation that they touch one another, allowing him to suspend one of the horses in midair. *Coming Through the Rye* was also reproduced as a larger-than-life plaster sculpture for the Louisiana

The Bronco Buster
© The Metropolitan Museum of Art, New York, Bequest of Jacob Ruppert, 1939

Purchase Exposition (St. Louis, Missouri) in 1904, but Remington was unsatisfied with the texture and fragility of plaster.

With *Polo*, Remington substituted recreational combat for Western subject matter and produced his most dynamic exploration of truly nonplanar action. Three horses and riders—one fallen to the ground, one suspended in midair, and another rearing up over the fallen horse—generate a frozen spiral of bodies in motion. Similarly, *The Buffalo Horse* shows a pony and rider flung into the air by a charging buffalo, inspiring one critic to call it "a daring violation of many of the rules of sculpture" (see *Remington*, 1998). Remington only made one life-size bronze, *The Cowboy*, for Fairmont Park in Philadelphia, which has a rich, dappled surface resulting from his increasing interest in Impressionism. In 1909, the final year of his life, Remington completed another version of *The Bronco Buster*, starting from scratch. Larger and more loosely rendered than the previous casts, this final version is more monumental and expressive, summing up the trajectory in which his sculpting career was headed before his early death from peritonitis at the age of 45. Remington's sculptures have continued to be popular, and hundreds of *surmoulages*, or recasts, from first-

generation casts, have been made, which complicates the task of authenticating pieces cast under the artist's supervision.

GREG FOSTER-RICE

Biography

Born in Canton, New York, United States, 4 October 1861. Enrolled at Yale College of Art, New Haven, Connecticut, 1878; trained by painters John H. Niemeyer and John F. Weir; never graduated; traveled to Montana, 1881; recorded ranch experiences in sketches; became illustrator in Brooklyn, New York, 1885; attended Art Students League in New York City for three months, traveled to Southwest, and launched a successful career as an illustrator with *Harper's Weekly*, 1886; first exhibited at National Academy of Design (N.A.D.), 1887; received silver medal for painting at Paris International Exposition, 1889; bought home and studio in New Rochelle, New York, 1890; elected associate member, N.A.D., 1891; received honorary bachelor of arts degree from Yale, 1900; solo exhibition of bronzes, M. Knoedler and Co., 1905; other exhibitions at M. Knoedler and Co, New York City, 1906, 1907, 1909, Union League Club, New York City, Corcoran Gallery of Art, Washington, D.C., 1908, and Art Institute of Chicago, 1909. Died in Ridgefield, Connecticut, United States, 26 December 1909.

Selected Works

1895 *The Bronco Buster*; bronze; Amon Carter Museum, Fort Worth, Texas, United States (1909 recast also in Amon Carter Museum); Metropolitan Museum of Art, New York City, United States (1910 cast)

1896 *The Wounded Bunkie*; bronze; Amon Carter Museum, Fort Worth, Texas, United States

1900 *The Norther*; bronze; Thomas Gilcrease Institute of American History and Art, Tulsa, Oklahoma, United States

1901 *The Cheyenne*; bronze; Metropolitan Museum of Art, New York City, United States

1902 *Coming Through the Rye*; bronze; Art Institute of Chicago, Illinois, United States; plaster cast: 1904, for Louisiana Purchase Exposition, St. Louis, Missouri, United States (destroyed)

1904 *Polo*; bronze; The R.W. Norton Art Gallery, Shreveport, Louisiana, United States

1906 *Paleolithic Man*; bronze; Thomas Gilcrease Institute of American History and Art, Tulsa, Oklahoma, United States

1907 *The Buffalo Horse*; bronze; Thomas Gilcrease Institute of American History and Art, Tulsa, Oklahoma, United States

1907 *The Horse Thief*; bronze; Thomas Gilcrease Institute of American History and Art, Tulsa, Oklahoma, United States

1908 *The Cowboy*; bronze; Fairmont Park, Philadelphia, Pennsylvania, United States

1908 *The Savage*; bronze; Amon Carter Museum, Fort Worth, Texas, United States

1908 *The Sergeant;* bronze; Amon Carter Museum, Fort Worth, Texas, United States

Further Reading

Greenbaum, Michael D., *Icons of the West: Frederic Remington's Sculpture*, Ogdensburg, New York: Frederic Remington Art Museum, 1996

Hassrick, Peter H., *Frederic Remington: Paintings, Drawings, and Sculpture in the Amon Carter Museum and the Sid W. Richardson Foundation Collections*, New York: Abrams, 1973

Naylor, Maria, "Frederic Remington: The Bronzes," *Connoisseur* 185 (February 1974)

Nemerov, Alexander, *Frederic Remington and Turn-of-the-Century America*, New Haven, Connecticut: Yale University Press, 1995

Remington: The Years of Critical Acclaim (exhib. cat.), Santa Fe, New Mexico: Gerald Peters Gallery, 1998

Shapiro, Michael Edward, *Cast and Recast: The Sculpture of Frederic Remington*, Washington, D.C.: Smithsonian Institution Press, 1981

Shapiro, Michael Edward, "Frederic Remington: The Sculptor," in *Frederic Remington: The Masterworks* (exhib. cat.), St. Louis, Missouri: St. Louis Art Museum, 1988

Vorpahl, Ben Merchant, *Frederic Remington and the West*, Austin: University of Texas Press, 1978

Wear, Bruce, *The Bronze World of Frederic Remington*, Tulsa, Oklahoma: Gaylord, 1966

RENAISSANCE AND MANNERISM

The pervasive interest in the Classical past associated with 15th-century Italian thinking signaled a shift in the conception of the role of humankind in relation to creation—human or divine. This shift spread throughout Europe during the following century. In sculpture the emphasis on individual achievement for communal betterment and the desire to re-create a golden age resulted in the emulation of Greco-Roman examples. Bronze and marble, recognized as the "true" antique materials, became the Renaissance sculptor's favored media.

Although sculptors retained Classical forms and motifs throughout the Romanesque and Gothic pe-

riods, Lorenzo Ghiberti considered the revival of the Classical tradition to have been not a slow process but an abrupt transformation that had taken place in the 15th century. Conversely, Giorgio Vasari credited the 13th-century artist Nicola Pisano with resurrecting the Classical style. Nicola's pulpit for the Pisa Baptistery evinces the knowledge of Antiquity that was to influence style and technique throughout the Renaissance. Here, the human figure heralds Renaissance interests: his *Fortitude* integrates a naturalism expressed through the Polycleitan ideal, approaching the monumentality and potential for movement sought by later sculptors.

Italy

The principal locus of humanist thought was the city of Florence. Favorable circumstances in patronage during the early 15th century led to competition and innovation, principally in sculpture. In fact, sculpture was the first of the arts to fully develop the Renaissance style. Traditionally, the seminal moment in this development is thought to be the 1401 competition for the second set of doors for the Florence Baptistery. The surviving competition panels by Ghiberti and Filippo Brunelleschi attest to the twofold Renaissance interest in using the Classical nude as an embodiment of the ideal body and of Christian virtue. Ghiberti's panel, declared victorious, presents a pictorial and narrative unity that stimulated a rapid redefinition of the Donatello historiated relief. Ghiberti's *Gates of Paradise* represent an early summit of the form, incorporating the pictorial devices of atmospheric and linear perspective developed by and Brunelleschi during the first decades of the 15th century. Concurrently, Ghiberti reintroduced the lost-wax (*cire perdue*) method in monumental scale in his figure of *Saint John the Baptist* for the Church of Orsanmichele, Florence. His workshop became a hub for artists of the highest caliber, including Donatello, Masolino, Paolo Uccello, and Michelozzo. These artists' notorious ability to transform an idea into matter furthered the claim that *disegno*, an intellectual activity, was the true essence of artistic creation.

Donatello's explorations in subject and technique established the problems that occupied sculptors throughout the Renaissance. Focusing on optics and on psychological expression, Donatello sought to approach the underlying principles of antique art. First side-by-side in the Florence Cathedral, and later at the Church of Orsanmichele, Nanni di Banco and Donatello introduced the new Classical style. Donatello's *Saint Mark* represents a definite break from the delicate International Gothic. Thought by many to be the first unmistakably Renaissance sculpture, it communicates the stoic virtue celebrated by humanist thinkers.

The commission to complete the earliest surviving bronze equestrian, Donatello's *Gattamelata*, which harks back to the Roman tradition embodied by the *Marcus Aurelius*, then at the Basilica of San Giovanni in Laterano in Rome, further challenged Donatello's capacity as a bronze sculptor demonstrated in his *David* and *Judith*. Humanists associated Antiquity with civic liberties and (misconstrued) religious piety, allusions that sculptors transferred to the Renaissance versions. Andrea del Verrocchio refined the casting technique for his equestrian monument of Bartolommeo Colleoni. Both Antonio del Pollaiuolo and Leonardo experimented with the equestrian motif in Milan, but their plans never came to fruition.

The Sienese sculptor Jacopo della Quercia pursued an antiquarian tendency in the treatment of figural representation, demonstrated, for example, in his *Fonte Gaia* in Siena and Tomb of Ilaria del Carretto. His *Genesis* reliefs for the Church of S. Petronio in Bologna relegate landscape representation to a minimum, favoring the human figure as the expressive vehicle.

The humanist preoccupation with the achievements of the individual manifested itself in the creation of the humanist tomb type in the 15th century. Bernardo Rossellino's tomb of Leonardo Bruni and Desiderio da Settignano's Monument for Carlo Marsuppini refined the classicizing tripartite format introduced by Donatello and Michelozzo in the tomb of Coscia. Bernardo's brother Antonio Rossellino translated the vocabulary of the secular tomb into a spiritual program for the tomb of the cardinal of Portugal.

Mino da Fiesole imported the humanist tomb and portrait bust format to Rome; Niccolò di Pietro Lamberti and his son Pietro (Piero) di Niccolò blended the florid style current in Venice with Tuscan forms. Nanni di Bartolo, another Florentine expatriate, contributed his knowledge of the Florentine style in his collaborations with the sculptors from the Bon workshop in Venice. There, the Venetians Antonio Bregno and Antonio Rizzo embraced the idea that a tomb should be a self-contained architectural unit. Pietro and Tullio Lombardo rejected the Lombard tradition; Tullio's monument of Andrea Vendramin reaches a distilled Classicism achieved through the collection and study of antiquities.

The desire for prestige and immortality led to the popularity of portrait busts modeled after the Roman ancestor type and prompted a revival of ancient techniques: the casting of death and life masks. Antonio Rossellino's marble *Portrait of Matteo Palmieri* exemplifies the search for naturalism in physiognomy and character. His more abstracted female counterparts, such as those created by Francesco da Laurana and Verrocchio, preserve a youthful ideal countenance for the sitters. Stimulated by a similar impulse, Antonio

Pisanello revived the ancient medal portrait where naturalism and symbolic allusions to virtue coalesce. His signature, prominently displayed in most examples, proclaims the elevated status of the artist.

Small bronze statuettes, patinated to resemble antiques, gained popularity during the last three decades of the 15th century. Antonio del Pollaiuolo, a gifted designer who completed monumental bronze tombs for Sixtus IV and Innocent VIII, is best known for his bronze statuette of *Hercules and Antaeus*, laden with violent motion. Andrea Riccio in Padua and Antico in Milan set a high standard for the practice, which became commonplace among 16th-century sculptors.

Overwhelming his contemporaries in the 16th century, Michelangelo Buonarroti was the first artist to be recognized as a genius during his own lifetime. Scholars have hailed his oeuvre, spanning a long career, as the parameter of High Renaissance and the catalyst for Mannerism. The works themselves, however, defy categorization under these art-historical labels.

Michelangelo worked in several media and practiced poetry but favored subtractive sculpture. After a short apprenticeship with Domenico Ghirlandaio in 1488, Michelangelo joined the household of Lorenzo de' Medici. There, he became acquainted with Neoplatonism, a philosophy that often underlies his works.

Michelangelo's early reliefs and freestanding figures reveal a propensity toward the antique and Donatello. The actual size of these early works is often belied by the monumentality of the human figure, which serves, as in later works, as the expressive agent for an underlying theological or philosophical concept. Monumentality of concept and scale characterizes Michelangelo's *David* and works produced thereafter.

Inspired by, or perhaps challenging, Donatello's achievements, Michelangelo ambitiously captured the poignant relationship between mother and son in various versions of the Pietà and of Mary with the infant Christ. The Vatican *Pietà* displays a subdued Classicism, apparent in the restrained emotion and underlying geometry of composition. Pure Carrara marble lends the work a pervasive abstract and ideal quality that signals the High Renaissance. Leonardo's cartoon of the *Virgin and Child with Saint Anne* prompted a series of mother-and-child representations in search of volumetric unity, such as the Pitti Tondo. Accepted by its patron in an unfinished state, it demonstrates the demand for Michelangelo's works and the Renaissance belief, based on Pliny, that an unfinished work is valuable because it reveals the artist's thought process. This maxim, however, does not apply to other unfinished works by the artist. Perhaps the most frustrating of such projects was the tomb of Julius II and the Medici Chapel. A stylistic change characterizes Michelangelo's *Medici Madonna* and the *Victory*. Their elegant serpentine and refined proportions and physiognomies anticipate the cultivated *maniera* of the following decades.

Michelangelo's increasing religious concerns led to another stylistic change in his old age. Rejecting the body as the recipient of divine grace, he renounced idealization and in sculpture moved toward an immateriality obvious in the *Rondanini Pietà*, his last work.

Under Michelangelo's inspiring influence, artists developed a Mannerist style characterized by quotation of his works and antique models, a refinement of poses, and delicate finish. Vincenzo Danti and Bartolommeo Ammannati exemplify the early stages of this trend. Baccio Bandinelli sought to surpass rather than emulate the master. His awkward *Hercules and Cacus* demonstrates unease with form as it relates to concept. Benvenuto Cellini's *Perseus* translates the same victor-over-vanquished motif into monumental bronze. Cellini's autobiography records the details of direct casting and offers a valuable, albeit biased, account of the problems faced by the 16th-century sculptor.

The Flemish sculptor Giambologna dominated the Florentine sculptural scene toward the close of the 16th century. His Fountain of Neptune and Mercury in Bologna integrates architecture, sculpture, and the kinetic element of water augurs the energetic compositions of the Baroque. Giambologna's understanding of Michelangelo's serpentine figure is also evident in the marble *Rape of a Sabine*, where artifice and theatricality prefigure Gianlorenzo Bernini's inventions. Giambologna also explored the ambiguous relationships between art and nature, notably in his *Appennine* at Pratolino. The scientific and courtly aspects of his works appealed to a large market, prompting a refinement of multimold casting by his assistants. Adriaen de Vries propagated Giambologna's style while working at the court of Rudolph II in Prague.

The Florentine Jacopo Sansovino dominated Venetian sculpture in the 16th century. His pupils Danese Cattaneo and Alessandro Vittoria explored the Mannerist alternatives. Vittoria's *Portrait of Doge Niccolò da Ponte*, in terracotta, brings into sculpture a painterly and bravura quality reminiscent of Titian.

France

Cellini, Rosso Fiorentino, and Francesco Primatticcio developed in France an elegant style based on the artificial elegance and sophisticated aesthetic of the Italian *maniera*. Cellini's enameled gold saltcellar, for Francis I of France, and his bronze *Nymph of Fontainebleau* influenced Jean Goujon, who dominated French sculpture in the mid 16th century. Goujon's Mannerism emphasizes elegance and surface finish, as does

Cellini's, but is imbued with a higher degree of Classicism.

Rosso and Primatticcio brought to Fontainebleau the technique of highly polished stucco decorations popular in Rome before the Sack of Rome. In the Galerie François I in Fontainebleau, Rosso designed the stucco decoration to follow Classical principles, emphasizing circular and square panels surrounded or inhabited by Michelangelo-like nudes, herms, putti, and fruit garlands. Other artists immediately imitated Rosso's innovative strap work, which became the norm in Mannerist decoration.

Germain Pilon represents the last stage of the Renaissance in France. Mainly concerned with portrait busts and medals in marble and bronze, Pilon developed a dramatic style that, aware of Italian advancements, foreshadowed the range of expression achieved in the Baroque.

Spain

The development of the Renaissance style in Spain was due to Philip II. Following the tastes of his father, Holy Roman Emperor Charles V, Philip patronized sculpture modeled after Roman prototypes in an antiquarian mode, such as the ceremonial armor by Anton Pfeffenhauser and Kolman Helmschmid. The task of romanizing the figures of Charles and Philip fell on Pompeo Leoni. His bronze of *Charles V Triumphing over Fury* is a Mannerist exercise in variety and complexity, alternatively representing the monarch as an ideal nude or, dressed in Roman armor, as a parameter of morality. Contemporary with the antiquarian strain, Alonso Berruguete and El Greco turned to the native tradition of polychrome wood sculpture, creating a unique breed of Mannerism.

Netherlands

In the Netherlands, Jan van Steffeswert, a sculptor active in Maastricht at the beginning of the 16th century, crossed the threshold into the Renaissance. By 1550 the local tradition had absorbed the Renaissance style. Low demand for monumental sculpture before and after the Reformation, in addition to the iconoclastic revolts that plagued the area, presented a challenging market for sculptors. Although the sporadic demand afforded few employment opportunities for sculptors—and thus few training opportunities—many sculptors of the highest ranks working elsewhere in Europe were natives of the Netherlands, among them Willem Danielsz, van Tetrode, Johan Gregor van der Schardt, Elias and Peter de Witte, Hubert Gerhard, Paulus van Vianen, and Adriaen de Vries. Inspired by

Italian innovations, Pieter Coecke van Aelst, his student Cornelis Floris de Vrient, and Hans Vredeman de Vries produced ornamental prints and pattern books that became models for sculptors throughout Europe.

After 1550 local traditions and influences from Italy and France gave rise to a Mannerist hybrid that united realism in the depiction of figures and objects with a flare for highly ornamental decorative patterns. The commissions to refurbish churches, tombs, epitaphs, and facades of civic buildings and private houses, which followed the outbreaks of iconoclasm from 1566 to 1580, show the adoption of this rich Renaissance style that evolved into the Baroque during the following century. Hendrick de Keyser I, the most important sculptor of the first quarter of the 17th century, produced realistic portrait busts of high psychological intensity, leading the transition to the Baroque in this area.

England

Henry VIII's desire to glorify his father's reign and to compete with French nobility prompted a stylistic change in England during the first decade of the 16th century. Pietro Torrigiani, a Florentine trained in Ghirlandaio's workshop, received the commission for the construction of the tomb of Henry VII and Elizabeth of York, the most important Renaissance work in England. Torrigiani's design harmoniously combines quattrocentesque motifs with prevalent Gothic forms, concurrently introducing bronze and white marble as the primary materials. A similar combination of styles and media characterizes his tomb of Lady Margaret Beaufort in Westminster Abbey. Florentine materials and modes of representation appear throughout Torrigiani's English oeuvre: profile portraiture in bronze appears in the monument of Sir Thomas Lovell, and the sculptor introduced terracotta in busts of *Henry VII* and the so-called *Bishop Fisher*. Benedetto da Rovezzano and Giovanni da Maiano II followed Torrigiani, disseminating northern Italian, rather than Florentine, forms. Giovanni da Maiano's work for Cardinal Wolsey also suggests his acquaintance with French sources, which dictated English taste between 1500 and 1560.

Owing to loss of Church patronage following the Reformation, sculptural production focused on funerary monuments. A small group of tombs in East Anglia, constructed by anonymous artists in the 1530s, displays Torrigiani's limited influence. In the tombs of the first and second Lords Marney in Essex, terracotta architectural ornament, inspired by French Renaissance sources, supersedes Gothic decoration. Concurrently, Renaissance motifs appeared in southern England in the tombs of Bishop Toclyve and Bishop Poyntz at Winchester. The alabaster tomb makers of

Pietro Torrigiani, detail from Tomb of Henry VII and
Elizabeth of York, 1512–18
The Conway Library, Courtauld Institute of Art

the Midlands adopted Renaissance motifs that, often
misunderstood, appear in works otherwise Gothic in
character. Exceptional craftsmanship and understand-
ing of Renaissance visual motifs and their meanings
appeared only at midcentury in the tomb of Thomas
Howard, third duke of Norfolk, in Framlingham.

The Tudor encouragement of funerary monuments
that would establish the pedigree of newly landed lords
coincided with the arrival of sculptor-refugees from
the Netherlands, which in turn signaled a decline of
French and Italian influences. Local alabaster, often
painted and gilded, became the primary material.

The Netherlandish sculptors, known as the
Southwark school, produced homogeneous works that
defy individual attribution. Leading family workshops,
such as Cure (Cuer), Johnson (Jansen), and Colt, are
identifiable through documents. They brought to Eng-
land Continental innovations and originated new
forms, such as the use of coffered arched canopies in
altar tombs. Notable examples are the marble tombs
at Westminster Abbey of Mary, Queen of Scots, by
Cornelius and William II Cure and of Elizabeth I by
Maximilian Colt.

A renewed interest in Italian models and materials
together with the rise of native artists characterized the
sculptural landscape at the turn of the 17th century.
The first native English sculptor to achieve a refined
Renaissance style was Epiphanius Evesham, who fol-
lowed the Southwark tradition. Evesham developed a
pictorial treatment of sculpture motivated by French
Mannerism, visible in the tomb of the second Lord
Teyham.

Charles I patronized Francesco Fanelli, François
Dieussart, and Hubert Le Sueur, among other foreign
artists, but the leading sculptor during his and James I's
reigns was Nicholas Stone, an English mason-sculptor
who studied under Hendrick de Keyser I. Considered
by many as the first major native sculptor, Stone pro-
duced highly sophisticated works that reveal the influ-
ence of Inigo Jones. The outbreak of civil war in 1642
hindered sculptural production for two decades. When
sculptural production resumed, Stone's influence had
been lost to the Baroque.

Ireland

The amalgam of Renaissance and medieval forms that
characterized English sculpture in the 16th century had
a local parallel in Ireland, where it prevailed until the
17th century. The arrival of wealthy English landlords
during the 16th and 17th centuries provided renewed
patronage for sculptors, embellishing their houses with
sculptural overlays in the new style derived from for-
eign engraved sources. Native merchants in cities such
as Galway and Kilkenny also spurred building and dec-
oration, causing a resurgence of domestic sculpture
that appealed to English sculptors. Domestic ornamen-
tation did not, however, supplant the main concern of
Irish sculpture, the sculpted tomb. Fine examples that
reveal an interest in the Renaissance style, dating from
1600 to 1630, include the tomb of Sir Arthur Chiches-
ter in St. Nicholas's Church, Carrickfergus; the funer-
ary monuments to Richard Boyle, First Earl of Cork,
in St. Mary's Church, Youghal; the monument to
Archbishop Thomas Jones in St. Patrick's Cathedral
in Dublin; and the O'Connor War Memorial in Sligo
Abbey.

Hungary, Poland, and Bohemia

The Hungarian King Matthias Corvinus in the 15th
century embraced the Florentine version of the Renais-
sance style. Appearing first in architectural decoration
in his court, Tuscan ornamental motifs spread to other
noble houses and to Poland. Fragments from Buda and
Visegrád reveal the influence of the Florentines Bene-
detto da Maiano and Desiderio da Settignano in portrai-
ture. The victory of the Ottoman Turks at Mohács in
1526, which destroyed the royal court, signaled the
demise of the style in occupied lands, while, surpris-
ingly, it continued to flourish in Baranya and Koloz-
svár. Religious sculpture in other centers in western
Hungary found inspiration in Austrian rather than Flor-
entine sculpture. The influence of the Danube school
is most visible in the high altar of St. George at the
parish church at Pozsonyszentgyörgy (Jur pri Bratis-
lave, Slovakia), completed about 1527.

Although funerary monuments represented the ma-
jority of sculptural commissions, they often followed
local interpretations of the Gothic style rather than for-
eign innovations until the 17th century, when the style

became the choice for epitaphs for middle-class patrons. Larger wall tombs in the Renaissance style, imported by wealthy patrons, also appeared at the beginning of the 17th century. At the same time an increase in demand prompted the revival of local stone-carving technique and the desire to approximate the quality achieved abroad. The woodworkers Andrea Hertel of Kraków and Christof Kolmitz of Moravia and the Danish sculptor Hans Schmidt, who collaborated in the construction of the organ case and pulpit of the Church of St. James in Lőcse, exemplify the diverse associations characteristic of the 1620s. Hungary's geographical location facilitated the arrival of new ideas from both northern and southern Europe, but distinct native forms also flourished, as in the altarpiece at Szeresváralja (Spisské Podhradie, Slovakia).

The Florentine Renaissance vocabulary was adopted by the Polish King Sigismund I, whose taste was influenced by the Italian humanist Filippo Buonacorsi, as well as his travels to Hungary, where the style was well established by 1500.

Not surprisingly, royal use of the modern style focused on dynastic sepulchral chapels. Early examples, such as the chapel of Cardinal Tomás Bakócz of Erdeüd in Ezstergom from the early 16th century, became the model for dynastic tombs. Although less popular, Lombard-inspired decorations also appeared, for example, in the Lázoi Chapel in Gyulafehérvár Cathedral (Alba Julia, Transylvania).

The most important Renaissance monument in Poland is the Sigismund Chapel in Kraków. Designed by the Italian Bartolommeo Berrecci, the chapel manifests a familiarity with the work of Antonio Sansovino in Rome. Berrecci's wall tombs follow the familiar triumphal arch design but substitute the recumbent sleeping figure type with effigies of the deceased shown as if asleep. The semirecumbent sleeping figure (*statue accoudée*) type was to dominate tomb sculpture in Poland, remaining fashionable until the mid 17th century. Sculptors widely adopted this type in the 1530s, as in the tombs of Barbara Teczynska Tarnowa, of Bishop Tomicki in Wawel, and of Bishop Jan V Turzo of Wrocław. Later ecclesiastics of Silesia followed, such as the tomb of Balthasar of Promnitz in Nysa Cathedral.

Middle-class patrons soon adopted modern designs, for example, Andreas Walther I's chapel of Henrich Rybirch in the Church of St. Elizabeth, Wrocław. Children, represented as ancient putti, appeared in infant monuments throughout the territory.

Two types of humanist epitaphs developed in the 1490s and 1500s. The earliest type originated with Veit Stoss's epitaph of Filippo Buonaccorsi. Rooted in the German tradition, it incorporates Classical motifs that surround the naturalistic effigy. This type reappeared in the 1530s in Silesia.

The second type, first introduced by Joannes Florentinus in Ezstergom, consists of a simple red Hungarian marble tomb slab carved with a coat of arms and Classical symbols. In Poland the mausoleum of Jan Laski, the Giezno tombs for Archbishop Maciej Drzewicki and for Erazm Mielinski, and the tomb of Jan Karnkowski in Wloclwek imitated the Hungarian tombs of Bernardo Monelli at Buda and of Nikolaus Szentléleki at Csatka. While no precedent for this type existed in Italy, the development may represent an attempt to revive ancient Roman slabs popular in Transdanubia (Hungary) during the 2nd century AD.

In the second half of the 16th century, effigies of the deceased, shown in medallions *all'antica* (after the antique), began to appear in wall epitaphs and in other funerary monuments. The profile of Galeazzo Guicciardini, inserted in the obelisk of his wall tomb in the Dominican cloister in Kraków, is one of the earliest examples (1557). Gianmaria Mosca, called Padovano, furthered the application of the Classical style to architectural and sculptural projects and popularized the double-decker wall tomb in a monument for the Tarnowski family in the Tarnów Cathedral. The success of the type prompted the transformation of the Royal Tomb in the Sigismund Chapel in the 1570s, where Padovano incorporated the recumbent effigy of Sigismund II August in the existing program. Santi Gucci, who raised the tomb of the former monarch to accommodate the additional sarcophagus, completed the work.

An evolution toward a Mannerism influenced by Netherlandish figure treatment and ornamentation appeared in the tombs of the Kraków bishops Andrzej Zebrzydowski and Filip Padniewski in Wawel Cathedral by the Polish artist Jan Michalowicz from Urzedów.

Santi Gucci continued the Italian-inspired strain, combining Ammannati's and Bernardo Buontalenti's ideas with Polish precedents. His works, such as the tombs of the Montelupo and Cellari families in the Kraków Church of Our Lady, reveal renewed patronage of commemorative portraiture in funerary settings.

The last decades of the 16th century witnessed a diversification of styles and centers of production. In Gdánsk (Danzig) the Dutchman Willem van den Blocke and his son Abraham introduced the kneeling figure tomb type. Hybrid styles evolved by Jan Bialy, Hieronymus Hulte, Henry Horst von Groningen, and Hans Pfister embraced Italian and Netherlandish Mannerism, providing renewals of local traditions.

Germany

Although in Germany the Renaissance style was assimilated early into the sister arts, it did not flourish

in sculptural media until the 1520s, subsequently dominating until the beginning of the Counter Reformation. The extensive espousal of Renaissance forms seen in Hungary under King Matthias Corvinus or in Poland under Sigismund I did not appear in Germany until Duke Ludwig X of Bavaria adopted the style for the Stadtresidenz in Landshut in the 1530s.

The advent of the Reformation and the religious tensions that ensued restrained sculptural patronage and forms, which often present simplified themes and designs. The most prevalent form of production during this period was the epitaph memorial, which represented a constant charge for sculptors in a period of otherwise low demand. Funerary monuments in Germany, however, were not as diverse as in Italy and France: equestrian monuments, freestanding tombs, and life-size figures rarely appeared before 1600. Usually small and conservative, the surviving corpus reveals a preference for epitaphs that show the deceased praying in front of the cross without other references to religious affiliation. Peter Vischer the Younger, Loy Hering, Hans Bildhauer, and the Dutchman Cornelis Floris introduced themes and motifs that were quickly embraced by their contemporaries. Hans Schenck's Mannerist inventions, which represent a love of novelty and difficulty, stand as an exception and had no true effect on German lands. Sculptors carved most tombs and epitaphs from local stone, although marble, Solnhofen limestone, and Mosan alabaster appeared as luxurious imported materials in Salzburg. Artists used bronze and brass less often, in examples of remarkable quality, such as those produced by the Vischer family workshop in Nuremberg.

Peter Vischer the Younger's small brass epitaphs, inspired by a stay in north Italy, disseminated humanist themes and Renaissance techniques throughout Europe. His epitaph of *Dr. Anton Kress* transformed the Germanic epitaph both in the sensitive rendering of the patron and in the introduction of wax casting. This contribution immediately inspired emulation, such as Hans Vischer's epitaphs of *Provost Hektor Pömer* and of *Bishop Sigismund von Lindenau* and the anonymous epitaph of *Wolfgang Peisser the Elder* in Franziskanerkirche in Ingolstadt.

Several other family workshops dominated sculptural production in specific regions, such as the Dells in Würzburg, the Rottalers in Landshut, the Brabenders in Münster, and the Herings in Eischstätt. The latter provided models, inspired by Albrecht Dürer's engravings, of refined execution and sophisticated design emulated by sculptors in Franconia and Bavaria.

Loy Hering's epitaph of *Canon Martin Gozmann* and Johann Brabender's epitaph for *Theodor von Schade* exemplify the growing practice, begun in the 1520s, of ordering compositions with architectural frames. As patrons increasingly demanded grander monuments, artists embraced Classical architectural and decorative features; many inspired by Netherlandish precedents or directly borrowed from Cornelis Floris's *Veelderleij niewe inventien van artijcksche sepultueren*, spreading his influence throughout German territories and eastern Europe, while Willem van den Blocke took it to the Baltic. Floris was also responsible for the Prussian memorials in Köningsberg (Kaliningrad) Cathedral and for larger works for Danish and German nobles that became the most influential monuments in the area produced during the third quarter of the 16th century. Floris elaborated upon Italian compositional motifs, such as Sansovino's half-recumbent figure, which remained popular beyond the 17th century. Eclectic use of Classical motifs typifies the epitaphs of the 16th century, but Netherlandish influence prevailed after midcentury, as seen, for example, in Hans Bildhauer's epitaph of *Johann Segen* and Hans Schenck's Antwerp strap work in the epitaph of *Gregor Begius* in Berlin.

Dynastic monuments appeared in few, yet impressive, ecclesiastic and princely series in Catholic and Protestant territories. At Würzburg Cathedral, Tilman Riemenschneider first introduced pseudo-Renaissance decorations in the tomb of Lorenz von Bibra, while Loy Hering's tomb of Konrad von Thürgen achieved true Renaissance clarity and unity of composition. The cathedrals at Mainz and Trier, led by Dietrich Schro and Hieronymus Bildhauer, respectively, emulated these funerary series. Sem Schlör's memorial for the counts of Württemberg in the Stiftskirche in Stuttgart presented a novel response to genealogical representation; incorporating 11 life-size figures within one architectural frame, Schlör separated each figure with antique herms.

In vernacular sculpture the modern style appeared with increasing frequency beginning in 1530. Scenographic architectural sculpture decorated the exterior of German houses and palaces. Fountains, friezes, medallion reliefs, and simple statues proliferated. Christoph I and Hans Walther at Dresden and Torgau, Alexander Colin in Heidelberg, and Thomas Hering and Italian artists in Landshut played significant roles in this development.

The rediscovery of Classical portraiture in Germany occurred later than in neighboring territories. Bourgeois and noble patrons embraced medals and small-scale relief portraits at the beginning of the 16th century. Hans Schwarz popularized the form, catering to the members of the 1518 Diet of Augsburg, humanists, patricians, and merchants. Following Schwarz's departure from Nuremberg in 1520, Matthias Gebel, Friedrich Hagenauer, Christopher Weiditz, and Hans Reinhart filled the demands of this ever-increasing market. Schwarz's success further inspired a throng of anonymous medalists active in Augsburg, Nuremberg, Saxony, and along the Rhine. Although rare, sculpted

portraits in profile and, gradually, in three-quarter view appeared in royal game pieces and in architectural programs where princes adopted the guise of ancient worthies. A few masters pursued independent portraiture. Extant works include Dietrich Schro's *Ottheinrich, Elector Palatine* and Johan Gregor van der Schardt's busts of *Willibald Imhoff, Anna Harsdöffer*, and *Frederick II, King of Denmark.*

Between the iconoclastic riots of the 1520s and the 1555 Diet of Augsburg, the production of religious sculpture in German-speaking lands diminished abruptly. The three most important religious commissions of the period were Cardinal Albrecht von Brandenburg's Neue Stift in Halle, Ottheinrich's transitional palace chapel at Neuburg an der Donau, and Elector Johann Friedrich's Schloss Hartenfels at Torgau, the first "true" Protestant chapel. Wittenberg and Torgau led in Protestant production, later to be replaced under August of Saxony by Dresden. Otherwise, ecclesiastic and lay large-scale commissions virtually disappeared. In some Protestant towns enterprising artisans maintained their trade by supplying pieces to Catholic patrons elsewhere, as was the case for Hans Dürer, Georg Herten, Georg Penz, Peter Flötner, Pankraz Labenwolf, and Melchior Baier, who collaborated in the creation of the Silver Altar commissioned by Sigismund I. Such foreign royal commissions were, however, too sporadic to secure the artists' livelihoods.

In rare cases workshops specialized in religious artifacts: the Dells in Würzburg, the Herings in Eichstätt, and the Schros in Mainz and Halle are notable examples. Other Catholic cities, such as Cologne and Munich, did not support native artists. Similarly, lands controlled by the Zwinglians and later the Calvinists supported very few sculptors of secular or funerary art. Loy Hering, the most financially successful sculptor of the period, was involved in at least 133 religious projects—an exception in this period. Peter Dell the Elder, patronized by both Protestants and Catholics, became the first sculptor of Lutheran themes, while Hans Reinhart contributed a new form: the religious medal, inspired by antique coins and Lutheran sermons.

After 1555 sculptural commissions from both Catholic and Protestant nobles, principally from Albrecht V, Duke of Bavaria, and Electors Moritz and August of Saxony, respectively, reaffirmed religious affiliation. Albrecht V's artistic campaigns spurred developments in Augsburg, Würzburg, Trier, Inglostad, and Innsbruck. Under Moritz and August the Albertine desire to communicate the triumph of the Reformation nurtured the first coherent school of Protestant sculpture in Dresden, where the evangelical message materialized through a north Italian sculptural idiom in the works of Giovanni Maria Nosseni and Hans Walther. Dresden

Palatine chapels propelled a flourishing of didactic evangelical pulpits and altar sculpture throughout northern German protestant towns during the 1560s and 1570s.

Following the Diet of Augsburg and the Council of Trent, sculpture as part of Catholic reformation did not flourish in German lands until the 1580s and 1590s. Key projects espoused an archaizing style reminiscent of pre-Reformation sculpture, such as the Paulus Mair High Altar for the imperial Benedictine Monastery of St. Ulrich and Afra in Augsburg. Netherlandish Mannerism also heavily influenced important projects, such as Hans Ruprecht Hoffmann's sandstone pulpit for Trier Cathedral.

Denmark

Elements of Renaissance architectural design reached Denmark as early as 1530, soon influencing sculpture, as seen in the gravestone for Archbishop Absalon, attributed to Martin Bussaert, at Søro Church. After the Reformation reached Denmark, the novel needs of the Lutheran Church encouraged the creation of new types of sculptural representation. Sculptors applied the Renaissance style, used in didactic programs, to pulpits, pews, altarpieces, baptismal fonts, and galleries. Like tombs and epitaphs, these works evince the influential style developed by Netherlandish masters. Cornelis Floris's funerary monuments for King Frederick I, King Christian III, and other members of the royal family and the nobility spurred a flourishing of freestanding tombs in northern Germany. As in Germany, freestanding tombs became associated with nobility, but a royal decree issued in 1576 restricted their construction in Denmark to the commemoration of royalty and princely men. Patricians and wealthy merchants were allowed wall tombs and epitaphs.

After 1574 Netherlandish and German sculptors lured to large building projects in Denmark, such as Kronborg Castle in Helsingør, created magnificent courtyard decorations and pleasure gardens with fountains executed in the new style. Commissioned by King Frederick II, Georg Labenwolf's 6-meter-high bronze Neptune fountain at Kronborg courtyard was the grandest of the princely fountains in Germany and Denmark produced during the 1570s. Labenwolf's contribution spread to collectible bronze statuettes, which he probably produced in collaboration with Johan Gregor van der Schardt. The latter's Netherlandish heritage, Italian training, taste for the antique, and interest in the southern German tradition offered a comfortable style to Danish patrons who desired portraits. His style, however, was not lasting; by the turn of the 17th century Hubert Gerhard, Adriaen de Vries, Hans Krumper, Caspar Gras, and Georg

Petel—influenced by Giambologna's Mannerism—would dictate fashionable portraiture.

Sweden and Finland

From the 15th century to the time of the Protestant Reformation, the development of northern German, Danish, and Netherlandish sculpture influenced that of Sweden. As in other countries that embraced the Reformation, sculptural production in Sweden focused on funerary works. The needs of new Lutheran churches represented a secondary source of commissions.

Dutch artists executed the most influential monuments of the period here. Willem Boy's tomb of Gustav I and Katarina von Sachsen-Lawenburg and Margareta Leijonhufvud (his two wives) in Uppsala Cathedral reprised the tomb chest with recumbent-figure type. Herkules Mida's tomb of Duke Karl in Strägnäs Cathedral and Willem van den Blocke's monument of Ture Bielke and Margareta Sture in Linköping Cathedral further demonstrate the dissemination of Dutch Classicism.

Sculptural production in Renaissance modes gained momentum during the 1620s and 1630s. The leading master of the period was the Dutchman Aris Claeszon, whose funerary monuments to Gustav Banér in Uppsala Cathedral and to Svante Banér in Danderyd Church typify the Netherlandish love of naturalism and ornamentation.

Wood sculpture, revitalized at the beginning of the 16th century by Jakob Kremberg in Skåne, shows the influence of the court of Denmark. The opulent sculptural program of the warship Vasa maximized the propagandistic potential of the style and the local familiarity with the material. King Gustav II Adolf's ambitious and catastrophic commission (it sank at the harbor the day of its maiden voyage, 10 August 1628), it comprised approximately 700 figures and 300 pieces of carved ornament. The recovered figures have been categorized into four stylistic groups, the most prominent attributed to Mårten Redtmer and to Johan Thesson (Tijsen?). The remaining two groups represent a small fraction of decoration not yet attributed to a master or workshop.

The first insinuations of the Baroque style that appeared in architecture at the beginning of the 1620s reached sculpture by the end of the decade, while the Renaissance style had barely reached or peaked in some Scandinavian centers. Under the administration of Sweden, German sculptors produced Finnish sculpture during the 17th century—particularly sepulchral monuments and church decorations. The limestone monument to Arvid Tönnesson Wildeman and Anna Hansdotter Björnram in Pernå Church by Arent Passer and his workshop is an example of the amalgamation of Renaissance motifs and modes that remained current in Scandinavia while southern centers were embracing the Baroque.

ALEJANDRA GIMENEZ

See also **Ammanati, Bartolomeo; Bandinelli, Baccio; Berruguete, Alonso; Cellini, Benvenuto; Colin, Alexander; Danti, Vincenzo; Desiderio da Settignano; Dieussart, François; Donatello (Donato di Betto Bardi); Fanelli, Francesco; Floris de Vriendt, Cornelis II; Flötner, Peter; Gerhard, Hubert; Ghiberti, Lorenzo; Giambologna; Gras, Caspar; Hagenauer Family; Hering, Loy; Jacopo della Quercia; Keyser, Hendrick de; Krumper, (Johann) Hans; Leoni Family; Le Sueur, Hubert; Lombardo Family; Michelangelo (Buonarroti); Michelozzo di Bartolomeo; Mino da Fiesole; Nanni di Banco; Pisanello (Antonio di Puccio Pisano); Pisano, Nicola; Pollaiuolo, Antonio; Primaticcio, Francesco ("il Bologna"); Riccio, Andrea; Riemenschneider, Tilman; Rossellino Family; Sansovino, Andrea; Schardt, Johann Gregor van der; Stone, Nicholas; Torrigiani, Pietro; Verrocchio, Andrea del; Vischer, Family; Vittoria, Alessandro; Vries, Adriaen de**

Further Reading

Blunt, Anthony, *Art and Architecture in France, 1500–1700*, London and Baltimore, Maryland: Penguin, 1953; 5th edition, revised by Richard Beresford, New Haven, Connecticut: Yale University Press, 1999

Checa Cremades, Fernando, editor, *Felipe II: Un príncipe del renacimiento: Un monarca y su época* (exhib. cat.), Madrid: Sociedad Estatal para la Commemoración de los Centenarios de Felipe II y Carlos V, 1998

De Tolnay, Charles, *The Art and Thought of Michelangelo*, New York: Pantheon, 1964

Fucíková, Eliška, et al., editors, *Rudolf II and Prague: The Court and the City* (exhib. cat.), London and New York: Thames and Hudson, and Prague: Prague Castle Administration, 1997

Greenhalgh, Michael, *Donatello and His Sources*, New York: Holmes and Meier, and London: Duckworth, 1982

Hibbard, Howard, *Michelangelo*, New York: Harper and Row, 1974; London: Lane, 1975; 2nd edition, Cambridge, Massachusetts: Harper and Row, and London: Penguin, 1985

Olson, Roberta, *Italian Renaissance Sculpture*, London: Thames and Hudson, 1992

Pope-Hennessy, John, *An Introduction to Italian Sculpture*, 3 vols., London: Phaidon, 1963; 4th edition, 1996

Smith, Jeffrey Chipps, *German Sculpture of the Later Renaissance, c. 1520–1580: Art in an Age of Uncertainty*, Princeton, New Jersey: Princeton University Press, 1994

Vasari, Giorgio, *Le vite de più eccellenti architetti, pittori, e scultori italiani*, 3 vols., Florence: Torrentino, 1550; 2nd edition, Florence: Apresso i Giunti, 1568; as *Lives of the Painters, Sculptors, and Architects*, 2 vols., translated by Gaston Du C. de Vere (1912), edited by David Ekserdjian, New York: Knopf, and London: Campbell, 1996

REVIVALISM

Scholars most often view the phenomenon of revivalism as the resurrection of a particular style of a previous time; revivals of the sculpture of earlier periods have occurred throughout most of the history of art, particularly in the West. More than any other periods, the sculpture of Classical Greece and Rome has motivated revivals, but revivals of other periods have occurred as well. Revivals have often been triggered by a longing for an idealized or romanticized past way of life, the belief that the art of a particular previous era was superior to the art of the present, or by an interest in the formal and stylistic qualities of an art recently discovered—often through archaeological excavations. Revivals in art vary greatly in their scope and duration and are often associated with revivals in other fields, such as literature and architecture. The Italian Renaissance was the most extensive and influential revival in Western sculpture, but it was just one of several.

The Roman Empire saw various revivals of Classical Greek sculpture. One of the most visible involved the imperial sculpture of the reign of Augustus, when such works as the cuirass statue of Augustus from Prima Porta and the *Ara Pacis Augustae* revived the 5th-century BCE Attic style. A revival of Greek sculpture of the 5th and 4th centuries BCE occurred within the Roman Empire of the 2nd and 3rd centuries CE as a part of a much more comprehensive interest in the past that included revivals in philosophy, rhetoric, history, and fiction, as well as the art of painting. This revival included the copying of large numbers of Classical Greek sculptures, as well as the making of new ones in a similar style. Its products, particularly the copies, have served as a major source of modern information regarding Classical Greek sculpture, since few Classical freestanding Greek sculptures exist. Roman emperors did not always look to Greece for inspiration. The successors of strongly disliked emperors often chose internal revivals of the more objective portraiture of the republic for their portraits.

Revivals need not be limited to stylistic traits. They may also make use of certain types of statues or monuments, in a revivalistic style or not. The cuirass statue of Augustus was a Greek type; so too was the equestrian statue, which was resurrected by the Romans and reappeared at various times beginning in the 9th century. Other types of ancient statues also found a new life in later times. One notable example is the column statue of the type dedicated to Trajan and Marcus Aurelius, which, among numerous other occasions, was revived with a narrative frieze in Bishop Bernward's column at Hildesheim, Germany (*ca.* 1022); at the Place Vendôme in Paris some 800 years later; without the frieze in Nelson's column erected in London in 1842; and surmounted by a winged victory on the 1910 Monument of National Independence, Mexico City.

Bishop Bernward's bronze column and doors at the Church of St. Michael were rare and early examples of a return to monumental sculptural works during the pre-Romanesque Middle Ages and were part of a Classical revival of the arts and learning that began with the Carolingian revival of the 9th century. Monumental figural sculpture in the manner of the Greeks and Romans, however, was not a part of this revival. It was the Renaissance that truly saw an extended and far-reaching revival of the sculpture of the Classical world; like the Roman revival of Greek Classicism during the 2nd and 3rd centuries, the Renaissance saw an increased interest not just in Classical art but in all areas of learning. Sculptors such as Lorenzo Ghiberti and Donatello led the way, and the Renaissance saw a return to a greater sense of naturalism, as well as the reintroduction of monumental freestanding statues, a convincing *contrapposto* (a natural pose with the weight of one leg, the shoulder, and hips counterbalance one another) stance, and the nude figure, all of which had essentially been absent since antiquity. The Renaissance reached its high point in the early 16th century, by which time it had spread throughout most of Europe.

To an extent, archaeological discoveries fueled the revival of Classicism during the Renaissance; during the 18th century such discoveries were crucial to the Neoclassical movement in the arts and architecture. Considered by many to have been the creator of both the modern discipline of art history and scientific archaeology, Johann J. Winckelmann was the primary early force behind the revival of Classical art and architecture known as Neoclassicism during the 18th and

Paul Manship, detail from *Prometheus* frieze and fountain; gilded bronze; Rockefeller Center, New York City, United States
© Karen Tweedy-Holmes / CORBIS

19th centuries. His books, including his *Reflections on the Imitation of the Painting and Sculpture of the Greeks* (1755) and *History of Ancient Art* (1764), as well as the excavations he supervised at Herculaneum and Pompeii, were extremely influential in a revival of Classical art and architecture that would continue into the middle of the 19th century. The movement's leading sculptors included Antonio Canova, Bertel Thorvaldsen, and John Flaxman in Europe and Horatio Greenough and Hiram Powers in the United States.

The Gothic Revival of the 19th century was far less of a sculptural movement than was the Neoclassicism of the 18th century. Sculptors often made Gothic Revival sculpture to embellish buildings or monuments—much the way sculpture had been used during the Gothic period. Although excellent numerous examples of Gothic Revival sculpture exist in and on many buildings, often, as in the case of the Albert Memorial (1863–75) erected in Kensington Gardens, London, the sculpture was far less Gothic than was the structure to which it was joined.

Just as archaeological excavations in the 18th century had played a major role in the revival of Classical Greek art, 19th-century excavations of earlier Greek sites led to an increased interest in and exposure to the art of pre-Classical Greece. This interest, coupled with the changing aesthetic attitudes of the late 19th and early 20th centuries, which prized fidelity to nature far less than before, led some sculptors, including the American Paul Manship, to produce works that looked to archaic, rather than Classical, Greek art for inspiration. The revival known as "archaism" survived until the 1930s.

JEFFREY HAMILTON

See also **Canova, Antonio; Carolingian; Donatello (Donato di Betto Bardi); Flaxman, John; Ghiberti, Lorenzo; Greece, Ancient; Manship, Paul; Neoclassicism and Romanticism; Renaissance and Mannerism; Thorvaldsen, Bertel**

Further Reading

Barasch, Moshe, *Modern Theories of Art*, 2 vols., New York: New York University Press, 1990–98; see especially vol. 1, *From Plato to Winckelmann*, 1990

Brilliant, Richard, *Roman Art from the Republic to Constantine*, London: Phaidon, 1974

Brooks, Chris, *The Gothic Revival*, London: Phaidon, 1999

Clark, Kenneth, *The Gothic Revival: An Essay in the History of Taste*, London: Constable, 1928; 3rd edition, New York: Holt, Rinehart and Winston, 1962

Cook, Robert Manuel, *Greek Art: Its Development, Character, and Influence*, London: Weidenfeld and Nicolson, 1972; New York: Farrar, Straus & Giroux, 1973

Craske, Matthew, *Art in Europe, 1700–1830: A History of the Visual Arts in an Era of Unprecedented Urban Economic Growth*, Oxford and New York: Oxford University Press, 1997

Craven, Wayne, *Sculpture in America*, New York: Crowell, 1968

Curtis, Penelope, *Sculpture, 1900–1945: After Rodin*, Oxford and New York: Oxford University Press, 1999

Elsner, Jas, *Imperial Rome and Christian Triumph: The Art of the Roman Empire, AD 100–450*, Oxford and New York: Oxford University Press, 1998

Greenhalgh, Michael, *The Classical Tradition in Art*, London: Duckworth, 1978; New York: Harper and Row, 1981

Henig, Martin, editor, *A Handbook of Roman Art: A Comprehensive Survey of All the Arts of the Roman World*, Ithaca, New York: Cornell University Press, 1983; as *Handbook of Roman Art: A Survey of the Visual Arts of the Roman World*, Oxford: Phaidon, 1983

Irwin, David G., *Neoclassicism*, London: Phaidon, 1997

Osborne, Robin, *Archaic and Classical Greek Art*, Oxford and New York: Oxford University Press, 1998

Rather, Susan, "Toward a New Language of Form: Karl Bitter and the Beginnings of Archaism in American Sculpture," *Winterthur Portfolio* 25 (spring 1990)

Rather, Susan, *Archaism, Modernism, and the Art of Paul Manship*, Austin: University of Texas Press, 1993

Rosenblum, Robert, *Transformations in Late Eighteenth-Century Art*, Princeton, New Jersey: Princeton University Press, 1967

Rosenblum, Robert, and H.W. Janson, editors, *19th-Century Sculpture*, Englewood Cliffs, New Jersey: Prentice-Hall, and New York: Abrams, 1984; as *Art of the Nineteenth Century: Painting and Sculpture*, London: Thames and Hudson, 1984

Stokstad, Marilyn, *Medieval Art*, New York: Harper and Row, 1986

Strong, Donald, *Roman Art*, London and Baltimore, Maryland: Penguin, 1976

Whinney, Margaret, *Sculpture in Britain, 1530–1830*, London and Baltimore, Maryland: Penguin, 1964; 2nd edition, revised by John Physick, London and New York: Penguin, 1988

RIACE BRONZES

Anonymous

460–440 BCE

bronze

h. 1.98 m (A), 1.97 m (B)

Reggio Calabria, Museo Nazionale, Reggio, Italy

The Riace bronzes are over–life-size Classical Greek bronze statues discovered by chance in the sea off Riace Marina in southern Italy in August 1972, about 300 meters from the shore and in a depth of about 8 meters. Careful conservation in Florence (1975–80) and Reggio (1992–95) has recovered much of the figures' striking detail and fine surface finish and has also yielded rich scientific data. Original Greek statues of outstanding quality, the bronzes have fueled the imagination of scholars and the wider public alike, and many theories have developed concerning their correct identification and original setting.

Distinguished by their nudity and imposing size as warrior-heroes or gods, the statues, labeled bronze A and B, at first glance appear remarkably similar. They both stand with their weight on the right leg, while the relaxed left leg is slightly bent and set forward. Both feet rest firmly on the ground. The right arm is held alongside the body, while the left arm bends forward at the elbow. Both represent mature men, lean and heavily muscled, with dense beards. They originally held attributes that are now lost: on the left arm a large round hoplite shield, in the right hand a spear. Only the shield bands and the fragment of one handle remain.

Bronze A stands erect, shoulders almost level, the median line nearly vertical. His head is thrust to the right, the lips slightly parted with the teeth showing. Long S-shape strands form the beard and moustache, while the carefully executed hair radiates from the crown in fine parallel lines. A wide band, a mark of status, holds the hair, under which long separately cast corkscrew locks reach far down the neck. As on bronze B, the nipples and lips stand out in reddish copper, while the teeth are capped in silver. The eyeballs are made of ivory; the pupils, now missing, were made of glass paste. As traces on the headband show, bronze A may originally have worn a large metal wreath or, perhaps a later addition, a helmet.

Bronze B shows some subtle but important differences. The left foot is set less forward but slightly more to the side. The right hip thrusts out more, and the right shoulder is considerably lower than the left, resulting in a strong contraction of the right side of the body that is reflected in the curving median line. The head of bronze B is almost frontal, and although the beard is equally long and dense as that of A, the hair is much shorter. The top of the head was cast separately; contrary to A it is elongated and without any detail as it would from the beginning have been covered by a helmet, pushed up over the forehead to leave the face free. Over the forehead are traces of an additional element, perhaps representing a leather cap. Only the right eye remains. Unlike those of A, the eye is made of marble with an iris of ivory; the pupil is now missing. Whether this is the original eye is not quite clear. Analysis of the bronze alloy and core material has revealed that the lower left arm and probably the entire right arm of bronze B are the result of later restorations—these parts have the higher lead content typical of Hellenistic and Roman bronzes.

Taken separately, bronze A appears stylistically more in keeping with the late Severe Style of about 460–450 BCE (figures such as the Kassel and Tiber Apollos can be compared), whereas B seems influenced by the Polycleitan canon from after the middle of the 5th-century BCE. The hair over the forehead of B also recalls Polycleitan models, although the stance

Riace Warrior A
© David Lees / CORBIS

itself is distinctly different. Some scholars have therefore dated the statues up to 30 years apart from each other, and whether they belong together is a key question.

The unique character of the Riace bronzes as almost sole survivors of a once ubiquitous statuary type makes it somewhat hard to determine whether the similarities or differences in their technical execution should be considered more important. Analysis of the casting cores has provided intriguing new evidence that requires careful interpretation. The structures of both cores show distinct differences, and the material used for each seems to be of a different geographic origin. Scholars have ruled out south Italy and Sicily as sources for the core material; within Greece some have claimed that the material for both statues derives from a different microenvironment but the same geological basin, with Argos providing a particularly close match, or more specifically, that A shows close similarities to samples from Athens and B to those from Corinth. This theory, however, is still based on a limited number

of samples for comparison. Melucco Vaccaro has interpreted the particular structure of the casting cores with carefully arranged concentric layers as evidence for the direct lost-wax (*cire perdue*) technique, which would imply that both figures were based on different models. Others, such as Formigli, have thought it not incompatible with the indirect method, which would allow for both bronzes to be based on the same master model and which has so far been considered standard for this period.

On balance the close correspondence of their alloys, the analogous details of their piece molding, and the extremely similar measurements of even minor body parts suggest that sculptors made the two figures for the same context at about the same time. This theory would also best explain how two such apparently closely related figures came to be found together.

If one assumes that both bronzes came from the same monument, the perceived stylistic differences may be due to a collaboration of artists from different backgrounds (literary sources give ample evidence for this procedure when multifigure monuments are concerned), or more simply, they may be due to an intention to differentiate the subjects represented: A more aggressive and alert, B more relaxed. The discrepancies in the core material equally might reflect the involvement of two different workshops, although this account would challenge the current notion that large-scale bronzes were usually cast at the place were they were set up.

The statues had been torn off their bases in Antiquity, meaning that a key set of information available to the ancient viewer, the dedicatory inscription, is now lost.

An investigation of the seabed after the discovery of the statues yielded only insignificant results. It is unclear whether all of the material retrieved belongs to the same context, and not enough survives to reconstruct the date and details of the shipwreck (some have therefore proposed that the statues were merely jettisoned during a storm). Despite this scanty evidence, it is generally assumed and now seems confirmed by the scientific data that the statues came from mainland Greece and perished en route to Italy.

Their exceptional quality—the more outstanding through the lack of any comparable surviving originals—has led a generation of scholars to search for the artistic personality behind the statues and the monument to which they belonged. Scholars have suggested names of the foremost masters of the period, including Alcamenes, Hageladas, Onatas, and Pheidias, but the almost complete lack of any surviving originals securely attributed to these sculptors renders any such attribution hypothetical. This approach then, characterized by continuing scholarly disagreement, promises little success. Even if an exact attribution is not possible, one can deduce the general place and function of the statues.

If the Riace bronzes originally belonged to one single monument, then the character of their minor differences and overall similarity suggests that this monument was made up of a greater number of figures, since figures in Classical dedications tended to be subtly varied. The literary and epigraphic sources attest to a number of such monuments, mainly in the major sanctuaries such as Delphi and Olympia and often duplicated in the dedicating polis itself. One prominent example is a famous group at Delphi dedicated by the Athenians after the Battle of Marathon. A work of Pheidias, it contained statues of the ten tribal heroes of Athens and several other figures, among them gods and the general Miltiades. Another monument to the tribal heroes stood in the Athenian Agora. The city of Argos dedicated statues of the Seven against Thebes and their successors, the Epigonoi, at Delphi after the victorious Battle of Oinoe (after 460 BCE), works by the Thebans Hypatodoros and Aristogeiton, and a similar monument may have stood on the agora of Argos itself. About the same time the Achaeans dedicated at Olympia a group of ten Greek heroes before Troy, a work of the sculptor Onatas.

The Riace bronzes represent the generic type of warrior-hero most suitable for this kind of monument, and indeed they have been variously ascribed to each of these sculptors. Independent of any attribution, the bronzes are of great importance in providing a unique insight into the top level of Classical Greek bronze statuary otherwise lost to us.

THORSTEN OPPER

Further Reading

Edilberto, Formgli, "Le antiche terre di fusione, i problemi di formatura dei grandi bronzi e la technica di fusione dei bronzi di Riace," in *I grandi bronzi antichi: Le fonderie e le techniche di lavorazione dall'età arcaica al Rinascimento*, edited by Formigli, Siena, Italy: Nuova Immagine, 1999

I Bronzi di Riace: *Restauro come conoscenza*, edited by Alessandro Melluco Vaccaro and Giovanna De Palma, 2 vols, Rome: Artemide, 2003

Ioakimidou, Chrissula, *Die Statuenreihen griechischer Poleis und Bünde aus spätarchaischer und klassischer Zeit*, Munich: Tuduv-Verlagsgesellschaft, 1997

Lombardi, G., and M. Vidale, "From the Shell to Its Content: The Casting Cores of the Two Bronze Statues from Riace (Calabria, Italy)," *Journal of Archaeological Science* 25 (1998)

Lombardi Satriani, Luigi M., and Maurizio Paoletti, editors, *Gli eroi venuti dal mare; Heroes from the Sea* (bilingual English-Italian edition), Rome: Gangemi, 1986

Mattusch, Carol C., *Classical Bronzes: The Art and Craft of Greek and Roman Statuary*, Ithaca, New York: Cornell University Press, 1996

Melucco Vaccaro, A., "The Riace Bronzes 20 Years Later: Recent Advances after the 1992–95 Intervention," in *From the*

Parts to the Whole, edited by Carol C. Mattusch, Amy Brauer, and Sandra Elaine Knudsen, vol. 1, Portsmouth, Rhode Island: Journal of Roman Archaeology, 2000

Moreno, Paolo, *I bronzi di Riace: Il Maestro di Olimpia e i Sette a Tebe*, Milan: Electa, 1998

La Rocca, E., "Riace, Bronzi di," in *Enciclopedia dell'arte antica, classica e orientale*, suppl. vol. 4, Rome: Istituto della Enciclopedia Italiana, 1996

Schneider, G., and Edilberto Formigli, "Ipotesi sulla provenienza della terra dell' anima di fusione dei Bronzi di Riace," in *I grandi bronzi antichi: Le fonderie e le techniche di lavorazione dall'età arcaica al Rinascimento*, edited by Formigli, Siena, Italy: Nuova Immagine, 1999

Triches, Guglielmo B., *Due Bronzi da Riace: Rinvenmento, restauro, analisi ed ipotesi di interpretazione*, 2 vols., Rome: Istituto Poligrafico e Zecca dello Stato, 1984

RICCIO (ANDREA BRIOSCO) 1470–1532
Italian

Andrea Briosco, called Riccio (curly haired), was closely allied with a circle of sophisticated humanists in Renaissance Padua, the seat of one of Italy's most venerable universities. He is best known as the creator of several small bronze statuettes, particularly of satyrs, which are the quintessential plastic expression of the highly erudite Paduan culture of the time. This characterization of Riccio is made, however, at the expense of his few but magisterial surviving terracottas and his greatest work, the bronze Paschal candelabrum in the Basilica of Sant' Antonio in Padua (the Santo), from which many small bronzes were derived.

The enormous Paschal candelabrum (*h.* approx. 3.91 m [on a marble base carved by Francesco di Cola, approx. 1.43 m]), completely encrusted with allegorical and narrative reliefs and accented by figures of pagan hybrid creatures (sphinxes, centaurs, griffins, and satyrs), pierces the basilica's volume at the left of the reconstructed high altar where Donatello's bronze *Crucifix, Virgin and Child*, and flanking saints (1444–49) are found. This prejudicial juxtaposition has caused Riccio's work to be overlooked in their favor. Originally, however, the candelabrum was erected (1516) at the center of the choir. It was moved in 1591.

The commission for the work came to Riccio on the recommendation of Giambattista Leone, a professor of philosophy, who the year before had arranged for Riccio to create the reliefs *Judith and Holofernes* and *David with the Ark of the Covenant* for the entrance to the choir, which was already adorned by ten bronze panels of Old Testament subjects by Bartolomeo Bellano. Riccio was said to have worked with Bellano on the Roccabonella monument (Church of S. Francesco, Padua, *ca.* 1495). The candelabrum was the choir's centerpiece, and it must be remembered against the background of the twelve reliefs and with Donatello's *Crucifix* in its location at that time, over the choir's entrance. Although generally interpreted as an image

Paschal Candelabrum
© Alinari / Art Resource, New York

of the unity of Egyptian and Classical religions with Christianity, most of the candelabrum's iconographic elements, including those of its marble base, have yet to be adequately elucidated. Its memorial or commemorative purpose was underscored by a lost inscription, which called it a pyramid; its allusion to Christ's sacrifice, death, and resurrection is understood through its Easter function, in which the dramatic nighttime lighting of the Paschal candle (itself the symbol of the resurrected Christ) represents the deliverance of the faithful. Still the candelabrum begs for a new, profound, iconological inquiry: only four panels—the Adoration of the Magi, Christ's Descent into Hell, the Entombment, and the extraordinary Sacrifice of a Lamb—have clear subjects.

Nevertheless, the imagery of the candelabrum became one of the most influential in the history of European sculpture. It gave rise to hundreds of bronze statuettes and utensils that have been attributed to Riccio with abandon. Many are simply pastiches of elements drawn from the candelabrum, whereas others have

been identified as the work of Severo da Ravenna. The so-called Hell-Mountains (such as those at the Victoria and Albert Museum, London) were created by Agostino Zoppo; and the cylindrical incense burners inspired by Islamic prototypes (examples can be found in the Lehman Collection, Metropolitan Museum of Art, New York City) were incorrectly attributed to an artist who was mistakenly thought to be Riccio's follower, Desiderio da Firenze. They lack the overall delicacy and harmony of form and content of Riccio's finest works, as exemplified by the exquisite oil lamp in the Frick Collection in New York City. Many "Ricciesque" bronzes are now recklessly ascribed to Desiderio, even though his single securely documented work, a bronze voting urn in the Museo Civico (Padua), comprises no figure comparable to the numerous objects attributed to him. Moreover, Carrington emphasized that Desiderio's stylistic allegiance was to Florentine art, as his name would suggest. Most attributions to Desiderio are, therefore, to be approached with utmost caution. Riccio's authorship of many bronze casts of animals (such as lizards, crabs, and snakes) is also questionable.

An inscription (now lost) that had been under the base of the candelabrum stated that it would have been finished in three years had it not been interrupted by the War of the League of Cambrai. In 1509 imperial and French troops battled the Venetian Republic for control of Padua, which was bombed and looted. Church records note that in 1513 the "monastery began to be destroyed; the cloister was occupied as much by French and German soldiers as by those from the Veneto."

The protracted realization of the candelabrum is only one of the vexed problems in Riccio's chronology. Others include the reliefs for the tabernacle and altar of the cross formerly in the Church of Santa Maria dei Servi. The doors of the tabernacle would logically have been commissioned soon after the gift of a relic of the true cross in 1492, and indeed aspects of architectural compositions typically preferred by Donatello's earlier followers can be seen in the two panels. The reliefs for the tabernacle's altar, however, display a more original approach combined with characteristics favored by the mature Bellano and may date from about 1495 to 1500.

The chronology of the reliefs from the della Torre tomb is also unclear. The pink and white monument, whose design was unprecedented, comprised eight bronze reliefs in which reality merges perfectly with mythology. *The Soul's Departure* and *The Soul in Fortunate Woods* retain Bellano's lingering influence, but with *The Death of the Professor* and the other reliefs, Riccio's independence is declared. In contrast with Bellano's use of surging diagonals to express the chaos of action, Riccio's preference was for stately, balanced masses and isocephalic arrangements. Saxl's anachronistic observation on the looting of the reliefs by Napoléon Bonaparte's agents is worth quoting: "The classical dignity and unrealistic aloofness . . . were calculated to appeal to the contemporaries of David" (see Saxl, 1938–39).

Riccio also created a few majestic terracotta sculptures of the *Enthroned Madonna*, in addition to a terracotta *Lamentation*. They were originally polychromed and survive mostly in a fragmentary state. The reticence of the Madonnas contrasts markedly with Riccio's often tense and wiry bronze figures. Indeed, although Riccio's creations (particularly the oil lamps, whose ancestors were lit in a daily custom that may be the source of the Paschal candle's ritual) may seem relentlessly classicizing, an utter strangeness permeates them. His bronzes are at once magical, realistic, beautiful, and abstruse. They result from an intense intellectual effort to orchestrate highly complex subjects and compositions, often on an astonishingly small scale. Form and content blend in a uniquely original union, as ornament and meaning are repeatedly taken to the limit: as much as possible is crammed into the whole without loss of equilibrium or control. Even the *Shouting Horseman*, frequently interpreted as a small equestrian monument, is electrified with the same troubling energy and mystery; its arcane purpose may have had little to do with the standard function of any Classical prototype.

MARY L. LEVKOFF

See also **Donatello (Donato di Betto Bardi)**

Biography

Born probably in Trent, Italy (Padua also claimed as his birthplace), 1470. Likely trained by his father, Ambrogio, a Milanese goldsmith; generally believed to have worked under the direction of Bellano in the Church of S. Francesco (Padua) on the Rocabonella tomb, *ca.* 1492–95; completed tomb after Bellano's death (1498); did bronze doors for tabernacle of the reliquary of the cross in Santa Maria dei Servi (Venice), *ca.* 1492 or later; shortly after, did series of four reliefs of the Legend of the Cross for altar of the tabernacle; next commissioned to fabricate possibly the model, or simply a relief (*un quadro*), and some figures in wax for the Chapel of Saint Anthony in the Santo; two reliefs in the choir of the Santo, 1506–07; Paschal candelabrum begun 1507, completed in 1515 after wartime interruption; probably after war's end produced della Torre tomb, Church of S. Fermo Maggiore, Verona; bronze portrait bust for tomb of Antonio Trombetta, abbot of the Santo who confirmed the com-

mission of the Paschal candelabrum, 1521–24. Died in Italy (probably in or near Padua), July 1532.

Selected Works

ca. 1492– 1500	Tabernacle doors and altar reliefs for reliquary of the cross, for Church of Santa Maria dei Servi, Venice, Italy; bronze; Ca' d'Oro, Venice, Italy
1506–07	*Judith and Holofernes*; bronze; Basilica of Sant' Antonio, Padua, Italy
1506–07	*David with the Ark of the Covenant*; bronze; Basilica of Sant' Antonio, Padua, Italy
ca. 1506	*Amalthea's Goat*; bronze; Museo Nazionale del Bargello, Florence, Italy
ca. 1506/ 1516–21	Reliefs for della Torre tomb (*The Soul's Departure, The Soul in Fortunate Woods*, and *The Death of the Professor*), for Church of S. Fermo Maggiore, Verona, Italy; bronze; Musée du Louvre, Paris, France
1507– 09/ 1513–16	Paschal candelabrum; bronze; Basilica of Sant' Antonio, Padua, Italy
ca. 1507–15	Oil lamps; bronze; Victoria and Albert Museum, London, England; Frick Collection, New York City, United States; Ashmolean Museum, Oxford, England
ca. 1507–15	*Seated Satyr*; bronze; Kunsthistorisches Museum, Vienna, Austria
ca. 1510–15	*Shouting Horseman*; bronze; Victoria and Albert Museum, London, England
ca. 1516– 1521	*Moses*; bronze; Musée Jacquemart-André, Paris, France
1520	*Enthroned Madonna and Child*; terracotta; Scuola del Santo, Padua, Italy
ca. 1520–25	*Enthroned Madonna and Child* (half-length fragment); terracotta; J. Paul Getty Museum, Los Angeles, California, United States
1521–24	Bust of Antonio Trombetta; Basilica of Sant' Antonio, Padua, Italy
1530	*Lamentation*, for Church of S. Canziano; terracotta; fragments *in situ* and Museo Civico, Padua, Italy

Further Reading

Bellinati, Claudio, *La Basilica del Santo: Storia e arte*, Rome: Edizioni de Luca, 1994

Blume, D., "Antike und Christentum," in *Natur und Antike in der Renaissance*, Frankfurt: Liebieghaus Museum Alter Plastik, 1986

Carrington, Jill, "A New Look at Desiderio da Firenze and the Paduan Voting Urn," *Bollettino del Museo civico di Padova* 73 (1984)

Ciardi Dupré dal Poggetto, Maria Grazia, *Il Riccio*, Milan: Fratelli Fabbri, 1966

Jestaz, Bertrand, "Riccio et Ulocrino," in *Italian Plaquettes*, edited by Alison Luchs, Washington, D.C.: National Gallery of Arts, 1989

Leithe-Jasper, Manfred, "Zum Werke Agostino Zoppos," *Jahrbuch des Stiftes Klosterneuburg* 9 (1975)

Martineau, Jane, and Charles Hope, editors, *The Genius of Venice, 1500–1600* (exhib. cat.), London: Royal Academy of Arts, 1983; New York: Abrams, 1984

Planiscig, Leo, *Venezianische Bildhauer der Renaissance*, Vienna: Schroll, 1921

Planiscig, Leo, *Andrea Riccio*, Vienna: Schroll, 1927

Pope-Hennessy, John, *An Introduction to Italian Sculpture*, 3 vols., London: Phaidon, 1963; 4th edition, 1996

Radcliffe, Anthony, "Bronze Oil Lamps by Riccio," *Victoria and Albert Museum Yearbook* 3 (1972)

Radcliffe, Anthony, "A Forgotten Masterpiece in Terracotta by Riccio," *Apollo* 118 (July 1983)

Saxl, F., "Pagan Sacrifice in the Italian Renaissance," *Journal of the Warburg Institute* 2 (1938–39)

SHOUTING HORSEMAN
Riccio (Andrea Briosco) (1470–1532)
ca. 1510–15
bronze
h. 33.5 cm
Victoria and Albert Museum, London, England

The origins of Riccio's *Shouting Horseman* are unknown prior to its appearance in Paris in the possession of the dealer and collector Frédéric Spitzer during the second half of the 19th century. It was the most expensive object bought at the Spitzer sale in 1893 by the renowned collector George Salting, whose outstanding bequest to the Victoria and Albert Museum in 1910 included this bronze.

The warrior, dressed in antique armor, rides bareback, his knees gripping his mount, the hilt of a sword grasped in his taut right hand, and his head turned sharply to the right. His open mouth, coupled with his intense gaze, has been variously interpreted as emitting a battle cry, a cry of fear, or a combination of both. The bared teeth and flared nostrils of the horse, as well as its pose, reflect the rider's tension and develop the impression of agitation, movement, and even danger.

While in Spitzer's possession, the group underwent fairly extensive repairs, carried out in the workshop of Alfred André. The tail of the horse and the majority of the three supporting legs were replaced. Areas of loss include an element from the top of the helmet and the blade of the sword; there is also a hole in the top of the horse's head, which is apparently original. The rider's left hand most probably held a shield in the

antique manner; a circular *plaquette* (small bronze relief) by Galeazzo Mondella, called Moderno (presumably added by Spitzer and later removed) formerly served in its place.

Like Riccio's other bronzes, this is a unique cast, both horse and rider having been modeled in wax around a fired clay core and cast separately. The rider is hollow underneath where the core has been removed, and its hammered surface creates a lively effect. The statuette was not, therefore, replicated by Riccio, but numerous after-casts and variants of the rider emanated from the notorious counterfeiters Spitzer and André. The copies appear on a variety of horses, some genuine products of the 16th century, but only one replica of the horse itself has so far been discovered. Despite its restored state and the lack of provenance, the *Shouting Horseman* is universally accepted as one of Riccio's great masterpieces in bronze, so much so that the image has been used on several book covers, effectively representing the genre of the small bronze, and testifying to its lasting reputation. The only dissenting voice has been that of George Hill, whose scathing comments are, not surprisingly, rarely cited (see Hill, 1910).

A number of influences can be traced in the composition, notably various passages in the treatise *De Sculptura* (On Sculpture) by Riccio's friend, Pomponius Gauricus, published in 1504. Anthony Radcliffe convincingly argued that Riccio had this text in mind when devising the sculpture, including a passage describing a nervous and excited horse quoted from a Classical text, the *Sylvae of Statius* (see Radcliffe in Krahn, 1995). In his treatise, Gauricus suggested that sculptors should draw both on literary sources and their own observation, and he provides telling examples of both. He highlights the two different styles of horsemanship: the armored or heavy cavalry, where the rider stands up in the stirrup (as seen in the equestrian monument [*ca.* 1480–92] to the condottiere Bartolommeo Colleoni by Andrea del Verrocchio, which was cast by Alessandro Leopardi after Verrocchio's death) and the light cavalry. The description of the latter closely resembles Riccio's horseman, and certainly during the War of the League of Cambrai the Venetian *stradiotti*, or colonial light cavalry, would have been a familiar sight. But instead of contemporary armor, Riccio reproduced a Classical-inspired, muscled cuirass of the type produced either in bronze or molded leather. The helmet, decorated with typically Ricciesque *erotes* (winged putti), is reminiscent of the elaborate designs for parade armor *all'antica* (after the Antique) favored at the time, although somewhat less fanciful. Similar equestrian figures are found in Antiquity, such as Trajan's Column in Rome, but Classical images of combat generally show horsemen either bare-headed or with simpler forms of helm. The lack of a saddlecloth, which adds to the impression of urgency, is unusual both in Antiquity and the 16th century (compare, for example, Riccio's own relief of *The Victory of Constantine* [after 1498] in the Galleria Giorgio Franchetti alla Ca'd'Oro in Venice).

The remarkably accurate representation of armor is akin to that produced by Andrea Mantegna, an artist with whom Riccio had close stylistic associations. Here, for example, the dramatic cry and musculature of the rider recalls Mantegna's *Battle of the Sea Gods* (1470s). Riccio may also have known Leonardo da Vinci's studies of grotesque heads, as well as his drawings of horses, as seen in the *Battle of Anghiari* (1503; destroyed but much copied) and the designs for the Sforza (1483–93) and Trivulzio monuments (*ca.* 1511). The portrayal of the rider is extremely close to a passage regarding the representation of the conquered in battle in Leonardo da Vinci's notebook, and the group reflects a similar interest in physiognomy and the appropriate representation of emotion and physical type. This study, expounded by Gauricus, was linked to the humoral system of medicine and the belief that man's nature was expressed in his physical appearance. Strength and virtuous heroism, for instance, were associated with leonine features, which according to Plutarch were seen in the bust of Lysippos's 4th-century-BCE *Alexander the Great*. Bertrand Jestaz tentatively suggested that Alexander was the subject of

Shouting Horseman
© Victoria and Albert Museum, London / Art Resource, NY

the *Shouting Horseman* (see Jestaz, 1983), and similar lionlike qualities have been recognized in the warrior's features (see Ebert-Schifferer, 1985). Surviving images of Alexander are not, however, closely comparable, but it does seem likely that the bronze represented a particular soldier or event.

The *Shouting Horseman* was doubtless commissioned by one of Riccio's humanist friends and patrons, many of whom were scholars at the university, including the philosopher Giambattista de Leone, who devised the elaborate iconography of the Paschal candelabrum. By comparison with the decorative details of this masterwork, the *Shouting Horseman* has been dated to about 1510–15, coinciding with considerable military activity in the region. Another friend was the writer, diarist, and collector Marcantonio Michiel, who probably owned bronzes by the artist and had admired Bertoldo di Giovanni's small "equestrian" bronze of *Bellerophon and Pegasus* (early 1480s), then in a prestigious Paduan collection and presumably known to Riccio. A Pegasus appears in Riccio's relief of *Fame Triumphant Over Death* from the tomb of Girolamo and Marcantonio della Torre, both professors of medicine, the latter being a pioneer in the field of anatomy who advised Leonardo in his studies. Unlike its monumental equestrian counterparts, the *Shouting Horseman* is a vibrant and intimate object designed to be handled and admired. It would doubtless have been kept alongside other such objects, both ancient and contemporary, and in addition to its aesthetic and intrinsic value, it probably encapsulated different levels of meaning that we have yet to rediscover.

PETA MOTTURE

Further Reading

Ebert-Schifferer, Sybille, editor, *Natur und Antike in der Renaissance* (exhib. cat.), Frankfurt: Liebieghaus Museum Alter Plastik, 1985

Hill, George, "The Salting Collection—I. The Italian Bronze Statuettes," *The Burlington Magazine* 16 (March 1910)

Jestaz, Bertrand, "Un groupe de bronze érotique de Riccio," *Fondation Eugène Piot: Monuments et mémoires* 65 (1983)

Krahn, Volker, editor, *Von allen Seiten schön: Bronzen der Renaissance und des Barock* (exhib. cat.), Heidelberg, Germany: Edition Braus, 1995

Mantegna, Andrea, *Andrea Mantegna* (exhib. cat.), edited by Jane Martineau, Milan: Olivetti/Electa, and London: Royal Academy of Arts, 1992

Motture, Peta, " 'None but the Finest Things': George Salting As a Collector of Bronzes,' " *Sculpture Journal* 5 (2001)

Pyhrr, Stuart W., and José-A. Godoy, *Heroic Armor of the Italian Renaissance: Filippo Negroli and His Contemporaries* (exhib. cat.), New York: Metropolitan Museum of Art, 1998

Radcliffe, Anthony, "John Caius and Paduan Humanist Symbolism," *The Caian* (1987)

Stone, Richard E., "Antico and the Development of Bronze Casting in Italy at the End of the Quattrocento," *Metropolitan Museum Journal* 16 (1982)

GERMAINE RICHIER 1904–1959 *French*

Germaine Richier is best known for her monumental sculptures from the 1940s and 1950s of human-animal hybrids in bronze. Similar in their roughly hewn surfaces to Alberto Giacometti's sculptures of the same period, Richier's work grew out of the vocabulary of pre–World War II Expressionism and Surrealism and the influence of Auguste Rodin and Pablo Picasso, but they contain an organic force that is unique. Richier was exhibited frequently during her lifetime and was influential to the work of French sculptor César Baldaccini and the British sculptors Lynn Chadwick, Kenneth Armitage, and Reg Butler.

Born in 1904 near Arles, Richier studied at the École des Beaux-Arts in Montpellier under Louis-Jacques Guigues, a former student of Rodin. In 1925 she moved to Paris where she studied with Emile-Antoine Bourdelle, also a student of Rodin's, and whose Classical subject matter and large-scale memorials impressed the importance of monumentality upon the young Richier. In her early years, Richier was accepted into the established venues for sculpture in Paris. Beginning in 1928, she regularly exhibited at the Salon d'Automne and the Salon des Tuileries; in 1936 she won the Blumenthal prize and received her first solo exhibition at the Galerie Kaganovitch; and in 1937 she won the sculpture prize for her contribution to the Exposition Universelle in Paris.

Throughout the 1930s, Richier was sought after for her portrait busts and her female nudes (such as *Regodias*), and she was able to establish her own studio and take in pupils in 1930. These years are usually given short shrift in the exhibitions and literature on Richier, as her work of this period is tied closely to the Classical figuration of Bourdelle. Contemporary critics compared her with Charles Despiau, who also worked as an assistant to Rodin but whose sculpture was more Classical.

During the Occupation, Richier, like Giacometti, lived in Switzerland. When she returned to Paris after World War II, she found an artistic community in the throes of rupture. Expressionism and Surrealism, dominant before the war, had given way to the polarizing factions of abstraction and realism: the former was seen as a symbol of freedom and resistance in reply to the Classical forms encouraged by the Nazis, whereas realism was advocated by communist parties in France and in Russia, and thus had its own political dimension. Richier's work of this period was emphatically neither abstract nor realist, which has made her, as well as Giacommetti and the late Picasso, hard to categorize.

Her sculpture of the 1940s evinces an interest in the melding of human and animal forms, and it is this work that is understood to be her most innovative. Richier's

Preying Mantis
The Conway Library, Courtauld Institute of Art
© 2003 Artists Right Society (ARS), New York and ADAGP
(Paris)

handling of bronze became more rugged in the 1940s, as she made less of an attempt to erase her tactile connection to her materials. Critics of these years called these sculptures of insects, winged men, and obese nudes "hybrid beings" and linked her work to the violent forms of Expressionism and the enigmatic figures of Surrealism. Richier's work also bears some similarities to the primitivism of Jean Dubuffet, although her forms evoke an organic monumentality that is not at all violent. In addition, her interest in fossils and skulls, which appears in *The Bird* (1953–55) and *The Bullfight*, connects her to American postwar sculptors such as David Smith, who incorporated representations of the organic remains of life into his smaller sculpture.

When asked, Richier explained that her work metamorphosed in this period because she had grown tired of her earlier studies of form and had become inter-

ested in her own memories and in the folklore of her native Provence. In *Man of the Forest*, Richier employed the Surrealist technique of collage, but to more primitivistic ends: she incorporated a branch that she had picked up during a country walk as the figure's right arm, and his plantlike hand was derived from a leaf that she found. Richier similarly used a found object in *The Shepherd of Landes*, in which the figure's head consists of a block of brick and cement that had been eroded by the ocean.

Preying Mantis, of which there are 11 extant versions, is 120 centimeters in height. The sculpture's rough, moltenlike surface is typical of Richier's later work in its registering of the sculptor's touch. The mantis's limbs are unnaturally attenuated, as in the sculpture of Giacometti, but Richier's forms interact with the space around them in a more volatile, active manner. She remarked that she did not wish to convey movement per se in her sculpture: she intended her hybrids to appear to be temporarily at rest, a moment which *Preying Mantis* captures. This sculpture has also been understood to be emblematic of Richier's nascent feminism, since she knew that the female preying mantis devours the male after copulation. As such, it can be read in juxtaposition to the many Surrealist works that fragment and transmogrify the female body into nightmarish apparitions.

That same year, Richier made *The Spider*, the first sculpture that incorporated wires. This addition gave form to the spider's web; in addition, it served as a visualization of movement and effectively used space as a canvas upon which the sculptor could draw. In later sculptures, such as *The Diabolo Player, Don Quixote* (1950–51), *The Claw* (1952), and *The Ant*, Richier continued to manipulate wires, often using them to create connections between attenuated limbs and the sculpture's bronze pedestal.

Other important works of the 1940s and 1950s include her nudes, two of the best known of which are *The Thunderstorm* and its companion, *The Storm*. The former, a corpulent male nude with unsettlingly splayed hands, was based on Nardonne, who had modeled for Rodin's *Balzac*. Her *Christ d'Assy*, produced for a church in Assy designed by Le Corbusier, was received with outrage and was promptly removed from the sanctuary as a result of its highly abstract, sticklike representation of Christ. In the late 1950s Richier began to cover her bronze sculptures with bright enamel, as in *Great Chessboard*.

MARISA ANGELL

See also **Bourdelle, Emile-Antoine; Butler, Reg (Reginald Cotterell); César (Baldaccini); Despiau, Charles; Dubuffet, Jean; Giacometti, Alberto; Picasso, Pablo; Rodin, Auguste; Smith, David; Surrealist Sculpture**

Biography

Born in Grans, near Arles, France, 16 September 1904. Attended École des Beaux-Arts de Montpellier under Louis-Jacques Guigues, 1922–25; moved to Paris, became student of Emile-Antoine Bourdelle, 1925; began to exhibit regularly at Salon d'Automne and Salon des Tuileries, 1928; first solo exhibition, Max Kaganovitch Gallery, Paris, 1934; won Blumenthal Prize for sculpture, 1936; awarded honorary diploma for contribution to Exhibition Universelle, Paris, 1937; took part in International Exhibition, New York, 1939; lived in Switzerland, 1939–45; retrospective at Maeght Gallery, Paris, 1948; *Christ d'Assy*, for Le Corbusier's church at Assy, was removed, and article condemning it appeared in *l'Osservatore Romano*, the official organ of the Vatican, 1950; participated in exhibitions in Belgium, Chile, England, France, Holland, Italy, Sweden, Switzerland, and the United States, 1940s–1950s; included in "The New Decade: 22 European Painters and Sculptors," (1955) and "New Images of Man" (1959), Museum of Modern Art, New York City. Died in Montpellier, France, 31 July 1959.

Selected Works

1938 *Regodias*; bronze; collection of the family of Germaine Richier

1945 *Man of the Forest*; bronze; casts: Krugier-Ditesheim Art Contemporain, Geneva, Switzerland

1946 *Preying Mantis*; bronze; casts: Beeldhouwkst Middelheim, Antwerp, Belgium

1946 *The Spider*; bronze; casts: Fondation Basil et Elise Goulandris, Andros, Greece

1947–48 *The Storm*; bronze; casts: Musée Nationale d'Art Moderne, Centre Georges Pompidou, Paris, France

1948–49 *The Hurricane*; bronze; Musée Nationale d'Art Moderne, Centre Georges Pompidou, Paris, France

1950 *Christ d'Assy*, for Le Courbusier's church, Assy, France; bronze; Wallraf-Richartz Museum, Cologne, Germany

1950 *The Diabolo Player*; bronze; casts: Tate Gallery, London, England; Musée Nationale d'Art Moderne, Centre Georges Pompidou, Paris, France

1951 *The Shepherd of Landes*; bronze, Louisiana Museum, Humlebaek, Denmark

1953 *The Ant*; bronze; private collection, Germany

1953 *The Bullfight*; bronze; Louisiana Museum, Humlebaek, Denmark

1959–61 *Great Chessboard*; bronze painted with enamel; collection of the family of Germaine Richier

Further Reading

Cassou, Jean, *Germaine Richier*, New York: Universe Books, and London: Zwemmer, 1961

Ceysson, Bernard, et al., *L'École de Paris? 1945–1964*, Luxembourg: Musée National d'Histoire et d'Art, and Paris: Adagp, 1998

Da Silva, Vieira, *Germaine Richier*, Amsterdam: Stedelijk Museum, 1955

Germaine Richier, 10 octobre–9 décembre, 1956, Paris: Éditions des Musées Nationaux, 1956

Germaine Richier, 1904–1959, Arles, France: Musée Réattu, 1964

Germaine Richier, Paris: Galerie Creuzevault, 1959

Lammert, Angela, and Jörn Merkert, editors, *Germaine Richier* (exhib. cat.), Cologne, Germany: Wienand, 1997

Morris, Frances, *Paris Post War: Art and Existentialism, 1945–55*, London: Tate Gallery, 1993

Prat, Jean-Louis, *Germaine Richier: Retrospective*, Saint-Paul, France: Fondation Maeght, 1996

Staub, Helena, *Bourdelle et ses élèves: Giacometti, Richier, Gutfreund*, Paris: Paris Musées, 1998

TILMAN RIEMENSCHNEIDER *ca.* 1460–1531 *German*

A contemporary of Albrecht Dürer, Tilman Riemenschneider spent most of his active life, from 1483 until 1531, in the Franconian city of Würzburg. Born in Heiligenstadt in Thuringia, he probably received his apprenticeship in Strasbourg and Ulm, the two major sculptural centers in Germany. Riemenschneider's conception of sculpture as a kinetic experience, in which the viewer is invited to move around the work, either physically or through the mind's eye, derived from Nikolaus Gerhaert von Leiden of Strasbourg. The introspective, almost elegiac quality of Riemenschneider's art reflects the influence of Michel Erhart and the sculpture of Ulm. In addition, through his intimate knowledge of the engravings of Martin Schongauer, Riemenschneider indirectly absorbed lessons in the formal elegance and restrained pathos of Rogier van der Weyden. After Riemenschneider acquired the title of master in Würzburg in 1485, his workshop rapidly grew into one of the most prolific in Germany. It received commissions from ecclesiastical and municipal authorities in Würzburg and other towns in the vicinity, as well as in cities outside the diocese, such as Bamberg and Wittenberg.

From the beginning of his career Riemenschneider demonstrated his proficiency in a variety of materials. His earliest works include engaging carvings in alabaster, a medium he used for at least 20 years. His ease at carving sandstone is apparent in his over–life-size

Adam and Eve, commissioned in 1491 by the municipal council of Würzburg for the Chapel of the Virgin. Riemenschneider's stone sculpture evinces an extremely subtle, almost sensual treatment of surfaces. During the same period he worked on a monumental limewood altarpiece for which he had signed a contract with the municipal council of Münnerstadt in 1490. He erected the retable, unpolychromed, in 1492 in the choir of the Church of Mary Magdalene. His next important commission came in 1496 from Prince-Bishop Lorenz von Bibra, for the funerary monument to his predecessor, Rudolf von Scherenberg. Carved of red Salzburg marble with a sandstone framework and installed in Würzburg Cathedral in 1499, the memorial is one of the high points in Riemenschneider's oeuvre. A striking physiognomy, the effigy is remarkable for its sensitive treatment of surfaces and its integration of figure and architecture.

Throughout his career Riemenschneider produced numerous altarpieces, or retables, only two of which have survived intact. In April 1501 Riemenschneider signed a contract with the municipal council of Rothenburg for the execution of sculpture for the Holy Blood altarpiece in the west choir of the Church of St. Jacob; the encasement had been commissioned in 1499 from a local joiner. Riemenschneider delivered the figures in installments between 1502 and 1505. The central shrine includes his rendering of the *Last Supper*, flanked by the *Entry into Jerusalem* and the *Agony in the Garden* on the wings. The predella (a painted panel at the bottom of an altarpiece) contains two angels with instruments of the Passion on either side of a crucifix. The superstructure holds the figures of the Virgin and Gabriel, forming an *Annunciation*, with the *Man of Sorrows* at the top. The Church of St. Jacob was a pilgrimage church, and the altarpiece was designed as a gigantic monstrance for the display of the relic of the Holy Blood, housed in an earlier cross held by two angels in the superstructure.

As with the Münnerstadt retable, the Holy Blood altarpiece had no polychromy, but a lightly tinted glaze, giving the wood a warm, amberlike tone. At the other end of the nave, in the east choir, stands Friedrich Herlin's altarpiece (1466), which combines fully polychrome figures in the shrine and paintings on the wings. Despite the limitations imposed by the absence of color, Riemenschneider found other means to engage the viewer in his altarpiece. The retable is site specific. The open predella allows a view of the masonry of the choir. The back of the shrine, behind the figures, is open through a series of glazed lancet windows that resemble both in form and in tracery the architectural windows of the choir. The ribbed vaulting above the *Last Supper* in the shrine follows, at least in part, the same pattern as the structural vaulting in

the choir above. These clues are more subtle than those offered by paint, yet they allow an actualization of the scene by placing it in an identifiable setting. The unification of the space of the sculpture with that of the viewer reveals an intense reflection on the nature of representation, which is made all the more acute by the inclusion of the relic in the superstructure. Riemenschneider's sculptured group offers a visualization of the Last Supper, and the relic above it establishes a direct link between the viewer and the event. Opening the back of the altarpiece also allowed the sculptor to exploit changes in natural light in the choir, so as to put various elements into focus at different times of day.

Riemenschneider used natural light to its full advantage in his Assumption of the Virgin altarpiece in the Church of Our Lord in Creglingen to create what might be termed chiaroscuro sculpture. The retable receives much less light than the one in Rothenburg. Inside the church the eye grows accustomed to darkness and sees the figures slowly take form. The draperies contain rich contrasts between florid and quiet passages, which create a complex play of light and dark. The development of the graphic arts in Germany in the 15th century paved the way for the acceptance of monochrome sculpture, and the Creglingen altarpiece recalls the rich tonal range of Schongauer's engravings, which Riemenschneider often took as a point of departure for his own compositions.

The masterpiece of Riemenschneider's late career, his sandstone *Lamentation* relief in Maidbronn, integrates ten figures into an organic whole, in which foreground and background flow effortlessly into one another. Compared with earlier sculpture, an abstraction has taken place: less-individualized faces and simplified draperies, with fewer and rounder folds revealing more distinct bodies through the fabric. Another monument of Riemenschneider's late style is his Virgin and Child on the Crescent Moon, in which the volumetric approach of earlier works has given way to a planar treatment that favors frontal viewing.

Riemenschneider's career ended abruptly in 1525 when he served on the Würzburg municipal council and sided with the peasants against Prince Bishop Konrad von Thüngen during the unsuccessful Peasants' Revolt. Whether Riemenschneider had the peasants' interest at heart or opposed the prince bishop in an attempt to maintain Würzburg's independence from feudal control, his political stance has greatly colored the way his oeuvre came to be interpreted in the course of history.

JULIEN CHAPUIS

See also **Erhart, Michel; Gerhaert von Leiden, Nikolaus; Germany: Gothic–Renaissance; Lamentation and Deposition Groups**

Biography

Born in Heiligenstadt in Thuringia (present-day Germany), *ca.* 1460. Son of Tilman, who moved to nearby Osterode am Harz and became master of the Mint, 1465. Probably trained in Strasbourg and Ulm; found employment in a sculptor's workshop in Würzburg and joined the Guild of St. Luke for painters, sculptors, and glaziers, 1483; became master, 1485; began hiring assistants and selling sculpture under his name; ran one of the most prolific workshops in Germany for 40 years; fell out of grace with Catholic nobility after Peasants' Revolt, 1525; no major works after this point. Died in Würzburg, Germany, 7 July 1531.

Selected Works

ca. 1485 *Annunciation*; alabaster; Rijksmuseum, Amsterdam, the Netherlands

ca. 1485–90 Passion altarpiece; limewood with polychromy (dispersed); two groups and a *Lamentation:* Staatliche Museen, Berlin, Germany; *St. John and the Holy Woman, Caiphâs and His Soldiers:* Bayerisches Nationalmuseum, Munich, Germany; *Agony in the Garden* and *Resurrection:* Schlossmuseum, Berchtesgaden, Germany; *St. Matthew:* Church of Sankt Matthäus, Heroldsberg, Germany

ca. 1490 *St. John the Baptist*; limewood; Church, of Saint Totnan und Kolonat, Hassfurt, Germany

1490–92 High altar, Church of St. Mary Magdalene, Münnerstadt, Germany; limewood (dispersed); elements: statues of *St. Kilian* and *St. Elizabeth of Hungary: in situ*; statue of St. Mary Magdalene with six angels: Bayerisches Nationalmuseum, Munich, Germany; *Noli me tangere* (scene of Christ telling disciples, "Don't touch me," just after Resurrection), the *Feast in the House of Simon*, and busts of the apostles: Staatliche Museen, Berlin, Germany

1491–92 *Adam and Eve*, from south portal, Chapel of the Virgin, Würzburg, Germany; sandstone (removed; copies *in situ*); Mainfränkisches Museum, Würzburg, Germany

1496–99 Funerary monument to Prince-Bishop Rudolf von Scherenberg; red Salzburg marble; Würzburg Cathedral, Germany

1499–1513 Tomb of Emperor Henry II and Kunigunde; Solnhofen stone; Bamberg Cathedral, Germany

1501–05 Holy Blood altarpiece; limewood; Church of St. Jacob, Rothenburg ob der Tauber, Germany

ca. 1505–10 Assumption of the Virgin altarpiece; limewood; Church of Our Lord, Creglingen, Germany

1516 Crucifix; limewood; parish church, Steinach an der Saale, Germany

ca. 1520–25 *Lamentation*; sandstone; high altar, Cistercian Abbey (now Church of St. Afra), Maidbronn, Germany

1521–22 *Virgin and Child on the Crescent Moon*; limewood; House Collection, Dumbarton Oaks, Washington, D.C., United States

Further Reading

Baxandall, Michael, *The Limewood Sculptors of Renaissance Germany*, New Haven, Connecticut: Yale University Press, 1980

Bier, Justus, *Tilmann Riemenschneider*, vols. 1–2, Würzburg, Germany: Verlagsdruckerei, 1925–30; vols. 3–4, Vienna: Anton Schroll, 1973–78

Bier, Justus, *Tilmann Riemenschneider: His Life and Work*, Lexington: University Press of Kentucky, 1982

Chapuis, Julien, et al., *Tilman Riemenschneider: Master Sculptor of the Late Middle Ages* (exhib. cat.), Washington, D.C.: National Gallery of Art, and New Haven, Connecticut: Yale University Press, 1999

Kahsnitz, Rainer, *Tilman Riemenschneider: Zwei Figurengruppen unter dem Kreuz Christi*, Berlin: Kulturstiftung der Länder, and Munich: Bayerisches Nationalmuseum, 1997

Kalden, Iris, *Tilman Riemenschneider: Werkstattleiter in Würzburg*, Ammersbek, Germany: Verlag an der Lottbeck, 1990

Krohm, Hartmut, "Der Schongauersche Bildgedanke des Noli me Tangere aus Münnerstadt: Druckgraphik und Bildgestalt des nichtpolychromierten Flügelaltars," in *Flügelaltäre des späten Mittelalters*, edited by Krohm and Eike Oellermann, Berlin: Reimer, and Staatliche Museen, Berlin, Preussischer Kulturbesitz, 1992

Tilman Riemenschneider: Frühe Werke (exhib. cat.), Regensburg, Germany: Pustet Verlag, 1981

RILIEVO SCHIACCIATO

See Relief Sculpture

RIMINI MASTER late 15TH CENTURY
South Netherlandish or French

The conventional name the Rimini Master has been given to the leading personality in a highly productive alabaster workshop that was probably located in the Tournai-Lille region of the southern Netherlands or northern France in the second quarter of the 15th century. A location in Paris is also possible. The name derives from his masterpiece, the alabaster *Crucifixion* group with clusters of flanking figures and 12 apostles,

from the Church of Santa Maria delle Grazie in Rimini-Covignano, now at the Liebieghaus in Frankfurt. That group, with figures averaging about 45 centimeters high, may have been supplied for the consecration of the church's high altar in 1432. The workshop that made them seems to have carved alabasters of similar small scale for export not only to Italy but also to Spain, Germany, and the northern Netherlands. As small traces of gesso and paint on hair and garments in the Victoria and Albert Museum *Virgin with the Dead Christ* suggest, these were sometimes polychromed; it is by no means certain whether this was done in the sculptor's workshop or at the patron's behest after receiving the work. The Rimini altar figures, in any case, are unpainted except for traces of red on lips and wounds. The sculptor and many of his clients clearly prized the richness and luminosity of uncolored alabaster.

The master's meticulous, ornamental treatment of costume and hair points to early training in a goldsmith's workshop. His closest affinities, however, are to the contemporary painting of the Master of Flémalle, now usually identified as Robert Campin. This is a principal reason why a south Netherlandish location for his workshop has seemed likely. Following the 1913 sale of the Rimini *Crucifixion*, various scholars believed the sculptor was Rhenish, perhaps working in Italy and possibly to be identified with Master Gusmin from Cologne, who was discussed in Lorenzo Ghiberti's commentaries. Increasingly, however, there has been recognition of the close affinities between the figures from Rimini and the paintings by Campin. These are starkly clear, for instance, in a comparison of the agonized head of the thorn-crowned, crucified Christ in Frankfurt with that of the dead Christ in the Holy Trinity group by Campin (also in the Städelsches Kunstinstitut, Frankfurt). Such similarities, along with the handling of modeling and of such features as drapery folds and fine-stranded curling hair, point to an intimate connection between the painter and sculptor.

The Rimini Master seems to have been most appreciated for his ability to portray suffering and death. He created a recurrent, harrowing depiction of pain by means of knitted brows, eyes narrowed to sharp slits, and half-open mouths with grimacing, bared teeth. Some of his figures, however, show emotional restraint with stoically set mouths and sometimes strange, lidless knobs for eyes, as in the centurion in the Frankfurt group. At the same time, the master's treatment of ornamental details takes on a poignantly expressive character: straight-ridged folds standing forth like blades; hair in fine, wiry lines; and vine leaves with jagged serrated edges bordering the Cross and framing the evangelist symbols.

The sculptor's chisel exulted in the possibilities of alabaster for shaping decorative and naturalistic forms. Locks of hair and beards spiral into tight rings at the ends, loincloths are delicately hatched to give texture, edges of garments are finely fluted, narrow ridges outline the edges of eyelids, sensitively studied anatomy heightens the pathos of the three Frankfurt *Crucifixion* victims, and an opulent profusion of deeply cut, sweeping curvilinear folds bedecks draped figures in graceful swaying poses. The latter connect the master with the Late Gothic International style, but his attention to naturalistic and expressive narrative detail evokes the development of early Netherlandish painting. If the Frankfurt group comprised an altarpiece, as seems most likely, its very creation in stone would recall Gothic sculpture's historic links to architecture before the transition to wood carving as the predominant medium for major altarpieces in the later 15th century.

The Rimini Master's workshop must have had a large staff and exercised a powerful influence. Alabaster carvings from the workshop or followers are numerous in museum collections. These clearly answered an international demand that supported a wide trade in small alabaster figures for public and private devotional purposes. A case in point is the group of three heavily draped mourning women now in the National Museum in Warsaw, which were part of a Crucifixion group documented as purchased from a merchant in Paris by the abbot of the Sandkloster at Wrocław (Breslau) in 1431. Their style is close to that of the Rimini Master, even if they are not from the master's hand. A recent reexamination of the relevant document (see Schmidt, 2001) stresses that the group is described as made in Paris, suggesting the Master's workshop could have been based there. The 1431 sale supports both the principal general dating of his works and the existence of merchants who saw to the dispersal of such small, portable alabaster groups throughout Europe.

ALISON LUCHS

Biography

There is virtually no known definitive information on the artist's life. All that is known for certain about the Rimini Master is that he was the leading personality in a highly productive alabaster workshop either in the southern Netherlands or northern France, in the second quarter of the 15th century, and that several alabaster groups and figures can be attributed to his hand.

Selected Works

ca. 1430 *Crucifixion*, for the Church of Santa Maria delle Grazie, Rimini; alabaster; Liebieghaus, Frankfurt, Germany

ca. 1430 *Head of St. John the Baptist*; alabaster; Bayerisches Nationalmuseum, Munich, Germany

ca. 1430 *Head of St. John the Baptist*; alabaster; Church of St. Willibrordus, Utrecht, the Netherlands (attributed)

ca. 1430 Kneeling angel; alabaster; Metropolitan Museum of Art, New York City, United States

ca. 1430 *Pietà* (also known as *Madonna dell'Acqua*); alabaster; Church of San Francesco, Rimini, Italy

ca. 1430 *The Virgin with the Dead Christ*; alabaster; Victoria and Albert Museum, London, England

Further Reading

Beck, Herbert, *Liebieghaus, Museum alter Plastik: Guide to the Collections, Medieval Sculpture*, Frankfurt: Liebieghaus, 1980

Defoer, H.L.M, "Een alabaster Johannes-in-disco in de St. Willibrordus te Utrecht," in *Miscellanea I.Q. van Regteren Altena: 16/V/1969*, Amsterdam: Scheltema en Holkema, 1969

Legner, Anton, "Der alabaster altar aus Rimini," *Städel-Jahrbuch* (1969) (fundamental monograph with reconstruction of the Rimini altar; richly illustrated, with comparative material and discussion of numerous attributions)

Liebieghaus, Museum Alter Plastik: Nachantike grossplastische Bildwerke, Melsungen, Germany: Gutenberg, 1981–; see especially vol. 2, *Italien, Frankreich und Niederlande, 1380–1530/40*, edited by Michael Maek-Gérard (most thorough on the Rimini-Frankfurt group; comprehensive bibliography)

"Master of Rimini," in *The Dictionary of Art*, edited by Jane Turner, New York: Grove, and London: Macmillan, 1996

Müller, Theodor, *Sculpture in the Netherlands, Germany, France, and Spain, 1400 to 1500*, London and Baltimore, Maryland: Penguin, 1973

Sander, Jochen, *Die Entdeckung der Kunst: Niederländische Kunst des 15. und 16. Jahrhunderts in Frankfurt* (exhib. cat.), Mainz, Germany: Von Zabern, 1995

Schmidt, E.D., "Maestro dell'Altare di Rimini," in *Il potere, le arti, la guerra: Lo splendore dei Malatesta* (exhib. cat.), edited by Angela Donati, Milan: Electa, 2001

Williamson, Paul, *Northern Gothic Sculpture, 1200–1450*, London: Victoria and Albert Museum, 1988

DELLA ROBBIA FAMILY *Italian*

Luca Della Robbia 1399/1400–1482

Born in Florence into a family of wool traders (the name Robbia derives from *rubia tinctoris*, a red cloth dye), Luca became the greatest purely Classical sculptor of his time and the founder of a dynasty of artists who worked in stone and glazed terracotta. His friendship and collaboration with the architect Filippo Brunelleschi helped establish the Early Renaissance style of architecture in Florence. Luca's invention of glazed terracotta, for which he is best known, provided a durable, popular framework for Marian reliefs, altarpieces, and civic decoration throughout Tuscany and beyond and significantly extended the range of expressive devotional images.

Although Luca's training is sparsely documented, an early association with Nanni di Banco seems likely, and some sources mention his participation in one or both of Lorenzo Ghiberti's bronze doors. Other sources mention his literate and devout character. He matriculated as a sculptor in the Arte dei Maestri di Pietra e Legname (stonecutters' and woodworkers' guild) in 1432, by which time he had received his first great commission, one of several for Florence Cathedral: the so-called *Cantoria* (a marble singing gallery), a keystone of his early style and absorbing material for comparison with the contemporary *Cantoria* by Donatello. Luca's visual rendition of the joyful Psalm 150 is detailed and orderly compared to the raw Classicism of Donatello's work; both are indebted to Roman sarcophagi. In 1436, even before the completion of the *Cantoria*, the humanist Leon Battista Alberti praised Luca in the Italian translation of his treatise *De Pictura* as one of the five Florentine artists whose creative genius rivaled that of the ancients. It may have been the protagonist of the group, Brunelleschi, who encouraged the revival of terracotta, a genre adopted by Ghiberti and Donatello and soon transformed by Luca's innovative and secret method of applying vitreous tin glazes to fired clay sculptures and then refiring them.

The earliest known appearance of this new medium was in the decorative inlays for a marble tabernacle for the Church of Santa Maria Nuova (now in Santa Maria a Peretola), begun in early 1441. Luca soon adapted the technique on a monumental scale in the *Resurrection* over the entrance to the North Sacristy of Florence Cathedral, a space later filled by the bronze door he created in collaboration with Michelozzo and

Luca Della Robbia, *Cantoria*
© Alinari / Art Resource, NY

Maso di Bartolomeo. In works such as the great roundels of the *Apostles* for the Pazzi Chapel of the Church of Santa Croce, Luca's presence was vital to the enrichment of the sober early Renaissance architecture. Luca's Madonna reliefs in glazed terracotta are unparalleled for their simple serenity, and mature works such as the so-called *Madonna of the Apple* (*ca.* 1440; 70 cm high) and the *Madonna of the Rosegarden* (*ca.* 1450–55; 83 cm high) project an accessible humanizing spirit attuned to the direct devotional needs of many Florentines; whether imbued with pathos or benevolence, they are among the crowning achievements of his day, the sculptural equivalents of painted Madonnas by Domenico Veneziano and Filippo Lippi. Their technique is attentive and refined, and the straightforward tonalities of the figures, usually in luminous white against a background of a rich blue glaze, are sometimes nuanced by secondary colors used for eyes and natural elements such as vegetation. A life-size *Visitation* group (completed by 1445) seems uncomplicated yet conveys a deeply emotional intensity. When created in half-length format, Luca's figures were clearly conceived as upper sections of full-length compositions, thus echoing ancient Roman examples and anticipating Andrea del Verrocchio.

A further genre, much expanded by Luca's followers, was the *stemma* (heraldic emblem or coat of arms) made for Florentine officials and inexpensively applied to countless building facades or commissioned as a more elaborate work (such as Luca's notable *Stemmi* for Florentine guilds at the Church of Orsanmichele, Florence, and the *Stemma of King René of Anjou* for the Palazzo Pazzi).

Luca's only immediate followers outside his family were the Florentine Benedetto Buglioni and his relative Santi Buglioni. Benedetto based some of his compositions in the Della Robbia style on contemporary sculpture; he received notable commissions in Perugia, Bolsena, and throughout Tuscany. Santi's animated glazed and painted narrative exterior frieze of the *Seven Works of Mercy* for the Ospedale del Ceppo in Pistoia, executed for the rector of the hospital, Leonardo Buonafede, remains his best-known work. After 1527, when artists of the Della Robbia family still active in Florence died of the plague, Santi was the only one there who knew the secrets of their glazes.

Vasari called Luca Della Robbia's art "everlasting" and "new, useful, and most beautiful," and the evolution of the all-weather glazed terracotta medium ran parallel to the widespread production of figures in pigmented and gilded terracotta or stucco that were being acquired in large quantities by Florentine society. Yet aesthetic concerns surely lay behind Luca's clarity of color, no doubt influenced by Brunelleschi's view of architectural decoration. Sculptures by the later Della

Robbias were more chromatically varied, and with expanded production of copies and increasingly profuse floral and vegetal decoration, the medium declined, although it never lost its popular appeal.

Andrea Della Robbia 1435–1525

Andrea di Marco di Simone's documented activity during the early 1450s indicates his early training with and gradual independence from his uncle Luca. Andrea matriculated in the Arte dei Maestri di Pietra e Legname (stonecutters' and woodworkers' guild) in 1458, eventually becoming head of the lucrative and productive family shop. Among his best-known reliefs are the roundels of *Foundling Infants* for the Hospital of the Innocenti in Florence, installed in 1487, and the sacred figures for the Hospital of San Paolo dei Convalescenti, executed with assistants in the early 1490s, set within architectural exteriors by Brunelleschi and Michelozzo. Andrea's work thus became a ubiquitous element of the civic and ecclesiastical fabric of Florence.

Andrea's style was more lively and generally more expressive than that of Luca. By the mid 1470s he was

Luca Della Robia, *Meeting of Mary and Elizabeth*
© Scala / Art Resource, NY

receiving full-scale commissions from outside Florence, especially from the Observant branch of the Franciscan order, which led to such masterpieces as the *Coronation of the Virgin with Four Saints and a Female Donor* (mid 1470s). His statue of *Saint Francis* (mid 1470s) for the Church of S. Maria degli Angeli in Assisi became the most popular image of the saint. Andrea's bold naturalistic images of holy figures were sent to the remote Franciscan hermitage at La Verna (e.g., altarpieces of the *Annunciation*, the monumental *Crucifixion*, and *Ascension*) and remain there today as expressions of a direct and appropriate form of religious piety. Andrea received assistance from several of his many sons, including Giovanni and Luca the younger.

Giovanni Della Robbia 1469–1529/30

Giovanni Antonio di Andrea was a collaborator and follower of his father, Andrea. The lavabo for the sacristy of the Church of Santa Maria Novella in Florence, whose elaborate conception includes a painted landscape, exemplifies Giovanni's approach to terracotta. The pictorial qualities of his exuberant compositions, sometimes inspired directly by paintings in Florence, intensified after 1515 with the use of polychrome glazing, marking a shift away from the blue and white traditionally used by the family workshop. In the early 1520s he collaborated with Giovanni Francesco Rustici on a relief of the *Noli me tangere* for an altarpiece. Among his last important works were the Marian scenes and coats of arms on the portico of the Ospedale del Ceppo, Pistoia; Santi Buglioni completed the decoration.

Girolamo Della Robbia 1488–1566

Girolamo Domenico di Andrea was the 11th of Andrea's 12 sons. He moved to France in 1518, where he began working for Francis I and his court as a sculptor, leading a prestigious but still mysterious career, partly in association with his brother Luca the younger beginning in 1529. Girolamo's unfinished marble sculpture of *Catherine de' Medici*, made for the tomb of her husband, Henry II, reveals a drama far removed from the language of his 15th-century relatives.

FRANK DABELL

See also **Donatello (Donato di Betto Bardi); Ghiberti, Lorenzo; Michelozzo di Bartolomeo; Nanni di Banco; Sarcophagus**

Luca Della Robbia 1399/1400–1482

Biography
Born in Florence, 1399/1400. May have trained with Nanni di Banco; enrolled as a sculptor in the Arte dei Maestri di Pietra e Legname (stonecutters' and wood-

workers' guild), Florence, 1432; after an early collaboration with Lorenzo Ghiberti, was engaged on important commissions for Florence Cathedral, 1430s; collaborated with the architect Filippo Brunelleschi, 1420s; invented technique for tin-glazing terracotta, *ca.* 1440; succeeded by his nephew Andrea (di Marco) Della Robbia and by numerous descendants who continued to work in this new medium. Died in Florence, 20 February 1482.

Selected Works

1431–38	*Cantoria* (Singing-gallery), for the organ loft of Florence Cathedral; marble; Museo dell'Opera del Duomo, Florence, Italy
1441	Tabernacle; marble, tin-glazed terracotta; Church of Santa Maria a Peretola, Florence, Italy
1442–44	*Resurrection* lunette; tin-glazed terracotta; Florence Cathedral, Italy
ca. 1445–50	Roundels of the *Apostles*; Pazzi Chapel, Church of Santa Croce, Florence, Italy
ca. 1450	Meeting of Mary and Elizabeth; glazed white terracotta; San Giovanni Fuorci Vitas, Pistoia, Italy
1454–56	Tomb of Bishop Benozzo Federighi; marble, *maiolica* (tin-glazed earthenware); Church of Santa Trinita, Florence, Italy
1460–61	Medallions of the *Four Cardinal Virtues*; tin-glazed terracotta; Chapel of the Cardinal of Portugal, Church of San Miniato al Monte, Florence, Italy
1460s	Bronze doors (with Michelozzo and di Bartolomeo); North Sacristy, Florence Cathedral, Italy

Andrea Della Robbia 1435–1525

Biography
Born in Florence, 1435. Trained with his uncle Luca Della Robbia, 1450s; enrolled as a carver in the Arte dei Maestri di Pietra e Legname (stonecutters' and woodworkers' guild), Florence, 1458; become head of the lucrative and productive family workshop, *ca.* 1470; began to receive full-scale commissions from outside Florence, especially from the Observant branch of the Franciscan order, mid 1470s; created the most popular statuary image of Saint Francis, for the Church of Santa Maria degli Angeli, at Assisi, 1470s; created reliefs and statues for the architectural exteriors by Brunelleschi and Michelozzo, early 1490s. Died in Florence, 1525.

Selected Works

1475	*Virgin and Child with Cherubim* (known as *Madonna of the Stonemasons*); glazed

terracotta; Museo Nazionale del Bargello, Florence, Italy

1481 *Crucifixion with Saints Francis and Jerome*; tin-glazed terracotta; Cappella delle Stimmate, Santuario della Verna, La Verna, Tuscany, Italy

1487 Roundels of *Foundling Infants*; tin-glazed terracotta; Hospital of the Innocenti, Florence, Italy

1487–93 Tabernacle; marble, glazed terracotta; Church of Santa Maria delle Grazie, Arezzo, Italy

ca. Roundels of *Acts of Mercy, Franciscan*
1493–95 *Saints*, and *Meeting of Saints Francis and Dominic*, and two portraits of the donor Bernino Bernini; tin-glazed terracotta; Loggia, Hospital of San Paolo dei Convalescenti, Florence, Italy

Giovanni Della Robbia 1469–1529/30

Biography
Born in Florence, 19 May 1469. Son of the sculptor Andrea Della Robbia. Trained under, then collaborated with, his father; worked in terracotta and, after *ca.* 1515, used polychrome glazing; collaborated with Giovanni Francesco Rustici on a relief for an altarpiece now in the Bargello, Florence, early 1520s. Died probably in Florence, 1529/30.

Selected Works
1498 Lavabo for sacristy; glazed terracotta; Church of Santa Maria Novella, Florence, Italy

ca. 1513 Altarpiece for the Church of San Girolamo del Sasso Rosso; glazed terracotta; Church of San Medardo, Arcévia, Italy (inaccurate recomposition)

1515 *Temptation of Adam*, for triumphal entry into Florence of Pope Leo X; polychrome-glazed terracotta; Walters Art Museum, Baltimore, Maryland, United States

1525–26 Marian scenes and coats of arms (with Santi Buglioni); Ospedale del Ceppo, Pistoia, Italy

Girolamo Della Robbia 1488–1566

Biography
Born in Florence, 9 March 1488. The 11th of 12 sons of Andrea Della Robbia. Trained under his father; moved to France, where he began working as a sculptor for King Francis I and his court, 1518; led a prestigious

but still largely unknown career, partly in association with his brother Luca the Younger, from 1529; left unfinished his marble sculpture of *Catherine de' Medici*, Paris, 1565. Died in Paris, 4 August 1566.

Selected Works
1529 Bust of King Francis I of France; glazed terracotta; Metropolitan Museum of Art, New York City, United States

1565 *Catherine de' Medici* (unfinished); marble; Musée du Louvre, Paris, France

Further Reading

Bellosi, Luciano, editor, *Una scuola per Piero: Luce, colore, e prospettiva nella formazione fiorentina di Piero della Francesca* (exhib. cat.), Venice: Marsilio, 1992

Caglioti, Francesco, *Donatello e i Medici: Storia del David e della Giuditta*, 2 vols., Florence: Olschki, 2000

Gentilini, Giancarlo, "Della Robbia, Andrea [to] Della Robbia, Marco Giovanni (fra' Mattia)," in *Dizionario biografico degli Italiani*, vol. 37, Rome: Istituto della Enciclopedia Italiana, 1989

Gentilini, Giancarlo, *I Della Robbia: La scultura invetriata nel Rinascimento*, 2 vols., Florence: Cantini, 1990–92

Gentilini, Giancarlo, "Buglioni [Family]," in *The Dictionary of Art*, edited by Jane Turner, London: Macmillan, and New York: Grove, 1996

Gentilini, Giancarlo, "Robbia, della [Family]," in *The Dictionary of Art*, edited by Jane Turner, London: Macmillan, and New York: Grove, 1996

Gentilini, Giancarlo, editor, *I Della Robbia e l'arte nuova della scultura invetriata* (exhib. cat.), Florence: Giunti, and Fiesole, Italy: Fiesole Musei, 1997

Italian Renaissance Sculpture in the Time of Donatello (exhib. cat.), Detroit, Michigan: Founders Society, Detroit Institute of Arts, 1985

Marquand, Allan, *The Brothers of Giovanni della Robbia: Fra Mattia, Luca, Girolamo, Fra Ambrogio*, edited by Frank Jewett Mather, Jr., and Charles Rufus Morey, Princeton, New Jersey: Princeton University Press, and London: Milford, 1928; reprint, New York: Hacker Art Books, 1972

Pope-Hennessy, John, *An Introduction to Italian Sculpture*, 3 vols., London: Phaidon, 1963; 4th edition, 1996; see especially vol. 2, *Italian Renaissance Sculpture*

Pope-Hennessy, John, "Thoughts on Andrea della Robbia," *Apollo* 109/205 (March 1979)

Pope-Hennessy, John, *Luca della Robbia*, Ithaca, New York: Cornell University Press, and Oxford: Phaidon, 1980

Pope-Hennessy, John, "The Healing Arts: The Loggia di San Paolo," *FMR* 8 (January–Febuary 1985)

Vasari, Giorgio, *Le vite de' più eccellenti architetti, pittori, e scultori italiani*, 3 vols., Florence: Torrentino, 1550; 2nd edition, Florence: Apresso i Giunti, 1568; as *Lives of the Painters, Sculptors, and Architects*, 2 vols., translated by Gaston du C. de Vere (1912), edited by David Ekserdjian, New York: Knopf, and London: Campbell, 1996

NICOLÒ ROCCATAGLIATA ca. 1560– before 1636 *Italian*

Nicolò Roccatagliata and his son Sebastian Nicolini were two major representatives of the art of small

bronzes, a special genre of sculpture that as a manifestation of humanistic culture embodied perfectly the spirit of the Italian Renaissance. Roccatagliata's first biographer, Soprani (1674), called him "industrious in casting," and the artist could, in fact, even be called the last exponent of the great tradition of creating different kinds of highly decorative objects in bronze that were extremely popular in Venice during the 16th century. Roccatagliata, together with his son Sebastian, carried the specific Venetian expression of this tradition, which had flourished earlier in Florence and Padua, most successfully into the 17th century. Like many artists of Venice, however, he was not a native of that city. He came from Genoa, where he was a pupil of the silversmith Agostino Groppo and his son Cesare. At some point Roccatagliata left Genoa, most probably together with Cesare, and went to Venice, where he executed, according to Soprani, models for Tintoretto. The next secure notice presents Roccatagliata already as an independent artist working in Venice, where he executed in the mid 1590s several works in bronze for the Church of San Giorgio Maggiore. These first known works are characteristic of the range of his oeuvre: the two statuettes of *St. Stephen* and *St. George* are small-scale sculptures, whereas the candelabra and wall sconces fall into the category of decorative art. It is especially in the latter field that Roccatagliata seems to have been most active, and there are countless attributions to him of all kinds of objects intended for practical use, such as andirons, door knockers, candelabra, and inkstands.

The candelabra in San Giorgio Maggiore, with their elaborate figural and ornamental decorations, demonstrate the high quality and artistic level that could be achieved when the master himself was at work. They are characterized by a feature for which Roccatagliata became famous: the playful putto with chubby body, sweet face, and curly hair. These charming creatures are rightly considered to be the embodiment of Roccatagliata's style and can be found either as single statuettes, such as putti playing musical instruments (such as those in the Kunsthistorisches Museum, Vienna), or as decorations on utilitarian objects, such as andirons (for instance, those in the Bargello, Florence). Roccatagliata's nickname "master of the putto," coined by the Viennese scholar Leo Planiscig, seems therefore justified, since the putto indeed became a leading motif in the artist's oeuvre. However, the artistic profile of Roccatagliata has in the past been too exclusively associated with this kind of figure, and many attributions have in fact little to do with him but are generic products of the prolific Venetian foundries. Roccatagliata's signed *Virgin and Child* is a remarkable demonstration of his sculptural abilities and proves that he was more than a producer of figured utensils. This becomes par-

Madonna and Child
© The Metropolitan Museum of Art, New York

ticularly clear when looking at his late masterpiece, the antependium in the Church of San Moisè, Venice, executed together with his son in 1633. The large bronze relief represents a many-figured *Eucharistic Allegory*; it is characteristic for Roccatagliata and son that, even when expressing complex, dogmatic ideas of the Counter Reformation, their approach remains essentially genrelike, stressing the narrative components. This impression is enhanced by the countless putti that fill every corner of the relief with their eager activities, which are depicted in such a playful manner—albeit meaningfully in most cases—that the serious subject appears to be almost delightful. That this relief is sometimes considered the first expression of Baroque taste in Venice may be due not so much to its style as to the iconography and its interpretation. Traditionally, Roccatagliata's style was placed in the orbit of Jacopo Sansovino, but his essentially anti-Classical approach speaks rather to the contrary. He seems, in fact, to owe much to the more lively style of Alessandro Vittoria, especially in the formulation of his trademark putto.

Stylistically, Sebastian Nicolini followed his father so closely that it is almost impossible to distinguish their hands, be it in the antependium or in their oeuvres in general. Sebastian's candelabra for the Church of San Giovanni e Paolo (1633) are skillful variations on

those of his father for San Giorgio Maggiore, whereas his four statuettes depicting the *Fathers of the Church* (1614; St. Mark's, Venice) are characterized by the same genrelike approach and sense for decorative details in the vestments that can be found in Roccatagliata's *St. George* and *St. Stephen.* Accordingly, the impressive group of statuettes in San Giorgio in Braida in Verona that can be safely attributed to "the Roccatagliatas" may have been executed by either alone or by both together.

This stylistic uniformity is typical for workshops such as the prolific one run by Roccatagliata, his son, and several collaborators. Father and son specialized in the production of small bronzes in a typical, familiar style. Although they also occasionally executed important larger commissions, they cannot be regarded as artists of the same stature as Sansovino or Vittoria because their field was not large sculpture but the more intimate *bronzetto* (small bronze). In their métier, however, they created some outstanding pieces, and their works still enjoy great popularity today.

CLAUDIA KRYZA-GERSCH

See also **Sansovino, Jacopo; Vittoria, Alessandro**

Biography

Born in Genoa, Italy, *ca.* 1560. Joined the workshop of the silversmith Agostino Groppo as an apprentice, 1571, and stayed for nine years; trained also with Cesare Groppo, Agostino's son, with whom he probably went to Venice; first documented commission, to execute two bronze statuettes for the Church of San Giorgio Maggiore in Venice, 1584; commission for 22 wall sconces for the same church, 1594; commission to execute two candelabra, again for the Church of San Giorgio Maggiore, together with Cesare Groppo, 1596; settled permanently in Venice and established a flourishing workshop specializing in the production of small sculptures and objects in bronze; together with his son, Sebastian Nicolini, signed the bronze antependium in the Church of San Moisè, 1633. Died probably in Venice, Italy, between 1633 and 1636.

Selected Works

date unknown	*Putti Playing Musical Instruments*; bronze; Kunsthistorisches Museum, Vienna, Austria	
date unknown	*Firedogs*; bronze; Museo Nazionale del Bargello, Florence, Italy	
1594	*St. Stephen* and *St. George*; bronze; Church of San Giorgio Maggiore, Venice, Italy	
1596	Two candelabra (with Cesare Groppo);	

bronze; Church of San Giorgio Maggiore, Venice, Italy

ca. 1620	*Virgin and Child*; bronze; Musée de la Renaissance, Écouen, France	
ca. 1625	*Four Evangelists, St. Zeno,* and *St. Lorenzo Giustiniani* (probably with Sebastian Nicolini, or by the son altogether); bronze; Church of San Giorgio in Braida, Verona, Italy	
1633	*Eucharistic Allegory* (with Sebastian Nicolini); bronze; Church of San Moisè, Venice, Italy	

Further Reading

Kryza-Gersch, Claudia, "New Light on Nicolò Roccatagliata and His Son Sebastian Nicolini," *Nuovi studi* 5 (1998)

Kryza-Gersch, Claudia, "Nicolò Roccatagliata e suo figlio Sebastian Nicolini," in *La bellissima maniera: Alessandro Vittoria e la scultura del Cinquecento* (exhib. cat.), edited by Andrea Bacchi, Lia Camerlengo, and Manfred Leithe-Jasper, Trent, Italy: Castello del Buonconsiglio, Monumenti e Collezioni Provinciali, 1999

Planiscig, Leo, *Venezianische Bildhauer der Renaissance*, Vienna: Anton Schroll, 1921

Pope-Hennessy, John, *An Introduction to Italian Sculpture*, 3 vols., London: Phaidon, 1963; 4th edition, 1996; see especially vol. 3, *Italian High Renaissance and Baroque Sculpture*

Soprani, Raffaele, *Le vite de pittori, scoltori et architetti genovesi*, Genoa, Italy: Bottaro i Tiboldi, 1674; Bologna, Italy: Forni Editore, 1970

Venturi, Adolfo, *Storia dell'arte italiana*, 11 vols., Milan: Hoepli, 1901; reprint, Millwood, New York: Kraus Reprint, 1983, see especially vol. 3, *La scultura del Cinquecento*

ROCOCO

See **Baroque and Rococo**

ALEXANDER RODCHENKO 1891–1956
Russian

Sculpture constitutes a relatively small but highly significant portion of Alexander Rodchenko's artistic oeuvre. Early in his career he experimented with drawing and painting; later he turned to graphic design and photography, the work for which he is best known. In between, from 1918 to 1921, Rodchenko explored the possibilities of constructed sculpture. His constructions, characterized by linear and planar elements, were pivotal in the development of Constructivist ideas.

Along with Vladimir Tatlin, Rodchenko was a founding member of the Constructivist movement. Tatlin and Rodchenko were both politically active and investigated the possible intersections of art and society, hopeful that their constructions could aid in the

ideological building of a new society. Rodchenko's first experiments in three dimensions emerged in 1918, following the revolutions of the previous year. All of his sculptural work developed in series, as variations on a fundamental idea. The first six abstract *Spatial Constructions* drew visual connections with Rodchenko's earlier painted works, as well as with Tatlin's constructions from a few years previous. Rodchenko's *Spatial Constructions* were vertical in composition and assembled from many component parts. A variety of planar, geometric branches pivoted from a treelike vertical axis, and whole constructions could be easily dismantled and reassembled. The planar appendages exhibited Rodchenko's concern with static and dynamic balance and replaced the traditional sculptural characteristic of mass with a sense of volumetric space. Although Rodchenko considered these creations a move from the painted canvas into "real space," they retained affinities with his earlier work. The fitted planes constituted a two-dimensional reference to Rodchenko's painted forms, particularly his investigations of line. Critics have also often perceived these first forays into constructed sculpture as being rooted in Tatlin's counterreliefs; Rodchenko's works, however, extended into space in such a way as to be clearly intended as sculpture in the round, whereas Tatlin's constructions retained a frontal aspect. Rodchenko also added a temporal element by creating constructions that would fold and unfold rather than remain static.

Through the *Spatial Constructions*, Rodchenko attempted to abandon painting and to experiment with subjects and materials new to sculpture. His works were not modeled, were nonrepresentational, and were made of such mundane materials as cardboard, all denoting a departure from traditional sculpture. In these works Rodchenko also sought to emphasize motion and to isolate color from form. Because he perceived white as neutral, or a noncolor, he believed that this series of constructions, which he also referred to as "white sculptures," effectively separated color and form in a manner impossible in painting. The planar elements attached to the central axis in turn suggested a visual motion or dynamism by projecting through space.

From 1919 to 1920 Rodchenko produced a second series of 25 constructions, also deemed *Spatial Constructions*. He built each sculpture with pieces of wood all of equal dimension. By experimenting with standard parts and thus repeating a single line or plane, he hoped to visually emphasize sculpture's linear aspects. He had previously accentuated the line in both painting and sculpture and later expounded upon the virtues of the line in a 1921 manuscript, citing it as an integral element of three-dimensional construction. Rodchenko's standard constructions may also have been a direct reference to contemporary industrial standard-

Alexander Rodchenko, *Oval Construction Number 12, ca. 1920*, plywood, open construction partially painted with aluminum paint, and wire, 24″ × 18 1/2″, The Museum of Modern Art, New York. Acquisition made possible through the extraordinary efforts of George and Zinaida Costakis, and through the Nate B. and Frances Spingold, Matthew H. and Erna Futter, and Enid A. Haupt Funds.
Photograph © 2001 The Museum of Modern Art, New York, The Estate of Alexander Rodchenko / RAO, Moscow / VAGA, New York

ization, an attempt by the artist to make his art relevant to the new society.

Rodchenko's third and final series of constructed sculptures further explored the possibilities of line in three dimensions. Building on his previous works, his *Spatial Constructions* of 1920–21, sometimes also called *Hanging Constructions*, represent a three-dimensional culmination of his linear explorations. Each construction focuses on a single geometric shape, ranging from the circle to the hexagon. He cut the shapes, which were repeated and enlarged in concentric formations, from single pieces of plywood, allowing for uniformity of appearance, economy of material, and collapsible, flat storage. When hung, the shapes floated at angles to one another, extending the line into space through the geometric forms. The angularity also suggested a visual dynamism, and the kinetic quality displays similarities to Naum Gabo's contemporary experiments. In perhaps another attempt to implicate industrial construction, Rodchenko painted the plywood pieces to imitate a metallic sheen. Particularly during exhibition, the metallic surfaces incorporated light and shadow into the sculpture, enhancing the spatial effects during slow rotation.

The sculptural ideas embodied in Rodchenko's *Hanging Constructions* echoed many of the ideas set forth by Gabo and Antoine Pevsner in their *Realistic Manifesto* (1920). Although Rodchenko disagreed

from his late, mostly erotic sketches, which are executed in pale, single lines, lightly tinted with rosy beige tones.) From the clay sketch, Rodin made numerous plaster casts, each of which could be modified until he achieved a satisfactory composition. Thus a variety of states of the same fundamental idea frequently occur in plaster. Further modifications could be obtained by means of photography: probably more than any other sculptor of his time, Rodin used photography not only to record and interpret his own oeuvre but also as a tool in forming a sculpture. Alterations to the silhouette, proportions, or base of a sculpture could easily be determined by shading the photographic image of it. Larger versions of the same composition could be worked up in clay or produced by assistants who used mechanical methods of enlargement.

Most of Rodin's sculptures were cast in bronze. Besides the commercial advantage it offered in the production of multiple versions of the same composition (more than 300 casts of *The Kiss* were sold during Rodin's lifetime, for example), the tensile strength of bronze permitted complexity not attainable in stone. Many of the wild projections in *The Gates of Hell* would have been impossible in stone; as individual sculptures, however, removed from the relief ground, several figures from *The Gates of Hell* were re-created independently in marble.

Aided by a number of studio assistants (including Émile-Antoine Bourdelle, Jules Desbois, and François Pompon), Rodin produced a variety of sculptures in marble, most notably portraits. Marble sculptures in general, and portraits in particular, brought a large amount of revenue to the artist. The technique characteristic of Rodin's marble sculptures leaves them apparently unfinished, with rough hatch marks and sharp indentations from pointing left plainly obvious, especially in the hair and bases of the sculptures, from which the more highly finished surfaces of the figures seem to emerge. This treatment of marble was derived from the unfinished areas of Michelangelo's sculptures.

Rodin also worked indirectly in ceramic. Early in his career, when he was associated with Carrier-Belleuse, he provided a number of designs for the decoration of a series of Sèvres vases. In his later years (ca. 1905–06), Rodin also made an agreement with Paul Jeanneney to produce a limited number of glazed ceramic versions of at least one of the figures that composed *The Burghers of Calais*. A few of Rodin's sculptures were realized in tinted *pâte de verre* (a translucent medium, often polychrome, obtained by firing powdered glass).

When Rodin bequeathed his collections to France to establish the Musée Rodin (in Paris, with an extension at his country house in nearby Meudon), he intended the new museum to be financed through the casting of more bronze examples of his sculptures. The bronzes produced by the Musée Rodin were not numbered until 1981, when the edition was limited to eight examples marked by Arabic numerals, with four supplementary examples destined for public institutions. These are designated by Roman numerals.

MARY L. LEVKOFF

See also **Bourdelle, Émile-Antoine; Canova, Antonio; Carrier-Belleuse, Albert-Ernest; Claudel, Camille; Michelangelo (Buonarroti); Modeling; Modernism**

Biography

Born in Paris, France, 12 November 1840. Given name François Auguste René. Attended boarding school in Beauvais, 1851–54, and Petite École in Paris, 1854–57; completed earliest known surviving sculpture, a portrait bust of his father, in 1860; lived in Brussels, Belgium, 1871–77, with one important trip to Italy likely in early 1876; created *The Age of Bronze*, exhibited 1876, which indirectly led to first public commission in 1880, *The Gates of Hell*; gained entrance to Parisian society and began liaison with Camille Claudel, 1883; won commission for *The Burghers of Calais*, 1884, and monuments to Jules Bastien-Lepage, 1886, to Victor Hugo, 1889, and to Honoré de Balzac, 1891, the last of which was rejected by patrons in 1898; international retrospectives in Paris, 1900, and Prague, 1902; named Officer of the Legion of Honor, 1892; first significant exhibition of drawings in 1907 and increased interest in enlarged versions of preexisting sculptures; sculptor's observations about French medieval cathedrals published in 1914; took fourth trip to Italy in 1915; next year offered collections to French state so Musée Rodin could be established at site of Hôtel Biron; suffered stroke in March 1916. Died in Paris, France, 17 November 1917; Musée Rodin officially recognized in 1918.

Selected Works

Most of Rodin's sculptures exist in more than one version, often in plaster and another medium (marble or bronze). The Musée Rodin (Paris and Meudon, France) is the greatest repository of them. There is no complete catalogue of Rodin's sculptures, although the first comprehensive attempt was made by Georges Grappe (see Grappe, 1927). Because several titles often designate the same composition, the dates of many of the sculptures are uncertain. Additional examples of many works listed below can be found in collections not cited here.

1863–64 *Mask of the Man with a Broken Nose*; bronze; example in Musée Rodin, Paris, France

1876 *The Age of Bronze*; bronze; example in Musée Rodin, Paris, France

1878 *Saint John the Baptist Preaching*; bronze; large versions in Musée Rodin, Paris, France; Ny Carlsberg Glyptotek, Copenhagen, Denmark; Rodin Museum, Philadelphia, Pennsylvania, United States

1880–ca. 1900 *The Gates of Hell*; plaster, two versions, one at Musée Rodin, Meudon, and one on loan to Musée d'Orsay, Paris; bronze, several examples, including Musée Rodin, Paris, France; Rodin Museum, Philadelphia, Pennsylvania, United States; Iris and B. Gerald Cantor Center, Stanford, California, United States; National Museum of Western Art, Tokyo, Japan

ca. 1880 *The Thinker*, for *The Gates of Hell*; bronze; several examples and sizes, including Musée Rodin, Paris and Meudon, France; Norton Simon Museum, Pasadena, California, United States

1884 *The Burghers of Calais* (commissioned; definitive plaster completed by 1889); Musée Rodin, Paris and Meudon, France; bronze versions: Hôtel de Ville de Calais, Calais, France; Ny Carlsberg Glyptotek, Copenhagen, Denmark; Norton Simon Museum of Art, Pasadena, California, United States; Metropolitan Museum of Art, New York City, United States; Houses of Parliament (outdoors), London, England; Rodin Museum, Philadelphia, Pennsylvania, United States; Kunstmuseum, Basel, Switzerland; Hirschhorn Museum, Washington, D.C., United States; National Museum of Western Art, Tokyo, Japan

1886 *The Kiss*; plaster; Musée Rodin, Paris, France; marble versions: 1888, Musée Rodin, Paris, France; Ny Carlsberg Glyptotek, Copenhagen, Denmark; Tate Gallery, London, England

1889 Monument to Victor Hugo; plaster and marble versions; Musée Rodin, Paris, France; plaster versions: Ny Carlsberg Glyptotek, Copenhagen, Denmark, Musée Rodin, Meudon; bronze versions: Avenue Victor-Hugo, Paris, France; Musée Rodin, Paris, France; Iris and B. Gerald Cantor Foundation, Los Angeles, California, United States

1898 Monument to Honoré de Balzac (final version); plaster and studies; Musée Rodin, Paris and Meudon, France; plaster version: National Gallery, Prague, Czech Republic; bronze versions: several locations, including boulevard Raspail, Paris, France; Museum of Modern Art, New York City, United States; Los Angeles County Museum of Art, Los Angeles, California, United States

1898 *Hand of God*; marble; private collection, United States; other examples in marble: Musée Rodin, Paris, France; Metropolitan Museum of Art, New York City, United States; numerous examples in bronze

1900 *Walking Man*; bronze; Musée Rodin, Paris, France

Further Reading

The bibliography on Rodin is vast. Publications up to 1983 are listed in J.A. Schmoll gen. Eisenwerth, *Rodin-Studien*, Munich: Prestel, 1983. Several monographs issued since then can be found in "Panorama Bibliographique," *Revue de l'Art* 104 (1994)

1898: Le Balzac de Rodin (exhib. cat.), Paris: Musée Rodin, 1998

Barbier, Nicole, *Marbres de Rodin: Collection du musée*, Paris: Éditions du Musée Rodin, 1987

Butler, Ruth, *Rodin: The Shape of Genius*, New Haven, Connecticut: Yale University Press, 1993

Descharnes, Robert, and Jean-François Chabrun, *Auguste Rodin*, Lausanne: EDITA, 1967; as *Auguste Rodin*, London: Macmillan, and New York: Viking, 1967

Elsen, Albert, editor, *Rodin Rediscovered* (exhib. cat.), Washington, D.C.: National Gallery of Art, 1981

Fonsmark, Anne-Birgitte, *Rodin: La collection du brasseur Carl Jacobsen à la Glyptothèque*, Copenhagen: Ny Carlsberg Glyptotek, 1988

Goldscheider, Cécile, *Auguste Rodin: Catalogue raisonné de l'oeuvre sculpté, 1840–1886*, Paris: Wildenstein Institute, and Lausanne: Bibliothèque des Arts, 1989 (comprehensive study of the sculptures up to 1886)

Grappe, Georges, *Catalogue du Musée Rodin*, vol. 1, *Hôtel Biron*, Paris: s.n., 1927; 5th edition, 1944

Grunfeld, Frederic, *Rodin: A Biography*, New York: Holt, and London: Hutchinson, 1987

Judrin, Claudie, Monique Laurent, and Dominique Viéville, *Auguste Rodin: Le monument des Bourgeois de Calais (1884–1895) dans les collections du Musée Rodin et du Musée des Beaux-Arts de Calais*, Paris: Musée Rodin, 1977

Laurent, Monique, "Observations on Rodin and His Founders," in *Rodin Rediscovered* (exhib. cat.), edited by Albert Elsen, Washington, D.C.: National Gallery of Art, 1981

Le Normand-Romain, Antoinette, editor, *Vers l' "Age d'Airain": Rodin en Belgique* (exhib. cat.), Paris: Musée Rodin, 1997

Levkoff, Mary, *Rodin in His Time: The Cantor Gifts to the Los Angeles County Museum of Art*, Los Angeles: Los Angeles County Museum of Art, and New York: Thames and Hudson, 1994 (2nd revised ed., Los Angeles County Museum of Art and New York: Rizzoli, 2000)

Pingeot, Anne, editor, *Le corps en morceaux* (exhib. cat.), Paris: Reunion des Musées nationaux, 1990

La Porte de l'Enfer (exhib. cat.), Paris: Musée Rodin, 1999

Tancock, John, *The Sculpture of August Rodin: The Collection of the Rodin Museum, Philadelphia*, Philadelphia, Pennsylvania: Philadelphia Museum of Art, 1976

GATES OF HELL
Auguste Rodin (1840–1917)
1880–ca. 1900
bronze
h. approx. 6 m
Plaster models in Musée Rodin, Paris and Meudon, France. Multiple casts in bronze: Musée Rodin, Paris, France; Rodin Museum, Philadelphia, Pennsylvania, United States; National Museum of Western Art, Tokyo, Japan; Kunsthaus, Zurich, Switzerland; Iris and B. Gerald Cantor Center for the Visual Arts, Stanford, California, United States; Prefectural Museum, Shizuoka, Japan; Rodin Gallery, Seoul, South Korea, all cast posthumously

The Gates of Hell is a monumental high relief commissioned from Auguste Rodin by the French government in 1880. It was intended to be the ornamental door to a new museum of decorative arts in Paris. The museum was never built, and *The Gates of Hell* was not cast in bronze until after Rodin's death. The sculpture's subject was derived from the *Inferno*, the first book of Dante's 14th-century epic poem *The Divine Comedy*. The choice of subject, which enjoyed a certain vogue in the 19th century, is generally acknowledged to have been Rodin's own.

The Gates of Hell comprises almost 100 smaller sculptures that are also known as separate compositions; one of Rodin's contemporaries estimated that about 300 figural elements exist in the ensemble. It may have reached a state of near completion in 1884–85, when Rodin sought estimates for the cost of casting it in bronze. However, he continued to adapt the composition at least up to 1900, the year of his retrospective at the Place de l'Alma in Paris during the Exposition Universelle. A plaster example of *The Gates of Hell*, missing many subsidiary figures in high relief, was displayed there. It is generally assumed that Rodin considered modifications to the work virtually until his death.

The Gates of Hell was one of several public commissions that were not realized (that is, cast in bronze) during Rodin's lifetime. The financial crisis of 1881–82 may have diminished the French government's enthusiasm for completing it; in 1904 the commission for the bronze cast was annulled. Rodin was further distracted by many other projects. His ambitious variants of *The Gates of Hell* became impossible to realize

either because of their very complexity or because of practical hindrances (the building for which the sculpture was destined and later, alternative sites were themselves not realized). The monumentality of the composition and the importance of the commission, however, brought considerable attention to Rodin.

The Gates of Hell was Rodin's first major public commission. It followed the scandal of his nude sculpture known as *The Age of Bronze*, the object of false charges brought against him for the mistaken belief that it had been cast from life. As with his first portrait of Victor Hugo and *Saint John the Baptist Preaching*, Rodin used *The Gates of Hell* to show that he could create sculptures without recourse to life casts. The small scale of the figures in *The Gates of Hell* would prove that they were originals that sprang from his mind and hands alone.

The earliest sketches for *The Gates of Hell* (a wax model and drawings in the Musée Rodin, Paris) follow a traditional formula for bronze doors to churches consisting of two vertical sets of rectangular reliefs designed as an episodic narrative. Lorenzo Ghiberti's east doors of the Florence Cathedral Baptistery (1425–52) likely inspired Rodin's first ideas for the composition.

Gates of Hell (model), Musée d'Orsay, Paris, France
© Giraudon / Art Resource, NY

He must have known that the gilt-bronze doors were popularly called the *Gates of Paradise*—a name anecdotally attributed to Michelangelo. Within a year, Rodin decided to create two full-scale nude figures of Adam and Eve to be set in the ground in front of the portal. Rodin, however, quickly relinquished the idea of sharply defined panels in favor of a fluid design that bears comparison to Michelangelo's fresco of the *Last Judgment* in the Sistine Chapel.

Two compositions were created in the round for important characters in Dante's epic. *Ugolino and His Sons*, which shows a starving man, condemned for treason, with his children and grandchildren dying around him, was inserted into the left panel of *The Gates of Hell* while the lovers Paolo and Francesca were represented in a sculpture that was ultimately not directly incorporated into the work. Instead, it became famous independently as *The Kiss*, although variants of the composition occur as sketchy, low reliefs in the frame of the door. Paolo and Francesca instead appeared in *The Gates of Hell* in a new combination of two different figures oriented horizontally.

The sculpture known as *The Thinker* was soon created as the central figure of the transom. The model for it was exhibited in 1888 with the alternative titles *The Thinker* and *The Poet*: Rodin must have already decided that this sculpture could represent Dante as the creator of the trapped population beneath him. This seated figure became one of the most frequently reproduced (and parodied) sculptures in Western art, the complexity of its composition often being overlooked in the process. Deceptively, the body is unnaturally twisted so that the right elbow is supported on the left knee, resulting in a contortion that endows the form with remarkable physical intensity. Various figures may have inspired Rodin's sculpture: the *Belvedere Torso* (1st century CE), Jean-Baptiste Carpeaux's *Count Ugolino and His Sons* (1857–61), and a figure customarily called "the condemned man" in Michelangelo's *Last Judgment*, but the universality of Rodin's creation sets it apart from its predecessors. *The Thinker* was cast in an enlarged version (1902–04) for installation in front of the Pantheon in Paris; this was later transferred to Meudon to mark Rodin's grave. A number of casts in different sizes exist (see Tancock, 1976, for partial listing).

Many early drawings (several reproduced by Elsen, 1985) illustrate specific characters in Dante's epic, but Rodin modified his initial ideas, diminishing Dante's characters in number in favor of unidentifiable figures expressing the regret, anguish, and despair of the human condition. Most of these (for example, *La Douleur*, *The Falling Man*, "*I Am Beautiful*," *Despairing Adolescent*, and *Fugit Amor*) are known by names assigned to them by Georges Grappe, author of the first catalogue of the major sculptures in the Musée Rodin. Throughout the ensemble, dozens of figurated

elements (for example, skulls and disembodied, crying heads on the register above *The Thinker*) are juxtaposed against shapeless masses of bronze. Thorny brambles are twisted across the uppermost register of the frame. Above the lintel, three nude male figures, derived from *Adam*, represent the *Three Shades*.

The Gates of Hell is a remarkable telescoping of time and space: it simultaneously represents a view into hell both by way of the depth of relief (almost 1 meter) as well as through the examination of the ensemble from top to bottom, where rectangular blocks, customarily called the *Tombs*, emphasize the ambiguous definition of space. *The Thinker* can be interpreted as imagining characters of an epic that has not yet been written, contemplating the timeless condition of humankind, or the hopelessness of events that already occurred. During the years Rodin worked on *The Gates of Hell*, his distinct personal style emerged, and he came to grips with the symbolic nature of his own creations.

MARY L. LEVKOFF

See also **Belvedere Torso**; **Ghiberti, Lorenzo**

Further Reading

Audeh, Aida, "Rodin's *Gates of Hell*: Sculptural Illustration of Dante's *Inferno*," in *Rodin: A Magnificent Obsession*, edited by R. Blackburn, London: Merrell Holbertson, 2001

De Caso, Jacques, "Rodin at the Gates of Hell," *The Burlington Magazine* 106 (February 1964)

Elsen, Albert Edward, *The Gates of Hell by Auguste Rodin*, Stanford, California: Stanford University Press, 1985

Le Normand-Romain, Antoinette, *Rodin: The Gates of Hell*, Paris: Musée Rodin, 1999

Le Pichon, Yann, and Carol-Marc Lavrillier, *Rodin: La Porte de l'Enfer*, Paris: Pont Royal, 1988

Tancock, John, *The Sculpture of August Rodin: The Collection of the Rodin Museum, Philadelphia*, Philadelphia, Pennsylvania: Philadelphia Museum of Art, 1976

MONUMENT TO HONORÉ DE BALZAC

Auguste Rodin (1840–1917)

1898

plaster

h. 2.7 m

Musée Rodin, Paris and Meudon, France; other casts: Musée d'Orsay, Paris, France; National Gallery, Prague, Czech Republic. There are 14 bronzes of Auguste Rodin's monumental Balzac cast in the period 1931–70; notable examples may be found in Middleheim Museum, Antwerp, Belgium; boulevard Raspail, Paris; Museum of Modern Art, New York City; Open-Air Museum, Hakone, Japan; National Gallery of Victoria, Melbourne, Australia; Consolidado Cultural Centre, Caracas, Venezuela

Rodin considered the monument to Balzac his aesthetic testament. He predicted a major landmark in the history of art, showing the way for the "new synthetic sculpture" designed for the open air. The monument to Balzac was commissioned by the Societé des Gens de Lettres (Association of Men of Letters) in 1891. Rodin explained the sculpture subject matter clearly: he wanted to represent the full potency of the writer's creative intellect—in particular, the power of observation that had enabled Balzac to write *La Comédie Humaine* (*The Human Comedy*, the name given by Balzac in 1841 to describe the entirety of his work) and which set him above other writers. The project began under the ethos of naturalism; it was thanks to Émile Zola that Rodin had secured the commission. Naturalism demanded its own working methods based on thorough research. The collection of preparatory works in the Musée Rodin bears witness to this commitment. Rodin labored seven years on *Balzac* until it satisfied him.

When he first exhibited the definitive plaster in May 1898 at the Paris Salon, Rodin paired it with *The Kiss* to invite a fundamental revaluation of his practice and its new direction. The aesthetic dispute the work provoked irreversibly altered the conception of sculpture; the whole notion of representation was questioned. Rodin had hoped to frame the debate by opposing "art" to conventional notions of realism. As he stated: "For me modern sculpture cannot be photography. The artist must work not only with his hands but above all with his brain. . . . Modern sculpture must exaggerate forms at the service of significance" (*Le Figaro*, 12 May 1898). Monumental public sculpture could thus be concerned with conceptual rather than visual reality. This was one aspect of Rodin's legacy. The mode of representation Rodin devised for *Balzac* worked on a principle of analogy; he used the physical presence of the three-dimensional medium to transpose the idea of intellectual potency. Connoted images evoking natural forces were embedded in a rigorous structure. This strategy invited comparison with monumental art and power cults in distant civilizations, such as "Menhir" or "Egyptian." *Balzac* demanded a new mode of art criticism, one that grappled with the technique of sculpture. According to Rodin, his principle was to imitate life, not just form: "I search for life in nature, amplifying it, exaggerating it, after which I search for a synthesis of the whole" (*Le Journal*, 12 May 1898).

After interviewing Rodin, art critics such as Camille Mauclair came to articulate a theory of sculpture developing the sculptor's concepts. *Synthesis* referred to the technique of eliminating details and reducing transitions to obtain a unity of surface. This concept related to Rodin's method of working via the profiles of the sculpture to convey a general movement developing in space. *Value* concerned the sense of materiality and

Monument to Honoré de Balzac, boulevard Raspail, Paris, France
The Conway Library, Courtauld Institute of Art

how depth could be inferred. *The considered accentuation of planes* concerned the spatial experience of sculpture. This was Rodin's solution to his long preoccupation that the figure be solidly anchored in space yet interplayed with the surrounding atmosphere.

Notwithstanding the quality of the arguments deployed to explain *Balzac*, Rodin could not control the cultural reception of the sculpture. On 11 May the Société des Gens de Lettres announced their decision to reject the work as "that sketch in which we refuse to recognise Balzac." The sculptor, it was felt by many, was left with three options: to bring a lawsuit against the society, to sell the work to one of the private collectors who had approached him, or to sell the sculpture to a group of admirers who were in the process of organizing a public subscription to see *Balzac* erected in Paris. Rodin made his decision public on 10 June: *Balzac* was to return to the sculptor's studio and remain there.

The crisis had profound repercussions. One concerns the understanding of the relation between sculpture and the political sphere. As Mathias Morhardt, who organized the 1898 subscription, subsequently explained, if *Balzac* was not erected as a monument in 1898, this was because it had become inextricably bound up in the Dreyfus affair, a crisis of French history, when society was torn apart around the campaign for the retrial of a military officer of Jewish descent who had been sentenced to life deportation for treason, despite growing evidence attesting to his innocence. The political persona of Rodin's advocates, and more subtly the ethical and ideological values conveyed in the language of art criticism explain why, in 1898, the boundaries between aesthetics and politics were blurred. Indeed, Octave Mirbeau, Séverine (Carolyne Rémi), Gustave Geoffroy, Morhardt, and other spokesmen of Rodin were implicated, at various levels, in the Dreyfus cause, as it had been shaped by Zola's intervention in the winter of 1898. Their political opponents denigrated the advocates of Rodin's aesthetics as they had done the defenders of Dreyfus and supporters of Zola, applying the word *intellectual* as a term of abuse. The struggle that tore apart the cultured bourgeoisie in the summer of 1898 made it unlikely that the city of Paris would grant a site for the display of *Balzac*. Rodin had no other choice than to retract his work. Out of respect for the subscribers, he vowed not to sell the sculpture.

Another set of repercussions concerned the development of sculptural practice and its institutions. Rodin had an agenda for *Balzac*. The necessity for artists to develop strategies to take control over the diffusion as well as the production of their work had become all the more apparent to him. *Balzac* remained anchored in the public domain. The international circles of writers and critics devoted to his art made it the focus of a debate about aesthetics in the early 20th century. It was mostly in the medium of photography that *Balzac* initially remained a visual presence. The photographs of Eugène Druet, Jacques Bulloz, and Edouard Steichen were published in magazines and included in Rodin's exhibitions to guide the debate on his sculptural theory. The status of *Balzac* was that of "master class."

The crisis over *Balzac* strengthened the campaign to ensure the perpetuation of Rodin's art, which was fulfilled on creation of the Musée Rodin, ratified by the French government in 1916. This institution's legal rights over the casting of Rodin's oeuvre after his death made it possible for *Balzac* finally to be cast in bronze. It was erected as a monument in Paris in July 1939. Thus Rodin's strategies for *Balzac* paved the way for institutional structures essential to 20th-century art practice, the diffusion of multiple bronze casts in the international network of art museums, and the creation of a social space solely dedicated to the contemplation of sculpture.

CLAUDINE MITCHELL

Further Reading

1898: Le Balzac de Rodin (exhib. cat.), Paris: Musée Rodin, 1998 (contains an extensive bibliography and documents the complete series of preparatory works and the history of the monument)

Cladel, Judith, "L'affaire du Balzac," in *Rodin: Sa vie glorieuse et inconnue*, Paris: Grasset, 1936

Elsen, Albert, editor, *Rodin and Balzac: Rodin's Sculptural Studies for the Monument to Balzac from the Cantor Fitzgerald Collection* (exhib. cat.), Beverly Hills, California: Cantor Fitzgerald, 1973

Martinez, Rose-Marie, *Rodin: L'artiste face à l'état*, Paris: Séguier, 1993

Mauclair, Camille, "La technique de Rodin," in *Auguste Rodin et son oeuvre*, Paris: La Plume, 1900

Mirbeau, Octave, "Ante Porcos," *Le Journal* (15 May 1898); reprint, in *Combats esthétiques*, edited by Pierre Michel and Jean-Francois Nivet, vol. 2, Paris: Séguier, 1993

Morhardt, Mathias, "La bataille du Balzac," *Mercure de France* (15 December 1934)

Newton, Joy, and Monique Fol, "La correspondance de Zola et Rodin," *Cahiers naturalistes* 59 (1985)

ROLDÁN FAMILY *Spanish*

Pedro Roldán (the Elder) 1624–1699

Pedro Roldán, a sculptor, architect, and painter, unified all three arts in the design of theatrical altarpieces that embody Spanish Baroque art. The Roldán family was the nexus of one of the largest, most important sculptural ateliers of Seville during the last third of the 17th century. Pedro's daughter Luisa trained in his studio and maintained his style but also created smaller, more intimate works in terracotta. She went on to work for the king in Madrid. Artists trained by Roldán even made their imprint on New World sculpture, for the atelier style is identifiable in the Americas.

Of the major Baroque sculptors of Seville, Pedro Roldán was the only one to be born there. At 14 he entered the studio of Alonso de Mena in Granada. He established his independent artistic identity once he opened his own studio in Seville in 1647. There, he combined the classicizing compositions of his teacher with more dynamic elements drawn from José de Arce, the preeminent Sevillan artist, such as ample swirling draperies and seemingly wet hair that frames the face with ribbed curls. Roldán expressed his artistic strengths in grand compositions and in individual figures that display interior sorrow with gentle compassion. His impassioned yet intimate style suited a city decimated by the plague in 1649. During the years of Seville's recovery, Roldán became its leading artist.

He used polychromed wood sculpture as his primary medium for images of spiritual expression, yet they were palpably real. In Counter Reformation Spain the beholder was meant to experience the presence of these lifelike figures while meditating on the mysteries of Christianity.

Those who formed Roldán's workshop included his nephews, his children, and his colleagues Gaspar de Ribas, *estofador* (painter and gilder of sculpture), and the painter Juan Valdés Leal. Two masterworks demonstrate the collaborative nature of Spanish Baroque sculpture: the *Descent from the Cross* and *Entombment of Christ*, both made for retables in Seville. In 1666 Roldán contracted to make the high altar of the chapel of the Basque community in the Church of San Francisco. He carved for it the *Descent*, a group arranged around the body of Jesus as they take him down from the cross. Francisco de Ribas produced the elaborate architectural framework, and Valdés Leal painted the relief background.

In the early 1670s Roldán produced the *Entombment of Christ* for the high altar of the Church of San Jorge in the Hospital de la Santa Caridad, Seville, with Bernardo Simón, Valdés Leal, and Bartolomé Esteban Murillo. Here, mourners place the dead Christ into an ornate sarcophagus. The swags of the funeral shroud underline the grace with which Christ's body is suspended over the coffin. The burial of Jesus was an act of charity by Joseph of Arimathea, who donated his own tomb. La Caridad regularly saw works of mercy, including burial, performed; thus, Roldán's figures enact a familiar scene within its spiritual context. The major actors express tender concern for the deceased while their calm suggests confidence in the Resurrection to come. The skillful grouping together with the naturalistic scale of figure to architecture and the gradual transition from figures in the round to high and then low relief achieve an equilibrium between the central group and its setting.

Roldán expertly represented the pathos of the suffering of Jesus in various figures made for *pasos*, floats for religious processions. He vividly rendered the mortification of the flesh, but the beauty of the image inspires faith. Outstanding examples include the *Cristo de la Expiración* (*Crucified Christ*), captured in the last instant of life, gazing upward into heaven; the *Jesús Nazareno* (*Nazarene Carrying the Cross*), an *escultura de vestir*, one of the most beloved "figures to dress" of the Sevillan Holy Week processions; and *Christ of the Flagellation*, a striking figure of Jesus, bleeding and bound to a column. In his later years, with his failing health, Roldán's assistants carried on the work and the studio did not dissolve until a decade after his death in 1699.

The carvings of the patron saints of Cádiz, *St. Germanus* and *St. Servandus* (which have been ranked as masterworks of Spanish sculpture by Martín González), demonstrate the difficulty in separating the work of one member of the group from another. During a recent cleaning, a note was found enclosed in the head of one of the figures recording that the design was by Pedro Roldán, the carving by Luisa Roldán, and the painting and gilding by her husband, Luis Antonio de los Arcos. A similar, earlier effort is the group *Christ and Thieves on the Cross*, a *paso* for which they each carved different figures. Although Luisa Roldán married fellow apprentice de los Arcos in 1671 against her father's will, the couple continued to work in the Roldán studio until about 1686, when they moved to Madrid.

Luisa (Ignacia) Roldán (La Roldana) 1652–1706

Charles II appointed Luisa Roldán, called La Roldana, sculptor to the king's chamber about 1692. One of the few women artists to achieve distinction within her own time, she was reappointed by Philip V in 1701. The title, which did not carry a regular salary, allowed La Roldana to sign her work as "Escultora de Cámara,"

Pedro Roldán, *Entombment of Christ*, 1670–73, Church of San Jorge, Hospital de la Santa Caridad, Seville, Spain
The Conway Library, Courtauld Institute of Art

which surely resulted in status for her clients and greater remuneration for her in a time of general economic crisis. In Madrid she turned to smaller-scale works in terracotta, which were coming into vogue and which were appropriate for private patrons. In a letter she described them as "jewels" by her hand, a label appropriate for the preciousness of the work, a precursor of Rococo sensibility. Like her father, La Roldana excelled at figural groupings. At the same time, differences of style emerge in works such as her terracotta *Death of St. Mary Magdalene*; angels minister to the dying woman while animals in the landscape symbolize the spiritual struggle between passion and penitence. La Roldana replaced her father's pathos with dulcitude: the angels' garments slip off their shoulders and sensuously reveal their delicate limbs. Such sweetness does not mean that her work lacks in emotional impact. Her contemporary Antonio Palomino described his reaction to her large-scale *Jesús Nazareno*, commissioned by Charles II: "It seemed irreverent not to be on my knees to look at it, . . . everything looked like life itself" (see Palomino, 1742). He also reported that Luisa wept with compassion when she executed such works. Of her many large-scale sculptures, *Saint Michael Conquering Satan*, ordered by Charles II for the Monastery of S. Lorenzo el Real—burial place of the kings—is most memorable. Opening out the composition with broad movements and twisting bodies, the plumed archangel effortlessly conquers the writhing Satan, a beautiful male nude whose lower torso is being consumed by the flames of hell. Sumptuous in its color, the dramatic monumental work guaranteed her fame. Luisa Roldán's artistic achievement was recognized when she was honored with the title Accademica di Merito by the Roman Accademia di San Lucca.

ELIZABETH VALDEZ DEL ALAMO

See also **Spain: Renaissance and Baroque**

Pedro Roldán (the Elder)

Biography

Born in Seville, Spain, 14 January 1624. Resided in Orce (now Granada), Spain; apprenticed to sculptor Alonso de Mena in Granada, 1638–46; returned to Seville, 1646; established studio, 1647; collaborated with Juan Valdés Leal, painter; maintained close relationship with family of Pedro de Mena, 1662–72; taught drawing in Accademia de la Lonja, Seville, founded by Bartolomé Esteban Murillo, 1660; worked in various sites in Andalusia including Jaén, Córdoba, Jérez, and Cádiz; after his death, son Marcelino Roldán supervised workshop until 1709. Had eight children, five of whom became artists, including daughter Luisa. Died in Seville, Spain, August 1699.

Selected Works

1650–51	*Jesús Nazareno*; polychromed wood; Confraternity of Nuestra Señora de la Candelaria, Church of San Nicolás de Bari, Seville, Spain
1650–51	*Virgin of the Seven Sorrows*; polychromed wood; Church of La Magdalena, Seville, Spain
1652	High altar (with Blas de Escobar); polychromed wood; Convent of Santa Ana, Montilla, Córdoba, Spain
1666	*Descent from the Cross* retable (with Francisco Dionisio de Ribas and Juan Valdés Leal), for Chapel of the Basques, Church of San Francisco, Seville, Spain; polychromed wood; Chapel of the Sagrario, Seville Cathedral, Spain
1668	*Immaculate Conception*; polychromed wood; Church of the Trinitarios Descalzos, Córdoba, Spain
1670–73	*Entombment of Christ* retable (with Bernardo Simón, Valdés Leal, and Murillo); polychromed wood; Church of San Jorge, Hospital de la Santa Caridad, Seville, Spain
1671	*San Fernando*; polychromed wood; Sacristy, Seville Cathedral, Spain
1675–84	Statues and reliefs for the facade; stone; Jaén Cathedral, Spain
1680	*Cristo de la Expiración* (Crucified Christ); polychromed wood; Church of Santiago, Seville, Spain
1683–84	*Christ*, for *Christ and Thieves on the Cross*; polychromed wood; Hermandad de la Exaltación y Nuestra Señora de las Lágrimas, Church of Santa Catalina, Seville, Spain
1685	*Jesús Nazareno* (*Nazarene Carrying the Cross*); polychromed wood; Church of Nuestra Señora de la O, Seville, Spain
1689	*Christ of the Flagellation*; polychromed wood; Church of San Juan, La Orotava (Tenerife), Spain

Roldán, Luisa (La Roldana)

Biography

Born in Seville, Spain, before 8 September 1652. Third daughter of sculptor Pedro Roldán. Trained in father's studio; married fellow apprentice Luis Antonio de los Arcos, 25 December 1671; lived in Cádiz, Spain, *ca.* 1684–87; moved again with family to Madrid, 1688–89; named Escultora de Cámara (Sculptor of the King's Chamber) by Charles II, 1692, and reappointed by Philip V, 1701; granted title Accademica de Merito by

the relics of Saint Saturninus, the canons of the Church of Saint-Sernin in Toulouse, France, provided an entrance facing a major thoroughfare: the south transept portal (*ca.* 1080–90) was given a deep-set double opening framed by columns and the first surviving portal capitals with a clearly defined iconographic program— the *Punishment of the Vices*, vividly rendered. In the spandrel between the two openings was the image (destroyed during the French Revolution) of Saint Saturninus, who would assist the churchgoer in overcoming the Vices and intercede on the sinner's behalf. The figure of the saint appeared under an arch, flanked by lions, and to the sides were his companions. Salvation from vice also serves as the theme of the west portal of Jaca Cathedral, Spain, where public penance was introduced after 1076. Here, the arched doorway (*ca.* 1090–1100) is filled with a tympanum, where lions flank a Chrismon (Christ's monogram) and hold down, on the left, a prostrate penitent. Between 1099 and 1120 Wiligelmo carved a frieze with scenes from Genesis for the facade of Italy's Modena Cathedral. The doorjambs feature prophets in arched niches, arranged vertically. The entrance, beneath a projecting porch supported by columns resting on lions at either side, represents a typical Italian entranceway that would be developed further by Niccolò, for example, at Verona Cathedral (*ca.* 1139). Found in Provence, Spain, and England, this arrangement had great impact. The pair of lions may refer to the throne of Solomon and to the function of these doorways as a place of judgment. Activities staged at the door included oath taking, trials, and signing of marriage documents.

The Church of Saint-Sernin in Toulouse witnessed the development of a sculptural style that became widespread through the European Mediterranean— southern France, northern Spain, and Italy. The marble altar table signed by Bernardus Gelduinus and consecrated by Pope Urban II in 1096 is a product of the same group of artists who worked there for about 20 years, until about 1118. Toulouse was not the only site that could make this claim. Closely related sculptures, with fleshy figures and heavy hair, are found throughout Languedoc and Christian Spain—hence, the nomenclature *Hispano-Languedocian*. Some of the same artists' work may be identified at the great Spanish pilgrimage church, the Cathedral of Santiago de Compostela (Galicia), in construction by 1075. The Hispano-Languedocian portals are characterized by a historiated tympanum framed by simple archivolts springing from variously decorated capitals, sometimes with ornamental columns; in the spandrels are figural plaques. At the Church of San Nicola in Bari, Italy, the marble throne of Bishop Elia is supported by three figures in a related style. It may have been a gift on the occasion of a visit by Pope Urban II in 1098.

Because so many of these sculptures appeared at pilgrimage sites, they have been described as having a "pilgrimage" style; however, recent scholarship indicates that the similarities likely resulted from economics and the ability to build at a particular time rather than a conscious program to make all pilgrimage churches look similar, for they do not.

The image that would have greatest success, *Christ in Majesty*, appears in a tympanum (*ca.* 1090–1100) in the Burgundian Church of Saint-Fortunat in Charlieu. An immediate antecedent for the carved tympanum may have been wall painting. Painted tympana were produced during the last years of the 11th century, for example in France's Church of Saint-Savin-sur-Gartempe, where *Christ Enthroned at the Last Judgment* appears. Since early Christian times, mosaics and paintings in the semidome of the apse (imitated by a flat, semicircular tympanum) often depicted a majestic Christ or Virgin Mary.

Judgment and revelation of Christ's divinity represent the themes of the great portals that originated in Burgundy. The powerful Benedictine monastery of Cluny, together with the papacy in Rome, orchestrated the consolidation of Church power in part by promoting Christ as the princely judge of the dead and by granting the individual some say in his or her soul's future by the practice of penance—all suggested by the imagery of the portals, the capitals around the church, and the corbels supporting the roof. The *Christ* of Charlieu was elaborated for the third church at Cluny (*ca.* 1107–15), of which only fragments now remain. The sculptors, however, also worked elsewhere. At the Church of Saint-Lazare (now Autun Cathedral), in about 1125–35, a sculptor, until recently assumed to be the Gislebertus whose name appears under Christ's foot, produced one of the most awe-inspiring *Last Judgment* scenes in the history of art. His colleagues produced the triple portal of Vézelay, with scenes from the life of Christ and figures of saints on the doors and the *trumeau* (column or pier) supporting the central tympanum and dividing the passageway in two. The impact of Cluny was felt in Moissac (Languedoc, in southern France), where, on the south porch, Christ is surrounded by the Elders of the Apocalypse in the tympanum, and lateral reliefs at eye level contrast Christian virtue with horrific images of the Vices. Densely packed, twisting forms express the agony of the damned and the ecstasy of the saved in these dramatic sculptures, an aesthetic that pervades the smaller-scale capitals and ornament as well.

Burgundian sculpture is marked not only by high drama but also by extremely attenuated figures making angular gestures. Because of Cluny's international presence, Burgundian style had enormous impact. The figures on the doorjambs were reinterpreted, perhaps

by some of the same artists, as full-statue columns for the early Gothic portals of the Basilica of Saint-Denis and Chartres Cathedral (1140–50). In the Cathedral of Santiago de Compostela, by 1188 Master Mateo integrated Burgundian and local traditions into an ensemble that marked simultaneously the culmination of Romanesque sculpture in Spain as well as the first Gothic portal there.

Because Burgundian portals are so frequently used to define Romanesque sculpture, it is often forgotten what a rich variety of compositions existed in other regions and how much artistic exchange took place. Not only the churchmen who commissioned art traveled and drew inspiration from what they saw, but also through the sculptors—whether working as part of a group of stonemasons or independently. In this sense, they differed from ivorycarvers or manuscript illuminators, who were usually part of a monastic community and therefore more confined. One individual dubbed the Cabestany Master worked in Italy, Provence, and Catalonia. The sculptors of the cloister of Monreale Cathedral, Sicily, Italy, were probably Provençal. In the Crusader Kingdom, an artist from the Rhone Valley carved the reliefs for the Church of the Annunciation in Nazareth (ca. 1160). The carvers of the reliefs at Lincoln cathedrals in England seem to have known Modena. Early Romanesque cubic capitals demonstrate the shared artistic vocabulary of England, the Holy Roman Empire, and Normandy, whereas Insular and Scandinavian ornament made its way onto stone architecture, as at the Church of Saints Mary and David Kilpeck in Hereford and Worcester, England, and, in Scandinavia, onto wood buildings. The entwined creatures on panels at the 11th-century Church of Urnes in Norway serve as a prime example.

The widespread use of portals without tympana but with radiating archivolts densely covered with figures may be seen from western France to the British Isles to the Iberian Peninsula. The Church of Notre-Dame-la-Grande in Poitiers, France, is encrusted with reliefs, compound piers, and decoratively shaped masonry, so that the entire structure is unified by its richly textured surface. Such *horror vacui* is characteristic of most Romanesque sculpture, no matter where it was produced or in what medium. As a strategy for conversion, the Church often integrated pre-Christian folklore into its decoration, thus Christianizing local traditions. It was this policy that made possible the experimentation and originality of the artists working at this time, but these very qualities also make Romanesque sculpture a challenge to interpret today.

Together with elaborate entranceways, the other new field for monumental sculpture was the cloister, the arcaded garden that provided passageway through the monastic or cathedral compound. By 1100 some of the most magnificent surviving examples were in production, for example, at the monasteries of Saint-Pierre in Moissac, Languedoc, France, and of Santo Domingo in Silos, Castile, Spain. In a cloister, the arcade capitals combined biblical subjects, saints' lives, and paradisial imagery of birds, animals, and foliage. The piers supporting the gallery centers and corners provided further opportunity for sculpture. In the cloister of Saint-Trophîme in Arles, Provence, France (mid 12th century), scenes from the life of Christ on the piers are flanked by figures of apostles and saints. At Monreale Cathedral (ca. 1180), lush foliate capitals, many historiated, surmount columns decorated with glittering *cosmati* (mosaic inlay of stone and/or glass) work—all combining to suggest the heavenly Jerusalem. Whereas exterior portals were meant to attract and inspire the public to enter the church, cloister sculpture served as educational and meditative instruments for the religious community that lived within.

Later Romanesque sculpture was marked by figures carved in increasingly high relief wearing garments with heavy, rounded, swirling folds. This phenomenon was shared by the arts from the 1130s through about 1200, a manifestation of experiments in the representation of three-dimensional space in both Romanesque and Gothic art. Because of the chronological overlap, this style often carries the label *transitional*; the term is misleading, however, because no clear evolution from one early style to a later one is manifest. The phrase *dynamic style* seems to convey best the restless motion and rounded bodies characteristic of this period, something that first appeared in Byzantine apse mosaics such as at Cefalù Cathedral, Sicily, Italy. In sculpture, inspiration also came from Hellenistic and Roman works. Italian sculpture never lost sight of its Roman past. The pulpit by Guglielmo for Pisa Cathedral (ca. 1160; now in the Cagliari Cathedral) and the portals of cathedrals in west Tuscany—Pisa, Lucca, and Pistoia—beginning in the mid 12th century render scenes from the life of Christ in vividly physical terms. The facade of the Church of Saint-Gilles-du-Gard in southern France, based on the design of a Roman theater, exemplifies the profound Classicism of the moment. In Castile the later reliefs of the Abbey of Silos (before 1158) formulated the dynamic style of Christian Spain. Master Mateo, working at Santiago from 1168 to after 1188, and Benedetto Antelami, working in Parma in 1178, represent this final phase of Romanesque sculpture.

Although architectural sculpture was the innovation of Romanesque, masterpieces of church furnishings—including elaborate pulpits and baptismal fonts—also saw production at this time. Wood and metal altarpieces continued to employ the image of *Christ in Majesty* surrounded by his apostles. Devotional images in

wood were ubiquitous. Large-scale figural groups representing Mary and John the Evangelist mourning the Crucified Christ often were an important part of Easter rituals. In almost every church there must have existed a *Sedes sapientiae*, a statue in which the infant Christ personifies Wisdom enthroned in the Church who is his mother, Mary. Such figures in the round were meant to make the presence of Christ and the saints visible and were carried in processions. One of the best-known freestanding figures in goldsmith's work is that of Sainte-Foy (11th–12th centuries) at the abbey in Conques, Aveyron, France. A child martyr, her jeweled image of gold over wood was augmented constantly by gifts from the devout throughout the Middle Ages. Enamels—important centers of production include Conques, Limoges, and the Mosan region—covered reliquary boxes made to hold the fragmentary remains of saints. The imagery used on reliquaries and liturgical implements often contrasted, in the same dramatic terms as large-scale sculpture, the fearful results of disobedience to Church teachings with the happy results of faith. The ivory crucifix (approximately 53 centimeters high) given by King Ferdinand I and Queen Sancha to the Basilica of San Isidoro in León, Spain, in 1063, and the bronze candlestick (about 51 centimeters high) given by Abbot Peter to Gloucester Cathedral, England (*ca.* 1107–13) both employ twisting, entangled figures wending their way to salvation—not unlike the *trumeau* now inside the church at Souillac (*ca.* 1125).

Perhaps because of its tendency to high emotion and distortion of the human figure, Romanesque sculpture was largely unappreciated from the Renaissance on, until Modern art developed in the early 20th century. However different in purpose, Modern art and Romanesque sculpture are closely tied. This may be illustrated by Pablo Picasso, who was actively engaged with Romanesque sculpture, reflected in his works of about 1902–07, such as *The Two Sisters*. Meyer Schapiro began his career as a specialist in Romanesque sculpture; his students included Abstract Expressionists of New York City. As Schapiro taught, "by the eleventh and twelfth centuries there had emerged . . . [an art] imbued with values of spontaneity, individual fantasy, delight in color and movement, and the expression of feeling that anticipate modern art" (see Schapiro, 1947).

ELIZABETH VALDEZ DEL ALAMO

See also **Architectural Sculpture in Europe: Middle Ages–19th Century; Gothic Sculpture**

Further Reading

Demus, Otto, *Byzantine Art and the West*, New York: New York University Press, and London: Weidenfeld and Nicolson, 1970

Kendall, Calvin B., *The Allegory of the Church: Romanesque Portals and Their Verse Inscriptions*, Toronto and Buffalo, New York: University of Toronto Press, 1998

Petzold, Andreas, *Romanesque Art*, New York: Abrams, and London: Weidenfeld and Nicolson, 1995

Porter, Arthur Kingsley, *Romanesque Sculpture of the Pilgrimage Roads*, 10 vols., Boston: Jones, 1923; reprint, New York: Hacker Art Books, 1985

Schapiro, Meyer, "On the Aesthetic Attitude in Romanesque Art," in *Art and Thought: Issued in Honor of Dr. Ananda K. Coomaraswamy on the Occasion of His 70th Birthday*, edited by K. Bharatha Iyer, London: Luzac, 1947; reprint, in *Romanesque Art*, vol. 1, *Selected Papers*, by Schapiro, New York: Braziller, 1977

Shaver-Crandell, Annie, Paula Lieber Gerson, and Alison Stones, *The Pilgrim's Guide to Santiago de Compostela: A Gazetteer*, London: Harvey Miller, 1995

Stokstad, Marilyn, *Medieval Art*, New York: Harper and Row, 1986

Stokstad, Marilyn, et al., *Art History*, 2 vols., New York: Abrams, 1995; revised edition, 1999; 2nd edition, 2002; see especially vol. 1

Toman, Rolf, editor, *Romanesque: Architecture, Sculpture, Painting*, Cologne, Germany: Koneman, 1997

Vergnolle, Éliane, *L'art roman en France: Architecture, sculpture, peinture*, Paris: Flammarion, 1994

Zarnecki, George, *Romanesque Art*, London: Weidenfeld and Nicolson, and New York: Universe Books, 1971

Zarnecki, George, *Art of the Medieval World: Architecture, Sculpture, Painting, the Sacred Arts*, Englewood Cliffs, New Jersey: Prentice Hall, and New York: Abrams, 1975

ROMANTICISM

See **Neoclassicism and Romanticism**

ANCIENT ROME

Sculpture was a ubiquitous part of the physical environment in the ancient Roman world. Artists produced sculpted objects such as statues, figural and nonfigural relief, architectural decorations, and furniture and domestic decor for a wide range of public and private settings. Ancient Roman sculptors are perhaps best known for their innovations in portraiture and historical relief sculpture. The Roman sculptural repertoire, however, was far broader: it included cult images and votive offerings; tomb sculptures, sarcophagi, and funerary reliefs; copies and adaptations of Greek statues; garden sculpture and marble furniture; and smaller objects, such as coins, medallions, cameos, and gems. In addition to these predominantly figural works, a large category of the marble sculpture consisted of nonfigural architectural ornament produced for monumental marble buildings. The accomplishments of the architectural sculptors who produced the intricate and technically sophisticated capitals, friezes, and moldings for buildings in both Rome and provincial cities often equal those of the figural sculptors in the same areas.

Within the Roman sculptural repertoire is a wide spectrum of styles and levels of production, ranging from virtuoso works made for the state and the wealthy elite class to pieces of lower quality and cost produced primarily for the middle and plebeian classes. Regardless of quality and visual appeal, the status of Roman sculpture as "fine art" was almost always secondary to the religious, political, or social functions that the works fulfilled in Roman society.

Owing to the fragmentary nature of the evidence, the history of Roman sculpture must be reconstructed from a variety of sources. The works themselves provide the most significant body of evidence, yet their survival is, to a large extent, serendipitous. Despite the seemingly large quantity of Roman sculpture preserved in museums and at archaeological sites, far more has been lost or destroyed. In order to contextualize the works that do survive, art historians and archaeologists deploy numerous methods and resources. Archaeological investigation assists in providing valuable information concerning the context and chronology of Roman sculpture while ancient literary texts contribute additional information about the manufacturers, patrons, and functions of the works. Finally, the examination of the works themselves from a range of perspectives—art historical, archaeological, anthropological, and scientific—assists in the reconstruction of the repertoire, function, and meaning of sculpture within the context of ancient Roman society.

Ancient Roman sculpture is heterogeneous in subject matter and style, due in part to the broad chronological and geographical parameters of Rome's influence. The official history of ancient Rome begins with the legendary foundation of the city by its first king, Romulus, in 753 BCE. A monarchy ruled Rome until 510/509 BCE, when the expulsion of the last king brought about the establishment of the Roman Republic, in which power was vested in the Senate, popular assemblies, and elected officers. The republic survived until the late 1st century BCE, but increasing political unrest marked its final decades. The victory of Octavian (later known as Augustus) over his rival Mark Antony and the Ptolemaic queen Cleopatra at the Battle of Actium in 31 BCE marks the end of civil war and the beginning of the imperial period of Roman history. Surveys of art history generally use the date of Emperor Constantine's death, 337 CE, as the end point for their discussions of ancient Roman art, and the reign of Constantine, during which the practice of Christianity was legalized and the capital city was moved from Rome to Constantinople, provides a convenient historical break. It is, however, an artificial break, and the emperors who followed Constantine (and who are categorized as Byzantine) considered themselves direct heirs to the Roman Empire.

At the time of its foundation, the kingdom consisted solely of the city of Rome and its immediate environs; at its largest, under Emperor Trajan in 117 CE, the Roman Empire extended from Britain to Mesopotamia and included the Levant and North Africa, as well as much of northern Europe. Not only was the territory vast but it was also populated by a diverse range of ethnic groups, each of which had to be assimilated into the Roman Empire. The visual arts, particularly sculpture, played an important role in the "Romanization" of these diverse populations: portraits of the emperors provided the "face" of the regime, and public monuments reinforced the "civilizing" benefits of Roman rule. Nowhere perhaps is this propagandistic intent more apparent than in the most ubiquitous form of Roman sculpture, coinage, on which were depicted imperial portraits, as well as emblematic representations of historic events and imperial values.

Historical and dynastic divisions provide a means of defining the official culture of a specific period in Roman history, and certain categories of sculpture, such as portraits of the emperor and monuments commemorating historical events, fit neatly into this framework. However, to assess the entirety of Roman sculptural output by the evidence of elite, metropolitan monuments marginalizes the significant body of material that falls outside of these parameters, including sculpture produced for private contexts, works commissioned by and representing the provincial patrons, and pieces made for the middle and lower classes.

The Roman sculptural repertoire was distinguished throughout its long history by a marked eclecticism: a multiplicity of styles can be found in all periods, and the differences can be attributed to a variety of factors, including patronage and class, subject matter, function, level of production, and regionalism. In order to understand better the historical development of Roman sculpture, one needs first to examine some of the threads that run throughout this history, most notably, materials and artists, patronage, and sculptural repertoire.

Materials, Artists, Workshops, and Patronage

Marble is the medium most commonly associated with Roman sculptural production, and Roman marble sculpture, particularly full-size, freestanding statuary, influenced the development of later sculptural movements from the Renaissance to the present day. (One must keep in mind, however, that, in contrast with the pristine whiteness that characterizes Neoclassical statues from later art historical periods, the entirety of Rome's marble sculpture would have been richly painted.) Although Roman marbles survive in signifi-

cant numbers, Roman artisans produced sculpture in a wide variety of materials, including bronze and other metals, which survive in far fewer numbers due to the value of the raw material from which these works were fashioned. In addition to the white variety, sculptures exploited colored marbles for their distinctive properties, particularly during the high imperial period, when the international marble trade made it possible to transport these materials across the empire with relative ease. Marble-poor areas, such as the provinces of the Near East and North Africa, either imported marble from quarries across the empire or used local stone for their architectural and sculptural production. Artists produced small-scale luxury works, such as cameos and jewelry, for elite patrons from precious metals and gemstones. Objects influenced by elite taste but made from less expensive materials, such as terracotta, were produced for middle-class consumers.

In the early periods of Rome's history, artists created monumental sculpture primarily from bronze, terracotta, and local stone, all materials that were used traditionally in the region. Marble was not locally available in Rome until the second half of the 1st century BCE, when the Luna marble quarries were first exploited. Marble sculpture, however, had appeared in Rome far earlier, in the late 3rd century BCE, in the form of plundered Greek works, and later, in the 2nd and 1st centuries BCE, in the carved marbles produced by Greek workshops for Roman patrons. As Rome expanded its territory under the emperors, a greater variety of raw materials became available as media for sculpture. With the imperial takeover of major marble quarries during the reign of Tiberius in the early 1st century CE, the imperial house positioned itself to exploit these materials for state commissions. Imperial control of the output of specific quarries is well exemplified by the use of porphyry, a rare red stone from Egypt particularly favored in the late 3rd and early 4th centuries CE, which was used exclusively for imperial commissions.

Relatively little is known about individual sculptors working in the Roman world, and scholars have reconstructed extant information about artists, workshops, and working methods from a fragmentary body of evidence scattered across time and geography. The literary record for Roman sculptural production, as can be found in Pliny the Elder's *Natural History* (77 CE) and Pausanias's travel guide, *Description of Greece* (mid 2nd century CE) is encyclopedic in nature, consisting primarily of lists of sculptors' names and works, sometimes with their original display contexts. The epigraphic evidence for sculptural production primarily includes funerary inscriptions and "signed" works that contain the names, patronyms, and home cities of the sculptors (or more likely, the workshop owners). This body of evidence provides practical information about sculptors that supplements the "famous names" given in the literary record. Most notably, virtually all of the sculptors' names recorded in the literary and epigraphic sources are Greek, demonstrating that artisans of Greek descent dominated sculptural production in the Roman world.

Archaeology provides another body of evidence to aid in reconstructing the activity of Roman sculptors. Workshop facilities, tools, casts, and models, as well as the debris that remained as a result of artisanal activity, are preserved for both bronze-casting and marble-working facilities. The marble sculptor's workshop at Aphrodisias, in western Asia Minor, is one of the most fully preserved examples, with finds including not only the physical facilities for sculpture production but also chisels and a variety of portrait and ideal statues in various states of completion. Further evidence for ancient sculpture workshops consists of images of sculptors' tools and of sculptors at work found on funerary reliefs from the Roman imperial period.

New technologies and scientific analysis, particularly in the area of marble provenance studies, have also contributed to the present understanding of sculptural production and trade in the Roman world. For example, one can ascertain the provenance of marble by scientific techniques, of which stable isotope analysis, which provides a distinctive geochemical signature for each type of marble, is the most common. Such research provides useful insights into patterns of marble circulation in the Mediterranean region, answering questions concerning the prefabrication of marble objects in specific quarries and the subsequent shipment of these objects elsewhere, based on market demand.

Patrons ranging from the imperial house and the state to members of the plebeian class largely drove the market for sculpture in the Roman world. Elite patrons placed the general artistic stamp on the period in large part because of the larger number and greater visibility of the monuments they commissioned. Aristocratic and imperial commissions included sculptural programs for public buildings and historical relief cycles for large-scale monuments, such as arches and columns commemorating specific political events or military successes. Sculpture also played an important role outside of the capital, and provincial patrons honored the gods, the emperor, and themselves with a comparable range of sculpture as was found in Rome. In provincial cities, however, iconography and style often differed from the metropolitan modes of representation, drawing instead on local traditions.

In addition to the state and the upper class, the middle class and prosperous freed slaves also participated in the patronage of sculpture, although on a more limited scale and at a lower level of production than their

more elite counterparts. The middle class did not engage in the patronage of large public monuments; it could, however, commission honorific portraits, as well as a variety of smaller monuments, such as altars for the imperial cult. A market for funerary sculpture, domestic pieces, and votives existed on all levels of society, and the range of quality and types produced reflected the economic diversity of its patronage.

Repertoire

Roman sculptural production encompassed a variety of categories, including portraiture, historical relief sculpture, ideal sculpture, and funerary sculpture. Portraiture was one of the most significant categories, as portraits were produced for both elite and middle-class patrons, for whom they fulfilled a range of functions relating to the commemoration of the portrait subject, either in life or in death. Sculptors produced Roman portraits in a variety of sizes, ranging from colossal (reserved exclusively for imperial portraits) to miniature; the majority of portraits were life-size. Full-length statues and busts were both common formats for Roman portraits, for which artists formulated a range of basic stock types, which they subsequently modified according to need or desire. A combination of costume, attributes, gestures, hairstyle, and physiognomy communicated the message of the Roman portrait. For example, the selection of a Roman toga, Greek himation, military cuirass, or heroic nudity tells much about the self-image of the male subject. In general, the portrait options for men were broader than those available for women, due to the wider range of public roles played by men in Roman society. Women, however, were not excluded from the portrait repertoire, and sculptors developed a number of formats to communicate values of feminine beauty and virtue.

Because the Roman emperor and his family were the subjects of the greatest number of identifiable portraits, developed and distributed for propaganda purposes, this body of material provides the fullest documentation of the range of portrait options available. Sculptors produced imperial portraits in fixed types intended for replication and distribution throughout the empire. The portraits of emperors and their consorts provided models for many private (nonimperial) portraits; members of both the elite and the middle classes emulated both sculptural styles and fashion elements, such as hairstyles. Other patrons, however, eschewed the imperial model, preferring instead to be represented in alternative modes, for reasons of politics, local customs, and personal roles and values.

Portrait statues played an important role in a network of public honors, in which important individuals would be recognized with portraits for various civic

contributions. Such portraits were displayed prominently in public contexts on inscribed bases that would include the name of the subject and selected biographical details. Portrait sculpture was also an important component of funerary monuments, where it served a commemorative function.

The term *historical relief* refers to the representation of Roman historical events carved on marble panels for public monuments. While a handful of historical relief cycles survive from the Roman Republican period, this category of sculpture flourished under the empire, when it became an important medium for the communication of the accomplishments and virtues of the emperor and his family. Overtly propagandistic in function, these sculptures could appear on an array of monuments, ranging from altars (*Ara Pacis*, 13–9 BCE) to arches (Arch of Titus, ca. 81 CE; Arch of Trajan at Benevento, 114–118 CE; Arch of Septimius Severus, 203 CE; Arch of Constantine, 312–315 CE) to historiated columns (Column of Trajan, 113 CE; Column of Marcus Aurelius, ca. 180–193 CE). These monuments were not limited to Rome and its environs, but were also set up in the provinces, where they often deployed a combination of metropolitan and local forms and iconography (such as the *Sebastian* at Aphrodisias [Asia Minor], mid 1st century CE, and the *Trophy of Trajan* at Adamklissi [Dacia], 109 CE). The emperor, the senate, or the political body of the city or town in which the work was erected generally commissioned the monuments, with the purpose of promoting imperial programs or currying favor. The subjects represented in historical relief cycles usually correspond to specific historical events: military victories, dedications of temples, distributions of money or food to the public, and so on. The message of the reliefs, however, extended beyond the simple commemoration of events to extol the virtues of the protagonists (bravery, piety, justice, etc.). The inclusion of divinities and personifications, such as Victoria, Roma, and Virtus, in reliefs that featured identifiable figures and historically accurate details assisted in the clear transmission of these symbolic messages.

Ideal sculpture is a broad category that includes representations of divinities, mythological subjects, portraits of historical figures from Greek history and literature, and copies of Greek statues. Thus, both a cult statue of a divinity and a marble copy of the *Doryphoros* (Spear Bearer; ca. 440–435 BCE) by the Classical Greek sculptor Polykleitos are considered to be ideal works. Sculptors produced ideal works for a variety of display contexts, including temples, civic buildings, theaters, and baths, as well as private homes. The meaning of the statues varied widely based on these different contexts, and a statue of a divinity installed in a Roman temple would have differed in function and

meaning from a statue of the same subject displayed in a bath or theater complex.

Within the private sphere the Roman taste for Greek ideal sculpture gave rise to a prosperous marble-working industry that produced not only versions of well-known Greek works but also new compositions and decorative objects for display in the private residences and gardens of the Roman elite. Within a domestic context these works served primarily to affirm the wealth, erudition, and good taste of the Roman home-owner. The term *Roman copy*, although convenient, is not entirely accurate, as copies or versions of Greek (and Roman) works display numerous adjustments in material and scale, as well as composition. Furthermore, the modern pejorative connotations of an artistic copy would have been irrelevant to the ancient Roman patrons and viewers.

The public commemoration of the dead was an important aspect of Roman funerary customs. Funerary ritual did not end with burial but rather continued in the form of ceremonial meals and the presentation of offerings at the tomb on the anniversary of death. Tombs and funerary sculpture thus provided a means for the ancient Romans to ensure the continuity of their memory after their death. As with other categories of sculpted monuments, patrons purchased what they could afford, and monuments ranged from lavish private tombs commissioned by the elite class and wealthy freed slaves to modest gravestones produced for the lower classes. The middle class purchased portrait statues and busts for individual and group tombs, as well as cinerary urns and funerary altars. The tombs themselves were richly adorned with reliefs representing scenes relevant to the lives of the deceased.

Funerary sculpture thus provided a vehicle for the expression of a range of activities and values for which the patron wished to be remembered. Portrait statues and busts of the deceased, both freestanding and in relief, expressed the self-image of the patron and could range from standard civic portraits to representations of individuals in the guise of divinities, such as the nude portraits of Roman matrons in the guise of Venus that became popular in the late 1st century CE. The relief sculpture produced for the exterior of tombs is similarly diverse, with subjects including not only family portraits but also representations of occupations, civic benefactions (such as the sponsorship of races or games), and other personal achievements.

In the 2nd century CE inhumation replaced the earlier custom of cremation, leading to the wide-scale production of carved marble sarcophagi. A broad range of formats were developed, of which the most common included garland sarcophagi, which were ornamented with vegetal and floral garlands; columnar sarcophagi, which used architectural elements to divide the surface into separate fields for the representations of figures; and frieze sarcophagi. Mythological sarcophagi represented a wide range of scenes, extending from heroic battles to horrific scenes of murder and revenge; many display pictorial conventions that suggest that the compositions were drawn from paintings. In many cases associations between the qualities of the represented mythological figures and the deceased (e.g., the valor of Achilles and the wifely devotion of Alcestis) were intended, and sculptors would at times provide some of the mythological figures with portrait heads of the deceased. Other mythological figures, such as Medea, defy such associations and may have been selected solely for their cultured connotations. The representation of mythological scenes on Roman sarcophagi reached its greatest popularity in the mid 2nd century, after which scenes of contemporary life—battles, hunts, civic life, and marriage—became more prevalent. Sarcophagi representing Dionysian subjects, however, gained in popularity during the 3rd century, due in large part to the association of the god Dionysus with cycles of physical and spiritual renewal.

Monarchy and the Roman Republic

Roman historians wrote the history of the earliest period of Rome's history, the period of kings, several centuries after the fact, drawing on a combination of foundation legends and historical records to reconstruct the events of the past. Very little sculpture survives from this formative period in Rome's history, and our knowledge of the artistic production of this period is reconstructed primarily from ancient literary sources, which suggest that the majority of Rome's sculpture was made in an Etruscan style by Etruscan craftsmen. During the early and middle republic, Roman aristocratic families, both individually and collectively (as the Senate and People of Rome), comprised the main patrons for sculpture. The handful of pieces to survive from early republican Rome, such as the well-known bronze *Capitoline Wolf (Lupa)* (ca. 500–480 BCE) in the Musei Capitolini, Rome, clearly demonstrate the continued importance of Etruscan techniques and styles; whereas the lupine subject suggests a Roman patron (possibly the city itself), the technique and style of the piece are purely Etruscan.

The bulk of the evidence for the production of sculpture during the republican period dates to the late republic (2nd–1st centuries BCE). By this time sculpture in Rome had fully assimilated forms and styles appropriated from Etruscan and Hellenistic sculptural traditions and had become clearly identifiable as "Roman." The diversity in subjects and styles that characterizes Roman sculpture throughout its long history was already visible during the republican period,

when sculptors produced veristic portraits characterized by a hard, unforgiving realism contemporaneously with classicizing, Greek-style depictions of gods and mythological subjects.

The late republic saw the maturation of an individualized portrait mode characterized by an exaggerated realism known as verism. The marks of advanced age that distinguish many of these portraits (and might appear unflattering to the modern viewer) communicated to the ancient viewer uncompromising, old-fashioned Roman values such as severity, authority, and gravity. The veristic mode was also an option for portraits of women, although a youthful, classicizing image deriving from Hellenistic portrait traditions was also popular.

A series of foreign wars resulting in significant territorial gains for Rome defined the republican period. The triumph of Marcellus in 211 BCE introduced plundered Greek works from Syracuse to the city of Rome, marking the beginning of the influx of Greek sculpture in Rome. The Romans' growing appreciation for Greek sculpture fueled the sculpture industry, which produced numerous copies and versions of Greek works for the expanding Roman market. Romans purchased many of these works for display in domestic settings, particularly the luxury villas of the Roman elite.

Imperial Period: Augustus to Trajan

Increasing political unrest marked the 1st century BCE, ultimately resulting in the collapse of the republic. From the turmoil emerged Augustus, a skilled military commander and politician, who was able to bring peace to Rome and consolidate power as Rome's first emperor and as the founder of a dynasty. All of the arts, and particularly sculpture, were important components of the imperial propaganda machine, as such images promoted both the image and the message of the ruling emperor. Coinage (the most ubiquitous form of Roman sculpture), portraits, and historical reliefs erected in Rome and in the provinces expressed the achievements and virtues of the emperor.

Augustus used sculpture to present the ideology of the new empire. The style used to communicate the values of his "golden age" was a cool Classicism deriving from 5th-century BCE Greece. The simplicity and restraint of the Classical style, seen in a range of public portraits and state reliefs, such as the *Ara Pacis*, contrasted markedly with the dramatic Hellenistic styles, as well as with the tough, emphatically aged image of the late Republican Roman aristocrat. Instead, an impassive, eternally youthful image of the emperor was introduced, remaining in circulation for the duration of Augustus's reign, his real age not withstanding. The well-known *Augustus of Prima Porta* (20 BCE) well exemplifies the goals of the new imperial style.

The format of the statue, with its Classical proportions and *contrapposto* (a natural pose with the weight of one leg, the shoulder, and hips counterbalancing one another) echoes Classical Greek works; the military costume and hand upraised in a gesture of address present the emperor in the role of general; the figures on the cuirass represent, in allegorical terms, a real historical event (the return in 20 BCE of Roman military standards captured by the Parthians in 53 BCE); and the bare feet and the figure of Eros riding a dolphin that serves as the statue support allude to the divine lineage of the emperor. Thus, this single portrait statue encapsulates the ideological program of the Augustan regime.

Nonetheless, both conservative members of the elite and patrons from the middle and freedman classes maintained the old, republican styles and modes of representation. Patrons from the freedman class consciously adopted the more old-fashioned, ultrarealistic style for their funerary portraits; the hard-bitten realism of these images expressed for them the qualities and values that had contributed to their success.

The emperor's heirs preferred the restrained and elegant Classicism of Augustan sculpture for their own public sculpture projects, in which the style communicated the message of dynastic continuity to the ancient viewer. Portraits of Tiberius and Gaius (Caligula) followed closely the idealized image presented by Augustus; although portraits of Claudius represented the emperor as an older man, the family connection was still clearly indicated. Similarly, historical relief sculpture, such as the panels from the so-called *Ara Pietatis Augustae*, carved during the reign of Claudius, perpetuate the style of Augustan state monuments such as the *Ara Pacis*.

While the imperial and elite classes embraced Classicism as the visual language appropriate to the public expression of the political regime, sculptures in a range of media representing Hellenistic subjects and styles were considered to be appropriate within the private sphere. For example, sculptures representing scenes from the life of the Homeric hero Odysseus recovered from Emperor Tiberius's private villa at Sperlonga are Roman versions of Hellenistic compositions carved in a dramatic Baroque style. Furthermore, elaborately carved cameos, such as the *Gemma Augustea* (ca. 15 CE) and the so-called *Grande Camée de France* (ca. 50 CE), symbolized the imperial order using the visual language of Hellenistic allegory. Both gems represent a half-draped, divine-looking ruler occupying the same world as, and interacting with, gods and personifications, as well as with members of his own family. Such luxury pieces would have served as gifts exchanged between members of the imperial family.

The excesses of Nero ultimately brought an end to the Julio-Claudian dynasty, which was followed in

70 CE, after a year of unrest, by the Flavian dynasty founded by Vespasian. Vespasian eschewed the portrait style of the recent past, favoring instead an image derived from the austere, commonsense image of the late Republic. The new emperor and his supporters were thus able visually to distance the new dynasty from the unpopular Neronian regime while promoting old-fashioned Roman values and virtues. In its various sculptured monuments, however, the Flavian period demonstrated stylistic eclecticism. This is exemplified most clearly by two contemporary Flavian state reliefs carved during the reign of Domitian: the cool, classicizing allegories of the Cancelleria reliefs (representing an imperial military departure and arrival) contrast markedly with the scenes of imperial triumph on the Arch of Titus, which are carved in a more dramatic, "baroque" style.

The downfall of the Flavian dynasty was followed by the brief reign of Nerva, in turn followed by his adoptive successor, Trajan, a powerful and respected general from Spain. Like its predecessors, Trajanic imperial sculpture was characterized by an eclectic mix of styles and a strong propagandistic message, closely tied to the military activities of the emperor. His victories over Dacia (modern Romania) in 102 and 106 CE formed the cornerstone of Trajan's ideological program and were featured prominently in Trajanic public monuments. The best known of these monuments is the column carved with an elaborate spiral frieze that represents scenes from the Dacian campaigns in a seemingly documentary fashion. The Column of Trajan (113 CE) presents the emperor as a practical general, engaged in activities such as planning strategy and addressing his troops. In contrast, the Great Trajanic frieze, a portion of which was reused in the central passageway of the Arch of Constantine, depicts the Roman victory in a dramatic Hellenistic style, presenting the emperor as a heroic warrior charging into battle on horseback (a representation that was purely fictitious but highly symbolic). These two monuments, both of which were installed originally in the Forum of Trajan in Rome, communicated the same message of imperial victory, but using different visual languages. The language of historical relief sculpture, however, was not devoted solely to the presentation of military subjects. An honorific arch erected in the Italian town of Benevento recognized Trajan's ambitious social program. The arch included a scene representing the emperor distributing the *alimenta*, funds allocated for the provision of food for children.

Imperial Period: Hadrian to Constantine

The death of Trajan in 117 CE marked a break in both the politics and the culture of the Roman Empire. Tra-

jan's chosen successor, Hadrian, shifted Rome's military policy away from the expansion of the empire to the consolidation of its existing borders. In terms of art and culture, Hadrian looked eastward toward Greece. A combination of imperial patronage and an influx of Greek aristocrats into the Roman Senate promoted a revival of Classicism that is evident in imperial and private portraits, in the Greek-style works commissioned by the emperor for his luxury villa at Tivoli, in state monuments, and in private commissions, including the developing repertoire of sarcophagi. Hadrian was the first Roman emperor to wear a beard, an affectation frequently attributed to his personal identification with and appreciation of Greek culture; the emperor's wife, Sabina, is often represented in a classicizing manner, with a simple, center-parted hairstyle, while his young male lover, Antinous, is depicted with the idealized beauty of an ephebic youth.

No significant changes in repertoire or subject matter characterize the marble sculpture produced in the 2nd century during the reigns of Hadrian and his Antonine and Severan successors. Rather, the major developments of the period occurred in the area of sculptural techniques. Beginning in the Hadrianic period sculptors rendered the eyes of portrait statues in greater detail, drilling the pupils and incising the irises, giving the faces a more lifelike quality. An interest in sophisticated surface textures is also evident, with highly polished flesh surfaces contrasting with the rougher textures of hair. Sculptors used the running drill extensively for contours and deeply undercut forms that created a dramatic chiaroscuro effect in both three-dimensional and relief sculpture. These techniques were particularly well suited to represent the long, curled beards and elegantly coiffed hairstyles fashionable for Antonine and Severan portraits, as well as for the increasingly elaborate mythological and battle scenes carved on marble sarcophagi.

These new techniques, particularly the use of the drill to create simplified, linear forms, contributed to a change in the style of Roman sculpture. The sculpture of the later Roman Empire contains stylistic elements that can be characterized as anti-Classical, especially when viewed alongside the consciously classicizing works of the Hadrianic period. The stacked military figures depicted on the base of the Column of Antoninus Pius (161 CE), the simplified narrative scenes on the Column of Marcus Aurelius (*ca.* 180–193 CE), and the starkly linear drilled forms on the Quadrifons of Septimius Severus at Leptis Magna (203 CE) are all formal features that can be characterized as Late Roman.

Such anti-Classical stylistic tendencies, combined with a reduction in the amount of sculpture produced (especially of large-scale pieces for public contexts)

are generally considered to be indicators of an overall decline in Roman sculptural production that parallels the military and economic decline of the empire. While the 3rd century CE did experience increased military threats, economic collapse, and the absence of sustained imperial leadership, certain categories of sculpture continued to be produced. The survival of large, elaborately carved, high-quality sarcophagi, as well as small-scale luxury objects made for votives or domestic decor, demonstrates that the notion of universal artistic decline is not entirely accurate.

Furthermore, imperial portraits were still necessary to validate the rule of the current emperor. The 3rd century CE imperial image displays a marked shift away from the cultured elegance of the Antonine emperors in favor of an overtly militaristic image. The short cropped hair, stubble beard, and lined face favored by 3rd-century emperors were intended to communicate a tough, authoritative image reminiscent of Republican portraiture.

From the instability of the later 3rd century emerged the emperor Constantine, who defeated his political and military rivals to gain full control over the empire in 324 CE. Two events that took place under Constantine had a significant impact on both Roman history and culture: in 313 CE the Edict of Milan legalized the practice of Christianity, and in 330 CE the city of Constantinople was dedicated as the new capital of the empire. The Edict of Milan made possible the patronage of a monumental Christian art, in which the emperor himself participated. Constantine's acceptance of Christianity, however, did not signal the immediate demise of pagan cult practices and pagan imagery in sculpture. Indeed, pagan statuary continued to be displayed in public and private contexts across the empire, including the new capital city of Constantinople. Over the course of the 4th and 5th centuries, however, subjects from pagan religion and Classical mythology largely ceased to be represented on a monumental scale, appearing instead in small-scale sculpture, such as statuettes and silverware, made primarily for domestic use. Furthermore, traditional Roman subjects and categories of monuments, such as portraits, historical relief, and funerary sculpture, continued to be produced. Perhaps the best-known Constantinian monument, the Arch of Constantine in Rome (312–315 CE) commemorated the emperor's military victory over his rival Maxentius with images of battle and postwar benefactions (some of which were newly carved, but many of which were reused panels from earlier imperial monuments), while images of the emperor borrowed aspects of Augustan and Trajanic portraiture, thus visually connecting the emperor with his distinguished historical predecessors. Despite outward appearances the Constantinian period did not mark a true break with

Roman historical and cultural traditions. Rather, the facility with which sculptors adapted their repertoire so as to integrate the requirements of the new Christian patrons with the older artistic traditions exemplifies the versatility of form, iconography, and style displayed by Roman sculpture throughout the course of its long history.

JULIE A. VAN VOORHIS

See also **Ara Pacis (Augustae); Column of Marcus Aurelius; Etruscan Sculpture; Polykleitos; Porphyry; Portrait; Precious Metals; Relief Sculpture; Sarcophagus; Tomb Sculpture**

Further Reading

D'Ambra, Eve, *Roman Art*, Cambridge: Cambridge University Press, 1998
Elsner, Jas, *Imperial Rome and Christian Triumph: The Art of the Roman Empire, AD 100–450*, Oxford: Oxford University Press, 1998
Fittschen, Klaus, and Paul Zanker, *Katalog der römischen Porträts in den Capitolinischen Museen und den anderen kommunalen Sammlungen der Stadt Rom*, Mainz, Germany: Von Zabern, 1983
Hannestad, Niels, *Roman Art and Imperial Policy*, Aarhus, Denmark: Aarhus University Press, 1988
Kleiner, Diana E.E., *Roman Sculpture*, New Haven, Connecticut: Yale University Press, 1992
Koch, Guntram, and Helmut Sichtermann, *Römische Sarkophage*, Munich: Beck, 1982
Pollitt, J.J., *The Art of Rome, c. 753 B.C.–A.D. 337: Sources and Documents*, Cambridge: Cambridge University Press, 1983
Strong, Donald, and David Brown, *Roman Crafts*, London: Duckworth, 1976
Torelli, Mario, *Typology and Structure in Roman Historical Reliefs*, Ann Arbor: University of Michigan Press, 1982
Vermeule, Cornelius C., *Roman Imperial Art in Greece and Asia Minor*, Cambridge: Belknap Press, 1968
Zanker, Paul, *Klassizistische Statuen: Studien zur Veränderung des Kunstgeschmacks in der römischen Kaiserzeit*, Mainz, Germany: Von Zabern, 1974
Zanker, Paul, *The Power of Images in the Age of Augustus*, Ann Arbor: University of Michigan Press, 1988

ROOD SCREEN

See **Screen**

ROSSELLINO FAMILY *Italian*

Bernardo Rossellino 1409–1464

Working independently and collaboratively, the brothers Bernardo and Antonio Rossellino created graceful, refined sculptures that bridged Florentine artistic developments from Lorenzo Ghiberti to Andrea del

Like the Chellini bust, the effigy of Cardinal James was partly carved from casts, including the face, from a death mask, and the hands. The cardinal's youth (he was not yet 26), acclaimed virtue (recorded in an inscription), and handsome features stand out against the rigid forms of his vestments. The angels create two upward arcs of motion from the sarcophagus to the Virgin and Child, who gaze with tenderness upon the image of the deceased. Their knowledge of death as a passage to eternal life is underscored by their traditional position above the tomb. The brilliant organization of the tomb and its integration into the chapel's decoration, the fine finish of the individual sculptures, and powerful religious drama enacted by the sculptures make the monument of the Cardinal of Portugal the most important funerary monument in Florence after the Bruni tomb.

Antonio completed the bust of Matteo Palmieri, now in the Bargello, in 1468. Greatly weathered as a result of its placement (until the 19th century) above the portal to Palmieri's house, the bust delineates the large, fleshy features of the Florentine poet and statesman. Similar in format to the Chellini bust and also unsparingly true to life, Antonio's sculpture recalls ancient Roman portraits.

There are a number of reliefs of the Virgin and Child attributed to Antonio on the basis of the Virgin and Child for the monument of the Cardinal of Portugal. One of the best of these is the relief in the Metropolitan Museum of Art in New York City. Of lower relief and less vivacious in treatment than the tomb sculpture, the New York *Madonna and Child* (ca. 1460–65) shows skillful surface details but little of the bravura form of Antonio's signed works.

Antonio worked on several tombs and other sculptures in the decades following the tomb of the Cardinal of Portugal. For the Cathedral of Prato he designed in 1473 a pulpit, freestanding on a single pedestal and supporting a circular box with five reliefs, three of which (*Assumption of the Virgin*, *Stoning of St. Stephen*, and *Funeral of St. Stephen*) are by Antonio and two are by Mino da Fiesole. From the handsome winged harpies at the foot of the pulpit to the delicate pilasters framing the illusionistic reliefs, the pulpit is an exceptionally coherent and harmonious sculptural ensemble.

One of Antonio's later projects was the marble altarpiece depicting the *Adoration of the Christ Child* for the Piccolomini Chapel in the Olivetan Church of Sant'Anna dei Lombardi (previously called S. Maria di Monteoliveto) in Naples. The chapel, built by order of Antonio Piccolomini, Duke of Amalfi, in memory of his deceased wife, Mary of Aragon (d. 1469), was modeled on the chapel of the Cardinal of Portugal with a tomb and an altarpiece. The altarpiece consists of a relief of the *Adoration of the Christ Child*, flanked by statues of two standing saints. A Classical architectural frame composed of plinth, pilasters, and entablature creates a triptych format topped by four putti with swags. The central relief of Mary, the Christ Child, Joseph, shepherds, and angels presents the illusion of deep space, which is accentuated by the perspective recession of the stable sheltering the Holy Family, the ox, and ass. With this relief Antonio demonstrated the consistent skill, imagination, and charm he could bring to his best sculpture.

JOHN HUNTER

See also **Fiesole, Mino da; Misericord; Pollaiuolo; Antonio Tomb Sculpture; Verrocchio, Andrea del**

Bernardo Rossellino

Biography

Born in Settignano, Italy, *ca.* 1409. Son of artist Matteo di Domenico Gambarelli and elder brother of Antonio Rossellino. Received early training with father and uncles, in Settignano, and with Filippo Brunelleschi; earliest documented work in architecture and sculpture, in Arezzo and Florence, 1433; gained preeminence with tomb monument of Leonardo Bruni; designed succession of tomb monuments and tabernacles, while devoting increased attention to architectural projects in the Palazzo Rucellai, Florence; also worked in Rome on the apse of St. Peter's Basilica and in Pienza, Tuscany, for Pope Pius II. Died in Florence, Italy, 1464.

Selected Works

1433	*Madonna della Misericordia* with *St. Lorentino* and *St. Pergantino*; marble; Misericordia, Arezzo, Italy
1434–36	*St. Donatus* and *St. Gregory*; marble; Misericordia, Arezzo, Italy
1435–36	Tabernacle; marble; Abbey of Sante Fiora e Lucila, Arezzo, Italy
1436–38	Tabernacle; marble; Badia Fiorentina, Florence, Italy
1446–48	Tomb monument of Leonardo Bruni; marble; Church of Santa Croce, Florence, Italy
1447– ca. 1458	*Virgin* and *Angel of the Annunciation*; marble; Church of San Stefano, Empoli, Italy
1449–50	Tabernacle; marble; Church of Sant'Egidio, Florence, Italy
1451	Tomb of the Beata Villana; marble; Church of Santa Maria Novella, Florence, Italy
1456–57	Tomb of Orlando de' Medici; marble;

Church of Santissima Annunziata, Florence, Italy

1458 Tomb of the Beato Marcolino da Forlì (with Antonio Rossellino); marble; Pinacoteca Communale, Forlì, Italy

1458 Tomb of Neri Capponi; marble; Church of S. Spirito, Florence, Italy

1462–64 Tomb of Giovanni Chellini; marble; Church of San Domenico, San Miniato al Tedesco, Italy

Antonio Rossellino

Biography

Born in Settignano, Italy, 1427. Trained by his brother Bernardo Rossellino and other brothers Domenico (*b.* 1407), Giovanni (*b.* 1422), and Tommaso (*b.* 1422), all sculptors; completed first independent work, portrait bust of Giovanni Chellini, 1456; focused on tombs for most of career, most famous being the monument for Cardinal James (Prince James) of Portugal, 1461–66; in addition to personal commissions, completed work assigned to Bernardo; became more independent in the early 1460s and rented his own workshop in 1469. Died in Florence, Italy, 1479.

Selected Works

1456 *Giovanni Chellini*; marble; Victoria and Albert Museum, London, England

1458 Tomb of the Beato Marcolino da Forlì (with Bernardo Rossellino); marble; Pinacoteca Communale, Forlì, Italy

1458 Tomb of Neri Capponi; marble; Church of S. Spirito, Florence, Italy

1460 *St. Sebastian*; marble; Collegiata, Empoli, Italy

1461–66 Monument of the Cardinal of Portugal; marble; Church of S. Miniato al Monte, Florence, Italy

1462 Tomb of Filippo Lazzari; marble; Pistoia Cathedral, Italy

1468 *Matteo Palmieri*; marble; Museo Nazionale del Bargello, Florence, Italy

1469–73 *Assumption of the Virgin, Stoning of St. Stephen*, and *Funeral of St. Stephen*; marble; Cathedral of Prato, Italy

1471–74 *Adoration of the Christ Child*; marble; Piccolomini Chapel, Church of Sant'Anna dei Lombardi, Naples, Italy

1474–79 Monument of Mary of Aragon; marble; Piccolomini Chapel, Church of Sant'Anna dei Lombardi, Naples, Italy

1476 Monument of Lorenzo Roverella; marble; Church of San Giorgio, Ferrara, Italy

Further Reading

Carl, Doris, "New Documents for Antonio Rossellino's Altar in the S. Anna dei Lombardi, Naples," *The Burlington Magazine* 138 (May 1996)

Dunkelman, Martha Levine, "A New Look at Donatello's Saint Peter's Tabernacle," *Gazette des Beaux-Arts* 118 (July/August 1991)

Hartt, Frederick, Gino Corti, and Clarence Kennedy, *The Chapel of the Cardinal of Portugal, 1434–1459, at San Miniato in Florence*, Philadelphia: University of Pennsylvania Press, 1964

Lightbown, Ronald, "Giovanni Chellini, Donatello, and Antonio Rossellino," *The Burlington Magazine* 104 (1962)

Mack, Charles R., "Studies in the Architectural Career of Bernardo di Matteo Ghamberelli, called Rossellino," Ph.D. diss., University of North Carolina, 1972

Pope-Hennessy, John, *An Introduction to Italian Sculpture*, 3 vols., London: Phaidon, 1963; 4th edition, 1996; see especially vol. 2, *Italian Renaissance Sculpture*

Pope-Hennessy, John, and Ronald Lightbown, *Catalogue of Italian Sculpture in the Victoria and Albert Museum*, 3 vols., London: HMSO, 1964; see especially vol. 1

Schulz, Anne Markham, *The Sculpture of Bernardo Rossellino and His Workshop*, Princeton, New Jersey: Princeton University Press, 1977

PROPERZIA DE' ROSSI *ca.* 1490–1530
Italian

Properzia de' Rossi has the distinction of being the only woman artist included in the first edition of Giorgio Vasari's 16th-century *Lives of the Painters, Sculptors, and Architects*, and she remained the only woman given a separate vita in his 1568 edition. What likely accounted for this singularity was not just that de' Rossi was a woman artist at a time when women could rarely receive training in the field but more amazingly that she was a woman sculptor, which was virtually unheard of during the Renaissance. Although Vasari never met de' Rossi—he was in Bologna at the time of her death—much of the information he gathered from others was still fresh and relatively accurate, as Jacobs has shown (see Jacobs, 1993). Unfortunately, Vasari's account is far from complete, and today there still remains much that is unknown about this exceptional artist. We do not know, for example, what inspired her to take up the "masculine" manual labor of carving; there is neither evidence that her father was an artist nor any other proof of her having trained under another artist. De' Rossi's earliest extant works are miniatures using the humble medium of the peach pit. These carvings were far from considered lowly, however, and in fact were highly praised for the miraculous skill required to represent scenes from the Passion of Christ on a single stone.

De' Rossi's first public commission came in 1524 when she carved relief decorations for the canopy of the high altar in the Church of S. Maria del Baraccano

(Bologna, Italy). However, a more ambitious opportunity presented itself in 1525 when sculptors were needed to furnish reliefs for the side portals of the Church of San Petronio, Bologna. According to Vasari, de' Rossi's husband (who is still unidentified, although documents confirm that she was married as of 1515) went before the church's committee to ask that his wife be considered for the task, whereupon they requested that she first provide an example of her work in marble. She is then said to have carved the bust of Conte Guido de' Pepoli, the father of one of the church officials, which won her the commission (this work is usually identified as the bust now in the Museo di San Petronio, Bologna, although Pietrantonio believes it is a portrait relief in the Pepoli family's Villa della Palata [see Pietrantonio, 1981]).

The marble relief that de' Rossi certainly executed for San Petronio, and for which she is best known today, was *Joseph and Potiphar's Wife*. This work has unfortunately received more attention for its supposed parallel to the sculptor's frustrated love life, as first related by Vasari, than for its masterful execution. The depiction is, in fact, one of the most powerfully dramatic representations of this scene of unrequited lust in any medium. The wife of Potiphar (the supposed representative of de' Rossi herself) aggressively

lunges for Joseph and catches onto his flowing cloak, revealing a strong, Michelangelesque arm. Her breasts are exposed from an opened bodice while her legs are splayed apart in an active yet somewhat awkward pose, which demonstrates de' Rossi's study of anatomy. Particularly notable are the intense expressions of fear and desire on the faces of the two protagonists, which has led many historians to accept its purported autobiographical inspiration. The strong profiles, compositional clarity, and fluid sense of line also suggest the artist's study of the antique, as well as the art of Raphael; Vasari relates that he owned some drawings by de' Rossi that were modeled after works by the great Renaissance master.

Documents indicate that de' Rossi executed two reliefs for San Petronio, with some historians attributing the related scene of *Potiphar's Wife Accusing Joseph* (*ca.* 1525–26; Museo di San Petronio, Bologna) to the artist. In addition, she designed other models executed by other artists, as well as angels (still unidentified) and reliefs of sibyls that decorate the pilasters of the side portals. However, her work at San Petronio seems to have abruptly halted in 1526, which Vasari says was the result of professional jealousy on the part of a certain "Maestro Amico," likely Amico Aspertini, who worked among the team of artists there. Court documents reveal that de' Rossi had a violent streak, which indeed might have aggravated her fellow sculptors; she was charged with disorderly conduct in 1520 and assault in 1525.

Although her reliefs for San Petronio were widely praised, de' Rossi seems not to have continued her career as a sculptor, instead, according to Vasari, turning to the art of engraving, although no prints have yet been authentically linked to her hand. De' Rossi evidently did not enjoy much success in that medium, for in 1529 she is documented as residing in the Ospedale di San Giobbe, which treated indigents. She died there in 1530, likely of the plague—a sad ending for a woman whom her biographer praised as a "great miracle of nature."

JULIA K. DABBS

Joseph and Potiphar's Wife
© Alinari / Art Resource, New York

Biography

Born in Bologna, Italy, *ca.* 1490. Worked in Bologna, sculpting reliefs for Church of San Petronio, 1525–26, and a marble portrait for Conte Guido de' Pepoli; did engravings and drawings modeled after Raphael; discussed by Vasari as one of few women sculptors in the 16th century; listed as a patient in the Ospedale de San Giobbe, Bologna, April 1529. Died in Bologna, Italy, February 1530.

Selected Works

ca. 1520 Crest of the Grassi Family; filigreed silver, peach stones; Museo Civico Medievale, Bologna, Italy

1524 Canopy relief for high altar; stone; Church of S. Maria del Baraccano, Bologna, Italy

ca. 1525 Bust of Conte Guido de' Pepoli; marble; Museo di San Petronio, Bologna, Italy

ca. 1525–26 *Joseph and Potiphar's Wife*; marble; Museo di San Petronio, Bologna, Italy

Further Reading

Bluestone, Natalie H., "The Female Gaze: Women's Interpretations of the Life and Work of Properzia de' Rossi, Renaissance Sculptor," in *Double Vision: Perspectives on Gender and the Visual Arts*, by Bluestone, Madison, New Jersey: Fairleigh Dickinson University Press, and London and Cranbury, New Jersey: Associated University Presses, 1995

Jacobs, Fredrika H., "The Construction of a Life: Madonna Properzia de' Rossi 'Schultrice' Bolognese," *Word and Image* 9 (April–June 1993)

Pietrantonio, Vera Fortunati, "Per una storia della presenza femminile nella vita artistica del Cinquecento bolognese: Properzia De Rossi, 'schultrice,' " in *Il Carrobbio* 7 (1981)

Vasari, Giorgio, *Le vite de' più eccellenti architetti, pittori, e scultori italiani*, 3 vols., Florence: Torrentino, 1550; 2nd edition, Florence: Apresso i Giunti, 1568; as *Lives of the Painters, Sculptors, and Architects*, 2 vols., translated by Gaston du C. de Vere (1912), edited by David Ekserdjian, New York: Knopf, and London: Campbell, 1996

VINCENZO DE' ROSSI *ca.* 1525–1587

Italian

Vincenzo de' Rossi was a strong individualistic figure in 16th-century Florentine sculpture. Throughout his life, his style was constantly inspired by a strong pictorial sensibility that decisively influenced his artistic solutions. Restless surfaces, an impressionistic rendering of shapes, and the pursuit of theatrical attitudes are the distinctive features of his work, and they are all elements of mimesis and *rhetorica ars*. With these solutions, de' Rossi achieved results so extraordinary that they can be read as precursors of the Baroque, but they failed almost entirely to gain the appreciation of his contemporaries.

After an apprenticeship with Baccio Bandinelli, de' Rossi soon rejected his master's academic composure but cultivated his Hellenistic use of chromatic effects, developing it within a language of his own that (in tune with the new trend of painting then gaining ground in post-Michelangelo Florence) combined suggestions from northern prints, painterly devices from the Venetian school, and sizable infusions of a Classicism derived from Andrea Sansovino but brought up to date by recent archaeological discoveries.

De' Rossi was working at a very early age. At the beginning of the 1540s, when he was still apprenticed to Bandinelli, he followed his master to Rome and helped execute the tombs of Pope Leo X and Pope Clement VII in the Church of Santa Maria sopra Minerva. De' Rossi stayed in Rome and achieved his first independent successes in that city, gradually gaining the attention of the local artistic circles. A high relief depicting the *Liberation of St. Peter* (*ca.* 1650), in the Church of S. Salvatore in Lauro, can be considered his first major work. Despite inevitable youthful incongruities in the composition, de' Rossi's decided bent for episodic characterization is already apparent in his unwavering descriptive attention to skin and drapery.

After a short stay in Florence to undertake work on the main entrance to Palazzo Vecchio, de' Rossi returned to Rome. In 1545–47 he sculpted a large marble group of *St. Joseph and the Young Christ* in the Pantheon, where touches of sharp realism coexist with passages of extraordinary proto-Baroque rhetorical emphasis. In the 1550s de' Rossi executed a series of works for the Cesi chapel in Santa Maria della Pace: the tombs of Angelo Cesi and his wife, Francesca Carduli Cesi, and the chapel's facade decorations, marble statues of *St. Peter* and *St. Paul*, and high reliefs in marble depicting prophets and angels. These works show the artist's language reaching its maturity, playing over more distinctive registers and pursuing vibrant painterly effects and broken lines that (especially in the half-recumbent figures of the deceased) reinterpret Sansovino's standardized schemes in a tortuous, expressionistic key. In the same decade de' Rossi was commissioned by the city authorities to produce a monumental statue of Pope Paul IV; it was sited on the Capitoline but later destroyed by a mob in an uprising that followed the pope's death in 1559.

His Roman period ended with a marble group of *Theseus Abducting Helen*, which he presented to Grand Duke Cosimo I de' Medici, ruler of Tuscany. Following the teachings of Michelangelo and Giorgio Vasari, he carved this sculpture from a single block of marble as a display of his technical skill. His sensual and naturalistic treatment of flesh and vibrant skin reached a nearly virtuoso level in this piece and was immediately applauded by his contemporaries.

In 1560 de' Rossi returned definitively to Florence and entered the grand duke's service. Besides completing several works that Bandinelli had left unfinished in the Audience Hall of Palazzo Vecchio, he set to work on a group of sculptures depicting the *Twelve Labors of Hercules*, probably intended for a monumental fountain. He worked on them until his death, but completed only seven: *Hercules and Cacus, Hercules and the Centaur, Hercules and Antaeus, Hercules Bearing Atlas's Globe, Hercules and the Amazon*

Dying Adonis
© Arte & Immagini srl / CORBIS

Queen, Hercules and the Erymanthian Boar, and *Hercules and Diomedes*. In accordance with the Bandinelli tradition, these pieces were designed to be seen only from the front. In the dramatic and agitated modeling, a frenzied Michelangelism produces results that are grotesque and brutal, yet not devoid of strong realism.

During this period de' Rossi provided the model for the bronze, over–life-size *Rape of Proserpina*, which was cast by Raffaello Peri. In the mid 1560s he also sculpted *Dying Adonis* for Isabella Medici Orsini's country house (later renamed Poggio Imperiale). In its painterly effects and structural tensions (clearly expressed through the broken outlines), this piece is a fully mature version of what de' Rossi had wrought in the Cesi tombs.

In 1572 de' Rossi executed a bronze *Vulcan at the Forge* for Francesco I's study (the *Studiolo*) in the Palazzo Vecchio. Bronze was a medium particularly well suited to capture the vibrancy de' Rossi held so dear and to exalt the northern spirit that pervades and animates this statuette.

Toward the end of his life, de' Rossi participated in the execution of a series of apostles for Florence Cathedral. In his statues of *St. Matthew* and *St. Thomas*, the pre-Baroque theatricality—which was already present in the *St. Joseph* he made for the Pantheon—produced a highly suggestive effect of monumentality that was enhanced, rather than weakened, by the contrived modeling and composition.

CARLO CINELLI

See also **Bandinelli, Baccio; Sansovino, Andrea**

Biography

Born in Fiesole, Italy, *ca.* 1525. Studied with Baccio Bandinelli; followed mentor to Rome, and remained there until 1560; received first independent commission, 1545; took short trips to Florence, but after Bandinelli's death, moved to Florence permanently, and was under Medici patronage, 1560; became member of Florentine Accademia del Disegno, Florence; coordinated events related to Medici family, including wedding of Francesco I and Joanna of Austria, 1565; completed unfinished works of Bandinelli; Ilarione Ruspoli and Raffaello Peri among his pupils. Died in Florence, Italy, 1587.

Selected Works

1545–47 *St. Joseph and the Young Christ*; marble; Pantheon, Rome, Italy
ca. Tombs of Angelo Cesi and Francesca
1550–55 Carduli Cesi; marble; Church of Santa Maria della Pace, Rome, Italy
1558–60 *Theseus Abducting Helen*; marble; Buontalenti Grotto, Boboli Gardens, Florence, Italy
1561–87 *Twelve Labors of Hercules* groups (seven completed); marble; Salone dei Cinquecento, Palazzo Vecchio, Florence, Italy; Villa Poggio Imperiale, Florence, Italy
1565 *Rape of Proserpina*; bronze; Victoria and Albert Museum, London, England (on loan from The National Trust)
ca. *Dying Adonis*; marble; Museo Nazionale
1565–70 del Bargello, Florence, Italy
ca. 1570 *Laocoön*; marble; private collection, France
1572 *Vulcan at the Forge*; bronze; study of Francesco I, Palazzo Vecchio, Florence, Italy
1580 *St. Matthew*; marble; Florence Cathedral, Italy
1581 *St. Thomas*; marble; Florence Cathedral, Italy

Further Reading

Boström, Antonia, "A Bronze Group of the Rape of Proserpina at Cliveden House in Buckinghamshire," *The Burlington Magazine* 132 (December 1990)
Boström, Antonia, "The Florentine Sculptor Raffaello Peri," *The Burlington Magazine* 140 (April 1998)
Heikamp, Detlef, "Vincenzo de' Rossi Disegnatore," *Paragone* 169 (1964)
Heikamp, Detlef, "Die Laokoongruppe des Vincenzo de' Rossi," *Mitteilungen des Kunsthistorischen Institutes in Florenz* 34 (1990)
Schallert, Regine, *Studien zu Vinzenzo de' Rossi: Die frühen und mittleren Werke (1536–1561)*, Hildesheim, Germany, and New York: Olms, 1998
Utz, Hildegard, "The Labors of Hercules and Other Works by Vincenzo de' Rossi," *The Art Bulletin* 53/3 (1971)

Vasari, Giorgio, *Le vite de' più eccellenti architetti, pittori, e scultori italiani*, 3 vols., Florence: Torrentino, 1550; 2nd edition, Florence: Apresso i Giunti, 1568; as *Lives of the Painters, Sculptors, and Architects*, 2 vols., translated by Gaston du C. de Vere (1912), edited by David Ekserdjian, New York: Knopf, and London: Campbell, 1996

Vossilla, Francesco, "Vulcano," in *Magnificenza alla corte dei Medici: Arte a Firenze alla del Cinquecento*, Milan: Electa, 1997

THESEUS ABDUCTING HELEN

Vincenzo de' Rossi (ca. 1525–1587)
1558–1560
marble
h. ca. 180 cm
Buontalenti Grotto, Boboli Gardens, Florence, Italy

In 1558 Vincenzo de' Rossi wrote a letter to his former teacher Baccio Bandinelli explaining his intention to move from Rome to Florence. As was customary at the time, de' Rossi offered a gift of his artwork to duke Cosimo I de' Medici as a way of entering into the duke's service. As Giorgio Vasari relates, de' Rossi presented him with the large group of *Theseus Abducting Helen* when the duke visited Rome in 1560. Cosimo I had the sculpture taken to the Pitti Palace in Florence, and the sculptor was well paid.

About the same time, in 1560, the competition for the commission of the Neptune Fountain in Florence (Piazza della Signoria, Florence, Italy) opened. Although de' Rossi did not design *Theseus Abducting Helen* specifically for the competition, it was the work with which he sought to gain the commission. In a letter of the same year, he reminded the duke of his sculpture, which, he said, proved his great ability in working large marble statues such as the *Neptune*. Although he did not win the commission, de' Rossi was employed to execute a monumental cycle of the *Twelve Labors of Hercules*.

Theseus Abducting Helen is one of the first post-Classical groups that depicts the erotic subject of rape in a large format. Earlier 16th-century examples of this theme are all objects of applied art, such as *faiences* (a general term comprising various kinds of glazed earthenware and porcelain) or prints. There is, perhaps, only one other large sculpture that could be cited: *Atalante and Meleager* by Francesco Mosca of Rome (Nelson-Atkins Museum of Art, Kansas City, Missouri). But it remains difficult to assess which work was produced first.

In his composition, de' Rossi follows two ancient *topoi*, which his contemporaries recognized. First, he created the group from a single block of marble, a practice that gained fame with the discovery of the *Laocoön* (1st century CE) in 1506. Second, he achieved a great likeness with nature, which Bocchi described as "che il marmo sia carne diventata" (marble that had become flesh). Bocchi refers to an ancient *topos*, which stems from the contest between Zeuxis and Parrhasios. Creating the type of composition of the *symplegmata*, or a group of entwined figures, de' Rossi without a doubt alluded to Kephisodotos's famous statue of a *symplegmata* in ancient Pergamon (probably a statue of Hermaphrodite and Satyr), which he could have known from the exact description by Pliny. In his erotic *symplegmata*, de' Rossi repeated the strong grip emphasized by Pliny on Kephisodotos's statue, "notable for the way the fingers seem to press on flesh rather than marble" (*Natural History* 36, p. 24).

It is likely that de' Rossi intended the work to be ambiguous, something typical of late-16th-century art. His own choice was to call the sculpture *Theseus Abducting Helen*, thus affording great importance to the personality of Theseus. The image of the ancient virtuous hero served for the sculpture's self-representation. In the 16th century, sculptors and painters identified themselves in their works with virtuous heroes of ancient mythology, such as Hercules or Theseus, thus illustrating the artists' own *fatica* (labor) and *virtù*, as is shown, for example, by Peter Vischer the Elder's tomb of St. Sebaldus (1507–19) in the Church of St. Sebald, Nuremberg, Germany, where the artists places the figures of the virtuous heroes Hercules, Theseus, Samson, and Nembrod just over his signature in order to underline his own virtuous effort in carrying out this work.

The reference to Theseus's virtuous deeds, which de' Rossi gave with the hero's attributes, is of particular importance because the statue was intended as a gift to secure his employment by Cosimo I de' Medici. The sculptor's identification with the ancient hero is emphasized in the signature "Vincentius de Rubeis civis floren. Opus" (Work by Vincenzo de' Rossi, Florentine citizen), which is carved prominently on the ribbon that diagonally crosses Theseus's chest. The words "civis floren." reinforced the sculptor's hope to return to Florence, which, of course, depended on the success of his gift.

De' Rossi chose the theme of Theseus abducting Helen, represented in form of a monumental two-figured marble sculpture, in order to prove his abilities and *virtù* as a sculptor. The group depicts the abductor lustfully attempting to embrace Helen (in the sculptor's own words, "Teseo che rapì Elena" [Theseus abducting Helen]). Theseus is represented as an ancient mythological hero with his large sword and tied Sow of Crommyon. These two attributes were linked to the cycle of deeds that establish Theseus as a virtuous hero. But de' Rossi's biographers Vasari and Raffaele Borghini were

Although Rosso continued to exhibit and sell works to major collectors and museums in Europe, he made only one new sculpture after the turn of the century, the haunting *Ecce puer* (Behold the Child).

Despite an apparent end to his creativity in his final 20 years, Rosso continued to produce art. Unlike most 19th-century sculptors, who delegated casting to outside foundries, Rosso participated in all aspects of the process, even building a minifoundry in his atelier. During his last years in Italy and France, he rethought, recast, and revised his oeuvre in plaster, wax, and bronze, overturning traditional rules of casting to achieve startling effects. He also expressed his theories on sculpture in writing, from personal letters to published manifestos on art, in an odd mixture of languages, grammar, and orthography. Like many sculptors of his time, he photographed his works, but he was unique in allowing wildly unpredictable accidents of light, focus, and positioning of his objects within the photographic frame; intervening on negative plates; cropping finished prints; and sometimes using the resulting photos as part of sculpture exhibition installations. In many ways these photographs encapsulated Rosso's work, highlighting the play between two and three dimensions, painting and sculpture, light and shadow, material object and the intangible environment that surrounds it. Such a breadth and scope of interests—ways to further dematerialize sculpture—confirm that Rosso was much more than simply the "Impressionist sculptor."

SHARON HECKER

See also **Daumier, Honoré; Degas, Edgar; Rodin, Auguste**

Biography

Born in Turin, Italy, 21 June 1858. Moved with family to Milan; while serving in Italian army, based in Pavia, 1881, began exhibiting sculpture, without official artistic training; briefly enrolled at Accademia di Belle Arti di Brera of Milan, 1882–83, which ended in expulsion; exhibited in Milan, 1882, at Esposizione di Belle Arti, Rome, 1883, and at Esposizione Nazionale, Venice, 1887; exhibited at Salon de Peinture, Sculpture, et Gravure du Groupe des Artistes Indépendents, Paris, 1885, at the Salon des Indépendants, Paris, 1886, and in London, 1888; moved to Paris, 1889; exhibited at Exposition Universelle and at La Bodinière; established friendship with Auguste Rodin, 1894, and exchanged sculptures; exhibited with Pre-Raphaelites at Goupil Galleries, London, 1896, at the Exposition Universelle Paris, 1900, and in Impressionist exhibitions organized in the Netherlands by his patroness Etha Fles, 1901; naturalized as French citizen, 1902; exhibited at the Secession in Vienna, 1903, at the Salon d'Automne, Paris, 1904 and 1906, and at the International Society of London, 1906; solo exhibition at Eugène Cremetti Gallery, London; had exhibition at first French Impressionism show in Florence, 1910, and later at the Esposizione Internazionale di Belle Arti, Rome, 1911; exhibition at the Esposizione Internazionale d'Arte, Venice, 1914, and the *Prima mostra del novecento italiano* exhibition, Milan, 1926. Died in Milan, Italy, 31 March 1928.

Selected Works

Many of Rosso's original plaster molds are preserved in the Museo Medardo Rosso in Barzio, Italy, along with wax and bronze casts. His casts are also in major museums and private collections throughout the world.

1883	*Carne altrui* (Flesh of Others); wax; Galerie de France, Paris, France	
1883	*Portinaia* (The Concierge); wax; two versions: Galleria Nazionale d'Arte Moderna, Rome, Italy; Museum of Modern Art, New York City, United States	
ca. 1886	*Aetas aurea* (The Golden Age); wax; two versions: Petit Palais, Paris, France; California Palace of the Legion of Honor, San Francisco, California, United States	
1889	*Après la visite* (After the Visit); bronze; Gilgore Collection, Naples, Florida, United States	
ca. 1890	*Petite rieuse* (Laughing Woman [small version]); bronze; Musée Rodin, Paris, France	
ca. 1891	*Grande rieuse* (Laughing Woman [large version]); bronze; Galleria d'Arte Moderna, Florence, Italy; Galleria d'Arte Moderna, Milan, Italy	
ca. 1893	*Impression de boulevard: La femme à la voilette* (Impression of the Boulevard: Woman with a Veil); wax; Galleria d'Arte Moderna Ca' Pesaro, Venice, Italy	
ca. 1894	*Bookmaker*; plaster; private collection, Milan, Italy	
ca. 1895	*Bambino malato* (Sick Child); wax; Middlebury College Museum of Art, Middlebury, Vermont, United States	
ca. 1896	*Madame X*; wax; Galleria d'Arte Moderna Ca' Pesaro, Venice, Italy	
ca. 1897–98	*Madame Noblet*; plaster; Galleria d'Arte Moderna Ricci-Oddi, Piacenza, Italy	
1906	*Ecce puer* (Behold the Child); plaster; Scottish National Gallery of Modern Art, Edinburgh, Scotland	

Further Reading

Barr, Margaret Scolari, *Medardo Rosso*, New York: Museum of Modern Art, 1963

Claris, Edmond, *De l'Impressionnisme en sculpture: Lettres et opinions de Rodin, Rosso, Constantin Meunier, etc.*, Paris: La Nouvelle Revue, 1902 (includes an interview with Rosso)

Hecker, Sharon, "Medardo Rosso's First Commission," *The Burlington Magazine* 138 (December 1996)

Hecker, Sharon, "Medardo Rosso's Brera Petition," *The Burlington Magazine* 142 (December 2000)

Meier-Graefe, Julius, "Medardo Rosso," in *Entwicklungsgeschichte der modernen Kunst*, 3 vols., Stuttgart: Hoffmann, 1904; as *Modern Art, Being a Contribution to a New System of Aesthetics*, translated by Florence Simmonds and George W. Chrystal, vol. 2, New York: Putnam, and London: Heinemann, 1908; reprint, New York: Arno, 1968

Mostra di Medardo Rosso (1858–1928) (exhib. cat.), Milan: Società per le Belle Arti ed Esposizione Permanente, 1979

Moure, Gloria, *Medardo Rosso* (exhib. cat.), Barcelona: Polígrafa, 1997

Rosso, Medardo, "Concepimento-limite-infinito," *L'Ambrosiano* (12 January 1926)

Rosso, Medardo, "Chi largamente vede, largamente pensa, ha il gesto," *L'Ambrosiano* (15 January 1926)

LOUIS-FRANÇOIS ROUBILIAC 1702–1762 *French, active in England*

Louis-François Roubiliac was the most innovative and technically accomplished sculptor working in England in the 18th century. His workshop created a series of tombs in Westminster Abbey that introduce a high degree of lively emotion and naturalistic treatment and which anticipate in their varied designs the major stylistic movements in Europe. Little is known about his history before he arrived in London in 1730 at the age of 28.

Roubiliac seems to have come from an unusual background of liberally educated bourgeois merchants and bankers, as opposed to a family of artisans or craftsmen. Lyon, the town of his birth, was also the home of several major sculptors of the previous generation, including the families of Coysevox and Coustou, who had moved to Paris and risen in the ranks of the French Academy. Roubiliac may have trained in Paris under Nicolas Coustou immediately prior to coming to England. Roubiliac's mastery of contemporary central European Baroque stylistic trends also supports the idea that he worked with Balthasar Permoser on the Zwinger Pavilions in Dresden. The French Academy Records in Paris confirm that he won second prize for sculpture in 1730; the next secure date in his history is that of his first marriage in 1735, to Catherine Helot, a Huguenot, in London.

Roubiliac's first commissions in England are supposed to have sprung from an act of honesty: he returned money and papers to their owner, Sir Edward Walpole, which resulted in the patronage of Walpole and his powerful father, the prime minister. This patronage directly led to Roubiliac's recommendation to the sculptor Henry Cheere and then, through his work in Cheere's flourishing studio, to the impresario Jonathan Tyers. Roubiliac produced for Tyers his most famous and innovative statue, that of the musician *George Frideric Handel*. The sculpture was set in the pleasure grounds of Vauxhall Gardens, where Londoners seeking fashionable entertainment gathered to hear the composer's operas. Roubiliac—trained in France at a time when the royal court was commissioning many lively sculptures of goddesses, nymphs, and zephyrs from Coysevox and Coustou to decorate the great ornamental park at Marly, the gardens at Versailles, and the grounds of private châteaux—was an inspired choice. The Vauxhall statue presents Handel in informal dress, leaning on a pile of his own compositions, in the act of composing and testing his ideas on a lyre. A small boy or putto accompanies him, acting as an amanuensis, transcribing the composition as it finds form. Set in a grove, as a modern embodiment of Music, Handel replaces traditional, Classical representations of Music, such as Orpheus or Apollo. The terracotta for this statue is particularly successful in capturing the impression of arrested movement, but the finished marble also retains the spirit, variety, and realism of Roubiliac's model. In addition to busts of Handel, he also sculpted Handel's tomb in 1761 for Westminster Abbey. It developed from an intimate rendering in terracotta to a final magnificent theatrical monument. In marked contrast to the informality of the earlier Vauxhall statue, Handel stands here as the impressive, inspired genius, clad in a rich fur-lined cloak, among a setting of modern orchestral instruments (bass, horn, and harp); he is conducting a celestial rendering of the aria "I Know That My Redeemer Liveth," from his most famous work, *The Messiah*.

From the mid 1730s onward Roubiliac produced a series of portrait busts in marble and terracotta that reflect his developing friendships and connections, as well as his own interest in poetry and music. In each bust—such as *Jonathan Tyers* with a characteristic head tilt, *Handel*, *William Hogarth* narrowing his eyes, or the heavily jowled Dr. Martin Folkes—Roubiliac experimented with modern dress and a highly realistic treatment of features and expression closely paralleling contemporary approaches to portraiture in France. At the same time he developed a parallel type of Classically draped bust, still with markedly individualized features, in his four renderings of a heavy-eyed *Alexander Pope*, his patron *Sir Robert Walpole*, *Sir Andrew Fountaine*, and *The Earl of Pembroke*. A group of portrait busts of the Baillie and Binning families, commissioned by Lady Grizel Baillie for the interior at Mellerstain House in Scotland in the 1740s, exhibit a more

subtle treatment, using Roman prototypes. Roubiliac's later portraits of a contemplative *David Garrick*, an autocratic *Joseph Wilton*, and his virtuosic *Self-Portrait* demonstrate his fully developed command of modern dress, Italian Baroque *contrapposto* (a natural pose with the weight of one leg, the shoulder, and hips counterbalancing one another) models, and French animated realism.

Of Roubiliac's full-length statues, the *William Shakespeare* is one of the most famous. The figure of *Sir Isaac Newton* at Trinity College, Cambridge, is the most imposing; some evidence suggests that Roubiliac worked from two copies of Newton's death mask to achieve the head's powerful naturalism. Subsequent relocation has weakened the effect of many statues designed for particular sites, but the inspired and dramatic pose of his *Lord President Forbes* is still startling and effective. Commissioned by the Scottish Faculty of Advocates and sited in the Outer Parliament House in Edinburgh, it depicts the judge leaning ani-

Monument to George Frideric Handel, Westminster Abbey, London, England (*ca.* 1762)
The Conway Library, Courtauld Institute of Art

matedly forward, hand outstretched and lips parted, about to pronounce judgment.

Appreciation of the monumental work completed by Roubiliac, much of which is prominently visible in Westminster Abbey, has increased in recent years. Prominent in scale, arresting in design, and emotional in sentiment, his works provoked astonishment when they were made; subsequent generations considered them overindulgent. Critics now consider what had often been seen as a weakness in large-scale composition to be more in keeping with Rococo qualities of movement, variety of surface texture, and spirited characterization. Nonetheless, critics have always appreciated relief monuments executed by his workshop, such as the monument to William and Elizabeth Harvey at Hempstead, Essex, for their brilliance of carving and delicacy of effect. His first large-scale commission, for the monument for Westminster Abbey to John Campbell, second duke of Argyll, established his reputation throughout Europe when it was unveiled. The aged military hero quietly considers his achievements for England and his imminent death, surrounded by History, Minerva, and Eloquence, in a format that draws on French and Italian models. Roubiliac's monument to General Wade at Warkton shows Time vindicating Wade's military activities, whereas the monument to the second duke of Montagu deals more directly with the pathos of family loss. The hero bursting the bounds of death and rising from the tomb is the dramatic Christian theme of the monument to General Sir William Hargreave, whereas a triumphant modern hero in contemporary regimentals, surrounded by the panoply of successful warfare, is the dominant figure on Field Marshall Viscount Shannon's surprising tomb (1755) at Walton-on-Thames. Most innovative and successful of all of Roubiliac's designs is the large monument to Joseph Gascoigne and Lady Elizabeth Nightingale at Westminster Abbey. This extraordinary personal and dramatic narrative shows Death emerging suddenly from the base of the monument to strike down the young pregnant Lady Elizabeth with a violent lunge, despite the strenuous efforts of her horrified husband to shield her.

Roubiliac had few assistants and seems to have carried out much of his output himself. His range of work, from dignified and unpretentious reliefs to ambitious monuments, is impressive. One can study much of his technique and working practice from the group of preliminary terracotta models at the British Museum. His greatest strengths lay in his expressive realism, especially in representations of older sitters, and his ability to represent lively movement.

J. PATRICIA CAMPBELL

See also **Coustou Family; Coysevox, Antoine; Permoser, Balthasar**

Biography

Born in Lyon, France, before 31 August 1702. Trained at Académie Royale de Peinture et de Sculpture, Paris; won second prize for sculpture in Prix de Rome competition, 1730; may have trained before that in Liège, in Dresden, Germany, with Balthasar Permoser, and in Paris with Nicholas and Guillaume Coustou or Robert Le Lorraine; moved to London, 1730; became assistant to London sculptor Sir Henry Cheere; first independent commission, statue of Handel for Vauxhall Gardens, London, 1737; established own studio in St. Peter's Court, off St. Martin's Lane; became lecturer at St. Martin's Lane Academy, 1745; received first commission for Westminster Abbey, 1748; became a modeler at the Chelsea china factory, *ca.* 1749; visited Italy, 1752; joined committee publicizing works of English artists, 1755. Died in London, England, 1 November 1762.

Selected Works

1738 *Alexander Pope*; marble; City Art Gallery, Leeds, England

1738 *George Frideric Handel*; marble; Victoria and Albert Museum, London, England; terracotta version: Fitzwilliam Museum, London, England

1738 *Handel*; marble; Windsor Castle, Berkshire, England; terracotta version: 1739, National Portrait Gallery, London, England

1740 *William Hogarth*; marble; National Portrait Gallery, London, England; terracotta version: *ca.* 1741, National Portrait Gallery, London, England

1741 *Alexander Pope*; marble; private collection, Scotland

1745–49 Monument to John Campbell, second duke of Argyll and Greenwich; marble; Westminster Abbey, London, England

1747 *Sir Andrew Fountaine*; marble; Wilton House, Wiltshire, England

1748–52 *Lord President Forbes*; marble; Parliament House, Edinburgh, Scotland

1754–55 *Sir Isaac Newton*; marble; Trinity College, Cambridge, England

1757–58 *William Shakespeare*; marble; British Museum, London, England

1758 Monument to William and Elizabeth Harvey; marble; St. Andrew, Hempstead, Essex, England

ca. 1758 *David Garrick*; marble; National Portrait Gallery, London, England

1758–61 Monument to Joseph Gascoigne and Lady Elizabeth Nightingale; marble; Westminster Abbey, London, England

ca. 1761 *Joseph Wilton*; marble; Royal Academy of Arts, London, England

year unknown *Self-Portrait*; marble; National Portrait Gallery, London, England

Further Reading

Baker, Malcolm, "Roubiliac's Models and 18th-Century English Sculptors' Working Practices," in *Entwurf und Ausführung in der Europäischen Barockplastik*, edited by Peter Volk, Munich: Bayerisches Nationalmuseum, 1986

Baker, Malcolm, "Lord Shelburne's 'Costly Fabrick': Sheemakers, Roubiliac, and Taylor as Rivals," *The Burlington Magazine* 132 (1990)

Baker, Malcolm, "Cheere and Roubiliac in the 1730s: Collaboration and Sub-Contracting in Eighteenth-Century Sculptors' Workshops," *Church Monuments* 8 (1995)

Baker, Malcolm, "The Making of Portrait Busts in the Mid-Eighteenth Century: Roubiliac, Scheemakers, and Trinity College, Dublin," *The Burlington Magazine* 137 (1995)

Bindman, David, and Malcolm Baker, *Roubiliac and the Eighteenth-Century Monument: Sculpture as Theatre*, New Haven, Connecticut: Yale University Press, 1995

Craske, Matthew, "The London Sculpture Trade and the Development of the Imagery of the Family in Funerary Monuments of the Period 1720–26," Ph.D. diss., Westfield College, 1992

Esdaile, Katherine Ada, *The Life and Works of Louis François Roubiliac*, London: Oxford University Press, 1928

Murdoch, T., "Louis François Roubiliac and His Huguenot Connections," *Proceedings of the Huguenot Society of London* 24 (1983)

Pearson, Fiona, editor, *Virtue and Vision: Sculpture and Scotland, 1540–1990*, Edinburgh: Trustees of National Galleries of Scotland, 1991

Physick, J., "Westminster Abbey: Designs for Poets' Corner and a New Roubiliac in the Cloister," *Church Monuments* 4 (1989)

Vertue, George, *Vertue Note Books*, 7 vols., Oxford: University Press, 1930–55; see especially vol. 3

Whinney, Margaret, *Sculpture in Britain, 1530–1830*, London and Baltimore, Maryland: Penguin, 1964; 2nd edition, revised by John Physick, London and New York: Penguin, 1988

Woodward, Robin, "Sculpture in Scotland," Ph.D. diss., Edinburgh University, 1977

FRANÇOIS RUDE 1784–1855 *French*

One of the most important European sculptors of the Romantic period, François Rude, like some of the other leading sculptors of his time, escapes easy classification. Older than the Romantic "men of 1830" in France, he shared their predilection for realistic depiction of uncanonical subjects in a forceful, dramatic style. Yet the classicizing ideals he had absorbed from his teachers remained with him, emerging from time to time in works now regarded as uncharacteristic of Rude's inherent naturalism.

Rude's father, an artisan in Dijon, imparted his passionately held republican opinions to his son during the French Revolution. François was able with difficulty to study at the local art academy only in his hours away from the family business. One of his earliest surviving works, a terracotta *Napoléon as a Roman Emperor*, reveals him as already a fervent Bonapartist. It was only after his father's death that Rude was able to take up full-time study in Paris in 1807. There he discovered the ideals of Neoclassicism in the studio of Pierre Cartellier and at the École des Beaux-Arts, where he was awarded the Grand Prix de Rome in 1812. His prize work, *Aristaeus Mourning the Loss of his Bees*, was a suave exercise in Neoclassical idealization, but after his only trip to Italy, more than 30 years later, he destroyed it (although a bronze version survives).

Although his period of exile in Brussels (1815–27) offered Rude no opportunities for monumental figural sculpture, he kept busy with decorative commissions. The most important of these, the reliefs (destroyed) for the Château de Tervueren, seem to have been relatively conventional works in a classicizing idiom.

From his first appearance at the Paris Salon, in 1828, Rude made a favorable critical impression. His *Neapolitan Fisherboy Playing with a Tortoise* (Salons of 1831 and 1833) was a popular success that established his reputation. It was highly original in depicting the nude figure as an everyday genre subject, treated with realism and humor.

Although Rude was invited to submit various proposals for the sculptural decoration of the Arc de Triomphe, he was commissioned to execute only one of the four principal reliefs on the monument. In this work, the famous *Departure of the Volunteers of 1792* (also known as *La Marseillaise*), Rude combines his classicizing training (antique costumes, heroic nudity, and a female allegorical figure) with an intensely realistic expression of patriotic enthusiasm. Led by the strident, shouting figure of France, the volunteers move forward with impulsive energy.

Despite the success of the *Departure of the Volunteers of 1792*, Rude was considered politically suspect on account of his republicanism and received no further state commissions until the fall of the July Monarchy in 1848; he also declined to participate at the conservative Salons from 1838 onward. Rude did accept private commissions for works depicting Ancien Régime rulers and their retainers, such as a silver *Adolescent Louis XIII* (1840–42) and a marble *Maréchal Maurice de Saxe* (1836–38). Although well executed, these works lack a strong psychological involvement on the artist's part.

In 1845 Rude, lacking major public commissions, began work on two monuments for which he offered his services without fee. The first, the tomb of Godefroy Cavaignac, was an effigy for a recently deceased republican leader of the political opposition to the royal government. The gaunt, unidealized bronze figure, wrapped in a shroud and lying on a narrow marble base, recalls medieval *gisant* (reclining) tomb figures and Renaissance religious paintings such as Hans Holbein the Younger's stark *Dead Christ* (1521).

Rude worked concurrently on a bronze *Napoléon Awakening to Immortality* for the property of the Bonapartist Claude Noisot at Fixin, near Dijon. The work, unique iconographically, is rendered still more remarkable by its remote, romantic setting. Originally planned as a recumbent figure like the Cavaignac tomb, the sculpture depicts a youthful Napoléon, in uniform, awakening and lifting his shroud; like Rude's other funerary monument, this modern version of a Resurrection or a Raising of Lazarus shows the sculptor applying the traditions of religious art to a contemporary, secular subject. Although relief-like and somewhat difficult to read clearly, its extraordinarily mysterious quality gives it an exceptional resonance.

The advent of the Second Republic provided Rude with renewed patronage, including the project for a monument to *Maréchal Michel Ney*, the martyred Bonapartist general, placed at the spot in Paris where Ney was executed. Rude first intended to show Ney fearlessly opening his coat before the barrels of the firing squad. The monument, inaugurated under Emperor Napoléon III, actually depicts the general with his saber raised, calling energetically to his men to follow him, like the figure of France in the *Departure of the Volunteers of 1792*.

In contrast to these and other Bonapartist projects of the late 1840s, Rude spent his last years working on commissions for a pair of mythological subjects for his native Dijon; both were unfinished at his death. The marble *Hebe and the Eagle of Jupiter* (1846–55) and *Cupid, Ruler of the World* show nostalgia less for the Neoclassicism of the *Aristaeus* than for the playful eroticism of the Rococo style that was current during Rude's childhood. The slender, rather chilly *Hebe* suggests that Rude was less at home sculpting the female nude than the heroic male. The smaller *Cupid* lacks the energy of most of Rude's best work, but in it the sculptor (whose own son died young) still displays the affectionate sympathy for youth evident earlier in his *Neapolitan Fisherboy* and *Departure of the Volunteers of 1792*.

Rude's artistic development was slow: his most original sculptures all were created after 1831, when he was nearing the age of 50. His work is also uneven. Rude was usually at his best in subjects in which his sympathies and political passions were fully engaged and when he permitted himself to work in the naturalistic approach that he taught to his many students. The

exceptional late works, particularly the *Cupid*, reflect the Olympian, apolitical calm of Rude's last years rather than a decline in ability. Rude was the leading image maker of 19th-century French sculpture prior to Auguste Rodin.

DONALD A. ROSENTHAL

See also **Neoclassicism and Romanticism**

Biography

Born in Dijon, France, 4 January 1784. Son and apprentice of a locksmith and stove maker. Worked in family business and studied at Dijon academy with François Devosge by 1800; by 1807, went to Paris and worked with decorative sculptor Edmé Gaulle and then in ateliér of Pierre Cartellier; worked at École des Beaux-Arts, which awarded him Grand Prix de Rome in 1812; unable to claim stipend due to shortage of state funds; a Bonapartist, he fled to Brussels in 1815, remaining until 1827, and did commissions for decorative relief sculptures, exhibited at Paris Salon from 1828; appointed Chevalier of the Legion of Honor, 1833, but never elected to membership in Académie des Beaux-Arts; received one major governmental commission, for the Arc de Triomphe in Paris, a large stone relief—*Departure of the Volunteers of 1792*, also known as *La Marseillaise*; traveled in Italy, 1843; executed series of major monuments honoring deceased Bonapartist and republican political figures, from 1845. Died in Paris, France, 3 November 1855.

Selected Works

1804 *Napoléon as a Roman Emperor*; terracotta; Musée des Beaux-Arts, Dijon, France

1812 *Aristaeus Mourning the Loss of His Bees*; plaster (destroyed by the artist); bronze cast: 1830, Musée des Beaux-Arts, Dijon, France

1826–31 Bust of Jacques-Louis David; marble; Musée du Louvre, Paris, France

1828–34 *Mercury Fastening His Sandal*; bronze; Musée du Louvre, Paris, France

1831–33 *Neapolitan Fisherboy Playing with a Tortoise*; marble; Musée du Louvre, Paris, France

1833–36 *Departure of the Volunteers of 1792* (also known as *La Marseillaise*); stone; Arc de Triomphe de l'Étoile, Paris, France

1845–47 *Napoléon Awakening to Immortality*; bronze; Parc Noisot, Fixin, near Dijon, France

1845–47 Tomb of Godefroy Cavaignac; bronze; Montmartre Cemetery, Paris, France

1848–52 Crucifixion; bronze; Church of St-Vincent-de-Paul, Paris, France

1848–53 *Maréchal Michel Ney*; bronze; Avenue de l'Observatoire, Paris, France

1848–55 *Cupid, Ruler of the World*; marble; Musée des Beaux-Art, Dijon, France

Further Reading

Calmette, Joseph, *François Rude*, Paris: Floury, 1920

Darr, Alan, "François Rude," in *The Romantics to Rodin*, Los Angeles: County Museum of Art, 1980

Delteil, Loys, *Le peintre graveur illustré, XIXe et XXe siècles*, 31 vols., Paris: s.n., 1906–30; reprint, New York: Da Capo, 1969; see especially vol. 6, *Rude; Barye; Carpeaux; Rodin*

Drouot, Henri, *Une carrière: François Rude*, Dijon, France: Impr. Bernigaud et Privat, 1958

Fourcaud, Louis de, *François Rude, sculpteur: Ses oeuvres et son temps: 1784–1855*, Paris: Librairie de l'Art Ancien et Moderne, 1904

Hamerton, Philip Gilbert, *Modern Frenchmen: Five Biographies*, London: Seeley Jackson and Halliday, and Boston: Roberts, 1878; reprint, Freeport, New York: Books for Libraries Press, 1972

Lami, Stanislas, *Dictionnaire des sculpteurs de l'école française au dix-neuvième siècle*, Paris: Champion, 1921

Quarre, Pierre, editor, *François Rude, 1784–1855: Commémoration du centenaire*, Dijon, France: Musée des Beaux-Arts, 1955

Ward-Jackson, Philip, "Rude, François," in *The Dictionary of Art*, edited by Jane Turner, New York: Grove, and London: Macmillan, 1996

DEPARTURE OF THE VOLUNTEERS OF 1792 (LA MARSEILLAISE)
François Rude (1784–1855)
1833–1836
stone
h. 12.81 m
Arc de Triomphe de l'Étoile, Paris, France

La Marseillaise, or the *Departure of the Volunteers of 1792*, its official title, was designed to decorate the Arc de Triomphe de l'Étoile in Paris, a monument of unprecedented scale in the 19th century. Rude's sculpture depicts the national volunteer army that fought off an invasion by the European allies during the French Revolution. Although today considered highly successful, the *Departure of the Volunteers* was controversial in its time. For one thing, it seemed to reject the subsidiary role proper to sculpture in the context of an architectural monument. Rude's preference for deep carving violated the arc's flat facade and effectively upstaged the architecture. More generally, his group was the most emphatic example of new tendencies in sculpture during the 1830s, in particular, the

exploitation of dramatic and pictorial effects and anatomic realism.

Contemporaries perceived these qualities as dangerous because they were signs of Romantic artists' rejection of sculpture's traditional public functions, as expressed through an inherited form of classicizing allegory. One can best understand the work's innovations by looking at its pendant on the arc, the relief entitled *The Triumph of Napoleon* (1834–36) by the academic sculptor Jean-Pierre Cortot. While Cortot's work was not exceptionally praised, critics considered it the most successful of the four arc trophies, since it best fulfilled the traditional function of architectural relief. The differences between the Rude and Cortot reliefs are obvious and, as contemporaries noted, jarring. Cortot's strongly symmetrical composition consists of large, generalized groups lying flush with the arc's facade. *Departure of the Volunteers*, by contrast, offers an extremely varied and detailed surface, with strong shadows and highly lit protruding elements generating dramatic three-dimensional effects.

Critics were quick to apply the pejorative term *picturesque* to the *Departure of the Volunteers*, referring in part to Rude's meticulous depiction of costume: the exotically carved shields and war paraphernalia and the *génie*'s Phrygian cap, with its unusual amalgam of modern, ancient, and medieval motifs. This level of detail appeared more proper to painting, particularly to Romantic painting, with its preference for exotic accessories. However, the derisive label *picturesque* was not fortuitous. Rude's work has strong formal and thematic affinities with at least one painting from the period, Delacroix's *Liberty Leading the People* (1830). As in the painting, the *génie* crowns the composition, which is pyramidal in structure, the other figures falling off from this pivotal one and pressing toward the foreground. Given the medium and genre in which Rude was working, it was not an option for him to depict his figures in modern dress. In order to vary his group, the sculptor offers an array of bodily types, describing a particular musculature for each figure— a strategy that finds it parallel in Delacroix's carefully rendered corpses.

Rude's anatomical exactness is without precedent in the first half of the 19th century, excepting certain works by Rude's coeval, David d'Angers. This tendency is at work in the group's central figure, the nude boy-warrior, whose vulnerable nakedness and youth together make him a touchstone for the relief's drama. It is, on the one hand, an ideal body, a type of Apollo or *ephèbe*, as contemporaries dubbed him. However, Rude's faithful description of an adolescent's state of muscular development distances this nude from academic ones. The sculpture in fact solicits a comparative study of body types by having the boy's extended leg mirror the tensely planted limb of his bearded companion. A third point on this anatomic spectrum is the far-right soldier with bared chest, whose slightly slack skin and soft posture suggest middle age.

The sculptor's detailed attention to the figures helps establish the viewer's sense of an event unfolding in time. Rather than proper allegory, the relief appears to embody an instantaneous moment charged with historic significance. The viewer imagines the imminent displacement of soldiers who will eventually coalesce into an army filing off to battle. Rude's depiction of the dense figure group on the verge of dispersal has led to the oft-repeated comment that the *Departure of the Volunteers*'s most salient aspect is its evocation of movement. Rude achieved this effect through a rather unusual composition. The relief is organized by a rough division between upper and lower halves, a break that registers strongest at the point immediately above the two central figures' heads, or just below the *génie*'s spread limbs. This lacuna, partially filled in with drapery, is a veritable catalyst of narrative drama. As a hole in the composition, it is a sign for the contingent nature of the relief's figural organization. It also evokes, paradoxically, an imaginary generative source,

Departure of the Volunteers of 1792 (La Marseillaise)
The Conway Library, Courtauld Institute of Art

for the *génie* appears to give birth to the army, which she shelters under her wing and her expansive gesture.

It would be wrong to exaggerate the *Departure of the Volunteers*'s rejection of the traditional functions of public sculpture as defined in the first half of the 19th century. Had it broken with these entirely, the work would have been opaque for its audience. We can note that Rude was careful to incorporate some conventional symbolism. The soldiers gathered in the relief's lower register are readable as an ages-of-man theme, a standard motif whose inclusion would have been a conscious decision on Rude's part. It is a choice that, along with the sculptor's commitment to Classical accessories, adroitly sidesteps questions of social class, an issue that loomed large for subjects relating to the first Republic. During France's Second Republic (1848–52), such nationalist depictions tended to become more socially specific; nevertheless, *Departure of the Volunteers of 1792* served as the basis for all subsequent sculpted images of the Republic and has enjoyed an unprecedented influence on French patriotic art generally.

LUCIA TRIPODES

Further Reading

Butler, Ruth, "Long Live the Revolution, the Republic, and Especially the Emperor! The Political Sculpture of Rude," in *Art and Architecture in the Service of Politics*, edited by Henry A. Millon and Linda Nochlin, Cambridge, Massachusetts: MIT Press, 1978

Jouin, Henri, "Arc de Triomphe de l'Étoile," in *Inventaire général des richesses d'art de la France*, vol. 1, *Paris, Monuments, civils*, Paris: Plon, 1880

Rabreau, Daniel, "L'Arc de Triomphe: De la gloire au sacrifice," in *La sculpture française au XIXe siècle* (exhib. cat.), Paris: Éditions de la Réunion des Musées Nationaux, 1986

CAMILLO RUSCONI 1658–1728 *Italian*

When Camillo Rusconi arrived in Rome in the early 1680s, the most prominent representative of Roman Baroque sculpture Gianlorenzo Bernini had just died. It was in the Roman workshop of Ercole Ferrata, one of Bernini's most gifted collaborators, that Rusconi began working. Here he became conversant with the most modern tendencies of Roman Baroque sculpture, at the same time acquainting himself with the antique and Renaissance heritage of the Eternal City.

Rusconi's first independent commission after Ferrata's death in 1686 comprised four allegorical, stucco figures of *Fortitude*, *Temperance*, *Prudence*, and *Justice* set in the corner niches of the Ludovisi Chapel at the Church of Sant'Ignazio in Rome. These figures, although still Berninesque in appearance, are characterized by a more immediate affinity between clothing and underlying body, and less extreme gestures and facial expressions, than those used by the late Bernini.

The four stucco figures, although esteemed by his peers, did not result in the success that Rusconi had expected. Instead, his official commissions remained scarce and he was mainly restricted to participating in huge decorative campaigns, such as the stucco decorations of the Church of San Silvestro in Capite. The only autonomous commission Rusconi received in these meager years was the stucco altar of Saint Onophrius, which, however, he executed for a location outside Rome, the Church of S. Chiara in Montefalco. It was not until the end of the 17th century, when he received the commission for two *Angels* on the side wall of the Chapel of Sant'Ignazio in the Church of Il Gesù in Rome, that Rusconi actually managed to work on marble sculpture.

In reaction to this comparative lack of public opportunity, Rusconi began to concentrate on private commissions. The tomb of Giuseppe Paravicini in the Church of San Francesco a Ripa and the portrait bust of Raffaele Fabretti (which would become part of Fabretti's tomb in the Church of Santa Maria sopra Minerva) were created in these years (1690s) and bear witness to the sculptor's extraordinary technical skills and artistic gifts. In fact, it was this sustained quality of execution that brought Rusconi to the attention of the most prominent patrons in Rome, among whom Niccolò Maria Pallavicini would become a key figure. For this patron Rusconi executed, among other things, the famous allegories of the Four Seasons, which were sold to the English king George I after Pallavicini's death.

Rusconi's biographers are in agreement that contact with Pallavicini was also made through the good offices of Carlo Maratti, the leading painter of Late Baroque Rome. Maratti, in his turn, had the most decisive influence on Rusconi's artistic development, inducing him to shift from an early affiliation with the Berninesque style to a Baroque interpretation of Classical tendencies according to Maratti's own ideals.

Rusconi's mature style was already fully developed when he executed the statue of *Saint Andrew*, begun in 1705, which was his first contribution to the nave sculptures for the Basilica of San Giovanni in Laterano, one of the most prestigious sculpture commissions in 18th-century Rome. The statue, whose drapery only sporadically assumes a life of its own, is obviously inspired by one of the most classically conceived statues in the whole Roman Baroque oeuvre, François du Quesnoy's *St. Andrew* (1629–40) in the crossing of St. Peter's Basilica. Rusconi's own version revised the model by twisting the Apostle's torso to the left, thereby creating a statue that exploited Francesco Borromini's projecting, convex niche by offering three different viewpoints. In

Prudence
© Andrea Jemolo / CORBIS

other words, Rusconi conceived his *Saint Andrew* as a freestanding sculpture, whereas du Quesnoy's *St. Andrew* was designed for only a frontal view.

Although initially entrusted only with the *Saint Andrew*, Rusconi was successively awarded the commissions for the statues of *Saint John the Evangelist*, *Saint Matthew*, and *Saint James the Greater*. When he completed these works in 1718, he became the only sculptor to have realized more than two of the colossal Lateran statues.

The commission of the Lateran Apostles meant that Rusconi had now achieved preeminent rank as a sculptor and, in the years following, he would accept commissions of only the most distinguished status. Among these were the marble tomb of Gregory XIII in St. Peter's Basilica, executed to substitute a late-16th-century one in stucco. Although the composition is at heart based on that which Bernini had pioneered in his own tomb of Urban VIII (1627–47; St. Peter's Basil-

ica), Rusconi also quoted from more contemporary models, such as Pierre-Étienne Monnot's tomb of Pope Innocent XI (1697–1701; St. Peter's Basilica), where the figure of Religion—with her upturned head—gazes at the enthroned pope in almost the same manner. Stylistically, Rusconi's tomb of Gregory XIII capitalizes on the accomplishments of the Lateran campaign: again a voluminous, but relatively naturalistic, drapery enshrouds fairly agitated bodies. The net result is a monumental and vivid composition with the blessing pope sitting above a sarcophagus flanked by allegorical figures representing Religion on his right and Magnificence on his left. The latter lifts a fabric to unveil a relief of *The Institution of the Gregorian Calendar* on the front of the sarcophagus, from beneath which exits a dragon that alludes to the pope's heraldic arms.

Concurrently with the tomb for Gregory XIII, Rusconi was entrusted with the tomb of Giulia Albani, Clement XI's aunt, from which only the superb portrait bust has survived. A monumental relief representing the *Glory of Saint Francis de Regis* destined to grace the Iglesia del Noviciado in Madrid (today in the Church of Las Descalzas Reales of Madrid) and the small but exquisite tomb of the Polish crown prince Alexander Sobieski in the Church of Santa Maria della Concezione, Rome, were the last commissions Rusconi was able to finish before his death. When the sculptor died on 9 December 1728, other works, such as the marble statuette of a *Faun* for an unknown friend (today in Berlin) or the colossal statue of *Saint Ignatius* for St. Peter's Basilica, remained unfinished. They were completed by his longtime pupil and collaborator Giuseppe Rusconi (no relation to Camillo, but involved in his workshop for more than 20 years and adopted his name). He, like other pupils from the Rusconi workshop—such as Giovanni Battista Maini, Filippo della Valle, and Pietro Bracci—perpetuated the brand of Late Baroque Classicism devised by Rusconi, a style that continued to flourish until the Roman debut of Antonio Canova.

FRANK MARTIN

See also **Bernini, Gianlorenzo; Canova, Antonio; du Quesnoy, François; Ferrata, Ercole**

Biography

Born in Milan, Italy, 14 July 1658. Began training as a sculptor at age 15 in the workshop of Giuseppe Rusnati, Milan; moved to Rome, early 1680s; worked initially under Ercole Ferrata in Rome; opened own studio after Ferrata's death in 1686; became member of the Accademia di San Luca, Rome, 1707; Clement XI visited his workshop twice, 1709 and 1720; was made a Cavaliere di Cristo, 1718; elected *principe* (essen-

tially the director) of the Accademia di San Luca, Rome, 1727. Died in Rome, Italy, 9 December 1728.

Selected Works

1685–86 Allegories of *Fortitude, Temperance, Prudence,* and *Justice*; stucco; Ludovisi Chapel, Church of Sant'Ignazio, Rome, Italy

1689–97 Putti and angels; stucco; Church of San Silvestro in Capite, Rome, Italy

1692 Altar of Saint Onophrius; stucco; Church of S. Chiara, Montefalco, Italy

ca. 1695 Tomb of Giuseppe Paravicini; marble; Church of San Francesco a Ripa, Rome, Italy

1695–99 Two angels; marble; Chapel of Sant'Ignazio, Church of Il Gesù, Rome, Italy

ca. 1700 Allegories of the Four Seasons; marble; Royal Collection, Windsor Castle, Berkshire, England

ca. 1700 Portrait bust of Raffaele Fabretti; marble; Church of Santa Maria sopra Minerva, Rome, Italy

1705–09 *Saint Andrew*; marble; Basilica of San Giovanni in Laterano, Rome, Italy

1709–12 *Saint John the Evangelist*; marble; Basilica of San Giovanni in Laterano, Rome, Italy

1711–15 *Saint Matthew*; marble; Basilica of San Giovanni in Laterano, Rome, Italy

1715–18 *Saint James the Greater*; marble; Basilica of San Giovanni in Laterano, Rome, Italy

1715–23 Tomb of Gregory XIII; marble; St. Peter's Basilica, Rome, Italy

1718–20 *Giulia Albani degli Abati Olivieri*; marble; Kunsthistorisches Museum, Vienna, Austria

1723–27 *Glory of Saint Francis de Regis*; marble; Church of Las Descalzas Reales, Madrid, Spain

1727–28 Tomb of Prince Alexander Sobieski; marble; Church of Santa Maria della Concezione, Rome, Italy

1728 *Faun* (with Giuseppe Rusconi); marble; Skulpturengalerie, Staatliche Museen Preussischer Kulturbesitz, Berlin, Germany

1728–33 *Saint Ignatius* (with Giuseppe Rusconi); marble; St. Peter's Basilica, Rome, Italy

Further Reading

Baldinucci, Francesco Saverio, *Vite di artisti dei secoli XVII–XVIII: Prima edizione integrale del Codice Palatino 565*, edited by Anna Matteoli, Rome: DeLuca Editore, 1975

Conforti, Michael, "The Lateran Apostles," Ph.D. diss., Harvard University, 1977

Della Valle, Filippo, "Filippo della Valla a monsig. Gio. Bottari," in *Raccolta di lettere sulla pittura, scultura ed architettura scritte da' più celebri personaggi dei secoli XV, XVI e XVII*, vol. 2, edited by Giovanni Gaetano Bottari and Stefano Ticozzi, Milan: Silvestri, 1822; reprint, Bologna, Italy: Forni, 1979

Enggass, Robert, "Rusconi and Raggi in Sant'Ignazio," *The Burlington Magazine* 116 (1974)

Enggass, Robert, *Early Eighteenth-Century Sculpture in Rome: An Illustrated Catalogue Raisonné*, University Park: Pennsylvania State University Press, 1976

Martin, Frank, " 'L'emulazione della romana anticha grandezza': Camillo Rusconis Grabmal für Gregor XIII," *Zeitschrift für Kunstgeschichte* 61 (1998)

Pascoli, Lione, *Vite de' pittori, scultori, ed architetti moderni*, 2 vols., Rome: De' Rossi, 1730; reprint, Perugia, Italy: Electa Editori Umbri, 1992

Tamborra, Giandavide, "Camillo Rusconi, scultore ticinese, 1658–1728," *Bollettino storico della Svizzera italiana* 100/1 (1988)

Wittkower, Rudolf, "Die vier Apostelstatuen des Camillo Rusconi im Mittelschiff von S. Giovanni in Laterano in Rom: Stilkritische Beiträge zur römischen Plastik des Spätbarock," *Zeitschrift für bildende Kunst* 60 (1926/27)

WILLIAM RUSH 1756–1833 *United States*

The son of a Philadelphia ship carpenter, William Rush transcended his artisanal origins to become one of the most important sculptors of the new republic. In his youth he exhibited promise as a carver and was by his early teens apprenticed to the English-trained figurehead carver Edward Cutbush. A few years later Rush opened his own shop. His career was disrupted in 1777 by service in the Philadelphia militia during the American Revolutionary War. Following the war Rush reestablished his business, attaining wide acclaim in his native Philadelphia. His skillful carving attracted the patronage of prominent merchant Stephen Girard, for whom Rush carved at least 12 figureheads. Little of Rush's early work survives, but many of the commissions are well documented. Although most of his figureheads are symbolic or allegorical, his work for Girard included four figurehead portraits of the French philosophers Voltaire (1795), Rousseau (1801), Helvetius (1804), and Montesquieu (1806), prefiguring the sculptor's later work as a portraitist.

In 1794 Rush was among the 40 artists, including Charles Willson Peale, who founded Philadelphia's first art academy, the short-lived Columbianum, marking the beginning of Rush's long involvement with artistic and civic organizations in the city. In 1801 he was elected to Philadelphia's Common Council and was a continual presence on either it or the Select Council until 1826. In 1805 he became a founder of the Pennsylvania Academy of the Fine Arts and

served as its director for all but one year until his death in 1833.

In the opening decades of the 19th century, ship-building suffered a decline in Philadelphia, and Rush began to redirect his energies to larger freestanding sculptures and portrait busts. A full-length female figure holding a dove, now called *Peace* (*ca.* 1805–10), marks the beginning of this transition in Rush's career. Although he likely carved the work as a figurehead for some unknown ship, it possesses a monumentality and grace that would be the hallmark of his later public sculptures. In 1808 he created the first of his major public sculptures with two over–life-size pine figures, *Comedy* and *Tragedy*. Completed for the Chestnut Street Theater in Philadelphia, these figures are stylistically related to *Peace* but are more boldly carved since they were intended to be placed above the viewer in two second-story niches.

Rush's 1809 *Water Nymph and Bittern*, or *Allegory of the Schuylkill River*, is the best known of his public sculptures, despite the fact that few traces of the original work remain. This full-length pine statue of a nymph and bittern stood in the middle of a fountain in front of the Benjamin Latrobe–designed waterworks pumphouse in Philadelphia's Center Square. Rush had served on the city council's Watering Committee, which built the waterworks to improve the city's drinking water in 1801. The project was an unqualified success from both a technological and an architectural standpoint, with the fountain serving as its crowning civic achievement. Rush carved the nymph from life, using Louisa Vanuxem, daughter of the chairman of the Watering Committee, as the model. When the waterworks were relocated and expanded in the late 1820s, the statue was moved to the new location on the Schuylkill River at Fairmount. By 1872 the sculpture had deteriorated to such an extent that the city ordered a bronze cast to replace the wooden original. The pine head of the nymph, the only surviving remnant of the original, is now in the collection of the Pennsylvania Academy of the Fine Arts.

In 1810 Rush was elected the first president of Philadelphia's Society of Artists; a year later he was appointed professor of sculpture. At the same time Rush continued to direct the Pennsylvania Academy of the Fine Arts and began exhibiting there in 1811. Despite early intentions to collaborate, developing tension between the academy and the Society of Artists led Rush to terminate his relationship with the society in 1812. In the same year he was made an academician of the academy, and the following year he began supervising the academy's first life class.

Around 1810 Rush began to model terracotta busts of family and friends. Inspiration for these portraits likely came from antique models and perhaps the work

Tragedy
© Philadelphia Museum of Art / CORBIS

of foreign artists working in the United States, such as Jean-Antoine Houdon and Giuseppe Cevacchi. After exhibiting his early efforts, Rush began to receive commissions for pine and terracotta portrait busts of prominent men. These portraits constitute nearly half of his work as a sculptor. More naturalistic than his allegorical subjects, the portrait busts reflect a mixture of Classical conventions with careful observation.

Rush's most ambitious portrait was his full-length statue of George Washington, carved out of pine and whitewashed to emulate Classical sculpture. He perhaps looked too closely at Classical models, as Washington leans against a column support not necessary for a light wooden sculpture. Yet in this work Rush broke most convincingly with his artisanal roots and created a dynamic human presence. He proudly exhibited *George Washington* at the Pennsylvania Academy of the Fine Arts, hoping to earn profits through a subscription for plaster replicas. Although this never materialized, the work was later placed in Independence Hall in Philadelphia, where it remained for well over a hundred years.

Rush simultaneously continued producing architectural sculpture, carving decorative elements for churches, a figure of Commerce (1819) for William Strickland's Custom House, Philadelphia, and a group of allegorical figures for Masonic Hall, Philadelphia (1820–21)—ironically, carved not of stone but of wood and painted to resemble marble. Among the last of his works in this genre are the two large reclining figures for the millhouse of the newly expanded waterworks, *Allegory of the Schuylkill River in Its Improved State* and *Allegory of the Waterworks*. Rush completed both in 1825 with the assistance of his son, John. Rush also ventured occasionally into new terrain. For example, in the 1820s he drew up plans for at least two public parks. Although he continued to work into the 1830s, by the time of his death the first generation of American Neoclassical marble sculptors had eclipsed Rush's homespun technique with European training and replaced painted pine with real marble.

AKELA REASON

Biography

Born in Philadelphia, Pennsylvania, United States, 4 July 1756. Apprenticed to figurehead carver, Edward Cutbush, *ca.* 1771; established business carving ornaments for ships by 1774; received assignment to serve as ensign in Philadelphia militia, 1777; gained recognition as superior craftsman; commissioned by U.S. Congress to provide ornamental carvings for six frigates of United States Navy, 1794; founding member, along with artist Charles Willson Peale, of Philadelphia art academy, named the Columbianum, 1794; also established its successor, the Pennsylvania Academy of the Fine Arts, 1805, and served as director, 1805–07 and 1808–33; elected first president of Society of Artists in Philadelphia; appointed professor of sculpture, 1811, but resigned due to conflict with Academy; appointed academician, 1812. Died in Philadelphia, Pennsylvania, United States, 17 January 1833.

Selected Works

1808 *Comedy* and *Tragedy*; pine; Philadelphia Museum of Art, Pennsylvania, United States

1809 *Water Nymph and Bittern* (or *Allegory of the Schuylkill River*); pine; Pennsylvania Academy of the Fine Arts, Philadelphia, Pennsylvania, United States

1814 *George Washington*; pine; Independence National Historical Park, Philadelphia, Pennsylvania, United States

1822 *Self-Portrait*; terracotta; Pennsylvania Academy of the Fine Arts, Philadelphia, Pennsylvania, United States

1825 *Allegory of the Schuylkill River in Its Improved State*; Spanish cedar; Philadelphia Museum of Art, Pennsylvania, United States

1825 *Allegory of the Waterworks*; Spanish cedar; Philadelphia Museum of Art; Pennsylvania, United States

Further Reading

Craven, Wayne, *Sculpture in America: From the Colonial Period to the Present*, New York: Crowell, 1968; new and revised edition, Newark, New Jersey: University of Delaware Press, and New York: Cornwall Books, 1984

James-Gadzinski, Susan, and Mary Mullen Cunningham, editors, *American Sculpture in the Museum of American Art of the Pennsylvania Academy of the Fine Arts*, Philadelphia: Museum of American Art of the Pennsylvania Academy of the Fine Arts, 1997

Marceau, Henri, *William Rush, 1756–1833: The First Native American Sculptor*, Philadelphia: Pennsylvania Museum of Art, 1937

Naeve, Milo, "William Rush's Terracotta and Plaster Busts of Andrew Jackson," *The American Art Journal* 21 (1989)

Sewell, Darrel, *Philadelphia: Three Centuries of American Art*, Philadelphia, Pennsylvania: Philadelphia Museum of Art, 1976

William Rush: American Sculptor (exhib. cat.), Philadelphia: Pennsylvania Academy of the Fine Arts, 1982

RUSSIA AND SOVIET UNION

The history of sculpture in Russia does not begin until the late 17th to the early 18th centuries. Before this time, such works had been forbidden by the Orthodox Church, and, with the exception of an episode in the 12th century, sculpture was not used in churches. Secular art did not yet exist.

The end of Russia's isolation and the reforms of Peter the Great led to an influx of Western artists working in the European manner. Special emphasis must be made on the czar's great personal interest in sculpture, which resulted in an important collection of representative works by the Venetian masters of the early 18th century. The founding of St. Petersburg in 1703 and the production of great works in the new capital demanded a complimentary invitation to sculptors from Europe. Besides the series of craftsmen known only from Russian documents and who left no verifiable works, Andreas Schlüter arrived in St. Petersburg in 1713 and died the next year. Also significant was Nicola Pineau, who worked in St. Petersburg for more than ten years (1716–27) as a decorator and woodcarver. The most versatile and brilliant of these sculptors was the Florentine Bartolomeo Carlo Rastrelli, who arrived in St. Petersburg in 1716 and worked there

until his death. There he created a series of outstanding works in the spirit of the Baroque, which include portraits of Peter the Great and an equestrian monument to the czar, the latter completed only after the artist's death.

At the end of Peter the Great's reign, an effort was made to send young Russians to the Venetian sculptor Pietro Baratta in Italy for training in the art of sculpture. After their return, these artists participated in various works, including collaborations with Rastrelli. However, even the most talented of these, Vasily Selivanov, left no verifiable works.

The practice of employing foreign sculptors continued in Russia until the second half of the 18th century. The Austrian Johann Antoni Zwenhoff arrived in 1732. His compatriot Johann Franz Dunker worked extensively with the architect Bartolomeo Francesco Rastrelli. According to documents, one of Dunker's pupils, Mikhail Pavlov, produced a series of portrait busts that were much valued by his contemporaries; none survive today.

Only with the 1758 arrival of Nicolas-François Gillet from Paris did training of professional sculptors in Russia begin. Gillet was put in charge of sculpture at the Academy of Arts, which was founded in 1757. Already in the 1770s whole groups of young craftsmen, some educated in Rome, some in Paris, began to appear. In these European centers of art they were able to choose the direction that seemed most attractive and best corresponded to their talents. Apparently, the presence of French sculptor Étienne-Maurice Falconet, who was working on the equestrian monument of Peter the Great (1766–82), in St. Petersburg proved to be an important factor in the development of the art.

It was Gillet's Academy of Arts students who became the first successful Russian sculptors. Fedot Shubin perfected his craft in Paris after graduation from the academy, and he then worked in Italy and England. He worked mainly in portraiture, creating expressive and veracious marble busts of his contemporaries, including Aleksandr Golitsyn (1773; State Tretyakov Gallery, Moscow), Grigorii Potemkin (1791; State Russian Museum, St. Petersburg), and the sculptor Johann Gottlieb Schwarz (1792; State Russian Museum, St. Petersburg).

Fyodor Gordeyev worked with Falconet on the final stages of the monument to Peter the Great. He also made professionally executed marble tomb monuments for Natalya Golitsyna (1780; Donskoi Monastery, Moscow), Aleksei Golitsyn (1788; Church of the Annunciation, Aleksandr-Nevsky Crypt, St. Petersburg), and Dmitry Golitsyn (1791; Donskoi Monastery, Moscow). Each gravestone includes a human figure, as was the custom in Europe. Gordeyev's extended

Sculpture of robed woman holding a sickle, St. Petersburg, Russia, *n.d.*
© Steve Raymer / CORBIS

pedagogical activities at the Academy of Arts were also important.

The most versatile and interesting sculptor of this generation was Mikhail Kozlovsky, who was also a student of Gillet's. His mature works show various stylistic tendencies. In the bronze image of the crucified Polycrates (State Russian Museum, St. Petersburg), the sculptor achieved the height of tragic pathos that is associated with the Baroque tradition. In the marble statues *Hymenaeus* (1796; State Russian Museum, St. Petersburg) and *Cupid with Arrow* (1797; State Russian Museum, St. Petersburg), he seems to have been an elegant and delicate craftsman affiliated with Classical tendencies. The elegiac nature of the marble group *Vigil of Alexander of Macedon* (1780s; State Russian Museum, St. Petersburg) recalls ancient Greek sculpture. Kozlovsky was also the author of a simple but expressive monument to the military leader Aleksandr Suvorov (1801; Field of Mars, St. Petersburg). Unfortunately, the artist's most significant monumental work—the bronze group *Samson with Lions*,

completed in 1800 for a fountain at Peterhof—was destroyed during World War II.

The work of Ivan Prokof'iev is distinguished by its intimate character. He also created a series of monumental marble statues for the ornamentation of fountains at Peterhof—*Akid* (1800) and *Volkhov* (1801). However, the sculptor's gift for ornament shows itself best in the small models of unrealized works such as *Triumph of Neptune* (1817; State Russian Museum, St. Petersburg).

Yet another great craftsman from the turn of the century, Feodosy Shchedrin, left a series of refined marble statues in the manner of French sculpture of the day. His *Venus* (1792; State Russian Museum, St. Petersburg) and *Diana* (1798; State Russian Museum, St. Petersburg) recall the work of Christophe-Gabriel Allegrain and Augustin Pajou. Shchedrin's most famous work, *Nymphs Carrying the Globe*, was created for an ensemble at the Admiralty in St. Petersburg from 1811 to 1812.

Although Ivan Matros was the same age as the above-mentioned sculptors, his work shows a clear shift toward strict Classicism. In the 1780s he produced a series of tombs which, despite a sincerity and freshness of emotion, show the influence of Baroque styles. These include tombstones for Sof'ia Volkonskaia (1782; State Tretyakov Gallery), Praskov'ia Brius (1786–90; Donskoi Monastery, Moscow), and Elena Kurakina (1792; Museum of Urban Sculpture, St. Petersburg). However, a bronze statue for the tombstone of Elizaveta Gagarina (1803; Museum of Urban Sculpture) reveals a consistently Classical style. This style is even more notable in the most famous of Matros's works, the monument to Minin and Pozharsky on Red Square in Moscow (1804–18).

At the beginning of the 19th century, Classicism enjoyed stylistic dominance among the next generation of craftsmen. Classicism proved to be a consonant aspect of Russian architecture, which eagerly employed monumental sculpture for the enrichment of palace facades and churches. However, craftsmen in the chamber genres, such as the medalist Fyodor Tolstoi and the highly successful portrait artist Samuil Gal'berg, also worked in this style.

Among the monumental sculptors, special consideration must be given to Vasily Demut-Malinovsky, who was once a student of Antonio Canova's in Rome and a frequent collaborator with Stepan Pimenov. In 1807 Demut-Malinovsky and Pimenov created bronze statues of the Apostle Andrew and Prince Vladimir for the Kazan Cathedral in St. Petersburg. After that, from 1809 to 1811, Demut-Malinovsky completed the group *The Rape of Proserpina*, and Pimenov finished the group *Hercules and Antaeus* (both from local stone) for the ornamentation of the College of Mines building,

which was built according to Andrei Voronikhin's plans. Later, beginning in the 1820s, the two worked together with the architect Carlo Rossi. The most famous sculptural group created by Demut-Malinovsky and Pimenov is an image of the chariot of Fame carried by two waves. This group is made of stamped copper and stands above the arch of the general staff in St. Petersburg (1827–30).

At the same time, two talented and capable but uneducated craftsmen were developing into successful artists. Boris Orlovsky, a descendant of serfs, drew attention to himself with his exceptional abilities and was sent to Rome, where he was advised by Bertel Thorvaldsen. A series of his works done in the strict Classical style belong to this period (*Paris*; plaster, 1824; marble, 1838; both are in the State Russian Museum, St. Petersburg). Upon his return to St. Petersburg, Orlovsky completed significant monuments to the military commanders Mikhail Kutuzov and Barclay de Tolly (1832), both of which stand before the Kazan Cathedral.

Ivan Vitali, a descendant from an Italian family, also began his career as a simple journeyman. He created many monumental compositions for the decoration of buildings and churches in Moscow and St. Petersburg. Among these are the bronze reliefs *Adoration of the Magi* (1839–44) and the *Meeting of St. Isaac and Emperor Feodosy* (1842–45), both for the Isaakiyevsky Cathedral in St. Petersburg.

The work of Orlovsky and Vitali marks the final stage in the development of Classicism in Russian sculpture. The artists of the next generation, such as Nikolay Pimenov, Aleksandr Loganovsky, Nikolai Ramazanov, and Peter Stavasser, created only one or two successful works each, which followed established models and blazed no new trails. Among the artists of this generation, only Aleksandr Terebenev deserves special mention. He is the creator of the colossal and expressive *atlantes* (sculptured male figures serving as support) in granite that stand on the portico of the New Hermitage in St. Petersburg (1845–52).

Pyotr Klodt, although he was older than the sculptors mentioned earlier, turned to sculpture at a mature age and was connected to a lesser degree with the traditions of Classicism. He gained general recognition with his portrayal of the struggle between men and horses in four bronze groups for the Anichkov Bridge in St. Petersburg (1833–50). Still for the most part tied to Classical tradition, these groups revealed new possibilities in the sculptural portrayal of animals and exerted influence on later generations. After that, Klodt completed two monuments for St. Petersburg, one for the poet Ivan Krylov (1851–55; Letny Sad) and one for Czar Nikolai I (1856–59; Isaakievskaia Square).

These are also significant for their realistic treatment of animals.

Sculpture from Russia during the second half of the 19th century shows remarkable variation in orientation and genre, but, with the exception of Antokol'sky, not one successful artist came forth from this time period. Artists sought new themes for large statues and groups, and by turning their attention to nationalist thematics they achieved some success: Sergey Ivanov created the statue *Boy in the Bath* (1858; State Tretyakov Gallery, Moscow); Fyodor Kamensky sculpted the group *First Steps* (1872; State Russian Museum, St. Petersburg); and Matvey Chizhov sculpted the composition *Peasant in Misfortune* (1872; State Tretyakov Gallery, Moscow). However, these successes are unique in the work of all three sculptors.

The search for innovation in animal sculpture proved to be more original and culminated in the achievements of Klodt. Other important innovators were Nikolay Liberikh, Evgeny Lanser, and Artemy Ober, who was a significant and as yet unappreciated artist.

Sculptors of this time clearly lacked new ideas. It was probably no accident that the most important monumental commissions were given not to professional sculptors but to the painter and draftsman Mikhail Mikeshin. He authored the project for the monument *Millennium of Russia* (1859–62; Novgorod) and one to Catherine II (1863–73; Ostrovsky Square, St. Petersburg). These monuments are compositionally complicated and designed to require detailed scrutiny of each figure. The work was completed by professional sculptors, the most significant having been Chizhov, sculptor of the figure of Catherine II, and Aleksandr Opekushin. Opekushin subsequently became the sculptor of the majority of monumental works created in Russia's cities up to the beginning of World War I. His best original work is the famous monument of Alexander Pushkin, which was simply and tranquilly done in a realist style and is on Tverskoy Boulevard in Moscow (1870–80).

The most famous Russian sculptor of the second half of the 19th century was Mark Antokol'sky. Remaining in close contact with the Peredvizhnik painters, Antokol'sky began his career with two small wooden reliefs in the genre style—*The Jewish Tailor* (1864; State Russian Museum, St. Petersburg) and *The Jewish Miser* (1865; State Russian Museum, St. Petersburg). He later found his themes in stories taken from Russian and European history, as well as from sacred writings. These themes were treated with great attention to detail and tend toward naturalism, such as the statues *Ivan the Terrible* (1875; State Tretyakov Gallery, Moscow), *The Death of Socrates* (1875–78; State Russian Museum, St. Petersburg), *Mephistopheles*

(1883; State Russian Museum, St. Petersburg), and *Nestor the Chronicler* (1890; State Russian Museum, St. Petersburg). It must be emphasized that the sculptor created the majority of his mature works in Italy and France.

At the end of the 19th century there arose a typical conflict between the academic schools and new tendencies in art inspired by the work of Auguste Rodin. The Impressionist Pavel (Paolo) Troubetzkoy, sculptor of numerous elegant statuettes and small-scale groups in bronze, was very popular in Europe. In Russia he worked for a long period on a monument to Czar Aleksandr III (1902–09). This work is extraordinarily expressive in its emphatic monumentality. Anna Golubkina sculpted a series of successful portraits in an Impressionistic style. More varied is the work of Nikolay (Andreyevich) Andreyev, creator of the monument to Nikolai Gogol in Moscow (1906–09). A great sculptor of the early 20th century, Sergey Konenkov, created an entire series of works employing the tradition of peasant wood carving, such as *Starichok-Polevichok* (the old men in folklore who live in the fields, 1910; State Tretyakov Gallery, Moscow) and *The Poor* (1917; State Russian Museum, St. Petersburg). The most powerful sculptural images created in the early 20th century belong not to a professional sculptor but to a painter, Mikhail Vrubel', who used the effect of polychromatics on works such as *The Demon's Head* (1894; State Russian Museum, St. Petersburg) and *Tsar Berendei* (1899–1900; State Tretyakov Gallery, Moscow).

The majority of sculptors who began working in the early 20th century continued to work in Russia after the Russian Revolution of 1917. This time was marked by the vigorous development of the avant-garde, whose work was recognized by the new power for a brief period after the revolution. The work of the avant-garde includes the abstract compositions of Vladimir Tatlin, Naum Gabo, and Alexander Rodchenko. However, the new state gradually began to dictate conditions to artists, encouraging realism and denying commissions to nonconformists. This was especially true after the 1932 Party Resolution concerning the restructuring of literary and artistic organizations. Simultaneously, the doctrine of socialist realism was drawn up and quickly transformed into dogma. It will fall to future historians to investigate the evolution of the most talented artists as they adapted to the demands of the time. Thus the above-mentioned Andreyev created a series of professional but superficial portraits of Vladimir Lenin, portraits that laid the foundation for all future interpretations of the leader of the revolution. Sergey Merkurov, who began his career with expressionistic images (the monument to Fyodor Dostoyevsky in Moscow created from 1911 to 1913), created

official monuments to Lenin, among them one for the Moscow Canal in 1939. Vera Mukhina, who studied in Paris under Antoine Bourdelle and made her sculptural debut in the Constructivist spirit, created the classic sculpture of socialist realism, the group *Worker and Kolkhoznitsa* (Exhibition of the Achievements of the People's Agriculture, Moscow, 1935–37). Another classic of Soviet sculpture, Ivan Shadr (Ivanov), who created a landmark work—the composition *The Cobblestone Is the Weapon of the Proletariat* (1927; State Tretyakov Gallery, Moscow)—in the end never managed to realize his extraordinary creative potential. Only Andrey Matveyev, who did pay tribute to revolutionary themes (such as the 1927 work *October*, now in the State Russian Museum, St. Petersburg), was able to defend the independence of his work and created figures of nude women and children marked by high professional mastery, such as his *Female Figure* (1937; State Russian Museum, St. Petersburg).

SERGEI ANDROSSOV

See also **Antokol'sky, Mark Matveyevich; Falconet, Étienne-Maurice; Gabo, Naum; Golubkina, Anna; Klodt, Pyotr; Kozlovsky, Mikhail (Ivanovich); Matveyev, Aleksandr; Mukhina, Vera; Rastrelli, Bartolomeo Carlo; Rodchenko, Alexander; Shadr, Ivan; Shubin, Fedot; Tatlin, Vladimir; Troubetzkoy, Paolo; Vitali, Ivan**

Further Reading

Gosudarstvennyi Russkii Muzei (Russian State Museum), *Skul'ptura, XVIII—nachalo XX veka: Katalog* (Sculpture of the 18th–Early 20th Centuries: Catalog), Leningrad: Iskusstvo, 1988

Grabar', Igor', *Istoriia russkogo iskusstva* (The History of Russian Art), 6 vols., Moscow: Knebel, 1909–14; see especially vol. 5, *Istoriia skul'ptury* (The History of Sculpture)

Grabar', Igor', *Istoriia russkogo iskusstva* (The History of Russian Art), 13 vols., Moscow: Izd-vo Akademii Nauk SSSR, 1953–69

Kovalenskaia, Nataliia, *Istoriia russkogo iskusstva XVIII veka* (The History of Russian Art of the 18th Century), Moscow: Iskusstvo, 1940

Kovalenskaia, Nataliia, *Istoriia russkogo iskusstva pervoi poloviny XIX veka* (The History of Russian Art of the First Half of the 19th Century), Moscow: Iskusstvo, 1951

Petrukhin, V.Y., et al., "Russia," in *The Dictionary of Art*, edited by Jane Turner, New York: Grove, and London: Macmillan, 1996

Shmidt, Igor', *Russkaia skul'ptura vtoroi poloviny XIX–nachala XX veka* (Russian Sculpture from the Second Half of the 19th to the Beginning of the 20th Century), Moscow: Iskusstvo, 1989

GIOVANNI FRANCESCO RUSTICI
1474–1554 *Italian*

Giorgio Vasari remains the principal source for the activity of Rustici, whose family name is often given as Rustichi. The sculptor's grandfather was the goldsmith Marco di Bartolommeo Rustichi, celebrated for his account of a voyage to the Holy Land in 1447–48. Vasari, informed by his pupil Ruberto Lippi (son of the painter Filippino Lippi), states that Rustici trained with Andrea del Verrocchio, although it is more likely that the sculptor studied with Lorenzo di Credi, who managed Verrocchio's workshop after the latter's death in 1488. In 1500 Rustici took out a lease on the former workshop of Benedetto da Maiano.

Rustici's first dated work is a 1503 memorial to Giovanni Boccaccio consisting of a half-figure in marble of the famous 14th-century Tuscan poet set into a wall cenotaph in the Collegiate Church in Certaldo; the cowled figure is a competent but conventional work. Rustici must have already demonstrated his talent, since by the following year Pomponio Gaurico mentions him as among the most promising youths of his generation (together with Benedetto da Maiano, Michelangelo, and Andrea Sansovino). No other early works have been recognized, however, and with few exceptions the chronology of his oeuvre remains vague.

Rustici's style is difficult to define, since his career was erratic and he tried his hand at so much. His fame rests on a revolutionary group of three bronze figures contracted in December 1506 to replace older Gothic statues over the north door (completed by Lorenzo Ghiberti in 1424) of the Baptistery in Florence. The *St. John the Baptist Preaching* was installed and first exhibited on the Feast of the Baptist in 1511 and remains there to this day. The dramatic interaction of the figures, which are 2.6 meters tall, and their naturalistic, unclassical individuality are deeply impressive. The almost painterly effects of light and shade are not the only echo of Leonardo da Vinci, traditionally identified as his collaborator, and with whom Rustici shared a house and studio in 1507–08; the older artist no doubt advised him on the psychological moods underlying each of the three vigorous figures and the work as a whole and may have determined its general design. Vasari's description of the work is detailed and perceptive.

Shortly before August 1509, Rustici received a commission from the Florentine silk guild for a *Virgin and Child with the Infant St. John the Baptist*, which illustrates his reaction to works such as Michelangelo's *Taddei Tondo* but also echoes Donatello and Desiderio da Settignano in its intimate pairing of mother and child. In 1510 Rustici executed a bronze candlestick for the Baptistery (untraced). In 1512, according to Vasari (whose description of the sculptor's eccentricities and social life make engaging reading), he founded an artists' social club, the Compagnia della Cazzuola, and was a leading member of the Compagnia del Paiuolo. In

1515 Rustici was one of several artists to execute decorations for the entry of Pope Leo X into Florence, apparently earning a commission from the pope's kinsman Cardinal Giulio de' Medici (later Pope Clement VII) to complete the fountain that stood in the courtyard of the Palazzo Medici with a bronze *Mercury*. The water jet issuing from the mouth of this dynamic figure rotated an instrument held in its hand. Another work mentioned by Vasari as commissioned by Cardinal Giulio was a *David* planned as a replacement for Donatello's bronze *David* once the latter had been removed from the Palazzo Medici to the Piazza della Signoria in 1495; Caglioti has persuasively identified a 22-centimeter-high bronze in the Musée du Louvre, Paris, as the statuette cast in preparation for this larger unrealized work (see Caglioti, 1996).

The sculptor's fame was further established during the 1520s: Cesariano's commentary in the new edition of Vitruvius's *De Architectura* (1521) briefly alludes to the Baptistery statues, and in the same year an attempt was made (in vain, as earlier with Raphael) to secure Rustici's authorship for the tomb of Francesco Gonzaga, duke of Mantua (*d.* 1519). Vasari states that Rustici was also a painter, and a *Conversion of Saint Paul* described by him can be identified as the painting in the Victoria and Albert Museum, London. During this period, Rustici collaborated at least once with Giovanni Della Robbia, who colored and glazed his terracotta relief of the *Noli me tangere* with a *Saint Augustine* in the lunette, a commission for the Augustinian nuns of San Luca in the Via San Gallo (not Santa Lucia, as Vasari erroneously stated, although his correction in the errata of 1568 has almost always been ignored). The bright yellow against which the enameled white figures are set recalls an archaic gold background. In 1526 he was paid for a series of terracotta roundels with figures from Greek mythology set into the courtyard walls of Jacopo Salviati's suburban villa; they echo antique gems and the similar, mid 15th-century roundels of the Palazzo Medici. Further work in terracotta was Leonardesque in theme: privately commissioned groups of *Fighting Horsemen*, inspired by Leonardo's mural of the Battle of Anghiari, are tightly knit expressions of motion and fury.

In 1527 Medici rule was interrupted, and during this upheaval many artists fled north. With an introduction from Giovan Battista della Palla, Rustici went to France, joining other Italians at the court of King Francis I, who gave him the herculean task of casting a bronze equestrian monument, for which the sculptor received substantial payment in 1531–33 in Paris. The undertaking, which recalls Leonardo's earlier protracted attempt to create such a statue for the Duke of Milan, Ludovico Sforza, was likewise fraught with difficulty and remained incomplete at the king's

St. John the Baptist Preaching to or Flanked by a Levite and a Pharisee
The Conway Library, Courtauld Institute of Art

death in 1547. Documents for Rustici's activity in France are scarce, although a small group of works in bronze from this period have been recognized, including the so-called *Madonna of Fontainebleau*, an 86-centimeter-high relief probably cast from an older model and nostalgically emulating Donatello, and a two-meter-high statue of *Apollo Pythias*. Vasari states that the aged artist lost his position under King Henry II but was cared for by Piero Strozzi in Tours, where he died in 1554.

FRANK DABELL

See also **Benedetto da Maiano; Desiderio da Settignano; Donatello (Donato di Betto Bardi); Ghiberti, Lorenzo; Michelangelo (Buonarroti); Verrocchio, Andrea del**

Biography

Born in Florence, Italy, 13 November 1474. Grandfather was Marco di Bartolommeo, a goldsmith. Trained initially in Verrocchio's workshop; first dated work, 1503; closely associated with Leonardo da Vinci, who probably collaborated on celebrated bronze statuary group *St. John the Baptist Preaching*; prior to 1520s, received several civic and ecclesiastical commissions for works in marble and bronze; occasionally painted, and also explored the medium of terracotta, both plain and enameled; joined team of decorators for the official entry of Pope Leo X into Florence in 1515; commissioned by Cardinal Giulio de' Medici to create bronze *Mercury* for a fountain in the Palazzo Medici; after expulsion of the Medici from Florence in 1527, settled in France, *ca.* 1529, and was principally employed by King Francis I for an equestrian bronze mon-

ument, which was canceled before completion, by the new king, Henry II, 1547. Died in Tours, France, 1554.

Selected Works

1503 *Giovanni Boccaccio*; marble; Collegiate Church, Certaldo, Italy

1506–11 *St. John the Baptist Preaching to or Flanked by a Levite and a Pharisee*; bronze; Baptistery, Florence, Italy

ca. 1509 *Virgin and Child with the Infant St. John the Baptist*; marble; Museo Nazionale del Bargello, Florence, Italy

ca. 1515 *Mercury*; bronze; Fitzwilliam Museum, Cambridge, England

ca. 1520–25 *Noli me tangere* (with Giovanni della Robbia); glazed terracotta; Museo Nazionale del Bargello, Florence, Italy

1526 Series of mythological tondo reliefs; terracotta; Villa Salviati, Ponte alla Badia, near Florence, Italy

ca. 1530 *Madonna of Fontainebleau*; bronze; Musée du Louvre, Paris, France

Further Reading

Avery, Charles, "Rustici, Giovanni Francesco," in *The Dictionary of Art*, edited by Jane Turner, New York: Grove, and London: Macmillan, 1996

Barocchi, Paola, editor, *Il giardino di San Marco: Maestri e compagni del giovane Michelangelo* (exhib. cat.), Florence: Silvana, 1992

"The Boscawen Collection at the Fitzwilliam Museum, Cambridge," *The Burlington Magazine* 139 (supplement) (December 1997)

Caglioti, Francesco, "Il perduto 'David mediceo' di Giovanfrancesco Rustici e il 'David' Pulszky del Louvre," *Prospettiva* nos. 83–84 (1996)

Cox-Rearick, Janet, *The Collection of Francis I: Royal Treasures*, Antwerp, Belgium: Fonds Mercator Paribas, 1995; New York: Abrams, 1996

Karwacka Codini, Ewa, and Milletta Sbrilli, editors, *Archivio Salviai: Documenti sui beni immobiliari dei Salviati* (exhib. cat.), Pisa: Scuola Normale Superiore, 1987

Pope-Hennessy, John, *An Introduction to Italian Sculpture*, 3 vols., London: Phaidon, 1963; 4th edition, 1996; see especially vol. 3, *Italian High Renaissance and Baroque Sculpture*

Valentiner, William R., "Rustici in France," in *Studies in the History of Art: Dedicated to William E. Suida on His Eightieth Birthday*, London: Phaidon, 1959

Vasari, Giorgio, *Le vite de più eccellenti architetti, pittori, e scultori italiani*, 3 vols., Florence: Torrentino, 1550; 2nd edition, Florence: Apresso i Giunti, 1568; as *Lives of the Painters, Sculptors, and Architects*, 2 vols., translated by Gaston du C. de Vere (1912), edited by David Ekserdjian, New York: Knopf, and London: Campbell, 1996

Waldman, Louis A., "The Date of Rustici's 'Madonna' Relief for the Florentine Silk Guild," *The Burlington Magazine* 139 (December 1997)

JOHN MICHAEL RYSBRACK 1694–1770
Flemish, active in England

The flow of foreign sculptors into England in the 1700s revitalized the national art world, bringing the country to the same artistic level as the rest of Europe. At the beginning of the 18th century in England, at a time in which new political stability and the growth of economic well-being contributed to the rise of a cultivated and refined dominant class, these foreign artists were popular with the public and critically acclaimed because of the quality of their technique and the up-to-date stylistic standards of their work. Together with his younger colleagues Louis-François Roubiliac and Peter Scheemakers, John Michael Rysbrack became one of the most important sculptors in the English art world because of his style, which conspicuously included both the figurative culture of the late Baroque and direct citations from and references to Classical art.

The son of the painter Pieter Rysbrack, Michael was born in Antwerp, Belgium, in 1694 and completed his apprenticeship with Michiel van der Voort I, one of Antwerp's most famous sculptors, whose work imitated the stylistic tradition of his famous countryman François du Quesnoy. Rysbrack and his brother Pieter Andreas, a painter, moved in 1720 to London, where Michael, thanks to a letter of presentation, established an immediate and fruitful friendship with the architect James Gibbs. Their first collaboration was a monument to the poet Matthew Prior in London's Westminster Abbey. The monument was designed by Gibbs to give a definitive arrangement to the bust of Prior brilliantly sculpted by the French sculptor Antoine Coysevox about 1700. Rysbrack's contribution betrayed a strong connection to Flemish sculpture, which can be seen in the two du Quesnoy–influenced putti lying down above the tympanum. Yet the two Muses positioned on the sides of the small sarcophagus, Clio and Euterpe, are elegantly opposed and are animated by the rich draperies of their robes, which owe most of their vitality to the sculptor's chisel rather than to the architect's design. The two artists continued to collaborate successfully on other monuments in Westminster Abbey, and their last work was the monument to the philanthropist Sir Edward Colston in All Saints Church in Bristol.

While working with Gibbs, Rysbrack also took part in an important decorative undertaking directed by the painter and architect William Kent at Kensington Palace. The relief he sculpted for the Cupola Room, *A Roman Marriage*, was inspired by a work of the same name in the Palazzo Sacchetti in Rome, which Rysbrack saw in an engraving by Pietro Santi Bartoli published in Giovan Pietro Bellori's volume *Admiranda*

Antiquitatum Romanarum (1693). Its lines slightly softened in comparison to the original, Rysbrack's composition reflects his deep understanding of Classical sculpture, an understanding that seems even more extraordinary considering that Rysbrack never visited Rome and therefore gained his knowledge of Classical art through copies and prints. Sculptural reliefs of Classical subjects became a characteristic element of Neo-Palladian interior design, of which Kent and Rysbrack were the two most notable interpreters, as can be seen in the Stone Hall in Norfolk, probably the finest example of this genre.

In the 1730s Rysbrack's fame reached its apex; the technical superiority of his work was universally recognized, and his career achieved the final consecration thanks to some prestigious official commissions. In fact, Rysbrack sculpted the famous monument to Sir Isaac Newton and monument to John Churchill, First Duke of Marlborough, both based on Kent's designs. The figure of Marlborough, dressed in the Roman style in armor, a laurel wreath, and a commander's baton, stands out on a high pedestal that towers over the gray-veined marble sarcophagus on which representations of History and Fame rest. Flanked by his wife and two children, the duke forms the fulcrum of a composition that is complex and perhaps a bit overcrowded; nevertheless, its unity is guaranteed by the large dark marble pyramid that forms the background. Inspired by papal tombs in Rome realized by artists such as Pierre Legros and Camillo Rusconi, the monument to Marlborough is one of the most splendid and flamboyant sculptures of the Late English Baroque.

Despite his success in the 1730s, by the beginning of the 1740s Rysbrack's popularity was somewhat undermined by the works of two younger sculptors. In 1740, Peter Scheemakers achieved enormous success and his name quickly became famous throughout England with his monument to William Shakespeare in Westminster Abbey, and in 1745 the commission for the monument to the duke of Argyll in Westminster Abbey went to Roubiliac, whose design was preferred to that by Rysbrack. Notwithstanding these vicissitudes, the quality of Rysbrack's work remained very high, as can be seen in the small terracotta sculptures he produced during this period. In the *Hercules* at Stourhead, Rysbrack returned to Classical statuary, liberally inspired by the Farnese *Hercules* in the Museo Nazionale in Naples. In the three small statues representing his compatriots Peter Paul Rubens, Sir Anthony Van Dyck, and François du Quesnoy (1743), Rysbrack, almost rivaling Scheemakers's Shakespeare, modeled the terracotta with a vibrant and elegant touch, creating works that were actually closer to Rococo.

In these years Rysbrack continued to experiment and create new compositional solutions. In his monu-

ment to the second and third dukes of Beaufort, he brilliantly resolved the problem of how to arrange two figures by placing one in a standing position while the other reclines. For Rysbrack this was an innovative choice that attests that he "may by now have paid attention to Roubiliac's exploitation of asymmetrical designs, and here be trying his hand at a new fashion" (see Whinney, 1988).

One of the most significant aspects of Rysbrack's work was his conspicuous production of portrait busts, the success of which can be measured by the fact that in 1732 Rysbrack had already sculpted more than 60 examples (see Vertue, 1930–55). This vast catalogue contemplates all of the various possibilities of fashionable iconography in Georgian England: one finds, among others, the Roman-style portrait bust of Daniel Finch, second earl of Nottingham, a work that serves as a point of reference for all subsequent Classical portraiture, but also the portrait bust *en negligé* of James Gibbs, which depicts the architect in an informal pose wearing everyday clothes. Rysbrack also knew how to confront his choice of subjects, both his contemporaries as well as those taken from history, with equal mastery and an immutable capacity for psychological penetration as is evident in the series of busts in the garden of the Temple of British Worthies in Stowe, where Queen Elizabeth I coexists with King William III and John Milton.

CRISTIANO GIOMETTI

See also **Coysevox, Antoine; du Quesnoy, François; Roubiliac, Louis-François; Rusconi, Camillo; Voort, Michiel van der, the Elder**

Biography

Born in Antwerp, Belgium, before 27 June 1694. Son of landscape painter Pieter Rysbrack. Apprenticed in workshop of Michael van der Voort, 1706–12; became member of Guild of St. Luke in Antwerp, 1714; moved to London with brother Pieter Andreas, landscape painter, 1720; throughout long career, collaborated with important architects such as James Gibbs and William Kent; clients included such dignitaries as Lord Burlington and Queen Caroline. After success of works such as the monuments to Sir Issac Newton and the Duke of Marlborough, popularity ebbed owing to growing success of Peter Scheemakers and Louis-François Roubiliac. Died in London, England, 8 January 1770.

Selected Works

1723 Monument to Matthew Prior; marble; Westminster Abbey, London, England

1723	*A Roman Marriage*; marble; Cupola Room, Kensington Palace, London, England
ca. 1723	Bust of Daniel Finch, second earl of Nottingham; marble; Victoria and Albert Museum, London, England
ca. 1723–29	Monument to Edward Colston; marble; All Saints Church, Bristol, England
1726	Bust of James Gibbs; marble; Victoria and Albert Museum, London, England
1726–30	Overdoors and chimneypieces; marble; Stone Hall, Houghton Hall, Norfolk, England
1730	Bust of Alexander Pope; marble; National Portrait Gallery, London, England
1731	Monument to Sir Isaac Newton; marble; Westminster Abbey, London, England
1732	Busts of Queen Elizabeth, Francis Bacon, William Shakespeare, King William III, John Locke, Isaac Newton, and John Milton; stone; Temple of British Worthies, Stowe House, Buckinghamshire, England
1733	Monument to John Churchill, first duke of Marlborough; marble; Blenheim Palace, Oxfordshire, England
1733–36	Equestrian statue of William III; bronze; Queen Square, Bristol, England
1743	Bust of Sir Anthony van Dyck; terracotta; The City of Bristol Museum and Art Gallery, Bristol, England; marble version: 1747, Hagley Hall, Hereford and Worchester, England
1744	*Hercules*; terracotta; The National Trust, Stourhead, Wiltshire, England; marble version: 1756, Noble Temple, Stourhead, Wiltshire, England
1754–55	Monument to Henry Somerset and William Somerset, Second and Third Dukes of Beaufort (completed posthumously; installed 1785); marble; Church of St. Michael, Great Badminton, Avon, England

Further Reading

Craske, Matthew, *Art in Europe, 1700–1830*, Oxford and New York: Oxford University Press, 1997

Esdaile, Katharine, and Ada McDowall, *The Art of John Michael Rysbrack in Terracotta*, London: Spink, 1932

Eustace, Katharine, *Michael Rysbrack, Sculptor, 1694–1770* (exhib. cat.), Bristol, Avon: City of Bristol Museum and Art Gallery, 1982

Gunnis, Rupert, *Dictionary of British Sculptors, 1660–1851*, London: Odhams Press, 1953; Cambridge, Massachusetts: Harvard University Press, 1954; revised edition, London: Abbey Library, 1968

Physick, John Frederick, *Designs for English Sculpture, 1680–1860*, London: HMSO, 1969

Snodin, Michael, *Rococo: Art and Design in Hogarth's England* (exhib. cat.), London: Trefoil Books, 1984

Vertue, George, *Vertue Note Books*, 7 vols., Oxford: University Press, 1930–55

Webb, Marjorie Isabel, *Michael Rysbrack: Sculptor*, London: Country Life, 1954

Whinney, Margaret, *Sculpture in Britain, 1530–1830*, London and Baltimore, Maryland: Penguin, 1964; 2nd edition, revised by John Physick, London and New York: Penguin, 1988

Whinney, Margaret, *English Sculpture, 1720–1830*, London: HMSO, 1971

MONUMENT TO SIR ISAAC NEWTON
John Michael Rysbrack (1694–1770)
1731
marble
Westminster Abbey, London, England

In 1642, the same year that Galileo Galilei died, Isaac Newton was born in Woolsthorpe (Lincolnshire). The vastness of his research, which ranged from mathematics to optics, and the exceptionality of his discoveries that culminated in the theory of universal gravity made Newton one of the most celebrated and famous men of his time. An honorary member of the Royal Society and the director of the Mint with the task of renovating the English monetary system, Newton "had almost the equivalent popularity of the modern film star" (see Webb, 1954). While he was still alive, his portrait was painted numerous times by illustrious painters such as Sir Peter Lely and Sir Godfrey Kneller. But the true "apotheosis of Newton in art" (see Haskell, 1987) occurred in the years immediately succeeding his death in 1727. His image, painted or sculpted, began spreading throughout the nation, and there was not an artistic enterprise of a certain level that did not plan or provide for the presence of Newton's image. In 1730, for example, Lord Cobham, in commissioning William Kent and Michael Rysbrack for the garden of his Temple of British Worthies in Stowe, wanted to reserve a niche for Newton in his gallery of Whig heroes. Queen Caroline also had Rysbrack sculpt a bust of Newton (1733; Kensington Palace, London) for her small pantheon dedicated to scientists and philosophers in the grotto of the garden in Richmond.

Despite all of these celebrated initiatives, that which was destined to achieve the most lasting resonance was Rysbrack's monument to Sir Isaac Newton in Westminster Abbey. Before analyzing the work, it is necessary to underline the importance and the symbolic value of its location in Westminster Abbey. In fact, the nave of the abbey opened its doors to notable personalities in 1727 with the monument to Secretary of State James Craggs designed by James Gibbs and

Terracotta Sketch (1730) for Monument to Sir Isaac Newton
(Westminster Abbey)
© Victoria and Albert Museum, London / Art Resource, NY

sculpted by Giovan Battista Guelfi, thus becoming the place for the exaltation of England's most illustrious sons' moral values and independence of thought. Placed against the external walls of the choir, the space that divided the public part of the church from the part reserved for royalty, Newton's memorial was the first that "elevated the notion of intellect as a power comparable to that of military commanders, kings, and princes, transforming the nave . . . into a place of national celebration in its own right" (see Bindman, 1995).

The monument was commissioned the day after Newton's death by John Conduitt, Newton's close friend as well as his successor as director of the Mint. Conduitt, who played an important part in the creation of the work's iconography, commissioned the memorial's design to Kent and its execution to the skilled hand of Rysbrack. Kent's design and Rysbrack's terracotta model of the reclining figure of Newton are conserved at the Victoria and Albert Museum in London, whereas a second design by Rysbrack that is much more similar to the finished work is at the British Museum. Wrapped in a tunic in the Classical manner, Newton reclines on an elegant sarcophagus; he is resting his right arm on a pile of books while with his left hand he seems to point at a scroll, supported by two chubby putti, that bears an engraved diagram of the solar system. These figures are framed by the background pyramid, a symbol of immortality, at the center of which a half-relief globe stands out. The globe displays the major constellations as well as the trail of the 1681 comet that Newton discovered. Above the globe, with her gaze directed at Newton, is the figure of *Weeping Astronomy*, represented as the Queen of

the Sciences by the scepter in her right hand. At the apex of the pyramid, the composition is completed by a star that today is covered by a Neo-Gothic pediment added in the 19th century by Edward Blore.

The references to Newton's numerous discoveries are copiously depicted in the graceful bas-relief on the front of the sarcophagus. A note published in the 22 April 1731 edition of *Gentleman's Magazine* describes the relief with an abundance of details:

> On a Pedestal is placed a Sarcophagus . . . upon the front of which are Boys in Basso-rilievo with instruments in their hands, . . . one with a Prism on which principally his admirable Book of Light and Colours is founded; another with a reflecting Telescope . . .; another Boy is weighting the Sun and Planets with a Stilliard, the Sun being near the Centre on one side, and the Planets on the other, alluding to a celebrated Proposition in his Principia; another is busy about a Furnace, and two others (near him) are loaded with money as newly coined, intimating his Office in the Mint. (Haskell, 1987)

Characterized by a Classical orderliness, yet permeated with a certain typically late Baroque elegance, the monument has always been considered one of the Abbey's most successful tombs of the modern age and has had, from the moment of its inauguration, unprecedented success. George Vertue, one of the most acute commentators of the London art scene in the first half of the 18th century, described the monument in April 1731 as "a noble and Elegant work by Mr. Michael Rysbrack," underlining that the magnificence of the work was principally due to the ability of the sculptor, rather than to Kent's weak design. In fact, according to Vertue, "the design or drawing of it on paper was poor enough, yet for that only Mr. Kent is honored with his name on it (Pictor and Architect inventor), which if it had been delivered to any other Sculptor besides Rysbrack, he might have been glad to have his name omitted."

A version of the same composition with a reclining figure, but with some variations in the clothing and background, was also utilized by Kent and Rysbrack in the monument to the first earl of Stanhope (1733), which is next to Newton's monument on the other side of the choir entrance.

CRISTIANO GIOMETTI

Further Reading

Bindman, David, "Public Space and Public Sphere: From Parish Church to Westminster Abbey," in *Roubiliac and the Eighteenth-Century Monument*, by Bindman and Malcolm Baker, New Haven, Connecticut: Yale University Press, 1995

Haskell, Francis, "The Apotheosis of Newton in Art," in *Past and Present in Art and Taste*, by Haskell, New Haven, Connecticut: Yale University Press, 1987

Webb, Marjorie Isabel, *Michael Rysbrack: Sculptor*, London: Country Life, 1954

S

SACRED MOUNTS

Sacred mounts are mountainous locations conceived and constructed purposely as pilgrimage sites and considered sacred by the Roman Catholic Church. The sacred mount, studded with chapels and created in a preexisting geographic setting, is usually reached by a footpath leading up from a village. As the pilgrims make their way slowly upward, they are more and more immersed in nature and in the inner silence necessary to approach God. The mountainous setting was no casual choice, because it calls to mind places described in the Old Testament, from Mount Ararat, where Noah was saved from the Flood, to Mount Bethel above Jerusalem, and from Mount Carmel to Mount Sinai. Moreover, mountainous settings appear in the New Testament—suffice it to mention the Crucifixion on Golgotha—and in the stories of many Catholic saints and hermits; St. Francis, for instance, retired to Mount Verna in Tuscany, where he received the stigmata.

Perched on their mountaintops, these small citadels of faith were conceived for teaching purposes, initially as symbolic reconstructions of places in the Holy Land that could no longer be visited because of the Turkish invasion, and later, after the Council of Trent, as responses to Protestantism. Indeed, it was during the Reformation that the Church conceived this particular iconographic formula, which could be easily understood by the masses. Calling on architects, sculptors, and craftsmen, the Church commissioned numerous pilgrimage sites intended to constitute a true *Biblia pauperum*, a Bible for the poor. Pilgrims were supposed to proceed along an easily understandable itinerary marked by numerous stations, like a true *Via Crucis*. They were supposed to stop, kneel, and pray at each chapel along the path. Each chapel contains sculpture describing an episode that any believer can recognize easily. Each sacred mount has a nature of its own—it may be dedicated to the Virgin Mary, Jesus Christ, or a particular saint (such as St. Francis at Orta or St. Charles at Arona). The chapel statues representing the various personages are usually in polychromed terracotta. As a rule, they are life-size and designed to be admired in all their expressiveness from a kneeling position. Each sacred mount contains a wealth of artwork. For instance, the one at Orta, overlooking the lake of that name, has as many as 20 chapels, 900 frescoes, and 376 statues.

To offer multiple viewpoints, the chapels usually have several windows. Pilgrims can walk around each chapel to discover new details and experience different emotions. Although many pilgrimages took place at night, the architects who designed the chapels were always very attentive to natural lighting. The daylight entering from the windows and skylights was calculated to give the sculptures the maximum theatrical effect.

Sacred mounts are spread throughout Europe; there are 20 in Italy, 7 in Portugal, 10 in Spain, 19 in Poland, and 2 in France. The Italian sacred mounts are concentrated in the foothills of the Alps in Piedmont and Lombardy. This singular concentration did not occur by chance; during the Counter Reformation, the Church tried to combat Protestant ideas where they might enter Italy most easily. Accordingly, the foothills of the Alps were studded with soaring citadels of faith intended to encourage devotion to Catholicism. Pilgrimages to

Gaudenzio Ferrari, *Calvary, ca.* 1518–20; Varallo, Italy
© Alinari / Art Resource, NY

these sites increased enormously, thanks in part to accounts of miraculous events said to have occurred there.

The history of sacred mounts in Italy began in 1491 with the completion of the first chapel of the "New Jerusalem" at Varallo (now in the province of Vercelli, but then part of the dukedom of Milan). Varallo stands out from the other sacred mounts because of the presence of works by artists such as Gaudenzio Ferrari and the painter Tanzio da Varallo. The other examples are later, having been conceived and built between the end of the 16th century and the beginning of the 17th century; the one in Varese, for instance, dates from the first quarter of the 17th century.

The proliferation of sites led to the formation of groups of specialized craftsmen. The same architects and decorators often worked at different sacred mounts. Moreover, there were striking similarities in the theological programs because they were nearly always drawn up by the cousins Carlo and Federico Borromeo, figures of fundamental importance in the Milan diocese. The patrons, however, were almost always the ecclesiastic orders. The Franciscans were among the most active, perhaps because St. Francis was the person who created the first crèche, or Nativity scene. The idea of the Christmas manger—that is, the representation of a sacred event by means of wooden or terracotta statues—is exactly the same idea that underlies the sacred mounts, although in the latter case the stories are complex and comprise numerous episodes in stages.

Many of the chapels were built with donations from aristocratic families. The sculptors who worked on them insisted that the sculptures be easy to read and true to life. In addition, they nearly always transposed the personages from the Scriptures to their own envi-

ronment, so that the Virgin Mary, apostles, and saints were dressed according to the fashion in 17th-century Lombardy. Following the same "psychological" principle, the good characters were depicted according to the canons of Classical beauty—handsome, well proportioned, blond if possible, and with rosy complexions—and clearly the opposite of the bad characters, who were ugly, sometimes even deformed, and with facial features often contorted by a smirk. In every way, the expressive statues of the sacred mounts thus belong to popular art.

Among the artists who worked in northern Italy were Francesco Silva from the Ticino, who was active at the sacred mount of Varese; his son Agostino Silva, who distinguished himself at Ossuccio like the earlier Ferrari; and the Fleming Jean de Wespin, known as Tabachetti, who worked first at Crea and then at Varallo. Curiously, besides the names of professional sculptors, there appears that of a Franciscan friar, Father Latini, who worked at Crea in the mid 19th century, duplicating in his own way many of the Tabachetti statues that the Jacobin wrath had destroyed in 1801.

GIOVANNA CHECCHI

Further Reading

Barbero, Amilcare, and Carlenrica Spantigati, editors, *Sacro monte di Crea*, Alessandria, Italy: Cassa di Risparmio di Alessandria Spa, 1998

Bianconi, Piero, et al., *Il sacro monte sopra Varese*, Milan: Electa, 1981; 2nd edition, 1985

Colombo, Silvano, *Conoscere il sacromonte*, Varese, Italy: Edizioni Lativa, 1982

Papavassiliou Gatta, Piera, *Il sacro monte di Ossuccio: Guida alle cappelle*, Milan: Mondadori, 1996

Pradillo y Esteban, Pedro José, *Via Crucis, calvarios y sacromontes: Arte y religiosidad popular en la Contrareforma*, Guadalajara, Spain: Diputación Provincial de Guadalajara, 1996

Viotto, Paola, *Sacro monte di Varese*, Varese, Italy: Macchione, 1997

Zanzi, Luigi, *Sacri monti e dintorni: Studi sulla cultura religiosa ed artistica della Controriforma*, Milan: Jaca Book, 1990

AUGUSTUS SAINT-GAUDENS 1848–1907
Irish, active in United States

Augustus Saint-Gaudens, the United States' foremost sculptor at the turn of the 20th century, was born in Dublin, Ireland. His father, a French-born shoemaker, immigrated with his Irish wife and infant son to the United States, where he established a successful shoemaking business in New York City. Between the ages of 12 and 17, Saint-Gaudens worked as a cameo cutter's apprentice, beginning at an early age his mastery of bas-relief. He spent evenings attending drawing

classes at The Cooper Union for the Advancement of Science and Art. In 1866 he enrolled at the National Academy of Design, where he studied under several instructors, including sculptor John Quincy Adams Ward.

Saint-Gaudens traveled to Paris to see the Exposition Universelle of 1867 and studied at the Petite École. In 1868 he became the first American to enter the atelier of François Jouffroy at the École des Beaux-Arts. There Saint-Gaudens immersed himself in academic training and came under the influence of contemporary French sculptors such as Paul Dubois.

The outbreak of the Franco-Prussian War in 1870 forced Saint-Gaudens to abandon Paris for Rome, where he established himself as an independent sculptor. He made bust portraits and copies of Roman busts for wealthy Americans vacationing in Italy. His first large-scale work, *Hiawatha*, was begun during his stay in Rome.

Saint-Gaudens returned to New York in 1872, where he modeled a portrait of statesman William M. Evarts, met architect Henry Hobson Richardson, and won his first major commission, *Silence*, for New York's Masonic Temple. Saint-Gaudens returned to Italy in 1873. Former New York governor Edwin Morgan, visiting Saint-Gaudens's studio in Rome, commissioned a marble version of *Hiawatha*. It was at this time that Saint-Gaudens met Augusta Homer, a Boston artist studying in Rome.

Returning to New York for the second time in 1875, Saint-Gaudens met architects Stanford White and Charles McKim and artist John La Farge. Under La Farge's direction, Saint-Gaudens participated in the decorating of Trinity Church in Boston (1876–77), designed by H.H. Richardson. Through La Farge, Saint-Gaudens produced reredos for St. Thomas's Church in New York City. In 1876 he obtained the Farragut monument commission from Ward, who turned it down in favor of his younger colleague.

When his work was rejected by the National Academy of Design in 1877, Saint-Gaudens became a founding member of the Society of American Artists, an organization that successfully promoted the work of younger artists. He married Augusta Homer in Boston that year, and they traveled to Europe, where in Paris he produced his first bas-relief portraits of fellow artists and friends. In Paris he worked on the Farragut monument, which was unveiled in New York's Madison Square in 1881. It was Saint-Gaudens's first major success and signaled a departure from Neoclassicism in American sculpture. The innovative pedestal bench included elements of Art Nouveau.

Between 1881 and 1883, Saint-Gaudens produced decorative works for New York City mansions built by Cornelius Vanderbilt II and Henry Villard. The idealized female figures Saint-Gaudens produced during this period formed the genesis for his later allegorical figures. Commissions for *Abraham Lincoln: The Man* (*Standing Lincoln*) and *The Puritan*, a tribute to Deacon Samuel Chapin, solidified Saint-Gaudens's position as one of the United States' leading sculptors.

In 1891 Saint-Gaudens purchased property in Cornish, New Hampshire. His home and studio there became the center of the Cornish colony, which included artists, musicians, writers, and architects. It is today the Saint-Gaudens National Historic Site.

Saint-Gaudens's *Diana* was installed atop the Stanford White–designed Madison Square Garden in 1891. Along with his *Amor Caritas, Diana* remains one of his most popular female figures. Another important work unveiled at this time was his hooded figure for the Adams memorial, a memorial to Henry Adams's wife.

As adviser on sculpture for the Chicago World's Fair of 1893, Saint-Gaudens's efforts led to the formation of the National Sculpture Society. The 1890s saw the unveiling of two public monuments dedicated to Civil War heroes, the General Logan monument for Grant Park in Chicago and the Shaw memorial for Beacon Street, Boston.

Saint-Gaudens moved to Paris in 1897 to complete another Civil War tribute, the Sherman monument. The equestrian statue of General William Tecumseh Sherman was unveiled in New York in 1903. In Paris until 1900, the sculptor won honors at the Paris Salon and the World's Fair of 1900. It was at this time that he became ill with cancer.

Saint-Gaudens spent his last seven years at Cornish, where he oversaw a number of commissions, including the Parnell monument for Dublin and a second Lincoln statue for Chicago, *Abraham Lincoln: Head of State*. His last major commission was done at the request of President Theodore Roosevelt for the U.S. government, the redesign of the ten- and twenty-dollar circulating gold pieces.

Known as a perfectionist, Saint-Gaudens often made a number of sketches on paper, or in clay or plaster, before arriving at a solution to compositional problems. Preliminary work on the Brooks monument (1896–1907) included more than 30 sketches that trace the evolution of an angel in the background to that of a figure of Christ. Saint-Gaudens took several years to make about 40 busts of African American soldiers in preparation for the Shaw memorial. For the eagle destined for Saint-Gaudens's gold coinage, 70 plaster sketches were used to arrive at the final design. He preferred working from life, even for allegorical figures, and for his *Standing Lincoln* he used life casts of the president's head and hands. For *the Victory* figure of the Sherman monument, Saint-Gaudens spent

stands is virtually what I indicated" (see Saint-Gaudens, 1913).

Years later, Saint-Gaudens attempted to explain why it took him so long to complete the work:

> In justice to myself I must say here that from the low-relief I proposed making when I undertook the Shaw commission, a relief that reasonably could be finished for the limited sum at the command of the committee, I, through my extreme interest in it and its opportunity, increased the conception until the rider grew almost to a statue in the round and the Negroes assumed far more importance than I had originally intended. Hence the monument, developing in this way infinitely beyond what could be paid for, became a labor of love, and lessened my hesitation in setting it aside at times to make way for more lucrative commissions, commissions that would reimburse me for the pleasure and time I was devoting to this. (*Reminiscences*, vol. 1)

The evolution of the Shaw memorial illustrates how Saint-Gaudens, when emotionally drawn to a subject, worked painstakingly toward a perfect composition. Inspired by Ernest Meissonier's *1814, the Campaign of France* (1864), which depicts Napoléon and his officers on horseback followed by rolls of infantry, Saint-Gaudens modified his original low-relief equestrian design to include the soldiers of the 54th Regiment. Determined to conform to reality, he recruited African American models from the street in order to portray a wide range of facial features and age types. Of the nearly 40 plaster busts he made over several years, he incorporated 16 into the final work.

The unveiling of the Shaw memorial took place on 31 May 1897; speeches by William James, who had two brothers serve as junior officers under Shaw, and Booker T. Washington, the famous African American educator, dedicated the memorial. Survivors of the Massachusetts 54th Regiment played a prominent role in the celebration.

For the soldiers, Saint-Gaudens modeled about 40 heads in plaster. These small busts are imbued with the sculptor's trademark realism, in stark contrast to the manner in which African Americans were routinely depicted—too often as caricatures—in the latter part of the 1800s. Shaw's mother summoned Saint-Gaudens to her Beacon Street home, where she told the sculptor, "You have immortalized my native city; you have immortalized my dear son; you have immortalized yourself."

Even at the unveiling, Saint-Gaudens considered the memorial opposite the Boston State House an "imperfect original" and continued to work on the plaster model after moving to Paris in 1897. The still-unfinished plaster was exhibited at the Paris Salons of 1898 and 1900, where it received much praise. By 1901, and after 18 years of labor, Saint-Gaudens was satisfied with the revisions—principally the changed angle of the angel's head—and exhibited the plaster at the Pan American Exposition in Buffalo, New York. The patinated plaster version of the Shaw memorial was moved from the Albright-Knox Art Gallery in Buffalo to Cornish, New Hampshire, in 1949. The revised Shaw memorial was exhibited outdoors at what was to become the Saint-Gaudens National Historic Site in Cornish from 1959 until 1993. Damaged by the elements, the plaster underwent extensive restoration in the mid 1990s. It was used to cast in bronze Saint-Gaudens's final version of the memorial, which was unveiled at the Saint-Gaudens National Historic Site on 13 July 1997, 100 years after the unveiling of the Boston version. The restored plaster model has been on loan to the National Gallery of Art in Washington, D.C., since 1997.

Colonel Shaw and his mount, placed in the center, are projected outward from the background to the extent that they are almost entirely freestanding. On either side of Shaw march his soldiers in high relief, led by their drummer boy. An ethereal angel of death, with flowing drapery, hovers over the doomed men. The mix of allegory and realism, along with the varying levels of relief and sculpture in the round, comes together in Saint-Gaudens's vision to form a moving tribute to the courage of men and the struggles of a race.

WILLIAM HAGANS

Further Reading

Burchard, Peter, *One Gallant Rush: Robert Gould Shaw and His Brave Black Regiment*, New York: St. Martin's Press, 1965

Cox, Clinton, *Undying Glory: The Story of the Massachusetts 54th Regiment*, New York: Scholastic, 1991

Kirstein, Lincoln, *Lay This Laurel: An Album on the Saint-Gaudens Memorial on Boston Common, Honoring Black and White Men Together, Who Served the Union Cause with Robert Gould Shaw and Died with Him July 18, 1863*, New York: Eakins Press, 1973

Saint-Gaudens, Augustus, *The Reminiscences of Augustus Saint-Gaudens*, edited by Homer Saint-Gaudens, 2 vols., New York: Century, and London: Melrose, 1913; reprint, New York: Garland, 1976

Saint-Gaudens, Augustus, *Augustus Saint-Gaudens, 1848–1907: A Master of American Sculpture*, Toulouse, France: Musée des Augustins, and Paris: Somogy, 1999

The Shaw Memorial: A Celebration of an American Masterpiece, Conshohocken, Pennsylvania: Eastern National, and Cornish, New Hampshire: Saint-Gaudens National Historic Site, 1977

Shaw, Robert Gould, *Blue-Eyed Child of Fortune: The Civil War Letters of Colonel Robert Gould Shaw*, edited by Russell Duncan, Athens: University of Georgia Press, 1992

NIKI DE SAINT PHALLE 1930–2002
French

Niki de Saint Phalle was born in France but spent most of her early life in the United States. During her nascent career, she worked as an actress and model, appearing on the cover of various magazines by the age of 18. Soon after, she married Harry Mathews, with whom she had two children. The restrictions this lifestyle placed on her led to feelings of frustration that culminated in a nervous breakdown in 1953. During her recuperation, she took up oil painting, previously only a hobby; her first solo exhibition was held in 1956 at the Galerie Restaurant Gotthard in St. Gall, Switzerland, titled *Niki Mathews New York, Gemälde, Gouachen.*

After meeting the Swiss sculptor Jean Tinguely in 1955, Saint Phalle began making assemblages and working with the Nouveaux Réalistes. In 1961 she created a "target" painting, *Saint Sébastien* or *Portrait of My Lover*, which was shown at the Musée d'Art Moderne de la Ville de Paris in the group exhibition entitled *Comparaison: Peinture Sculpture.* This was a pivotal work, in which the head was represented by a dart board at which members of the public were invited to throw darts. From these, Saint Phalle developed her "shooting paintings" or *tirs*, which were assemblages of found objects and bladders of paint, covered with white plaster. When shot at, the paint would explode, drip down, and color the relief. The first shooting paintings were created on 12 February 1961 in a vacant lot behind the artist's studio in Paris. The works were shot by the artist and by her friends, members of the Nouveaux Réalistes, including Pierre Restany, Arman, Hugh Weiss, Daniel Spoerri, and Tinguely. In 1962 Saint Phalle created her only shooting sculpture, *Vénus de Milo*, during the performance of Kenneth Koch's play *The Construction of Boston.*

From 1962 to 1964, concurrent with the shooting paintings, Saint Phalle also worked with assemblages concerned with the depiction of women and the idea of woman as Goddess. Works such as *L'accouchement rose* made use of found objects, mostly children's plastic toys: babies, animals, and airplanes. These works prefigured her body of work known as the *Nanas* (French slang equivalent of "chicks" or "babes"). Inspired by the pregnancy of her friend, the American artist Larry Rivers's wife, Clarice Rivers, in 1964, the *Nanas* were exuberant, lively figures that constituted a distinct shift away from the work of the Nouveaux Réalistes. Initially they were constructed from chicken-wire frameworks covered with fabric and yarn to yield a textured surface; later they were made from painted plaster or plastic. The vibrant and voluptuous figures wore brightly colored costumes, often in energetic and overtly sexual poses. Their massive bodies were crowned with small heads. The *Nana* form celebrated the fecundity of the female body by using a mode of expression very different from that of Saint Phalle's peers (male artists) and also quite alien to the male-dominated world of art criticism of the late 1960s and 1970s. They were first exhibited in Paris at the Galerie Alexandre Iolas during autumn of 1965 and in New York in the following year.

The *Nana* motif reached its apotheosis in the installation *Hon*, a playful collaboration with Jean Tinguely and Per Olof Ultvedt. Between 9 June and 4 September 1966, this colossal *Nana*, weighing 6 tons and measuring 26.7 meters long, 6.1 meters high, and 9.15 meters wide, occupied a gallery in the Moderna Museet in Stockholm. *Hon* (Swedish for *she*) lay prostrate on the ground, legs apart. Visitors entered through the vagina and could visit, among other things, a 12-seat cinema screening a Greta Garbo film and a milk bar placed inside the sculpture's left breast.

Hon provided the opportunity for Saint Phalle to develop her work on the *Nana* series while exploring the possibilities of working on a larger scale. In 1967 she and Tinguely provided *Le paradis fantastique* for the French pavilion at Expo '67 in Montreal (now on permanent display at the Moderna Museet, Stockholm). The rooftop exhibition consisted of nine large-scale works by Saint Phalle and six kinetic sculptures by Tinguely. This was a high-profile work for the French government, one which led to other public commissions for the artist. In 1982–83 Saint Phalle and Tinguely created the Stravinsky fountain, perhaps their most famous work, outside the Centre Georges Pompidou, Paris. In 1988 they reproduced the fountain outside the town hall at Château-Chinon, Nièvre, France, commissioned by the French president, François Mitterrand.

Between 1979 and 1997 Saint Phalle devoted much of her time and artistic output to her Tarot Garden at Caravicchio in southern Tuscany. In 1955 she had visited Antonio Gaudí's Park Güell (1900–14), which sparked a long-term desire to create her own sculpture park. The park today consists of monumental sculptures and architectural spaces based on the 22 major arcana of tarot.

At this time Saint Phalle was also working on a series of sculptures called *Skinnys*, in which she investigated the idea of linear sculpture. These works retained the high-spirited colors of the *Nanas* while exploring the links between graphic art and three-dimensional sculpture.

Saint Phalle's later body of work constituted a rapprochement with her early work as a painter. As an homage to Tinguely, who died in 1991, she began a series of kinetic paintings that she called *Tableaux*

the spiritual. Many sculptures for the Church of San Fermin de los Navarros and the Oratory del Olivar were destroyed in 1936.

Isabella Farnese, the second wife of Philip V, commissioned numerous works from Carmona for the Church of Nuestra Señora del Rosario in San Ildefonso. For this church Carmona sculpted, among other figures, *Christ the Redeemer*, *Saint Rita* meditating on the crucifix, and *Saint Inés* as an elegant woman of the period. His *Christ the Redeemer*, inspired by a *Christ the Redeemer* by the 17th-century sculptor Manuel Pereira for the Church of the Rosary in Madrid, kneels on a globe painted with figures of Adam and Eve to suggest that his sacrifice was necessary for the redemption of mankind.

Carmona executed sculptures in stone of *Doña Sancha*, *Ramiro I*, *Ordoño II*, *Philip IV*, and *Juan V of Portugal* for the Palacio Real in Madrid. These delicate works have theatrical, windswept drapery. He also worked for ecclesiastical institutions in Madrid in the early to mid 1750s. His polychrome wood image of the crucified *Saint Librada*, *Saint Pascual Bailón*, and *Crucifixion* (*ca.* 1750–55) for the Church of S. Miguel in Madrid show less Baroque emotion than other of his works. Carmona sculpted his most dynamic version of *Saint Michael* for the parish church in Rascafría in 1756.

For the parish church at Lesaca in the province of Navarre, Carmona sculpted the *Immaculate Conception*, *Saint Martin*, and other works that he arranged as he had done the sculptures at Segura. For the parish church at Azpilcueta he sculpted *Saint Barbara* in drapery similar to *Saint Inés* at La Granja, as well as refined versions of the *Virgin of the Rosary*, *Saint Andrew*, and the *Crucifixion* for the major retable in 1759. Between 1754 and 1760 Carmona executed works for retables in the province of Toledo. For the parish church at El Real de San Vicente, he sculpted dramatic scenes related to the Passion, including the *Virgin of Sorrows*, *Christ of Nazareth*, and *Flagellant Christ*.

Carmona's students, Francisco Gutiérrez and Alfonso Chaves, and his nephews José Salvador Camona, who worked as a sculptor, and Manuel Salvador Carmona and Juan Antonio Carmona, who worked as engravers, carried on his work. In addition, Juan Antonio Carmona made engravings after his uncle's work with inscriptions describing their locations.

JENNIFER OLSON-RUDENKO

See also **Spain: Renaissance and Baroque**

Biography

Born in Nava del Rey, Valladolid, Spain, 15 November 1708. Apprenticed to Juan Alonso Villabrille y Ron in Madrid, *ca.* 1723; after Ron's death, worked in studio of Ron's son-in-law José Galbán until 1732; influenced by Baroque sculptors Gregorio Fernández and Pedro de Mena as well as French court-sculptors René Frémin, Jean Thierry, and Jacques Bousseau; established workshop in Madrid, 1732; executed many commissions in Madrid and throughout Spain, such as those for Santa Maria de Vergara, for Segura in Guipúzcoa, and for Los Yébenes in province of Toledo; worked on Palacio Real under Giovanni Domenico Olivieri, 1746–51; professor at Real Academia de Bellas Artes de San Fernando in Madrid with Olivieri, 1752; served as Deputy Director of Sculpture, 1752–65; exhibition, *Compendio de la vida y obras de Don Luis de Slavado y Carmona* (Collection of the Life and Works of Don Luis de Salvador Carmona), Real Academia, 1775. Died in Madrid, Spain, 3 January 1767.

Selected Works

1736–41 Retable (designed by Miguel de Irazusta), including statues of *Saint Marina*, *Martyrdom of Saint Marina*, *Saint Jerome*, *Saint Augustine*, *Saint Abdón*, *Saint Senén*, *Saint Theresa of Jesus*, and a *Savior*; polychromed wood; Church of Santa Marina de Vargara, Guipúzcoa, Spain

ca. *Saint Joseph*; polychromed wood; Church
1740–47 of San José, Madrid, Spain

1741–45 *Divina Pastora*; polychromed wood; Convent of the Capuchines, Nava del Rey, Spain

1743–66 Sculptural decorations, including *Virgin of Sorrows* (1743), *Virgin of the Pillar* (*ca.* 1745–50), *Saint Francis Xavier* (*ca.* 1745–50), *Christ the Redeemer* (1751), *Saint Rita* (1754), *Saint Inés* (1754), *God the Father* (1754), *Sacrament and Souls* (1754), *Virgin of the Rosary* (*ca.* 1754–57), *Saint Matthew* (1757), and *Virgin of Solitude* (*ca.* 1759); polychromed wood; Real Sitio, Church of San Ildefonso, La Granja (Segovia), Spain

1746 *Saint Joseph*; polychromed wood; Confraternity of the Holy Rosary, Church of San Fermin de los Navarros, Madrid, Spain

1746 *Virgin of the Rosary*; polychromed wood; Confraternity of the Holy Rosary, Church of San Fermin de los Navarros, Madrid, Spain

1746 *Virgin of the Rosary*; polychromed wood; Oratory del Olivar, Madrid, Spain

1747 Retables (with Diego Martínez de Arce), including sculptures of *Saint John the Baptist*, *Saint Joseph*, *Saint Joaquin*, *Saint*

Anna, the *Assumption*, and the *Trinity*; polychromed wood; parish church, Segura, Spain

1749–50 Sculptural decorations, including *Ramiro I*, *Doña Sancha*, *Philip IV*, *Juan V of Portugal*, and *Ordoño II*; stone; Palacio Real, Madrid, Spain

1754–58 Statues of the *Virgin of Sorrows*, *Christ of Nazareth*, and *Flagellant Christ*; polychromed wood; parish church, El Real de San Vicente, Spain

1756 *Saint Michael*; polychromed wood; parish church, Rascafría, Spain

1759 Statues of *Saint Barbara*, the *Virgin of the Rosary*, *Saint Andrew*, and the *Crucifixion*; polychromed wood; parish church, Azpilcueta, Spain

1760 Retables (with Diego Martinez de Arce), including statues of the *Assumption*, *Crucifixion*, and *Eternal Father*; polychromed wood; parish church, Los Yébenes, Toledo, Spain

Further Reading

Martín Gonzàlez, Juan José, *Escultura barroca en España, 1600–1770*, Madrid: Càtedra, 1983; 3rd edition, 1998

Martín Gonzàlez, Juan José, *Luis Salvador Carmona: Escultor y académico*, Madrid: Alpuerto, 1990

Sánchez Cantón, Francisco Javier, *Escultura y pintura del siglo XVIII*, Madrid: Editorial Plus-Ultra, 1965

FRANCISCO SALZILLO 1707–1783

Spanish

Francisco Salzillo is one of the most celebrated 18th-century Spanish sculptors. His wood-carved polychromatic religious sculptures still provoke fervor and passion in those who participate in the Holy Week festivities in his hometown of Murcia, during which some of his works are a focal point of an annual religious procession.

The son of Italian sculptor Nicolás Salzillo, Francisco Salzillo was born during a time of major international influences throughout Spain. Such influences are apparent in what many have referred to as his Italian Baroque sculptural style. It is impossible to ignore the realistic portrayal of these icons and their religious devotion. Salzillo, like his Italian contemporaries, adhered to the guidelines as outlined by the Council of Trent in his depiction of significant biblical events. Salzillo's saints appeal to the Roman Catholic Church's plea of religious awe to her congregation. Furthermore, the vibrant colors of the polychromy that adorns these life-size wooden statues heighten their naturalistic portrayal, thus adding an emotive quality to the art.

Before establishing himself as an artist, Salzillo studied at La Anunciata, a Jesuit college, and worked on drawings for the cleric and painter Manuel Sánchez. Salzillo abandoned his studies at the time of his father's death and devoted his life to sculpture.

The elder Salzillo taught Francisco all the rudimentary techniques of working in wood. Francisco Salzillo's earlier compositions are believed to be highly influenced by his father. Certain compositional choices such as the gestures of the saints—the left hand on the chest with the right arm extended up to the heavens—point to this possibility. Most of these earlier statues share this quality. But perhaps his most influential teacher was Antonio Dupar, who introduced the younger Salzillo to different art-making concepts such as the play of light and how to achieve pictorial effects in depicting morbid anatomies. Mastering these techniques has almost certainly secured Salzillo's position as one of Spain's premier sculptors.

Salzillo's first commissioned works are characterized by their domestic atmosphere. One of his grandest pieces from this period is his *Holy Family* (*ca.* 1765). This sculpture of the Christ Child with the Virgin Mary standing on his right and Joseph on the left depicts an intimate familial setting in such a monumental fashion. Seemingly larger than life, the carved wood figures are painted in naturalistic hues, whereas the vibrant colors are reserved for the drapery that is made up of quilted material treated with polychromy.

Salzillo realized that his wood sculptures were in line with the Spanish artistic tradition. His application of vibrant colors and draping his pieces in fabric allowed him to combine with this traditional sculpture technique an aesthetic associated with the French Rococo. The elegance of the various textures of the fabrics used and the lively combinations of tones resulted in a dramatic style praised and sought after by the Spanish churches.

Salzillo's most celebrated works are those included in the annual procession in Murcia during Holy Week. These pieces are essentially sculpted scenes of many of the Stations of the Cross. Each of the monumental group sculptures depicts one of the scenes that make up Christ's journey from his trial through carrying the cross to his crucifixion. *La Caída* (1752) is the scene of one of Christ's falls while carrying the cross. This particular work is made up of five life-size figures arranged in a realistic space of this dramatically emotional scene. Although the detail of the fabric worn by the figures, especially the purple robe with a gold grapevine pattern wrapped around Christ's body, recalls the Rococo style of Salzillo's other works, this scene is essentially Baroque in style. The large wooden cross propped by the fallen Christ is the central diago-

The cardinals' tombs brought Sansovino into a working relationship with Bramante and subsequently introduced him to Raphael. With Raphael, Sansovino completed a monument in the Church of S. Agostino of the *Virgin and Child with St. Anne*, dedicated to St. Anne by the humanist and native of Luxembourg, Johann Goritz. Raphael's fresco of the prophet Isaiah is placed above the sculpture group. Although Sansovino's sculpture may have been inspired by Leonardo's lost cartoon of the Holy Family (known by the Burlington House Cartoon [1499–1501] in the National Gallery of London and the Musée du Louvre painting of the *Virgin and Child with St. Anne [ca.* 1508–10]), the figural composition departs sharply from its presumed model. St. Anne is seated beside the Virgin and on a slightly higher level so that, when the sculpture is viewed obliquely, St. Anne looms over the Virgin. The playful Christ Child reclines in the cradling arm of his mother. The two women are carefully differentiated in age; Mary's firm, almost voluptuous body and taut facial features contrast with St. Anne's mature body and aged fleshy face. Both figures seem tighter and more self-contained than the expansive figures in Genoa and Florence of a few years earlier. The artist's maturity, as well as the influence of Roman Classicism, seems to have dampened his impulses toward exuberance.

The Holy House of Loreto in the Church of Santa Casa, Loreto, occupied Sansovino for most of the remainder of his life. Begun by Bramante in 1509, who prepared the design for Pope Julius II, but left incomplete after the death of Sansovino, this ambitious project was not fully realized until the bronze doors on the north and south were finished in 1576. The work of superintending the structure and sculpture was entrusted first to the sculptor Gian Cristoforo Romano and then, after his death, to Pietro Amoroso. After Pope Julius died, in 1513, Pope Leo X appointed Sansovino successor to Amoroso, placing him in charge of the building fabric and sculpture. Because of unsatisfactory progress, Sansovino's role after 1517 was limited to the sculpture. During the pontificate of Adrian VI (1522–23), Sansovino absented himself from Loreto and returned intermittently until 1527, when he quit the project definitively.

The Holy House, a marble encasement of a dwelling belonging to the Virgin that, according to legend, was magically transported from Palestine to Loreto, is a monumental structure (installed in 1532–34), really a freestanding building within the cathedral. Rectangular in plan, the Holy House has two long sides (north and south) and two short sides (east and west) and is organized in a pattern of alternating narrow projecting bays (at the corners and middle of the long sides) and wide intervening bays. Because various artists were responsible for the reliefs set in these bays, the result is somewhat detrimental to the harmony of the whole.

Sansovino, responsible for the design and execution of many scenes within the bays, completed several reliefs for the Holy House between 1518 and 1524: *The Annunciation* (west wall) and the *Annunciation to the Shepherds* and the *Adoration of the Shepherds* (south wall). He began the *Marriage of the Virgin* (north wall), which was finished by Niccolò Tribolo from Sansovino's model. *The Annunciation* is a visually dynamic interpretation of the subject, with energetic figures executed in extremely high relief that are nearly liberated from the dramatic architectural backdrop. In several instances, figures and objects literally burst beyond the enclosing frame. Sansovino recaptured here the lively spirit of his best Florentine work, setting aside the compact stillness of some of his later Roman creations. *The Annunciation* relieves the staid Classicism of the monumental enclosure of the Holy House, suggesting that, had there been a better balance in the enclosure between architecture and sculpture, as in this relief, the Holy House would have been a more successful and striking ensemble.

JOHN HUNTER

See also **Sansovino, Jacopo; Tribolo, Niccolò**

Biography

Born in Monte Sansovino, Italy, between 1467 and 1470. Inscribed in the *Arte dei maestri di pietra e legname* (Guild of The Masters of Stone and Wood), 1491; earliest training speculative, possibly with Antonio Pollaiuolo (according to Vasari), Benedetto da Maiano, or Ferrucci studio; first worked in Florence; from *ca.* 1492 worked in Portugal, but returned to Florence by 1502; acted as mentor to Jacopo Sansovino, starting 1502; called to Rome by Pope Julius II, 1505; appointed *capomaestro generale della fabbrica Loretana* (head architect and general master of the Loretan works) in Rome by Pope Leo X, 1513; supervised Holy House of Loreto (except for a period in Monte Sansovino) until the Sack of Rome in 1527. Died in Monte Sansovino, Italy, 1529.

Selected Works

ca.
1491–92 Corbinelli altar (commissioned 1485), including *Lamentation over the Dead Christ, Coronation of the Virgin, Last Supper*, figures of St. Matthew and St. James, a tabernacle, and a relief of the Resurrected Christ; marble; Church of S. Spirito, Florence, Italy

ca. 1501 *Virgin and Child* and *St. John the Baptist*; marble; Genoa Cathedral, Italy

1502 Baptismal font; marble; baptistery,
 Volterra, Italy
1502–05 *Baptism of Christ*; marble; Florence
 Baptistery, Italy
ca. Tombs of Cardinal Ascanio Maria Sforza
1505–09 and Cardinal Girolamo Basso della
 Rovere; marble; Church of Santa Maria
 del Popolo, Rome, Italy
1512 *Virgin and Child with St. Anne*; marble;
 Church of S. Agostino, Rome, Italy
1513–27 Holy House; marble; Church of Santa
 Casa, Loreto, Italy

Further Reading

Bonito, Virginia Anne, "The Saint Anne Altar in Sant'Agostino,
 Rome," Ph.D. diss., New York University, 1983
Hofler, Janez, "New Light on Andrea Sansovino's Journey to
 Portugal," *The Burlington Magazine* 134 (April 1992)
Pope-Hennessy, John, *An Introduction to Italian Sculpture*, 3
 vols., London: Phaidon, 1963; 4th edition, 1996; see espe-
 cially vol. 3, *Italian High Renaissance and Baroque Sculp-
 ture*

TOMBS OF ASCANIO MARIA SFORZA AND CARDINAL GIROLAMO BASSO DELLA ROVERE

Andrea Sansovino (ca. 1467/70–1529)

1505–1509

marble

Church of Santa Maria del Popolo, Rome, Italy

Toward 1505, while carving the *Baptism of Christ* for the Florence Baptistery, Andrea Sansovino was called to Rome by Pope Julius II. Leaving incomplete his sculptures of Christ and St. John the Baptist, Sansovino journeyed to Rome to undertake one of the most important commissions of his career, one that became a key monument in the history of Renaissance funerary sculpture. Sansovino used his experience gained in Florence and Portugal to transform the Roman tomb monument into a type that served as a model for other tombs for the remainder of the 16th century.

Julius II decided as early as 12 June 1505 to honor Cardinal Ascanio Maria Sforza (who died on 27 May 1505) with a tomb to be erected in the Church of Santa Maria del Popolo. This church was essentially an enclave of the pope's family, the della Rovere, and a favorite resting place of cardinals. Ascanio, who was not related to Julius II, was the son of Francesco Sforza and brother of Galeazzo Maria and Ludovico il Moro, the latter succeeding his father as ruler of Milan. In fact, the pope and cardinal were adversaries and only reconciled as Ascanio, ill and infirm, made peace before his death.

Pope Sixtus IV made Ascanio a cardinal in 1484, reputedly as a reward for the marriage of Caterina Sforza, daughter of Ludovico il Moro, to the pope's nephew, Girolamo Riario. Mired in the intrigues of Rome and international papal maneuvers, Ascanio cast his fate with the Borgia pope, Alexander VI, rival of Giuliano della Rovere (later Pope Julius II), and chose the wrong side in a war that erupted between Milan and Venice. Taken prisoner in 1500, he was held as a captive in Bourges until the election in 1503 of Julius II, when he was released. He returned to Rome, where he became gravely ill and died. The inscription on his tomb sanitizes his life: "To Ascanio Maria Sforza, son of the Duke of Milan, Francesco Sforza, Cardinal Deacon, Vice-Chancellor of the Holy Church of Rome. Modest in good fortune, he was yet an excellent man in adversity. He lived 50 years, 2 months and 25 days. Pope Julius II, remembering his qualities and forgetting their disagreements, when this chapel was being built from its foundation, put up this monument, 1505."

When Julius II made a decision by 1505 to create a tomb for Ascanio, he also decided to employ his favorite architect, Bramante, to rebuild the choir of Santa Maria del Popolo, where the tomb would be placed. Bramante built a large square presbytery attached to the 15th-century church, then a barrel-vaulted space with a half-domed apse. The tomb was intended to fill a shallow recess on the left side of the presbytery; another tomb was planned for a similar location on the right side. Pinturicchio provided frescoes (1509–10) for the ceiling of the presbytery, and Guillaume de Marcillat designed window glass with scenes of the Virgin and Christ, all as part of an integrated decorative scheme. Bramante may have proposed the design of the tombs, because they are unified with their setting. However, Sansovino may have assumed complete responsibility because he had already experimented with similar architectural elements in the design for the Corbinelli monument and unbuilt tomb designs for the Portuguese royal family.

An ink drawing in the Victoria and Albert Museum, London, supposedly represents an initial or alternative scheme for the Sforza monument. However, the second tomb must originally have been intended for a cardinal other than the one to whom it is dedicated, because Cardinal Girolamo Basso della Rovere died on 1 September 1507, two years after the project was begun. Girolamo, a distant cousin of Julius II, was the nephew of Pope Sixtus IV, who made Girolamo a cardinal in 1484. Unlike Ascanio, Girolamo was a man of good character who gained the admiration of his contemporaries. His tomb's inscription simply recounts his virtue: "To Girolamo Basso of Savona, nephew of Pope Sixtus IV, Bishop of Recanati, and Cardinal of Santa Sabina. In his whole life he was steadfast, virtuous and devout.

Tomb of Cardinal Girolamo Basso della Rovere, Church of Santa Maria del Popolo, Rome
The Conway Library, Courtauld Institute of Art

Pope Julius II erected this in memory of his worthy cousin, 1507."

Both tombs are similar in design. Each consists of a triumphal arch flanked by lower and smaller arches, a motif that echoes the Serliana window in the wall above each tomb. The arched central bay opens onto a deep barrel-vaulted chamber that contains the effigy. The tripartite division of the tomb is articulated by highly ornamented Corinthian half-columns, which support an entablature that follows the advancing and receding planes of the architecture. This highly sculptural architecture, with its shifting planes and multiple levels, serves as setting and armature for a diverse program of relief and freestanding sculpture.

Sansovino reserved relief sculpture primarily for the most forward planes of the architecture. In between the framed panels that adorn the plinth are coats of arms with the *galerus rubeus* (red hat), the symbol of the cardinalate, and a central inscription identifying the deceased and identifying Julius II as patron. Winged Victories fill the spandrels of the central arch, and in the deep recess, a tondo, with a high-relief image of the Madonna and Child flanked by winged cherubim, occupies the lunette.

The basically static forms of architecture with its relief ornament is animated by freestanding sculpted figures. Standing figures of the cardinal virtues fill the niches—*Justice* and *Prudence* for the Sforza monument and *Fortitude* and *Temperance* for the della Rovere monument. Atop the flanking bays for both monuments are seated figures of the theological virtues, *Faith* and *Hope*. Above the crowning shell with a shield bearing the symbols of the della Rovere pope is the seated figure of God the Father. Reclining on the sarcophagus is the effigy of the deceased. Both figures, dressed in liturgical vestments and miter, rest with head propped up on one arm.

All of the freestanding figures have lively poses accentuated by smooth, fluid drapery that sometimes reveals the underlying human form. Sansovino highlights the *contrapposto* (a natural pose with the weight of one leg, the shoulder, and hips counterbalancing one another) of the standing figures, as he did for the *Virgin and Child* (1501; Genoa) and *Baptism of Christ* (1502–05; Florence). The seated figures, particularly the theological Virtues (which are likened to Raphael's personifications on the ceiling of the Stanza della Segnatura) show the same mix of nobility and voluptuousness as Sansovino's Virgin in the *Virgin and Child with St. Anne*.

Although most of the figures can be traced back to types in Sansovino's earlier work, the effigies of the deceased present an entirely new motif for Renaissance tomb monuments. Although they recall the reclining figures on Etruscan tombs, these figures are slumbering, not wide awake. More important, they are not the inanimate figures found on tombs since the mid 13th century, but living beings. Although the formal invention of this motif must be credited to Sansovino, the inspiration for the design must have originated in the circle of advisors to the pope. Such a profound change in attitude toward the representation of the deceased and presentation of the funerary ritual must be due to theologians and humanists in the court of Julius II, who also advised Michelangelo and Raphael on projects at the Vatican.

For their liturgical vestments, both cardinals wear a floor-length, wide-sleeved dalmatic over an alb. These garments are appropriate for Ascanio Sforza, who at his death held the rank of cardinal-deacon of the titular Church of San Vito in Macello. Girolamo Basso della Rovere, on the other hand, was a cardinal-bishop when he died (jurisdiction of Palestrina) and should have been shown wearing a poncholike chasuble over the dalmatic. The fact that he is not properly attired, which is inconsistent with other effigies of cardinals, suggests that the effigy was carved to represent another

cardinal-deacon before Julius II decided to dedicate the tomb to Girolamo.

Sansovino's tripartite triumphal arch design is an innovation in Roman funerary monuments dominated mainly by the single arched tomb derived from Bernardo Rossellino's tomb monument of Leonardo Bruni (1446–48) and popularized in Rome by Andrea Bregno. Pietro Lombardo (Monument of Pietro Moncenigo; 1476–81) and Tullio Lombardo (Monument of Andrea Vendramin; *ca.* 1489–95) developed somewhat similar designs for Venice in the last quarter of the 15th century that may have been familiar to Sansovino. Nevertheless, Sansovino's tomb monuments exercised a decisive influence over 16th-century tomb design, especially in Rome, and the slumbering figure became the norm for tomb effigies.

JOHN HUNTER

Further Reading

Davies, Gerald S., *Renascence: The Sculptured Tombs of the Fifteenth Century in Rome, with Chapters on the Previous Centuries from 1100*, London: Murray, 1910; New York: Dutton, 1916

Portoghesi, Paolo, *Roma del Rinascimento*, Milan: Electra, 1971; as *Rome of the Renaissance*, translated by Pearl Sanders, London: Phaidon, 1972

JACOPO SANSOVINO *ca.* 1486–1570
Italian

A Florentine sculptor and architect renowned for his architectural designs, Jacopo Sansovino transformed the Piazza San Marco in Venice. Although perhaps best remembered for these buildings, Sansovino was also an influential sculptor, sought after by many patrons in Florence, Rome, and Venice. Throughout his long career, he produced numerous sculptural works rooted in a thorough knowledge of antique precedents, combining Roman and Tuscan styles in the form of architectural sculpture, freestanding statuary, and relief sculpture.

Sansovino was born Jacopo Tatti in Florence. He adopted the surname of the sculptor Andrea Sansovino about 1502, when he began his apprenticeship with the artist, who was working during this period on the marble *Baptism* group for the Baptistery in Florence. As the pupil of the elder Sansovino, Jacopo gained experience as a sculptor, working on a number of important commissions. In 1505, when Andrea went to Rome to work on commissions at the Church of Santa Maria del Popolo, Jacopo followed shortly afterward as the student of Giuliano da Sangallo. Although Jacopo studied under Sangallo while in Rome, stylistic simi-

larities between some of Jacopo's works and those of Andrea Sansovino's Roman period suggest that Jacopo also continued to work with his former teacher. Jacopo Sansovino returned to Florence about 1510 and quickly established himself as a rival to Michelangelo, gaining several important commissions for marble statuary. His first full-scale sculpture commission was for the *Bacchus* and derives from a combination of several Classical models. In 1518 he returned to Rome for a period of almost ten years, where he worked primarily on architectural commissions.

The time spent in Rome studying and copying Classical sculpture proved to be formative period for Sansovino's stylistic development. Vasari reports that in 1507 or 1508, Sansovino won a contest, devised by the architect Donato Bramante and judged by Raphael, for the best copy of the antique sculpture *Laocoön*. The stylistic impact of Sansovino's time studying the antique in Rome is evident in the artist's adherence to Classical models throughout his career.

After the Sack of Rome in 1527, Sansovino left the city, as did many of his contemporaries, to seek out new commissions. While on his way to France to serve King Francis I, Sansovino stopped in Venice, where

Bacchus
© Arte & Immagini srl / CORBIS

he was persuaded to stay. He remained in Venice for the rest of his life, quickly establishing himself as one of the preeminent artists in the city. Eventually hired as *proto* (chief architect) to the procurators of San Marco, he received many commissions—both public and private, sculptural and architectural. Throughout his career in Venice, Sansovino continued to adhere to Classical models while also incorporating Florentine and Roman models, as well as local artistic sensibilities. Much of the artist's sculptural work in Venice is realized in bronze rather than marble.

In addition to his statuary commissions (examples include *Bacchus, St. James the Greater,* and *St. John the Baptist*), Sansovino also produced a number of bronze reliefs. Although he did receive a number of private commissions during his career in Venice, much of his work is tied to architectural projects in and around the Piazza San Marco, including the reliefs for the sacristy door and the choir of San Marco and the gods for the Loggetta—statues depicting *Apollo, Mercury, Pallas Athene,* and *Peace.*

Similarities have been made between Sansovino's later relief works such as the *Miracle of the Maiden Carilla* and the Classical *Ara Pacis Augustae.* In addition to the obvious compositional affinities, Sansovino's relief conveys the same sense of rhythm in its expressive figures. Both in his relief sculpture and in other forms of sculpture, Sansovino's figures share a similar surface quality with Augustan models of relief sculpture, although he supercedes them in his ability to create drapery that is not merely rhythmic pattern but instead reveals the body and its implied motion through delicately carved curves and folds. Vasari praised Sansovino's skill in sculptural rendering of form as greater than that of Michelangelo and proclaimed that the artist had no equal in the ability to create drapery.

During his lifetime and after, Sansovino also received praise for his ability to effectively convey emotion and tenderness. His *Madonna del Parto,* created for Giovan Francesco Martelli during the sculptor's second Roman period and conceived in similar formal terms to Michelangelo's powerful Sibyl figures on the Sistine Chapel ceiling, while at the same time capturing the human tenderness of a mother and child, eventually became a cult image.

Vasari regarded Sansovino with equal and sometimes higher esteem than Michelangelo. Both contemporaries and later scholars viewed Sansovino's sculptural compositions as akin to the stylistic developments of contemporary painters such as Titian and Andrea del Sarto. Even in the years before his death, when his commissions waned due to the rising fame of the architect Palladio, Sansovino was still regarded as an important and influential Venetian sculptor and archi-

tect. During this period, Sansovino also worked on several large-scale tomb commissions but increasingly relied on his studio assistants to execute his designs.

ELIZABETH PETERS

See also **Ara Pacis (Augustae); Laocoön and His Sons; Michelangelo (Buonarroti); Sansovino, Andrea**

Biography

Born in Florence, Italy, before 2 July 1486. Given name Jacopo Tatti; adopted surname Sansovino during apprenticeship with Andrea Sansovino, *ca.* 1502; became pupil of Giuliano da Sangallo and left Florence for Rome, 1505; won competition judged by Raphael for the best copy of unearthed antique sculpture *Laocoön,* 1507/08; returned to Florence; received several important commissions including first full-scale, free-standing work *Bacchus,* 1510–11; shared studio with Andrea del Sarto, 1511–18; traveled to Rome, 1518, and worked mainly on architectural commissions until Sack of Rome in 1527; went to Venice and gained prominence as sculptor and architect; appointed *proto* (chief architect) of San Marco, 1529, and held this office for four decades; began work in 1535 on redesign of Piazza San Marco, including the Zecca (public mint), library, and Loggetta gods, *Apollo, Mercury, Pallas Athene,* and *Peace,* installed by 1540; received commission for tomb of Doge Francesco Venier, 1550s, which he completed in 1577–78 with assistants from his Venetian workshop; *Mars* and *Neptune,* in Doge's Palace, were also workshop productions. Died in Venice, Italy, 27 November 1570.

Selected Works

1508	*Descent from the Cross* (studio model for Perugino); wax; Victoria and Albert Museum, London, England
1510–11	*Bacchus*; marble; Museo Nazionale del Bargello, Florence, Italy
1511–18	*St. James the Greater*; marble; Florence Cathedral, Italy
1516	*Madonna del Parto*; marble; Church of San Agostino, Rome, Italy
1520	*St. James of Compostela*; marble; Church of Santa Maria di Monserrato, Rome, Italy
ca. 1534	*St. John the Baptist*; marble; Church of Santa Maria Gloriosa dei Frari, Venice, Italy
1536	*Miracle of the Maiden Carilla*; bronze; installed 1563, Basilica of Sant'Antonio, Padua, Italy
1537–40	*Apollo, Mercury, Pallas Athene,* and *Peace*

(Loggetta Gods); bronze; Loggetta, Piazza San Marco, Venice, Italy

1537–42 Six relief panels for choir; bronze; Church of San Marco, Venice, Italy

1546 Sacristy door relief panels; bronze; installed 1572, Church of San Marco, Venice, Italy

1554–66 *Mars* and *Neptune*; marble; Scala dei Giganti, Doge's Palace, Piazza San Marco, Venice, Italy

Further Reading

Boucher, Bruce, *The Sculpture of Jacopo Sansovino*, 2 vols., New Haven, Connecticut: Yale University Press, 1991

Garrard, Mary DuBose, "The Early Sculpture of Jacopo Sansovino: Florence and Rome," Ph.D. diss., Johns Hopkins University, 1970

Howard, Deborah, *Jacopo Sansovino: Architecture and Patronage in Renaissance Venice*. New Haven, Connecticut: Yale University Press, 1975

Lewis, Douglas, "Jacopo Sansovino, Sculptor of Venice," in *Titian: His World and His Legacy*, edited by David Rosand, New York: Columbia University Press, 1982

Tafuri, Manfredo, *Jacopo Sansovino e l'architettura del '500 a Venezia*, Padua, Italy: Marsilio, 1969; revised edition, 1972

Vasari, Giorgio, *Le vite de' più eccellenti architetti, pittori, e scultori italiani*, 3 vols., Florence: Torrentino, 1550; 2nd edition, Florence: Apresso i Giunti, 1568; as *Lives of the Painters, Sculptors, and Architects*, 2 vols., translated by Gaston du C. de Vere (1912), edited by David Ekserdjian, New York: Knopf, and London: Campbell, 1996

APOLLO

Jacopo Sansovino (ca. 1486–1570)

ca. 1540–1545

bronze

h. 147 cm

Loggetta, Piazza San Marco, Venice, Italy

Jacopo Sansovino's architectural and sculptural work redesigning the Piazza San Marco in Venice, which began in the 1530s, is the crowning glory of his prolific career. Along with his work on the library and the Zecca (public mint), Sansovino's renovation of the Loggetta redefined the focus of the piazza in terms of physical space as well as of spirit and emphasis. The individual elements of Loggetta's iconographic program, and indeed Sansovino's entire renovation of the piazza, served to convey and commemorate the power and prominence of the city of Venice.

The Loggetta is a small pavilion at the base of the Campanile that functioned as a meeting place for noblemen and the procurators of the Church of San Marco during the 16th century. While the structure has undergone several changes since Sansovino's construction, the basic elements remain. The facade comprises three bays and is articulated with pairs of freestanding columns. Between each pair of columns is a niche occupied by a bronze statue. In addition to the frieze of bronze relief panels running above the portals, a relief panel is above each of the niches.

As a group the bronze Loggetta gods set into the niches—depicting *Apollo, Mercury, Pallas Athene,* and *Peace*—functioned as an allegorical expression of the self-confidence and optimism of the Venetian republic. Each conveys Sansovino's keen ability to translate ancient and Early Renaissance models into contemporary terms. He cast all four about 1542 in the lost-wax bronze method. However, his workshop probably began preliminary models a year or two earlier. The use of bronze allowed Sansovino a degree of accuracy and detail, as well as a sense of movement and finesse, not afforded by the use of marble.

Nowhere is Sansovino's achievement in bronze better illustrated than in the figure of *Apollo*, the bronze god in the left central niche on the Loggetta's facade. The statue is also a key part of the iconographic program of the Loggetta and, by association, the piazza. The only nude figure of the four gods, *Apollo* is a sinuous, slender, almost androgynous figure with a small head. The figure stands in an exaggerated *contrapposto* (a natural pose with the weight of one leg, the shoulder, and hips counterbalancing one another), its torso turned at an angle toward the niche and its left arm crossed over the body to create an S-curve. *Apollo* holds a quiver at his right side; his left hand originally held a lyre, now only a fragment.

Formally, the *Apollo* owes much to the *Apollo Belvedere*; however, the lean, muscular body of Sansovino's bronze is reminiscent of figures such as Donatello's *David* from the early to mid 15th century, as well as works by his former teacher Andrea Sansovino. In addition to benefiting from Sansovino's ability to draw on a vast storehouse of antique precedents, the long, gracefully slender body and small head characteristic of the *Apollo* and the other gods clearly relate to the ideal of beauty expressed by Leonardo da Vinci in his *Trattato della Pittura*, a treatise rooted in antique models and theories.

Much of the information concerning the Loggetta's iconography comes from the description by Jacopo Sansovino's son Francesco, in his 1556 guidebook of Venetian monuments and places. As allegorical representations of the republic's supreme qualities of wisdom (*Pallas Athene*), harmony (*Apollo*), deliberation (*Mercury*), and tranquility (*Peace*), the bronzes form a key aspect of the Loggetta's iconographic program. Specifically, the *Apollo* embodies three interconnecting ideas. He is associated with the Sun, a unique body among the planets; he is also the god of music,

which is a symbol of harmony. Thus, *Apollo* conveys both the singularity of the Venetian government as well as the harmony of the Venetian state. With the relief of *Apollo and Marsyas* above the niche, Sansovino makes clear that the idea of harmony is to be inferred. The scene illustrates the musical contest between the two gods, from which Apollo emerges victorious. In this context, the reference to music does not simply signify the pleasure Venetians derived from music but serves to suggest the harmony of the state.

The Loggetta is on an axis with the Scala dei Giganti in the Doge's Palace across the piazza. All important visitors used this staircase, the setting for important ducal functions, to enter or exit the palace. As the staircase's focal point, the Loggetta provided a prominent location for the republic and thus became a powerful vehicle for political propaganda. The Loggetta's program acted both to impress on visitors the power and supremacy of the Venetian state and to constantly remind residents of the "myth of Venice." Charles David has provocatively suggested that the Loggetta as a whole may have even been intended to function as an artificial memory structure with places and images related to the Venetian state (see Davis, 1985). If so, the Loggetta could be understood not merely as an illustration of Venetian values but as a portrait of the Venetian state.

As the first large-scale public articulation of the myth of Venice, the Loggetta had a lasting implication for later public iconography in Venice and elsewhere. In addition, the *Apollo* and the other sculptural works associated with the Loggetta helped to define 16th-century Venetian sculpture and, along with Sansovino's many artistic endeavors in the city, formed the basis for later sculpture and architecture in the city.

ELIZABETH PETERS

See also **Apollo Belvedere**; **Donatello (Donato di Betto Bardi)**

Further Reading

Bury, J.B., "The Loggetta in 1540," *The Burlington Magazine* 122 (September 1980)

Davies, Paul, "A Project Drawing by Jacopo Sansovino for the Loggetta in Venice," *The Burlington Magazine* 136 (August 1994)

Davis, Charles, "Jacopo Sansovino's 'Loggetta di San Marco' and Two Problems of Iconography," *Mitteilungen des Kunsthistorichen Institutes in Florenz* 29 (1985)

JACQUES SARAZIN 1592–1660 *French*

The artist chiefly responsible for revitalizing the role of sculpture in 17th-century France was undoubtedly Jacques Sarazin. He was recognized for this accomplishment by his contemporaries, being the only sculptor included in Charles Perrault's *Les Hommes Illustres Qui ont Paru en France Pendant ce Siècle* (1700). After receiving initial training from his father and then assisting Nicolas Guillain in Paris from 1606 to 1610, Sarazin followed the course of study taken by other ambitious French artists of his day: he went to Rome, where he studied ancient and Renaissance art, as well as obtained commissions, between 1610 and 1627. His first major works were vigorous mythological stucco figures for the gardens of the Villa Aldobrandini at Frascati. Possibly as a result of that commission, the sculptor came into contact with one of the leading painters of Baroque Rome, Domenico Zampieri (Domenichino); subsequently, Sarazin provided stucco work to complement the painter's works in the churches of Sant' Andrea della Valle and San Lorenzo in Miranda (both in Rome). His atlantes provide an early indication of a recurrent interest in synthesizing the idealized naturalism of Classical sculpture with the greater movement and animation typical of the Baroque style.

While in Rome, Sarazin also met the premier French painter of the Early Baroque period, Simon Vouet. Both artists left Italy in 1627 and a year later were together in Paris, where the sculptor carved four wonderfully animated stucco angels to accompany Vouet's *Assumption of the Virgin* for the high altar of the Church of St. Nicolas-des-Champs. The great success of this altarpiece led to further collaboration, particularly in domestic interior decoration, which flourished in 17th-century France. Sadly, much of this work is no longer extant, with only written descriptions and occasional engravings documenting their efforts.

Sarazin's oeuvre gained a greater identity of its own in the 1630s and 1640s, when he and his atelier provided sculptural decoration for some of the grandest private residences of the period, including Maisons (1643–48) and Wideville. Even earlier, Sarazin was appointed *sculpteur et peintre ordinaire* to King Louis XIII (1631), which assured him of regular royal commissions, principally religious works. A significant secular request came in 1639, when he was asked by the superintendent of buildings to carve caryatids and reliefs for the Pavillon de l'Horloge of the Louvre. The four monumental pairs of caryatids are undoubtedly Sarazin's best-known works, typically cited as the earliest example of French Classicism in sculpture. Carved by his foremost assistants, Philippe de Buyster and Gilles Guérin, their majestic poses, naturalistic proportions, idealized faces, and broad drapery folds readily indicate Sarazin's study of the antique, in particular the Cesi *Juno* (Musei Capitolini, Rome). Yet the artist's ingenious bonding of these sisterly matrons through pose and gesture serve to enliven the caryatids,

as well as distinguish them from their ancient predecessors.

In addition to architectural sculpture and religious figures, Sarazin created numerous funerary monuments, including two works dedicated to the memory of the Cardinal de Bérulle. The Louvre monument is one of the sculptor's most moving and innovative works, for he transformed the traditional praying effigy of the deceased into a dramatic portrait of heartfelt communion with God. The greater emotional expression witnessed in much of the French sculptor's oeuvre may reflect the influence of Domenichino's emphasis on the *affetti* (expression of the passions), designed not only to characterize the subject, but also to engage the emotions of the audience.

A more ambitious funerary project was the *Monument for the Heart of Henri II de Bourbon*, which honored the recently deceased prince of Condé. Commissioned by his son, the Grand Condé, the monument comprised an ensemble of six allegorical figures and 14 reliefs, all cast in bronze. Originally located in the

Faun sculpture for château and grotto, Wideville, Yvelines, France
© Arthur Thévenart / CORBIS

Church of St.-Louis-des-Jesuits (Paris), the sculptural group was fortunately saved from being melted down during the French Revolution and was later reinstalled at the château of Chantilly in the 19th century. Although the placement of figures and reliefs was altered, the figures still command their space by means of Sarazin's synthesis of classicizing majesty and expressive animation. The bas-reliefs depict the triumphs of Fame, Time, Eternity, and Death in the form of Classical processions and were based on the writings of Petrarch, providing evidence of Sarazin's intellectual interests. Among the procession of Classical and Renaissance artists in the *Triumph of Fame* is a portrait of the French sculptor himself with Michelangelo depicted at his side. Sarazin, in fact, was often compared to the great Italian master since he was not only a gifted sculptor, but also a painter (although few of his works, mainly religious in nature, are extant).

While designing the *Triumph of Death* relief, Sarazin fell ill and died in 1660; the Condé monument was thus completed by his assistants. One of the sculptor's most significant contributions was in developing the next generation of Parisian sculptors, many of whom would go on to work at Versailles, including Gilles Guérin, Philippe de Buyster, and Gérard van Opstal; Michel Anguier, François Girardon, and Gaspard and Balthazar Marsy also revealed the influence of Sarazin's elegant and expressive Classicism, whether through direct or indirect contact with the artist. In addition to teaching in his atelier, Sarazin helped found and actively participated in the French Académie Royale de Peinture et de Sculpture, being named one of its 12 *anciens* (professors) in 1648. His impact extended to the 18th century as well, particularly in the form of the ubiquitous playful putti adorning Parisian residences in the form of reliefs or small freestanding groups. Popularized by Sarazin's charming *Children Playing with a Goat* and the *Sphinxes and Children* (completed after the sculptor's death, *ca.* 1660) for Versailles, in addition to the lively reliefs for the Pavillon de l'Horloge and the Château de Maisons, this newly introduced theme featuring the innocence of early childhood again reveals the depth of Sarazin's Roman experience, in this case deriving inspiration from the works of François du Quesnoy and Titian, yet transformed into his own unique idiom.

JULIA K. DABBS

Biography

Born in Noyon, France, 8 June 1592. Trained by father, a sculptor in wood; apprenticed to Nicolas Guillain, Paris, *ca.* 1606–10; worked and studied in Rome, *ca.*1610–27; received golden chain and medal from Accademia del Disegno, Florence, 1627; met and

SARCOPHAGUS

Etruscans, from the earliest phases of their culture, seem to have believed that the container of human remains should represent the deceased. Ash urns of the 7th century BCE often have lids shaped like human heads and are placed on chairs that were buried inside larger jars. By the 6th century BCE, terracotta receptacles for ashes sometimes represented full-length figures, as in a handsome example from Cerveteri (ca. 520 BCE, Museo Nazionale di Villa Giulia, Rome) For the remainder of Etruscan history, the reclining figure or pair of figures remained by far the most popular treatment for sarcophagus lids, and this format appeared again in Roman funerary sculpture. The sculptural style of the Cerveteri sarcophagus shows the influence of Greek Archaic sculpture in the mannered smiles and patterned hair of the couple, but the subject material is Etruscan. A Greek woman would not have reclined on a banqueting couch beside her husband, as this elegantly dressed aristocrat does. The Etruscan couple appear to enjoy an eternal banquet in the next life, a theme that often appears in tomb paintings as well. Living relatives were obliged to ensure this happy state of affairs by holding feasts in honor of the dead every year, to which the ancestral spirits were invited.

Etruscan sculptors also worked in stone, although they were far less adept in that medium and lacked access to high-quality marble. During the Classical and Hellenistic periods, nonetheless, stonecarvers produced both full-length sarcophagi and miniature boxes for ashes. The reliefs on these boxes usually borrowed from the Greek mythological repertory, with a preference for battle scenes. Etruscan deities, such as Vanth, the escort of the dead to the next world, would often appear to lead away fallen warriors.

Roman sculptors fell heir to all of the traditions discussed thus far, although by far the most influential was that of the Hellenistic Greeks. Cremation was the Roman method of choice for disposing of human remains until the early 2nd century CE, with a few notable exceptions. The philhellenic Scipio family, for example, preferred to place intact bodies in sarcophagi. That of Lucius Cornelius Scipio Barbatus (who was consul in 298 BCE), now in the Vatican Museum (Rome, Italy), takes the form of a handsome Ionic altar carved from a soft volcanic stone called tufa. A Latin inscription on the box details the events of Scipio's career as a soldier and politician, a distinctively Roman commemoration of the deceased for the edification of future generations. It was, in fact, those descendants who honored their ancestor with this monument, because L. Cornelius Scipio lived and died some time before his sarcophagus was made. His remains must have been reburied in the early 2nd century BCE.

Not until the time of Hadrian (117–38 CE), however, did stone sarcophagi gain widespread popularity. The earliest examples appear to have mythological friezes, but a richly diverse vocabulary of ornament soon developed. Distinctive regional styles also emerged, reflecting diverse provincial customs. Sarcophagi of the Latin-speaking west, for example, tend to be fully decorated only along their fronts. The sides, if carved at all, usually have shallow and sketchy reliefs, whereas the backs are usually blank. Economic concerns dictated this practice: these sarcophagi stood in niches of family mausoleums where their ends and backs were permanently concealed. Decoration of those sides would have wasted expensive labor. In Greece and Asia Minor, on the other hand, sarcophagi stood in the open along roadways where viewers could walk around them. Thus all four sides usually have sculptured friezes.

Decoration could often take the form of a continuous frieze devoted to mythological scenes, such as the *Meleager Sarcophagus* (ca. 170–80 CE; Palazzo Doria Pamfili, Rome) or scenes from the life of the deceased, such as the *Battle Sarcophogus* (ca. 250 CE; Palazzo Altemps, Museo Nazionale Romano, Rome). Sculptors of the mythological type seem to have adapted many established compositions, sometimes perhaps copied from monumental paintings that are now lost. Of necessity, however, they modified those scenes for the long and narrow format of the sarcophagus front, usually so that narration could flow from left to right like a written text. Sculptors obviously used standard pattern books, but just as obviously adapted those patterns according to the wishes, beliefs, or budget of each patron. One of the most enduringly popular myths on Roman sarcophagi is the Calydonian boar hunt, in which the hero Meleager demonstrates his valor against the fearsome wild beast (ca. 180 CE; Palazzo Doria Pamfili, Rome). The aftermath of the hunt, however, leads to the hero's untimely death, a scene portrayed here on the lid. The composition of two men carrying the corpse as a grieving old man lifts the dead man's limp arm was a common motif, almost a visual cliché, for the death of a young hero. This iconography unmistakably survives in many Renaissance and Baroque treatments of the Deposition from the Cross and Entombment of Christ. The myth of Meleager thus combined a celebration of *virtus*, or manly bravery, with an elegiac quality. Another popular myth was the rape of Persephone, a story that again depicts untimely death, but this time also hints at the hope for an afterlife because the goddess returns yearly from the underworld. Sarcophagi that depict this myth typically show Hades carrying his victim away while Demeter pursues him. The sculptors evidently relied on the viewer's knowledge of the story to supply the happy ending.

Figures in mythological scenes sometimes bear portrait faces, and even when they do not, one can often

infer an identification between the deceased and the hero or heroine, but some sarcophagi directly portrayed events from the lives of their occupants. These scenes are often too stereotypical to be taken literally, but they represent the key events in an aristocratic man's career: a battle, a scene in which he accepts surrender and grants clemency, a public sacrifice, and a marriage. A Roman aristocrat might indeed have done all these things, but the episodes also encapsulate the Roman virtues of *virtus, clementia* (mercy), *pietas* (loyalty to gods and ancestors), and *concordia* (harmony). Not all of these scenes need be represented, however: if the deceased never had a military career, for example, the battle could be eliminated or replaced by a hunt. If, on the other hand, he was proud of his military service or desired a symbolic emphasis on victory, the battle scene could occupy the entire front. Other biographical scenes were relegated to the lid, as on two large and impressive sarcophagi from the area of Rome: one from Portonaccio (*ca.* 180–90 CE; Museo Nazionale Romano, Palazzo Massimo, Rome), and one found near the Porta San Lorenzo: the great *Ludovisi Battle Sarcophagus* (*ca.* 250 CE, Museo Nazionale Romano, Palazzo Altemps, Rome). Both show the triumphant general in the center of a wild melee of figures. He rides a rearing horse and raises his right arm, a gesture of victory with precedents at least as early as the *Alexander Sarcophagus*. The human bodies, however, have become lanky and distorted, particularly on the later example, and their movements are more expressive but less organic than those of the Classical and Hellenistic Greek tradition. The face of the deceased general on the earlier sarcophagus was never finished, but a portrait specialist with a style somewhat different from that of his colleagues carved the general's face on the Ludovisi sarcophagus.

Many other formats for sarcophagi were available besides the continuous frieze: one that had appeared earlier on small cinerary altars was swags of garlands draped across the box, as real garlands might be draped on a house or tomb during a funeral. The spaces within the swags could contain small mythological scenes or nonnarrative elements. Many of these survive in an unfinished or partly finished condition, and they shed considerable light on the methods of Roman stoneworkers. Some preparatory work took place at the quarry where the stonecutters would rough out semicircular loops with triangular areas of stone between them. Delicate finished details were to be added after the marble reached its destination. The Metropolitan Museum of Art in New York City owns a partially finished example that is datable to the first half of the 3rd century CE. The pattern of curved swags and triangles left the sculptors a great deal of latitude: the triangles could become any of several types of supports,

whereas the motifs within the garlands could be customized to the wishes of the patron. Other decorative motifs were available as well, such as a pattern of vertical S-shaped flutes, or strigils, across the facade, which became popular in the later 2nd century CE. The strigilated pattern could appear alone or combined with panels at the ends or in the middle of a frieze. Sculptors could mass-produce these monuments, leaving a few strategic areas blank for the pattern or figure of the patron's choice: portraits of himself and his wife, an open door suggesting a passage to the next world, or a mythological scene.

The treatment of the sarcophagus as a miniature temple, with columns and architectural ornament, also survived from the Hellenistic period and enjoyed enormous popularity. Most examples come from the Greek-speaking eastern colonies, particularly Asia Minor, where the tradition had its early roots and where famous architectural tombs such as the mausoleum still exerted artistic influence. The Greek and Asian custom of decorating all four sides of a sarcophagus allowed the architectural treatment of the box to be most fully realized, but Italian sculptors also employed this format, placing colonnades across the facades. The spaces between the columns could hold portrait images of the deceased, biographical scenes (the handclasp between husband and wife enjoying particular popularity), mythological scenes, single figures of gods and goddesses, or a combination of all of the above. The lids might take the form of gabled roofs, as on their Greek and Hellenistic predecessors, but an architectural box often supported a lid in the form of a bed or banqueting couch with a portrait figure of the deceased. A sarcophagus of this format, clearly from the eastern Mediterranean, found its way to Melfi in Italy, and Italian sculptors were quick to imitate such imports (*ca.* 160–70 CE; Museo Nazionale Archeologico, Melfi). One spectacular example from Velletri, near Rome, is decorated on all four sides with two stories of architecture, and its niches are filled with a veritable encyclopedia of mythological scenes (possibly *ca.* 150 CE; Museo Nazionale, Velletri) Because no scene follows a standard iconography, they must have been custom designed for the patron, and all share a common theme of triumph over death. In this case, the wealthy patron's religious beliefs achieve lavish expression.

Finally, a Roman sarcophagus need not be rectangular, although that was the most common format. A number of surviving examples have an oval and slightly flaring shape resembling old-fashioned bathtubs. Their decorations display the same diversity as the rectangular examples, but one decorative element distinctive to the oval format explains their meaning. At each end of one long side, the sculptors often represent large spouts in the form of lion's heads. These

identify the oval basin as a *lenos*, or wine trough. Dionysus, the god of wine and revelry, was also a god of rebirth. Like Persephone, he is an agricultural deity who restores life to the vines in spring, and in fall he transforms the fermented and malodorous pulp of grapes into wine. Many of the myths about him involve miraculous regeneration. Small wonder, then, that his triumphal procession, his discovery of the sleeping Ariadne, and other such episodes are popular themes, particularly on sarcophagi that imitate wine troughs. The Metropolitan Museum of Art in New York City houses a particularly splendid example, about 220–35 CE, in which graceful figures of the seasons accompany a triumphant Dionysus riding on a panther. Another *lenos* sarcophagus in the same collection, about 190–210 CE, displays the lion's-head spouts, although the sculptural frieze here depicts the story of Selene and Endymion, rather than a myth from the Bacchic cycle.

The popularity of marble sarcophagi survived long after the fall of Roman paganism and the establishment of Christianity as the official religion of the empire in the 4th century. Sculptors continued to produce sarcophagi in familiar formats, often adapting existing motifs to represent Christian subjects. A peasant carrying a lamb to a shrine for sacrifice could, for example, easily become the Good Shepherd; winged Victories could become angels; *amores* (or cupids, as they are properly known today) could become cherubim; Dionysiac vines could now refer to Communion wine. Wealthy patrons such as the family of Junius Bassus (prefect of Rome, *d.* 359 CE) still patronized splendid custom-made monuments. His sarcophagus (now in St. Peter's Museo Petriano, Rome) once enjoyed a prestigious location near the high altar of the Constantinian-era church. Bassus's monument boasts an ornate architectural facade with two stories of columns framing biblical scenes. The upper central niche portrays Christ enthroned in majesty, whereas the scenes that surround him share the motif of redemption and rescue from death. Old Testament events, the sacrifice of Isaac and the sufferings of Job, find New Testament parallels in the Passion of Christ and the martyrdoms of St. Peter and St. Paul.

Less wealthy patrons could obtain sarcophagi by the simple method of appropriating and reusing them from earlier burials. These works thus remained visible and influential on sculptural style and iconography throughout the Middle Ages and the Renaissance. The handsome biographical sarcophagus of a Roman aristocrat from the 2nd century CE, for example, became the centerpiece of an elaborate Gothic tomb in the Church of San Lorenzo Fuori le Mura in Rome where it held the remains of Cardinal Fieschi (*d.* 1256). The Gothic Campo Santo of Pisa houses many such reused ancient works, one of which may have provided a di-

Sarcophagus of Junius Bassus, St. Peter's Museo Petriano, Rome
The Conway Library, Courtauld Institute of Art

rect inspiration for Jacopo della Quercia. His exquisite tomb for Ilaria del Carretto in the cathedral at Lucca could easily be mistaken from a distance for a reused Roman garland-type sarcophagus, although it is in fact entirely of the early 15th century. The treatment of the lid as a couch on which the deceased reclines, typical of many medieval tombs, continues the tradition of countless ancient monuments. Ilaria's sarcophagus was originally intended to form part of a larger complex with an architectural canopy above the box.

Renaissance and Baroque tombs often surrounded sarcophagi with elaborate architectural and sculptural compositions, of which Michelangelo's magnificent tombs for Lorenzo and Giuliano de' Medici in the Church of San Lorenzo, Florence (1519–34 CE), are well-known examples. Immediate sources for Michelangelo's architectural designs can be found across the transepts of San Lorenzo, in the Old Sacristy, to which the later structure formed a pendant. The sculptural decorations of that chapel by Donatello and Andrea del Verrocchio, and in particular the handsome tomb of Piero and Giovanni de' Medici (1472; Church of San Lorenzo, Florence), provided models to emulate. The scrolled lids of Michelangelo's tombs, and the incorporation of the sarcophagi into architectural settings, probably owed some inspiration to the earlier bronze sarcophagus by Verrocchio. Michelangelo had obviously also observed ancient Roman sarcophagi, however, and as usual, imaginatively adapted the traditions of antiquity. His sarcophagi, like Roman examples, support reclining figures, but they are now the dynamic and dramatic personifications of Day and Night, Dawn and Twilight, rather than effigies of the deceased, and they lean, seemingly somewhat precariously, on gracefully scrolled lids, rather than resting their weight firmly on flat surfaces. The portrait statues

now rise well above the sarcophagi proper in architectural niches, and sit up rather than recline.

Many of Gianlorenzo Bernini's funerary monuments, in turn, display Michelangelo's influence, such as the tomb of Pope Urban VIII (1627–47) in St. Peter's Basilica in Rome. Here the physical remains of the deceased are theatrically elevated well above the viewer's eye level in a bronze sarcophagus surrounded by mourning figures. On the lid, a figure of winged Death inscribes the pope's name in his book. The statue of Urban VIII himself, in turn, rises triumphantly above this image of mortality.

Seventeenth- through 19th-century sculptors continued to produce sculptural sarcophagi for high-ranking church officials and aristocratic families, especially when the patron desired an association with the traditions of imperial Rome. The Habsburg rulers of the Holy Roman Empire, for obvious reasons, desired such references in their art and architecture. The Imperial Crypt in the Capuchin convent, Vienna, contains bronze sarcophagi ranging in date from 1633 to 1895 and in style from Baroque to Rococo, the latter culminating in the flamboyantly ornamented monument of Maria Theresa and her husband Francis of Lorraine (1754, by Balthasar Ferdinand Moll). The severely simple copper casket of Joseph II (1790) contrasts dramatically with his parents' sarcophagus and illustrates the spirit of the Enlightenment, but the tradition of imperial burials in impressive sarcophagi continued for another century. Indeed, where continuity of Roman tradition carries ideological significance, the custom continues to thrive. The most recent papal tomb in the crypt of St. Peter's Basilica, Rome, is that of John Paul I, who died in 1978 after a brief reign and whose remains now lie in a simple but monumental stone sarcophagus, decorated with classicizing reliefs of angels, like those of so many of his predecessors.

SUSAN WOOD

See also **Tomb Sculpture**

Further Reading

Die antiken Sarkophagreliefs, 13 vols., Berlin: Deutsches Archäologisches Institut, 1890–1997

Bartman, Elizabeth, "Carving the Badminton Sarcophagus," *Metropolitan Museum Journal* 28 (1993)

Bonfante, Larissa, "Daily Life, and Afterlife," in *Etruscan Life and Afterlife: A Handbook of Etruscan Studies*, edited by Bonfante, Detroit, Michigan: Wayne State University Press, 1986

Buhl, Marie-Louise, *The Late Egyptian Anthropoid Stone Sarcophagi*, Copenhagen: Nationalmuseet, 1959

Eaton-Krauss, Marianne, *The Sarcophagus in the Tomb of Tutankhamun*, Oxford: Griffith Institute, Ashmolean Museum, 1993

Ewald, Bjørn Christian, "Death and Myth: New Books on Roman Sarcophagi," *American Journal of Archaeology* 103 (1999)

Huskinson, Janet, *Roman Children's Sarcophagi: Their Decoration and Social Significance*, Oxford: Clarendon Press, and New York: Oxford University Press, 1996

Koortbojian, Michael, *Myth, Meaning, and Memory on Roman Sarcophagi*, Berkeley: University of California Press, 1995

McCann, Anna Marguerite, *Roman Sarcophagi in the Metropolitan Museum of Art*, New York: Metropolitan Museum of Art, 1978

Panofsky, Erwin, *Tomb Sculpture: Four Lectures on Its Changing Aspects from Ancient Egypt to Bernini*, edited by H.W. Janson, New York: Abrams, and London: Thames and Hudson, 1964

Ridgway, Brunilde Sismondo, *Hellenistic Sculpture I: The Styles of ca. 331–200 B.C.*, Madison: University of Wisconsin Press, 1990

Ridgway, Brunilde Sismondo, *Fourth-Century Styles in Greek Sculpture*, Madison: University of Wisconsin Press, 1997

Robins, Gay, *The Art of Ancient Egypt*, Cambridge, Massachusetts: Harvard University Press, 1997

Toynbee, J.M.C, *Death and Burial in the Roman World*, Ithaca, New York: Cornell University Press, 1971

SCANDINAVIA: DENMARK

The earliest evidence of carving in Denmark comes from the Mesolithic Maglemose culture, (*ca.* 9300–6800 BCE), mainly in the form of bone carvings. *Tupilak*, troll-like figures of bone, were meant to ward off enemies. Gold ornaments soon followed, especially pendants with delicate patterns. In about 400 CE, the use of Scandinavian animal symbols came into use. The production of ceramics and bronze is evident just before the Christian era, but only after the onset of Christianity did ties to other European cultures began to appear. Initially promoted by first the Roman Catholic and then the Danish National Lutheran churches, the development of sculpture became a royal prerogative; as the country adopted a more democratic constitution in the mid 19th century, however, support shifted to the civic government.

The Vikings, who flourished in what is now Denmark, Norway, and Sweden, about 800–1050 CE, brought home with them new ideas from their distant travels, which took them down Russian rivers to Byzantium as well as around Gibraltar into the western Mediterranean. They began to imitate the carved pictures on stones they had seen in foreign places and to carve fantastic creatures on the wooden prows on their ships. During the Romanesque era, stone carvings featuring animals developed. One of the finest examples of 11th century Viking stone carving was found in 1852 in St. Paul's churchyard in London. The thick slab, once a tombstone, is now in three pieces. Two carved beasts on the face of the stone, a lion and a snake, are entwined and battling one another. The work probably was originally painted black and brown on a

light-colored background. In addition, artists hammered fire-gilded sheets of copper onto wooden armatures to construct golden altars; a few of these still exist in museums in Copenhagen and Nuremburg—as well as parish churches at Sahl, Stadil, Lisberg, Odder, and Lyngayo—and date from 1150–1250.

The decorations the Vikings added to their weapons also had an eventual impact on the decoration of Christian churches, where flowering vines, geometric patterns, and real or imaginary animal figures appear. Long before 995, worshippers of Thor and Odin lived side by side with Christians in the Viking city of Hedeby. Gold Christian crosses and the symbol of Thor's hammer coexisted harmoniously. Inspired by foreign marble masterpieces, the cathedral at Ribe, site of one of the country's important masons' schools, has a tympanum titled *Descent from the Cross* or *Deposition*, which dates to 1250. The church has a masterfully carved entryway with four pillars borne by lions. Despite the hardness of stone, which gave a stiffly cut appearance to the body of Christ, the artist was able to evoke a sense of power and reverence.

After 1200, the Gothic era brought with it a profusion of local styles, some inspired by southern Germany. However, a crucifix at Herlufsholm shows the influence of the northern French artists, while an outstanding rood screen in Soro, carved in relief rather than in the round, may be an example of a ban by one of the religious orders against fully carved figures. A substantial amount of wood sculpture, including some 300 rood screens in addition to crucifixion scenes and statues, dates from the 13th century in parish churches.

An important figure of the Gothic period is Claus Berg (*ca.* 1470–1532), from Lübeck, who had an impact with his great altarpiece at the Odense Cathedral, while Hans Brüggemann (*ca.* 1480–after 1523) is known for his altarpiece at Schleswig Cathedral that demonstrates the influence of Albrecht Dürer's (1471–1528) wood carvings. Adam van Düren (*fl.* 1487) was a carver who, along with Berg, Brüggemann, and others, drew influence from the southern German Gothic style. Together they unwittingly ushered the Renaissance style into Denmark.

The rise of the Hanseatic League saw an influx of obviously northern German works from about 1425 until the Reformation in 1536, with a concomitant decline of native Danish work. Hundreds of carvings of crucifixes and altar retables survive from this era. Many artists departed Denmark in 1536 as a result of the breach with the Roman Catholic Church rather than compromise their faith under an absolutist ruler. King Christian III became head of the national church and promoted the arts for the country's as well as his own and his family's aggrandizement. The Renaissance in Denmark depended heavily on Dutch and German art-

ists, which is evident in the revisions of Helsingør's (Elsinore) Kronborg Castle (1574–86). Cornelis Floris (1513/14–75), a Netherlander from Antwerp, mainly produced sepulchral monuments for the royal family, such as Christian III's canopied tomb (1568–75) in Roskilde Cathedral. Johann Gregor van der Schardt (*ca.* 1530–*ca.* 1581) created works depicting Frederick II and his queen (1577–79), while Georg Labenwolf (before 1533–1585), from Nuremberg, Germany, created a magnificent bronze Neptune Fountain (*ca.* 1576) for the Kronborg courtyard.

Although several Danish sculptors continued to carve tombstones with figures in relief for the nobility, in the early 17th century Christian IV actively sought foreign sculptors, especially with Baroque leanings. In 1616 he commissioned Dutch sculptor Adriaen De Vries (*ca.* 1556–1626) to create 16 bronzes for a Neptune Fountain to be modeled and cast in Prague, where De Vries was working at the time, then delivered to Denmark at the start of 1620. In 1659 Swedish King Charles X Gustav confiscated these fountain figures from the Frederiksborg Castle in Denmark and took them to Drottningholm Palace in Stockholm, where 69 additional looted sculptures by De Vries and others are located. A copy of De Vries's fountain was reerected at Frederiksborg Castle after the fire of 1888, but it is not an exact reconstruction. Another foreign sculptor working in Denmark, the Flemish François Dieussart (*ca.* 1600–61), created an equestrian statue of Christian IV in 1643–44, as well as a portrait of him, now at Rosenborg Slot in Copenhagen.

Because of the proximity to other nations, a Danish Academy of Fine Arts (Akademie for de skonne Kunster) to promote native talent was not established until

Cathedral of Roskilde, Chapel of Christian I
© Archivo Iconografico, S.A. / CORBIS

1738. Denmark's "Golden Age" of art, approximately 1814–48, focused around the work and impact of the painter Christoffer Wilhelm Eckersberg (1783–1853), who selected national themes but was also influenced by the international Romantic movement. Foreign artists such as Carl Gustaf Pilo (1711–93) of Sweden and French sculptor Jacques-François-Joseph Saly (1717–76) were brought in to teach at the academy. Saly produced the impressive equestrian statue of King Frederick V (unveiled in 1771) at Amalienborg in Copenhagen, which stands before the royal palace.

Sculptor Bertel Thorvaldsen (1770–1844) gained international renown for his work in Rome, impressing Antonio Canova with his statue *Jason with the Golden Fleece* (1803–28). Like Canova, he concentrated on Classical themes in white marble. His final return to Copenhagen in 1838 was a personal and national triumph. Within four years of his death in 1844 the Thorvaldsens Museum opened in Copenhagen, housing his works and eventually his remains. The clean lines of Thorvaldsen's Neoclassical style, as well as his well-run studio, had tremendous impact on the sculptors who followed him, both Danes and others.

One of Thorvaldsen's best students and later his collaborator was Hermann Wilhelm Bissen (1798–1868). Bissen completed the *Danish Soldier after the Victory* monument (1850–58) for the port city of Fredericia, west of Copenhagen, but in a style more realistic than Neoclassical. His *Orpheus*, *Wounded Philoctetes*, and *Electra*, all from the 1850s, reside in the Ny Carlsberg Glyptoteck, which he also helped to decorate. Hermann Ernst Freund (1786–1840), another pupil of Thorvaldsen, focused on Nordic mythology, while still another, Jens Adolf Jerichau (1816–83; not to be confused with his painter grandson of the same name), reacted against Neoclassicism in spite of a 14-year sojourn to Rome, and went on to become director of the Kongelige Dansk Kunstakademi in Copenhagen, 1857–63. Gerhard Henning (1880–1967), born in Stockholm, became a naturalized Dane in 1931, having traveled in France and Italy and lived in Denmark from 1909. He worked at the Kongelige Porceleinfabrik for nine years, winning the medal at the Paris Salon in 1912 for his highly refined porcelain groups in the French Rococo style.

The Danish sculptor Kai Nielsen (1882–1924) found inspiration, as did so many others, in the work of Auguste Rodin. Another contemporary, sculptor Astrid Noack (1888–1954), spent much of her time in Paris. Among the expatriates, Christian Petersen (1885–1961) was a Dane who left his native country for the United States when he was nine years old, so it is debatable how much he was influenced by Danish concepts when he became the first artist-in-residence

Hermann Wilhelm Bissen, Monument to the Danish Dead (*Danish Soldier after the Victory*), 1850–58, Fredericia, Copenhagen
The Conway Library, Courtauld Institute of Art

at an American university (Iowa State University) in the 1930s.

Many contemporary Danish sculptors have focused on nature and natural materials. Sculpture parks such as Krakamarken, a 70-acre nature art park in Randers, in the center of Denmark, exhibit the works of international sculptors who use natural materials. Nobou Sekine (*b.* 1942) combined a highly polished metal column with rough stone for his *Phases of Nothingness* (1970). The works of native sculptors such as Bent Winkler, Kent Rasmussen, Ole Barslund, Britt Smelvaer, Mogens Otto Nielsen, Marianne Hesselbjerg, and Vibeke Glarbo have compared favorably in direct competition with international sculptors.

Jens Galschiot Christophersen (*b.* 1954), a former locksmith, is an activist artist responding to political and social conditions around the world, especially with his *Pillar of Shame*. Since 1996, copies of this work have marked sites of inhuman atrocities around the world. About 7.5 meters tall, and featuring some 40 twisted human bodies, the obelisk undoubtedly was inspired by Gustav Vigeland's *The Monolith* (1929) in Oslo.

Robert Jacobsen (1912–93), who settled in Paris until 1969, worked in iron constructions, then humanoid figures, and, finally, large-scale reliefs in wood and iron. Per Kirkeby (*b.* 1938) has had a broad international impact. His expeditions to Greenland as a geologist have affected his output—simple yet large-scale brick forms as well as dark bronzes.

Through its ministry of culture, established in 1961, Denmark officially encourages its artists to develop their talents, rather than dictating their production. The government also attempts to involve as many people as possible in cultural activities. In addition, support for foreign travel and study is strong, which accounts for colonies of Danish artists in places such as Pietrasanta in Lucca, Italy. Presently the government contributes a significant percentage of its total public expenditures to the arts and has arranged a sliding scale of taxation to alleviate the fluctuating income of artists.

DONALD CLAUDE NOEL

See also **Brueggmann, Hans; Floris de Vriendt, Cornelis II; Schardt, Johann Gregor van der; Thorvaldsen, Bertel; Vries, Adriaen De**

Further Reading

Beckett, Francis, *Danmarks Kunst*, 2 vols., Copenhagen: Koppels, 1926

Bliss, Patricia Lounsbury, *Christian Petersen Remembered*, Ames: Iowa State University Press, 1986

DeLong, Lea Rosson, and Patricia Lounsbury Bliss, *Christian Petersen, Sculptor*, Ames: Iowa State University Press, 2000

Helsted, Dyveke, Eva Henschen, and Bjarne Jørnaes, *Thorvaldsen*, Copenhagen: The Thorvaldsen Museum, 1986; as *Thorvaldsen*, translated by Ann Paludan and Janus Paludan, Copenhagen: The Thorvaldsen Museum, 1990

Krogh, Leila, *Kunst i rummet: Monumentaludsmykning i Danmark, 1964–1988*, Copenhagen: Borgen, 1989

Poulsen, Vagn, *Danish Painting and Sculpture*, translated by Sigurd Mammen, Copenhagen: Danish Institute, 1955; 2nd edition, revised by H.E. Nørregaard-Nielsen, 1976

Poulsen, Vagn, *Illustrated Art Guide to Denmark*, translated by Elaine Hagemann, Copenhagen: Gyldendal, 1959

Poulsen, Vagn, Erik Lassen, and Jan Danielsen, editors, *Dansk kunsthistorie: Billedkunst og skulptur*, 5 vols., Copenhagen: Politiken, 1972–75

SCANDINAVIA: FINLAND

Finland was under the rule of Sweden from the Viking era (*ca.* 1157), when the Swedes introduced Christianity, until 1809, after which Russia held sway until 1917. In 1947 the Finns were forced to cede the culturally rich Karelian Isthmus to the Soviet Union, which included Vyborg (Viipuri) as well as the Fisher Peninsula and the Pechenga (Petsamo) fjord. Although the Finns are of the Finno-Ugrian language group, and of neither Slavic nor Scandinavian origin, traces of Russian and Swedish cultures still exist.

Stone Age discoveries—mainly pottery with large, pointed bases featuring combed diamond-shaped patterns—date from the Neolithic era; Karelian pottery is among the best. Carved wooden animal heads, such as an elk head from Rovaniemi in the far north, date to about 5900 BCE. During the Stone Age, the animal head theme also appears on Karelian handles of daggers, knives, and wooden spoons. It is only about the middle of the 1st century that decorative geometric shapes, such as lines, triangles, bulls' eyes, and lozenges, appeared in western Finland, an indication of Viking influence and domination.

The first building material of churches was wood, then gray stone and granite, in a Romanesque style. The Gothic style surfaced after 1200, indicating the influence of the Order of Teutonic Knights. Although the Teutonic Knights were founded at Jerusalem about 1190 CE in imitation of the Knights Templar and Hospitallers of St. John, members were restricted to the German nobility. They eventually advanced into Prussia and controlled the region for 300 years and thus were instrumental in spreading the Gothic style around the Baltic regions, such as Malbork Castle, built in 1309 in present-day Poland. Although artists decorated churches with painted murals, wooden statues of Christ and the saints began to appear, many of them imported. For example, the St. Barbara altarpiece was by a Dominican friar, Master Francke. He likely produced an oak relief carving for the Cathedral of Turku about 1412. Removed after the Reformation, the work resurfaced in 1908 at a small church in Nykyrko in southwest Finland. In addition, an altarpiece at Niederwildunge by Conrad von Sost's workshop dates to 1424. The work consists of a large calvary in addition to 12 paintings.

In the 14th century, the Swedish island of Gotland, a center for stonecarvers because of its good limestone, exerted a strong influence on the times. The style of the Master of Lieto is like that of the Gotland carvers, but he himself may have been Finnish. He was active in Turku in the first half of the 14th century, and 20 items are attributed to him or his school, such as *Virgin and Child* (*ca.* 1330) in the Turku Provincial Museum. North German masters appeared in the Hame region soon after. Local sculptors developed a clearly Finnish style only after about 1500, using birch wood rather than the oak and other woods artists commonly used in sculpture, especially near Turku, in the west.

The Renaissance styles emerged in the 16th century in castle architecture. As in Denmark, the Reformation brought much sculptural activity to a halt because of the closing of monasteries and an impoverished Roman Catholic Church. Nonetheless, Renaissance models of city planning are clear in the layout of 15 new cities in the 17th century. The creation of native sculpture

was rare during this period, as the country was impoverished and isolated to a great extent from Europe, although tomb monuments and church sculpture were produced.

With no training schools for native artists, foreigners such as the German Peter Schultz provided Baroque monuments, including one (1678) in imported black and white marble in the Cathedral of Turku. Little additional sculpture was produced until the work of Erik Cainberg (1771–1816), who attended the Royal Academy of Arts in Sweden and later received a six-year stipend to study in Rome, returning home in 1809. Although he adopted a Neoclassical style during his travels, his work soon began to express a Finnish nationalism. The work of later sculptors, such as Walter Magnus Runeberg (1838–1920) and Johannes Tanken (1849–83), reflect Cainberg's influence. Runeberg studied in Copenhagen with famed Danish sculptor Hermann Wilhelm Bissen but completed some of his work in Rome before returning to Helsinki.

The Swedish sculptor Carl Eneas Sjöstrand, who also studied under Bissen, created Finland's first monument to honor a public figure, *Henrik Gabriel Porthan*, unveiled in 1864. A teacher in Helsinki, Sjöstrand often sent his students to Copenhagen, then very much under the Neoclassical influence of Danish sculptor Bertel Thorvaldsen. Emil Wikström (1864–1942) produced a bronze bust of Finnish artist Akseli Gallen-Kallela in 1886. Gallen-Kallela was a leader in the move toward folk-inspired sculpture and worked in wood and other media. The sculptor Eemil Halonen (1875–1950) imbued a sense of nationality into his work, whereas Ville Vallgren (1855–1940) introduced Art Nouveau into Finnish sculpture. His Havis Amanda Fountain (1905–8), in granite and bronze for the Helsinki Market Square (Kauppatori), was shown at the Paris Salon of 1907 before being reassembled

in Helsinki. The statue still figures prominently in Labor Day eve celebrations, when young men attempt to place their caps on the figure's head. Halonen continued Gallen-Kallela's primitivistic style with works such as *Man with Reindeer*, which was shown in Paris at the Finnish pavilion at the Exposition Universelle of 1900. A few years later, he experimented with granite sculpture, a forerunner of later Finnish sculpture. Hilda Flodin (1877–1958) introduced themes of bears, pine cones, and squirrels, much in line with Wikström's large stylized *Bear* (1905–10), which graces the entrance to the National Museum of Finland in Helsinki.

With independence from Russia, sculptors such as Hannes Autere (1888–1967) furthered the sense of national Romanticism, especially in wood carvings. Wäinö Aaltonen (1894–1966), considered the greatest of the Finnish sculptors, scandalized many with his bronze nude sculpture of a well-known Finnish athlete, *Paavo Nurmi Running* (1925), now outside the Olympic Stadium in Helsinki, although he is also known for his nonrepresentational work. Finnish Impressionism and Expressionism arose in sculpture after World War I. Some artists of the time, such as Unto Pusa (1913–73), joined a Finnish group called *Prisma*, who were open to international influences as opposed to nationalistic post–World War I movements.

Felix Nylund (1878–1949) employed Nordic social realism in his art of the 1930s, as in his bronze *Three Smiths* (1932). Architect and engineer Alvar Aalto (1898–1976) experimented with laminated wood, which led to a revolution in the use of materials not only for sculpture, but also in furniture and architecture. Through his efforts, as well as those of his friend Maire Gullichsen, Finnish Modernism took hold by the 1950s. Harry Kivijärvi (*b.* 1931) is known for his work with black granite slabs, as in his *Killi and Nalli* (1982). Medalists Aimo Tulainen (1917–96) and Raime Heino (1932–95) were especially noted for their portrait medals, and sculptor Juhani Linnovaara created elaborate forms in jewelry.

After 1945 Finnish sculpture reflected the diversity found in international circles. Eila Hiltunen's abstract welded metal monument (1967) to the composer Jean Sibelius in Helsinki provoked a great deal of discussion because the public wanted a figurative representation of the musician, but the work was finally highly regarded. Contemporary Finnish sculpture is thriving, owing in part to organizations such as the Suomen Kuvanveistajaliitto ry (Union of Finnish Sculptors).

DONALD CLAUDE NOEL

See also **Aaltonen, Wäinö**

Further Reading

Hoesli, B., W.M. Mose, and L. Mosso, *Alvar Aalto: Synopsi: Painting, Architecture, Sculpture*, Basel, Switzerland, and Stuttgart, Germany: Birkhauser, 1980

Eila Hiltunen, Jean Sibelius Monument
© Charles and Josette Lenars / CORBIS

Juva, Karl, *Suomalaista veistotaidetta; Finnish Sculpture* (bilingual Finnish-English edition), Helsinki: Söderström, 1980

Karjalainen, Tuula, et al., editors, *Eila Hiltusen Sibeliusmonumentii, Passio Musicae* (The Sibelius Monument Passio Musicae, by Eila Hiltunen), Helsinki: Helsinki City Art Museum Publications, 1998

Lindgren, Liisa, *Elävä muoto: Traditio ja modernisuus 1940-ja 1950-luvun suomalaisessa kuvanveistossa* (Living Form: Tradition and Modernity in Finnish Sculpture of the 1940s and 1950s), Helsinki: Finnish National Gallery, 1996

Schildt, Göran, *Modern Finnish Sculpture*, London: Weidenfeld and Nicolson, and New York: Praeger, 1970

Schildt, Göran, *Alvar Aalto: Masterworks*, London: Thames and Hudson, and New York: Universe, 1998

Sinisalo, Soili, and Jaakko Lintenen, *Kimmo Kaivanto*, Espoo, Finland: Weilin and Göös, 1982

Valkonen, Markku, *The Golden Age: Finnish Art, 1850–1907*, translated by Michael Wynne-Ellis, Porvoo, Finland: Werner Söderström Osakeyhtiö, 1992

SCANDINAVIA: NORWAY

Norway's sculptural history dates back to Neolithic rock carvings. The Bronze Age followed, with a seeming sculptural hiatus during the Iron Age. The distinctive interlace patterns (500–700 CE) continued to develop and be embellished. By the Viking era, from the 8th to the 10th century, a more vigorous and unique art began to flourish. The very lines of the Vikings' practical and magnificent ships, designed to go forward or backward in narrow fjords, are indicative of their innate sense of beauty. Their burial ships, such as the Oseberg ship in Vestfold, dating from about 850 CE and uncovered in 1904, give striking evidence of the Vikings' artistic abilities, especially in the form of carved wooden animal representations. That wood carving was a highly developed and wide-ranging art form is evident in the decoration of the banquet hall called Olav Pá in Iceland, built for the wedding of a chieftan's daughter about 960 CE, with carvings depicting scenes from Norse mythology.

Christianity came to the region with the martyrdom of St. Olaf (King Olaf II) in 1030. Thus, members of the aristocracy became patrons of art, and with the Church came the construction and embellishment of churches and monasteries. Nevertheless, as in the portal of the Hylestadt Stave Church in Setesdal (*ca.* 1200 CE), full-blooded pagan heroic carvings continued to appear. Eventually, however, the Classical tendril motif was joined to the animal carvings, though some now sprouted wings and became European dragons. The florid carvings on the Tuft stave church (*ca.* 1250) in Telemark are flatter than those of western Norwegian portals. Of almost 1,000 stave churches, fewer than 30 survive, dated primarily from 1150–1250.

Signs of the Romanesque style can be seen at the churches in western Norway, which was receptive to new trends and not as isolated from European influences. The church at Urnes (*ca.* 1150), features a calvary group as well as a carving of *Christ as Stern Judge* that manifests a Byzantine style. Nordic and Gothic styles also began to appear in the Trondheim area, as well as in Bergen. The devastation of the plague in about 1350 suppressed the development of sculpture for some time. For some 400 years, the small and scattered population of Norway, on the fringes of Europe, was unable to promote an independent artistic milieu, although folk art continued to flourish.

The country felt the economic dominance of the Hanseatic League of Germany along the Baltic Sea since Bergan, the seat of government of one of the Hanseatic ports, had strong economic ties with England and Germany. Politically, Norway came under the control of Denmark in about 1450. The Reformation and introduction of Protestantism, imposed by Denmark in 1537, ended the patronage of the Roman Catholic Church, leaving the artists who depended on this patronage in something of a lacuna for almost 100 years.

In 1624 Christian IV rebuilt Oslo, the capital since 1299, and renamed it Christiana. In the renewal the arts flourished. By the mid 1650s Norway became a leader in the art of cast-iron stoves, including beautiful low-profile bas-reliefs and even shapes of full human figures. Christopher Ritter (*fl.* 1650s) was one of the best-known cast-iron artists working in Norway's some 20 iron works, which even exported their products out of the country. The ivory carver Magnus Berg (1666–1739), originally trained as a woodcarver in Copenhagen, completed a powerful ivory relief portraying St. Jerome (1731) that resides in the Kunstindustrimuseum in Oslo.

Artists of the Gudbransdal area in central Norway embellished the acanthus style introduced by a Dutch carver about 1100 in the Church of Our Savior in Christiana (Oslo); the style featured tendrils of the plant interwoven at times with lurking animal figures, but eventually the pattern flowered into plant shapes alone. Carvers such as Jakob Bersveinsson Klukstad (*ca.* 1715–*ca.* 1773), the so-called Acanthus Master, perfected the style. His altar and pulpit carvings in Lesja Church show the fantastic elaborations of the old Norse carvers. Kristen Listad was a remarkable rural artist who carved in virtually any style, from Gothic to Baroque and Louis-Seize. His full figure of St. Peter in Sodorp Church, along with his figured candlesticks and playful toy horse-on-wheels in the Sandvig Collection, Lillehammer, remain among the unique examples of the acanthus carvers. The acanthus tendril style permeated Norwegian sculpture through the late 18th century, not only in public buildings but even in the exteriors of homes and barns, as well as household furnishings such as beds and cabinets.

United with Denmark for some 400 years, Norway adopted a constitution in 1814, although the country was forced into a union with Sweden. It was only in 1905, after separating from Sweden, that the parliament elected Danish Prince Charles as King Haakon VII (*r.* 1905–57). Hans Michelsen was the outstanding native sculptor after 1814. Lacking a national school of art in Norway, he went, with state support, to study in Stockholm and later in Rome, with Danish sculptor Bertel Thorvaldsen (1770–1844). King Charles XIV (*r.* 1818–44) commissioned Michelsen to create *Twelve Apostles* (installed 1840; destroyed 1983) for Trondheim Cathedral. Julius Olavus Middelthun (1820–86), considered Norway's most classicizing sculptor, taught an entire generation of Norwegian sculptors. Because of his own critical outlook, his output was minimal and included mainly portrait busts, such as the marble bust of poet Johan Sebastian Welhaven (1865). His statue (1870–83) of historian Anton Martin Schweigard is considered his greatest work. Brynjulf Larsen Bergslien (1830–98?), who played an important role in the formation of the young Gustav Vigeland (1869–1943), studied at the Kongelige Danske Kunstakademi in Copenhagen under Hermann Wilhelm Bissen, one of Thorvaldsen's best students. Bergslien created the first Norwegian traditional bronze equestrian statue, *Charles XIV* (unveiled 1875), in Oslo's Slottsplassen. He also produced the likeness of the new king for the Konsberg Mint on the coins placed in the cornerstone of the Norwegian Storting (Parliament) Building.

Thereafter, Norway saw a trend toward Nordic subject matter by sculptors, such as Soren Lexov-Hansen (1846–1919), who depicted figures from Norse mythology. Mathias Skeibrok (1851–96) portrayed a Viking king in his *Ragnar Lodbrok in the Snake Pit* (1878), as well as subjects from the Icelandic sagas. However, the only Norwegian with a European reputation in the 19th century was Stephan (Abel) Sinding (1846–1922), a pupil of classicist Albert Wolff in Berlin, who lived in Denmark beginning in 1833 and ultimately became a Danish citizen. He produced works with highly Romantic Nordic themes, such as *Adoration* (1903). By the end of the 19th century Gunnar Utsond (1864–1950) completed *The Journey to Hell*, which depicted the mythical Nanna and Balder on horseback, plunging into the kingdom of death.

Norway's most prolific and controversial sculptor of the 20th century was Gustav Vigeland (1869–1943). Asked to produce what was expected to be a portrait figure of mathematician Niels Henrik Abel, he created a figure flying naked through the air on the backs of two other male figures. The work was unveiled in 1908 in Oslo's Slottspark. Vigeland's biggest achievement is the masterful Vigeland Park. He was still at work

Gustav Vigeland, Nude sculptures at Vigeland Sculpture Park, 1900–1930, Oslo, Norway
© Stephanie Colasanti / CORBIS Aritsts Rights Society (ARS), New York, and BONO, Norway

on some 200 granite and bronze figures for it when he died. Vigeland's studio (Vigeland Museum) in Frogner Park and Vigeland Park are major tourist draws in Oslo.

Contemporary Norwegian sculpture is both active and flourishing. After World War II, the government initiated a variety of far-reaching arts programs. As a result, a large number of sculptors emerged to participate in experimentation of all kinds. Norway first saw a tendency toward the avant-garde, readily accepted by the public as the proper direction in which to proceed; although the highly respected Norwegian painter Edvard Munch (1863–1944) set the tone in one direction and Vigeland in another, younger generations leaned toward myriad forms of expression. Nevertheless, opposition arose when sculptors Aase Texmon Rygh (*b.* 1925) and Arnold Haukeland (1920–83) both developed a nonfigurative style.

Typical of late 20th-century artists is Norwegian sculptor and painter Jan Valentin Saether (*b.* 1944), part of the Neo-Romantic movement in Oslo in around 1970. He worked in California for 18 years before teaching figurative painting at the Oslo College of Art, part of the national Academy of Fine Arts. Art critic Hans-Jakob Brun judged Bard Breivik (*b.* 1948) to be the most prominent Norwegian sculptor at the turn of the 21st century for his "dialogue between nature and mankind's treatment of nature."

As with other nations, a division developed in Norway between those who embraced historical trends of casting in bronze or carving in stone and others who wanted to experiment with a variety of materials, including three-dimensional computer creations. Although some aimed to break the boundaries, others looked back for some continuity in the national culture. Some young sculptors merely wanted to explore the materials, with little regard to form; others were drawn to Installation. At the start of the 21st century sculptors were drawn to the integrity of natural materials, as evidenced by the number of exhibitions and sculpture parks fostering such work by both Norwegian and international sculptors. Such a variety has instilled an energy and vitality into the state of sculpture in Norway today.

DONALD CLAUDE NOEL

See also **Vigeland, Gustav**

Further Reading

Hauglid, Roar, editor, *Native Arts of Norway*, Oslo: Mittet, 1953; as *Native Art of Norway*, New York: Praeger, 1967

Jones, Gwyn, *The Norse Atlantic Saga, Being the Norse Voyages of Discovery and Settlement to Iceland, Greenland, [and] America*, London and New York: Oxford University Press, 1964; 2nd edition, 1986

Lindholm, Dan, *Stabkirchen in Norwegen: Drachenmythos und Christentum in der altnorwegischen Baukunst*, Stuttgart, Germany: Verlag Freies Geistesleben, 1968; as *Stave Churches in Norway: Dragon Myth and Christianity in Old Norwegian Architecture*, translated by Stella Bittleston and Adam Bittleston, London: Steiner, 1969

Parmann, Øistein, *Norwegian Sculpture; Norwegische Skulptur* (bilingual English-German edition), Oslo: Dreyers Forlag, 1969

Sawyer, Peter, editor, *The Oxford Illustrated History of the Vikings*, Oxford and New York: Oxford University Press, 1997

Wilson, David MacKenzie, and Ole Klindt-Jensen, *Vikingetidens kunst*, Copenhagen: National Museum, 1965; as *Viking Art*, Ithaca, New York: Cornell University Press, and London: Allen and Unwin, 1966; 2nd edition, Minneapolis: University of Minnesota Press, and London: Allen and Unwin, 1980

SCANDINAVIA: SWEDEN

A sculptural account of Continental significance began in Sweden with the definitive establishment of Christianity in Scandinavia during the second half of the 11th century and the resultant intensive church building. In this context sculpture nearly always involved architecture. Most sculptural production during the Early Middle Ages was concentrated in the southern areas of present-day Sweden; the construction of the cathedral in Lund, Scandinavia's first archbishopric, consecrated in 1103, became a catalyst for Romanesque art there. Lund Cathedral's sculptural decoration shows the strong influence of the Lombard style, probably transferred via the Rhineland. A significant sculptural production during the Romanesque period was stone fonts, some decorated with rich reliefs that have classicizing features mixed with indigenous traditional animals motifs. Sandstone and limestone fonts from Gotland, a Swedish island rich in those materials, were exported to the rest of Sweden and abroad.

The Gothic influence came above all from France, also transferred by way of northern Germany. Naturally, this involved a certain delay and shift of artistic expression. An important difference from France was that the use of brick as the dominant building material in northern Europe reduced the need for stone sculpture. Of particular significance for the spread of the new style was the building of Uppsala Cathedral between 1287 and 1435. Some of the most important High Gothic cathedral workshops can also be found on Gotland, where, for example, the portal of Stånga Church from the middle of the 14th century shows examples of rich figurative reliefs.

In Sweden a large amount of high-quality medieval wood sculpture survives from both the Romanesque and Gothic periods. Even before the Medieval period, the craft-oriented Scandinavians were familiar with wood as a material, and the new iconography brought by Christianity encouraged further development of this art. Sweden followed developments on the Continent, both through imports and through its own production, although always with some delay. A large number of imported altarpieces from the Netherlands and Germany are notable. The most spectacular wood sculpture is in Storkyrkan in Stockholm: the detailed polychrome monumental sculpture of *St. George and the Dragon*, completed in 1489. The work has been attributed to Bernt Notke from Lübeck, but the exact circumstances surrounding its production are unclear.

Following Gustav Vasa's assumption of power in 1523 and the Reformation just after, sculptors shifted from religious to secular commissions. Playful sculptural ornament was adapted from the Netherlands and Germany, often derived from graphic sources, but it gave way to a stricter classicism in the 17th century. Freestanding sculpture consisted almost exclusively of funerary monuments during the 16th century. In Uppsala Cathedral, for example, is Gustav Vasa's grave (1562–83), executed by the Flemish sculptor Willem Boy. During the medieval period tomb sculpture had consisted of a simple slab, but this monument is an architectural tomb-casket, decorated with the deceased's portrait in high relief.

The rich sculptural decoration of the sunken royal ship *Vasa* (1626–28) is testament to the continuing importance of wood sculpture in Sweden, but also to the role of polychromy. The sculptural decoration of

the Vasa has been shown to have close relationships with contemporary stone facade decoration, of which a large part is still present in the old parts of Stockholm. Stucco was also very common in Sweden from the mid 16th century. From the mid 17th century the work of the Italian brothers Carlo and Giovanni Carove is particularly noticeable, for instance at the newly constructed Drottningholm Castle and the stuccoes in the sepulchral chapel of Lars Kagg in Floda Church, signed by Carlo Carove in 1667.

In the 1670s and 1680s Nicolaes Millich, originally from Antwerp, produced sculpture for the staircase of Drottningholm Castle in a strongly classicizing style. Furthermore, during the second half of the 17th century, the influence of Italy and France increased. The most renowned architects of the period were inspired by the study trips they took to the Continent. The Roman Baroque thus became noticeable in many church interior decorations that Nicodemus Tessin the Younger (1654–1728) executed, such as the king's pews in Storkyrkan (1686), and also the pulpits in Storkyrkan (ca. 1700), and in Uppsala Cathedral (1707) executed by the German-born sculptor Burchard Precht.

The most important examples of sculptural art to date were advanced by the construction of Stockholm Palace after the fire of 1697. Tessin the Younger and his successor Carl Hårleman (1700–53) engaged several sculptors and ornament carvers from France, such as Bernard Foucquet (ca. 1640–1711), René Chauveau (1663–1722), Charles Guillaume Cousin (1707–83), Jacques Philippe Bouchardon (1711–53), and Pierre Hubert L'Archevêque (1721–78) (French artists also played a decisive role in the establishment of the Swedish Art Academy, after the French model, in 1735). In the 1760s there was still a lack of public monumental sculpture in Sweden. L'Archevêque's statue depicting Gustav Vasa (erected in 1774) and the equestrian monument of Gustav II Adolf (cast in 1779) were the first sculptures of this type.

Indigenous sculpture was born with L'Archevêque's pupil Johan Tobias Sergel (1740–1814). This development also coincided with sculpture's emancipation from architecture, and for the first time a rich, Swedish production of freestanding sculpture can be discussed. Sergel spent his entire youth (1767–78) in Rome and found himself in the forefront of sculptural developments in Europe that transitioned between Rococo and Classicism. His work—for instance, the marble sculpture of *Cupid and Psyche* (1787)—appears to catch a moment between activity and rest. After Sergel's return to Sweden, his task was mainly to provide the royal family with portrait busts and medallions, but in his monument to Gustav III (erected 1808), his art is at its finest expression. The statue,

placed by the water, represents the king as a victorious ruler and at the same time as an Apollo of the arts.

Sergel's legacy was well administered by his pupils Johan Niclas Byström (1783–1848) and Eric Gustaf Göthe (1779–1838), as well as Bengt Erland Fogelberg (1786–1854) and Carl Gustaf Qvarnström (1810–67). These sculptors also spent many years in Rome, where they worked in the circles of Antonio Canova and Bertel Thorvaldsen. Against the background of an emerging Romanticism and an increasing interest in old Norse mythology during the 1830s and 1840s, Fogelberg created monumental marble sculptures of the gods *Odin*, *Thor*, and *Balder*. Johan Peter Molin (1814–73) created a Romantic sculpture of nearly painterly character and of a dramatic realism. Particularly noteworthy is his *Bältespännarna* (Belt Wrestlers, cast in bronze in 1862), in which a new original strength and movement is enacted.

Toward the middle of the 19th century, the increased interest in Sweden's own history and sculpture's new role in decorating public spaces also brought a growth in sculptures of the country's great men and heroes, such as, for instance, John Börjeson (1835–1910). Per Hasselberg's (1850–94) sensual interpretations were innovative, and Christian Eriksson's (1858–1935) simple and rugged figures conveyed Swedish national Romanticism. This feeling for simplicity and craft was also shared by Carl Eldh (1873–1954). His *Branting Monument* (1930–42), at that time the largest relief ever made in Sweden, can also be regarded as a typical representative of early 20th-century political art.

One of the 20th century's most significant sculptors was Carl Milles (1875–1955), who was from the beginning influenced by French Impressionism. Soon his work became characterized by a Classical formal language and by movement, often in combination with water, since he made many fountains. His sculptures decorate many public places, not only in Swedish cities (e.g., the *Orpheus Fountain* in Stockholm) but also in the United States, such as the Cranbrook Academy in Bloomfield Hills, Michigan, where he was the director of the sculpture department from 1931 to 1951.

The demand for public sculpture continued even after the turn of the century, but its expression changed. The source of inspiration was often the surrounding reality and society, and the century's various artistic directions are mirrored in 20th century Swedish sculpture. Bror Hjorth (1894–1968) was influenced early on by French Modernism. His work, often a cross between painting and sculpture, has elements of Cubism, native primitivism, and exoticism. A primitive realism can be found also in Axel Petersson's (1868–1925; also called "Dödhultaren") simple carved figures drawn from the craft tradition of his own home district. Bror Marklund

(1907–77) worked in Hjorth's following, and his sculptures have a naïve but severe and simplified formal narrative joy. With Christian Berg (1893–1976), Cubist forms are dispersed in abstract works, although always with a certain anchoring in original natural forms. Arne Jones (1914–76) abstracted human forms into stylized, architectonic constructions.

During the postwar period, public sculptural commissions grew with the expansion of building activities. The Swedish sculptor through whom Surrealism gained its greatest expression was Eric Grate (1896–1983). His art often emerged from so-called *objets trouvés*. Asmund Arle (1918–90) and Hertha Hillfon (*b.* 1921) can be seen as the representatives of experimental sculpture, while others such as Liss Eriksson (1919–2000) have stood for an increasingly form-orientated tradition. Karl-Göte Bejemark's (1922–2000) portrait sculpture, Stig Blomberg's (1901–70) content-rich and burlesque sculptures, and Sivert Lindblom's (*b.* 1931) monumental bronzes belong to the most renowned and popular public works of art. In the latest sculptural art, Lars Englund (*b.* 1933), Per Olof Ultveldt (*b.* 1927), Lars Erik Falk (*b.* 1922), Einar Höste (*b.* 1930), Carl Magnus (*b.* 1943), and Mikael Fagerlund (*b.* 1955) are notable.

LINDA HENRIKSSON

See also **Canova, Antonio; Milles, Carl; Netherlands; Notke, Bernt; Polychromy; Neoclassicism and Romanticism; Sergel, Johan Tobias; Stone; Stucco (Lime Plaster); Thorvaldsen, Bertel**

Further Reading

Hökby, Nils-Göran, Ulf Cederlöf, and Magnus Olausson, editors, *Sergel* (exhib. cat.), Stockholm: Nationalmuseum, 1990

Josephson, Ragnar, Nils Gösta Sandblad, and Gösta Lilja, editors, *Svenska skulptur idéer*, 2 vols., Malmö, Sweden: Allhems, 1952

Larsson, Lars, *Signums Svenska konsthistoria*, Lund, Sweden: Signum, 1994–

Lindgren, Mereth, et al., *Svensk konsthistoria*, Lund, Sweden: Signum, 1986; as *A History of Swedish Art*, translated by Roger Tanner, Lund, Sweden: Signum, 1987

Nationalmuseum, Stockholm: Illustrerad katalog över äldre svensk och utländsk skulptur; Nationalmuseum, Stockholm: Illustrated Catalogue, Swedish and European Sculpture (bilingual Swedish-English edition), Stockholm: Nationalmuseum, 1999

Olausson, Magnus, "Johan Tobias Sergel," in *Art in Rome in the Eighteenth Century* (exhib. cat.), edited by Edgar Peters Bowron and Joseph J. Rishel, London: Merrell, and Philadelphia, Pennsylvania: Philadelphia Museum of Art, 2000

Soop, Hans, *The Power and the Glory: The Sculptures of the Warship Wasa*, Stockholm: Kungl. Vitterhets Historie och Antikvitets Akademien, 1986

Svanberg, Jan, *Sankt Göran och draken*, Stockholm: Tidens Förlag, 1993; as *Saint George and the Dragon*, translated by David Jones, Stockholm: Rabén Prisma, 1998

Wennberg, Bo, *French and Scandinavian Sculpture in the Nineteenth Century: A Study of Trends and Innovations*, Stockholm: Almqvist och Wiksell, and Atlantic Highlands, New Jersey: Humanities Press, 1978

JOHANN GOTTFRIED SCHADOW
1764–1850 *German*

Johann Gottfried Schadow's career as a sculptor, draftsman, printmaker, and art theorist exerted wide influence over several generations of Berlin artists. From his public monuments to private portrait commissions to his position as teacher and director of the Berlin Akademie der Künste, his work marks a synthesis of realism and idealization, in which historically grounded, strong likenesses seamlessly combine with ideal beauty and form, creating monumentality out of specificity. His career straddled the movement from Neoclassicism to Romanticism in the cultural realm in Germany and offers a glimpse into the complex period of the late 18th to early 19th century.

After attending a monastery school, Schadow lived until about 1780 with the Belgian artist Jean-Pierre-Antoine Tassaert, head of the sculpture workshop at the court of the Prussian king Frederick II in Berlin. From age 13 Schadow learned drawing from Tassaert's wife, Marie-Edmée de Moreau. In 1778 he enrolled at the Berlin Akademie der Künste, concentrating on life drawing. In 1783 he became a paid assistant to Tassaert.

Schadow's first sculptural work was a bust of Henriette Herz, done in a rather severe manner unlike that of Tassaert. Having used an etched frontispiece to lampoon a government minister, Schadow fled to Rome in 1785 with Marianne Devidels, a Jew recently converted to Catholicism (Schadow converted to Catholicism in order to marry her). Rome was the most important city for any sculptor at the time, and he worked briefly there in the studio of Alexander Trippel. Schadow became friends with Antonio Canova, whose work he admired. Canova's soft monumentality and sensitive treatment of material influenced Schadow, but as his career progressed Schadow became less interested in Classical idealization and more in historical reality and expressive detail. He studied antique sculpture in the collections of the Vatican and the Capitol and worked from casts at the French Academy in Rome. In 1786 he won a prize in the Concorso Balestra at the Academy of St. Luke in Rome for his terracotta group *Perseus and Andromeda*. Friedrich Anton von Heinitz, curator of the Berlin Akademie, helped him return to favor with the Prussian court, and Schadow returned to Berlin in 1787, revoking his recent conversion to Catholicism. The next decade was the most successful of his career.

The first major work after Schadow's return from Rome was the tomb of Graf Alexander von der Mark, the illegitimate son of King Frederick William II. This monument combines a sarcophagus with classicizing sculptural reliefs and a reclining life-size effigy of the young boy within an architectural environment; it was originally installed in a church in Berlin. The mixing of the real and ideal realms shows the influence of Canova's tomb sculpture, particularly in details such as the drapery falling over the edge of the sarcophagus.

One of Schadow's earliest yet most famous and visible works is that of the Quadriga of Victory for the Brandenburg Gate in Berlin. The model dates to 1789; the sculpture was completed in 1791 and installed in 1793. Schadow worked on this commission together with the architect Carl Gotthard Langhans, who designed the severely Neoclassical gate, ordered by King Frederick William II to replace an earlier Baroque gate to the city, which faces inward toward the city as do the goddess-driven chariot and the four horses who appear to be galloping triumphantly into the city, atop the gate. Following the defeat of Prussia by Napoléon's forces in 1806, Napoléon entered Berlin through this gate as a symbol of his triumph. He took the quadriga back to Paris as part of the artistic booty he accumulated throughout his reign. The Brandenburg Gate remained empty of the quadriga until the fall of Napoléon, when it was returned and reinstalled in 1814.

In 1791 Schadow traveled to Stockholm, Copenhagen, and St. Petersburg to study new developments in equestrian statuary (e.g., Etienne Falconet's equestrian monument of Peter the Great; 1766–82) and large-scale bronze casting in relation to a proposed equestrian statue of Frederick II. While in Copenhagen, Schadow executed the original plaster oval relief of *Bacchus and Ariadne* as his admission piece to the Berlin Akademie. In the late 18th century the artistic community debated whether to use Classical versus historical or contemporary dress for public monuments. Schadow had previously engaged in this debate with the poet Johann Wolfgang von Goethe; Schadow was in favor of contemporary costume, whereas Goethe favored the idealization and timelessness of Classical dress. Also debated was whether Frederick II should be shown standing, reclining, or on horseback. Schadow submitted many designs of Frederick II on horseback, borrowing the traditional equestrian form of the Roman statue of Marcus Aurelius on horseback that had been revived in the Renaissance. Throughout, Schadow favored a historical rather than a universalistic approach to public sculpture, and surviving drawings (1797) by Schadow for this unexecuted monument represent Frederick II on horseback. Realism and historical accuracy of pose and costume of the figure and horse contrast sharply with a severely Neoclassical rec-

tangular base that is articulated by sculptural reliefs on all sides and full-scale allegorical or mythological figures at each corner.

Of Schadow's full-size public monuments, the 1790–94 monument to General Hans von Zieten was one of a series of works dedicated to Prussian generals. Originally erected in Wilhelmsplatz in Berlin, it relates to another of his marble sculptures of Frederick II (1792–93). Both depict over-life-size images of the figures in historical costume and with relief sculpture on pedestals. Von Zieten stands in a casual but ready pose; he looks off to his right and cradles his chin with his hand, a gesture related to images of philosophers engaged in deep thought. While the sculpture is balanced and classically inspired in terms of pose, it is perhaps overly grounded in the specificity of military dress and weaponry; yet the eyes and facial expression of this contemporary figure reveal an almost tragic knowledge of the world, which connects him to philosophical prototypes.

Another large-scale marble sculpture that tends to the ideal while still grounded in the real is that of the *Princesses Luise and Friederike of Prussia*. This commission grew out of an earlier plaster bust portrait of the two princesses that their father-in-law, King Frederick William II, ordered. The older sister, Luise, was married at the time to the future king Frederick William III, while Friederike was married to his younger brother. The full-scale sculpture is a monument to their affection for each other as sisters, as well as to their youth and celebrated beauty. The group strongly emphasizes the Neoclassical ideas of Johann Joachim Winckelmann, "calm grandeur and noble simplicity," but is combined with a growing Romantic sensibility of personality and emotional introspection. The clothing of the two young sisters is modern and form revealing without the frivolity or eroticism of Baroque or Rococo portraiture. Here, Schadow reconciled modern dress, modern hair styles, and distinct personalities (the younger sister looks down and holds on more strongly to her older sister, who is overall more confident in appearance) with a universalizing and Classical feel. The drapery and relationship of the two figures to each other make reference to antique prototypes of sculptures of intertwined goddesses, particularly the *Three Goddesses* from the east pediment of the Parthenon (completed by 438 BCE). Their warm embrace and the tenderness of their interaction, as well as the lifelike quality of the textures, which defy the solidity of the marble, prevent any hint of coldness associated with self-contained, fully Neoclassical Winckelmannian sculpture.

In addition to full-size portrait sculpture, Schadow created many bust-length portraits. In 1807 he received a commission, along with other artists, from Crown

Princesses Louise and Friederike of Prussia
© Erich Lessing / Art Resource, NY

Prince Ludwig I of Bavaria for a series of 15 busts for the Walhalla at Regensburg (opened 1842), a pantheon of northern heroes. Part of Ludwig I's nationalistic enterprise was to commission marble busts of famous men of German history through the present time. One of the busts by Schadow is of the philosopher Immanuel Kant, a likeness that is recognizably contemporary and unidealized, particularly in the face and the neck. Schadow achieved an uncanny feeling similar to that of a Classical herm (a statue with the head and torso of a human, but a pillar as a bottom house) by juxtaposing the real and the abstracted in the truncation of the shoulders and chest in the squared-off base carved with the philosopher's name. Schadow carved *Kant*, although unadorned by the traditional motif of the laurel wreath, in the style of an ancient Roman philosopher (examples of which Schadow would have seen in Rome), with blank, unarticulated eyes that nevertheless see beyond the realm of mundane reality.

Throughout his career Schadow held a number of academic positions, first as a member of the Berlin Akademie der Künste (after 1787), where he taught sculpture. In 1788 he became director of sculpture at the ministry of architecture in Berlin and soon became the head of the court sculpture workshop (a position inherited from his former master Tassaert upon the latter's death). Toward the end of his life Schadow's eyesight began to fail, and he turned increasingly toward writing; he was a prolific writer of art theory and practice on issues of beauty and Classical principles. While his sculpture portrays a strong Romantic tendency and a softening of Classical values, his theoretical writings and teaching concentrated on Classical form, proportion, and anatomy. His *Polyclet, oder, von den Massen der Menschen nach dem Geschlechte und Alter* (Polykleitos, or on the Proportions of the Body according to Gender and Age; 1834) reflects on the work of the Greek sculptor Polykleitos and his canonical rules and proportions. Yet Schadow once again mitigated this Classical tendency in his *Kunst-Werke und Kunst-Ansichten* (Art Works and Opinions on Art; 1849), which serves as an important source of information on the history of Berlin art and culture, emphasizing the local color and history favored during the Romantic era.

Schadow was the most important of a family of artists. His son Rudolf (called Ridolfo) Schadow, also a sculptor and active in Rome from 1810, studied with the Danish sculptor Bertel Thorvaldsen. Another son, Friedrich Wilhelm Schadow, went to Rome with his brother Rudolf, where he was associated with the Nazarenes. A painter, writer, and teacher, he served as director of the Düsseldorf Kunstakademie from 1826 to 1859. The youngest son, Felix Schadow, was a painter based in Dresden.

KRISTIN O'ROURKE

See also **Germany: Baroque–Neoclassical**

Biography

Born in Berlin, Germany, 20 May 1764. Son of a master tailor; son Rudolf (Ridolfo) Schadow a sculptor, son Friedrich Wilhelm Schadow a painter, writer, teacher, and director of Düsseldorf Kunstakademie, and son Felix a painter. Attended monastery school; lived with Jean-Pierre-Antoine Tassaert until *ca.* 1780; later learned drawing from Tassaert's wife Marie-Edmée de Moreau; enrolled at the Berlin Akademie der Künste, 1778; assistant to Tassaert, 1783; left for Rome and worked in studio of Alexander Trippel, 1785; returned to Berlin, 1787; became member of Berlin Akademie and taught sculpture, 1788; appointed director of sculpture at ministry of architecture and head of court sculpture workshop, 1788; became vice-director of Berlin Akademie in 1805 and director from 1815 until his death. Won prize in Concorso Ba-

lestra at Academy of St. Luke in Rome, 1786. Died in Berlin, Germany, 27 January 1850.

Selected Works

1781–83 Bust of Henriette Herz; plaster; Alte Nationalgalerie, Berlin, Germany; marble version (untraced)

1786 *Perseus and Andromeda*; terracotta; Musée Bonnat, Bayonne, France

1788–90 Tomb of Graf Alexander von der Mark; marble; Alte Nationalgalerie, Berlin, Germany

1790–94 *General von Zieten*; marble; Bodemuseum, Berlin, Germany

1791 *Bacchus and Ariadne*; plaster; Kongelige Danske Kunstakademi, Copenhagen, Denmark; later marble versions: Hamburger Kunsthalle, Hamburg, Germany; Märkisches Museum, Berlin, Germany

1791 Quadriga; bronze (damaged in World War II; copy after earlier plaster cast *in situ*); Brandenburg Gate, Berlin, Germany

1796–97 *Princesses Luise and Friederike of Prussia*; marble; Alte Nationalgalerie, Berlin, Germany

1808 Bust of Immanuel Kant; marble; Walhalla Donaustauf, Regensburg, Germany

Further Reading

Eckardt, Götz, *Johann Gottfried Schadow, 1764–1850: Der Bildhauer*, Leipzig: Seemann, 1990

Gerlach, Peter, *Schadows Schrift zur Proportionsfrage*, Budapest: Akadémiai Kiado, 1969

Gramlich, Sybille, and Rolf Bothe, *". . . und abends in Verein": Johann Gottfried Schadow und der Berlinische Künstler-Verein, 1814–1840* (exhib. cat.), Berlin: Arenhövel, 1983

Lücken, Gottfried von, *Johann Gottfried Schadow, 1764–1850: Bildwerke und Zeichnungen*, Berlin: Nationalgalerie, 1964

Keienburg, Ernst, and Joachim Lindner, *Wo die Götter wohnen: Johann Gottfried Schadows Weg zur Kunst: Biographische Erzählung*, Berlin: Verlag der Nation, 1974; 3rd edition, 1982

Krenzlin, Ulrike, *Johann Gottfried Schadow*, Stuttgart: Deutsche Verlags-Anstalt, 1990

Maaz, Bernhard, editor, *Johann Gottfried Schadow und die Kunst seiner Zeit* (exhib. cat.), Cologne, Germany: DuMont, 1994

Mirsch, Beate Christine, *Anmut und Schönheit: Schadows Prinzessinnengruppe und ihre Stellung in der Skulptur des Klassizismus*, Berlin: Deutscher Verlag für Kunstwissenschaft, 1998

Schadow, Johann Gottfried, *Polyclet, oder, von den Massen der Menschen nach dem Geschlechte und Alter*, Berlin: Wasmuth, 1834

Schadow, Johann Gottfreid, *National-Physionomien, oder beobachtungen unter den unterschied der gesichtszüge und die äussere gestaltung des menschlichen kopfes*, Berlin: Verfasser, 1835

Schadow, Johann Gottfried, *Lehre von den Knochen und Muskeln: Von den Verhältnissen des menschlichen Körpers und von den Verkürzungen*, Berlin: Wasmuth, 1892

Schadow, Johann Gottfried, *Kunst-Werke und Kunst-Ansichten*, Berlin: Decker, 1849; revised edition, as *Kunst-Werke und Kunst-Ansichten: Ein Quellenwerk zur Berliner Kunst- und Kulturgeschichte zwischen, 1780 und 1845*, 3 vols., edited by Götz Eckardt, Berlin: Deutscher Verlag für Kunstwissenschaft, 1987

JOHANN GREGOR VAN DER SCHARDT *ca.* 1530–*ca.* 1581 *Dutch, active in Italy, Germany*

Johann Gregor van der Schardt was born around 1530 in Nijmegen, Holland; no documents pertaining to his heritage and training have been uncovered. The earliest reference to him appeared in 1566 when Ludovico Guicciardini mentioned that he was an outstanding sculptor. Some vague information about his many years in Italy only appears in letters sent by the imperial ambassador Veit von Dornberg to Emperor Maximilian II. In these letters, von Dornberg reported that the sculptor had copied antiques in Rome. These terracottas, which are imitations of antiques and sculptures by Michelangelo as well as Schardt's own original designs, have been preserved in part (private collection, Canada; Victoria and Albert Museum, London).

There must have been many collections of sculptural models of antiques, but none is as well documented as Schardt's. The terracottas became part of the Paulus Praun Collection and were inventoried in the early 17th century. A considerable portion later appeared in the collection of the Dresden sculptor Ernst Julius Hähnel and are documented in photographs. More than any of the other pieces that have been preserved, these terracottas were for centuries erroneously believed to be works by Michelangelo. Other works in Italy by Schardt are not verifiable; in 1569, mention was made of a stucco figure in the Palazzo Communale in Bologna. Since the sculptor was in contact with architectural theorist Daniele Barbaro, it can be assumed that he worked in the famous Barbaro Villa by Palladio in Maser (Treviso): two figures in the interior of the *nymphaeum* (an architectural fountain inspired by the antique) are very similar to Schardt's style.

In 1569 Schardt was summoned away from Italy to Vienna, where he entered into the service of Maximilian II. Afterward, however, he cannot be traced to the imperial court, but rather to Nuremberg. The reason for this was his collaboration on a large silver fountain for Maximilian II, which was under the direction of goldsmith Wenzel Jamnitzer. From this fountain,

which is a marvel in the Mannerist style, only four bronze caryatids depicting the Four Seasons survive. Two bronze figures of planet deities from another as yet unidentified fountain have also been preserved: *Sol* and *Luna*.

Schardt's most important works are the figures of the gods *Mercury* and *Minerva*, which were certainly created for Maximilian II. *Mercury* appears in the imperial collection in both a large and a small format; however, Praun also owned both bronzes. Only one *Minerva* figure in small format has remained.

Both of the slender, elegant figures of these two gods are among the first Mannerist figures to emerge north of the Alps. In terms of style, they are similar to the figures of the gods on the pedestal of the Florentine statue *Perseus* by Benvenuto Cellini in the Museo Nazionale del Bargello, Florence. Schardt's style obviously developed in the middle of the 16th century in Italy. *Mercury* and *Minerva* support this conclusion through the superb quality of the casts, which are superior to the products from the foundries in Nuremberg. Presumably the sculptor was influential in bronze casting as well.

In addition to the works in bronze, Schardt produced many of his sculptures, predominantly portraits, in

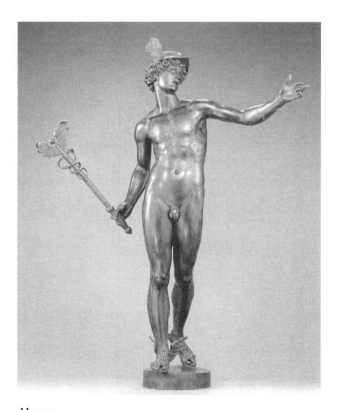

Mercury
Photo courtesy J. Paul Getty Museum, Los Angeles,
California

painted terracotta—both large busts and relief medals. Already during his first year in Nuremberg, he had produced portraits of the merchant and art collector Willibald Imhoff, who also ordered a female figure with a child in 1572. The monumental Imhoff bust is modeled in solid, slightly stylized forms and is painted in the Naturalist style. Imhoff is depicted holding a ring in his right hand; thus he is presented as a collector. The slightly smaller bust of his wife, Anna Imhoff, was created as a counterpart in 1580.

Schardt's most impressive portrait is his larger-than-life-size self-portrait. Although he normally sculpted clothing in detail, in this work he portrayed himself with a bare chest in the Classical style. The head is turned to the side with a melancholic expression on his face. This is not a representative portrait of the artist, but rather an intensive self-examination.

In 1576, after the death of Maximilian II, Schardt was apparently not taken into the service of the successor to the throne, Rudolph II. He accepted a new position in 1577 under the Danish king Frederick II. He resided in Denmark for over two years; only the production of bronze busts of the king and the queen, Sofie, can by verified through documentation: the portraits cast in Denmark have not been preserved. Among the artist's posthumous works, another pair of bronzes, as well as a colored terracotta portrait of Frederick II, all from 1577/79, were found. After his return to Nuremberg in 1579, Schardt reestablished his connection with bourgeois collectors. In 1580 he produced the portrait medals of Imhoff and Praun and the bust of Anna Imhoff. The last documentation of the sculptor's life is provided by a portrait painting of Hans Hoffmann by Schardt, which has not been recovered but is inventoried in the Praun Collection. Schardt presumably died in 1581, or shortly thereafter, in Nuremberg. Hanne Honnen de Lichtenberg's hypothesis that he lived and worked for another decade in Denmark cannot be substantiated.

Schardt thus lived to be just over 50 years old. Although many of his works have been destroyed, a representative portion of his oeuvre has remained. This is mainly thanks to collector Praun. During the sculptor's lifetime, Praun may have already acquired several works; more significant still was his purchase of the entire body of the estate. Praun's extensive collection, which is documented through inventories, remained intact until 1801. As a result, Schardt's posthumous property is the best documented of any 16th-century sculptor. In addition to the partially preserved study collection of practice models and copies, there were also bronzes and painted terracottas. The considerable portion of important pieces in his estate—versions of bronzes in the collections of the emperor and the Danish king—leads to the conclusion that Schardt died

while in the midst of working and left behind almost finished pieces, which were perhaps chiseled by goldsmith Heinrich Han, with whom Schardt is said to have been living at the end of his life.

URSEL BERGER

Biography

Born in Nijmegen, Netherlands, *ca.* 1530. Visited Italy, 1560s, particularly Rome, probably Florence as well, and later Venice and Bologna; produced small terracottas while in Italy, including copies of antiques and works by Michelangelo; entered service of Emperor Maximilian II, in Vienna, 1569, who commissioned a pair of figures, *Mercury* and *Minerva*; worked in Nuremberg, from 1570, and with goldsmith Wenzel Jamnitzer produced the Silver Fountain, which was later installed at the Prague Castle, for the emperor; journeyed to Italy, 1571; maintained residence at Danish court of Frederick II, 1577–79; returned to Nuremberg, 1579; last documented reference was 1581. Died in Nuremberg, Germany, 1581 or later.

Selected Works

1570 *Willibald Imhoff*; terracotta, painted; Skulpturengalerie, Staatliche Museen, Berlin, Germany

ca. 1570 *Mercury*; bronze; J. Paul Getty Museum, (large version) Los Angeles, California, United States; (small version) Kunsthistorisches Museum, Vienna, Austria

ca. 1570 *Minerva*; bronze; private collection, United States

ca. 1570 *Four Seasons*, caryatids for the Silver Fountain; gilded bronze; Kunsthistorisches Museum, Vienna, Austria

ca. 1570–80 *Crucifix on a Mineral Mountain*; bronze, various stones; Gewerbenmuseum, Nuremberg, Germany

ca. 1570–80 *Luna*; bronze; Kunsthistorisches Museum, Vienna, Austria

ca. 1570–80 *Self-Portrait*; painted terracotta; private collection, United States

ca. 1570–80 *Sol*; bronze; Rijksmuseum, Amsterdam, the Netherlands

1577–79 Busts of Frederick II, King of Denmark and Sophia of Mecklenburg, Queen of Denmark; bronze; Rosenborg Palace, Copenhagen, Denmark

1580 *Anna Imhoff*; terracotta; Skulpturengalerie, Staatliche Museen, Berlin, Germany

1580 Portrait medal of Paulus Praun; terracotta, painted; Germanisches Nationalmuseum, Nuremberg, Germany

Further Reading

Achilles-Syndram, Katrin, *Die Kunstsammlung des Paulus Praun: Die Inventare von 1616 und 1719*, Nuremberg, Germany: Stadrats zu Nürnberg, 1994

Berger, Ursel, "Die Negervenus, eine Statuette von Johann Gregor van der Schardt?" in *Von allen Seiten schön: Rückblicke auf Ausstellung und Kolloquium*, edited by Volker Krahn and Wolfgang Schmitz, Cologne, Germany: Letter Stiftung, 1996

Honnens de Lichtenberg, Hanne, *Johan Gregor van der Schardt: Bildhauer bei Kaiser Maximilian II., am dänischen Hof, und bei Tycho Brahe*, Copenhagen: Museum Tusculanum Press, University of Copenhagen, 1991

Kloek, W.Th., Willy Halsema-Kubes, and Reinier Baarson, *Kunst voor de beeldenstorm: Noordenderlandse Kunst, 1525–1580*, Amsterdam: Rijksmuseum, and The Hague: Staattsuitgeverji, 1986

LeBrooy, Paul James, *Michelangelo Models Formerly in the Paul von Praun Collection*, Vancouver, British Columbia: Creelman and Drummond, 1972

Leithe-Jasper, Manfred, *Renaissance Master Bronzes from the Collection of the Kunsthistorisches Museum, Vienna*, Washington, D.C.: Scala Books, 1986

Peltzer, R.A., "Johann Gregor van der Schardt [Jan de Zar] aus Nymwegen: Ein Bildhauer der Spätrenaissance," *Münchner Jahrbuch der bildenden Kunst (1916–18)*

Prag um 1600: Kunst und Kultur am Hofe Kaiser Rudolfs II., Freren, Germany: Luca Verlag, 1988

Schoch, Rainer, Katrin Achilles-Syndram, and Bernd Mayer, *Kunst des Sammelns: Das Praunsche Kabinett: Meisterwerke von Dürer bis Carracci*, Nuremberg, Germany: Germanisches Nationalmuseum, 1994

OSKAR SCHLEMMER 1888–1943 *German*

Oskar Schlemmer headed the stone and wood sculpture workshops at the Bauhaus school in Weimar from 1922 to 1925. Known primarily for his paintings and choreography, Schlemmer's sculptural work includes freestanding figures, relief panels, and large architectural reliefs combined with mural painting. Sometimes using innovative materials such as wire and glass, he developed highly abstracted typologies of the human figure, the motif that stood at the center of all his artistic activity.

In the early 1910s Schlemmer belonged to the circle around the pioneer abstract painter Adolf Hölzel in Stuttgart, which also included Willi Baumeister, Johannes Itten, and Otto Meyer-Amden, to whom Schlemmer was deeply attached. Schlemmer's first reliefs from 1919 relate closely to Cubist reliefs, particularly the sculpto-paintings of Alexander Archipenko. Schlemmer built up his sometimes polychromed figurative panels from a restricted vocabulary of rounded geometric forms structured by asymmetrical

rectangular grids. His reputation grew in 1920 when he exhibited jointly with Baumeister in Berlin, Dresden, and Hagen.

In December 1920 Schlemmer accepted a position at the Bauhaus, where Walter Gropius was assembling an impressive group of modern artists, including Itten, Lyonel Feininger, Wassili Kandinsky, and Paul Klee. After briefly heading the mural workshop, Schlemmer became the head of the stone and wood sculpture workshops in 1922; in 1923 he also took over the theater workshop. For the 1923 Bauhaus summer exhibition Schlemmer designed a series of reliefs and murals for the interior of the workshop building. (Joost Schmidt, Schlemmer's student, designed the reliefs for the vestibule of the main Bauhaus building.) Following the original ideals of the Bauhaus, Schlemmer hoped to join together painting, sculpture, and architecture as a unified artistic totality. Geometric figurative reliefs, one male and one female, line the entrance, while a triangular ceiling relief indicates the three possible directions of movement into the building. Two relief panels articulate the architectural lines of a short staircase, with elongated figures in gold patina arranged horizontally, vertically, and diagonally. Like the murals that also belong to the overall scheme, Schlemmer's reliefs use typologies of the human figure as the measure and scale of architecture. Although many praised Schlemmer's reliefs and murals for the workshop building, functionalist critics such as Adolf Behne faulted them as regressively decorative and a fundamental misunderstanding of Modernism.

Schlemmer made his only freestanding sculptures during his first years at the Bauhaus. The S-curved *Groteske I*, although freestanding, remains emphatically flat, its striking profile underscored by the elongated base that swivels to point either backward or forward but always reinforcing the plane of the figure. Schlemmer's best-known sculpture, *Abstract Figure, Freestanding Sculpture G*, combines allusions to antique statuary with the machined style that has become synonymous with the Bauhaus. The abruptly sliced-off limbs of the helmeted, armored figure undermine the sculpture's equipoise, making it both Classical Apollo and grotesque war victim. For Schlemmer, who was deeply skeptical of Gropius's shift toward greater industrial cooperation, the interest in restrictive geometries of the human figure was unrelated to any machine aesthetic. His fundamental belief in the transcendent spiritual aspect of art precluded the artist from becoming an industrial designer. Although most of his sculptures are reliefs, Schlemmer wrote in 1924, possibly in reference to *Abstract Figure:* "Sculpture is three-dimensional (height, width, depth). It is not to be grasped in a single moment, but rather in a temporal succession of vantage-points. . . . The more individual

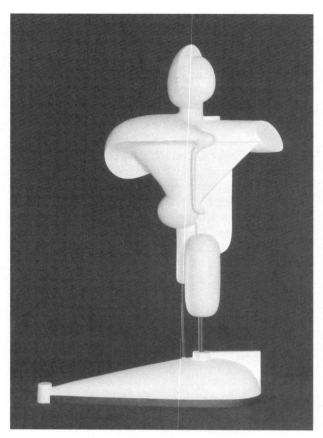

Abstract Figure, Freestanding Sculpture G
© Staatsgalerie Stuttgart, Germany, and The Oskar Schlemmer Secretariat and Archive

views a work has, the more it deserves the name sculpture" (see Schlemmer, 1972; translation altered by author).

In the theater workshop Schlemmer developed his *Triadisches Ballet*, twelve scenes of simplified movements, gestures, and relationships escalating from the comic to the sublime for one to three dancers, including Schlemmer himself. For the ballet, first performed in Stuttgart in 1922, he designed eighteen highly stylized and physically restrictive costumes and masks (made with the help of his brother Carl) that he conceived of in sculptural terms.

In 1925 Schlemmer moved with the Bauhaus to Dessau but no longer directed the sculpture workshop, which was now headed by Joost Schmidt. Schlemmer continued to develop dances for the theater workshop, but his ideas came under attack by students who were interested in developing a mechanical stage devoid of human performers and were highly critical of his insistence on apolitical theater.

Schlemmer left the Bauhaus in 1929 and accepted a teaching position at the Breslau Academy of Art.

Among his most important projects was his *Three-Part Wall Arrangement: Sitting Homo with Back-View Figure in Its Hand, Coordinate Element (Sun), and Large Profile* for a house near Leipzig, a striking relief group again presenting the human form in radically shifting scale as the measure of architectural space. A large seated figure made of metal wire holds a small figure, seen from behind, and looks across the wall at an enormous 5.35-meter-high profile outlined in copper ribbon. Changing light conditions produce real shadows that merge with areas of painted shadow on the wall behind the seated figure's limbs and torso. During this period Schlemmer also designed opera sets in Breslau and Berlin for works by Igor Stravinsky and Arnold Schoenberg.

With the rise of National Socialism, critics attacked Schlemmer's work for its "un-German" character and his connection to the supposedly Bolshevik Bauhaus. Already in 1930 Schlemmer's reliefs and murals in Weimar were destroyed by Paul Schultze-Naumburg, newly appointed as director of the Weimar art school by the National Socialist minister of education in the Thuringian provincial government. After the Breslau Academy was closed in 1932, Schlemmer accepted a teaching appointment in Berlin only to be dismissed the next year. Convinced of the deep Germanic roots of his art that he felt to be consistent with National Socialist principles, Schlemmer could never understand why his work was denounced. The 1937 Nazi exhibition of "Degenerate Art" included examples of his paintings and graphics, but no sculpture. From 1940 on Schlemmer worked at a paint and lacquer laboratory in Wuppertal, whose owner offered employment and sanctuary to a handful of modern artists, including Baumeister, Georg Muche, and Gerhard Marcks. Schlemmer painted sporadically but, except for a series of miniature plaster reliefs in 1942, he made no sculpture from the mid 1930s until his death in 1943.

PAUL PARET

Biography

Born in Stuttgart, Germany, 4 September 1888. Apprenticed at Stuttgart wood-inlay factory, 1903–05; attended classes at Stuttgart Kunstgewerbeschule; studied at Akademie der Bildenden Künste, Stuttgart, 1906–11, with landscape painters Christian Landenberger and Friedrich von Keller; lived in Berlin, 1911–12; returned to Stuttgart as master student of Adolf Hölzel; served in the infantry and as a cartographic draftsman during World War I; joined faculty of Bauhaus in Weimar, December 1920, and after 1925 in Dessau; directed sculpture workshop, 1922–25; left Bauhaus and taught at Breslau Academy in Germany (now Wrocław, Poland), from 1929 until its demise in 1932; appointed to Vereinigte Staatschulen für Kunst und Kunstgewerbe in Berlin, 1932, and dismissed, 1933; Nazi regime ordered his art removed from many German museums; included in National Socialist exhibition *Entartete Kunst* (Degenerate Art), Munich, 1937; worked as industrial painter in Stuttgart, 1938, and from 1940 in paint and lacquer factory in Wuppertal (owner provided support to artists). Died in Baden-Baden, Germany, 13 April 1943.

Selected Works

1919 *Architectural Sculpture R*; plaster; Schlemmer family estate, Staatsgalerie, Stuttgart, Germany; aluminum version (edition of 11): 1959, Bauhaus Archiv Museum für Gestaltung, Berlin, Germany

1919–23 *Ornamental Sculpture on Divided Frame*; painted wood; Kunstsamlung Nordrhein-Westfalen, Düsseldorf, Germany

1921–23 *Abstract Figure, Freestanding Sculpture G*; plaster; Schlemmer family estate, Staatsgalerie, Stuttgart, Germany; nickel-plated bronze version: 1961 (edition of 11), Baltimore Museum of Art, Maryland, United States

1922 Costumes from the *Triadisches Ballet*; various materials; reconstruction, Bühnen Archiv Oskar Schlemmer, Oggebbio, Italy

1922 Masks from the *Triadisches Ballet*; painted, gilded papier mâché; Bühnen Archiv Oskar Schlemmer, collection U. Jaïna Schlemmer, Oggebbio, Italy

1923 *Groteske I*; wood, ivory, metal; Neue Nationalgalerie, Staatliche Museen, Berlin, Germany

1923 Reliefs for the Bauhaus Workshop Building, Weimar, Germany; stucco (destroyed 1930; partially reconstructed *in situ*, 1980s)

1930–31 *Three-Part Wall Arrangement: Sitting Homo with Back-View Figure in Its Hand, Coordinate Element (Sun), and Large Profile*; wire, metal, paint; Rabe House, Zwenkau, near Leipzig, Germany

Further Reading

Diserens, Corinne, et al., *Oskar Schlemmer* (exhib. cat.), Marseille, France: Musées de Marseille and Paris: Réunion des Musées Natonaux, 1999

Eberle, Matthias, *World War I and the Weimar Artists: Dix, Grosz, Beckmann, Schlemmer*, New Haven, Connecticut: Yale University Press, 1985

Grohmann, Will, *Oskar Schlemmer: Zeichnungen und Graphik: Oeuvrekatalog*, Stuttgart, Germany: Hatje, 1965

Herzogenrath, Wulf, *Oskar Schlemmer: Die Wandgestaltung der neuen Architektur*, Munich: Prestel Verlag, 1973

Lehman, Arnold L., Brenda Richardson, and Vernon L. Lidtke, editors, *Oskar Schlemmer* (exhib. cat.), Baltimore, Maryland: The Baltimore Museum of Art, 1986

Maur, Karin von, *Oskar Schlemmer: Sculpture*, New York: Abrams, 1972

Maur, Karin von, *Oskar Schlemmer*, 2 vols., Munich: Prestel, 1979

Müller, Maria, editor, *Oskar Schlemmer: Tanz, Theater, Bühne* (exhib. cat.), Ostfildern-Ruit, Germany: Hatje, 1994

Schlemmer, Oskar, *Briefe und Tägebucher*, edited by Tut Schlemmer, Munich: Langen-Müller, 1958; as *The Letters and Diaries of Oskar Schlemmer*, translated by Krishna Winston, Middletown, Connecticut: Wesleyan University Press, 1972

Schlemmer, Oskar, *Man: Teaching Notes from the Bauhaus*, edited by Heimo Kuchling, translated by Janet Seligman, Cambridge, Massachusetts: MIT Press, and London: Lund Humphries, 1971

Schlemmer, Oskar, *Idealist der Form: Briefe, Tagebücher, Schriften, 1912–1943*, edited by Andreas Hüneke, Leipzig: Reclam, 1990

Schlemmer, Oskar, Laszlo Moholy-Nagy, and Farkas Molnár, *The Theater of the Bauhaus*, edited by Walter Gropius, translated by Arthur S. Wensinger, Middletown, Connecticut: Wesleyan University Press, 1961

Wingler, Hans Maria, *Das Bauhaus, 1919–1933: Weimar, Dessau, Berlin*, Bramsche: Gebr. Rasch, 1962; 2nd revised edition, as *Das Bauhaus, 1919–1933: Weimar, Dessau, Berlin, und die Nachfolge in Chicago seit 1937*, Cologne, Germany: DuMont Schauberg, 1968; 2nd edition, as *The Bauhaus: Weimar, Dessau, Berlin, Chicago*, translated by Wolfgang Jabs and Basil Gilbert, edited by Joseph Stein, Cambridge, Massachusetts: MIT Press, and London: Cambridge Press, 1969; 3rd revised edition, Cambridge, Massachusetts: MIT Press, 1976

ANDREAS SCHLÜTER *ca.* 1660–1714
Polish

Little is known about Andreas Schlüter's training as a sculptor. He was born in Danzig, where he was taught beginning at a young age by his father, the sculptor Gerhard Schlüter, and the sculptor Christoph Sapovius. The Jesuit and royal architect Bartolomeus Wasowski, who had been involved with the building of the Warsaw Royal Chapel, most likely brought Schlüter to Warsaw.

In Warsaw, Schlüter entered the service of the Polish king John III Sobieski and the nobleman Jan Dobrogost Krasinski, working as an architect as well as a sculptor. Several architectural drawings in his hand indicate that he was influenced by the Dutch architect Tillman van Gameren, who was active in Warsaw. They collaborated in the building of the Krasinski Palace.

Schlüter's work for the king presumably led to his appointment in 1696 as a teacher of sculpture at the newly established art academy in Berlin, meant to emulate the famous academies in Rome and Paris. His appointment included sculptural work for the Prussian court *"es sey von Stein, Marmor, Elfenbein, Alabaster oder Holtz"* (in stone, marble, ivory, alabaster, or wood). In the spirit of international artists such as Gianlorenzo Bernini in Rome, Charles Le Brun in Paris, Jacob Van Campen in Amsterdam, and Tilman Van Gameren in Warsaw, he strove to unify the arts. In that sense he may be considered a master of the Baroque *Gesamtkunstwerk*, or total work of art. He created designs for facades, interior paintings, sculpture, and stucco. Examples in Berlin may be found in a villa in the Dorotheenstrasse, the Zeughaus (now the Deutsches Historisches Museum), where he led the building activities, and his masterpiece, the expansion of the royal castle (destroyed in 1945).

The sculptures that grace these buildings evince the influence of the Classical style of François du Quesnoy, in whose style he worked, according to his Warsaw colleague Agostino Locci, and Artus I Quellinus, whose work for the Amsterdam Town Hall must have been a major influence. The freestanding sculptures on the facade facing the courtyard of the Berlin palace bore witness to his knowledge of the sculpture of northern Netherlandish artists and Roman artists like

Equestrian monument to Frederick Wilhelm, Grand Elector
© Foto Marburg / Art Resource, NY

Gianlorenzo Bernini. He may have owned prints and drawings of the work of du Quesnoy, Quellinus, and Bernini.

Schlüter's commissions for independent sculptures consisted primarily of monumental bronzes. A monumental posthumous equestrian statue of, the "Great Elector," cast in bronze, surpasses all his other bronzes. This sculpture attests to Schlüter's virtuosity like no other. He portrayed the impressive rider and horse so as to glorify the historical Prussian prince, and four life-size figures of intensely gesticulating slaves surround the magnificent pedestal (original oval pedestal now in Sculpturensammlung, Staatliche Museen, in Berlin). The pedestal was not placed until 1709. Master Jacobi, who had also worked on the statue of Louis XIV by the sculptor François Girardon, cast the bronze in Paris. The close similarities between the two equestrian statues indicate that Schlüter likely took his inspiration from Girardon's earlier work.

Schlüter was fired from his position as master builder in 1706 when one of his buildings, an enormous tower to house the mint at the Berlin castle, shifted on its foundations even before completion. Although he retained his other positions as court sculptor and teacher at the academy, surviving correspondence suggests that Schlüter never quite recovered from the blow. Nonetheless, after the death of his patron, King Friedrich I, in 1713, he received the commission to create the monumental sarcophagus, which was placed in the Berlin Cathedral next to the bronze tomb of Queen Sophie Charlotte, also created by Schlüter in 1705. When Friedrich Wilhelm I ascended the throne, all court artists were fired, and Schlüter was forced to leave the city. He entered the service of the Russian czar Peter the Great and worked on, among other projects, the Summer Palace and the design of the gardens at St. Petersburg. He also developed designs for the Winter Palace and for an art cabinet, although they were only realized later by others. He died within a year of moving and was buried in St. Petersburg, where he had moved the year before, in May 1714.

EYMERT-JAN GOOSSENS

See also **Central Europe**

Biography

Born in Danzig (present-day Gdansk, Poland), *ca.* 1660. Son of the sculptor Gerhard Schlüter. Trained in Danzig under his father and the sculptor Christoph Sapovius; worked in Warsaw, 1689–93, for the Polish king John III Sobieski and members of the nobility; worked in Berlin for the court, the city, and the local nobility, from 1694; appointed to teach at the Akademie der Künste, Berlin, 1696; traveled to France, 1695, then made a journey to Italy to collect plaster castings of Classical and modern sculpture for the Berlin Akademie der Künste, 1696; returned to Berlin and directed a workshop; taught sculpture at Academy of Sciences, 1696–1710; director of the Akademie der Künste, Berlin, 1702–04; fired from post as master builder, 1706, after errors in construction; gave up residence in Berlin and withdrew to his country house, *ca.* 1712, occupying himself with research into perpetual motion and astronomy. Died in St. Petersburg, Russia, May 1714.

Selected Works

ca. 1685	Ceiling decoration; stucco; Langer Markt 7–8, Gdansk, Poland
ca. 1689–93	Sculptural decoration (with Agostino Locci); stucco and sandstone; Royal Palace, Wilanów, Poland
1689–94	Pediment reliefs (with architect Tillman van Gameren); sandstone; Krasinski Palace, Warsaw, Poland
ca. 1691	Tomb for the wife of Field Marshall Barfuss; marble; Brandenburg Cathedral, Germany
1692–94	Monuments for Teofila, Jakub, and Mareck Sobieski and Stanislaw Danilowicz; alabaster; churches in Njestjerow, Ukraine
1696	Decoration of the Zeughaus facade; sandstone; Deutsches Historisches Museum, Berlin, Germany
1696–1708	Equestrian monument to "Grand Elector" Frederick Wilhelm; bronze (cast 1708); Schloss Charlottenburg, Berlin, Germany
1697–98	*Frederick III, Elector of Brandenburg*; marble (untraced)
ca. 1704	Bust of Landgrave Frederick II; bronze; Schloss, Bad Homburg vor der Höhe, Germany
1705	Sarcophagus for Queen Sophie Charlotte; gilded pewter; Berlin Cathedral, Germany
1708	Sarcophagus for Frederick Ludwig of Orange and Prussia; gilded pewter; Berlin Cathedral, Germany
1713	Sarcophagus for Frederick I; gilded pewter; Berlin Cathedral, Germany

Further Reading

Kremeier, Jarl, "Schlüter, Andreas," in *The Dictionary of Art*, edited by Jane Turner, New York: Grove, and London: MacMillan, 1996

Kühn, H., "Andreas Schlüter als Bildhauer," in *Barockplastik in Norddeutschland*, by Jörg Rasmussen and Sigfried Asche, Mainz, Germany: Von Zabern, 1977

Ladendorf, Heinz, *Der Bildhauer und Baumaister Andreas Schlüter: Beiträge zu seiner Biographie und zur Berliner Kunstgeschichte seiner Zeit*, Berlin: Deutscher Verein für Kunstwissenschaft, 1935

Ladendorf, Heinz, *Andreas Schlüter*, Berlin: Rembrandt-Verlag, 1937

Ladendorf, Heinz, *Andreas Schlüter: Das Denkmal des grossen Kurfürsten*, Stuttgart, Germany: Reclam, 1961

Mossakowski, Stanislaw, and Juliane Marquand-Twarowski, *Tilman van Gameren: Leben und Werk*, Munich: Deutscher Kunstverlag, 1994

Reslob, E., "Andreas Schlüter und die plastik der Niederlande," *Zeitschrift für Kunstwissenschaft* 9 (1955)

THOMAS SCHÜTTE 1954– *German*

Thomas Schütte is widely regarded as one of the most significant German artists of his generation. Schütte's eclectic influences have produced a stylistically diverse body of work whose only defining feature is its heterogeneity. Although thought of primarily as a sculptor, since the early 1980s Schütte has produced watercolors, drawings, architectural models, and installations. There is no apparent linear progression in Schütte's work. Instead he moves constantly in and out of styles, media, and subject matter and is equally at home with figurative and nonrepresentational forms. His work is characterized by a fascination with scale and the tension between the private and public realms.

Schütte's interest in art was established in 1972 following his visit to *Documenta*, the renowned international art exhibition held every five years in Kassel, Germany. In 1973 he enrolled at the Düsseldorf Kunstakademie. Having studied under Fritz Schwegerand and Gerhard Richter, both renowned painters of their generation, it is ironic that Schütte's subsequent work should be predominantly three-dimensional. His early installations, such as *Large Wall*, saw him experimenting with the interaction of the viewer in space, drawing upon the legacy of Minimalist and Conceptual art. The architectural concerns of *Large Wall* would later be explored in a series of works that occupy an ambiguous position between art and architecture. One of Schütte's first works to resemble architectural models was *Model for a Museum*, which ironically proposes a vast crematorium for the incineration of art. Other architecturally inspired works took their cue from theatre design, such as *Man in Mud*, which consists of three interlocking raised circular platforms, reminiscent of a stage, upon which a small figure stands as if emerging from a mire. Schütte's love of the theatrical was put to powerful use in his *House of Remembrance* on the site of a former Nazi labor camp in Neuengamme, near Hamburg, Germany. Blood-red walls and banners displaying the names of those who lost their lives at the camp present a powerful engagement with the horrors of Germany's past.

Schütte turned once more to the commemorative role of sculpture with his bust of Alain Colas. However, Schütte is constantly experimenting with diverse media, and he chose to make his sculpture from an unconventional mixture of wood, clay, and polystyrene. A tribute to the French sailor lost in the Atlantic, *Alain Colas* presents a kind of antimonument, its ephemeral materials and packing-case base undermining the immortal quality of the sculpted portrait bust with its connotations of glory and fame. In 1993–94 Schütte shifted media again, this time using the hobbyist's synthetic modeling clay Fimo to produce the *United Enemies*. These miniature figures with faces fixed in cartoonlike grimaces are bound together in pairs, wrapped in scraps of fabric. Some critics have seen the reunification of East and West Germany played out in these grimacing puppetlike figures, forced into uneasy coexistence. A more overt political reference can be found in the artist's *The Strangers*. Three figurative sculptures with stylized features and closed eyes stand on abstracted conical bases reminiscent of flowerpots. Made from glazed ceramic and equipped with bags and packing cases, these incongruous characters were first exhibited at a time when the issue of Turkish "guest workers" and other refugees was the cause of political concern in Germany. Since their original installation above a department store in Kassel as part of *Documenta* in 1992, these itinerant sculptures have traveled across the world and have been exhibited in varying configurations, most recently at London's Tate Gallery. The critic Alexander Alberro, in particular, has championed this political dimension of Schütte's output.

Schütte has undertaken a number of commissions for public sculpture, such as *Cherry Column* for a civic car park in Münster, Germany. Stylistically the work owes much to Claus Oldenberg, yet Schütte saw a dark irony in the mundane positioning of the work. However, the artist became disheartened by the lack of respect held for such commissions and became suspicious of the cynical manipulation of such projects by commercial concerns.

Perhaps Schütte's most commanding sculpted work to date is a series of polished aluminium casts called *Large Ghosts*. Like gleaming science-fiction aliens, their fluid abstracted forms defy the solidity of their medium and question the traditional function of commemorative statuary. Schütte's most recent work continues the artist's anxious engagement with the art of the past. His colossal series of *Steel Women* reinvents the reclining female nude of art history, presenting lumpen corroded steel bodies equipped with shockingly visceral gaping mouths. Once again experimenting with a different media, in this case cast steel, Schütte's rejection of a signature style could be seen as a

rebuke to the egocentric art world of the 1980s in which he was nurtured. A constant innovator, Schütte continues to raise questions concerning the position of the avant-garde artist in today's pluralistic world. In 1990 Schütte stated, "I don't see my work as pluralist in the postmodern sense. . . . It's just that I'm against this mono-culture. I try to see one thing from five different view points" (see *Possible Worlds*, 1990).

JONATHAN R. JONES

Biography

Born in Oldenburg, Germany, 16 November 1954. Studied at the Kunstakademie, Düsseldorf, under Fritz Schwegerand and Gerhard Richter, 1973–81; participated in numerous group shows including *Documentas VIII, IX,* and *X* (1987, 1992, and 1997) in Kassel, Germany, and the Münster Sculpture Projects (1987 and 1997). Lives and works in Düsseldorf, Germany.

Selected Works

1977 *Large Wall*, for Düsseldorf Academy, Germany; wood, oil paint (removed); artist's collection

1981–89 *Model for a Museum*; wood; Produzentengalerie, Hamburg, Germany

1982–83 *Man in Mud*; wax, cardboard, steel (location unknown)

1987 *Cherry Column*; painted cast aluminium, sandstone; Harsewinkelplatz, Münster, Germany

1989 *Alain Colas*; wood, clay, polystyrene, paint; Collection Museo Cantonale d'Arte, Lugano, Italy

1992 *The Strangers*; glazed ceramic; Marian Goodman Gallery, New York City, United States

1993–94 *United Enemies*; Fimo, fabric, wood, glass; Tate Gallery, London, England

1995 *House of Remembrance*; temporary installation realized at Neuengamme concentration camp, near Hamburg, Germany

1996 *Large Ghosts*; cast aluminium; Saatchi Collection, London, England

1998–89 *Steel Women I = -IV*; steel; Marian Goodman Gallery, New York City, United States

Further Reading

Alberro, Alexander, "No Place Like Home," *Frieze* 38 (January/February 1998)

Benezra, Neal, "Thomas Schütte: Ironic Outdoor Monuments," *Flash Art* (January/February 1997)

Heynen, Julian, James Lingwood, and Angela Vettese, *Thomas Schütte*, London: Phaidon, 1998

Hilty, Greg, *Young German Artists 2 from the Saatchi Collection: Grünfeld, Gursky, Hablützel, Honert, Ruff, Schütte* (exhib. cat.), London: Saatchi Gallery, 1997

Parkett 47 (1996) (special issue on Thomas Schütte)

Possible Worlds: Sculpture from Europe (exhib. cat.), London: Institute of Contemporary Arts, and Serpentine Gallery, 1990

Thomas Schütte (exhib. cat.), Krefeld, Germany: Museum Haus Lange Krefeld, 1986

KURT (HERMAN EDWARD KARL JULIUS) SCHWITTERS 1887–1948

German

Schwitters's works from the years 1908–17, primarily oil paintings and drawings, evolved from conventional naturalism toward an Impressionistic style. In 1918 he encountered Expressionist art and began to paint fantastic landscape scenes in a more aggressive, painterly manner (e.g., *Mountain Graveyard*, 1912). By the beginning of 1919 he had formed an association with participants in the Berlin Dada movement, among them Richard Hülsenbeck, Hannah Höch, and Jean (Hans) Arp. His work after this time began to follow the directions for which he became best known; he produced his first nonobjective compositions in 1919. In these works, most of which were collages and assemblages, he gathered together found objects from the streets of Hannover and arranged them in a distinctive way that was intended to express his self-avowed aesthetic of *Merz*. Taken from *Kommerz*, this word may loosely be understood to mean "detritus," "rejects," or "discards." With it Schwitters coined a term denoting "essentially the combination of all conceivable materials for artistic purposes, and technically, the principle of equal evaluation of the individual materials" (see Elderfield, 1985).

Schwitters's fascination with the expressive potential of form put him at odds with the aggressively political program of the Dada movement in Germany, and both Hülsenbeck and Schwitters acknowledged the significance of this disparity. Schwitters's dark short story "The Onion" (published in *Der Sturm*, 1919) bears more in common with Expressionism's romantic conception of the artist as a figure alienated from society than with Dada's violently satirical and anarchic engagement with the world. Indeed, most of Schwitters's sculpture from the years 1922–33 are a sympathetic response to the formalism of De Stijl and the Russian Constructivists, often concertedly apolitical in their purity of structure, line, and rhythm (e.g., *Untitled*, 1923). In this same period, however, he initiated

a series of essays, drawings, and collages exploring his notion of the *i-kunstwerk* (i-artwork), by which he referred to a kind of "ready-made" or found-object artwork that acquires an identity as art only through its selection and presentation by the artist.

As early as 1920 Schwitters undertook the design and construction in Hannover of a huge work of sculpture called the *Merzbau* (left unfinished at the time of the artist's exile from Germany in 1937 and destroyed during Allied bombing in 1943). Evolving out of a *Merz Column* that the artist had completed by 1936, the *Merzbau*, a mostly monochromatic formalist labyrinth loosely conforming to the scale and plan of parts of the artist's home (in which it was built), was Schwitters's most ambitious and accessible expression of the concept of *Merz*, which by this time had come to stand for the organic synthesis of the aesthetic and nonaesthetic material world. Effectively a kind of three-dimensional catchall for a myriad of half-improvised and half-completed assemblages that the artist had combined from his vast collection of *objets trouvés*, the *Merzbau* was an almost comically impractical, quasi-architectural armature constructed out of wood, wire, and plaster that served ultimately to support and reveal (and sometimes to conceal) artifacts selected both from Schwitters's domestic routine and from the outlying physical environment of Hannover. After moving to Lysaker, Norway, Schwitters began work on a new *Merzbau* (destroyed in 1951), which is thought to have tempered Constructivist formalism with more organic line and texture. (No visual documentation of this project is known to exist.)

In England from 1940, Schwitters continued to produce relief sculpture using whatever materials were available to him: rocks, cork, rags, string, and even bread. Some of these works (for example, *Untitled*, 1947, a bowler hat attached to a plaster surface) achieve a new degree of formal simplicity that recalls his earlier conception of the *i-kunstwerk*, although the most striking works of the late years are actually non-objective freestanding sculptures constructed of wood and plaster (e.g., *Untitled* [*Heavy Relief*], 1945, and *Little Dog*, 1943/44), which are not out of step with larger trends toward an organic formalist sculpture in England during these years (Henry Moore, Barbara Hepworth, Ben Nicholson). Schwitters's final large-scale project was a *Merzbau*, located in Langdale Valley (begun in 1941, left unfinished at the time of the artist's death in 1948 and partially removed to the University of Newcastle-upon-Tyne in 1965), in which many of Schwitters's career-long formal interests are recombined with a naive, childlike randomness that suggests at once the Dada experiments of Arp, the regressive abstract surrealism of Joan Miró, and the organic abstraction of Moore and Hepworth.

Considered as a whole, Schwitters's three-dimensional work seems in its formal aestheticism an unlikely oeuvre for a Dadaist. Indeed, Schwitters's insistent manipulation and presentation of formal elements and his willful pursuit of natural formal beauty in the face of an anti-aesthetic movement place him somewhat outside the current of radical Modernist plastic art that characterized Dada. The multimedia assemblages from the middle part of his career anticipate the "appropriation-art" constructions of Robert Rauschenberg and the boxes of Joseph Cornell. His small reliefs are nearly all exercises in the formal possibilities that their ready-made components suggested to him. The *Hannover Merzbau*, in its conflation of sophisticated abstract design and a nearly idiotic jumble of *i-kunst* of ready-mades, launched the primeval expressive potency of the humble found into the ocean of grand modernist aesthetic ideas.

ANDREW MARVICK

See also **Assemblage**

Biography

Born in Hannover, Germany, 20 June 1887. Studied at Dresden Kunstakademie, 1909–14; served as technical artist and draftsman in German army during World War I; associated with members of Berlin Dada from 1919; made collages, composed poetry, worked as art dealer, publisher, and promoter of exhibitions throughout Europe, 1920–37; joined Paris-based Abstraction-Création alliance in 1931, and began work on the small-scale work *Merzbilder* and constructions, during visits to Norway; Nazis ridiculed his art in *Entartete Kunst* (Degenerate Art) exhibition, Munich, 1937; left Germany same year; relocated for short time in Lysaker, Norway; interned by British on Isle of Man in a camp for foreign nationals, 1940–41; later resided in Kendal, England. Died in Kendal, Westmoreland, England, 8 January 1948.

Merzbau
© Artists Rights Society (ARS), New York and VG-Bild Kunst, Bonn and The Conway Library, Courtauld Institute of Art

Selected Works

1920 *Ausgerenkte Kräfte* (Disjointed Forces); assemblage of painted wood, cardboard, wire, and paper; Kunstmuseum, Bern, Switzerland

1923–36 *Merzbau*; wood, plaster, scrap (destroyed 1943); 1980–83, reconstruction; Sprengel Museum, Hannover, Germany

1923–37 *Merz Column in the Hannover Merzbau*; mixed media (destroyed)

1924 *Merzbild 1924: Relief mit Kreuz und Kugel* (Relief with Cross and Sphere); painted wood, cardboard; Marlborough Fine Art, London, England

1924 *Merz 1003; Pfauenrod* (Peacocks Tail); oil and wood on composition board; Yale University Art Gallery, New Haven, Connecticut, United States

1926 *Bild 1926, 12: Kleines Seemannsheim* (Picture 1926, 12: Little Sailor's Home); assemblage; Kunstammlung Nordrhein-Westfalen, Düsseldorf, Germany

1938–39 *Untitled (Cork Sandwich)*; assemblage on plywood; private collection of R. Crippa, Milan, Italy

Further Reading

Elderfield, John, *Kurt Schwitters*, London and New York: Thames and Hudson, 1985

Elger, Dietmar, *Der Merzbau von Kurt Schwitters: Eine Werkmonographie*, 2nd edition, Cologne, Germany: Verlag der Buchhandlung Walther König, 1999

Helms, D., "The 1920s in Hannover," *The Art Journal* 22/3 (1963)

Kurt Schwitters (exhib. cat.), Cologne, Germany: Galerie Gmurzynska, 1978

Kurt Schwitters in Exile: The Late Work, 1937–1948 (exhib. cat.), London: Marlborough Fine Art, 1981

Schmalenbach, Werner, *Kurt Schwitters*, Cologne, Germany: DuMont Schauberg, 1967; as *Kurt Schwitters*, New York: Abrams, and London: Thames and Hudson, 1970

Steinitz, Kate Traumann, and Kurt Schwitters, *Kurt Schwitters: A Portrait from Life*, Berkeley: University of California Press, 1968

Stokes, Charlotte, and Stephen C. Foster, editors, *Dada Cologne Hannover*, New York: G.K. Hall, and London: Prentice Hall International, 1997

SCOTLAND

The earliest peoples of Scotland included Scots, Picts, Gaels, Romans, Vikings, Angles, and Britons. The earliest forms of sculpture in Scotland were standing stones. With the advent of Christianity, particularly the mission of Irish monk St. Columba at Iona, stone crosses were used extensively as boundary markers, meeting places, and visual aids in the story of Christ and the Bible. The Scottish stone crosses seen after 1000 CE used Irish models, featuring elaborate Celtic vine and knot patterns, coupled with figures on horseback or biblical scenes; crosses in the north and the Outer Hebrides also used Scandinavian imagery and runes. Such crosses, of which the Ruthwell Cross is one of the most celebrated, marked graves of important figures or sites of auspicious events. Many incorporate Pictish iconography, especially the "spectacle" image, as well as stylized beasts and Pictish language runes.

Scotland had only indigenous architecture and sculpture until the Normans began building in the 13th century. This link with France began the "Auld Alliance," a symbiotic relationship that protected both

Ruthwell Cross, Dumfries, South Scotland
The Conway Library, Courtauld Institute of Art

nations against English incursions and led to artistic exchange as well. Sculpture of this period is often architectural wood- and stone-carved decoration within Roman Catholic abbeys and monasteries—sculptors executed no autonomous figure carving of note. This tradition of decorative sculpture, along with native stonemasonry, has continued throughout Scotland's sculptural history.

After the victory of Robert the Bruce over the English at Bannockburn in 1314, Scotland's links with France became even stronger, and French influence can be clearly seen in Scottish sepulchral slabs of the same type and period as in France. Architects based the great Scottish buildings of the time, including abbeys at Holyrood and Seton, on French designs. The Gothic era in Scotland is manifest in excellent funerary work, as well as relief carving of heraldry and tracery. Scotland continued its native stonemasonry tradition with added help from France. Built by Knights Templar in 1446, Roslyn Chapel in Roslyn, Midlothian, is a unique example of the exuberant use of stone carving during this period; it exhibited an extensive exchange of skills between the foreign and native carvers.

The Renaissance arrived in Scotland through the Stuart court. Although the arts did not flourish to the same extent as in Italy and France, one can discern a European idiom, especially in the elegant Beaton Panels for Arbroath Abbey and the lively carved wooden roundels and portraits of Stirling Castle executed for King James V in the first part of the 16th century. Because patronage of sculpture came especially through the court and the church, Protestant iconoclasm championed by John Knox and the Reformation movement in the 1560s severely hurt Scottish sculpture by simultaneously stifling ecclesiastical patronage and destroying what had already been created. A typical consequence of this activity can be seen at Dunfermline Abbey, Fife, where carved figures have been rendered headless.

With the crowns of Scotland and England united in 1607 and the Scottish Parliament suspended in 1707, Scottish arts began to decline. As talent and patronage drained south, a period of English and European hegemony regarding the commission and execution of sculpture existed well into the 19th century. The stonemason's traditions notwithstanding, a native body of sculptors was virtually nonexistent. Flemish and other foreign artists were brought in, or work was completed elsewhere and imported, with a resulting lack of opportunity for local labor to develop necessary taste, skill, and ambition for fine art. Works created in the 17th century were often as functional as they were decorative, such as the carved garden sundials at Newbattle Abbey, Midlothian.

In the 18th century, as in England, Scotland had no strong sculptural tradition when compared to the Continent. Artisans still used stonecutting for architectural decoration and funerary monuments, but these "mason-sculptors" had no pretensions to fine art. One exception was James Tassie, who executed small profile portraits of great men of the day in the unusual material of vitreous glass paste. The year 1760 saw the start of the Board of Trades and Manufactures Trustees' Academy in Edinburgh, which was the beginning of formalized art education in Scotland, although it taught drawing, not sculpture. In the typical Scottish pattern, young men wishing to sculpt would start in the trades, usually as stonemasons, until natural talent attracted the patronage necessary to fund further education, which always included a period of time in Italy.

Scottish sculptors in the 19th century such as Laurence Macdonald and Thomas Campbell spent many years in Italy and London and saw success within the Neoclassical styles of Antonio Canova and Bertel Thorvaldsen. Although Campbell and Macdonald were successful, market forces compelled them to move abroad; native demand for sculpture to satisfy the physical, intellectual, and aesthetic needs of the artists was still scarce.

Not until Sir John Steell became active did Scotland see a vibrant sculptural environment that supported its native sculptors. With his *Sir Walter Scott* (Princes Street, Edinburgh) of 1846, he became the first Scottish sculptor to execute a marble monument publicly commissioned in Scotland; he was also first to open a bronze foundry in Scotland, introducing casting to the nation with his Wellington Monument (Princes Street, Edinburgh) in 1852. Other Scots, mostly in Edinburgh, survived by executing portrait busts and funerary work, with the occasional large monument commission. Among these were A.H. Ritchie, William Brodie, and in Glasgow, the Mossman family of sculptors.

As the 20th century dawned, Scottish arts drew energy from developments in Europe. Pittendrigh Macgillivray displayed a freedom in his composition and modeling that showed understanding and regard for the work of Auguste Rodin. Macgillivray also strongly advocated a "Scottish school," distinct from any conception of British or English art. By the end of the first quarter of the 20th century, Scotland finally had formal sculptural education available at the Edinburgh College of Art and Glasgow School of Art. Although sculptors continued to flock to what Macgillivray called "Octopus London," Scotland supported its artists through public works commissions such as the National War Memorial at Edinburgh Castle, where architect Sir Robert Lorimer employed Scottish sculptors such as Pilkington Jackson, Alexander Carrick, and

Phyllis Bone to execute commemorative work in bronze and stone.

In modern times, Sir Eduardo Paolozzi has had a huge postwar career examining popular culture, toys, and combined Modern and Classical elements. Continuing the Scottish tradition of Neoclassicism in both form and text, Ian Hamilton Finlay enjoys esteemed international acclaim. Fife native David Mach has built a reputation for wry social commentary on a monumental scale, using commercial elements such as tires, magazines, and shipping containers, while Andrew Goldsworthy displays a deep connection with nature, gently intervening in its processes to create ephemeral works in forests, beaches, streams, and ponds.

ROCCO LIEUALLEN

See also **Neoclassicism and Romanticism**

Further Reading

Abrioux, Yves, *Ian Hamilton Finlay: A Visual Primer*, Edinburgh: Reaktion Books, 1985; 2nd edition, London: Reaktion Books, 1992

Daiches, David, editor, *The New Companion to Scottish Culture*, Edinburgh: Polygon, 1993

Finlay, Ian, *Art in Scotland*, London and New York: Oxford University Press, 1948

Gunnis, Rupert, *Dictionary of British Sculptors, 1660–1851*, London: Odhams Press, 1953; Cambridge, Massachusetts: Harvard University Press, 1954; revised edition, London: Abbey Library, 1968

Macmillan, Duncan, *Scottish Art, 1460–1990*, Edinburgh: Mainstream, 1990

Pearson, Fiona, editor, *Virtue and Vision: Sculpture and Scotland, 1540–1990*, Edinburgh: National Galleries of Scotland, 1991

Read, Benedict, *Victorian Sculpture*, New Haven, Connecticut: Yale University Press, 1982

Ritchie, James Neil Graham, and Anna Ritchie, *Scotland: Archaeology and Early History*, London: Thames and Hudson, 1981; 2nd edition, Edinburgh: Edinburgh University Press, 1991

SCREENS

A screen is a partition, which can vary in size and materials, that divides an interior into sections. In Christian ecclesiastical architecture up until the 16th century, a screen of some form usually divided the area of the high altar and choir from the nave and side aisles. This division of the area used primarily by the clergy from that of the laity and the catechumens was recorded by Eusebius as early as the 4th century. In his *Historia ecclesiastica* (History of the Church), he describes the use of trellislike wooden partitions in front of the chancel in a church in Tyre. His reference to the chancel as the "Holy of Holies" suggests that the screen was considered as a reflection of the partition in the Temple of Solomon.

By the 5th century, a *cancello* (a low barrier of rectangular panels of carved wood or marble) was typical in Christian churches. Bordered by raised moldings, the panels contained relief decorations of Christian symbols, monograms, and geometric or floral motifs. These chancel barriers not only enclosed the area of the chancel but at times also extended westward from the apse into the crossing or nave, as seen in restored interior of the Basilica of Santa Sabina, Rome. Similar panels were also placed between the columns of the nave to demarcate the liturgical space of the nave from the side aisles, as in the Church of St. Mary, Ephesus, or the Church of the Acheiropoietos, Thessalonica.

The furnishings for the Church of Hagia Sophia, Istanbul, described by Paulus Silentarius in the 6th century are more elaborate. Slender columns frame the low panels of 5th-century screens; the columns support an architrave in the manner of a Classical temple, hence the term *templon*. While the decoration of the rectangular panels resembled those of the 5th century, the columns and architrave held incised, bust-length images of Christ, the Virgin Mary, angels, apostles, and prophets within medallions, as is also found in two 12th-century screens, one at the Church of Santa Maria in Valle Porclaneto at Rosciolo and the other in the *diakonikon* (a sacristy that may function as an archive, library, or vestry) of Blachernitissa Church. The 6th-century chancel screen at Hagia Sophia, however, not only projected westward from the apse but also linked, via a narrow walkway of low parapets, to the ambo located in the nave, a practice that was common in 5th-century churches in Syria and the later 9th- and 10th-century churches of Bulgaria. Variations of this format appear in the 12th-century Church of San Clemente, Rome, where the *cancello* of the choir has an attached ambo and pulpit. Evidence suggests that by the 9th century, portable icons were attached to the columns and gates of the *templon*. The earliest extant example of icons attached permanently to the architrave are those in the Monastery of St. Catherine at Mount Sinai, Egypt, dated to the 10th century.

Whereas in the Orthodox East and Russia the chancel screen became a frame for tiers of painted icons of Christ, the Virgin Theotokos, saints, archangels, and major feasts of the church, in the Latin West it served as a support for devotional and narrative sculpture. As early as the 8th century, Pope Gregory III ordered the chancel screen of St. Peter's Basilica, Rome, adorned with figures of Christ and the apostles on one side and of the Virgin Mary and virgin saints on the other. Two features of the 6th-century screen of Hagia Sophia that continued in the West included the placement of candles or lamps along the architrave and the central position of an elevated cross.

In England the term for the carved wooden crucifix, the great rood, referred originally to the beam of wood of the cross; over time it also became associated with the figure of the Crucified Christ. Whether suspended above the screen by chains or mounted on the architrave by a tie rod, the crucifix was the dominant image seen by the laity from the nave. Known also as the *Croix Triomphale* or *Triumph-Kreuz*, these early crucifixes emphasized the emblematic meaning of the cross as a symbol of triumph and salvation. Consequently, the arms and legs of Christ conform to the horizontal and vertical beams of the cross. Christ's legs are parallel, requiring a nail in each foot. Christ is shown crowned, his eyes open, and his torso relaxed, as seen in the 11th-century stone rood at Romsey, England. Now part of a wall, it is difficult to say whether this rood was part of a screen. Inventories from the 15th and 16th centuries in England show that these images of Christ wore sumptuous coats of velvet or satin and silver shoes that suggest comparison with the 11th-century polychrome crucifixes of Catalonia based on the *Volto Santo* in the Church of San Martino, Lucca. The English traditions of veiling the image during Lent and unveiling the crucifix at the reading of the words "Ave Rex noster" on Palm Sunday and again at the Easter Vigil mass also establish the triumphal nature of the rood.

Most roods, whether stone or wood, were painted and gilded. By the 12th century it was common for the crucifix to be flanked by statues of the Virgin Mary and St. John the Evangelist. Larger screens might also include figures of the Twelve Apostles. Frequent, too, was the addition of winged cherubim on either side of the crucifixion group, inspired perhaps by the Old Testament description of cherubim on the partition of the Temple of Solomon. Around 1200, Gervase described a screen with cherubim flanking the crucifixion group as part of the Bishop Lanfranc's rebuilding program for Christ Church, Canterbury, between 1070 and 1089. Although later destroyed, it may have served as the model for the 13th-century rood screen of Westminster Abbey, known through drawings in the *Islip Roll*, as well as for the screen of Halberstadt Cathedral, given the ties between England and Lower Saxony.

Dated to about 1215, the attenuated figures at Halberstadt Cathedral present a more naturalistic, yet restrained, narrative tableau of the crucifixion typical of 13th-century roods. Christ's head is bowed, eyes closed, and his arms are bent at the elbow, suggesting the weight of the torso. Although the body inclines slightly to the left, the legs are still parallel as in the victorious type. The pleated vertical folds of the mourning Virgin's robe accentuates her elongated form, which is reminiscent of the columnar tree trunk from which it was carved. More animated is the figure of *Saint John*, who raises his hand to his face in grief. The hieratic character of the austere cherubim standing on wheels with gaunt, overlapped wings counters the emotion of the figures. In the trilobed medallions at the ends of the horizontal beam of the cross are grieving angels, at the summit a bust of *God the Father*, and at the base a reclining but reawakened *Adam*. Busts of the apostles under heavy-roofed canopies decorate the architrave.

The side walls of the slightly earlier choir screens at St. Michael's Church, Hildesheim, and at the Liebfrauenkirche, Halberstadt, from about 1200, divide the choir from the transepts and show instead a preference for large-scale relief sculpture. Below an open arcade of ornate columns are polychrome stucco reliefs of the apostles. Perhaps following 10th- or 11th-century Byzantine models, these full-length figures, swathed in voluminous drapery, are based on Byzantine models and show great affinity to the relief panels of the deesis brought from Constantinople in 1204 and installed in the south aisle of the Basilica of S. Marco in Venice.

Impressive for its architectural and sculptural complexity is the screen at Wechselburg, Germany, from about 1235. Torn down in 1683, it was reconstructed in 1972. The two tiers of the round-arched arcade support a tall, trilobed podium for the crucifixion group that has parallels in an illumination from a *Bible moralisée* (Vienna, Österreichische Nationalbibliotek, cod. 1179). The tall arches of the central zone serve as a frame for the Altar of the Cross at the lower level and for the pulpit in the upper level. A relief of the deesis decorates the frontal of the projecting pulpit. In the deep recesses of the upper level are freestanding figures of Old Testament kings and prophets: David, Solomon, Daniel, and possibly Isaiah or Ezekiel. On the lower level flanking the altar are almost–life-size figures of Abraham and Melchizedek. Envisioned as a courtly knight, Abraham wears a classicizing cuirass, cloak, sword, and shield. The figures of the crucifixion group show a greater naturalism in the roundness of the contours, and the figure of Christ conforms to the suffering type in the greater shift in the angle of Christ's torso and in the twisting of the legs to secure the feet with a single nail according to the three-nail type.

Mid 13th-century Gothic screens in large cathedrals or mendicant churches were typically of the open loggia or porch type with an upper walkway, pulpit, or organ loft. In some cases they had lay altars or chapels in the upper as well as lower levels. Jan Van Eyck's detailed painting *Madonna in a Church* portrays a screen of this type. Fragments and drawings of sculpture of the destroyed screens from Chartres, Amiens, Mainz, and Strasbourg Cathedrals show scenes of events in the life of Christ, of the Last Judgment, and

of Christian Virtues, such as the seven corporal works of mercy. Usually carved in high relief across the architrave or in the spandrels or gables of the arches, these scenes show a bold characterization of gesture and expression and an attention to details of contemporary life suggesting comparison with the exempla and style of vernacular sermons of the period. Particularly well-preserved reliefs are those on the architrave of the west choir screen of Naumburg Cathedral that flank a crucifixion portal.

During the 13th century in Sweden, a distinctive circular frame around the crucifix united narrative and typological scenes. At Öja, Gotland, elongated, kneeling angels of Romanesque proportions fill the upper quadrants, while the lower ones contain scenes of *The Fall of Man* and *The Expulsion from the Garden*. A later example at Fröjel, suspended from chains above the division of the chancel, is dense with figurative imagery. In medallions around the ring are busts of the apostles, in the upper quadrants are angels, and in the lower ones, figures of *Ecclesia* and *Synagoga*. The end tablets of the horizontal beam of the cross display *The Expulsion from the Garden* and *The Harrowing of Hell*. *Christ and Doubting Thomas* appears at the summit. Expanding the narrative sequence of the crucifixion are scenes of *Christ in Gethsemane* and *Christ the Gardener* along the vertical beam.

Late Gothic screens in France and Germany tend to be lighter in structure and decorated with delicate tracery work, functioning more as partitions, such as the screen at Albi Cathedral (1474–83) in France. At Lübeck Cathedral between 1470 and 1477, Bernt Notke designed an elaborate wooden screen with an over–life-size *Triumph-Kreuz* in the form of the Tree of Life. The powerful figure of Christ is of the suffering type, shown with closed eyes, open mouth, and a massive crown of thorns. Adding to the naturalism is the use of string or strips of leather for the veins. Also noteworthy are the kneeling figures of *Mary Magdalene* and of the patron, *Bishop Albert II Krummerdieck*, at the foot of the cross. Flanking them are the heavily draped figures of the *Virgin Mary* and *Saint John the Evangelist*. Nude figures of *Adam* and *Eve* are at the ends of the architrave.

In later medieval Italy the design of rood screens followed both the Byzantine and northern Gothic traditions. At Modena a bridgelike screen or *pontile* supported on columns resting on the backs of lions forms an architectural link between the nave, the lower crypt, and the raised chancel. The front of the upper walkway is decorated by polychrome marble relief panels attributed to "il Maestro della Passione di Cristo," who is thought to have been a member of the Campione workshop, and are thus dated to the end of the 12th century. The reliefs of the pulpit at the left side of the screen are

of the 13th century. The upper church of the Basilica of San Francesco in Assisi, especially the fresco titled "Miracle of the Crib at Greccio" and attributed to the St. Francis Master, show church interiors with screens constructed of tall marble panels. Mounted in the center, however, is not a sculptural rood but a painted crucifix. The 13th-century chancel screen of the Basilica of San Marco, Venice, is thought to have had tall stone relief panels or icons, perhaps those now on the north facade with images of Christ and the Four Evangelists. The 14th-century screen by the Dalle Masegne family looks back to earlier Byzantine models in the use of the *templon* schema and to the 8th-century screen of St. Peter's Basilica in its placement of free-standing figures along the architrave.

Drawings and archaeological remains attest to the use of the Gothic porch type in the *ponte* (bridge) at the Church of Santa Maria Novella and the *tramezzo* (partition or rood screen) at the Church of Santa Croce in Florence. At Vezzolano in Piedmont, a 13th-century *tramezzo* survives that is decorated with reliefs of the genealogy of Christ. In these churches the screen was connected to the cloister, permitting the brothers to enter the choir unseen by the laity. Donatello's bronze crucifix for the Basilica of San Antonio in Padua was designed for a new *tramezzo* begun in 1444, which according to Angelo Portenari's description of 1623, was accompanied by four figures of the *Virtues*. For the Church of Santa Maria Gloriosa dei Frari in Venice, Pietro Lombardo designed a choir screen of finely carved *all'antica* (after the antique) relief sculpture.

The iconoclastic fervor of the Reformation and the subsequent liturgical changes of the Catholic Church in the late 16th and 17th centuries contributed to the dismantling of rood screens throughout Europe. Baroque Catholic churches reintroduced the low chancel barrier of the early Christian period, often with balusters in place of the carved panels. In England the Elizabethan Settlement of 1561, while approving the dismantling of the rood sculpture, insisted on the preservation of the architectural screen. As a result screens continued to be designed, but with decoration in which the figurative aspect was subordinated to the architectural. Using the Classical orders, rounded arches, and extensive strap-work decoration, the screens at the Church of St. Mary, Bridgewater, Somerset, the Church of Croscombe, Somerset, and the Church of St. John, Leeds, are outstanding examples of the post-Reformation period.

The Gothic Revival movement was instrumental in reinstituting figural sculpture on chancel screens in 19th-century England. A noted proponent for this trend in Roman Catholic churches was the architect and designer Augustus-Charles Pugin, who set forth his ideas in his *Treatise on Chancel Screens and Rood Lofts*,

Their Antiquity, Use, and Symbolic Significance (1851). The screens he designed show an eclectic synthesis of patterns and forms taken from medieval churches in the British Isles and on the Continent, such as the screen at the Church of St. Giles, Cheadle (1842), or at the Church of St. Chads, Birmingham (1839–40), which incorporates a German Gothic Crucifixion group. Rood screens continued to be designed in the early 20th century, such as the diaphanous screen by Ninian Comper at the Church of St. Cyprian, Clarence Gate, London (1903), where the use of stark cherubim flanking the Crucifixion group returns to the format of Halberstadt Cathedral and Christ Church, Canterbury.

NANCY KIPP SMITH

See also **Donatello (Donato di Betto Bardi); Lombardo Family; Masegne, dalle, Family; Notke, Bernt**

Further Reading

Addleshaw, G.W.O., and Frederick Etchells, *The Architectural Setting of Anglican Worship: An Inquiry into the Arrangements for Public Worship in the Church of England from the Reformation to the Present Day*, London: Faber and Faber, 1948

Biget, Jean-Louis, *Sainte-Cécile d'Albi: Sculptures*, Graulhet, France: Odyssée, 1997

Brieger, P., "England's Contribution to the Origin and Development of the Triumphal Cross," *Medieval Studies* 4 (1942)

Flemming, Johanna, *Dom und Domschatz zu Halberstadt*, Berlin: Union, 1972

Hall, Marcia B., "The *Tramezzo* in Santa Croce, Florence, Reconstructed," *Art Bulletin* 56 (1974)

Hall, Marcia B., "The *Ponte* in S. Maria Novella: The Problem of the Rood Screen in Italy," *Journal of the Warburg and Courtald Institute* 37 (1974)

Hütter, Elisabeth, and Heinrich Magirius, *Der Wechselburger Lettner: Forschungen und Denkmalpflege*, Weimar, Germany: Böhlau, 1983

Jung, Jacqueline E., "Beyond the Barrier: The Unifying Role of the Choir Screen in Gothic Churches," *Art Bulletin* 82 (2000)

Niehr, Klaus, *Die mitteldeutsche Skulptur der ersten Hälfte des 13. Jahrhunderts*, Weinheim, Germany: VCH, 1992

Thordeman, Bengt, and Aron Andersson, *Medieval Wooden Sculpture in Sweden*, 5 vols., Stockholm: Almqvist and Wiksell, 1964–80; see especially vol. 2, by Andersson, *Romanesque and Gothic Sculpture*, 1966

Vallance, Aymer, *English Church Screens: Being Great Roods, Screenwork, and Rood-Lofts of Parish Churches in England and Wales*, New York: Scribner, and London: Batsford, 1936

Xydis, Stephen, "The Chancel Barrier, Solea, and Ambo of Hagia Sophia," *Art Bulletin* 29 (1947)

SCULPTURE GARDENS

See **Garden Sculpture**

GEORGE SEGAL 1924–2000 *United States*

George Segal was born and raised in the Bronx, New York. His parents were recent Jewish immigrants from eastern Europe, and the family was anything but affluent. The home environment, although rich in arguments and politically concerned, did not encourage the young Segal to follow his artistic leanings. Nonetheless, in 1941 he attended a painting class at The Cooper Union for the Advancement of Science and Art in New York City. The family eventually moved to South Brunswick, New Jersey, where they ran a chicken farm, and Segal enrolled at Rutgers University. In 1947 he attended the Pratt Institute of Design in New York, where he met many of the Abstract Expressionists. Segal was initially fascinated by the movement, but not without reservations. On the one hand, he was captivated by, for instance, the Russian-born Mark Rothko's abstract spiritualism; on the other hand, the need to keep in touch with the realities of everyday life led him to reject the poetic conceptions of the New York School Expressionists and Surrealists. In the late 1950s, when he gave up painting for sculpture, his feeling for realism—for the world's harsh objectivity—seemed to have won out. His earliest sculptures date from 1958 and were clearly influenced by Europe's *Nouveau Réalisme* (Arman, Yves Klein, Piero Manzoni) and Claes Oldenburg's junk-based assemblages (*Man on a Bicycle I*; 1958–59).

In 1961 Segal began to experiment with plaster casts that would eventually lead him to the visionary installations for which he is renowned. *Man Sitting at a Table* is one such example. Segal's technique was simple and effective: using surgical gauze soaked in wet plaster, he took multiple casts directly from people's bodies, manipulating and transposing the shapes as he worked. When the plaster was dry, he would put all of the parts together, creating a ghostly dummy that he would then install in a real environment: in a bathroom, in a butcher shop, or on a park bench. The eerie naturalism of these installations—which seem nearly exotic, perhaps because of their paradoxical hypernormality—recalls the paintings of Edward Hopper. Mysteriously encased in plaster, under the glare of livid neon lights, Segal's figures occupy a familiar, mundane space surrounded by ordinary objects and often captured in banal gestures.

With the plaster technique—a precise, almost surgical instrument for capturing reality—Segal took samples of life, lumps of the quotidian, and displayed them in the form of impenetrable plaster people inserted into a perfectly normal setting: a woman leaning over a counter (*The Dry Cleaning Store*, 1964); a truck driver petrified at the wheel (*The Truck*); and the sad, bent-over figure portrayed in *Walking Man* (1966). The verisimilitude of the setting contrasts with the disturbing figures that inhabit it, creating a strongly alienating effect. Like spectators at a Happening, the viewer is caught in something like a short circuit: everyday ob-

George Segal, *The Bus Driver*, 1962, figure of plaster over cheesecloth; bus parts including coin box, steering wheel, driver's seat, railing, dashboard, etc. Figure: 53 1/2″ × 26 7/8″ × 45″; overall 7′5″ × 51 5/8″ × 6′4 3/4″, The Museum of Modern Art, New York
Photo © 2000 The Museum of Modern Art, New York, and The George and Helen Segal Foundation/Licensed by VAGA, New York

jects and situations—the ordinary dimension—acquire surprising forms and unprecedented implications. One is led to reflect and look with new eyes on familiar but only apparently insignificant gestures and habits. The connection with Allan Kaprow's Happenings (the first of which was staged at the Segal family farm in 1957) and the influence of John Cage's poetic conception are evident; indeed, it has been suggested that Segal's sculptures can be thought of as frozen Happenings.

The casts from the early 1960s are rather imprecise. The surfaces are fragmented and lumpy and give the figures an abstract air, an almost impersonal aspect (*Man Leaning on a Car Door*, 1963). Toward the end of the decade, Segal began to use an industrial plaster (hydrostone) with which he could make perfectly detailed casts, capturing the model's most subtle expressions (*Girl Sitting against a Wall I*, 1968).

In the 1970s Segal's work was marked by the introduction of color. He painted his plaster specters bright pink, electric blue, and fire red, creating sensuous and disturbing works (such as *Red Girl behind Red Door*,

1976, and *Magenta Girl on Green Door*, 1977). In the same period, elements and objects modeled on those depicted in famous paintings also appeared in his installations (*Picasso's Chair*); in quoting these famous images, Segal was using a technique featured in Pop art.

Segal's sculpture is thus related to Pop art in various ways. He was indubitably influenced by Kaprow's performances and by the plaster casts of anatomical parts in Jasper Johns's *Target* series, and his works often contained references to Pop iconography. In *The Gas Station*, for instance, the unmistakable Coca-Cola logo stands out among bottles and emblematic tin cans; and in *Cinema*, the figure of a bill poster putting up an enigmatic *R* is overshadowed by a huge neon sign—an aggressive yet familiar object dear to Pop artists. Generally speaking, Segal's installations can be seen as a sort of three-dimensional photographic negative: just as on film, the white bodies give rise to an eerie, yet exact, vision, assuring a distorted but precise conformity to the subject they represent. Reference to photographic images, repetition of forms, and the continuous intrusion of consumer articles are the building blocks of Pop aesthetics.

Nonetheless, Segal's adoption of this style was only momentary and perhaps only superficial. An essential component of his art was the social concern that emanates from all of his grim and troubling sculptures. This dimension of critical awareness and commitment is wholly absent from the glittering images of Pop art, whose strong social impact is a secondary effect nearly independent from and foreign to the artists' poetic and ideological intentions. The chilling scene in *The Execution*, where corpses are strewn about on absurdly green artificial grass, contrasts against the playful Pop universe and testifies to the depth of Segal's social concerns. The will to create works with social implications led him on the one hand to tackle charged issues related to sexual emancipation (such as *Lovers on a Bed I*, 1963, and *Embracing Couple*) and homosexuality (*Gay Liberation*), and on the other hand to take up the challenge of important public monuments such as the contested *In Memory of May 4, 1970, Kent State: Abraham and Isaac*, which honors the four students killed at an antiwar rally at Kent State University in Ohio, and *The Holocaust*, a bronze group dedicated to the victims of Nazi extermination.

LUCIA CARDONE

See also **Arman (Fernandez); Assemblage; Installation; Kienholz, Edward and Nancy Reddin; Klein, Yves; Manzoni, Piero; Merz, Mario**

Biography

Born in New York City, United States, 1924. Studied painting at The Cooper Union, New York City, 1941–

42, Rutgers University, New Jersey, 1942–46, Pratt Institute of Design, Brooklyn, New York, 1947, and New York University (B.A. in art education), 1949; met Allan Kaprow, 1953, who later staged first Happening at Segal's chicken farm, 1957; gave up painting for sculpture, late 1950s; employed from 1958 to 1964 as English and art teacher in New Jersey schools; began to create installations, 1961. Awarded important commissions for public monuments, from 1970s, including monuments for the Kent State killings and the Holocaust. Died in South Brunswick, New Jersey, United States, 9 June 2000.

Selected Works

1961 *Man Sitting at a Table*; plaster, wood, and glass; Städtische Kunsthalle, Mannheim, Germany

1962 *The Bus Driver*; plaster, wood, and metal; Museum of Modern Art, New York City, United States

1963 *Cinema*; plaster, metal, Plexiglas, fluorescent light; Albright-Knox Art Gallery, Buffalo, New York, United States

1963–64 *The Gas Station*; plaster, metal, glass, stone, rubber; National Gallery of Canada, Ottawa, Canada

1965 *The Butcher Shop*; plaster, metal, wood, vinyl, Plexiglass, other objects; Art Gallery of Ontario, Toronto, Canada

1966 *The Truck*; plaster, wood, metal, glass, vinyl, film projector; Art Institute of Chicago, Illinois, United States

1967 *The Execution*; plaster, wood, metal, rope; Vancouver Art Gallery, Canada

1973 *Picasso's Chair*; plaster and mixed media; Guggenheim Museum of Art, New York City, United States

1975 *The Corridor*; plaster, wood; Tomayo Museum, Mexico City, Mexico

1975 *Embracing Couple*; plaster; Walker Art Center, Minneapolis, Minnesota, United States

1978 *In Memory of May 4, 1970, Kent State: Abraham and Isaac*; bronze; Princeton University, Princeton, New Jersey, United States

1980 *Gay Liberation*; plaster, metal; Museum of Modern Art, Seibu Takanawa, Karuizawa, Japan

1983 *The Holocaust*; bronze; Lincoln Park, San Francisco, California, United States

Further Reading

Compton, Michael, *Pop Art*, London and New York: Hamlyn, 1970

Friedman, Martin, and Graham Beal, *George Segal: Sculptures*, Minneapolis, Minnesota: Walker Art Center, 1978

Hunter, Sam, *American Art of the 20th Century: Painting, Sculpture, Architecture*, New York: Abrams, and London: Thames and Hudson, 1973

Hunter, Sam, and Don Hawthorne, *George Segal*, New York: Rizzoli, 1984

Livingstone, Marco, *George Segal Retrospective: Sculptures, Paintings, Drawings*, Montreal, Quebec: Montreal Museum of Fine Arts, 1997

Price, Marla, *George Segal: Still Life and Related Works*, Fort Worth, Texas: Modern Art Museum of Fort Worth, 1990

Schwartz, Ellen, *Sculpture in the 70s: The Figure*, New York: Pratt Institute, 1980

Seitz, William, *Segal*, New York: Abrams, 1972; as *George Segal*, London: Thames and Hudson, 1972

Tuchman, Phyllis, *George Segal*, New York: Abbeville Press, 1983

Van der Marck, Jan, *George Segal*, New York: Abrams, 1975; revised edition, 1979

JOHAN TOBIAS SERGEL 1740–1814
Swedish

Johan Tobias Sergel was one of Europe's leading Neoclassical sculptors at the end of the 18th century. Best known for the mythological statues and groups executed during his years in Rome, he was also a prolific draftsman and etcher. His lively caricatures and genre scenes reveal his facility in a range of media and provide a record of contemporary life in artistic circles in Rome and Sweden.

Sergel first trained in the workshop of his father and then studied drawing, modeling, and anatomy under several teachers. His most influential teacher was Pierre Hubert L'Archevêque, a French sculptor who had come to Stockholm to work on the sculptural program of the Royal Palace.

In 1758 Sergel accompanied L'Archevêque to France, where he studied at the Academy of Art in Paris and was influenced by Edmé Bouchardon, L'Archevêque's former teacher. He also met the Comte de Caylus, whose *Tableaux tirés d'Homère et de Virgile* (1757) later provided inspiration for many of Sergel's classically themed sculptures. On returning to Sweden Sergel continued to assist L'Archevêque and began to execute independent works, particularly portrait medallions. He became master sculptor in 1763.

In 1767 Sergel traveled to Rome on a royal stipend. He worked intensively and creatively during his 11 years in Italy, gaining prominence as a Neoclassical sculptor. In Rome he joined an international circle of artists who inspired each other both thematically and stylistically. Especially important were his friendships with Henry Fuseli, Nicolai Abraham Abildgaard, and Julien de Parme.

Sergel's studies in Rome, where his self-professed masters were "Antiquity and Nature," included four

years at the French Academy. He studied Classical sculpture and plaster casts as well as Renaissance and Baroque art. Drawing live models at the academy and in the fencing halls, he developed a keen eye for anatomical realism. He derived his subjects primarily from Classical mythology and history.

Sergel first won critical acclaim with his 1774 *Resting Faun*, which depicts a nude figure luxuriantly reclining on an animal skin. Based on Classical prototypes, the work displays a vivid realism that would become Sergel's artistic hallmark. His next important work, *Diomedes Stealing the Palladium from Troy*, depicts a different type of male nude. This sculpture shows the Greek hero Diomedes carrying away the Palladium, a sacred statue of Athena, protector of Troy. Although Diomedes, an active hero, contrasts with the indolent faun, both figures reveal Sergel's ability to merge "nature"—including a lifelike rendering of the human body—with a taut Classicism.

Sergel sculpted not only single figures but also numerous classically themed groups, in particular amorous couples. For example, in *Mars and Venus* he por-

Cupid and Psyche
Photo courtesy Nationalmuseum, Stockholm, Sweden

trayed a moment recounted by Homer when Venus, wounded in battle, faints in the arms of her rescuer. Although Sergel produced the original terracotta sketches for this work during his early years in Rome, he did not block out the marble version until 1778; he finished the work in 1804 in Stockholm. Many other planned sculptures with comparable themes, such as *Jupiter and Juno* (1769–70), *Venus and Anchises* (ca. 1771–72), and *Mercury and Psyche* (ca. 1770), exist solely as terracotta sketches. These sketches display a playful eroticism reminiscent of the lively Rococo terracottas by French sculptors such as Bouchardon and Clodion.

Summoned back to Stockholm in 1778 by King Gustav III, Sergel returned via Paris, where he became *agréé* (admitted) of the Academy of Art on the strength of his terracotta sketch for *Otryades, General of the Lacedaemonians*. This work depicts a dying Spartan who performs the final heroic act on the battlefield of inscribing "to the victorious Jupiter" on his shield in his own blood, thereby claiming victory for Sparta. The theme of the dying hero proved increasingly popular in late 18th-century France, and Sergel's psychologically fraught work influenced other Neoclassical artists, such as the painter Jacques-Louis David.

After his return to Sweden in 1779 and appointment as court sculptor, Sergel embarked on a new phase of his career. Although devoted to Gustav III, Sergel looked back on his stay in Italy as the most productive and inspired time of his life. His longing for Italy prompted him to write to a younger artist: "The air of Rome is unique, the breath of life to an artist's soul. . . . All the Nordic countries are graves to artistic genius" (see *Age of Neo-Classicism*, 1972). He returned to Italy only once, accompanying the king on a tour in 1783–84. As court sculptor Sergel occupied himself with official commissions, which did not allow him the artistic flexibility and freedom he had enjoyed earlier. He devoted himself increasingly to portraiture, producing numerous busts and medallions.

In 1780 the king commissioned a copy of the antique statue *Callipygian Venus*, which Sergel sculpted with the features of the royal mistress, Countess Ulla von Höpken. The figure was placed in the Hall of Mirrors of the Royal Palace, along with a copy of the *Apollino* done during Sergel's years in Rome. Sergel's commissions also included several portrait busts of the king. Following Gustav III's assassination in 1792, Sergel sculpted a herm bust, which combined realistic features, based on the king's death mask, with Classical drapery. Sergel's last important work was a bronze posthumous monument to the monarch, which shows Gustav III in Swedish royal costume, in a pose derived from the *Apollo Belvedere*. Not completed until 1808,

this work stands in front of the Royal Palace in Stockholm.

Sergel was considered one of Europe's leading sculptors during his lifetime, but his reputation has since declined. As Neoclassicism fell out of favor, regard for his sculpture diminished, although his expressive and often intensely personal drawings have received more critical attention. He is also poorly known internationally because the majority of his sculpture is in Sweden, and most scholarship on him remains untranslated. Nonetheless, Sergel is an important precursor to now more famous Neoclassicists, such as the sculptors Antonio Canova and Bertel Thorvaldsen.

EVA BOWERMAN

See also **Bouchardon, Edme; Clodion (Claude Michel); Thorvaldsen, Bertel**

Biography

Born in Stockholm, Sweden, 28 August 1740. Son of a German-born court embroiderer in Stockholm. Became apprentice in father's workshop, 1756; studied drawing under Jean Eric Rehn and modeling under decorative sculptor Adrien Masreliez; began studies with sculptor Pierre Hubert L'Archevêque, 1757; went with L'Archevêque to Paris, 1758; studied at French Academy of Art for three months; received "the second of the annual prizes" as student there; assisted L'Archevêque on Hall of State in Stockholm Palace, 1759–63; awarded Academy of Art's silver medal (first class) for modeling, 1761; became master sculptor, 1763; studied engraving under Per Floding, royal engraver, 1765–67; studied in Rome, 1767–78, including four years at French Academy, 1771–75; study trip to Naples, Pompeii, and Herculaneum, 1768; called to Sweden by Gustav III, 1778; returned via Paris and London, becoming agréé (admitted) at French Academy; arrived in Stockholm, 1779; became member of the Academy of Art, 1779, and professor, 1780; knight of the Order of Vasa, 1782; accompanied King Gustav III to Italy, 1783–84; appointed surveyor of royal works of art, 1803; ennobled, 1808; became director of Academy of Art in Stockholm, 1810. Died in Stockholm, Sweden, 26 February 1814.

Selected Works

1770　Resting Faun; terracotta; Nationalmuseum, Stockholm, Sweden; marble versions:
1773　Apollino (after the antique); marble; Nationalmuseum, Stockholm, Sweden
1774　Sinebrychoff Art Collection, Helsinki, Finland; 1774, Nationalmuseum, Stockholm, Sweden

1774　Diomedes Stealing the Palladium from Troy; marble; Nationalmuseum, Stockholm, Sweden
1775　Mars and Venus; terracotta; Nationalmuseum, Stockholm, Sweden; marble version: 1804, Nationalmuseum, Stockholm, Sweden
1779　Otryades, General of the Lacedaemonians; terracotta; Nationalmuseum, Stockholm, Sweden
1780　Callipygian Venus (after the antique); marble; Nationalmuseum, Stockholm, Sweden
1787　Cupid and Psyche; marble; Nationalmuseum, Stockholm, Sweden
1792　Gustav III; marble; Nationalmuseum, Stockholm, Sweden
1808　Gustav III; bronze; front of Royal Palace, Stockholm, Sweden

Further Reading

The Age of Neo-Classicism (exhib. cat.), London: The Arts Council of Great Britain, 1972

Antonsson, Oscar Arvid, "Sergel (vor der Nobilitierund Sergell), Johan Tobias, Schwed. Bildhauer," in Allgemeines Lexikon der bildenden Künstler von der Antike bis zur Gegenwart, edited by Ulrich Thieme, Felix Becker, and Hans Vollmer, vol. 30, Leipzig, Germany: Engelmann, 1936; reprint, Leipzig, Germany: Seemann, 1978

Antonsson, Oscar Arvid, Sergels ungdom och Romtid, Stockholm: Norstedt, 1942

Antonsson, Oscar Arvid, "Johann Tobias Sergel," The Burlington Magazine 83 (December 1943)

Bjurström, Per, Johan Tobias Sergel, 1740–1814 (exhib. cat.), edited by Werner Hofmann, Munich: Prestel-Verlag, 1975

Bjurström, Per, Drawings of Johan Tobias Sergel (exhib. cat.), Chicago: University of Chicago Press, 1979

Grate, Pontus, and Sten Åke Nilsson, "Sergel [Sergell], Johan Tobias," in The Dictionary of Art, edited by Jane Turner, New York: Grove, and London: Macmillan, 1996

Hökby, Nils-Göran, Ulf Cederlöf, and Magnus Olausson, editors, Sergel (exhib. cat.), Stockholm: Nationalmuseum, 1990

Josephson, Ragnar, Sergels fantasi, 2 vols., Stockholm: Natur och Kultur, 1956

O'Brien, Elvy Setterqvist, "Johan Tobias Sergell (1740–1814) and Neoclassicism: Sculpture of Sergell's Years Abroad, 1767–1779," Ph.D. diss., University of Iowa, 1982

Pressly, Nancy L., The Fuseli Circle in Rome: Early Romantic Art of the 1770s (exhib. cat.), New Haven, Connecticut: The Yale Center for British Art, 1979

CLÉMENCE SOPHIE DE SERMÉZY 1767–1850 French

Clémence Sophie de Sermézy (née Daudignac), a student of Joseph Chinard, was a gifted sculptor whose strongest works were portraits of friends and family. Little is known about her early years, and questions

related to her early artistic development remain unanswered. She was an amateur, and so her career did not follow the trajectory of her teacher Chinard. As a woman, she could not train in a studio or secure a position at Lyon's École des Beaux-Arts. However, as a member of Lyon's upper class, there was no need for her to do either. Her social milieu partially compensated for the professional restrictions against women. Nonetheless, although an accomplished and original sculptor (she was the first woman sculptor to become an associate member of the Académie de Lyon), she had no followers, and her posthumous reputation was obscure.

Madame de Sermézy's earliest extant works date from the 1790s. The first, from 1792, a medallion portrait of a friend as *Diana*, is competent but heavy and makes clear the mediocrity of her artistic education up to this point. A slightly later work, *Mademoiselle Vitet*, is striking for its simplicity and refinement; it impressed contemporaries, some of whom assumed that an accurate attribution would include Chinard. Although such an attribution is unlikely, it does demonstrate Chinard's influence, which was the most important factor in Madame de Sermézy's development as an artist. The dates of his instruction are unknown, but the improvement represented by *Mademoiselle Vitet* suggests that he began to work with her during the mid 1790s. Political events, especially Chinard's own problems with the revolutionary government, also make likely this chronology.

Madame de Sermézy's sitters typically belonged to Lyon's social and cultural establishment, although some had also achieved international celebrity; for example, her bust of *Madame Récamier* portrays a family friend who was also a well-connected Parisian hostess. Of all the portraits of Madame Récamier, Madame de Sermézy's is among the most successful in suggesting what Madame Récamier was like. It retains the details of Neoclassicism, such as the drapery and coiffure, but emphasizes the traits particular to the sitter. Madame de Sermézy's *Madame Récamier* is an attractive woman in her late twenties, chaste and attentive, with round cheeks, a heavy neck, and a slight double chin. The artist based this work on Chinard's own sensual bust of *Madame Récamier* (1801–02). Despite similarities, such as the pose, the two works are physically and psychologically distinct. They also differ in quality, Madame de Sermézy's workman-like execution suffering in comparison with Chinard's genius.

The portrait of *Madame Daudignac* realistically depicts the artist's mother, a placid old woman with a fleshy, dimpled face. The sculptor was also influenced by Antonio Canova, whose Neoclassical style inspired some of her least distinguished work. Her first portrait of the history painter *Fleury Richard* (1810), for

example, imposes regular features and antique austerity on a man who liked to joke about his ugliness. Although the work succeeds as an exercise in Neoclassical aesthetics, it is not a persuasive portrait. Her second portrait of *Fleury Richard* (1812–13) is more realistic and convincing, depicting the sitter's furrowed brow and large nose in addition to conveying his vigor and charisma.

Madame de Sermézy also produced works with religious, mythological, and literary themes, as well as allegories, such as *Filial Piety*. Other works reflect national events, such as the *Duchess of Berry Mourning the Death of Her Husband*. Aside from portraits, her most important work is the model for a sepulchral monument planned after her daughter's death in 1810. The *Figure Kneeling on a Grave* depicts a grieving young woman in Classical dress and contrasts greatly with the worldly figures of *Fleury Richard* and *Madame Récamier*.

In 1815, during the unrest that followed Napoléon's abdication, a mob sacked the house in which Madame de Sermézy lived in the Place Bellecour, destroying an unknown quantity of her work and in turn making the evolution of her work difficult to examine. Moreover, few contemporary references exist; she exhibited only once, at the Hôtel de Ville in Lyon in January 1827. In addition, a large collection of her work in Charentay was dispersed by auction in 1934.

AMY E. GALE

See also **Canova, Antonio; Chinard, Joseph; Neoclassicism and Romanticism**

Biography

Born in Lyon, France, 28 July 1767. Student of Joseph Chinard, beginning in the mid 1790s; lived and worked for most of her life in Lyon; successful as a portraitist among the upper classes of Lyon; much of her work destroyed when a mob sacked her house in Place Bellecour, Lyon, 1815; named to the Académie de Lyon, 1818; exhibited her work only once, at the Hôtel de Ville, Lyon, 11 January 1827. Died in Charentay, France, 30 October 1850.

Selected Works

1792 *Diana*; plaster (untraced)
1799 *Mademoiselle Vitet*; terracotta (untraced)
1804 *Madame Daudignac*; plaster; Musée des Beaux-Arts, Lyon, France
1804 *Madame Récamier*; plaster; Musée des Beaux-Arts, Lyon, France
1810 *Figure Kneeling on a Grave*; plaster; Musée des Beaux-Arts, Lyon, France

1810 *Fleury Richard*; plaster; Musée des Beaux-
 Arts, Lyon, France
1812–13 *Fleury Richard*; plaster (untraced)
1819 *Plato Contemplating the Immortality of the
 Soul*; plaster (untraced)
after *Duchess of Berry Mourning the Death of
1820 Her Husband*; terracotta (untraced)

Further Reading

Hallays, André, "L'exposition rétrospective des artistes lyon-
 nais," *Journal des debats* (25 November 1904) (a review of
 the Lyon exhibit)
Leprade, Victor de, "Madame de Sermézy," *Revue du lyonnais*
 (1850) (obituary)
*Les Muses de Messidor: Peintres et sculpteurs lyonnais de la
 Révolution à l'Émpire* (exhib. cat.), Lyon, France: Musée
 des Beaux-Arts, 1989
Portraitistes lyonnais, 1800–1914 (exhib. cat.), Lyon, France:
 Musée des Beaux-Arts, 1986
Reboul, Edmond, *Regards sur—: L'Académie des sciences,
 belles-lettres et arts de Lyon*, Nîmes, France: Lacour, 1991
Richard, E., "Une page de la vie lyonnais sous l'Émpire: Confér-
 ence faite le 15 février 1895 à l'Université Catholique de
 Lyon," *Revue du Lyonnais* (1895)
Tapissier, Anne, *Madame de Sermézy, élève de Chinard (1767–
 1850)*, Lyon, France: Audin, 1936
*Ville de Lyon, catalogue illustré de l'exposition rétrospective
 des artistes lyonnais* (exhib. cat.), Lyon, France: Palais Mu-
 nicipal des Expositions, 1904

GIACOMO SERPOTTA 1656–1732 *Italian*

Giacomo Serpotta, who worked mainly in Sicily, Pal-
ermo in particular, was among the most important and
representative artists of the 18th century and certainly
one of the greatest stucco sculptors of all time. The
interior decorations he executed, some designed by
himself and others by illustrious architects, reflected
a concept widely implemented in the 18th century: that
of commissioning artists working in the same style to
realize a perfect synthesis of architecture, sculpture,
and painting. In an Arcadian-Rococo discourse along
a line connecting oratories, churches, and chapels, Ser-
potta created an imposing body of work of which the
most memorable components, besides the allegorical
and sacred angelic figures, are "sculptural theaters."
These multifaceted works depicted stories from the
Old and New Testaments and from the lives of saints,
a number of portraits, several equestrian and funerary
monuments, and models of religious paraphernalia to
be cast in silver.

The first major complex exhibiting Serpotta's
unique talents as a stucco sculptor is the Rosary Ora-
tory, an annex to the church of St. Zita in Palermo.
The ensemble is brimming with pilasters, candlestick
motifs, angels, putti, allegorical and Biblical figures,
"sculptural theaters" depicting the *Mysteries of the Ro-*

sary and the *Battle of Lepanto*, and an extravagant,
ultra-decorated drape fills the entire back wall of the
room. The design was based on a doctrinal program
aiming at "the apotheosis of the mystical practice of
the Rosary" (Meli, 1934). The project was interrupted
several times and took more than thirty years (1675–
1718) to complete, which accounts for the stylistic
changes. Nonetheless, Serpotta succeeded in blending
these and the myriad iconographic elements in a uni-
fied, intensely pictorial and theatrical vision marked
by exuberant vitality and a sumptuous decorativeness
that reflects Late Baroque taste, but with a clear incli-
nation for proto-Rococo details. Mannerist elements
(the candlesticks) and elements derived from Anto-
nello Gagini (the composition of the *Mysteries*) are
interpreted in a modern language. The broad frame of
reference is the artistic language developed in Rome,
from Gianlorenzo Bernini and François du Quesnoy,
to Carlo Maratta's school of painting and the contem-
porary theater. Serpotta's openness to the Roman style
and use of drapery was inspired by the Sicilian archi-
tect Giacomo Amato and the painter Antonino Grano,
whose direction he worked under several times in his
career.

Another memorable enterprise was the stucco deco-
ration of the Oratory of San Lorenzo, an annex to the
Palermo Church of St. Francis of Assisi (1699–1706).
The building had been remodeled by Amato, and, as
at St. Zita, Serpotta executed the decoration in stages,
starting in the apse. Here Serpotta created a frame sup-
ported by two angels for a Caravaggio painting from
1609 (*Nativity with Sts. Laurence and Francis of As-
sisi*, stolen in 1969). Next, the inside of the front wall
was decorated with a large high-relief of the *Martyr-
dom of St. Laurence* (1703) based on a 17th-century
French composition. The side walls of the apse were
then decorated with letters and the ceiling with a small
dome (1705). The stories from the lives of Sts. Laur-
ence and Francis of Assisi (presented as "sculptural
theaters") along the side walls of the room, and the
Virtues beside them, were all based on graphic proto-
types. The complex symbolic values and the extraordi-
nary wealth of iconographic and stylistic details based
on Roman models inserted by Amato and Serpotta are
transfigured in a strong compositional unity and a per-
fect synthesis, thanks to Amato's rigorous design and
the supreme qualities of Serpotta's style. The result is
one of the greatest monuments of the 18th century.
Amato's and Serpotta's use of figurative models char-
acteristic of the 16th century (pilasters with candles-
ticks, the apse prospect and the "sculptural theaters"),
but updated in keeping with an Arcadian-Rococo taste,
demonstrated that both artists had a deep understand-
ing of Sicilian Renaissance art. They were determined
to modernize the space–time relationship in an illusive,

dramatic key, bringing theater, song, recitation, and music into a continuous dialogue with Serpotta's sculptural symphonies.

Two more masterpieces are the stucco decorations in the Church of St. Agostino (1711–29) and in the Holy Rosary Oratory annexed to the Church of St. Dominic (1714), both in Palermo. St. Agostino had been remodeled by Amato, and elegant figures of male and female *Saints of the Augustin Order* mark the rhythms of the pilasters and arches in front of the fictive chapels along the single wide nave. The animated stories from the lives of the saints in the chapel lunettes likewise suggest Roman reminiscences. At the Rosary Oratory, stupendous allegorical figures are placed in niches along the walls, and the apse is arranged like a proscenium space. Great oval high-relief medallions with stories from the Old and New Testaments are situated high along the walls. In Serpotta's intensely scenographic interpretation, the complex doctrinal program intended to exalt the Rosary is translated into a pantomime as vibrant with pictorial effects and worldly touches as a fairy tale. The solution adopted in the apse is significant as a perfect synthesis of Baroque elements from Bernini and Francesco Borromini, modified in light of Father Andrea Pozzo's efforts in the area of perspective and close to those of Antonio Gherardi (Carandente, 1967).

In portraiture, Serpotta rejected objective naturalism and psychological investigation, and his inexhaustible creative imagination filtered through idealizing classicism. In the *Portrait of Giovanni Ramondetta* (tomb, Church of St. Dominic in Palermo), he produced only an abstract heraldic presence. The *Portraits of Donna Francesca Balsamo et Aragona and Don Baldassarre Bologna*, at the House of the Crucifer Fathers in Palermo, were nearly literal translations from etchings or paintings. But Serpotta touched a different register in the magnificent bronze *Equestrian Monument to Charles II* (1680–84), which is now lost, but a trial casting or bronze model remains in the Pepoli Museum in Trapani. Sources for this work include Pietro Tacca's bronze *Equestrian Monument to Philip IV* (Madrid) and Bernini's marble *Equestrian Monument to Constantine* (Vatican Museums).

Only in recent years have advances been made in determining Serpotta's training. The extraordinarily high quality of Serpotta's work and the sharp difference between his style and that of the local stuccowork tradition and Sicilian sculpture in general, as well as the innumerable Roman iconographic and stylistic elements in his language, suggest that he must have traveled to Rome. However, historians now recognize that the cultural environment in Palermo in the late 17th and early 18th century was rich and complex. Sicilian artists were influenced on the one hand by Maratta's

Fortitude, Oratony of San Lorenzo, Church of St. Frances of Assisi, Palermo
© Alinari / Art Resource, NY

Roman classicism and on the other by the Neapolitans, both indirectly, through the numerous imported paintings present in Palermo, and directly, through their frequent sojourns in Rome and Naples. Serpotta should rightly be placed among the followers of the Sicilians, Paolo Amato, and, above all, Giacomo Amato and Antonino Grano. In Serpotta's complexes, Baroque variety is drastically reduced to a duality of medium (stucco) and light (white). The overall effect is of grandiose monochromes that tend to expand the spaces, reducing the astonishing gallery of images to lofty decorative signs. This was the work of a "painter-sculptor." It paved the way for the breaking of space by the great 18th-century decorators still to come, but we can also glimpse a relationship to mural paintings of scenes and prospects. Serpotta, working within a rigid architectonic framework, fills the walls with cornices, niches, pillars, medallions, "sculptural theaters" and figures, rampant groups and picturesque friezes. There can be no doubt that Serpotta's images embody a secular, worldly ideal that jars with the religious nature of the buildings. In the oratories, where he attains a unity perhaps never equaled again, and characterized with evident harbingers of Rococo, everything reflects

a serene and joyous naturalism, superhuman beauty, and splendor. These putti, angels, cherubs, male and female saints, Virtues, melodramatic heroes and heroines, all dressed in surprising contemporary costumes, were taken from a huge repertory of etchings and paintings from Mannerism, Italian and French Classicism, and the Baroque. The classicism derived from Carlo Maratta sometimes pushed Serpotta to the point of creating images so academic as to become Neoclassical (for instance the reserved *Allegories* in the Giusino church in Palermo). Serpotta has the merit of having captured "the fundamental unity of the 17th century tradition, which was at once different and consistent on both its Baroque side and its classical side," and "of having transmitted the sense of this unity, expressed in nonacademic but creative forms, to the 18th century" (Nava Cellini, 1982).

<div align="right">TEODORO FITTIPALDI</div>

See also **Baroque and Rococo; Bernini, Gianlorenzo; du Quesnoy, François; Tacca Family**

Biography

Born 10 March 1656 in Palermo. Son of Gaspare, a stonecarver and stucco craftsman; maternal grandfather Nicolò Travaglia a sculptor from Carrara. Died 27 February 1732 in Palermo. Buried in Church of St. Matthew in Palermo.

Selected Works

1680–84 *Equestrian monument to Charles II*; bronze (lost); formerly in Piazza del Duomo, Messina (executed from Serpotta's model; a bronze model, or perhaps a trial casting, is in the Pepoli Museum, Trapani, Italy)

1685– 88, 1707– 08, 1717–18 Pilasters with candlesticks, allegorical figures, angels, putti, *Esther, Judith, Fifteen Mysteries of the Rosary, Battle of Lepanto*, drape with putti, cherubs, shells, garlands, acanthus plants, eagles, war trophies, and six medallions depicting the *five glorious mysteries* and the *battle of Lepanto*; stucco statues and high- and low-reliefs; Rosary Oratory, Church of St. Zita, Palermo

1691 *Tomb of Giovanni Ramondetta, President of the Royal Tribunal*; inlaid polychrome marbles; Church of St. Dominic, Palermo (executed from Paolo Amato's design and Serpotta's wax models)

1699– 1706 Allegorical figures (*Fortitude, Charity*), putti, angels, cherubs, columns with candlesticks, floral festoons and shells; five *Stories from the Life of St. Laurence*; four *Stories from the Life of St. Francis of Assisi; Christ Bearing the Cross; St. Francis of Assisi in Glory*; stucco statues and high- and low-reliefs; Oratory of San Lorenzo, Church of St. Francis of Assisi, Palermo, Italy

1707–12 Medallion with portrait of Donna Francesca Balsamo ed Aragona, Princess of Roccafiorita; medallion with portrait of Don Baldassarre Bologna; stucco bas-reliefs; House of the Crucifer Fathers, Palermo, Italy

1711 Angels bearing inscribed scroll; stucco statues, Church of St. Agostino, Palermo, Italy (signed and dated)

1714 Allegorical figures, putti, cherubs, garlands, architectural elements; *stories from the Book of Prophets; stories of the mystic lamb from the revelation of St. John the Divine*; stucco statues and high- and low-reliefs, Rosary Oratory, Church of St. Dominic, Palermo, Italy

1718 Drape held by putti, with angel and plant motifs; stucco high- and low-reliefs; rear façade, Church of St. Agostino, Palermo, Italy

1724 *Sts. Peter and Paul, Peace, Meekness, Fortitude, Purity, The Mother of Sorrows, St. Mary Magdalene*; stucco statues; St. Francis of Paola Abbey Church, Alcamo, Italy

1728–29 *Penitence, Justice, Clemency* (lost), *Faith* (lost), two angels, two putti, *Jesus Christ Transforms the Alms Collected by the Brothers into Comforting Roses and Scatters Them over the Souls in Purgatory*; stucco statues and high- and low-reliefs; church of St. Matthew, Palermo

Further Reading

Argan, Giulio Carlo, "Il teatro plastico di Giacomo Serpotta," *Il Veltro*, vol. 1 (Rome, 1957)

Aurigemma, M.G., *Oratori del Serpotta a Palermo*, Roma, 1989

Carandente, G., *Giacomo Serpotta*, Torino, 1967

Fittipaldi, T., "Contribuo a Giacomo Serpotta opere indedite e rapporti cultural," in *Napoli Nobilissima*, vol. 16, fasc. 3– 5, 1977

Garstang, Donald, *Giacomo Serpotta and the Stuccatori of Palmero, 1560–1790*, London: A. Zwemmer, 1984

Guttilla, M., "Apologetica mariana e stucchi del Serpotta nell' Oratorio del Rosario di San Domenico a Palermo," "*Storia dell'Arte*," 59, 1987

Malignaggi, D., "La scultura della seconda metà del Seicento e del Settecento," in *Storia della Sicilia*, vol. 10, Palermo 1981

Meli, F., *Giacomo Serpotta, La Vita e le Opere*, vols. 1–2, Palermo, 1934

Nava Cellini, A., *La scultura del Settecento*, Torino 1982

Paolini, M.G., *Giacomo Serpotta*, Palermo 1983, con bibl. prec.

CHARITY (LA CARITÀ)

Giacomo Serpotta (1656–1732)

1699–1706

stucco

Oratory of San Lorenzo, Palermo, Italy

Work on this group of sculptures began in 1699. Serpotta's first contract for decorative work is dated March 15 for work beginning in the apse of the architect Giacomo Amato's project, although the figures are Serpotta's (see Meli, 1934). The contract from February 4, 1701, to decorate the "quattro finestri di stucco" (four stucco windows) in the oratory in continuation of the already completed works confirms that the construction of the apse had been finished for some time (see Meli, 1934). The group's composition, although inspired by Cesare Ripa's *Iconologia* (Iconology), does not adhere to the canonical description of Ripa's text and the *xilografia* that illustrates it; in addition, the feminine figure is lacking the "fiamma di fuoco ardente" (flame of the impassioned fire) on her head. Serpotta's liberties were due to both personal and modern expressive exigencies.

The group, not inadvertently, is related to the depicted Virtues: Mercy, Alms, and Hospitality, all in connection with the "teatrino plastico" (plastic little theater) representing the division of goods of the Church of San Lorenzo, connected to the same wall of the *cornu evangelii*; "per fare meglio intendere il gesto generoso e benefico del giovane diacono" (to do better, understand the generous and beneficent gesture of the young deacon" (see Meli, 1934).

Charity (La Carità) is a paradigmatic work of Serpotta's vast and extremely varied oeuvre. It is a perfect synthesis of formal abstraction and naturalism, of tender and delicate sentiments, yet it is saved from sentimentality by a vigilant stylistic rigor and borrowed psychological observations. The baby sucking his finger on the lower left, the nudes crying in each other's arms on the right; and the very tender nudity of the breast of the sensual female figure and of the baby in the act of sucking, set in the ample curve of the woman's arm and drapery of her clothing, are unforgettable. In the dynamic compositional equilibrium and the formal smoothness, Serpotta manifests his adherence to the classicism of Carlo Maratta, yet does not renounce the flowing liveliness of the line designed

as an *espirit du contour*, like an authentic Rococo arabesque.

The impression that one gets from the study of the structural foundation is that of a ponderous high relief that cannot do without the wall in the background to which it must adhere and that supports it. Yet again, the wall is a fundamental expressive element of the poetic world of Serpotta and is conditioned by the same images. The group recovers the space of the wall and from the reflection of the stereoscopic positions of the putti and of the very elegant cadences of the drapery, as well as the serpentine gait of the lopping figures. Graceful without pretense in the attitudes or movements, the calculated pictorial effects and the vivacious naturalistic notes come from a subtle humor. There is a dazzling early version of this in a natural terracotta sketch, in the Regional Gallery of Sicily at the Abatellis Palace in Palermo (see Fittipaldi, 1977).

TEODORO FITTIPALDI

Further Readings

Carandente, G., *Giacomo Serpotta*, Turin, Italy, 1967

De Logu, G., *Antologia della scultura italiana*, Milan, Italy, 1956

Fittipaldi, T., *Contribuo a Giacomo Serpotta opere indedite e rapporti culturali*, in "Napoli Nobilissima," vol. 16, fasc. 3–6, 1977

Martinelli, V., *Scultura Italiana dal Manierismo al Rococò*, Milan, Italy, 1968

Meli, F., *Giacomo Serpotta, La Vita e le Opere*, vols. 1–3, Palermo, Italy, 1934

RICHARD SERRA 1939– *United States*

Richard Serra gained popularity in the late 1960s as one of a group of artists working with and building on the abstract language and forms of Minimalism. Often given the misnomer Post-Minimalists, Serra and other artists such as Eva Hesse, Barry Le Va, and Lynda Benglis explored process and materials in the creation of literalist sculpture. For Serra, this greater interest in materiality closely related to his use of gravity and time.

Whether made of splashed molten metal, galvanized rubber, or his characteristic materials of lead or steel, Serra's sculptures resulted from a straightforward action or set of actions applied to a material. This method is most evident in his series of prop pieces (often called *antinomies*, drawing on the equal and energetic properties of opposites) composed of lead plates leaning against each other or a wall. The most famous of these, *One-Ton Prop (House of Cards)*, made the form of the geometric Minimalist cube reliant on the weight of the material and the act of propping. Although the work appears at first to be akin to the cubes and boxes that

characterized Minimalist sculpture, further investigation reveals that it is not a stable object or geometric form. The work is a contingent arrangement of materials—the heavy steel plates literally propping each other. Viewers become aware of the weight of the materials and the gravity working on the sculpture, seeing it more as a literal thing rather than as a representational object. As Serra stated in 1970, "The perception of the work in its state of suspended animation, arrested motion, does not give one calculable truths like geometry, but a sense of presence, an isolated time. The apparent potential for disorder, for movement endows the structure with a quality outside of its physical or relational definition" (see Serra, 1994). In other words, the viewer's cognizance that the propped plates could collapse creates a further awareness that the artwork is not timeless and transcendent but exists moment to moment alongside the viewer, with both existing in the same space and being codetermined by the same environmental conditions. Serra made materiality and form fully interdependent by directly acting upon raw materials. Works such as *One-Ton Prop* draw on the core traits of sculpture—mass, weight, and a relationship to gravity—in order to increase the immediacy of the impact on the viewer.

Serra's interest in materials, process, time, and the viewer's immediate and direct perceptual encounter with the object developed, in his work beginning in the 1970s, into a highly sophisticated investigation into the peripatetic experience of sculpture. In his installations and public works such as *Clara-Clara* or *Berlin Junction*, the viewer must walk around the large leaning or propped steel plates and through the spaces and passages they create. The immediate impact of his earlier propped pieces becomes in these works extended to the viewer's movement through and around the piece. One must enter into a physical and perceptual relation with these works. They resist being seen all at once, instead encouraging a self-consciously durational experience. This phenomenological concept has become the central area of exploration in Serra's works, the majority of which use curved planes of steel to lead the viewer along a path, progressively occluding and facilitating the process of vision. This structuring of the viewer's experience, along with Serra's heroic use of gigantic steel plates, has led some to criticize what they see as Serra's machismo and aggressive control of the viewer. With the sculptures' precarious structure, it is not surprising that some viewers experience Serra's massive works as manipulation. While a criticism of this aspect of Serra's work would be valid, to reduce his art-theoretical concerns to this issue alone would be potentially to lose sight of the implications his work has for the history and theory of sculpture. Serra's works expose the funda-

mentals of sculpture as material and temporal processes. All sculpture involves peripatetic experience, materials, process, gravity, time, and perception, even if they have been denied or obscured in traditional justifications for sculpture. Serra has attempted to make the viewer self-conscious of these basic elements as a way of activating and amplifying one's experience of sculpture. By providing a concentrated manifestation of these issues, his work could also be understood to provide an entry into investigating questions of spatial control throughout the history of sculpture.

Because of Serra's insistence on the direct use of materials and the avoidance of all figuration or representation, his public sculptures have often encountered resistance, especially in the United States. The most famous incident revolved around the public misunderstanding and disdain for his *Tilted Arc*, commissioned by the U.S. General Services Administration for the Federal Plaza in New York City. The gently curving, 36.6-meter-long, 3.66-meter-high Corten steel sculpture bisected a large open plaza. Over the years after its installation, *Tilted Arc* became increasingly unpopular among the workers whose passage through the plaza was now impeded, and eventually a public campaign for its relocation formed. Because *Tilted Arc* was site specific, Serra refused to allow it to be moved. After years of legal battles, *Tilted Arc* was destroyed in 1989. The implications of this landmark case for First Amendment and artists' proprietary rights are still being realized, and *Tilted Arc* has become symbolic of the often-antagonistic relationship between contemporary art and the public.

Since the *Tilted Arc* controversy, Serra has continued to be an advocate for artists' rights and produced a number of major public sculptures and large-scale installations. Rather than ending his career, the drawn-out battle seems to have incited Serra to increase his

Tilted Arc
© ART on FILE / CORBIS, and (2003) Richard Serra/Artists Rights Society (ARS), New York

efforts. His more recent sculptures, such as *Intersection II* (based on his public sculpture *Intersection* in Basel) and *Torqued Ellipses* are vastly more complex and ambitious than his earlier work. With the public exhibition of these works, in turn, critics have given Serra widespread acclaim for these complex objects that, in the age of mediation and simulation, continue to assert the viewer's immediate perceptual and physical encounter with the object as the core issue for sculpture.

DAVID GETSY

See also **Andre, Carl; Contemporary Sculpture; De Maria, Walter; Hesse, Eva; Judd, Donald; Minimalism; Morris, Robert; Public Sculpture; Smithson, Robert**

Biography

Born in San Francisco, California, United States, 2 November 1939. Studied at University of California at Berkeley and Santa Barbara, 1957–61; graduated, BA in English Literature; studied with Joseph Albers at Yale University, 1961–64; completed BFA and MFA; received Yale traveling fellowship to Paris, 1965, and U.S. Fulbright grant to Florence, 1966; received Guggenheim Fellowship, 1970; *Tilted Arc* commissioned by U.S. General Services Administration for Federal Plaza, New York City, 1979, installed, 1981; received honorary fellowship from Bezalel Academy, Jerusalem, 1983, and Carnegie Prize, 1985; after four years of legal battles, *Tilted Arc* destroyed by U.S. government, 1989. Lives and works in New York City, United States, and Cape Breton, Nova Scotia, Canada.

Selected Works

1967/68	*Scatter Piece*; rubber latex; estate of Donald Judd, Marfa, Texas, United States
1968	*Splashing*; lead (destroyed)
1969	*One-Ton Prop (House of Cards)*; lead antimony; Museum of Modern Art, New York City, United States
1969–71	*Strike (to Roberta and Rudy)*; steel; Guggenheim Museum of Art, New York City, United States
1970–72	*Shift*; concrete; private collection, Toronto, Canada
1971–75	*Sight Point*; Corten steel; Stedelijk Museum, Amsterdam, the Netherlands
1974–76	*Delineator*; Corten steel; Lembachhaus, Munich, Gemany
1979–81	*Tilted Arc*, for the Federal Plaza, New York City, United States; Corten steel (destroyed)
1983	*Clara-Clara*; Corten steel; Tuileries Gardens, Paris, France
1986–87	*Berlin Junction*; Corten steel; Berlin, Germany
1990	*Afangar*; basalt; Reykjavík, Iceland
1992–93	*Intersection II*; Corten steel; Museum of Modern Art, New York City, United States
1996–97	*Torqued Ellipses (I, II, Double Torqued Ellipse)*; Corten steel; Dia Foundation, New York City, United States

Further Reading

Bering, Kunibert, *Richard Serra: Skulptur, Zeichnung, Film*, Berlin: Reimer, 1998

Berswordt-Wallrabe, H.-L. Alexander von, editor, *Richard Serra: Neuere Skulpturen in Europa, 1977–1985, eine Auswahl; Recent Sculpture in Europe, 1977–1985, Selected*, Bochum, Germany: Galerie für Film, Foto, Neue Konkrete Kunst und Video, 1985

Crimp, Douglas, "Richard Serra: Sculpture Exceeded," *October* 18 (fall 1981)

Ferguson, Russell, Anthony McCall, and Clara Weyergraf-Serra, editors, *Richard Serra: Sculpture, 1985–1998*, Los Angeles: Museum of Contemporary Art, and Göttingen, Germany: Steidl, 1998

Foster, Hal, and Gordon Hughes, editors, *Richard Serra*, Cambridge, Massachusetts: MIT Press, 2000

Güse, Ernst-Gerhard, editor, *Richard Serra*, Stuttgart, Germany: Hatje, 1987; as *Richard Serra*, New York: Rizzoli, 1988

Hoppe-Sailer, Richard, *Richard Serra: Das Druckgraphische Werk*, Germany: Galerie für Film, Foto, Neue Konkrete Kunst und Video, 1988

Janssen, Hans, editor, *Richard Serra: Drawings; Zeichnungen, 1969–1990: Catalogue raisonné* (bilingual English-German edition), Bern, Switzerland: Benteli, 1990

Krauss, Rosalind E., *Richard Serra: Sculpture*, edited by Laura Rosenstock, New York: Museum of Modern Art, 1986

Richard Serra: Arbeiten, 66–77; Richard Serra: Works, 66–77 (bilingual German-English edition), Tübingen, Germany: Kunsthalle Baden-Baden, 1978

Richard Serra: Props (exhib. cat.), Duisburg, Germany: Wilhelm Lehmbruck Museum, and Düsseldorf, Germany: Richter, 1994

Serra, Richard, *Writings, Interviews*, Chicago: University of Chicago Press, 1994

Weyergraf-Serra, Clara, and Martha Buskirk, editors, *The Destruction of Tilted Arc: Documents*, Cambridge, Massachusetts: MIT Press, 1991

SETTIGNANO, DESIDERIO DA

See **Desiderio da Settignano**

SEVERO DI DOMENICO CALZETTA DA RAVENNA *ca.* 1465/75–1525/38 *Italian*

Our knowledge about the personal identity and artistic oeuvre of Severo di Domenico Calzetta da Ravenna has slowly come into focus only during the course of the last century, although he was singled out for special

praise by the Neapolitan humanist Pomponius Gauricus in 1504. Writing in *De Sculptura*, Gauricus referred to Severo as an "outstanding sculptor in bronze and in marble, chaser, woodcarver, modeler, and painter." Regardless of this early notoriety, Severo's status as one of the leading bronze sculptors in Renaissance Padua was soon forgotten. His enormously varied and prolific output of Renaissance bronze statuettes and associated utilitarian objects was misattributed in the early scholarly literature as the work of the Paduan bronze sculptors Bartolomeo Bellano or Andrea Riccio. This indiscriminateness was due in large measure to the publication of Leo Planiscig's pioneering monograph on Riccio into which practically every kind, style, and quality of bronze statuette and artifact produced in Renaissance Padua erroneously found its way.

Nevertheless, it was Planiscig who later discovered the bronze inkwell in the form of a sea monster bearing the signed inscription "O[pus]. Severi. R.A.," which enabled him to publish a small core group of statuettes by Severo, whom the author nicknamed "The Master of the Dragon." Included among this interrelated series of Mantegnesque "dragons" was the more dynamic model of *Neptune Riding a Sea-Monster*, which probably is the example itemized in the 1542 inventory of bronzes in the Mantuan collection of Isabella d'Este. Like the vast majority of bronzes associated with Severo's name, this is recorded in a number of different examples. Aside from another signed small bronze, *Kneeling Satyr*, the only other signed creation by Severo is the large marble *St. John the Baptist*. The congeniality of style between this marble and a superb and unique bronze statuette of the same subject at the Ashmolean Museum in Oxford allowed John Pope-Hennessy in the early 1960s to attribute the latter work to Severo's hand. In doing so, this scholar initiated the long-overdue reexamination that Severo was one of the major protagonists of the bronze statuette of Renaissance Italy, and that he headed a large workshop that operated on a quasi-industrial scale.

In subsequent decades, countless other bronzes—most of which were designed to serve as inkstands, candlesticks, oil lamps, or other staple commodities—have been ascribed to Severo or his workshop. Existing in multiple examples of diverse quality, these remarkably inventive creations are composed of two or more separately cast parts uniting figural statuettes or busts with useful, auxiliary accoutrements including naturalistically rendered seashells for holding ink, small pots for sand used in blotting, or fanciful cornucopias to accommodate wax candles. These component elements are joined to each other as well as threaded into sockets located on geometrically shaped bronze bases or similarly mounted atop freestanding, bronze eagle-

Kneeling Satyr
© Arte & Immagini srl / CORBIS

claw feet by way of projecting and hand-cut, conical screws. Moreover, these prefabricated and freely interchangeable pieces could then be assembled in different combinations to form various compositions personally adapted to meet the needs and tastes of the individuals for whom they were made.

Although Gauricus criticized Severo for his lack of formal education, the Classical subject matter of most of his bronze statuettes and desk accessories amply demonstrates that they were undertaken primarily, but not exclusively, for the humanist clientele living in and around the territories dominated by the intellectual ambiance generating from the University of Padua. Hence Severo's intact oeuvre elicits a propensity for bronzes representing mythological figures drawn from the bountiful Classical pantheon of gods, goddesses, heroes, heroines, base pagan satyrs, or small-scale reductions after antique sculptures. It seems that Severo understandingly succumbed to the lure of the more profitable market for bronzes, the themes of which evoked the spirit of the lost Classical past for the enjoyment and edification of their cosmopolitan owners, whether these antiquarians or dilettantes resided in Padua, Ravenna, or elsewhere. Although statuettes of Christian devotional subjects appear to have been more

rare in Severo's repertory, he by no means neglected this genre, as evinced, for instance, in his multiple statuettes of *St. Sebastian*, *St. Christopher*, and, most notably, by the sublime and unique bronze *Corpus Christi*.

Recent scientific investigation into the idiosyncratic casting technique employed by Severo and his workshop conducted mainly by Richard Stone has kept abreast of art historical studies about this sculptor. Visual surface examination and radiography to disclose the internal structure of Severo's bronzes have revealed that this bronze sculptor—like his near-contemporary Antico—developed his own peculiar method of indirect casting for replicating bronze statuettes through the use of piece molds, which enabled the original models to be preserved. Additionally, it has been established that in the case of his standing nude figures, Severo consistently located the square-sectioned pins or chaplets used in the casting process on the small of the back over the kidneys, frequently on the shoulders, and sometimes elsewhere. Conversely, they are often positioned on the shoulders of his draped figural bronzes. We also know that Severo removed the plaster core from the interior of each bronze figure by drilling a hole between the legs and buttocks, probably to lighten the weight of the statuette for aesthetic purposes. It appears that these apertures were not intended originally to be filled, but many of them have been over the course of intervening centuries.

JOSEPH R. BLISS

See also **Antico (Pier Jacopo Alari Bonacolsi); Riccio (Andrea Briosco)**

Biography

Born in Ferrara or Ravenna, Italy, *ca.* 1465/75. Father was the Ferrarese sculptor Domenico de Calcetis (or Calzetta); possibly related to Pietro Calzetta and Francesco Calzetta (two painters working in the orbit of Mantegna in Padua). First documented in a painter's will notarized in Ravenna, 1496, where he is described as *magistro*, intimating he was a mature artist; moved to Padua by June 1500; received commissions for the marble *St. John the Baptist* (finished in 1502) and a never-executed marble relief; presumably fled Padua in 1509 due to Charles V's invasion or because of Riccio's preeminent position there; documents place him back in Ravenna between 1511 and 1525; entrusted only with ephemeral and modest works, as primary role became that of a maker of small bronzes. Succeeded by his son, Niccolo, who continued producing bronzes using his father's models, until at least 1543. Died in Ravenna, Italy, between 1525 and 1538.

Selected Works

1500– *St. John the Baptist*; marble; Basilica of
1502 Sant'Antonio, Padua, Italy
ca. 1502 *St. John the Baptist*; bronze; Ashmolean Museum, Oxford, England
ca. 1507 *St. Sebastian*; bronze; Musée du Louvre, Paris, France
ca. 1520 *Kneeling Satyr*; bronze; private collection, Zurich, Switzerland
ca. 1525 *Hercules Wielding a Club*; bronze; Minneapolis Institute of Arts, Minnesota, United States
ca. 1527 Running woman (Thetis?); bronze; Cleveland Museum of Art, Ohio, United States
early 16th century Inkwell in the form of a sea monster; bronze; Frick Collection, New York City, United States
early 16th century *Corpus Christi*; bronze; Cleveland Museum of Art, Ohio, United States
early 16th century *Neptune Riding a Sea-Monster*; bronze; Frick Collection, New York City, United States
early 16th century *St. Christopher* and the *Christ-Child*; bronze; *St. Christopher*: Musée du Louvre, Paris, France; *Christ-Child*: National Gallery of Art, Washington, D.C., United States

Further Reading

Avery, Charles, and Anthony F. Radcliffe, "Severo Calzetta da Ravenna: New Discoveries," in *Studien zum europäischen Kunsthandwerk: Festschrift für Yvonne Hackenbrock*, edited by Jörg Rasmussen, Munich: Klinkhardt and Biermann, 1983

Bliss, Joseph R., "Italian Renaissance and Baroque Bronzes at the Minneapolis Institute of Arts," Disssertation, Case Western Reserve University, 1997

Davidson, Bernice F., *Severo and the Sea-Monsters*, New York: The Frick Collection, 1997

De Winter, Patrick M., "Recent Accessions of Italian Renaissance Decorative Arts, Part 1: Incorporating Notes on the Sculptor Severo da Ravenna," *Bulletin of the Cleveland Museum of Art* 73 (March 1986)

Middeldorf, Ulrich, "Glosses on Thieme-Becker, III, Severo da Ravenna," in *Festschrift für Otto von Simson zum 65. Geburtstag*, edited by Lucius Grisebach and Konrad Renger, Frankfurt: Propylaen Verlag, 1977

Munhall, Edgar, *Severo Calzetta, Called Severo da Ravenna* (exhib. checklist), New York: The Frick Collection, 1978

Pope-Hennessy, John, "An Exhibition of Italian Bronze Statuettes, I," *The Burlington Magazine* 105 (January 1963)

Radcliffe, Anthony F., "Replicas, Copies, and Counterfeits of Early Italian Bronzes," *Apollo* 295 (September 1986)

Stone, Richard E., "Antico and the Development of Bronze Casting in Italy at the End of the Quattrocento," *Metropolitan Museum Journal* 16 (1981)

IVAN SHADR 1887–1941 *Russian*

Ivan Dmitriyevich Shadr (originally Ivanov) occupies a significant place in the history of Soviet socialist realism and is best known for his monumental sculptures created during the early Soviet epoch. His heroic depictions of workers, peasants, cultural luminaries, and Soviet leaders earned him high standing within the ranks of Soviet sculptors. Although he was a sculptor of tremendous merit, Shadr has not been the subject of rigorous art-historical study since the Soviet era; therefore, it is sometimes difficult to distinguish between fact and myth in the discussion and interpretation of his work.

Following his training in both applied arts and sculpture at the Artistic Industrial School in Yekaterinburg, Shadr moved to St. Petersburg and found work as an actor while studying sculpture at the Society of the Encouragement of the Arts. Shadr's works from this period display an interest in Modernism, especially the work of Symbolist artists Mikhail Vrubel and Nicholas Roerich. After being encouraged by famed Russian painter Ilya Repin to continue his study of fine arts, Shadr received a small stipend from the city council of his hometown to study in Paris, where he went in 1910. As an homage to his town, he adopted the name Shadr in early 1918. Soviet sources claim Shadr studied under Émile-Antoine Bourdelle and Auguste Rodin, but for how long and in what capacity is unknown. However, Shadr's first monumental sculptural project, the *Monument to World Suffering* (1915–18), thematically and visually reflects a definite acquaintance with Rodin's *Gates of Hell* (1880–ca. 1900).

Like many artists living in Russia after the revolution, Shadr began working for the Bolsheviks by fulfilling commissions for public sculptures. Shadr was among the 50 sculptors commissioned to create works for the Plan for Monumental Propaganda, the goal of which was the erection of statues of revolutionary heroes to replace sculptures associated with czarism. Shadr's first major commission—which came in 1922—was for three sculptural figures: a worker, a peasant, and a Red Army soldier. The sculptures would serve as the basis for images printed on the new currency and stamps issued by the Soviets. *The Sower* remains the best known of the series, capturing the essential physicality of the peasant's life with a grace of movement not usually associated with agrarian pursuits. Shadr relied on individual workers and peasants as models, yet he attempted to create idealized types rather than portray an individual's specific features.

Although the doctrine of socialist realism had not yet been codified, these three figures represent the early stages of this style and method, which would reach its apogee in the 1930s and 1940s.

Several unrealized projects occupied Shadr between 1923 and 1925, including a complex figural group entitled *Storming the Earth*, which would have depicted a man on a tractor symbolizing technological improvements in agriculture.

Shadr is perhaps best known for his numerous depictions of Vladimir Lenin, the leader of the Bolshevik Revolution. Shadr was one of only two sculptors commissioned to create a portrait of the dead Lenin; he was allowed to make clay models for this project while Lenin lay in state after his death in January 1924. The demand for portraits of Lenin allowed Shadr to explore the possibilities of large-scale monumental sculptures, which were to become standard features of the Soviet urban landscape.

After a brief trip to Paris in 1926, Shadr began working on a monumental sculpture of Lenin, which he envisioned as standing almost 9 meters in height atop a 12-meter pedestal. This enormous project was realized in the republic of Georgia, which had officially joined the Soviet Union in 1924. The statue was placed near the Zemo-Avchal'skaya hydroelectric plant and stood against the Georgian landscape of hills and rivers. Although in the original model Lenin's arm is outstretched and pointing skyward, Shadr redesigned the figure so that Lenin's outstretched arm now pointed directly to the dam, underlining Soviet technological triumph. The monument was considered so successful that Shadr received a commission for a slightly smaller version to be placed in the Museum of the Revolution in Moscow. This monument provided the model and inspiration for numerous statues of Lenin, most notably Sergei Merkurov's statue of Lenin intended for the top of the Palace of Soviets.

Another work from the 1920s is exemplary of the emerging method of heroic realism: *The Cobblestone is the Proletariat's Weapon*. Originally conceived as a monument to the 1905 revolution, this sculpture was later appraised as a more general paean to the revolutionary worker inspired to join the class struggle. Although the figure's pose is somewhat awkward, Shadr evokes the tension and focus of an athlete before a race, or perhaps even the biblical David before his strike against Goliath.

Shadr was occupied with more large-scale sculptures and monuments to heroes of Soviet culture throughout the 1930s, and, according to his reminiscences, he believed that monumental sculpture had the power to promote the socialist ideal. He submitted a sketch and model to the competition for a monumental sculpture of a *Worker and Collective Farm Worker*,

but lost to Vera Mukhina, whose colossal sculpture of the same name still stands in Moscow. He also sculpted the tombstones for several prominent citizens, including Nadezhda Alliluyeva, Joseph Stalin's second wife. Shadr's project for a statue of Pushkin survives in a portrait bust and two clay models, all of which express Shadr's interest in Pushkin's romantic, and even tragic, sensibility and evokes comparison with Rodin's sculpture of Honoré de Balzac (1898).

In 1939 Shadr secured first prize in the competition for a monument to the deceased writer Maxim Gorky, which was to be erected in Moscow. Shadr decided to depict the writer as he had known him: older, yet energetic and idealistic. Because of illness and his eventual death in 1941, Shadr was never able to complete the statue, but Mukhina, his competitor and colleague, finished the project and the statue of Gorky was finally erected in 1951 in Moscow. Shadr died a beloved sculptor of the Soviet regime.

PAMELA KACHURIN

See also **Bourdelle, Émile-Antoine; Muhkina, Vera; Rodin, Auguste: Monument to Honoré de Balzac; Russia and Soviet Union**

Biography

Born in Shadrinsk (now in Kugan region), Russia, 11 February 1887. Studied sculpture at the Artistic Industrial School in Yekaterinburg, under Teodors Zalkans, 1903–07; attended the drawing school at the Society for the Encouragement of the Arts in St. Petersburg, 1907–08; in Paris, attended the Academie de la Grande Chaumiere, 1910, and the Institute of Applied Arts in Rome, 1911–12; lived in Moscow from 1914 until death; participated in exhibition devoted to the 10th anniversary of the revolution and contributed to many competitions for public monumental sculptures; member of the Society of Russian Sculptors. Died in Moscow, USSR, 3 April 1941.

Selected Works

1922 *The Sower*; plaster; Central Museum of the Revolution, Moscow, Russia; bronze cast: 1951, State Tretyakov Gallery, Moscow, Russia

1924 *V.I. Lenin on His Bier*; bronze; Lenin Museum, Moscow, Russia

1927 *The Cobblestone is the Proletariat's Weapon*; bronze; State Tretyakov Gallery, Moscow, Russia

1927 *Monument to Lenin*, for Zemo-Avchal'skaya Hydroelectric Station, Georgia, Russia; bronze (dismantled)

1929 *Seasonal Worker*; bronze; State Tretyakov Gallery, Moscow, Russia

1933 Tombstone of Nadezhda Alliluyeva; marble; Novodevichye Cemetery, Moscow, Russia

1939 Scale model for monument to Maxim Gorky; bronze; State Tretyakov Gallery, Moscow, Russia

1940 Scale model for monument to A.S. Pushkin; bronze; State Tretyakov Gallery, Moscow, Russia

Further Reading

Dudko, Aleksander, *Khudozhnik revoliutsii: Ivan Dmitrevich Shadr* (Artist of the Revolution: Ivan Dmitrevich Shadr), Chelyabinsk: Iuzhno-Ural'skoe Knizhnoe Izdatel'stvo, 1974

Kolpinskii, IUrii, *Ivan Shadr*, translated by Faina Solasko, Moscow: Foreign Languages Publishing House, 1960

Shalimova, V.P., *Ivan Dmitrevich Shadr*, Leningrad: Khudozhnik RSFSR, 1962

Voronova, O., *Shadr*, Moscow: Mod. Gvardiia, 1969

Voronova, O., editor, *Shadr: Literaturnoe nasledie: Perepiska: Vospominaniia o skul'ptore* (Shadr: Literary Legacy: Correspondence: Reminiscences about Sculpture), Moscow: Izobrazitelnoe Iskusstvo, 1978

FEDOT SHUBIN 1740–1805 *Russian*

An outstanding master of the sculptural portrait, Fedot Shubin is justifiably called "the Russian Jean-Antoine Houdon." He created an entire gallery of physiognomically precise and psychologically multifaceted depictions of his contemporaries. His works, permeated by the unique spirit of the 18th century, unite compositional resolutions of formal solemnity and the profound realism of images composed by an Enlightenment-epoch artist. This sculptor had an innate sense of plasticity and forms, and he was completely proficient in the technique of marble cutting. He possessed boundless possibilities for creative self-expression and for conveying the physical and spiritual individuality of his models. Not surprisingly, Shubin's portraits surpass other depictions (both painting and graphic) of various historical personages.

Born to a family of bone carvers in northern Russia, Shubin assimilated the traditions of popular art from childhood: the inseparable bond between artist and nature; an ardent, always sincere vision of real life; and a thorough knowledge of the innate properties of the materials, which is inherently characteristic of the folk trade. The artistic skills Shubin acquired in his youth maintained their significance, for in contrast to other famous students of Nicolas-François Gillet's sculptural class, he was accepted into the Academy of Arts at the relatively seasoned age of 21. His French teacher

had only a few years to instill in him knowledge of European sculpture, and Shubin's gifts developed very rapidly.

Sent to Paris in 1767, the Russian sculptor, by a fortuitous combination of circumstances, found himself in the studio of Jean-Baptiste Pigalle, whose portrait art exerted a beneficial influence on him. "I go to the academy every day," wrote Shubin in a report dated 9 November 1768. "Sometimes I . . . model, and sometimes I draw from real life, making round and bas-relief portraits under the supervision of my teacher. . . . We had M. [Denis] Diderot's permission to visit him, and we took advantage of his sage counsel, following his wise advice directed toward the encouragement of our minds."

Shubin's stay in Italy was also important to his creative formation. He went there for the first time at the end of 1770. This trip was in large part furthered by Étienne-Maurice Falconet and Charles-Nicolas Cochin, who in their dispatch from Paris to the St. Petersburg Academy noted Shubin's "genuine talents" and insistently advised that he not be summoned back to Russia until he had visited Italy. In Rome, along with diligent copying of masterworks from antiquity and daily study at the French Academy, Shubin began to work actively in the field of portrait sculpture. His works of the early 1770s—a bust of Catherine II, bas-reliefs of the brothers Alexei and Fyodor Orlov, a medallion of Ivan Shuvalov, and a bust of Fyodor Golitsyn—show the distinct impact of Classical tendencies, which were oriented toward antiquity. The portraits of the couple Nikita and Alexandra Demidov, begun in Paris in 1772 and completed in 1775 after his return to Russia, however, are much more original. They seem to signify the formation of an artistic credo that is reflected in the best of Shubin's subsequent works.

The artist's numerous portraits resulted from a thoughtful understanding of real-life observations and were absolutely devoid of fleeting impressions. It is not coincidental that Shubin is described as portraying not faces, but personalities. Because of his capacity to perceive the nuances of people's characters, he was able to summarize and clarify their essence, achieving an exceptional expressiveness of images. Among his genuine masterpieces are the busts of Vice Chancellor Prince Alexander Golitsyn, General Field Marshal Count Pyotr Rumyantsev-Zadunaisky, Prince Grigory Potemkin, and Count Alexander Bezborodko, as well as several family portraits of members of well-known Russian families such as the Orlovs, the Chernyshevs, and the Sheremetevs.

Shubin's creative development was also clearly manifested in his numerous portrayals of Empress Catherine II. From his earlier portraits, which adhere to Classical conventions, the sculptor arrived at a lifelike

Catherine II: The Law-Giver
© The State Russian Museum, St. Petersburg / CORBIS

robustness in his busts of 1783 and 1789, and then at the striking realistic power of his sculptural portraits of the 1790s. The uncompromising truthfulness of his late work could not appeal to the all-powerful customer. Besides, the taste of the Russian public at the beginning of the 19th century was already defined by mature Classicism, anticipating the Empire style.

ELENA KARPOVA

See also **Falconet, Étienne-Maurice; Houdon, Jean-Antoine; Russia and Soviet Union**

Biography

Born in Techkovskaya, Arkhangel'sk Oblast, Russia, 28 May 1740. Family were state peasants; made bone carvings as child; lived in St. Petersburg, 1759; enrolled in Academy of Arts, 1761–66; studied under Nicolas-François Gillet; received gold medal in 1766 and won scholarship to study abroad; studied in Paris, 1767–70 and 1772; in Rome, 1770–72; produced portrait busts of prominent individuals, including one of Catherine II in 1771; granted membership to Clementine Academy, Bologna, Italy; visited London; re-

ceived honorary titles of academician from St. Petersburg Academy of Arts, 1774; produced notable statue of Catherine II and received title of professor, 1790; taught sculpture course at Academy of Arts, St. Petersburg, beginning in 1803. Died in St. Petersburg, Russia, 24 May 1805.

Selected Works

1771 Bust of Catherine II; marble; Victoria and Albert Museum, London, England
1771 *I.I. Shuvalov*; marble; State Tretyakov Gallery, Moscow, Russia
1772–75 Busts of Nikita and Alexandra Demidov; marble; State Tretyakov Gallery, Moscow, Russia
1773 Bust of A.M. Golitsyn; marble; State Tretyakov Gallery, Moscow, Russia
1778 Bust of Pyotr Rumyantsev-Zadunaisky; marble; Russian Museum, St. Petersburg, Russia
1780–82 Statues and bas-reliefs; marble; Marble Palace, St. Petersburg, Russia
1782 Busts of Boris Sheremetev and Anna Sheremeteva; marble; State Museum of Ceramics and Kuskovo, Moscow, Russia
1783 Bust of Catherine II; marble; Russian Museum, St. Petersburg, Russia
1789–90 *Catherine II: The Law-Giver*; marble; Russian Museum, St. Petersburg, Russia
1790 Bust of Catherine II; marble; Russian Museum, St. Petersburg, Russia
1791 Bust of Grigory Potemkin, Count of Tauris; marble; Pushkin, St. Petersburg Oblast, Russia
1792 *Metropolitan Gavril*; marble; Russian Museum, St. Petersburg, Russia
ca. 1798 Bust of Alexander Bezborodko; marble; Russian Museum, St. Petersburg, Russia
1800 Bust of Emperor Paul I; marble; Russian Museum, St. Petersburg, Russia

Further Reading

Androssov, Sergei, "Shubin, Fedot (Ivanovich)," in *The Dictionary of Art*, edited by Jane Turner, New York: Grove, and London: Macmillan, 1996
Gosudarstvennyi Russkii Muzei (Russian State Museum), *Skul'ptura, XVIII–nachalo XX veka: Katalog* (Sculpture, 18th–Early 20th Centuries: Catalogue), Leningrad: Iskusstvo, 1988
IAkovleva, Nonna Aleksandrovna, *Fedot Ivanovich Shubin, 1740–1805*, Leningrad: Khudozhnik RSFSR, 1984
Isakov, Sergei Konstantinovich, *Fedot Shubin*, Moscow: Iskusstvo, 1938
Lazareva, Ol'ga Pavlovna, *Russkii skul'ptor Fedot Shubin* (The Russian Sculptor Fedot Shubin), Moscow: Iskusstvo, 1965
Shaposhnikova, L.P., and IU.L. Sinitsyna, *Fedot Shubin, 1740–1805: Katalog vystavki k 250-letiiu so dnia rozhdeniia* (Fedot Shubin, 1740–1805: Exhibit Catalog for the 250th Anniversary of His Birth), Saint Petersburg: Gos. Russkii Muzei, 1994

SILOÉ FAMILY *Gil de Siloé ca. 1450–ca. 1500 Hispano-Flemish*

The origins of the leading proponent of the Hispano-Flemish style in late 15th-century Spanish sculpture, Gil de Siloé, are unknown, although scholars usually suggest a Flemish parentage. By 1486 he had arrived in Burgos, a flourishing Castilian city on the pilgrimage route to Santiago de Compostella. As a center for the wool trade, Burgos was a natural destination for Flemish textile manufacturers and, eventually, northern artists as well; the city also received special economic privileges from Ferdinand and Isabella the Catholic Monarchs and their artistic patronage. Gil de Siloé enjoyed Isabella's royal favor, designing for her an ensemble of dynastic tombs and retable for the church of the Carthusian monastery of Miraflores outside Burgos. Another important project involved the decoration of the Capilla de Condestable in Burgos Cathedral, for which he began the retable of St. Anne. Siloé's figures for the retables at Miraflores and the cathedral at Burgos retain the heavy flat folds of drapery falling in a diagonal and full-cheeked faces with hooded eyes and prominent noses characteristic of his northern European predecessors. Gil's genius lies rather in the large, elaborate settings he creates for the figures, overwhelming them with a profusion of explosive ornament in which Flamboyant and Mudéjar (Islamic) elements intermingle. This distinctive combination is most clearly seen in the tomb of Alfonso Infante at Miraflores. Here the monument is dominated by an ogive arch from which is suspended an elaborate concoction of acanthus scrolls that is reminiscent of tracery, yet the kneeling effigy is set against a backdrop of the repetitive and compartmentalized single motifs that one associates with Moorish design. With their intensely ornate combination of the flamboyant northern Gothic and Islamic (Mudéjar) decorative traditions, Gil's works are considered prime examples of the Hispano-Flemish style, or *estilo Isabel*. Although he certainly influenced his sculptor son Diego de Siloé, Gil may be regarded as among the last purveyors of the Hispano-Flemish tradition.

Diego de Siloé *ca. 1490–1563*

Spanish

Spanish contemporaries hailed Diego de Siloé as a prophet of the style *a lo romano*. Together with fellow

Diego de Siloé, *Escalera Dorada*, Burgos Cathedral, Spain
© Scala / Art Resource, NY

Spaniards Bartolomé Ordóñez, Alonso Berruguete, and Pedro Machuca, and Italian sculptors, Diego introduced to 16th-century Spain a Classicism that signaled a break from the Hispano-Flemish style for which his father, Gil de Siloé, was famous. In Burgos, Diego would have known the French artist Felipe Vigarny, who is credited with introducing the Italian Renaissance style to Castile after 1498. Diego's absorption of the Renaissance idiom continued during a trip to Italy in the second decade of the 16th century; he evidently traveled to Italy as an assistant to the older sculptor and fellow Burgalese Ordóñez. The two executed the altar for the Caracciolo Chapel in Naples, whose statuettes of St. John the Baptist and St. Sebastian, attributed to Diego, are the earliest examples of his receptivity to contemporary central Italian trends.

Upon returning to Burgos, Diego introduced an Italianate vocabulary in two notable monuments begun in 1519 for the Burgos Cathedral: the tomb of Bishop Luis de Acuña and the *Escalera Dorada* (Golden Staircase). The Acuña tomb stands in the chapel in which is also found the Hispano-Flemish retable of St. Anne with the Tree of Jesse by Gil de Siloé. In the contract for the tomb, the patron specifies a style *alla romana* (in the Roman manner), Diego fulfilled this mandate by modeling the tomb after Antonio Pollaiuolo's monument for Sixtus IV in the Vatican. Interestingly, Pollaiuolo's tomb had also inspired an earlier tomb by Domenico Fancelli for the Italophile Cardinal Diego Hurtado de Mendoza in Seville Cathedral (1508–10).

Diego's reliefs for the Acuña tomb's *Virtues*, with their heroic, muscular proportions, follow Michelangelo's rather than Pollaiuolo's example. The same pattern prevails for the *Escalera Dorada*, where Michelangelesque reliefs adorn a framework inspired by a Roman project. Here, Diego devised a variation on Donato Bramante's stair in the Cortile del Belvedere at the

Vatican and decorated it with elaborate grotesques derived from High Renaissance ornament and from figures observed in the recently completed Sistine Chapel ceiling.

Diego's work from the 1520s demonstrates further reflections of his knowledge of Michelangelo, particularly a series of Madonna and Child reliefs that depend on reliefs of the same subject by Michelangelo. More notable is one of Diego's most beautiful works of sculpture in the Classical manner: the small marble figure of St. Sebastian of 1525–28. The statuette of Sebastian (1516–18), of unknown provenance, for the altarpiece of the Caracciolo Chapel in Naples, anticipates this figure. Diego's *St. Sebastian* clearly shows Michelangelo's influence; its provocative *contrapposto* (a natural pose with the weight of one leg, the shoulder, and hips counterbalancing one another) and its seductive tilt of the head echo that of Michelangelo's *Dying Slave*, begun in Rome in 1513–16. The languid qualities of the *St. Sebastian* also occur in the reclining effigy of Andrea Bonifacio by Diego's master Ordóñez. Not all of Diego's figures embody the lyrical idealism of the *St. Sebastian*, however. The wooden relief of St. John the Baptist for the choir stalls at the Church of S. Benito, Valladolid, displays an increasingly wiry asceticism associated with the Spanish sensibility.

At Burgos, Diego de Siloé was also commissioned in the 1520s to complete a series of retables begun by Gil de Siloé for the Capilla del Condestable in Burgos Cathedral, itself a florid Gothic extravaganza by Simon de Colonia. The retable of St. Anne, for example, embodies the divergent Hispano-Flemish and Italianate styles of late 15th- and 16th-century Spanish sculpture in that a Late Gothic tabernacle by Gil provides the framework for Diego's highly naturalistic *Man of Sorrows*. At this time Diego evolved a triumphal arch scheme similar to Andrea Sansovino for wall monuments, which he used, for example, in the tomb of Diego de Santander in Burgos Cathedral. However, Diego embellished the tomb with an inventive ornamentation that distinguishes it from Italian models and reveals its Spanish provenance; it is a harbinger of his later work in architecture.

By 1528 Diego had emerged as an architect worthy of the royal commission to complete Granada Cathedral for Charles V; this and other building projects in Andalusia dominated the second half of Diego's professional life. The abundant decorative carving that characterizes much of his architecture earned him the praise of Francisco de Holanda, and any consideration of his work as a sculptor must necessarily take into account his architectural ornament. At Granada Cathedral he designed four portals whose highly innovative exterior design have come to define the style called

Plateresque. The most influential of these is the Puerta del Perdón, a transept entrance begun in 1532 whose lower story may be assigned to Diego. As foreshadowed by the Santander tomb, the design combines a classicizing triumphal arch with grotesques whose density and profusion recall Mudéjar decoration. The Spanish taste for abundant decorative detail, perhaps a result of the Islamic legacy, is the common denominator for the work of both Gil and Diego de Siloé and defines the flavor of their collective oeuvres.

CHARLOTTE NICHOLS

See also **Berruguete, Alonso; Ordóñez, Bartolomé; Spain: Renaissance and Baroque; Vigarny, Felipe**

Gil de Siloé

Biography
Born probably in the Netherlands, *ca.* 1450. Background and training unknown; worked primarily in and near Burgos, Spain, and established residence by 1486; documented works date from 1486; patronized by Ferdinand and Isabella, of Aragon and Castille, Spain, and other local aristocrats and ecclesiastics; worked on many retables in wood with the assistance of Diego de la Cruz; thought to be mentor of sons Diego and Juan de Siloé, who were sculptors. Died in Burgos, Spain, *ca.* 1500.

Selected Works
1486–88 Retable with the Tree of Jesse (with Diego de la Cruz); wood; Chapel of St. Anne, Burgos Cathedral, Spain
1487–96 Facade portal; Chapel of the Colegio de San Gregorio, Valladolid, Spain
1488–89 Retable for high altar (with Diego de la Cruz); wood; Chapel of the Colegio de San Gregorio, Valladolid; (destroyed)
1489–93 Tomb of Alfonso Infante; alabaster; Charterhouse of Miraflores, Burgos, Spain
1489–93 Tomb of John II of Castile and Isabella of Portugal; alabaster; Charterhouse of Miraflores, Burgos, Spain
1496–99 Retable with *Crucifixion* (with Diego de la Cruz); wood; Charterhouse of Miraflores, Burgos, Spain
1500–1505 Retable of St. Anne; wood; Capilla del Condestable, Burgos Cathedral, Spain
1500–1505 Tomb of Juan de Padilla; alabaster; Museo Arqueológico Provincial, Burgos, Spain

Diego de Siloé

Biography
Born probably in Burgos, Castile, Spain, *ca.* 1490. Son of sculptor Gil de Siloé. Early training with father; presumably traveled to Italy as assistant to Bartolomé Ordóñez, *ca.* 1516–19; returned to Burgos, possibly via Barcelona, by 1519; first documented works dated to 1519; completed sculptural projects with brother Juan for wealthy Castilian patrons, Bishop Juan Rodríguez de Fonseca, Bishop Luis de Acuña, and Pedro Fernández de Velasco, 1519–28; collaborated occasionally with Felipe Vigarny; moved to Granada, 1528; commissioned by Charles V to supervise project for Granada Cathedral; worked mainly on architecture in Andalusia, second half of career, 1528–63, including cathedrals of Seville, Málaga, Guadix, and Plascencia, and El Salvador at Ubeda; developed influential Plateresque style for sculpted portals, imitated throughout Spain and colonies. Died in Granada, Spain, 22 October 1563.

Selected works
1516–19 *St. John the Baptist* and *St. Sebastian*; marble; altar, Cappella Caracciolo di Vico, Church of San Giovanni a Carbonara, Naples, Italy
1519–20 Tomb of Bishop Luis de Acuña; alabaster; Chapel of St. Anne, Burgos Cathedral, Spain
1519–23 *Escalera Dorada*; marble; Burgos Cathedral, Spain
1519–28 *Virgin and Child*; alabaster; Victoria and Albert Museum, London, England
ca. 1522 *Man of Sorrows*, for Altar of St. Anne; wood; Capilla del Condestable, Burgos Cathedral, Spain
1523–24 Tomb of Diego de Santander; marble; Burgos Cathedral, Spain
1523–26 High altar (with Felipe Vigarny); wood; Capilla del Condestable, Burgos Cathedral, Spain
1525–28 *St. Sebastian*; marble; Parroquia de la Visitacíon, Barbadillo de Herreros, Burgos, Spain
1528 *St. John the Baptist* and other reliefs for choir stalls at S. Benito; wood; Museo Nacional de Escultura, Valladolid, Spain
1529 Tomb for Bishop Mercado; marble; Church of San Miguel, Oñate, Guipúzcoa, Spain
1529 Tomb of Cardinal Fonseca; marble; Convent of St. Ursula, Salamanca, Spain
1532 Puerta del Perdón; Granada Cathedral, Spain

Further Reading
Gómez-Moreno, Manuel, *Las águilas del Renacimiento español: Bartolomé Ordóñez, Diego Silóee, Pedro Machuca,*

SILOÉ FAMILY

Alonso Berruguete, 1517–1558, Madrid: Gráficas Uguina, 1941; reprint, Madrid: Xarait Ediciones, 1983

Gómez-Moreno, Manuel, *Diego de Siloée: Homenaje en el IV centenario de su muerte*, Granada, Spain: University of Granada, 1963

Kasl, Rhonda, "Diego de Siloe: *Man of Sorrows*," in *Circa 1492: Art in the Age of Exploration*, edited by Jay A. Levenson, New Haven, Connecticut: Yale University Press, 1991

Kubler, George, and Martin Sebastian Soria, *Art and Architecture in Spain and Portugal and Their American Dominions, 1500–1800*, Baltimore, Maryland, and London: Penguin, 1959 (for Diego de Siloé)

Müller, Theodor, *Sculpture in the Netherlands, Germany, France, and Spain: 1400–1500*, Baltimore, Maryland: Penguin, 1966 (for Gil de Siloé)

Nichols, Charlotte F., "The Caracciolo di Vico Chapel in Naples and Early Cinquecento Architecture," Ph.D. diss., New York University, 1988 (for Diego de Siloé)

Proske, Beatrice Gilman, *Castilian Sculpture, Gothic to Renaissance*, New York: Hispanic Society of America, 1951

Rosenthal, Earl E., *The Cathedral of Granada: A Study in the Spanish Renaissance*, Princeton, New Jersey: Princeton University Press, 1961 (for Diego de Siloé)

Wethey, Harold, *Gil de Siloe and His School: A Study of Late Gothic Sculpture in Burgos*, Cambridge, Massachusetts: Harvard University Press, 1936

Wethey, Harold, "A Madonna and Child by Diego de Siloe," *Art Bulletin* 22 (1940)

Wethey, Harold, "The Early Works of Bartolomé Ordóñez and Diego Siloe, I: Naples II: Burgos," *Art Bulletin* 25 (1943)

Zalama, Miguel Angel, *Reyes y mecenas: Los Reyes Católicos, Maximiliano I y los inicios de la casa de Austria en España*, S.l.: Electa España, 1992

Zalama, Miguel Angel, "Diego de Siloé en Burgos: Irrupcion, Desarollo y Asimilacion del Rinacimiento," in *Actas: IX Congreso espagñol de historia del arte: León, 1992*, León: Universidad de León, 1994

TOMB OF JOHN II OF CASTILE AND ISABELLA OF PORTUGAL

Gil de Siloé (ca. 1450–ca. 1500)
1489–1493
alabaster
h. 2.17 m
Charterhouse of Miraflores, Burgos, Spain

Queen Isabella, the Catholic daughter of King John II and Isabella of Portugal, commissioned the northern sculptor Gil de Siloé in 1486 to create her parents' tomb. Executed between 1489 and 1493, the freestanding, star-shaped alabaster tomb forms part of an important and lavish ensemble undertaken for Isabella by Siloé in the eastern end of the church of the Carthusian monastery at Miraflores outside Burgos. The tomb is directly in front of the high altar, behind which soars a retable by Siloé with a *Crucifixion* and kneeling portraits of the deceased (created with Diego de la Cruz). Directly adjacent along the north wall of the church is Siloé's alabaster tomb of Alfonso Infante, Isabella's

brother. Her interest in finishing the church and situating the royal tombs there must have been partly motivated by a desire to establish a highly visible commemorative locus in a city that was strategically important to her royal hegemony in Castile.

John II of Castile founded the Carthusian monastery of Miraflores in 1442 on the site of his family's royal palace. As elsewhere in Europe, the Carthusian order undoubtedly appealed to the king because of its emphasis on prayers for the departed. Juan de Colonia began the structure, which was completed in 1486 by his son, Simon de Colonia. Simon worked in the flamboyant Gothic style that had been imported to Spain by his father; one sees this particularly in the star-shaped design for the vaulting of the choir, beneath which is situated the exceptionally ornate tomb of John II of Castile and Isabella of Portugal.

Siloé's alabaster tomb for John II and Isabella consists of a rectangle superimposed on a square to form an eight-pointed star, two points of which lie along the main axis of the church. (Alabaster was readily available from the nearby quarry of Atapuerca.) The main axis of the monument measures 4.8 meters, the minor axis is 3.7 meters, and the maximum height is 2.2 meters. The unusual star shape of the tomb has been compared to a Mudéjar motif for the wooden doors of the cloister of Las Huelgas at Burgos; however, a rotated square is a common geometric exercise in Medieval Gothic masonry. In addition, the crown of Queen Isabella contains Moorish motifs; the intricacy of Mudéjar design would obviously appeal to the northern sensibility of artists such as Gil de Siloé, and its exotic quality distinguishes the work of Hispano-Flemish sculptors from their northern European counterparts.

The two reclining effigies of John and Isabella lie parallel to the main axis of the tomb and face the altar. A canopy surmounts each of the figures, which are separated by a low grill. Thus, they are prone versions of the royal figures found on the facades of Gothic cathedrals. Their faces turn outward; Isabella, who died insane, holds a book. Both John and Isabella wear crowns and jewel-encrusted royal vestments. The voluminous drapery of the figures falling in flat folds along a diagonal and masking the contours of the body beneath is typical of Gil de Siloé's work. As has been noted, the realism of the bejeweled borders is the sculpted equivalent of the work of Jan van Eyck, whom King John received.

Seated figures of the four Evangelists would have rested on the four corners of the rectangular slab, and the points of the lower square slab would have carried standing figures, probably of the Twelve Apostles. Four of these figures are now missing from the tomb, one of which may be the Saint James now in the Metro-

politan Museum of Art/Cloisters, New York. This work is approximately 47 centimeters tall and made of alabaster. Here, too, one sees widely spaced, flattened folds falling on a pronounced diagonal. *St. James*'s facial features include the small mouth and long, prominent nose seen in other figures for the tomb.

The side elevation of the tomb consists of a profusely decorative Gothic border that all but obscures the sculptures it enframes. The 16-sided tomb includes figures of seven Old Testament figures, seven *Virtues*, and two figures of Mary. Critics have described the *Virtues* as the most beautifully carved figures on the tomb. Their iconography may follow late Gothic French models. Kasl has proposed that the current arrangement of these small statues is incorrect.

Approached from the entrance of the nave, the tomb takes shape against the enormous wooden retable by Gil de Siloé and Diego de la Cruz. The gilded, polychromed retable fills the entire apse of the church. Essentially square in shape, a circular roundel, within which is contained the *Crucifixion* and around which are smaller roundels, dominates its design. This arrangement has been compared to German Rosary altars (*Rosenkranzaltaren*). Islamic motifs may be present in the design as well. Siloé achieved a sense of visual unity between the retable and the architectural decoration of the church by the interaction of the vaulting ribs edged with finials and the finials along the top of the rectangular retable. The wall monument to Alfonso Infante adjacent to the tomb uses an ogive arch to contain the kneeling effigy with prié-dieu, which faces the altar; the evenness of its decorative border is typical of Mudéjar decoration.

Completed just before 1500, the tomb of John II of Castile and Isabella of Portugal constitutes one of the last wholly Gothic ensembles in Spanish art and represents Gil de Siloé's finest achievement. His use of Mudéjar and Hispano-Flemish elements for the projects at Miraflores defined the Isabelline style as it developed in the late 15th century, and it may be seen as emblematic of the courtly splendor to which Isabella aspired in all acts of patronage. Indeed, the sumptuousness of the ensemble rivals similar aristocratic projects at the charterhouses of Champmol and Pavia. The Miraflores commission may also have been a direct response to the dynastic chapels of Don Alvaro de Luna (a close associate of John II) in the Toledo Cathedral (1448–89), and of the Velasco family in the Capilla del Condestable (Burgos Cathedral, begun in 1482). It is one of the ironies of Spanish Renaissance patronage that a sovereign who so vigorously advocated the Hispano-Flemish style should herself rest in a tomb by Domenico Fancelli, a Tuscan sculptor.

CHARLOTTE NICHOLS

Further Reading

Brown, Jonathan, "Spain in the Age of Exploration: Crossroads of Artistic Cultures," in *Circa 1492: Art in the Age of Exploration*, edited by Jay A. Levenson, Washington, D.C.: National Gallery of Art, and New Haven, Connecticut: Yale University Press, 1991

Gómez Barcena, María Jesús, *Escultura gótica funeraria en Burgos*, Burgos, Spain: Excma. Diputación Provincial de Burgos, 1988

Kasl, Rhonda, "Gil de Siloe: *St. James the Greater*," in *Circa 1492: Art in the Age of Exploration*, edited by Jay A. Levenson, Washington, D.C.: National Gallery of Art, and New Haven, Connecticut: Yale University Press, 1991

"St. James the Great," *The Metropolitan Museum of Art Bulletin* 46 (winter 1988–89)

SILVER

See **Precious Metal**

SKOPAS *fl.* 395–330 BCE Greek

With the exception of an *Aphrodite Pandemos* seated on a horse in Elis, which is in bronze, Skopas seems to have worked exclusively in marble. For this reason his oeuvre lacks victory or honorary statues and contains much in the way of architectural sculpture, in addition to gods and heroes. In Tegea he is referred to only as the architect responsible for the restoration of the Temple of Athena Alea, which was burned down in 395 BCE and completed around the middle of the 4th century BCE. Skopas likely supervised the sculptural decoration of the temple structure as well. After the middle of the 4th century BCE, he was involved in the pictorial decoration of the mausoleum at Halikarnassos. For the Temple of Artemis, renovated after 356 BCE, he created a column in relief.

Skopas created a particularly large number of statues for locations on the Peloponnese. In addition to the *Aphrodite Pandemos* in Elis, statues of *Asculapios* and *Hygieia* in Gortys, a stone image of *Hecate* in Argos, and a *Hercules* in Sikyon are mentioned as being situated there. Outside the Peloponnese, there stood in Thebes an *Athena Pronaia* and an *Artemis Eukleia*, and in Megara, an *Eros* and a group containing *Himeros* and *Pothos*. In Athens were two *Furies*; in the island of Chryse, a statue of *Apollo Smintheus*; on Samothrace, an ensemble with *Aphrodite, Pothos*, and *Phaeton*; in Ephesos, *Leto with Ortygia*, who holds a child in both arms; and in Knidos, a *liber pater* (*Dionysos*), as well as an *Athena*. Many statues of unknown origin were displayed in Rome during the Imperial age: for example, a supine *Hygieia* flanked by two candelabras, two *canephorae*, a supine *Ares* of colossal proportions, a naked *Aphrodite*, and a group that was clearly held in high regard, consisting of *Poseidon*,

Thetis, and *Achilles* seated on dolphins, as well as several other details contributing to the scene. The *Apollo Palatinus* probably originated in Rhamnous. The original locations of a *Hermes* by Skopas, mentioned in an epigram, and an equally important and highly praised raving *Bacchanal* are unknown.

In Antiquity, Skopas was regarded along with Praxiteles and Lysippus as one of the greatest sculptors of his time. His status today is contentious, depending on the approach one takes to his work. Even though Skopas is only mentioned as an architect in Tegea, the unique Skopasian style can be detected in the architectural sculpture there as well. The recovered heads are of a unique compact, cubic construction with a low forehead, deeply inset eyes, and exaggerated mimesis. Similar proportions are displayed by the head of the *Hercules Hope*, which, thanks to images on coins, can be identified as a copy of the *Hercules* in Sikyon. The head of the Lansdowne *Hercules* (J. Paul Getty Museum, Los Angeles, California) is stylistically similar, as is the *Meleager*, which has been preserved in numerous replicas and is therefore continually linked back to a Skopasian creation (perhaps the beardless *Asculapios* in Gortys).

In terms of facial construction, the head of a statuette in Dresden, which may recreate the raving *Bacchanal* of Skopas in reduced scale, is similar to the Tegea sculptures. The body rises, writhing and twisting. The billowing garment is held together only by a belt at the hips and comes apart on the left side. In this motif, though not in the stylistic presentation, the *Bacchanal* is reminiscent of *acroterion* figures in Tegea. The motif emerges again on several friezes of the mausoleum at Halikarnassos, particularly in the case of an *Amazon*, the form of which is highly reminiscent of the *Bacchanal* and that, along with four others, appears on the east side of the structure that Skopas was responsible for decorating.

The divine images attributed to Skopas give a different perspective of his stylistic uniqueness. The only known large-scale sculptural depiction of the story of Pothos, preserved in many replicas, may well be one of the two representations of Pothos alleged to have been produced by Skopas. With crossed legs and the left arm raised, the god leans far to the left. His robe falls deeply down his shoulder in almost even folds. The head is raised, and the long hair falls from the part to the neck in even waves. The dramatic movement and mimesis of the heads from Tegea or the *Bacchanal* are absent here, although the deep-set eyes and compact proportions of the head are reminiscent of them. The stance and structure of the figure point to the *Sauoktonos* of Praxiteles.

A votive relief in the collection with the *Asculapios* and *Hygieia* in Tegea provides some idea of the group's character. *Asculapios* is leaning to the left on a staff. A robe wrapped around his body leaves the breast, right shoulder, and right arm uncovered. *Hygieia* is wearing a chiton, belted below her chest, and her hips are draped with a cloak, the ends of which envelop her slightly elevated left forearm. There appear to be no large-scale sculptural copies of the two statues. Fortunately, the upper body of the statue of *Hygieia* in Tegea has been preserved, which not only makes apparent the significant qualitative gap separating it from the sculptural architecture but also announces its opposition to a relationship with Attic creations of the middle of the 4th century BCE.

Images on coins from the Hellenistic and imperial era recreate the image of the *Apollo Smintheus* on Chryse. The god stands peacefully, clad in a robe, holding the bow in his left hand and a basin in his right. The stiff posture, the proportions, and the hem of the robe, which drapes like steps in a staircase, express an archaism that emerges in none of the other representations attributed to Skopas and seems in this instance to be grounded in local traditions.

A more precise picture exists of another Apollo statue by Skopas, the *Apollo Palatinus* probably created for Rhamnous. Only fragments of the head and foot of the original have been preserved. Nonetheless, as this statue appears on a relief base in Sorrento along with other masterpieces collected on the Palatine, it may be identified with a type preserved in many replicas. The right leg is the supporting leg, while the left leg is set far back. The left arm clasps around the kithara. The god is wearing a garment unusual for a man: a chiton or peplos with an *apoptygma* falling to the upper thigh. The arrangement of the folds and the relationship between the body and the garment call to mind Attic works from before the middle of the 4th century BCE.

Skopas drew on Attic models in his capacity as the architect of the Athena temple in Tegea as well. Nonetheless, he clearly worked in close collaboration with Peloponnesian workshops, whose influence emerges most prominently in the architectural sculpture of the Temple of Athena Alea in Athens. Works such as the *Pothos*, the *Apollo Palatinus*, or the *Hygieia* in Tegea demonstrate that even the ancients were uncertain whether to attribute certain representational works to Praxiteles or Skopas, such as a *Niobe* group in the Temple of Apollo Sosianus, a *lanus pater*, which Augustus stole out Egypt, and an *Eros* carrying a lightening bolt.

PETER C. BOL

See also **Greece, Ancient; Lysippos; Praxiteles**

Biography

Born in Greece, probably late 5th century BCE. Referred to by Pausanias as architect for the reconstruc-

tion of the Temple of Athena Alea, Tegea, Greece, in first half of 4th century BCE, but also likely to have supervised sculpture there; active as sculptor throughout the Peloponnese in Greece, mid 4th century BCE, and beyond to Thebes, Megara, Athens, and Samothrace, as well as Ephesus, Knidos, and Halicarnassus, in Asia Minor; regarded in antiquity as an equal to Praxiteles and Lysippus. Died in Greece, after 330 BCE.

Selected Works

ca. 395 BCE	*Asklepios* and *Hygieia*; marble; Temple of Athena Alea, Tegea, Peloponnese, Greece
mid 4th century BCE	*Aphrodite Pandemos*; bronze; Elis, Peloponnese, Greece
mid 4th century BCE	*Apollo Palatinus*, at Rhamnous; marble (no longer extant)
mid 4th century BCE	*Apollo Smintheus* (lost)
mid 4th century BCE	*Asklepios* and *Hygieia*; marble; Gortyn, Greece
mid 4th century BCE	*Hecate*; stone; Argos, Argolis, Peloponnese, Greece
mid 4th century BCE	*Hercules*; marble (lost)
mid 4th century BCE	(Head of) *Hercules Hope* (copy of the *Hercules* originally in Sicyon); marble; County Museum of Art, Los Angeles, California, United States
mid 4th century BCE	Statuette; marble; State Art Collection, Dresden, Germany
mid 4th century BCE	Winged youth (probably *Pothos*); Musei Capitolini, Rome, Italy
4th century BCE	(Head of) *Hygieia*, at Tegea; Parian marble; National Archaeological Museum, Athens, Greece (attributed)

Further Reading

Delivorrias, Angelos, and Andreas Linfert, "Skopadika: La statue d'Hygie dans le temple d'Alea à Tégée," *Bulletin de correspondance hellenique* 107 (1983)

Linfert, Andreas, *Von Polyklet zu Lysipp: Polyklets Schule und ihr Verhältnis zu Skopas von Paros*, Cologne, Germany: Kleikamp, 1969

Stewart, Andrew F., *Skopas of Paros*, Park Ridge, New Jersey: Noyes Press, 1977

HEAD OF *HYGIEIA*
Skopas (fl. 395–330 BCE)
4th century BCE
Parian marble
h. 28.5 cm
National Archaeological Museum, Athens, Greece

A female head discovered in 1901 during the French School's excavations at Tegea (1889–1910) has often been identified as the head from a statue of *Hygieia*, the goddess of health. The Greek traveler Pausanias mentions this image in the 2nd century CE. The head was found at the southeast corner of the Temple of Athena Alea at Tegea, beneath a column drum located near a statue base. Placed in the Tegea Museum after its discovery, it was stolen in 1916 and buried nearby. The piece was recovered in 1925 and placed in the Athens National Museum.

In his 2nd century CE *Description of Greece*, Pausanias records statues in Pentelic marble of *Asklepios* and *Hygieia*—which were at the time located in the Temple of Athena Alea at Tegea—by the sculptor Skopas of Paros. The two works are the only sculptures Pausanias attributes to Skopas. Norman suggests that they were possibly originally located near a fountain in a sanctuary of Asklepios just northeast of the temple

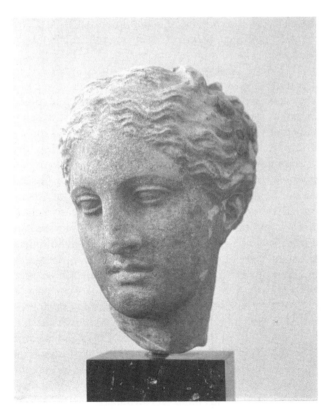

Head of *Hygieia*
© Scala / Art Resource, NY

and moved into the structure for safekeeping after the temple's cult statue of Athena was carried off for the Roman emperor Augustus in the 1st century BCE (see Norman, 1986). Other scholars rely on Pausanias's indication that the two statues were created by Skopas, presumably for the temple (see Ridgway, 1997, and Stewart, 1977).

The so-called head of *Hygieia* is relatively well preserved. Despite the weathering of the overall surface and some mutilation to the ears, it retains most of its original nose and hair. The work is characterized by the long oval face (turning slightly downward to her right) and such details as the simplified eyelids and brows, small, slightly parted lips, and wide nostrils. The nose is slightly damaged on the tip, but this does not detract from the unique vertical quality of the profile. Part of the hair is pulled back from the front and gathered in a knot (not fully carved) on the back. The disposition of the woman represented in the marble head is composed and thoughtfully reflective.

The style of the head is not Skopic, at least based on what is known of his style in the heads from the pediment of the temple at Tegea. The delicate features of the female head are at odds with the deep-set eyes and protruding brows of the cubelike male heads. In addition, Dugas, Berchmans, and Clemmensen have noted that the hair of the female head is similar to that of a head of Aphrodite in the Musée du Louvre, Paris (see Dugas, Berchmans, and Clemmensen, 1924). The head from Tegea, however, is missing the attributes of Aphrodite, including the diadem.

The head of *Hygieia* retains qualities attributed to the mid 4th-century Greek sculptor Praxiteles, such as the sensitive attention to the modeling of the flesh. Scholars have noted the Praxitelian quality of the head, especially when it is compared with Praxiteles's muses from the Mantineia base. The ancient writer Pliny the Elder mentions that Skopas was part of the Praxitelian school, so the head cannot be definitively dismissed as not being a work by Skopas. The display of a pensive, inner quality no doubt contributed to early scholars attributing the head to Skopas, a sculptor recognized for imbuing his sculptures with a psychological element. Although the female head from Tegea is marked by characteristics of the art of the 4th century BCE, and its high quality suggests that it was carved by a master sculptor such as Skopas, it may be appropriate to attribute the work to some unknown master.

The history of the interpretation of the head is complicated. The initial description in the archaeological report published in 1901 states that it would be appealing to identify the head as *Hygieia*, the work of Skopas mentioned by Pausanias (see Mendel, 1901). Moreover, the report both points out that the marble (Parian)

of the head is not the same as that mentioned by Pausanias and questions whether Pausanias may have been mistaken on this point. Scholars debated this initial attribution to Skopas; nevertheless, the head still took on the desirable identity of *Hygieia*. Another early interpretation identified the head as that of *Aphrodite*, although the lack of attributes weakened the credibility of the argument (see Dugas, Berchmans, and Clemmensen, 1924). The head was also paired with a torso and interpreted as the figure of *Atalanta* from the pediment of the Tegean temple, although the material of the fragments of the figure (Parian) do not match the material of the recovered temple sculptures (Doliana). Also, the head shows differences of style when compared with a fragmentary female head believed to be from the pediment. Ridgway has suggested that the head dates to the early Hellenistic period (see Ridgway, 1997), while Croissant points out that it is reminiscent of a Praxitelian-style *Aphrodite* but dates to the third quarter of the 4th century BCE (see Croissant, 1990).

The most persuasive argument identifies the head as a muse or nymph from the so-called Federal Altar, located near the temple at Tegea. Pausanias described the altar as being made by Melampus and decorated with muses and nymphs, among other elements. However, no solid evidence indicates that either the altar or the sculptures from the altar were created at the same time as the temple.

LINDA ANN NOLAN

Further Reading

Croissant, Francis, "Hygieia," in *Lexicon Iconographicum Mythologiae Classicae*, vol. 5, Zurich: Artemis Verlag, 1990

Dugas, Charles, Jules Berchmans, and Mogens Clemmensen, *Le sanctuaire d'Aléa Athéna à Tégée au IVᵉ siècle*, Paris: Geuthner, 1924

Gardner, Ernest Arthur, *A Handbook of Greek Sculpture*, London: Macmillan, 1896; 2nd edition, 1915; reprint, 1929

Karouzou, Semne, *National Archaeological Museum: Collection of Sculpture: A Catalogue*, translated by Helen Wace, Athens: General Direction of Antiquities and Restoration, 1968

Mendel, Gustave, "Fouilles de Tégée," *Bulletin de Correspondance Hellénique* 25 (1901)

Norman, Naomi J., "Asklepios and Hygieia and the Cult Statue of Tegea," *American Journal of Archaeology* 90 (1986)

Picard, Charles, *Manuel d'archéologie grecque: La sculpture*, 4 vols., Paris: Picard, 1935–63; see especially vol. 4

Ridgway, Brunilde Sismondo, *Fourth-Century Styles in Greek Sculpture*, Madison: University of Wisconsin Press, 1997

Sobel, Hildegard, *Hygieia: Die Göttin der Gesundheit*, Darmstadt, Germany: Wissenschaftliche Buchgesellschaft, 1990

Stewart, Andrew F., *Skopas of Paros*, Park Ridge, New Jersey: Noyes Press, 1977

Waywell, Geoffrey B., "The Ada, Zeus, and Idrieus Relief from Tegea in the British Museum," in *Sculpture from Arcadia*

and Laconia, edited by Olga Palagia and William Coulson, Oxford: Oxbow Books, 1993

RENÉ-MICHEL [MICHEL-ANGE] SLODTZ 1705–1764 *French*

The Prix de Rome was one of the most prestigious awards that a 17th- or 18th-century French artist could hope to win. Since 1666, when the Paris Academie Royale de Peinture et de Sculpture opened its Roman seat, the young prizewinners received the opportunity to study the masterpieces of Italian art for four years, plus a scholarship and lodging at the academy. In exchange, the *pensionnaires du Roi* were required to make copies of the most beautiful works of Classical and Renaissance art in Rome and send them to Paris. Although René-Michel Slodtz never won the Prix de Rome, he ranked second in the 1724 and 1726 competitions, and in 1728 he was sent to study at the French academy in Rome all the same. Thus began a period rich in experiences and important commissions that ended only with Slodtz's return to France in 1746.

René-Michel was the son of Sébastien Slodtz, a sculptor from Antwerp who worked in Paris. Sébastien was the head of a family prolific in artists: three of his 13 children became sculptors (Sébastien-Antoine, Paul-Ambroise, and René-Michel), and two became painters (Jean-Baptiste and Dominique-François). The Slodtzes worked almost exclusively on royal commissions, mostly being in charge of designing and constructing grandiose ephemeral installations for funerals and fireworks displays organized by the Menus Plaisirs du Roy.

After learning the basics of his craft from his father, René-Michel Slodtz completed his training and honed his style at the French academy in Rome. Partly due to the esteem in which he was held by the director, Nicolas Vleughels, Slodtz remained at the academy for eight years, twice the usual term of the scholarship. Like the other students, he copied a famous statue, in his case Michelangelo's *Christ* in the Church of Santa Maria sopra Minerva (the work earned Slodtz the nickname Michel-Ange). During the early years of his Roman sojourn, Vleughels was his most loyal patron. Slodtz sculpted a bust of Vleughels and, most important, Vleughels's tomb in the Church of St. Louis des Français. This work, the first of a series of important commissions, stands out for its elegant simplicity and for its explicit reference to the models of François du Quesnoy: a chubby putto holding a palette, a figure very similar to du Quesnoy's putti, is unveiling the medallion containing Vleughels's portrait in low relief.

After 1736, when he left the academy and opened a studio of his own, Slodtz became one of the most highly reputed and sought after sculptors in Rome. In the works of this period he continued to combine elements from Roman figurative culture and an elegant and restrained academic style, attenuating the most flamboyant swirlings of Bernini-style Baroque. The beautiful relief depicting the *Ecstasy of Saint Teresa*, carved for the Discalced Carmelite nuns of the Church of Santa Maria della Scala, is one of the most successful examples of this happy compromise. While the figures of the saint and the angel echo Gianlorenzo Bernini's illustrious prototype in the Church of Santa Maria della Vittoria, Rome, the composition as a whole is striking for its gracefulness and technical skill and for the delicate atmosphere that seems to permeate the emotional intensity of the scene. The same elegance of motion also pervades Slodtz's *St. Bruno*, universally recognized as his masterpiece. Commissioned by the Carthusian order and completed in 1744, this statue is one of a series of Founding Saints placed in niches along the nave of St. Peter's Basilica in Rome. St. Bruno, standing 4.4 meters high, is represented refusing the bishop's mitre and staff tendered by the putto at his feet, standing on the edge of the niche. Despite the monumental scale of this work, Slodtz's graceful style remained unaltered. The delicate facial features and the way in which the drapery folds of the habit wrap the figure bear witness to the artist's care and attention to detail. The composition reveals its stylistic debt to the Late Baroque works of the French sculptors working in Rome, especially Pierre Legros's *Saint Louis Gonzaga in Glory* at the Church of S. Ignazio; Legros's *Saint Louis* can be considered the direct predecessor of Slodtz's *St. Bruno*.

While in Rome, Slodtz also executed works that were exported to France. The tomb of Cardinal de La Tour d'Auvergne and Archbishop Montmorin in Vienne Cathedral, commissioned by the cardinal himself, is a grandiose tableau vivant staged on a high plinth with a pyramid as background. The figure of the archbishop, reclining on a black marble sarcophagus, dominates the composition; the cardinal approaches from the left, wrapped in a mantle so large and richly draped that it flows out of the frame. A putto transcribes the historic event in a large book.

After returning to Paris in 1746, Slodtz continued to work in the same manner. The tomb of Jean-Baptiste Languet de Gergy resembles the monument described above. Placed in a chapel in the Church of St. Sulpice, of which Languet de Gergy had been the titular priest, the monument symbolizes the immortality of the Christian soul and its victory over Death, here represented as a threatening skeleton. However, because of the variety of materials and the magniloquence of the not altogether well-balanced composition, the artist's contemporaries did not appreciate this work. Most of his other commissions during this final phase of his

Tomb of Jean-Baptiste Languet de Gergy, Church of St. Sulpice, Paris, France
The Conway Library, Courtauld Institute of Art

career met the same fate; Slodtz did not gain at home the success he had achieved in Rome. Apart from an unfinished *Cupid* commissioned by Madame de Pompadour, in his Paris years Slodtz worked mainly on important decorative projects, including reliefs for the portico at the Church of St. Sulpice and for Place de la Concorde, the latter depicting *The Progress of Commerce* and *Royal Magnificence*.

CRISTIANO GIOMETTI

See also **Bernini, Gianlorenzo; du Quesnoy, François; Legros II, Pierre; Michelangelo (Buonarroti)**

Biography

Born in Paris, 17 September 1705. Son of was the Flemish sculptor Sébastien Slodtz. After training in his father's studio, won second place in the 1724 and 1726 Prix de Rome competitions; sent to study at the Académie de France, Rome, 1728–36; opened his own studio and obtained prestigious commissions for both Rome and France; returned to France, 1746; worked with his brothers, the sculptors Sébastien-Antoine and Paul-Ambroise, but was unable to equal the fame and suc-

cess of his Roman years; upon Paul-Ambroise's death in 1758, succeeded to his position of *dessinateur de la chambre et du cabinet du roi*; most important pupil was the sculptor Jean-Antoine Houdon. Died in Paris, 26 October 1764.

Selected Works

1731–36 *Christ of the Minerva* (copy from Michelangelo); marble; Hôtel des Invalides, Paris, France
1736 Bust of Nicolas Vleughels; marble; Musée Jacquemart-André, Paris, France
1737 Tomb of Nicolas Vleughels; marble; Church of San Luigi dei Francesi, Rome, Italy
1737–38 Model for bas-relief of *Ecstasy of St. Teresa*; terracotta; Accademia di San Luca, Rome, Italy
1738 Relief of *Ecstasy of St. Teresa*; marble; Church of Santa Maria della Scala, Rome, Italy
1744 *St. Bruno*; marble; St. Peter's Basilica, Rome, Italy
1744–46 Tomb of Cardinal de La Tour d'Auvergne and Archbishop Montmorin; polychrome marbles; Vienne Cathedral, France
1746 Tomb of Marchese Capponi; polychrome marble; Church of San Giovanni dei Fiorentini, Rome, Italy
1750–57 Tomb of Jean-Baptiste Languet de Gergy; polychrome marble, bronze; Church of St. Sulpice, Paris, France
after 1758 Reliefs of *The Progress of Commerce* and *Royal Magnificence*; marble; Place de la Concorde, Paris, France

Further Reading

Bowron, Edgar Peters, and Joseph J. Rishel, editors, *Art in Rome in the Eighteenth Century* (exhib. cat.), London: Merrel, 2000
Cipriani, Angela, editor, *Aequa Potestas: Le arti in gara a Roma nel Settecento* (exhib. cat.), Rome: De Luca, 2000
Kalnein, Wend von, and Michael Levey, *Art and Architecture of the Eighteenth Century in France*, London: Penguin, 1972
Nava Cellini, Antonia, *La scultura del Settecento*, Turin, Italy: UTET, 1982
Pinelli, Antonio, editor, *The Basilica of St. Peter in the Vatican*, 4 vols., Modena, Italy: Panini, 2000
Souchal, François, *Les Slodtz, sculpteurs et décorateurs du Roi (1685–1764)*, Paris: De Boccard, 1967
Wittkower, Rudolf, *Art and Architecture in Italy, 1600–1750*, London and Baltimore, Maryland: Penguin, 1958; 6th edition, 3 vols., revised by Joseph Connors and Jennifer Montagu, New Haven, Connecticut: Yale University Press, 1999

CLAUS SLUTER *ca.* 1360–1406

Netherlandish

Although relatively little is known about his career as a whole, Claus Sluter holds an important place in the development of late 14th- and early 15th-century sculpture, particularly in Burgundy. His attention to nature and ability to infuse his sculptural works with life served as models for his Burgundian peers, as well as for subsequent generations of northern European sculptors.

Much of what is known about Sluter's life and career stems from his 21 years of service as chief sculptor to Philip the Bold, duke of Burgundy. Based on the appearance of a Claes de Slutere van Herlam in the guild lists of Brussels stonecutters and masons around 1379, scholars estimate that Sluter was probably born in Haarlem around 1360, although some have suggested that he may have been born as early as 1340. His continued association with Brussels artists, together with the influence of his contemporaries on his work, suggests that his stay in Brussels was both productive and relatively lengthy.

Sluter's association with the court of Philip the Bold began in the early part of 1385 when he was hired by Jean de Marville as a workshop assistant. Upon the death of Marville four years later, Sluter became the head of the workshop and stayed in the service of the duke for the remainder of his career. The main duty of the workshop, which was in operation as early as 1384, was to provide sculpture for the duke's largest artistic enterprise, the Charterhouse of Champmol, a Carthusian monastery near Dijon. Philip the Bold and his brother Jean, Duke of Berry, played a key role in the development of a Burgundian style or school as major patrons of art in the late 14th and early 15th centuries. While few works clearly identifiable as coming from Sluter or his workshop remain, three extant sculptural projects from the charterhouse provide examples of the sculptor's style and achievement.

Sluter worked on the portal sculpture for the charterhouse while still an assistant to Jean de Marville. Although the project began under the direction of Sluter's predecessor, very little had actually been completed at the time of Marville's death. Upon assuming the direction of the project, Sluter redesigned the portal to better accommodate his own program, which was infused with realism as well as drama. The portal sculpture depicts the presentation to the Virgin Mary of the donors, Philip the Bold and his wife, Margaret of Flanders, by St. John the Baptist and St. Catherine. The adaptation of a donor scene into sculpture, traditionally found in painting of the period, was innovative. For the first time, mortals were depicted on a church portal alongside heavenly personages. The figures are characterized by a sense of realism, conveyed as much by Sluter's ability to create a form with weight and mass as by his keen attention to surface textures and skill at portraiture, evidenced by the carefully rendered features of the donors. As the focal point both in terms of the scene and the perspective, the *trumeau* figure of the Virgin Mary bending over the Child forms a key part of the program. Indeed, the portal architecture almost becomes a backdrop to the drama of the presentation scene that unfolds in front of the viewer.

The *Well of Moses* is the only extant work known to be completely conceived and executed by Sluter. Situated atop the wellhead in the main cloister of the charterhouse, the *Well of Moses* comprised the hexagonal base for a large cross at the center of a sculpted calvary scene. Today only the *Well of Moses*, decorated with life-size statues of Moses and five prophets, remains. As with the portal figures, the sculpture of the well is characterized by an acute observation of nature. The figures, somewhat reminiscent of jamb statues of Gothic portals, are nearly freestanding and are clothed in heavy drapery with voluminous folds. Ducal records and traces of paint on sections of the well indicate that the entire work was once painted. Sluter's ability to convincingly render and differentiate between textures is even more fully developed here, as the coarseness of drapery, the smoothness of flesh, and the silkiness of hair are clearly articulated.

The tomb of Philip the Bold is perhaps Sluter's greatest achievement and was his final project. Marville, who received the original commission in 1381, was probably responsible for the overall design and decorative arcade. Sluter and his workshop, however, executed the majority of the sculptural work, which was ultimately completed by Sluter's nephew and successor, Claes de Werve, after his uncle's death in 1406. The monument, executed almost entirely after Philip the Bold's death in 1404, depicts the duke's recumbent figure on a slab of marble with a lion at his feet and two angels holding a helmet at his side. Around the sides of the tomb, in the open arcade, Sluter depicted a mourning procession of 40 alabaster figures of weepers. The sculpted procession and the portrait figure of Philip represent the culmination of Sluter's style. In addition to the skillful rendering of the human form, the figures, particularly the weepers, convey a close observation of human emotion and gesture. The expressive qualities embodied in the individual figures of the procession, as well as in the group as a whole, demonstrate Sluter's keen observation of the human condition. Although not an identifiable portrait, each weeper is individually rendered in a variety of stages of grief, both emotionally and physically.

Sluter's sculpture represents a stylistic shift from the sculpture of the late 14th and early 15th centuries.

While his main achievement lay in his ability to infuse his figures with life and emotion, the ideas embodied in Sluter's work grew out of an existing tradition. Indeed, a similar fascination with tangible and specific elements of the visible world developed on a parallel track in the painting of the same period. In many ways Sluter's work was a bridge between the elegant flowing lines of the International Gothic style and the gravity of sculptural figures in the work of early Renaissance sculptors such as Donatello. While the medieval Burgundian school was fairly brief, the sculpture as embodied in the works of Claus Sluter and his workshop had a lasting impact on the art produced in the region for the next several decades.

ELIZABETH PETERS

See also **Architectural Sculpture in Europe: Middle Ages–19th Century; Netherlands and Belgium**

Biography

Born in Haarlem, Netherlands, *ca.* 1360. First documented in Brussels, *ca.* 1379, as Claes de Slutere van Herlam, a stonecutter; probably trained in family workshop in Haarlem; hired as assistant in 1385 to Jean de Marville's workshop, which provided sculpture for Philip the Bold, Duke of Burgundy; became head of workshop after Marville's death in 1389; appointed head of ducal workshop in Dijon, France; remained in the service of the duke; suffered lengthy illness in 1399; received pension and privileges in the Abbey of Saint-Etienne, Dijon, 1404; uncle of Claes de Wevre, a sculptor. Died in Dijon, France, 1406.

Selected Works

ca. 1385–93	*Virgin and Child, St. John the Baptist, St. Catherine of Alexandria, Philip the Bold,* and *Margaret of Flanders*; marble; portal, Charterhouse of Champmol, near Dijon, France
ca. 1390–96	*Virgin, St. John the Baptist,* and *St. Anthony,* for two-storey ducal oratory at Champmol, near Dijon, France, stone (destroyed 1792)
ca. 1391–1406	Tomb of Philip the Bold (completed by Claes de Werve after 1406), for Charterhouse of Champmol, near Dijon, France; alabaster, black marble; Musée des Beaux-Arts, Dijon, France
ca. 1393	Pastoral scene for Duke and Duchess of Burgundy's castle of Germolles, near Chanlon-sur-Saône; stone (untraced)
ca. 1396–	*Well of Moses* (base of the *Calvary*), including statues of *Moses, David,*
1406	*Jeremiah, Zachariah, Daniel,* and *Isaiah*; stone; Charterhouse of Champmol, near Dijon, France; fragments of *Calvary*: Musée d'Archeologique, Dijon, France

Further Reading

David, Henri, *Claus Sluter,* Paris: Tisné, 1951

Gras, Catherine, *Claus Sluter en Bourgogne: Mythe et représentations* (exhib. cat.), Dijon, France: Musée des Beaux-Arts de Dijon, 1990

Morand, Kathleen, *Claus Sluter: Artist at the Court of Burgundy,* Austin: University of Texas Press, and London: Miller, 1991

Quarré, Pierre, *La Chartreuse de Champmol: Foyer d'art au temps des ducs Valois,* (exhib. cat.), Dijon, France: Musée des Beaux-Arts de Dijon, 1960

Quarré, Pierre, *Les pleurants dans l'art de Moyen Âge en Europe* (exhib. cat.), Dijon, France: Musée des Beaux-Arts de Dijon, 1971

WELL OF MOSES
Claus Sluter (ca. 1360–1406)
ca. 1396–1406
stone
h. 3.25 m
Charterhouse of Champmol, near Dijon, France

Philip the Bold, duke of Burgundy, founded the Charterhouse of Champmol, a Carthusian monastery in Dijon, in part to ultimately house a dynastic mausoleum for his family. Although construction seems to have begun as early as 1383, the charter was only officially signed in 1385. The architectural structures of the charterhouse complex were completed by 1388; around this time most of the sculptural projects began in earnest. Almost from the start, the complex as a whole served as a nexus for ducal patronage, at the center of which was Claus Sluter and his workshop. Along with his work on the portal sculpture for the charterhouse and the monumental tomb of Philip the Bold, the so-called Moses Well and Great Cross in the main cloister form an important piece of 15th-century Burgundian sculpture.

The duke commissioned the *Well of Moses* in 1395 for the center of the monastery's main cloister. Workshop records indicate that Sluter and his workshop began work on the project by 1396. The well, still *in situ* in the cloister, was originally surmounted by a large cross that served as the centerpiece for a calvary scene. Much of the calvary group was destroyed some time in the 18th century; portions of the figure of the *Crucified Christ* are still extant and housed at the Musée Archéologique in Dijon. From the time of its execution until the destruction of the calvary figures,

Well of Moses
The Conway Library, Courtauld Institute of Art

Sluter's entire sculptural structure was referred to simply as the cross or the great cross. After the Cross was destroyed, however, this distinction no longer made sense and the sculpture soon became known as the *Well of Moses*.

Intended to function as the base for the Calvary group, the *Well of Moses* is a hexagonal pier bearing life-size statues of Old Testament figures *Moses*, *David*, *Jeremiah*, *Zachariah*, *Daniel*, and *Isaiah* on each side of the structure. Thin columns separate the statues; atop each column is a figure of a grieving angel with outspread wings. Along with some identifying attribute, each figure holds a scroll, book, or both, with an inscription of his prophetic text proclaiming the unavoidable suffering of Christ. The duke's coat of arms and that of his wife appear on a cornice, at the water level, below the prophet figures. According to ducal records the prophets were completed and installed in two stages. The first group, consisting of *David*, *Moses*, and *Jeremiah*, were installed in 1402. The remaining figures of *Zachariah*, *Daniel*, and *Isaiah* were installed in 1404 or 1405. Workshop records indicate that the *Well of Moses* was originally painted, shortly after its installation, by the painter Jean Malouel and gilded by Hermann of Cologne. Traces of paint and gilding are still visible on portions of the sculptural group.

Iconographically, Sluter associated each prophet figure with the coming of Christ and his ultimate sacrifice. Sluter depicted *David*, the founder and first ruler of Israel and Judah, as a king in his prime. Visible under his cloak is a harp, a traditional reference to his musical talents. The name *David* means "anointed one" or messiah; Sluter further suggests David's connection to Christ by the presence of the Tree of Jesse, a popular medieval reference to the belief that Jesus was from the same lineage as David and therefore the "new Messiah." Sluter portrayed the figure of *Moses*, seen theologically as the precursor to Jesus as an intermediary between God and the people of Israel, with horns on his head, symbolic of his transformation after seeing God, and holding the tablets of the Law in his right hand. The prophet *Jeremiah*, associated through his writings with the new covenant and the Eucharist, is portrayed by Sluter in the act of reading the book he holds. The figure of *Zachariah*, father of John the Baptist, by the inclusion of a pen and inkwell with stopper removed, suggests that he has just finished writing a prophetic text. The final two figures of *Daniel* and *Isaiah* face each other as though engaged in conversation. The writings of Daniel formed the basis for popular medieval dramas meant to portray the prophecies of the coming of Christ; likewise, the writings of Isaiah contain many references to the coming of a Messiah who would suffer persecution for the sins of others and ultimately triumph. The prophet figures and the calvary scene presented the viewer with the opportunity for contemplation of the sacraments of baptism and the Eucharist, as well as the ultimate salvation through Christ's sacrifice for humankind.

As in Sluter's other sculptural projects, the statues showcase his ability to infuse each figure with a sense of vitality and realism. As in his other works, he gave primacy to the humanity of the figure. Indeed, Sluter individualized the figures to virtually embody each prophet's strength of character. Sluter also clothed each figure in heavy drapery with voluminous folds. This figure treatment, characteristic of Sluter's style, helps convey the sense that the statues are weighty, massive figures. Each prophet, although not a true portrait, embodies a similar sense of portraiture as found in Sluter's other sculptures. He clearly depicted the figure of *Isaiah*, for instance, with the characteristics of an aging man, including a bald head, a rare occurrence in medieval sculpture. The addition of actual materials to some of the figures further illustrates Sluter's attention to detail and commitment to realism. The figure of Jeremiah originally wore authentic metal-framed spectacles to aid his reading, while David's

harp bears indications that it was originally fitted with metal strings.

Philip the Bold's ambitious patronage of the arts provided a catalyst for the emergence of a Burgundian style, led in large part by Sluter and his workshop. As the only extant sculptural work to be executed completely under Sluter's supervision, the *Well of Moses* provides an important example of the sculptor's style and achievement in late 14th- and early 15th-century sculpture.

ELIZABETH PETERS

Further Reading

Kleinclausz, Arthur Jean, *Claus Sluter et le sculpture borguignonne au XVe siècle*, Paris: Librairie de l'Art Ancien et Moderne, 1905

Morand, Kathleen, *Claus Sluter: Artist at the Court of Burgundy*, Austin: University of Texas Press, and London: Harvey Miller, 1991

DAVID SMITH 1906–1965 *United States*

David Smith was formally trained as a painter, and his work is clearly indebted to that art form. Throughout his career he sought to reconcile painting and sculpture into a unique expression. So much was he attuned to the Modernist strains affecting painters during his time period that critics have paralleled comparable tendencies in his sculptures to the changing terrain of American painting.

Smith's transition from painting to sculpture occurred in 1931–33 while working in collage. His first major sculpture, *Agricola Head*, executed in 1933, was the earliest welded sculpture produced in the United States. It was inspired by the welded metal sculptures by Pablo Picasso and Julio González, which Smith saw reproduced in the magazine *Cahiers d'art*. Smith realized that the metalworking skills that he had developed while working during the summers in a car factory could be applied to sculptural production.

Smith's early sculptures tended to be small with an eclectic blending of various materials, hues, and textures, which reveal his collage experience. In the 1930s and 1940s, the artist produced relief plaques, cast forms in bronze and aluminum, and welded sculptures in iron and steel, which sometimes integrated found objects. Many of his early sculptures, such as *Reclining Figure* (1935), allude to the human form, but other works are more abstract with organic and geometric shapes, such as *Aerial Construction* (1938). Smith's *Interior* (1937) was the first completely linear sculpture that he created, and it is indebted to some of Alberto Giacometti's works from the late 1930s, such as the *Palace at 4 A.M.* (1932–33).

Surreal images of metamorphosis, violence, brutality, and entrapment are prevalent in Smith's work from the 1940s and reflect the impact of the war. Rosalind Krauss has noted the dominance of certain themes in Smith's oeuvre, which she termed "cannons," "totems," and "spectres" (see Krauss, 1971). Another persistent motif in Smith's work is the reposing female form (*ca.* 1935–55). Some of his small-scale cast bronzes, such as *Atrocity* (1943), are devoted to cannon/phallus subjects, and others, such as *War Spectre* (1944), comment on the injustices and hypocrisy of war. The series of bronze plaques titled *Medals for Dishonor, War Exempt Sons of the Rich*, influenced by Sumerian seals, are antiwar and antifascist protests. Smith said that the goal of his work was the conception of contemporary symbols, and that he preferred to work in metals such as steel because "the metal possesses little art history. Its associations are primarily of this century. It is structure, movement, progress, suspension . . . and at times destruction and brutality."

During the second half of the 1940s, some of Smith's sculptures explored his own psyche, such as *Home of the Welder* (1945), which in its title and personal symbolism is psychoautobiographical. Other motifs were related to mythology and paleontology. *The Royal Bird* (1947–48) is based on Smith's study of a prehistoric bird skeleton. Themes in later works are less evident because they are more hidden. The artist Dorothy Dehner, to whom Smith was married, said that abstraction attracted him because he could work out inner concerns without feeling that he was fully revealing himself. The multiple allusions in Smith's work came from the artist's interest in the unconscious as the source for artistic inspiration.

With such works as *Hudson River Landscape*, a whole new category of sculptures related to natural and man-made landscapes was inaugurated. Thereafter, Smith's sculptures became larger, and many of these pieces were grouped into series and numbered sequentially. Among them are the *Agricola, Tanktotem*, and *Raven* series produced in the 1950s. This manner of working allowed the sculptor to delve deeply into and improvise on an idea. Many of these sculptures, such as *Sentinel 1* (1956), are obviously based on the human figure (Smith called them "personages"). In these over–life-size pieces, Smith experimented with wheels and other inventive supports in his desire to escape traditional sculptural bases. Such affects enhance their mortal suggestiveness. In his monumental outdoor sculptures constructed in the 1960s, Smith experimented with the noncorrosive and reflective properties of stainless steel. His virtuosity is demonstrated in the series *Voltri*, in which he produced 26 massive sculptures in 30 days. The sculptures of the series *Cubis*, like those for his series *Zig*, are even

larger scaled and are composed of abstract geometric forms. It is clear that Smith conceived of color as an essential part of sculpture.

Smith has stressed that his sculptures were not prearranged, although they were often based on drawings. He explained: "When I start a sculpture, I begin with only a realized part. The rest is travel to be unfolded much in the order of a dream." Karen Wilkin wrote that Smith seemed to combine two approaches in his work: one was based on his discovery of personal symbolic images and the other on his being alert to the inventive possibilities that his work presented to him during the creative process (see Wilkin, 1984). "The work is a statement of my identity, it comes from a stream, it is related to my past works . . ." Smith said.

MARY ELLEN ABELL

See also **Abstract Expressionism; Caro, Anthony; Dehner, Dorothy; di Suvero, Mark; Giacometti, Alberto; Metal Casting; Minimalism**

Biography

Born in Decatur, Indiana, United States, 9 March 1906. Studied cartoons at Cleveland Art School, 1923; took art course at Ohio University, 1924; at The Art Students League with John Sloan and Jan Matulka, 1926–32; as a welder, worked in South Bend, Indiana, 1925, and American Locomotive Company, 1942; moved to studio "Terminal Iron Works," a welding shop near his Brooklyn home, 1932. Awarded Guggenheim Foundation fellowship, *ca.* 1950, and creative art award from Brandeis University, Massachusetts, 1964. Died near Bennington, Vermont, United States, 23 May 1965.

Selected Works

1933 *Agricola Head*; iron and steel, painted red; collection of Rebecca and Candida Smith
1938–40 *Medal for Dishonor, War Exempt Sons of the Rich*; bronze; Hirshhorn Museum and Sculpture Garden, Washington, D.C., United States
1943 *Atrocity*; bronze; private collection
1944 *War Spectre*; steel, painted black; Museum of Fine Arts, Houston, Texas
1945 *Home of the Welder*; bronze; collection of Rebecca and Candida Smith
1951 *Australia*; painted steel; Museum of Modern Art, New York City, United States
1951–52 *The Hero*; steel painted with red; Brooklyn Museum of Art, Brooklyn, New York, United States
1951 *Hudson River Landscape*; steel, stainless

steel; Whitney Museum of American Art, New York City, United States
1960 *Tanktotem IX*; steel painted blue, black, and white; collection of Rebecca and Candida Smith
1961 *Zig IV*; steel painted red, orange, and chartreuse; Lincoln Center for Performing Arts, New York City, United States
1962 *Voltri VII*; steel; National Gallery of Art, Washington, D.C., United States
1964 *Cubi XIX*; stainless steel; Tate Gallery, London, England
1965 *Cubi XXVI*; stainless steel; National Gallery of Art, Washington, D.C., United States
1965 *Cubi XXVII*; stainless steel; Guggenheim Museum of Art, New York City, United States

Further Reading

Carmean, E.A., Jr., *David Smith* (exhib. cat.), Washington, D.C.: National Gallery of Art, 1982
Cummings, Paul, *David Smith: The Drawings* (exhib. cat.), New York: Whitney Museum of American Art, 1979
Day, Holiday T., Dore Ashton, and Lena Vigna, *Crossroads of American Sculpture* (exhib. cat.), Indianapolis, Indiana: Indianapolis Museum of Art, 2000
Fry, Edward F., *David Smith* (exhib. cat.), New York: Guggenheim Foundation, 1969
Fry, Edward F., and Miranda McClintic, *David Smith: Painter, Sculptor, Draftsman* (exhib. cat.), Washington, D.C.: Hirshhorn Museum and Sculpture Garden, Smithsonian Institution, and New York: Braziller, 1982
Krauss, Rosalind E., *Terminal Iron Works: The Sculpture of David Smith*, Cambridge, Massachusetts: MIT Press, 1971
Krauss, Rosalind E., *The Sculpture of David Smith: A Catalogue Raisonné*, New York: Garland, 1977
Lewison, Jeremy, et al., *David Smith: Medals for Dishonor, 1937–1940* (exhib. cat.), Leeds, England: Henry Moore Centre for the Study of Sculpture, 1991
Marcus, Stanley E., "The Working Methods of David Smith," Ed.D. diss., Teachers College, Columbia University, 1972
Marcus, Stanley E., *David Smith: The Sculptor and His Work*, Ithaca, New York: Cornell University Press, 1983
McCoy, Garnett, editor, *David Smith*, New York: Praeger, and London: Allen Lane, 1973
Merkert, Jörn, editor, *David Smith, Skulpturen, Zeichnungen* (exhib. cat.), Munich: Prestel-Verlag, 1986; as *David Smith, Sculpture and Drawings* (exhib. cat), Munich: Prestel-Verlag, 1986
Smith, David, *David Smith by David Smith: Sculpture and Writings*, edited by Cleve Gray, London: Thames and Hudson, 1968; as *David Smith*, New York: Holt Rinehart and Winston, 1968
Smith, David, *David Smith: Medals for Dishonor, 1937–1940* (exhib. cat.), New York: Independent Curators Incorporated, 1996
Wilkin, Karen, *David Smith*, New York: Abbeville, 1984

CUBIS
David Smith (1906–1965)
1959–1965
h. varies, between 1.8 and 3.35 m

Cubi I, Detroit Institute of Art, Detroit, Michigan, United States; *Cubi VII*, Art Institute of Chicago, Chicago, Illinois, United States; *Cubi IX*, Walker Art Center, Minneapolis, Minnesota, United States; *Cubi XII*, Hirshhorn Museum and Sculpture Garden, Washington, D.C., United States; *Cubi XIV*, St. Louis Art Museum, St. Louis, Missouri, United States; *Cubi XVI*, Albright-Knox Art Gallery, Buffalo, New York, United States; *Cubi XIX*, Tate Gallery, London, England; *Cubi XXIII*, Los Angeles County Museum of Art, Los Angeles, California, United States; *Cubi XXVI*, National Gallery of Art, Washington, D.C., United States; *Cubi XXVII*, Guggenheim Museum of Art, New York City, United States

Cubis, David Smith's final series of sculptures (28 discrete pieces), are perhaps the penultimate representation of this sculptor's oeuvre that continues his investigation of modern materials and forms while capturing the fluidity of gesture and expression. Assembled stainless-steel cubes, the *Cubis* allude to the anthropo-

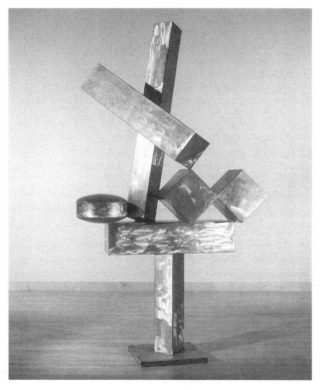

Cubi XIX (1964)
© Tate Gallery, London / Art Resource, NY, and Estate of David Smith/Licensed by VAGA, NY

morphic figures in the drawings of Luca Cambiaso, a 16th-century Italian painter. As Rosalind Krauss wrote, "No other series has elicited such diverse and mutually contradictory interpretation. Some writers treat the *Cubis* as abstract gestures or rhythms. Others . . . think of them as colossal construction" (see Krauss, 1971).

Smith conducted his own research and experimentation with a wide range of traditional and nontraditional materials in preparation for the *Cubis* series sculptures, which were intended to be outdoor sculptures. Although the rectangular forms in the sculptures were precut, their surfaces were burnished to reflect changing lighting conditions. "I make them and I polish them in such a way that on a dull day they take on a dull blue, or the color of the sky in the late afternoon sun, the glow, golden like the rays, the color of nature," Smith told the critic Thomas Hess. Like others in the group, *Cubi XIX* is an additive sculpture that was inspired by the constructions of cardboard boxes. Its varying steel rectangular shapes and one cylindrical form are precariously balanced in a dynamic equilibrium. A kinetic energy activates the forms and surrounding space. It is, in Smith's words, "a structure that can face the sun and hold its own against the blaze and the power." Some of the *Cubis*, such as *Cubi II* and *Cubi V*, allude to the human figure; others, for instance *Cubi XXVII*, seem more architectural. Although Smith's welded sculptures from the 1960s influenced the British sculptor Anthony Caro, his modular forms of the *Cubis* also affected the Minimalists.

MARY ELLEN ABELL AND KIM UIYON

Further Reading

Cone, Jane Harrison, *David Smith, 1906–1965: A Retrospective Exhibition* (exhib. cat), Cambridge, Massachusetts: s.n., 1966

Krauss, Rosalind E., *Terminal Iron Works: The Sculpture of David Smith*, Cambridge, Massachusetts: MIT Press, 1971

KIKI SMITH 1954– *German-born, active in United States*

Kiki Smith is recognized for her probing depictions of the human form, which literally turn the figurative tradition of artistic visualization inside out. In modern sculpture of the first half of the 20th century, the human form has been termed "the figure," a neutral motif to be formally reworked, especially through construction and deconstruction. In contrast, Smith's sculptures are representations of the body in all its visceral, social, political, and spiritual aspects. She began by bringing the internal organs outside the body, in effect reifying hands, brains, stomachs, and wombs by

turning them into sculptural objects made of latex, glass, bronze, and other malleable materials. Smith went on to sculpt entire figures and eventually to create tableaux of the surrounding natural and celestial world. Metaphorically speaking, Smith is a geographer of the body. She investigates humankind's perception of its physical and psychological terrain through an expansive range of media, materials, and environments. Smith forays into this territory using the methods and ideas of Postmodern sculpture without any of its irony, primarily a fluid engagement with political and conceptual concerns, an inventive use of disparate and unorthodox materials, and the production of objects grouped within larger installations.

Smith is largely self-taught and learned to depict the body not by drawing the nude, but from knowing it in a visceral, immediate way. She gained this experience by preparing death masks of her father and sister and while training to be an emergency medical technician in 1985. Smith's immersion in the organic aspects of human anatomy would help her better understand how the workings of the body (including her own) might be a resource for her art. The resulting direct physical and emotional encounter between the artist, the viewer, and Smith's independent sculptural objects, which isolate and make strangely surreal the body's various parts, such as the digestive system, spinal column, lymph nodes, and skin, clearly derives from Smith's investigative process. Smith's earliest sculptural works comprise body parts or organs, such as *Glass Stomach* of 1985, or *Untitled (Heart)*, a plaster heart encased in silver leaf from 1986. She cast *Womb* (1986) in shimmering bronze, a disembodied swollen uterus that is hinged on one side and split open to reveal its emptiness (see Posner, 1998). Similarly fragile and beautiful is *Ribcage* (1987), a white terracotta armature that is delicately sewn together with thread and hung, albeit precariously, on the wall. These bronzed and gilded pieces are formally intricate and masterful, unlike the medical models from which they derive inspiration. At the same time, Smith chooses and even relies upon a certain vulnerability or evanescence within her forms; this particular approach to the tenuity of her art represented, according to Smith, a certain feminist sensibility that included a commitment to crafts-oriented materials and more personal, private iconographies. Although Smith's sculptures disregard conventional codes of beauty, the work retains an aura of preciousness and tenderness, qualities that might also be interpreted as beautiful.

Smith's first full-size sculptures of the body were a male and female couple made from beeswax in 1990 (*Untitled*). Profoundly corporeal, both bodies are sensitively modeled such that the surface of their "skin" evokes the signs of battering, bleeding, bruising, and even decay. The female figure's nipples leak milk, thereby reinforcing a sense of vitality and life to the pair, despite the fact that they hang, corpselike, from tall metal poles that stand away from the wall so that the viewer can walk around these painfully brutal effigies. Other whole figures followed, both male and female, although the latter predominated. These included *Virgin Mary* (1992), sculpted of wax with pigment, cheesecloth, and wood, *Pee Body* (1992), made of wax and glass beads, and *Tale* (1992), comprised of wax, pigment, and papier mâché. Smith has acknowledged the dual influences of art history and religious mysticism—especially Catholicism—on her work. The major mysteries of that religion, "the Immaculate Conception, the Crucifixion and the Resurrection . . . the Ascension and the Assumption of the Virgin Mary emphasize the role of the human body as vessel of divine spirit" (see Heartney, 1997). In *Virgin Mary*, the figure is naked, standing tall with feet together and hands upturned, perhaps in supplication, surrender, or even acceptance, but her skin has been removed, revealing the sinewy tapestry of bone and muscle that undergirds human flesh. In each of these works Smith reveals how earthly pain might symbolize spiritual, psychological, and emotional trauma. Rather than emphasize the preciousness or transcendence of such subjects, however, Smith's figures are exposed in all their embarrassingly intimate and abject physicality, as if to suggest the divinity of the lowly. The sculptures speak to corporeality in all its functions: giving birth, lactating, defecating, urinating, bleeding, and dying.

Interested in reclaiming the body, especially the female body, without resorting to idealizing it, Smith went on to present Western mythological heroines as powerful and transgressive archetypes. For example, Smith's *Lilith* (1994) depicts the Norse goddess, who according to myth ate her own children, as an agile creature crawling ferally upside-down on the wall.

According to the artist, the body is a universal motif that individuals each experience uniquely and differently. Smith's primary attraction to the body stems from its symbolic inconclusiveness and consummate ability to signify an array of ideas and subjective associations. Smith's work builds on critical issues of 1970s feminist art—in particular multimedia artists Louise Bourgeois, Nancy Spero, Hannah Wilke, and Judy Chicago. Smith claims that the Western (and certainly feminine) body is (culturally) subject to subjugation, dismissal, and disappearance. She allies herself with a group of 1970s feminists who have continued to highlight the culturally devalued arenas of women's history, the body, nature, and the decorative arts. Smith subtly merges these taboo aspects of humanity with the more prized ones of science, the intellect, and culture. Her work evokes the historical 17th-century

Cartesian mind-body dualism that she treats with complexity and compassion in pieces such as her Neoclassically inspired statue *Train* (1993), which menstruates glistening jewel-like red beads, or a piece made in response to the AIDS epidemic, *Untitled* (1986), a wall-mounted shelf of apothecary jars, each etched in Gothic script with the name of a bodily fluid: blood, semen, sweat, pus, mucus, saliva, and so on. The work invokes not only the taboo of bodily disease and decay, but its medicalization and scientific treatment.

Smith's sources are varied and rich, and include specific motifs in the realm of art history such as the figure, portraiture, and the still life. Smith explores a spectrum of materials as egalitarian as her sources of conceptual inspiration; and since the 1990s she has expanded her métier to include photography, video, and multimedia installation. Smith's inventive and adventurous use of paper, wax, glass, plaster, fabric, ceramics, fiberglass, beads, bronze, and steel have prompted critics to interpret her work as redefining and reinterpreting the body through the framework of 1970s feminism, but with all the subtlety and evocativeness of sculptors such as Louise Bourgeois and Eva Hesse. Bourgeois and Hesse were among the first artists of their generation to imaginatively rework the body into abstraction through the Anti-Form aesthetic, using primarily soft materials such as latex, plaster, wax, and paper. In Smith's work, paper is sewn and used for papier mâché, offering a translucence and vulnerability to her figures that is reminiscent of veils of skin. Although paper is an unusual material for sculpture, it is ideal as a medium for conveying the body's fragility and transience. In particular, Smith has incorporated the contrasting and vulnerable surfaces such as are found in Hesse's transubstantiations in latex and rubber. Although Hesse's work is more abstract than Smith's, it suggested ways to give emotional and societal traumas a strong, physical presence that rely less upon the subject matter (or narrative) than on the material means of communication. From Bourgeois's work, we can perceive the expressionistic, emotion-wrought surfaces as well as an iconography that evokes female embodiment or experience.

Smith's borrowing of less conventional sculptural materials has also been informed by the previous generation of Minimalist and Postminimalist sculptors (including her father, the Minimalist sculptor Tony Smith and his one-time assistant Richard Tuttle), who demonstrated that material choice is primary to the sculptural practice. Moreover, Christian iconography and ritual, medieval prayer books, 16th- and 17th- century anatomical studies, Northern European art of the Late Gothic period, mythology, and fairy tales all function as sources of visual interest for Smith in her work, many of which appear and reappear both symbolically and as iconography in her corpus.

Like much contemporary sculpture, Smith's artwork is more fully understood under the rubric of Installation art. Conceived of as parts of larger environments, Smith's figures, her scattered floor pieces, and her miniature "curios" are orchestrated to create complex tableaux with fluid and interchangeable meanings. This is exemplified in her first solo installation at New York City's alternative gallery space, the Kitchen in 1982, *Life Wants to Live*, which was an all-over sensory environment of changing images and sounds alluding to the constant striving of the life force. Correlatively, Smith's later figural sculptures challenge convention and express insurgence through physical acts of defiance. While she gained recognition during the early 1990s, a time in the New York art world's history in which highly charged political art seemed to be the norm, Smith's works were subversive without resorting to agitprop. Her sculptures represented a healing synthesis of the culturally polarized concepts of the physical and spiritual, which lay at the heart of the debates on gender, sexuality, religion, and medicine. Her work is part of a constellation of artists, including Ann Hamilton and Robert Gober, who rely on a humanistic practice of exploring the subjective and objective world, and beyond that, the cosmos. Likewise, spirituality is shown as a part of the human compulsion for myth-making and is not definitively Egyptian, Greek, or Christian. In Smith's work, it is a creative tapestry of all of these things. Consequently, although centered on the primary issues of her generation, Smith's oeuvre has a timelessness that eclipses cultural specificity.

CLAIRE SCHNEIDER

See also **Contemporary Sculpture; Bourgeois, Louise; Hamilton, Ann; Hesse, Eva; Installation; Minimalism; Postmodernism**

Biography

Born in Nuremberg, Germany, 18 January 1954. Grew up in South Orange, New Jersey; daughter of the Minimalist sculptor Tony Smith; granddaughter of an altar carver; sister of Seton Smith, a photographer/artist. From childhood through her early twenties, exposed to art informally (helped build father's models, made array of craft-oriented objects, such as puppets, and participated in avant-garde performance and music in various settings); attended Hartford Art School, 1974–76; moved to New York City, joined Collaborative Projects (Colab), 1976; started working in glass at New York Experimental Glass Workshop, 1985; began working at Art Foundry in New Mexico, 1992; first

solo commercial gallery exhibition, Joe Fawbush Gallery, New York, 1988; joined Pace Gallery, New York, 1994; exhibited in Aperto section of Venice Biennale, 1993. Lives and works in New York City, United States.

Selected Works

1983	*Hand in Jar*; glass, algae, latex, water; collection of the artist
1984–86	*Honey Brain*; cardboard, beeswax (no longer extant)
1985	*Glass Stomach*; glass; collection of the artist
1986	*Womb*; bronze; collection of Jane L. Smith
1986	*Untitled*; 12 glass jars arranged on a shelf; private collection
1986	*Untitled (Heart)*; plaster with silver leaf; collection of Knight Landesman
1987	*Ribcage*; terracotta, ink, thread; Guggenheim Museum of Art, New York City, United States
1990	*Pee Body*; paper; collection of the artist
1990	*Untitled*; beeswax and microcrystalline wax male and female figures on metal stands; Whitney Museum of American Art, New York City, United States
1992	*Virgin Mary*; wax with pigment, cheesecloth, wood on steel base; collection of the artist
1993	*Train*; wax, glass beads; private collection
1994	*Lilith*; silicon, bronze, glass; Metropolitan Museum of Art, New York City, United States
1995	*Jersey Crows*; silicon bronze; private collection
1996	*Sky*; glass, bronze; collection of the artist
1997	*Lot's Wife*; bronze; The Detroit Institute of Arts, Michigan, United States

Further Reading

Colombo, Paolo, et al., *Kiki Smith* (exhib. cat.), The Hague: Sdu, 1990

Haenlein, Carl Albrecht, editor, *Kiki Smith: All Creatures Great and Small* (exhib. cat.), Hannover, Germany: Kestner Gesellschaft, 1998 (in German); New York: Scalo, and London: Thames and Hudson, 1999 (in English)

Heartney, Eleanor, "Postmodern Heretics," *Art in America* 85 (February 1997)

Kiki Smith (exhib. cat.), London: Trustees of the Whitechapel Art Gallery, 1995

Kiki Smith: Unfolding the Body (exhib. cat.), Waltham, Massachusetts: Rose Art Museum, Brandeis University, 1992

McCormick, Carlo, "Kiki Smith," *Journal of Contemporary Art* (summer 1991)

Posner, Helaine, *Kiki Smith*, Boston: Bulfinch, 1998 (with a thorough bibliography)

Schleifer, Kristen Brooke, "Inside and Out: An Interview with Kiki Smith," *Print Collector's Newsletter* 22 (July–August 1991)

Shearer, Linda, and Claudia Gould, *Kiki Smith* (exhib. cat.), Columbus: Wexner Center for the Arts, The Ohio State University, 1992

Tallman, Susan, "Kiki Smith, Anatomy Lessons," *Art in America* 80 (April 1992)

Tillman, Lynne, *Madame Realism*, New York: s.n., 1984

LOT'S WIFE
Kiki Smith (1954–)
1997
bronze
h. 2.06 m
The Detroit Institute of Arts, Michigan, United States

Lot's Wife is one in a series of full-scale figurative bronze sculptures based on women from the Bible, created by Kiki Smith approximately between 1993 and 1997, a group that also includes the *Virgin Mary*, *Lilith*, and *Mary Magdalene*. A first version of this subject, made of plaster and salt (1993), is no longer extant.

The fate of Lot's wife is a minor though dramatic episode in the story of Lot (Genesis 19:15–26) and the destruction by fire of Sodom and Gomorrah. Lot welcomes two angels, arriving at the gates of Sodom, and gives them hospitality for the night. He protects the angels from a marauding band of Sodomites, and the angels warn Lot that God is about to destroy the cities of the plain for their iniquities and counsel him to flee with his wife and daughters. They admonish the family not to look back at the destruction as they flee: "Flee for your life; do not look back . . . lest you be consumed." But Lot's wife, apparently unable to resist the temptation, ignores their warning and looks over her shoulder. She is turned instantly into a pillar of salt, while Lot and his daughters continue their escape. The verse describing the moment of her transformation is the only time Lot's wife is directly mentioned. Unlike her husband and two daughters, she has no recorded given name and no other personal history. Her importance for the narrative lies only in her function as an example of swift and exacting punishment for failure to obey God. She is neither mourned nor referred to again in the continuing story of Lot and his daughters.

Smith has described *Lot's Wife* as "looking back to her people, the past, and the physical" (see Posner, 1998). She has given the figure convincing physical substance through rough, abstracted modeling with little realistic detail. An uneven, bubbly surface suggests the violence of the instantaneous transformation into salt. The thick grayish-white patination and crys-

Kiki Smith, *Lot's Wife*
Founders Society Purchase, W. Hawkins Ferry Fund, with funds from the Friends of Modern Art
© 1997 The Detroit Insitute of Arts and Pace/Wildenstein, New York

talline-like accretions on the surface belie the use of bronze (the work at first appears to be made of cement) and mimic the material that Lot's wife's body has become. Smith's *Lot's Wife* portrays the moment of transformation: head turned just enough to glance over her shoulder, she has begun to stiffen and become columnar. Depicted without feet, as if already losing her connection to the earth and humanity, she is a figure in stop-action, halfway between a living being and an object. For Smith, *Lot's Wife* is an analogy of matter and mind.

Smith's work prompts the viewer to realize a greater awareness of one's own experience of the body and also of the ways in which external forces can manipulate that experience. This episode of corporeal transformation, retribution for sexual curiosity and disobedience, is for Smith an example of the Catholic predilection for personalizing emotional and spiritual ideas, as well as an instance in which women are expendable and their histories unrecognized. In Smith's view, Lot's wife was open to her own vulnerability,

yet she was not a victim. She is neither pathetic nor tragic. The sculpture portrays her action as an unrepentant willingness to take the risk. Her calm demeanor and air of self-containment in this moment of violent change implies an acceptance of the consequences of her transgression. Smith's retelling of the story of Lot's wife, who is usually seen as an example of the weaknesses inherent in the feminine, is one of independent thinking in the face of male power and convention.

Through works such as *Lot's Wife*, Smith challenged and radically altered the tradition of figurative sculpture, engaging and reshaping the religious, literary, and art historical tales that have governed the way humankind perceives its origins and being. Smith's choices of both subject and medium bring a fresh view of the communicative and narrative possibilities of bronze. The evocative surface treatment adds a critical element to the narrative that would be communicated less directly in a traditional bronze finish. More important, her female subject is unidealized, not erotic, yet the implications of both the narrative and the depiction of the figure itself are sexual. Although the figure is nude, it clearly portrays an older woman; her sagging breasts, thick waist, and rounded belly suggest her personal history of bearing children. As in her treatment of the other women of this series, Smith suggests a three-dimensional personality as well as a body, rescuing Lot's wife from her identity as a didactic symbol and drawing strength from the tension of the pull between the individual and the universal. The work itself, although subtle and allusive, revives a narrative tradition of sculpture, this time focusing on aspects of female experience hidden from view in the long history of men depicting women.

MARYANN WILKINSON

Further Reading

Heartney, Eleanor, "Postmodern Heretics," *Art in America* 85 (February 1997)
Posner, Helaine, *Kiki Smith*, Boston: Bulfinch, 1998

ROBERT SMITHSON 1938–1973 *United States*

Robert Smithson is remembered by the general public for his contributions to the earthworks, or Land art, movement that arose in the United States in the late 1960s and early 1970s. His *Spiral Jetty* is one of the best-known works of 20th-century art and is seen by many as the quintessential expression of the Earthworks movement.

Smithson, however, was much more than a protagonist of earthworks, and he looms larger in the history of American art as we gain more hindsight into his

career. He was a graphic artist, a painter, a sculptor, a lecturer, a filmmaker, and an art critic of great (if relatively unschooled) talent. Smithson used all of these media, or outlets, to challenge the many assumptions about art that prevailed in New York at mid century. On the one hand, Smithson has been called one of the first Postmodern American artists because he vigorously questioned the Modernist ideas of critics like Clement Greenberg and artists such as Jackson Pollock. As one recent biographer put it, Smithson was concerned, a generation ago, with issues that emerged from the critical dialogues of Modernism and Postmodernism in art and philosophy. His themes included art's place in time and history; the possibilities and the limits of decentering the structure, site, and context of the work; the question of the medium (earth, for example), its resistance to form, and art's ability (or inability) to let matter challenge our conceptions and presuppositions; the role of language and textuality in reading art work; and the place of the artist after and despite the collapse of modern conceptions of creativity, genius, and autonomy (see Shapiro, 1995). On the other hand, Smithson's sublime Earthworks have been tied to a lingering yearning for the Romantic landscape and its place within the world of human endeavors. Critics such as Donald Kuspit have noted the essentially Modernist quality of Earthworks such as Smithson's that seem "to articulate living death (the sublime) and to advocate spiritual rebirth in the same breath, as though they were aspects of the same indescribable, unnamable thing" (see Kuspit, 1993).

Smithson engaged not only the Modernist artists and critics of the New York School, but the entire Renaissance humanist tradition that seemed to him to separate humanity from the rest of the universe, to give humans the feeling that they were distinct from, and superior to, their environment. The Renaissance *Weltanschauung* (worldview) "cut art off . . . from a broader and deeper sense of reality, and falsified the relationship between art and the surrounding universe, making the art experience isolable from the 'real' " (see Flam, 1996). Smithson spent his brief career trying to create an art "that would be continuous, even to some degree coterminous, with the real world, . . . an art that could evoke the farthest reaches of time and the most remote and incomprehensible notions of space."

Smithson's career can be divided into several phases. Between 1955 and 1964, he was primarily a painter, draftsman, and graphic artist, experimenting with a variety of styles that were current in the New York art world at the time. He was strongly attracted at first to Abstract Expressionism, and works such as his 1959 *Walls of Dis* (a reference to Dante Alighieri's description of Hell) were painted in that style. But after a trip to Europe and several extended periods of

hitchhiking around the United States, his work became more representational and featured collages that contained references to themes as varied as natural history, science fiction, popular culture, and the symbols of various myths and religions. A typical work from this period, *It's King Kong* (1962), is reminiscent of concurrent pieces by Pop artists such as Robert Rauschenberg.

Around 1963–64, Smithson stopped exhibiting in order to reflect on how and what he might contribute to the art world. When he reappeared on the New York gallery scene in 1965, it was as a sculptor and a writer with a clear direction of his own, no longer imitating any of the other artists with whom he had been keeping company. He started to exhibit geometric sculptures made primarily of steel, plastics, and mirrors. Pieces from this period include *The Eliminator*, *Four-Sided Vortex*, and *Enantiomorphic Chambers*. These works were often construed as belonging to the Minimalist movement or the Conceptual art movement (two approaches rapidly emerging as the nascent avant-garde of the time), but Smithson's goals in creating these pieces had little to do with Minimalism or Conceptualism. He desired that the viewer see him or herself reflected in the art, and thus become part of the artwork; and he wanted to convey the idea, through multiple mirrored surfaces that reflected their surroundings in a very fragmentary manner, that human experience (particularly visual experience) was not necessarily as ordered, coherent, or rational as our conscious minds might desire it to be.

By 1968 Smithson had moved into a third and final phase of his oeuvre in which he took sculpture outside of the gallery and into the environment, often on a near monumental scale. His goal was to strengthen the connection between art and the real world (again, to make art "coterminous" with the real world), to remove art from what seemed to be the rarified, unnatural atmosphere of the gallery and museum space. Smithson, along with other Land artists such as Robert Morris, Richard Long, Michael Heizer, and Walter De Maria, radically redefined the boundaries of sculpture as a way of mapping an "expanded field" that included sculpture, landscape, and architecture and was not defined or limited by media or materials (see Krauss, 1986). Before embarking on the ambitious *Spiral Jetty* of 1970, he experimented with what he called *site/nonsites*, in which he collected stone, gravel, sand, maps, photos, and other objects from abandoned industrial sites and exhibited them, decontextualized, in the gallery. He also created what he called *mirror-displacements*, in which he would place mirrors randomly in an outdoor setting and photograph the scene, recording on film the visual distortions created by the mirror reflections. The mirror-displacements fractured

the subject's relation to a given space and implied that the landscape was not a stable, knowable entity, but rather subject to the vagaries of human activity and nature. Smithson relied on archeological metaphors in his critical writing about the artist's mind and creativity: "The deeper an artist sinks into the time stream the more it become *oblivion*; because of this, he must remain close to temporal surfaces . . . Floating in this temporal river are the remnants of art history, yet the 'present' cannot support the cultures of Europe, or even the archaic or primitive civilizations; it must instead explore the pre- and post-historic mind; it must go into the places where remote futures meet remote pasts" (see Smithson, 1968).

The *Spiral Jetty* was a natural outgrowth of Smithson's experiments with site/nonsite and the mirror displacements, and of his evolving ideas about the nature of art and the nature of the universe. So were the various land-reclamation projects that he proposed during the last three years of his life, only one of which became a reality: *Broken Circle/Spiral Hill*, a 1971 project located in Emmen, the Netherlands. To practice art as land reclamation was, according to one of its practitioners, Robert Morris, to restore and renew abandoned and nearly destroyed precious quarries, mines, and other vast sites as significant monuments of the 20th century.

Smithson, who was to be a major part of this ecological recrudescence, died in an airplane crash near Amarillo, Texas, while photographing the site for his latest project, *Amarillo Ramp*. As a result, he had to leave the development of this second phase of the Earthworks movement to those in the group who survived him, artists such as Morris, Nancy Holt, Michael Heizer, and James Turrell.

Smithson's vital legacy was the persistent way in which he challenged Modernist assumptions about art in the postwar era. In both his writings and his art, Smithson set a new standard for questioning the canons of art, a standard that leaves many contemporary artists and thinkers in awe.

MARK SULLIVAN

See also **De Maria, Walter; Heizer, Michael; Long, Richard; Modernism; Morris, Robert; Postmodernism; Turrell, James**

Biography

Born in Passaic, New Jersey, United States, 2 January 1938. Grandson of artisans who created decorative plasterwork for the New York City subway system, the Metropolitan Museum of Art, and elsewhere. Studied at The Art Students League, New York City, and the Brooklyn Museum School, 1953–56, while living with his parents in Clifton, New Jersey; moved to New York City, 1957; met artists such as Franz Kline, Sol LeWitt, Donald Judd, and Dan Flavin, and writers such as Jack Kerouac and Allen Ginsberg; taught art at the Police Athletic League, New York, 1959; first solo exhibition at Artists' Gallery, Lexington Avenue, New York City, 1959; first overseas solo exhibition at Galleria George Lester, Rome, 1961; exhibited geometric sculptures of steel, plastic, and mirrors, 1964–65; helped lead the Land art, or Earthworks, movement over next decade; published ideas on art and aesthetics widely, in journals such as *Artforum*, *Harper's Bazaar*, *Art International*, and *Metro*. Died near Amarillo, Texas, United States, 20 July 1973.

Selected Works

1964 *The Eliminator*; steel, mirror, neon; private collection, artist's estate

1965 *Enantiomorphic Chambers*; painted steel, mirrors (untraced)

1965 *Four-Sided Vortex*; stainless steel, mirrors; private collection, artist's estate

1968 *Gyrostasis*; painted steel; Hirshhorn Museum and Sculpture Garden, Washington, D.C., United States

1968 *Mono Lake Nonsite*; painted steel, cinders, map; La Jolla Museum of Contemporary Art, California, United States

1968 *A Nonsite, Franklin, New Jersey*; painted wood bins, metal ore; Museum of Contemporary Art, Chicago, Illinois, United States

1969 *Yucatan Mirror Displacement*; mirrors; temporary installation realized at an outdoor setting in Yucatan, Mexico

1970 *Partially Buried Woodshed*; woodshed, earth; Kent State University, Kent, Ohio, United States

1970 *Spiral Jetty*; black basalt, limestone, salt crystals, mud, water; Rozel Point, Great Salt Lake, Utah, United States

1971 *Broken Circle/Spiral Hill*; water, sand, rocks, earth; Emmen, the Netherlands

1973 *Amarillo Ramp*; earth, rocks; Stanley Marsh Ranch, Amarillo, Texas, United States

Further Reading

Boym, Per Bj., editor, *Robert Smithson Retrospective: Works, 1955–1973*, Oslo: National Museum of Contemporary Art, and Stockholm: Moderna Museet, 1999

Flam, Jack D., editor, *Robert Smithson: The Collected Writings*, Berkeley: University of California Press, 1996

Hobbs, Robert, *Robert Smithson: A Retrospective View—40th Venice Biennale 1982*, Ithaca, New York: Herbert F. Johnson Museum of Art, 1982

Hobbs, Robert, editor, *Robert Smithson: Sculpture*, Ithaca, New York: Cornell University Press, 1981

Holt, Nancy, editor, *The Writings of Robert Smithson*, New York: New York University Press, 1979

Krauss, Rosalind, "Sculpture in the Expanded Field," in *The Originality of the Avant-Garde and Other Modernist Myths*, London, England and Cambridge, Massachusetts: MIT Press, 1986

Kuspit, Donald, "The Only Immortal," in *Signs of Psyche in Modern and Postmodern Art*, Cambridge, Massachusetts: Cambridge University Press, 1993

Morris, Robert, "Notes on Art as/and Land Reclamation," in *Continuous Project Altered Daily: The Writings of Robert Morris*, Cambridge, Massachusetts, and New York: MIT Press and the Solomon R. Guggenheim Museum, 1993

Shapiro, Gary, *Earthwards—Robert Smithson and Art after Babel*, Berkeley: University of California Press, 1995

Sobieszek, Robert A., *Robert Smithson: Photo Works* (exhib. cat.), Los Angeles: County Museum of Art, and Albuquerque: University of New Mexico Press, 1993

Smithson, Robert, "A Sedimentation of the Mind: Earth Projects," originally published in *Artforum* (September 1968); reprinted in Nancy Holt, *The Writings of Robert Smithson*, New York: 1979

Tsai, Eugenie, *Robert Smithson Unearthed: Drawings, Collages, Writings* (exhib. cat.), New York: Columbia University Press, 1991

Spiral Jetty (aerial view from 1996)
© Scott T. Smith / CORBIS and Estate of Robert Smithson/ Licensed by VAGA, New York

SPIRAL JETTY

Robert Smithson (1938–1973)
1970
black basalt, limestone, salt crystals, mud, water
l. 457.2 m
Rozel Point, Great Salt Lake, Utah, United States

Spiral Jetty has become Robert Smithson's signature work. To many scholars it is the archetypal work of the Earthworks movement of the late 1960s and early 1970s. It is even seen, by some writers of today, as characteristically related to the shift from Modernist to Postmodernist art and philosophy in American art.

The *Spiral Jetty* was built in 1970 at Rozel Point on the northeastern shore of the Great Salt Lake in Utah. It is comprised of black basalt, limestone, salt crystals, mud, and water, all materials that were found near the site and moved into the lake by bulldozers to create a spiral 457 meters long, 4.6 meters wide, and 49 meters in diameter. In its creation, 6,032,800 kilograms of earth were moved for an artwork which, for most of the past 30 years, has been submerged in a lake in which the water level can change by as much as 3 meters from year to year.

Smithson was financially backed in his project by Virginia Dwan of Dwan Gallery in New York, who donated $6,000 toward its construction, and by Doug-

las Christmas, owner of the Ace Gallery in Los Angeles, who paid the $6,000 in production costs for the 30-minute film that documented the creation of *Spiral Jetty*.

Before creating *Spiral Jetty*, Smithson tried for several years to generate art that would transcend the limits of the museum or gallery space and challenge cultural and art world assumptions about the materials of art and the ways in which art is made. He became fascinated by the dynamics of *sites* and *nonsites* as he called it (or *sight* and *nonsight*): the idea of creating an artwork in a remote area where few people could actually see it and then exhibiting photographs of or materials from that site in a gallery or museum setting.

Smithson was drawn to that part of the Great Salt Lake partly because it was a remote place, and partly because he had heard that the water there had an almost unique reddish hue (due to algae) that could be found at only a few locations in the world. (Indeed, photographs of the work reveal shimmering, translucent and ever-changing coloristic effects ranging from reddish-pink to bluish-lavender.) When he got to Rozel Point, he was greatly impressed not only by the color of the water, but by the network of cracks on the floor of the lake, which seemed to suggest a spiral; by the spiral-shaped salt crystals that were lying everywhere in the area; and by a local legend that the lake was connected to the Pacific Ocean by an underground channel that created an enormous whirlpool in the middle of the Great Salt Lake. He was also moved by the entropy he found all around him at Rozel Point, the signs of decay and desolation that seemed to suggest "matter collapsing into the lake mirrored in the shape of a spi-

ral." The spiral is thus a metaphor for entropic flux as well as a symbol of regeneration and recrudescence.

In his 1972 essay, Smithson suggested that there were numerous literary and artistic influences at work within him when he was building the jetty. These, he said, became additional layers, or strata, of meaning in the *Spiral Jetty*. He was partly inspired, for instance, by a Constantin Brancusi sketch (an abstract labyrinthine portrait) of James Joyce as a "spiral ear" (1929). He was also reminded, at the time, of a Jackson Pollock painting entitled *Eyes in the Heat*, which seemed to capture the blazing sunlight and blood-red water found at the Great Salt Lake. Other influences included the pastoral landscapes of Baroque painter Nicolas Poussin, the writings of 17th-century scientist and philosopher Blaise Pascal, and Pythagoreanism.

Much of the critical discussion of the *Spiral Jetty* in the last 30 years has centered around whether the *Spiral Jetty* film and the essay (and some other outgrowths of the *Spiral Jetty* project, such as a photocollage and plans for an underground museum/visitor's center at Rozel Point) should be seen as works of art on par with the actual jetty itself. In the 1970s, the film and the essay were often seen as simply documentation of the Earthwork, but in recent years it has become clear that Smithson himself saw each manifestation of the project as having equal value, as being a serious, independent contribution to a different artistic discipline.

In the last few years, critics have also been trying to put the *Spiral Jetty* into a larger historical context, by seeing it, for instance, as an echo of the Futurist movement, or as having many parallels to the performance art movement of the 1970s. Two authors have even explored the similarities between the *Spiral Jetty* and Thomas Pynchon's 1973 novel, *Gravity's Rainbow*.

Among the most stimulating recent discussions of the *Spiral Jetty* have been the attempts by writers such as Gary Shapiro, Jessica Prinz, and Caroline A. Jones to understand the *Spiral Jetty* as an expression of Smithson's views on life and art. Jones focused on how Smithson was trying to get art out of the studio and the gallery space, whereas Prinz wrote at length about the *Spiral Jetty* project as a radical attempt to change the discourse on art that was going on at the time in New York art circles (see Jones, 1996; Prinz, 1991). Shapiro considered the *Spiral Jetty* as a work in which Smithson questioned not only "the place of the artist after and despite the collapse of modern conceptions of creativity, genius, and autonomy," but also the human tendency to think of oneself as separate from, and superior to, the surrounding universe (see Shapiro, 1995).

Due to severe drought conditions, the *Spiral Jetty* became visible again in the fall of 2002 for the first time in many years. The *Spiral Jetty* was acquired in 1999 by the Dia Center for the Arts as a gift from the estate of Robert Smithson. The Dia Center was instrumental in preserving other monuments of the Earthworks movement, such as Walter De Maria's *Lightning Field* of 1979 and Michael Heizer's ongoing *City Project* in Nevada. The Dia Center plans to create easier access to the *Spiral Jetty* site and to gather the documents relating to *Spiral Jetty* into a single archive for future scholars.

MARK SULLIVAN

Further Reading

Alloway, Lawrence, "Robert Smithson's Development," *Artforum* 11/3 (November 1972)

Beardsley, John, *Earthworks and Beyond: Contemporary Art in the Landscape*, New York: Abbeville Press, 1984; 3rd edition, 1989

Childs, Elizabeth C., "Smithson and Film: The Spiral Jetty Reconsidered," *Arts Magazine* 56/2 (October 1981)

Johnston, John, and Jeremy Gilbert-Rolfe, "*Gravity's Rainbow* and the *Spiral Jetty*," *October* 1–3 (1976)

Jones, Caroline A., *Machine in the Studio: Constructing the Postwar American Artist*, Chicago: University of Chicago Press, 1996

Krauss, Rosalind E., *Passages in Modern Sculpture*, London: Thames and Hudson, and New York: Viking Press, 1977

Leider, Philip, "How I Spent My Summer Vacation; or, Art and Politics in Nevada, Berkeley, San Francisco, and Utah," *Artforum* 9/1 (September 1970)

Owens, Craig, "Earthwords," *October* 19 (fall 1981)

Prinz, Jessica, *Art Discourse/Discourse in Art*, New Brunswick, New Jersey: Rutgers University Press, 1991

Shapiro, Gary, *Earthwards—Robert Smithson and Art after Babel*, Berkeley: University of California Press, 1995

MASSIMILIANO SOLDANI BENZI 1656–1740 *Italian*

Born in Montevarchi (near Arezzo) into a wealthy local family, Soldani traveled to Florence in 1675 to study the figurative arts. Count Ludovico Caprara and Marquis Cerbone Bourbon Del Monte introduced him to Grand Duke Cosimo III de' Medici. Pleased with the young man's talents, Cosimo commissioned him to prepare a series of medal designs. From 1678 to 1681 Soldani completed his studies at the Medici Academy in Rome, under the guidance of Ciro Ferri and Ercole Ferrata. After Soldani returned from Rome as a specialist in the execution of medals, Cosimo sent him to Paris for ten months of study with the medalist Joseph Roettier I. At the court of Versailles Soldani met Louis XIV, for whom he executed a medal. Upon his return to Florence Soldani set to reorganizing the mint and meeting the pressing demand for medals. He then

began an intense career as a goldsmith, silversmith, and creator of bronze sculptures in various sizes.

Under the patronage of Grand Prince Ferdinando de' Medici, Soldani executed important works such as the series of reliefs depicting an allegory of the *Four Seasons* and cast in two versions between 1708 and 1711. Heavily engaged in meeting pressing official requests, between the late 17th and early 18th century he worked mainly on major religious sculptures for the Church of S. Maria a Carignano in Genoa, the chapel at the Palazzo Sansedoni in Siena, and the collegiate Church of San Lorenzo in Montevarchi. Soldani also created refined mythological scenes drawn from Classical literature and worked a great deal in this vein for the Medici family and the Florentine nobility. Among his most interesting Arcadian sculptures is a pair of bronzes depicting *Leda and the Swan* and *Ganymede and the Eagle*, executed for Marquis Giovan Gualberto Guicciardini. In keeping with Florentine tradition, the artist devoted part of his work to copying ancient sculptures and 16th-century Tuscan masterpieces. Most of these pieces were commissioned by important foreign patrons, including the Prince of Liechtenstein and the Duke of Marlborough.

In the 1720s Soldani worked almost exclusively on two bronze funeral monuments for Valletta Cathedral, Malta. A series of medals dedicated to famous European personages distinguished the last part of his career. Soldani died at Villa Petrolo in Galatrona (near Arezzo) and was buried in the Church of S. Pier Maggiore in Florence.

SANDRO BELLESI

Biography

Born in Montevarchi, Arezzo (now in Italy), 25 July 1656. Went to Florence to study figurative arts, 1675; sent by Grand Duke Cosimo III de' Medici to Rome, where he studied at the Medici Academy with Ciro Ferri and Ercole Ferrata, 1678–81; studied with medalist Joseph Roettier I in Paris, 1681; returned to Florence, 1682, and was appointed director of the grand-ducal mint; worked assiduously for the Tuscan court and nobility, specializing in bronze and silver; received commissions from Genoa, Siena, and foreign countries (Austria, Germany, England, and Malta). Died at Villa Petrolo in Galatrona (near Arezzo), 23 February 1740.

Selected Works

1682 Portrait medal of King Louis XIV; bronze; Fitzwilliam Museum, University of Cambridge, England
1689–93 Four urns with putti and swans;

touchstone, bronze; Galleria Palatina, Florence, Italy
1691–93 Medallions with portrait of Francesco Feroni and ship emblem; bronze; Church of Santissima Annunziata, Florence, Italy
1691–94 *Jesus and St. John the Baptist as Children*; bronze; Museo degli Argenti, Florence, Italy
1692– Stories of the Blessed Ambrogio
1700 Sansedoni; bronze; Palazzo Sansedoni, Siena, Italy
1695–97 *Truth Revealed by Time*; gilded bronze; Liechtenstein Collection, Vaduz, Liechtenstein
1695– Urns depicting Amphitrite and Triton;
1700 bronze; National Gallery, London, England
1708–11 Reliefs of the *Four Seasons*; bronze; casts: Bayerisches Nationalmuseum, Munich, Germany; Windsor Castle, Berkshire, England
1711 Statues of *Dancing Faun*, *Wrestlers*, *Scythian*, and the Medici Venus (copies of ancient works); bronze; Duke of Marlboroughs's Collection, Blenheim Palace, Oxfordshire, England
1717 *Leda and the Swan* and *Ganymede and the Eagle*; bronze; Fitzwilliam Museum, University of Cambridge, England
1722–25 Tomb of Marcantonio Zondadari; bronze; Church of St. John, Valletta Cathedral, Malta
1725–29 Tomb of Manuel de Vilhena; bronze; Church of St. John, Valletta Cathedral, Malta

Further Reading

Baumstark, Reinhold, et al., *Die Bronzen der fürstlichen Sammlung Liechtenstein*, Frankfurt: Liebieghaus, 1986
Bellesi, Sandro, "Precisazioni su alcune opere eseguite da Massimiliano Soldani Benzi per il Gran Principe Ferdinando de' Medici," *Paragone* 497 (1991)
Bellesi, Sandro, "La scultura," in *Il Settecento a Prato*, edited by Renzo Fantappiè, Prato, Italy: CariPrato, 1999
Draper, James D., Johanna Hecht, and Olga Raggio, editors, *Die Bronzen der Fürstlichen Sammlung Liechtenstein*, Frankfurt: Liebieghaus, 1986
Kunst des barock in der Toskana: Studien zur kunst unter den letzten Medici (exhib. cat.), Munich: Bruckmann, 1976
Lankheit, Klaus, *Florentinische Barockplastik: Die Kunst am Hofe der letzen Medici, 1670–1743*, Munich: Bruckmann, 1962
Lankheit, Klaus, *Die Modellsammlung der Porzellanmanufaktur Doccia: Ein Dokument italienischer Barockplastik*, Munich: Bruckmann, 1982
Lankheit, Klaus, and Jennifer Montagu, "Introduction," in *The Twilight of the Medici: Late Baroque Art in Florence, 1670–1743* (exhib. cat.), edited by Susan F. Rossen, Florence: Centro Di, 1974

Montagu, Jennifer, "Massimiliano Soldani's Bust of Enea Caprara Rediscovered," *Apollo* 100 (1974)

Nissman, Joan, *Florentine Baroque from American Collections* (exhib. cat.), New York: Columbia University Press, 1969

Pratesi, Giovanni, editor, *Repertorio della scultura fiorentina del Seicento e Settecento*, 3 vols., Turin, Italy: Allemandi, 1993

Procacci, Ugo, "Massimiliano Soldani architetto," in *Festschrift Ulrich Middeldorf*, edited by Antje Kosegarten and Peter Tigler, vol. 1, Berlin: De Gruyter, 1968

Vannel, Fiorenza, and Giuseppe Toderi, *La medaglia barocca in Toscana*, Florence: SPES, 1987

JESÚS RAFAEL SOTO 1923– *Venezuelan*

Jesús Rafael Soto, like other Latin American sculptors who were active in both Europe and Latin America, needs to be situated within the context of vanguard artistic tendencies in both Paris and Venezuela. Soto came to prominence in the French capital in the 1950s, but his influence on abstract art in Venezuela cannot be overlooked. In the same way that Lucio Fontana had ties to both the Italian avant-garde and to Post-Grupo Madi abstraction in Argentina early on in his career, Soto was involved with the Kinetic art movement in Paris as well as with the important Venezuelan artists Carlos Cruz Diez and Alejandro Otero.

Soto had solidified an artistic and intellectual friendship with his compatriots since their student days; consequently, they were all crucial in the development of abstraction in Venezuela. All shared, to a degree, a focus on spatial concerns, but it was Soto who advanced the idea that sculpture was not only an object in space but that there was a phenomenological relationship between it and the spectator that went beyond the optical and into the social field. Soto's sculptures are by nature kinetic yet paradoxically physically static, and their visual dynamism is activated by the movement of the spectator. Soto's mature sculptures are thus related to space, the temporal through the spectator's physical interaction with them, as well as the social history of the spectator that mediates his or her aesthetic experience.

Rhythm
© David Lees / CORBIS, (2003) Artists Rights Society (ARS), New York, and ADAGP, Paris

Originally trained as a painter, Soto's initial formal explorations into sculpture incorporated both forms of artistic practice. One of his early experiments after his arrival in Paris in 1950 consisted of two superimposed mounted plates of Plexiglas that jutted from the wall and were painted with irregular patterns and that seemed to shift as the viewer moved, creating a visual vibratory experience. What this early work also evinces is Soto's initial progression from painting to sculpture motivated by his search for a dynamic solution to what he thought was the inertia of the two-dimensional format. Although Soto's early works generally maintained an engagement with planarity that was a radical sculptural resolution to his painting, they increasingly began to be more kinetic and hence three-dimensional. The shift to the third dimension at first seemed to be inspired by optical experiments alone, and only later would it involve movement generated by the spectator.

Kineticism as a bona fide artistic endeavor was first associated with Paris-based artists such as Jean Tinguely, Yaacov Agam, and Victor Vasarely, but it also had its precursors in the work of Alexander Calder, Lázsló Moholy-Nagy, and the *Rotative Demi Sphere* (1925) and the *Roto-reliefs* (1925) of Marcel Duchamp. When Kinetic art was linked with the painter Victor Vasarely, whose work was concerned with optical effects, Soto was misconstrued as only engaging aesthetics, rather than trying to articulate a critical formalism that went beyond a retinal experience of art. This is evident in the *Penetrable* (1969), which was dependent on movement of the spectator for visual activation. This sense of movement in relation to sculpture was something that the Brazilian artists Hélio Oiticica and Lygia Clark were also exploring.

Where Soto differed from the Brazilians and with Tinguely, and what placed Soto in a class by himself, was in the total obliteration of any social referent in his purely abstract sculptures. Oiticica's *Bolides* (1967) occasionally incorporated photographs, and Clark's *Bicho* (1962) referred to a machine animal. Tinguely used found objects and other media that had readymade qualities, but it was Soto who used the most up-to-date synthetic materials that gave his work an otherworldly appearance that bordered on the futuristic. This aesthetic direction would culminate in his *Penetrable* and site-specific installations but was already discernible as early as the 1950s.

A work that manifested these tendencies was Soto's *Spiral with Red* (1955). Although still maintaining planarity, this work created a kinetic illusion that seemed to encompass and subsume the viewer and theoretically collapse the work of art and its site of visual experience. What aided this formal innovation was the material that became a Soto artistic trademark:

Plexiglas. This material allowed Soto to construct planes that were embellished with various colors. He called this body of work *Kinetic Structures of Geometrical Elements*. Soto maintained this strategy of line, vertical stripes in various configurations on planes in assorted units, until 1957.

After 1957 Soto's work began to free itself from planarity and occasionally acquired a mobile-like quality. Soto's hanging sculptures expanded Calder's use of the mobile in that they created a different overall visual sensation and relationship with the spectator, for they were sometimes dependent on physical interaction, thus diminishing the divide between the art object and the real world. Spectator dependency was underscored by the use of lighting in the hanging sculptures that altered their visual experience as one moved in relation to them. These works were followed by indoor and outdoor installations, which further explored the dynamic between the work of art, the spectator, and the social use of form beyond aesthetic ends. Evidencing this is *Kinetic Sculpture* (1967), which was a mass of suspended rods that revolved by mechanical motion and that appeared to envelop the spectator. It is with this work as well as with his earlier *Vibrating Columns* (1965) that we can see Soto progressing toward his most famous and innovative sculpture: *Penetrable*.

In 1969 Soto created *Penetrable*, a work consisting of nylon fibers that hung from metal rods from the ceiling. With this work the spectator finally becomes a full participant, for *Penetrable* was dependent on the participant's penetration into it from the periphery into the center. Not only was *Penetrable* visual, but its experience was also contingent on tactility.

Soto's *Penetrable*, as well as his overall oeuvre, was a major contribution to kinetic art in general. Yet Soto advanced sculpture into wholly different registers by reconfiguring the relationship between artwork and reception, between object and subject, between the aesthetic and the social.

RAÚL ZAMUDIO

See also **Calder, Alexander; Duchamp, Marcel; Fontana, Lucio; Latin America; Moholy-Nagy, Lázsló; Tinguely, Jean**

Biography

Born in Cuidad Bolivar, Venezuela, 5 July 1923. As a teenager, worked as commercial painter creating movie posters for Cuidad Bolivar Theatre; studied at Escuela de Artes Plásticas, Caracas, on scholarship, 1942–47; director, Escuela de Bellas Artes, Maracaibo, 1947–50; first exhibition at Taller Libre de Arte, Caracas, 1949; awarded six-month scholarship to travel to Paris, 1950; associated with Jean Tinguely, Yaacov Agam, and Victor Vasarely; exhibited at Salon des Réalistes Nouvelles, 1951 and 1954; began his *Vibration Series*, 1958; represented Venezuela at Brussels International Exposition, where he won Grand Wolf Prize, and participated in São Paolo Biennialĕ, 1958; exhibited at Venice Biennialĕ and won David Bright Prize, 1964; retrospective exhibitions, Museo de Bellas Artes, 1971, and Guggenheim Museum of Art, New York City, 1974. Lives and works in Paris, France, and Caracas, Venezuela.

Selected Works

1954 *Displacement of a Luminous Element*; paint, collage, Plexiglas, wood; Collection Patricia Phelps de Cisneros, Caracas, Venezuela

1955 *Kinetic Structure with Geometric Elements*; acrylic, Plexiglas, wood; private collection, Caracas, Venezuela

1955 *Spiral with Red*; Plexiglas, wood, enamel; Villanueva Collection, Caracas, Venezuela

1964 *Rhythm*; paint, wood, metal, nylon; private collection

1965 *Vibrating Columns*; metal, paint, wood; Jose Rafael Viso collection, Caracas, Venezuela

1965 *Vibration*; metal, oil, wood; Guggenheim Museum of Art, New York City, United States

1966 *Olive and Black*; metal, plywood, paint, composition board; Museum of Modern Art, New York City, United States

1969 *Penetrable*; metal, painted wood, nylon tubing; installation realized at Musée d'Art Moderne de la Ville de Paris, France

1970 *Global Writing*; metal, paint, wood; Collection Patricia Phelps de Cisneros, Caracas, Venezuela

1974 *Guggenheim Penetrable*; steel, nylon tubing; Guggenheim Museum of Art, New York City, United States

1975 *Hurtado Writing*; paint, wire, wood, nylon cord; Museum of Modern Art of Latin America, Washington, D.C., United States

Further Reading

Amaral, Aracy, "Abstract Constructivist Trends in Argentina, Brazil, Venezuela, and Columbia," in *Artistas latinoamericanos del siglo XX; Latin American Artists of the Twentieth Century* (bilingual Spanish-English edition; exhib. cat.), by Waldo Rasmussen, New York: Museum of Modern Art, 1993

Boulton, Alfredo, *Soto*, Caracas, Venezuela: Armitano, 1973

Boulton, Alfredo, and Masayoshi Homma, *Jesús Rafael Soto*, Kamakura, Japan: Museum of Modern Art, 1990

Brett, Guy, *Kinetic Art*, London: Studio-Vista, and New York: Reinhold, 1968

Carvajal, Rina, "Venezuela," in *Latin American Art in the Twentieth Century*, edited by Edward J. Sullivan, London and New York: Phaidon Press, 1996

Joray, Marcel, and Jesús Rafael Soto, *Soto*, Neuchâtel, Switzerland: Editions du Griffon, 1984

Soto (exhib. cat.), New York: Marlborough-Gerson Gallery, 1969

Soto: A Retrospective Exhibition (exhib. cat.), New York: Solomon R. Guggenheim Museum, 1974

Soto: Cuarenta años de creación, 1943–1983, Caracas, Venezuela: Museo de Arte Contemporáno de Caracas, 1983

Soto: Oeuvres actuelles, Paris: Centre Georges Pompidou, Musée National d'Art Moderne, 1979

SPAIN: ROMANESQUE

Sculpture in Spain from the Romanesque period of the 11th and 12th centuries includes architectural works and representations of saints and other holy figures, as well as funerary monuments and church decorations. A division in materials largely distinguished sculptural type: architectural and funerary sculpture derived from stone, hagiographic works from polychromed wood, and church decorations from ivory, metal, or wood. One may witness many exceptions to this general rule, however, such as the stone furnishings by Master Mateo for the Cathedral of Santiago de Compostela.

Scholars have long recognized that during the Romanesque period the Muslim presence in Iberia greatly affected the development of sculpture, indeed of all the arts. While at least three-quarters of the peninsula rested in Muslim hands at the beginning of the 11th century, Christians progressively drove the Muslims south; by 1085, Toledo, in the center of the country, was conquered, but not until 1492 were the Muslims definitively expelled from Iberia. While many and varied examples of cultural interchange existed between the various peoples who inhabited the peninsula during the Middle Ages, and while motifs can be seen to have been widely exchanged, evidence also shows that some Romanesque sculpture was propagandistic, or at least expressed a Christian response to the presence of people seen as intruders. Williams has called the unusual choice of Genesis scenes for the main entrance to the Romanesque Church of San Isidoro in León, which opens from the church's south aisle, virtual "reconquest iconography" (see Williams, 1977). In addition, some have seen the portal at Santa María at Ripoll, which contains many scenes derived from Old Testament manuscript illuminations produced in the 11th century in Catalonia, as reflecting Catalan pride in recent Christian victories.

If the campaign against the Muslims brought a certain unity of spirit to the various counties and kingdoms of northern Spain, so too were these regions unified by the activities that took place on the pilgrimage road to the Cathedral of Santiago de Compostela in northwest Spain, a route that crossed Spain's Christian kingdoms. Santiago de Compostela was the reputed burial site of the apostle James, whose fame spread rapidly throughout Europe during the Romanesque period and whose tomb and the cathedral that housed it had become objects of significant veneration. Although scholars perhaps once overemphasized the importance of the pilgrimage road for the development of Romanesque art in Spain (see Porter, 1923), works along the route certainly reveal a stylistic concordance, such as at Jaca, León, Frómista, and Santiago de Compostela, to cite some major Iberian centers. In fact, Spanish sculpture of the period stood at the center of many early 20th-century investigations on Romanesque art that attempted to trace various sculptors and styles across Italy and France, as well as into Spain. An international troupe of investigators discovered and then published their findings on Romanesque monuments. In many cases the apparent goal was to establish the precedence of one region over another, leading to such discussions as the so-called Spain or Toulouse controversy or the Jaca-Modena debate.

The efforts of these scholars were rewarded by the wealth, in both quantity and quality, of Romanesque sculpture found across the north of Spain. At Santiago, for example, an early 12th-century portal, the Puerta de las Platerías, contains sculpture designed for that location as well as sculpture originally included on the cathedral's north and west portals. The present west portal, the Pórtico de la Gloria, is the work of Master Mateo and dates to 1188. The presence of monumental portals along the pilgrimage roads, for example, at Jaca, Sangüesa, Estella, Carrión del los Condes, León, and Compostela, warrants attention, although fully carved portals can also be found in a variety of other locations, including Ripoll in Catalonia, Uncastillo in Aragon, and Soria in Castille.

In addition to portal decorations, carved capitals and corbels decorate a large number of Romanesque churches. Architectural sculpture can also be appreciated in decorated cloisters that survive in Spain: Ripoll, Girona, San Benet de Bages, San Cugat del Vallès, San Juan de la Peña, Silos, Pamplona (whose capitals are today in the Museo de Navarra), San Pedro de la Rua at Estella, and Soria are noteworthy. While major cloister programs certainly also existed outside Spain, the combination in northern Spain of summers warmed by intense sun and winters chilled by coastal and mountain breezes allows the modern visitor to appreciate the Iberian cloister as an exceptionally well-appointed monastic feature.

A common interest in the antique past also manifests itself in Spanish Romanesque sculpture, evident in stylistic terms and also in the employment of various motifs, such as the Chrismon (the monogram of Christ), which appears in the tympana of a large number of churches in Aragon and Navarra. Moralejo-Alvarez's analysis points to the importance of the 2nd-century sarcophagus from Husillos (today in the Museo Arqueológico Nacional, Madrid) that must have been seen by sculptors working at nearby Frómista and that also served as a model for figure types and arrangements at Jaca and Santiago de Compostela, as well as at other sites along the pilgrimage road (see Moralejo Alvarez, 1976). A virtual homage to antique style can be seen in the work by the so-called Cabestany Master, who was probably Italian but worked in Catalonia and Navarra, as well as in France. He was involved in the decorations of the large program at San Pere de Rodes (Girona), where his *Calling of Saints Peter and Andrew*, today in the Museo Frederic Marés in Barcelona, is actually carved on the back of an antique sarcophagus.

Despite certain unifying themes and tendencies across the north of Spain, regional schools or centers often reflect a predilection for a certain type or style of art. Thus, León seems to have been a center of ivory production, Burgos (or Silos) a center of enamel and metalwork, and Catalonia a center of carved and painted altar frontals and polychromed wooden deposition groups and crucifixes.

The Romanesque style had a long life in Spain. Many of the major Romanesque sculptural groupings, in fact, were carved in the second half of the 12th century, after the introduction of Gothic style in France. These include works at Avila, Carrión de los Condes, Santiago de Compostela, and the Cámara Santa at Oviedo, as well as the large body of work credited to the so-called San Juan de la Peña Master and his assistants or followers. One suspects that the long survival of the Romanesque style in Spain is not so much a provincial adherence to old forms—since Spanish artists reflected a clear awareness of French styles and developments—but a reflection of the concerns and values that distinguished Spain from its northern neighbor.

Spain's relative poverty and the disastrous social consequences of the Spanish civil war of the 1930s made Spanish art the easy object of foreign collectors. American museums acquired many works of Spanish Romanesque sculpture, such as the altar supports from the monastery of San Paio de Anteáltares at Santiago de Compostela (Fogg Art Museum, Cambridge, Massachusetts), the tympanum and lintel from Errondo (Metropolitan Museum of Art, New York), and the portal from San Miguel de Uncastillo (Boston Museum of Fine Arts).

DAVID L. SIMON

See also **Polychromy; Spain: Gothic**

Further Reading

The Art of Medieval Spain: A.D. 500–1200, New York: Metropolitan Museum of Art, 1993

Canellas-López, Angel, and Angel San Vicente Pino, *Aragon roman*, La Pierre-Qui-Vire, France: Zodiaque, 1971

Chamoso-Lamas, Manuel, and Bernardo Regal, *Galice romane*, Saint-Leger-Vauban, France: Zodiaque, 1978

Durliat, Marcel, *L'art roman en Espagne*, Paris: Braun, 1962

Durliat, Marcel, *La sculpture romane de la route de Saint-Jacques: De conques à Compostelle*, Mont-de-Marsan, France: Comité d'Études sur l'Histoire et l'Art de la Gascogne, 1990

Junyent, Eduard, *Catalogne romane*, 2 vols., La Pierre-Qui-Vire, France: Zodiaque, 1960–61

Moralejo Alvarez, Serafin, "Sobre la formación del estilo escultórico de Frómista y Jaca," in *Actas del XXIII Congreso Internacional de Historia del Arte*, Granada, 1973

Lojendio, Luis-María de, *Navarre romane*, La Pierre-Qui-Vire, France: Zodiaque, 1967

Palol, Pedro de, and Max Hirmer, *Early Medieval Art in Spain*, London: Thames and Hudson, and New York: Abrams, 1967

Porter, Arthur Kingsley, *Romanesque Sculpture of the Pilgrimage Roads*, 10 vols., Boston: Jones, 1923

Rodríguez, Abundio, *Castille romane*, 2 vols., La Pierre-Qui-Vire, France: Zodiaque, 1966

Viñayo-González, Antonio, *L'ancien royaume de León roman*, La Pierre-Qui-Vire, France: Zodiaque, 1972

Williams, John, "Generationes Abrahae: Reconquest Iconography in León," *Gesta* 16 (1977)

SPAIN: GOTHIC

The definition of Gothic sculpture is clearer for France than it is for Spain because the definitive forms, the statue column (a figure carved in the form of a column) and the pointed ribbed vault, appeared together at the Abbey of Saint-Denis in the Île-de-France, about 1140. The introduction of Gothic sculpture into Spain is best understood by separating style, subject matter, and format, since these elements were imported in a number of differing ways.

In the Iberian Peninsula, "Gothic" subject matter—the glorification of the Virgin Mary, the celebration of the humanity of Christ and the saints, and the amplification of narrative—appeared in sculpture before the format of the typical French portal with statue columns. A prime example is the *Tree of Jesse*, a composition illustrating the genealogy of Christ. Burgundian manuscripts and French stained glass lie behind the several *Tree of Jesse* reliefs produced in Spain, the first being the relief (before 1158) in the cloister of the Abbey of Santo Domingo de Silos (Castile) and continuing with the *trumeau* column of the Pórtico de

la Gloria in the Cathedral of Santiago de Compostela (Galicia), about 1168–88, and the roughly contemporary apse columns in the Cathedral of Santo Domingo de la Calzada (Navarra). The first large-scale sculptural portrayals of the subject, these reliefs incorporate a particularly Spanish motif, a Trinity embodying the Church Triumphant, at the summit.

Gothic style first appeared in the Iberian Peninsula melded with local styles. In Silos, the cloister reliefs representing the *Tree of Jesse* and the *Annunciation-Coronation of the Virgin* initiated a stylistic movement associated with late Romanesque and Gothic art, using complex drapery to construct strongly three-dimensional figures. From 1170 to 1190 several impressive portals appeared. At the Church of Santa María la Real in Sangüesa (Navarra), a *Last Judgment* tympanum was set over slender statue columns derived from Chartres Cathedral; an artist's name, "Leodegarius," is inscribed.

Burgundy was an important source for Early Gothic art in Spain, as it was for France, but the Spanish sculpture maintains a distinctive quality of naturalism and expressiveness. For example, at the west portal of the Church of San Vicente in Ávila (Castile, *ca.* 1170–75), the statue columns in high relief turn to one another to converse, a harbinger of future developments. That same vivid presence of the figure is elaborated in the Pórtico de la Gloria of the Cathedral of Santiago de Compostela (Galicia), signed by Master Mateo in 1188. Old and New Testament figures gesture as if in conversation with those by their sides, as well as the figures across the porch, something that is seen later in the transept porches of Chartres. The Pórtico de la Gloria was one of the catalysts for the Classical revival of sculpture in the years around 1200.

During Blanche of Castile's regency in Paris (1226–34), Bishop Maurice of Burgos, who was educated in France, brought French sculptors to Burgos Cathedral. Burgos soon became the leading center of Gothic art in 13th-century Spain. The tympanum representing *Christ in Majesty* on the *Puerta del Sarmental* (1240–45) is closely related to the *Beau Dieu* at Amiens Cathedral (*ca.* 1230–35). The statue columns are under a continuous arcade, perhaps the first anywhere. Work continued at the cathedral through the early 14th century. The mature Burgos style is characterized by stocky figures, with broadly folded garments, gesturing to each other. This style is also seen in polychromed wood sculpture, such as the *Deposition* (*ca.* 1265) in the royal convent at Las Huelgas, near Burgos. Within the cathedral cloister, life-size statues appear at the corners of the arcade and on the walls. In the cloister portal, the diaper pattern of the castle (Castile) and lion (León) beneath the jamb figures and over the doorway emphasizes the cathedral's royal associations. Similar patterning decorates royal tombs, such as that of Alfonso VIII and Leonor Plantagenet at Las Huelgas.

Some sculptors went from Burgos to León to begin the cathedral there around 1255, work that continued into the 14th century. One of the most ambitious projects of the 13th century, the cathedral has triple portals at the south and west. They reflect the artists' Burgos experience and, just as clearly, contemporary Amiens and Reims Cathedrals. The sculptor of the *Last Judgment* portal (*ca.* 1275) produced one of the most memorable of such compositions for the west facade. Distinctive for the expressiveness and delicacy of his work, the master of the *Last Judgment* also produced the tomb of Martín Fernández (*d.* 1250) in the cathedral cloister. Another artist carved the *Virgen Blanca* (White Virgin) for the *trumeau*, the column that supports the tympanum of the Last Judgement. Several Castilian portals retain indigenous detail; for example, the polychromed portal of Toro Cathedral (Zamora; *ca.* 1270–80) is rigidly geometric, while at the Church of Santa María la Blanca of Villalcázar de Sirga (Palencia), local conventions are recognizable in the friezes with an *Apostolado* (apostles under an arcade) that spans the wall above the tympanum. Unlike French portals, Spanish portals include few allegorical figures, suggesting that popular accessibility predominated in portal design. At Toledo Cathedral, the *Puerta del Reloj* (Portal of the Clock, *ca.* 1289–1308) initiates a series of tympana and choir screens divided into several registers filled with narrative cycles, a device found internationally in large- and small-scale sculpture.

Sepulchral monuments develop the liturgical and lamentation scenes of earlier tombs, reflecting the custom of elaborate public displays of grief and a belief in the the Resurrection. Leodegarius, who signed the Sangüesa portal, may have produced the tomb of Queen Blanca (*d.* 1156) at Santa María la Real in Nájera, the model behind tombs such as those at the Church of Santa María la Blanca in Villalcázar de Sirga, exquisitely painted (*ca.* 1280–90), and at the monastery of Santa María in Alcobaça (Portugal). Often designed for circumambulation, lively narrative marks saints' monuments, for example, those of St. Vincent in San Vicente de Ávila (*ca.* 1170) and St. Pedro in the Cathedral of El Burgo de Osma (Soria, *ca.* 1258). Effigies include those of St. Domingo of La Calzada (*ca.* 1210–25), resembling Eleanor of Aquitaine's, and of Bishop Maurice (*d.* 1238) in the Cathedral of Burgos, in enamel. The tombs at Toledo inspired 14th-century production as far away as Seville. One of the finest Catalan sepulchres is that of Archbishop Lope Fernández de Luna (1376) in Saragossa Cathedral by sculptor and metalworker Pere

Moragues. In addition, stone and wood polychromed images of the Madonna and Child and of the Crucified Christ were produced in quantity to manifest the presence of the holy in every church.

In Navarra the transition to the Gothic can be traced through the churches of Tudela to Olite (*ca.* 1300) and the Cathedral of Pamplona's cloister. Its influential *Puerta preciosa* (*ca.* 1330), named for the verse "Precious in the sight of God," is a funerary portal with an extensive Marian cycle, culminating with *Mary's Coronation in Heaven*. Continuing artistic exchange with France is evident, but a later portal in the Pamplona cloister, with the *Dormition of the Virgin*, may be by a German artist. Counted among the great portals of the 14th century are those of Vitoria and Laguardia, Basque cathedrals that follow Pamplona. In Catalonia, by 1277, fully mature Gothic sculpture was produced at the Cathedral of Tarragona. Gerona, Huesca, Valencia, and Mallorca Cathedrals were in production from the late 13th through the 14th century.

It was during the 14th century that Catalan Gothic art flowered. Local alabaster was the material of choice for altarpieces and tombs. The Kingdom of Aragón united Aragón and Catalonia, extending from Cartagena, Saragossa, and Barcelona to Mallorca, Marseille, Sardinia, and Sicily. Italian art, therefore, had enormous impact in Catalonia. A Pisan artist carved the sarcophagus of St. Eulalia in Barcelona Cathedral, and, by 1327 had been contracted to carve the altarpiece there, and French, Italian, and English sculptors are documented together with their Catalan counterparts at sites such as the Monastery of Santes Creus. Ambitious projects for royal tombs were undertaken there and in Poblet Abbey, Catalonia, now largely destroyed. The brilliant artists working first under Master Aloy (1340–68) and then with Jaume Cascalls (1345–79) formulated the sculptural style of the second half of the 14th century, exemplified by Cascalls's works in Gerona, Poblet, and Tarragona. At Lérida Cathedral, where the full development from the Romanesque to the Gothic may be traced, Bartomeu Robio developed the altarpieces characteristic of the region. His gracefully idealized figures inhabit dramatically composed narrative panels.

The late 14th and 15th centuries were marked by the International Gothic style, a product of the papal court in Avignon, which brought together artists from northern and southern Europe and was nourished by the tastes of the powerful dukes of Burgundy, tastes that Spanish patrons shared. Pere Sanglada exemplified the internationalism of the moment with his trip in 1394 to Flanders to purchase the oak for the choir stalls he made for the Cathedral of Barcelona. Pere Oller, his apprentice, became an outstanding sculptor of alabaster altarpieces and tombs. The impact of Flemish sculpture and English alabasters in the Iberian Peninsula resulted in a combination of idealized beauty, still "Gothic" in its sensibility, with extreme naturalism. The Isabelline style, so-called after Queen Isabel, wife of Ferdinand, represents the final flowering of Spanish Gothic art, which lasted well into the 16th century.

ELIZABETH VALDEZ DEL ALAMO

Further Reading

Actas simposio internacional sobre "O pórtico da Gloria e a arte do seu tempo," Santiago de Compostela, 3–8 Outubro de 1988, Galicia, Spain: Xunta de Galicia, 1991

Ara Gil, Clementina-Julia, *Escultura gótica en Valladolid y su provincia*, Valladolid, Spain: Institución Cultural Simancas, Exma, 1977

Dalmases Bulañá, Núria de, et al., *Història de l'art català*, 9 vols., Barcelona: Edicions 62, 1983–96; see especially vol. 3, *L'art gòtic, s. XIV–XV*

Deknatel, F.B. "The Thirteenth-Century Gothic Sculpture of the Cathedrals of Burgos and Léon," *The Art Bulletin* 17 (1935)

Duby, Georges, Xavier Barral i Altet, and Sophie Guillot de Suduiraut, *La sculpture: Le grand art du Moyen Âge du Vᵉ au XVᵉ siècle*, Geneva: Skira, 1989; as *Sculpture: The Great Art of the Middle Ages from the Fifth to the Fifteenth Century*, translated by Michael Hero, New York: Skira/Rizzoli, 1990

Durán Sanpere, Agustín, *Los retablos de piedra*, 2 vols., Barcelona: Editorial Alpha, 1923–34

Durán y Sanpere, Austín, and Juan Ainaud de Lasarte, *Escultura gótica*, Madrid: Editorial Plus-Ultra, 1956

Español Bertran, Francesca, *El escultor Bartomeu de Robio y Lleida: Eco de la Plastica Toscana en Catalunya*, Lérida, Spain: Universitat de Lleida, 1995

Franco Mata, María Angela, *Escultura gótica en León*, León, Spain: Institución Fray Bernardino de Sahagún de la Excma, Disputación Provincial, 1976; expanded edition, as *Escultura gótica en León y provincia: 1230–1530*, León, Spain: Instituto Leonés de Cultura, 1998

Gómez Barcena, María Jesús, *Escultura gótica funeraria en Burgos*, Burgos, Spain: Excma, Diputación de Burgos, 1988

Sureda Pons, Joan, editor, *La España gótica*, Madrid: Ediciones Encuentro, 1987–

Williamson, Paul, *Gothic Sculpture, 1140–1300*, New Haven, Connecticut: Yale University Press, 1995

Yarza, Joaquín, *La edad media*, Madrid: Alhambra, 1980; 2nd edition, 1988

SPAIN: RENAISSANCE AND BAROQUE

The 16th through 18th centuries marked a period of dazzling sculptural activity in Spain. The production is, unfortunately, little known outside the Iberian Peninsula, largely for historiographical reasons and the overtly religious content of most Renaissance and Baroque pieces.

Spain participated actively in the Counter Reformation, and the resulting religious revival continued well into the 18th century as many new churches, monasteries, and convents were founded while others were

renovated, all of them requiring new artwork. The particular nature of the Spanish sculptural tradition dictated several aspects that distinguish these pieces from others in Europe, particularly in their vivid polychromy and the inclusion of naturalistic features. Most sculpture was executed in wood, frequently gilded and painted using a characteristic technique, *estofado* (a process in which paint is applied over gilding and then scratched away to reveal the gold below), to great effect. In pursuit of ever greater verisimilitude, sculptors often included features such as glass eyes or tears, real hair, accessories, and jewelry. Because patrons prized images that followed traditional types and evoked a strong emotional impact, artists had to adhere closely to an established iconography and thus worked within more limited parameters to demonstrate their talents. The vibrant, colorful imagery that they created differs considerably from the Neoclassical concept of pure sculpture and has further hindered an appreciation of their work. Perhaps the greatest obstacle to a proper evaluation of these sculptors lies in the nature of their art: to produce the monumental projects commissioned, most artists had to direct large workshops, a practice that frequently makes it difficult to define individual authorship and stylistic personalities beyond general traits.

Religious commissions typically ranged from enormous *retablos* (painted and gilt wood retables of great height), wood choir stalls, and stone tombs to smaller projects for conventual or domestic altars. Throughout the Renaissance and Baroque, sculptors executed most projects in wood. Although some celebrated sculptors created monumental stone altars, these became less common after the 16th century. Similarly, tombs, whether of marble, alabaster, or local stone, occurred less frequently in the Baroque era. Although exceptions exist (Granada Cathedral being the most notable), facades were generally left uncarved before the 18th century. Likewise, few figures or reliefs were carved in stone to decorate church interiors.

With its tradition of terracotta, Seville offers a significant alternative to the emphasis on polychromed wood found throughout Spain. In the late 15th and early 16th centuries Lorenzo Mercadante de Bretaña, Pedro de Millán, and Miguel Florentín sculpted monumental figures and reliefs in terracotta for the facade of the Seville Cathedral. Local artists, most notably Pietro Torrigiani in the 16th century and Luisa Roldán in the 17th century, also created celebrated freestanding figures and groups in this medium.

The case of gold, silver, and bronze sculpture presents more complications. Although few sculptors cast large-scale projects, the art of metalworking continued in Spain as goldsmiths and silversmiths, among the most famous of whom are members of the Arfe family,

created monumental *custodias*, or monstrances, for the display of the Host in the church and to be borne in processions. These works could include figures and reliefs of exceptional quality. Nonetheless, when the kings of Castile, Charles V and Philip II, wanted life-size bronze sculptures, they turned abroad to the Leoni family.

Unlike in Italy and other European countries during this period, secular sculpture and images deriving from Classical antiquity were almost completely absent in Spain. Furthermore, sculpture did not figure as prominently in royal and aristocratic collections as elsewhere in Europe, and the pieces that did appear were generally of religious subjects. Garden sculpture comprises a notable—if small—exception. When Philip II and Philip IV sought to decorate their palaces they turned to Italian and Flemish artists. Similarly, equestrian portraits of Philip III and Philip IV were commissioned from Giambologna and Pietro Tacca.

A stylistic analysis of Spanish sculpture of the 16th, 17th, and 18th centuries does not always conform readily with the traditional classifications of Renaissance, Baroque, and Rococo. At the end of the 15th century, Spain resembled northern Europe and France in its preference for an elegant Gothic style. In Castile, sculptors such as Gil de Siloé and Sebastián de Almonacid (Sebastián de Toledo) created impressive funerary monuments in this style, and another, Felipe Vigarny (*d.* 1542), began his career practicing the northern Gothic that he had learned in his native France. Erected during this period, the multistoried high altar at the Cathedral of Toledo represents another outstanding example of a Gothic work, here executed by a team of artists, many of them from northern Europe.

A greater familiarity in Spain with Italy in the early 16th century led to an adoption of Renaissance art, but it was generally limited to new systems of architecture and architectural decoration. Even so, Spanish artists showed little interest in the sense of balance and total composition found in Italy, preferring instead additive and decorative compositions. This understanding of the new style largely resulted from a different appreciation of Classical Antiquity; although Spaniards recognized its artistic achievements, they did not engage in the active dialogue with Roman art that Italian artists did, nor were there as many ruins or statues in Spain to inspire such endeavors. Thus the reception of Italian Renaissance motifs comprises an episodic and idiosyncratic history in which Spanish sculptors grafted new features onto traditional types, even as Gothic artists continued to practice their art well into the century.

Among the first monuments created in a completely Renaissance style are a series of tombs carved in Italy and imported to Spain. Not only did Italian sculptor

Domenico Fancelli (1469?–1519) carve several of these, but his example inspired other artists, such as Vasco de la Zarza (*d.* 1524) and Bartolomé Ordóñez (*d.* 1520). Although it remains unproven, the latter two had probably worked with the Italian on previous projects. In fact, Fancelli's unfinished projects were picked up by Ordóñez and then completed by his Genoese assistant, Pietro Aprile.

Elsewhere, various sculptors who had traveled to Italy now returned, bringing with them a more Italianate style; the most notable of these, Diego de Siloé (*ca.* 1490–1563), who was active in Burgos (1519–28) and later in Granada (1528–63), and Alonso Berruguete (*ca.* 1489–1561), active in Valladolid, played a significant role in the stylistic development of sculpture in Castile. In his long career, Berruguete executed several large-scale projects notable for their striking compositions and twisting figures, which have evoked comparisons to Michelangelo and Donatello. The success of Berruguete's style and his effective management of a large atelier guaranteed his work a widespread following for most of the 16th century. Other sculptors adopted Italian motifs and architecture more slowly as they came into contact with these motifs either directly in Italy or through contact with artists in Spain. Some scholars have hypothesized that Damián Forment (*ca.* 1470–1540) made a trip to Italy as well, but this theory remains unproven. Nonetheless, his work in Valencia and, later, Aragon offers conflicting evidence; parts clearly derive from a Gothic tradition whereas some figure types suggest Classical examples, but only toward the end of his life did he adopt Renaissance motifs in the architecture of his altarpieces. Similarly, the career of the sculptor Vigarny shows an artist slowly incorporating Italianate motifs, probably as a result of his partnerships with Diego de Siloé and Berruguete.

The nature of Italian influence also changed as two sculptors, Gaspar Becerra (1520?–70) and Juan de Juni (*ca.* 1507–77), introduced a more Mannerist aesthetic into Spain, characterized by more muscular figures and a heightened sense of motion. Becerra's surviving sculptural work is limited, but the altar of Astorga Cathedral (commissioned in 1558) attests to his talent. Juni, who had settled in Valladolid by 1543, undertook several important commissions, carving the high altar of the Church of S. Maria la Antigua and several versions of the *Entombment.*

In the mid 16th century, Charles V and Philip II turned to the Italians Leone Leoni (*ca.* 1509–90) and his son Pompeo Leoni (*ca.* 1530–1608) for a series of portraits in bronze and marble. These were so well received that the sculptors received the commission in 1579 for the high altar at the Monastery of S. Lorenzo el Real de el Escorial (near Madrid); after Leone's death,

his son continued, creating the monumental ensembles of the kneeling figures of the families of Charles V and Philip II on either side of the altar. These groups, as well as the other tombs that Pompeo erected in Spain, marked another change in taste. However, the impact of this type was limited; patrons subsequently erected fewer funerary monuments, and when they did, they may have looked elsewhere, as the count of Monterrey did when he turned to Giuliano Finelli for his tomb at the church of Las Agustinas Descalzas, Salamanca.

During the 17th century, most commissions were for altars, choir stalls, and small devotional figures for monasteries and convents. As the century progressed, a new genre arose: processional images, whether single figures or multifigured floats called *pasos*, taken out for the increasingly elaborate processions held during Holy Week. These projects constituted prestigious commissions, and most important Spanish sculptors, including Gregorio Fernández (1576–1636), Juan Martínez Montañés (1568–1649), and Juan de Mesa (1583–1627), were called on to create them. Baroque sculpture displayed increasingly naturalistic features, and processional images even more so as sculptors strove for ever greater emotional impact.

In the 17th century, three centers stood out: Valladolid, Seville, and Granada. Fernández dominated production in Valladolid with an impressive output of *pasos*, monumental reliefs for altarpieces, and individual figures, such as *Christ at the Column*. In all his works, but perhaps in none more so than in his figures of Christ and the Virgin, he managed to attain an impressive impact while preserving an almost Classical figural balance.

No city maintained a higher level of sculpture than Seville throughout the 17th century. There, Martínez Montañés established himself as the foremost sculptor, carving large *retablos*, as well as powerful *Crucifixions* and serene *Virgins of the Immaculate Conception*. His example inspired others, among them Juan de Mesa. Little appreciated by scholars until the 20th century, Mesa is best known today for his harrowing *Crucifixions*; but he was also capable of moments of lyricism, such as in the statues *Virgin and Child* or *Saint John the Baptist* carved for the Church of Cartuja de las Cuevas (1623–24) outside Seville. In their works, Martínez Montañés and Mesa established a repertory of types for subsequent sculptors, who nonetheless met this challenge and produced altars and statues of exceptional quality. Under the brothers Felipe de Ribas (1609–48) and Francisco Dionisio de Ribas (1616–79), the Ribas family atelier produced numerous altarpieces throughout the century. Similarly, Pedro Roldán (1624–99) carved several important projects, most notably the *Entombment* (1670–73) for the Hospedal de la Caridad in Seville, an ensemble combining fully

carved figures with relief. His daughter, Luisa Roldán (1652–1706), was a talented sculptor in her own right whose career eventually took her to Madrid, where she was named sculptor to the king. Although she carried out large projects, she is most famous for her small terracotta groups of religious scenes, which captivatingly evoke a range of religious moods.

As a youth, Pedro Roldán had studied in Granada, the other leading center of sculpture in Andalusia. Alonso Cano (1601–67), the Mena family, and the Mora family dominated activity there during the 17th century. Cano divided his career between his native Granada and Seville, Madrid, and Málaga, where he was active not only as a sculptor, but also as a painter. In comparison, the Mena and Mora families offer a more representative example, having worked largely in Granada and devoted themselves to sculpture. Nonetheless, these artistic dynasties produced two celebrated figures of the Spanish Baroque: Pedro de Mena (1628–88) and José de Mora (1642–1724). Interestingly, Mena undertook no retables, concentrating instead on single figures, where he developed types for the *Penitent Mary Magdalene*, *Saint Francis*, the *Mater Dolorosa*, and *Ecce Homo*, which would be repeated in numerous versions. How artists could follow these types while offering their own interpretation ap-

pears in the oeuvre of José de Mora, whose interpretation of the *Ecce Homo*, with its emaciated and bruised Christ, differs markedly from Mena's gentle and withdrawn versions.

Similar revisions characterize 18th-century sculpture. Artists as varied as José Risueño (1665–1732), Pedro Duque de Cornejo (1678–1757), Luis Salvador Carmona (1708–67), and Francisco Salzillo (1707–83) continued to execute traditional commissions while maintaining a personal style at a high level. The period did, however, witness changes. With the death of Charles II (1700), Spain passed from the Habsburgs to the Bourbons, and these monarchs brought new attitudes toward the arts and patronage. For sculpture, this meant different royal commissions, such as the garden statues and fountains for the palace that Philip V, the first Bourbon king, was building at San Ildefonso de la Granja (Segovia); however, these projects were entrusted to French artists. Similarly, the decoration of the royal palace in Madrid required numerous statues that initially were to be carved by a team of Italian and French artists, but Spaniards, including Salvador Carmona, were subsequently called in. With a greater foreign presence, stone and marble sculpture of portrait busts, tombs, and facades became more common, and local fashions began to take note of developments in France and Italy. Spain, which had had no academy for art instruction, only saw one founded in 1752 (the Real Academia de Bellas Artes de San Fernando [Royal Academy of Fine Arts of San Fernando]). Giovanni Domenico (Juan Domingo) Olivieri, one of the Italian sculptors working on the royal palace, taught sculpture at the academy, and over the long term, the academy offered a rigorous training that fostered the development of a Neoclassical school. But just as Renaissance and Gothic styles had coexisted for much of the 16th century, so too during the 18th century did traditional figure types and compositions survive the inroads made by the new style.

PATRICK LENAGHAN

See also **Berruguete, Alonso; Cano, Alonso; Fancelli, Domenico; Fernández, Gregorio; Finelli, Giuliano; Juni, Juan de; Leoni Family; Mena (y Medrano), Pedro de; Mesa, Juan de; Montañés, Juan Martínez; Ordóñez, Bartolomé; Roldán Family; Salvador Carmona, Luis; Salzillo, Francisco; Siloé Family; Vigarny, Felipe**

Pedro Duque de Cornejo, Choirstalls, 1748–57, Córdoba Cathedral, Córdoba, Spain
The Conway Library, Courtauld Institute of Art

Further Reading

Azcárate, José María de, *Escultura del siglo XVI*, Madrid: Editorial Plus Ultra, 1958

Estella, Margarita, "Decoración escultórica de los Jardines Reales del siglo XVI al XVII según el texto di Alvarez di Colmenar (1707) y estado actual," in *Struggle for Synthesis:*

A obra de Arte Total nos Séculos XVII e XVIII; The Total Look of Art in the 17th and 18th Centuries (bilingual Portuguese-English edition), Lisbon: IPPAR, 1999

Gómez-Moreno, Manuel, *La escultura del renacimiento en España*, Florence: Pantheon Casa Editrice, 1931; as *Renaissance Sculpture in Spain*, translated by Bernard Bevan, Florence: Pantheon-Casa Editrice, 1931; reprint, New York: Hacker Art Books, 1971

Gómez-Moreno, Manuel, *Las águilas del renacimiento español: Bartolomé Ordoñez, Diego Silóee, Pedro Machuca, Alonso Berruguete, 1517–1558*, Madrid: Consejo Superior de Investigciones Científicas Instituto Diego Velázquez, 1941; reprint, Xarait Ediciones, 1983

Lenaghan, Patrick, "Reinterpreting the Italian Renaissance in Spain: Attribution and Connoisseurship," *The Sculpture Journal* 2 (1998)

Lenaghan, Patrick, *Images in Procession: Testimonies to Spanish Faith* (exhib. cat.), New York: American Bible Society, and The Hispanic Society of America, 2000

Marías, Fernando, *El largo siglo XVI: Los usos artísticos del Renacimiento español*, Madrid: Taurus, 1989

Martín González, Juan José, *Escultura barroca en España, 1600–1770*, Madrid: Cátedra, 1983; 2nd edition, 1991

Proske, Beatrice Gilman, *Castilian Sculpture, Gothic to Renaissance*, New York: The Hispanic Society of America, 1951

Redondo Cantera, María José, *El sepulcro en España en el siglo XVI: Tipología e iconografía*, Madrid: Ministerio de Cultura, 1987

Trusted, Marjorie, "Moving Church Monuments: Processional Images in Spain in the Seventeenth Century," *Journal of the Church Monuments Society* 10 (1995)

Trusted, Marjorie, *Spanish Sculpture: Catalogue of the Post-Medieval Spanish Sculpture in Wood, Terracotta, Alabaster, Marble, Stone, Lead, and Jet in the Victoria and Albert Museum*, London: Victoria and Albert Museum, 1996

Trusted, Marjorie, "Art for the Masses: Spanish Sculpture in the Sixteenth and Seventeenth Centuries," in *Sculpture and Its Reproductions*, edited by Anthony Hughes and Erich Ranfft, London: Reaktion Books, 1997

Webster, Susan Verdi, *Art and Ritual in Golden-Age Spain: Sevillian Confraternities and the Processional Sculpture of Holy Week*, Princeton, New Jersey: Princeton University Press, 1998

SPERLONGA SCULPTURES

Hagesandros, Polydoros, and Athenodoros of Rhodes (fl. ca. 10–20)
mid 1st century CE
marble
h. 2.0–2.2 m; 3.5 m; 1.84 m
Sperlonga Museum, Italy

The four marble sculptural groups that comprise the Sperlonga ensemble represent scenes from the world of the Homeric epics, with a focus on the deeds of the hero Odysseus, whose adventures during the Trojan War and subsequent return to his home were frequently depicted in Greek and Roman art. The sculptures were discovered in 1957 during the excavation of a large seaside villa at Sperlonga on the west coast of Italy,

south of Rome; this luxury villa was built during the late Republican period and was later owned by the emperor Tiberius (r. 14–37 CE). The sculptures, which date to the late 1st century BCE or early 1st century CE, are marble versions of earlier Hellenistic compositions in bronze.

The Sperlonga sculptures consist of two two-figured groups and two multifigured ensembles, all carved in the heroic Baroque style that is one of the hallmarks of Hellenistic sculpture. One of the two-figured groups depicts a warrior carrying the corpse of one of his comrades (a well-known Hellenistic statue type known as the *Pasquino* group); the other represents Odysseus and Diomedes with the cult image of Athena that they have stolen from Troy. The subjects of the multifigured compositions are the blinding of Polyphemus by Odysseus and his comrades and the attack of Odysseus's ship by the sea monster Scylla. The Baroque style of the sculptures, characterized by complex, intertwined compositions and dramatic displays of emotion, was appropriate to the subject matter and may have been developed to represent such heroic figures from the mythological realm.

The four statues were created for and displayed in a natural grotto that had been incorporated into the villa as an elaborate alfresco dining area. The grotto included a dining platform that overlooked a circular pool with a recessed cave behind. The *Scylla* group was installed in the center of the pool, as demonstrated by its base, which was found *in situ*; the *Polyphemus* group would almost certainly have been set at the back of the cave, which provided an appropriate backdrop for the dramatic scene represented by the sculptures. The two smaller groups have been restored on either side of the pool, where they frame the larger tableaus.

The *Pasquino* group represents a bearded and armed warrior supporting the dead body of a youthful nude male. Known in multiple marble replicas, the Sperlonga example preserves only the helmeted, bearded head of the older warrior and the limp lower legs of the deceased. Most scholars identify the two figures of the *Pasquino* group as the Greek hero Menelaos retrieving the body of Patroklos, the youthful warrior who was slain in battle by Hector. In the Sperlonga version of the *Pasquino* group, the figures may have been adapted to represent Odysseus retrieving the body of the slain Achilles, thus maintaining an overall Odyssean theme for the ensemble.

The other smaller group, titled *The Rape of the Palladion*, represents the struggle between Odysseus and Diomedes for an archaic idol of Athena that they have stolen from the temple of the goddess in Troy. The Sperlonga group preserves only the heads of the two heroes and the upper portion of the statue gripped by the muscular hand of Diomedes. The overall composi-

tion consisted of the two figures arranged in a V-shaped composition, with Diomedes, clutching the idol, moving left and Odysseus moving right.

While the two-figured groups focus on events that took place during the Trojan War, the multifigured ensembles represent events from Odysseus's journey home. The *Polyphemus* group depicts the escape of Odysseus and his companions from the one-eyed giant who had imprisoned them in his cave. The sculptural ensemble includes the colossal reclining figure of the drunken cyclops, the hero Odysseus and two of his companions carrying the large torch with which they blinded Polyphemus, and a third companion carrying a wineskin from which the cyclops had drunk. The subject was frequently represented in Greek and Roman art, and a close copy of the head of the wineskin bearer from Hadrian's villa at Tivoli, and now at the British Museum, London, suggests that the emperor had installed a similar group there.

Odysseus and his companions faced another threat in the form of the Scylla, a man-eating sea monster that in legend guarded the Straits of Messina; she is represented here with the upper body of a woman and a lower body with tentacles terminating in ravenous dogs' heads. Badly battered and now very fragmentary, the *Scylla* group is a complex and sophisticated sculptural composition that includes the monstrous female figure rising from the water and the stern of Odysseus's ship. The anguished figure of the helmsman desperately grasps the rudder as the hand of Scylla seizes his head in order to pluck him off board. Although this composition does not survive in other sculptural copies, it also most likely reflects a now-lost Hellenistic group.

Signatures inscribed on the stern of Odysseus's ship identify the sculptors of the Sperlonga statues as Athanadoros, son of Hagesandros; Hagesandros, son of Paionios; and Polydoros, son of Polydoros, all from Rhodes. Their workshop was active some time between the late 1st century BCE and the early 1st century CE; while the date of the sculptures is generally considered to be Tiberian, based on the emperor's documented ownership of the villa, the prosopography of the artists' names suggests that they may date to the late republican or early Augustan period. The names of the three Rhodian sculptors of the Sperlonga sculptures are the same as those listed by Pliny the Elder as responsible for carving the well-known marble group representing the punishment of the Trojan priest Laocoön and his sons. The Sperlonga sculptures and the *Laocoön* suggest that this Rhodian workshop specialized in the production of virtuoso marble versions of Hellenistic mythological groups created in the Hellenistic Baroque style.

While each group from the Sperlonga ensemble replicates an earlier Hellenistic composition, the installation of the four groups together in the grotto was conceived by the villa's Roman patrons. The sculptures clearly form a coherent program, organized around the character and deeds of Odysseus, that reflects the taste of one of the villa's owners, possibly Tiberius. The Sperlonga grotto provided a grandiose environment for the dining and entertainment that took place there. It provides a particularly extravagant example of the widespread phenomenon among the Roman elite classes of decorating their private houses and villas with marble copies or versions of well-known Greek statues.

JULIE A. VAN VOORHIS

See also **Rome, Ancient**

Further Reading

Conticello, Baldassare, and Bernard Andreae, *Die Skulpturen von Sperlonga*, Berlin: Mann, 1974

de Grummond, Nancy T., and Brunilde S. Ridgway, editors, *From Pergamon to Sperlonga: Sculpture and Context*, Berkeley: University of California Press, 2000

Rice, E.E., "Prosopographika Rhodaika, pt. II: The Rhodian Sculptors of the Sperlonga and Laocoon Groups," *Annual of the British School at Athens* 81 (1986)

Stewart, A.F. "To Entertain an Emperor: Sperlonga, Laokoon and Tiberius at the Dinner Table," *Journal of Roman Studies* 57 (1977)

SPINARIO

Anonymous
late 1st century BCE (ca. 50–20 BCE)
bronze
h. 73 cm
Musei Capitolini, Rome, Italy

The *Spinario* in the Conservatori Collection of the Capitoline Museums is a late 1st-century BCE bronze statue of a boy who, seated on a rock, pulls a thorn from his left foot. The modern name *spinario* is an Italian expression that means thorn puller. The excellent condition of the statue and the fact that it is recorded already in the 12th century prior to any campaigns of excavation indicate that it has stood above ground from its creation until today. Although in antiquity this bronze statue was probably not famous, during the Renaissance it was extremely influential and is significant to our present understanding of Late Hellenistic and ancient Roman sculpture production.

The Conservatori statue of the *Spinario*, like the equestrian portrait statue of Marcus Aurelius, was one of the few large-scale ancient bronzes known to the

Spinario
© Courtesy Archivio Fotografico dei Musei Capitolini, Rome

scholars and artists of the Renaissance, who admired the piece for its antiquity and aesthetic charm. Filippo Brunelleschi's entry in the 1401 competition for the bronze doors of the Baptistery in Florence features a seated thorn puller in the foreground, showing that the *spinario* motif was already known outside of Rome. In 1471 Pope Sixtus IV, recognizing its value, gave the statue to the public Capitoline collection.

The numerous copies in bronze and marble made by late 15th- and 16th-century artists attest to the statue's popularity. Notably, Ippolito d'Este and Cardinal Giovanni Ricci gave copies as gifts to Francis I and King Philip II, respectively. The popularity and consequent copying continued into the 17th century; for instance, Philip IV of Spain commissioned Velásquez to procure one. Despite their admiration and study of the *Spinario*, scholars of the period were unsure of its subject. The statue was popularly believed to represent a shepherd named Martius who diligently delivered a message to the Roman Senate, only afterward stopping to remove a thorn from his foot. Only in the 20th century were questions about the subject and the original date of the statue satisfactorily answered.

The playful generic subject of the *Spinario* is typical of the Hellenistic period. During this period highly na-

turalistic genre scenes, which provided glimpses of country life and that often had—through their outdoor setting, nakedness, or drunkenness—connections to the world of Dionysus, were for the first time made on a life-size scale, with delightfully virtuoso handling. The admired original creations of such scenes were copied with various degrees of rigor in that period and in the ensuing Roman period. They were used both as public votives in temples and as a decoration in private settings. Other statue types, such as the "Boy Strangling a Goose," "Drunk Old Woman," and "Old Fishermen," provide similar examples of this Hellenistic tendency.

Because these genre scenes were popular in the Roman Empire, it is not surprising that the type of the Conservatori *Spinario* exists in other Roman period copies that correspond closely in size and detail. There are at least five accurate marble copies of the body of the *Spinario* and ten separate copies of the head. Two essential observations have been made about the copies. First, only one of the copies of the body, the so-called Castellani *Spinario* statue, preserves a head. This statue, originally a fountain sculpture, was found on the Esquiline Hill in Rome and resides in the British Museum. Its head, however, is not the charming ephebic head of the Conservatori *Spinario* but rather portrays a realistic rustic lad with a grimace. The second observation concerns a marble copy of the Conservatori *Spinario* head type. Given the position of its neck muscles, this head was joined not to the *spinario* body type but to a statue posed in a different manner.

Modern scholars have, furthermore, noted that the hair of the Conservatori *Spinario* defies gravity. It does not fall forward in accordance with the head's downward bend. The simple Classical appearance of the Conservatori *Spinario* head type, moreover, seems to date to the second quarter of the 5th century BCE, in contrast to the distinctly Hellenistic subject and style of the body.

Taken together, these observations have led modern scholars to conclude that the Castellani statue in the British Museum represents a Roman-period copy of an original work of the early Hellenistic period. The Conservatori *Spinario*, on the other hand, is thought to be an eclectic work of the 1st century BCE that was designed to "improve" upon its Hellenistic model by combining the body type with a famous and pretty head type of the early 5th century BCE.

It is also possible, however, that both the Castellani *Spinario* and the Conservatori *Spinario* are Roman-period copies of two virtually contemporary originals dating from the early 1st century BCE that featured the same body with different heads. This suggestion is based on the lack of secure evidence that the motif of the seated male pulling a thorn from his foot appeared

prior to the early 1st century BCE. Moreover, the motif occurs in other media that can be dated positively to the early 1st century BCE, and the basic composition of a seated figure who leans forward is found in several statues dating to the same period. Finally, eclectic statues—that is, statues that add heads or bodies of the Classical period to later inventions—appear first in the 1st century BCE.

It is presently impossible to determine definitively whether the master of the original statue on which the eclectic Conservatori *Spinario* was based was attempting to improve the appearance of the original, on which the Castellani statue was based, or whether the realistic original model of the Castellani was instead "correcting" the eclectic and unnatural original model of the Conservatori *Spinario*. For the present time it seems probable that both original models date after the late 2nd century BCE and were intended to depict no subject more specific than a country boy with a thorn in his foot.

JULIA LENAGHAN

See also **Rome, Ancient**

Further Reading

Carpenter, Rhys, "Observations on Familiar Statuary in Rome," *Memoirs of the American Academy in Rome* 18 (1941)

Haskell, Francis, and Nicholas Penny, *Taste and the Antique: The Lure of Classical Sculpture, 1500–1900*, New Haven, Connecticut: Yale University Press, 1981

Jones, Henry Stuart, *A Catalogue of Ancient Sculptures Preserved in the Municipal Collections of Rome: The Sculptures of the Palazzo dei Conservatori*, Oxford: Clarendon Press, 1926

Ridgway, Brunilde, *The Severe Style in Greek Sculpture*, Princeton, New Jersey: Princeton University Press, 1970

Smith, R.R.R., *Hellenistic Sculpture: A Handbook*, London and New York: Thames and Hudson, 1991

Zanker, Paul, *Klassizistische Statuen: Studien zur Veränderung des Kunstgeschmacks in der römischen Kaiserzeit*, Mainz, Germany: Von Zabern, 1974

DANIEL SPOERRI 1930– *Romanian, active in Germany, France, United States, and Italy*

Daniel Spoerri's random assembly of objects taken from daily life places him squarely in the context of the 1960s artistic generation's return to the Dada spirit. His readymades echo the irony and playfulness of Marcel Duchamp, an important progenitor for the Conceptual art trends that seek to recover ordinary objects. At the center of Spoerri's artistic activity is the theme of food as an symbolic object of consumption and a starting point for reflecting on the artist's role in a society dominated by mass production.

In 1960 Spoerri met Yves Klein in Paris through their mutual friend Jean Tinguely, and he became one of the founding members of the Nouveau Réalisme group. That same year he began to create his first *Tableaux Piège*. These were wall-hung tabletops with plates, glasses, and bits of food glued onto them. By presenting oddly assorted tableware and leftovers as works of art, Spoerri created an ironic, debunking reversal of values that negated the traditional prestige attached to the still-life genre. By hanging his peculiar sculptures from the wall like normal paintings, he defied gravity and erased the traditional boundaries separating the two- and three-dimensional arts.

Spoerri's "traps" for mundane objects proposed an ironic metaphor for life and were situated between life's ephemeral nature and the artist's will to capture it in works of art. In *Kichka's Breakfast I*, the remains of a breakfast—cups and saucers, flatware, a sugar bowl, newspapers, leftover food, and so forth—were glued onto a table and hung on the wall. In 1963 Spoerri drew near to the Fluxus international movement, which proposed to eradicate barriers between art and life. The *Collection of Spices* he created that year is an assembly of bottles on mundane kitchen shelves. The artist's intervention is reduced to a minimum; daily life becomes a work of art. Also in 1963 Spoerri turned the Parisian Gallery J temporarily into a restaurant where art critics served dishes from France, Switzerland, Romania, and other countries.

With this banquet and his invention of the Eat art performances, Spoerri proposed a close identification between food and artwork. Performance enabled him to put into practice his long experience in the theater and erase the line between art and life. An important event in this period was his trip to the United States for a Nouveau Réalisme show in New York. Here Spoerri met artists Dick Higgins, George Brecht, Bob Watts, and Al Hansen, who were trying out new modes—performances, Happenings, and so on—of artistic expression.

In 1968 Spoerri opened a restaurant in Düsseldorf, and in 1970 he opened the Eat Gallery where he presented edible artworks produced by him and by his friends Joseph Beuys, Fernandez Arman, Richard Lindner, César, and Niki de Saint Phalle. Edible artworks were first produced in the 1920s by the Italian Futurists, who strove to revolutionize every aspect of human life.

During the same period that Spoerri was engaged in these experiments, Piero Manzoni presented *Dynamic Consumption of Art* (1960) in Milan. Visitors were invited to eat boiled eggs the artist had cooked himself. Some years later, Aldo Mondino and other members of the Italian group Arte Povera created sculptures out of food such as nougat, sugar, and bread.

Spoerri was the creator of the edible art objects from the Eat Gallery, which were marketed by the produc-

tion firm MAT (Multiplication d'Art Transformable), which he established in 1960. The problem of serial production and the consumption of artworks was fundamental to Spoerri's thinking about art. The production of multiples, widespread in the 1960s, was a form of protest against the emergent commercial art market. It was also intended to prompt serious reflection on the artist's role in a world dominated by mass production. In 1979 Spoerri presented his *Musée Sentimentale* at the Musée Nationale d'Art Moderne, Centre Georges Pompidou in Paris. With this work, he construed that the traditional institution is a living museum where historical documents tell stories.

In 1992 he set up the Spoerri Foundation Garden—*Hic Terminus Haeret*—in Seggiano, a country town in Tuscany. It hosts 50 bronze works by Spoerri and other artists, which share a sense for the poetics of objects and conceptual reflection. In designing the garden, Spoerri drew on his experience in staging and organized the distribution and integration of the works in nature—their effects, impressions, and wonderment.

This fantastic and playful exhibition meanders between nature and art. It is a true descendant of the 16th-century Italian gardens, a topic on which Spoerri is an expert. His first trip to Italy, in 1963, was devoted to visiting the Park of Monsters at Bomarzo, a bizarre 16th-century garden that was commissioned by Vinicio Orsini for his dead wife and blends dream and reality. At the entrance to Spoerri's garden, as the starting point of a symbolic journey, is a bronze sculpture titled *No Entry without Slippers—Tribute to Joseph Beuys*. This is a sort of joke on Beuys's work in which ugly, lightweight, soft, warm, and cheap felt has been turned into beautiful, heavy, glossy, cold, and expensive bronze. In monumentalizing the mundane, Spoerri disregards Beuys's social and political goals and reflects ironically on the relationship between artistic representation and the ceaseless flow of life. Down the garden path one finds Spoerri's *Tableaux Piège* cast in bronze. *Eternal Breakfast* immobilizes a fleeting moment in an instant. The artworks are ensconced in nature either by contrast, as in the case of the bronzes, or by assimilation. The monumental *Grass Sofa*, made of grass and fully immersed in nature, is an interesting example. Two armchairs offer a good place from which to view the emblematic *Labyrinth*, a narrow, winding path tracing the pre-Columbian image of the sensual union between Father Sun and the first woman. The garden's defining feature is its constantly evolving nature, which grows in perennial expression and modification. For this reason, Spoerri placed his home and workshop at the center. Every Saturday from 4 to 8 P.M., *Ghersi* grows. *Ghersi* is a sort of gigantic yurt, or tent, raised on a framework. Everyone is invited to help *Ghersi* grow by adding old clothes, rags, tires,

plastic bags, or wire to it. Spoerri has created a modern *Merzbau* in the center of his monumental garden, rendering tribute to German artist Kurt Schwitters and the poetry of Dada. In this way, he credits Dada with having posed the fundamental problem of the relationship between art and ever-changing life, negating the value of artistic technique and opening the "sanctuaries of art" to the common man.

CATERINA BAY

See also **Arman (Fernandez); Assemblage; Beuys, Joseph; César; Duchamp, Marcel; Saint Phalle, Niki de; Schwitters, Kurt (Herman Edward Karl Julius)**

Biography

Born in Galati, Romania, 27 March 1930. Father killed by Nazis; moved to Zurich and was adopted by an uncle, 1942; worked as designer, composer, and choreographer at Kellertheater in Bern; moved to Darmstadt as deputy director of Landestheater, 1959; returned to Paris; organized banquets, festivals, and exhibitions; collaborated with Tinguely on Autothéatre, 1963; moved to New York City for Nouveau Réalisme show at Alan Stone Gallery, 1964; lived on small Greek island of Simi, 1966–67; moved to Düsseldorf, 1967; traveled in the United States, 1970; first retrospective, Stedelijk Museum, Amsterdam, 1971; showed at Centre National d'Art Contemporain, Paris, 1972; moved to Selle-sur-le-Biel, France, 1973; taught at Cologne Art School, 1977–82, and at Munich Art Academy, 1983–89; moved to Seggiano, Italy, and set up Spoerri Foundation Garden, where he presently lives and works, 1992.

Selected Works

1960 *Kichka's Breakfast I*; cups, saucers, flatware, sugar bowl, newspapers, food, wood plank, chair; private collection, Switzerland

1963 *Collection of Spices*; bottles, shelves; Moderna Museet, Stockholm, Sweden

1970 *Eat Art Dinner*; performance at Eat Gallery, Düsseldorf, Germany

1972 *Restaurant Spoerri Tische*; coffee cup, plate, newspapers, ashtray, sugar, teaspoon, wood plank; Sohier-Torriani Collection

1979 *Musée Sentimentale*; performance; Musée Nationale d'Art Moderne, Centre Georges Pompidou, Paris, France

1992 *Grass Sofa*; iron, earth, grass; Spoerri Foundation, Seggiano, Italy

1992 *No Entry without Slippers—Tribute to*

1994 *Joseph Beuys*; bronze; Spoerri Foundation, Seggiano, Italy

1994 *Eternal Breakfast*; bronze; Spoerri Foundation, Seggiano, Italy

1996 *Labyrinth*; cement; Spoerri Foundation, Seggiano, Italy

2000 *Ghersi*; assemblage consisting of clothes, rags, tires, plastic bags, wire, and other items; Spoerri Foundation, Seggiano, Italy

Further Reading

Brock, Bazon, and Daniel Spoerri, *Daniel Spoerri* (exhib. cat.), Innsbruck, Austria: Galerie Krinzinger, 1981

Hahn, Otto, *Daniel Spoerri*, Paris: Flammarion, 1990

Jouffroy, Alain, and Daniel Spoerri, *Daniel Spoerri* (exhib. cat.), Milan: Galleria Schwarz, 1961

Mazzanti, Anna, and Irma Benjamino, *Il giardino di Daniel Spoerri* (exhib. cat.), Florence: Maschietto e Musolino, 1998

Spoerri, Daniel, *Topographie anécdotée du hasard*, Paris: Galerie Lawrence, 1960; revised edition, as *An Anecdoted Topography of Chance*, London: Atlas Press, 1995

Spoerri, Daniel, *J'aime les keftèdes*, Paris: Morel, 1970

Thomkins, André, *Dogmat-mot*, Cologne, Germany: Galerie der Spiegel, 1965

Violand-Hobi, Heidi E., *Daniel Spoerri: Biographie und Werk*, Munich and New York: Prestel, 1998

Williams, Emmet, *Six Variations upon a Spoerri Landscape*, Halifax: Lithography Workshop, Nova Scotia College of Art and Design, 1973

STATUETTE

As a class of sculpture, statuettes occupy an ambiguous position. Their smallness of scale and emphasis on detail tend to lend them an ornamental character, thereby placing them in a difficult territory between fine art and decorative art, two disciplines that have been in a competitive relationship since the late 18th century. With such a dual identity the statuette eludes straightforward definition. While it is tempting to evaluate it according to sculptural qualities, the statuette cannot simply be defined as a small version of a statue. Its classification must also include works purposefully conceived on a small scale, as well as figurines employed in the embellishment of other objects, such as decorative candelabra or clocks. Further, its definition is not limited by material; sculptors have used bronze, zinc, precious metals, marble, stone, wood, ivory, terracotta, porcelain, and even plastic in statuette production. While the diversity of statuettes makes them difficult to classify precisely, their very inclusiveness should be recognized and valued as part of their significant role in the history of sculpture. Statuettes have served a variety of functions in ancient and modern history: as religious icons, totems, fetishes, works of art, luxury goods, and souvenirs. In modern periods interest has increasingly shifted to their aesthetic and decorative qualities rather than to their symbolic capacity.

Statuettes were a well-developed form of sculpture long before the Christian era. Small figurines made of terracotta, bronze, or stone, measuring about 15 to 18 centimeters, were widespread throughout the ancient world. Terracotta was a particularly common material, and archaeologists have excavated large numbers of statuettes from ancient civilizations, including ancient Egypt, Greece, Minoan Crete, and Cyprus, as well as early Asian civilizations. The figures often represented deities and may have been used in religious ceremonies and as thank-offerings. The bronze and terracotta figurines surviving from the Geometric period, between the late 11th and late 8th centuries BCE, display a similarity in form and design, partly explained by their function as votive offerings, which demanded a certain uniformity, but that also suggests that production was organized to maximize output. While the religious function of statuettes seems to have been an important factor in their popularity and prevalence, the large numbers of secular sculptures that survive suggest that they were equally significant as artifacts, mementos, souvenirs, and toys. After the 7th century BCE statuettes depicting ordinary men and women engaged in everyday activities became commonplace. Such genre subjects have been found in Cyprus and Crete, for example, representing groups of dancers, actors, warriors, horsemen, and animals, often in lively and animate poses. The group of statuettes known as the Tanagra terracottas, dating to the 3rd century BCE, are the most famous of this kind of sculpture. The fine modeling and painting of the Tanagra figures, discovered in Boeotia in central Greece, demonstrate a high level of sophistication in Greek statuette design. The main subject matter of the statuettes, made with molds, is female figures in traditional attire, in standing or sitting poses. The clothing, depicted in detail, shows different kinds of garments and headwear and occasionally includes a fan or mirror. Artists painted the figures in bright colors, with blue, red, pink, and yellow garments, pink or red flesh, and blue eyes. They also used some gilt to highlight details. Discovered in the 19th century, the Tanagra statuettes fueled that era's fascination with ancient sculpture. They became extremely popular and sought after and, as a result, were frequently forged to satisfy collectors' demands.

Artists in ancient times also used bronze in statuette production. By the 6th century BCE sculptors had developed molding and casting techniques to a sophisticated degree. The process of lost-wax casting facilitated the production of multiple copies, allowing the production of large quantities of the most popular fig-

ures. Early examples of serially produced statuettes in Greece date to the 8th century BCE.

Ancient Romans continued to make statuettes, which increasingly acquired artistic meanings that extended beyond religious function. After the 1st century CE the use of terracotta decreased and bronze became the dominant material. The Romans adapted methods devised for making military equipment to efficiently produce large numbers of bronze statuettes by casting, welding, and riveting. While much of the Roman portraiture and relief work was fresh in conception, their freestanding sculptures were frequently copies of Greek originals. This process of reproduction and imitation suggests that they may have regarded certain kinds of sculptures as independent art objects, indicating awareness of a concept of art history. By the 4th century CE the production of small bronze sculpture declined in Europe, and not until the 13th century was there a revived demand for small cast objects.

While the influence of Greek and Roman art on later cultures is widely acknowledged in terms of sculpture and architecture, the specific historical role of statuettes has been less studied. Beginning in the 15th century interest in archaeology, Greek and Roman history, and mythology was a considerable factor in encouraging a continuing fascination with early bronze and terracotta statuettes, especially in Italy. This interest contributed to the efflorescence of the small bronze during the Renaissance. By the late 1430s the collecting of Classical bronze statuettes became an established practice in the more prosperous cities and in the universities of Italy, with a trade in imitation antiques also flourishing. The practice of copying from antiques was at that time not so much intended to deceive as to cater to current tastes among humanist circles. Notable statuette makers of the 15th and early 16th centuries who engaged in this practice included Antonio Pollaiuolo and Andrea Riccio. Sculptors conceived these statuettes both as autonomous figures to be held and examined and as useful objects, such as inkwells and candleholders, with the same workshop often producing both types of objects. The workshop of Giambologna, one of the most important and prolific makers of bronze statuettes in the 16th and early 17th centuries, produced both original designs and large numbers of large and small bronzes that were either copied directly from antiques or adapted from known examples.

The plain bronze statuette fell out of favor during the Baroque and Rococo eras, when tastes turned increasingly to the lighter colors of gilding, precious metals, marble, and porcelain. Although bronze continued to play an important role, the emphasis shifted to its decorative capacity in the production of objets d'art. The predilection for glamor and elaborate decoration affected the treatment of statuettes. As the wealthy and noble collectors of the 17th and 18th centuries sought to adorn their private homes with luxury objects, the decorative capacity of statuettes became more pronounced. Artists often used gilded and polychrome figurines in the embellishment of domestic objects, and collectors often desired sculptures in such applied forms more than they did autonomous works of art. Not surprisingly, many sculptors of the period diversified into the decorative arts. Distinguished artists such as Étienne-Maurice Falconet, Clodion, and Jean-Baptiste Pigalle not only made freestanding statues and statuettes, but also provided designs for decorative objects in ceramic (*biscuit*).

Under the patronage of Louis XIV, France evolved into an increasingly important artistic center, and many Italian artists traveled to France to work on the decoration of the royal residencies. The French monarchy also nourished national manufacture. The Sèvres porcelain factory led the European taste in ceramics beginning in the late 18th century. Catering exclusively to the luxury market, its output comprised domestic tableware as well as fine porcelain statuettes, which became highly collectible. Sèvres employed notable sculptors to direct its statuette productions, including Falconet, Clodion, and Pigalle in the 18th century and Albert-Ernest Carrier-Belleuse in the 19th century.

The influence of the styles developed under the reigns of Louis XIV and Louis XV remained visible in Europe throughout the 19th century, particularly in the continuing popularity of the decorative applications of sculpture. Original 18th-century examples of sculpture for furniture became especially desirable and saw a phenomenal rise in value. Falconet's *Three Graces* clock, for example, which cost Madame du Barry £96 in 1768, sold for more than £4,000 in 1881. However, collectors valued these kind of objects not primarily as works of sculpture but as decorative luxury objects. The erosion of the sculptural qualities of statuettes during the 18th century permanently affected their identity and resulted in a more self-conscious effort to demarcate a boundary between decorative and sculptural small objects, a shift mirrored in attitudes to art history and aesthetics. It is against this background that the revival of the autonomous freestanding small sculpture in the late 19th century should be evaluated. During this period collectors began to seriously study and collect bronze statuettes dating between the late 14th and 16th centuries. Wilhelm von Bode was the first notable 19th-century collector and scholar of Renaissance statuettes, producing numerous catalogues that continue still to provide measures for classification. Bode's acquisitions contributed to the collections of the Victoria and Albert Museum in London and the Ashmolean Museum in Oxford and formed the

basis of the Renaissance collections of the Staatliche Museen, Berlin.

Bode's emphasis on sculptural aesthetics contributed to a shift in the viewing and classifying of the small bronze. As the Renaissance bronze statuette increasingly ranked with other acknowledged great works of the era, a more general awareness of the sculptural qualities of small modern objects also emerged. Although statuettes continued to occupy an ambiguous territory, a conscious split between their ornamental and sculptural role became evident in scholarship and collecting habits. While middle-class taste continued to be drawn to the visual charm and glamour of decorative objects, serious connoisseurs and scholars preferred to focus on sculptural values. A line was thereby drawn not only between two types of art but between two types of art appreciation—one grounded in luxury consumption, the other in intellectual pursuit. To some degree the development of the modern statuette market, which catered to a fairly inclusive audience, also reflected this distinction. Statuettes were available in a variety of materials, including plain bronze and polychromed or gilded versions, addressing at once the appetite for decorative objects and the demand for fine works of art.

The statuette became central to many sculptors' activities. With the expansion of middle-class wealth and the development of more efficient production techniques, such as sand casting and electrotyping, statuettes grew into a large profitable industry. Until the early 19th century artists reproduced sculptures using the pointing method, a laborious and time-consuming process. The invention in the first half of the 19th century of an accurate mechanical device for reducing and enlarging sculptures was a key moment in the history of statuettes. Achille Collas patented his *machine à réduction* in 1837 in France. Aware of the commercial importance of his invention, Collas went into business with the Parisian founder Ferdinand Barbedienne, who became the leading manufacturer of statuettes of the period.

The large popular market for small sculpture courted by French founders such as Barbedienne and Susse Frères played an instrumental role in ensuring Paris's influence in the development of sculpture in 19th-century Europe. They exported statuettes internationally, and works by current artists, such as James Pradier, François Rude, and Jean-Baptiste Carpeaux, became well known in other European art markets, including London and Brussels. The role of founders became central to the commercial development of sculpture, and many sculptors relied heavily on producers such as Barbedienne to generate income from their work. The founder held the artist under contract, often managing everything from production and marketing to quality control. Founders could produce statuettes efficiently and cost effectively, allowing them to target a wider market than works edited by artists themselves, although some artists preferred to maintain their personal involvement. Antoine Louis Barye, for example, one of a group of sculptors specializing in animal subjects, known as *Les animaliers*, set up his own foundry and, using the superior lost-wax process, produced unique high-quality bronzes. Although Barye achieved international recognition as a sculptor, the burden of producing and marketing his own work proved too difficult. Financial losses forced him to sell his models to Barbedienne's factory, which produced his works serially by sand casting.

Barye's example illustrates the difficult situation in which sculptors found themselves. Autograph casts were too specialized and expensive to benefit from the popular market that had been opened by commercial producers. Only a connoisseur would appreciate the excellence of a lost-wax cast. The kind of audience that bought statuette editions from Barbedienne was not interested enough in the subtleties of quality that Barye sought to achieve and was content with ordinary editions at lower prices.

In contrast to Barye, the commercial activities of Carpeaux suggest that some artists could succeed in taking control of their own output. In the early years of his career, Carpeaux relied on Barbedienne to produce, distribute, and sell small versions of his sculptures. By the 1870s, however, he took his business in hand himself, establishing the Atelier Carpeaux as a commercial outlet for his work. Carpeaux shrewdly exploited his best-known works. He split the composition of *The Genius of the Dance*, for example, into separate figures, which were reduced in size and edited as statuettes and busts. He therefore offered the statuette as a kind of souvenir of the famous original. Such reductions became a popular class of statuette, as they automatically ensured a degree of artistic credibility on the strength of the original sculpture from which they derived.

The profitability of producing bronze editions inevitably attracted pirate manufacturers. By taking molds from existing works, a process known as *surmoulage*, unscrupulous founders could produce an infinite number of editions. Reputable firms fought against pirate rivals, which devalued the market with works poor in quality and overproduced in volume. Manufactures such as Barbedienne and Susse Frères were keen on controlling quality and established their international reputations on the strength of the artistic integrity of their output. Notably in England, Barbedienne was seen less as a commercial manufacturer than as an "artist" and "interpreter" of small sculptures. Many believed that founders played a worthy role in raising

public taste by encouraging an interest in sculpture through the sale of statuettes.

An important aspect of the 19th-century statuette was its adaptability to the diverse tastes that abounded during the period. With the development of Parian ware, a type of white clay that resembled marble, foundries could mass-produce at relatively low cost statuettes catering to the taste for Classical themes and forms. The predilection for rich colors and luxurious materials prevailed alongside Neoclassicism. Often foundries produced statuettes in a variety of materials. James Pradier's *Leda and the Swan*, for example, was available in plain porcelain or bronze, as well as in a deluxe polychrome edition of ivory, silver, and turquoise. The work of Pradier and other French sculptors, including Carrier-Belleuse and Auguste Clésinger, illustrates how influences overlapped and were deliberately fused. Appealing to a broader spectrum of tastes, the sculptures evoke the new Romantic aesthetic, as well as incorporating Classical and Rococo elements. The statuette was an important part of these artists' activities. Many of Pradier's and Carrier-Belleuse's statuettes use overtly Classical allusion, such as subject matter and "Greek" drapery, hairstyles, and facial features, yet do away with the austerity and severity of their more strictly Neoclassical peers. By using a more mannered style, erotic poses, gilding, and polychromy, they instead achieved a lighter look that deliberately appealed to the middle-class market. A thriving niche market also existed for more overtly erotic, even pornographic, statuettes; some of Pradier's small sculptures appealed to this taste. Such works were not meant for public display but deliberately conceived for private sales.

Bronze was perhaps the most widely used material for statuette production, but other materials were also important, particularly as they defined different sectors of the market. Plaster, terracotta, and *carton-pierre* (a type of papier mâché), for example, were less expensive and widely used by the commercial factories. Porcelain continued to be widely used. Porcelain figures from the 17th and 18th centuries became collector's items, but new productions also proliferated. In England, Minton's and Wedgwood focused mainly on Classically influenced productions, with models sculpted by English, French, and Italian sculptors. While good-quality porcelain ware produced in the 18th century had been targeted to the upper end of the market, the 19th century saw a broader appeal. Manufacturers mass-produced statuettes aimed at the burgeoning middle-class market, while some manufacturers in Staffordshire also catered to the lower market with their simple earthenware figures.

Sculptors were quick to recognize the opportunities offered by porcelain. The English sculptor John Bell, for example, realized the market potential of porcelain when he contracted Minton's to reproduce his marble statue *Dorothea* in porcelain. The success of this enterprise prompted Bell to create works specifically for reproduction in porcelain, thus sparing himself the expense of making a marble statue. As Bell's example suggests, sculptors often considered statuettes as economic opportunities. However, it also reveals that statuettes frequently came into existence not as reductions but specifically as small works of art. This development is particularly pertinent to late 19th-century England. A group of sculptors active in the 1880s and 1890s, including Alfred Gilbert and Hamo Thornycroft, frequently produced small works that had no life-size equivalents. A tradition of figure sculpture that hovered between statuette and statue was fairly common in the 18th century, in the work of Falconet for example, and carried on throughout the 19th century, notably by Carrier-Belleuse in France and Alfred Gilbert in England. The sculptural qualities of these works, cast at a slightly larger scale, resonate more fully without sacrificing the intimacy of the small decorative object.

By the time of the Art Nouveau and Art Deco periods, the statuette, particularly in the form of the female nude, again became prolific for embellishing household objects. While modern productions exaggerated the decorative capacity of the statuette, the collecting of antiques remained a purposeful and scholarly activity, sustaining the statuette's importance in the history of sculpture. At the turn of the 20th century, Italian firms such as Chivazzi (also called Fondazione Riunite Artistiche) catered to a tourist trade in statuettes for souvenirs, producing reproductions of renowned Classical statues in reduced versions in a choice of materials.

Statuettes continue to be produced and collected. A wider range of materials is now available, and statuettes are often factory produced, with varying levels of quality, and aimed at different sectors of the market. At the lower end statuettes have become important to the souvenir trade. Cheap reproductions of famous works and antiques are available in department stores, while porcelain and metallic reproductions continue to be aimed at the middle-class market.

MARTINA DROTH

See also **Art Deco; Barye, Antoine-Louis; Bronze and Other Copper Alloys; Carpeaux, Jean-Baptiste; Carrier-Belleuse, Albert-Ernest; Clésinger, (Jean-Baptiste) Auguste; Clodion (Claude Michel); Egypt, Ancient; Falconet, Étienne-Maurice; Giambologna; Gilbert, Alfred; Greece, Ancient; Pigalle, Jean-Baptiste; Pollaiuolo, Antonio; Polychromy; Pradier,**

James (Jean-Jacques); Riccio (Andrea Briosco); Rome, Ancient; Rude, François; Thornycroft Family

Further Reading

Avery, Charles, and Madeleine Marsh, "The Bronze Statuettes of the Art Union of London: The Rise and Decline of Victorian Taste in Sculpture," *Apollo* 121 (May 1985)

Cadet, Pierre, *Susse Frères: 150 Years of Sculpture*, Paris: Susse Frères, 1992

Cooper, Jeremy, *Nineteenth-Century Romantic Bronzes: French, English, and American Bronzes, 1830–1915*, Newton Abbot, Devon: David and Charles, and Boston: New York Graphic Society, 1975

Krahn, Volker, editor, *Von allen Seiten schön: Bronzen der Renaissance und des Barock: Wilhelm von Bode zum 1500 Geburtstag* (exhib. cat.), Berlin: Edition Braus, 1995

Montagu, Jennifer, *Bronzes*, London: Weidenfeld and Nicolson, and New York: Putnam, 1963

Penny, Nicholas, *Catalogue of European Sculpture in the Ashmolean Museum, 1540 to the Present Day*, 3 vols., Oxford: Clarendon Press, and New York: Oxford University Press, 1992

Radcliffe, Anthony, *European Bronze Statuettes*, London: Connoisseur, and New York: Praeger, 1968

Savage, George, *A Concise History of Bronzes*, London: Thames and Hudson, 1968

Shedd, Meredith, "A Mania for Statuettes: Achille Collas and Other Pioneers in the Mechanical Reproduction of Sculpture," *Gazette des Beaux-Arts* 120 (July–August 1992)

Wassermann, Jeanne L., editor, *Metamorphoses in Nineteenth-Century Sculpture*, Cambridge, Massachusetts: Fogg Art Museum, Harvard University Press, 1975

STELA

The stela or stele, defined generally, is an inscribed block of stone with figural work carved in relief on its facade. Inscriptions and iconography often demarcate the stela as a grave, votive, or site marker. The ancient Greeks and Romans frequently used stelae as grave markers. Other cultures have also made extensive use of the stela. In 14th-century BCE Egypt, for example, Akhenaten used stelae decorated with figural representations and hieroglyphics to demarcate his territory in the modern El-Amarna. In China, during the Ch'in dynasty (221–206 BCE), the ritual erection of a stela inscribed only with text was a means to preserve the country's rich textual tradition. Mesoamerican stelae of the 3rd century CE offer rich hieroglyphic texts indicating calendrical information or historical biographies of rulers and their families.

Marked changes in the stela's architectural form and depictions of the human figure evince a distinct chronological development in Greece. One of the earliest Greek examples dates to the 16th century BCE at Mycenae. Limestone stelae, ranging between 1.05 and 1.86 meters in height, at one time demarcated the aristocratic shaft graves presently located within the city's citadel. Decoration, carved by incision or in low relief, included ornamental spiral patterns surrounding the figural panels that depicted animals, such as lions and bulls, or warriors and charioteers.

Attica during the 6th century BCE was the source for numerous grave markers reserved for the elite. The stelae's provenance seems to indicate that wealthy individuals were buried on their estates. The marble markers consist of a low inscribed base with a slender slab carved in low relief. Painted or carved decorations sometimes are visible directly above or below the figure. Typically, full-length male figures standing in profile occupy the relief panel. They assume the guise of warriors, athletes, or the aged. A sphinx or palmette surmounts the slab.

A new artistic trend occurred in Attica around 430 BCE. The overall structure of the marble stela changed, as an architectural frame, temple-like in composition, surrounded the figures carved in low relief. In addition to single-figure depictions, two or more figures, male or female, arranged in various poses (e.g., seated, frontal, or profile) make up the general composition of the carved panel. Inscriptions generally appear on the lintel. The faces lack emotion, but the use of gesture and gaze emphasizes intimacy between figures. Subjects include representations of the family, youthful athletes, and the aged. Less common was the appearance of the warrior, whose burial was relegated to communal state graves. The Classical stela, then, became synonymous with representing the private individual. Compositionally, the figures take up a large proportion of the recess reserved for the figural representations. Figures represent an ideal synonymous with youth. Inscriptions appearing on the stelae do not tend to record the age of the deceased or details about their family life. It is often difficult to assess who the deceased was among those depicted on a stela.

The Stele of Hegeso from Athens is illustrative of the typical Classical style. The marble grave marker has an architectural frame surmounted by pediment and measures 1.58 meters in height. It depicts a seated woman picking out jewelry from a box held by a young woman who stands before her. Emphasis is placed clearly on the human form both in composition and style. The figures take up a large proportion of the stela's recess, and a translucent cloth drapes lightly over the women's bodies. Attention is also given to intimate gestures between figures as the seated woman, idealized in both her age and beauty, carefully picks out jewelry.

The Hellenistic period in Athens shows evidence of a stylistic transformation. This change coincided with a late 4th-century BCE Athenian funerary legislation promulgated by Demetrios of Phileron that forbade the building of large-scale funerary monuments. Here, the

traditional stela with architectural frame gave way to a less ostentatious and smaller columnar marker. The Athenian funerary law did not appear to affect areas of Asia Minor and the Greek islands. The tradition of carving the figure within an architectural frame still continued but tended to be more three-dimensional in form. Figures carved in relief were set into an architectural framework complete with projecting base and columns, which supported an entablature and pediment. Figures of idealized youthful men and women, full-length and frontal, appear within the frame; children or slaves are diminutive in size. Instead of showing the individual in a private role, the Hellenistic stela emphasized individuals in their public roles as priestess, citizen, or warrior.

Unlike the grave markers belonging to the Greek aristocracy, stelae datable to the late Roman republic and early Roman Empire frequently demarcated the burials of both the freeborn and manumitted slaves. The style of the stela was by no means uniform throughout Italy. Frequent use of stelae carved out of local limestone or marble is evident in Roman municipalities such as Ravenna, Atria, Padua, Bologna, and Capua. Like their earlier Greek counterparts, some examples contain low figural relief carved within an architectural framework. Unlike the Greek stelae, however, individuals are depicted as full- or bust-length and can appear with subsidiary objects denoting the deceased's occupation. Moreover, the figures are carved in profile, frontal, or three-quarter view. The clothing styles of the deceased indicate their Roman citizenship. Male figures generally wear the toga; women usually wear the tunic, *stola* (a long outer garment), and *palla* (a long and wide upper garment pinned at the shoulder by a brooch). Occasionally, when portraits are not present, subsidiary objects indicating some personal associations with the deceased appear. Other times only an inscription appears, with no decoration on the stela's facade.

The Roman inscription provides the viewer with important information concerning the deceased. For example, it usually includes his or her name and legal status, familial relationships, and the circumstances under which the stela was erected; occasionally, it also includes the age of the deceased and dimensions of the burial plot.

Stelae provide a window into important economic and social dimensions of the ancient world. For ancient viewer and modern scholar alike, the stela perpetuates the religious, political, or social concerns of the individual living in the ancient world.

LISA A. HUGHES

See also **Greece, Ancient; Rome, Ancient**

Further Reading

Clairmont, Christoph W., *Classical Attic Tombstones*, 6 vols., Kilchberg, Switzerland: Akanthus, 1993

Frederiksen, Martin, "Republican Capua: A Social and Economic Study," *Papers of the British School at Rome* 27 (1959)

Heurtley, W.A., "The Grave Stelai," *Annual of the British School at Athens* 25 (1921–23)

Kern, Martin, *The Stele Inscriptions of Ch'in Shih-huang: Text and Ritual in Early Chinese Imperial Representation*, New Haven, Connecticut: American Oriental Society, 2000

Marinatos, S., "The Stelai of Circle B at Mycenae," *Archaiologika Analekta ex Athenon* 1 (1968)

Murnane, William J., and Charles C. Van Siclen III, *The Boundary Stelae of Akhenaten*, London and New York: Kegan Paul International, 1993

Mylonas, G.E., "The Figured Mycenaean Stelai," *American Journal of Archaeology* 55 (1951)

Pfuhl, Ernst, and Hans Möbius, *Die ostgriechischen Grabreliefs*, 2 vols., Mainz, Germany: Von Zabern, 1977–79

Pomeroy, Sarah B., *Families in Classical and Hellenistic Greece: Representations and Realities*, Oxford: Clarendon Press, and New York: Oxford University Press, 1997

Richter, Gisela Marie Augusta, *The Archaic Gravestones of Attica*, Cambridge, Massachusetts: Harvard University Press, 1944

Smith, R.R.R., *Hellenistic Sculpture: A Handbook*, London and New York: Thames and Hudson, 1991

Zanker, Paul, "The Hellenistic Grave Stelai from Smyrna: Identity and Self-image in the Polis," in *Images and Ideologies: Self-Definition in the Hellenistic World*, edited by Anthony W. Bulloch, Berkeley: University of California Press, 1993

ALFRED STEVENS 1817–1875 *British*

One of the most versatile artists working in the 19th century, Alfred Stevens's skills embraced sculpture, painting, architectural and interior decoration, furniture, and industrial design. His deep admiration for Renaissance art underlined his belief in the unity of the arts and a commitment to applying the highest standards to all areas of design and workmanship. At a time of rigid segregation between the fine and decorative arts, his approach was remarkable, although his actual output was relatively small. His perfectionist and uncompromising working methods prevented the completion of many of his projects, although his drawings survive in large numbers and his influence was considerable. His greatest achievement, the Wellington monument in London's St. Paul's Cathedral, is unique among the memorial sculpture of its time and stands as a complete expression of his belief in the dynamic relationship between sculpture, architecture, and the applied arts.

As a youth in Blandford Forum, Stevens worked for his father, a house decorator and heraldic sign painter, and enjoyed a local reputation as a talented copyist and portrait artist. He had hoped to take up an apprenticeship in London with the animal painter

Edwin Landseer, but the latter's fee proved prohibitive, and instead Stevens went to study in Italy. This trip, begun when he was 15, extended to nine years and laid a solid foundation for his work and ideals as an artist. He studied Renaissance art and architecture in Naples, Venice, Milan, Bologna, and other centers and received some training at the academy in Florence. In Rome the Neoclassical sculptor Bertel Thorvaldsen employed him in 1841–42 as an assistant.

Several works Stevens executed soon after his return from Italy show Thorvaldsen's influence, including five plaster reliefs for Chettle House, Dorset, and a series of pen drawings illustrating Homer. The rigorous classicism of Thorvaldsen's figurative style had a lasting effect on Stevens, who later described the Danish sculptor as his strongest single influence. Stevens's contributions to the Palace of Westminster fresco competitions of 1843–44—a scene from *Paradise Lost* and a panel illustrating *Richard III*—drew on his studies of the fresco paintings of Giotto and Michelangelo.

Stevens's appointment in 1845 to the post of instructor in architecture, perspective, and modeling at the Government School of Design at Somerset House was one for which his wide-ranging skills made him ideally suited. The experience was a fruitful one in terms of his development as an applied artist and in the personal contacts he made there, but he disagreed with the school's governing principal that design could be taught separately from fine art, and he resigned in 1847. In the following years he worked on several independent projects, including the interior decoration scheme for Deysbrook House, Liverpool, some unrealized designs for the base of Nelson's Column, London, and his first important sculptural commission—also unexecuted—the bronze doors for the Geological Museum, Jermyn Street, London. The latter, represented in a finished drawing in the Victoria and Albert Museum, London, were to incorporate relief panels with figures symbolizing minerals and scenes of men forging, mining, and quarrying. In these Stevens translated the influence of Michelangelo, Florentine Renaissance precedents, and Thorvaldsen's reliefs into a dynamic and perfectly balanced figurative scheme.

Stevens put his interest in design and the industrial arts to practical use as chief designer to Hoole and Company, the Sheffield iron manufacturers (1850–57). This period proved to be his most productive in terms of realized sculptural work—albeit on a small scale—and it represents one of the high points of industrial design in 19th-century England. For Hoole, Stevens made such items as the Hot Air and "Boy" stoves, employing intricate Renaissance-inspired motifs (scrollwork, masks, griffins, putti); a pair of firedogs based on the seated *ignudi* (nude figures) of the Sistine Chapel ceiling; and the *Pluto and Proserpine* fireback decorated with a mythological scene in low relief. Worked up extensively from sketches, the pieces are remarkable in their formal inventiveness and technical assurance. The firm's products received wide recognition at the Great Exhibition, London, of 1851 and the Paris Exposition Universelle of 1855, where they won several medals. Stevens also produced a few designs for other manufacturers, such as the Sheffield cutler George Wostenholm, the Coalbrookdale Iron Company, the Sheffield silversmith Joseph Bradbury, and Minton's ceramics.

In the 1850s Stevens designed the lions sejant (sitting) for the railings of the British Museum in London, and he competed unsuccessfully for the Memorial to the Great Exhibition of 1851. In 1856 he began work on the two projects that would dominate the last 20 years of his life and that in different ways represented his greatest achievements. The client Robert Stainer Holford intended the scheme for the decoration of the dining room and saloon at Dorchester House, London, to be standard "decorator's work," but it became in effect Stevens's most elaborate and expensive interior ensemble. Although the painted decorations were never executed, Stevens completed many of the interior fittings and sculptural elements. Some were later removed from the house prior to its demolition, includ-

Monument to the Duke of Wellington
The Conway Library, Courtauld Institute of Art

ing the magnificent dining room doors with carved walnut figurative medallions, the double-story apsidal buffet, the saloon mantelpiece, and the dining room chimneypiece flanked by marble life-size female caryatids. The latter—indebted to Michelangelo's tomb figures in their powerful *contrapposto* (a natural pose with the weight of one leg, the shoulder, and hips counterbalancing one another)—were, despite their size, carefully integrated into the room's decorative scheme. Stevens is said to have had a "strong contempt for furniture statues which might stand in the dining-room one day and equally well in the hall the next" (see Towndrow, 1939).

The other major commission of the mid 1850s, the Wellington monument in St. Paul's Cathedral, epitomizes the uniqueness of Stevens's approach to sculptural design. Although he was placed only fifth in the competition held for the monument in 1856 (the winner was William Calder Marshall), judges chose his model as the most suitable for the intended setting; it was the only one that took account of the great architectonic spaces of the cathedral's interior. The 12-meter-high monument consists of a bronze recumbent effigy of the duke above that rises an arched canopy on 12 columns carrying on either side bronze allegorical groups of *Truth and Falsehood* and *Valour and Cowardice*; an equestrian statue stands on the tall attic pedestal. The varied interplay of architectural and sculptural features, of space and mass, bronze and marble, and the rich use of ornamentation—from the oak-leaf diaper work of the lower columns to the tablets on the base inscribed with the names of the duke's 48 victories—creates a complex but ultimately coherent structure, fulfilling the monument's dual function as mortuary pile and triumphal arch. Prototypes include the high altar of the Church of Santi Giovanni e Paolo, Venice, with its columnated canopy; the sarcophagi and tabernacle structures of the 14th-century Scaligeri monuments in Verona; and for the two allegorical figure groups, English medieval sculpture and High Renaissance sources. Stevens's endeavors to unify these varied elements on such a scale resulted in a work of remarkable power and originality. The breaking down of distinctions between architecture, sculpture, and applied art—he had submitted his design with the motto "I know of but one Art"—was a concept taken up in the New Sculpture movement of the 1880s and 1890s. Of the monument's individual parts, sculptors widely imitated the format of the two allegorical figures. Stevens's struggles to complete the monument—compounded by a reduced budget and by his own laborious working methods and disputes with his clients—were also characteristic of his working life, and the monument was only completed after his death.

MARTIN GREENWOOD

See also **England and Wales: Baroque-Neoclassical; Michelangelo (Buonarroti); Thorvaldsen, Bertel**

Biography

Born in Blandford Forum, Dorset, England, 31 December 1817. Traveled to Italy to study Renaissance art and architecture, 1833–42; received some training at Accademia, Florence; worked as assistant in studio of Danish sculptor Bertel Thorvaldsen, 1841–42; employed in Blandford Forum, 1842–44; instructor of architectural drawing, perspective, and modeling at Government School of Design, Somerset House, London, 1845–47; chief designer for Hoole and Co. of Sheffield, iron manufacturers, 1850–57; firm won Council Medal at Great Exhibition, London, 1851; Stevens won silver medal and firm won Medal of Honour at Paris Exposition Universelle, 1855; in London working on various projects from 1851; obtained commission for decoration of Dorchester House, London, 1855–56; design awarded joint fifth place in competition for Wellington monument in St. Paul's Cathedral, 1856; eventually obtained commission, 1858; last years chiefly occupied working to complete Dorchester House and Wellington Monument; revisited Italy, *ca.* 1859. Died in London, England, 1 May 1875.

Selected Works

Large collections of Stevens's drawings covering most of his sculptural designs as well as his other projects are in the Victoria and Albert Museum and the Royal Institute of British Architects, London. Other important collections of his drawings are in the Tate Gallery, London; the Walker Art Gallery, Liverpool; the British Museum, London; the Fitzwilliam Museum, Cambridge (see Beattie, *Catalogue of the Drawings Collection of the Royal Institute of British Architects: Alfred Stevens*, 1975, p. 5).

ca. 1843 Five reliefs (after Bertel Thorvaldsen); plaster; Chettle House, Blandford Forum, Dorset, England

1851 "Boy" Stove; cast iron, bronze; Victoria and Albert Museum, London, England

1851 Hot Air Stove; cast iron, bronze, brass, ceramic; Victoria and Albert Museum, London, England

1852 Firedogs; bronze; models: National Gallery of Scotland, Edinburgh, Scotland

1855 *Pluto and Proserpine* fireback; cast iron; Victoria and Albert Museum, London, England

1856–63 Decorations for Dorchester House (destroyed), Park Lane, London, England;

fragments: dining room, door roundels, mirror frames, great buffet; saloon mantelpiece; marble, walnut, other woods; Walker Art Gallery, Liverpool, England; dining room chimneypiece with caryatids; marble; Victoria and Albert Museum, London, England

1858–75 Monument to the Duke of Wellington (completed posthumously by Hugh Stannus and installed in 1878; equestrian figure cast by John Tweed and installed 1912); marble, bronze; St. Paul's Cathedral, London, England

Further Reading

Beattie, Susan, *Alfred Stevens, 1817–75* (exhib. cat.), London: Victoria and Albert Museum, 1975

Beattie, Susan, *Catalogue of the Drawings Collection of the Royal Institute of British Architects: Alfred Stevens*, Farnborough, Hampshire: Gregg, 1975 (with a detailed bibliography)

Beattie, Susan, *The New Sculpture*, New Haven, Connecticut: Yale University Press, 1983

Morris, Edward, "Alfred Stevens and the School of Design," *Connoisseur* 190/763 (September 1975)

Physick, John Frederick, *The Wellington Monument*, London: HMSO, 1970

Read, Benedict, *Victorian Sculpture*, New Haven, Connecticut: Yale University Press, 1982

Stannus, Hugh Hutton, *Alfred Stevens and His Work*, London: Autotype Company, 1891

Stocker, Mark, "Stevens, Alfred (George)," in *The Dictionary of Art*, edited by Jane Turner, New York: Grove, and London: Macmillan, 1996

Towndrow, Kenneth Romney, *Alfred Stevens, Architectural Sculptor, Painter, and Designer*, London: Constable, 1939

Towndrow, Kenneth Romney, *The Works of Alfred Stevens, Sculptor, Painter, Designer, in the Tate Gallery*, London: Tate Gallery, 1950

STONE

Stone has been used as a material for sculpting since the Old Stone Age. Paleolithic people shaped stones to create tools, and it is not surprising that they used this familiar material to create sculptures as well. From the very beginning, sculptors used stones of different degrees of hardness, but it is not surprising that a vast number of artworks from around the world were carved from the softer sedimentary stones.

One of the earliest and most well-known sculptures made from a sedimentary stone, limestone, is the *Venus of Willendorf* (*ca.* 23,000 BCE). Limestone, a common stone, is composed primarily of calcium carbonate, usually in the form of calcite or aragonite, and may contain quite large amounts of magnesium carbonate as well as small impurities, including fossils.

Generally it is granular in appearance, but a variety composed of tightly compacted, tiny, rounded granules, found in Caen and India; can usually be polished to a matte finish. Most varieties used for sculpting are gray or cream colored.

Because limestone blocks range widely in size, sculptors may carve small-scale as well as monumental figures. Its ease in carving allowed ancient Egyptian sculptors to create trial pieces as well as the models that were used in their stone workshops as prototypes for royal sculpture. However, they also created statues and reliefs from this material. Greek sculptors often used it to create the drapery-covered bodies of statues whose heads and hands were fashioned from the more prestigious white marble. Because limestone can be deeply undercut and pierced, the medium served as one of the main materials for the decoration of profane as well as religious architecture in medieval Europe. Much of the intricate tracery of Gothic cathedrals as

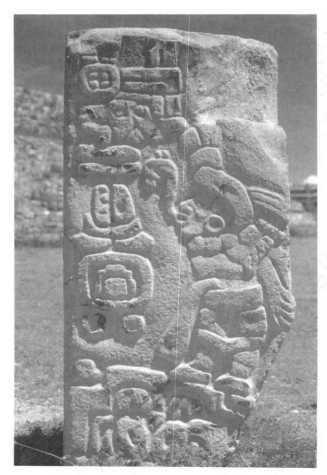

Detail showing carved slab from Pre-Columbian sculptural program at the building of the Danzantes, Mexico, 600–100 BCE
© Michael Freeman / CORBIS

well as their figurative decoration have limestone as their source. Sculptors preferred marble from the Renaissance on, but in the 20th century many sculptors returned to limestone and other sedimentary stones. Sculptors outside Europe also made ample use of limestone: in pre-Columbian America, this soft material permitted sculptors, who had only stone tools and abrasives, to create soft volume and avoid blocklike figures.

Sandstone, another common sedimentary stone that has been popular around the world, was frequently adapted for carving in northern Europe in particular. Sculptors along the Rhine used this material for fine sculpture as well as architectural decoration. Among the finest examples of the use of local red sandstone is Strasbourg Cathedral in Alsace.

Sandstone comes in many colors including gray, cream, pale yellow, and rusty brown. It is a porous and composed of fine grains of sand (quartz) bound together with silica, clay, iron oxide, or calcite. The ability of sandstone to withstand weathering depends on the variety, as does its ability to take a polish. It is a stone that is generally easy to work with, especially when it has just been quarried and is still moist. Over time the water evaporates, and the minerals left behind harden the stone.

Very fine figures and reliefs of sandstone were carved in India, where an outstanding variety is found in the Vindhya range. This stone has small pores and is cream to deep red in color, rather hard, durable, and so fine grained that it can sometimes be polished. Mauryan sandstone sculpture of the 3rd century BCE, for example, is characterized by its fine "Mauryan gloss." Generally, the soft and often grainy character of this material is perfectly suited for the undulating, round volumes and swerving curves of Indian art. However, the tactility of some Indian sandstones allowed the fine sensitivity of some figures whose soft, swelling musculature and flesh were contrasted against finely textured jewelry and fabric.

The influence of Indian sculpture reached beyond the subcontinent into Cambodia during the period of Khmer rule (9th–13th century). In Cambodia, however, the sculptures were not fully integrated with the temple architecture as they were in India. Detached, they assumed an autonomy and a presence of their own, giving them the strength to stand alone, even when they were taken from their original contexts. Such power is usually generated by a much harder kind of stone.

One of the earth's most common rocks is granite, an igneous rock composed of feldspar and quartz with a small amount of hornblende, mica, and minor accessory minerals. Granite is usually gray or whitish with speckles of crystals of a different color; if potash feldspar is present, it is pink or flesh colored. Other igneous rocks used for sculpting are diorite and the banded diorite. Both are composed of plagioclase feldspar (white) and hornblende (black) or biotite (black or dark green) and are fine or coarse grained.

Granites and diorites are extremely resistant to the effects of weather. Harder than sandstone, limestone, or marble, they are so difficult to carve without power tools or carbide-tipped chisels that they rarely appeared in sculpture before the 19th century—except in the ancient Near East. In ancient Egypt, granites and diorites enjoyed immense popularity and were carved into colossal as well as miniature statues. We can reconstruct the process of sculpting such hard stone from numerous surviving unfinished statues, beginning with the raw rectangular block. Before the actual carving began, a grid was applied to the stone with powdered string and the figure was outlined on all four sides of the block. After blocking out the body and head, the sculptor worked the stone from all sides, using picks, drills, and pounding stones to define the form and grind it into shape, finally polishing it with abrasives. The Egyptians certainly used stone tools and rubbers, but it is not clear at which point metal tools were employed.

Granite statues are massive, blocklike, and economic in detail, which suits the hard material. When sculptors outline fingernails, mouths, and eyes, the incised or slightly raised lines they use are clear and crisp. Perforations and undercutting are avoided, the space between limbs and the body is always filled, and most standing or seated figures have the additional support of a back slab. All this is necessary to secure the figure; hammering by direct blows at right angles is used during sculpting, which weakens the stone and could cause cracking. After polishing, granite sculpture has a smooth, glossy shine and is exceptionally resistant to weathering.

Basalt, another type of igneous rock, has properties similar to granite and diorite. It is black, blackish green, or brown and sometimes speckled and was used to create vessels in pre-dynastic Egypt. Using stone drills, picks, and abrasives, the Olmecs and later pre-Columbian cultures in Mexico carved monumental heads and reliefs from this material. In India, basalt and granite were often carved in rounded, somewhat soft-edged volumes. The sculptors even included small perforations and negative space but maintained the massiveness and hard-surfaced appearance that is characteristic of this stone.

Basanite appears among a number of other hard stones that have been used to create sculpture. Its color varies from a very dark green to rusty brown. Porphyry, another hard stone, is deep red or purple with fine-grained speckles of white feldspar and poses extraordinary difficulties in cutting, sawing, and polish-

ing. It was quarried in Egypt under the Ptolemies. After its introduction to Rome, it was associated with the emperor. However, the art of working porphyry fell into disuse after the fall of Rome, and the quarries closed. Because of its prestige, ancient porphyry found reuse in architecture, and in the late 16th century ancient porphyry pieces were laboriously worked into decorative sculptures.

The toughest stones used for sculpture are called "hardstones." The most popular of them, jade, occurs in two types: jadeite, a silicate of sodium and aluminum, and nephrite, a silicate of calcium and magnesium. Both are extremely tough because of their tightly interlocked, microscopic crystal structure. Because of its apple green or emerald color and its vitreous luster when polished, jadeite is more commonly thought of as jade than nephrite, which has an oily shine and is green, milky white, pale gray, yellow, brown, or (rarely) black.

The art of jade carving is primarily associated with China. To work this hard stone, Chinese artists used abrasives such as "yellow sand" (quartz) or powdered garnet, which was later replaced by carborundum. These abrasive powders or pastes were used with rubbers, drills, or saws made from twisted bowstrings containing the abrasive. Jade carvers both inside and outside of China used similar tools, including lathes and tools made from sandstone, slate, bronze, and iron.

The earliest Chinese jades date to the Hongshan culture in the 4th millennium BCE. During the Han dynasty, carvers worked small sculptures in the round and intricate openwork ornaments whose curved and curly shapes defy the hardness of the stone. In the 18th century, delicate objects with soft forms were favored, and Chinese carvers imported jadeite from Myanmar.

Nephrite was carved in India from the 14th century on, and its use was culminated in the creation of luxury items at the Mughal court. In Mexico, the Olmecs produced human figures and axes with incised figurative designs from the Middle Formative period on (ca. 800–300 BCE). Central and South American pre-Columbian artists also prized jade carving and the less hard obsidian.

Many hard stones are types of quartz, including rose or smoky quartz, reddish-brown cornelian, translucent violet amethyst, bloodstone, and many kinds of chalcedony (chalcedonic silica). Chalcedony is found in layers of varying opacity, translucency, and color. They include cornelian, jasper, and agate. When agate is cut horizontally to create cameos, it is called onyx. Sardonyx is an onyx in which one layer is sard, and onyx is called nicolo when the layers are dark brown or black and bluish white.

Using tiny drills and wheels, ancient Mediterranean lapidaries worked agates and quartzes into intaglio seals or cameos and occasionally small sculptures in the round. Intaglio seals, often in the form of *scaraboid* (beetle-shaped) swivel rings, were carved with tiny individual animals or figures as well as entire scenes of astonishing delicacy and detail. Although there were some large cameos such as the *Gemma Augustea* (1st century CE) most cameos were small. Often the paler stratum of the stone was cut into relief and silhouetted against the darker layer of the stone, but sometimes the dark layer was carved. To showcase their virtuosity, artists carved background details so thin that the bottom layer could shine through it to enhance the effect of pictorial depth. Although the art of cutting hard stone ranked among the most prized art forms in antiquity, it is hardly even mentioned in modern textbooks. Instead, marble statuary predominates.

Rock crystal, a clear, translucent variety of the silica mineral quartz, is harder than jade, but it is equally difficult to work with and was treasured before the late 15th century. The ancient Egyptians were the first to practice rock-crystal carving, later passing their art on to China and western Europe. Ancient as well as modern pieces were collected by European kings and stood on the altars of the richest churches. Because large, flawless pieces of rock crystal are very rare, most pieces are quite small.

Marble bears such a close connection to sculpture in Western thinking that it has become the sculpting material par excellence. However, marble, while the favored stone of the ancient Greeks and Romans, lacked the significance in the non-Western world that it possessed in Europe, and even there it was not universally available, particularly in the north. Transporting the large, heavy blocks caused difficulty, and sculptors quarried local stone before the desire for this material, so superbly suited for carving, outweighed the cost and effort of shipping it.

A metamorphic rock formed of crushed limestone, marble is fine-grained, compact, and crystalline. Many marbles are white or grayish white, but impurities may give it a flecked or banded appearance and a tint of any color. Some varieties sparkle when broken or cut; others are matte, and some are slightly translucent. Marble allows polishing to exactly the desired degree. Large blocks of marble are often available, allowing the production of large-scale works. Its hardness allows for use out of doors, but its water absorption makes it subject to frost erosion. Like limestone, marble is composed of calcium carbonate, which is susceptible to destruction from acids and acid particles in the atmosphere. As a result, the erosion of marble used for public statues and architectural decoration has been accelerated in the industrial world.

The Cyclades claim the earliest known marble sculptures, which depicted flat, sharp-edged female

figures. These were made from small pieces into which the figure's outlines were scratched and cut, perhaps with obsidian blades. The artist then worked out the volume by rubbing, applied a polish with pumice, and added details by incising.

Sculptors in 7th century BCE Greece began using marble as a substitute for wood and the local limestone, and the influence of ancient Egypt on the sculpture of the period was considerable. However, Greek sculptors avoided certain Egyptian conventions of stone carving, such as the back slab and the fusion of the limbs to the body. Even the earliest kouroi are carved with negative space between body and arms, and they take a daring step into space on legs not joined to one another, which distinguishes them from their Egyptian models.

Archaic Greek figurative sculpture and the ornamental part of architectural decoration were usually painted. Assembling figures from various materials held sway in Greece, though marble constituted the exposed parts such as arms and heads. The cumbersome and expensive nature of marble may have precluded it from being used exclusively for individual sculptures.

In the 5th century BCE, sculptors using new tools and techniques began undercutting and incorporating shade into the design of their work. To avoid spoiling the effect, the marble was often simply waxed, tinted, and left partially unpainted and bare. The marble itself became appreciated, and connoisseurship of the various types of marble began. The admiration of Renaissance artists of unpainted Roman marbles and Greek originals stripped of their paint over time began the tradition of unpainted stone sculpture in the West.

The brilliant white, fine-grained Parian marble from Mount Margessa, with its alabaster-like translucency, is perhaps the finest Mediterranean marble, but most blocks were too small for carving an entire figure. Other kinds of Parian marble are grayish white. The off-white Pentelic and the coarse-grained white Naxian marble have also enjoyed popularity. The most famous of marble quarries opened by the Romans were on the island of Proconessos (now Marmara) in northwest Turkey and provided marble streaked with bands of black and bluish gray. Quarries in the Appenine Mountains in Italy produced the white Apuan marble.

The desire of Greek stone sculptors to create figures with animated, often twisted poses necessitated the inclusion of supports that were also needed when the Romans began making marble copies of bronze statues. The prestige of ancient statuary from the Renaissance on explains why European sculptors usually did not hesitate to include these devices, although the finest sculptors created designs that tended to conceal them.

With the fall of the Western Roman Empire, the demand for marble decreased and the quarries closed. Throughout the Middle Ages marble, primarily used for architectural ornament, was plundered from ancient buildings and monuments. Increasing demand for white marble, at first primarily for architectural purposes, led to the reopening of the Appenine marble quarries. The exportation of small white marble statuettes and reliefs from Italy and the admiration of ancient art in Renaissance Europe, however, led to a vivid trade in Italian marble. Marble became the chief material for sculptural expression in Europe and, in the 19th century, also in the United States. Apart from imported marbles, American sculptors also use local marbles such as Vermont and Georgia white, Colorado yule, Alabama cream, and Tennessee pink.

From the late 16th century on, sculptors occasionally used colored marbles, perhaps inspired by Roman figures that were composed of several materials like bronze, porphyry, and marbles in a variety of tints. Some of the most noteworthy of these were the Belgian black, Apuan violet, the yellow *giallo antico*, and a number of banded, striated, or flecked marbles.

Outside of Europe, marble became popular in west central Hopei and the Ting-chou and Pao-ting regions of China. Between the early 6th and the middle of the 8th century, these regions became the centers of the production of small sculptures depicting the Buddha and bodhisattas (Buddhist saints). Marble became an important material for sculpture again during the Ming dynasty. In the 11th and 12th centuries, India white marble was used for Jain temple sculpture, and it was employed by the Mughal conquerors of India for the decoration of their finest architecture. The outstanding white marble for the Taj Mahal was quarried in Makrana, India, which is about 120 kilometers from the site. However, marble never achieved the same popularity in India or China as it did in Europe.

SUSI COLIN

See also **Porphyry**

Further Reading

Adam, Sheila, *The Technique of Greek Sculpture in the Archaic and Classical Periods*, London: British School of Archeology at Athens, 1966

Bassett, Jane, and Peggy Fogelman, *Looking at European Sculpture: A Guide to Technical Terms*, Los Angeles: J. Paul Getty Museum, and London: Victoria and Albert Museum, 1997

Gnoli, Raniero, *Marmora romana*, Rome: Edizioni dell'Elefante, 1971

Hansford, S. Howard, *Chinese Jade Carving*, London: Humphries, 1950

Hardinge, Charles Edmund, *Jade: Fact and Fable, with Lists of Reported Finds of Jadestone and of Prehistoric Objects of Worked Jade*, London: Luzac, 1961

Lucas, Alfred, *Ancient Egyptian Materials and Industries*, New York: Longmans Green, and London: Arnold, 1926; 4th edition, revised and enlarged by J.R. Harris, London: Histories and Mysteries of Man, 1989

Miller, Alec, *Stone and Marble Carving: A Manual for the Student Sculptor*, London: Tiranti, and Berkeley: University of California Press, 1948

Newman, Richard, *The Stone Sculpture of India: A Study of the Materials Used by Indian Sculptors from ca. 2nd Century B.C. to the 16th Century*, Cambridge, Massachusetts: Center for Conservation and Technical Studies, Harvard University Art Museums, 1984

Penny, Nicholas, *The Materials of Sculpture*, New Haven, Connecticut: Yale University Press, 1993

Westropp, Hodder Michael, *A Manual of Precious Stones and Antique Gems*, London: Low Marston Low and Searle, 1874

NICHOLAS STONE 1586/87–1647 *British*

The head of one of the most prolific and important workshops in England in the transitional period between Renaissance and Baroque, Nicholas Stone created more than 80 tombs of considerable variety in format throughout England as well as in Ireland, Scotland, and the Netherlands. He was also responsible for the design and completion of entire buildings and worked directly with Inigo Jones on significant commissions such as St. Paul's Cathedral, London.

The son of a quarry man, Stone was baptized on 21 July 1587 at Woodbury near Exeter. He worked for three years with Isaac James before leaving England for Amsterdam with Hendrik de Keyser either in 1606 or 1607. Having spent approximately seven years in Amsterdam with de Keyser (whose daughter Marie he married before returning to England in 1613), Stone became one of the decisive figures in the transmission of Netherlandish Mannerist influence to English sculpture. The Reformation in England had had disastrous effects on the art of sculpture not only through outright destruction but also by discouraging the development of a younger generation of artists. Although contacts with Italy and France were limited, the English maintained relations with Protestants, particularly with the Netherlands, resulting in what could justifiably be called an Anglo-Dutch school.

By absorbing Dutch influences Stone by extension also transmitted the style of French late 16th-century sculpture to England, for a significant amount of de Keyser's work is marked by characteristics peculiar to the style of Germain Pilon. De Keyser's dimpled draperies on such sculptures as *Saint John the Evangelist* on the rood screen from s'-Hertogenbosch, the *Virtues* on the tomb of William of Orange, and the *Portrait of Vincent Coster* and their tapering forms came no doubt as a result of contact with Pilon's work.

These same characteristics also appear in the numerous allegorical figures on the monuments Stone executed, particularly in the early part of his career. The poor state of preservation of the surviving fragments from Stone's earliest documented work, the monument to Henry Howard, earl of Northampton, from Dover, prevents a valid stylistic judgment, but the tomb's format, recorded in a drawing in the Society of Antiquaries in London, reveals that it possibly derived from that of de Keyser's monument to William of Orange and thus indirectly from the tomb of Henry II at the Basilica of Saint-Denis, France. Saint-Denis, Stone's Digges monument may have ultimately owed its form to the heart monument of Anne de Montmorency by Barthélémy Prieur, as it consists of four Virtues set on the corners of a freestanding monument, the primary element of which is an Ionic column at the center. In all likelihood designs by du Cerceau and Vredemann de Vries provided further inspiration.

French influence is evident in a rather banal form in the style of the allegories of the Dussen epitaph in Delft. Similarities to figural types associated with the late school of Fontainebleau occur both in the physiques and in the compositional motifs of reclining allegorical figures in Stone's epitaph of Sir Thomas Bodley. A more telling example of originality is the epitaph of Martha Palmer, where Stone executed the drapery of the allegorical figures with the long, bladelike creases similar to that of two angels in alabaster (*ca.* 1590) now in the library of the École des Beaux-Arts in Paris. The Palmer monument's allegories have no feet but instead seem to be floating with the ends of their drapery tucked under the epitaph's central medallion: they show the truly mannered, eccentric nature of Stone's early work, astutely characterized by Whinney as "restlessness" (see Whinney, 1964). Over the next three decades Stone's style in general became more stately and monumental. This change likely came about not only from his own maturation but also by the growing awareness in England of Classical and Italian sculpture, significantly through the collections of Thomas Howard (Earl of Arundel and great-nephew of Henry Howard), Charles I, and the Duke of Buckingham.

Many of Stone's funerary monuments were console-shaped epitaphs mounted on walls, whose popularity was due at least in part to the dwindling amount of floor space that remained in English churches at the time. Stone nonetheless received commissions for funerary monuments of other types, including the floor slab of Sir William Curle, which is notable as much for the high relief in which the figure was carved as for the body's naturalistic attitude and the surprisingly economic rendering of the form. The altar tomb of Elizabeth, Lady Carey, is one of Stone's outstanding works. To judge from his accounts, this white-and black-marble monument was one of the most costly of

his career up to that time. He represented the deceased naturalistically as though asleep, rendered the elaborate costume with a full command of sculptural form and decoration, and treated the sarcophagus with a fine balance between severe restraint and ornamental lyricism. Although it is by no means as sumptuous as the canopied Morrison tomb from about a decade later (1628–30) or the costly Villiers monument, the mastery of composition and detail foreshadows the success of Lady Morrison's effigy, which is noteworthy for its harmoniously arranged, soft curving folds of drapery and graceful positioning of the hands. Lady Morrison commissioned the tomb herself, so the quality of her effigy may well reflect her personal interest in it. The monument with the most unusual format in England at the time is that of Francis Holles in Westminster Abbey, which shows the deceased dressed in classical armor, seated on a freestanding, columnar pedestal.

In addition to funerary monuments Stone had a ready patronage for work ranging from mantelpieces, statues of England's sovereigns, and Classical deities (a Hercules fountain at Windsor and *Apollo*, *Diana*, *Juno*, and other deities for Sir William Paston at Oxnead near Norwich) to baptismal fonts and full-scale architectural projects. Among the latter the most original are probably the three boldly rusticated gateways to the Botanical Garden at Oxford, commissioned in 1631. Stone's accounts, apparently written retrospectively, end in 1640, but he continued with diary entries of varying lengths that describe significant episodes of the civil war. It is reasonable to believe that the fever that left the sculptor bedridden for 12 weeks beginning in February 1640 really occurred in February 1641; the second entry after that one relates "my lord of Straford [sic] was beheaded . . . and others fled . . . to Francs [sic]" (see Spiers, 1919). Even though Stone received commissions for two epitaphs in 1642, his work could not have remained untouched by the war's tragic events.

MARY L. LEVKOFF

See also de Keyser, Henrik; Pilon, Germain; Prieur, Barthélemy

Biography

Born in Devon, or Woodbury near Exeter, England, 1586/87. Son of quarry worker. Worked for three years with Isaac James; traveled with Hendrik de Keyser to Amsterdam, 1606/07; remained in the Netherlands until 1613; went to Edinburgh, worked on wainscoting of Holyrood Palace's chapel and on the organ, 1616; master mason under Inigo Jones for Whitehall, 1619; continued to receive commissions for funerary monuments, primarily epitaphs; appointed Charles I's *capo-*

maestro (master mason and architect) for Windsor Castle, 1626; responsible for work on Ionic portico, St. Paul's Cathedral, 1633; wrote will, calling his body "sickly," 1640; accounts end, 1642; will reaffirmed, 1643. Died in London, England, 24 August 1647.

Selected Works

1614 Dussen epitaph (attributed); marble, alabaster, touchstone (?); Oude Church, Delft, the Netherlands

1615 Monument to Henry Howard, Earl of Northampton, for Church of St. Mary in Castro, Dover, England; marble (mostly destroyed); fragments: Trinity Hospital, Greenwich, England

1615 Bodley epitaph; marble, alabaster (?); Chapel of Merton College, Oxford University, England

1617 Palmer epitaph; marble; St. Andrew's Church, Enfield, Middlesex, England

ca. 1617 Curle tomb; marble; St. Etheldreda's Church, Hatfield, England

1617–19 Tomb of Elizabeth, Lady Carey; marble; St. Michael's Church, Stowe, England

1622? Francis Holles monument; alabaster, marble; Westminster Abbey, London, England

1625 *Edward V, Richard III, and Henry VII*, for Royal Exchange, London, England; stone (destroyed); *Elizabeth I*, for Royal Exchange, London, England; stone; possibly Guildhall Museum, London, England

1628–30 Morrison tomb; alabaster, marble; St. Mary's Church, Watford, England

1631 Villiers monument; marble; Westminster Abbey, London, England

1631–32 Digges monument; marble; St. Mary's Church, Chilham, England

1631–33 Rusticated gateways; stone; Botanical Garden, Oxford, England

1634 *Apollo*, *Diana*, and *Juno*; medium unknown (Portland stone?) (destroyed)

Further Reading

Bullock, Albert Edward, *Some Sculptural Works of Nicholas Stone: Statuary, 1586–1647*, London: Batsford, 1908

Esdaile, Katharine Ada McDowall, *English Monumental Sculpture since the Renaissance*, London: Society for Promoting Christian Knowledge, and New York and Toronto, Ontario: Macmillan, 1927; reprint, Westport, Connecticut: Hyperion Press, 1979

Esdaile, Katherine Ada McDowall, "Notes on Three Monumental Drawings from Sir Edward Dering's Collections in the

Library of the Society of Antiquaries," *Archaeologia Cantiania: Transactions of the Kent Archaeological Society* 47 (1935)

Esdaile, Katherine Ada McDowall, "The Inter-Action of English and Low Country Sculpture in the Sixteenth Century," *Journal of the Warburg and Courtauld Institutes* 6 (1943)

Mann, J.G., "English Church Monuments, 1536–1625," *Walpole Society* 21 (1932–33)

Spiers, Walter L., "Notebooks and Account Books of Nicholas Stone," *Walpole Society* 7 (1919)

Whinney, Margaret, *Sculpture in Britain, 1530–1830*, London and Baltimore, Maryland: Penguin, 1964; 2nd edition, revised by John Physick, London and New York: Penguin, 1988

WILLIAM WETMORE STORY 1819–

1895 *United States, active in Italy*

William Wetmore Story was born in Salem, Massachusetts, into an elite New England family. The son of Supreme Court Justice Joseph Story, he studied law at Harvard University. During his early adulthood he cultivated friendships with the painter Washington Allston, the writer Ralph Waldo Emerson, and the poet James Russell Lowell. In 1840 he entered the Boston law practice of future senator Charles Sumner. Between practicing law and writing legal publications, Story maintained his friendships with Bostonian cultural and intellectual figures. Although committed to a professional career, he managed to devote some of his time to writing poems, modeling in clay, and sketching.

Story married in 1843 and settled into his chosen profession. His career took an unexpected turn in 1845 when he was asked to design a monument to his recently deceased father for Mount Auburn Cemetery. In order to prepare for the project, Story traveled to Italy in 1847 to study sculpture. During two extended trips abroad, he absorbed the rudiments of sculpture and studied from antique models. When his monument to Justice Story was unveiled in 1854, it was highly praised. He made a brief attempt to return to his law career but found it less appealing after his experiences in Italy. Encouraged by his recent success, Story decided to move permanently to Rome and become a sculptor. In Rome the Storys remained at the center of a lively Anglo-American intellectual circle that included the Brownings and a host of American artists living abroad.

Unlike most other American sculptors abroad, Story was a man of fairly independent means. He did not have to rely on portrait commissions for his survival, which allowed him the freedom to explore ideal subjects derived from literature and history, for which he quickly demonstrated a preference. His early ideal works, such as *The Arcadian Shepherd Boy* and *Marguerite*, also illustrate Story's life-long interest in med-

itative themes over active heroism. *The Arcadian Shepherd Boy* was only his second full-length figure but shows the rapid assimilation of his Roman training. The sculpture is of a seminude youth seated and playing a flute; although it is not derived from a specific source, it was clearly inspired by the Classical themes that surrounded Story in Rome. *Marguerite* is among the first of Story's literary subjects, showing the ill-fated heroine of *Faust* quietly plucking the petals from a flower to determine Faust's love for her. The figure's action is subtle and delicate—the dramatic content is provided by the viewer's knowledge of the play. Story emphasized her gentleness and purity through the naive simplicity of her action and the prominently placed cross around her neck. Although *The Arcadian Shepherd Boy* was acquired by subscription for the Boston Public Library, new commissions were not forthcoming.

Story's first major successes in the ideal mode were of two powerful and contemplative women, *Cleopatra* and the *Libyan Sibyl*. When Story's work was rejected by the American committee of the 1862 International Exhibition in London, Pope Pius IX helped pay for these two works to travel to the exhibition, where they

Cleopatra
The Conway Library, Courtauld Institute of Art, Metropolitan Museum of Art, NY

were shown alongside contemporary Roman sculpture. The international press took notice of these works, and Story's career finally gained momentum. *Cleopatra* was also honored with a glowing description in Nathaniel Hawthorne's novel *The Marble Faun*. Both sculptures capitalized on contemporary interest in exotic Eastern subjects. Like *Marguerite*, these two sculptures show careful attention to historical detail, which reinforces the narrative context and ultimately the tragic implications for the subjects. These figures also mark a break with his earlier subject matter in their turbulent and brooding power. Although *Marguerite* represented a delicate, chaste feminine ideal, Story would now show a preference for strong women doomed by their circumstances. Story's *Cleopatra* portrays the imposing queen melancholically ruminating in a chair, proud yet withdrawn. Her exposed breast is not merely a reminder of her feminine wiles but a clear allusion to her later suicide. The sculpture was so popular that Story carved several versions.

In the wake of *Cleopatra*, Story created a succession of sculptures of strong tragic women including *Judith*, *Delilah*, *Salome*, and *Medea Contemplating the Murder of Her Children*. His *Medea* renders the mistreated heroine contemplating her revenge, absently holding a knife. Her inner conflict is ably reflected in her pose and expression. This work garnered Story additional recognition at home when it was exhibited at the Metropolitan Museum of Art, New York City, in 1874. Two years later it won a medal at the Philadelphia Centennial. Although Story created several successful male figures, most notably his *Saul* of the mid 1860s, his best ideal subjects were of women.

Story also produced portraits throughout his career, primarily undertaken for his personal interest in an individual. Despite the success of ideal works with European audiences, Americans tended to prefer Story's portraits, and he received many commissions late in life for major public portraits. In contrast to his ideal subjects, most of his portraits were of men. For these works he often used bronze, rather than the marble that dominated his ideal figures. He executed portraits of many notable figures, including George Peabody, the Smithsonian's Joseph Henry, Chief Justice John Marshall, Ezra Cornell, and Francis Scott Key.

Just as Story's career began with a monument to a departed loved one, so too it ended. His final work was a memorial to his wife, who died in 1893. In this work Story abandoned the restrained Classical influences of his earlier work and expressed the full tragic implications of his personal loss. The monument is located in Rome's Protestant Cemetery and consists of an angel of grief collapsed in anguish over the grave marker dedicated to Mrs. Story. Story ceased sculpting after he completed this moving memorial and died at his daughter's home in Vallombrosa in 1895. After his death, his family asked Henry James to prepare a biography of the sculptor. Story's son Thomas Waldo also became a sculptor.

AKELA REASON

See also **United States: 18th Century–1900**

Biography

Born Salem, Massachusetts, United States, 12 February 1819. Graduated Harvard Law School, 1840; received commission to sculpt memorial to father, Supreme Court Justice Joseph Story, for Mount Auburn Cemetery, 1845; traveled to Rome, 1847; returned to Boston to continue legal career, 1855, but positive reception of father's portrait led him to pursue art; settled permanently in Rome to work as a sculptor, 1856; exhibited at International Exhibition in London, 1862; visited United States, 1877; began memorial to his wife, 1893. Son, Thomas Waldo, also a sculptor. Died in Vallombrosa, Italy, 5 October 1895.

Selected Works

1851–58 *Marguerite*; marble; Chrysler Museum of Art, Norfolk, Virginia, United States

1852 *The Arcadian Shepherd Boy*; marble; Boston Public Library, Massachusetts, United States

1854 *Joseph Story*; marble; Portrait Collection, Harvard University, Cambridge, Massachusetts, United States

1858 *Cleopatra*; marble; County Museum of Art, Los Angeles, California; Metropolitan Museum of Art, New York City (1869 version), United States

1861 *Libyan Sibyl*; marble; Metropolitan Museum of Art, New York City, United States

1866 *Medea Contemplating the Murder of Her Children*; marble; version, 1868: Metropolitan Museum of Art, New York City, United States

1881 *Joseph Henry*; bronze; mall, Smithsonian Institution, Washington, D.C., United States

1893–95 *Angel of Grief*; marble; Protestant Cemetery, Rome, Italy

Further Reading

Gerdts, William, "William Wetmore Story," *American Art Journal* 4/2 (1972)

Gerdts, William, "American Memorial Sculpture and the Protestant Cemetery in Rome," in *The Italian Presence in Ameri-*

can Art, 1860–1920, edited by Irma B. Jaffe, New York: Fordham University Press, and Rome: Istituto della Enciclopedia Italiana, 1992

James, Henry, *William Wetmore Story and His Friends*, 2 vols., Edinburgh and London: Blackwood, and Boston: Houghton Mifflin, 1903; reprint, London: Thames and Hudson, and New York: Grove Press, 1957

Kasson, Joy S., *Marble Queens and Captives: Women in Nineteenth-Century American Sculpture*, New Haven, Connecticut: Yale University Press, 1990

Phillips, Mary Elizabeth, *Reminiscences of William Wetmore Story: The American Sculptor and Author*, Chicago and New York: Rand McNally, 1897

Ramirez, Jan Seidler, "A Critical Reappraisal of the Career of William Wetmore Story, (1819–1895): American Sculptor and Man of Letters," Ph.D. diss., Boston University, 1985

Story, William Wetmore, *Conversations in a Studio*, 2 vols., Boston and New York: Houghton Mifflin, and Edinburgh: Blackwood, 1890

VEIT STOSS ca. 1445/50–1533 *German, also active in Poland*

Veit Stoss is one of the most, if not the most, significant German sculptors in the transitional period from the late Middle Ages to the Renaissance. He also worked, however, as an engraver and painter. That he was born in the Horb on the Neckar River is certain. He probably spent his journeyman years in Swabia and in the Upper Rhine region. There he was impressed by the art of Hans Multscher and his church masons' guild in Ulm, as well as the works of Jörg Syrlin the Elder. In the Upper Rhine region, Stoss clearly became acquainted with the formal world of the graphic artists Master E.S. and Martin Schongauer, whose influence continued to resonate in Stoss's late engravings. He probably also familiarized himself with the outstanding sculpture of Nikolaus Gerhaert von Leiden, who was then working in Strasbourg.

None of Stoss's early works made during this period have been recorded or uncovered. Clearly, he must have accomplished some high-quality works in order to be called to Kraków to create the high altar retable for the Church of St. Mary. The work on the altar, one of his chief works, lasted until 1489. Beginning in 1484, he also became active as Kraków's master builder, and probably participated in the plans for a new city fortification, the so-called Barbarkane. In addition, he produced funerary monuments and crucifixes during his Kraków period. Among these is the stone cross funded by Heinrich Slacker in the Church of St. Mary, the funerary monument to King Kasimir IV in the Wawel Cathedral, and memorial slabs in Gnesen Cathedral and the Dominican church in Kraków.

For reasons not entirely clear, Stoss returned to Nuremberg in 1496. In 1496 Paulus Volckamer entrusted him with the production of a large epitaph for the Church of St. Sebaldus. The work was completed in 1499 and consists of three monumental pictorial reliefs, as well as figures of the Master Dolorosa and Christ as the Man of Sorrows. In 1500, together with his assistants, Stoss produced a carved altar standing just 12 meters high for the Church of Our Dear Lady in Schwaz in Tyrol, a wealthy Bergau community at that time. Eventually Stoss fell for a fraudulent financial speculation and lost a considerable part of his fortune. To win his money back, he falsified a bill of exchange in 1503 and was punished with imprisonment and a public branding: both of his cheeks were pierced through. In addition, he was forced to take an oath never to leave Nuremberg again during his lifetime without the consent of the town council. He lost the right to train apprentices and journeymen in his workshop. However, the punishment was unusually mild, probably because Stoss was a highly acclaimed woodcarver. He fled to Münnerstadt in 1504, where he polychromed the high altarpiece created between 1490 and 1492 by Tilman Riemenschneider for the Church of St. Mary Magdalene, and he decorated the exterior of the wings with paintings. From Münnerstadt he repeatedly appealed to the Nuremberg council to accept him back as a citizen with full rights.

After his return to his native city, he was subject to renewed humiliations and reprisals. Even his son Stanislaus turned his back on his father and set up his own workshop in Kraków. Stoss raised the council's ire against him again and again in seeking his rights. In 1506 he was forbidden from mounting a carving he bequeathed to the Church of St. Sebaldus for being a sinner and swindler. Despite the commissions received from the emperor to participate on the ruler's tomb in the Church of the Franciscans in Innsbruck—the wood models for the over–life-size bronze castings of Elisabeth of Tirol and Zimburgis of Mazovia are probably his—his reputation in Nuremberg did not improve as he had hoped it would.

Presumably between 1505 and 1508 the lack of commissions in Stoss's workshop threatened its existence. The Nuremberg patrons apparently withdrew from their association with him. Orders seem to have mounted again only in the second decade of the century. In 1516 he completed the *Tobias and the Angel* group in the round for the silk trader Raffaello Torrigiani, who also owned a franchise in Nuremberg; this group was erected in the city's Dominican church. In the fold formations of the garments of these two sculptures, Stoss exploited the possibilities of mastering this material to a degree never seen before and lending the wood in the depicted subject an ethereal quality.

Stoss was most famous as the master of crucifixes. Around 1505–10 he created the monumental crucifix for the Hospital of the Holy Spirit, and around 1512

the crucifix for the Church of St. Sebaldus in Nuremberg. An unknown patron ordered the sculpture of *St. Roch* for the Church of the Santissima Annunziata in Florence. Giorgio Vasari called the sculpture "a miracle in wood." Anton II Tucher, a Nuremberg merchant and patrician, ordered a monumental sculptural work from the master called the *Angelic Salutation* depicting the Annunciation. Completed in 1518, it hangs in a huge medallion wreath in the choir of the Church of St. Lorenz, Nuremberg. Stoss's last great work was the current Bamberg altarpiece, originally known as the *Mary Altar*, created between 1520 and 1523 for the Church of Our Savior in the Carmelite monastery in Nuremberg, in which his eldest son, Andreas, occupied the office of the prior. Because the monastery was secularized in the imperial city immediately after the Reformation was introduced, and the bill for the retable was not yet completely paid, the work was sold to Bamberg in 1543. The style derived from the Late Gothic is combined here with a deep echelon formation in the figural groups and a virtuosic landscape in the background scenery.

Stoss was active as an artist even in his last years, preferring then to work on small-scale sculptures. Until 1532 he is alleged to have sold his carvings at a stand in the Nuremberg Church of Our Lady. He died in 1533.

Stoss's manner of depiction is characterized by his use of extreme dramatic tension to express an inner power driving individuals who seem to be transported from their surroundings. His style is also marked by a realism reaching into fine details, together with decorative forms set in unruly motion, which grew out of his spiritualist understanding of the world. He remained bound to the Late Gothic language of forms. He developed a carving technique of the highest virtuosity and introduced a series of new compositional motifs. In Poland his work brought about a rupture with the past and had a formative influence on a number of Polish masters, as well as many from Silesia and Danzig. Master Paul von Leutschau, who came from the Nuremberg workshop, relayed the master's style to Slovakia and Transylvania. Claus Berg of Lübeck even carried it into Denmark. Stoss did not, however, have a student or successor who achieved his level of importance, much less surpassed him.

FRANK MATTHIAS KAMMEL

See also **Gerhaert von Leiden, Nikolaus; Multscher, Hans; Riemenschneider, Tilman; Syrlin, Jörg, the Elder**

Biography

Born in Horb on the Neckar River, Swabia, Germany, *ca.* 1445/50. Journeyman in Swabia and Upper Rhine region; influenced by the Master E.S. and Nikolaus Gerhaert von Leiden; settled in Nuremberg; moved to Kraków, 1477; returned to Nuremberg, 1486; worked in Nuremberg with short stays in Schwaz in Tyrol, the lower Franconian city of Münnerstadt, 1504, and trip to Breslau, Silesia, 1526. Died in Nuremberg, Germany, 20 September 1533.

Selected Works

1477–89 High altar; limewood, polychromy; Church of St. Mary, Kraków, Poland
1492 Tomb of King Kasimir IV Jagellio; marble; Wawel Cathedral, Kraków, Poland
1495 Epitaph for Philippus Callimachus; bronze; Dominican church, Kraków, Poland
1496– Volckamer Donation; wood, sandstone;
1500 Church of St. Sebaldus, Nuremberg, Germany
1505–10 Crucifix, for Hospital of the Holy Spirit, Nuremberg, Germany; limewood; Germanisches Nationalmuseum, Nuremberg, Germany
1516 *St. Roch*; limewood; Church of Santissima Annunziata, Florence, Italy
1516 *Tobias and the Angel*, for the Dominican church, Nuremberg, Germany; limewood; Germanisches Nationalmuseum, Nuremberg, Germany
1517–18 *Angelic Salutation*; limewood; Church of St. Lorenz, Nuremberg, Germany
1520 Domestic Madonna from the artist's residence; limewood; Germanisches Nationalmuseum, Nuremberg, Germany
1520–23 Bamberg altarpiece; limewood; Bamberg Cathedral, Germany

Further Reading

Barthel, Gustav, *Die Ausstrahlung der kunst des Veit Stoss im Osten*, Munich: Bruckmann, 1944
Germanisches Nationalmuseum, editor, *Veit Stoss in Nürnberg: Werke des Meisters und seiner Schule in Nürnberg und Umgebung*, Munich: Deutscher Kunstverlag, 1983
Kahsnitz, Rainer, editor, *Veit Stoss: Die Vorträge des Nürnberge Symposions*, Munich: Deutscher Kunstverlag, 1985
Keller, Harald, *Veit Stoss: Der Bamberger Marien-Altar*, Stuttgart, Germany: Reclam, 1959
Lutze, Eberhard, *Katalog der Veit Stoss-Ausstellung im Germanischen Museum*, 2nd edition, Nuremberg, Germany: Germanisches Nationalmuseum Nüremberg, 1933
Lutze, Eberhard, *Veit Stoss*, Berlin: Deutscher Kunstverlag, 1938; 4th edition, Munich: Deutscher Kunstverlag, 1968
Sello, Gottfried, *Veit Stoss*, Munich: Hirmer Verlag, 1988
Skubiszewski, Piotr, *Wit Stwosz*, Warsaw: Arkady, and Berlin: Henschelverlag, 1985; as *Veit Stoss*, Berlin: Henschelverlag, 1985

VEIT STOSS *ca.* 1445/50–1533

Stafski, Heinz, "Veit Stoss," in *Fränkische Lebensbilder*, edited by Gerhard Pfeiffer and Alfred Wendehorst, vol. 6, Würzburg, Germany: Schönigh, 1975

HIGH ALTAR, CHURCH OF ST. MARY
Veit Stoss (ca. 1445/50–1533)
1477–1479
limewood, polychromy
h. 13.95 m
Church of St. Mary, Kraków, Poland

The *St. Mary* altarpiece in Kraków stands as Veit Stoss's chief work. It is among the most splendid and is the largest of the preserved altarpieces from the Late Gothic period. Its tremendous significance was recognized in the beginning of the 19th century when the Danish sculptor Bertel Thorvaldsen, one of the most important European Classicist artists, expressed tremendous admiration for the work, which he saw during a visit to Kraków. No other altarpiece from the 15th century achieved the original size of the *St. Mary*; today, even following intensive restoration, the work measures 12.8 meters high, although it had an original height of nearly 14 meters. Stoss based the size and form of the piece on the measurements of the choir. The retable consists of the shrine cabinet with a pair of wings, a predella (a painted panel, usually small, belonging to a series of panels at the bottom of an altarpiece) below, and the pinnacle decoration of bars and tabernacles jutting up over the shrine. The patron of the Kraków parish church provided him with the basic theological theme and the primary motif for the composition: the *Death* and *Ascension of the Mother of God*. The project was funded by the entire congregation of the Church of St. Mary. The town council instituted a committee to supervise the work on the new altarpiece, and the artist received a total payment of 2,808 Hungarian ducats for the finished work.

Stoss's high altar depicts Mary's Assumption with more drama and magnitude than any other work of art. The pictorial composition chosen was by no means new for that time. Rather, it originated in Bohemian art about 1400. The so-called Dormitio scene (*dormire* is Latin for "to sleep" or "to fall asleep"), which depicts the Virgin kneeling in the arms of the apostle St. John, can be traced back as far as the altar in Raudnitz from 1410, which is now in the Prague National Gallery. Shortly after 1400, a group of large-format figures, including the apostles and a dying Virgin Mary on her knees, was produced in a ceramic sculpture studio in Nuremberg. Parts of the group are now located in the Germanisches Nationalmuseum in Nuremberg, and others are in the Heiligkreuz (Holy Cross) parish church in western Bohemia. Since this group may orig-

High altar, Church of St. Mary, Kraków, Poland
© Erich Lessing / Art Resource, NY

inally have been displayed in Nuremberg, it is perhaps how Stoss became acquainted with the motif. Unlike the Byzantine form of Mary's death on her deathbed, the poignant representation of her death appeals very strongly to the viewers' sensibilities; indeed, the viewing experience itself suggests a participation in the joyous *Ascension of the Mother of God*. The way her death is represented, with suffering and doubt, and the entrance of her soul into heaven provided confidence and comfort in faith.

In terms of the composition, this type of depiction focuses everything on the figure of the Virgin Mary. The decorative background, which reveals the reading of the last rites, the waving of incense, and the sprinkling of holy water around her, have a secondary generic character. In Kraków the motif was used in monumental proportions and presented by the sculptor much like a theatrical stage. The scene is the center of the entire retable presentation, arranged visually in such a way as to achieve its effect from either a near or far perspective. The seemingly chaotic gathering of the stricken apostle figures is masterfully arranged in a flat arch along the narrow ramp of the stage. That

Stoss was an exceptional observer of human physiognomies is attested to by his realist, indeed verist, approach to detail. He handled his artistic medium both as a virtuoso and a sovereign. The mimeses and gestures of the apostle figures are characterized by their expressive forms. Stoss created a new role for the youngest apostle, which stands in contrast to every imaginable model: shocked by her sudden death, St. John does not stand by the Virgin Mary, but rather recoils in horror. In his place, St. Bartholomew catches her falling body. The shocked and upset figures of the apostles are superbly and effectively juxtaposed to the gentle death of the woman. In the shrine of the Kraków altar, Stoss created a powerful stage, the showplace of an event, which enables the viewer to participate in the internal drama of the scene. It has been rightly interpreted as less a reconstruction of an historical event than as a vision transcending time and space.

The images on the retable are devoted to the life of the Virgin Mary. The predella bears the *Tree of Jesse*, the allegorical image of the genealogy of Mary and Christ. In the pinnacle decoration, which grows out of the shrine cabinet, the crowning of Mary is depicted. The group, which is constructed strictly along the main axis and consists of the Virgin, God the Father, the Son, and the Holy Ghost in the form of a dove, as well as a pair of angels on either side playing music and the Polish patron saints Stanislaus and Adalbert, was produced by one of Stoss's assistants. The weekday side of the retable consists of a pair of standing wings on either side of the shrine and the exterior sides of a pair of folding wings. On this side, the viewer sees a narrative consisting of 12 individual scenes. The flatly carved reliefs create the impression of a gigantic open book or a monumental, 12-part mural. In terms of composition, some reliefs are more strongly influenced by Late Gothic structural principles, whereas others show traits of the Renaissance in their figures and use of space. The reason for the difference in the carving style can be found in both the duration of the technical work, which took many months, and in the participation of Stoss's assistants. Depicted are events from the lives of Mary and Jesus: the Annunciation to Joachim and his encounter with St. Anne, the mother of the Virgin, at the Golden Door; the *Birth of Mary*; *Mary's Visit to the Temple* and the *Presentation of Jesus in the Temple*; *Christ in the Temple*; his *Arrest*; the *Crucifixion*; the *Lamentation* and the *Burial of Christ*; the *Encounter of the Risen Christ with Mary Magdalene* (*Noli me tangere*); the *Visit of the Three Marys to Christ's Grave*; and *Christ's Descent into Limbo*. On the feast day—which features the fully opened shrine—the reliefs on the wings depict the *Annunciation to Mary*, the *Birth of Christ* and the *Adoration of the Three Magi*, and the *Resurrection* and the *Ascension of Christ*, as well as the outpouring of the Holy Spirit and all of the joyful events in the life of the holy Virgin Mary.

When the images on the retable were to be changed was determined by the switch from working days to Marian feast days according to the church calendar. The opening of the wings on high feast days signified an intensification of the impact of the artistically realized theological subject matter, which supported the specific liturgical concern. From the ends inward, toward the ideological and compositional center of the winged altar, the sculptural volumes and visual expression of forms intensify the figural aspects of the work to the point of three-dimensionality for the rounded figures of the shrine. Whereas the working-day side consists of flat reliefs, the images on the feast-day side were created in high relief. The opening of the Kraków retable has been compared with the raising of a theater curtain, which reveals an overwhelming *theatrum sacrum* (holy theater). The transition from the multifarious colorfulness of the working-day side to the dominating colors of blue and gold, the colors symbolizing heaven, in the scenery of the shrine also heightens the viewing experience. The frame of the shrine with its rounded arches and tracery baldachin illustrate the entrance into the kingdom of heaven, the gate to Paradise, of which the faithful catch a glimpse here.

FRANK MATTHIAS KAMMEL

Further Reading

Chrzanowski, Tadeusz, *Krakauer Marienaltar, Veit Stoss*, Warsaw: Interpress, 1985

Funk, Veit, *Veit Stoss: Der Krakauer Marienaltar*, Freiburg, Germany: Herder, 1985

Stuhr, Michael, *Der Krakauer Marienaltar von Veit Stoss*, Leipzig: Seemann, 1992

STUCCO (LIME PLASTER)

Stucco is a highly plastic, white substance that, once molded and dried out, becomes durably stable and has an appearance similar to marble. Because of these properties, stucco has been used since the earliest civilizations in different types of artistic production and with different functions, from simple protective or decorative facing on architectural works to the large, decorative complexes in bas-relief or in the round that appeared all across Europe beginning in the 16th century.

From a chemical standpoint, stucco is an amalgam of substances; the ingredients have varied slightly over time and according to local availability as well as the types of application. The most common form of stucco is a combination of lime, powdered marble, washed sand, and casein mixed in varying proportions. The

production of any good-quality stucco requires a lengthy, controlled process. The first step is to slake limestone at 880 degrees Celsius (1,472 degrees Fahrenheit) or marble at 1,000 degrees Celsius (1,832 degrees Fahrenheit). The importance of this preparatory phase was already well known even in ancient times; Vitruvius, in *De Architectura*, recommended the use of well-processed and well-sieved lime. The sand must also be very clean, but according to a recipe worked out by Giovanni da Udine in the early 16th century, it can be replaced with powdered marble to obtain a glossier white stucco.

After a dense, uniform mixture has been obtained, it can be shaped by hand with the aid of putty knives and sticks, or filled into molds for recurrent frieze and rosette motifs. If the design of a relief calls for projecting parts, they can be added by inserting metal pins. If stucco is used for freestanding sculpture, the first step is to build a wood, stone, or metal armature to support the stucco and guarantee the composition's stability. Especially in the case of ceiling decoration, stucco tends to flake over time, gradually losing its outer layers. The direct causes of deterioration include insufficiently slaked lime and, above all, humidity. In the 18th century, in fact, the stucco craftsmen from Lombardy, who were working in Germany and England, would pack up and go home in winter because the climate did not allow the stucco to set and dry out. One of the most frequent indirect causes of deterioration is the damage of the internal armature, which can get rusty if made of metal or be attacked by xylophagous insects if made of wood.

The earliest evidence of the use of stucco comes from ancient Egypt. Between 2575 and 2150 BCE, the Egyptians would coat the heads of mummies with stucco; once dry, it formed a sort of funeral mask of the deceased. The abundance of the constituent elements contributed to stucco's rapid spread eastward to Persia and India and throughout the Mediterranean region. In Crete, for instance, the Knossos Palace walls were decorated with large panels in low relief depicting bullfighting scenes and processions of cup bearers. In 6th-century BCE Greece, preference was given to marble over stucco because carving techniques had become extremely refined; stucco was used mainly for wall facing and architectural decoration. In Hellenistic Alexandria, stucco was used for still another purpose: to create small reliefs that served as models for jewelry. Because of the influence of Greek and Hellenistic civilization, the technique quickly spread to Italy. Here, and especially in Rome, it reached extremely high levels of refinement beginning in the 1st century BCE, when the Farnesina House reliefs were created. These are characterized by great expressive freedom and by a compositional scheme that is no longer constrained by the architectural structure, but plays on the alternation of airy landscapes and mythological scenes. In early Christian and Byzantine times, the popularity of stucco continued unabated, and new variants were added. The rich ornamental motifs created in regions under Islamic influence were probably carved into dry stucco. In the West, particularly in Ravenna, stucco enriched with glass paste and gilding was used to create imitations of jewelry and for complex architectural decorations, as in the triple arches at the Orthodox Baptistery (458 CE, Ravenna).

From the 12th century on, stucco also fulfilled a function complementary to painting and wood sculpture. Panel painters would coat their raw wooden boards with numerous layers of a chalk-and-glue mixture that, once dry and smoothed down, gave them an absolutely smooth and compact surface to work on. Another base used in decorating wood surfaces was *pastiglia*, in which marble powder was added to the usual chalk-and-glue mixture. This technique developed in the Late Gothic period and was used to decorate chests until the end of the 16th century. A length of canvas was coated with *pastiglia* and then attached to the wood surface, after which the *pastiglia* was molded in low relief or painted and gilded.

In Rome, at the height of the Renaissance, stucco took a leading role in architectural decoration. This development was due mainly to Raphael and his assistants, who lowered themselves into the underground chambers of the Domus Aurea to study the elegant, bone-white ornamentation. Giorgio Vasari wrote that Giovanni da Udine worked long to obtain a quality of stucco similar to that of the Romans. After numerous attempts, "finally, he had a powder made from flakes of the whitest marble that could be found, . . . mixed it with lime made from white travertine and found, with no doubt at all, that that was how the real ancient stucco was made." Some of the most famous works of 16th-century Rome were made with this technique, such as the Vatican Loggias (1518–19), Cardinal Bibiena's stove in Castel Sant'Angelo (1516), and the loggia of Villa Madama (after 1516), which was patterned on examples from ancient Roman baths. After completing his work at Villa Madama, Giulio Romano, the pupil who inherited Raphael's workshop, exported the new decorative style to Mantua, where he had been commissioned to design and decorate Palazzo del Te (1524–34). Primaticcio brought the technique from Mantua to France, where, under the direction of Rosso Fiorentino, he created the stuccos for the famous Gallery of Francis I at Fontainebleau (1534–40).

The great ease with which stucco can be modeled made it one of the materials best suited to interpret the vibrant interior decorations of the Baroque age. Most of the numerous scenographic compositions designed

by Gianlorenzo Bernini, including the splendid *Organ* in Santa Maria del Popolo in Rome (1657–58), were executed by his skilled collaborator Antonio Raggi. Raggi also molded the stucco angels on the ceiling of the Gesù church in Rome, where the painted sculptures combine with Giovanni Battista Gaulli's frescos breaking the rigid architectural framework.

Specialized craftsmen, largely from Lombardy, became the interpreters of Rococo taste in northern Europe. Among them were Giuseppe Artari, who worked in England, and various members of the Carlone family, who worked in Germany and Austria creating some of the most amazing and bustling compositions produced in 18th-century Europe. In England, the leading craftsman working in the Neoclassical style was Robert Adam, whose stuccos reflect both Classical and Renaissance influences. They alternate with sober painted decorations, all in very light hues; a good example of Adam's style is the refined Etruscan Room at Osterley House in Middlesex (1761).

With the exception of a few important works, such as the Opéra in Paris designed by Charles Garnier and completed in 1875, artistic stucco decoration began to die out after the mid 19th century, gradually replaced by cheaper, mass-produced ornamental modules.

CRISTIANO GIOMETTI

Further Reading

Azarnoush, Massoud, et al., "Stucco and Plasterwork" in *The Dictionary of Art*, edited by Jane Turner, New York: Grove, and London: Macmillan, 1996

Beard, Geoffrey, *Stucco and Decorative Plasterwork in Europe*, New York: Harper and Row, and London: Thames and Hudson, 1983

Maltese, Corrado, editor, *Le tecniche artistiche*, Milan: Mursia, 1973

Penny, Nicholas, *The Materials of Sculpture*, New Haven, Connecticut: Yale University Press, 1993

SURREALIST SCULPTURE

One of the thorniest difficulties in the study of Surrealist sculpture is the paradox at the core of the concept itself. On one hand, during the 1920s the Surrealists openly denounced sculpture as bankrupt and stale as an aesthetic category in comparison to literature and painting; André Breton, for example, made his most explicit statement about Surrealism and sculpture in 1947 when he wrote that "with the exception of [Constantin] Brancusi, [Jean (Hans)] Arp, and [Alberto] Giacometti, sculpture has become increasingly desiccated through intellectualism over the last 30 years." Yet on the other hand, as in the field of literature and painting, the boldest iconoclasts of the Surrealist movement are now canonized as some of the most

important artists of the 20th century. Thus, any inquiry into Surrealist sculpture may need to examine the possibility that the Surrealists' theories on sculpture were correct on two counts: the presence of sculptors such as Arp and Giacometti in art history surveys, after all, corroborates the Surrealist view that sculpture had been thoroughly exhausted as a means of expression by World War I. The second observation that could be made is that the success of Arp and Giacometti is also a testament to Surrealist warnings that the art market, tenured academics, and museum curators can recuperate and reify even the most radical gestures over time.

The issues that best frame Surrealism's interest in non-sculpture and anti-sculpture were most prominent in the group's writings on the "crisis of the object" between 1933 and 1939. Heavily inflected by Surrealist experiments with Hegelian dialectical thinking, the crisis of the object was a concerted effort to disrupt the relationship between mental and physical realities—in other words, the accepted conventions of the limits between subjectivity and objectivity, or as Max Ernst put it, between "conscience and self-consciousness." Not merely hallucinatory in quality, constructions assembled according to these theories were supposed to instigate a reciprocal collapsing of sensory and psychological categories for both artist and viewer alike. It was hoped that the result of the encounter with a Surrealist object would lead to a revolutionary reintegration and reconciliation of the mental spaces with those of the physical objects of the world. It was assumed that the interpenetration between exterior and interior conditions would neutralize the atmosphere of alienation that pervades modern life and thus radically transform existence in new and meaningful ways.

Anchoring these debates were intense discussions over whether or not sculptural elements, means, and values could or should be brought to bear in the manufacture of Surrealist objects. For example, one argument was that Surrealist objects should not be invested in the creation of unique three-dimensional forms in space that can be evaluated by its relatedness to standard visual and tactile aesthetic considerations. Instead, the Surrealist sculptor should deploy dream imagery, psychoanalytic metaphor, or the unsettling collision of collage elements in order to totally reconfigure and reconsider already existing objects of everyday life.

Further complicating matters was the inclusion of sculpture-objects in Surrealist exhibitions not produced by those active in the Surrealist movement. In these cases, it was the viewer who was being challenged to "surrealize" the form in space through his or her own visual encounter with it. This includes works by children and psychiatric patients; monuments

and coins by ancient Gaulish tribes; sculptures by Brancusi, Pablo Picasso, and Alexander Calder; architectural environments by Ferdinand "the Postman" Cheval, Antonío Gaudí, and Hector Guimard; ritual objects produced by aboriginal artisans in the South Pacific and the Pacific Northwest; and three-dimensional oddities such as wooden models of topological algebraic equations, a Venus's-flytrap plant, a journeyman's training exercise by a 19th-century wheelwright, and wine goblets melted by the heat of an erupting volcano in Martinique. Consider, too, the collaborative photo essay by Salvador Dalí and the photographer Brassaï on "involuntary sculpture" for a Surrealist journal in 1933 that included things like a torn, crumpled bus ticket from the pocket of a bank employee, a slightly deformed chunk of a bread roll sold in a Parisian bakery, and a worn shard of soap from the sink of a public restroom. (Dalí, incidentally, had cheered Charles Richefeu's monument to Napoléon Bonaparte in the Hall of Flags at the Hôtel des Invalides as a "masterpiece of bad taste" that was far preferable to the works of "the most depressing Impressionist in the history of sculpture," Auguste Rodin.)

All told, there were artists known for work that typically corresponds to accepted definitions, aesthetics, and functions for sculpture that earned praise from Surrealist commentators. Brazilian-born Maria Martins, for example, was one of those singled out by Breton as a sculptor of note. In an essay for an exhibition of her sensual ecological amalgamations of human, animal, and vegetable forms in New York City, Maria (as she was known) was hailed by Breton as a creator who "owes nothing to sculpture, past or present." Consider also the achievements of Surrealist sculptor Isabelle Waldberg who, inspired as much by the folk arts of Africa, India, and the Arctic Circle as Giacometti and Arp, exhibited her forms of flexible wood sticks and metal rods at Surrealist shows in the 1940s and 1950s. More recently, the "convulsive" limestone and hardwood sculptures of cabinetmaker Robert Green were characterized by Surrealist Edouard Jaguer as "situated at the meeting point of *art brut* and a Baroque style of some legendary Middle Ages." What is stirring about Green's sculptures only becomes obvious to us "whenever we hear chairs and tables creaking during our semi-slumber in the silence of the night," said Jaguer. "Only then do we realize that our furniture is *visited* by creatures similar to those of Robert Green."

DON LACOSS

See also **Arp, Jean (Hans); Bellmer, Hans; Bourgeois, Louise; Brancusi, Constantin; Calder, Alexander; Dalí, Salvador; Ernst, Max; Giacometti, Alberto**

Further Reading

Breton, André, "Situation surréaliste de l'objet: situation de l'objet surréaliste," in *Position politique du surréalisme*, Paris: Sagittaire, 1935

Breton, André, "Picasso dans son élément (1933)," "Crise de l'objet (1936)," "Exposition surréaliste d'objets (1936)," "Maria (1947)," "Triomphe de l'art gaulois (1954)," "Agustín Cárdenas (1959)," and "Silbermann (1964)," in *Le Surréalisme et la peinture*, by Breton, Paris: Gallimard, 1965; as *Surrealism and Painting*, translated by Simon Watson Taylor, London: Macdonald, and New York: Harper and Row, 1972

Dalí, Salvador, "Le vision de Gaudí," in *Oui 2: L'archangélisme scientifique*, Paris: Denoël/Gonthier, 1971

Jaguer, Edouard, "Five American Surrealists," *Arsenal: Surrealist Subversion* 4 (1989)

Krauss, Rosalind E., *Passages in Modern Sculpture*, London: Thames and Hudson, and New York: Viking Press, 1977

Maddox, Conroy, "The Object in Surrealism," *London Bulletin* (June 1940)

Martins, Maria, *Maria: The Surrealist Sculpture of Maria Martins* (exhib. cat.), New York: Emmerich Gallery, 1998

ANTONIO SUSINI 1558–1624 *Italian*

Born in Florence's San Felice in Piazza district, Antonio Susini received an education in the plastic arts beginning in boyhood. He first studied bronze working with the expert Tuscan sculptor Felice Trabellesi. Later, under the patronage of the nobleman Jacopo Salviati, he continued his studies in Giambologna's workshop. Giambologna soon put his young pupil to work casting large and small metal sculptures. A journey with Giambologna to Rome and through northern Italy marked the end of Susini's apprenticeship and the start of his mature period, as attested by his admission to Florence's Accademia del Disegno in 1589.

Susini's earliest known works—which include hunting scenes and images of Christ—date from the 1580s. Based on ancient compositions and on models by Giambologna, these pieces stand out for the high quality of their execution and the skillful rendition of the details.

In 1594 Susini received a commission to execute statues of *Saints Andrew and Philip* for the Company of San Giovanni Battista dello Scalzo, a monastery in Florence. (These works—the only ones Susini is known to have carved in stone—have not yet been identified.) In 1596, working in the framework of Giambologna's commissions, he executed a series of bronze statuettes of *Christ* and various saints for the Galluzzo Charterhouse in Florence. These pieces originally adorned a marble ciborium; at present they have been identified only in part. Susini did a great deal of work under Giambologna's commissions. In the 1580s he executed bas-reliefs for the Salviati chapel in the Dominican Church of Son Marco in Florence and also

Lion Attacking Horse
City of Detroit Purchase
© 2001 The Detroit Institute of Arts

collaborated with Giambologna and other assistants on the majestic *Equestrian Statue of Cosimo I de' Medici*, installed on the Piazza della Signoria. Susini translated a number of ancient masterpieces and famous compositions by Giambologna into bronze but according to 17th-century documents was known chiefly for a series of castings based on the Farnese Hercules and an unknown but certainly large number of medium-size replicas of Giambologna's *Nessus and Deianeira* group.

Susini's fame spread beyond the borders of the grand duchy of Tuscany. After Giambologna's death in 1608, Susini continued to work intensely on his own as a bronze sculptor. In 1613 he created two small copies of the Classical group depicting the *Story of Dirce*, better known as the Farnese Bull. In 1615 he executed a pair of holy water fonts for the Cloister of Vows (Chiostro dei Voti) in the Servite sanctuary at the Church of the Santissima Annunziata in Florence. He organized these pieces, the only ones Susini is known to have designed from their inception, into complicated Late Mannerist compositions featuring chubby-cheeked cherubs, fanciful shells, and drapes knotted to pilasters with elaborate volutes.

Susini's works were much in demand until his death, and he became quite wealthy, eventually buying a house that served in part as his workshop on Via de' Pilastri. He died in Florence and was buried in the Church of the Santissima Annunziata. His nephew Giovan Francesco, likewise a famed sculptor who specialized in bronze, inherited most of his estate.

SANDRO BELLESI

See also **Giambologna**

Biography

Born in Florence, 2 September 1558. First trained as a bronze craftsman with Felice Traballesi, then became pupil and assistant of Giambologna; admitted to the Accademia del Disegno, Florence, 1589; an excellent metal caster, worked in Florence, mainly translating copies of celebrated ancient sculptures and works by Giambologna into bronze; became an independent sculptor on Giambologna's death in 1608. Succeeded by his nephew, the bronze sculptor Giovan Francesco Susini. Died in Florence, 9 June 1624.

Selected Works

ca. 1580 *Crucifix* (copy after Giambologna); bronze; Cleveland Museum of Art, Ohio, United States

ca. 1580 *Crucifix* (copy after Giambologna); bronze; Museo dell'Opera del Duomo, Prato, Italy

ca. 1580 *Lion Attacking a Horse* (copy after Giambologna); bronze; casts: The Detroit Institute of Arts, Michigan, United States; Museo di Palazzo Venezia, Rome, Italy

ca. 1580 *Lion Attacking a Bull* (design after an ancient work); bronze; casts: Museo di Palazzo Venezia, Rome, Italy; Musée du Louvre, Paris, France

ca. 1580–88 *Christ at the Column* (copy after Giambologna); bronze; Staatliche Museen, Berlin, Germany

ca. 1594 *Saints Andrew and Philip*; stone (lost)

1595 *Candlestick* (copy after Giambologna); bronze; Church of Santissima Annunziata, Florence, Italy

1596 *St. Luke* (copy after Giambologna); bronze; Herzog Anton Ulrich Museum, Brunswick, Germany

1596 *Angel* (copy after Giambologna); bronze; National Gallery, Canberra, Australia

1596 *St. Mark* (copy after Giambologna); bronze; University of Kansas, Lawrence, Kansas, United States

1596 *Christ Resurrected* (copy after Giambologna); bronze; Metropolitan Museum of Art, New York City, United States

1599 *Self-Portrait of Giambologna* (with Giambologna); bronze; Rijksmuseum, Amsterdam, The Netherlands

1613 Copies of the Farnese Bull; casts: Galleria Borghese, Villa Borghese, Rome, Italy; Hermitage, St. Petersburg, Russia

1615 Two holy water fonts; bronze; Church of Santissima Annunziata, Florence, Italy

Further Reading

Avery, Charles, *Giambologna: La scultura*, Florence: Cantini, 1987

Avery, Charles, and Anthony Radcliffe, editors, *Giambologna, 1529–1608: Sculptor to the Medici* (exhib. cat.), London: Arts Council of Britain, 1978

Baldinucci, Filippo, *Notizie de' professori del disegno da Cimabue in qua*, 6 vols. in 5, Florence: Santi Franchi, 1681–1728; edited by Ferdinando Ranalli, 5 vols., Florence: Batelli, 1845–47; reprint, 7 vols., Florence: S.P.E.S., 1974–75; see especially vol. 4

Bellesi, Sandro, "La scultura nel Seicento," in *Il Seicento a Prato*, edited by Claudio Cerretelli and Renzo Fantappiè, Prato, Italy: CariPrato, 1998

De Winter, P.M., "Recent Accessions of Italian Renaissance Decorative Arts (Part II)," *Bulletin of the Cleveland Museum of Art* 73 (1983)

Haskell, Francis, and Nicholas Penny, *Taste and the Antique: The Lure of Classical Sculpture, 1500–1900*, New Haven, Connecticut: Yale University Press, 1981

Luchinat, Cristina Acidini, *Magnificenza alla corte dei Medici: Arte a Firenze alla fine del Cinquecento* (exhib. cat.), Milan: Electa, 1997

Pratesi, Giovanni, editor, *Repertorio della scultura fiorentina del Seicento e Settecento*, 3 vols., Turin, Italy: Allemandi, 1993

Schlegel, Ursula, *Italienische Skulpturen: Eingang durch die Berliner Skulpturengalerie*, Berlin: Mann, 1989

GIOVAN FRANCESCO SUSINI 1585–ca. 1653 *Italian*

The reemergence of Giovan Francesco Susini as a significant figure of early 17th-century Florentine sculpture is one of the important results of developments in the study of the great Flemish sculptor Giambologna's career in recent years. Susini is best known for the modeling, casting, and finishing of bronze statuettes, an expertise learned from his uncle, Antonio Susini, who took the surfaces and patinas of the small bronzes of his associate Giambologna to new standards of perfection. Giovan Francesco first assisted his uncle and, after Antonio's death, inherited his workshop, reproducing small bronze copies after Giambologna's models and antique statuary, as well as those of his uncle. His versions of Giambologna's models (some of which he modified to reflect the new Baroque style) may be identified by comparison with examples in two important concentrations of his bronzes in the Liechtenstein and Colonna (formerly Salviati) family collections. Giovan Francesco also created models after his own designs for small bronzes and for life-size figures in marble of a quality that confirms his place in 17th-century Italian sculpture. These original models reveal a cultivated and receptive intelligence, and are crucial today for an understanding of stylistic developments in Florence in the lengthy transition between Giambologna and the Late Florentine Baroque of Giovanni Battista Foggini.

Susini's earliest independent commission is recorded in 1614, when he and Baccio Lupicini, another former pupil of Antonio Susini, undertook the execution of a bronze antependium grille for the Palazzo Pitti (lost). Giovan Francesco seems to have served a long apprenticeship: his entry into the Florentine Accademia del Disegno was registered in 1617 when he was 31, and an autographed manuscript dated 1618 containing drawings and notes has the character of a student's notebook. Filippo Baldinucci mentions a visit to Rome, which probably took place after Antonio's death in 1624 and before 1626: signed small bronze copies after examples of antique statuary are only recorded after 1620, and Susini's signed bronze statuette group of *The Abduction of Helen*, one version of which is dated 1626, shows the influence of Bernini's *Pluto and Proserpina* (1621–22).

Susini's *The Abduction of Helen* is one of the most beautiful small bronze compositions of the 17th century. Designed in a style based upon that of Giambologna, but drawing also upon the ideas of Bernini, this, the last of the great two-figure groups of the Giambologna school, in which one figure lifts another, is in a new style essentially of Susini's own creation. Examples are known of all Susini's small bronze copies after the antique listed by Baldinucci, comprising the *Dying Gaul*, the *Gaul Killing Himself and His Wife*, and the *Seated Mars* (then all in the Ludovisi collection), the *Hermaphrodite* in the Borghese collection, the Farnese *Hercules*, the Farnese *Bull*, the *Wild Boar* in the Medici collections, and the so-called *Dioscuri* of the Quirinal Hill, Rome.

The predominance of the Medici court sculptor, Pietro Tacca, depended upon works on a monumental scale, but Susini's small bronzes, both after the antique and his own designs, were highly prized well into the 17th century. Susini supplied crucifixes after his own designs, both life-size and on a smaller scale: Don Lorenzo de' Medici, Susini's principal patron in the Medici court, commissioned one life-size bronze crucifix for the Church of Santi Michele e Gaetano (Florence), executed in 1636. The physical type of his bronze crucifix for Santi Michele e Gaetano is, like Tacca's, based on that of the large-scale works designed by Giambologna. However, whereas Tacca's design employs naturalism as an important route out of Mannerism, Susini's figure is a rethought and innovative design that employs the Baroque idiom of later treatments of the Crucifixion by the painter Guido Reni, also a source for Bernini.

In the same decade Susini produced two more compositions of high inspiration: one of these, *Venus Burning Cupid's Arrows*, survives both as a life-size marble group dated 1637 and in bronze statuette copies paired with another composition representing the complementary theme of *Venus Chastising Cupid with Flowers*. Pairs of these *Venus* subjects are found in Vaduz (dated 1638) and Paris (dated 1639). The bronze versions are both paired with another composition, representing the complementary theme, *Venus Chastising Cupid with Flowers*, and may have been created in response to the marriage in 1637 of Ferdinando II de' Medici. Both are by an artist profoundly steeped in Classical sculpture and tempered by contact with High Baroque Classicism. Their narrative quality is closer in mood and style to the classicizing bronzes of François du Quesnoy than to anything in Florence at the time.

Susini's practice in marble is less well known since only one of the three statues in this medium recorded by Baldinucci (*Dissimulation*; 1622) has survived, but five more have since been rediscovered or identified through archival research. *Dissimulation*, a female figure in the Giambolognesque style but with gestures derived from the antique, and a *Cupid Aiming an Arrow*, one of four playful Amori now surmounting grotesque fountains (1623–24), were executed in connection with Giulio Parigi's *Fontana di Venere*, whose statuary was relocated around these gardens. Both of these compositions reflect the Classical Greek sculpture that Susini reproduced and that provided a sound basis for his personal stylistic development. Indeed two antique statues, the Belvedere *Antinous* (2nd century CE copy after bronze 4th century BCE original) and the *Eros* of Lysippos (4th century BCE), were important sources to which Susini subsequently added the dramatic narrative group of the *Gaul Killing Himself and His Wife*, an example of a type of late Hellenistic statuary that was influential both for Bernini and for the stylistic development of the two-figure group in Florence. Of the works recently rediscovered the most important is a signed marble group of *Bacchus and an Infant Satyr* (Musée du Louvre). The Hellenistic Rococo mood and modest compositional development of this work reveal Susini's important intermediary role between the interlocked spiral groups of Giambologna and the frontally oriented, two-figure groups of Ferdinando Tacca.

Susini's last recorded commission, whose contract is dated 28 May 1648, was the elegant bronze grille for the altar of S. Giuliano in the Bonsi Chapel in the Church of Santi Michele e Gaetano (Florence). Another signed small bronze version of the *David and Goliath* theme by Susini appeared in 1989 on the London art market. This work's composition, which extends along a frontal plane, is based on an antique statue, the *Meleager* in the Vatican Museums, Rome. Its narrative emphasis relates stylistically to the horizontally developed small bronze groups of Ferdinando Tacca and may be dated to Susini's late maturity.

ANTHEA BROOK

See also **Giambologna; Susini, Antonio**

Biography

Born in Florence, Italy, 1585. Apprenticed to his uncle the sculptor Antonio Susini; entered the Accademia del Disegno, Florence, 1617; made study trip to Rome, *ca.* 1624–26; set up studio in Florence, purveying small bronze copies after the antique and after Giambologna, Antonio Susini, and his own models, as well as designs for sculptures in marble and reconstructions of antiquities; employed extensively by Medici court during the redevelopment of the Boboli Gardens, Florence, 1620s–40s. Died in Italy (city unknown), *ca.* 1653.

Selected Works

1622 *Dissimulation*; marble; Galleria Palatina, Palazzo Pitti, Florence, Italy 1626 *The Abduction of Helen*; bronze casts; Skulpturensammlung, Staatliche Museen, Dresden, Germany; J. Paul Getty Museum, Los Angeles, United States

1634 Crucifix; bronze; Church of Santi Michele e Gaetano, Florence, Italy

1637 *Venus Burning Cupid's Arrows*; marble; Villa la Pietra, Florence, Italy

1638/39 *Venus Burning Cupid's Arrows* and *Venus Chastising Cupid with Flowers*; bronze; pairs of casts: Collection of the Princes of Liechtenstein, Vaduz, Liechtenstein; Musée du Louvre, Paris, France

1639–41 Artichoke Fountain; marble, bronze; Palazzo Pitti, Florence, Italy

year *David with the Head of Goliath*; bronze; unknown Collection of the Princes of Liechtenstein, Vaduz, Liechtenstein

Further Reading

Avery, Charles, and Anthony Radcliffe, editors, *Giambologna, 1529–1608: Sculptor to the Medici*, London: Arts Council of Great Britain, 1978; 2nd edition (for exhibition at the Kunsthistorisches Museum), edited by Avery, Radcliffe, and Manfred Leithe-Jasper, Vienna: Kunsthistorisches Museum, 1979

Brook, Anthea, "Florentine Sculpture between Giambologna and Foggini," in *Il Seicento fiorentino: Arte a Firenze da*

Ferdinando I a Cosimo III (exhib. cat.), Florence: Cantini, 1986

Carinci, Filippo, editor, *Catalogo della Galleria Colonna in Roma: Sculture*, Busto Arsizio, Italy: Bramante, 1990

Götz-Mohr, B. von, "Die Kunst der 'allieven': Antonio und Giovanni Francesco Susinis Bronzen nach Giambologna, nach der Antike und eigenen Entwürfen," in *Die Bronzen der Fürstlichen Sammlung Liechtenstein*, edited by James David Draper, Frankfurt: Das Liebieghaus, 1986

Kraus, Volker, editor, *Von allen Seiten schön: Bronzen der Renaissance und des Barock* (exhib. cat.), Heidelberg, Germany: Edition Braus, 1995

Liechtenstein—The Princely Collections (exhib. cat.), New York: Metropolitan Museum of Art, 1985

Lombardi, G., "Giovan Francesco Susini," *Annali della Scuola normale superiore di Pisa* (series 3) 9 (1979)

Pizzorusso, Claudio, *A Boboli e altrove: Sculture e scultori fiorentini del Seicento*, Florence: Olschki, 1989

Pratesi, Giovanni, editor, *Repertorio della scultura fiorentina del Seicento e Settecento*, Turin, Italy: Allemandi, 1993

Radcliffe, Anthony, *The Robert H. Smith Collection: Bronzes, 1500–1650*, London: Zwemmer, 1994

SUVERO, MARK DI

See **Di Suvero, Mark**

SWEDEN

See **Scandinavia**

JÖRG SYRLIN THE ELDER 1420/30– 1491 *German*

Jörg Syrlin the Elder maintained a joiner's workshop in the south German city of Ulm as early as 1449 but more likely after he acquired his house in 1456. A debate, now almost a century old, surrounds Syrlin's activity as an artisan. As a joiner he made objects comprised of joined boards (panels for paintings, cabinets, etc.) but would not have produced works of sculpture. In fact, in some cities, where it was forbidden by guild laws, Syrlin would not have been allowed to create any sculpture. Joiners in Ulm belonged to the city guild of joiners and adhered to its codes. Such codes varied from place to place, and in Ulm a strong distinction remained between those who carved figures and those who worked as joiners. As a joiner Syrlin likely would not have worked as a sculptor, and for that reason many scholars do not include him on the roster of 15th-century sculptors.

Syrlin's name is connected with the choir stalls in Ulm Cathedral as well as with the cathedral's main retable, or altarpiece. Some interpret the inscription of Syrlin's name on the choir stalls and retable as his signature as a sculptor. Other scholars suggest that Syrlin's role in the creation of these works was strictly as a joiner who contracted other sculptors to create the figurative work; since the work contract would have been given to Syrlin, his name is inscribed on the finished product.

The Ulm choir stalls comprise one of the most impressive ensembles of church furniture from the second half of the 15th century. Philosophers, sibyls, Old Testament prophets, apostles, and numerous saints form two rows of finely carved wooden sculpture. The arrangement of these figures indicates the evolution of salvation through God's Word. The philosophers and sibyls only guess at salvation; the pious figures of the Old Testament professed salvation; the apostles and saints actually lived salvation. In terms of stylistic unity these figures were most likely the work of many sculptors, perhaps six or more. Some scholars do not attribute any of these works to Syrlin, while others suggest that he carved the philosophers located at the ends of the choir stalls. Michael Baxandall has most recently argued that these figures are the work of Michel Erhart, a contemporary sculptor in Ulm, based on the strong stylistic similarities between the choir-stall figures and other known works by Erhart (see Baxandall, 1980). All of the figures display strong individualized faces that, according to Baxandall, are stylistically

Choir stalls, Ulm Cathedral, Germany
© Erich Lessing / Art Resource, NY

indebted to the legacy of Hans Multscher, himself an influential Ulm sculptor from the first half of the 15th century.

Syrlin's signature also appears on an oak lectern in Ulm Cathedral that depicts the Four Evangelists: *Matthew, Mark, Luke,* and *John.* Dated to 1458 and carved out of one large block of wood, such an item—a piece of church furniture—belongs to the repertoire of a joiner and would represent the maximum extent of Syrlin's figurative work.

If Syrlin's work was limited to church furnishings and the like, the result naturally leads one to question Syrlin's actual achievement. If he was not a sculptor, the main retable and choir stalls for Ulm Cathedral were nonetheless significant undertakings, and they count among the finest works of their day. His talents as a sculptor would thus be replaced by his entrepreneurial skills in managing large-scale projects in which he would have selected the finest sculptors, located the best materials, coordinated the work of multiple artisans, and assembled the final work according to the contract and to the satisfaction of the patron. Indeed, Syrlin's reputation as a fine craftsman was well known in the city of Ulm. When he retired in 1482 and turned his workshop over to his son, Jörg Syrlin the Younger, he continued to supervise work in Ulm Cathedral—a responsibility only given to those of the highest merit.

KEVIN MCMANAMY

See also **Erhart, Michel**

Biography

Born perhaps near Ulm, Germany, 1420/30. Came from a family of joiners (German *Schreiner*) in the nearby city of Söflingen; father of Jörg Syrlin the Younger, also a joiner. Early training and journey years likely in immediate surroundings in southern Germany; recorded as joiner, not sculptor, and degree of Syrlin's sculptural activity is debated; maintained citizenship in Ulm, 1449–91; acquired house at Ulmer Gasse (Ulm Street) by 1456; probably established workshop shortly thereafter; retired workshop to son, 1482; continued to work for city council in Ulm Cathedral. Died in Ulm, Germany, 1491.

Selected Works

1458 Lectern; oak; Ulmer Museum, Germany
1469–74 Choir stalls; wood; Ulm Cathedral, Germany
1474–81 High altar retable; wood; Ulm Cathedral, Germany

Further Reading

Baxandall, Michael, *The Limewood Sculptors of Renaissance Germany*, New Haven, Connecticut: Yale University Press, 1980

Deutsch, Wolfgang, "Der ehemalige Hochaltar und das Chorgestühl: Zur Syrlin und zur Bildhauerfrage," in *Festschrift: 600 Jahre Ulmer Münster*, edited by Hans Eugen Specker and Reinhard Wortmann, Ulm, Germany: Stadtarchiv, and Stuttgart: Kohlhammer, 1977

Huth, Hans, *Künstler und Werkstatt der Spätgotik*, Augsburg, Germany: Filser, 1923; 2nd edition, Darmstadt, Germany: Wissenschaftliche Buchgesellschaft, 1967

Müller, Theodor, *Sculpture in the Netherlands, Germany, France, and Spain: 1400 to 1500*, translated by Elaine Robson Scott and William Robson Scott, London and Baltimore, Maryland: Penguin, 1966

Otto, Gertrud, *Die Ulmer Plastik der Spätgotik*, Reutlingen, Germany: Gryphius, 1927

Roth, Michael et al. *Michel Erhart and Jörg Syrlin der Ältere* (exhib. cat. Spätgotik in Ulm), Stuttgart: Thesiss, 2002

Vöge, Wilhelm, *Jörg Syrlin und seine Bildwerke*, 2 vols., Berlin: Deutscher Verein für Kunstwissenschaft, 1900; reprint, 1950

T

TACCA FAMILY *Italian*

Pietro Tacca *ca.* 1577–1640

After his entry into Giambologna's studio, Pietro Tacca quickly progressed from working in marble to specializing in founding and finishing sculpture in bronze. This expertise was the source of his value and importance to the Giambologna workshop and his Medici patrons and eventually led to his inheritance of the studio after his master's death in 1608. Pietro maintained the studio as Giambologna had organized it: as an efficient production team of highly skilled craftsmen. By continuing Giambologna's focus on production in bronze, he maintained the preeminence of Florence as the center of bronze casting in Europe during his lifetime. However, where Giambologna had eventually confined his participation to the creation of the model in order to increase the efficiency of workshop production, Pietro played a vital role both in the modeling and founding processes. That his artistic gifts were noted early is evident from his contribution in 1601 of a relief of the *Adoration of the Magi* for the bronze doors of the Cathedral of Pisa. Of the sculptures that Pietro produced for his Medici patrons, monumental portrait statuary in bronze predominated, and Pietro executed four equestrian portrait monuments, which culminated in his last and greatest work, the monument *Philip IV, King of Spain.* The first equestrian portrait on a monumental scale to be successfully cast with the horse's forequarters raised above the ground (gracefully poised in the dressage action of the *levade*, or forequarters' lift), it ranks among the finest technical

and artistic achievements in the history of Western sculpture. Other civic sculpture in bronze executed by Pietro for the Medici family included the completion of Giovanni Bandini's marble portrait monument of Ferdinando I de' Medici at Livorno (1601) flanked by four colossal bronze figures of galley slaves (known as the four *Moors*) and a pair of grotesque fountains on the Piazza della Santissima Annunziata in Florence (cast in 1627 and probably completed in that year). Documents also attest to his continuation of the workshop production of small bronze statuettes after Giambologna's models, which were intended as Medici gifts: Pietro executed 15 statuettes and groups in connection with the marriage negotiations between the Medici and English courts (1611 or 1612, untraced). Tacca also created models for his own small bronzes. In 1614 he reworked five of Giambologna's models for the *Labours of Hercules* for another Medici gift. In response to the changes of taste that characterized the Baroque style he nearly doubled their size. He also created a new, larger-scale model for an equestrian portrait statuette of Louis XIII of France (1608–11), with the horse in the action of the *levade*, or "forequarters lift," whose mane and tail he remodeled to create a vivacious silhouette for another equestrian statuette group, *Carlo Emmanuele I, Duke of Savoy.* With the advent of the Baroque in the 1620s, a new challenge to the Tacca workshop emerged—not only stylistically, but also with the lure of Gianlorenzo Bernini's projects in Rome—which Pietro skillfully averted by persuading Ferdinando II de' Medici to provide his workshop team with employment, such as converting in 1631 from marble to bronze the two projected monu-

mental portraits of Medici Grand Dukes for the Cappella de' Principi at the Church of San Lorenzo, Florence. He also undertook a small number of commissions in marble that were executed by assistants, the most important of which is the colossal statue of "the queen" (likely Marie de' Medici, wife of Henri IV), a late Giambologna project that Tacca completed as *Abundance* (1636; Boboli Gardens, Florence). Pietro died prematurely at 63, his health ruined by his dedication to his casting operations. The continuing preference of his Medici patrons for the highly finished court style perfected by Giambologna inevitably formed the basis of Pietro's earliest style, but his original models progressively demonstrate a specifically Florentine response.

Ferdinando Tacca 1619–1686

Upon his father's death in 1640, Ferdinando Tacca was appointed first sculptor to Ferdinand II de' Medici, Grand Duke of Tuscany, but after Ferdinando had completed his father's commissions, including the bronze equestrian monument to Philip IV of Spain in Madrid and the bronze monumental statues of Grand Dukes Ferdinand I and Cosimo II de' Medici in the Cappella de' Principi, Church of S. Lorenzo, Florence (1642–44), the court ceased to patronize the once-famous workshop in Borgo Pinti. Working in a modestly developed version of the exquisitely finished Giambolognesque style he inherited, Ferdinando nevertheless practiced sculpture until 1665 through private commissions. Most notable among these are his bronze church furnishings for the Bartolommei family in the Church of San Stefano al Ponte Vecchio, Florence (antependium relief of the *Stoning of St. Stephen* and two *Kneeling Infant Angels*).

Trained also as an architect and engineer, Ferdinando had developed a parallel career as a theater architect and stage designer, which eventually supplanted his sculptural practice. Ferdinando was unable to counteract the movement of taste away from Florence toward Gianlorenzo Bernini's Rome and the decline in Medici patronage of local sculptors. Despite the artist's nominal importance as first sculptor, his grand-ducal patron no longer wanted his image projected in the outmoded Mannerist style. Ferdinando is best known today as a gifted creator of two-figure statuette groups of subjects taken from the epic poem "Orlando Furioso" by Ludovico Ariosto and the loves of the gods, which open up the Giambolognesque spiral composition and develop it laterally into a theatrical tableau. His groups with their single, frontal viewpoint, graceful, swaying movements, theatrical gestures, and often humorous themes have a freshness and spontane-

ity that distinguish them from the deeply cogitated designs of Giambologna's statuette groups and anticipate those of the Late Baroque styles of Giovanni Battista Foggini and François Lespingola.

ANTHEA BROOK

See also **Giambologna**

Pietro Tacca

Biography

Born in Carrara, Italy, before 6 September 1577. Entered Giambologna's workshop, 1592; became chief assistant, 1601; finished Giambologna's incomplete Medici commissions, including monumental equestrian portrait statues *Ferdinando I de' Medici*, in Florence, *Henri IV, King of France* (destroyed), and *Philip III, King of Spain*, in Madrid; succeeded Giambologna as court sculptor, 1609, serving the Medici Grand Dukes Cosimo II and his successor Ferdinand II; completed last important equestrian statue, *Philip IV, King of Spain*, in 1640, just before his death. Died in Florence, Italy, 26 October 1640.

Selected Works

1617–27	Four *Moors*, for the monument to Ferdinando I de' Medici; bronze; Piazza Darsena, Livorno, Italy
1619–21	*Carlo Emmanuele I, Duke of Savoy*; bronze; Staatliche Schlösser und Gärten des Landes Hessen, Kassel, Löwenburg, Germany
1626–34	*Cosimo II de' Medici* (completed and installed by Ferdinando Tacca); bronze; Cappella de' Principi, Church of San Lorenzo, Florence, Italy
1626–34	*Ferdinando I de' Medici* (completed and installed by Ferdinando Tacca); bronze; Cappella de' Principi, Church of San Lorenzo, Florence, Italy
1627	Pair of grotesque fountains; bronze; Piazza della Santissima Annunziata, Florence, Italy
1634–40	*Philip IV, King of Spain* (installed in 1642 by Ferdinando Tacca); bronze; Plaza de Oriente, Madrid, Spain

Ferdinando Tacca

Biography

Born in Florence, Italy, 28 October 1619. Apprenticed to father, Pietro Tacca; received early parallel training as architect and engineer; inherited father's position as court sculptor to Ferdinand II de' Medici, Grand Duke of Tuscany, 1640; followed Giambologna workshop tradition as sculptor-founder in bronze, 1639–65; suc-

ceeded Alfonso Parigi as theatrical impresario to the Medici court, 1656; appointed grand-ducal engineer, 1661; elevated to position of principal grand-ducal architect and surveyor. Died in Florence, Italy, before 24 February 1686.

Selected Works

1647–49 Two statues of *Angels with Candelabra;* bronze; Wallace Collection, London, England
1649–56 *Stoning of St. Stephen* relief; bronze; Church of S. Stefano al Ponte Vecchio, Florence, Italy
1650–55 *Kneeling Infant Angels;* bronze; Getty Museum, Los Angeles, United States
1658–65 Fountain of Bacchus; bronze; J. Paul Palazzo Pretorio, Prato, Italy

Further Reading

Brook, Anthea, "Rediscovered Works of Ferdinando Tacca for the High Altar of S. Stefano al Ponte," *Mitteilungen des Kunsthistorischen Institutes in Florenz* 29 (1985)
Brook, Anthea, "Ferdinando Tacca," in *The Dictionary of Art,* edited by Jane Turner, vol. 30, New York: Grove, and London: Macmillan, 1996
Krahn, Volker, editor, *Von allen Seiten schön: Bronzen der Renaissance und des Barock: Wilhelm von Bode zum 150. Geburtstag* (exhib. cat.), Heidelberg, Germany: Edition Braus, 1995
Pope-Hennessy, John, *An Introduction to Italian Sculpture,* 3 vols., London: Phaidon, 1963; 4th edition, 1996; see especially vol. 3, *Italian High Renaissance and Baroque Sculpture*
Pratesi, Giovanni, editor, *Repertorio della scultura Fiorentina del Seicento e Settecento,* 3 vols., Turin, Italy: Umberto Allemandi, 1993
Radcliffe, Anthony, "Ferdinando Tacca: The Missing Link in Florentine Baroque Bronzes," in *Kunst des Barock in der Toskana: Studien zur Kunst unter der Letzten Medici,* Munich: Bruckmann, 1976
Torriti, Piero, *Pietro Tacca da Carrara,* Genoa, Italy: Sagep, 1975
Watson, Katharine, *Pietro Tacca, Successor to Giovanni Bologna,* New York: Garland, 1983
Watson, Katharine, "Tacca, Pietro," in *The Dictionary of Art,* edited by Jane Turner, vol. 30, New York: Grove, and London: Macmillan, 1996

MONUMENT TO FERDINANDO I DE' MEDICI AT LIVORNO

Pietro Tacca (1577–1640)
1617–1627: Four Moors, armorial trophies, and grotesque fountains
marble standing portrait [1595–1599] by Giovanni Bandini)
bronze
h. (of four Moors) 2.0, 2.5, 2.5, 2.5 m
Piazza Giuseppe Micheli, Livorno, Tuscany, Italy

The intention of Ferdinando I de' Medici, Grand Duke of Tuscany, was to erect a monument on the quayside of the duchy's only seaport in a form based on the ancient Roman triumph. Ferdinando I was to be represented as the commander of the naval Order of S. Stefano, with armorial spoils at his feet in the form of Turkish weaponry, such as a scimitar, a bow, a quiver, and arrows, and figures of chained captives below. Two grotesque fountains were to be placed adjacent to the monument. The monument, situated in the area of the quayside called Piazza Micheli, is no longer complete, having lost its bronze weaponry during the French occupation between 1796 and 1799. The monumental marble standing portrait statue was originally commissioned from Giovanni Bandini in 1595 as part of a sequence of Medici portrait statues intended as dynastic propaganda and placed by Ferdinando I in the principal cities of Tuscany during the 1590s. The marble standing portrait statue by Bandini was completed by 1599, but no further progress in its installation was made until 1616 when Ferdinando's son and successor, Cosimo II, having completed the enclosing mole of the marina, commissioned Pietro Tacca to construct a pedestal on the main quayside. Once Bandini's sober image was unveiled in 1617, the Duke allowed Tacca to complete the monumental ensemble as originally planned, which his successor Ferdinando II (Cosimo II died in 1621) permitted him to continue. The first pair of colossal bronze captives facing the sea was installed in March 1623, and the second pair in June 1624, whereas the bronze armorial trophies and the fountains were cast and probably completed in 1627. The trophies were installed by Tacca's son Ferdinando in 1638, but the fountains were transferred to Piazza della Santissima Annunziata in Florence (unveiled 1641) to accompany the monumental equestrian portrait of Ferdinando I (completed 1605) cast by Giambologna and Pietro Tacca.

The purpose of the monument was relatively straightforward: Ferdinando I intended to celebrate the roles played by himself and his father (Cosimo I de' Medici) in the rebuilding of Livorno as an important city and trading port and to focus on the dual function of the city both in maritime trade and in the protection from piracy by the Order of S. Stefano, which was founded by Cosimo I. According to the original inscription on the pedestal (lost but recorded in a fresco by Volterrano), Tacca's four captives personified the principal rivers of the four continents, symbolism that could be extended to signify their dominion by Tuscan trade, but the popular assumption that they represented corsairs captured by the navy could only be enhanced by their African and Arab appearance. The monument's significance is rendered more complex and interesting, however, by its appropriation of the *tropeium*

LORADO TAFT 1860–1936

The Patriots
© Philip Gould/CORBIS

28), or "peep-shows," of studios of famous artists of the past and collected casts of great sculpture in anticipation of the formation of a never-realized world-sculpture study museum. He also published the first book in a projected Little Museum series; the first and only volume contains photographs of works of Greek art meant to be cut and mounted for study purposes.

PATRICIA SISKA

Biography

Born in Elmwood, Illinois, United States, 29 April 1860. Received degrees from University of Illinois, 1879 and 1880; in France, 1880–83 and 1884–85; studied at École des Beaux-Arts, Paris; established Midway Studios, Chicago, in 1906; associated with Art Institute of Chicago, 1886–1929; led art tours abroad for Bureau of University Travel; won medals for work exhibited at World's Columbian Exhibition, Chicago, 1893; Pan American Exposition, Buffalo, 1901; Universal Exposition, St. Louis, 1904; Pan Pacific Exposition, San Francisco, 1915; and Holland Society, New York, 1932; director of American Federation of Arts, 1914–17; member of Chicago Painters and Sculptors, National Sculpture Society, American Academy of Arts. Died in Chicago, Illinois, United States, 30 October 1936.

to have been a fountain. The other intended fountain was the *Fountain of Creation, or Evolution.* The sculptor's Midway design was never fully realized, possibly because of a change in public taste by 1922, when the *Fountain of Time* was completed. The Thatcher memorial fountain is another allegorical fountain by Taft, which includes personifications of Colorado and the three civic virtues of patriotism, education, and love.

Taft's 1917 lectures from the Scammon lecture series at the Art Institute of Chicago resulted in a book, *Modern Tendencies in Sculpture* (1921). In 1919 he lectured to soldiers stationed in France about French cathedrals for the Young Men's Christian Association (YMCA). He also spoke abroad with the Bureau of University Travel and at the University of Chicago. Taft became a nonresident professor of art at the University of Illinois in 1919, and the university established the Lorado Taft lecture series in 1930. In the last years of his life, Taft's interest in educating the public, especially youth, in art manifested itself in various ways. He made eight educational dioramas (1927/

Selected Works

1885	*Rev. Robert Whittaker McAll*; plaster; Krannert Art Museum, Champaign, Illinois, United States
1893	*Sleep of the Flowers* and *Awakening of the Flowers*, for horticultural building, World's Columbian Exposition, Chicago, Illinois, United States; plaster (demolished)
1901	*Solitude of the Soul*; plaster; Art Institute of Chicago, Illinois, United States; marble version: 1914, Art Institute of Chicago, Illinois, United States
1907–08	*The Blind*; plaster; Krannert Art Museum, Champaign, Illinois, United States
1909	*Eternal Silence* (Dexter Graves Monument); bronze and granite; Graceland Cemetery, Chicago, Illinois, United States
1909	Washington monument; bronze; University of Washington, Seattle, Washington, United States
1911	*Black Hawk*; reinforced concrete; Lowden State Park, Oregon, Illinois, United States
1912	Columbus fountain; marble; Union Station Plaza, Washington, D.C., United States
1912	*Fountain of Creation*; plaster; Krannert

Art Museum, Champaign, Illinois, United States
1913 *Fountain of the Great Lakes*; bronze; Art Institute of Chicago, Illinois, United States
1918 Thatcher Memorial Fountain; bronze, granite, marble; City Park, Denver, Colorado, United States
1922 *Fountain of Time*; concrete; Washington Park, Chicago, Illinois, United States
1929 *Alma Mater Group*; bronze; University of Illinois at Urbana-Champaign, Illinois, United States

Further Reading

Garvy, Timothy J., *Public Sculptor: Lorado Taft and the Beautification of Chicago*, Urbana: University of Illinois Press, 1988

Lorado Taft: A Retrospective Exhibition, January 16 to February 20, 1983, Urbana-Champaign: Krannert Art Museum, University of Illinois, Urbana, 1983

"Lorado Taft—Sculptor, 1860–1936," in *The Index of Twentieth-Century Artists*, vol. 4, New York: College Art Association, 1937

Taft, Ada Bartlett, *Lorado Taft, Sculptor and Citizen*, Greensboro, North Carolina: Smith, 1946

Taft, Lorado, *The History of American Sculpture*, New York and London: Macmillan, 1903; new edition, New York: Macmillan, 1924; reprint, New York: Arno Press, 1969

Taft, Lorado, *Modern Tendencies in Sculpture*, Chicago: University of Chicago Press, 1921; reprint, Freeport, New York: Books for Libraries Press, 1970

Taft, Lorado, *Lorado Taft's "Little Museum,"* Worcester, Massachusetts: The School Arts Magazine, 1936

Weller, Allen Stuart, *Lorado in Paris: The Letters of Lorado Taft, 1880–1885*, Urbana: University of Illinois Press, 1985

Williams, Lewis W, "Lorado Taft: American Sculptor and Art Missionary," Ph.D. diss., University of Chicago, 1958

TAILLE DIRECTE

See Carving

VLADIMIR YEVGRAFOVICH TATLIN
1885–1953 *Ukrainian*

Vladimir Yevgrafovich Tatlin was a Ukrainian sculptor, painter, designer, and teacher who is credited as the main founder of Russian Constructivism. As a youth he attended school in Kharkiv and trained to become a merchant seaman, traveling widely in this capacity. He began his artistic career in Moscow as an icon painter and later enrolled at the Moscow School of Painting, Sculpture, and Architecture (1902–03), where he studied with Konstantin Korovin and Valentin Serov. He then attended the I.D. Sileverstov College of Art in Penza (1904–10), studying under Ivan Goryushkin-

Sorokopudov and Aleksey Afanas'ev. He befriended Mikhail Larionov and the Burlyuk brothers, who were important figures in the development of Russian Futurism. Through his attendance at advanced art exhibitions and events, as well as his visits to the art collections of Sergey Shchukin and Ivan Morozov in Moscow, which contained works by such artists as Claude Monet, Paul Cézanne, Pablo Picasso, and Henri Matisse, Tatlin was introduced to avant-garde developments in Western painting. He exhibited with many advanced Russian groups, such as the Jack of Diamonds, the Union of Youth, and the Donkey's Tail. Many of the artists associated with these groups were not only interested in Modernist strains in art, but also concerned with maintaining authentic Russian cultural expressions (such as folk art and icons) in their work.

During a trip to Paris in 1914, Tatlin visited Picasso's studio and saw examples of Cubist paintings and constructions. In this same year, Tatlin switched from painting to sculpture and produced a series of constructed painterly reliefs made from cardboard, wood, and metal, which he exhibited in his *First Exhibition of Painterly Reliefs* at his studio in Moscow. His reliefs were also shown in the exhibit *Tramway V: The First Futurist Exhibition of Paintings* held in Petrograd (now St. Petersburg) in 1915 and also in the exhibition *0.10, The Last Futurist Exhibition* of paintings held in the same year. Tatlin's series of *Counter-Reliefs* (ca. 1910–16) were composed of commonplace materials, rather than traditional fine-art substances, and were suspended by wires across the corner of a room, the traditional position for icons in Russian homes. These works were among the earliest examples of Constructivism and were pioneering instances of pure abstraction in sculpture.

Tatlin believed in using his art to support the ideology of the new Soviet state. His abstract reliefs composed of assorted materials were seen to reject individual expression in favor of a materialist approach esteemed by the revolutionary government. Tatlin was nominated to serve in many important positions. In 1917 he was chosen to serve on the art section of the Soviet of Workers' Deputies. He was also a director of IZO (the fine arts department) within Narkompros (People's Commissariat of Education) in 1918–19. In this capacity, he exerted a major influence and was a key figure in Lenin's plan for monumental propaganda. Drawing on his interests in engineering and architecture, the artist produced a model for a *Monument to the Third International* in 1919–20, which was to have been about a 396-meter-high structure intended to function as an administrative and propaganda center for the Communist Third International, an organization dedicated to the promotion of world revolution. This structure, had it been built, was to be constructed of

Tretyakov Gallery can be traced until 1943, when it disappeared during the evacuation.

Because of its tangible nature, the model remained the best-known version of Tatlin's monument although it accounted only for the volumetric and spatial, but not the constructional, properties of the original design. In the project Tatlin sought to explore the aesthetic potential of industrial materials such as iron and glass; in the model, glass was replaced with paper, strips of wood represented metal bars, and their curvature purported to demonstrate the properties of steel as essential to modern construction practice. In the project, the function of supporting the suspended elements was mainly allocated to the spirals; in the model, it was transferred to 20 long poles forming an inclined, truncated cone attached to the spine. Thus the function of the model's spirals, which were both structural and plastic in the project, became entirely plastic, whereas the introduction of additional elements substantially reduced the amount of space inside the structure.

The principle of suspension was originally introduced to prevent the interiors of the glazed halls from being cramped with structural supports. In the model (where the cube was replaced with another cylinder), the functional import of this system was altogether lost.

Model of the *Monument to the Third International*
Photo by Jacques Faujour.
© Réunion des Musées Nationaux/Art Resource, New York, and Artists Rights Society (ARS), New York, Estate of Vladmir Tatlin / RAO, Moscow / VAGA, New York

Immobile when exhibited in Petrograd, the suspended elements were probably rotated by hand in Moscow. To imitate steel, the wooden parts of the model were painted gray, the color that Tatlin preferred for the frames of his reliefs. This deliberately misleading use of materials was a notable deviation from his usual artistic practice. In the attempt to make the project superficially accessible, Tatlin's model for *Monument to the Third International* continued the tradition of architectural presentation models.

Although certain features of the model could not be understood without reference to Tatlin's utopian project (such as the arches in its lower part, which were to span the river Neva), the degree of public attention that it received encouraged the appreciation of its qualities as an autonomous object. It was seen as a new type of three-dimensional composition where tension was generated by setting in motion essentially static geometric units and fixing a dynamic spiral form. It was also an important demonstration of the new method of making plastic objects by joining various materials together. With its massing of solid parts and clear definition of inner volume, the model has an unmistakably sculptural quality.

Tatlin's model for *Monument to the Third International* was one of the first works associated with Constructivism that won international recognition. Characterized by the complexity of formal conception together with the economy of material means and spatial organization, it was a precocious statement of the methods and values of Constructivist architecture and sculpture.

ANATOLE TCHIKINE

Further Reading

Kopp, Anatole, *Constructivist Architecture in the USSR*, London: Academy Editions, and New York: St. Martin's Press, 1985

Lodder, Christina, *Russian Constructivism*, New Haven, Connecticut: Yale University Press, 1983

TEMPLE OF ZEUS, OLYMPIA

Libon of Elis
ca. 470–456 BCE
limestone, stucco, gold, ivory, marble
Primary location of sculptures: Olympia Museum, Greece

The early Classical Temple of Zeus at Olympia was designed by a local architect, Libon of Elis. Olympia, located in the southern portion of Greece called the Peloponnese, "island of Pelops," was the site of one of the most important sanctuaries of Zeus in the ancient world and the sponsor of Panhellenic (all-Greek)

games held every four years in honor of the chief Greek deity. The temple is thought to have been dedicated by the Eleans in thanksgiving to Zeus for victory in a local war against the Pisans. In its plan and elevation, proportions, and details, it is considered the canonical paradigm of the Classical Doric order, although some would argue that the building is conventional and uninspired compared, for instance, with the somewhat later Parthenon. It was made of limestone coated with stucco. The cult statue that the temple only just barely contained—a colossal 13-meter-high gold-and-ivory seated image of Olympian Zeus, one of the Seven Wonders of the Ancient World—was installed some 20 or more years after the completion of the building. It was made by a specialist in chryselephantine (sculptures of wood, ivory, and gold that suggest drapery over flesh) cult statues, Pheidias, the Athenian sculptor who is named by ancient sources as the "overseer" of the sculptural program of the Parthenon at Athens and also the creator of its cult statue. Pheidias undertook the Olympian *Zeus* after he was exiled from Athens ostensibly on account of misdeeds associated with the construction of the *Athena Parthenos*. Like the *Athena Parthenos*, no trace of Pheidias's *Zeus* remains, although his workshop, with some of the molds used to make the statue, has been discovered at Olympia. Such was the wonder the statue engendered on account of its colossal size that contemporaries speculated that if the seated god were to rise, he would crash through the roof. Pheidias himself is reported to have claimed that his only model was three lines from Homer's *Iliad* that describe the great god nodding with his dark brow, his ambrosial locks cascading from his head, and causing all of Mount Olympus to quake.

Real-life earthquakes have taken their toll at Olympia as elsewhere in Greece; of this once splendid temple, only the most fragmentary remains are visible today. Yet, between ancient literary descriptions and careful excavation in the late 19th century, the building can be reconstructed with virtual certainty. Our most important ancient source is Pausanias, a travel writer of the 2nd century CE, who visited the site and recorded its appearance at some length in Book V of his *Description of Greece*; his account tells us a great deal about the history of construction of the building, its architect, and its sculptural decoration. As useful as it is, however, certain aspects of Pausanias's account are problematic. His identification of the sculptors of the pediments as Paionios (east) and Alkamenes (west) is generally regarded as erroneous. Because these attributions cannot be supported, the distinctive and influential Peloponnesian style displayed throughout the sculptural decoration of the Temple of Zeus is attributed to an anonymous "Olympia Master" and his assistants.

The temple was lavishly appointed with *acroteria* (sculptures placed at the apex and corners of pediments) with sculptures in both of its pediments and, just inside the colonnade, 12 carved metopes, 6 across each of 2 porches. The metopes over the exterior colonnade remained empty. Compared with other ancient architectural ensembles, the sculptures are well preserved, although the precise arrangement and positions of the figures within the pediments and the order of the metopes are still debated. The east pediment depicts the tense moments just before the chariot race between Pelops and Oinomaos for the hand of Hippodamia, the latter's daughter. The iconography is particularly apt for this part of Greece. First, the homeland of Oinomaos, the loser of the race (because Pelops cheated), was Pisa, the neighboring city that the Eleans had defeated in war. Second, there was an archaic shrine to Pelops at Olympia. Third, the chariot race was the most prestigious event at the Olympic Games, which were said, according to one account, to have been originated by Pelops after his victory. Zeus appears as the largest figure in the center of the pediment. The composition of the east pediment is thought to be static, but this may be deliberate, in order to convey the apprehensive mood of the proceedings. To add to the aura of foreboding, an old seer gazes at the scene

Atlas, Hercules, and Athena with the Apples of Hesperides, from Metope 10, Temple of Zeus
© Alinari/Art Resource, NY

with head in hand, a fearful expression on his face, from the right corner of the pediment, as if he is having a premonition of the final outcome of Pelops's treachery: the curse on the house of Atreus, the family of Agamemnon and Menelaus. The west pediment is as active as the other is quiet. It shows the battle between the Lapiths and Centaurs at the wedding of Perithoös, a favorite subject for Greek artists, who apparently relished the challenge of intertwining equine and human bodies in *chiastic* (X-shaped) poses. The central figure of Apollo is an imperious, if expressionless presence; his extended arm is intended to calm but is having no ascertainable effect on the tumult around him.

The 12 metopes are the masterpieces of early Classical relief. They depict the labors of Hercules (Heracles), six of which took place in the Peloponnese. In metope 3, Athena, clad simply in peplos with aegis and looking youthful and lovely seated on a rock, assumes a complex, torsioned pose as she turns to receive the Stymphalian birds from the hero; the naked torso of Hercules in three-quarter view represents the summit of anatomic understanding for the period. His body is even more sensuously arrayed in an S shape against the body of the Cretan bull in metope 4. And in the most famous of all, metope 10, a striding Atlas brings the apples of the Hesperides to Hercules, who shoulders his burden (the world) with a pillow and with the aid of Athena's always helpful hand. The goddess stands frontally in a *contrapposto* pose (a natural pose with the weight of one leg, the shoulder, and hips counterbalancing one another); the hero is in profile, while Atlas is in three-quarter view. Together, the three form a composition that echoes the tripartite geometry of the adjacent triglyphs.

The deceptively plain, often unfinished, appearance of the Olympia Master's carving belies the fact that details would have been added in paint and in bronze that do not survive. The statues of the pediments are more like high-relief than sculpture in the round; they are unfinished at the back and not fully realized as three-dimensional entities. The doughy folds of the pedimental figures' garments reveal that the nature of drapery is not yet fully grasped and the extent of its expressive possibilities is still undiscovered. Eyes are heavy lidded, even dreamy; cheeks and chins tend to be full. Faces show theatrical expressions or none at all. There is a sense of potential at Olympia, a sign of what is to come. Yet the style stands on its own as the one, of all Greek art, perhaps best representative of what J.J. Winckelmann, the 18th-century German archaeologist and art historian (who, incidentally, never saw these sculptures), called "noble simplicity and quiet grandeur."

MARY STIEBER

See also **Pheidias**

Further Reading

Ashmole, Bernard, Nicholaus Yalouris, and Alison Frantz, *Olympia: The Sculptures of the Temple of Zeus*, London: Phaidon, 1967

Boardman, John, *Greek Sculpture: The Classical Period: A Handbook*, London and New York: Thames and Hudson, 1985

Brommer, Frank, *Herakles: Die zwölf Taten des Helden in antiker Kunst und Literatur*, Münster, Germany: Böhlau, 1953; as *Heracles: The Twelve Labors of the Hero in Ancient Art and Literature*, translated and enlarged by Shirley J. Schwarz, New Rochelle, New York: Caratzas, 1986

Clayton, Peter A., and Martin J. Price, *The Seven Wonders of the Ancient World*, London and New York: Routledge, 1988

Dörig, José, *The Olympia Master and His Collaborators*, Leiden and New York: Brill, 1987

Rodenwalt, Gerhart, and Walter Hege, *Olympia*, Berlin: Deutscher Kunstverlag, 1936; 3rd edition, 1941

Uhlenbrock, Jaimee Pugliese, editor, *Herakles: Passage of the Hero through 1000 Years of Classical Art*, New Rochelle, New York: Caratzas, 1986

TERRACOTTA

See **Clay and Terracotta**

THAILAND

Introduction and Historical Background

Thailand (known as Siam before 1939), like Cambodia, experienced an enormous influx of Indian culture. However, compared with their neighbors, the Thai arrived in their land very late—the 10th century. For that reason, they perceived the Indian influence in a mediated form through their predecessors in the territory, primarily the Mon and Khmer. This allowed the first Thai kingdoms—Sukhothai and Lan Na—to create beautiful and, for the most part, unique works of art, especially in the realm of sculpture.

Although the earliest artifacts of material and artistic culture found in what is now modern Thailand date from the 3rd millennium BCE, the first historical testimony belongs to the 1st centuries CE. According to Buddhist tradition, Buddhism was brought to Suvarnabhumi (the seaboard of the Indo-Chinese peninsula along the Andaman Sea) as early as the 3rd century BCE. However, its presence in this area is supported archaeologically only from the 4th century CE. The primary settlements in what is today's central Thailand were established by the Mon. These lands were a vassal princedom within the territory of the Funan Kingdom that in the 7th century became an independent state.

The Dvāravatī kingdom extended to all of central and eastern Thailand, including the Menam (Chao Phraya) Valley and the Khorat Plateau, although this is probably a question of tribal confederation and outlying vassalages. The basic activity of the population was agriculture, with sea trade playing a significant role as well. Until recent times, Dvāravatī was considered a Classical Hinduized kingdom whose culture and art were heavily influenced by India. However, the latest research allows for the conclusion that autochthonous elements characteristic of Southeast Asia played an equally important role in the composition of Dvāravatī culture. Particular emphasis has been placed on the Pre-Angkor period (7th and 8th centuries CE) in ancient Cambodia. Continuing research in this direction may bring about a change in the very concept of "Hinduization."

The Dvāravatī kingdom's greatest flourishing occurred from the final quarter of the 7th century to the final quarter of the 8th. During this period, many cities were constructed, including the new capital, Nakhon Pathom.

The sparse testimony of epigraphs shows that from the end of the 8th century, Dvāravatī began to experience pressure from its southern neighbor. The maritime power Srivijaya (settled on the islands of Sumatra and Java) captured the entire Malakkan Peninsula (Malay Peninsula) in the southern domain of Dvāravatī. Soon Cambodia began to attack the eastern borders of the kingdom as well. Consequently, for more than 200 years beginning in the 11th century, southern and central Thailand were under Khmer sway. Dvāravatī ceased to exist as an independent state. Still, the Mon continued to live in the southern regions for centuries as an ethnic community, forming a vigorous stratum of Thai culture.

The center of Khmer power in Thai territory, as well as the cultural center of the region, was the city of Lavo (Lavapuri, an early Dvāravatī capital now known as Lop Buri). Its most advanced outpost was located in the northern reaches of the country's central region in a small town called Sukhothai (Sukhodaya). It was here in the mid 13th century that the first proper Thai state came onto the scene.

From the 4th to 6th century, Thai tribes began migrating west and south from their settlements in the Chinese provinces of Guangdong, Guangxi, and Guizhou. They appeared in the northernmost regions of today's Thailand no later than the 10th century, although traditional Thai historiography places the start of this process at a much earlier time. Gradually moving south and settling along the river valleys of the Menam basin, the Thai reached the southern lands of today's Thailand in the Nakhon Si Thammarat region. In around 1240 two Thai chieftains took possession of the Khmer gov-

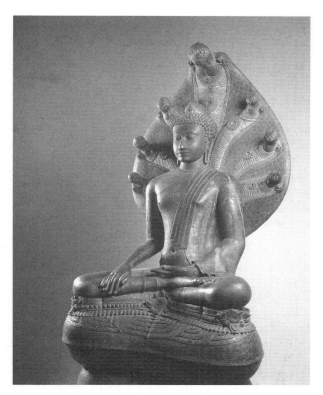

Buddha of Grahi
© Luca I. Tettoni/CORBIS

ernor's residence in Sukhothai and proclaimed the creation of the independent Thai state of Sukhothai (*ca.* 1240–1438). One of the chieftains, Sri Indraditi, founded the Sukhothai royal dynasty.

The most famous ruler of this new state was Ram Khamhaeng. Under his rule, Sukhothai included nearly all of contemporary Thailand, excluding only the northernmost areas. During this period, Thai animists accepted Theravada Buddhism. Ram Khamhaeng is considered the inventor of Thai writing. A surviving stela bearing the first Thai inscription (1292) gives a prolix description of the capital's appearance, as well as descriptions of certain habits and holidays of the population. Many generations of researchers, relying on this inscription uncovered in the mid 19th century, considered Ramkhamhaeng's rule a time of flourishing for Buddhism and culture in Sukhothai. It was conjectured that his reign saw the creation of remarkable monuments of Buddhist architecture and especially sculpture. A series of unsolved problems and questions resulting from this reading of the inscription led to doubts about its authenticity. Only at the very end of the 20th century, thanks to a nontraditional approach to the problem, did American researcher Betty Gosling, as well as many others, bring to light a true picture of Thai historical development (see Gosling,

1996). At the end of the 13th and beginning of the 14th centuries, Buddhism in Sukhothai was a mere shell; beneath this public veneer, people preserved the old animistic cults and views quite openly. They began building religious structures and casting bronze sculptures only toward the end of the 14th century, traditionally considered a period of political weakness and cultural and artistic decline. The absence of any mention of these monuments in the stela had stymied scholars in the late 20th century.

Meanwhile, another group of Thai tribes, the Thai Yuan, settled in northernmost Thailand toward the 13th century. One northern prince called Mengrai gradually united all of the northern lands under his rule. Under Mengrai, Theravāda Buddhism was actively disseminated and much religious construction was pursued. This is the origin of the northern Thai state Lan Na, which was known until the end of the 18th century as Chiang Mai (New City) after Mengrai's capital city, founded in 1296. Culture and art flourished in Lan Na under the rule of King Tiloka (1441–87) and his closest successors.

Yet another principality, Ayutthaya, appeared in south-central Thailand in the mid 14th century. This community may have been founded by an immigrant from the north. This Thai prince, the adoptive son of his father-in-law, the Mon ruler of the U Thong principality, moved the capital to a new location after the latter's death. In 1351 he was crowned Ramathibodi I, and with that coronation, the new state of Ayutthaya was founded. At first Ayutthaya made its northern neighbor and rival Sukhothai into a vassal (1378), but the state grew to such measure that in 1438 it completely swallowed up the principality. By the same method, Ayutthaya united all Thai lands under its power, except for the northernmost region. The process of assimilation between the Thai and Mon, which lasted several centuries, also concluded in the 15th century, arriving at what until 1939 was known as Siam and the Siamese. (The English captain James Lancaster introduced the name at the very end of the 16th century; in fact, medieval Thai culture and art should be called Siamese.)

The Ayutthaya period experienced the rise of unified, common cultural traditions throughout the entire country (except the northernmost region), including the most important social institutions, an administrative system, principles of legitimization for royal power, and religious traditions. A single national style of art gained prevalence. From the 15th to the 17th century, traditional Siamese society experienced its pinnacle. Siam maintained active contact with many European powers. However, under King Narai, France attempted to subjugate Siam with the help of Catholic missionaries. With Narai's dismissal from power, the country moved to a "closed door" political system, which kept Siam isolated from the cultural and technical achievements of the West for more than 150 years.

The politics of self-isolation gradually led to a general weakening in the country. As a result, the Burmo-Siamese war, begun in 1759, ended with Siam's complete rout in the spring of 1767. A large part of the Menam Valley came under the control of the Burmese, the capital was destroyed, and a great number of Siamese were taken into captivity. Siam disintegrated into several separate principalities. Southwestern Siam became the center for opposition to the occupation. The head of the struggle was General Tak Sin, who succeeded in driving the Burmese from Siam in mid 1770. He united the country under his rule, but a conflict between King Tak Sin and the highest clergy forced him to renounce the throne. In April 1782 the government of General Chakri came to power, and he became the founder of the royal dynasty that rules Thailand to this day.

Beginning in 1556, Chiang Mai (which was known interchangeably as Lan Na until the late 18th century) remained a Burmese vassalage for almost 200 years. A number of cities were ruled by Burmese governor-generals. After the expulsion of the Burmese, Chiang Mai entered the kingdom of Siam under Rama I Chakri. Chiang Mai had the rights of an autonomous principality and retained its own royal dynastic government, administrative system, and literature. At the end of the 19th century, under Rama V Chulalongkorn, the Chiang Mai territory came under a system of government united with all of Siam.

Religious Background

Like the art of any traditional society, the art of the people settled in Thailand was religious. This is true of the art of the area before the arrival of the Thai, as well as that of the Thai themselves until the 20th century. Here, as elsewhere in Southeast Asia, the two major ancient Indian religions, Hinduism and Buddhism, were widely disseminated in the 1st centuries CE. In Dvāravatī, the Sanskrit Hinayana Buddhism had primacy, although preserved images of Garuda and other lesser deities show that Hinduism was also known to the population. Hindu cults grew stronger in the 8th century with the spread of Srivijaya influence on the Malay Peninsula. However, Mahāyāna Buddhism developed in the area at the same time. Slightly later, when central Thailand became a possession of Angkor Cambodia, both Hinduism and Mahāyāna Buddhism received the stimulus needed to put down roots in the Menam Valley and the northeastern region on the Khorat Plateau.

The rise of the first Thai states in the 13th century coincided with the spread of Pali Theravāda Buddhism (the School of the Elders) in the Indo-Chinese peninsula. Under Ram Khamhaeng, the School of the Elders arrived in Sukhothai from Nakhon Si Thammarat on the Malay Peninsula. This area had already established direct ties with Sri Lanka, the stronghold of Theravāda Buddhism. In the 14th century under the successors of Ram Khamhaeng, Sukhothai itself entered into close relations with Sri Lanka, which facilitated a deeper inculcation of Theravāda Buddhism here. Analogous processes occurred later (the end of the 14th and early 15th centuries) in the northern region of Chiang Mai. However, both in Sukhothai and in Chiang Mai, the roots of Buddhism were spliced with the animist beliefs of the Thai people, and especially with the cult of spirit protectors (*phi*).

In the 16th and 17th centuries, common religious establishments and norms were developed for the entire country. This turn of events occurred in connection with the rise of Ayutthaya and the consolidation of Thai lands around a single monarchy.

However, it ought not to be forgotten that one of the unique characteristics of Siamese (Thai) Buddhism throughout its 500 years (from the late 13th to the late 18th century) has been the presence of a definite Hindu element. The Brahman priests in the Buddhist king's court, the use of series of rituals and symbols, and the creation of Hindu representations continue to play an important role to this day, though to a much lesser extent.

Ancient and Medieval Sculpture

The Bang Chang culture, discovered in the mid 1960s and dating from 3000 BCE to 200 CE, is characterized only by various ceramic and bronze wares. The history of the plastic arts in Thailand can be said to begin no earlier than mid 1000 CE.

The first period of ancient and medieval Thai art based on the historical knowledge of its time was worked out by Prince Damrong Rajanubhab. The prince was an excellent scholar and the founder of a genuinely historical approach to the history, archaeology, and art of Siam. Since that time the periodization has undergone many refinements, additions, and alterations brought about by new archaeological discoveries and the development of the historical sciences in general. The foundations of this periodization lie now in historical factors (Damrong), in geography (see Le May, 1938), in the combination of developing artistic schools and geographic factors (see Boisselier, 1974), and, in rejection of all previous positions, with ethnic factors (see Piriya Krairiksh, 1977). Each successive periodization clarifies some problems while compli-

cating or obscuring others. The final decades of the 20th century saw several controversial theories and attempts at a complete revision of the history of Thai art's development. A generally accepted, unified periodization has yet to be resolved. Therefore, the following will single out only those fundamental stages in the history of Thai sculpture, while taking into account all of the late 20th century's archaeological amendments and elaborations.

The earliest preserved monuments of sculpture on Thai territory are small representations of the Buddha, brought there from India by merchants or monks. For example, a bronze statuette of the Buddha found on the Khorat Plateau in northeast Thailand originated in southern India or Sri Lanka and may be dated to the 7th or 8th century. The minute folds of the Buddha's monastic garb are characteristic of these regions and in no way typical of later Thai art, which follows the traditions of northern India in its treatment of clothing. One also encounters Indian images from the Gupta period. These also are small in size, with smooth, tight-fitting clothing that appears to be glued to the body's contours (such as the figurine of the Buddha made from sandstone, from Viang Sa, a province of Surat Thani on the Malay Peninsula).

Dvāravatī Sculpture

The Mon who settled Dvāravatī were Hinayāna Buddhists. Dvāravatī sculpture took form under the influence of Indian Gupta and post-Gupta period art, as well as the Amarāvatī school. It focused primarily on the image of the Buddha Śakyamuni. These works were most commonly made of stone—limestone or quartzite—although some were cast in bronze. The typical Dvāravatī image was a standing figure in tight-fitting clothes. Early statues still retain the Indian pose *tribhaga* (the triple bend in posture). Later (7th to 10th century), the position of the body was strictly frontal, and the ethnic type of face acquired local characteristics: high cheekbones on a wide face; a broad, slightly flat nose and thick lips; slightly bulging eyes; brows united in a single curved line; and great locks of hair. The upper part of the monastic garb (*uttarasanga*) covers both shoulders and falls symmetrically along the sides. The rear panel forms identical groups of folds to the right and left of the ankles. In 7th-century statues, the Buddha's right hand usually completed the *vara-mudra*, the gesture of the gift, while the left held the gathered end of the robe at chest level. Later, love of symmetry prevailed: both raised hands give the same gesture at chest level, usually the *vitarka-mudra*, the gesture of teaching. In this position, the part of the *uttarasanga* hanging from the hands describes a U-shaped curve. The faces are illuminated by soft, gentle

smiles and express serenity, compassion, and deeply internalized spirituality.

Seated representations are rarely encountered. Occasionally one finds the *pralambapada asana* pose, with legs lowered in "European position." But much more frequently, the Buddha is seated with crossed legs in the *virasana* pose (the right leg, bent at the knee, lies atop the left). This is the pose that attends the plot of *Buddha Muchalinda*, in which the Buddha sits on the coiled body of the serpent Naga Muchalinda, whose seven hoods are displayed behind the Buddha's head. The earliest image of this plot in Thailand is a 7th-century work from Muang Fai in the Nakhon Ratchasima province. In place of the *virasana* pose one often sees *sukhasana*, in which the legs are not completely gathered but cross only at the ankles. Analogous poses in sculpture are met only in the Amaravati school of southern India.

Along with freestanding sculpture, the craftsmen of Dvāravatī created reliefs portraying iconographic scenes from the life of the Buddha (*The Great Miracle of Shravasti*, *The First Sermon*). Sculptural decor in the temples included, besides representations of the Buddha, figures of various lesser personages from the pantheon—deities, dwarfs, and demons, for example.

Buddhist Sculpture

No other country in the Buddhist world besides Thailand offers the iconography of the Buddha on a mythical animal. Stelae represent the Buddha (at times with companions to the right or left) standing or seated on the head of some fantastic creature. The meaning of such reliefs is yet to be understood. At times they are treated as the scene of the Buddha's descent from heaven (Tavatimsa), where he preached his teachings to his own mother. Others read the images as the embodiment of Buddhism's supremacy over Hinduism. It may be that these stelae once supported the hub of the Wheel of the Law (many examples have rounded protuberances on the reverse sides), but in short, the images have yet to be deciphered.

Images of the Wheel of the Law (*Dharmacakra*), symbolizing the teachings of the Buddha (*Dharma*), are no less original. Outside of Thailand, these images were created only in northern India during the Maurya dynasty (317–180 BCE) and in the southern Amaravati school. The wheel predates the appearance of anthropomorphic representations of the Buddha and was used in art to symbolize his presence. In Thailand the images of the wheel are found only in the Mon culture of the Dvāravatī. More than 40 such stone wheels are preserved. They are two-sided stone disks measuring from 75 centimeters to more than two meters in diameter. Numerous spokes radiate out from a central hub,

and garlands ornament the sides. It is assumed that these wheels may be capitals for tall, freestanding columns like the Indian *Dharma-cakra-sthambhas*. However, archaeologists have found them attached to small brick bases. The wheels' decor shows the same tendency toward a growing geometrization and simplification that marks the style and iconography of Dvāravatī sculptural and architectural images of the Buddha. Until the mid 1990s, the prototype for the decorative motif on the wheels and spokes was considered to be Indian art of the Gupta period. Scholarship beginning in the late 20th century shows that the influence is not Indian, but rather that of neighboring Pre-Angkor Cambodia. The decor of ancient lintels in the Khmer temples from the 7th and 8th centuries seems to have been most influential. Thus it is possible to speak of a close symbiotic relationship between these two southeastern continental cultures, a relationship in which the Indian substratum is no longer dominant.

Hindu Sculpture

A number of Hindu images are preserved, the majority of which date to the 7th through the 9th century. The question of their relation to Dvāravatī art is debatable, and Hindu images are often singled out into separate groups. The Hindu images stylistically resemble south Indian art of the 7th-century Pallava dynasty. The majority of these statues represent the four-armed Visnu holding his attribute—the conch shell, baton, disk (*cakra*), and lotus, or in place of the lotus a ball representing Earth. Visnu wears a miter on his head and his lower torso is wrapped in a sarong. The majority of similar images come from the southern and eastern parts of Thailand. The oldest of these, found in Chaiya, is considered the earliest example of this type in all of Southeast Asia.

The Hindu sculpture of Si Thep, in the north central province of Petchabun, stands out. Here wondrous images of Visnu, Krishna, and Surya were created with a perfection of plastic modeling reminiscent of Pre-Angkor Khmer sculpture, rather than the contemporaneous Dvāravatī works.

Srivijaya Sculpture (8th–13th Century CE)

In the 1st millennium CE, the Malay Peninsula was divided into separate, tiny principalities. From the 8th to the 13th century, the region was under the cultural and political influence of Srivijaya, and thus the art of the period is traditionally called Srivijaya art. However, the absence of precise geographic boundaries, as well as of common stylistic characteristics, has generated innumerable arguments among scholars regarding

the validity of the name and the grouping of these works in general.

The location of the peninsula made it open to various artistic, cultural, and political influences. Indian influences came through central Java, the Srivijaya stronghold, and directly from India. On the other hand, the many principalities had very little contact with each other, which complicates the picture of artistic development in the region. Hinduism stood side by side with Mahayana Buddhism. Craftsmen worked both in stone and bronze. Many works from the peninsula are among the most perfect in all of Southeast Asian art. Unlike the Dvāravatī sculptors, these artists daringly and freely worked with stone, creating many-armed figures without supporting arcs or braces. Consequently, almost all works that survive to our time are in severely damaged condition.

The originality and beauty of Srivijaya art shows itself clearly in the images of the bodhisattva, the most popular of which was Avalokitesvara. These sculptures were made in both stone and bronze, but they differ in iconography. The stone images have two arms and a small amount of ornamentation. The bronze statues are many-armed and rich in ornament. The unchanging attribute of Avalokitesvara is an antelope skin slung across the left shoulder. The bodhisattva stands rigid or slightly bent in the *tribhanga* pose, his long clothes are held at the hips by a belt, and his upper torso is bare. He has a rounded face with full cheeks, and his hair is arranged in a complicated, towering hairstyle. One of the most remarkable Srivijaya works is a bronze torso of Avalokitesvara from Chaiya. It dates to the 8th or 9th century and is distinguished for its special beauty and delicacy of detail.

Almost all bronze and stone statues of Avalokitesvara present him in a standing position. On the other hand, the Buddha is most often portrayed sitting in the *virasana* pose, with his hands in the gesture of *bhumisparsamudra*, "the calling the earth to witness."

One of the most famous Srivijaya Buddhas is the so-called *Buddha of Grahi*, a bronze sculpture of the Buddha being protected by the Naga Muchalinda. This Buddha's arms are not folded in his lap in the usual manner, but rather make the gesture of *bhumisparsamudra* (the fingers of the right hand touch the earth and the left hand is lying in the lap), a much rarer characteristic. The date inscribed on the pedestal has proven to be controversial. It can be read either as 1183 or 1291, the latter being more commonly accepted. The *Buddha of Grahi* possesses many iconographic and stylistic traits characteristic of Khmer art of the 12th and 13th centuries. This similarity is explained by the widespread influence of Khmer art in the Indo-Chinese peninsula.

Angkor Sculpture (10th–14th Century CE)

From the 10th to the 14th century, the territory of central, eastern, and northeastern Thailand was under the political control of the Angkor Empire. This region gave rise to the Khmerized school of Lop Buri, which took its name from the capital city of Khmer in Thailand. This school produced works of Khmer art as well as local repetitions and interpretations. However, the Lop Buri school was not merely a provincial variant of Khmer art. In fact, it was rather independent, having experienced the influence of the Khmer tradition, the Dvāravatī and Srivijaya traditions, and even the Indian art of the Pala and Sena dynasties. Craftsmen primarily created bronze, stone, and plaster sculptures of the Buddha Sakyamuni, Avalokitesvara, and Maitreya, although images of other Mahayana personages have been found.

Already in the 11th century, standing, strictly frontal images of the Buddha were being created in Phimai on the Khorat Plateau in northeastern Thailand. These Buddhas have hands raised in identical gestures and wear clothing that covers both shoulders and falls in symmetrical folds, a clear echo of the Dvāravatī tradition. Analogous crowned figures, in which monastic garbs are combined with a crown and ornaments, first appeared in Phimai during this same time. This iconographic type was later adopted by the Thai school of Ayutthaya. Later Thai art took other elements of the Lop Buri decorative tradition, such as the ornamental belt supporting the lower garments or the longitudinal strip of vertical folds (both details were thought to be translucently apparent through the upper garments). Another example is the thin fillet dividing the hairline from the forehead. The final period of Lop Buri art is the most interesting and original. Beginning in the second quarter of the 13th century, the Khmer influence began to wane, and images attained greater originality. Nevertheless, until the end of the 19th century, the eastern provinces were captives of Angkor period artistic and iconographic traditions.

Sukhothai Sculpture (13th–16th Century CE)

Formation of independent principalities and liberation from Khmer political pressure made possible the active development of creative powers among the young population of Sukhothai. The American scholar Alexander Griswold was the first to propose a classification of Sukhothai artistic monuments (see Griswold, 1957). He divided the works into three historical groups: the Preclassical period in the 13th century; the Classical period, chiefly in the 14th century; and the Postclassical period, stretching from the 15th to the 16th century. However, late-20th-century research forced a serious

review of this schema. Until the 1340s the area saw an intensive search for new architectural and plastic forms. Beginning in the mid 1340s, when the prince-monk Si Satha returned from a decade's residence in Sri Lanka and brought Sinhalese craftsmen with him, the government engaged in an enormous construction program. This program defined the appearance of the capital for the next half century. During this period, in the course of assimilating Sinhalese influences, artisans began to use brick and plaster decor more intensively, in sharp contrast to the almost exclusive use of laterite in the late 13th century. Throughout its history, Thai architecture dealt with two types of structures: the *vihan* (a place for the faithful) and the *bot* (a place for initiation into the monk's life). Contrary to traditional opinion regarding their simultaneous appearance as early as the 13th century, it has been shown that the *bot* appeared only in the mid 14th century, at the same time as the large, bell-shaped stupas. The same is true of stupas made in the form of the lotus bud symbolizing the state and culture of Sukhothai and not found in later architecture. These stupas, one of which decorates Wat Mahathat, the religious center of the capital and the Sukhothai state, appeared no earlier than the mid 1340s.

The sculpture of Sukhothai is among the most original in all of Asian Buddhist art. Sukhothai sculptors created their own iconographic canon of images of the Buddha, distinct from those that existed in Dvāravatī or Lop Buri art. Its most important elements are the following: the Buddha adopts a *virasana* pose; the long flap of the folded garment along the chest ends in a forklike manner on the abdomen, and the finial of the *ushnisha* (the protuberance on the Buddha's head) has the form of an extended tongue of flame (*ketumala*); the head is oval and slightly elongated, with an egg-shaped face; the eyes are half-closed; the lips, emphasized by engraved outlines, show a barely perceptible smile; tightly curled locks of hair dip into the middle of the forehead to form a point; and the elongated earlobes are pointed and bent slightly outward. The sculptures of Sukhothai are distinguished by amazing animation, refinement, and at times a certain femininity. All lines are smooth and fluid. In general, the silhouettes have no sharp angles. The sculpture shows none of the metal's bulk or weight. The texture of bronze, the favorite material of Sukhothai sculptors, makes such fluidity of line and smooth surface possible.

Sukhothai sculptors were the first in Asia to portray the Buddha in all four canonical poses: sitting, standing, walking, and reclining. The creation of the Walking Buddha is the pinnacle of both Sukhothai and Siamese art. Attempts to convey the walking pose can be found in reliefs from ancient India, Java, and Sri Lanka, but only Sukhothai artists managed to present the pose in freestanding sculpture. This iconography, usually treated as the image of the Buddha's descent from Tavatimsa (Heaven) after preaching the doctrine to his mother, embodies the missionary aspect of the Buddha and Buddhism. Having descended, the Buddha leaves a footprint, a sign that the given territory is now included in the "divine geography" of Buddhism.

One of the most significant images of the Walking Buddha (from the late 14th century) is preserved in the temple at Benjamabopit in Bangkok. The weight of the body rests on the left foot while the right heel is raised. The lower part of the garment, clinging to the body, flutters with the step. The unnaturally exaggerated proportions make the figure seem to float above the ground. Plaster images of the Walking Buddha survive, as, for example, a 15th-century relief from the temple at Mahathat in Chalieng, which stands as tall as two people.

Images of the Sitting Buddha, which are executed in the same iconographic and stylistic manner, almost always portray the *bhumisparsamudra* gesture, one of the most popular of Thai iconography. In the 15th century, iconography experienced certain innovations. The face became longer and its features flatter. The edge of the garment had great folds. These characteristics distinguish the production of the craftsmen for Kampeng Phet and Si Sachalanai, two centers of growing artistic activity in the 15th and 16th centuries. Although this period saw the territory of Sukhothai swallowed up by Ayutthaya, the workshops continued to work in their own traditions.

The Reclining Buddha (departing for Nirvana) is the rarest of the canonical images in Sukhothai art, and for that matter in all Buddhist art. These images are curious because they are standing figures that have been laid on their sides. All characteristics of the garment associated with the standing figure are preserved, contrary to the laws of gravity.

Alongside Buddhist sculpture, Sukhothai art has left images of certain Hindu deities: Visnu, Siva, Uma, and Harihara. The sculptures of Siva and Visnu from the National Museum in Bangkok are, to all appearances, those cast in the mid 14th century by order of King Lüthai. This is clear from the epigraphy as well as the stylistic proximity to works of the same period (such as engraved illustrations for the *Jataka*s [stories of previous lives of the Buddha] in Wat Si Chum and plaster reliefs of the adorants in Wat Phra Phai Luang).

Although the independent existence of the Sukhothai state was relatively short, that culture created art of wonderful durability. The image-making principles of this art exercised enormous influence over its contemporaries and the Thai art that followed it.

Lan Na Sculpture (11th–Mid 15th Century CE)

The art of northern Lan Na possessed two fundamental iconographic types of Buddha portraits. The appearance of the first type is traditionally connected with the influence of Pala art, either directly or mediated through Burma. Its most important features are thick, squat proportions; the edge of the garment that comes to the nipple; the *vajrasana* (the legs crossed at the ankles) pose; the rounded end of the *ushisa* in the form of a precious stone; and the right hand that lies on the right knee. The second type was clearly formulated under the influence of Sukhothai stylistics. Its main characteristics are elongated proportions, the edge of the folded garment that comes to the navel, the *virasana* pose, the end of the *ushnisha* in the form of a tongue of flame, and the right hand that rests on the right shin. That this style arose in the far north around the end of the 14th century has never been disputed. Heated polemics regarding the dates of the first type of Lan Na art have raged for more than 50 years. Time frames vary from the 11th to the 12th century to the mid 15th century. Research in the late 20th century seems to confirm the latter point of view. According to this view, images with such iconography should be called "Sihing type." "Sihing" here does not refer to the Thai sanctuary Wat Phra Sing, in Chiang Mai, with its Sihing Buddha statue (made, according to legend, in the 2nd century CE in Sri Lanka); rather, it designates a type of image with two key characteristics: squat proportions and the right hand on the knee.

The most widespread scene in Lan Na art is the "Buddha calling the Earth to witness," known in the area as the Buddha Maravijaya, or "Buddha triumphant over Mara." Northern Buddhist iconography is more varied than that of Sukhothai. Alongside images of the Buddha, among which the Crowned Buddha is quite frequent, one also encounters images of monks and disciples of the Buddha, as well as kneeling donors. The plaster reliefs in the main temple at Chiang Mai, Wat Chet Yot, are significant for their portrayal of deities and flying adorants.

U Thong Sculpture (14th–15th Century CE)

The U Thong school flourished in the southern region of central Thailand. Although its artists were probably Thai, the works of this school can be traced precisely to three groups of influence: the Mon, the Khmer, and the Sukhothai. Consequently, the school is divided into three groups of monuments, U Thong A, B, and C. Traditionally the school was situated in the broadly defined chronological framework from the 12th to the first half of the 15th century. This framework has been drastically narrowed in recent years. The earliest chronological boundary is now considered the 14th century, which at the very least makes U Thong C contemporaneous with the beginning stage of Ayutthaya art. Therefore, U Thong C is seen as early Ayutthaya art.

Ayutthaya Sculpture

Certain researchers have accused Ayutthaya art of mediocrity and of mechanical copying "in the Western sense." The art of Ayutthaya is indeed inferior to that of Sukhothai in many respects. It lacks animation and delicate harmoniousness. It is not marked by the originality characteristic of certain works from Lan Na. Nevertheless, the Ayutthaya epoch saw the creation of beautiful examples of sculpture. This sculpture is also distinguished for its amazing variety not seen in earlier periods. This strict, reserved style, which swallowed up regional schools (excepting the far north) and worked out a single national look, undoubtedly created more room for artisanal imitation. Without dispute, however, the school of Ayutthaya possessed originality.

The art of Ayutthaya brought forth new gestures and poses, hitherto unknown, and these were connected with various episodes from the life of the Buddha. The old classical gestures were reconsidered and given new meaning. The image of the Crowned Buddha acquired a truly stately meaning. There are, however, very few dated works. Researchers' attempts to create a consistent picture of the development of Ayutthaya art are more often based on the evolution of types of decoration, which, in turn, followed the shifts in courtly fashion. There are many images of the lesser deities of the pantheon, such as celestial beings, adorants, and fantastic creatures. The style of Ayutthaya art is reserved and slightly cold, and the decorative element in it grew stronger with time.

Rama I Chakri and his closest successors strove to preserve and continue the Ayutthaya tradition, especially in art and culture. This allowed the style of late Ayutthaya art, in which the decorative principle had grown very strong, to move smoothly and imperceptibly into the final phase in the evolution of medieval Siamese art, the art of Bangkok. This art was the logical conclusion of a tendency clearly visible in the late art of Ayutthaya.

OLGA DESHPANDE

Further Reading

Boisselier, Jean, *La sculpture en Thailande*, Paris: Bibliothèque des Arts, and Fribourg, Switzerland: Office du Livre, 1974

Bowie, Theodore Robert, editor, *The Arts of Thailand: A Handbook of the Architecture, Sculpture, and Painting of Thailand (Siam)*, Bloomington: Indiana University Press, 1960

Fournereau, Lucien, *Le Siam ancien, archéologie—épigraphie—géographie*, 2 vols., Paris: Leroux, 1895–1908

Gosling, Betty, *A Chronology of Religious Architecture at Sukhothai, Late Thirteenth to Early Fifteenth Century*, Ann Arbor, Michigan: Association for Asian Studies, 1996

Griswold, Alexander B., *Dated Buddha Images of Northern Siam*, Ascona, Switzerland: Artibus Asiae, 1957

Griswold, Alexander B., *Towards a History of Sukhothai Art*, Bangkok: Fine Arts Dept., 1967

Le May, Reginald, *A Concise History of Buddhist Art in Siam*, Cambridge: University Press, 1938; reprint, Rutland, Vermont: C.E. Tuttle, 1963

Piriya Krairiksh, *Art Styles in Thailand: A Selection from National Provincial Museums, and an Essay in Conceptualization*, Bangkok: Ministry of Education, Department of Fine Art, 1977

Woodward, Hiram W., *The Sacred Sculpture of Thailand: The Alexander B. Griswold Collection, The Walters Art Gallery*, London: Thames and Hudson, and Baltimore, Maryland: The Walters Art Gallery, 1997

THEATER SCULPTURE

Theater is surely one of the most ephemeral forms of art, because it is usually conceived for immediate enjoyment, often for pure amusement, and thus is poorly documented. Sculpture, the most "solid" and material-dependent of the arts, would thus not appear to have much to do with the theater compared with the other forms of expression. Suffice it to think of how theater history has progressed because of the documentary support of etchings, paintings, photographs, reviews, and film footage. In analyzing the relationship between sculpture and theater, it is safe to say that there are essentially two categories of "theatrical sculpture." One testifies to something that really happens in a theatrical space, or in any case has to do with the direct protagonists and characters, for example the actors and mask characters; the other is created especially for a specific theatrical event. The first category includes all direct evidence, such as terracotta, ivory, or bronze statuettes depicting characters in Greek and Roman theater. It also includes all the indirect evidence, such as the numerous, beautiful porcelain statuettes of stock characters from the old Italian popular comedy known as the *Commedia dell'Arte*. The second category includes sculptures designed for a specific theatrical event, whether staged once or repeatedly: wooden statues, booths, and shrines used in the medieval mystery plays, and "sacred representations;" the triumphal arches, almost always in wood and papier mâché, erected during the Renaissance along the streets where an important personage was to make his or her official entry into the city on the occasion of the wedding or baptism of a member of the reigning family; and even the wooden marionettes, leather masks, and sets created for 20th-century plays.

Some very interesting Greek terracotta statuettes depicting Middle Comedy characters are preserved in the Rogers Collection at the Metropolitan Museum of Art in New York. From their "personalized" gestures, these figurines, which feature bloated bellies, unconcealed male organs, and masks, evidently represent stock characters. We know, in fact, that each of these characters was traditionally played in a particular acting style in order to be immediately recognized by the audience. The Rogers Collection also contains a lovely bronze statuette depicting a farce actor or mime. He wears a short tunic, has lost his arms, and has a face so grotesque as to seem a caricature, although he has realistic features such as a hooked nose, huge eyes and ears, and a beard. Another interesting piece, at the Petit Palais in Paris, is the ivory statuette of a tragic actor from Roman theater. He wears a mask and seems much taller than he really is because of his voluminous wig and his buskins, the high-heeled boots worn to make tragic actors more visible from the farthest seats. His rich, elegantly decorated habit has long sleeves, a detail that identifies it as a stage costume. He is caught in a dynamic pose, as if defending himself against someone or something; his body is curved and his right arm is bent across his chest. But for a better idea of what the tragic scene must have been, we must look at other works, such as a painted terracotta relief in the National Museum in Rome. In this richly detailed piece, numerous characters of different sizes are in the foreground, probably adults and a child, and two more adults are in the background. Although the perspective depth is primitive, the artist evidently took some pains with the details of the clothing and of the mask on the right-hand side. The National Archeological Museum of Naples likewise has some fine pieces related to the Roman theater, among them a large terracotta relief depicting a comic scene. Five characters are on stage: two servants, the young romantic lead, an old man, and a musician. The young man's gestures are broad, stylized, and pathetic, and the old man's and the servant's are more violent and comic.

Very little physical evidence remains from medieval theater. An extremely rare piece preserved from a mystery play is *Christ Riding an Ass*, a 13th-century polychrome wood sculpture at the Schweiz Landesmuseum in Zurich. The sculpture is installed on a wheeled platform because it was drawn into the church during the religious ceremony held every Palm Sunday to mark the date of Christ's entry into Jerusalem. Two fine statuettes of dancing jesters should also be mentioned, a 16th-century bronze at the Victoria and Albert Museum in London and a painted carving by Erasmus Grasser at the Stadtmuseum in Munich. Both figures

are shown in caps, bells, wide-sleeved garments, and asymmetrical, nearly off-balance poses.

Some of the finest artists of the age created the ephemeral sculptures conceived and built for special occasions at the courts of Renaissance Italy. Leonardo da Vinci, for instance, worked on festive installations for the Milanese court. He was responsible for the structures set up for the celebration held in 1490 to honor Duke Gian Galeazzo Sforza's wife, and in 1496 he designed a huge rotating stage for the Danae festival. In 1513, Cardinal Bernardo Dovizi da Bibbiena's comedy *La Calandria* was staged under the direction of Baldassarre Castiglione at the Ducal Palace in Urbino. Girolamo Genga's sumptuous set presented an eight-sided temple worked in stucco with fake alabaster windows, lintels, and cornices decorated in fine gold and ultramarine blue and with a triumphal arch on the side. A fake marble triumphal arch also dominated the set designed by Sebastiano da Sangallo (nicknamed Aristotele for his mastery in inventing theatrical devices) for Lorenzino de' Medici's play *L'Aridosia*, staged in Florence in 1536 for the wedding of Duke Alessandro de' Medici and Margaret of Austria. But the most famous festivities organized in Florence in the second half of the 16th century were those designed by Bernardo Buontalenti, an artistic genius who attended to every last detail. He had a special series of statues made for the Uffizi theater, with the figures supporting glass vases; the vases, filled with colored water and appropriately illuminated, emitted colored light. He also decorated the banquet table with statues carved in butter. This bizarre gastronomic invention may not be surprising since Buontalenti is remembered in Florence as the inventor of ice cream.

Ephemeral sculpture extends even to objects created for funerals. During the Medici period in Florence, luxurious wood-and-cloth catafalques were built to display the remains of deceased members of the reigning family. Numerous written and iconographic descriptions of these funerals have come down to us.

Many sculptures of stock characters from the *Commedia dell'Arte* have survived from the regions in which this type of theater was especially popular. The Venetian villa La Deliziosa, in the town of Montegaldella (Vicenza), has a rare and beautiful set of 17th-century garden sculptures depicting the best-known characters: Harlequin, Pulcinella (Policinelle), Brighella, the Captain, and Pantaloon. These pieces were carved by Orazio Marimali, and despite centuries of exposure to the elements their features are still legible. The characters were immortalized in dynamic poses and gesture broadly. They also appear in numerous statuettes made for a large market, such as in the precious Meissen porcelains. Among the most famous artists working for the German factory of Meissen were Johann Joachim Kaendler, considered a master in modeling statuettes, and Johann Melchior Steinbrück, who in 1722 created three tea services decorated with Italian characters. Their success was so great that the fashion was soon taken up by other European pottery manufacturers, such as the Buen Retiro in Madrid and Chelsea in England. The Chelsea statuettes are less decorated than the Meissen statuettes, but much rarer.

As for 20th-century theater, one cannot fail to mention the sculptor Amleto Sartori and the leather masks he created, after numerous studies in plaster, for plays directed by Giorgio Strehler at the Piccolo Teatro in Milan. Sartori also did bronze statues of *Commedia dell'Arte* characters and contemporary actors (*Portrait of Marcello Moretti with a Harlequin Mask*, 1957; Museo Teatrale della Scala, Milan). The sculptor Mario Ceroli made a fundamental contribution with his wood sets and props. Also celebrated are the "material-rich" sets designed for opera productions at the Maggio Musicale Fiorentino (Florentine May Music Festival) by sculptors such as Dani Karavan (for Gian Carlo Menotti's *Il Consule* in 1972), Giacomo Manzù (for Christoph Willibald Gluck's *Iphigénie en Tauride* in 1981), and Fausto Menotti (for Stravinsky's *Le Chant du Rossignol* in 1982).

GIOVANNA CHECCHI

Further Reading

Calvesi, Maurizio, editor, *Ceroli* (exhib. cat.), Florence: Casa Usher, 1983

Greco, Franco Carmelo, editor, *Pulcinella maschera del mondo* (exhib. cat.), Naples: Electa Napoli, 1990

Molinari, Cesare, *Teatro*, Milan: Mondadori, 1972; revised and updated edition, as *Storia del teatro*, Milan: Mondadori, 1997; as *Theatre through the Ages*, translated by Colin Hamer, New York: McGraw Hill, and London: Cassell, 1975

Molinari, Cesare, editor, *La Commedia dell'Arte*, Milan: Mondadori, 1985

Monti, Raffaele, editor, *Pittori e scultori in scena*, Rome: De Luca, 1986

Sánchez Beltrán, Maria Jesús, *La porcelana de la Real Fábrica del Buen Retiro*, Madrid: Electa, 1998

Sartori, Donato, and Bruno Lanata, editors, *Arte della maschera nella Commedia dell'Arte* (exhib. cat.), Florence: Casa Usher, and Abano Terme, Italy: Centro Maschere e Strutture Gestuali, 1983

Scafoglio, Domenico, and Luigi M. Lombardi Satriani, *Pulcinella: Il mito e la storia*, Milan: Leonardo, 1992

THORNYCROFT FAMILY *British*

With a combined career spanning almost a century, the Thornycroft family occupied a central place in the British art establishment during the Victorian era. More reformers than radicals, the Thornycrofts consistently sought to invigorate English sculpture and carve out a national style from Neoclassical conventions

dominating 19th-century sculpture in Britain. It was in the studio of the sculptor John Francis that the young Thomas Thornycroft met his fellow student Mary Francis, Francis's daughter. The two were married in 1840, and their children included the extremely successful sculptor W. Hamo, the painters Alyce, Helen, and Theresa (mother of Siegfried Sassoon, the poet), and the famous marine engineer, John. The most significant collection of archival materials relating to the Thornycroft family can be found at the Centre for the Study of Sculpture of the Henry Moore Institute, Leeds, England, and at the University of Leeds.

Thomas Thornycroft 1815–1885

Overall, Thomas Thornycroft achieved less success than either his wife or his son. He sought to innovate the art of sculpture and planned to create a series of monumental groups illustrating the history of England, whether allegorical scenes of British historical figures (*Alfred the Great Encouraged to the Pursuit of Learning by His Mother*) or contemporary subjects such as the *Equestrian Statue of Queen Victoria*, a full-size version of which was made for the 1851 Great Exhibition. Although the latter statue was not commissioned in a permanent material after the exhibition, Thomas oversaw the production of an edition of statuettes through the Art Union of London. Setting up his own bronze foundry and developing a process of electro-bronze casting, Thomas achieved a technical refinement in the casting process rarely seen in the Victorian period. Consequently, these statuettes have become, along with the *Commerce* group from the Albert Memorial in Hyde Park, London, Thomas's best-known and most-prized work. During the mid-Victorian period, Thomas was a leading proponent of the use of modern dress in sculpture, and through this work he helped to popularize the idea of the historically accurate portrait. In part because of the difficulties encountered with the *Equestrian Statue of Queen Victoria* and the response to modern dress, Thomas's most ambitious work takes as its subject an episode from the history of Britain under the Roman Empire, in which Neoclassical garb and British history could be combined. *Bodicea and Her Daughters* epitomizes Thomas's desire for an appropriate English sculpture and occupied him for over two decades. In the later years he abandoned sculpture (including removing his name from candidacy for the Royal Academy in order to avoid interfering with Hamo's election in 1881). He became increasingly interested in marine engineering, and he and his son John (the designer of World War I torpedo boats) developed a variety of methods for increasing boat speed. This interest dominated his later life, and it was primarily through the efforts of his wife

and son John that *Bodicea and Her Daughters* received a permanent placement in London.

Mary Thornycroft 1809–1895

Mary Thornycroft stands out as one of the most successful female artists of the 19th century, although this achievement has been obscured by the relative inaccessibility of her works, the majority of which are in the British Royal collections and residences. Her father was a moderately successful portraitist who encouraged Mary's interest in sculpture and trained her alongside his male apprentices. Mary, in turn, capitalized on this opportunity to become a professional sculptor and subsequently fostered such traits in her own children. Her skill was highly admired, and the leading mid-Victorian sculptor John Gibson recommended her in his stead for a commission for portraits of *The Royal Children as the Four Seasons*. Queen Victoria and Price Albert greatly admired Mary's statues, which subsequently achieved some popular acclaim as engravings and Parian porcelain reductions. Mary's success with these statues guaranteed a lifelong relationship with the royal family, and by the end of her career she had made portraits of four generations of its members as well as trained Princess Louise, the sculptor. These royal commissions supported the family while Thomas engaged in uncommissioned projects.

In all her works, Mary captured vitality and freshness in her allegorical portraits without overly idealizing her subjects. The complex use of facial expression, gaze, and an implication of movement all built on the portrait work of both her father and his teacher, Francis Chantrey. Beyond her work in portraiture Mary also sculpted a series of ideal figures, *The Skipping Girl* shown at the 1855 Paris Exhibition being her most successful.

William Hamo Thornycroft 1850–1925

Mary and Thomas collaborated on many works, and this spirit of working together extended through the home environment to their children. In 1875 Hamo and his parents collaborated on the now-destroyed *Poet's Fountain* (formerly Park Lane, London), in which all three sculptors influenced and corrected each other's work. Taking from his parents a commitment to technical sophistication and the desire to renew sculpture for the English audience, Hamo created a series of highly influential ideal sculptures that laid the foundation for the dominant sculpture movement of the late Victorian era—"The New Sculpture." In the early 1880s Hamo exhibited *Artemis and Her Hound* and *Teucer*, both of which sought to imbue the Classical format with a

William Hamo Thornycroft, *Teucer*
© Tate Gallery, London/Art Resources, NY

one leg, the shoulder, and hips counterbalancing one another). The arrangement of the body echoes the psychological traits Hamo ascribed to Gordon through a face that conveys both strength and thoughtfulness (and it is in Gordon's face and others that Mary's influence can be seen most concretely).

Hamo also exceeded the traditional expectations of architectural sculpture with his ambitious frieze for the Institute of Chartered Accountants. Over his long career, Hamo employed his particular blend of naturalism and formal innovation in some of the best-known public monuments in Britain, including the memorial to William Ewart Gladstone on the Strand in London, the *Oliver Cromwell* outside Westminster Cathedral, and the *King Alfred* in Winchester.

DAVID J. GETSY

Thomas Thornycroft

Biography
Born in Cheshire, England, 1815. Self-taught until apprenticed to John Francis; began exhibiting at the Royal Academy, 1836; married Mary Francis, 1840. Died in Kent, England, 30 August 1885.

Selected Works
1850 *Alfred the Great Encouraged to the Pursuit of Learning by His Mother*; marble (untraced)
1851 Equestrian statue of Queen Victoria, for 1851 Great Exhibition; plaster (destroyed); bronze statuette versions in numerous locations
1856–71 *Bodicea and Her Daughters*; bronze (cast posthumously); Westminster Bridge, London, England
1866 *Albert, Prince Consort*; bronze; Liverpool, England (another version at Wolverhampton, England, also 1866; an earlier version of 1864 at Halifax, England)
1870 Equestrian statue of Queen Victoria; bronze; Liverpool, England
1872 *Commerce*; marble; Albert Memorial, Hyde Park, London, England
1875 *The Poet's Fountain* (with Mary and William Hamo Thornycroft), for Park Lane, London, England; bronze, marble (destroyed)

Mary Thornycroft

Biography
Born in Thornham, Norfolk, England, 13 July 1809. Daughter of John Francis. Exhibited almost yearly at

heightened naturalism, a dynamic formal composition, and an implication of movement and energy. The refinement of these two works contributed greatly to the development of the New Sculpture and its attention to the naturalistically rendered figure. Hamo continued with *The Mower*, the first heroic-size ideal sculpture of a laborer in Europe. This work transforms the Classical ideal Hamo so admired in the sculpture of antiquity into a contemporary English pastoral ideal. Like his parents' desire to animate sculpture and make it relevant to English life and history, *The Mower* was an earnest attempt to establish a new set of parameters for the subject matter of sculpture in England without abandoning the aspirations to the ideal or descending into "base realism" (a trait Hamo disliked in French sculpture). These ideal statues of the 1880s firmly established Hamo's position as a leading sculptor (he was one of the youngest academicians ever elected), and he subsequently received many important commissions. Of these, *General Gordon* is exemplary in its complicated bodily arrangement that expands on traditional *contrapposto* (a natural pose with the weight of

the Royal Academy, 1834–77; married Thomas Thornycroft, 1840. Died in Marlfield, England, 1 February 1895.

Selected Works

Numerous busts and imaginative portrait statues by Mary Thornycroft are housed in the collection of Her Majesty Queen Elizabeth II, distributed among Windsor, Sandringham, Frogmore, Kensington, and Osborne House, among others

1839 *The Orphan Flower Girl*; marble (untraced)
1845–50 *The Royal Children as the Four Seasons*; marble; Osborne House, Isle of Wight, England
1851? *Queen Victoria*; marble; Royal Collections, England
1852 *Martin Tomb*; marble; Ledbury Parish Church, Herefordshire, England
1854–59 *The Royal Children* (*Helena as Peace, Louise as Plenty, Arthur as a Hunter, Leopold as a Fisher Boy*, and *Beatrice in a Nautilus Shell*); marble; Osborne House, Isle of Wight, England
1855 *The Skipping Girl*; bronze (untraced)
1875 *The Poet's Fountain* (with Thomas and William Hamo Thornycroft), for Park Lane, London; bronze, marble (destroyed)

William Hamo Thornycroft

Biography

Born in London, England, 9 March 1850. Son of Mary and Thomas Thornycroft. Trained in parents' studio and at the Royal Academy Schools, 1869–75; exhibited at Royal Academy from 1872; won Royal Academy Sculpture Gold Medal, 1875; elected Associate of the Royal Academy, 1881, and full Academician, 1888; knighted, 1917; awarded Gold Medal of the Royal Society of British Sculptors, 1923. Died in Oxford, England, 18 December 1925.

Selected Works

1875 *The Poet's Fountain* (with Thomas and Mary Thornycroft), for Park Lane, London, England; bronze, marble (destroyed)
1880 *Artemis and Her Hound*; plaster; Macclesfield Town Hall, Macclesfield, England; bronze: Eaton Hall, Chester, England
1881 *Teucer*; bronze; Tate Gallery, London, England; bronze: 1882, Art Institute of Chicago, Illinois, United States
1884 *The Mower*; plaster; Walker Art Gallery, Liverpool, England; bronze: 1894, Walker Art Gallery, Liverpool, England
1886 *The Sower*; bronze (cast posthumously); Kew Gardens, London, England
1888 *General Gordon*; bronze; Embankment Gardens (formerly Trafalgar Square), London, England
1889–92 Institute of Chartered Accountants Frieze; Portland stone; Moorgate Place, London, England
1896 *Queen Victoria*; marble; Royal Exchange, London, England; Durban, South Africa
1899 *Oliver Cromwell*; bronze; Westminster Hall, London, England
1901 *King Alfred*; bronze; Winchester, England
1902 *Dean John Colet*; bronze; St. Paul's School, London, England
1905 William Ewart Gladstone Memorial; bronze; Strand, London, England
1909 *Alfred, Lord Tennyson*; marble; Trinity College, Cambridge, England
1912 *Lord Curzon of Kedleston*; bronze (partially extant); Victoria Memorial Hall, Calcutta, India

Further Reading

Armstrong, Walter, "Mr. Hamo Thornycroft, R.A.," *The Portfolio* 19 (1888)
Beattie, Susan, *The New Sculpture*, New Haven, Connecticut: Yale University Press, 1983
Friedman, Terry, "'Demi-gods in Corduroy': Hamo Thornycroft's Statue of *The Mower*," *The Sculpture Journal* 3 (1999)
Friedman, Terry, editor, *The Alliance of Sculpture and Architecture: Hamo Thornycroft, John Belcher, and the Institute of Chartered Accountants Building*, Leeds, Yorkshire: Henry Moore Centre for the Study of Sculpture, Leeds City Art Galleries, 1993
Getsy, David, "The Difficult Labour of Hamo Thornycroft's *Mower*, 1884," *The Sculpture Journal* 7 (2002)
Gosse, Edmund, "Our Living Artists: Hamo Thornycroft, A.R.A.," *The Magazine of Art* 4 (1881)
Gosse, Edmund, "The New Sculpture: 1879–1894," *Art Journal* 56 (1894)
Manning, Elfrida, *Marble and Bronze: The Art and Life of Hamo Thornycroft*, London: Trefoil Books, and Westfield, New Jersey: Eastview Editions, 1982
McCracken, Penny, "Sculptor Mary Thornycroft and Her Artist Children," *Woman's Art Journal* (1997)
Read, Benedict, *Victorian Sculpture*, New Haven, Connecticut: Yale University Press, 1982
Spielmann, M.H., *British Sculpture and Sculptors of Today*, London and New York: Cassell, 1901
Stephens, F.G., "The Late Mrs. Mary Thornycroft," *The Magazine of Art* (1895)
Thornycroft, Elfrida, *Bronze and Steel: The Life of Thomas Thornycroft, Sculptor and Engineer*, Shipton-on-Stour: King's Stone Press, 1932

Thornycroft, Hamo, "The Study of Ancient Sculpture," *The Architect* 27 (1882)

White, Adam, *Hamo Thornycroft and the Martyr General*, Leeds, Yorkshire: Henry Moore Centre for the Study of Sculpture, Leeds City Art Galleries, 1991

BERTEL THORVALDSEN 1770–1844
Danish

Bertel Thorvaldsen's early relief *Cupid Resting* from 1789 already reveals the qualities that were to be the essence of his sculptural works: the restful, expectant, and thoughtful elements in the figure's expression and the sculpture's harmonious structure. At the Royal Academy of Fine Arts in Copenhagen, Denmark, Thorvaldsen was influenced by the sculptor Johannes Wiedewelt and the painter Nicolai Abildgaard, both of whom had an intimate knowledge of innovative and revolutionary Neoclassicism as conceived in Rome in the second half of the 18th century. Abildgaard in particular became Thorvaldsen's mentor and protector at the academy. With a bursary from the academy, Thorvaldsen traveled to Rome, where he arrived 8 March 1797 and initially attached himself to the artists Asmus Jacob Carstens and Joseph Anton Koch, sharing their grandiose visions of a radical and revolutionary art during the years shortly after the French Revolution and working in harmony with the freedom movements throughout Europe.

The work signifying a breakthrough in Thorvaldsen's career, the sculpture *Jason with the Golden Fleece*, derived its motif from a composition by Carstens. *Jason* differs from most of Thorvaldsen's other sculptural work in its emphasis on determination and in the way in which it actively engages the space around it. A work both presupposing the extrovert power of *Jason* and at the same time pointing to a later stage in Thorvaldsen's development is the relief *Briseis Led Away from Achilles by Agamemnon's Heralds* (1787–90). The figure of Achilles has all the vehement power and almost intolerable fury of the *Sturm und Drang* period, while Briseis stands reflective and introspective until being led away by the heralds. After this, Thorvaldsen rapidly received a number of commissions, including some from the Russian countess Irina Vorontsov for the sculptures *Bacchus, Apollo, Ganymede*, and *Cupid and Psyche Reunited in Heaven*, all smaller in size than *Jason with the Golden Fleece*, in the years between 1804 and 1807. The figures are presented as being reflective and withdrawn in their own space, a quality long at the forefront of Thorvaldsen's sculptures. The sculpture *Adonis* (1808) was immediately ordered by Crown Prince Ludwig, subsequently king of Bavaria.

Thorvaldsen reached an initial pinnacle in his renown with the rapid execution of the more than 35-meter-long relief *Alexander the Great's Entry into Babylon* for a room in the Palazzo del Quirinale being decorated for Napoléon I's expected arrival in Rome. Marble versions were later made, one for the Villa Carlotta by Lake Como, Italy. The years from about 1810 to 1820 are known as the "Classical period" in Thorvaldsen's art because the works from this time were most closely inspired by Classical Greek art and thus also closest to our idea of "the Classical": perfect harmony and balance and a sculptural idiom characterized by great simplicity. Of works from this period, mention should be made of *Venus* (1813–16); the funeral monument for Philipp Bethman-Hollweg (1814); the reliefs *Night* and *Day*, with many examples of this work made in marble even in Thorvaldsen's own workshops; *The Three Graces* (1817–18); *Ganymede with Eagle of Jupiter; Shepherd Boy* (1817); and *Mercury as the Slayer of Argus*. An atypical work concerning Thorvaldsen's sculptural language was the statue *The Goddess of Hope* (1817), which was inspired by archaic rather than Classical Greek sculptures and created in the years during which Thorvaldsen was recreating for Crown Prince Ludwig an archaic group of figures from the Temple of Aphaia at Aegina.

In July 1819, Thorvaldsen went to Copenhagen to conclude negotiations on works for the new monumental buildings that were under construction after the fires at the end of the 18th century and the British bombardment of the city in 1807. For the Cathedral Church of Our Lady, he was commissioned to produce the statues *Christ and the Apostles*. In December 1820 he was back in Rome. Commissions for large monuments from various countries dominated this period until he left Rome in 1838. For all of these monuments, the clients' intentions were to make an assertion of national identity in accordance with the trends found throughout Europe during these years. The earliest of these monuments by Thorvaldsen was *Lion of Lucerne* (1819–21), carved in a cliff face near Lucerne, Switzerland, by Lucas Ahorn. The equestrian statue of the hero of the Polish struggle for freedom, *Count Poniatowsky*, and the statue of the astronomer Nicolaus Copernicus (1822), both intended for erection in Warsaw, followed. The statue *Friedrich von Schiller* (1835–39) was commissioned for Stuttgart and executed by Wilhelm Matthiä on the basis of Thorvaldsen's sketch.

Despite the nationalist origins of several of the great monuments, Thorvaldsen endeavored to portray the historical figures without national characteristics and always took inspiration from the art of the ancient world. In doing so, he came into conflict with the demand for historical accuracy that was inevitably a consequence of the national historical sympathies of his clients, something that found clear expression in negotiations on the execution of the equestrian statue *Count*

Jason with the Golden Fleece
The Conway Library, Courtauld Institute of Art

Poniatowsky. In several of the monuments from the 1830s—for instance, the equestrian statue *Maximilian I* (1833–39) for Munich and the statue *Johann Gutenberg* (1833–37) for Mainz, executed by Hermann Wilhelm Bissen after Thorvaldsen's sketch—there was nevertheless increased attention to historically accurate features in dress. A great honor was given to Thorvaldsen with the commission for the sepulchral monument to Pope Pius VII to be erected in St. Peter's Basilica in Rome. The first sketches for this work betray an intense psychological empathy and an understanding of the pope's physiognomy and personality, whereas the finished monument is to an extent lacking in strength in relation to the enormous space and the powerful, commanding Baroque papal monuments.

From the earliest years in Copenhagen and until his death, Thorvaldsen also made portraits, first as medallions and then in the form of numerous portrait busts. In their monumental format, the earliest busts from 1803 to 1805 are closely related to the heroic Classi-

cism in Thorvaldsen's other works from this time. From about 1815, the number of portrait busts rose markedly. These are primarily life-size works that reveal a common objective of the ideal portrayal; at the same time, however, each bust encompasses carefully observed individual features, such as in the portrait busts of Lord Byron (1817), or Clemens Metternich (1819).

After 40 years in Rome, Thorvaldsen returned to Copenhagen in 1838, prompted by thoughts of creating in his native city a museum for the original models for his life's work in addition to his extensive collections of contemporary paintings and artifacts from antiquity. Thorvaldsens Museum was built between 1839 and 1848. During his last six years in Copenhagen and at the mansion of Nysø, Thorvaldsen made a number of smaller works characterized by humor and charm. If striving for the ideal is less apparent in these works, the expression is realistic and immediate, and some of the reliefs almost have the quality of genre art. Thorvaldsen's last great work was the statue *Hercules*, which in its extroversion and self-confidence harks back to *Jason with the Golden Fleece*.

STIG MISS

Biography

Born in Copenhagen, Denmark, 19 November 1770. Father, Gotskálk Thorvaldsen, was a woodcarver who emigrated from Iceland. Admitted to Royal Academy of Fine Arts, Copenhagen, 1781; received academy's gold medal, 1793; arrived in Rome on scholarship from academy, 8 March 1797, and made copies of antique marble busts, which initiated career as prolific portrait sculptor; lived in small studio near Palazzo Barberini, from 1803, then at Casa Buti, from 1804 until he left Rome in 1838; traveled to Italy, Germany, and Poland and received commissions; made one short trip to Copenhagen, 1819–20; lived in Copenhagen from 1838. Died in Copenhagen, Denmark, 24 March 1844.

Selected Works

1789 *Cupid Resting*; plaster; Thorvaldsens
 Museum, Copenhagen, Denmark
1803–28 *Jason with the Golden Fleece*; marble;
 Thorvaldsens Museum, Copenhagen,
 Denmark
1804–6 *Hebe*; marble; Thorvaldsens Museum,
 Copenhagen, Denmark
1807 *Cupid and Psyche Reunited in Heaven*;
 plaster; Thorvaldsens Museum,
 Copenhagen, Denmark
1812 *Alexander the Great's Entry into Babylon*;

plaster; Palazzo del Quirinale, Rome, Italy;
plaster cast: Thorvaldsens Museum,
Copenhagen, Denmark; marble versions:
Villa Carlotta, Lake Como, Italy;
Christiansborg Palace, Copenhagen,
Denmark

1813–16 *Venus*; marble; Thorvaldsens Museum,
Copenhagen, Denmark

1815 Reliefs of *Night* and *Day*; marble;
Thorvaldsens Museum, Copenhagen,
Denmark

1818 *Mercury as the Slayer of Argus*; marble;
Thorvaldsens Museum, Copenhagen,
Denmark

1821–24 *Christ and the Apostles*; marble;
Copenhagen Cathedral, Denmark

1824–31 Tomb of Pope Pius VII; marble; St.
Peter's Basilica, Rome, Italy

1826–27 *Count Poniatowsky*; plaster; Thorvaldsens
Museum, Copenhagen, Denmark; bronze
version: 1832 (destroyed World War II);
replica: 1952, Krakowskie Przedmiscie,
Warsaw, Poland

1843 *Hercules*; plaster; Thorvaldsens Museum,
Copenhagen, Denmark; bronze cast
(posthumous): 1845–50, Prins Jørgens
Gård, Copenhagen, Denmark

Further Reading

Bott, Gerhard, and Frank Günter Zehnder, editors, *Bertel Thorvaldsen: Unters. zu seinem Werk u. zur Kunst seiner Zeit*, Cologne, Germany: Museen d. Stadt Köln, 1977

Di Maio, Elena, Bjarne Jørnæs, and Stefano Susinno, editors, *Bertel Thorvaldsen: 1770–1844: Scultore danese a Roma* (exhib. cat.), Rome: De Luca, 1989

Hartmann, Jörgen Birkedal, and Klaus Parlasca, *Antike Motive bei Thorvaldsen: Studien zur Antikenrezeption des Klassizismus*, Tübingen, Germany: Wasmuth, 1979

Helsted, Dyveke, Eva Henschen, and Bjarne Jørnæs, *Thorvaldsen*, Copenhagen: Thorvaldsens Museum, 1986; as *Thorvaldsen*, translated by Ann and Janus Paludan, 1990

Hemmeter, Karlheinz, *Studien zu Reliefs von Thorvaldsen: Auftraggeber, Künstler, Werkgenese, Idee und Ausführung*, Munich: Klein, 1984

Jørnæs, Bjarne, *Bertel Thorvaldsen: La vita e lopera dello scultore*, Rome: Luca, 1997

Kragelund, Patrick, and Mogens Nykjær, *Thorvaldsen: L'ambiente, L'influsso, il mito*, Rome: L'Erma di Bretschneider, 1991

Peters, Ursula, editor, *Künstlerleben in Rom* (exhib. cat.), Nuremberg, Germany: Verlag des Germanischen Nationalmuseums, 1991

Tesan, Harald, *Thorvaldsen und seine Bildhauerschule in Rom*, Cologne, Germany: Böhlau, 1998

Thiele, Just Mathias, *Den danske billedhugger Bertel Thorvaldsen og hans værker*, 4 vols., Copenhagen: Forfatterens Forlag i Thieles Bogtrykkeri, 1831–50

Thiele, Just Mathias, *Thorvaldsens biographi*, 4 vols., Copenhagen: Reitzels Forlag, 1851–56

Thiele, Just Mathias, *The Life of Thorvaldsen*, translated by Mordaunt Roger Barnard, London: Chapman and Hall, 1865

Thorvaldsen w Polsce (exhib. cat.), Warsaw: Zamek Królewski, 1994

Wittstock, J., "Zur Reproduzierbarkeit der künstlerischen Idee: Die Skulptur Bertel Thorvaldsens," in *Ideal und Wirklichkeit der bildenden Kunst im späten 18. Jahrhundert*, edited by Herbert Beck, Peter Bol, and Eva Marek-Gérard, Berlin: Mann, 1984

JEAN TINGUELY 1925–1991 *Swiss*

Jean Tinguely was a central figure in the development of kinetic sculpture. Beginning in 1953, he was one of the first artists to make works powered by motors, and he continued building his distinctive machines until his death in 1991. Neo-Dada in spirit, Tinguely became a founding member of the French movement Nouveau Réalisme in 1960. He is best known for his self-destroying or suicidal machines, including the *Homage to New York*, which destroyed itself in the Sculpture Garden of the Museum of Modern art in New York in 1960.

Tinguely received his artistic training as an apprentice window dresser and at the Allgemeine Kunstgewerbeschule in Basel. The Bauhaus emphasis of this training is evident in Tinguely's underlying aesthetic.

Tinguely and his wife, the artist Eva Aeplli, moved to Paris in late 1953. There, Tinguely began his career as an artist in earnest, making his first hand-driven kinetic wire sculptures, including the series of *Moulins a prière* (Prayer Mills). He also produced the abstract Meta-Malevich motorized paintings, exhibited at his first show in 1954. Later in the 1950s, he produced machines that playfully critiqued contemporary art movements. His series of Metamatic painting machines drew small pictures reminiscent of the work of the American Abstract Expressionists and the French *Informel* group. These and later works established him firmly as an *enfant terrible*, although his making light of the traditional sanctity of art was not universally appreciated.

Beginning in the 1950s and continuing throughout his career, Tinguely consciously explored the use of sound in his works, influenced in part by the *musique concrete* of the French composer Pierre Schaeffer. He also included his machines in performances incorporating elements of Eugene Ionesco's Theater of the Absurd, most notably in the 1959 performance *Art, Machines, and Motion* at the Institute of Contemporary Art in London. As part of this performance, Tinguely read a text that was immediately and continuously corrected by an English professor and played slightly out of phase on two tape recorders while two professional cyclists powered painting machines in a race to produce the most art in the course of the performance.

From 1958 to 1959 Tinguely collaborated on a number of works with the French artist Yves Klein. The most important of these was the installation *Pure Speed and Monochrome Stability*, for which Tinguely contributed two spinning disks painted with Klein's trademark blue monochrome. The disks became a blue ambiance and visually "dematerialized" as they picked up speed.

The *Homage to New York* of 1960 is a testament to Tinguely's belief that art must celebrate change, rather than become static and mired in tradition. A large Rube Goldberg machine, it was 7 meters long by 8 meters high and painted white. After laboring for about a half an hour it caught fire and, fearing a larger conflagration, Tinguely and firefighters extinguished the blaze. Tinguely followed this self-destructive spectacle with two more pyrotechnic works, built in 1961 and 1962, and entitled *Study for an End of the World, Nos. 1 and 2*. These included explosive charges and destroyed themselves at the Louisiana Museum outside Copenhagen and in the Nevada desert, respectively.

One of the most significant aspects of Tinguely's works is that, despite what he called the "sugar coating of humor," they address many of the most important political and social issues of the postwar years. His "ends of the world" were staged when the Cold War was at its height and the arms race was accelerating.

Tinguely joined the French Nouveaux Réalistes in 1961. In the United States he collaborated with prominent American artists, including Robert Rauschenberg, Jasper Johns, and the choreographer Merce Cunningham, in the staging of various theatrical performances.

Beginning in 1960, Tinguely began living with the French American artist Niki de Saint Phalle, with whom he collaborated artistically until his death. One product of this collaboration was *Høn* (She), a gigantic, brightly colored, supine female figure exhibited at the

Metamatic Number 1
© 2001 Artists Rights Society (ARS), New York, ADAGP, Paris

Moderna Museet in Stockholm in 1966. Visitors entered between her legs. Once inside, they could experience various rooms furnished by different artists, including Tinguely.

Throughout the 1960s Tinguely made machines ranging in size from the tabletop-size *Balubas*, which ironically refers to the contemporaneously unfolding tragedy of independence in the Belgian Congo, to the massive *Eureka*, made for the Swiss Expo in 1964 as an ironic commentary on Swiss efficiency. In addition, the *Rotozazas* of 1967 lampooned the endless cycle of capitalist production and consumption.

Beginning in the mid 1960s, a recurring theme in Tinguely's work was desire and its consequences. The numerous works in the Bascule, Eos, and Chariot series ironically mimic activities associated with human sexual desire and the attendant male posturing. Some of these works include phallic elements that, despite their impressive rigidity and size, either move hilariously awkwardly or threaten to capsize the machines that drive them. In 1970, to celebrate the tenth anniversary of the founding of the Nouveau Réaliste group, Tinguely constructed a 6.7-meter-high penis entitled *La Vittoria* in the Piazza del Duomo in Milan. The night that it was unveiled, it shot fireworks from its tip before catching fire and burning to cinders.

Tinguely participated in many collaborative enterprises, including the *Dylaby* (1964) with Rauschenberg, Saint Phalle, Daniel Spoerri, Per Olof Ultvedt, and Martial Rayasse; the *Fantastic Paradise* made for the 1967 World's Fair in Montreal with Saint Phalle; and the Stravinsky Fountain in Paris, also with Saint Phalle. Of the collaborations, the one that occupied him the longest was *The Head, Cyclops* outside Paris. Begun at Tinguely's instigation in 1971, it was not completed by the artists he invited to participate until 1994.

During the 1970s and 1980s, Tinguely produced a number of enormous meta-relief sculptures. Their most prominent features are massive wheels associated with traditional heavy industry but painted in bright primary colors. They make sounds that are orchestral in their cacophonous polyphony.

In 1981 Tinguely produced his first mechanical altar, the *Cenedoxus-Isenheim Altarpiece*. This and later altarpieces are replete with references to death, including ox crania and symbols of Christian martyrdom. These sacred symbols are juxtaposed with various kitsch items produced by Western consumer capitalism. The *Triptych of Plenty and of Totalitarian Mercantilism*, exhibited in Moscow in 1990, was an ironic offering to the newly capitalist Russian people.

In 1985 Tinguely suffered a nearly fatal heart attack. In the works he produced during the 1980s, including the groups of works entitled *Inferno* and *Mengele*, the macabre and death became more prominent. At the

1662

same time, he became a national hero in Switzerland. Today, the most extensive collection of his works, many donated by Saint Phalle, can be seen at the Musée Jean Tinguely in Basel. The museum is funded by the Swiss pharmaceutical firm Hoffmann–La Roche and was designed by Mario Botta.

ANDREW DOERR

See also **Klein, Yves; Saint Phalle, Niki de; Spoerri, Daniel**

Biography

Born in Fribourg, Switzerland, 22 May 1925. Moved to Basel, 1927; studied at Allgemeine Kunstgewerbeschule in Basel and apprenticed as window dresser, 1941–44; met Daniel Spoerri, 1949; moved to Paris, 1953; first exhibition of kinetic sculptures at Galerie Arnaud, 1954; first trip to United States, 1960; produced *Homage to New York* and joined Nouveaux Réalistes with Arman, François Dufrêne, Raymond Hains, Yves Klein, Villeglé, Martial Raysse, and Daniel Spoerri; "Movement in Art" exhibition at Stedelijk Museum, Amsterdam, and Moderna Museet, Stockholm, 1961; built *Eureka* for Swiss Expo '64, 1963–64; James Johnson Sweeney purchased entire "Meta" exhibition at Galerie Alexandre Iolas for Museum of Fine Arts, Houston, 1964; "2 Kinetic Sculptors" exhibition at Jewish Museum, New York, 1965; moved to Neyruz, Switzerland, 1968; began *The Head, Cyclops*, 1971; produced first altar, *Cenedoxus*, 1981; suffered heart attack and underwent bypass surgery, 1985; major retrospective at Palazzo Grassi, Venice, Italy, 1987. Died in Berne, Switzerland, 30 August 1991.

Selected Works

1958 *Vitesse pure et stabilité monochrome* (with Yves Klein); no longer extant

1960 *Homage to New York*; scrap metal and motor; Museum of Modern Art, New York City, United States

1960 *Autoportrait conjugal*; scrap iron, metal, dead bird, electric motor with moveable elements, Kunstmuseum Basel, Switzerland

1965 *Spiral Rörelse*; metal motorized spiral; Kunsthalle Mannheim, Germany

1967 *Eos XII*; metal, iron; Kunsthalle Mannehim, Germany

1969 *Memorial to the Sacred Wind*; steel, Tate Gallery, London, England

1970 *Débricollage*; steel, mixed media and electrical mechanism; Tate Gallery, London, England

1970 *La Vittora*; no longer extant

1979 *Méta-Harmonie II*; mobile scrap metal, musical instruments, iron, brass, plastic, rubber, lead, glass, wood; Kunstmuseum, Basel, Switzerland

1971– *The Head (Cyclops)*; monumental mixed
1994 media sculpture with fountain; Government of France, Ministry of Culture, Milly-la-Forêt, France

1983 *Igor Stravinksy Fountain*; mixed media; Centre National d'Art et Culture Georges Pompidou, Paris, France

Further Reading

Bischofberger, Christina, compiler, *Jean Tinguely: Catalogue raisonné: Sculptures and Reliefs, 1954–1968*, Küsnacht, Switzerland, and Zurich: Edition Galerie Bruno Bischofberger, 1982

Hahnloser-Ingold, Margrit, *Pandämonium, Jean Tinguely*, Bern, Switzerland: Benteli, 1988

Hahnloser-Ingold, Margrit, editor, *Briefe von Jean Tinguely an Maja Sacher*, Bern, Switzerland: Benteli, 1992

Hultén, Karl Gunnar Pontus, *Jean Tinguely: "Méta,"* Berlin: Propyläen-Verlag, and Frankfurt: Verlag Ullstein, 1972; as *Jean Tinguely: "Méta,"* translated by Mary Whittall, London: Thames and Hudson, and Boston: New York Graphic Society, 1975

Hultén, Karl Gunnar Pontus, *Jean Tinguely: A Magic Stronger than Death*, Milan: Bompiani, London: Thames and Hudson, and New York: Abbeville Press, 1987

Klüver, Billy, "The Garden Party," in *The Machine, As Seen at the End of the Mechanical Age* (exhib. cat.), by Karl Gunnar Pontus Hultén, New York: Museum of Modern Art, 1968

Seitz, William Chapin, *The Art of Assemblage* (exhib. cat.), New York: Museum of Modern Art, 1961

Tomkins, Calvin, *The Bride and the Bachelors: The Heretical Courtship in Modern Art*, New York: Viking Press, and London: Weidenfeld and Nicolson, 1965; expanded edition with new introduction, as *The Bride and the Bachelors: Five Masters of the Avant Garde*, New York: Viking Press, 1968

Violand-Hobi, Heidi E., *Jean Tinguely: Life and Work*, Munich and New York: Prestel, 1995

TINO DI CAMAINO *ca.* 1280–1337 *Italian*

Tino di Camaino's training as a sculptor may well have begun under his father, the architect and sculptor Camaino di Crescentino. It is likely that he also worked alongside Giovanni Pisano, whom he probably accompanied to Pisa in 1297. One collaborative venture with Pisano appears to have been the pulpit of the Church of S. Andrea, Pistoia; the relief of the *Three Magi*, in particular—because of its heavy forms—recalls Tino's work, and its arrangement of planes to create spatial recession differs from the piling up of figures seen in the other panels.

Tino's first independent works were for the Cathedral of Pisa. He sculpted a tomb for St. Ranierus,

which, with great novelty, he set on consoles above an altar (also made by him). Thus the tomb's relief panels acted as an altarpiece of sorts, especially as they reflected the style of contemporary Sienese painting. Tino went on to carve the font for the Cathedral of Pisa with reliefs of the life of St. John the Baptist (signed and dated 1312), the surviving fragments of which, together with a signed statue of the *Virgin and Child* (1313–14), reveal an obvious debt to Giovanni Pisano, especially in the physiognomies of the figures and the style of the drapery. Tino's grandest commission for the Cathedral of Pisa was the tomb of Emperor Henry VII; in the commissioning document, Tino is mentioned as Pisano's successor as master of works at the cathedral. The tomb's original appearance is unknown; it was dismantled in 1494 and has been only partly reassembled. It has been suggested (see Kreytenberg, 1984) that at the bottom there would have been an unadorned sarcophagus, carried on massive consoles and spiral columns; in the middle a recumbent effigy of the emperor, flanked on either side (and at either end) by reliefs representing the Apostles and Evangelists; and at the top, under a baldachin, an imposing sculpture of the enthroned emperor surrounded by statues of standing councilors. Tino must have received help in carving this monument, because he was due to receive his last payment only five months after starting work. (This payment never came, however, because he fled to Siena to fight for the Guelphs). The work of a second sculptor—possibly Lupo di Francesco, who succeeded him as master of the cathedral works—has been discerned in the sculptures of the councilors; certainly their faces and draperies are more coarsely modeled than those of the emperor.

In Siena, Tino created his tomb of Cardinal Riccardo Petroni, who died in Genoa in 1314 and was buried in the Cathedral of Siena in March 1317. Here, for the first time, Tino's debt to the Sienese tradition and especially to the paintings of Simone Martini becomes clear. The four figures that stand on the tomb base to support a sarcophagus (which is decorated with reliefs of the life of Christ after the Resurrection), as well as the two figures above the sarcophagus who hold open the tentlike curtains of a death chamber to reveal the effigy of the deceased lying on a bed, are characterized by a new slenderness. A new serenity and sweetness is visible in the figures' expressions and a new rhythmic flow characterizes their draperies. Similar tendencies are encountered in Tino's three monumental statues of *Apostles* (*ca.* 1317–18), which may once have formed part of the decoration of the nave of the Cathedral of Siena. It is possible that at this time Tino also assisted with the production of a shrine for St. Bartolo in the Church of S. Agostino, San Gimignano, but this is difficult to ascertain be-

cause only a few fragments of it remain. From the accounts of the cathedral works in Siena, Tino appears to have been engaged in the city again for the first nine months of 1320, although on what projects it is unclear.

For just over a year from the autumn of 1318, Tino was active in Florence. In the Church of S. Croce, he produced a tomb for Gastone della Torre, patriarch of Aquileia, who had died in Florence in August 1318. Once again, few fragments survive because the tomb was dismantled in 1566. From what remains it is clear that this tomb showed variations on the general theme of the Petroni monument. For instance, although the choice of scenes for the sarcophagus is similar, in these reliefs, in an attempt to create an allusion of space, the figures have been flattened out. Also, the topmost group of sculptures, showing the deceased being presented to the Virgin and Child, is here framed not by a small tabernacle but by a large baldachin, which makes the ensemble more architectonic. The Barucci family commissioned Gastone della Torre's tomb, so it is possible that Tino was chosen to produce a tomb for a member of this family in the Church of Santa Maria Maggiore (1319). Today, only fragments survive, which makes definite attribution difficult.

Tino's best-known work in Florence after his return to the city (probably about October 1320) was the tomb he created in the cathedral for Bishop Antonio d'Orso, who was buried there 18 July 1321. What remains in place is a base on consoles, a sarcophagus supported by lions, and, on top of the sarcophagus, a statue of the deceased, who is shown, uniquely, sitting down. It has been suggested that in addition to this structure, two angels within a canopy may have flanked a representation of Orso's soul ascending to heaven, with some kind of baldachin overarching the whole (see Kreytenberg, 1979). The iconographic program of this tomb, which concerns the triumph of Death (seen in the reliefs of the spandrels of the base), and the Last Judgment (the sarcophagus relief shows a deceased person being presented to Christ), was doubtless influenced by the writings of the poet and notary Francesco da Barberino, who was the executor of the bishop's will. Tino's last known works in Florence were three sculptural groups, including scenes from the life of John the Baptist, to adorn the three doorways of the baptistery. Tino presumably undertook further work in Florence, because several other marble fragments have come to light, including a figure of *Charity* and a figure in adoration, although their original locations are unknown.

Documented as living in Naples from May 1325, Tino probably arrived there in late 1323 or early 1324. Thereafter, he worked exclusively for the Angevin court. He produced a series of magnificent tombs, starting with one for Catherine of Austria, the first wife

of Charles of Calabria (*d.* 1323) in the Church of S. Lorenzo Maggiore. It is of interest because it is the first tomb for a woman that Tino produced; it is free-standing and supported by caryatid figures standing on the ground rather than by consoles fixed halfway up a wall. Mary of Hungary, the wife of Charles II, also died in 1323, and the tomb (finished in 1325) that Tino produced for her in the Church of Santa Maria Donnaregina shows the successful combination of many of the ideas with which he had been experimenting up to that point, namely a baldachin overarching a death chamber and relief sarcophagus, which is supported by caryatids and adorned at the pinnacle by sculptures of the deceased being presented to the Virgin Mary. The work came to influence the design of many later tombs, including two of his own, namely those of Charles, Duke of Calabria, and the duke's second wife, Mary of Valois, in the Church of S. Chiara, Naples. Although some scholars have dismissed Tino's Neapolitan work as lacking any signs of new creativity and being less refined than his earlier work (facial features, for instance, are frequently less defined), Tino was certainly creative in the way he combined in the decoration of his tomb's own Tuscan style with the esteemed *cosmati* (mosaic inlay of stone and/or glass) style of polychrome decoration. From official documents, it is clear that Tino was also employed by the Angevin rulers on various royal building projects, notably the construction—with Francesco de Vico—of the Certosa of S. Martino (1325–37), and the Castello di S. Elmo (from 1329), as well as the enlargement of both the arsenal (1334) and the harbor (1335).

SUSANNA AVERY-QUASH

See also **Pisano, Giovanni**

Biography

Born in Siena, Italy, *ca.* 1280. Son of the architect and sculptor Camaino di Crescentino, under whom he probably trained. In Pisa, 1297–1315; worked under Giovanni Pisano during the building of the Siena Cathedral; mentioned as Giovanni's successor as *capomaestro* (chief architect) of the Cathedral of Pisa, February 1315; in Siena as a *capomaestro* for the Cathedral of Siena, 1315, and in Florence, 1318–19 and 1320–23/24; from 1323/24 in Naples, in the service of King Robert, and later employed by the Angevin court. Died in Naples, Italy, 1337.

Selected Works

1298– 1301	*Three Magi*; marble; Church of S. Andrea, Pistoia, Italy
1301–6	Altarpiece and tomb of St. Ranierus for the Cathedral of Pisa; marble; Museo dell'Opera del Duomo, Pisa, Italy
1312	Font for the Cathedral of Pisa; marble; Museo Nazionale di S. Matteo, Pisa, Italy
1315	Tomb of Emperor Henry VII; marble (dismantled): statues of emperor and six councilors, Museo dell'Opera del Duomo, Pisa, Italy
1315–17	Tomb of Cardinal Riccardo Petroni; marble; Cathedral of Siena, Siena, Italy
1318–19	Tomb of Gastone della Torre; marble (dismantled): fragments in Museo dell'Opera di S. Croce, Florence, Italy; Museo Nazionale del Bargello, Florence, Italy; Palazzo Vecchio, Florence, Italy; Liebieghaus, Frankfurt, Germany
1320–21	Tomb of Bishop Antonio d'Orso; marble; Cathedral of Florence, Italy
1321	*Charity*; marble; Museo Bardini, Florence, Italy
1322–23	Life-size statues for three portals of the baptistery in Florence; marble: heads of *Christ, St. John the Baptist*, and two *Virtues*, Museo dell'Opera del Duomo, Florence, Italy
1324–25	Tomb of Catherine of Austria; marble; Church of S. Lorenzo Maggiore, Naples, Italy
1325–26	Tomb of Mary of Hungary; marble; Church of Santa Maria Donnaregina, Naples, Italy
1329	Tomb of Maria of Anjou; marble; Church of S. Chiara, Naples, Italy
1332–33	Tomb of Charles of Calabria; marble; Church of S. Chiara, Naples, Italy
1333	Tomb of Mary of Valois; marble; Church of S. Chiara, Naples, Italy
1335–37	Tomb of Giovanni of Durazzo; marble; Church of S. Domenico Maggiore, Naples, Italy
1335–37	Tomb of Philip of Taranto; marble; Church of S. Domenico Maggiore, Naples, Italy

Further Reading

Carli, Enzo, "Giovanni Pisano e Tino di Camaino," in *Il Museo dell'opera del Duomo a Pisa*, edited by Guglielmo De Angelis d'Ossat, Milan: Silvana, 1986

Dan, Naoki, *La tomba di Arrigo VII di Tino di Camaino e il rinascimento*, Florence: Pan Arte, 1983

Kreytenberg, Gert, "Tino di Camainos Grabmäler in Florenz," *Städel-Jahrbuch* 7 (1979)

Kreytenberg, Gert, "Fragments of an Altar of St. Bartholomew by Tino di Camaino in Pisa Cathedral," *The Burlington Magazine* 124/951 (June 1982)

Kreytenberg, Gert, "Das Grabmal von Kaiser Heinrich VII. in Pisa," *Mitteilungen des Kunsthistorischen Institutes in Florenz* 28 (1984)

Kreytenberg, Gert, editor, *Tino di Camaino*, Florence: Museo Nazionale del Bargello, 1986

Kreytenberg, Gert, *Die Werke von Tino di Camaino*, Frankfurt: Liebighaus, 1987

Previtali, G., "Un'arca del 1272 ed il sepolcro di Bruno Beccuti in Santa Maria Maggiore di Firenze, opera di Tino di Camaino," in *Studi di storia dell'arte in onore di Valerio Mariani*, Naples: Libreria Scientifica Editrice, 1971

Valentiner, Wilhelm Reinholt, *Tino di Camaino: A Sienese Sculptor of the Fourteenth Century*, Paris: The Pegasus Press, 1935

Valentiner, Wilhelm Reinholt, "Tino di Camaino in Florence," *Art Quarterly* (Detroit) 17 (1954)

TOMB OF MARY OF HUNGARY

Tino di Camaino (ca. 1280–1337
1325–1326
marble
Church of Santa Maria Donnaregina, Naples, Italy

The tomb of Mary of Hungary, which Tino di Camaino produced in 1325–26 for the Franciscan Church of Santa Maria Donnaregina, Naples, is arguably his most important work. Certainly his most characteristic, the tomb was produced for the French Angevin rulers of Naples, who became Tino's most important patrons. The Angevin rulers were determined from the foundation of their dynasty in 1266 to transform Naples into a splendid cultural and artistic capital city for their kingdom of Sicily. Consequently, many new buildings, including churches, were erected and embellished by leading French and Italian artists and sculptors, including Giotto, Pietro Lorenzetti, Simone Martini, and Tino. Mary of Hungary, wife of Charles II, had paid for the rebuilding of the Church of Santa Maria Donnaregina (1307–20), and after her death in 1323, Tino was commissioned to produce a tomb for her, in collaboration with the Neapolitan architect Gagliardo Primario. Tino also provided several other tombs for the Franciscan Church of Santa Chiara, which Sancha of Mallorca, Mary's daughter-in-law, had had rebuilt (1310–28). This church became the necropolis of the royal family.

No other trecento sculptor received so many significant commissions in the field of funerary monuments or developed a similar range of innovative ideas concerning their structure. Tino produced at least a dozen tombs in Pisa, Siena, Florence, and Naples, whereas his noted predecessors and contemporaries produced far fewer: Giovanni Pisano created one for Queen Margaret of Luxembourg (d. 1311) in San Francesco di Castelletto, Genoa; Nicola Pisano sculpted the shrine of St. Dominic for San Domenico, Bologna; and Nicola's pupil, Arnolfo di Cambio, was involved with just a handful of tombs, albeit influential ones, notably that for Cardinal Guillaume de Braye in San Domenico, Orvieto (1282).

The tomb of Mary of Hungary is particularly significant because it brought together for the first time several important funerary motifs that Tino had started to popularize in his earlier funerary monuments (although not originally devised by him) and which afterward became part of the standard vocabulary for this type of sculpture.

In many ways the main part of the tomb structure, excluding the baldachin, recalls the one that Tino had created for his tomb of Cardinal Riccardo Petroni the Siena Cathedral of Siena (1315–17). Being developed further and being a more prestigious commission, however, the design of Mary of Hungary's tomb had far greater influence on later tomb art. Certainly the central component of the tomb—the recumbent effigy of the deceased lying in a tomb chamber, with two angels holding back the curtains—recalls the Petroni monument. These elements ultimately derive from earlier tombs by Pietro di Oderisio, such as the tomb of Pope Clement IV (1268) in S. Francesco, Viterbo (which is the first time a recumbent effigy was used in medieval Italian art), and the tomb of Cardinal Guillaume de Braye by Arnolfo (which also shows curtain-bearing angels). Whereas Arnolfo did not put figures inside the tomb chamber, however, Tino placed there the figures of two acolytes.

In the tomb of Mary of Hungary, Tino set the main structure under an overarching baldachin. Although this combination would become a trademark of his, he had not always made use of a baldachin; for instance, he had not done so in the Petroni monument. Possibly he was following the design of Pietro di Oderisio's tomb of Pope Clement IV and that of the prefect Pietro di Vico (d. 1268), both in San Francesco, Viterbo. Also, Tino may have been induced to construct a baldachin on this occasion because he had the help of the architect Gagliardo Primario. Certainly the canopy makes the ensemble architectonic and impressive.

The idea of having a relief sarcophagus borne by caryatids was also popularized by Tino. Load-bearing figures appeared only rarely in earlier Italian art, such as in Giovanni Pisano's tomb of Margaret of Luxembourg. It was on the Petroni monument that Tino first employed caryatid figures himself; he used them again on the tomb of Gastone della Torre in the Church of S. Croce, Florence. In the tomb of Mary of Hungary, however, the caryatids have been transformed into winged Virtues, recognizable through the traditional attributes they hold. Tino had employed figures of the theological virtues once before in his tomb of Catherine of Austria in San Lorenzo Maggiore and was to do so again, in his tomb of Maria of Valois in S. Chiara. Also quite unusual in earlier Italian tomb art, although

Tino di Camaino, Saints and Kings from the Tomb of Mary of Hungary
© Mimmo Jodice © CORBIS

show themselves to be simpler versions of the tomb of Mary of Hungary, with minor variations.

Additionally, Tino's tomb of Mary of Hungary acted as a starting point and model for an enormous number of tombs by other artists in Italy, especially in southern Italy, who copied the combination of sarcophagus supported on consoles, a death chamber surmounted by a tabernacle, and a baldachin covering the whole. Although Tino's formal vocabulary can be seen, for instance, in Giovanni di Balduccio's tomb of Guarniero degli Antelminelli in San Francesco, Sarzana (*ca.* 1327–28), the sculptors who were most influenced by it (although never entirely losing their more inflexible Florentine characteristics) were probably Giovanni and Pacio da Firenze. The former is recorded as having helped Tino build the monastery of San Martino, Naples; the double tomb of Robert the Wise (1343) in S. Chiara, Naples, on which Giovanni and Pacio collaborated, strongly recalls Tino's work.

SUSANNA AVERY-QUASH

Further Reading

Bauch, Kurt, *Das mittelalterliche Grabbild: Figürliche Grabmäler des 11. bis 15. Jahrhunderts in Europa*, Berlin and New York: de Gruyter, 1976
De Castris, Leone Pierluigi, *Arte di corte nella Napoli angioina*, Florence: Cantini, 1986
Morisani, Ottavio, *Tino di Camaino a Napoli*, Naples: Libreria Scientifica Editrice, 1945
Venturi, A., *Storia dell'arte italiana*, 11 vols., Milan: Hoepli, 1901–40; reprint, Nendeln, Liechtenstein: Kraus Reprint, 1967; see especially vol. 4, *La scultura del Trecento e le sue origini*, 1906; reprint, 1967

TOMB SCULPTURE

This historic survey of tomb sculpture begins with ancient Egypt and terminates in the late 19th century. Within each period, subdivisions based on taxonomic methodologies shaped by that era have been established in order to provide an organized system for straightforward reference—a departure from the lines of inquiry used by authors cited in the bibliography.

For ancient Egypt, monuments are grouped into three major categories. The first consists of tomb statues of the deceased employed as *ka* receptors. These works served as a kind of alter ego for the interred individual. If any mistake occurred in the mummification process that resulted in the decay of the body, the *ka*—or invisible life force—would then be able to enter its recognizable, three-dimensional counterpart. Because mummification was practiced throughout pharaonic Egypt's lengthy duration, the abundance of examples in this genre is not surprising. During the Old Kingdom, these figures were deposited in special

characteristic of Tino's work, was the placing of statuettes at the pinnacle of the tomb, showing the deceased being presented by angels to the Virgin and Child. This idea had been used by Tino first in his Gastone della Torre monument. In his tomb of St. Ranierus for the Cathedral of Pisa, the two donors are presented by saints.

In addition to the innovative combination of structural forms that Tino pioneered in the tomb of Mary of Hungary, he exploited the decorative effects of polychrome marble and mosaic inlay. Previously he had emphasized polychromy in his sculptures by using other materials. He employed colored paint and gilding, traces of which are still visible in the faces and draperies of some of his statues, such as the Turin *Madonna and Child*, as well as different-colored marble, for instance, on the bier of the Petroni monument. Being sensitive to his new artistic context, where the Roman Cosmati style of decoration was in vogue, Tino used it in his work in Naples, on his tomb of Catherine of Austria and later on other Angevin funerary monuments. No other trecento sculptor employed color to the extent that Tino did, or to such good effect to enhance the overall decorative quality and aesthetic effect of richness of his monuments.

Tino's combination of certain funerary motifs with abstract decoration proved very popular with the Angevin court, whose leaders consequently gave Tino other commissions. Many of Tino's later Neapolitan tombs do not survive, but those of Charles of Calabria and of his wife, Mary of Valois, in S. Chiara do, and they

chambers called *serdab*s. One of the earliest surviving *serdab*s was made for the pharaoh Djoser and dates to about 2680 BCE (Egyptian Museum, Cairo). It was found in the necropolis built by the royal architect Imhotep at Saqqara behind a *serdab* wall outfitted with two small holes that enabled whomever brought offerings to the deceased king to interact vicariously with the statue. The enthroned, life-size, painted limestone object displays the image of a powerful ruler whose stern, imposing visage still prevails despite the object's aged and damaged condition. A later, New Kingdom example represents the pharaoh Hatshepsut (*ca.* 1470 BCE; Metropolitan Museum of Art, New York City), one of only a few women throughout the course of ancient Egypt's history who ruled alone. This seated figure was probably situated on the upper terrace in the room for cult offerings of her mortuary temple at Deir el-Bahari.

The second category of tomb sculpture consists of cuboid or block statues, which were also carved in the round. Cuboid statues—designated as such because the figure appears in a squatting position with only the head and extremities visibly protruding from the block of stone—developed during the Middle Kingdom. Two examples from about 1975 BCE (Egyptian Museum) belonged to Hetep, a court official who lived during the 12th Dynasty. They were discovered in adjacent chambers of his tomb; both were oriented toward the east, the horizon of the rising sun, thus implying the concept of resurrection and the desire to accompany the sun god, Amun-Re, on his diurnal and nocturnal sojourns. In fact, inscriptions on the granite figure invoke daytime activities, whereas those on the limestone refer to nightly deeds. Cuboid statues remained part of sepulchral practice well into the Late Period.

A third major group includes funerary stelae—painted low-relief objects often of a formulaic nature. Designed to ensure a blissful, eternal afterlife, these polychrome artifacts always contain hieroglyphs that name the deceased and offer prayers and nourishment to sustain him or her. In addition, pertinent visual information, such as the tomb dweller or dwellers and a table laden with various and abundant foodstuffs, are depicted. The slab stela of Iunu, dated about 2590 BCE (Pelizaeus-Museum, Hildesheim, Germany), and that of Amenemhat of about 1980 BCE (Egyptian Museum) demonstrate the prevalence of this talismanic stela. There are legions of other three-dimensional objects enclosed within the tombs of ancient Egyptians—*ushabtis* (small servant figures included to carry out any work for the deceased) and family groupings, furniture and jewelry, and others.

Both freestanding statues and stelae form part of the tradition of funerary sculpture in ancient Greece, although with markedly different characteristics and locations than those of Egypt. The kouros, or standing male nude, is the common type. The grave plot upon which the kouros was erected designates an individual who was considered a hero either in military escapades or in athletic competitions. One such monument, executed in marble, is the kouros (*ca.* 525 BCE) from Anavysos (National Archaeological Museum, Athens Greece). The inscription identifies the individual buried beneath it as Kroisos, a soldier slain in battle.

Grave stelae are more common because they were more affordable. As such, they display a remarkable range of imagery—for example, the stela of Xanthippos of the mid 5th century BCE (British Museum, London, England). The relief shows the seated figure of a bearded, mature man dressed in a loose-fitting toga accompanied by his two small daughters. He contemplates a cobbler's last that serves to identify his trade. On another monument, that of Damaistrata (National Archaeological Museum), four figures are represented: a seated woman, in all likelihood Damaistrata herself, who holds the hand of an elderly man standing before her, presumably her father; behind Damaistrata's chair appear two other women who complete the family group. The subject of this early 4th century BCE stela is somewhat ambiguous in that all three women direct their gazes at the man. Is it he who bids farewell to his relatives? This would appear to be the case.

The third category of tomb sculpture in ancient Greece is found at architectural sites known as tower tombs. The most celebrated example, which exists now only in fragments, is the tomb of Mausolus and Artemisia at Halicarnassus (Asia Minor), which was completed about 351 BCE (British Museum). At the top a quadriga was installed; freestanding figures were placed in the interstices of the peristery (a row of columns that stood around the perimeter of the structure). There were also three friezes depicting an *amazonomachy* (battle between Greeks and a race of female warriors), a *centauromachy* (battle between centaurs and Lapiths, a tribe of northern Thessaly), and a chariot race. The names of the sculptors who worked on this monument are even known: Skopas, Leochares, Bryaxis, and Pytheos. The fame of this structure begat the term *mausoleum*, which became a synonym for large-scale tombs that is used even to this day.

For the Etruscans, two genres of tomb sculpture can be identified: the cinerary urn and the sarcophagus. The haunting, human-headed terracotta urn of about 675–650 BCE (Museo Etrusco, Chiusi, Italy) is an example of the former; an example of the latter is the delightfully charming sarcophagus from Cerveteri of about 525 BCE (Museo Nazionale di Villa Giulia, Rome Italy) showing a fully three-dimensional vivacious

husband and wife reclining on a couch, smiling, and gesticulating into space.

In the ancient Roman Empire, four major classifications that contain tomb sculpture are distinguished: the architectural mausoleum, the *cippus* (sepulchral altar), the tombstone, and the sarcophagus.

A late republican period mausoleum, that of Marceius Vergileus Eurysaces (Porta Maggiore, Rome), has a frieze showing various stages in the bread-making process, from sorting grain to placing loaves in an oven. An inscription on the tomb identifies the deceased as a master baker, providing an explanation for the activities depicted. One example from the imperial period is the richly carved mausoleum of the Haterii of the late 1st century CE (Museo Gregoriano Profano, Vatican City, Italy). On it are carved a number of scenes: the *conclamatio*, or mourning, over the formally laid-out body of the matriarch of the family, the Roman street where the funeral cortege passed, and the construction of the tomb itself.

Another type of ancient Roman tomb sculpture was the *cippus*. The 1st century CE *cippus* of L. Volusius Heracla (Lateran Museum, Rome, Italy) displays a veritable zoo of animal imagery: swans, serpents, rams, eagles, and butterflies are sculpted amid festoons of laurel leaves and vases.

In the realm of tombstones or stelae, mention can be made of those of Lucius Ampudius Philomosus and his wife and daughter (British Museum), and that of Gaius Julius Helius (Palazzo dei Conservatori, Rome), which illustrate the usual features of a bust-length portrait of the deceased either singly or in a family group, along with identifying inscriptions. Both date to the 1st century CE.

The most typical ancient Roman funerary sculptures was the sarcophagus. The *Seasons Sarcophagus* of about 220–230 CE (Metropolitan Museum of Art, New York City) depicts a bacchanalian theme, and the *Ludovisi Battle Sarcophagus* of about 250 CE (Museo Nazionale Romano, Palazzo Altemps, Rome, Italy) exhibits a densely populated and vigorously carved war waged between the Roman army and unspecified barbarian adversaries.

Examples from the Middle Ages can be divided into six units. The first is the sarcophagus with narrative reliefs found from the early Christian through Gothic periods. The sarcophagus of Junius Bassus (359 CE; St. Peter's Basilica, Museo Petriano, Rome) displays in two registers a number of Old and New Testament scenes, some of which emphasize the theme of salvation, tantamount to the assurance of entry into heaven. The Merovingian sarcophagus of St. Agilbert (*d.* 672), preserved in the crypt of St.-Paul at Jouarre, bears an image of Christ in majesty surrounded by standing figures lifting their arms in gestures of acclamation or ecstasy. The sarcophagus of Doña Blanca (*d.* 1156) is extensively carved on the surfaces of both the coffin and its lid with a variety of scenes including, among others, the death of the queen in childbirth and the lament by her husband (Santa María la Real, Nájera, Spain). The *Arca di San Domenico*, a coffin containing the body of the Dominican order's founding father (S. Domenico, Chapel of St. Dominic, Bologna), was designed by Nicola Pisano about 1265, although sculptural embellishment extended into the 16th century. Besides reliefs of episodes from the life of St. Dominic, the *Arca* is decorated with garland motifs and free-standing statuary. Finally, the tomb of Rolandino dei Passageri (Piazza S. Domenico, Bologna), a university professor who died in 1300, shows a relief of the entombed addressing a lecture class.

In the category of tomb slabs and effigies, the observed tendencies exhibit a chronological progression from low to high relief and a change from a standing to a recumbent image. This type actually makes its debut rather late in the Medieval period. The bronze, low-relief tomb slab of Rudolf of Swabia (*d.* 1080) sets the standard. Installed on the floor of the Cathedral of Meersburg in Germany, it honors the deceased who is buried below. Rudolf appears as a standing figure holding the attributes of kingship: a scepter and an orb. More than a century later the tomb slab evolved into a more robustly sculptural object, as seen in the one executed for Bishop Evrard de Fouilloi (*d.* 1220) at the Cathedral of Amiens in France. The image of the prelate, dressed in garments appropriate for his ecclesiastical station and accompanied by acolytes and censing angels, stylistically resembles the jamb statues on the exterior of this High Gothic edifice. The effigy, more properly speaking, is a transposition of the sculptural form of the deceased onto a coffin. Arnolfo di Cambio's tomb of Pope Honorius IV (S. Maria in Aracoeli, Rome) of the late 13th century shows the defunct in full papal regalia as if lying in state with his head resting on two elaborately carved cushions. A most unusual effigy of an unknown English knight dating about 1295–1305 in Dorchester (Oxfordshire) exhibits an energetic pose, with legs crossed and an arm about to draw his sword from its scabbard.

A third medieval group consists of royal burials, wherein both single and double recumbent effigies are found. The effigies, also termed *gisants* (reclining figures), of Henry II Plantagenet, king of England (*d.* 1189), and his wife, Queen Eleanor of Aquitaine (*d.* 1204), lie side by side amid other Plantagenet tombs at Fontevrault Abbey in France. Henry is shown grasping a scepter, whereas Eleanor reads from a small prayer book. Other notable royal couples represented together include Duke Henry the Lion and Duchess Matilda at Brunswick Cathedral (*ca.* 1240) in stone,

and King Henry III of England and Queen Eleanor of Castile (Westminster Abbey, London), which was made by the goldsmith William Torel in gilt bronze in the early 1290s. The *Monument to Dagobert*, an early Merovingian king, was actually erected by Louis IX in the 13th century at the royal abbey of St.-Denis just outside Paris. It combines a single *gisant*, at the lower portion of the tomb, with narrative reliefs on the wall above it that display scenes from his life. Queen Nanthilde, his wife, and their son Clovis stand on either side of the monument. Above them rises an arch, inside of which are carvings of angels; beneath the arch appears the soul of the king as a naked child rising to heaven. Finally, one of the most innovative of single-effigy monuments belongs to Margaret of Brabant, who died in 1311. Carved by Giovanni Pisano, it originally showed her actively rising from her tomb, a motif not encountered again until the Baroque era. Today it exists in a severely damaged state (Sant' Agostino, Museo di Architettura e Scultura Ligure, Genoa, Italy).

Tombs decorated with funeral ceremonies comprise the fourth category of medieval monuments under consideration. Sometimes referred to by the French term, *tombeaux de grande cérémonie*, the type consists of one or more parts of a five-part iconographic scheme: an effigy of the deceased, the elevation of the soul, the image of Christ, a priest performing funerary rites, and secular mourners. One elaborate example, the tomb of Presbyter Bruno (*d.* 1194) at Hildesheim Cathedral, contains most of the qualifying elements. The tomb of Louis de France of about 1260 (St.-Denis, abbey church, near Paris) includes a *gisant* of the eldest son of Louis IX recumbent with hands folded in prayer and a relief of his funeral cortege on the four sides of the sarcophagus. In a number of Spanish Gothic examples, although the effigy lying atop the sarcophagus is the largest sculpted element, the carving of the funeral is given emphasis by the sheer number of figures and wealth of detail. Clerics and acolytes robed in a variety of ecclesiastical garments that specify their roles in the solemn ritual carry their appropriate liturgical implements such as books, censers, and *situlas* (holy water buckets). Family members, friends, mourners, knights, and subordinates from the estates of the deceased are also represented in all manners of dress as befits their class. These elaborate scenes often appear around the sides of the coffin, as in the tomb of Doña Elena (*ca.* 1270) at the Cathedral of Salamanca, Spain, but are even more prominently displayed on the rear wall above the effigy, as in the tomb of Ermengol VII, Count of Urgel, dated mid 14th century (Metropolitan Museum of Art New York City).

A fifth category features arcosolia, or canopied wall structures that display an effigy of the deceased reposing on a bier, which in turn is placed on a sarcophagus.

An angel standing at the head and another at the feet lift back a curtain to reveal the body lying in state. An image of the enthroned Madonna and child in either painted or sculpted form generally surmounts this entire affair. These tombs may also include any number of saints on this upper register, such as examples from the Late Gothic period in Italy: Arnolfo di Cambio's tomb of Cardinal Guillaume de Braye (*d.* 1282) at the Church of S. Domenico at Orvieto and Tino di Camaino's tomb of Cardinal Richard Petroni (*d.* 1314) in the Duomo at Siena.

A final group of medieval tomb sculpture highlights the equestrian monument, also popular in Italy and also dating to the late Gothic era. This was especially fashionable with the Veronese ruling family of Scaligers; all were erected at the Church of Santa Maria Antica in Verona, Italy. The earliest belongs to Cangrande della Scala of 1335, followed by that of Mastino II, which was designed by Perrino da Milano in 1355. The last and most sumptuous was executed for Can Signorio della Scala by Bonino da Campione in 1365. The formula for this type often includes a sarcophagus with an effigy of the deceased, narrative panels of his life, and, surmounting the entire arrangement, the signature piece of sculpture, the ruler on horseback.

For the Renaissance era, five distinct types can be charted; three are grouped by social class and two by genre. In the first are tombs of high-ranking ecclesiastics such as that of Jacopo, cardinal of Portugal, which is dated 1460–62 and carved by Antonio Rossellino (S. Miniato al Monte, Florence, Italy). Set into a wall niche, it displays the prelate recumbent on a bier set upon a sarcophagus. Above him, two angels kneel, and on the wall above them is a wreathed roundel inside of which is a bust-length image of the Virgin and Child. The entire arrangement stands on a richly carved base. The bronze tomb of Pope Sixtus IV by Antonio Pollaiuolo (1484–93; Vatican Grottoes, Rome) takes the shape of a truncated pyramid with the effigy, his papal coat of arms, an inscription plaque, and personifications of the Seven Cardinal Virtues on the upper surface. The concave slopes on the side of his tomb display additional personifications, including the Seven Liberal Arts, Philosophy, Theology, and Perspective. Michelangelo's design for the tomb of Pope Julius II (S. Pietro in Vincoli, Rome) shows influences of both Pollaiuolo's project and Roman sarcophagi. Commissioned in 1505, it was not completed until some 40 years later, and in that time, it underwent distinct transformations from the original plan.

Sculptors of several aristocratic tombs in northern Europe altered the medieval representation of funerals by isolating the somber mourning figures and carving them more fully in the round. Claus Sluter's tomb for Philip the Bold, Duke of Burgundy (1391–1406;

Musée des Beaux-Arts, Dijon, France), originally contained 40 alabaster mourners, or *pleurants*, the often-used French designation. Those for Isabella of Bourbon, dated 1476, comprise a veritable portrait gallery of her relatives. Like the tomb of Philip the Bold, it survives in a fragmented condition with the effigy at the Cathedral of Antwerp, Belgium, and ten of the *pleurants* at the Rijksmuseum in Amsterdam, the Netherlands. The monument to Philippe Pot, *grand seneschal* of Burgundy (*ca.* 1480; Musée du Louvre, Paris, France) is the supreme example of this type. Eight hooded, freestanding pallbearers dressed in black mourning attire, their heads bowed in grief, bear on their shoulders the lid of the tomb upon which the *gisant* lies. Italian examples, such as those for the Dukes Giuliano de' Medici (*d.* 1478) and his brother Lorenzo de' Medici (*d.* 1492) executed by Michelangelo (Medici Chapel, Florence), are less funereal and instead reflect the fusion of Christian beliefs with Neoplatonic thought. Each of the rulers is seated in his own wall niche separated from his sarcophagus below. Reclining on Giuliano's coffin are representations of Day and Night, whereas Lorenzo's displays Twilight and Dawn.

Tombs of the less exalted in status form a third category, although this designation should in no way suggest that their places of eternal rest are less impressive. The tomb of Ilaria del Carretto (*d.* 1406) by Jacopo della Quercia at Lucca Cathedral, Italy, exudes a quiet dignity. The effigy of the splendidly attired woman lies with her eyes closed and hands folded on her stomach. Bernardo Rossellino's *Monument of Leonardo Bruni* of about 1445 (S. Croce, Florence) displays the humanist scholar and chancellor lying on his coffin holding a large volume on his chest, presumably his own *History of Florence.* Angels carved in low relief on the sarcophagus display an inscribed tablet, and in a tympanum above, adoring angels flank a roundel of the Virgin holding the Christ Child. The entire ensemble is installed in a niche framed by Corinthian pilasters and an arch that contains lush ornamental motifs. Crowning the whole are a pair of angels carrying a shield with a lion rampant, symbol of the Florentine Republic. A Spanish example in the Capilla de S. Catalina of the Cathedral of Sigüenza, Spain, the tomb of Don Martín Vázquez de Arce (a knight of the Order of Santiago), shows the deceased very much alive propped up on his coffin, absorbed in reading, posed with his legs crossed.

Among the most fascinating of all sculpted tombs, Renaissance or otherwise, is the category known as the *transis*. These monuments began to appear in the late 14th century and achieved their height in the 15th and 16th centuries. *Transi* tombs consist of two representations of the deceased: the effigy or *gisant* carved

in the upper part of the sepulchral structure and the *transi*, or incipiently decomposing cadaver, below. One of the earliest instances actually shows the *transi* alone, lying on his pall, and accompanied by life-size statues of his family members standing behind him. This is the gruesome tomb of François I de la Sarra executed in the last decade of the 14th century (La Sarraz, Switzerland). It displays the nude corpse with frogs on his face and genitalia and with long worms slithering in and out of holes in his body. What prompted the use of such horrific imagery? The answer may be found in other *transi* tombs, such as that of Cardinal Jean de Lagrange (*d.* 1401), whose fragmented tomb may be found at Avignon's Musée Calvet, or that of Henry Chichele, archbishop of Canterbury (*d.* 1443), buried at his episcopal see. Both monuments literally and visually refer to the transience of life and the putrefaction of flesh after death, not only through the inscriptions they bear but also in the appearance of the supine effigy atop the coffin and the rotting corpse below. The *transi* tomb may thus be considered a *memento mori*, or a reminder of mortality, as well as a display of humility and the abnegation of one's mortal remains. This type of tomb was sought out by the governess of the Netherlands, Margaret of Austria, for herself and her already deceased husband, Philibert le Beau (*d.* 1504), for their funeral chapel at Brou, where she engaged her favorite sculptor, Conrad Meit, to begin work in 1526. The separate *transi* he produced remain some of the most striking in this genre. They barely show the effects of bodily decomposition; instead, they move us by subtle changes such as sagging lips and the excessive growth of hair. In addition to the singly represented *transi*, there is also a group of monuments for royal French couples, all installed at St.-Denis, shown in similar guise. These are, to say the least, quite extravagant. The earliest, completed in 1535 for Louis XII and Anne de Bretagne, shows the king and queen fully carved in three dimensions kneeling at a prie-dieu. The sculptors, Antonio and Giovanni Giusti, repeated the image of the pair on the lower level, this time, however, as recumbent, nude bodies radiating a classical beauty. Although the viewer is spared the macabre element of putrefaction, their torsos reveal embalmers' incisions and sutures. In addition to the royal couple, the tomb is equipped with personifications of the Four Cardinal Virtues seated at the four corners of its base, small statues of the Twelve Apostles, and four bas-reliefs depicting military episodes from the king's life. Primaticcio and Germain Pilon made the grand finale of regal *transi* tombs between 1560 and 1570 for Henry II and Catherine de' Medici (St.-Denis). Through its magnitude and three-dimensional embellishments, it is as much architectural as it is sculptural.

Epitaphs represent the fifth category of Renaissance tomb sculpture. These are individually commissioned relief panels that reflect the deceased's personal taste. For instance, the *Epitaph of Jean Fiévez* (*d.* 1425) displays his funeral service, which itself is modeled on iconographic prototypes for the vigils of the dead in contemporary manuscript painting (Musées Royaux des Beaux-Arts de Belgique, Brussels). The *Epitaph of Jean du Bos and Catherine Bernard* (*ca.* 1440) at the Cathedral of Tournai, Belgium, shows the couple kneeling before the enthroned Virgin and Child; they are accompanied by their respective patron saints standing behind them.

For the Baroque and Rococo eras, tomb sculpture can be grouped by artist. The quintessential master, Gianlorenzo Bernini, received two very important papal commissions, both of which were installed at St. Peter's Basilica in Rome. The first, for Urban VIII, was begun in 1628 and completed in 1647 and consists of a gilt bronze statue of the enthroned pope gesturing emphatically. The nearly freestanding figures of the Virtues carved in marble invigilate over the sarcophagus at either end. Making his debut between the volutes of the coffin is the skeleton of Death. He inscribes the pontiff's name in the large Book of Life, which he holds. The second project, executed in colored marble and gilt bronze, was made for Alexander VII between 1671 and 1678. Here, the kneeling pontiff at the summit of the tomb is attended by Truth, Charity, Justice, and Prudence; Death, holding his signature hourglass, is pivotally installed at the entrance door to the tomb itself. Other tomb sculptures that Bernini designed are the *Epitaph of Suor Maria Raggi* (1643; S. Maria sopra Minerva, Rome) and the tomb of Blessed Lodovica Albertoni (1672–74; S. Francesco a Ripa, Rome). The first depicts a portrait medallion of the deceased at the point of death carved on a colored marble tablet that resembles a billowing cloth. The second shows the defunct at the same crucial moment; this time, however, the entire body is represented in a state that can only be described as violently ecstatic, if not erotically convulsive. Charles Le Brun and Jean-Baptiste Tuby, the artists responsible for the tomb of Julienne Le Bé (*d.* 1668), also injected a theatrical tone into their work by showing the defunct half-risen from her coffin with her hands folded in prayer. An angel soaring above her beckons the woman to follow him to heaven. The similarity between this monument and Pisano's monument for Margaret of Brabant of the late Medieval period is striking.

Several 18th-century examples are decidedly more secular in content. That of the astronomer and physicist Galileo, carved by Giovanni Foggini between 1732 and 1737 (S. Croce), celebrates his achievements by depicting him gazing up to the sky in the company of personifications of Geometry and Astronomy. Louis-François Roubiliac's tomb of Lady Elizabeth Nightingale (1761; Westminster Abbey) is a metaphorical depiction of the manner in which the deceased met her end. The animated, shrouded figure of Death thrusts an arrow at the woman vainly being protected by her husband; Lady Nightingale was struck by lightning. A final example is not without a trace of humor for what it commemorates. This is Clodion's terracotta tomb for Ninette (Musée Historique Lorrain, Nancy, France). As befitting the burial of a pet dog, the sculpture is populated exclusively with canine motifs. Surmounting the monument is a draped urn with the dead animal reclining beneath it as if asleep. The tombstone itself shows two dogs standing on their hind legs, much like caryatids, holding a pair of funerary torches in their rear paws.

Nineteenth-century tomb sculpture has been divided into stylistic classifications beginning with Neoclassicism. In fact, the earliest manifestations of the movement began in the late 18th century. Antonio Canova received several prestigious commissions for tomb designs, which caused his reputation to rise meteorically. One tomb that he worked on between 1783 and 1787 was for Pope Clement XIV (SS. Apostoli, Rome). Severe restraint and timeless serenity have now replaced the emotional drama enacted by figures in Baroque papal tombs. The enthroned pontiff, situated above his sarcophagus, is here accompanied by the virtues of Temperance on the left, who leans on the coffin, and Humility sitting on a plinth with a lamb. Canova's other project, the tomb of the Archduchess Maria Cristina (1798–1805; Augustinerkirche, Vienna, Austria) is a veritable tableau of mourners who have come to pay tribute to the deceased. The five figures file in procession from left toward a doorway in the center of the pyramid, a symbol of life everlasting. A medallion held aloft by two flying genii near the apex contains a profile bust of the Archduchess. Canova's English counterpart, John Flaxman, was also responsible for a number of tomb projects, among which is his monument for Agnes Cromwell (Chichester Cathedral, England) and another for Lady Fitzharris (Christchurch Priory, Hampshire, England). The first, dated 1797–1800, has the appearance of a Greek stela. Its subject is the ethereal transportation by celestial spirits of the soul of the deceased, which has assumed the likeness of the body according to the mystic Swedenborgian concept. The second example, of 1816–17, is a freestanding sculpture that shows Lady Fitzharris reading to her three children, one of whom she cradles in her arms while the other two stand before her rapt in attention.

The other important trend manifested in early 19th-century art was Romanticism, here epitomized in two

stunning, but wildly different, works, themselves significant of the diversities of this movement. Matthew Cotes Wyatt's monument to the 5th Duchess of Rutland, unveiled in 1828, looms at 20 feet high (Belvoir Castle, Leicestershire, England). It is an apparition in white marble with a decidedly theatrical atmosphere enhanced by contrived lighting via stained glass windows. Framed by two Romanesque proscenium arches is a medieval-inspired coffin, out of which rises the elegant Duchess, resplendent in her long flowing garments. Awaiting her arrival in heaven are four cherubs, who represent the souls of her deceased children. Antoine Étex's tomb of the Raspail family of 1854 is a haunting elegy in marble. Erected in the famous Père Lachaise Cemetery in Paris, France, this unassuming mausoleum has a single, but eloquently conceived, statue adorning it: that of a mysterious and eerie female figure wrapped in a shroud. She reaches up to a window equipped with bars as if to implore the occupants of the tomb to admit her to their sepulchral chamber. However, she may also be interpreted as the embodiment of Grief or Remembrance, popular in both European and American cemeteries during the second half of the 19th century.

Among the sepulchral counterparts to the realist movement in painting, two works may be cited: Lorenzo Bartolini's tomb of Countess Zamoyska (1837–44; S. Croce) and Auguste Préault's 1866 grave monument for Philibert Rouvière (Cimetière de Montparnasse, Paris). The first, for an exiled Polish aristocrat, freely combines Italianate elements of Renaissance derivation with frank and stark details commonly associated with realism. Bartolini loosely appropriated Rossellino's roundel of the Madonna and child from the Bruni tomb at the same location, but he updated the monument to include an effigy of the countess lying on her deathbed dressed unceremoniously in a nightgown. Préault's tomb for the great French actor is a modest but sensitive portrait head juxtaposed with an overturned thespian mask.

A stylistic eclecticism reveals itself in fin de siècle tomb monuments. For instance, Giovanni Dupré's tomb of Fiorella Favard (1877; Villa Favard, Florence, Italy) exhibits a commingling of Italian Renaissance and Neoclassical elements. The life-size marble statuary consists of a young woman being assisted out of her coffin by an angel standing over her. Both figures wear flowing robes. This group is another interpretation of Emanuel Swedenborg's beliefs as discussed in relation to Flaxman's Cromwell monument.

Augustus Saint-Gaudens's *Adams Memorial* (1891) in Rock Creek Cemetery, Washington, D.C., owes as much to the Buddhist concept of nirvana as it does to the organic style of Art Nouveau. Commissioned by the author Henry Adams for his wife, Marion, it repre-sents a slightly over life-size woman swathed in heavy, sinuous drapery seated on a block of stone. Her eyes are closed in contemplation as she brings her right hand up toward her cheek. This bronze statue is a noble embodiment of late-19th-century symbolist thought. The memorial to the drowned young poet Percy Bysshe Shelley (*ca.* 1890, University College, Oxford) by Edward Onslow Ford displays a nude body lying on its side on an irregular surface that suggests a beach. This sits on a high base supported by a pair of winged lions. Daniel Chester French's *Martin Milmore Memorial* (1892; Forest Hills Cemetery, Boston, Massachusetts), subtitled *Death and the Sculptor*, is an over life-size tomb monument consisting of two figures carved in such high relief that they border on freestanding statuary. At left is the personification of Death in the guise of a winged, veiled woman. She is dressed in long, undulating drapery and reaches out with her left hand to halt the sculptor busily carving the relief of a Sphinx. Milmore is shown with his back to the viewer holding a mallet and chisel. The last example, Alfred Gilbert's tomb of the Duke of Clarence (1892–1928; Albert Memorial Chapel, Windsor, England) is a work in mixed media. The artist employed marble, bronze, ivory, and, for the first time on a large scale, aluminum. The tomb itself, an amalgamation of Gothic and Art Nouveau elements, represents the Duke dressed in military uniform with sword in hand poised as if for battle; he actually died of pneumonia. A large swirling cape encircles his body. Kneeling at his head is a large aluminum angel bowing toward the Duke and holding an intricately designed crown. Surrounding the base of the tomb is a highly ornamental bronze grille embellished with 12 statuettes of saints in ivory and bronze. The prominence given to tomb sculpture as a major form of three-dimensional art began to wane in the 20th century as sculptors pursued personal aesthetics and formal issues.

STEPHEN LAMIA

See also **Sarcophagus**

Further Reading

Binski, Paul, *Medieval Death: Ritual and Representation*, London: British Museum Press, 1996
Boase, T.S.R., *Death in the Middle Ages: Mortality, Judgment, and Remembrance*, London: Thames and Hudson, and New York: McGraw Hill, 1972
Cohen, Kathleen, *Metamorphosis of a Death Symbol: The Transi Tomb in the Late Middle Ages and the Renaissance*, Berkeley: University of California Press, 1973
Gardner, Julian, *The Tomb and the Tiara: Curial Tomb Sculpture in Rome and Avignon in the Later Middle Ages*, Oxford: Clarendon Press, and New York: Oxford University Press, 1992
Jacob, Henriette Eugénie, *Idealism and Realism: A Study of Sepulchral Symbolism*, Leiden, The Netherlands: Brill, 1954

Lamia, Stephen, "Funeral/Burial," in *Encyclopedia of Comparative Iconography: Themes Depicted in Works of Art*, edited by Helene E. Roberts, Chicago and London: Fitzroy Dearborn, 1998

Moskowitz, Anita Fiderer, *Nicola Pisano's Arca de San Domenico and Its Legacy*, University Park: Pennsylvania State University Press, 1994

Panofsky, Erwin, *Tomb Sculpture: Four Lectures on Its Changing Aspects from Ancient Egypt to Bernini*, edited by H.W. Janson, New York: Abrams, and London: Thames and Hudson, 1964

Toynbee, Jocelyn M., *Death and Burial in the Roman World*, London: Thames and Hudson, and Ithaca, New York: Cornell University Press, 1971

Tummers, H.A., *Early Secular Effigies in England: The Thirteenth Century*, Leiden: Brill, 1980

Valdez del Alamo, Elizabeth, and Carol S. Pendergast, editors, *Memory and the Medieval Tomb*, Aldershot, Hampshire: Ashgate, 2000

Whittick, Arnold, *History of Cemetery Sculpture*, London: Mineral, 1938

TOOLS

Sculptors' tools can be dated to the dawn of the Paleolithic period. Primitive tools made from bone or stone enabled prehistoric people to shape and control their environment by allowing them to make weapons and other functional objects. Their tools also empowered them to control their spiritual world through the creation of images and deities from stone and bone. Stone tools are the earliest evidence of human craftsmanship and civilization.

Paleolithic toolmakers collected stones from the earth's surface to make tools. In Europe and Africa they used flint; in Armenia, obsidian; and in Asia, where flint was rare, they used quartzite, fossilized wood, and other rocks. To make a tool, the artisan split the rock into shards and sharpened suitable pieces into a point or blade by flaking. A variety of simple stone tools suited for particular purposes emerged, including axes, adzes, knives, chisels, drills, and abrasive stones.

In the Neolithic period, mining for higher quality toolmaking material began, and more specialized stoneworking and mining tools were developed, such as antler and stone picks, stone hammers, and wooden and bone wedges. Over time stone tools were refined and improved: increasingly fine flaking and rubbing with sand made cutting edges sharper and also improved the shape of the tools. By the end of the Stone Age, the sculptor had a kit of basic—and astonishingly efficient—tools at his disposal, including gouges and bone rasps. Magnificent examples of sculptures in stone, wood, ivory, and other materials made in pre-Columbian America as well as precontact Australia and Oceania speak of the quality of the work that is possible using stone tools alone.

The introduction of copper, bronze, and, later, iron sped the development of specialized tools for particular materials and processes. Metal tools could be given any desired shape, allowing them to perform tasks that were impossible to do with stone ones. Metal was also superior to stone because it was less prone to breaking, even if it was worked into a sharp edge or a point, especially when the techniques of hardening improved. The new high-performance metal tools expanded the possibilities of fabrication and even facilitated the development of new art forms and styles. This phenomenon occurred wherever metal tools were introduced by trade or colonization. The introduction of metallurgy also required the development of a whole set of new tools for the hot and cold metalworking processes. Interestingly, one of the new processes, casting, required the involvement of the plastic materials: modeling in clay or wax.

The Middle Ages saw the creation of highly specialized tools for the emerging trades, such as carpentry, cabinetmaking, and woodcarving. In late medieval Europe, individual guilds not only claimed control of particular products but regarded the use of specific tools as their exclusive right. Incidents in which the guilds attempted to prevent sculptors from using certain tools are documented. The emancipation of the artist from the guilds in the Renaissance ended such disputes.

With the arrival of machines in the age of industrialization came the distinction between tools and equipment. Although the difference between tools and equipment remains vague, the term "tool" is generally used for portable implements, whereas equipment is regarded as stationary, even though a piece of equipment such as the table saw may have evolved from a hand tool. In the 20th century, power tools entered the artist's studio to assume their place beside the hand tools. Powered by compressed air (pneumatic tools) or by electricity, these tools minimize physical effort and save time. Power tools make slicing, cutting, or carving so easy that the fabrication of sculpture can be, to a degree, divorced from craftsmanship. It remains unclear if the phenomenon that 20th-century Western sculpture largely disregards craftsmanship and emphasizes formal and conceptual concerns may, perhaps, be explained by the introduction of power tools.

For modeling in clay, sculptors need two basic tools: wires for cutting and spatulas for pressing. Stone Age cutting tools most likely consisted of thin loops of reeds and knives made from bone or wood. Modern cutting tools are metal wires bent into an almost endless variety of shapes, which the sculptor can modify to suit his needs. Straight or curvilinear wooden or bone spatulas are used for pressing as well as cutting. Their shape may also be adapted to the sculptor's needs. Wire cutters and spatulas leave distinct mark-

ings on the clay. Throughout history sculptors attempted to conceal traces of tools. With the exception of Gianlorenzo Bernini, who made use of tool marks in his terracottas, only 19th- and 20th-century sculptors, beginning with Honoré Daumier, Auguste Rodin, and Henri Matisse, integrated such marks as expressive elements in their plastic work.

Stone tools such as picks, hammers, chisels, and drills were among the earliest implements. In spite of the crudeness of these tools, artists around the world have created sculptures of astonishing beauty and sophistication with them, as for example the pre-Columbian carvers of Central America. Except for improvements in hardening metal, stoneworking tools have remained virtually unchanged since antiquity. Excavations at Egyptian quarries have revealed stone hammers for splitting and dressing stone, as well as copper and bronze chisels that are not essentially different in shape from modern ones. Metal tools were introduced to Egypt from Mesopotamia. However, stone sculpture is almost nonexistent in this region, and it is questionable whether the Egyptians adopted stoneworking tools from there. No one knows how the Egyptians hardened their tools; the conclusion is that they produced hard copper tools by hammering. The composition of Egyptian bronze was such that bronze tools were suited for working the softer stones.

The Greek sculptors' stoneworking tools were similar to those of today and included picks, the bush hammer (*boucharde*), the point (or punch), claw and toothed chisels, a narrow-edged, flat chisel, drills, files, rasps, saws, and gouges.

The point, or punch, the most versatile and most important of the stone-carving tools, can be used from the first to the final stages of carving. Bigger points are used in the roughing-out phase of carving to remove large masses of stone; smaller points serve to define the final form. The results of carving with the point depend on its size and the angle toward the material when working: at a 45-degree angle the sculptor produces sharp grooves; the more acute the angle, the smoother the surface becomes. The blunt point of the bull point is used for pecking.

Claw or toothed chisels have been in use in Europe since the 6th century BCE (ancient Greece). The toothed chisel has a flat, serrated cutting edge with flat or pointed teeth. It is used to remove superficial layers of stone and for carving the main forms of the sculpture after the initial use of the point. Coarse claw chisels are used for rough, and fine-toothed ones for more intricate work. Teeth may be sharp to penetrate deeply into the stone, or blunt to "shave" the surface. The claw was Michelangelo's tool of choice.

Stone sculptors use a variety of hammers and mallets to drive their chisels. Heavier metal hammers are used for rougher work with the chisel, and lighter wooden mallets soften the blow and are used for fine carving requiring more control.

The bush hammer, or *boucharde*, is a hammer with two blunt striking ends whose surfaces are covered with small pyramidal teeth. This tool is used to weaken the surface of a stone and to wear it down by pulverizing it. Coarse bush hammers with few teeth are used for roughening-out; finer bush hammers with more teeth are for preparing surfaces for carving with the flat chisel. Bush hammers are well suited for working with igneous rock like granite and were used for this purpose by ancient Egyptian sculptors. Bush hammers should not be used on soft stones, like marble, although it is possible to achieve good results when working with care. The bush chisel's point is fashioned like a bush hammer. Its advantage is that the sculptor can control it better than a *boucharde*, allowing him or her to do finer work. Bush chisels are driven like points. The pick, a pointed hammer on a short wooden handle, is used in much the same way as a *boucharde*. The sculptor uses it to crack stones and chip or flake away large volumes of material to block out the form.

Drills fitted with stone tips have been known since the Stone Age. Rotary motion was achieved first by rubbing the shaft between the palms, but later the more effective bow drill came into use. Egyptian stone carvers were able to operate several drills at the same time. Later developments were the pump drill, fiddle drill, and the brace, which was introduced from Asia. Contemporary sculptors use power drills with a variety of bits. Drills are used for boring stone, wood, and metal.

Axes and adzes have been in use since the Paleolithic period. Axes are two-handed splitting tools whose heads are set parallel to the haft to facilitate hitting and cutting. They are used primarily for felling and preparation of timber and only rarely for sculpting per se. Adzes, however, have served as a major wood-carving tool everywhere. Used for shaping and smoothing, adze blades are set at a right angle to the haft. Over time, variants of this tool appeared as different methods of fastening the adze head to the haft were developed. Haft shape and the fastening of the blade characterize different types of the tool, such as the bent-knee hafted adze, the iron-collared adze, and the Mesopotamian shaft-hole and socketed adze (3rd millennium BCE). The socketed adze was originally limited to Mesopotamia but was eventually adopted by the Romans and Northern Europeans and is still in use today. Stone and shell adzes (Oceania) had straight heads, and so did the early metal ones before gently curved heads replaced them. Such metal adzes appeared in Ur as early as 2700 BCE and resemble adzes used today. Curved heads and hafts of most adzes improve control of this one-handed tool, which is used

with a swinging motion directed toward the sculptor's legs. In the West, adzes served for preliminary carving; non-Western artists used adzes of diminishing size for intricate work, which is usually done with the chisel and mallet. Master carvers' adze hafts in Africa and Oceania may be decorated with figures, patterns, and figurative finials. In the Cook Islands, ceremonial carvers' adzes were symbolic representations of the tutelary gods of artists and craftsmen.

Woodcarvers have used chisels and gouges since the Stone Age and have developed a vast number of different shapes and sizes to perform specific tasks. Chisels have flat blades and straight cutting edges, whereas gouges are curved. Gouges with a pronounced scoop shape are known as U-gouges, and those with a V-shaped blade are V-gouges or parting tools. Chisel, gouge, and parting tools are driven with a mallet.

Prehistoric stone chisels and gouges were long, narrow pieces of flint or hard stone whose end had been flaked or ground into a sharp edge. They were used without handles. The earliest Copper and Bronze Age chisels and gouges were similar, but soon sported tangs and sockets to accommodate wooden handles. Woodcarving chisels are generally constructed of tangs. Medieval chisels were cast with shouldered tangs but no ferrules (hoops that are slipped over the handle to secure the blade). Most woodcarving chisels have octagonal handles that provide a good grip. Modern woodcarving tools are made of fine, well-tempered steel and are available in many sizes for rough and fine work.

Chisels are cutting tools whose sharp cutting edge slices into the wood and separates it while the bevel and thickness of the blade wedges and forces it apart. A low (acute) bevel or wedge angle makes carving easy. However, for soft woods, chisels with low bevels are used, and for hard woods, higher wedge angles are more efficient.

Differently shaped shanks and cutting edges allow the carver to perform particular operations more easily and efficiently. The carpenter's firmer chisel with a straight shank and blade and a cutting edge with one bevel is designed for the preparation and planing of flat surfaces, but artists use it for many jobs. The woodcarver's firmer chisel is beveled on either side of the cutting edge to allow the carver to apply the tool at steeper angles. The shank of the short-bent or spoon chisel is sharply curved at its tip to make deep cutting easier. The cutting edge of the skew chisel is not at a right angle to facilitate the excavation of deep-angled grooves and corners. Making two cuts with the backward corner of this tool, the sculptor can carve V-sections. Skew chisels are often shown in Renaissance illustrations, where they frequently appear with a slightly curved edge. Fishtail chisels have wide, flared blades and are used to smooth surfaces.

To prevent splitting and cracking, the backs of many wood sculptures are hollowed out, an operation often accomplished with the gouge. This U-shaped tool comes in a variety of different sizes and sweeps to facilitate the excavation of concave surfaces like drapery folds. For better scooping, gouges are beveled on the outside. Long-bent gouges and short-bent or spoon-bit gouges cut deeply into the wood because of their scooping motion. Spoon-bit gouges allow the artist to carve backsides, for example the underside of deep, overhanging folds. Fishtail gouges are flared like the fishtail chisel and excavate wide, shallow chips of material. Straight, bent, and fishtail gouges also come with skewed cutting edges.

The V-tool or parting chisel serves to carve sharp-edged grooves to define hair and patterns. To allow the carving of grooves of different depth and width, the cutting edge comes with angles of varying steepness. There are long- and short-bent or spoon parting tools for carving concave surfaces and areas that are difficult to reach. A variant is the box tool, whose rectangular boxlike cutting edge is used to excavate a rectangular groove.

The characteristically round shape of woodcarving mallets, used to drive chisels, gouges, and parting tools, allows the sculptor to strike the chisel without having to worry about which part of the mallet is going to strike. Heavier mallets, made from the hardest woods like dogwood or lignum vitae, are used for bigger chisels. Lighter mallets drive fine chisels and are fashioned from softer wood.

The modern carver has hand tools as well as an immense variety of compressed air- and electric-powered tools at his disposal. Reciprocating carvers can be fitted with traditional bits and rotary tools fitted with burrs similar to dentist's drills. A broad range of differently shaped burrs in grits ranging from coarse to fine perform cutting as well as shaping operations. Many rotary hand pieces can also be fitted with small circular texture saws, wheel sanders, and sanding sleeves of various grits.

Carving knives are used to carve small-scale pieces that the artist holds in his or her hand while working. Carving knives are distinguished by the shape of their blades suited for specific operations working toward or away from the carver's body. The most common types are the versatile bench knife, a short kitchen knife with straight cutting edge, and the whittling knife with its curved cutting edge for heavier cuts and roughing out. Chip knives are used for chip carving and details. The slanted cutting edge of the skew knife produces skew and stop cuts. Knives with crooked and multicurved cutting edges and blades are useful for special cuts.

Saws have been used for trimming and very rough shaping for millennia, but rarely for sculpting wood. In the 20th century, however, powered chain saws are frequently used to create large sculptures.

Rasps and files are used for shaping, abrading, and finishing. The abrasive surfaces of files consists of ridges or fine diamond grit, whereas rasps are covered with sharp, raised points. Rifflers are shaped rasps or files that permit the carver to work on hard-to-reach areas.

Metalworking tools date back to the Copper, Bronze, and early Iron Age. Specialized metalworking tools probably originated in western Asia. Finds of bronze at Ur date to about 3500 BCE, but bronze could not have originated in southern Mesopotamia because of the absence of metallic ores there. The usage of bronze spread from Asia to Egypt and later to Europe. In West Africa, metallurgy developed independently. Evidence shows that iron was used before copper, bronze, and brass. African and Eurasian metalworking hand tools are similar, having been developed for the same processes. Specific tools for cutting, joining, drilling, and forming hot and cold metal were developed. Many of these tools were modifications of existing tools such as saws, hammers, chisels, and files. Some new tools appeared, such as tongs (for holding hot pieces of metal) and anvils.

Metal (including precious metals) is cut with saws and shears. Hand and power hacksaws allow for simple cutting. Hacksaw blades are exchangeable since softer, thicker metals require blades with few teeth per inch, whereas harder metals require many more. Power hacksaws are heavy and must be anchored to the floor. The reciprocating blades of power jigsaws create straight as well as curved cuts. Jewelers' saws have very fine blades and are used for intricate cutting. The tapered tip of the keyhole saw is designed for plunging and widening holes. Hand and power shears make long cuts into metal sheets, and nibblers create fine cuts and patterns; an assortment of pliers is used for wire cutting. Cutting can also be done with a chisel, a technique used by Egyptian goldsmiths who had no knowledge of shears.

Due to the elasticity of metals, different forming processes required the development of new tools as well as the adaptation of existing tools, such as the hammer. Forming cold metal by direct hammering requires a variety of differently shaped hammers to produce various effects. Metalsmithing hammers range from flat-ended metal chasing hammers to round-ended ball peens. Egyptians made use of rounded stone hammers. Modern rubber hammers and rawhide mallets prevent surface damage caused by pounding the metal. Hammers are used to form the surface of a sculpture by combining them with wood, pitch blocks,

and sandbags covered with leather. The anvil, the most commonly known implement used for hot and cold forming, provides a flat surface on the top and a curved one at the horn. Anvils can also be fitted with metal-forming stakes in a wide range of shapes. Various forms of the long-handled forging tongs permit the smith to hold the metal.

Files and abrasives are used for the finishing of metal surfaces. Old hand tools have largely been replaced by powered stationary or portable grinders fitted with sanding wheels (which also do cutting), belts, sheets, and disks, as well as buffing wheels.

SUSI COLIN

Further Reading

Bassett, Jane, and Peggy Fogelman, *Looking at European Sculpture: A Guide to Technical Terms*, Los Angeles: J. Paul Getty Museum, and London: Victoria and Albert Museum, 1997

Blackburn, Graham, *The Illustrated Encyclopedia of Woodworking Handtools, Instruments, and Devices*, New York: Simon and Schuster, and London: Murray, 1974; 3rd edition, Bearsville, New York: Blackburn Books, 2000

Casson, Stanley, *The Technique of Early Greek Sculpture*, Oxford: Clarendon Press, 1932; reprint, New York: Hacker Art Books, 1970

Etienne, Hendricus John, *The Chisel in Greek Sculpture: A Study of the Way in Which Material, Technique, and Tools Determine the Design of the Sculpture of Ancient Greece*, Leiden: Brill, 1968

George, Mike, *The Complete Guide to Metalworking*, Marlborough, Wiltshire: Crowood Press, 1987; 2nd edition, as *Metalworking: A Manual of Techniques*, Swindon, Wiltshire: Crowood Press, 1990

Goodman, William Louis, *The History of Woodworking Tools*, London: Bell, 1964; New York: McKay, 1966

Hayes, M. Vincent, *Artistry in Wood: Ideas, History, Tools, Techniques: Carving Sculpture, Assemblage, Woodcuts, Etc.*, New York: Drake, 1972; Newton Abbott, Devon: David and Charles, 1973

Krar, Stephen F., editor, *Illustrated Dictionary of Metalworking and Manufacturing Technology*, New York: McGraw-Hill, 1999

Lawal, Ibironke O., compiler, *Metalworking in Africa South of the Sahara: An Annotated Bibliography*, Westport, Connecticut: Greenwood Press, 1995

Lindquist, Mark, *Sculpting Wood: Contemporary Tools and Techniques*, Worcester, Massachusetts: Davis, 1986

Lucas, Alfred, *Ancient Egyptian Materials*, New York: Longmans Green, and London: Arnold, 1926; 4th edition, as *Ancient Egyptian Materials and Industries*, revised and enlarged by John Richard Harris, London: Arnold, 1962; Mineola, New York: Dover, 1999

McCreight, Tim, *The Complete Metalsmith: An Illustrated Handbook*, Worcester, Massachusetts: Davis, 1982; revised edition, 1991

Odell, George H., editor, *Stone Tools: Theoretical Insights into Human Prehistory*, New York: Plenum Press, 1996

Penny, Nicholas, *The Materials of Sculpture*, New Haven, Connecticut: Yale University Press, 1993

Petrie, William Matthew Flinders, *Tools and Weapons Illustrated by the Egyptian Collection in University College, London, and 2,000 Outlines from Other Sources*, London: Brit-

ish School of Archaeology in Egypt, 1917; reprint, Encino, California: Malter, and Warminster, Wiltshire: Aris and Phillips, 1974

Scheel, Bernd, *Egyptian Metalworking and Tools*, Princes Risborough, Buckinghamshire: Shire, 1989

Verhelst, Wilbert, *Sculpture, Tools, Materials, and Techniques*, Englewood Cliffs, New Jersey: Prentice-Hall, 1973; 2nd edition, 1988

Wittkower, Rudolf, *Sculpture: Processes and Principles*, London: Allen Lane, and New York: Harper and Row, 1977

PIETRO TORRIGIANI 1472–1528 *Italian, active in England and Spain*

Pietro Torrigiani, a talented and versatile Florentine Renaissance artist, produced his most significant and influential works in early-16th-century England and Spain. The relative inaccessibility of Torrigiani's mature sculpture in Italy and his infamous reputation for breaking Michelangelo's nose while a student at the Medici Academy in Florence have led to the generally unsympathetic image of Torrigiani and his work that was promoted by Cellini, Giorgio Vasari, and other contemporary followers and supporters of Michelangelo. Generally credited with introducing the Italian Renaissance style to England, Torrigiani rose to prominence outside Italy and reflected in his work the Florentine styles of such significant sculptors as Andrea del Verrocchio, Antonio Pollaiuolo, Benedetto da Maiano, the Della Robbia family, and Bertoldo di Giovanni.

According to Vasari, the young Torrigiani studied drawings and terracotta, bronze, and marble sculpture with Bertoldo in the Florentine academy of Lorenzo de' Medici. Vasari describes Pietro's early works as "very beautiful," but thought his personality haughty (*superbo*), overbearing, and prone to violence. The rivalry between Torrigiani and Michelangelo led to the famous fight around 1492, which in turn led to Torrigiani's ousting from Florence. By August 1492 he is recorded in Bologna making a terracotta bust (untraced) of a physician, Stefano della Torre. Vasari further records that Torrigiani then moved to Rome to work with Andrea Bregno and Pinturicchio and their workshops on the stucco and marble decoration of the Torre Borgia in the Vatican for Pope Alexander VI, including the marble doorways of *Sala dei misteri* and *Sala dei arti* in Rome for Pope Alexander VI. Documents discovered in the late 20th century, dating between 1493 and 1506, establish that Torrigiani was active as a sculptor in Rome, Florence, Siena, and elsewhere in Italy and in Avignon and that he may not have moved northward to northern Europe and England until after 1506 (see Darr, 1992).

Cardinal Adriano Castellesi, Pope Alexander VI's secretary, commissioned Torrigiani, documented in Rome as "Magistro Petro Scarpelino Florentino" and also called "Petrus Scarpelinus florentinus," to produce a series of large marble sculptural monuments and architectural sculptures, including a cantoria, marble doorways, tombs and monuments for the Church of S. Giacomo degli Spagnoli (now called the Church of Nostra Signora del Sacro Cuore) on the Piazza Navona in Rome. Torrigiani also produced at least three finely carved busts (*Santa Fina*, *Saint Gregory*, and *Christ*), for his landlord in Rome, the priest Stefano Coppi. Torrigiani supplemented his income by enlisting as a mercenary in Cesare Borgia's army in the war of Romagna (1499–1500), then joining the Florentines in their battle against Pisa (autumn 1499) and later fighting at Gargliano (December 1503) with Piero de' Medici and the French forces. During this time Torrigiani produced the marble statue of *Saint Francis* for Cardinal Francesco Piccolomini's family altar in the Cathedral of Siena (*in situ*, completed by Michelangelo). Piccolomini, the cardinal protector of England from 1492 to 1503, before being elected as Pope Pius III, and Cardinal Castellesi, Torrigiani's two main patrons during his formative years, were highly influential with the courts in England and Spain. Along with Florentine banking families (Baroncelli, Bardi, Cavalcanti, Frescobaldi), they helped arrange the necessary introductions for the prestigious commissions Torrigiani would later receive in England.

In February 1504 Torrigiani is documented in Avignon, where he received commissions to sculpt three statues for a *Crucifix with the Virgin and Saint John* (untraced). In and out of Florence also during these years, Torrigiani made many drawings and marble and bronze sculptures (all untraced) for merchants. In January 1505/06 he purchased in Rome two large blocks of marble owned by Michelangelo, suggesting the two sculptors maintained professional contacts (see Darr, 1992). Thus, until 1506 Torrigiani traveled and worked throughout Italy and southern France while remaining active in Rome and Florence, probably with the workshops of Andrea Bregno, da Maiano, and Pollaiuolo.

Sometime around 1506–07 Torrigiani traveled north. In April 1510 he is documented as working for Margaret of Austria, regent of the Netherlands, where in Bruges he repaired a bust of Mary of France, daughter of Henry VII, king of England, and advised Margaret on the tomb of Mary of Savoy and unnamed funerary commissions. He is first recorded in England in November 1511, when he received the commission to create the tomb of Lady Margaret Beaufort, the mother of Henry VII, in the newly built Henry VII chapel, Westminster Abbey, London.

Torrigiani was likely in London by 1507, where he probably worked for Henry VII, advised on plans for royal monuments, modeled the bust of Mary (untraced, but which he later probably repaired in Bruges in 1510)

Tomb of Henry VII and Elizabeth of York, Westminster
Abbey, London
The Conway Library, Courtauld Institute of Art

for her proposed marriage of 1507–08 to Margaret of
Austria's nephew Charles I (later Emperor Charles V),
and produced the three superb polychromed terracotta
busts of *Henry VII*, the young *Henry VIII*, and *John
Fisher, Bishop of Rochester*, as well as the poly-
chromed plaster and wood death mask and funeral ef-
figy of King Henry VII upon the king's death in April
1509.

Torrigiani produced all his documented sculptures
for Westminster Abbey between 1511 and 1522/25,
when he departed for Spain. In London, Torrigiani col-
laborated with various northern craftsmen on the dis-
tinctive black touchstone, white marble, and gilt-
bronze tomb of Lady Margaret Beaufort. Verrocchio's
earlier Medici tomb in the Church of San Lorenzo in
Florence and Pollaiuolo's papal tombs in Rome during
the 1480s and 1490s probably inspired this new combi-
nation of precious materials. The surviving contract
and documents establish that Torrigiani designed and
carved a timber model of the tomb chest incorporating
Italian Renaissance decorations and produced the ve-
ristic gilt-bronze effigy and canopy based on a two-
dimensional design by Maynard Vewicke, a London
painter.

For the tomb of Henry VII and Elizabeth of York,
commissioned in 1512, Henry VIII allowed Torrigiani
considerable freedom in design and execution. For this
central monument in the Henry VII chapel, Torrigiani
rejected the earlier 1506 estimate and design that
Guido Mazzoni had submitted, based on the tomb of

Charles VIII of France (died 1498, in St. Denis, north
of Paris). Instead, Torrigiani designed four elegant gilt-
bronze Italianate seated angels holding the epitaph and
royal arms to flank the two gilt-bronze effigies that
lie on a sarcophagus with Italian Renaissance motifs
(naked Verrocchiesque putti, grotesques, garlands,
birds) and six roundels with reliefs representing the
king's patron saints. The monument, called "the finest
Renaissance tomb north of the Alps" (see Pope-Hen-
nessy, 1972), influenced subsequent tombs in 16th-
and 17th-century England, especially those by Hubert
Le Sueur (also in the Henry VII Chapel), court sculptor
to Charles I of England.

Torrigiani's success with this tomb led to other im-
portant commissions. In January 1519 he received the
commission to design and produce even larger and
more monumental tombs for Henry VIII and Catherine
of Aragon (later abandoned). In 1516 he received the
commission to produce the Henry VII chapel's high
altar, a sumptuous altar of gilt-bronze reliefs, poly-
chromed and white glazed terracotta statues, and deco-
rations of marble and black touchstone. In 1519 Torrig-
iani traveled to Florence, hiring additional assistants
and collaborators, one of whom was probably Bened-
etto da Rovezzano, to pursue these works and others
in London. Torrigiani designed and produced several
other portrait busts and tombs in marble, bronze, and
terracotta in London during these years, including the
wall tomb of Dr. John Yonge for the Rolls Chapel,
Chancery Lane, the first completely Renaissance-style
monument in England, the wall tomb of Dean John
Colet in Old St. Paul's (mostly destroyed in the Great
Fire of 1666, London), the marble head and roundel
of *Christ the Redeemer*, and the bronze profile bust of
Sir Thomas Lovell. Torrigiani's Florentine followers,
including Giovanni da Maiano II and Benedetto da
Rovezzano, continued producing Italianate sculpture at
the Tudor court for several decades after his departure.

Torrigiani left for Spain either in 1522, when
Charles V visited Catherine of Aragon, his aunt, and
Henry VIII in London, or about 1525, when he is
recorded soon after modeling a terracotta bust (un-
traced) of Isabella of Portugal for her marriage in 1526
to Charles V in Seville. Torrigiani may have worked
for Isabella in Portugal and also on the royal tomb in
the Cathedral of Granada. He was at the royal monas-
tery of Guadalupe in 1526 producing a polychromed
terracotta statue of *Saint Jerome in Penitence* (now in
the sacristy), originally placed on the high altar. In
Seville, Torrigiani modeled and painted life-size terra-
cotta statues of *Penitent St. Jerome* and two *Virgin
and Child* groups. These powerful, expressive statues
influenced subsequent Spanish sculptors and painters,
including Juan Martínez Montañés, Velásquez, Fran-
cisco de Zurbarán, and Goya. Imprisoned by the In-

quisition over an injustice, Torrigiani starved himself to death in 1528.

ALAN P. DARR

See also **Benedetto da Maiano; Bertoldo di Giovanni; Le Sueur, Hubert; Mazzoni, Guido; Michelangelo (Buonarroti); Montañés, Juan Martínez; Pollaiuolo, Antonio; Robbia, Della, Family; Verrocchio, Andrea del**

Biography

Born in Florence, Italy, 22 November 1472. Studied drawing and sculpture with Bertoldo di Giovanni, in the academy of Lorenzo de' Medici, until about 1492; expelled from Florence for breaking Michelangelo's nose, 1492; recorded in Bologna, 18 August 1492, producing terracotta bust (untraced); recorded in Rome, on and off between 1493 and 1506, in service of pope Alexander VI and others for Torre Borgia decorations in Vatican Palace and for other work in Rome; worked for Cardinal Adriano Castellesi, the pope's secretary, on various sculptural work at the Spanish National Church, S. Giacomo degli Spagnoli (now called Nostra Signora del Sacro Cuore), Piazza Navona; worked for Cardinal Francesco Piccolomini, papal protector of England, on life-size statue of *St. Francis* (1501) for Piccolomini altar (Cathedral of Siena, Italy). Also recorded working in Fossombrone (1500), in Avignon, France, in 1504, and again in Rome in January 1505/06; also worked as sculptor in Florence, Siena, and elsewhere, 1493–1506; recorded in Bruges, Belgium, in service to Margaret of Austria, regent of the Netherlands, April 1510 (latest); moved to London, but quite possibly there by 1507, to work for Henry VII; commissioned to produce tomb of Lady Margaret Beaufort, for Henry VII Chapel, Westminster Abbey, London, 23 November 1511; received many other commissions for tombs and other works in Westminster Abbey and elsewhere in England, 1511–ca. 1522/25; moved to Seville, Spain, ca. 1522/25; angered by inadequate payment from the duque de Arcos, destroyed a terracotta statue of the *Virgin and Child*; imprisoned for sacrilege and starved himself to death. Died in Seville, Spain, 1528.

Selected Works

1493/ 1494	Doorways of *Sala dei misteri* and *Sala dei arti* (with Bregno workshop); marble; Borgia Apartments, Vatican Museums, Rome, Italy
1498	*Christ*; marble; Museo d'Arte Sacra, San Gimignano, Italy
1498	*Santa Fina*; polychrome marble; Ospedale of Santa Fina, San Gimignano, Italy
1498	*St. Gregory*; polychrome terracotta; Ospedale of Santa Fina, San Gimignano, Italy
1499– 1502	Cantoria, three exterior marble doorways, and an altar dedicated to Francisco Gundisalvo de Valladolid; marble; Church of Nostra Signora del Sacro Cuore, Rome, Italy
1500	*Virgin and Child*; polychrome terracotta; Palazzo Ducale, Urbino, Italy
1500– 1501	Wall monuments dedicated to Pietro Suarez Guzmán and Don Diego Valdez; marble; cloister of Santa Maria di Monserrato, Rome, Italy
ca. 1501	*St. Francis*; marble; Piccolomini Altar, Cathedral of Siena, Italy
1509	Death mask and funeral effigy of King Henry VII; polychromed wax, wood; Westminster Abbey Museum, London, England
ca. 1509–11	*King Henry VII*; polychrome terracotta; Victoria and Albert Museum, London, England
ca. 1509–11	*King Henry VIII* and *John Fisher, Bishop of Rochester*; polychrome terracotta; Metropolitan Museum of Art, New York City, United States
1511–12	Tomb of Lady Margaret Beaufort; marble, touchstone, gilded bronze, traces of pigment; Henry VII Chapel, Westminster Abbey, London, England
1512–18	Tomb of Henry VII and Elizabeth of York; marble, touchstone, gilded bronze; Henry VII Chapel, Westminster Abbey, London, England
1516	Tomb of Dr. John Yonge; marble, terracotta; Museum of the Public Records Office, London, England
1516–22	High altar of Henry VII's Chapel; colored marbles, bronze, gilded bronze, glazed and polychromed terracotta (reconstructed 1932–35); Henry VII Chapel, Westminster Abbey, London, England
ca. 1522	*Christ the Redeemer*, for Abbot Islip's Chapel, Westminster Abbey; marble, limestone with pigment; Wallace Collection, London, England
ca. 1522/24	*Sir Thomas Lovell*; bronze; Westminster Abbey Museum, London, England
ca. 1525/28	*St. Jerome in Penitence*; polychrome terracotta; Museo de Bellas Artes, Seville, Spain
ca. 1525/28	*Virgin and Child*; polychrome terracotta; Museo de Bellas Artes, Seville, Spain

ca. *Virgin and Child*; polychrome terracotta;
1525/28 Museo Provinciale (University), Seville,
 Spain
ca. 1526 *St. Jerome in Penitence*; polychrome
 terracotta; sacristy, royal monastery,
 Guadalupe, Extremadura, Spain

Further Reading

Darr, Alan Phipps, "The Sculpture of Torrigiano: The Westminster Abbey Tombs," *Connoisseur* 200 (1979)

Darr, Alan Phipps, "Pietro Torrigiano and His Sculpture for the Henry VII Chapel, Westminster Abbey," Ph.D. diss., New York University, 1980

Darr, Alan Phipps, "From Westminster Abbey to the Wallace Collection: Torrigiano's *Head of Christ*," *Apollo* 116 (1982)

Darr, Alan Phipps, "New Documents for Pietro Torrigiani and Other Early Cinquecento Florentine Sculptors Active in Italy and England," in *Kunst des Cinquecento in der Toskana*, edited by Monika Cämmerer, Munich: Bruckmann, 1992

Darr, Alan Phipps, "Verrocchio's Legacy: Observations regarding His Influence on Pietro Torrigiani and Other Florentine Sculptors," in *Verrocchio and Late Quattrocento Italian Sculpture*, edited by Steven Bule, Alan Phipps Darr, and Fiorella Superbi Gioffredi, Florence: Le Lettere, 1992

Darr, Alan Phipps, "Torrigiani, Pietro," in *The Dictionary of Art*, edited by Jane Turner, vol. 31, New York: Grove, and London: Macmillan, 1996

Galvin, C., and P.G. Lindley, "Pietro Torrigiano's Tomb for Dr. Yonge," *Church Monuments* 3 (1988)

Galvin, C., and P.G. Lindley, "Pietro Torrigiano's Portrait Bust of King Henry VII," *The Burlington Magazine* 130 (1988)

Grossmann, F. "Holbein, Torrigiano, and Some Portraits of Dean Colet," *Journal of the Warburg and Courtauld Institute* 13 (1950)

Lindley, P.G., "Una grande opera al mio re: Gilt-bronze Effigies in England from the Middle Ages to the Renaissance," *Journal of the British Archaeological Association* 143 (1990)

Lindley, P.G., "Playing Check-Mate with Royal Majesty? Wolsey's Patronage of Italian Renaissance Sculpture," in *Cardinal Wolsey: Church, State, and Art*, edited by Steven J. Gunn and P.G. Lindley, Cambridge and New York: Cambridge University Press, 1991

Pope-Hennessy, J., "The Tombs and Monuments," in *Westminster Abbey*, Radnor, Pennsylvania: Annenberg School Press, 1972

TOTEM POLE

The so-called totem poles of the Pacific Northwest are among the most monumental sculptural forms created by Native Americans. A number of Northwest coast tribes in southern Alaska, British Columbia, and Washington State, including the Tlingit, Haida, Kwakiutl, and Tsimshian, among others, created carved cedar poles of varying types and functions. Although historic totem poles were decorated with a complex array of stylized animal and human figures, these poles never functioned as totemic objects intended for worship. More typically, historic poles recounted mythologies and heraldic information related to the owner of the pole.

Totem poles were expensive undertakings intended in part to demonstrate the wealth or success of its owner. Poles could either be freestanding or incorporated into the structure of a house. Among some tribes pairs of elaborately carved interior posts told the family history of a house's occupants. Poles could also serve a similar function when situated outside of the house. The Haida placed such poles either next to the entrance or as portals into the house, used only on ceremonial occasions. Many tribes used totem poles as memorial objects. In these cases they usually decorated the pole with figures relevant to the life of a deceased chief. A new chief would often erect such a pole to commemorate the life of his predecessor. Other poles functioned as mortuary objects. These poles contained cavities in which the bones or ashes of the deceased were placed. Again, the motifs carved into the pole would relate information about the deceased and his family. A final type of pole was known as a shame pole, erected to publicly ridicule the misdeeds of another person.

The creation of a pole was a time-consuming and highly specialized process. Pole carvers were selected for their skills and were well compensated for the months of labor needed to create a totem pole. Because the stories told on the pole related to the lives of specific individuals, the carver probably had little say as to which emblems were used. Totem poles were usually made from a single, carefully chosen red cedar. Once the tree was felled the pole carver would first strip the trunk of its bark and branches before beginning the process of roughing in the figures with chisels and adzes. The carver would then use more detailed tools to refine the figures. The earliest poles displayed a more sparing use of paint than do more recent poles. With the arrival of Europeans, steel tools and marine paints began to replace the traditional stone tools and natural pigments used on the earliest poles. As a result later poles are more brightly colored.

Relief carvings of human and animal figures, along with supernatural beings and objects, typically embellish both historic and modern poles. Poles can be decorated with single figures or with multiple forms stacked on top of one another. A vocabulary of geometric forms shape and ornament the figures. Most figures are compressed into the tubular shape of the trunk, although some figures can extend far beyond these limitations. To those not conversant with the style, some figures can seem unrecognizably abstracted. Many of the figures depicted on the poles are stylized images of animals found in the Northwest Coast. Killer whales, ravens, eagles, bears, frogs, and other native species make their appearances on the poles. These animals also figure in the mythologies of the various tribes.

In their designs Tribolo managed to find a successful way of integrating sculpture into an architectural composition by visually fusing architectonic and decorative elements. The bands of dancing putti that envelop the shaft of the villa's great fountain enhance the bizarre effect of architecture interlaced with sculpture.

As a fountain designer, Tribolo was certainly aware that a work of sculpture displayed in the round should present more than one coherent profile to the viewer. His last autograph work, a small bronze statuette, *Pan Playing the Pipes*, with its spiraling movement and system of undulating lines that alter their pattern as the viewpoint changes, fully reveals itself only when examined from a number of angles. It was only the next generation of Florentine sculptors who fully exploited Tribolo's innovative use of serpentine composition to create a continuous viewpoint in sculpture. In the evolution of sculptural thinking, Tribolo thus provided an important link between Michelangelo and Giambologna.

ANATOLE TCHIKINE

Biography

Born in Florence, Italy, in 1500. Studied carpentry under Nanni Unghero for three years until apprenticed to Jacopo Sansovino; after leaving Sansovino's workshop, first appeared as an independent artist in Rome, ca. 1524; worked in Bologna, 1525–27, then briefly in Pisa, 1527 or early 1528; during siege of Florence in 1529, worked on a sculpted relief map of the city for Pope Clement VII; worked in Loreto on decoration of the Holy House, 1530–33; assisted Michelangelo in the Medici chapel in Florence, 1533–34; entered service of Duke Alessandro de' Medici in Florence, 1536; worked in Bologna, 1536–37; remained in the employment of Duke Alessandro's successor Cosimo I de' Medici as a sculptor and garden designer from early 1538; took part in the systematization and installation of Michelangelo's statuary in the Medici chapel of San Lorenzo in Florence, 1546. Died in Florence, Italy, 7 September 1550.

Selected Works

525–27 Portal reliefs; marble; Church of San Petronio, Bologna, Italy
1528 *Goddess of Nature*; marble; Musée du Louvre, Paris, France
1530–33 *Translation of the Holy House of Nazareth* (right half) and *Marriage of the Virgin* (right half) reliefs; marble; Basilica della Santa Casa, Loreto, Italy
1535 Copies of Michelangelo's *Dawn, Dusk,*

Day; terracotta; Museo Nazionale del Bargello, Florence, Italy
1536–37 *Assumption of the Virgin*, (for Church of the Madonna di Galliera, Bologna); marble; Capella Zambeccari, Church of San Petronio, Bologna, Italy
1539 Model for the monument to Giovanni delle Bande Nere; terracotta; Wallace Collection, London, England
1540s *Fountain of Hercules*; marble and bronze; Villa Medici at Castello, near Florence, Italy
1540s *Fountain of the Labyrinth* (originally in the Villa Medici at Castello, near Florence); marble and bronze; Villa Petraia, near Florence, Italy
ca. 1545 *The River God*; sandstone; Villa Corsini (formerly Villa Rinieri), near Florence, Italy
before 1547 *Fiesole*; sandstone; Museo Nazionale del Bargello, Florence, Italy
1549 *Pan Playing the Pipes*; bronze; Museo Nazionale del Bargello, Florence, Italy

Further Reading

Avery, Charles, *Florentine Renaissance Sculpture*, London: John Murray, 1970
Holderbaum, James, "Notes on Tribolo," *The Burlington Magazine* 49 (1957)
Holderbaum, James, "Tribolo," in *The Dictionary of Art*, edited by Jane Turner, vol. 31, New York: Grove, and London: Macmillan, 1996
Pope-Hennessy, John, *An Introduction to Italian Sculpture*, 3 vols., London: Phaidon, 1963; 4th edition, 1996; see especially vol. 3, *Italian High Renaissance and Baroque Sculpture*
Vasari, Giorgio, *Le vite de più eccellenti architetti, pittori, e scultori italiani*, 3 vols., Florence: Torrentino, 1550; 2nd edition, Florence: Florence: Apresso i Giunti, 1568; as *Lives of the Painters, Sculptors, and Architects*, 2 vols., translated by Gaston du C. de Vere (1912), edited by David Ekserdjian, New York: Knopf, and London: Campbell, 1996
Venturi, Adolfo, *Storia dell'arte italiana*, 11 vols., Milan: Hoepl, 1901–40; reprint, Nendeln, Liechtenstein: Kraus Reprint, 1967
Wiles, Bertha Harris, "Tribolo in His Michelangelesque Vein," *The Art Bulletin* 14 (1932)
Wiles, Bertha Harris, *The Fountains of the Florentine Sculptors and Their Followers from Donatello to Bernini*, Cambridge, Massachusetts: Harvard University Press, 1933; reprint, New York: Hacker Art Books, 1975

TRIUMPHAL ARCH

From its Roman republican origins to the present day, the monumental or triumphal arch has primarily been associated with military victory or individual celebration. Two forms are most common: the single-vaulted

passageway, usually topped with an attic story, and the expanded three-arched form, in which the center span is typically wider and taller than the two flanking arches. Although at times existing solely or initially as a temporary structure in wood or plaster, permanent triumphal arches in stone, concrete, or marble served as much more than just a prominent architectural form. Their sculptural embellishments became a powerful propagandistic tool for individuals or for an entity such as the state, many times transcending any immediate event or personage the arch intended to celebrate.

As a type of honorific monumental sculpture, the precise origins of the triumphal arch are vague. Presumably, the arched passageway form developed out of arched town gates found in Asia Minor and Italy during the 4th and 3rd centuries BCE. These gates would form imposing entrances through which individuals passed, marking a focal point within the city. The Romans were the first to exploit the freestanding arch, adding sculptural embellishment, particularly in the form of statuary and relief panels, as early as the 2nd century BCE. However, none of these examples is extant. They are known only through literary sources or coins, making it virtually impossible to discuss the earliest developments in terms of form and decoration. At least three known arches date from the republican period. Pliny the Elder indicates that Lucius Stertinius erected a triumphal arch in Rome in 196 BCE. After his victory over Hannibal and Antiochus III in 190 BCE, Scipio Africanus the Elder placed one on the Capitoline Hill. Finally, the first triumphal arch in the Roman Forum, erected in 121 BCE over the Via Sacra, was the Fornix Fabiorum, commemorating the many achievements of the family of the consul Quintus Fabius Maximus Allobrogicus.

Most triumphal arches date to the Roman imperial period, beginning with the first emperor, Caesar Augustus. Although it is believed that nearly every Roman city throughout the far reaches of the Roman Empire had at least one triumphal arch erected, the surviving remains today number slightly more than 120. The proliferation of the form, and certainly its relative uniformity of design, can be primarily attributed to Roman militarism and bureaucracy. Beginning in the republican era, Roman generals often paraded war booty (objects as well as people) through the streets of Rome, with full sanction of the Senate, which formally honored them with a triumph. This practice led to the erection of temporary monuments placed over the parade route, creating a symbolic gateway that could later be constructed in permanent materials. Whereas military triumphs initially led to the building of honorific arches, later emperors with little or no military experience also used the form to propagandize their family or social programs.

In its most basic form, the Roman triumphal arch consisted of a single-vaulted arch springing from two piers articulated with engaged Corinthian or Composite pilasters or columns. The most famous of this type was the Arch of Titus in Rome from the 1st century CE. However, honorific arches also took on a more complex three-arched appearance, such as in the Arch of Constantine from the early 4th century CE. A more unusual example is the four-sided tetrapylon (essentially a four-way arch) built in the 3rd century CE for Septimius Severus at Leptis Magna. Sculptural figures located in the spandrels typically represented allegorical figures such as winged Victories, whereas more figural scenes occurred in the architrave's continuous Ionic frieze and inside the archway on large relief panels. Statuary figures, many times done in bronze, were placed atop the structure or within carved niches. Additionally, the attic level usually provided space for a dedicatory inscription carved in marble. Although the arch's structural form may place it in the realm of architecture, it is notable that Vitruvius's classic work *De architectura*, about 40 BCE, made no mention of the triumphal arch, bolstering the supposition that it was perceived by the Romans as monumental sculpture.

Early Augustan triumphal arches typically consisted of a single, wide-spanning arch, such as found at Rimini (27 BCE) and at Aosta (25 BCE). However, the Arch of Augustus that once stood in the Roman Forum (known today only from coins) provides an interesting case study concerning how a triumphal arch could be upgraded by an emperor during his lifetime. In honor of his victory over Mark Antony at Actium, Augustus erected a triumphal arch in 29 BCE. For the Romans, as is true with many of their honorific monuments, the placement of the triumphal arch in relation to other civic and religious buildings usually played as important a role as its actual embellishment. Its location

Arch of Constantine (312–13), Rome, Italy
© Ruggero Vanni/CORBIS

Leander Touati, Anne-Marie, *The Great Trajanic Frieze: The Study of a Monument and of the Mechanisms of Message Transmission in Roman Art*, Stockholm: Svenska Institutet i Rom, 1987

Peirce, Philip, "The Arch of Constantine: Propaganda and Ideology in Late Roman Art," *Art History* 12/4 (1989)

Pfanner, Michael, *Der Titusbogen*, Mainz, Germany: Von Zabern, 1983

Rotili, Mario, *L'Arco di Traiano a Benevento*, Rome: Istituto Poligrafico dello Stato, Libreria, 1972

Strong, Eugénie Sellers, *Roman Sculpture from Augustus to Constantine*, London: Duckworth, and New York: Scribner, 1907; reprint, New York: Hacker Art Books, 1971

Studi sull'arco onorario romano, Rome: L'Erma di Bretschneider, 1979

Westfehling, Uwe, *Triumphbogen im 19. und 20. Jahrhundert*, Munich: Prestel, 1977

Wisch, Barbara, and Susan C. Scott, editors, *Art and Pageantry in the Renaissance and Baroque*, University Park: Department of Art History, Pennsylvania State University, 1990

Yarden, Leon, *The Spoils of Jerusalem on the Arch of Titus: A Re-investigation*, Stockholm: Svenska Institutet i Rom, 1991

PAOLO TROUBETZKOY 1866–1938

Russian

Paolo Troubetzkoy's career was shaped by a life spent in Italy, Russia, France, and the United States. He was born in Intra, near Lake Maggiore in Italy, the second son of the Russian prince Peter Troubetzkoy and the American singer Ada Winans. Until 1898 Paolo lived in Italy, where he developed interests in both painting and sculpture. His brief formal training consisted of lessons from the painter Daniele Ranzoni and the sculptor Ernesto Bazzaro. Other early influences came from the painter Tranquillo Cremona and the sculptor Giuseppe Grandi, artists whose work featured vigorously modeled and impastoed surfaces. Troubetzkoy rejected conventional academic training, preferring to work outdoors from life. Largely self-taught, he devoted much of his early work to animal studies, often horses, dogs, and other domestic pets rendered in a broad, Impressionist style. *Indian Scout*, a depiction of a horse and rider inspired by a traveling Buffalo Bill show, won the gold medal at an exhibition in Rome and served to establish the artist's reputation in Italy. Troubetzkoy's work was represented at key exhibitions, including the Universal Exposition of 1900 in Paris, where he contributed works to both the Italian and the Russian sections. His work appeared throughout Europe, including Berlin, Dresden, Milan, Venice, and Paris, where he exhibited a group of bronzes at the Salon d'Automne in 1904. He was also known in the United States as early as 1893 when he contributed to the World's Columbian Exhibition in Chicago.

Portraiture was the most significant theme in Troubetzkoy's career. Often his subjects were young women occupied with simple domestic chores, shown seated or reclining. He also frequently depicted mothers and young children. Far surpassing them in number, however, were his numerous society portraits. Among them were commissions from Mrs. Harry Payne Whitney, Baron Henri de Rothschild, Princess Scipione Borghese, and several members of the Vanderbilt family. Rendered in both small-scale, bust-length bronzes and full-length figures, these portrait studies were Troubetzkoy's most significant contributions to late-19th- and early-20th-century sculpture. Stylistically, they were Impressionistic in handling of the surfaces—robustly modeled and textured.

Troubetzkoy created many of his most accomplished portraits in Russia, where he settled from 1898 to 1905. His sitters included prominent members of the intelligentsia, including the painter I. Levitan, the singer Fyodor Chaliapin, Prince Galitsyn, Princess Tenisheva, and Leo Tolstoy. The sculptor's frequent visits to Tolstoy at the writer's estate in Yasnaia Poliana resulted in small portrait busts of the writer as well as a large-scale equestrian statue. Troubetzkoy's most important commission during his years in Russia was a large equestrian monument to Czar Alexander III erected in Znamenskaya Square in St. Petersburg. Completed in 1909, it was an unconventional and somewhat unflattering rendering of the autocrat. Alexander (*r.* 1881–94) appears arrogant and self-absorbed, unable to successfully take charge of his horse, whose head plunges downward, stubbornly refusing to look ahead and move forward. The demeanor of Alexander III contrasts with Étienne-Maurice Falconet's famous equestrian monument of Peter the Great (1766–82) in St. Petersburg's Decembrists' Square, in which the westward-looking czar takes full command of the energetically rearing horse.

Troubetzkoy enjoyed critical success at the turn of the 20th century. Appointed professor of sculpture at the Academy of Fine Arts in Moscow in 1898, his pedagogical methods stressed working from direct observation, thereby rejecting the classical academic practice of studying from plaster casts, which was still in place in the St. Petersburg Academy of Arts. In this context Troubetzkoy's work parallels the outlook of the group of Russian artists known as the Wanderers, or Peredvizhniki, represented by artists such as Ivan Kramskoy and Ilya Repin, whose brand of realism shaped the progressive teaching of the Moscow school.

Troubetzkoy aimed to convey a lifelike quality in his portraits, imparting the personality and psychological aspects of his sitters, expressed in pose and gesture as well as in technique. He was among the first sculptors in Russia to develop an Impressionistic manner, working in wax or clay quickly and vigorously with a palette knife. Rough and uneven, the thickly modeled surfaces allowed for complex and energetic effects of

chiaroscuro. A sketchy quality, or lack of finish, ran counter to established academic style. A similar approach can be seen in the work of Anna Golubkina and Nikolai Andreev, two contemporary Russian sculptors. Moreover, Auguste Rodin's influence is abundantly clear; Troubetzkoy, along with Golubkina and Andreev, shared with Rodin a naturalist sensibility manifested in heavily modeled surfaces and a concern for conveying a directness in psychological expression.

Rodin became the subject of one of Troubetzkoy's portraits produced during the latter's stay in Paris from 1905 to 1914. Leaving Russia permanently, Troubetzkoy spent the remainder of his life in Europe and the United States. In Paris before World War I, he concentrated on portraits of well-known personalities, among them Rodin, Anatole France, George Bernard Shaw, and Gabriele D'Annunzio. At the outbreak of war Troubetzkoy traveled to the United States, where he lived from 1914 to 1921 and exhibited widely in major cities, including Chicago, Detroit, San Francisco, and Los Angeles. His small-scale bronze portraits included several prominent Americans, including Franklin Roosevelt and Mary Pickford. After 1921 Troubetzkoy returned to Europe, living first in Paris from 1921 to 1932, then residing in Italy until his death in 1938.

TAMARA MACHMUT-JHASHI

Biography

Born in Intra, near Lake Maggiore, Italy, 15 February 1866. Short formal training in painting under Daniele Ranzoni and in sculpture under Ernesto Bazzaro; lived in Russia, 1898–1905, and met Leo Tolstoy; appointed professor of sculpture at Academy of Fine Arts in Moscow; awarded Grand Prix at the Universal Exposition, Paris, 1900; exhibited at Salon d'Automne, 1904; lived in Paris, 1905–14, carrying out many portrait commissions; moved to United States, 1914–21; exhibited work in Chicago, Detroit, Washington D.C., San Francisco, and Los Angeles; returned to Paris, 1921–32; returned to Italy, 1932. Died in Suna di Novara, Italy, 12 February 1938.

Selected Works

1892 *Gabriele D'Annunzio*; bronze; Vittoriale of the Italians, Gardone Riviera, Italy
1894 *Indian Scout*; bronze; Gezira Museum, Cairo, Egypt
1900 *Leo Tolstoy on Horseback*; bronze; State Tretyakov Gallery, Moscow, Russia
1905–06 *Auguste Rodin*; plaster; Museo del Paesaggio, Pallanza, Italy
1907 Portrait of the Conte Robert de

Montesquiou; bronze; Musée d'Orsay, Paris, France
1909 Monument to Czar Alexander III, for Znamenskaya Square, St. Petersburg; bronze, granite; State Russian Museum, St. Petersburg, Russia
1911 *Franklin Roosevelt*; bronze; Franklin D. Roosevelt Library and Museum, Hyde Park, New York, United States
1919–20 Monument to General Harrison Gray Otis; bronze; Otis Art Institute; Los Angeles, California, United States
1925 *Giacomo Puccini*; bronze; La Scala Theater Museum, Milan, Italy

Further Reading

American Numismatic Society, *Catalogue of Sculpture by Prince Paul Troubetzkoy*, New York: s.n., 1911
Bossaglia, Rossana, Piergiovanni Castagnoli, and Luigi Troubetzkoy, *Paolo Troubetzkoy scultore: Verbania, 1866–1938*, Intra, Italy: Alberti Librario Editore, 1988
Giolli, Raffaello, *P. Troubetzkoy*, Milan: Alfieri and Lacroix, 1914
Paolo Troubetzkoy, 1866–1938, Verbania Pallanza, Italy: Museo del Paesaggio, 1990
Paolo Troubetzkoy: I ritratti, Milan: Mazzotta, 1998
Sculpture by Prince Paul Troubetzkoy, London: Colnaghi, 1931

JAMES TURRELL 1941– *United States*

James Turrell's art investigates human perception of light and space. Technologically engaging and informed by perceptual psychology, his work examines the liminal aspects of the human eye's sensitivity to light and color. Although he is not a painter, his works relate to the canvases of color-field painters such as Mark Rothko. Just as the viewer is expected to meditate on the interactions of hues and tonal subtlety in Rothko's abstract tonal canvases, viewers also look at pure fields of color in Turrell's work. However, these fields of color are achieved not by pigment, but by projected and manipulated light in carefully constructed architectural settings.

As with many other conceptual artists who gained international fame in the 1960s, Turrell's works resist display in the traditional rectilinear, white spaces of museums and galleries. Indeed, his work requires the space to be structurally modified for his art to be properly shown. In this sense, Turrell works at the intersection between architecture, painting, and sculpture. Although he produces elaborate models of his works, they are by-products and not the primary artwork as far as he is concerned.

Light, as a medium, defies art's standard categories; it cannot be worked on directly as with clay, marble,

or pigment. Nonetheless, Turrell's works reveal the physical properties of light. Although they contain no image, in many of his works, the light either appears to produce a solid wall where there is a void or gives the appearance of a recess where there is a wall. Turrell creates *ganzfelds*, indistinct fields of light that contain neither foreground nor background nor a focus point. Disoriented by the sensations his *ganzfelds* produce, some viewers have fallen down and others have needed to crawl out of his installations.

Turrell hopes to bring to his viewer's consciousness the light inhabiting the inner mind and the light of dreams. When viewers enter a Turrell environment, they must patiently wait for their eyes to adjust to the darkened space. During this process, the viewer's perception of the light and its effect on the space change. Turrell considers the entry into the room where his art is displayed a fundamental aspect of the piece; for many works, viewers must walk through a darkened corridor, allowing time for their eyes to adjust, before entering the installation. Such "pre-loading," as Turrell has described it, is a crucial aspect of his art.

The term *pre-loading* also refers to the effect of context on the viewer's perception. For example, a viewer can watch a night-blooming desert flower in a hothouse or hike through a desert by moonlight, find the same species of flower, and watch it bloom *in situ*. In both places, the flower bloomed; however, the context alters the viewer's perception of the experience. Turrell wants his art to be viewed as in the conditions of traveling to the desert instead of stepping into a hothouse. The viewer must actively enter his work rather than passively look at it. Turrell's art requires complete perceptual immersion as well as the passage of time to act upon the eye. In this regard, he forces the museum patron to slow down; instead of looking

at numerous works of art displayed in a gallery, his works demand sustained contemplation and need isolation; they cannot be shown in a room with works by other artists.

Turrell's first projects were produced at the Mendote Hotel, a building he rented and used as his studio and home in Ocean Park, California, from 1966 to 1972. He initially closed off the interior of this studio from any source of outside light and removed all objects so that the rectilinear spaces had no irregularities. In this pure space, he experimented with projection pieces. These pieces, such as *Afrum-Proto*, consisted of cross-projected halogen lights that interacted with the walls, producing geometric shapes that appeared as solid constructions attached to the walls. In many regards, *Afrum-Proto* is a Minimalist sculpture produced with light—a straightforward, unromantic form that produces an immediate gestalt in the viewer's mind. However, unlike the cubes of Minimalism, which the viewer looks *at*, the observer looks *into the sculpture Afrum-Proto*; the work is an immaterial mirage, an "object" produced with light and space.

After several years of working with projections from artificial light sources, Turrell began to take advantage of outside light sources. The resulting work, *Mendota Stoppages*, incorporated elements of Happenings, site specificity, and performance art. To see the piece required setting up an appointment with the artist himself, who would act as a sort of master of ceremonies. Because this work used the moon, streetlights, and moving car lights of the exterior world and their interaction with the interior spaces of the Mendote Hotel, it could not be reproduced in a museum or gallery. The stoppages, or apertures, related to the amount of ambient light Turrell allowed into the space where his audience was seated.

At the beginning of the evening Happening-performances, Turrell left the interior lights on in his studio, artificially illuminating it. After the audience settled down, he turned out the lights. The shades of the windows were opened fully, allowing light from the street to play across the walls of the room. Over time, the shades were closed and other, increasingly smaller, apertures were opened, gradually diminishing the external light. Through a sequence of phases, whose durations depended on Turrell's assessment of the audience's interest, all outside light was eliminated. This moment of darkness illustrates Turrell's concept of pre-loading; it was simultaneously the climax and midpoint of the performance, as Turrell reversed the process until the room was once again artificially lit.

Turrell, an avid pilot, considers his experiences with flying to be central to his work: "My airplane is my studio," he said. The way light is perceived while flying through clouds, in fog, or on clear days provides

James Turrell, *Roden Crater*, 1972–present. The Painted Desert, Arizona.
© James Turrell. Photo by James Turrell. Courtesy Dia Center for the Arts

Turrell with inspiration. In the early 1970s, Turrell began flying throughout the Western states in search of a place to construct a permanent site that would simultaneously draw on the visual qualities of the sky and reproduce the experiences of *Mendota Stoppages*. In 1977 he purchased Roden Crater, northeast of Flagstaff, Arizona, and began to work on a scale no other sculptor has attempted.

Over the last quarter of the 20th century, Turrell transformed Roden Crater into a series of chambers, tunnels, passageways, and openings that interact with the course of the sun, moon, and stars, declaring that he was creating spaces that would "engage celestial events." He consulted with astronomers so that the chambers and their openings would precisely frame specific events, such as when the moon is at its southernmost declination. This event occurs once every 18.61 years and will be framed by an inner chamber within the fumarole. The moon's image, at this moment, will be projected precisely onto the middle of the opposing wall. The shapes of a dozen or so spaces are determined not by aesthetics, but by optimal conditions for natural light. The longest tunnel brings the viewer to the center of the crater's bowl, which has been perfectly shaped into a parabola. From this point, the sky appears to flatten out and is perceived as flat, radically altering our common impression of the sky as a vaulted dome.

This experience typifies Turrell's art; he allows the viewer to experience space and light in unexpected ways, thereby challenging given conceptions of the relationship between the physical world and subjectivity. Unlike other monuments, *Roden Crater* does not celebrate historical events; rather it implicates humanity's understanding of the cosmos and place within it. Truly sublime, Turrell's work commemorates the vagaries of human perception.

BRIAN WINKENWEDER

See also **Contemporary Sculpture; Minimalism**

Biography

Born in Los Angeles, California, United States, 6 May 1941. Received psychology degree, Pomona College, Claremont, California, 1965; studied with Tony De Lap and John McCracken at the University of California, Irvine, 1965–66; rented studio and exhibition space at Mendote Hotel, Ocean Park, California, and executed first light projection work; completed M.A. in art, Claremont Graduate School, 1973; purchased small airplane (Helio Courier) and flew throughout Western states looking for natural setting for art; moved to Flagstaff, Arizona, and purchased Roden Crater (extinct volcanic crater), 1977; worked in studios at Northern Arizona Museum and transformed Roden Crater into an earthwork, 1979; currently continues work on this project. Received National Endowment for the Arts Fellowship, 1968, Guggenheim Fellowship, 1974, Dia Art Foundation Grant, 1977, Visual Arts Fellowship, Arizona Commission for the Arts and Humanities, 1980, and MacArthur Foundation Fellowship, 1984. Currently lives and works in Flagstaff, Arizona.

Selected Works

1966 *Afrum-Proto*; quartz-halogen projection; private collection
1969–74 *Mendota Stoppages*; projection pieces and performance; private collection
1972 *Skyspace I*; interior light, direct sky; private collection
1974 *Lunette*; interior light, argon light, open sky; private collection
1979– 2000 *Roden Crater*; earthwork; collection of the artist, near Flagstaff, Arizona, United States
1980–86 *Meeting*; interior tungsten light, open sky; Public School 1, Long Island City, New York, United States
1988 *Blue Blood*; interior tungsten light, open sky; Center for Contemporary Art, Santa Fe, New Mexico, United States
1989 *Danae*; tungsten, ultraviolet light; permanent installation, Mattress Factory, Pittsburgh, Pennsylvania, United States
1999 *Elliptic Ecliptic*; interior light, direct sky; temporary installation, Penzance, Cornwall, England

Further Reading

Adcock, Craig, *James Turrell: The Art of Light and Space*, Berkeley: University of California Press, 1990
Beardsley, John, *Earthworks and Beyond: Contemporary Art in the Landscape*, New York: Abbeville Press, 1984; 3rd edition, 1998
Brown, Julia, editor, *Occluded Front: James Turrell*, Los Angeles: Fellows of Contemporary Art, 1985
Roden Crater www.rodencrater.org
Sonfist, Alan, editor, *Art in the Land: A Critical Anthology of Environmental Art*, New York: Dutton, 1983
Tiberghien, Gilles A., *Land Art*, Paris: Éditions Carré, 1993; as *Land Art*, London: Art Data, and New York: Princeton Architectural Press, 1995

U

UNITED STATES: 18TH CENTURY–1900

Sculpture in the 18th- and 19th-century United States reflected the political maturation of the British colony into an independent country and ultimately into a nation of international stature. Americans used sculpture to extol the importance of the new republic through historical links with its Classical European heritage and to promote the vitality of the new democracy by focusing on the country's own short history and contemporary heroes. European trends—Neoclassical and Beaux-Art aesthetics—influenced and encouraged American sculpture, which was nevertheless continuously tempered by the nation's inherent mechanical inventiveness and taste for realism. A dichotomy between the two became the norm.

At first, sculpture played only a minor role in the country. The colonists could not afford such luxuries. On the rare occasion when a public event or site mandated something sophisticated—such as a figurine—a European sculptor or his completed work would be imported from abroad. Consequently, carvings reflected the culture of the Western European countries the colonists had left, rather than the art of the natives they had conquered.

The early artistic expressions by craftsmen consisted of decorations for functional objects: furniture and gravestones. Most residents of the 13 colonies were Protestant and followed the church's dictum discouraging religious iconography. Few religious buildings contained statues or embellishments. Stone carvers engraved skulls, bones, and other motifs on small funerary slabs. In the 19th century, grave markers continued to furnish a source of income, although such

work was occasionally done by trained sculptors rather than mere artisans. After the Boston botanist John Bigelow developed the idea of picturesque rural cemeteries with the 1831 establishment of Mount Auburn in Cambridge, Massachusetts, tombstones became elaborate, sometimes monumental sculpture, such as Daniel Chester French's Milmore Memorial (*The Angel of Death and the Sculptor*, ca. 1890s) in Mount Auburn. Garden cemeteries encouraged the inclusion of monumental sculpture in the design of the new large public parks, beginning in 1866 with John Quincy Adam Ward's *The Indian Hunter*, the first statue to be placed in New York City's Central Park.

In the late 18th and 19th centuries, American-born woodcarvers furnished the needs of the mercantile and shipping industries. The Skillin Shop (John, Simeon Jr., and their father) in Boston and William Rush in Philadelphia carved shop signs and ship mastheads, as well as furniture and architecture work, sometimes painting the wood figures to enhance their realism. Rush was one of the few craftsmen during this period to make the transition to sculptor; his monumental wood figures, vigorously carved and painted white to imitate stone, began in 1808 with a pair, *Comedy* and *Tragedy*, for the facade of a new Philadelphia theater. Well into the 1820s he continued to carve allegorical figures garbed in Classical attire, echoing the nascent taste for Neoclassicism that was taking hold in the United States.

Sculpture's role altered substantially as the new republic desired to express its patriotism and belief in the superiority of its democratic institutions. Sculptors depicted notable personalities in politics, literature, and education. While both Daniel Webster and Henry Clay

were favorites, George Washington was the logical preeminent national hero to depict. Charles Sumner insisted that a sculptural portrait of Washington was the "highest work with which an American artist [could] occupy himself" (see Gardner, 1945). Images of Washington as the leader of the Revolution and the country's first president flourished. Having earned nonpartisan approval, he symbolized national unity. Thomas Jefferson was instrumental in hiring noted French sculptor Jean-Antoine Houdon to create the first full-length portrait of Washington in marble for the Virginia State Capitol in Richmond. Houdon arrived in the United States in 1785; while there, he also created exquisite busts of John Paul Jones, Robert Fulton, and Joel Barlow that stimulated the art of portrait sculpture in the United States. Several decades later, Antonio Canova in Italy and Englishman Sir Francis Chantrey in New England carved additional monuments for the North Carolina State Capitol and the Massachusetts State House, respectively, thereby adding to the foreign development of Washingtonia. Houdon dressed his calm, dignified Washington in contemporary military uniform, while Canova preferred a more literal Classicism, depicting the American leader in the uniform of a Roman general.

The issue over the modernity of the sitter's attire would divide American Neoclassicist sculptors for

Thomas Crawford, *Flora*, 1847, Newark Museum, New Jersey, United States
© Newark Museum / Art Resource, NY

generations: Rush in his painted wood statue of 1814 aligned himself with Houdon (but energized Washington through a strong *contrapposto*, a natural pose with the weight of one leg, the shoulder, and hips counterbalancing one another), while Horatio Greenough, working abroad, pursued a stricter Classicism than even Canova's Rococo Italianate style. Greenough portrayed his 1832 Washington for the U.S. Capitol Rotunda (the first major government commission accorded an American-born sculptor) as a partially nude but dignified god, basing him on the Olympian *Zeus* statue by Pheidias, originally in the temple at Elis. The balance between naturalism and ideality even appeared within a single work. For example, John H.I. Browere, a master in the technique of life masks, traveled around the country in the mid 1820s taking the masks of eminent men such as Jefferson, Lafayette, Philip Hone (mayor of New York City), and Gilbert Stuart; he transformed each high relief into a three-dimensional head by adding the back of the skull and hair, then attaching it to a neck and shoulders. Many, but not all, of these busts were cloaked in Classical togas or drapes. In 1828 Browere presented them as a group in New York City, hoping to inspire an interest in forming a national portrait gallery.

The U.S. Capitol building in Washington, D.C., became a major signifier of the new democracy by referring to the first democracies through its Neoclassical architecture and sculpture. In 1806 the federal government hired two Italians, Giuseppe Franzoni and Giovanni Andrei, to carve stone architectural embellishments. Throughout the 19th century it continued commissioning artists, both foreign and American-born, who would retain the Neoclassical style. No other single building had such a lasting impact on the arts in the United States.

The basic training in the few existing art schools—the Pennsylvania Academy of the Fine Arts, Philadelphia, and the National Academy of Design, New York City—encouraged the belief in the primacy of Classical art. As in European academies, students would draw from plaster casts of famous antique sculpture; the use of Classical study casts further encouraged the dominance of Neoclassicism in American sculpture. Many young sculptors went abroad (primarily to Italy) to study and remained there, dependent to a large extent on the trade of grand tour visitors. There, they became members in the international circle of expatriate writers and artists, able to study the numerous original examples of Greek and Roman art, as well as learning from the leading European Neoclassicists, Bertel Thorvaldsen and Lorenzo Bartolini. Such was the fate of Greenough, Hiram Powers, and Thomas Crawford, the first generation of American expatriates in Italy (arriving beginning in the late 1820s), as well as the second wave (1849–70):

Randolph Rogers, William Wetmore Story, and many lesser exponents such as William Rinehart and Franklin Simmons. Erastus Dow Palmer and others worked at home but still synthesized elements of Neoclassicism into their iconography and style.

Both generations supported themselves largely through portrait commissions, although most sculptors aimed to focus on more imaginative ideal themes and to find financial and popular success through public commissions. The tendency was increasingly toward a greater degree of realism, despite the Classical emphasis on the idealized human form. Greenough's portrait busts of the 1830s evince an aristocratic spirit and flair. Powers demonstrated his ability to combine tour-de-force naturalism with the sitter's essence even before he moved to Italy, as shown in his early bust of Andrew Jackson (1835); Bartolini considered him the greatest portrait sculptor living.

Palmer was one of the few American sculptors to devote many of his figures to religious subjects; photographs of these works sold by the hundreds. Chiefly, Americans produced countless idealized figures, primarily young and healthy females dubbed Daphne, Proserpine, Pandora, and so on, whose characters were meant to tell a story (from Classical mythology or Romantic literature and poetry) and serve as a moral lesson to the American viewer. American Neoclassicists believed they were improving on the Greeks by adding a dimension of spiritual refinement from Protestant Christianity. Beauty was thus linked to dignity, democracy, and, ultimately, freedom. Powers obtained considerable public admiration with his nude *The Greek Slave* (1841), despite the pervasive puritanism of American culture, by relating it to the fate of the modern Greeks in their fight for independence from the heathen Turks.

Second-generation expatriates demonstrated their technical virtuosity with large, powerful figures. Mechanical inventiveness had always been a distinctly American attribute, but the later Neoclassicists added a sense of refinement. Story's *Cleopatra* (1858) sits on a Classical chair, its velvet pillow convincing in its softness. The deeply cut creases of the swirling skirt of Randolph Rogers's *Nydia: The Blind Girl of Pompeii*, based on the contemporary best-seller, *The Last Days of Pompeii* (1834), by Edward Bulwer-Lytton, suggests the haste in which Nydia fled the erupting volcano. The Roman papacy sent *Cleopatra* to the 1862 London International Exhibition, thereby initiating Story's reputation for dramatic heroines (usually seated and contemplating a momentous act that would determine their fate). Rogers's *Nydia* was so popular that it almost became an industry; the sculptor produced 52 replicas. Almost every major art museum in the United States owns an example.

Women contributed significantly to the growth of American sculpture. Historians have often ranked Patience Wright, commended at home and abroad for her waxed portrait images, as the first sculptor in the United States. Later in the mid 19th century so many American female sculptors lived in Italy that Henry James dubbed them the "White Marmorean Flock." Although critics constantly questioned their physical strength and therefore their ability to carve, these women received numerous private commissions and could often support themselves largely through portrait busts. Harriet Hosmer's most important Neoclassical marble, *Zenobia* (1859), is a large and weighty figure that equals the intensity of Story's heroines. Following her example, many other female sculptors selected esoteric Classical stories about the plight of their own gender. The circle in Rome included Vinnie Ream Hoxie, Emma Stebbins, and Anne Whitney. In idealized figures of Native Americans and African Americans, Edmonia Lewis, an African American sculptor, created an iconology about race and gender that surpassed the most ardent feminist interpretations. Her sculptures caused a sensation when exhibited at the 1876 Centennial Exhibition in Philadelphia.

Although women were hindered from obtaining government commissions, especially for large monuments, by the mid 19th century American male sculptors began to be considered for such projects. Captain Montgomery Meigs, the chief engineer of the U.S. Capitol, invited both Crawford and Powers to submit designs for the building's extension. Crawford became the most successful of the Neoclassicists in receiving such commissions: in the 1850s he won the competition for an equestrian monument of Washington for the Virginia State Capitol, together with several U.S. Capitol commissions, including the Senate pediment design, the reliefs for the doors of the House of Representatives and Senate, and *Armed Freedom* (1855), the colossal bronze statue atop the dome.

The issue of slavery and the subsequent Civil War eventually superseded other nationalist concerns, demonstrated in sculpture by the appearance of portraits of noted abolitionists. Genre sculpture also rose in importance, such as Ward's *Freedman* (1863) and in John Rogers's early sculpture groups of the 1860s. Augustus Saint-Gaudens's memorial to Robert Shaw (1897–1917) in Beacon Hill, Boston, was the culmination of a more democratic art: Saint-Gaudens included in the enormous relief (approximately 3.4 by 4.3 meters) not only an equestrian portrait of the leader of the only black Civil War regiment, but also the figures of his troop, each of the black soldiers rendered as an individual personality.

Abraham Lincoln, president of the country during the devastating Civil War, replaced Washington as the

most popular sculpted historical personality. In *Emancipation Group* (1865), Thomas Ball presented Lincoln as the great liberator of the slaves, encouraging a young slave to rise to freedom. Controversy over how to portray such an emotionally charged figure—whether seated or standing, in a genre group or alone—plagued sculptors for decades. With the encouragement of the Symbolist movement, artists transformed Lincoln into the great thinker, destined to contemplate the fate of the African American and the country as a whole for eternity. He became truly iconic in two of the finest American memorials: Saint-Gaudens's *Seated Lincoln* (1897–1906), designed for Chicago, and French's *Standing Lincoln* (1912), for Lincoln, Nebraska.

With the expanding middle class, a new market opened to American sculptors by midcentury, to which they responded by reproducing popular images in multiples and smaller formats (tabletop statuettes). No bronze foundry as yet existed in the United States, so in the late 1840s several American-born sculptors—including Robert Ball Hughes, Clark Mills, and Henry Kirke-Brown—set up their own in their studios and began experimenting. Hughes cast the first bronze statue, of Nathaniel Bowditch (1847), for Mount Auburn Cemetery. Kirke-Brown cast in his studio statuettes of a Native American hunter and distributed them through the American Art Union, an organization established to encourage demand for American art. The first volume-cast bronzes were Thomas Ball's *Daniel Webster* (1853) and *Henry Clay* (1858), by Ames Manufacturing Company in Chicopee, Massachusetts. In 1851 Kirke-Brown had urged this long-established cannon and ironwork company to try casting art, and it eventually became an eminent bronze art foundry. By the time Ward, a student of Kirke-Brown, reproduced his Central Park statue *The Indian Hunter*, foundry work had become so sophisticated that he could use the polished metal to contrast the hunter's skin with the exquisite chasing of the furry pelt. Ward's bronzes were at the high end of the scale in terms of quality and price; John Rogers transformed sculpture into a truly populist art form. He modeled scenes of middle-class daily life in genre ensembles and then manufactured them as painted plaster statuettes. Selling thousands for modest prices over the course of decades, Rogers evinced a truly egalitarian temperament.

The 1850s also witnessed the first bronze equestrian monuments to be cast in the United States: Mills's dynamic *Andrew Jackson* for Lafayette Square in Washington, D.C., Crawford's Richmond monument, and Kirke-Brown's Washington memorial in Union Square, New York City. Kirke-Brown's Washington equestrian demonstrated a new phase in American monuments: the presentation of sculpture on multiple tiers and plinths. The top statue retained a strong realism and allegiance to American subject matter, while on the lower levels emblems or allegorical figures appeared. Such elaborate monuments proliferated after the Civil War, as towns, cities, and states erected countless memorials honoring their slain and living heroes. The tradition of war memorials would continue in earnest through World War I. The equestrian statue experienced a similar life span, reaching its zenith in the early 20th century with two simple monuments: Saint-Gaudens's gilded *General William Tecumseh Sherman* (1903) in Grand Army Plaza, outside Central Park, and Cyrus Dallin's powerful *The Appeal to the Great Spirit* (exhibited 1908) in front of the Boston Museum of Fine Arts.

With the increasing wealth of the nation and its entry into the international political scene, governments initiated major building projects, erecting distinguished state capitols, courthouses, and public libraries (including the Library of Congress and Lincoln Memorial in Washington, D.C., and the Superior Court House in Essex County, New Jersey). The City Beautiful movement further encouraged this tendency. In addition, by the late 1880s the new millionaires—the Vanderbilts, the Rockefellers, and Carnegie—hired the finest artists and craftsmen to create elaborate mansions. Known as the American Renaissance, this later period witnessed the collaboration of painters, sculptors, architects, and interior and landscape designers in the creation of an integrated whole. Sculptors created the required architectural embellishments, fountains, and statuary. Most of the artists who supplied the creativity for these commissions received their training in France, not Italy, and represented a new style, that of the Parisian École des Beaux-Arts.

French masters and teachers such as Jean-Baptiste Carpeaux, Aimé-Jules Dalou, and Emmanuel Frémiet demonstrated how much more appropriate bronze was for the new taste. The Parisian manner encouraged Americans to manipulate their clay more, so that the bronze surface would sparkle with ripples and deep shadows. The Beaux-Arts aesthetic emphasized plasticity and eventually led American sculptors to think in terms of abstract form rather than descriptive representation. By the turn of the century, they were willing to abandon anecdote and moral instruction and create art for art's sake. Among the leading disciples of the Beaux-Arts school were Saint-Gaudens, French, and Frederick MacMonnies.

Saint-Gaudens ranked supreme. He realized the significance of creating symbolic figures, transforming the specificity of historical personalities into emblems of national and universal import, as in *The Puritan* (1887). Originally designed as an imaginary portrait of Deacon Samuel Chaplin for a Springfield, Massachusetts, square, this dramatic standing figure—dominated by the simple shape of his cloak—came to represent to the

many who purchased the small version the religious fervor and determination of their New England ancestry. French's *Minute Man* (1873–75), MacMonnies's *Nathan Hale* (1890) for New York City Hall, and Ward's *Henry Ward Beecher* (1889–90) in Cadman Plaza, Brooklyn, were also among the most successful single-figure bronze monuments from the period.

Although Ball and Ward were the foremost realist portraitists of the second half of the 19th century, Saint-Gaudens transformed the genre. By resurrecting the Renaissance technique of relief, he infused commemorative portraiture with a new vitality. A master of bas-relief, Saint-Gaudens often combined the figural representation with inscribed text so that the surface of his large plaques was simultaneously flat and active with movement. The writer Robert Louis Stevenson was the most popular of his sitters, but he also depicted artists, critics, and prominent society personalities. Especially elegant and rich, this new type of portraiture accorded well with the decor of the mansions of the new wealthy class. Saint-Gaudens further transformed commemorative sculpture by reconceptualizing the bases of his monuments. By simplifying them to flat walls and carving a symbolic decorative low relief on them, he turned them into an integral element of the sculptures.

Imaginary statuary differed substantially from idealized Neoclassical sculpture. Although Americans continued to employ Classical themes, such as Charles Henry Neuhaus in his *Silenus* (*ca.* 1883), the emphasis was no longer on the ideal nude form or on its power to instruct the viewer. Instead, Americans rejected literary themes to explore sculpture as an expressive medium. MacMonnies, for example, enjoyed Impressionist immediacy in the modeling of *Young Faun and Heron* (*ca.* 1890). William Rimmer, an isolated figure active in Boston during the 1860s and 1870s, created the most inventive and tortured art. Despite his naturalism and extreme plastic style, which he owed to his medical training, his robust, twisted figures were more symbolic of his tragic personal life.

Allegorical statuary found its most appropriate manifestation in the international fairs that celebrated American culture and industry during the late 19th and early 20th centuries: Philadelphia's Centennial Exhibition (1876), the Chicago Columbian Exposition (1893), the Saint Louis Fair (1904), and the Panama-Pacific Exposition in San Francisco (1915), as well as many others in smaller cities. The placement and design of the major fairway, usually represented by ponds, fountains, and colossal sculpture (made from temporary material called "staffage"), always determined the scheme of the fairgrounds. Millions of visitors attended the fairs, often bringing home small replicas, postcards, or photographs of the statues, thereby ensuring widespread exposure of Beaux-Arts statuary.

The 1893 Columbian Exposition celebrated the American West as a distinctly national theme, one that continued in popularity well into the 20th century. The American Indian and cowboy were becoming American myths. Historian Frederick Jackson Turner declared the American frontier closed during a lecture he presented at the fair: the Native American was pacified (and living in reservations), and the rough lifestyle of the cowboy was disappearing as urbanization and industrialization transformed the frontier into a settled Western civilization. As Indians were now part of the American historical past and no longer considered a threat to nonnative civilization, sculptors reminisced nostalgically. Earlier Native Americans, their customs, appearance, and cultural myths, had been the subject of James Fenimore Cooper's popular novels and George Catlin's paintings. American sculptors occasionally depicted them singly, as in Palmer's *Indian Girl* (*The Dawn of Christianity*) from 1856, or part of an ensemble devoted to the New World theme, as in Crawford's pediment design for the U.S. Capitol. Later equestrian interpretations conveyed a far greater degree of emotions, varying from the Native American's dignity as a "noble savage" to the pathos of his defeated race. Cyrus E. Dallin and Hermon Atkins McNeil were the leading specialists. But James Earle Fraser's *End of the Trail*, a young warrior hunched over his horse in despair, was perhaps the most poignant; one of the key monuments decorating the grounds of the 1915 San Francisco fair, it remains the most famous.

Despite their New World theme, the American West sculptures were part of an international fascination with exotic races, encouraged in part by Western imperialism. European Orientalists created portraits that focused on the physiognomy of different races, presenting them in pseudoscientific terms. The Americans preferred to present their native population in genre vignettes of bygone times, overlaid with a heavy dose of romantic nostalgia or allegorical idealism.

Frederic Remington and Charles Russell most notably immortalized the cowboy in sculpture. Russell claimed to be the first specialist who was also a cowboy; his bronzes tended to be modest in size. Remington captured the cowboy and soldier in action, conveying all the drama and excitement supposedly inherent to the frontier. His bronzes quickly became synonymous with the Old West and went through large editions (often continuing after his death, with his wife as overseer). Even today, numerous unauthorized recasts flood the marketplace, attesting to the theme's continuing popularity.

The public equally desired sculptures of wild animals, modeled in the Romantic-realist style of the Beaux-Arts school. Antoine Barye set the taste with his bronze *animaliers*, which were highly prized by American collectors; the Corcoran Gallery of Art,

isted: the first generation, including Robert Laurent and Zorach, preferred to leave part or all the surface rough, suggestive of its natural texture, such as the grain of the wood or the artist's chisel marks; the second generation of artists, such as José De Creeft, usually polished their surfaces to a high gloss. The degree that the sculptor departed from the glyptic form of the material also varied substantially. First-generation carvers promoted the belief that the shapes and forms of the sculpture were inherent in the stone and wood and that the sculptor only realized and set free the spirit of the material in the act of cutting away the solid material. The second-generation carvers, while not totally abandoning such a philosophy, preferred to preconceive their subject matter and design prior to carving. Neither generation emphasized the use of preparatory sketches and models.

Only with direct carvers did sculpture in the United States become truly national and its practitioners ethnically diverse. The sculptural program of the Art Institute of Chicago and the federally funded art projects established in all the states during the Great Depression encouraged the practice of sculpture throughout the country. Among the major sculptors active during the 1930s were Donal Hord, Sargent Johnson, and Peter Krasnow, all in California, and Medellin in Texas. Each created a distinctive art, reflecting their ethnic heritage or the locale in which they worked.

Although the popularity of direct carving eclipsed bronze casting, both were subsequently buried by the numerous expansions in materials, techniques, and principles that emerged during the Great Depression, World War II, and its aftermath. Eventually, these changes undermined the basic premise of sculpture as a static form. Found objects, which had first been used by the Dadaists, found fuller expression in the enigmatic work of Joseph Cornell. He filled ordinary wooden boxes with disparate objects (often junk) and materials not usually associated with sculpture, a practice that would find wide acceptance in the post–World War II era when artists, especially the Beats and California assemblagists, considered the detritus of modern society both the material and the theme of their art.

Most of the carvers and a few other pre–1930s artists worked in an idiom clearly derived from Cubism. Their human and animal shapes, however, reveal that few Americans fully understood the theoretical premise of the European aesthetic. To them, Cubism meant the simplification of volumes into basic geometric shapes rather than the relationship of forms to the surrounding space. John Storrs went a step further by incorporating the idea of movement and time in a group of polychrome marbles, where the viewer is forced to walk around the entire carving in order to understand the structure of the figure as presented through a series of intersecting planes. But it was Alexander Calder who undermined the entire premise of Western sculpture as a solid form distinct from its surrounding space. With his constructions of the late 1920s—animals, circus performers, and dancers such as Josephine Baker, as well as portrait heads of famous personalities—he used thin wire to draw three-dimensional outlines in space. The negative space visually perceived as within the wire boundaries, rather than the positive material form that usually displaced air, constituted the sculpture. By adding movement to his early mobiles of the 1930s, he further abandoned the idea of sculptural unity; motors, weights and balances, and chance (i.e., the wind) activated parts so the sculpture as a whole changed over time.

With the fascist promotion of socialist realism and rejection of abstraction, nonobjective art acquired a new symbolism, that of a free society. Along with Calder, the most precocious Americans to create innovative sculpture, first in the form of geometric and biomorphic constructions, were Ibram Lassaw, Isamu Noguchi, Theodore Roszak, and David Smith. Some experienced the European avant-garde abroad: Calder and Noguchi assimilated the trends of Cubism, Constructivism, and Surrealism in the late 1920s and early 1930s in Paris, and Roszak fell under the spell of the Bauhaus in Prague.

Surrealism offered artists a way to infuse abstract art with a personal content. Unlike European artists, American sculptors of the 1930s and 1940s did not focus on nihilism; rather, they sought to combine Surrealist concern for the primitive with contemporary issues. Bauhaus and other Constructivist principles encouraged a utopian idealism as artists sought to design a pristine world unfettered by objective reality. Artists such as Roszak and Gertrude Greene constructed wooden reliefs of geometric forms, painted almost entirely in white, as their answers.

The desire for a new, well-ordered society encouraged the enlargement of sculpture and its return outdoors into public spaces. In the late 1930s Noguchi led the way with his large Environmental sculptures and designs for playgrounds, gardens, and fountains. A decade later Louise Nevelson and Louise Bourgeois expanded the vocabulary of installation art while retaining the Constructivist use of painted wooden elements and the Surrealist use of the found object. Nevelson created monochromatic reliefs of wall proportions, while Bourgeois clustered vertical totems into abstract constellations.

The paramount new technique, however, was welding. The incorporation of this industrial technology into standard art practice enabled sculptors to work directly with metal, unlike the elaborate bronze-casting process. A novel kind of metal sculpture appeared, one

that could be flat or linear but that most of all denied the physicality of solid three-dimensional form. Lassaw was one of the first to experiment with welding in 1933, eventually constructing exceptionally delicate wire boxes and cagelike forms. Through this process, as well as screw cutting and polishing, Roszak transformed his early metalwork into whimsical, yet elegant, constructions. Smith, a metalworker in an automobile plant, followed the example of Pablo Picasso and Julio Gonzalez, incorporating found objects into his welded sculptures. Postwar sculptors would more fully exploit welded structures as they searched for a process to echo the power and violence of the war.

Self-expression had continued to win champions since the influence of Rodin. But only with Abstract Expressionism did the sculptural process itself become equal in significance to the end product, the work of art. The process became part of the theme, the personal evocation of its creator as well as a universal comment about the world and life. Freudian psychology and Jungian philosophy encouraged such exploration, and Noguchi and Smith created the most original works based on primal metaphors.

Noted critic Clement Greenberg had set the stage for the postwar rise of American sculpture when he asserted in 1948 that sculpture rather than painting was best endowed with a greater range of expression for the modern sensibility. For the first time in the history of American sculpture, three-dimensional art was no longer relegated to a secondary position in the media hierarchy or even worse, to the role of pure decoration. By 1960 Americans were not only establishing major reputations abroad—as Calder and Noguchi had done earlier—but came to dominate the international scene.

IIENE SUSAN FORT

See also **Bourgeois, Louise; Calder, Alexander; Lachaise, Gaston; Manship, Paul; Modernism; Nevelson, Louise; Noguchi, Isamu; Saint-Gaudens, Augustus; Smith, David; Surrealist Sculpture; Taft, Lorado**

Further Reading

Andersen, Wayne V., *American Sculpture in Process, 1930–1970*, Boston: New York Graphic Society, 1975
Ashton, Dore, *Modern American Sculpture*, New York: Abrams, 1968
The Coming of Age of American Sculpture: The First Decades of the Sculptors Guild, 1930s–1950s, Hempstead, New York: Hofstra Museum, Hofstra University, 1990
Conner, Janis C., and Joel Rosenkranz, *Rediscoveries in American Sculpture: Studio Works, 1893–1939*, Austin: University of Texas Press, 1989
Fort, Ilene Susan, and Mary Lenihan, *The Figure in American Sculpture: A Question of Modernity*, Los Angeles: County Museum of Art, 1995
Marter, Joan M., Roberta K. Tarbell, and Jeffrey Wechsler, *Vanguard American Sculpture, 1913–1939*, New Brunswick, New Jersey: Rutgers University, 1979
Marter, Joan M., Marian Clough, and Jennifer Tohler, *Beyond the Plane: American Constructions, 1930–65*, Trenton: New Jersey State Museum, 1983
Phillips, Lisa, *The Third Dimension: Sculpture of the New York School*, New York: Whitney Museum of American Art, 1984
Spahr, P. Andrew, *Abstract Sculpture in America, 1930–70*, New York: American Federation of Arts, 1991

UNKEI *ca.* 1151–1223 *Japanese*

Unkei led the foremost sculpture workshop when independent schools emerged following the Gempei War (1180–85), which brought to a close the rule of Japan by the Fujiwara family. The Minamoto and Taira (the Gen and Hei; together known as Gempei) families contended for control of Kyoto and the authority to appoint the emperor. A decade of Taira dominance was a vendetta of ruthless destruction, enemies exterminated or exiled, their major temples and the imperial palace burned. Whole blocks of Kyoto and Nara were laid waste.

The Taira demise, however, came at the hands of Minamoto Yoshitsune (1159–89) in the sea battle of Dan no ura, but his jealous brother Yoritomo (1147–99) tried various means to dispose of him, eventually forcing Yoshitsune to flee to the north; Yoritomo then had himself named shogun. His wife was a Hōjō, and he established his military government (*bakufu*) in the east coastal city of Kamakura, her family's district.

The aristocracy was displaced by military rulers, starting a pattern of Japanese government that lasted until the opening of the Meiji period (1868–1912). Patronage, tastes, and preferences diversified. The worship of Amida Buddha and the promises of salvation in the Pure Land—so popular at the Fujiwara court—spread through the social ranks. Aspects of Zen, brought to Japan from China by the priest Eisai in 1191, were slowly adopted by the warrior class as embodying ideals of discipline and loyalty.

Unkei was a fifth-generation descendant of the great Fujiwara-period (784–1185) sculptor Jōchō, who ran a workshop for Buddhist images on Seventh Avenue in Kyoto. This workshop had pioneered the multiple-block technique of wood sculpture (*yosegi-zukuri*), improving efficiency in each step of production and opening the possibilities for larger and more elaborate figures, including fabrication in the workshop and assembly at the patron's temple. When the Kamakura *bakufu* embarked on an energetic program of selectively repairing and replacing damaged and destroyed temples and their icons, this workshop was ideally prepared to undertake substantial commissions.

A branch of the workshop—which was popularly known as Kei-ha (Kei school) from the presence of *kei*

in so many of the artists' names—had apparently opened in Nara and eventually was run by Unkei. Unkei's earliest sculpture for which there is record—a black ink inscription on the pedestal—is the gilt-wood seated *Dainichi* (Sanskrit Mahavairocana; Great Illumination) *Buddha* of the Enjo-ji in Nara prefecture. It was begun in Angen (Japanese era dating) 1.11.24 (in 1175) and presented to the temple within 11 months. Although still a young man, most likely in his early 20s, Unkei is identified in the inscription as *busshi*, a ranked sculptor of Buddhist images; the inscription also notes that Unkei was apprenticed to Kokei, his father.

Extensive flaking of the gold leaf (*kirikane* [cut gold]) contrasting with black lacquered surfaces of the *Dainichi Buddha* suggests unsuccessful attempts at repairs. The "snail-shell" ringlets of the Fujiwara style have been replaced with perfectly combed hair in fine parallel lines over which rises a typically high Kamakura-period topknot. This coiffure is hidden by a tall, openwork gold crown. Quartz eyes were embedded from inside the head, a trademark of Unkei and his school. The curves of the drapery folds are now slightly looser and the folds in higher relief.

Members of the Kei school gravitated toward Kamakura, doubtless negotiating for contracts for work at the Tōdai-ji and Kōfuku-ji in Nara, both of which had been burned to the ground in 1180. Seichō, then head of the workshop, was working for Minamoto Yoritomo in Kamakura. In 1189 Unkei made the main image for a temple that Hōjō Tokimasa, father-in-law of Yoritomo, was building. The image does not survive, but before going to Kamakura, Unkei had carved a set of ten statues for the Ganjōjū-in, a temple in Nirayama town, Shizuoka prefecture. Inscriptions on wooden panels inside the figures date them to 1186 and refer to Unkei as having a low-ranking administrative position at the Kōfuku-ji.

A contract for images for the Tōkon-dō (East Golden Hall) of the Kōfuku-ji was awarded to the Kei group, but little more is known of that project except that Kyoto *busshi* were trying to purloin it in Unkei's absence. While still in the Kanto, Unkei created statues of an Amida (Sanskrit Amitabha, Amitayus; Buddha of the Western Paradise) and his two bodhisattvas (*Amida sanzon*), a Fudō (Sanskrit Acala), and a Bishamon-ten (Sanskrit Vaisravana; traditionally, Guardian King of the North, but often used alone) for the Jōraku-ji in Zushi city, Kanagawa prefecture, completed in 1189. The inscribed tablets inside the images also give credit to ten assistants. Because of slight differences in carving within the two sets of sculptures at the Ganjōjū-in and Jōraku-ji, it has been argued that the six without inscriptions are only imitators' replacements: in the Ganjōjū-in, the Amida Buddha and the two attendants of Fudō; and in the Jōraku-ji, the Amida Buddha and his two bod-

hisattvas. However, an equally good argument can be made that these were the work of assistants.

Unkei took over the workshop in Kyoto in about 1196, likely the year Kokei died. The previous year, Unkei had been given the title of *hōgen*, (eye of the law), the middle of three ranks of titles then awarded to artists for special service to the church (the lowest rank was *hokkyō* [bridge of the law]; the highest, *hōin* [seal of the law]). The newly rebuilt Daibutsu-den (Great Buddha Hall of Tōdai-ji in Nara) was dedicated in 1195 with much fanfare, and for it Unkei and others had been busy making the two large wood bodhisattvas for either side of the remodeled bronze Great Buddha and the images of Shitennō (Four Heavenly Kings). *Daibusshi* (hereditary chief of a sculptor's group) were assigned one king each; Unkei carved Jikoku-ten (Sanskrit Dhrtarastra) of the east. All have been destroyed.

Records next credit Unkei with two huge *Niō* (two Guardian Kings), gate figures for the Tō-ji, the great temple at the south entrance to Kyoto, the headquarters of the Shingon sect. Repairing and copying old statues being normal commissions, he repaired their 9th-century images, claimed by the temple to have been made by their sainted first head, Kōbō Daishi (774–835), and copied three of them for the Jingo-ji, a temple in the hills to the west of Kyoto. All of these have disappeared.

Unkei was now a prosperous man with strong political connections and a daughter in the inner circle of the court. He built his own family temple in Kyoto on Eighth Avenue in the district known as Takakura and apparently reformed his workshop on a larger scale. Many regard the culminating achievement of the Kei masters as the two *Niō* (1203) for the Nandai-mon (Great South Gate) of the Tōdai-ji in Nara. The statues stand 8.5 meters high as monumental guardians of the temple, the Great Buddha, and the faithful. The team creating the *Niō* included Unkei, Kaikei, two more sculptors with *daibusshi* rank, and 16 others. The Tōdai-ji staged another grand celebration for its reconstruction, and Unkei was honored with the title of *hōin*.

More work followed, including nine replacement statues for the Hokuen-do (North Octagonal Hall) of the kōfuku-ji in Nara, three of which have survived. The figure of Miroku (Sanskrit Maitreya; Buddha of the Future) bosatsu is relatively traditional, but those of two early Indian priests, Hossō sect patriarchs Mujaku (Sanskrit Asanga) and Seshin (Sanskrit Vasubandhu), represent the climax of the school's realistic style. Resembling Japanese monks, they are slightly over-life-size for effect. Once realistically painted, the quartz eyes give them a warm, human, intelligent, and dignified presence.

In 1213 Unkei was engaged in making a set of five esoteric Buddhas (Japanese, Go-butsu) and Four Heavenly Kings for the nine-story pagoda of the Hōshō-ji

in Kyoto, the magnificent retirement temple begun by Emperor Shirakawa in 1075. Unkei was aided by Tankei, his oldest son, and by members of both the In and En workshops. This unusual relationship could only mean that the patron expected the efficiency of the Kei school to be combined with the traditional style of the other schools in order to produce images compatible in appearance with the numerous Heian-period (784–1185) statues that adorned the temple's many other buildings. Unfortunately, all of the great Shirakawa temples were destroyed in the later civil wars.

Unkei was again commissioned by the Hōjō, but it appears that he made the statues in Kyoto and had them transported to Kamakura, one in 1218 and a set in 1219: a Yakushi (Sanskrit Bhaisajya-guru-vaidurya-prabha; Buddha of Healing) for a temple of Yoshitoki (1163–1224), son of Tokimasa, *shikken* (regent) from 1205, and a set of the five statues of Go-dai-myō-ō (incarnations of the Go-butsu) for a new part of a temple that Masako, Minamoto Yoritomo's wife, built for the repose of the soul of her son Sanetomo, the recently murdered third *shikken*. Unkei died in Kyoto in 1223. His six sons—Tankei, Kōun, Kōben, Kōshō, Unga, and Unjo—were sculptors, but statues remaining today can be identified only with Tankei, Kōben, and Kōshō.

The impact the Kei school had on the history of Japanese sculpture cannot be overestimated. Repairing Nara-period (710–94) statues (for instance, quartz eyes were put into some earlier images) and replacing Heian-period figures provided its members with full grounding in the traditions of techniques and styles. Aided by good organization and improved methods, they reinvented portraiture of the 8th century, taking it as far as possible; they did the same with the images of familiar Buddhist deities, giving them an unsurpassed heroic grandeur. Later generations were less imaginative, looking back on Kei school models for their inspiration.

J. EDWARD KIDDER JR.

Biography

Born in Kyoto, Japan, *ca.* 1151. Family were sculptors who operated a workshop, formally called Shichijō Bussho, later known as the Kei-ha; father was Kōkei, who formed Japanese Buddhist school of sculpture and was a member of the Kei school, which flourished in Kamakura period (1185–1333). Received *busshi* rank at early age; first dated statue completed 1176; had temporary workshop in Shizuoka; traveled to Kamakura to carve Buddhist sculptures for temples of the Hōjō military rulers, 1180s; returned to Kyoto with many commissions; became head of workshop after death of Kōkei, *ca.* 1196; worked on team productions for huge images of Shitennō (Four Heavenly Kings) for Great Buddha Hall of Tōdai-ji in Nara and was promoted to *hōgen* (the second-highest rank for sculptors), 1195; worked on gate guardian statues for Tō-ji in Kyoto, and Tōdai-ji in Nara, in 1203, and received highest rank of *hōin* same year; later made statues for the Kōfuku-ji in Nara, where he held administrative position, and made statues for retirement temple of Kyoto emperor, 1213; made statues for Hōjō family members in Kamakura, 1218–19. Had six sons who were sculptors. Died in Kyoto, Japan, 1223.

Selected Works

1175–76 *Dainichi Buddha*; wood; Enjō-ji, Ninnikusen, Nara city, Japan

1186 Statues of *Amida, Fudō*, and *Bishamonten*; wood; Ganjoju-in, Nirayama, Shizuoka prefecture, Japan

1189 Statues of *Amida, Fudō*, and *Bishamonten*; wood; Jōraku-ji, Zushi, Kanagawa prefecture, Japan

ca. 1200 *Jizo*; wood; Rokuhara Mitsu-ji, Kyoto, Japan

1203 *Niō* (with Kaikei); wood; Great South Gate, Tōdai-ji, Nara city, Japan

1208–12 Statues of Miroku bosatsu, Priest Mujaku, and Priest Seshin; wood; Kōfuku-ji, Nara city, Japan

Further Reading

Irie, Yasukichi, and J. Edward Kidder Jr., *Masterpieces of Japanese Sculpture*, Tokyo and Rutland, Vermont: Tuttle, 1961

Kuno, Takeshi, *Nihon no Chokoku* (Sculpture of Japan), Tokyo: Yoshikawa Kobunkan, 1959

Mason, Penelope, *History of Japanese Art*, New York: Abrams, and Upper Saddle River, New Jersey: Prentice-Hall, 1993

Moran, Sherwood, "The Statue of Muchaku, Hokuen-dō, Kōfuku-ji: A Detailed Study," *Arts Asiatiques* 1 (1958)

Mori, Hisashi, *Sculpture of the Kamakura Period*, translated by Katherine Eickmann, New York: Weatherhill, 1974

Mori, Hisashi, *Japanese Portrait Sculpture*, translated by W. Chie Ishibashi, New York: Kodansha International, 1977

Nishikawa, Kyōtarō, and Emily Sano, *The Great Age of Japanese Buddhist Sculpture*, AD 600–1300, New York: Japan Society, and Fort Worth, Texas: Kimbell Art Museum, 1982

Ooka, Minoru, *Temples of Nara and Their Art*, translated by Dennis Lishka, New York: Weatherhill, 1973

Roberts, Laurance, *A Dictionary of Japanese Artists: Painting, Sculpture, Ceramics, and Lacquer*, New York: Weatherhill, 1976

Tokyo Kokuritsu Hakubutsukan (Tokyo National Museum), *Tokubetsu-ten: Kamakura Jidai no Chokoku* (Special Exhibition: Japanese Sculpture of the Kamakura Period), Tokyo: Tokyo Kokuritsu Hakubutsukan, 1975

Watson, William, *Sculpture of Japan, from the Fifth to the Fifteenth Century*, New York: Viking Press, and London: The Studio, 1959

V

VACCARO FAMILY *Italian*

Lorenzo Vaccaro 1655–1706

Vaccaro, a pupil of Cosimo Fanzago, had a varied and intense career in Naples and the Kingdom of the Two Sicilies as a sculptor, silversmith, painter, architect, interior decorator, and inventor of apparatus for festivities. Fanzago's Late Baroque classicism was only a starting point, without regrets, for experiences that Vaccaro was not to channel only in the direction of Luca Giordano and Franceso Solimena. He also turned his attention to the inexhaustible manner of Gianlorenzo Bernini. In his experimental enterprise, influences from Alessandro Algardi and Neo-Mannerism merged into a perfect synthesis. He strove to modernize Neapolitan sculpture by freeing it from Late Baroque magniloquence and Fanzago's weighty influence, and developing a style of his own that was piquant yet delicate, decorative yet virtuosic. Not by chance, Vaccaro loved the "terzino" (one-third life-size) format and precious metals for sculpture and objects of all kinds. Together with a trenchant naturalism, a new pictorial sensibility, and strong decorative rhythms intended to refine the forms, these singular features testify on the one hand to the nature of a silversmith and goldsmith of supreme skill, and on the other to a refined taste with clear proto-Rococo touches. In the stucco *Telamon Angels* in the Church of the Gesù delle Monache in Naples one can see influences derived from his journey to Rome. Specific references to Bernini appear in the *Adoring Angels* (ca. 1689) that Vaccaro executed for the Crucifix Chapel in S. Giovanni Maggiort in Naples. Concerns for pompous officialdom and Late Baroque classicism, reflecting the influence of Solimena-style academic taste and of models sensitive to Carlo Maratta's teachings, are condensed in the magnificence that marks the monumental *St. Helena* and *Constantine* and *The Glory of the Eternal Father with Cherubs and a Putto* (all in stucco) in the Crucifix Chapel, and the marbles *David* and *Moses* (1689–90) in the church of S. Ferdinando in Naples. By contrast, the beautiful marble statues of *St. Michael Archangel*, the *Guardian Angel*, and the two *Angels* on the painting frame (1687) in the Church of the Morticelli in Foggia, Italy, exhibit unusual decorative rhythms and a strong new pictorial sensibility that tend to refine the sensual Late Baroque forms and verge on proto-Rococo.

The *Four Parts of the World*, in silver, ebony, and precious stones (1691–92, Cathedral of Toledo, Spain), are among the greatest accomplishments of contemporary European sculpture. Apparently presented to the Spanish King Charles II by Francisco de Benavides, viceroy in Naples from 1687 to 1696, they were eventually bequeathed to the cathedral by Charles's widow. Two singular gilded terracotta models depicting *Hercules Strangling the Nemean Lion* and *Hercules Killing the Hydra* (Museo Filangieri, Naples) illustrate Vaccaro's debt to the paintings of Luca Giordano.

Vaccaro had started a masterpiece that remained unfinished because of his tragic death, namely, the bronze *Equestrian Monument to Philip V* in Piazza del Gesù in Naples (1703–05). The statue was destroyed in 1707, but two copies made by Vaccaro himself in

one-third the original size remain at the Prado in Madrid, Spain.

Vaccaro was also appreciated as a portraitist, through liege to the teachings of Andrea Bolgi and Ercole Ferrata, sculptors whose work was present in Naples at the time). At least three marble pieces should be mentioned: the *Portrait of Giacomo Galecta* (1677, Cathedral of Naples), the *Portrait of Councillor Francesco Rocco* (1678, Church of the Pietà dei Turchini in Naples), and the *Portrait of Vincenzo Petra* (Church of S. Pietro a Maiella in Naples).

Domenico Antonio Vaccaro 1678–1745

Domenico Antonio Vaccaro, son of the sculptor Lorenzo, received his early training in his father's shop. He spent a short time in Franceso Solimena's shop, but soon left, "carried away by his great passion to paint from invention" (De Dominici). He worked as a sculptor, painter, and architect in Naples and the Kingdom of the Two Sicilies, creating innumerable projects, drawings and models for ornamental plasterwork, altars, ciboria, and lavabos, related above all to his intense activity as an architect. However, his training as a dazzling and refined painter intent on re-creating a style dependent upon Neo-Mannerism, the Genoese tradition, and from Neapolitan painting enabled him to temper in his sculpture the strong plastic and structural emphasis inherited from his father's style. Thanks to his versatility, fervid inspiration, and technical skill, Vaccaro accelerated Neapolitan art's departure toward the Rococo. Moreover, he expressed a rediscovered and renewed cultural identity by combining the highest instinctive qualities of a talented sculptor and painter, architect, scenographer, director, and formidable decorator. His small but important sculptural opus centers essentially on works executed for the Certosa di San Martino and the Church of San Paolo Maggiore in Naples. These were produced over a fairly long period and enable us to see the developments and modernity of his Rococo language. In 1706, after his father's sudden death, Domenico apparently had to finish Lorenzo's statue of *Preaching* (marble) and rework his *Prophecy* (marble), both for St. John the Baptist's chapel in the Church of the Certosa di San Martino. According to archive documents, in 1707 he completed the marble *Solitude* and in 1708 the marble *Penitence* for St. Bruno's chapel in the same church. Although both of these were based on Lorenzo's models, they show the signs of a moderate transition from Late Baroque to the freer forms typical of the 18th century. In the younger Vaccaro's interpretation, Lorenzo's solid volumetric arrangement of transversal planes connected internally by a sinuous rhythm becomes a supple curved pose, and the drapery is well ordered and arranged with a proto-Rococo taste for painterly effects and lighter decorative rhythms.

In 1718–19, at the full splendor of his artistic maturity, Domenico modernized the formerly Gothic Cappella di S. Giuseppe in the Certosa di San Martino with luxuriant gilded plasterwork. Medallions with prophets, putti, cherubs, columns, luxurious frames, and a huge drape contribute to the creation of one of the masterpieces of Neapolitan art during the Austrian vicereign, defining Vaccari's idea of making architecture an all-encompassing experience in which painting, sculpture, and decoration converge. In 1720–25 he executed the marble decoration of the chapel of S. Gennaro in the same church. His proposal for this sumptuous interior in the "Roman" style doubtless responded to the Carthusians' wishes. The arduous enterprise was condensed in the two statues of *Faith* and *Martyrdom*, the monumental high relief on the altar depicting *The Trinity and the Virgin Consigning the Keys of the City of Naples to St. Gennaro*, and four medallions with the *Evangelists* in high relief; the latter are among the greatest masterpieces of 18th-century sculpture. Vaccaro's work at Certosa di San Martino ended with the *Apotheosis* in the Rosary chapel, whose pavement he had designed in 1718.

Vaccaro's enterprise at the Church of San Paolo Maggiore centers on a (signed) marble statue of the *Guardian Angel*, probably executed before the end of 1724. This is a magnificent personal interpretation of the most striking angel figures created by Solimena, free from classicist academic influences and unreservedly seeking joyous and sensual Rococo images. In the four marble bas-reliefs depicting *Stories from the Life of St. Gaetano* (1719–24), the relief is graduated to exploit the luministic and atmospheric possibilities to the maximum, with dreamy levity and mobility and with a chromatic texture that are the equivalent of Vaccaro's most stunning touches. In the relief depicting *The Miraculous Healing of Niccolò Caffarelli*, Vaccaro takes up again, with only slight variations, the central part of a sketch of *St. Dominic Resuscitating Cardinal Stefano Creini's Nephew* (Museo Duca di Martina, Naples) he had painted before 1709 and submitted as a proposal for the ceiling fresco in the vestry of San Domenico Maggiore in Naples (the Dominican fathers had turned it down and awarded the commission to Solimena).

Teodoro Fittipaldi

Lorenzo Vaccaro 1655–1706

Biography
Born 10 August 1655 in Naples. Died 10 August 1706 in Torre del Greco from shotgun wounds inflicted in a fight over property lines.

Selected Works

ca. 1677 *Portrait of Giacomo Galeota*; Carrara marble bas-relief; Galeota Chapel, Cathedral of Naples, Italy

ca. 1678 *Portrait of Councillor Francesco Rocco*; Carrara marble statue; Church of Pietà dei Turchini, Naples, Italy

1679 Five *Medallions with Saints*; Carrara marble bas-reliefs; Spire of St. Dominic of Guzman, Piazza San Domenico Maggiore, Naples (executed from Vaccaro's models)

1680–85 *Telamon Angels*, putti, decorations; stucco statues and bas-reliefs; Chapels of the Virgin of the Immaculate Conception and of Sts. Clare, Anthony of Padua, and Theresa of Avila, Church of Gesù delle Monache, Naples, Italy

1687 *St. Michael Archangel, the Guardian Angel*, two angels; Carrara marble statues; Morticelli church, Foggia, Italy

ca. 1689 *St. Helena, Constantine, Glory of the Eternal Father with Cherubs and a Putto*; two *Angels with Adoring Putti*; stucco statues; Cappella del Crocifisso, S. Giovanni Maggiore, Naples, Italy

1691–92 *The Four Parts of the World*; statue in silver, precious stones and ebony; Cathedral of Toledo, Spain

1692–97 *Hercules Strangling the Nemean Lion, Hercoles Killing the Lernaean Hydra*; gilded stucco statues; Museo Filangieri, Naples, Italy

1693–98 Saints, angels, putti, cherubs, floral decorations; stucco statues, and high- and low-reliefs; choir, transept and dome, Church of Sant'Agostino degil Scalzi, Naples, Italy (executed with assistants)

1702–05 *Equestrian monument to Philip V*; bronze group (destroyed); Piazza del Gesù, Naples, Italy

1705 Two *Putti*; Carrara marble statues and frame; St. Bruno's chapel, Church of the Certosa di San Martino, Naples, Italy

1705–06 *Prophesy, Preaching, Penitence, Solitude*; Carrara marble statues; chapels of St. John the Baptist and St. Bruno, Church of the Certosa di San Martino, Naples, Italy (executed from Vaccaro's models; left unfinished to varying degrees at his sudden death; completed by son Domenico Antonio)

ca. end of 17th century *Portrait of Vincenzo Petra*, Carrara marble statue; Church of San Pietro a Maiella, Naples (attributed)

Domenico Antonio Vaccaro

Biography

Born 3 June 1678 in Naples. Died 5 July 1745 in Naples.

Selected Works

1706–07 *Preaching, Prophecy*; Carrara marble statues; St. John the Baptist's chapel, Church of the Certosa di San Martino, Naples, Italy (completed from father Lorenzo's work)

1707 *Solitude*; Carrara marble statue; St. Bruno's chapel, Church of the Certosa di San Martino, Naples, Italy

1708 *Penitence*; Carrara marble statue; St. Bruno's chapel, Church of the Certosa di San Martino, Naples, Italy

1709 *Busts of Sts. Martin and Gennaro*; Carrara marble; Great Cloister, Church of the Certosa di San Martino, Naples, Italy

ca. 1720–25 *The Trinity and the Virgin Consigning the Keys of the City of Naples to St. Gennaro*; four *medallions with the Evangelists*; *Faith* and *Martyrdom*; Carrara marble statues and high and low reliefs; St. Gennaro's chapel, Church of the Certosa di San Martino, Naples, Italy

1723–24 *Guardian Angel*; Carrara marble group; Church of S. Paolo Maggiore, Naples (signed)

1719–24 *St. Gaetano Twists the Sleeping Niccolò Caffarelli's Hand, The Miraculous Healing of Niccolò Caffarelli, The Infant Christ Appears to St. Gaetano on Christmas Night, Christ Showing the Cross to the Dying St. Gaetano*; Carrara marble reliefs; upper body of the Church of S. Paolo Maggiore, Naples

Further Reading

Fittipaldi, T., *Scultura Napoletana del Settecento*, Naples, 1980, with preceding bibliography.

Civiltà del Seicento a Napoli, exhibition catalogue, vol. 2, Naples, 1984

Catello, E., *Sanmartino*, Naples, 1988

Settecento napoletano. Sulle ali dell'aquila imperiale 1707–1734, exhibition catalogue, Naples, 1994

Catello, E., *Argenti napoletani del Seicento. Considerazioni du documenti inediti*, in *Ricerche sul '600 napoletano. Saggi e documenti 1998*, Naples, 1999

Pasculli Ferrara, M., *Arte napoetana in Puglia dal XVI al XVIII secolo*, Fasano 1983

SAINTS MARK, MATTHEW, LUKE, AND JOHN THE EVANGELIST

Domenico Antonio Vaccaro (1678–1745)

ca. 1720

Carrara marble, inlaid polychrome marbles

St. Gennaro's Chapel, Church of the Certosa di San Martino, Naples, Italy

These sculptures, executed by Domenico Antonio Vaccaro around 1720, display on the one hand stylistic similarities with his gilded stucco *Prophets* (1718–19) in the adjacent Cappella di S. Giuseppe, and on the other a close attention to Solimena's luminous painting in Naples. Solimena was then working along the same lines as Giacomo Del Po and Francesco Peresi, open to Rococo solutions of extraordinary decorative effect and lively formal refinements, with a more clearly "profane" taste even in the treatment of sacred themes. Vaccaro's are marked by a new formal concreteness and a studied structural and compositional monumentality. Devoid of any rhetorical or academic intention, they clearly reflect a proud, emulative competition. The electric vitality of the nudes and the drapery, and the vigorous plastic sense in a naturalistic key, take second place to glossy luminosities and to a palette of delicate and precious hues, as in Vaccaro's own paintings. Vaccaro used colored marbles in the backgrounds of the medallions and colored inlays in the frames to enhance their chromatic effect. In them, Vaccaro creates touches of genuine poetry and modernity that anticipate Giuseppe Sanmartino's finest works.

The results are very different from those achieved in the other marbles Vaccaro did for the same chapel (completed in around 1725). In the statues of *Faith* and *Martyrdom* (where the treatment of the beautiful nude is closely related to that of the *Guardian Angel*, about 1724, in the Church of San Paolo Maggiore, Naples), which partake of a refined Rococo classicism, Vaccaro seems to be approaching the intents of the purist Solimena of those same years. This development reappears in the monumental high relief on the altar, which depicts *The Trinity and the Virgin Consigning the Keys of the City of Naples to St. Gennaro*. The correct execution of the relief displays its celebratory concerns, which were partly due "to a craving for grandeur, or perhaps to an explicit polemic" with the old painting by Battistello Caracciolo on the same altar, which the monastic community, responding to the new winds of taste and constantly in pursuit of artistic feats, decided to replace with Vaccaro's marble. Not by chance, this was the first marble altarpiece installed in Naples in the 18th century, and it was followed only in 1766 by Francesco Celebrano's *Deposition* in the Cappella Sansevero, Church of Santa Maria della Pietà dei: Sangro, Naples.

TEODORO FITTIPALDI

Further Reading

Fittipaldi, T., *Scultura Napoletana del Settecento*, Naples, Italy, 1980

FILIPPO DELLA VALLE 1698–1768

Italian

Filippo della Valle was a popular artist in his day, possessing great technical facility and an ability to satisfy the academic tastes of contemporary patrons. Born in Florence, he studied under his uncle Giovanni Battista Foggini, who had been a pupil of Ercole Ferrata in Rome. Della Valle's early training consisted of modeling ancient statues, particularly those at the Galleria degli Uffizi, Florence. He also learned the art of metalworking from Foggini or possibly Massimiliano Soldani Benzi, striking a portrait medallion, *Cosimo III, Grand Duke of Tuscany*, early in his career. With Foggini's death in 1725, della Valle moved to Rome to continue his studies and seek papal commissions.

Della Valle quickly made a name for himself in Rome, sharing first prize with Pietro Bracci in a competition sponsored by the Accademia di San Luca for his relief *Josiah Assigning Money for the Temple*. Although contemporaries praised the relief for its technical mastery and classicizing composition, della Valle remained an assistant, entering the studio of Camillo Rusconi. He stayed there until Rusconi's death in 1728, at which time he established his own studio. His first independent public commission was for a bust of a Vatican magistrate, *Carlo Cerri*. In a manner strongly reminiscent of Gianlorenzo Bernini's bust of Gabriele Fonseca (*ca.* 1668–75), Cerri leans forward from his frame, his head turned toward the altar. Unlike Fonseca, Cerri maintains a stoic expression, typical of 18th-century Italian art. The lack of drama, the clarity of form, and subdued quality of the bust is representative of della Valle's style.

During the 1730s, della Valle's activity and reputation steadily increased. His most important commission came from Pope Clement XII (family name Corsini), who assembled the best artists in Rome to work on his familial funerary chapel in the Basilica of San Giovanni in Laterano. Della Valle received the commission to execute the statue of *Temperance* for the chapel, one of four Cardinal Virtues that occupies its

corners. His *Temperance* closely resembles Alessandro Algardi's *Liberality* from the tomb of Leo XI (1634–44) in St. Peter's Basilica, Rome, both in terms of its pose and its quiet, dignified manner. Della Valle's figure, however, is more dynamic owing to the strong S-curve formed by her twisting frame.

The S-curve appears throughout della Valle's work, as in the figure of Religion from his tomb of Sir Thomas Dereham. Dereham was the first in a long line of Englishmen to employ della Valle, whose classicizing style satisfied the British vogue for antique statuary. At the center of the tomb is a relief portrait of Dereham. Its sharply delineated curls and massive drapery folds are unusual for della Valle, whose portraits tend to be more severe, as in the monument to Emanuelle Pereira da Sampaio. Della Valle nevertheless inherited a predilection for ornament from Foggini. In his *St. Teresa in Glory*, for example, he surrounded the saint with a swirling mass of drapery to convey her religious ecstasy. As his work matured, such decorative elements became increasingly finer in detail. In his relief of the *Annunciation* for the Jesuit Church of Sant'Ignazio, Rome, della Valle even carved the coils of straw used to construct the basket in the foreground.

A similar attention to detail appears in della Valle's tomb of Innocent XII in St. Peter's Basilica. In his will, Pope Innocent requested to be buried in a simple urn. Nevertheless, his nephew Cardinal Vincenzo Petra commissioned della Valle to execute a monumental tomb for his uncle with the aid of designs by Ferdinando Fuga. The tomb resembles a pyramid, following a tradition established by Guglielmo della Porta's tomb of Pope Paul III Farnese (1549–75; St. Peter's Basilica). Its location above a doorway immediately recalls Bernini's tomb of Pope Alexander VII (1671–78), although Innocent's tomb is shallower and slightly slanted toward the viewer. Also unlike the monumentalizing papal depictions of the Renaissance, della Valle does not represent Pope Innocent as a vigorous or heroic character but reveals him to be an old man. Pope Innocent would have disapproved of the tomb; not only did its grand scale disagree with his asceticism, but its very construction recalled a problem he had fought to correct—papal nepotism.

The pope at the time, Benedict XIV, did not share Pope Innocent's concerns and fully supported Cardinal Petra's project. This is not surprising given Benedict's interest in art and his efforts to prepare Rome for the upcoming jubilee in 1750. To this end, he commissioned a series of statues representing founders of religious orders for St. Peter's Basilica. Della Valle was responsible for two of the six statues, *St. John of God* and *St. Teresa*. Neither figure was entirely his conception; Pietro Bianchi collaborated on the design of *St. John of God*, and Rusconi's *Saint John the Evangelist*

(1709–12) in the Basilica of San Giovanni in Laterano provided the basic model for *St. Teresa*. Yet both works remain true to della Valle's simple elegance, which reaches a new height here as his usual attention to detail is replaced with an awareness of the broad forms required by large-scale sculpture. This change is also evident in his roughly contemporaneous statues *Health* and *Fertility* for the Trevi Fountain (mid 18th century) in Rome, which rework designs for earlier projects such as *Temperance* in a more lucid fashion.

The figures for the Trevi Fountain were della Valle's last major project. He was assisted by Giovanni Battista Grossi, whose work represents the truest expression of della Valle's style among the next generation of artists. Della Valle's lack of further influence is surprising considering that he was one of the most important artists active in Rome during the second and third quarter of the 18th century, with contemporaries praising his work as equal to that of the greatest sculptors of any period. As with many other artists of the age, however, he eventually fell into obscurity, only to be rediscovered in the late 20th century.

DAVID L. BERSHAD AND GABRIELLA SZALAY

See also **Ferrata, Ercole; Foggini, Giovanni Battista; Rusconi, Camillo**

Biography

Born in Florence, Italy, 26 December 1698. Studied with uncle, sculptor Giovanni Battista Foggini, who taught modeling in style of ancients; learned metalworking from Foggini or Massimiliano Soldani Benzi; moved to Rome in 1725 after uncle's death; worked as assistant to Camillo Rusconi until his death; won first prize for relief at Accademia di San Luca, Rome, 1725; established independent studio, 1728; elected member of Accademia di San Luca, 1730, and director in 1752, 1753, 1760, and 1761. Died in Rome, Italy, 29 April 1768.

Selected Works

1723	*Cosimo III, Grand Duke of Tuscany* medallion; gilded bronze; Museo Nazionale del Bargello, Florence, Italy
1725	*Josiah Assigning Money for the Temple;* terracotta; Accademia di San Luca, Rome, Italy
ca. 1729	*Carlo Cerri*; marble; Cerri Chapel, Church of Il Gesù, Rome, Italy
1732–35	*Temperance*; marble; Corsini Chapel, Basilica of San Giovanni in Laterano, Rome, Italy

1738	*St. Teresa in Glory*; marble; Chapel of Santa Teresa, Church of Santa Maria Delia della Scala, Rome, Italy
1739	*Justice and Religion*; marble; central door, Palazzo della Consulta, Rome, Italy
1739–41	Tomb of Sir Thomas Dereham; marble; Church of San Tommaso degli Inglesi, Rome, Italy
1742	Monument to Clement XII; marble; Church of San Giovanni dei Fiorentini, Rome, Italy
1745	*St. John of God*; marble; St. Peter's Basilica, Rome, Italy
1746	Tomb of Innocent XII; marble; St. Peter's Basilica, Rome, Italy
1750	*Annunciation*; marble; Church of Sant'Ignazio, Rome, Italy
1754	*St. Teresa*; marble; St. Peter's Basilica, Rome, Italy
1756	Monument to Emanuelle Pereira da Sampaio; marble; Chapel of the Immaculate Conception, Church of Sant'Antonio dei Portoghesi, Rome, Italy
1759–62	*Health* and *Fertility*; marble; Trevi Fountain, Rome, Italy

Further Reading

Baldinucci, Francesco Saverio, *Vite di artisti dei secoli XVII–XVIII*, Rome: De Luca, 1975

Honour, H., "Filippo della Valle," *The Connoisseur* 144 (1959)

Minor, Vernon Hyde, "Filippo della Valle's Monument to Sampaio: An Attribution Resolved," *The Burlington Magazine* 117 (1975)

Minor, Vernon Hyde, "Della Valle and G.B. Grossi Revisited," *Antologia di Belle Arti* 2 (1978)

Minor, Vernon Hyde, "Della Valle's Last Commission," *The Burlington Magazine* 92 (1980)

Minor, Vernon Hyde, "Filippo della Valle as Metalworker," *The Art Bulletin* 66 (1984)

Minor, Vernon Hyde, "Filippo della Valle's Tomb of Innocent XII: Death and Dislocation," *Gazette des Beaux-Arts* 112 (1988)

Minor, Vernon Hyde, *Passive Tranquillity: The Sculpture of Filippo Della Valle*, Philadelphia, Pennsylvania: American Philosophical Society, 1997

Riccoboni, Alberto, *Roma nell'arte: La scultura nell'evo moderno dal Quattrocento ad oggi*, Rome: Casa Editrice Mediterranea, 1942

VAN BOSSUIT, FRANCIS

See **Bossuit, Francis van**

VAN DEN BROECK, WILLEM

See **Broeck, Willem van den**

VAN DER SCHARDT, JOHANN GREGOR

See **Schardt, Johann Gregor van der**

VAN TRICHT, ARNT

See **Tricht, Arnt van**

VAN WESEL

See **Wesel, Adriaen van**

VECCHIETTA (LORENZO DI PIETRO) 1410–1480 *Italian*

Lorenzo di Pietro, known as Vecchietta, was baptized in 1410 and is listed for the first time in the *Ruolo dei pittori senesi* (list of members of the Siena painters' guild) of 1428. His first documented artwork is a pair of painted wooden figures, now lost, for an *Annunciation*, intended for the high altar of the Cathedral of Siena. Prior to this the young artist painted alongside Masolino da Panicale in the Lombard Collegiata di Castiglione Olona. The frescoed details attributed to Vecchietta in the choir of the Collegiata show examples of foreshortened figures and faces that illustrate the artist's keen interest in Masaccio's solutions to problems of perspective. These early paintings imply an artistic formation drawn from the combined Sienese-Florentine cultures of the artists Il Sassetta, Masolino da Panicale, and Masaccio.

Until recently the corpus of Vecchietta's early sculpted works was inflated by the presence of two additional wooden polychromatic sculptures. These pieces, a *Resurrected Christ* and a *Madonna and Child*, have since been identified with the sculptor Domenico di Niccolò de' Cori. However, the misleading identification of these works with Vecchietta produced a confused understanding of his artistic personality, which was neatly but incomprehensibly divided into two distinct phases: an early phase characterized by the elegant elongated lines of 14th-century Sienese Gothic art and a mature phase in which he rejected his Sienese background completely and became a fervent disciple of the new Renaissance style proposed by the avant-garde artists of Florence. The sculptural production during this supposed first stage was contradicted by the indisputable Florentine influences perceived in the artist's juvenile contributions to the frescoes in Castiglione d'Olona. It is now clear that Vecchietta was among the first of the 15th-century Sienese artists to fully comprehend the stylistic innovations proposed

by artists such as Masaccio, Donatello, and Domenico Veneziano, and that this formation was based on consistent and attentive study of Florentine artistic production throughout his career.

Vecchietta's repertoire has been further diminished by the elimination of two bronze tomb *gisants* (reclining figures). The tomb of Cardinal Pietro Foscari (*d.* 1485) in Santa Maria del Popolo in Rome has been securely attributed to Giovanni di Stefano, the son of the Sienese artist Il Sassetta, active from the 1460s. Recent criticism has also raised doubts as to the reliability of a 16th-century document linking the tomb of Mariano Sozzini il Vecchio (*d.* 1467) to Vecchietta. On stylistic grounds the bronze effigy has been attributed to Vecchietta's pupil Francesco di Giorgio.

An initial brief apprenticeship with Domenico di Niccolò de' Cori on Vecchietta's part has been suggested. However, it is Donatello who seems to have inspired the artist from the initial stages of his sculpting career. The intense grief on the face of the Virgin in Vecchietta's *Pietà*, the all-too-realistic representation of the dead figure of Christ, and the three-dimensional isolated composition of the sculptural group confirm that Vecchietta's interest in Donatello's work originated well before the Florentine master's presence in Siena between 1457 and 1459. As a young artist Vecchietta must have admired Donatello's bronze casts on the baptismal font in the Sienese Baptistery (1427–30). In fact, Vecchietta's bronze work shows closer affinity to these smooth surfaces than to the constant play of vibrating light reflections that characterize the artworks produced by Donatello in his later Sienese period.

The two marble figures of *Saint Peter* (1458–62) and *Saint Paul* (1458–59) sculpted by Vecchietta for the Loggia della Mercanzia in Siena betray a profound firsthand study of Donatello, made possible by the latter's presence in the city during the period directly preceding their execution. Their natural poses, the fall of the drapery, their accurate anatomical descriptions, and their presence, which refuses to retract submissively into the architectural niche behind but stands imposingly before it, made these figures worthy replacements for the original *St. Peter*, which was conceived and sculpted as a high relief for the loggia in 1457 by Antonio Federighi.

In 1467 Vecchietta presented a model for the Rocca di Sarteano (fortress at Sarteano), which was designed in collaboration with Guidoccio d'Andrea. Vecchietta followed this with further design projects for fortifications in Orbetello and Montauto. On 26 April of the same year, the artist received his most important commission: the bronze ciborium (1467–72) for the high altar of the Church of the Annunziata at the Spedale di Santa Maria della Scala in Siena. Vecchietta had

Saint Bernardino of Siena
© Arte & Immagini srl/CORBIS

submitted a preparatory painting on canvas of his intended composition for the hospital's approval; it is preserved today in the Pinocoteca Nazionale, Siena. A payment of 1,100 florins and the artist's right to live the rest of his life in the house/workshop where work on the tabernacle had been carried out, in addition to an extra sum of 50 florins, were conferred to the artist 29 November 1472. The bronze architectural piece, ornate with its 25 figures cast in full relief, must have been one of Siena's most elaborate artistic creations of the second half of the 15th century, and its presence would have firmly established bronze casting as the ultimate technique among Sienese sculptors of the day. The ciborium was so highly esteemed that the Sienese government decided to transfer it from the hospital church to the high altar of the Cathedral of Siena in 1506. It was finally placed in its present position on the high altar, designed by Baldassare Peruzzi, in 1536.

A bronze plaque in the Frick Collection, New York, showing the *Resurrection of Christ* is signed by Vecchietta and dated 1472. The relief work alludes to the artist's probable inspiration presented by Donatello's lost models for the bronze doors of the Cathedral of Siena. Here, Vecchietta interprets the Florentine artist's late style, insisting on smooth finished surfaces and ignoring the spatial illusionism so integral to Donatello's reliefs.

After completing two sculptures for the city of Narni in Umbria in the first half of the 1470s, Vecchietta is recorded as having presented a petition, dated 20 December 1476, to the Spedale di Santa Maria della Scala requesting the right to decorate a funerary chapel for himself and his wife to be dedicated "al nome del Salvadore" (in the name of our savior). The boldness of the artist in requesting such a privilege and the fact that it was granted illustrate the elevated social standing enjoyed by a class of artists during the Renaissance. The chapel was dismantled not long after Vecchietta's death. The bronze figure of the *Risen Christ* (1476), which originally adorned the altar, was preserved and is now housed in the hospital church. The figure, with its elegant poise and polished finish, continues to display Donatellian influences in the realistic detailed attention paid to the musculature, bone structure, and veins, which sinew over the nude surfaces of Christ, and in the intense emotional pain expressed by the body position and facial features. At his death in 1480 Vecchietta left unfinished his work on the wood reliefs of the death of the Virgin and the assumption of the Virgin for the Church of San Frediano in Lucca, which were completed by his pupil Neroccio di Bartolomeo de' Landi.

PIPPA SALONIUS

Biography

Baptized in Siena, Italy, August 1410. Lorenzo di Pietro known as Vecchietta; enrolled in Ruolo dei Pittori Senesi (list of members of the Siena painters' guild), 1428; influenced by Florentine art, in particular Donatello; painter, sculptor, goldsmith, and architect; as sculptor he worked in wood and marble in early years, later in bronze; did choir frescoes in the Collegiata di Castiglione Olona, Lombardy, *ca.* 1435–39, working alongside the artists Masolino da Panicale and Paolo Schiavo; also painted frescoes in chapel of Cardinal Branda's palace in Castigliorie Olona, created bronze sculptures for the Cathedral of Siena, and designed funerary chapel for wife and self at Spedale di Santa Maria della Scala, Church of the Annunziata, Siena, 1476–77; included Pope Pius II among his patrons. Died in Siena, Italy, 6 June 1480.

Selected Works

1440–45 *Saint James the Less*; painted wood; private collection

ca. 1445 *Pietà*; painted wood; Parrocchia di San Donato in San Michele Arcangelo, Siena, Italy

1458–59 *Saint Paul*; marble; Loggia della Mercanzia, Siena, Italy

1458–62 *Saint Peter*; marble; Loggia della Mercanzia, Siena, Italy

1467–72 Ciborium for Spedale di Santa Maria della Scala; bronze; Cathedral of Siena, Italy

1472 *Resurrection of Christ*; bronze; Frick Collection, New York City, United States

before 1474 *Saint Bernardino of Siena*, for Church of San Bernardino a Narni; painted wood; Museo Nazionale del Bargello, Florence, Italy

1475 *Saint Anthony Abbot*; painted wood; Cathedral of Narni, Italy

1476 *Risen Christ*; bronze, marble; Spedale di Santa Maria della Scala, Church of the Annunziata, Siena, Italy

1480 *Death of the Virgin* and *Assumption of the Virgin* (latter finished by Neroccio di Bartolomeo de' Landi); painted wood; Museo Civico, Villa Guinigi, Lucca, Italy

Further Reading

Scultura dipinta: Maestri di legname e pittori a Siena, 1250–1450 (exhib. cat.), Florence: Centro Di, 1987

Bagnoli, Alessandro, "Donatello e Siena: alcune considerazioni sul Vecchietta e su Francesco di Giorgio," in *Donatello Studien*, edited by Monika Cämmerer, Munich: Bruckmann, 1989

Bellosi, Luciano, editor, *Francesco di Giorgio e il Rinascimento a Siena, 1450–1500*, Milan: Electa, 1993

Carli, Enzo, *Gli scultori senesi*, Milan: Electa, 1980

Del Bravo, Carlo, *Scultura senese del Quattrocento*, Florence: Editrice Edam, 1970

Munman, Robert, *Sienese Renaissance Tomb Monuments*, Philadelphia, Pennsylvania: American Philosophical Society, 1993

Rosenauer, Artur, "Die 'Madonna del Perdono'—Vecchietta als Mitarbeiter Donatellos," in *Musagetes: Festschrift für Wolfram Prinz su seinem 60. Geburtstag am 5. Februar 1989*, edited by Ronald G. Kecks, Berlin: Gebr. Mann, 1991

VINCENZO VELA 1820–1891 *Swiss, active in Italy*

Champion of the Italian *verismo* sculptural movement of the 19th century, Vincenzo Vela was born in Ligornetto in the Swiss canton of Ticino, near the Italian border. Although Swiss by birth, Vela is often categorized as an Italian artist because he studied in Milan and spent most of his active life in Turin. His baptismal record notes that he received the sacrament on 3 May 1820, but Vela himself said he was born in 1822. He began as a carver in the Besazio quarries at age 9 and was sculpting as early as the age of 12, when he worked as an apprentice to Zaverio Franzi. He also worked in Viggiù doing rough carving and as a stone dresser in

the Milanese cathedral workshops. Vela was influenced by the work of Lorenzo Bartolini, whose work moved from Neoclassicism toward a more realistic naturalism. One of Vela's earliest biographers, Romeo Manzoni, noted that Vela attended the Accademia di Brera, where he was the recipient of many prizes. After 1837 Vela transferred to the studio of Benedetto Cacciatori, a member and professor at Brera, with whom he studied until at least 1842.

Vela arrived in Rome in 1847, after winning the Accademia di Brera's grand prize, and began *Spartacus*, his first major work. Vela depicted Spartacus, an ancient Thracian slave who began a revolt against republican Rome, with his chains broken at his feet and rushing ahead, arms akimbo and fists tightly clenched. The Spartacus story was suggestive of the contemporary political troubles between Lombardy and Austria, struggles that resulted in wars in which Vela himself directly participated. He exhibited the plaster version of *Spartacus* in the Brera Exhibition in Milan in 1847 but did not complete the marble version, commissioned by Duke Antonio Litta, until 1850, because he was serving as a volunteer combatant in the Sonderbund War in November 1847 and the Lombard War of 1848 on the side of the Swiss. In 1852 Vela moved to Turin, where he remained for 15 years. There, he married Sabina Dragoni in 1853; they had a son the following year, whom they named Spartaco. *Spartacus* was exhibited at the Exposition Universelle in Paris in 1855, where it won an honorable mention from the jury. In 1856 Vela became professor of sculpture at the Accademia Albertina in Turin, where he held the highest teaching post at that time there and was certainly the leading sculptor in the city.

Although for most of his early career in Turin Vela did not often exhibit his work, this changed after 1861. He became known to the French court, receiving commissions from Emperor Napoléon III and the Empress Eugénie on more than one occasion, and in 1863 he was appointed to the rank of chevalier in the French Legion of Honor. Vela's marble sculpture *Last Days of Napoléon I*, begun in Turin right before he left that city permanently, was a great success at the Exposition Universelle of 1867 in Paris. Although many French critics, such as Maxime du Camp, did not appreciate the depiction of the ailing, defeated-looking emperor and were incensed by the overt realism in the carving, the supposed lack of heroic qualities in the work, and the sculpture's popularity, Napoléon III purchased *Last Days of Napoléon I* for Versailles, where it remains today. The emperor's fist hits the map precisely at Russia, the site of his most crushing defeat. Realistic and powerfully dramatic, depicting the seated emperor dressed in a nightgown and gazing forcefully upward toward a future that was for him not meant to be, *Last*

Spartacus
The Conway Library, Courtauld Institute of Art

Days of Napoléon I is certainly Vela's best known and most commanding work in the verismo style. It was typical of the many "life-cycle" images that were popular by midcentury and also of the numerous images of Napoléon I being produced throughout France. Bronze editions of the work also exist in private collections.

Vela resigned from the Accademia Albertina in 1867 and returned to his birthplace, Ligornetto, where he remained active, exhibiting in Europe, as well as at the 1876 Universal Exhibition in Philadelphia. Vela also completed nearly 100 portrait busts and numerous funerary monuments and tombs throughout his career. He was extremely popular with middle-class patrons, from whom he received the majority of his commissions. As late as 1882, he began one of his most intense and political works, a bronze relief entitled *Victims of Labor*. The relief commemorated the workers of the Saint Gotthard railway tunnel under the Alps, who died during the tunnel's construction, and Vela had hoped that the work would be placed at its entranceway. The

work depicts five figures: two bare-chested, gloomy-faced men carry the expired body of one of their fellow workers on a stretcher, while two others carry small lanterns and continue to toil. Vela poignantly and severely rendered here the heroic qualities of the common man. The subject proved to be too sensitive and was unpopular with the authorities; it was not placed at the entranceway to the tunnel, nor was it cast into bronze until 1932, more than 40 years after Vela's death.

Fascinating but less familiar to a general audience, the artists of the *verismo* movement attempted to reproduce reality in art with accuracy, yet they were also indebted to the first modern realist sculptor, Donatello. Vela and his realist contemporaries, such as Adriano Cecioni, Achille D'Orsi, and Vincenzo Gemito, were of major importance to the history of 19th-century sculpture in Italy.

Vela died at his home at Mendrisio in Ticino and was buried in a tomb designed by his students and his close friend, the architect Augusto Guidini.

CATERINA Y. PIERRE

Biography

Born in Ligornetto, Switzerland, 3 May 1820. Worked as apprentice first in Besazio and Viggiù, Italy, then Milan; studied at Accademia di Brera, Milan, *ca.* 1837; apprenticed to Benedetto Cacciatori until 1842; moved to Rome, 1847, and settled in Turin, 1852; married Sabina Dragoni, 1853; had one son, Spartaco; exhibited *Spartacus* at Exposition Universelle, Paris, 1855, and won honorable mention; appointed professor of sculpture at Accademia Albertina, Turin, 1856; resigned teaching position and returned to Ligornetto, 1867; exhibited at Exposition Universelle, Paris, 1867, at Universal Exhibition, Philadelphia, Pennsylvania, 1876, and at various international exhibitions throughout the 1870s and 1880s. Died in Mendrisio, Switzerland, 3 October 1891.

Selected Works

1846	*Morning Prayer;* marble; private collection, Milan, Italy
1847	*Spartacus;* plaster; Museo Vela, Ligornetto, Switzerland; marble version: 1850, Musée d'Art et d'Histoire, Geneva, Switzerland
1852	*Desolation;* marble; Villa Ciani, Lugano, Switzerland
1855	*Gaetano Donizetti;* bronze; Church of Santa Maria Maggiore, Bergamo, Italy
1860–65	*Massimo d'Azeglio;* plaster; Museo Vela, Ligornetto, Switzerland
1866–67	*Last Days of Napoléon I;* marble; Château, Versailles, Yvelines, France
1867	*Last Days of Napoléon I;* bronze; private collection, United States
1882–83	*Victims of Labor;* plaster; Museo Vela, Ligornetto, Switzerland; bronze cast: 1932, Galleria Nazionale d'Art Moderna, Rome, Italy

Further Reading

Bassaglia, Rossana, *Arte e socialità in Italia dal realismo al simbolismo, 1865–1915*, Milan: La Societá per le Belle Arti ed Esposizione Permamente, 1979

Fusco, Peter, and H.W. Janson, editors, *The Romantics to Rodin: French Nineteenth-Century*

Janson, H.W., "Realism in Sculpture: Limits and Limitations," in *The European Realist Tradition*, edited by Gabriel P. Weisberg, Bloomington: Indiana University Press, 1982

Janson, H.W., *Nineteenth-Century Sculpture*, New York: Abrams, and London: Thames and Hudson, 1985

Lavagnino, Emilio, *L'arte moderna, dai neoclassici ai contemporanei*, 2 vols., Turin, Italy: Unione Tipografico—Editrice Torinese, 1956

Meyer, Peter, *Art in Switzerland, From the Earliest Times to the Present Day*, translated by Mary Hottinger, Zürich: Schweizer Spiegel, and London: Nicholson and Watson, 1946

Scott, Nancy J., *Vincenzo Vela, 1820–1891*, New York: Garland, 1979

Sculpture from North American Collections (exhib. cat.), Los Angeles: Los Angeles County Museum of Art, and New York: Braziller, 1980

Wardropper, Ian, and Fred Licht, *Chiseled with a Brush: Italian Sculpture, 1860–1925, from the Gilgore Collections* (exhib. cat.), Chicago: Art Institute of Chicago, 1994

VENUS DE MILO

150 BCE
Anonymous
marble
h. 2.04 m
Musée du Louvre, Paris, France

The *Aphrodite of Melos*, or *Venus de Milo*, is an over-life-size marble statue depicting a woman who wears a slipping mantle draped around her lower body. Holes in the earlobes and around the upper arm indicate that the statue also featured earrings and an armlet made of metal. The ideal physiognomy of the nude upper body, in conjunction with the risqué drapery and jewelry, identify the subject as the goddess Aphrodite.

The statue was found in 1820 on the island of Melos in several separately made, attachable pieces. The sexual appeal of the statue and its apparent status as an original Greek statue (as opposed to a Roman copy of a

Greek statue) led at once to an exaggerated evaluation. When it was given to King Louis XVIII of France in 1821, it was heralded as possibly the most beautiful female statue in the world, as an original masterpiece of Praxiteles (*ca.* 395 BCE–*ca.* 326 BCE), and as a predecessor to his fully nude statue of the *Cnidian Aphrodite*. This initial perception and interpretation, neither of which are maintained today, have made the statue the best-known ancient sculpture in the modern era and an immediately recognizable symbol of beauty.

At the end of the 19th century, German archaeologist Adolf Furtwängler evaluated the statue in an objective manner and entirely changed its scholarly conception (see Furtwängler, 1895). Focusing on the niche in which the statue was found, the inscriptions discovered with the statue, and the statue type, he showed that the Melian statue was a late Hellenistic revision of an earlier figure of Aphrodite.

Although the *Venus de Milo* was said to have been found amid marble rubble gathered for use in a lime kiln, Furtwängler pointed out that lime kilns are characterized by random fragments of numerous marble statues, whereas in this case, only the *Venus*, three complete herms, and an architrave inscription were discovered. Moreover, the inscription of the architrave recorded the dedication by a gymnasium official of an exedra, possibly a statue, and herms of Herakles. Given that the niche in which the *Venus* and the herms were found is similar to exedrae known in other ancient gymnasiums, that herms were typical decoration for gymnasiums, and that such an official would likely have made a dedication in a gymnasium, it can be said with some conviction that the statue was probably found *in situ* and was probably part of the decoration of an exedra in a gymnasium. The inscription is dated by its letter forms between 150 and 50 BCE.

Also found with the statue was part of a plinth that Furtwängler showed once fit perfectly against the left foot of the statue. It featured a raised area with a slot for the insertion of an object on its upper surface and an inscription on the front. The inscription reads "Agesandros," or "Alexandros" (a man's name), "son of Menides, from Antioch on the Meander, made this." Because the city of Antioch on the Meander was founded in 280 BCE and the sculptor is unknown, this portion of the statue was deliberately disassociated (and lost) in the early 19th century, when scholars wanted the statue to be an original work of the 4th-century BCE Praxiteles.

Whereas most famous statues from Classical Greece are known in Roman copies, there is no known copy of the *Venus de Milo*. The *Venus*, however, resembles in pose and drapery a 4th-century statue type known as the *Venus of Capua*, whose fame in antiquity is attested by the many Roman-period copies of it. The

Venus de Milo
© Alinari/Art Resource, NY

figure of the *Venus of Capua* type, which admired its reflection in a shield propped on the raised left leg and held by the left arm, differs from the *Venus de Milo* in that (1) the head of the *Venus of Capua* is viewed in profile and tilts downward, (2) the face of the *Capua* is less round and more regular, (3) the hair of the *Capua* is carefully rolled at the back so no locks fall onto the nape, (4) the upper border of its drapery does not dip suggestively at the small of the back, and (5) the fold patterns of its drapery follow smooth, curving parallel paths. The *Venus de Milo* was then a Hellenistic reworking of a well-known earlier statue best preserved in the *Venus of Capua*.

What the *Venus de Milo* was doing is not certain. It is generally accepted that the right arm reached downward across the body and held the drapery near the left knee. There is a dowel hole under the right breast into which a small strut connected to the arm would have been inserted to support the arm, and the folds of the drapery above the left knee are noticeably disturbed.

A left arm with a hand that held an apple was found at the same time as the statue. Many scholars believed that the quality of the arm was not equal to that of the body and, therefore, concluded that it did not belong with the statue. In addition, it was postulated that the *Venus de Milo* formed a group with a statue of Ares or held a shield, in both of which cases a left hand with an apple would have been inappropriate. Furtwängler, when he showed that the piece of the plinth with a slot in its upper surface did pertain to the statue, in essence proved also that to the statue's left was likely a small pillar that fit into the slot on the base. Pillars were common in Classical sculpture, and coins of Melos actually depict a statue of a female deity who leans on such a pillar. Thus Furtwängler reconstructed the statue's left arm resting on the small pillar with the hand dangling over the front edge; the apple would have been in the palm, the back of which, facing downward toward the ground, would not have been visible. This would explain why the hand was not as well finished as the body. The apple, *melos* in ancient Greek, may also have been a clever pun. The statue would have been in two different senses an *Aphrodite of Melos*.

JULIA LENAGHAN

Further Reading

Delivorrias, Angelos, "Aphrodite," in *Lexicon Iconographicum Mythologiae Classicae*, vol. 2, Zurich: Artemis Verlag, 1984

Fuchs, Werner, *Die Skulptur der Griechen*, Munich: Hirmer, 1969; 4th edition, 1993

Furtwängler, Adolf, *Masterpieces of Greek Sculpture: A Series of Essays on the History of Art*, edited by Eugénie Sellers, London: Heinemann, and New York: Scribner, 1895; reprint, Chicago: Argonaut, 1964

Hamiaux, Marianne, *Les sculptures grecques*, edited by Alain Pasquier, Paris: Réunion des Musées Nationaux, 1992–; see especially vol. 2

Haskell, Francis, and Nicholas Penny, *Taste and the Antique: The Lure of Classical Sculpture, 1500–1900*, New Haven, Connecticut: Yale University Press, 1981

Neumer-Pfau, Wiltrud, *Studien zur Ikonographie und gesellschaftlichen Funktion hellenistischer Aphrodite-Statuen*, by Neumer-Pfau, Bonn: Habelt, 1982

Pasquier, Alain, *La Vénus de Milo et les Aphrodites du Louvre*, Paris: Éditions de la Réunion des Musées Nationaux, 1985

Ridgway, Brunilde Sismondo, *Hellenistic Sculpture*, Madison: University of Wisconsin Press, and Bristol, Avon: Bristol Classical Press, 1990–; see especially vol. 2

Robertson, Martin, *A History of Greek Art*, London: Cambridge University Press, 1975; abridged edition, as *A Shorter History of Greek Art*, Cambridge and New York: Cambridge University Press, 1981

Smith, R.R.R., *Hellenistic Sculpture: A Handbook*, New York: Thames and Hudson, 1991

ROMBOUT VERHULST 1624–1698 *Dutch*

Rombout Verhulst was born in Mechelen (Malines), the son of a baker. He started his career in 1633, at the age of nine, as a pupil of the mediocre sculptor Rombout Verstappen, according to the archives of the local Guild of St. Luke. Probably after Verstappen's death in 1636, Verhulst entered the workshop of another Mechelen sculptor, Frans van Loo.

Until his emergence in Amsterdam in 1646, nothing more is known of Verhulst's artistic upbringing. There is no evidence that he visited Italy, as has been suggested by an 18th-century source. He might have been trained in Antwerp before moving to Amsterdam, but this cannot be corroborated by any documentary evidence. Stylistically, however, his later works owe much to the exuberant Baroque idiom of Peter Paul Rubens and the sculptor Lucas Faydherbe, in whose workshop Verhulst could have been working in the early 1640s.

In 1646 and 1651 he is documented as living in Amsterdam, and in 1652 he was listed as a member of the Amsterdam Guild of St. Luke. He was, at the time, already working at a major sculpture project in Holland, the decoration of the new city hall of Amsterdam (today the Royal Palace at the Dam Square in Amsterdam) under the guidance of the Antwerp sculptor Artus Quellinus I. In a 1654 poem by Jan Vos, Verhulst is praised together with Quellinus and painters such as Rembrandt, Govert Flinck, and Bartholomeus Van der Helst, which suggests that he was already counted among the most prominent artists of the guild.

This position is reflected by several works from the same period. Exceptionally, Verhulst was allowed to produce some works for the town hall under his own name. He signed three major works for the galleries of the new building, the reliefs *Silence* and *Fidelity* and the large figure of *Venus*. The warm realism of these works distinguishes him from the more Classical style of his master, Quellinus. This realism would become the hallmark of his style during the rest of his career in the Dutch republic, where he was to become the leading sculptor of his day.

During his work for the Amsterdam town hall, Verhulst was also engaged in another project of national importance, the funeral monument to one of the maritime heroes of Holland, Admiral Maarten Tromp. The design of this monument was made by Jacob van Campen, the architect of the Amsterdam town hall, but Verhulst was entrusted with the execution (Willem de Keyser was allowed to carve the relief on the sarcophagus but had no role in the design or the execution of the tomb as a whole). Both artists formulated an entirely new kind of monument, which reflected at the same time the ambitions of the Dutch republic as a world power and the importance of the individual hero for the well-being of the state. The combination of a classicist architecture and very realistic sculptures of the Tromp monument was repeated in several other Dutch monuments to naval heroes.

Tomb of Admiral Michiel Adriaanszoon de Ruyter
The Conway Library, Courtauld Institute of Art

In 1658 Verhulst moved to Leiden, where he was engaged in several projects of the city. He produced the reliefs for the facade of the new Boterwaag (weigh house), the Pesthuis (hospital), and the Burcht (castle), and he was given two major commissions for private funeral monuments. The monument in Katwijk aan de Rijn, made for the widow of Baron Willem van Liere, represents a typical protestant nobleman's tomb: the deceased is lying on his deathbed, while his reclining wife looks at him from behind. She displays the virtues of a noble Christian widow by guarding the memorial of her late husband. Typical also is the ostentatious display of coats of arms on this monument to underline the noble birth of the deceased baron.

The other monument, dating from the same year, was erected to Johannes Polyander van Kerckhoven, Lord of Heenvliet (a courtier from The Hague). The impressive effigy shows the deceased asleep in his nightdress and wearing his slippers and nightcap. In a most informal way, this monument conveys the idea of death as eternal sleep and implicitly the hope of resurrection without applying the traditional allegorical imagery from Catholic countries. The motif of the sleeping effigy was repeated by Verhulst in some other monuments, notably in Stedum and Midwolde. Its original iconography can be considered an important contribution to the development of a Protestant type of tomb.

In 1664 Verhulst settled in The Hague, where he could expect more commissions from noble patrons, the court of the family of Orange, and from the States-General. He was to stay in The Hague until his death in 1698, producing a series of funeral monuments for several naval heroes, such as Willem van der Zaan (Old Church, Amsterdam), Willem Josef van Gendt, the brothers Evertsen (Abbey, Middelburg), Isaac Sweers (Old Church, Amsterdam), and Michiel Adriaanszoon de Ruyter. Among the private commissions,

the tomb to Duke Hieronymus Tuyl van Serooskerken (Stavenisse) is the most important. It seems that the Zeeland regent Jacob van Reygersbergh, who resided in The Hague, was instrumental in securing several of the private commissions; he was probably involved in the Katwijk monument as well as the wall monuments for Joannis van Gheel (Spanbroek) and the Thibaut family (Aagtekerke). In 1672 Jacob van Reygersbergh also had his own portrait carved by Verhulst, of which both the marble version and the terracotta model (Rijksmuseum, Amsterdam) are preserved. This portrait ranks among the finest 17th-century Dutch busts and testifies to the technical abilities of Verhulst. His qualities as a portrait sculptor are also evident in some other terracotta busts and portrait studies of Maria van Reygersbergh, and the admirals van Gendt and De Ruyter (Rijksmuseum, Amsterdam). In the 1680s it seems that Verhulst's production began to shift more and more toward garden sculpture. Although only a few statues have been preserved, among these a marble *Juno* (Rijksmuseum, Amsterdam), there is documentary evidence that garden sculpture formed a considerable part of his output. Upon his visit to Verhulst's studio in 1687, the Swedish architect Nicodemus Tessin the Elder saw 20 garden statues. Verhulst must also have produced small-scale works in wood and ivory, judging from old inventories and sale catalogues. No works of this kind have been convincingly attributed to him so far, apart from a large frieze of putti in the Orange Hall at Palace Huis ten Bosch (The Hague).

Among the pupils of Verhulst, the most important were Nicolaes Millich and Johannes Blommendael; both continued their master's style within a more courtly way, influenced by French models.

FRITS SCHOLTEN

Biography

Born in Mechelen, Netherlands, 15 January 1624. Studied with Rombout Verstappen and Frans van Loo in Mechelen and possibly with Lucas Faydherbe in Antwerp; moved to Amsterdam by 1646; assistant to Artus Quellinus I on new Amsterdam town hall, 1650–58; moved to Leiden, 1658; settled in The Hague, 1664; member of Guild of St. Luke, 1668; member of Academy "Pictura," 1676; mainly known for funeral monuments and portraits, but also produced garden statuary and statuettes in ivory and wood. Died in The Hague, the Netherlands, before 27 November 1698.

Selected Works

before 1658 Reliefs of *Silence* and *Fidelity* and statue of *Venus;* marble; Royal Palace, Dam Square, Amsterdam, the Netherlands

1658	Tomb of Maarten Harpertszoon Tromp (with Willem de Keyser; designed by Jacob van Campen); marble; Old Church, Delft, the Netherlands
1658–63	Decorations, including *The Butter-seller* (1662); marble, sandstone; facade, Weigh House, Leiden, the Netherlands
1661	Epitaph for Burgomaster Van der Werff; marble; Hooglandse Church, Leiden, the Netherlands
1662	Tomb of Johannes Polyander van Kerckhoven; marble; St. Peter's Church, Leiden, the Netherlands
1663	Tomb of Willem van Liere and Maria van Reygersbergh; marble; Reformed Church, Katwijk aan de Rijn, the Netherlands
1664–69	Tomb of Carel Hieronymus van In- en Kniphuisen and Anna van Ewsum; marble; Reformed Church, Midwolde, the Netherlands
1668	Epitaph for Joannis van Gheel; marble; Reformed Church, Spanbroek, the Netherlands
1671	Bust of Jacob van Reygersbergh; marble; J. Paul Getty Museum, Los Angeles, California, United States
1672–73	Tomb of Admiral Willem Joseph van Gendt; marble; Dom Church, Utrecht, the Netherlands
1677–81	Tomb of Admiral Michiel Adriaanszoon de Ruyter; marble; New Church, Amsterdam, the Netherlands

Further Reading

Neurdenburg, Elisabeth, *De zeventiende eeuwsche beeldhouwkunst in de Noordelijke Nederlanden: Hendrick de Keyser, Artus Quellinus, Rombout Verhulst en tijdgenooten*, Amsterdam: Meulenhoff, 1948

Notten, Marinus van, *Rombout Verhulst, beeldhouwer, 1624–1698: Een overzicht zijner werken*, The Hague: Nijhoff, 1907

Scholten, Frits, *Rombout Verhulst in Groningen, zeventiende eeuwse praalgraven in Midwolde en Stedum*, Utrecht, The Netherlands: Stichting Matrijs, 1983

Scholten, Frits, " 'Mea Sorte Contentus,' Rombout Verhulst's Portrait of Jacob van Reygersbergh," *The J. Paul Getty Museum Journal* 19 (1991)

Scholten, Frits, "Good Widows and the Sleeping Dead: Rombout Verhulst and Tombs for the Dutch Aristocracy," *Simiolus* 24 (1996)

ANDREA DEL VERROCCHIO 1435–1488

Italian

Known almost invariably since his own day as Andrea del Verrocchio, Andrea di Michele di Francesco Cioni was undoubtedly the leading Florentine sculptor in the latter years of the 15th century and the master of one of the most active, multifaceted workshops of the Renaissance. Those serving as apprentices or assistants included sculptors, painters, and goldsmiths, among whom the most prominent documented individuals were Leonardo da Vinci and Lorenzo di Credi. Testimony to Verrocchio's status as an artist is the praise sung to his skills by early sources such as Ugolino Verini and Pomponio Gaurico. The level of patronage he commanded included, among others, two (possibly three) generations of the Medici family, the Signoria and Opera del Duomo of Florence, the city council of Pistoia, and the Republic of Venice. Verrocchio also received a commission from Matthias Corvinus, king of Hungary, though he did not live to carry it out. He is reputed by 16th-century art historian Giorgio Vasari to have created sculptures for Pope Sixtus IV, but this supposition cannot be substantiated.

Little is known about Verrocchio's origins as an artist. That he began his career as a goldsmith is confirmed by his first *catasto* (tax return), made in 1457, in which he declares that he has abandoned that occupation because of lack of work. A traditional explanation since the 17th century, that he was trained by a goldsmith named Giuliano de' Verrocchi, whose surname he adopted, is controverted by documentary evidence. There is no record that he was trained by or worked for either Giuliano's father, Francesco, or his paternal uncle, Silvestro, who were goldsmiths. A recently published document offers a slim indication that he may have been a shop boy in the *bottega* (workshop) of another goldsmith, Antonio Dei, but if so, when and precisely what he did cannot be ascertained. Stylistic evidence suggests that, presumably after 1457, he may have been apprenticed for a time to Desiderio da Settignano or Antonio Rossellino (more likely Desiderio), both of whom specialized in marble carving. By the second half of the 1460s, Verrocchio was executing work in marble as well as bronze and terracotta. Indeed, a marble slab in the Church of Santa Croce, Florence, may be his earliest independent work in that medium and possibly also the clue to his adopted name. The slab covers the tomb of Fra Giuliano del Verrocchio, a Franciscan friar and theologian, and a brother of the above-mentioned Francesco and Silvestro. Though Fra Giuliano died in 1442, the carved relief on the tomb slab bears stylistic features that, in spite of its worn state, point to a date between 1465 and 1470 and bear a compelling relationship to works by Verrocchio. A document of 15 January 1467 identified him for the first time by the name of Verrocchio.

Probably Verrocchio's foremost sculpture is the bronze group the *Incredulity of Thomas*, commissioned by the Università della Mercanzia (the Florentine Mer-

chants' Tribunal) for an outside tabernacle at the Church of Orsanmichele acquired from the Parte Guelfa (Guelph Party). Ordered toward the end of 1466 or the beginning of 1467 and unveiled in 1483, *Incredulity of Thomas* was immediately acclaimed as a work of the greatest distinction. (Recently cleaned, it has been removed to the interior of Orsanmichele.) Two other monumental sculptures that have contributed to Verrocchio's lasting fame (even though they are somewhat compromised because they were finished by others) are the bronze equestrian monument to Bartolomeo Colleoni in the Campo di Santi Giovanni e Paolo, Venice, and the marble cenotaph of Cardinal Niccolò Forteguerri in the Cathedral of Pistoia. The first was completed some six years after Verrocchio's death by the Venetian bronze caster Alessandro Leopardi, who also designed and oversaw the execution of the base, in consequence of which his role in the project on occasion has been seen to challenge Verrocchio's. The second was not completed until the 18th century, and with unfortunate departures from the original design, known from a terracotta sketch model in the Victoria and Albert Museum, London. By themselves, the *Incredulity of Thomas*, Colleoni statue, and Forteguerri monument reveal Verrocchio as an accomplished artist of exceptional ingenuity and creative imagination. Other nonfigurative sculptures, such as the tomb of Piero I and Giovanni de' Medici in the Church of San Lorenzo, Florence, and the copper *palla*, or ball, which he made to surmount the lantern on the cupola of the Cathedral of Florence, also reveal his resourcefulness as a designer drawing upon architectural and engineering skills in the service of his art.

These characteristics are revealed in varying degrees in Verrocchio's sculpture throughout his career. Works for the Medici family, such as the expressive pigmented terracotta relief of the *Resurrection* in the Museo Nazionale del Bargello, Florence, made for the family villa at Careggi; the jauntily posed bronze *David*, sold in 1476 by the sons of Piero—Lorenzo the Magnificent and Giuliano—to the Signoria of Florence, also in the Bargello; and the lively bronze *Putto with a Dolphin*, made for a fountain at the aforementioned family villa and transferred in the 16th century by Duke Cosimo I to a new fountain in the *cortile* (courtyard) of the Palazzo Vecchio in Florence (removed after cleaning in 1959 to a room in the palace), offer more evidence of the range of his inventiveness. Along with these should be mentioned the bronze *Candlestick* in the Rijksmuseum, Amsterdam, commissioned for the signoria of Florence, which shows Verrocchio's superb command of measure and proportion; the marble portrait bust of *Woman Holding Flowers*, outstanding for the noble bearing of the pose and for the formal novelty of the inclusion of both arms and hands

in an arrangement at once natural and strikingly graceful; the pigmented terracotta relief *Virgin and Child*, also in the Bargello, memorable in its restrained expression of maternal joy and tenderness; and the dramatically composed silver relief of the *Decollation* (Verrocchio's only extant work in precious metal) made for a ceremonial altar for the baptistery of Florence, now in the Museo dell'Opera del Duomo (Florence).

Overall, Verrocchio's sculpture is distinguished by an unfailing sense of design, especially noticeable in the nonfigurative works. As a sculptor of figures, he ranks with Antonio Pollaiuolo in the understanding of human anatomy and the realistic portrayal of the body in movement. Verrocchio surpasses Pollaiuolo in sensitivity to graceful rhythms and the measured control of physical energy to accord with the subject. Verrocchio also had an imaginative concern with drapery, which he developed from a tame, relatively close-fitting form in the earliest works, to an animated style with sharply contoured folds of angular structure in his interim works, to a final style of looser, more pliant, and rhythmically organized folds that were yet responsive to the presence and movement of the body underneath. Another characteristic of his sculpture, which marks a fundamental break with that of his predecessors, is its openness, the sculpture in a sense conceived as a dialogue between solid matter and space. Also apparent is a notable pictorial quality. Verrocchio created a play of lights and darks with intermediate tones by combining different media in some works, but more specifically through the modeling or carving and the composition by which some planes and forms are made to emerge into the light and others to retreat into shadow and half shadows. Because this is particularly true of his work after 1469, it may be that this heightened pictorialism was stimulated by his exposure to Venetian color and atmosphere during a documented sojourn in the Veneto in that year. In any case, the years immediately following 1469–70 form a pivotal moment in the development of Verrocchio's style, affirming his maturity as an artist. Finally, and most decisive of all in the appraisal of Verrocchio's art and its influence, is a subtle intelligence; this lies at the heart of his inventiveness and of the communicative content of virtually all his sculpture.

As a painter, Verrocchio possessed a style paralleling that of his sculpture. An outstanding draftsman, he also left behind a number of well-known drawings that bear unmistakable stylistic relationships to his sculpture and painting.

DARIO A. COVI

Biography

Born in Florence, Italy, probably in 1435. Trained as a goldsmith; possibly also apprenticed or worked as assis-

tant to Desiderio da Settignano or Antonio Rossellino. Directed flourishing workshop in Florence executing commissions from donors in Florence, Pistoia, Venice, and elsewhere from mid 1460s to 1488; traveled to Veneto to procure copper for project of *palla*, or ball, commissioned for the Cathedral of Florence, 1469; shipped model of horse for the monument to Bartolomeo Colleoni to Venice, 1481; established workshop in Venice by spring of 1486 to execute monument, leaving Florentine studio in charge of his assistant, Lorenzo di Credi. Died in Venice, Italy, probably 30 June 1488.

Selected Works

ca. 1464–65	*Resurrection*; terracotta; Museo Nazionale del Bargello, Florence, Italy
1465–67	Tomb of Cosimo il Vecchio de' Medici; marble, porphyry, bronze; Church of San Lorenzo, Florence, Italy
ca. 1467–83	*Incredulity of Thomas*; bronze; Church of Orsanmichele, Florence, Italy
1468–69	*Candlestick*; bronze; Rijksmuseum, Amsterdam, the Netherlands
1468–71	Ball for lantern (destroyed, later restored); copper, iron; Cathedral of Florence, Italy
ca. 1470	*Putto with a Dolphin*; bronze; Palazzo Vecchio, Florence, Italy
1472	Tomb of Piero I and Giovanni de' Medici; marble, porphyry, bronze, *pietra serena* (sandstone); Church of San Lorenzo, Florence, Italy
by 1476	*David*; bronze; Museo Nazionale del Bargello, Florence, Italy
ca. 1476	*Virgin and Child*; terracotta; Museo Nazionale del Bargello, Florence, Italy
1476–88	*Cardinal Niccolò Forteguerri* (completed posthumously by Gaetano Masoni); marble cenotaph; Cathedral of Pistoia, Italy
1477–80	*Decollation*; silver; Museo dell'Opera del Duomo, Florence, Italy
ca. 1478	*Woman Holding Flowers*; marble; Museo Nazionale del Bargello, Florence, Italy
1480–88	Equestrian monument to Bartolomeo Colleoni (completed in 1494 by Alessandro Leopardi); bronze, marble; courtyard, Campo di Santi Giovanni e Paolo, Venice, Italy

Further Reading

Adorno, Piero, *Il Verrocchio*, Florence: Casa Editrice EDAM, 1991

Butterfield, Andrew, *The Sculptures of Andrea del Verrocchio*, New Haven, Connecticut: Yale University Press, 1997

Covi, Dario A., "Four New Documents concerning Andrea del Verrocchio," *Art Bulletin* 48 (1966)

Covi, Dario A., "Verrocchio and Venice, 1469," *Art Bulletin* 65 (1983)

Cruttwell, Maud, *Verrocchio*, New York: Scribner, and London: Duckworth and Co., 1904

Passavant, Günter, *Andrea del Verrocchio als Maler*, Düsseldorf, Germany: Schwann, 1959

Passavant, Günter, *Verrocchio: Skulpturen, Gemälde und Zeichnungen*, London: Phaidon, 1969; as *Verrocchio: Sculptures, Paintings, and Drawings*, translated by Katherine Watson, London: Phaidon, 1969

Seymour, Charles, *The Sculpture of Verrocchio*, Greenwich, Connecticut: New York Graphic Society, and London: Studio Vista, 1971

Verdon, Timothy, "Pictorialism in the Sculpture of Verrocchio," in *Verrocchio and Late Quattrocento Italian Sculpture*, edited by Steven Bule, Alan Phipps Darr, and Fiorella Superbi Gioffredi, Florence: Le Lettere, 1992

Weismann, Elizabeth Wilder, Clarence Kennedy, and Peleo Bacci, *The Unfinished Monument by Andrea del Verrocchio to the Cardinal Niccolò Forteguerri at Pistoia*, Florence: Tyszkiewicz, 1932

INCREDULITY OF THOMAS

Andrea del Verrocchio (1435–1488)

ca. 1467–83

bronze

h. 2.3 m

Church of Orsanmichele, Florence, Italy

A masterpiece of bronze sculpture, Andrea del Verrocchio's *Incredulity of Thomas* is the only monumental figure sculpture of his mature period that he lived to complete and that survives intact. It consists of two slightly-over-life-size statues, each cast hollow (except for the hands and feet) and open at the back, and was commissioned by the Università della Mercanzia (the Florentine merchants' tribunal) for the central tabernacle located on the exterior east facade of the Church of Orsanmichele, Florence, and acquired from the Parte Guelfa (Guelph Party) in 1463. Removed for cleaning in 1987, the sculpture is presently exhibited in a gallery in Orsanmichele. The tabernacle was made for the Parte Guelfa in about 1422 to house Donatello's gilt bronze statue *St. Louis of Toulouse* (1418–22). The Mercanzia began negotiations to acquire the tabernacle in 1460, and around the time or shortly after, the Parte Guelfa, for reasons not entirely clear (but probably both political and financial), was forced to relinquish it and removed its statue to a niche on the facade of the Church of Santa Croce.

Although Verrocchio's *Incredulity of Thomas* is exceptionally well documented, a contract for it is not known and it is uncertain when or how the sculptor was chosen. As late as 16 December 1466, no sculptor had been identified. The earliest record naming the artist is a document of 15 January 1467 (modern style) when the Mercanzia authorized a disbursement of 25

petty lire to Verrocchio so that he could proceed with the work. Thereafter, payments are recorded to him in the Mercanzia accounts from 1468 to 1483, when the sculpture was installed. To judge from these records, the sculpture was executed in two stages. The figure of Christ was modeled sometime between 1470 and 1476 and cast by 1477; that of St. Thomas the Apostle was modeled around or just before 1479 and cast that same year or the next, at the latest by August 1480. A series of payments in May and June 1483 document the final preparations to install the sculpture, which was unveiled on 21 June 1483. Financial problems very likely accounted for the delay in completing the sculpture after the casting of the St. Thomas figure. Indeed, Verrocchio was still owed for his work when he made his will on 25 June 1488, and a final payment was not recorded until November of that year—nearly five months after his death—when part of the balance still due him was deposited in the Monte (the public debt) as dowry for his nieces, the daughters of his brother Tommaso.

Noticeable differences of style confirm what the documents tell us about the progress of the work. In the figure of Christ, lingering traces of Verrocchio's early style may be seen in the spare modeling and in the sharp definition of details of anatomy, such as tendons, joints, and blood vessels; in the figure of St. Thomas, the modeling is broader and the details appear muted by comparison. Comparable differences also exist in the draperies. The folds of Christ's garment are nearly all sharp-edged and angular in construction, whereas the folds of St. Thomas's garment are rounded and flowing, and the garment as a whole is more pliant and loose-fitting. These differences notwithstanding, Verrocchio created a harmonious relationship between the two figures and also avoided crowding the tabernacle space designed for a single figure. He did this by placing Christ slightly to the right on a low plinth inside the niche and St. Thomas to the left at a lower level on the ledge before the niche. By this arrangement, as well as by the stance and actions of each figure and the repeating pattern of the drapery folds, he promoted a continuous movement from St. Thomas to Christ and back to St. Thomas. With St. Thomas effectively in our space, we are led by him to behold the reality of the risen Savior and to receive with him the same blessing he receives from Christ.

That the message of the narrative is the dispelling of doubt by tangible proof is clear. Although it was a message of particular significance for the Mercanzia, we do not know when or by whom the subject of the sculpture was decided. It was not until 1476, when the first stage of the work was nearly finished, that the statues were identified by name in the documents, and not until 1487, in a *provvisione* of the signoria, that

St. Thomas was described as—wrongly, as we shall note—putting his hand in the side of Christ, the gesture traditionally associated with the depiction of his incredulity. Verrocchio had access to this tradition, which was firmly established since early Christian times and exemplified in Florence by Verrocchio's day in paintings and relief sculptures, if not sculptures in the round. Although a panel painting by Taddeo Gaddi of the first half of the 14th century in the Galleria dell'Accademia, Florence, is a close precedent, it is a mosaic from about 1200 in the Basilica of San Marco, Venice, that appears more likely to have been Verrocchio's source. There, in addition to the almost similar placement of the figures (allowing for the flatness of the mosaic) and actions (with Christ standing on the steps before a nichelike setting, such as the tabernacle niche of the Orsanmichele sculpture), we find St. Thomas prominently displaying a scroll with the same Latin inscription, "Dominvs mevs et devs mevs" ("My Lord and my God", from John 20:28), which Verrocchio placed, coupled with the phrase "Et salvator gentivm" (and savior of the people) on the hem of St. Thomas's garment. Verrocchio could have seen the mosaic during a brief sojourn in the Veneto in 1469.

In one essential respect, however, Verrocchio broke with the tradition exemplified by both the Gaddi panel and the Venice mosaic. Instead of having St. Thomas

Incredulity of Saint Thomas
© Scala/Art Resource, New York

touch the wound in Christ's side, or moving as if intending to touch it, he presented Thomas holding his right arm close to his body and drawing back, as if respectfully refraining from touching him. We are thus made to understand that it is by seeing the wound rather than by touching it that Thomas recognizes the Savior. This is confirmed by the inscription on Christ's mantle, which begins with the words "Qvia vidisti me Thoma credidisti" ("Because you have seen me, Thomas, you have believed," from John 20:29).

So magisterial is the formal design of the sculpture and so subtle the relationship between physical action and expressive content that, at its unveiling, the diarist Luca Landucci praised it as "the most beautiful thing that can be found" and the head of Christ as "the most beautiful head of the Savior that has yet been made." In the 16th century, Giorgio Vasari, who otherwise had some critical things to say about Verrocchio's art, regarded the sculpture to be of such high order that it "well deserved to be placed in a tabernacle made by Donatello and to be ever afterwards held in the greatest esteem." The sculpture also caught the attention of artists of the time. For instance, the composition was copied by Giovanni della Robbia in a glazed terracotta relief at La Quiete; by Luca Signorelli, with some variations, in a fresco at Loreto; and by an anonymous artist in a woodcut used to illustrate a printed book, whereas Pietro Vannucci, called Perugino, adopted the pose and arrangement of the drapery of St. Thomas for one of the apostles in his *Tradition of the Keys* in the Sistine Chapel.

Some have speculated that the mastery shown in this sculpture may be indebted in some way to the intervention of Leonardo da Vinci. This cannot be dismissed out of hand, because Leonardo is documented as being in the workshop in 1476. However, he probably had just entered the shop as a pupil about the time Verrocchio received the commission, so it is doubtful that he would have played a significant role in the planning of the sculpture.

DARIO A. COVI

Further Reading

Beck, Herbert, Maraike Bückling, and Edgar Lein, editors, *Die Christus-Thomas-Gruppe von Andrea del Verrocchio*, Frankfurt: Henrich Verlag, 1996

Butterfield, Andrew, "Verrocchio's Christ and St. Thomas: Chronology, Iconography, and Political Context," *The Burlington Magazine* 134 (1992)

Butterfield, Andrew, *The Sculptures of Andrea del Verrocchio*, New Haven, Connecticut: Yale University Press, 1997

Covi, Dario A., "Date of the Commission of Verrocchio's 'Christ and St. Thomas,'" *The Burlington Magazine* 110 (1968)

Dolcini, Loretta, editor, *Verrocchio's Christ and St. Thomas: A Masterpiece of Sculpture from Renaissance Florence*, New York: Metropolitan Museum of Art, 1992

Van Ausdal, Kristen, "The Corpus Verum: Orsanmichele, Tabernacles, and Verrocchio's Incredulity of St. Thomas," in *Verrocchio and Late Quattrocento Italian Sculpture*, edited by Steven Bule, Alan Phipps Darr, and Fiorella Superbi Gioffredi, Florence: Le Lettere, 1992

FELIPE VIGARNY ca. 1470–1542 *French, active in Spain*

After arriving in Spain from France, Vigarny soon transformed sculpture in Burgos by introducing a more dynamic Gothic style. He subsequently played a notable role in the shift from Gothic to Renaissance in Castile, although he never abandoned certain aspects of his art. Throughout his career he collaborated with other sculptors, in particular forming partnerships with Alonso Berruguete and Diego de Siloé. Consequently, his style is frequently difficult to assess, and sculpture issuing from his workshop reveals various levels of quality. Contemporaries prized his work, and one of the earliest Spanish treatises cites his example for its proportions of human figures, calling him "a most singular artificer in the arts of sculpture and statuary" (Diego de Sagredo, *Medidas del Romano*, 1526).

Vigarny's training and career prior to his appearance in Spain remain mysterious. Born in Langres, Champagne, he presumably learned his art in France, but whether he traveled to Italy is less certain. Attracted by the economic and sculptural activity in Burgos, he probably entered the workshop of Gil de Siloé about 1497 (if not earlier), thereby leading recent scholars to hypothesize that Vigarny may have participated in that atelier's projects. By 1498 he had established himself sufficiently to receive the contract for the monumental stone relief of *Christ Carrying the Cross* on the cathedral trasaltar, the wall separating the high altar from the presbytery. The chapter commissioned further work from him in the following year, more reliefs for the trasaltar and various figures, and in all likelihood he had largely completed the two reliefs by 1502. With these scenes Vigarny introduced a new style of shorter figures moving in dynamic compositions to create animated and dramatic images. Although it differed significantly from the work of Gil de Siloé, whose style was prevalent in Burgos, Vigarny's work quickly found favor with local patrons.

In 1500 Vigarny entered the competition for the high altar of the Cathedral of Toledo with a statue of Saint Mark, but local artists prevailed. Two years later, however, he signed a contract for "four central reliefs," traditionally thought to include the *Adoration of the Child*, the *Assumption*, and perhaps the *Calvary*, all completed in 1504. Because of its size the project in-

volved many artists, and the payments offer few details as to the division of work.

At this time Vigarny actively sought and won other projects. From 1503 to 1505 he oversaw an altar of St. Jerome for the University of Salamanca. From this, 14 figures survive, but their quality suggests that his workshop carved most of them. On 1 August 1505 Vigarny received the commission for figures and busts for the high altar in the Cathedral of Palencia, while committing himself individually only to the hands and faces of the figures and three scenes: the *Entombment* (today in the Chapter Room), *Christ in Majesty*, and the *Assumption*. Vigarny delivered his work in 1509, but a later bishop moved the altar and expanded it to include paintings by Juan de Flandes and a sculpted crucifixion by Juan de Balmaseda. While completing this project, Vigarny was also directing the carving of the choir stalls of the Cathedral of Burgos. He had begun in 1505, assembling a team and working with Andrés de Nájera, and they had installed the stalls by 1512. The choir today, however, reflects subsequent additions and changes that make it difficult to appreciate the extent of Vigarny's contribution. In its time the ensemble exerted a great influence, serving as a model for those in the churches of S. Domingo de la Calzada and S. Benito, as well as perhaps the additions to the Cathedral of Toledo.

Vigarny continued his industrious output throughout the 1510s, but in 1519 his career changed decisively when he entered a four-year partnership with Alonso Berruguete. Together they may have carved the tomb of Chancellor Sauvage, although it is now too mutilated to permit significant stylistic evaluation. Vigarny and Berruguete subsequently traveled to Granada, where they worked in the Capilla Real. Vigarny carved the high altar, which marks a major shift in his style with its greater classicism, simplicity, and monumentality, although many types and features remain unchanged from his previous work. The new traits he adopted have suggested to scholars that Vigarny was now emulating either Berruguete or Jacopo Florentino, an Italian active in Granada at this time. After his association with Berruguete ended, Vigarny returned to Burgos.

In Burgos, Vigarny met Gil de Siloé's son, Diego, again. Diego had been an apprentice in Vigarny's workshop 1505–08, where he may have participated in the work on Burgos choirstalls (see Hernández Redondo, 2001). Although Diego de Siloé had left, alleging that Vigarny owed him money, they now collaborated on the high altar for the Capilla Condestable, Cathedral of Burgos (1523–25). Because the payments do not distinguish who carved which parts, art historians have relied on stylistic criteria to differentiate the two hands. Vigarny is traditionally credited with the

figures on the right-hand side of the central scene depicting the presentation of the Christ child (the high priest and the prophetess Anna), as well as the lower relief of the *Annunciation* and other figures found at the top. In this work Vigarny adapted Italianate aspects learned from Siloé to his style while maintaining his distinctive, short-figure canon and types.

While Siloé departed for Granada shortly after completion of the altar, Vigarny remained in Burgos, where his career thrived. During the 1520s Vigarny had undertaken two notable tombs in the Cathedral of Burgos, that of Gonzalo Díez de Lerma and that of the Capilla Condestable, Castile. Carved in jasper, the latter comprises one of Vigarny's greatest achievements with its finely rendered details, particularly in the faces, hands, and clothing. The success of these works led to further projects beyond Burgos: the tomb of Alonso de Burgos and the tombs of the bishop of Tuy and his parents. Although the first is destroyed, contemporary accounts describe an elaborate and sumptuous monument. For the second ensemble the sculptor typically turned to a team of assistants, but it remained unfinished at his death. Throughout the 1530s, Vigarny took on an ever increasing number of projects throughout Castile, and to meet this demand, he maintained three workshops: one in Burgos, a second in Toledo, and a third in Peñarando de Duero. In the process, he obviously had to depend on trusted assistants, and none more so than his son, Gregorio Pardo, a talented sculptor in his own right who would establish himself in Toledo and Madrid.

During these years, Vigarny carved two important works for the Cathedral of Toledo. In the Altar of the Descent of the Virgin, with its central relief *St. Ildefonse Receiving the Chasuble*, he sculpted characteristically short figures in active poses while accommodating Renaissance decorative motifs and architecture. His share of the upper choir of the cathedral—the chapter had divided the commission between him and Berruguete—represents the masterpiece of his old age. Aided by his son, Vigarny produced 36 reliefs in wood and 35 in alabaster, but he died before he could carve the episcopal seat. Whereas his figures lack the animated compositions of those that Berruguete carved on the facing side, Vigarny nonetheless created a series of elegant reliefs. On receiving the commission Vigarny had established the workshop in Toledo, and it was there that he died. Appropriately, he is buried in the cathedral at the foot of his Altar of the Descent of the Virgin.

PATRICK LENAGHAN

See also **Berruguete, Alonso; Siloé Family**

Biography

Born in Langres, Champagne, France, *ca.* 1470. Son Gregorio Pardo significant sculptor in his own right.

Arrived in Burgos, *ca.* 1497; introduced in Burgos a dynamic Gothic style that became popular; notable throughout life for partnership with other artists on major projects; in Burgos, worked with local artists, and later with Alonso Berruguete and Diego de Siloé; after traveling with Berruguete to Zaragoza and Granada, returned to Burgos and worked with Siloé; remained in Burgos until contracted for the Cathedral of Toledo choir stalls. Died in Toledo, Spain, 10 November 1542.

Selected Works

1498–	*Christ Carrying the Cross, Crucifixion,*
1502	and *Descent from the Cross/Resurrection*; stone; trasaltar, Cathedral of Burgos, Spain
1503–05	Altar of St. Jerome; polychromed wood; Chapel, University of Salamanca, Spain
1503–05	Reliefs; polychromed wood; high altar, Cathedral of Toledo, Spain
1505–09	High altar; polychromed wood; Capilla Mayor, Cathedral of Palencia, Spain
1505–12	Choir stalls (with Andrés de Nájera); wood; Cathedral of Burgos, Spain
1519	High altar; polychromed wood; Capilla Real, Granada, Spain
1523–25	High altar (with Diego de Siloé); polychromed wood; Capilla Condestable, Cathedral of Burgos, Spain
1523–27	Altar of the Descent of the Virgin, *St. Ildefonse Receiving the Chasuble*; alabaster; Cathedral of Toledo, Spain
1524	Tomb of Gonzalo Díez de Lerma; stone; Cathedral of Burgos, Spain
1525–32	Tomb, Pedro Fernández de Velasco, Condestable de Castilla and Conde de Haro, and his wife, Doña Mencía de Mendoza, Condesa de Haro; marble, jasper; Capilla Condestable, Cathedral of Burgos, Spain
1530–33	Tomb of Alonso de Burgos, for the college of S. Gregorio, Valladolid, Spain; stone (destroyed)
1536	Tomb of Diego de Avellaneda, bishop of Tuy; alabaster; Museo Nacional de Escultura, Valladolid, formerly Monasterio of San Jerónimo in Epeja (Soria), Spain
1539–43	Choir stalls of the upper choir; wood, alabaster; Cathedral of Toledo, Spain

Further Reading

Azcárate, José María de, *Escultura del siglo XVI*, Madrid: Editorial Plus-Ultra, 1958

Estella Marcos, Margarita M., *La imaginería de los retablos de la Capilla del Condestable*, Burgos, Spain: Cabildo Metropolitano, and Associación de Amigos de la Catedral, 1995

Gómez-Moreno, Manuel, *La escultura del renacimiento en España*, Florence: Pantheon Casa Editrice, 1931; as *Renaissance Sculpture in Spain*, translated by Bernard Bevan, Florence: Pantheon-Casa Editrice, 1931; reprint, New York: Hacker Art Books, 1971

Gómez-Moreno, Manuel, and Maria Elena Gómez-Moreno, *The Golden Age of Spanish Sculpture*, Greenwich, Connecticut: New York Graphic Society, and London: Thames and Hudson, 1964

Hernández Redondo, José Ignacio, "Diego de Siloe, aprendiz destacado en el taller de Felipe Bigarny," *Locus Amoenus* 5 (2000–2001)

Marías, Fernando, *El largo siglo XVI: Los usos artísticos del renacimiento español*, Madrid: Taurus, 1989

Proske, Beatrice Gilman, *Castilian Sculpture: Gothic to Renaissance*, New York: The Hispanic Society of America, 1951

Río de la Hoz, Isabel del, *El escultor Felipe Bigarny (h. 1470–1542)*, Salamanca: Junta de Castilla y León. Consejería de Educación y Cultura, 2001

GUSTAV VIGELAND 1869–1943

Norwegian

Originally named Adolf Gustav Thorsen after his father, Elisus Thorsen, Gustav Vigeland was born in Mandal, the southernmost coastal town of Norway. He was the second of five sons, born to a master carpenter who ran a furniture workshop. Vigeland attended school in Mandal but left his father at age 13 to join his mother and youngest brother, living with her father on a small farm at nearby Vigeland. The next year his father apprenticed him to a woodcarver in Kristiania (later Oslo), but in the evenings Vigeland drew at the Royal School of Design and visited the plaster casts in the Sculpture Museum.

During this time, Vigeland created woodcarvings and did much reading, especially on anatomy, with a view to continuing in sculpture. In October 1888 he briefly worked for a woodcarver. In February 1889, hungry and desperate, he knocked on the door of sculptor Brynjulf Bergslien, who was impressed with his talent and became his first teacher, allowing him to work in his studio. Vigeland exhibited his group *Hagar and Ishmael* in the fall of 1889 at the annual National Exhibition of Art, Oslo, where it was well received. He again attended classes in modeling and life drawing at the Royal School of Design and created reliefs with motifs from Homer. In 1890 Bergslien sent him to Mathias Skeibrok to work in his studio, where Vigeland completed several important works.

Vigeland was able to travel with the aid of various grants. He spent 1891 in Copenhagen working in the studio of Hermann Wilhelm Bissen, where he created the first of his life-size figures, originally called *Cain*, but later *The Accursed*. Back in Oslo in February 1892,

he produced *Young Girl* and exhibited his *The Accursed* both in Copenhagen and later in Oslo. He returned to Copenhagen at the start of December and then headed for Paris. There, in 1893, he rented a studio where he produced some small sculptures and visited museums, exhibitions, and studios, including several visits to Auguste Rodin's studio. Returning to Norway in June, he produced his first designs for a relief entitled *Hell*, perhaps influenced by Rodin's *Gates of Hell* (1880–ca. 1900), completing the first version the following year. He gave his first solo exhibition in the fall of 1894, showing 51 sculptures. Going to Berlin in 1895, he joined a group of international artists and writers. Among the portraits he created was that of Edvard Munch, who was staying at the same hotel. The Polish poet Stanislaw Przybyszewski, impressed by Vigeland's work, dedicated a small volume to him entitled *Auf den Wegen der Seele* (On the Paths of the Soul; 1897). Vigeland traveled to Florence in February 1896, studying the art of the Renaissance, ancient Egypt, and Classical Greece and also spending time in Rome, Naples, Pompeii, Herculaneum, and Orvieto. He returned to Oslo in August 1896 and began work on a new version of *Hell*.

Needing funds in 1898, Vigeland agreed to perform restoration work on the medieval Cathedral of Trondheim (Norway), even though the Gothic style was not to his liking. Nonetheless, the gargoyles and four biblical figures he produced there contributed to his fascination with dragons in later days.

Vigeland conceived the concept for his Frogner Park (which later became known as Vigeland Park) Fountain in 1900, the year of his brief marriage to Laura Mathilde Anderson (they divorced the next year). That same year he studied Gothic art in France

Frogner Park
© Giraudon/Art Resource, NY

and England. Norway's King Olaf made him a Knight of the Order of St. Olaf on 21 January 1901.

Back in Paris in 1901, he created the Nobel Peace Prize medal during March and April and traveled widely. He created four portraits of Henrik Ibsen on his return home and again went to Trondheim. Officials rejected his 1902 entry for the competition for the monument to mathematician Niels Henrik Abel because he ignored the entry rules, but eventually they awarded him the commission in 1902; he completed the statue in 1905. It was a daring, controversial portrayal, not a bust but a nude flying through space on the backs of two genies. The work is located in Slottspark, Oslo.

Commissioned to create a monument to the Norwegian composer Rikard Nordraak in 1902, Vigeland began working in an old studio in Oslo. There, in about 1903, he also produced 13 portraits, including *Edvard Grieg, Knut Hamsun, King Oscar II, Fridtjof Nansen, Henrik Ibsen,* and *Alfred Nobel*. He also worked on models of the 20 tree figures that would eventually surround his Frogner (Vigeland) Park Fountain.

In August 1905 Vigeland returned to Paris, where he produced the life-size model of his nude *Beethoven* statue, now in the Vigeland Museum courtyard in Oslo, where summer concerts are given. At this time, a Vigeland committee was formed to raise funds for the fountain. Vigeland also received a commission for the work *Henrik Wergeland*, a statue of the poet and writer, which he completed in 1908. He created a copy for the Norwegian community in Fargo, North Dakota, at the instigation of Norwegian-born Dr. Herman O. Fjelde. Vigeland also produced a small equestrian statue, *Theodore Roosevelt Riding at a Trot*, which eventually was cast for North Dakota, although the full-size version never materialized.

In 1915 Vigeland produced his first woodcuts, and during World War I began to work on 33 medium-size groups, some of which were incorporated later into his Frogner Park project. Initially he hoped to place his fountain in the Palace Garden and continued to work on the granite groups for it. He did a first plastic sketch of the *Monolith* column, which was to become the center of his entire Frogner Park project. Meanwhile, he began negotiations for a new studio with the Kommune of Kristiania (now Oslo). In February 1921 he signed a unique contract with the municipality, by which the city of Oslo became the owner of all works of art in Vigeland's possession, as well as models of any future sculptures. In return, the city built the huge museum in Frogner Park that was both his home and studio. Vigeland suggested that the fountain project be sited in front of the museum.

After a two-year debate, the entire monument project was slated for the center of a plot adjacent to Frogner Park. Vigeland and his new wife, Inga Syver-

sen, whom he married in 1922, moved into the new quarters of the studio building in 1924. Over the years Vigeland's proposal for a monumental fountain had grown. Now the city council approved his final plan for an 80-acre sculpture park, which included six bronze giants holding up a huge basin of water, plus 20 groups of trees—each 2 meters high—as well as 60 bas-reliefs around the base. Around the central *Monolith*, 36 life-size granite figure groups were placed on a circular platform of granite steps. The plan was modified the next year to include a main entrance and 58 single bronze figures and groups on the entry bridge. One of these, *Sinnetaggen* (Angry Little Boy; 1930) is one of Norway's most popular sculptures.

In 1928 three ironworkers started the gates for the park. The 17-meter-high raw granite *Monolith* block was raised *in situ* at the park in August. Three artisans began carving the *Monolith*, which was finally finished in July 1942. In 1934 Vigeland modeled the *Wheel of Life*, four colossal adults and three children in a circular composition around a void. It is aligned on the main axis of Vigeland Park, atop a stairway beyond the *Monolith*.

Vigeland modeled the 21 figures of *The Clan* in clay from 1934 to 1936, but a bronze version of the statue was not completed and placed in the park until 1988. The 36 bronzes on the bridge were in place by 1940, the year he started the eight figures for the *Children's Circle* between the park entrance and the bridge. He completed his *Self-Portrait*, which now stands near the main entrance to Vigeland Park, in 1942, along with reliefs for his mausoleum in the studio/museum. He died in 1943, and his ashes are held in the Vigeland Museum. By 1947 the museum opened to the public and the fountain's installation was complete.

DONALD CLAUDE NOEL

Biography

Born in Mandal, Norway, 11 April 1869. Apprenticed as woodcarver in Oslo; attended Royal School of Design, Oslo; sold woodcarvings and studied anatomy; worked for sculptor Brynjulf Bergslien in Oslo, 1889; returned to classes at Royal School of Design same year; studied with Mathias Skeibrok, 1890; traveled to Copenhagen to work with Hermann Wilhelm Bissen, 1891; completed first version of *The Accursed*, then exhibited in Copenhagen and in Oslo, 1892; established studio in Paris with Houen grant and studied Auguste Rodin's sculptures, 1893; traveled in Germany and Italy, 1895–98; created gargoyles for the Cathedral of Trondheim, Norway, 1898; exhibited sculptures in Oslo, 1899; created Nobel Peace Prize medal in Paris, 1901; received studio in Oslo, 1902, to do a fountain monument, 1921; offered works to Kommune of Kristiania, later the city of Oslo, in ex-

change for residence and lifetime funding; awarded membership to Royal Swedish Academy of Fine Arts, and to Art Academy in Carrara, Italy; awarded Grand Cross of St. Olav for 60th birthday, 1929; exhibited model for sculpture park, 1930. Died in Oslo, Norway, 12 March 1943.

Selected Works

1894 *Hell*; bronze (destroyed); another version: 1897, National Gallery, Oslo, Norway
1900–30 Frogner Park, including six bronze giants, monumental fountain, *Children's Circle*, *The Clan*, *Self-Portrait*, *Sinnetaggen* (Angry Little Boy), *Wheel of Life*, and other sculptures/groups; bronze, granite; Vigeland Park, Oslo, Norway
1903 *Henrik Ibsen*; marble; National Gallery, Oslo, Norway
1906 *Beethoven*; bronze; Vigeland Museum, Oslo, Norway
1908 *Henrik Wergeland*; bronze; Oslo, Norway; copy: Fargo, North Dakota, United States
1929 *Monolith*; granite; Vigeland Park, Oslo, Norway

Further Reading

Ginsberg, Robert, *Gustav Vigeland: A Case Study in Art and Culture*, Notre Dame, Indiana: Foundations Press, 1984
Hale, Nathan Cabot, and David Finn, *Embrace of Life: The Sculpture of Gustav Vigeland*, New York: Abrams, 1969
Stang, Ragna Thiis, *Gustav Vigeland: En kunster og hans verk*, Oslo: Tanum, 1965; as *Gustav Vigeland, the Sculptor and His Works*, translated by Ardis Grosjean, Oslo: Tanum, 1965
Vigeland, Gustav, *Vigeland*, Oslo: Normanns Kunstforlag, 1993
Wikborg, Tone, *Gustav Vigeland: His Art and Sculpture Park*, translated by Ruth Waaler, Oslo: Aschehoug, 1990

VIRGIN AND CHILD OF JEANNE D'EVREUX

Anonymous
1324–39
gold, silver gilt, enamel, rock crystal, pearl, garnet, blue glass
h. 68 cm
Musée du Louvre, Paris, France

The silver-gilt image of the *Virgin and Child* preserved in the collection of the Musée du Louvre, Paris, is the quintessential example of Gothic sculpture in precious metal. With her exquisitely modeled face, elegant stance, and attenuated fingers and the graceful fall of her drapery, the Virgin embodies contemporary French

ideals of regal beauty, even in the absence of the crown of pearls, gems, and *émaux de plique* that once graced her head and the flower-shaped brooch once at her chest. It is, at the same time, an intimate portrait of mother and child: the Virgin effortlessly cradles her Child against her left hip, supporting him with her arm, as he gently touches her cheek with his outstretched hand.

The *Virgin and Child* stand on a rectangular, box-like base that is decorated on each side with 14 scenes representing the *Nativity* and *Passion of Christ*. In each the figures, reserved in the gilt-silver metal with enamel used to accentuate drapery and facial features, are set against a translucent enamel ground. Four plaques are on each of the long sides of the rectangle, and three on each of the shorter ones. Beginning on the right side, the scenes represented are the *Annunciation*, the *Visitation*, and the *Nativity*; at the back, the *Annunciation to the Shepherds*, the *Adoration of the Magi*, the *Presentation in the Temple*, and the *Flight into Egypt*; on the left, the *Massacre of the Innocents*, the *Resurrection of Lazarus*, and the *Betrayal of Judas*; and across the front, the *Way to Calvary*, the *Crucifixion*, the *Resurrection*, and the *Descent into Limbo*. Twenty-two diminutive figures of prophets stand against miniature architectural buttresses that frame the enameled plaques at regular intervals around the base. At each corner are small, supporting lions (the *lionceaux* typically seen on French Gothic goldsmith work, such as the reliquary of Saint James preserved at the Church of Santiago de Compostela, and mentioned in contemporary princely inventories).

In her hand the Virgin holds a gold fleur-de-lis. Only one of the three petals of the lily survives in its original condition. It is inset with rock crystal that protects a relic. On the reverse of the lily is an inscription enameled in white on translucent green: "Des cheveus Nostre Dame. Ave gratia plena" (Of the hair of our Lady. Hail, full of grace).

A lengthy inscription enameled in blue and set along the beveled upper edge of the base establishes the provenance of the image: "Ceste ymage donna ceans ma dame la Royne Jeh[ann]e Devreux. Royne de France. et de Navarre Compaigne du Roy Charles le XXVIIIe jour d'avril M.CCC.XXXIX." Presented to the Basilica of Saint-Denis on 28 April 1339, the sculpture was part of a larger gift made to the royal abbey by Jeanne d'Evreux, widowed queen of Charles IV. A document of 1343 attesting to the donation includes the promised gift of a second reliquary sculpture, a smaller, gold image of Saint John the Evangelist, as well as of one of her crowns, and a silver-gilt *châsse* containing fragments of each of the principal relics of the Sainte-Chapelle. The Virgin is the only part of the gift that survives.

The language of the donation document seems to indicate that each of these objects was from the queen's own collection and not commissioned for the Abbey of Saint-Denis. It specifies that the queen would keep the image of Saint John the Evangelist until her death and refers to the *châsse* as "notre belle chace." Physical evidence confirms that the image of the Virgin was created prior to its gift to the abbey: the inscription panels frame the base on three sides only. The style of the figure is consistent with a date before 1339, perhaps even prior to the death of Charles IV in February 1328. The pose of the Virgin and the fall of her drapery closely resemble the Virgin of the Annunciation in the *Hours of Jeanne d'Evreux*, presented to Jeanne d'Evreux by her husband between 1324 and 1328.

Given its relatively precise dating, the figure offers an important point of comparison with other sculpture, not only images of the Virgin in goldsmith's work, such as those in the enameled shrines at the Pierpont Morgan Library, New York, or the one in the treasury of the Cathedral of Seville, but equally for monumental works. Key among the full-scale stone sculptures with which it can be compared are the Virgin of Mainneville and the one at Bourbonnes-les-Bains (Haute-Marne), originally from the Church of Saint-Savinien, Sens. The figure also serves to evoke the richness and ac-

Virgin and Child of Jeanne d'Evreux
Photo by M. Beck-Coppola. © Réunion des Musées Nationaux/Art Resource, New York

complished artistry of important commissions known only from princely inventory references, such as the reliquaries of Saint Margaret and of Saint Louis, each standing on an enamel base, still in Jeanne d'Evreux's possession at the time of her death.

While the royal accounts of the time of Charles IV and Jeanne d'Evreux document payments to a number of goldsmiths, the author of this image is unknown. No physical evidence indicates that the figure and the base were not conceived as a unit, and indeed, the form is consistent with other surviving and recorded examples (e.g., from inventories pairing a figure with a base decorated with enamels). Nonetheless, the work displays a degree of heterogeneity, in that distinct styles can be seen on the enamels of the base. The more accomplished hand has been associated in art historical literature with the work of Jean Pucelle, but the similarities are generic and certainly less compelling than comparisons to other contemporary enamels such as the triptych in Namur.

The 1634 inventory of the Abbey of Saint-Denis indicates that the figure also held relics "du laict notre Dame" and "des vestements de notre dame" as indicated by inscriptions on green enamel on the back of the lily. Relics are similarly contained inside the lily held by the Virgin in a wooden image given to Maubuisson at Jeanne d'Evreux's death. The 1343 inventory of the Cathedral of Notre-Dame in Paris includes an image of the Virgin in copper gilt, also containing relics of her milk. An image in silver with milk of the Virgin contained in the fleur-de-lis was presented to the Church of the Grand Carmes, Maubert, in November 1361, apparently by Jeanne d'Evreux.

The Virgin has seen few alterations since the time of its creation. Garnets, sapphires, pearls, and *émaux de plique* decorated the original crown of vermeil, which was lost during la Ligue, a period of religious upheaval of the 16th century, and replaced before the inventory of 1634 by a simpler crown. The crown and brooch were melted down in 1793. The brooch was in the form of a gold flower enameled with red with a sapphire center. The fleur-de-lis was restored before the 1634 inventory and again in 1828. In 1793 the Commission of Monuments consigned the Virgin and Child to the "Museum," the future Musée du Louvre.

BARBARA DRAKE BOEHM

Further Reading

L'art au temps des rois maudits: Philippe le Bel et ses fils, 1285–1328 (exhib. cat.), Paris: Réunion des Musées Nationaux, 1998
Gauthier, Marie-Madeleine, *Émaux du Moyen Âge occidental*, Fribourg, Switzerland: Office du Livre, 1972
Montesquiou-Fezensac, Blaise de, and Danielle Gaborit-Chopin, *Le trésor de Saint-Denis*, 3 vols., Paris: Editions Picard, 1973–77
Le trésor de Saint-Denis (exhib. cat.), Paris: Réunion des Musées Nationaux, 1991

VISCHER FAMILY *German*

Hermann Vischer the Elder *fl.* 1453–1488

From the middle of the 15th century and for nearly 100 years, the Vischer foundry in Nuremberg was the leading German foundry for quality and quantity of production. The founder, Hermann the Elder, who became a citizen of Nuremberg in 1453, appears to have emigrated from northern Germany, where there were many centers for bronze casting. The high number of memorial slabs ordered from Hermann—mostly from bishops, but also from nobles as far north as Poznan—indicates the wide regional sphere of his workshop's activities. It also produced other varieties of religious objects; one of the most famous pieces is the baptismal font in Schlosskirche (Castle Church) in Wittenberg.

The identity of the wood modeler, that is, the artist responsible for the form of the metal cast, is not known for any of the pieces. Little is known about the organizational procedure carried out with such assignments, but on the basis of other large workshops in the late Gothic period, Vischer likely acted as an entrepreneur who hired additional modelers if need be and who was responsible for his workshop's bookkeeping. This explains why bronze pieces bear only the signature of the caster and never that of the sculptor.

Peter Vischer the Elder *ca.* 1460–1529

Hermann's son Peter had to complete a masterpiece after his father's death in 1488; according to guild regulation, he could not be the head of the studio without first passing the master's examination. He had married several years previously and also had completed his training and worked in his father's workshop.

Whereas the life and work of Herman Vischer can only be reconstructed through a few references, the renown of his son Peter went far beyond the city of Nuremberg. A contemporary, the Nuremberg accountant, calligrapher, and writer Johann Neudörfer, reported in 1547 that Peter's artistry in casting was so famous, scarcely a lord or other important gentleman came to Nuremberg without visiting him in his workshop. This statement reflects in part the circle of royal and high clerical clientele already established by Peter's father, which continued to expand under the son. "Die grössten Güsse," wrote Neudörfer, "findet man

in Polen, Böhmen, Ungarn, auch bei Kurfürsten und Fürsten allenthalben im Reich" (The largest casts are to be found in Poland, Bohemia, Hungary, even among princes-electors and princes everywhere in the empire).

On the other hand, several accounts make clear that in his interests and intellectual stature, Peter Vischer had grown beyond the milieu of the exclusively artisan-entrepreneur that his father perhaps had embodied. According to Neudörfer, Peter gathered with his artist friends, including Adam Kraft, on holidays and during his retirement, to practice drawing as if they were apprentices. And Emperor Maximilian, who had two bronze figures for his tomb cast in the Vischer studio, noted that the bronze smith Peter in Nuremberg owned 300 to 400 "altfränkische bild" (old [historic] art), which the emperor wanted to have drawn (or perhaps copied). Whether he meant older Gothic sculptures, paintings, or coins, his remark illuminates Peter Vischer's artistic or historical interests, which went far beyond the necessary knowledge for running his workshop.

The enormous production capacity of the business under Peter the Elder was soon reinforced by the skilled collaboration of his sons. Neudörfer particularly mentions that it was a well-functioning family business. The Sebaldus tomb, the main piece of the Vischer workshop, was cast by Peter and his five sons, and all of the sons lived with their families in their father's house.

Hermann Vischer the Younger *ca.* 1486–1517

The eldest two sons of Peter the Elder, Hermann the Younger and Peter the Younger, played a leading role in the technical and artistic development of the workshop after 1500, forming a productive collaboration. Death brought the family business to an abrupt halt: Hermann the Younger, who had brought back from a trip to Rome many mostly architectural (and in part preserved) designs that had become important to the workshop, died in 1517 in an accident. Peter the Younger died in 1528, "in seinen besten Tagen" (in the prime of his life) (Neudörfer); their father died in 1529. Like his father, Herman the Younger is said to have possessed particular skill in "Giessen, Reissen, Masswerken und Conterfeien" (casting, drawing, tracing, and portraiture).

Peter Vischer the Younger 1487–1528

Hermann the Younger's brother Peter the Younger had, in addition to such talents needed for their craft, a love of literature and literary and humanistic themes, which found expression in his friendship with the Nuremberg humanist Pankratz Schwenter, as well as in numerous drawings with themes from Classical mythology. It is clear that the members of the Vischer foundry played a remarkably significant and autonomous role in the orientation of the leading artists in the city, most notably Dürer, to humanistic subjects and the modern Renaissance forms from Italy. Whether Peter the Younger also visited Italy, as has always been assumed, remains to be proved. According to an art historical legend, the father had embraced the shift to the Renaissance less than had his sons, or had even simply rejected it. There are, however, absolutely no grounds for this claim. Previous attempts to attribute certain works to an individual family member have been equally unsuccessful: a collective appearance was clearly part of the company's style.

The chief works of the foundry are the numerous, technically outstanding engraved memorial slabs in the Meissen Cathedral, including that of Bishop Dietrich von Schönberg (*d.* 1476), the tomb of Otto IV von Henneberg in St. Mary's Church in Römhild (Thuringia) (*ca.* 1488), and the tomb of Archbishop Ernst von Sachsen in the Cathedral of Magdeburg, with a reclining figure of the bishop and apostle statuettes on the sides, one of which was later recast for private use (St. Mauritius; German National Museum, Nuremberg), which indicates that the models remained in the possession of the foundry.

Vischer Workshop

Scholarship on the funerary monuments and tomb slabs attributed to the Vischer workshop is on the whole insufficient. In 1940 Schulz listed only about 70 funerary sculptures (see Schulz, 1978). Although a forthcoming critical catalog by Sven Hauschke of all known memorial slabs will for the first time provide a solid basis for research, there has been no overview concerning the accuracy of these attributions nor an attempt to organize the pieces stylistically to determine whether certain modelers can be singled out for different phases. Only then could one speculate about which forms the Vischers themselves produced.

The leading role that the Vischer workshop assumed vis-à-vis the other foundries in the country was also made apparent when their emperor, Maximilian I, entrusted their workshop with an assignment for two bronze statues for his tomb: *King Arthur* and *Theoderic*. Dürer produced the designs for the two figures, although which sculptor created the model is debated. Recent technical examinations have established that these are, according to Otto Knitel, "technical masterpieces of rare form and impressive perfection." The figures are cast in one piece and have a significantly

livelier bronze surface than the other casts. That the surface barely needed to be rechased, as did the earlier German casts—even those from the Vischer workshop in the 15th century—shows that the Vischers had learned to direct themselves toward contemporary Italian bronzes. This confirms the observation that only Italian casting methods have so far been identified for *King Arthur* and *Theoderic*.

With the Innsbruck bronzes, the tomb of the provost Anton Kress in Nuremberg (*d.* 1513), and even the chef d'oeuvre of the Vischer works, the Sebaldus tomb, the Vischer workshop clearly employed a different method for creating the form for the bronze cast than previously. The forms were no longer carved out of wood but rather formed in wax, making the modeling softer and more pliable. This accomplishment, surely an Italian import as well, enabled the efficient completion of the more than 100 figures on the Sebaldus tomb. The tomb of Anton Kress shows how the new technique also helped rid the forms of any Gothic austerity and created instead a personal, faintly elegiac pictorial milieu, very much in the spirit of the Italian Renaissance. The same is true for Peter the Younger's experiments with the genre of the medal—his self-portrait at the age of 22 (1609)—or the two well-known ink pots in Oxford that, with their unclad allegorical female figures and Classical ornamentation, belong among the incunabula of German small bronze pieces of the Renaissance period.

In order to conform to the customs of the workshop, the modeling of the forms in wax involved several internal working steps. Forming in wax, rather than woodcarving, for example, allowed for molding methods and *pentimenti* (or changes made to the wax model). The pieces molded in wax could perhaps have been made by the Vischers themselves in their workshop, such as the tomb for Anton Kress, which represents a beautiful Renaissance architectural design, surely molded after a very good drawing, but dilettante in the sculptural detail.

Although it is likely that the Vischers consciously adopted this modern technique of forming in wax, they did not use it exclusively thereafter. The tombs of Cardinal Albrecht of Mainz (1525) and of Elector Friedrich the Wise in Wittenberg Palace Church, both late works and signed, are clearly cast from models carved in wood (perhaps provided in part by the patron). Stylistically, as well, they remain completely tied to late Gothic monuments from about 1500. One must therefore conclude that the Vischer workshop did not systematically replace wood models with wax ones in the name of artistic progress, but rather that it used all conceivable forms of model production concurrently, depending on the particular conditions of an assignment. As a highly technologically competent specialty business, the Vischers knew how to employ these different methods to fulfill the requests of all their patrons, until the end of the workshop's prominence.

DOROTHEA DIEMER

Hermann Vischer the Elder

Biography
Born probably in Nuremberg, Germany, mid 15th century. Listed in the Nuremberg council's rolls for 1453; established a brass-casting foundry in Nuremberg, Germany, which produced tomb monuments for cathedrals in what are now Germany and Poland; succeeded as a sculptor and brass-caster in Nuremberg by his son Peter Vischer the Elder. Died probably in Nuremberg, Germany, before 1488.

Selected Works
1457 Baptismal font; brass; Schlosskirche (Castle Church), Wittenberg, Germany
ca. 1467 Tomb of Bishop George I of Schaumburg; brass; Cathedral of Bamberg, Germany
1476 Tomb of Bishop Dietrich of Schönberg; brass; Cathedral of Meissen, Germany

Peter Vischer the Elder

Biography
Born in Nuremberg, Germany, *ca.* 1460. Son of Hermann Vischer the Elder. Took over his father's brass-casting foundry, 1488; became a master founder, 1489; acted as master of the foundry works in Nuremberg until his death. Died in Nuremberg, Germany, 1529.

Selected Works
1486 Tombstone of Prince Ernst von Sachsen; brass; Cathedral of Meissen, Germany
ca. 1488 Tomb of Otto IV von Henneberg; brass; St. Mary's Church, Römhild, Germany.
1492 Tombstone of Bishop Heinrich III; brass; Cathedral of Bamberg, Germany
1495 Tomb of Archbishop Ernst von Sachsen; brass; Cathedral of Magdeburg, Germany
1496 Tombstone of Bishop Johann IV Roth; brass; Cathedral of Wroclaw, Poland
1496 Tombstone of Callimachus; brass; Dominican Church, Kraków, Poland
1505 Tombstone of Peter Knita; brass; Cathedral of Kraków, Poland
1507–19 Sebaldus Tomb (with Peter Vischer the Younger); bronze; Church of St. Sebald, Nuremberg, Germany

1513 *King Arthur* and *Theoderic*, for the tomb
 of Emperor Maximilian I; brass;
 Hofkirche, Innsbruck, Austria

Hermann Vischer the Younger

Biography

Born probably in Nuremberg, Germany, *ca.* 1486. Father was the sculptor and brass-founder Peter Vischer the Elder. Probably trained in the Vischer foundry with his father; played a leading role in the artistic and technical development of the foundry after 1500; brought back architectural designs from Rome for use in the studio, 1515. Died probably in Nuremberg, Germany, 1 January 1517.

Selected Works

ca. Tomb of Elizabeth and Hermann VIII of
1507–12 Henneberg; brass; St. Mary's Church,
 Römhild, Germany
ca. Fugger Screen, for the Nuremberg city
1515–40 hall; brass (mostly destroyed, 1806); two
 reliefs and two sections of the friezes:
 Musée Léon Matès, Annecy, France

Peter Vischer the Younger 1487–1528

Biography

Born in Nuremberg, Germany, 1487. Son of was the sculptor and brass-founder Peter Vischer the Elder. Assistant in his father's studio from his youth forward; recognized as an independent master after approval by the Nuremberg council of his wall tomb of Elector Frederick III, 1527. Died in Nuremberg, Germany, 1528.

Selected Works

1507–19 Sebaldus Tomb (with Peter Vischer the
 Elder); brass; Church of St. Sebald,
 Nuremberg, Germany
1513 Tomb of Provost Anton Kress; brass;
 Church of St. Lorenz, Nuremberg,
 Germany
1516 Tomb of Margrave Friedrich of Baden;
 brass; parish church, Baden-Baden,
 Germany
1525 Two inkpots with allegorical female
 figures; brass; Ashmolean Museum,
 Oxford, England
1526 Tomb of Elector Friedrich the Wise; brass;
 Wittenberg Palace Church, Germany
1527 Tomb of Elector Frederick III; brass;
 Hofkirche, Wittenberg, Germany

Further Reading

Diemer, Dorothea, *Handwerksgeheimnisse der Vischer-Werkstatt. Eine neue Quelle zur Entstehung des Sebaldusgrabes in Nürnberg, Münchner Jahrbuch der bildenden Kunst 3.* Bayerische Nationalmuseum, Munich, 1996, 24–54

Gothic and Renaissance Art in Nuremberg, 1300–1550 (exhib. cat.), Munich: Prestel-Verlag, and New York: Metropolitan Museum of Art, 1986

Knitel, Otto, *Die Gießer zum Maximiliangrab. Handwerk und Technik*, Privatdruck o.J., Innsbruck, Museum Ferdinandeum, n.d.

Liebmann, M.J., *Die deutsche Plastik, 1350–1550*, Leipzig, Germany: Seemann, 1982

Pechstein, Klaus, "Beiträge zur Geschichte der Vischerhütte in Nürnberg," Ph.D. diss., Freie Universität, Berlin, 1962

Schulz, Fritz Traugott, "Vischer (Fischer), Nürnberger Künstlerfamilie," in *Allgemeines Lexikon der bildenden Künstler von der Antike bis zur Gegenwart*, edited by Ulrich Thieme, Felix Becker, and Hans Vollmer, vol. 19, Leipzig, Germany: Engelmann, 1940; reprint, Leipzig, Germany: Seemann, 1978

Smith, Jeffrey Chipps, *Nuremberg: A Renaissance City, 1500–1618* (exhib. cat.), Austin: University of Texas Press, 1983

Wixom, William D., "Vischer," in *The Dictionary of Art*, edited by Jane Turner, vol. 32, New York: Grove, and London: Macmillan, 1996

Wuttke, Dieter, *Die Histori Herculis des Nürnberger Humanisten und Freundes der Gebrüder Vischer, Pangratz Bernhaubt gen. Schwenter*, Cologne, Germany: Böhlau 1964, 292–323

Wuttke, Dieter, Methodisch-Kritisches zu Forschungen über Peter Vischer d. Ä. und seine Söhne, *Archiv für Kulturgeschichte* 49, Cologne and Vienna: Böhlau, 1967, 208–261

SEBALDUS TOMB

Peter Vischer the Elder (ca. 1460–1529) and sons
1507–1519
bronze
h. 4.71 m
Church of St. Sebald, Nuremberg, Germany

The bronze case for the relics of St. Sebaldus, which still stands in its original place in the east choir of the Protestant Church of St. Sebald in Nuremberg, Germany, is among the most famous works of German Renaissance sculpture. It consists of a Gothic reliquary surrounded by a bronze structure ornamented with more than 100 figures and figurines from the workshop of bronze caster Peter Vischer the Elder and his sons; this Renaissance case is simultaneously its decoration and its treasure.

The figure of St. Sebaldus, honored at this site since the 11th century, is shrouded in historical darkness. The enigmatic pious pilgrim and hermit Sebaldus was considered the founder of the church in Nuremberg. Indeed, homage and pilgrimages paid to Sebaldus led largely to the emergence of the city of Nuremberg and its later prosperity. Sebaldus's official canonization

Peter Vischer the Elder (with Peter Vischer the Younger),
Sebaldus Tomb
© Foto Marburg/Art Resource, NY

occurred in 1425. In order to present his relics in a suitable fashion in the east choir, newly renovated between 1361 and 1379, a new reliquary in wood was produced in 1397. The erection of the bronze shrine in the middle of the choir at the Church of St. Sebald during the years 1507–19 represents the climax and conclusion of the city's efforts to honor its patron saint and thereby to heighten its own renown.

The church administrator Sebald Schreyer in the late 15th century urged the city to ornament the tomb of the church's founder more magnificently. In 1488 the city councillors commissioned the bronze smith Peter Vischer the Elder for a new, elaborate bronze casing for the shrine. The approximately 2-meter-high conceptual drawing for the casing, done on parchment, dated 1488, and marked with Peter Vischer's monogram, is preserved in Vienna (Akademie der Bildenden Künste). It depicts the foundational structure of the case with a pedestal ornamented in relief, as it was later cast, above which is the architectural construction of columns and railings that encloses the reliquary. Above this is pictured a High Gothic superstructure of

finials that, had it been produced, would have reached a height of more than 10 meters. Freestanding figures of the Twelve Apostles were intended to decorate the supporting columns above the relief.

Whether Peter Vischer the Elder, who was famous as a caster, could have been personally responsible for the conceptual drawing or whether other Nuremberg sculptors or painters were brought in for the task is an open question. This question ties in with the issues of the shrine's design and its production in bronze that have been debated for more than 100 years.

The actual production of the bronze work came 20 years after the design, probably owing to difficulties financing the project. The commencement of the work is announced by two inscriptions on the pedestal: "Ein Anfang dvrch mich Peter Vischer 1508" (A beginning by me, Peter Vischer, in 1508) and "Gemacht von Peter Vischer 1509" (Made by Peter Vischer in 1509). Its completion in 1519 is marked by an inscription around the pedestal, which states expressly that Peter Vischer (the Elder) created this piece with his sons. Compared with the conceptual drawing, many fundamental elements are changed in the final bronze. Although the basic structure is the same, the Gothic details on the stepped pedestal, columns, and the finials have been replaced with Renaissance forms such as balustrades and arches, and all of these architectural elements are covered with putti and other figurines. Vischer and his sons abandoned the High Gothic finials in favor of a somewhat awkward baldachin architecture. From details on the pedestal, it can still be seen that these changes were made only after the construction of the pedestal in the wax form had already begun.

The Sebaldus tomb from the Vischer workshop owes its fame to its figures. Yet in the age of Romanticism, there was great enthusiasm for the apostles, which undoubtedly spoke to the taste of the time with their simple, elongated forms, and which exude a certain noble and Classical quality. Later in the 19th century, in terms of form and iconography, the Classical figures were seen as an early assimilation of the Italian small bronzes of the Renaissance into a genuine German work. The four Cardinal Virtues are personified on the long sides of the pedestal, and four heroes are featured, unclad and with their individual attributes, in which Christian and Classical themes are mixed: Hercules with his cudgel, a hunter with bow and quiver (perhaps Nimrod), a hero with sword and shield (perhaps Theseus), and Samson with the jawbone of an ass. The pagan impression given by the pedestal is reinforced through allusion to the gods and mythology—Neptune, Jupiter, Pegasus, fauns, and nymphs with fish tails, a plethora of fantastic beings reminiscent of the northern Italian small-bronze industry of the period—and through the ubiquitous putti and animals.

Peter Vischer the Younger, Tomb of Provost Anton Kress
The Conway Library, Courtauld Institute of Art

The question about which members of the family of casters were responsible for the production of the models and artistic formation has often been debated in an effort to distinguish the work of Peter the Elder from that of his sons Peter the Younger, Hermann the Younger, and Hans. All previous attempts to distinguish the father's style from that of his sons have failed to be persuasive, which can be explained by the structure of their workshop. As an efficient large operation, as was typical for many sculptors' workshops in 16th-century Germany (e.g., Jörg Syrlin and Nikolaus Weckmann in Ulm, Martin Kriechbaum in Munich and Passau), it dealt with assignments through a division of labor. Evidence suggests that the workers cast other artists' models as well as their own and that the workshop as a whole adapted itself to the new stylistic trends, which had penetrated north of the Alps around 1500.

The discovery of a new written source can confirm this division of labor (see Diemer, 1996). For the numerous figures on the Sebaldus tomb, the workshop cast models in wax of various types en masse. These unrefined wax figures then underwent changes in their posture, physical appearance such as hair, beard, and clothing, and attributes. Thus, through a division of labor, a large number of figures could be produced in a short period of time. The Vischer workshop in general also adopted not only stylistic but also technological inspiration from the Italian tradition, although it is not known whether their knowledge was gleaned during (undocumented) trips to Italy or through Nuremberg's continual contact with the south during the time of Albrecht Dürer.

DOROTHEA DIEMER

Further Reading

Baxandall, Michael, *The Limewood Sculptors of Renaissance Germany*, New Haven, Connecticut: Yale University Press, 1980

Diemer, Dorothea, *Handwerksgeheimnisse der Vischer-Werkstatt. Eine neue Quelle zur Entstehung des Sebaldusgrabes in Nürnberg*, *Münchner Jahrbuch der bildenden Kunst* 3. Bayerische Nationalmuseum, Munich, 1996, 24–54

Feulner, Adolf, *Peter Vischers Sebaldusgrab in Nürnberg*, Munich: Piper, 1924

Metropolitan Museum of Art, *Gothic and Renaissance Art in Nuremberg, 1300–1550* (exhib. cat.), Munich: Prestel-Verlag, and New York: Metropolitan Museum of Art, 1986

Stafski, Heinz, *Der jüngere Peter Vischer*, Nuremberg, Germany: Hans Carl, 1962

IVAN (PETROVICH) VITALI 1794–1855
Russian

Ivan (Petrovich) Vitali, an outstanding Russian sculptor of the first half of the 19th century, was a brilliant

It is difficult to identify the stylistic models for the figures. The shrine was admired from the beginning and is clearly indebted to the northern Italian workshops in the essentially unchased bronze surface, which had been unusual in Germany until that point and that creates much of the Italian flavor. The figures of the heroes, as well as the unclad, hearty putti, also come from the Italian world of forms, although they hold no specific stylistic affinity to the bronzes of Andrea Riccio or Severo da Ravenna. The reliefs on the pedestal, the inside of which holds the shrine, depict scenes from the legendary life of St. Sebaldus, as intended in the original design, and are well suited to their location. On the west side, St. Sebaldus is characterized by his church habit, possessing no other distinguishing attributes. Much more striking, therefore, is the self-portrait of Peter Vischer on the opposite side, in his leather apron and boots, confidently working with his hammer, an ideal image of the steadfast German craftsman and one that was often recast in the 19th century.

representative of the romantic current. He worked in the areas of monumental, memorial, and independent studio sculptures, which he executed out of plaster of Paris, marble, limestone, bronze, cast iron, and copper.

Vitali's famous works in Moscow are monumental-decorative sculptures and bas-reliefs for public buildings, triumphal gates, and fountains. In 1829–1830 he executed the multifigured composition *Minerva Surrounded by Genii and Allegorical Figures of Science and Art* from limestone for the summit of the Moscow Technical School building (the architect of which was Dementy Ivanovich Zhilyardi). The sculpture is decorative and three-dimensional, and the arrangement of the figures fits into a triangle. The composition is stylistically close to Classicism, the main artistic current in Russian sculpture during this time.

From 1830 to 1834 Vitali worked jointly with the sculptor Ivan Timofeevich on the sculptural decor for the Triumphal Gates in Moscow, which were designed by the architect Osip (Ivanovich) Bove. The artists designed and executed six horses with a chariot and a figure of Glory, a decorative frieze with the coats of arms of 50 Russian cities, allegorical figures for the summit of the gate, figures of military leaders, reliefs of flying figures of Glory for the tympanum of the arch, and the reliefs *Moscow Liberated* (Vitali) and *The Expulsion of the French* (Timofeevich). The architectural design of the gates dates back to the traditions of famous Roman triumphal arches. The sculptural formation exemplifies the Empire style, and new romantic features were inherent in the two reliefs. The triumphal gates were displayed with great ceremony on 20 September 1834. These works represent significant examples of monumental-decorative sculpture from the first half of the 19th century in Moscow.

In the 1830s, Vitali worked on fountains for the decoration of Moscow squares. Among those preserved are the Nikolsky Fountain (Allegory of Four Rivers) in Lubyansky Square and the Petrovsky Fountain (Figures of Cupid) in Theater Square, in which traces of Italian Renaissance decorative techniques can be found. Fountain sculpture turned out to be an exclusively Moscow type of work for Vitali, later proving not to elicit much interest in St. Petersburg.

Memorial sculpture played an important role in Vitali's artistic practice. He executed tombstones for the Beketov couple for the cemetery of Novospassky Monastery (1823), Ivan Dmitrievich and Ekaterina Aleksandrovna Trubetsky for the cemetery of Andronikovsky Monastery (1833), Ivan Ivanovich Baryshnikov for the cemetery of Donskoi Monastery (1834), and others. The sculptor created his memorial works in the form of statues and reliefs in which both multifigured compositions and decorative, symbolic details are represented. Of the series of works, some are made from

Venus
© The State Russian Museum

marble, others from limestone, and some from Vitali's own bronze castings. He continued to create memorial sculpture in St. Petersburg.

Vitali worked fruitfully on portrait busts of various contemporary figures: Karl Pavlovich Briullov (1836), Aleksandr Sergeevich Pushkin (1837), Petr Fedorovich Sokolov (1837), Tsar Nikolai I (1826, 1835), the Grand Prince Mikhail Pavlovich (1847–48), and the grand princesses Olga Nikolaevna (1844), and Alexandra Nikolaevna (1844–45). The sculptor used chest-level busts and herms, decorating them with draperies and attributes. The images of men are full of inner

dignity and concentration, and the portraits of women are permeated with animation and lyricism.

In Moscow Vitali's sculptural method, his relations to form and its expression, reached maturation, and he oriented himself toward the highest standards of the Russian and European sculptural schools. He established his individual stylistic signature, embodying in his creations a highly inspired fervor and heartfelt lyricism. His statues are distinguished by their power and restraint; they are exquisitely beautiful and majestic, conveying a sense of movement.

Having won a competition for the creation of pediments for St. Isaac's Cathedral in 1839, the sculptor went to St. Petersburg in 1841. He created the bas-reliefs *Adoration of the Magi* and *St. Isaac Blesses the Emperor Theodosius* for the cathedral. For this work he was awarded an Order of St. Anna of the third degree. He devoted 15 years to this immense project for St. Isaac's Cathedral, creating more than 300 statues and reliefs, two pediment compositions, sculptures for the inner and outer doors, and arches and tympanum for the main cupola.

The most famous works of his late creative period were the bronze monument to *Tsar Paul I* in the city of Gatchina, which was ceremoniously displayed on 1 August 1851, and the marble statue *Venus*. For the latter work, Nikolai I presented him with an Order of St. Anna of the second degree with an imperial crown on 23 December 1852. The *Venus* statue, distinguished by its exquisite beauty and grace, was installed in the State Russian Museum, St. Petersburg.

OLGA A. KRIVDINA

Biography

Born in St. Petersburg, Russia, 28 February 1794. Born to the family of the Italian molder Pietro Vitali. Educated St. Petersburg Academy of Arts as an auditor and simultaneously worked in sculpture studio of Agostino Triscorni; established and headed a marble cutting studio, Moscow, 1818–41; commissions for the emperor Nicholas I, St. Petersburg, 1841–55; awarded the title of academician, 1840; professor of sculpture at St. Petersburg Academy of Arts from 1842. Died in St. Petersburg, Russia, 5 July 1855.

Selected Works

More than 300 of Vitali's statues and bas-reliefs decorate the facades and interior of St. Isaac's Cathedral in St. Petersburg. The majority of independent pieces are preserved in the collection of the State Russian Museum in St. Petersburg.

1823 *Faith and Hope* (part of tombstone of Mr.

and Mrs. Beketov), for cemetery of Novospassky Monastery, Moscow, Russia; bronze; A.V. Shchusev State Research Museum of Architecture, Moscow, Russia

1829–30 *Minerva Surrounded by Genii and Allegorical Figures of Science and Art*; limestone; Technical School building; Moscow, Russia

1829–35 Nikolsky fountain (Allegory of Four Rivers); bronze; Lubyansky Square; Moscow, Russia

1830–34 Sculpture for the Triumphal Gates; cast iron; Moscow, Russia

1831–35 Petrovsky fountain (figures of Cupid); bronze; Theater Square; Moscow, Russia

1833 Tombstone for I.D. and E.A. Trubetsky; cemetery, Andronikovsky Monastery, Moscow, Russia

1834 Tombstone for I.I. Baryshnikov, for cemetery of Donskoi Monastery, Moscow, Russia; marble; A.V. Shchusev State Research Museum of Architecture, Moscow, Russia

1836 Bust of K.P. Briullov; plaster; State Russian Museum, St. Petersburg

1837 Bust of A.S. Pushkin; plaster; bronze; State Russian Museum, St. Petersburg

1840 Bust of V.K. Shebuev; plaster; State Russian Museum, St. Petersburg

1841–55 Facades and interiors, including statues, pediments (*Adoration of the Magi* and *St. Isaac Blesses the Emperor Theodosius*), outer and inner doors; bronze, copper; St. Isaac's Cathedral, St. Petersburg, Russia

1844 *Madonna with Child*; marble; facade, Cottage Palace, Peterhof, St. Petersburg, Russia

1845–46 *Grand Princess Alexandra Nikolaevna*, for chapel, Tsarskoe Selo, Russia; marble; Pushkin Institute, St. Petersburg, Russia

1850 Monument to *Tsar Paul I*; zinc; Gatchina Palace, St. Petersburg, Russia

1852 *Venus*; marble; State Russian Museum, St. Petersburg

Further Reading

Androssov, Sergey, "Vitali, Ivan (Petrovich)," in *The Dictionary of Art*, edited by Jane Turner, vol. 32, New York: Grove, and London: Macmillan, 1996

Gosudarstvennyi Russkii Muzei (Russian State Museum), *Skul'ptura, XVIII–nachalo XX veka: Katalog* (Sculpture of the 18th–Early 20th Centuries: Catalog), Leningrad: Iskusstvo, 1988

Grabar', Igor', *Istoriia russkogo iskusstva* (The History of Russian Art), 6 vols., Moscow: Knebel, 1909–14; see especially vol. 5, *Istoriia skul'ptury* (The History of Sculpture)

Iakirina, T.V., and N.V. Odnoralov, *Vitali, 1794–1855*, Leningrad: Iskusstvo, 1960

Krivdina, O.A., "Materialy k biografii Ivana Petrovicha Vitali (1794–1855) (Materials for a Biography of Ivan Petrovich Vitali [1794–1855])," in *Presnovskie chteniia* (Presnov Readings), vol. 3, *Sbornik nauchnykh trudov* (Anthology of Scientific Works), St. Petersburg: Gosudarstvennyi Russkii Muzei, 1999

Krivdina, O.A., "Izyashchno, legko, svobodno: Tvorchestvo I.P. Vitali (1794–1855) (Graceful, Light, Free: The Works of I.P. Vitali [1794–1855])," *Mir muzeya* 4 (2000)

Nogaevskaia, E.V., "I.P. Vitali," in *Russkoe iskusstvo: Ocherki o zhizni i tvorchestve khudozhnikov, pervaia polovina XIX veka* (Russian Art: Essays on the Life and Creation of Artists of the First Half of the 19th Century), edited by A.I. Leonova, Moscow: Iskusstvo, 1954

Petrov, V.N., "Skul'ptura," in *Istoriia russkogo iskusstva* (The History of Russian Art), vol. 5, edited by Igor' Grabar', Moscow: Izd-vo Akademii Nauk SSSR, 1964

Semyonova, N., "Istoriia moskovskogo fontana (History of the Moscow Fountain)," in *Skul'ptura v gorode* (City Sculpture), Moscow: Sov. Khudozhnik, 1990

Paramonov, A.B., "Scul'ptory XIX," in *Khudozhniki narodov SSSR: Bibliograficheskii slovar' v shesti tomakh* (Artists of the Soviet People: Bibliographical Dictionary in Six Volumes), edited by Tat'iana Nikolaevna Gorina et al., vol. 2, Moscow and St. Petersburg: Iskusstvo, 1972

ALESSANDRO VITTORIA ca. 1525–1608

Italian

Alessandro Vittoria was the most talented sculptor active in Venice in the second half of the 16th century. Best known for his animated portrait busts, he was also a renowned stuccoist, designer of bronze statuettes and portrait medals, and carver of marble and stone figures. The diversity of genre, medium, and scale in Vittoria's oeuvre highlights his prodigious versatility, which sets him apart from his contemporaries, who tended to be specialists. Vittoria, who also practiced as an architect and amateur painter, was keen to be perceived as a *homo universalis* and strove throughout his career to emulate Michelangelo, favoring carving over modeling and the isolated expressive male nude over any other subject. Vittoria also drew inspiration from Classical sculpture, Parmigianino and the School of Fontainebleau, and contemporary painters in Venice such as Andrea Schiavone, Paolo Veronese, and Jacopo Tintoretto, with whom he collaborated. Vittoria owned more than 50 paintings—most famously, Parmigianino's *Self-Portrait in a Convex Mirror* (Kunsthistorisches Museum, Vienna)—as well as drawings by Parmigianino, prints, copies and casts after Michelangelo, and two antique busts.

Trained by Jacopo Sansovino in the early 1540s, Vittoria assisted him on several important commissions, such as the sacristy door and the north singing gallery of St. Mark's Basilica, Venice, and in 1550 he carved four *River-Gods* for spandrels of the Marciana Library, the others executed by much better known sculptors. Vittoria's first independent commission was a statuette of *St. John the Baptist* for S. Geremia, Venice (now in S. Zaccaria), which he subsequently repurchased and treasured in his house until he died. His most beloved creation, the statuette foreshadows his later work in the well-observed anatomy, the careful disposition of the extremities, the schematic fall of the drapery, and the overt emotion of the features.

After a year's sojourn in Trent, when he designed (but never executed) a Neptune fountain for the prince-bishop Cardinal Cristoforo Madruzzo and fashioned portrait medals of dignitaries present for the council, Vittoria moved to Vicenza. About December 1551 he had a bitter falling-out with Sansovino, which climaxed in the spring of 1552 when Vittoria tried unsuccessfully to purloin from Sansovino the commission to carve a colossal *Hercules* for the Duke of Ferrara. It was not until late 1552 that Pietro Aretino effected a reconciliation between the sculptors. Vittoria's most important project during his sojourn in Vicenza proved to be the stuccoes that he executed in Andrea Palladio's Palazzo Thiene. The Sala degli Dei is dominated by enormous Parmigianinesque goddesses and Michelangelesque gods who recline around the springing of the vault. Above are elaborate strapwork cartouches, the first of their kind in Italy. In the nearby Sala degl'Imperatori, eight classicizing busts, the first in Vittoria's oeuvre, are flanked by pairs of powerful river gods, with urns above flanked by pairs of muscular satyrs or svelte nymphs.

By May 1553 Vittoria had returned permanently to Venice and was working on two colossal caryatids, the *Feminoni*, for the Marciana Library. Several other prestigious commissions from Sansovino followed, including the bronze statue of *Tommaso Rangone*, the marble *Pietà* lunette relief for the Venier tomb (1557–58; S. Salvatore, Venice), and most significantly, the lavish stuccoes for the vaults of the ceremonial staircases of both the Doge's Palace and the Marciana Library. Vittoria also executed several important independent projects, such as four statues for the tomb of Alessandro Contarini. About 1560 Vittoria carved his first altarpiece, for Marc'Antonio Grimani, which comprised a dynamic portrait bust and two exquisite statuettes of Grimani's name saints (Grimani Chapel, S. Sebastiano, Venice), which delighted the patron and won Vittoria huge acclaim. As a result the government commissioned three large statues for the Montefeltro Chapel altar in S. Francesco della Vigna, and Girolamo Zane commissioned a huge high-relief stucco altarpiece of the *Assumption of the Virgin with Four Saints*, and a freestanding marble *St. Jerome* in front. Regrettably, the stucco *pala* was dismantled in the mid 18th century, and only two of the saints were salvaged to

either side. This represents a grave loss because this was Vittoria's first attempt to synthesize an altar's sculptural and architectural components. Nonetheless, the magnificent *St. Jerome*, Vittoria's most sophisticated response to Michelangelo, whose work the piece rivals in beauty and spiritual intensity, survives.

By the late 1560s Vittoria had become the preeminent sculptor of the city: on 22 January 1569 Veit von Dornberg, the imperial Venetian agent, informed Maximilian II that Vittoria was considered second only to Sansovino, who was too enfeebled to sculpt, with Danese Cattaneo a poor third. Just prior to this, in the second edition of his *Lives of the Painters, Sculptors, and Architects*, Vasari had eulogized Vittoria, concluding, "We are destined to see most beautiful works come daily from him, worthy of his name Vittoria [Victory], and . . . he is likely to be a really excellent sculptor and to win the palm from all the others of that place."

About 1570–72, Vittoria executed the monument to Procurator Giulio Contarini, his beloved patron whose features he had already given to the Zane *St. Jerome*. Comprising one of his finest portrait busts, centered before a dedicatory plaque flanked by caryatids, this monument formed the prototype for many of Vittoria's later tombs, including his own, as well as the plaque commemorating the visit of Henry III of France. Vittoria fashioned many other portrait busts during this decade, in which the torso became increasingly expansive, the torsion of head in relation to shoulders more complicated, and the chiaroscuro contrasts richer through deeper undercutting. These experiments culminated in Vittoria's greatest portrait, that of the nonagenarian *Doge Nicolò da Ponte* made for his monument formerly in S. Maria della Carità. Shortly afterward the painter Agostino Carracci praised Vittoria's portraits for their reality, concluding that "one cannot find better."

Forced to flee to Vicenza in September 1576 to avoid the plague, and then almost assassinated upon his return (perhaps engineered by a jealous rival), the later 1570s proved traumatic years for Vittoria. Nevertheless, he subsequently produced some of his greatest masterpieces, including two in bronze: the so-called *Pala Fugger*, based on Titian's *Annunciation* (S. Salvatore), and his *Virgin* and *St. John the Evangelist* for the Altar of the Crucifix in the Scuola di S. Fantin (now SS. Giovanni e Paolo, Venice). The *Virgin*, engulfed and weighed down by her cowl, grieves silently, in stark contrast to the clamorous, upward-straining *St. John*, who flings his arms out in desperate abandon.

From the early 1580s on, Vittoria made increasing use of assistants. While the workshop productions are rather formulaic, Vittoria's autograph works retain his characteristic brilliance and verve. For a second altar in the Scuola di S. Fantin, he carved a kneeling pathos-filled *St. Jerome*, and in the same years two standing figures of the *Prophet Daniel* and *St. Catherine of Alexandria* for the Mercers' altar, which achieve a new synthesis with the rest of the altar that prefigures many Baroque altar complexes. Vittoria's last major works were the statues of *St. Roch* and the sensuously writhing *St. Sebastian* for the Salami-makers' altar. By the mid 1590s Vittoria had virtually stopped carving, although he continued to direct his workshop and was frequently consulted on artistic matters of all kinds. Just before he died he carved a statuette of *San Zaccaria* as a pendant for his beloved *St. John the Baptist* and bequeathed them both to S. Zaccaria, where he had erected his own monument. Vittoria's personal papers (the *Commissaria Vittoria*) are preserved in the state archives of Venice within the archive of San Zaccaria.

VICTORIA AVERY

See also **Campagna, Girolamo; Sansovino, Jacopo**

Biography

Born in Trent, Italy, *ca.* 1525. Probably received rudimentary training from Paduan sculptors Vincenzo and Gian Gerolamo Grandi during their residence in Trent, 1534–42; moved to Venice by 25 July 1543; entered Jacopo Sansovino's workshop; graduated as a master mason of the *lavorante* type (a master without a workshop of his own) in the Stonemasons' Guild (*Arte dei Tagliapietra*), *ca.* 1544, and continued to work for Sansovino; relocated several times, but returned permanently to Venice, *ca.* April 1553, where he assisted Sansovino and undertook independent commissions for the state, lay and religious confraternities, and private individuals; hired first of ten apprentices, 7 May 1555; became a master mason of the *padrone di corte* type (a master with his own workshop) in the Stonemasons' Guild, 25 July 1557; joined Scuola Grande di S. Marco, 24 January 1563, and *Accademia del Disegno*, Florence, *ca.* 1567; purchased a house in Venice, 4 March 1569, part of which became workshop until his death; quit *Arte dei Tagliapietra*, 7 February 1599, but continued to advise and sculpt for his own pleasure. Died in Venice, Italy, 27 May 1608.

Selected Works

1550 *St. John the Baptist*; marble; Church of S. Zaccaria, Venice, Italy

1552 Decoration of vaults; stucco; Palazzo Thiene (now Banco Popolare), Vicenza, Italy

1553–55 *Feminoni*; marble; Marciana Library, Venice, Italy

ca. 1559	Decoration of vaults of *Scala d'Oro*; stucco; Doge's Palace, Venice, Italy
1560–61	Bust of *Marc' Antonio Grimani* and statues of *St. Mark* and *St. Anthony Abbot*; marble; Church of S. Sebastiano, Venice, Italy
1563–64	*St. Sebastian, St. Anthony Abbot,* and *St. Roch*; Istrian stone; Church of S. Francesco della Vigna, Venice, Italy
1566	*St. Sebastian*; bronze; Metropolitan Museum of Art, New York City, United States
1566-after 1576	*St. Jerome*; marble; Church of S. Maria Gloriosa dei Frari, Venice, Italy
ca. 1582–83	*Virgin* and *St. John the Evangelist*; bronze; Church of SS. Giovanni e Paolo, Venice, Italy
1582–84	Bust of *Doge Nicolò da Ponte*; terracotta; Seminario Patriarcale, Venice, Italy
1583–84	*Prophet Daniel* and *St. Catherine of Alexandria*; marble; Church of S. Giuliano, Venice, Italy
ca. 1583	*The Annunciation (Pala Fugger)*; bronze; Art Institute of Chicago, Illinois, United States
ca. early 1590s	*St. Sebastian* and *St. Roch*; marble; Church of S. Salvatore, Venice, Italy
ca. 1602–05	Funerary monument of Alessandro Vittoria; marble, stone, stucco; Church of S. Zaccaria, Venice, Italy

Further Reading

Attardi, Luisa, *La decorazione "all'antica" nella Vicenza di Palladio: Alessandro Vittoria in Palazzo Bissari-Arnaldi,* Vicenza: Neri Pozza, 1999

Avery, Victoria, "The Early Works of Alessandro Vittoria (c. 1540–c. 1570)," Ph.D. diss., Cambridge University, 1996

Avery, Victoria, "Documenti sulla vita e le opere di Alessandro Vittoria (c. 1525–1608)," *Studi Trentini di Scienze Storiche* 78 (1999)

Bacchi, Andrea, Lia Camerlengo, and Manfred Leithe-Jasper, *"La bellissima maniera": Alessandro Vittoria e la scultura veneta del Cinquecento,* Trent, Italy: Castello del Buonconsiglio, Monumenti e Collezioni Provinciali, 1999

Boucher, Bruce, "La scultura nell'età del Sansovino" in *Storia di Venezia—Temi: L'arte,* edited by Rodolfo Pallucchini, vol. 1, Rome: Istituto della Enciclopedia Italiana, 1994

Davis, Charles, "Shapes of Mourning: Sculpture by Alessandro Vittoria, Agostino Rubini, and Others," in *Renaissance Studies in Honor of Craig Hugh Smyth,* edited by Andrew Morrogh et al., vol. 2, Florence: Giunti Barbèra, 1985

Finocchi Ghersi, Lorenzo, *Alessandro Vittoria: Architettura, scultura e decorazione nella Venezia del tardo Rinascimento,* Udine, Italy: Forum, 1998

Laschke, Birgit, "Alessandro Vittoria: il progetto di una fontana per Trento," *Studi Trentini di Scienze Storiche* 84 (1995)

Leithe-Jasper, Manfred, "Alessandro Vittoria: Beiträge zu einer Analyse des Stils seiner figürlichen Plastiken unter besonderer Berücksichtigung der Beziehungen zur gleichzeitigen Malerei in Venedig," Ph.D. diss., University of Vienna, 1963

Martin, Susanne, *Venezianische Bildhaueraltäre und ihre Auftraggeber 1530–1620,* Marburg: Tectum Verlag, 1998

Martin, Thomas, "Vittoria, Alessandro," in *The Dictionary of Art,* edited by Jane Turner, vol. 32, New York: Grove, and London: Macmillan, 1996

Martin, Thomas, *Alessandro Vittoria and the Portrait Bust in Renaissance Venice,* Oxford: Clarendon Press, and New York: Oxford University Press, 1998

ST. SEBASTIAN
Alessando Vittoria (ca. 1525–1608)
1563–1564
Istrian stone
h. ca. 170 cm
Church of S. Francesco della Vigna, Venice, Italy

Alessandro Vittoria was commissioned to carve the life-size statue of *St. Sebastian,* together with a similarly sized *St. Roch* and a slightly larger *St. Anthony Abbot,* on 12 November 1561. These figures were to fill, respectively, the right, left, and middle niches of a marble triptych that had recently been carved by Francesco de Bernardin Smeraldi, called il Fraccà, for the altar of the funerary chapel of the condottiere Nicolò da Montefeltro, in the Franciscan Church of S. Francesco della Vigna. In his will Montefeltro had stipulated that his chapel be dedicated to St. Anthony Abbot—hence this saint's central position and greater size. The decision to also include images of St. Sebastian and St. Roch was undoubtedly a result of the terrible plague that broke out in Venice in 1556, just before work on the altar began: both saints were believed to possess thaumaturgical and apotropaic powers and were thus invoked against the plague. Vittoria's statues were the final component of the chapel to be commissioned by the procuratori di San Marco de Citra, who were the executors of Montefeltro's will. The choice of Vittoria to execute such a prestigious commission demonstrates the esteem in which he was held by the Venetian establishment, his reputation having been secured by the stucco vault decorations of the staircases in the Doge's Palace and the Marciana Library, Venice (*ca.* 1559–60).

The contract obliged Vittoria to carve the figures by the following September, "con ogni sua industria et diligentia" (with all his industry and diligence), to bring honor to himself and satisfaction to the procurators. In return, he would receive 150 ducats plus the cost of the stone. Because the contract makes no reference to a drawing or to any models, the design of the figures probably postdates the commission. That Vitto-

ria followed standard practice and made preparatory models for the statues appears confirmed by Jacopo Palma il Giovane's *Portrait of a Collector*, which includes what appears to be a gesso model for the *St. Sebastian*.

Although Vittoria should have completed the statues by September 1562, he did not commence carving the *St. Sebastian* until after 24 July 1563, for on that day, he recorded purchasing a block of Istrian stone from which it was to be carved from the widow and sons of his late colleague, the sculptor Pietro da Salò. Account books, maintained on behalf of the procurators, indicate that all three statues were finished by 25 August 1564, when porters were paid for transporting them to the church, and that minor adjustments had to be made to the base of the *St. Sebastian* before it could be installed. The procurators must have been pleased with Vittoria's work; despite its late completion, he was not penalized, receiving a total payment of almost 170 ducats. Although Vittoria signed all three statues, he was evidently most proud of the *St. Sebastian*, because this figure bears his fullest signature. All three figures were praised by Vasari as "molto belle, graziose e ben condotte" (very beautiful, graceful, and well executed).

Rather unusually, Vittoria portrayed St. Sebastian without arrows or bonds, and the only sign of his affliction is one discreet arrow hole under his left pectoral. It is Sebastian's uncompromised beauty, rather than his suffering, that is emphasized. Through his dynamic torsion and complex, gyrating pose, the *St. Sebastian* is a *figura serpentinata* par excellence, the result of melding a number of diverse sources, including Michelangelo's so-called *Dying Slave* (ca. 1513; Musée du Louvre, Paris), several of the martyrs in Vittore Carpaccio's painting of *The Martyrdom of the Ten Thousand Christians* (1515; Accademia, Venice), and Bartolomeo Bergamasco's *St. Sebastian* (Church of S. Rocco, Venice). Late Hellenistic sculpture was also influential: *St. Sebastian*'s pathos-filled head shares affinities with the older son of the *Laocoön* group as well as the *Dying Alexander*.

Furthermore, there is an intriguing *Study of a Standing Male Nude* (unlocated; sold Sotheby's, London, 23 March 1971, lot 131), in pen and brown wash, which corresponds so perfectly with the *St. Sebastian* (in the sharp left turn of the head, the twist of the upper torso, the vigorous torsion of the raised arm, and the disposition of the legs) that there must be a direct relationship between them. Because of certain similarities with the work of Parmigianino during his Rome-Bologna years (1524–30), and the fact that Vittoria is known to have owned numerous drawings by the Emilian, this *Study* has been attributed to Parmigianino, and as such cited as the most critical influence on the Montefeltro *Sebas-*

St. Sebastian
The Conway Library, Courtauld Institute of Art

tian. Other factors, however, such as the very sculptural use of wash and hatching to define form through shadows and highlights, the figure's complete isolation against a blank wall, and the identical pose arrived at after several changes, argue strongly in favor of its status as a preparatory study by Vittoria for the Montefeltro *St. Sebastian*, in 1562–63. If so, this sketch is of enormous significance, for only one other autograph drawing by Vittoria is known, his *Design for a Neptune Fountain* of 1551.

The sinuous composition of the *St. Sebastian* fascinated Vittoria, and he returned to it throughout his career; echoes of this composition can be seen in the caryatids for his own funerary monument in S. Zaccaria, Venice, the *Telamones* for Andrea Gritti, and the *St. Sebastian* for the Luganegheri altar in the Church of S. Salvatore, Venice. Vittoria also made three variant bronze statuettes of *St. Sebastian* (Metropolitan Museum of Art, New York City; private collection; Los Angeles County Museum of Art). Although they depend closely on the Montefeltro statue, they display more attenuated proportions, more idealized forms,

and a more exaggerated torsion. Vittoria was also proud of these bronzes; he signed two in large letters around their bases and retained one for his own pleasure in his upstairs study until his death. In his ninth and final will, Vittoria stipulated that the *St. Sebastian*, which he had retained, be sold to a prince or some other discerning collector "who would appreciate it." A preliminary model for the bronze variants may be recorded in Veronese's portrait of him (Metropolitan Museum of Art, New York City).

By combining a classical *contrapposto* with a mannerist *serpentinata* twist within the body of a sylphlike male nude, Vittoria created a proto-Baroque icon. The bronze statuettes, together with the preparatory models for these and the Montefeltro prototype, immediately became highly sought after collectors' pieces; plaster casts taken from them were widely disseminated in artistic circles. These appear in several paintings, such as David Bailly's *Vanitas Still-Life with the So-Called Bust of Seneca* (Haboldt and Co., New York), Evaristo Baschenis's *Musical Instruments with a Statuette* (Accademia Carrara, Bergamo), Jan Steen's *The Drawing Lesson* (J. Paul Getty Museum, Los Angeles), and Adam de Coster's complex *Double-Portrait of Duquesnoy and Petel* (Statens Museum for Kunst, Copenhagen). It was presumably from such a cast that Bartolomeo Passarotti sketched the figure, now heavily muscled and Michelangelesque in proportions, from four different views (J. Paul Getty Museum, Los Angeles). The composition was also known by Augsburg silversmiths of the 17th century, as shown by statuettes in the churches of Bad Mergentheim and Ehingen, Germany.

VICTORIA AVERY

Further Reading

Leithe-Jasper, Manfred, "Alessandro Vittoria, Hl. Sebastian (Marsyas?)[no. 83]," in *Von allen Seiten schön: Bronzen der Renaissance und des Barock* (exhib. cat.), edited by Volker Krahn, Heidelberg: Edition Braus, 1995

Leithe-Jasper, Manfred, "San Sebastiano (Marsia?)[no. 75]," in *La bellissima maniera: Alessandro Vittoria e la scultura veneta del Cinquecento* (exhib. cat.), edited by Andrea Bacchi, Lia Camerlengo, and Manfred Leithe-Jasper, Trent, Italy: Castello del Buonconsiglio, Monumenti e Collezioni Provinciali, 1999

Sponza, Sandro, "San Sebastiano [no. 66]," in *"La bellissima maniera": Alessandro Vittoria e la scultura veneta del Cinquecento* (exhib. cat.), edited by Andrea Bacchi, Lia Camerlengo, and Manfred Leithe-Jasper, Trent, Italy: Castello del Buonconsiglio, Monumenti e Collezioni Provinciali, 1999

Vasari, Giorgio, *Le vite de' più eccellenti architetti, pittori, et scultori italiani*, 3 vols., Florence: Torrentino, 1550; 2nd edition, Florence: Appresso i Giunti, 1568; as *Lives of the Most Eminent Painters, Sculptors, and Architects*, 10 vols., translated by Gaston du C. de Vere, London: Macmillan, 1912; reprint, edited by David Ekserdjian, 2 vols., New York: Knopf, and London: Campbell, 1996

VON HILDEBRAND, ADOLF,

see **Hildebrand, Adolf von**

MICHIEL VAN DER VOORT THE ELDER 1667–1737
Netherlandish

After probably training under Jan Cosyns and then Peter Scheemaeckers the Elder and becoming a master in the Guild of St. Luke in Antwerp in 1690, Michiel van der Voort visited Rome and Naples between 1690 and 1693. After this time he mainly worked in his home city of Antwerp, where he is recorded to have trained 13 pupils in his studio. His most important pupil was Michael Rysbrack, who, as a fully trained master, immigrated to London in 1720, where he pursued a successful career. In 1700 van der Voort married Elisabeth Verberckt, the aunt of the sculptor Jacques Verberckt. The couple had five children, among them the sculptor and painter Michiel van der Voort II, who was to make his career in Paris and Bordeaux.

Several influences can be discerned in the oeuvre of van der Voort. The Classicism of François du Quesnoy's *St. Susanna* (1629–33) was a source of inspiration for the two female figures of the Virgin and Child and Religion (or Faith) on the tomb monument to Archbishop Humbertus Guilielmus de Precipiano in the Cathedral of Mechelen. The portrait of the deceased prelate, rendered with remarkably sharp observation, is characterized by a naturalism that contrasts greatly with the idealized, nearly antique, female figures. The second tomb monument in the same church by van der Voort, to General Prosper Ambrosius de Precipiano, brother of Humbertus and lieutenant general in the army of King Charles III, is of a new type, incorporating an obelisk with a representation of Pallas in front. This prototype was followed widely in the southern Low Countries and is characteristic of the pre-Classical trend.

The classicizing tomb monuments in the former Dominican Church of Brussels, to Albertus de Coxie (1709) and to Jacobus Franciscus van Caverson (1713), must have been impressive creations. The first is exclusively known from drawings, terracotta sketches, and engravings. Of the second monument the marble bust *Jacobus Franciscus van Caverson* remains; now in the Musées Royaux des Beaux-Arts de Belgique, Brussels, it is an imposing state portrait in which the Classical spirit of synthesis is manifest.

Van der Voort also collaborated with a number of other sculptors, including Willem Kerricx, Alexander van Papenhoven, and Jan Claudius de Cock, on the *Mount of Calvary*, also called Garden of Jerusalem, next to the Church of St. Paulus at Antwerp. For this

project he chiseled more than 20 life-size statues. The angels he carved were directly inspired by those designed by Gianlorenzo Bernini for the Ponte Sant'Angelo (1668–69) in Rome. He also executed the Twelve Apostle figures (date unknown) in the nave of the same church, for which we still have his drawn designs. He closely followed du Quesnoy's example (inaugurated in 1640) from St. Peter's Basilica, Rome, in his own statue of St. Andrew.

One of van der Voort's masterpieces is without doubt the pulpit in the Cathedral of Antwerp, which was originally commissioned by the Abbey of Saint Bernard at Hemiksem (province of Antwerp). It is a perfect example of the transition between a Late Baroque pulpit and a naturalistic one. The sculptor rendered the flora and fauna lovingly, as if referring to the lessons of St. Bernard. The four constituent parts of the pulpit—pedestal, tub, stairs, and sounding board—are clearly recognizable. A few years later, in 1718, the Candele family ordered a tomb monument with the representation of the *Preparations for the Flagellation*, which was erected in 1719 in the Verrijzeniskapel (Chapel of the Resurrection) in the Church of St. Jacob. The sculptural group gives a dynamic

picture of Christ being tied to the flagellation column by two executioners.

One of van der Voort's most famous works is the relief of the *Erection of the Cross* for the Church of St. Jacob (Antwerp). He succeeded in giving an impression of depth by modeling the figures in high relief against a purely painterly low-relief background. Rubens's *Erection of the Cross* (1612–14) in the Cathedral of Antwerp was the source of inspiration for van der Voort's dynamic composition, for which he was praised during his lifetime.

In 1723 van der Voort completed several important commissions: the acutely realistic portrait bust—executed in terracotta painted white—*Abraham Genoels* and two life-size marble statues, *St. Paul* and *St. John the Evangelist*, placed at the northern access to the ambulatory of the Church of St. Jacob at Antwerp. For the powerful *St. Paul*, he sought inspiration in Michelangelo's *Moses* (*ca.* 1515). In the same year, he delivered the pulpit that the Norbertine Sisters had ordered in 1721 for their conventual Church of Leliëndaal at Mechelen, which since 1809 has been in the cathedral. On it is carved the dramatic conversion of St. Paul, who falls from his horse, below which is a representation of the mount of Calvary and the temptation of Adam and Eve. The naturalistic representation of leaves, animals, and especially birds in this richly decorated tableau testifies to his exceptional virtuosity. It is virtually impossible to disentangle the architectural elements among the rocky hill, trees, and different figures of the composition.

Besides the large number of commissions emanating from church authorities, van der Voort was also active in the delivery of secular sculpture, including the marble group *Andromeda Freed by Perseus* (1716). Other works are now only known through terracotta sketches, such as *Hercules as a Fluteplayer* (year unknown) and *Samson and the Lion*.

Remarkably, many designs of van der Voort have survived. The Stedelijk Prentenkabinet at Antwerp alone has more than 70. His signed *modelli* (models) are fascinating documents, allowing one to follow and understand the genesis of his creations. This is particularly interesting when drawn and modeled designs survive alongside the final version of a work.

Van der Voort worked between two spheres of influence: on the one hand, he followed the Late Baroque; on the other, he represented the pre-Classical strand. He often synthesized these diverging styles in the same composition. The majority of his work is religious: altars, pulpits, confessionals, and tomb monuments. In his religious works he also reveals himself as an excellent portraitist, capable of keen observation.

HELENA BUSSERS

Tomb monument to Humbertus Guillielmus de Precipiano
The Conway Library, Courtauld Institute of Art

Biography

Born in Antwerp, Southern Netherlands (present-day Belgium), 3 January 1667. Presumably apprenticed with Jan Cosyns, then with Peter Scheemaeckers the Elder; became master in Guild of St. Luke, Antwerp, 1689–90; visited Rome and Naples, 1690–93; married Elisabeth Verberckt, 1700, aunt to sculptor Jacques Verberckt; had five children, including the sculptor Michiel van der Voort II (1704–after 1777). Died in Antwerp, Southern Netherlands, 6 December 1737.

Selected Works

1701 Epitaph to the family Peeters-Van Eelen; marble; Our Lady's Chapel, Church of St. Jacob, Antwerp, Belgium

1706 *Samson and the Lion*; terracotta; Victoria and Albert Museum, London, England

1709 Tomb monument to General Prosper Ambrosius de Precipiano; red, brown, white marble; Cathedral of Mechelen, Belgium

1709 Tomb monument to Humbertus Guillielmus de Precipiano; marble; Cathedral of Mechelen, Belgium

1713 *Jacobus Franciscus van Caverson*; marble; Musées Royaux des Beaux-Arts de Belgique, Brussels, Belgium

1713 Pulpit; oak; Cathedral of Antwerp, Belgium

1718–19 *Preparations for the Flagellation*; marble; Verrijzeniskapel (Chapel of the Resurrection), Church of St. Jacob, Antwerp, Belgium

ca. 1719 Angels and Saints, for *Mount of Calvary*; sandstone; Church of St. Paulus, Antwerp, Belgium

1720 *Erection of the Cross*; Bentheim stone; Church of St. Jacob, Antwerp, Belgium

1721–23 Pulpit; oak; Cathedral of Mechelen, Belgium

1723 *Abraham Genoels*; terracotta; chapel of the Hospital of St. Juliaan, Antwerp, Belgium

1723 *St. Paul* and *St. John the Evangelist*; marble; Church of St. Jacob, Antwerp, Belgium

1726 High altar; painted, marbled wood; Church of St. Sulpitius and St. Dionysius, Diest, Belgium

Further Reading

17th and 18th Century Drawings: The Van Herck Collection, edited by Claire Baisier et al., Brussels: King Baudouin Foundation, 2000

17th and 18th Century Terracottas: The Van Herck Collection, edited by Claire Baisier et al., Brussels: King Baudouin Foundation, 2000

Bussers, Helena, "The 17th and 18th Centuries: Sculpture," in *Flemish Art from the Beginning till Now*, edited by Herman Liebaers et al., Antwerp: Mercatorfonds, and London: Alpine Fine Arts Collection, 1985; New York: Arch Cape Press, 1988

Gerson, Horst, "Een tekening van Michiel van der Voort de Oude," in *Album Amicorum J.G. van Gelder*, edited by J. Bruyn et al., The Hague: Nijhoff, 1973

Kockelbergh, Iris, "Voort (Vervoort), Michiel van der, I," in *The Dictionary of Art*, edited by Jane Turner, New York: Grove, and London: Macmillan, 1996

La sculpture au siècle de Rubens dans les Pays-Bas méridionaux et la principauté de Liège (exhib. cat.), Brussels: Musées Royaux des Beaux-Arts de Belgique, Musée d'Art Ancien, 1977

Tralbaut, Marc Edo, *De Antwerpse "Meester Constbeldhouwer" Michiel van der Voort de Oude (1667–1737): Zijn leven en werken*, Brussels: Paleis der Academiën, and Antwerp: Standaard Boekhandel, 1950

Tralbaut, Marc Edo, "De Antwerpse "Meester Constbeldhouwer" Michiel van der Voort de Oude (1667–1737): Zijn leven en werken," *Jaarboek van de Koninklijke Oudheidkundige Kring van Antwerpen* 28 (1955–57)

ADRIAEN DE VRIES ca. 1556–1626
Netherlandish

The artistic origins of Adriaen de Vries are still rather obscure. He must have been born around 1556 (and not ca. 1545, as is stated in earlier literature), the son of a wealthy apothecary, city councillor, and alderman of The Hague. De Vries may have received his first training from the goldsmith Simon Adriaensz Rottermont, his brother-in-law. It is also likely that he was artistically and personally acquainted with the Delft sculptor Willem Danielsz van Tetrode, whose career shows strong similarities with de Vries's own later career.

Well before 1581, de Vries traveled to Italy, as did many of his fellow countrymen. He is documented in Florence in March 1581 as an *orefice* (goldsmith) in the service of Giambologna; four years later he seems to have held a semi-independent position in the Giambologna workshop, when he had a *gruppo di figurine* cast by the Florentine bronze founder Domenico Portigiani. Early in 1586 de Vries accepted a post as chief assistant to Pompeo Leoni in Milan. Between 1586 and 1587 he was to have a major share in the execution of some life-size gilt bronzes for the high altar of the Monastery of S. Lorenzo el Real, Escorial, Madrid. This was the largest project for bronze sculpture of the period. In the Milan workshop of Leoni, de Vries probably refined his skills as a sculptor of monumental works. His work on this prestigious Spanish Habsburg project must have attracted the attention of Charles Emmanuel I, the Duke of Savoy and son-in-law of the Spanish king. De Vries was appointed court sculptor

to the Savoy court in 1588—his first independent position—but from this 18 months in Turin no sculptures have either survived or been documented.

In June 1589 de Vries left Turin for Prague to serve the Habsburg emperor Rudolf II. Two bronzes from this period are still extant, *Mercury and Psyche* and *Psyche Borne Aloft by Putti*. Both works display a tendency to emulate Giambologna's complex late Mannerist compositional style. Engravings after five of de Vries's designs from this period, among them *Mercury and Psyche*, were made by Jan Muller in Amsterdam. De Vries traveled to The Hague in 1594 and to Rome in the following year, where he remained until 1596. No records of this period are known, but his Roman experience seems to have been pivotal to his further development. Throughout his career, he was engaged in an artistic rivalry with antiquity, successfully trying to emulate the most famous Classical statues, such as the *Apollo Belvedere*, the Farnese *Bull*, or the *Laocoön* group. His later works especially contain many references to and borrowings from Roman sculpture.

De Vries moved to Augsburg in 1596, where he was commissioned to make two monumental fountains, devoted to Mercury (1596–99) and to Hercules (1597–1602), respectively. These fountains, which are still *in situ*, were clearly designed along Italian lines. They belong to the first public fountains of this new form and conception north of the Alps. For one of Augsburg's water towers, de Vries made a bronze water deity (1601), who pours water from a conch shell symbolizing the town's water supplies. It is one of his most successful works from about 1600.

In 1601 de Vries again entered the service of Emperor Rudolf II as *Kammerbildhauer* (sculptor to the court), remaining in Prague for the rest of his life. His arrival coincided with the reorganization of the imperial foundry. Most of the bronzes he made for the emperor were to be placed in the imperial *Kunstkammer* (treasury) and are thus of medium size. Among these are three reliefs—two allegories of the emperor as military commander (1604–05; Kunsthistorisches Museum, Vienna) and as patron of the arts (1609; Royal Collection, Windsor Castle, England) and a portrait bust of Rudolf II (1609; Victoria and Albert Museum, London)—a *Pacing Horse*, an allegory of *Imperium Triumphant over Avaritia* (National Gallery of Art, Washington, D.C.), and the group *Cain and Abel* (1610–12; University of Edinburgh).

High-court officials and noblemen also commissioned major works, increasingly so after Rudolf's death in 1612. Three patrons were of special significance in these years: King Christian IV of Denmark, for whom he made a large fountain consisting of 16 bronzes (1615–18; Nationalmuseum, Stockholm, and Drottningholm palace garden, outside Stockholm) to

be erected at Frederiksborg Castle; Count Ernst von Holstein-Schaumburg, who ordered two large bronze groups (*Venus and Adonis*, 1621, and *Rape of a Sabine*, 1621; Skulpturensammlung, Berlin), a baptismal font (1615; Evangelical Church, Bückeburg, Germany), and a bronze group of the *Resurrection of Christ* (1618–20) in the mausoleum at nearby Stadthagen, for which Giovanni Maria Nosseni delivered the architectural design; and Albrecht von Waldstein (Wallenstein), whose Prague palace garden was adorned with a series of monumental bronze statues of mythological subjects and a fountain (1623–27). These works, with their highly individual style, form the grandiose finale of de Vries's career. In the early 20th century pieces were found housed at the Nationalmuseum in Stockholm and in the garden of the Swedish royal palace, Drottningholm.

From his first known works until his final bronzes made for Waldstein, the style of de Vries's works gradually evolved from precise and sharp of line to extremely loose, sketchy, and expressive. The harmonious Late Mannerist compositions of his early works contrast with the free compositional style of his later, Early Baroque bronzes. The unique painterly quality of his sculptures is consistent with an early characterization of him as *bossierer* (modeler). The expressive impasto of this late phase seems to have been employed to convey artistic notions of authenticity, virtuosity, and *sprezzatura* (a cultivated nonchalance to display virtuosity). In this respect, de Vries's approach differs markedly from that of most bronze sculptors, who exploited the reproductive qualities of the casting process. Technical research has confirmed that—with only a few exceptions—all of de Vries's bronzes were made using the direct casting method, resulting in unique casts.

De Vries's sketchy style and the use of the direct casting method correspond to the fact that he did not run a large workshop with a well-developed division of labor, like his masters Giambologna and Pompeo Leoni. Instead, he seems to have worked with a small group of assistants who helped to prepare the full-scale models to be cast in bronze. The casting itself was done by professional founders, such as Wolfgang Neidhart (Augsburg) or Martin Hilliger (imperial foundry, Prague). Several of de Vries's sculptures are signed "Adrianus Fries Hagiensis Batavus" or a variation of this signature. In his Augsburg period, he twice used the monogram "AF," in imitation of Albrecht Dürer's famous monogram "AD."

No preparatory models in wax or clay by de Vries have survived, although these must have existed. A small body of drawings has been ascribed to him on stylistic similarities to a signed drawing in Dresden or his sculptural compositions. Some of these drawings seem to have been preparatory studies for sculptures.

Most of his works are now in Sweden (Nationalmuseum and Drottningholm palace garden), brought there as war booty from Denmark and Prague in the middle of the 17th century. These include the bronze sculptures for the Frederiksborg fountain and for the garden of Waldstein Palace.

FRITS SCHOLTEN

See also **Giambologna; Leoni Family**

Biography

Born in The Hague, Netherlands, *ca.* 1556. Brother-in-law Simon Adriaensz Rottermont was a goldsmith. Trained possibly by Willem Danielsz van Tetrode in Delft; moved to Florence; documented as goldsmith in the service of Giambologna, 1581–85; worked with Pompeo Leoni in Milan, 1586–88; became court sculptor to Charles Emmanuel I, Duke of Savoy, in Turin, 1588; departed from Turin, June 1589, for Prague to serve Emperor Rudolf II; first documented independent work, 1593; moved to Augsburg, Germany, 1596, to construct two monumental public fountains; entered the service of Rudolf II as *Kammerbildhauer* (sculptor to the court) at Prague, 1601. Died in Prague, present-day Czech Republic, *ca.* 15 December 1626.

Selected Works

1593	*Mercury and Psyche*; bronze; Musée du Louvre, Paris, France
ca. 1593–94	*Psyche Borne Aloft by Putti*; bronze; Nationalmuseum, Stockholm, Sweden
1596–99	Mercury Fountain; bronze; Maximilianstrasse, Augsburg, Germany
1603	Bust of Rudolf II; bronze; Kunsthistorisches Museum, Vienna, Austria
1603	*Christian II of Saxony*; bronze; Skulpturensammlung, Albertinum, Dresden, Germany
ca. 1603–08	*Hercules, Nessus, and Deianeira*; bronze; Musée du Louvre, Paris, France
1607	*Christ in Distress*; bronze; collection of prince of Liechtenstein, Vaduz, Liechtenstein
1607	*Pacing Horse*; bronze; Nationalmuseum, Stockholm, Sweden
ca. 1610–15	*Juggling Man*; bronze; J. Paul Getty Museum, Los Angeles, United States
1611	*Vulcan's Forge*; bronze; Bayerisches Nationalmuseum, Munich, Germany
1614	*Farnese Bull*; bronze; Schlossmuseum, Gotha, Germany
1623	*Laocoön and His Sons*; bronze; Nationalmuseum, Stockholm, Sweden
1626–27	*Hercules Pomarius*; bronze; National Gallery, Prague, Czech Republic

Further Reading

Cahn, Erich B., *Adrian de Vries und seine kirchlichen Bronzekunstwerke in Schaumburg*, Rinteln, Germany: Bösendahl, 1966

Larsson, Lars Olof, *Adrian de Vries, Adrianus Fries Hagiensis Batauus 1545–1626*, Vienna and Munich: Schroll, 1967

Larsson, Lars Olof, *European Bronzes: 1450–1700*, Stockholm: Swedish National Art Museums, 1992

Larsson, Lars Olof, *Adrian de Vries in Schaumburg: Die Werke für Fürst Ernst zu Holstein-Schaumburg, 1613–1621*, Ostfildern-Ruit, Germany: Hatje, 1998

Prag um 1600: Kunst und Kultur am Hofe Rudolfs II. (exhib. cat.), 2 vols., Freren, Germany: Luca Verlag, 1988

Scholten, Frits, editor, *Adriaen de Vries, 1556–1626: Imperial Sculptor* (exhib. cat.), Zwolle, The Netherlands: Waanders, 1998

Suermann, Marie-Therese, *Das Mausoleum des Fürsten Ernst zu Holstein-Schaumburg in Stadthagen*, Berlin: Fröhlich & Kaufmann, 1984

BUST OF RUDOLF II
Adriaen de Vries (1545–1626)
1603
bronze
h. 1.12 m
Kunsthistorisches Museum, Vienna, Austria

The monumental bust of Emperor Rudolf II that de Vries made in 1603 must have been one of the first commissions that the emperor awarded to de Vries after the sculptor's return to Prague in the previous year. Rudolph conceived the bust as the pendant to the bronze bust of Emperor Charles V, executed in 1553–55 by Leone Leoni, although it is not certain that the works were displayed side by side in Rudolf's *Kunstkammer*. The 1607–11 inventory of the imperial art collection describes Rudolf's bust as "one of the metal sculptures that were standing here and there on the tables and cabinets." Displaying the bust freestanding was completely reasonable, as it is modeled in the round and meant to be viewed from all sides.

While the similarities between Leoni's bust and de Vries's portrait are obvious, the stylistic differences are more significant. De Vries invested Leoni's rather rigid and frontal composition with a far more spatial interpretation, giving his figure's torso a slight *contrapposto* (a natural pose with the weight of one leg, the shoulder, and hips counterbalancing one another), which is most readily apparent in the opposing movements of the arm stumps. Due to this more dynamic body language, the figure of Rudolf appears more ex-

Bust of Rudolf II
© Erich Lessing/Art Resource, NY

pressive and dramatic than that of Charles V. De Vries achieved this effect partly by giving the armor horizontal accents with the broad collar and flared bottom of the cuirass. The emperor's face tilts upward more, and his already prominent chin juts further forward. De Vries indicated the pupils of his eyes merely with circular shapes that take on expression when the light reflects on them. This subtle touch lends the portrait a sense of timelessness.

Unlike the Leoni bust, de Vries's Rudolf wears a fictive cuirass, allowing the sculptor to elaborate on the emperor's grandeur by adding various motifs that allude to the majesty of his sitter. The front of the shoulders show personifications of Fame and Victory, while putti with the terrestrial globe and the heavenly vault, allu-

sions to Rudolf's dominions, appear on the back. The four animals on both sides of the cuirass—a lion, griffin, ram, and eagle—were originally Roman imperial motifs regularly applied in the Habsburg glorification of the emperorship. The lion refers to Herculean strength, the griffin stands for swiftness, the ram was Emperor Augustus's sign of the zodiac, which Rudolf adopted, and the eagle, a traditional symbol of emperors, refers to Jupiter, the supreme god of the Romans. The eagle supporting the bust has a similar connotation, but it may also allude to the immortality and apotheosis of the emperor; according to the Romans, an eagle carried the soul of deceased emperors to the gods.

The points of contact with Leoni's Charles V were not coincidental. Rudolf had brought the latter portrait, a replica of the one in Madrid (Museo del Prado), from the estate of Cardinal Granvelle, thus demonstrating his admiration for his forefather and predecessor. By commissioning his own portrait in the same visual form and size, he stressed the continuity and legitimacy of the Habsburg imperial dynasty. One should view the differences between de Vries's portrait and the Leoni bust in light of the political and artistic ambitions of the patron and the artist. Rudolf was evidently trying to outdo his great predecessor Charles V in imperial grandeur with this portrait, while de Vries wanted to surpass Leoni, in whose workshop he had himself worked almost 20 years before. The result of de Vries's transformation of the 16th-century portrait is a bust with manifestly Early Baroque features. He found a new form for the Habsburg *representatio majestatis* by giving the work a heightened sense of drama, spatiality, and expressiveness. As such, the bust marks an important moment in the development of portrait sculpture.

FRITS SCHOLTEN

See also **Portrait**

Further Reading

Larsson, Lars Olof, *Adrian de Vries*, Vienna and Munich: Schroll, 1967
Larsson, Lars Olof, "Bildnisse Kaiser Rudolfs II," in *Prag um 1600: Beiträge zur Kunst und Kultur am Hofe Rudolfs II*, Freren, Germany: Luca, 1988
Scholten, Frits, editor, *Adriaen de Vries, 1556–1626: Imperial Sculptor* (exhib. cat.), Zwolle, The Netherlands: Waanders Uitgevers, 1998

WALES

See **England and Wales**

JEAN WARIN *ca.* **1606–1672** *French*

Along with Guillaume Dupré, Jean Warin must be counted among the greatest of all French medalists. He was also a skillful sculptor and active as a painter (although none of his paintings survive). Born in Liège, he probably trained there under his father Jean, a die engraver. By 1625 he was living in Paris, and four years later, after converting to Catholicism and endearing himself to the wife of the mint's codirector René Olivier, he gained control of the Monnaie du Moulin (the mint). Warin wasted little time in his ascent to the top, creating flattering medals for the king and Cardinal Richelieu in 1629 and 1630. In 1636 Warin convinced Louis XIII to grant him a quarter of the Monnaie du Moulin and bolstered his holdings by purchasing two of the remaining three portions in 1639 and 1648. A coin engraver of exceptional talent and a ruthless businessman, by 1648 Warin had secured all the major posts connected with the execution of coinage, *jetons* (tokens), and struck medals in France, including the titles of *conductor général de monnaies au moulin de France et graveur d'icelles, graveur des sceaux, tailleur général,* and *controleur general des poinçons et effigies des monnaies de france.* In 1665 he became a member of the Royal Academy of Painting and Sculpture.

As a medalist, Warin had a tremendous impact on other medalists throughout Europe, and his influence continued well into the 18th century. His early cast medals for Cardinal Richelieu and Louis XIII from 1630 have identical reverses—victorious France riding on a triumphal cart—whose attenuated figures reveal lingering Mannerist tendencies. Also among his cast medals are those in gold of Anne of Austria and an exceptionally fine portrait of the Sun King, Louis XIV; the reverse of the latter medal shows Gianlorenzo Bernini's proposed design for the Palais du Louvre colonnade. Warin's early cast medals owe an unmistakable debt to his predecessor Guillaume Dupré; indeed, until recently scholars attributed Warin's medal of Antoine Ruzé to Dupré.

It was with his struck medals and coins that Warin proved truly innovative. In 1640 he was charged with the recoinage of France, and unlike his predecessors, he had at his disposal well-tested modern German machinery, improved by Pierre Regnier. His elegant coins met with the approval of the king, and he received license to establish mints anywhere he chose (an opportunity later restricted to a choice between Lyon and Paris). In 1643 Warin introduced the raised rim to portrait medals, at first combined with the traditional pearled border, then alone. This seemingly insignificant addition suited struck medals particularly well, and with it Warin established the standard for the next 200 years. Moreover, Warin's technique, considerable influence, and virtual monopoly over the machinery used in striking medals established the dominance of struck over cast medals into the 19th century. The formation of the Petite Académie in the early 1660s sought to combine the talents and judicial skills of prominent artistic and intellectual personalities to de-

sign and disseminate Louis XIV's propaganda program, and Warin played a fundamental role in creating a series of medals planned as part of the campaign: the early *Medallic Histories* of the Sun King's reign (many of which were later revised by other artists for the *Medallic Histories* of 1702 and 1723). The series arguably constitutes Warin's finest and most influential work. His struck medals, particularly those made for the *Medallic Histories*, combined sensitive portraits with carefully articulated reverse compositions on perfectly flat backgrounds, often based on antique sources.

Warin is documented as a sculptor, but his early work has not survived. Busts in gold and plaster of Cardinal Richelieu are lost, but several surviving bronze busts, probably after Warin's plaster model, were cast in the early 1640s. His reputation, at least in France, prompted comparisons and rivalries with Bernini. When Bernini visited France in 1665, Warin saw an irresistible opportunity to match his skills with the Italian master. Apparently Warin's first attempt to work in marble, it was, according to contemporary accounts, a success. His bust of Louis XIV eschewed the Italian Baroque style in favor of a more static, somber, and perhaps rigid approach to the king's portrait, anticipating Neoclassical concerns. Warin's meticulous detail and control of the medium pleased the king, and in 1671 the artist followed the portrait bust with a full-length marble statue, *Louis XIV*, with the king dressed in imperial Roman regalia. Warin intended the work, which recalls any number of Roman prototypes, to be a direct answer to Bernini's equestrian monument to Louis XIV (1669–77).

Despite Warin's extraordinary success, he seems to have spent much of his life under suspicion. He clearly used any means possible to secure prestigious and influential positions and wealth, but he was also arrested and imprisoned for forging coins in 1632 (a sentence that was revoked in 1633 on the advice of Cardinal Richelieu). He was further accused at various times of striking light coinage, that is, coins of inferior alloys or significantly low in gold weight. Charles Perrault, a contemporary of Warin and the earliest of his biographers, went so far as to suggest that the medalist continued his contact with counterfeiters throughout his life and that his death in 1672 was the result of poisoning related to earlier indiscretions or questionable associations.

ARNE R. FLATEN

Biography

Born in Liège, present-day Belgium, probably 1606. Son of Jean, a die engraver, brother of Claude, a medalist, son François, a die engraver and medalist. Moved to Paris by 1625; converted to Catholicism, 1628; began work at the Monnaie du Moulin, April 1629; by 1648 had gained all major posts for striking coins and medals in France; began work on *Medallic Histories*, 1660s; joined Royal Academy of Painting and Sculpture, 1665. Died in Paris, France, 26 August 1672.

Selected Works

Warin's medals survive in multiple locations. Only the most important locations or the best surviving examples are recorded here. Unless otherwise noted, all works listed below are medals.

1629	*Antoine Ruzé*; silver; British Museum, London, England
1630	*Cardinal Richelieu*; bronze; British Museum, London, England
1630	*Louis XIII*; bronze; British Museum, London, England
1641	Bust of Cardinal Richelieu (plaster and gold versions lost); bronze; Queen's Collection, London, England
1645	*Anne of Austria*; gold; Bibliothèque Nationale de France, Paris, France
1660s–72	Medals for *Medallic Histories*; bronze; various collections, including British Museum, London, England, and Bibliothèque Nationale de France, Paris, France
1665	Bust of Louis XIV; marble; Château, Versailles, Yvelines, France
1665	*Louis XIV* (with Gianlorenzo Bernini's design for Palais du Louvre on reverse); gold; British Museum, London, England
1671	Statue of Louis XIV; marble; Château, Versailles, Yvelines, France

Further Reading

Jones, Mark, and Duncan R. Hook, *A Catalogue of French Medals in the British Museum*, 2 vols., London: British Museum Press, 1988; see especially vol. 2

Mazerolle, Fernand, *Jean Varin, conducteur de la monnaie du Moulin, tailleur général des monnaies, controleur général des poinçons et effigies: Sa vie, sa famille, son oeuvre (1596–1672)*, 2 vols., Paris: Bourgey, 1932

Pény, Frédéric, *Jean Varin de Liège, 1607–1672*, Liège, Belgium: Vaillant-Carmonne, 1947

Tricou, Jean, *Médailles lyonnaises du XV^e au XVIII^e siècles*, Paris: Bourgey, 1958

WAX

The word *wax*, originally referring only to beeswax, was later adopted to describe various substances, natural or synthetic, similar to beeswax in character and

behavior. According to the origin, natural waxes are divided into animal, vegetable, and mineral.

Beeswax is produced by the ceruminous glands of worker bees, which use it to build honeycombs. The combs are melted several times in a steam cooker and the wax strained through a cloth. It can also be extracted with the aid of organic solvents. Ultraviolet light or chemical agents are used to refine and bleach the wax. Beeswax melts at about 60 degrees Celsius and is completely soluble in kerosene, turpentine, hydrocarbons, and chlorides, partially soluble in heated alcohol, but not soluble in water. It is most commonly used by artists for modeling and exists in various forms according to its provenance, degree of purity, and the methods used for its clarification.

Other types of waxes and waxlike products have varying melting points and uses. Chinese wax (melting point [m.p.] 79–83 degrees Celsius) is the result of the secretions of two kinds of insects (*Ceroplastes sinensis*, *Ericerus pela*) that are found on the leaves or buds of ash trees. Whitish, shiny, and crystalline, Chinese wax is harder than beeswax and is used as an alternative to that substance in the Far East. Spermaceti is obtained from the oil in the heads of whales. White, translucent, and crystalline, it has a lower melting point (m.p. 42–49 degrees Celsius), and has been used since the 19th century in the pharmaceutical industry and as a protective coating for sculpture. The best-known vegetable wax is carnauba, exuded by the leaves of the Brazilian carnauba palm (*Copernicia cerifera*) and imported into Europe during the 19th century. After extraction its color changes from light yellow to dark gray. It is the hardest of the natural waxes and has the highest melting point (m.p. 82–88 degrees Celsius). Japanese wax (m.p. about 50 degrees Celsius) is a vegetable fat drawn from the fruit of the *Rhus vernicifera*, native to Japan and China. The color varies from white to yellowish green, and it is employed in manufacturing cosmetics and crayons and for treating leather. The most common mineral wax, ozokerite, is extracted from the bitumen deposits of petroleum and is dark yellow, tending to green, in color. When refined and lightened, ozokerite is used to produce a whitish yellow substance called cerasin. Both are used in cosmetics and for manufacturing varnishes and printing inks. Initially extracted from lignite, paraffin wax (m.p. 50–80 degrees Celsius) was later drawn from bituminous rocks and from petroleum. Clearish white in color, it is used as a substitute for the more costly animal and vegetable waxes. Because microcrystalline waxes (m.p. 55–80 degrees Celsius) are richer in residual oils, they are used as plasticizers. They are more elastic and more resistant to cold than paraffin wax and are used as protective coatings in restoration work and to impregnate and preserve paper and cloth. Among the

chemically produced synthetic waxes is stearin, which is produced by hydrolyzing fat. Since 1821 stearin has replaced beeswax in the production of candles and for modeling.

Wax used for sculpture is a mixture of waxes to which the artist adds, depending on the need, various fatty substances capable of being blended when heated. However, the mixture's main component is beeswax, combined with vegetable waxes such as carnauba and Japanese wax. Less frequently, and in more recent times, paraffin and stearin have been adopted.

Methods of sculpture production vary according to the work involved. There are two main techniques: modeling and casting. In order to make the wax more malleable and improve its adhesive strength, resins such as Venetian turpentine, pitch, and colophony were usually added. The addition of turpentine, oil, and tallow are recorded in documents and confirmed by Pomponio Gaurico (1504), who also mentions bitumen.

Modeling in wax requires the same technique as modeling in clay. For sketches and models to be cast in bronze or in goldsmith's work, the figure is built by the addition of little balls of wax. The surface can be finished with a warm or cold spatula made of hard materials (e.g., bone, iron, or wood).

Wax casting has been used for sculpture, portraits, and anatomical specimens. The wax composition for this process is harder than that used for modeling and has a higher melting point through the addition of resins such as dammar and colophonia (rosin). The liquid wax was poured into plaster molds produced from terracotta models or, more rarely, into molds taken directly from the human form. An armature had to be built for the larger figures to support the first modeling in impure wax or plaster before the final layer was applied and the surfaces finished.

Different colors were obtained by adding white lead, coal dust, cinnabar or minium, earths, ochres, verdigris, azurite, and pitch, the last of which served to turn the wax black. The addition of kaolin, plaster, or aluminum gave the wax a more opaque aspect. Describing the working methods, Vasari stipulated that the colors must be reduced to powder and sifted before being mixed with the molten wax. More rarely, the coloration was achieved by painting the surface of the artifact with oil paints.

Wax has numerous advantages: being malleable, it lends itself well to modeling; it can be melted and shaped in a mold; it hardens quickly without firing, which in ceramics leads to the risk of shrinkage and damage; it is clean to work with and allows modifications and second thoughts; and because it does not require firing, wooden or iron armatures can be installed internally. The disadvantages include its increased expense over clay, its difficulty to obtain, its

fragility (which leads to cracks and breakages if the object is mistreated), and its sensitivity to heat that can lead to distortions and the loss of the projecting parts in the case of figures in the round. Because of these particular characteristics, the conservation of wax requires quite different forms of supervision than other materials. It is of primary importance to control the temperature in places where these works are housed, and then to maintain a constant degree of humidity (about 65 percent). Direct exposure to sunlight or heat-producing sources of artificial light must be avoided at all costs. Great care must be taken during moving operations, which should be kept to a minimum, and vibrations should be avoided, because they can lead to breakages and cause the support or armature—made of materials whose behavior and hardness differ from those of the wax—to become detached.

From the earliest times, wax was used for representational sculpture because of its malleability and the ease of producing remarkably close likenesses of models and a perfect imitation of flesh. Among the earliest uses of wax sculpture, testified to by Egyptian papyri, was its employ in connection with religious and magic rites, an area in which wax sculpture has lost its traditional role, now adopted only for certain popular religious celebrations. Pliny the Elder mentions the use of wax votive figures on small home altars, but painted images of the deceased, called *cerae* or *cerae pictae*, were carried at funerals or set on the tomb. A rare example is the mask found in the excavations of Cuma (1st century BCE; Archaeological Museum, Naples, Italy).

Although medieval sources testify to the continuity of the production of votive figurines or funerary masks, the representation of life-size figures wearing real clothes and ornaments seems to be a typically Renaissance phenomenon. In Florence, where there existed workshops for making wax images used as ex-voto, Giorgio Vasari records that Lorenzo the Magnificent commissioned Orsino Benintendi (*d.* 1498) to produce, with the collaboration of Verrocchio (1435–88), three life-size likenesses of himself to express his gratitude for having escaped the danger of the Pazzi conspiracy (1478). The Florentine Sanctuary of SS. Annunziata held an enormous number of these votive figures arrayed on stands, which were destroyed in the second half of the 18th century.

In France Michel Bourdin (1580–1650) modeled a funerary portrait bust of Henry IV in 1611; Antoine Benoist (1632–1717) later portrayed Louis XIV in a wax colored relief. Benoist obtained from the French king the monopoly to exhibit the French royal family and the court, setting up the first museum of wax figures in 1688.

Among the waxwork recorded in England in the 17th century are the figures in Westminster Abbey, London, the most important remaining group dating from 1686 to 1806. Mrs. Goldsmith (*fl.* 1695–1703; first name unknown) was one of the artists who modeled the effigies of William III and Mary II. The most celebrated English waxwork between the 17th and 18th centuries are the 140 figures modeled by Mrs. Mary Salmon (1650–1740), which formed tableaux with mechanical figures.

Among German artists, Daniel Neuberger the Young (*ca.* 1620–74/81) produced a life-size portrait of Emperor Leopold I in 1658, and Johann Schalch (1623–*ca.* 1704) displayed his waxworks of court figures in London and in other northern European countries.

The remarkable possibilities offered by wax were understood by Dr. Curtius (Philippe Creutz, 1737–94) in Paris, who, after some experience in Bern as a modeler of anatomical specimens, began to exhibit his small portraits and then larger figures to the public. In 1783 he opened in Paris, in the Boulevard de Temple, the Caverne des Grands Voleurs, with waxes obtained by casts from the heads of nobles guillotined during the French Revolution. His niece, Marie Grosholtz (1761–1850), later Madame Tussaud, followed his lead and opened the first wax museum in 1802 in the Strand in London. Other famous waxwork collections are the Panoptikum in St. Pauli, Hamburg (1879), and the Musée Grevin, Paris (1882). In the 1960s the Pop art movement rediscovered the extraordinary verisimilitude offered by the medium, although the wax was often replaced by synthetic resins.

A more strictly artistic use of wax is its employment for models and in the preparatory stages of bronze sculpture, goldsmith's work, and numismatics. Detailed descriptions of this practice survive in Renaissance treatises, in which the principal technical procedures were drawn from antiquity. The most common method of casting was the lost-wax technique (*cire perdue*), a procedure by which the molten bronze replaces the wax surface layer of the object, causing the wax to flow out in liquid form from the drainage holes (sprues).

Despite their fragility, numerous wax sketches and models still exist—often colored in red or black—that are attributed to Michelangelo (1475–1564) and his school, as well as to Benvenuto Cellini (1500–71), Cigoli (Lodovico Cardi, 1559–1613), and other sculptors working in Florence. During the 16th century wax was also adopted for some generally small- or medium-size complete works. A *Deposition* (*ca.* 1510; Victoria and Albert Museum, London, England), made by Jacopo Sansovino and considered one of the first "complete works" of its kind, was in fact first created to assist

the painter Perugino in designing his compositions. A later work, typical of the Late Mannerist style, is Guglielmo della Porta's *Crucifixion* (Borghese Gallery, Rome) in white wax mounted on black slate, perhaps in imitation of ivory. However, the most typical and successful form of wax sculpture in the 16th century was the miniature portrait, whose origins lie in medallion making. Vasari's 16th-century *Lives of the Painters, Sculptors, and Architects* provides an invaluable source for this period. One of the first artists to model medallions in wax was the Bolognese painter Francesco Francia (1450–1517), who appears to have dispatched miniature portraits to the Italian princes. From the white wax used in the earliest examples there was a move to colored wax, first achieved by painting the surface with oil paints and later by mixing pigments with the melted wax. One of Francia's contemporaries from Emilia, Alfonso Lombardi (1497–ca. 1537), worked in this medium and created portraits of most Italian rulers and noblemen, including Duke Alfonso of Ferrara, Emperor Charles V, and Ludovico Ariosto. From Emilia miniatures spread to southern Italy and to Germany. The most famous wax portraitist during the 16th century was Antonio Abondio (1538–91), who used a wide range of colored waxes, embellished with cloth, pearls, gems, and gold. Abondio began working in 1565 at the court in Vienna; his work includes a portrait of Maximilian II (Kunsthistorisches Museum, Vienna) and Archduke Ernest of Austria (London, Wallace Collection).

There are a number of wax portraits in the Wallace Collection in London, and among them is what is considered the earliest extant example of the form, the double portrait of Claude of Lorraine, Duke of Guise, and his wife, mounted in a leather case shaped like a diptych (1535–40; artist unknown). These small portraits were common at the European courts, and it is sometimes difficult to identify their authors. The same techniques were used to produce the small reliefs with sacred and profane subjects that became widespread at the end of the 16th century. A *Leda* in Schloss Ambras in Austria is recorded in the 1596 inventory and is ornamented with pearls and precious stones and kept in a glass case. The collection also includes a *St. Francis* and a *Mary Magdalene* mounted on ebony. Tableau compositions with allegorical or illustrative scenes set into deep cases are similar in style to the Christmas Nativity cribs that were common in the 17th century and continued to be made throughout the 19th century.

During the 17th century wax began to be used in the area of anatomical studies, to reproduce the human body for teaching purposes. The first model of a "flayed" body, dating from 1600, is by Ludovico Cigoli (Bargello, Florence). This trend was perfected at the end of the century by Gaetano Giulio Zumbo (1656–1701) of Syracuse in Sicily, who was commissioned by the Florentine Grand Duke Cosimo III to make four large allegories in wax on the theme of the transience of beauty and human life, a common theme in 17th-century art (for example, *The Plague* and *The Triumph of Time* in the Museo della Specola, Florence). Zumbo was also the first to model anatomical specimens in wax, producing minute details and offering the first real alternative to the dissection of corpses, which was forbidden by the Catholic church until the late 18th century. The possibility of reaching truly realistic results opened the way to a copious production of anatomical models for teaching purposes, in close collaboration with surgeons and physicians. A school for anatomical modelers in wax was opened in Bologna by Ercole Lelli (1702–66). This workshop became internationally famous and gave birth to the one in Florence, directed by Felice Fontana. Between 1771 and 1893 numerous human anatomical models were produced in wax to meet the demand of Italian and foreign universities. These models, reproducing pathological conditions that are rare today, supply important evidence more valid than any drawn or painted representation could be. The most important collection of these models resides in the Museo della Specola in Florence; and is nearly rivaled by the one produced for the Josephinum, the army medical school in Vienna. Numerous other small collections survive in European universities.

In 1788 Clemente Susini (1754–1814) started making models of life-size plants and flowers. This was the first organized production, introduced in the next century into France and England. In the 19th century the sculptor Luigi Calamai (ca. 1800–51) used specially created microscope lenses with which to model various specimens of plant organology when greatly magnified. Despite the artists' outstanding technical and artistic skill, these wax specimens lost their teaching role in around 1840 with the advent of photography.

The Neoclassical period saw a renewed fashion for small wax portraits, which spread to other subjects, either drawn or directly copied from the antique. John Flaxman in England, and Edme Bouchardon and Claude Michel Clodion in France continued to produce profile heads or busts in pink or white wax against a dark ground, like ancient cameos.

During the rest of the 19th century wax modeling was generally limited to the craft level, with sacred subjects chiefly designed for domestic devotions. At the end of the century, however, an increasing interest among European artists gave wax a new importance. In France Pierre Jules Mène (1810–79) was well known for his animal subjects, created from thin sheets of wax modeled only by his fingers. In the sphere of

modern art, the sculptor Medardo Rosso (1858–1928) found wax to be a suitable material for modeling without weight and creating the sculpture he sought to produce: the moment of enlightenment caught in the image of a face. His study of "open form," built by light, replaced the classical conception of sculpture.

In the 1960s, with the Pop art and hyperrealism movements, waxworks became again fashionable, and the popular exhibitions of famous persons endured during this period. Over time the wax saw replacement by synthetic resins, and the likeness of the subjects is now achieved through the aid of many measurements and photographs. As for Pop art sculpture, George Segal and Joseph Kienholz are worth mentioning for their "human mannequins" made by casting molds taken directly from the human body. Overall, however, these artists preferred plaster to wax. Contemporary admirers will likely need to look to earlier models for the true standard in wax sculpture.

MARIA GRAZIA VACCARI

Further Reading

Altick, Richard Daniel, *The Shows of London*, Cambridge, Massachusetts: Harvard University Press, 1978

Avery, Charles, "La Cera Sempre Aspetta: Wax Sketch Models for Sculpture," *Apollo* 119 (1984)

Lanza, Benedetto, and Liberto Perugi, *Le cere anatomiche della Specola*, Florence: Arnaud, 1979

Lightbown, Ronald, "Le cere artistiche del Cinquecento" (two parts), *Arte illustrata* 3 (June–September 1970 and October–December 1970)

Pope-Hennessy, John, and Ronald Lightbown, *Catalogue of Italian Sculpture in the Victoria and Albert Museum*, 3 vols., London: HMSO, 1964

Pyke, Edward John, *A Biographical Dictionary of Wax Modellers*, 2 vols., Oxford: Clarendon Press, 1973

NIKLAUS WECKMANN 1450/55–after 1528 *German*

After Hans Multscher, and together with Michel Erhart, Niklaus Weckmann was the most significant Late Gothic sculptor from Ulm. He was also the most prolific: approximately 600 objects are associated with Weckmann and his workshop.

It first became possible to recognize Weckmann's artistic personality in 1964, when the restoration of a statue of *Knight Stephan of Gundelfingen* revealed the artist's only known signature: "niclaus weckmann bildhawer zu . . . 1528." Although Julius Baum and Hans Rott had published most of the documents known today concerning his life (see Baum, 1911, and Rott, 1934), no one had been able previously to connect a single work with Weckmann's name; both Baum and especially Gertrud Otto, associating the *St. Stephan* with a group of works to which they thought it might

belong, provisionally assigned the group to Jörg Syrlin the Younger (see Baum, 1934, and Otto, 1927). In view of the newly discovered signature, however, Wolfgang Deutsch demonstrated convincingly that the whole oeuvre was Weckmann's (see Deutsch, 1968). By the late 1960s the primary remaining question seemed to be that of distinguishing Weckmann's sculpture from his like-named stepson's; this problem dissolved, however, with the discovery that Nicklaus Weckmann the Younger was not a sculptor at all but rather a fencing teacher. The signature of Syrlin the Younger is no doubt present on many Weckmann works because Syrlin was the contractor and joiner; Syrlin then passed on the figurative assignments to Weckmann.

Three new sets of problems arise concerning Weckmann's extensive, newly secured oeuvre: that of his training, that of the differentiation of hands inside his workshop, and that of the works' chronology. As for the first of these, nothing is known about Weckmann's origins or about his training before 1481. Although documents indicate that Weckmann became a citizen of Ulm in that year, he may have resided previously in or around Ulm. The destruction by iconoclasts in 1531 of his earliest known masterpiece, the 1490 altarpiece for the choir of the Church of St. Mary and Martin in Biberach, further exacerbates the difficulty of defining his early career. A contemporary account of this work by Joachim von Pflummern describes a predella (a painted panel at the bottom of an altarpiece) depicting the Tree of Jesse, a shrine with three figures, two "shrine attendants," and, in the crown, a figure of St. Martin, surrounded by small figures and four carved wings. Weckmann's style must have resembled, at least broadly, that of Nikolaus Gerhaert of Leiden. The resemblance, however, depends on stylistic elements that Weckmann could have picked up in Ulm. It is most likely, in fact, that Weckmann studied with the master of the Hausener altar, although some have also suggested that he could have trained with slightly older Michel Erhart or with the master of the 1471 Weil Pietà, an artist sometimes identified with Paul Lebzelter. Weckmann's early works characteristically have softly modeled faces and simply applied, flowing draperies; in their repetitive, schematic compositions and motifs, the works foreshadow the approaching age of mass production.

By the middle of the 1490s, Weckmann must already have been the overseer of a well-organized workshop that served clients from all over Swabia and from as far away as Graubünden, Switzerland. In polychroming the sculptures and in painting the altar wings, Weckmann would have worked together with a number of painters, just as did Bartolomäus Zeitblom (the master of the Kilchberg altar, the Bingen altar, the

Wengen altar in Ulm, and the Adelberg altar), Martin Schaffner (the master of the Hutz altar and the Wettenhausen altar), and the Strüb brothers (the masters of the Talheim altar). More unusual, Weckmann also produced a series of "transparently wooden" sculptures, sculptures that were largely unpainted, with only a few details accentuated in color. The earliest of these are the Ochsenhausen high altar, the Zwiefalten Passion reliefs, the Attenhofen retable, and the Alpirsbach retable. Only the Alpirsbach piece retains, despite numerous modifications, its original unpolychromed character; the others were all eventually covered over.

Unlike other shops in Ulm around 1500, the Weckmann workshop practiced a sort of serial production, one that allowed for sculptures of differing quality, ranging from detailed copies to new inventions based on existing models. For this reason it is difficult to distinguish the hands involved in separate works. Not only is it challenging to identify, on the dubitable basis of quality, the autograph works that Weckmann, as opposed to his associates, executed within the shop; it is also difficult to separate the sculptures of Weckmann's workshop from those of his numerous imitators and independent students. One of the few technical hallmarks of works from Weckmann's immediate circle is the use of *Spechtlöcher*, deep excavations in the backs of their figures' heads.

The reemployment of static schemata and motifs makes it likewise difficult to determine the chronology of Weckmann's autograph works. While the general design of his figures, their faces, and their poses remained quite constant through the decades, the figures' at first simple, flowing draperies gradually acquired richer creases and folds. One can perceive two decisive watersheds in his stylistic development. In the late 1490s, with the Ochsenhausen high altar—for which Jörg Syrlin the Younger contracted the shrine and from which only four figures survive—and with sculptures for the west facade of the Cathedral of Ulm, Weckmann acquired his mature style. Broadly applied swathes of drapery, deep reliefs of folds, powerful yet at the same time detailed modeling of heads, and virtuoso undercutting create a forceful plasticity and a monumental effect, which the workshop varied continuously over the next two decades with greater and lesser success. Weckmann's late style, which appears in the Talheim altar and in the Zwiefalten Passion reliefs, seems to incorporate a number of retrospective elements: the slim, attenuated figures, with flowing draperies and softly modeled faces, have an air of charming dreaminess. Another group of the works, related to the Hutz altar from the same years, has entirely different features, such as hard folds and spherical heads. This change points, perhaps, to the increasing independence of some of the members of Weckmann's workshop.

Weckmann seems to have died shortly after 1528—the year to which the *Knight Stephan of Gundelfingen* dates—and just shortly before the Reformation and the Iconoclast movements brought an abrupt end to the entire flourishing South German altar industry.

ULRICH PFISTERER

Biography

Born in an unknown location, 1450/55. Nothing known of origins and training. First documented as citizen of Ulm, 1481; painter Hans Schüchlin and sculptors Michel Erhart and Paul Lebzelter served as guarantors; beginning in November that year, regularly paid taxes, records of which can be followed until 1526; his many commissions and presumably large workshop (from mid 1490s) made him a respected master; frequently served as guarantor for others acquiring citizenship; became one of the Twelve Syndics (trustees or officials) of "Instrumentum Confraternitatis der Mahler, Bildhauer, Glasser vnd Brieftruckher" (the Painters' and Sculptors' confraternity) in Wengenkirche, Ulm, 1499; most important student was Daniel Mauch. Died in an unknown location, after 1528.

Selected Works

1492　　Retable; limewood; St. Sebastian altar, Cathedral of Ulm, Germany

1496–99　Retable, for the Ochsenhausen high altar; oak (dispersed): statues of *Mary* and *Sts. Peter and Paul*; parish church, Steinhausen an der Rottum-Bellamont, Germany; *St. George*; Liebieghaus, Frankfurt, Germany

before 1500　Seventeen figures of saints; wood; west portal, Cathedral of Ulm, Germany

ca. 1500–10　*Holy Family*; limewood (mostly destroyed); fragments: Metropolitan Museum of Art, New York City, United States

ca. 1510　Statues of *St. Barbara* and *St. Catherine*, for the cloister of Heggbach, Germany; limewood; Museum of Art, Philadelphia, Pennsylvania, United States

ca. 1510–20　*Virgin Enthroned over a Crescent Moon*; limewood; Kunsthistorisches Museum, Vienna, Austria

ca. 1515　*Adoration of the Magi*, for high altar, parish church, Attenhofen, Germany; limewood; Altes Schloss, Württembergisches Landesmuseum, Stuttgart, Germany

ca. 1515 *Holy Kinship*; limewood; Church of Sts. Alexander and Theodore, Haldenwang, Germany

ca. 1518 Talheim altar, for parish church, Talheim near Tübingen, Germany; limewood; Altes Schloss, Württembergisches Landesmuseum, Stuttgart, Germany

ca. 1520 Seven scenes of the *Passion of Christ*, for the monastery of Zwiefalten, Germany; limewood; Altes Schloss, Württembergisches Landesmuseum, Stuttgart, Germany

ca. 1520/25 Alpirsbach altar; limewood; Alpirsbach monastery, Germany

1521 Hutz family altar; limewood; Cathedral of Ulm, Germany

1528 *Knight Stephan of Gundelfingen*; limewood; Church of Sts. Peter and Paul, Riedlingen-Neufra, Germany

Further Reading

Baum, Julius, *Die Ulmer Plastik um 1500*, Stuttgart, Germany: Hoffmann, 1911

Deutsch, Wolfgang, "Jörg Syrlin der Jüngere und der Bildhauer Niklaus Weckmann," *Zeitschrift für Württembergische Landesgeschichte* 27 (1968)

Jasbar, Gerald, and Erwin Treu, *Bildhauerei und Malerei vom 13. Jahrhundert bis 1600*, Ulm, Germany: Ulmer Museum, 1981

Meurer, Heribert, *Meisterwerke Massenhaft: Die Bildhauer- werkstatt des Niklaus Weckmann und die Malerei in Ulm um 1500* (exhib. cat.), Stuttgart, Germany: Württembergisches Landesmuseum, 1993

Otto, Gertrud, *Die Ulmer Plastik der Spätgotik*, Reutlingen, Germany: Gryphius, 1927

Rott, Hans, *Quellen und Forschungen zur südwestdeutschen und schweizerischen Kunstgeschichte im XV. und XVI. Jahr- hundert: II. Alt-Schwaben und die Reichsstädte*, Stuttgart, Germany: Strecker und Schröder, 1934

Schädler, Alfred, "An Unknown Late Gothic Masterpiece: 'The Adoration of the Magi' by Niclaus Weckmann the Elder," *Apollo* 129 (1989)

ANNE WHITNEY 1821–1915 *United States*

Although she began her career relatively late in comparison with her peers, at about age 34, Anne Whitney produced an extraordinarily large body of work in her 93 years, installing her last public work, the monumental bronze of *Charles Sumner* (1902), in Harvard Square (Cambridge, Massachusetts) at age 81. Because she was from a wealthy and politically progressive family, Whitney could concentrate on producing works that reflected her personal and political interests, unhindered by excessive concern for the sculptures' salability. At the beginning of her career, she spurned the lucrative portrait-bust industry that supported many sculptors of the day and criticized contemporary sculptor Harriet Hosmer for reproducing her popular figures in large editions. Whitney's early training in anatomy and sculpture with artist-doctor William Rimmer, a true maverick and author of some of the most interesting and anomalous works of the period, was early encouragement for Whitney's innovative and often groundbreaking works.

Whitney's first full-figure work was a life-size marble *Lady Godiva*, after Tennyson. That same year she began a life-size standing male nude, reworked during her first visit to Rome as *The Lotus Eater*, also after Tennyson's poem on the Homeric theme, a subject also treated by her friend and fellow American sculptor, Emma Stebbins, in 1857–60.

Whitney soon moved to more overtly political subjects. In 1863–64 she sculpted *Africa*, a reclining female figure shown "waking from the sleep of slavery." The theme was intended as an abolitionist one, but today *Africa* may seem problematic in terms of where it places the responsibility for "submission" to slavery, and thus for liberation from it. The work, now destroyed but surviving in photographs, was a powerful rewriting of the grand odalisque form, with thick, highly textured locks of hair pulled to the back of the figure's head and deeply set eyes under a strong brow ridge that resists the formal prescriptions and Anglo-Saxon imperative of the Neoclassical style. Nevertheless, after seeing the figure on exhibit at the National Academy of Design, Colonel Thomas Wentworth Higginson, leader of the first black regiment during the Civil War, wrote to Whitney suggesting that the features of the figure were not African enough. Whitney did try to alter the features but was not satisfied with the results and destroyed the plaster original after returning from Europe, an action that she later regretted.

When Whitney arrived in Rome in 1867, the rest of the Italian peninsula had been united under the constitutional monarchy of Victor Emmanuel for some six years. Rome itself, however, was being uneasily defended by the troops of Napoléon III as the last papal stronghold in Italy. Whitney's response to the fraught political situation was one of her strongest works, the allegory *Roma*, in the form of a life-size seated bronze of an old beggar woman, weakly holding a permit to beg in her left hand, as two coins drop from her right. Along the hem of her skirt are relief medallions of Rome's most famous sculptural works—the Apollo Belvedere, the *Laocoön*, the *Dying Gaul/Gladiator*, *Hercules*—and an original portrait of Cardinal Antonelli, generally considered responsible for the worst of the papal government's abuses. When the portrait was recognized and destruction of the work threatened, Whitney had it smuggled to Florence, from whence it

was shipped to the United States. She eventually replaced the Antonelli portrait with a triple miter.

In *Roma* Whitney makes reference to a long tradition not only of representing cities with female allegorical figures but of representing Rome as a broken pauper woman, a figure that first appears in the Middle Ages after the Sack of Rome in the 5th century. Manuscript engravings of this figure could have been on display in the Vatican Library among other collections open to Whitney in Rome. But the most direct influence on Whitney's figure seems to have been the 2nd-century BCE sculpture of an old "drunken" woman after an original attributed to Myron of Thebes, in the Musei Capitolini. Through its use of the realistic portraiture and tormented drapery style of the Capitoline sculpture, Whitney's *Roma* not only represents the perceived decay of Rome but also introduces into the vocabulary of 19th-century American sculpture a striking and unusually naturalistic idiom that is informed by the Greek precedent but avoids its insensitive caricature of age and poverty.

A later bronze work sculpted in Paris, *Le Modèle*, also employs the figure of an aged woman to evoke the pathos of the professional model's social condition while referencing wider political events. Recalling the *Roma*, Mary A. Livermore, Whitney's first biographer in *Our Famous Women*, recognized an allegory for France in *Le Modèle*: "Whatever the idea of the artist, this bronze head fitly symbolizes France—broken by revolutions, worn out by war, overcome by domestic violence, degraded by submission to a despotism under the name of a republic—desiring only rest" (see Livermore, 1884). Both *Le Modèle* and *Roma* were exhibited to critical acclaim at the International Exposition in Philadelphia in 1876.

Another of Whitney's many politically resonant works was the statuette of the Haitian revolutionary leader, *Toussaint L'Ouverture*. The figure, with now undeniably African features, is portrayed seated on a stone block in prison. Wearing only loose knee breeches, he leans forward on his right leg to point with his right arm to an inscription on the plinth, "*Dieu se charge*" (God takes in his care), while his left arm and leg pull back in a dynamic, apparently unstable pose. The figure, far from "awakening from the sleep of slavery," seems ready to leap up at any moment to pursue the future that is fixed by his unwavering gaze.

Examples of portraiture, particularly of abolitionist and feminist leaders, increase in the latter part of Whitney's oeuvre. They range from the celebrated case of the Charles Sumner public monument commission, which Whitney won in a blind competition but was later rejected because of her gender, to a long series of statuary and busts of social reformers and friends of the artist. She also received public commissions for monumental statues of Samuel Adams and a bronze Leif Eriksson. Whitney designed at least two fountains, one a *Shakespeare: A Midsummer's Night Dream* (1897), and the other of a child angel playing in calla lily leaves. This bronze "Angel Fountain" or "Calla Lily Fountain" was installed in a traffic island in West Newton, Massachusetts, and has been the subject of an heroic campaign on the part of the community to save the work and the artist from obscurity.

NANCY PROCTOR AND MIRANDA MASON

Biography

Born in Watertown, Massachusetts, United States, 2 September 1821. A lifelong campaigner for social justice, reflected in subject matter of sculpture. Initially a teacher and writer; began to sculpt, *ca.* 1857; attended Pennsylvania Academy of the Fine Arts, Philadelphia, 1860; studied anatomy in hospital in Brooklyn, New York City, then under William Rimmer in Boston, 1862–64; worked in Rome, 1867–71; trip to Florence and Paris, 1875–76; won national competition for commemorative statue of abolitionist senator Charles Sumner, 1875; denied commission when judges discovered she was a woman; statue eventually erected in 1902 in Cambridge, Massachusetts; exhibited in Centennial Exposition, Philadelphia, 1876, and World's Columbian Exposition, Chicago, 1893; taught modeling at Wellesley College, Massachusetts, spring 1885; lifelong partner of painter Abby Adeline Manning. Died in Boston, Massachusetts, United States, 23 January 1915.

Selected Works

1859 *Laura Brown*; marble; Smithsonian Institution, Washington, D.C., United States

1862 *Lady Godiva*; marble; private collection, Dallas, Texas

1862–67 *The Lotus Eater*; plaster (destroyed); plaster statuette: Whitney Farm, Shelburne, New Hampshire, United States

1863–64 *Africa*; plaster (destroyed)

1869 *Roma*; bronze; Davis Museum and Cultural Center, Wellesley College, Massachusetts, United States

1873 *John Keats*; marble; Keats Memorial House, Hampstead, London, England

1875 *Le Modèle*; bronze; Museum of Fine Arts, Boston, Massachusetts, United States

1876 *Samuel Adams*; marble; United States Capitol Art Collection, Statuary Hall, Washington, D.C., United States; bronze

version: 1880, Faneuil Hall, Boston, Massachusetts, United States

1882–83 *Harriet Martineau*; marble (destroyed in fire)

1885 Calla Lily fountain (also called Angel fountain); bronze; West Newton, Massachusetts, United States

1885 *Leif Eriksson*; bronze; Commonwealth Avenue Mall, Boston, Massachusetts, United States

1902 *Charles Sumner*; bronze; Harvard Square, Cambridge, Massachusetts, United States

Further Reading

Borghi, Liana, "Anne Whitney: Letters Home," *Rivista di studi anglo-americani* 3/4–5 (1984–85)

Cikovsky, Nicolai, Marie H. Morrison, and Carol Ockman, *Nineteenth-Century American Women Neoclassical Sculptors* (exhib. cat.), Poughkeepsie, New York: Merchants Press, 1972

Craven, Wayne, *Sculpture in America*, New York: Crowell, 1968; new and revised edition, Newark: University of Delaware Press, and New York: Cornwall Books, 1984

Livermore, Mary A., "Anne Whitney," in *Our Famous Women*, Hartford, Connecticut: Worthington, 1884

Mousseau, Dede L., "Anne Whitney: Her Life, Her Art, and Her Relationship with Adeline Manning," master's thesis, California State University, Fresno, 1992

Payne, Elizabeth Rogers, "Anne Whitney: Sculptor," *Art Quarterly* 25 (1962)

Payne, Elizabeth Rogers, "Anne Whitney: Art and Social Justice," *Massachusetts Quarterly* 25 (1971)

Reitzes, Lisa B., "The Political Voice of the Artist: Anne Whitney's *Roma* and *Harriet Martineau*," *American Art* 8 (spring 1994)

Rubinstein, Charlotte Streifer, *American Women Sculptors*, Boston: G.K. Hall, 1990

Stebbins, Theodore E., *The Lure of Italy: American Artists and the Italian Experience, 1760–1914* (exhib. cat.), Boston: Museum of Fine Arts, 1992

Tufts, Eleanor, "An American Dilemma: Should a Woman Be Allowed to Sculpt a Man?" *Art Journal* 51 (Spring 1992)

Waters, Clara Erskine Clement, *Women in the Fine Arts: From the Seventh Century B.C. to the Twentieth Century A.D.*, Boston and New York: Houghton Mifflin, 1904; reprint, New York: Hacker Art Books, 1974

WILIGELMO *fl.* 1099–*ca.* 1140 *Italian*

The beginning of Italian Romanesque sculpture is linked with Wiligelmo (Wiligelmus) of Modena. He and his workshop were responsible for the sculptural decoration of the west facade of the Cathedral of Modena in Emilia. Work on the new cathedral started in 1099 when the foundations were laid; this is recorded in the two inscriptions on the apse and the facade. Although the building was consecrated only in 1184, it seems that it was finished long before in about 1140 (see Salvini, 1966). A large part of the sculptures on the facade can be dated to before 1110. In 1107 construction at the nearby Cathedral of Cremona was begun; part of Wiligelmo's workshop went there probably when most of the work at Modena was completed. Not only figures from Modena, but also the inscription panel of the facade, were copied there. Wiligelmo's share in the execution is, however, limited to the Cathedral of Modena (see Quintavalle, 1991).

Although Lanfranco, the architect of the cathedral, is named both in the inscription on the apse and in the 1106 documents concerning the translation of St. Geminiano's relics, we learn Wiligelmo's name from three lines added later to the inscription panel on the facade attesting to his fame as a sculptor. Wiligelmo's achievement consists in the reintroduction of monumental sculpture in Italy, closely linking his works with the architecture. The single reliefs, however, serve not only to structure Lanfranco's architecture, but also to articulate the architectural members as sculptures in their own right. Wiligelmo and his workshop created all the decorated parts of the architecture, such as the portal flanked by the four reliefs of the Genesis, the capitals of the semicolumns, the gallery's capitals, the consoles of the frieze, and the four apocalyptic animals. This closely interrelated ensemble has been changed by later additions, such as a rose window and the side portals leading to the elevated positioning of the lateral reliefs. It has been questioned, however, if these reliefs were created for the facade at all (see Quintavalle, 1964–65). The portal, the so-called *protiro*, is the first example of this particular two-story type with an open-arched porch resting on columns supported by lions. During the 12th century, it was very often imitated in Emilia and other parts of Italy. For this invention, no prototype can be named, but for the general conception as well as for the individual figure style, all evidence points to a French influence on Wiligelmo, if not his direct presence in France. The other component of his style is directly dependent on the antique, as was the greater part of the earlier French sculpture he emulated. This is manifested not only by the inclusion of two Roman spoils, the lions supporting the portal's columns, but even more by the two reliefs of torch-bearing winged genies carved by Wiligelmo in close imitation of antique sarcophagi. Despite these notable influences, Wiligelmo's style as it shows best in the reliefs of the Genesis story is very personal. It is characterized by the mass and monumentality of the rather sturdy single figures in high relief, their expressive gestures and sometimes angular stances, as well as an acute sensibility for rhythm in the disposition of the figures on the frieze. Starting from the left, the reliefs show God supported by angels in the *mandorla*, the creation of Adam and Eve, and the Fall; they then continue in the next field with Adam and Eve before

God, the Expulsion, and Adam and Eve working on the fields. The story of the first men unfolds with the two reliefs on the right of the portal, showing the story of Cain and Abel, and closes on the last relief with Lamech's killing of Cain and the subsequent story of Noah's ark. The figures are disposed under a continuous cornice supported by an arcaded frieze, within which some sustaining columns show. Rather than distributing his figures evenly under the apertures of the arcades, Wiligelmo sometimes breaks with the rhythm and enlarges a single story, as in the creation of Eve, or compresses it into a tight space, as in the field with God accusing Adam and Eve. The first three scenes, the scene of Cain and Abel sacrificing to God, and the panel that is born by Elias and Enoch bear inscriptions. As a possible written source for the choice of scenes and their disposition, a play such as the 12th-century *Jeu d'Adam* (anonymous) has been cited (see Frugoni, 1996).

The door under the porch is finely decorated. The outer face of the jambs consists mainly of an acanthus scroll winding upward, which is continued into the archivolt surrounding the open tympanum. The acanthus is supported by two male caryatids who bend their heads and knees under the weight. Animals and men, sometimes fable figures, are interwoven into the zigzagging rounded scrolls, culminating in the two-headed Janus on the top. The vivacity of these scenes and their variety of narrative elements are unmatched not only in the Italian sculpture of the day, but also in comparison with French sculpture of about 1100. The inner side of the posts is decorated with small rectangular reliefs of prophets standing under aediculae and looking to the doorway. These animated figures with large heads fill their niches almost entirely and display books or scrolls or point or look upward to their source of inspiration, where two angels appear on top of the jambs. Some authors have considered these figures the first step toward the later Romanesque and Gothic portals, which often show the same type of figures almost in the round.

As novel as these elements are, the bizarre capitals of the half-columns host a siren, grotesque heads with foliage, and rugged sitting men. Because of the missing framing elements, they can be considered the first genuine historiated capitals in medieval art (see Poeschke, 1998).

Wiligelmo and his workshop were extremely influential. The workshop not only decorated the two other portals of the Cathedral of Modena, but also created all of the remaining sculptures on the exterior and the majority of the interior. Away from Modena, the workshop was also responsible for the sculptural decoration at the Cathedral of Cremona and on the abbey church of Nonantola. At Piacenza the workshop divided; the older "school" worked on the left portal of the cathedral and the younger one worked on the right, where Niccolò, the next leading sculptor, emerged.

JOHANNES MYSSOK

Biography

There is virtually no known definitive information on the artist's life. All that is known for certain about Wiligelmo is that he was active in Emilia, Italy, from 1099 to *ca.* 1140.

Selected Works

1099– *ca.* 1110	Facade sculptures; limestone, white marble; Cathedral of Modena, Emilia, Italy
1107–17	Main portal (workshop); limestone, white marble; Cathedral of Cremona, Italy
1110–15	Porta dei Principi (workshop); limestone; Cathedral of Modena, Emilia, Italy
ca. 1115	Main portal (workshop); limestone; Abbey Church, Nonantola, Italy
1120–25	Porta della Pescheria (workshop); limestone; Cathedral of Modena, Emilia, Italy
1122– *ca.* 1130	Main portal (workshop); limestone; Cathedral of Piacenza, Italy

Genesis Relief, Facade sculptures, Cathedral of Modena, Italy
The Conway Library, Courtauld Institute of Art

Further Reading

Frugoni, Chiara, *Wiligelmo: Le sculture del duomo di Modena*, Modena, Italy: Panini, 1996

Hearn, M.F., *Romanesque Sculpture: The Revival of Monumental Stone Sculpture in the Eleventh and Twelfth Centuries*, Oxford: Phaidon, 1981

Lanfranco e Wiligelmo: Il Duomo di Modena (exhib. cat.), Modena, Italy: Panini, 1984

Poeschke, Joachim, Albert Hirmer, and Irmgard Ernstmeier-Hirmer, *Die Skulptur des Mittelalters in Italien*, 2 vols., Munich: Hirmer, 1998; see especially vol. 1

Quintavalle, Arturo Carlo, *La cattedrale di Modena: Problemi di romanico emiliano*, Modena, Italy: Bassi, 1964–65

Quintavalle, Arturo Carlo, *Wiligelmo e Matilde: L'officina romanica*, Mantua, Italy, and Milan: Electa, 1991

Salvini, Roberto, *Wiligelmo e le origini della scultura romanica*, Milan: Martello, 1956

Salvini, Roberto, *Il duomo di Modena e il romanico nel Modenese*, Modena, Italy: Cassa di Risparmio, 1966

Salvini, Roberto, *Medieval Sculpture*, Greenwich, Connecticut: New York Graphic Society, 1969

Tcherikover, A., "Reflections of the Investiture Controversy at Nonantola and Modena," *Zeitschrift für Kunstgeschichte* 60 (1997)

Wiligelmo e Lanfranco nell'Europa romanica, Modena, Italy: Panini, 1989

JOSEPH WILTON 1722–1803 *British*

Joseph Wilton was a prominent artistic figure in 18th-century England, attracting important commissions for portraits and public monuments, receiving official recognition from George III, and participating in the founding of the Royal Academy. However, even with all the advantages of wealth, political connections, excellent training, and study abroad, Wilton remained an inconsistent sculptor. He oscillated between a highly refined, late Baroque style and a Neoclassical aesthetic, and his compositions sometimes suffered from his inability to resolve the poses and treatment of his figures. Nevertheless, his portrait busts could be boldly innovative in their conception and handling, and his funeral monuments could achieve a dramatic poignancy that ranks them among the best British tombs of the period.

Wilton was sent by his father, a prosperous manufacturer of papier mâché ornaments, to train under Laurent Delvaux in Flanders. In 1744 Wilton went to Paris to study with Jean-Baptiste Pigalle, whose graceful compositions and vibrant portrait style may have provided a lasting influence. Arriving in Rome in 1747, Wilton began producing copies of famous antiquities for British collectors, a practice that gained him considerable praise and continued to sustain him after his return to London. He moved to Florence in 1751, becoming a member of the Florentine Academy and a close associate of British envoy Horace Mann. In 1755 Wilton sculpted a remarkable bust of Dr. Antonio Cocchi, Mann's close friend and the keeper of the Medici grand-ducal collections. The only known portrait from life executed by Wilton in Italy, the bust of Dr. Antonio Cocchi is unparalleled at this date for its nude chest, emphatic simplicity, and detailed rendering of the sitter's bald head and wrinkled flesh. Roman veristic portraiture, as well as the scientific interests of the sitter, may have inspired this extreme realism, but the bust serves as an early example of the stylistic inventiveness and dexterous carving of which Wilton was capable. That same year Wilton spent time with the architect Robert Adam, who had arrived in Florence in January. By the time Wilton left Italy in 1755, he had established many of the personal and professional associations that would nurture his career in England, such as that with Adam, the architect William Chambers, and the marble merchants in Carrara.

Returning to London with Chambers, the painter Giovanni Battista Cipriani, and the sculptor Giovanni Battista Cappezzuoli, Wilton set up shop in his father's house at Charing Cross. The bust of Philip Stanhope, fourth Earl of Chesterfield, reveals Wilton's continuing interest in undraped, rounded truncations and uncompromisingly realistic facial features. It was likely the earliest Neoclassical bust produced in England that embodied the stylistic values of Roman republican portraiture. In 1758 Wilton and Cipriani were appointed directors of the gallery of casts opened by the Duke of Richmond for use by art students. Wilton supplied some of the casts, as well as marble copies of the *Apollo Belvedere* and Medici faun. The sculptor was also an early participant in the Royal Society of Arts and became a founding member of the Royal Academy in 1768.

Like other British sculptors without enormous studios, Wilton relied on commissions of decorative sculpture that architects could provide, and his connections with Chambers and Adam brought him lucrative orders for chimneypieces and ornaments. Friendship with Chambers also facilitated Wilton's appointment as carver of state coaches to the king; he designed and carved part of George III's coronation coach, produced in new workshops opposite Marylebone Fields. In 1764 Wilton was appointed sculptor to His Majesty. Among his royal projects was a 1764 statue of *George III* in Roman imperial dress for the Royal Exchange and a lead equestrian statue of George III made under Wilton's direction and erected in Berkeley Square in 1766. This latter work was sagging so badly by 1812 that it had to be dismantled.

Wilton won numerous commissions for tomb monuments, including five in Westminster Abbey. The monument to Admiral Temple West is elegantly simple in its design, with a handsome bust set against a low-relief pyramid. The dramatic turn of West's head, the drapery that swirls around the bottom of the chest up to the opposite shoulder, and the expressive facial features reveal Wilton's mastery of a Late Baroque style. The monument to the Earl and Countess of Mountrath, designed in collaboration with Chambers, is similarly Baroque but much more elaborate in conception, with Lord Mountrath seated in heaven awaiting the arrival of his widow, who is guided by a dynamically posed angel in flight. Before the monument was altered in the 1820s, eliminating a key element of its

Monument to General James Wolfe
The Conway Library, Courtauld Institute of Art

design, it was one of Wilton's more ambitious exploitations of glance and pose to create an affecting narrative. The monument to Dr. Stephen Hales suffers from the figures' awkward poses and unresolved volumes, which place them somewhere between relief and sculpture in the round. The monument to General James Wolfe exhibits some of the same flaws and was further criticized for inconsistencies in style, composition, and costume. In the monument to Lady Anne Dawson, Wilton reduced the number of elements, concentrating on the expressive interaction of the figures; it is perhaps his most successful and dramatic funeral project.

Despite an ample inheritance from his father, Wilton was forced to sell his studio contents in 1786. He declared bankruptcy in 1793. Early biographers attributed Wilton's financial difficulties to his extravagant lifestyle, which included ownership of three houses, a family coach, a phaeton, and several saddle horses. However, expenses for the marble sculptor in London were very high, considering the cost of marble, tools, and travel, the need for a large yard and studio in an expensive area near town residences where it could serve as a showroom for potential clients, and the employment of numerous assistants to move large blocks as well as carve them. Many other sculptors, such as Richard Westmacott the Elder, Charles Rossi, and John Fisher, also declared bankruptcy. From 1790 until his death in 1803, Wilton held the post of Keeper of the Royal Academy, which provided a respectable retreat from active sculptural production.

PEGGY FOGELMAN

Biography

Born in London, England, 16 July 1722. Trained with Laurent Delvaux in Nivelles, Flanders (present-day Belgium); studied with Jean-Baptiste Pigalle in Paris, 1744; recorded in Rome by 1749, lived in Zuccari Palace with Matthew Brettingham and others; won gold medal for *Cain Slaying Abel*, at the Academy of St. Luke, 1750; patronized by William Locke of Norbury and began receiving commissions for copies of ancient statues; moved to Florence, 1751; became member of the Florentine Academy and associated with British envoy Horace Mann, Dr. Antonio Cocchi (keeper of the Medici grand-ducal collections), and later Robert Adam; returned to London, 1755, and set up workshop at Charing Cross; appointed codirector of Duke of Richmond's gallery of casts in Whitehall, London, 1758; named carver of state coaches to King George III, 1760, then sculptor to His Majesty, 1761; became foundation member of Royal Academy, 1768; exhibited at Royal Academy annual exhibitions from 1769 to 1783; sold contents of his studio at auction on 8–9 June 1786; appointed keeper of the Royal Academy, 1790. Died in London, England, 25 November 1803.

Selected Works

1755 Bust of Dr. Antonio Cocchi; marble; Victoria and Albert Museum, London, England

1757 Bust of Philip Stanhope, fourth Earl of Chesterfield; marble; British Museum, London, England

1757 Monument to Admiral Temple West; marble; Westminster Abbey, London, England

1758 *Bust of a Man* (after the antique); marble; J. Paul Getty Museum, Los Angeles, United States

ca. 1760 Bust of General James Wolfe; marble; Dalmeny House, Lothian, Scotland

1762 Bust of Oliver Cromwell; terracotta; Victoria and Albert Museum, London, England; marble: Victoria and Albert Museum, London, England

1762 Coronation coach for George III; wood and other materials; Royal Collection, Buckingham Palace, London, England

1762 Monument to Dr. Stephen Hales; marble, Westminster Abbey, London, England

1764 *George III*, for the Royal Exchange, London, England; marble (untraced)

1766 Equestrian statue of George III, for Berkeley Square, London, England; lead (dismantled in 1812)

1769 Monument to the second Duke of Bedford; marble; Chenies, Buckinghamshire, England

1769–74 Monument to Lady Anne Dawson; marble;

Dartrey Mausoleum, County Monaghan, Ireland

1771 Monument to the Earl and Countess of Mountrath; marble; Westminster Abbey, London, England

1772 Monument to General James Wolfe; marble; Westminster Abbey, London, England

1795 Monument to Sir Archibald Campbell; marble; Westminster Abbey, London, England

Further Reading

Blundell, Joe Whitlock, *Westminster Abbey: The Monuments*, London: Murray, 1989

Cunningham, Allan, *The Lives of the Most Eminent British Painters, Sculptors, and Architects*, London: John Murray, 1830

Gunnis, Rupert, *Dictionary of British Sculptors, 1660–1851*, London: Odhams Press, 1953; Cambridge, Massachusetts: Harvard University Press, 1954; revised edition, London: Abbey Library, 1968

Hodgkinson, Terence, "Joseph Wilton and Doctor Cocchi," *Victoria and Albert Museum Bulletin* 3 (1967)

Penny, Nicholas, *Church Monuments in Romantic England*, New Haven, Connecticut: Yale University Press, 1977

Physick, John Frederick, *Designs for English Sculpture: 1680–1860*, London: HMSO, 1969

Smith, John Thomas, *Nollekens and His Times*, London: Colburn, 1828; reprint, London: Century Hutchinson, 1986

Whinney, Margaret, *English Sculpture, 1720–1830*, London: HMSO, 1971

Whinney, Margaret, *Sculpture in Britain, 1530–1830*, London and Baltimore, Maryland: Penguin, 1964; 2nd edition, revised by John Physick, London and New York: Penguin, 1988

WOMEN SCULPTORS

The challenge of a history of women sculptors is one of critical reevaluation of written histories that tended until recent decades to neglect research on women in the arts. Women have made significant contributions to the visual arts throughout history, but the art-historical canon has not always sufficiently or consistently recognized how the dynamics of gender have shaped the discipline, its methodologies, and institutional practices such as collecting, exhibiting, and publishing. The present survey of the history of women sculptors and the cultural conditions under which they worked focuses on those artists active in Western Europe and North America in the modern era, from the 16th century to the present.

Historians over the last decades of the 20th century (primarily as a result of feminist scholarship from the 1970s onward) have outlined the obstacles faced by professional women artists, which included social re-strictions to becoming a professional, as opposed to an amateur, artist; familial responsibilities of domestic duties, pregnancy, and motherhood; limited if not denied access to the prevailing educational systems (for example, guild membership, apprenticeship, the atelier, and the academy); and prohibition to life-study classes until the late 19th and early 20th centuries. Women were restricted from studying the live nude male or female model in studios because it was believed that the weakness and susceptibility of their bodily and sexual drives would render them helpless and harm their moral character.

Women pursuing "the manly art" of sculpture faced additional social and financial restrictions. The public criticized female artists for the perceived "unfeminine" aspects of wielding a mallet, the overly strenuous physical work of stone or marble carving, and dressing in sculptor's costume (pants and tunic), the latter often attracting curiosity if not scandal. Sculpting required a considerable initial monetary outlay for materials (such as precious metals and marble), assistants, and large, ground-floor workshops. Women sculptors found it difficult to obtain patronage for large-scale or public commissions because patrons were reluctant to entrust ambitious or expensive projects to women, who, because of the very educational and institutional discrimination they sought to offset, often had limited work histories. Moreover, while women artists tended to work in the prevailing style of the day (and their work more often than not resembled the work of their male peers), critics usually described women artists as derivative, that is, influenced by the work of the male genius, a term which was antithetical with femininity. Despite these conditions, successful and prominent women sculptors did exist before the 20th century. It would be more accurate to suggest that as recently as the 19th century, institutions of culture reinforced the separation of male and female worlds and coded the realms of public and private in art as masculine and feminine, respectively. Social conventions and laws, of course, made such a division of labor not only theoretical or philosophical but a reality of men and women's lives. As the feminist scholar and art historian Janet Wolff has noted, "culture is not a passive vehicle for the transmission of already existing social values and ideologies," but rather, cultural representation participates actively in the construction of such values (see Wolff, 1990).

The earliest record of names of women in Western European medieval guilds appear most often in book and textile arts. Cultural conditions and educational practices for artisans excluded most women from stonework. To what extent the women whose names are listed in guild records actively participated in stonework is unclear. Scholars had previously identified Sa-

bina von Steinbach as the only named medieval woman sculptor, associated with work on the Cathedral of Strasbourg, but she is now known to have been a patron and not a carver.

Renaissance ideals of humanism and naturalism established the rise of the artist as individual and with it biographies of artists' lives. In the 16th century Giorgio Vasari recorded in his *Le Vite de' più eccellenti Architetti, Pittori, et Scultori Italiani* (The Lives of the Most Excellent Architects, Painters, and Sculptors of Italy; 1550 and 1568) the life of the first professional woman sculptor in Europe whose name and work have survived. Properzia de' Rossi, from the progressive city of Bologna that also produced the famed Renaissance women painters Lavinia Fontana and Elisabetta Sirani, received the commission in 1525 to create figures and relief work for the facade of the Church of S. Petronio in Bologna. Unfortunately, she died young at the height of her career, just as Clement VII was about to commission more substantial work from her.

Excluded from the traditional avenues of art education open to men, women artists usually acquired their training through male familial connections—either a father, brother, husband, or uncle. Luisa Roldán received art instruction while assisting in the workshop of her father, sculptor Pedro Roldán, in Seville. Charles

Harriet Goodhue Hosmer, *Puck*, 1856
© Smithsonian American Art Museum, Washington, D.C./Art Resource, NY

II in Madrid appointed Roldán, known for her life-size figures in polychromed wood for use on Holy Week floats, sculptor to the bedchamber (*Escultora de Cámara*) in 1692, and Philip V appointed her sculptor to the king in 1701. Not usually entrusted with the large, complex projects reserved for male court sculptors, Roldán created small, multifigured statuettes of polychromed terracotta. At her death she received the title *Accademica di Merito* from the Roman Accademia de San Luca.

Europe in the late 18th and early 19th centuries produced more women sculptors of note than did the previous centuries. With the shift in patronage from religious to aristocratic and royal commissions came an increased demand for portraiture. Portrait work could be realized on a relatively small scale and required little knowledge of life-study and a classical education, making it a more suitable genre of sculpture for women than the multifigured, large-scale, and historical or religious subjects of more public commissions. Ironically, critics associated the personal and intimate nature of portraiture with conventional characteristics of femininity (softness, sensitivity, intimacy, and privacy) that made women artists "better suited" to this type of work. Also, at a time when many European courts were headed by female monarchs, royal patronage for women sculptors adept at portraiture became easier to obtain. One such sculptor was Marie-Anne Collot of France. While in St. Petersburg, Russia, in 1766, modeling the head for the *Equestrian Statue of Peter the Great* commissioned from her teacher and future father-in-law Étienne-Maurice Falconet, Collot received additional commissions from Catherine II to execute 25 portrait busts. She remained the empress's official portrait sculptor until 1778. Collot later accompanied Falconet to The Hague in the Netherlands to jointly serve with him as court sculptor to William V. She gave up sculpture to nurse Falconet after his stroke in 1783 and never returned to it as a profession.

Two women active in England in the early 19th century became court sculptors to Queen Victoria and the English royal family. The first, Mary Francis Thornycroft, received her training from her father, the sculptor John Francis. While Thornycroft was in Rome, the English sculptor John Gibson admired her work and recommended her to Queen Victoria. Thornycroft returned to England and enjoyed years of royal patronage through which she supported her large family. The second sculptor, Susan Durant, studied privately with Baron Henri de Triqueti in Paris. One of Queen Victoria's favorite sculptors, Durant not only executed portrait busts and medallions of the royal family but also instructed Princess Louise in sculpture.

In Germany, Elisabet Ney also found success as a portraitist and court sculptor. The first woman admit-

ted to the sculpture classes at Munich's Academy of Fine Arts, Ney also studied with Neoclassicist Christian Rauch in Berlin. After making her name sculpting the likenesses of German royalty and European personalities, she received a commission to execute a full-length statue of *King Ludwig II of Bavaria*. Soon after, she immigrated to the United States. Ney and Durant designed ideals in addition to portraits, but these works were noncommissioned exhibition pieces; public commissions won by women sculptors at this time consisted primarily of large-scale or memorial portraits, such as Durant's Cenotaph to King Leopold I of Belgium (1866–67), commissioned by Queen Victoria, and Ney's *Sam Houston* (1891) and *Stephen F. Austin* (1893), commissioned by the Texas state legislature.

The 19th century produced a greater number of women sculptors active in the United States, England, and Continental Europe than ever before. The Neoclassical style and its manner of creation contributed to this increase. Neoclassicism's associations with the political and artistic ideals of Classical Greece, from which it derived, made for a style easily translated into the three-dimensional and an art form redolent with moralizing force. The didactic aspects of Neoclassical sculpture dovetailed with the 19th-century precepts of the "Cult of True Womanhood" (popularized by such influential rationalist thinkers as the French social critic Jean-Jacques Rousseau) and women's roles as cultural civilizers and benevolent reformers. When women translated ideas of social reform into Neoclassical sculpture, it served to not only educate but elevate the moral aspects of conventional male and female roles, thereby making women sculptors socially more acceptable.

The other aspect of Neoclassical sculpture that advanced female numbers in the medium, its manner of creation, also worked to make the concept of "the woman sculptor" more palatable to critics and patrons. The use of Italian assistants (where the tradition for academic figurative sculpture had a stronghold) was an accepted practice for both male and female sculptors at the time. Sculptors modeled from the motif using small-scale clay maquettes and then turned them over to workmen who, using the pointing system, eventually converted them into large-scale finished marble statues. Women sculptors could thereby circumvent the "unfeminine" aspects of the physical work with heavy tools, even though all sculptors of the time were capable of physically carving the marble themselves.

To make use of these technicians, sculptors from the United States and throughout Europe established their studios in Rome. Italy offered not only skilled stone carvers but also access to fine marble and large collections of Classical sculpture; instructors such as Bertel Thorvaldsen, Antonio Canova, and John Gib-

son; an inexpensive environment in which to work; and relaxed cultural restrictions, including the availability of live models who would pose. A number of American women sculptors went to study and work in Rome in the middle of the 19th century in pursuit of these advantages. Described by novelist Henry James (1903) as "that strange sisterhood of American 'lady sculptors' who at one time settled upon the seven hills in a white, marmorean flock," they included Harriet Hosmer, Anne Whitney, Edmonia Lewis, Vinnie Ream, Margaret Foley, Emma Stebbins, and Louisa Lander. Their arrival in Rome was not as a group, as James implies, but spanned nearly three decades, and although they worked to varying degrees in the Neoclassical style, they all studied privately with different instructors in Rome. Unlike women sculptors of earlier centuries they did not pursue court commissions but instead catered to wealthy potential American and British patrons visiting Europe on the grand tour.

These women took their sculpture well beyond the realm of private portraiture and fought for their share of public commissions. They not only focused on ideals based on historical and literary sources but, through their politically charged sculptures, also expressed their interests in subjects of social reform in class, race, and gender. Hosmer, the most well known and successful of these American women sculptors, received several important commissions, and her independent exhibition pieces, many of which depicted strong, independent women from history, met with critical acclaim. Whitney produced works of social commentary representing her political beliefs. Her fight against social injustice became a more personal one when in 1875 she won a blind national competition for a public statue of Senator Charles Sumner but was denied the award when it became known that the winning sculptor was a woman. Whitney never entered another competition. Twenty-five years later the bronze realization of her original model of *Senator Charles Sumner* (1902) was erected in Harvard Square, Cambridge, Massachusetts, through private subscription. Historians recognize Edmonia Lewis as the first important African American sculptor in the United States whose subjects related to the Civil War, abolition, and Native American culture. Her work embraced political and social issues of personal importance to her while still cultivating the prevailing air of Neoclassical restraint and Romantic emotionalism, thereby astutely negotiating the norms of the discipline and social convention.

In France, Félicie de Fauveau surpassed success in portraiture to achieve renown with her commissioned public work. In addition to major portrait commissions from a variety of European nobility, she carved high-relief religious and historical monuments in support of her political beliefs, executed in the Neo-Gothic "Style

Troubadour." Even more auspicious in terms of originality and opportunity was the Swiss-born Adele d'Affrey, Duchess of Castiglione-Colonna, who exhibited at the French salon under the masculine pseudonym Marcello (a not uncommon strategy for improving her chances of acceptance with the male jurors). Her dramatic depictions of mythological women in the stylistic manner of her friend and colleague Jean-Baptiste Carpeaux earned her critical success. Most notable, her *Pythian Sybil* (*ca.* 1870), depicting the oracle at the sanctuary of Apollo in Delphi interpreting a message, was commissioned for the grand reconstruction of the Paris Opéra under the architect Charles Garnier.

The 19th-century fight to open the educational system to women on an equal basis to men extended to reforms within art education. To achieve both social freedom and financial success for practicing artists, women viewed art education as a necessity in a time of growing industrialization. The twofold goal was to preserve the moral-renewing arts and to provide women with a degree of respectable self-sufficiency. In the 1860s many organizations and schools worked toward this goal, including the English Society of Female Artists, the French Union des Femmes Peintres et Sculpteurs (founded by sculptor Madame Leon [Hélene] Bertaux), and the Art Students League in New York City. Their battles included lobbying the established art system (the Royal Academy [London], École des Beaux-Arts E [Paris], and National Academy of Design [New York City], respectively) for admittance of female members, access to the same life classes attended by male artists, and equal exhibition opportunities.

Before these goals were achieved beginning in the last decade of the 19th century and continuing well into the 20th, women artists found other means of acquiring education and exhibition opportunities. The international exhibitions of the 1880s and 1890s often showcased women's work, including sculpture. For a group of American women sculptors looking for these advantages, Chicago's World's Columbian Exposition of 1893 provided income, training, and sources of commission. The exposition required so many workers to create facades and decorative sculpture molded and carved out of staff (a plaster and hemp fiber mixture used for most of the exteriors of the exposition buildings) that women were hired as assistants to the officially commissioned artists. When Lorado Taft was at work on his exposition sculpture, so the story goes, he informed the director of works, Daniel Burnham, that he "had several young women whom . . . [he] would like to employ." Burnham's reply: "Employ any one who could do the work—white rabbits, if they would help out" (see Scudder, 1925). Taft's studio assistants—Julia Bracken, Carol Brooks, Bessie Potter,

Janet Scudder, Zulime Taft, and Enid Yandell—henceforth became known in the art-historical literature as the "white rabbits." All but Zulime Taft, Lorado's sister, went on to successful careers in sculpture working in the Beaux-Arts style.

The Beaux-Arts style had begun to replace the Neoclassical in sculpture in the 1860s; eventually, textured bronze replaced smoothed marble, Baroque expressiveness replaced Classical reserve, and Paris replaced Rome as the city of choice for young artists. Many students flocked to Paris to study at the Académie Colarossi and independently with Frederick MacMonnies and, especially, Auguste Rodin. In addition to Yandell and Scudder, Harriet Frishmuth, Malvina Hoffman, Meta Warrick Fuller, and Gertrude Vanderbilt Whitney all took inspiration from the French style and used their Paris training to obtain commissions and produce fluid, energetic, and moving monuments, war memorials, fountains, and architectural and garden sculpture in the United States. Undoubtedly Rodin had the greatest influence on his French studio assistant Camille Claudel. Records of her early creative life were so closely linked to Rodin and his art production that such scholarship has interfered with an understanding of Claudel's artistic development and history. Critics praised Claudel for her imaginative compositions, expressive technique, and literary symbolism, yet officially censured her work for the sensual and sexual qualities it imbued. Her break with Rodin in 1898 and her rejection from the art section of the Exposition Universelle of 1900 led to depression and despair, and she spent the end of her life in a mental asylum.

Out of the declining social conditions and political upheavals of the early 20th century, several women artists expressed their sympathy with the human condition through sculpture. Anna Golubkina married politics and aesthetics in her three-dimensional commentaries on the turbulent political and social situation in Russia. In her persuasive and energetic sculpture, as in her graphic work, Käthe Kollwitz lamented the human suffering caused by political oppression, poverty, and war in Germany. Abastenia St. Léger Eberle advanced social reform in the United States through her realistic depictions of urban street life, the dignity (albeit sentimentalizing) of the working class, and the vulnerability of poor, young, and immigrant women to the evils of urban degradation.

The work of women sculptors active in postwar Europe and the United States is the product of cultural, social, and ethnic diversity. The shift away from Modernist discourse and early-20th-century abstraction in sculpture has allowed for an iconography of subjective experience: childhood, family histories and influences, and personal narratives have shaped artistic forays in postwar sculpture. Postwar women sculptors comprise

various geographic homelands (for example, England, Russia, France, Venezuela, Germany, and the United States), artistic training (the École des Beaux-Arts in Paris, Hans Hofmann's studio in Munich, Royal College of Art in London, Art Students League in New York City, and Yale School of Art and Architecture in New Haven, Connecticut), and stylistic approaches (such as Cubism, Expressionism, Surrealism, and Abstractionism). While women demonstrably faced specific discrimination based on prevailing social attitudes and beliefs surrounding the "condition" of being women artists, and were subject to critical standards that continually recognized their sexual difference from their male peers, their art was arguably shaped by the same factors as male artists: background, apprenticeship, education, and the pressure to either conform to or to challenge the prevailing style and aesthetic theories. While artists are unified by their study of many visual art forms, not only sculpture, and by the desire to create some portion of their oeuvre in monumental or environmental form, women sculptors are diverse in their use of materials (such as wood, stone, glass, metal, found objects, and fiberglass) and distinctive in their creative technical approaches to working in their selected medium.

In France, Germaine Richier cast angular, sharp, animalistic figures with rough-hewn surface textures resonant of the natural forms she observed during her childhood in Provence. Barbara Hepworth rejected casting for a return to direct carving, exploiting qualities of tactility and texture as the external signifier of an internal vision or state of mind. Her human and environmentally based sculptures, inspired by the English Yorkshire landscape of her youth, are visual metaphors for the human experience. The wooden constructed montages for which Louise Nevelson is well known had their origins in her father's Maine lumberyard, but in her hands they became large-scale walls of monochromed environments. Using found and carved ordinary objects, usually painted in black, gold, or white, Nevelson built gridded, somewhat surrealist, sculptures arranged in boxed enclosures. Louise Bourgeois, contemporaneous with the American Abstract Expressionists in New York, worked in whatever media necessary, ranging from soft wood to bronze to latex, to achieve her feminist and idiosyncratic expression of body-based and psychological subjects in addition to prevailing aesthetics of abstraction and formal purity. Bourgeois's sexually charged, psychically disturbing images, suggestive of human and animal life forms, represented a private sense of what she conceived as female experience. The French-born Venezuelan artist Marisol (Escobar) created large, mixed-media figurative assemblage tableaux as witty commentaries, mainly on American Pop culture.

During the eclectic period of the 1960s and 1970s, artists further stretched the possible boundaries of sculptural form and materials. From Eva Hesse's works using string from old weavings mixed with plaster and her process art using synthetic resin, cord, cloth, and rubber tubing, which cross the boundaries between two-dimensional and three-dimensional spatial concepts, to Nancy Graves's inventive juxtapositions of art and science in her welded constructions of organic plant and animal forms cast in bronze, contemporary sculptors have tested the use of nontraditional materials and novel forms. Drawing on Conceptualist, Minimalist, and Post-Minimalist thought, contemporary sculptors continue to push the margins defining sculpture by creating work that is resistant to the museum and gallery. Earthworks artists such as Nancy Holt, Mary Miss, and Alice Aycock made up a significant core of the Land art movement while adding yet another twist to their métier by relying on the active participation of the viewer to complete their outdoor sited works.

Throughout the modern era of the Western world, women have made innumerable and influential contributions to the artistic record. Working in small and large scale, producing public commissions and private exhibition pieces, in marble or bronze, wood and unorthodox media, women sculptors added significant, innovative, and lasting visual statements to the art of sculpting and its history.

CHARLENE G. GARFINKLE

See also **Bourgeois, Louise; Claudel, Camille; Durant, Susan D.; Fauveau, Félicie de; Golubkina, Anna; Hepworth, Dame Barbara; Hesse, Eva; Hoffman, Malvina; Hosmer, Harriet Goodhue; Kollwitz, Käthe; Lewis, Mary Edmonia; Marcello (Adèle d'Affry); Nevelson, Louise; Ney, Elisabet; Richier, Germaine; Roldán, Family; Rossi, Properzia de'; Thornycroft Family; Whitney, Anne**

Further Reading

Chadwick, Whitney, *Women, Art, and Society*, New York: Thames and Hudson, 1990; 2nd edition, revised and expanded, London: Thames and Hudson, 1996

Cikovsky, Nicolai, Jr., Marie H. Morrison, and Carol Ockman, *Nineteenth-Century American Women Neoclassical Sculptors*, Poughkeepsie, New York: Merchants Press, 1972

Dunford, Penny, *A Biographical Dictionary of Women Artists in Europe and America since 1850*, Philadelphia: University of Pennsylvania Press, 1989

Fine, Elsa Honig, *Women and Art: A History of Women and Sculptors from the Renaissance to the 20th Century*, Montclair, New Jersey: Allanheld and Schram, and London: Prior, 1978

Garb, Tamar, "L'Art Féminin: The Formation of a Critical Category in Late Nineteenth-Century France," *The Expanding Discourse: Feminism and Art History*, edited by Norma

Broude and Mary D. Garrard, New York: HarperCollins, 1992

Gaze, Delia, editor, *Dictionary of Women Artists*, 2 vols., London and Chicago: Fitzroy Dearborn, 1997

Greer, Germaine, *The Obstacle Race: The Fortunes of Women Painters and Their Work*, New York: Farrar Straus Giroux, and London: Secker and Warburg, 1979

Harris, Ann Sutherland, and Linda Nochlin, *Women Artists: 1550–1950*, Los Angeles: Los Angeles County Museum of Art, and New York: Knopf, 1981

Heller, Jules, and Nancy G. Heller, editors, *North American Women Artists of the Twentieth Century: A Biographical Dictionary*, New York: Garland, 1995

James, Henry, *William Wetmore Story and His Friends: From Letters, Diaries, and Recollections*, 2 vols., London: Thames and Hudson, and Boston: Houghton Mifflin, 1903; see especially vol. 1

Nochlin, Linda, "Why Have There Been No Great Women Artists?" *Women, Art, and Power and Other Essays*, New York: Harper and Row, 1988

Parker, Rozsika, and Griselda Pollock, *Old Mistresses: Women, Art, and Ideology*, New York: Pantheon Books, and London: Routledge and Paul, 1981

Petersen, Karen, and J.J. Wilson, *Women Artists: Recognition and Reappraisal from the Early Middle Ages to the Twentieth Century*, New York: Harper and Row, 1976; London: Women's Press, 1978

Rubinstein, Charlotte Streifer, *American Women Sculptors*, Boston: G.K. Hall, 1990

Scudder, Janet, *Modeling My Life*, New York: Harcourt Brace, 1925

Slatkin, Wendy, *Women Artists in History*, Englewood Cliffs, New Jersey: Prentice Hall, 1985; 4th edition, Upper Saddle River, New Jersey: Prentice Hall, 2001

Wolff, Janet, *Feminine Sentences: Essays on Women and Culture*, Berkeley and Los Angeles: University of California Press, 1990

Yeldham, Charlotte, *Women Artists in Nineteenth-Century France and England*, 2 vols., New York: Garland, 1984

WOOD

Wood sculpture has maintained its popularity over the ages for two reasons. Wood is easy to work, requiring no significant alteration by heat (as does glass, clay, and metal), and it is widely available and in most cases abundant. The difficulty of wood as a sculptural medium is one of preservation: it is not very durable, is distorted by temperature fluctuations such as cold, heat, and humidity, and is susceptible to water rot and insect infestation. Even so, wood remains an appealing sculptural material.

As a raw material, wood is separated into two categories: hardwood and softwood. Contrary to the names, these categories are not indicative of the strength or relative suppleness of the material but rather refer to the grain, which is of particular interest to the wood sculptor. Hardwoods, the wood of deciduous trees, are close grained and take a high polish. The close grain is achieved because of the narrow and often inconspicuous annual growth rings in the trunk, which make hardwood a desirable material even though it is more challenging to work. Coarse-grained wood or softwood, with its wider and more visible annual growth rings, exhibits considerable difference between springwood and summerwood. Conifers (or softwoods), such as balsam, cedar, and pine, are more porous, have simpler cell structure, and are subject to shrinkage and warping, but are easier to work with.

The earliest examples of wood sculpture date back 5,000 years to ancient Egypt, where nobles and kings adorned their tombs with figures symbolizing the offering of food to the dead in perpetuity. The Egyptians' belief in the afterlife encouraged them to prepare for eternity as best they could. Models of riverboats such as that found in the tomb of Meketre, a Theban official, include a singer and blind harpist entertaining Meketre on his boat. Tombs also preserved carved figures of buried nobles, possibly functioning as housing for the soul. The Egyptian *Kaaper* (*Sheikh el Beled*) (*ca.* 2400 BCE, 1.1 meters tall; Egyptian Museum, Cairo) represents an advanced representational sensibility and a masterful use of sophisticated tools during this period, indicating a craft not in its infancy but in full bloom.

Historically, wood sculpture has been painted, gilded, or otherwise concealed; this is evident in work such as *The Water and Moon Guanyin* (960–1127 CE, Liao or Northern Song dynasty; Nelson Atkins Museum of Art, Kansas City, Missouri), a painted wood statue of the bodhisattva. Ancient Chinese bodhisattva sculptures reflect the popular devotion afforded spiritual leaders believed to have forgone personal salvation to help humanity. *The Water and Moon Guanyin* exhibits the characteristic languid gesture of one arm draped over a bent knee surrounded with cascading fabric to create the impression of the Guanyin relaxing on lily pads drifting in a silvery moonlit lake. Buddhist priest-sculptors of the Song dynasties have contributed a generous number of large, painted wood statutes, work that captures the combination of magnificence and the quiet of religious figurative sculpture. An African reliquary guardian, sculpted by the Bakota people of Gabon and Cameroon, is another example of the diversity of surface treatment among wood sculpture. The wooden figure, sheathed and decorated with hammered brass and wire, is a fine example of abstract figurative work. The head of the reliquary guardian is a compilation of geometrically reduced facial features on a concave rigidly patterned oval; it sits atop a dramatically abridged, diminutive torso. Together these two disparate shapes create the impression of a mysterious and powerful protector.

One of the unique characteristics of wood is its tensile strength, the stress it can withstand before it breaks. The fibrous quality of wood provides for a high

level of tensile strength. Modern artists such as the English sculptor Henry Moore (1898–1986), whose abstract figurative sculpture *Reclining Figure* (1945–46, Cranbrook Academy, Bloomfield Hills, Michigan) took advantage of the tensile strength of wood in piercing the center of his sculpture, something not possible with stone. Moore's use of the negative space within a form or figure helped to expose the object's mass and emphasize the three-dimensional form. Barbara Hepworth (1903–75), Moore's contemporary, expanded the inherent sublimity of wood sculpture with her iconographic *Curved Form (Oracle)* of 1960. Hepworth's simple, majestic sculptures exploited the vagaries of wood by juxtaposing interior and exterior space and highly polished wood with rough, almost painterly textural surfaces.

In medieval and Baroque times the workshop was the home for woodcarving, and a specialized class of craftsman evolved in order to satisfy the demand for quality wood sculpture to adorn the great cathedrals of Europe. Carpenters prepared the wood and roughed out the shape of the figure, carvers finished the form, and then plasterers, painters, and gilders covered the surface of the piece. The workshop approach eventually fell out of favor, and modern artists such as Moore and Hepworth focused on their individual creativity in the studio, defining their particular vision through the process of working the material.

Sculpting any material, whether wood, metal, or glass, is either an additive or a subtractive process. The subtractive process, that of removing excess or waste wood in order to expose the desired form, results in functional and sculptural work. Functional works of art include utensils, weapons, and boats, to name a few. The Asmat war shields of the 20th century are shaped from mangrove tree root during special shield feasts and are embellished with painted relief carvings of military and virility motifs. The Maori tribe of New Zealand constructed canoes that could transport 40–80 warriors; the prows were carved with intricate patterns and fearsome animals that were both symbolic and decorative. The Norwegian Vikings are also known for their prow carving: *Animal Head for Prow* (825 CE) is the frightening head of a serpent embellished with rich interlacing of geometric forms. Carving with such exacting precision requires a variety of tools: chisels, gouges, parting tools, and woodcarving knives sturdy enough to be struck with a mallet. Abrasives for smoothing and polishing would also be among any woodworker's tools.

Sculptural work resulting from the subtractive process includes freestanding figurative sculpture, which is found around the world—although with a wide variation in size, shape, level of realism, and surface treatment. Artists Gregorio Hernandez (1576–1636)

and Ignaz Günther (1725–75) utilized Christianity as a contextual vehicle or theme for their popular freestanding figurative work. Hernandez, active in Castile, Spain, is best known for his *Pietà* (1617; Museo Nacional de Esculturas, Valladolid, Spain), a polychrome wood sculpture of the Virgin Mary lamenting the death of her son Jesus. Hernandez is considered more gothic, or brutal, than his contemporaries in his approach to emotional realism, and this is evident in the pleading, sorrowful expression on the Virgin's face and the dramatic draping of the dead Jesus across her lap. Günther's *Guardian Angel* (1763; Bürgersaal, Munich) exhibits strong Mannerist and Rococo influences through the figure, elongated to the point of distortion, and the highly ornamental and florid drapery swirling around the guardian and her small charge. Even among this flush of decoration and figurative exaggeration, Günther's figures maintain an immediacy of form and fresh realism uncommon among the stylized work of the Baroque period.

Other examples of freestanding figurative sculpture include tribal art objects, which are extremely diverse but share common ground in their religious or magical functions. African tribes such as the Dogon of Mali create figures intimately linked with the cult of the ancestors. Their elegant and abstracted figurative forms are carved with an adze, its cutting edge at right angles to the shaft; the result is a surface of facets that catches the light. A red-hot knife is used for most intricate work (as among the Ibibio of Nigeria), or the carving can be immersed in mud to darken its surface before oiling (as among the Dan people of the of Côte d'Ivoire). The Hopi Indians of the American Southwest carved kachina dolls from locally available, lightweight cottonwood. These fully frontal, simply carved figurines were used as toys and taught children to recognize individual kachinas, spirits who assist people to live harmoniously with nature. Each doll was painted and embellished with feathers and leather costumes to imitate the identity of a particular kachina.

However, not all freestanding wood sculpture is figurative. Although the Northwest Coast Indian tribes each developed a distinctive sculptural style, the totem form was common. Totem poles were halved and hollowed cedar logs that were carved and painted to represent the revered or respected guardian or ancestors of the commissioner, and they could stand up to 15.25 meters tall. Some were carved with family crests composed of stylized animals (eagles, whales, or fish) and reductive representations of people, serving as a visual record of clan history. Totems reached their peak in the 19th century, when they could be found in town, in burial grounds, or near or inside homes.

Relief carving, a process that ensures the image or design stands out "in relief" against a background that

has been cut away, is another subtractive process for the wood sculptor. The varying depths and angles at which the wood is carved determine the play of light and shadow within the relief. Much exceptional relief carving is found in Gothic cathedrals, especially on altarpieces. The German artist Tilman Riemenschneider is best known for his *Last Supper*, the center of the altarpiece of the Holy Blood (*ca.* 1499–1505; Saint Jakobskirche, Rothenburg ob der Tauber, Germany). The altarpiece represents the moment Jesus revealed one of his disciples would betray him, thus paying tribute to the church's most sacred relic, a drop of blood believed to be that of the dying Jesus. Riemenschneider's mass of flowing drapery, curling hair, individualized facial expressions all in high relief are ingeniously self-illuminated by the bull's-eye glass he placed in the clerestory windows within the relief. Riemenschneider was the first German woodcarver to leave the wood unpainted, letting the warm color of the limewood and its grain function as part of the finished work. Dutch artist Adriaen Van Wesel's 15th-century *Death of a Virgin* presents the apostles grouped around the dying Virgin, each with individualized expressions of grief, both in pose and facial expression. Van Wesel utilized the shallow space, or low relief of only a few inches, to create a dynamic compositional interaction of figures that contradicts any notion of cluttered composition in this small work. The evident natural grain of the oak enhances the texture created by the fine, carved detail of the faces, figurative poses, and drapery.

The additive process for wood sculpture has seen its most innovative uses during the modern era. Nevertheless, this constructive process is ancient, used by the ancient Egyptians when total carving was impractical—to add extended limbs to a standing figure such as the previously mentioned Egyptian *Kaaper*, for example. Japanese and Chinese wood sculpture took advantage of the additive process with the figurative portraits of bodhisattva and nobles. *Shunjobo Chogen*, dating from the early 13th century (Kamakura period), is an excellent example of physical realism and the use of multiple-block wood sculpture. The multiple-block process was used to overcome the warping and cracking that resulted when large sculptures were carved from a single block. It also allowed artists in workshops to focus on specialties such as hands, faces, or elbows. Additionally, the process was uniquely suited to the islands of Japan because of the lack of workable stone for large-scale sculpture.

Modern artists no longer resort to construction as a means of overcoming an obstacle in carving; they justify it as a unique woodworking process yielding its own aesthetic rewards. Louise Nevelson's (1899–1988) work is really an assemblage of wood ephemera.

Recycled wooden molding, lathes, wooden boxes, bowling pins, and discarded balusters are all collected into trays and boxes, which were assembled into larger walls or screens in a seemingly ordered pattern. Nevelson unifies the work through a monochromatic layer of paint, using the wood much like her ancient predecessors as a vehicle for greater contextual issues.

Venezuelan artist Marisol Escobar (*b.* 1930) works with mixed media assemblages combining blocks of wood carved and detailed with plaster, and drawing or painting with real objects in a realistic manner. *The Family* (1963) stands 2 meters tall and includes a father, mother, and four children, two of whom ride in a real baby buggy. Marisol presents the ideal American family and, by exploring its stereotypical traits, examines the values of the American people.

British sculptor Richard Deacon (*b.* 1949) and African American sculptor Martin Puryear (*b.* 1941) both use the constructivist method of sculpture. Gluing, joining, screwing, and bolting wood together to create an object of economy, precision, and concentration is a hallmark of Puryear's sculpture. Puryear's expression of the body in connection to nature, the craft of creating an object based on one's experience with the materials with no identification of the artist's hand or ego, harks back to early modernism—to Brancusi and his timeless pursuit of form. Deacon speaks of himself as a fabricator rather than a sculptor. His 1983 sculpture *For Those Who Have Ears #2* (Tate Gallery, London, England) exploits laminated wood for its whimsical and structural potential, manipulating the rigid wood into an organic linear form and leaving the resin to ooze from the wood, marking its journey, its scars through the fabrication process.

Folk or naïve art has always had a place for the woodcarver, even as merchants turned to the newly "machine-made" work. However, as a material for fine artists, wood has experienced periods of both favor and disfavor. Craftsmen and artisans with skills in woodcarving were particularly sought during the Gothic period of cathedral constructions, but wood fell out of favor during the Renaissance, when patronage shifted to the merchant class and their interest in the plastic arts. Sir Christopher Wren was primarily accredited with reviving an interest in wood carving in the 18th century during his tenure as head of the King's Works in England. A revival occurred again in the 20th century when artists became interested in the natural beauty of the grain and the individuality of the material. From the 1970s into the 21st century, artists such as Alice Aycock (*b.* 1946) and Robert Stackhouse (*b.* 1942) have constructed large-scale exterior sculptures addressing both archeological themes and our relationship to space. Japanese artist Tadashi Kawamata (*b.* 1953) and American Mary Miss (*b.* 1944) reflect the

evolution of site-specific wood sculpture, a move that has eliminated the focus on purity of material and embraces an inclusive and exploratory approach to wood sculpture and installation. Mary Miss's site-specific work often incorporates wooden constructions into natural environments that provide provocative visual transitions between the land and the water. Public projects such as "Untitled" (in collaboration with architect Stanton Eckstut and landscape architect Susan Child), in Battery Park City, New York, provide a breathtaking convergence of plaza, park, garden, and works of art, marking Miss as one of the more successful public artists working today. British artist Andy Goldsworthy (b. 1956), known for his subtle temporal alterations of the landscape with twigs, ice, leaves, and stones, introduces the fragility of wood as a medium in conjunction with the ephemeral qualities of nature as a contextual issue in wood sculpture. Goldsworthy further emphasizes the material and its immateriality as a primary ingredient in the discussion of site-specific wood sculpture today.

With the continued development of both wood sculpture (Deacon and Puryear) and site-specific sculpture (Aycock and Goldsworthy), the use of wood in art-making continues to expand. The ready availability and accessibility of wood as an art-making medium continues to ensure its vital role in the sculpture community.

JULIA MORRISROE

See also Balkenhol, Stephan; Riemenschneider, Tilman

Further Reading

Benezra, Neal David, *Martin Puryear*, New York and London: Thames and Hudson, 1991

Busch, Harald, and Bernd Lohse, editors, *Gotische Plastik in Europa*, Frankfurt: Umschau, 1962; as *Gothic Sculpture*, translated by Peter George, New York: Macmillan, and London: Batsford, 1963

Cheney, Sheldon W., *Sculpture of the World: A History*, New York: Viking Press, and London: Thames and Hudson, 1968

Goldsworthy, Andy, *Wood*, New York: Abrams, and London: Viking, 1996

Hayes, M. Vincent, *Artistry in Wood: Ideas, History, Tools, Techniques: Carving, Sculpture, Assemblage, Woodcuts, etc.*, New York: Drake, 1972

Lucie-Smith, Edward, *Sculpture since 1945*, New York: Universe Books, and London: Art Books International, 1987

MacKenzie, Lynn, *Non-Western Art: A Brief Guide*, Englewood Cliffs, New Jersey: Prentice Hall, 1995; 2nd edition, Upper Saddle River, New Jersey: Prentice Hall, 2001

Macnair, Peter L., Alan L. Hoover, and Kevin Neary, *The Legacy: Tradition and Innovation in Northwest Coast Indian Art*, Victoria, British Columbia: Provincial Museum, 1980; Seattle: University of Washington Press, 1984

Martin, John Rupert, *Baroque*, New York: Harper and Row, and London: Lane, 1977

Roukes, Nicholas, *Masters of Wood Sculpture*, New York: Watson-Guptill, 1980

Smith, William Stevenson, *The Art and Architecture of Ancient Egypt*, Baltimore, Maryland, and London: Penguin, 1958; revised edition, New Haven, Connecticut: Yale University Press, 1998

Willett, Frank, *African Art: An Introduction*, London: Thames and Hudson, and New York: Praeger, 1971

Y

YOSEGI-ZUKURI

Literally translated as "making (with) assembled wood," the term *yosegi-zukuri* refers to the technique found in the production of Japanese sculpture beginning in the 11th century of utilizing several blocks of wood. Although Japanese sculptors used many media, the most common was wood. Bronze casting gained importance in Buddhist arts in the late 6th century, but ambitious rulers depleted the ores in making the Great Buddha of Nara in the 740s. They repeated history later, having the Great Buddha of Kamakura cast in 1252, thus leaving little available copper for other uses. Unbaked clay and dry lacquer techniques were introduced from China by the mid 7th century, the images of the former polychromed, the latter lacquered and gilded. The building excesses of the 8th century drained the national economy, however, and such techniques proved to be too expensive to continue. Iron was employed in the 13th century; artisans relearned the techniques for working with iron from China. Independent stone figures were carved in early centuries, and cave and cliff-side high reliefs of Buddhist deities (*sekibutsu*) were popular in the 8th century and then reappeared as roadside figures, particularly in the 13th century along the pilgrimage routes.

Several good woods were available to the Japanese, who have had a long history of using wood selectively for specific purposes. This was rationalized in the early mythology—the deity, complaining about the lack of gold and silver, was grateful for the richness of the forests. Trees grew from the plucked hairs of his body, each designated for a particular use: cedar and camphor for boats, cypress for palace and shrine buildings, and pine for coffins. This pattern has been followed until modern times. Such pre-Buddhist mythology was reality based: cedar and camphor grow in moist air forests near coasts, cypress in the fertile mountains inland, and pine everywhere secondary growth has replaced primeval forests.

The wood preferred by Asuka- (552–645) and Hakuho-period (645–710) sculptors was camphor (*kusunoki*), with bases and repairs sometimes added or made in Japanese cypress (*hinoki*). Other fairly fine-grained and relatively hard woods identified as used for Buddhist sculptures are cedar or cryptomeria (*sugi*), yew (*kaya*), cassia (*katsura*), and zelkova (*keyaki*). One or two are of red pine (*akamatsu*). Japanese woodblock artists have elected to use cherry wood (*sakura*).

Camphor is an east Asian lauraceous tree (*Cinnamomum camphora*) that, like cedar and cypress, is relatively hard; shrinks, swells and warps little; takes paint well; and holds nails well. Nails, incidentally, were usually used in repairs, and the different types of early, medieval, recent, and modern Western-type nails can be easily identified in X ray films. The heartwood (the dark center) of these trees, which is proportionally large, is highly rated for its decay resistance. The fine splits (wood rays) are fairly evenly distributed across the heartwood and sapwood (outer rings).

Most early Buddhist sculptures were made of a single block of wood (*ichiboku*), but if taken literally, the term *single block* is rarely accurate. The simplest method was to split a log, hollow out the middle, and put the sections together (*warihagi*); for small sculptures, this technique was commonly used until the 11th century. For life-size images, the customary method

of working the wood was to split the log lengthwise and use half of it, then add the extremities if necessary. The problem was much more complex for seated figures. The block could be stepped—so the center of the log got as little use as possible—and the arms, knees, and feet then added to its front. For instance, the Asuka-period, meditating, thinker-type Miroku bodhisattva in the Chugu-ji, the convent of the Horyu-ji in Nara prefecture, datable to the early years of the 7th century, is actually a rather complicated structure that is made up of several separate blocks: the front and the back of the head, the two buns split down the middle; the back to the hips; the part of the pedestal with overhanging drapery (the biggest single piece), stepped in front; and the covering fitting piece of frontal drapery and feet. The lotus base of the pedestal comprises two blocks, and the arms are separately attached. Moreover, there are several inserted pieces, including an inside block in front of the big piece that constitutes the back and hips.

Generalizing is difficult in view of the few extant life-size wooden images, but no two statues were built up in quite the same manner. Each statue represents the ingenuity of its maker, each maker trying in some way to lessen the inevitable splitting and cracking. Some kind of a resin glue was used, the joints barely visible today. Gesso and polychroming or lacquering and gilding hid any remaining marks.

Wood sculpture went into a hiatus in the Nara period (710–794), diminished by the demand for the more exotic unbaked clay and dry lacquer products, but it returned to dominate the art from the early Heian period (794–893). The over-life-size standing images of the Toshodai-ji in old Nara city, a temple built by Chinese monks and their wooden images made in cloister, are as near to the definition of single-block sculptures as were ever made in Japan. A large Japanese cypress log split lengthwise became the full image, including the lotus on which it stands and a tenon to be mortised into a larger base below. Only the hands were added. The full faces, heavy, stiff bodies, massive hips, and repetitive drapery folds set a new style.

Seated life-size images, on the other hand, made a modest start on the multiple-block system. The large (192 cm), national treasure, a seated image of Yakushi Buddha in the Shin-yakushi-ji in Nara (*ca.* 793), made of *kaya* (yew), is called *ichiboku* (one block) in most books, but it is, in fact, a construction of more than a dozen pieces. Roughly half the size of the head is hollow space, the neck an open tube, and about half of the body is open inside. The face, neck, chest, and upper legs are one piece; two more were added in front for knees, lower legs, and feet. The back of the head to the foot is one piece, but cut at the top of the shoulders. On each side of the large middle cavity are three vertical boards of progressively smaller size, shaped for shoulders, outer parts of the arms, and knees. The lower arms and hands are additions. Ringlets of hair are separate and put on like a wig. For whatever reason, perhaps to replace an unsatisfactory or damaged piece, the back of the head was sawed so it could be removed, vertically to just behind the ears and then horizontally at mid ear level. To prevent some deformation of shape, then or at some later time, a narrow board resembling a shelf was put across the inside cavity just above hip level.

The term *yosegi-zukuri* was not used before the time of Kosho (d. *ca.* 1020), who was the head of a workshop in Kyoto that came to be called the Shichijo Bussho, or Seventh Avenue Buddhist (images) Workplace. Better known is his son, Jocho (*d.* 1057), his apprentice and the man who won fame as a sculptor for the Fujiwara in the first half of the 11th century. The technique of using several blocks with much joining and splicing was in place by the late 8th century; Kosho's "invention" was in fitting techniques and initiating and systematizing a workshop organization on assembly-line principles.

An important step in the sequence of modifications that ultimately saw the perfection of the multiple-block method was laying a block of appropriate length for the feet and legs across the front of a vertical block. A sculptor did this in 907 for a Yakushi Buddha in the Daigo-ji, Kyoto. Later, the vertical and horizontal blocks were all cut into smaller pieces, but the front horizontal blocks remained a standard feature for seated figures. The classic proportions for Fujiwara Buddhas were arrived at by Jocho, who discovered the perfect balance between the horizontal and vertical lengths and fitted an image exactly into an isosceles triangle. As the religious view gravitated toward seeing the images as the actual Buddhas, not their symbols, the style took on an increasingly captivating beauty. It spread rapidly, appearing in more distant areas ahead of the multiple-block technique that had helped to produce it.

Jocho's one surviving statue is the seated Amida Buddha in the Phoenix Hall of the Byodo-in at Uji, south of Kyoto, made in 1053 for the retirement temple of Fujiwara Yorimichi (992–1074). Its basic structure is four vertical blocks about 285 cm high and two horizontal blocks about 265 cm wide, but the walls of the image are only 4.5 cm thick throughout except as they thicken to 8.5 cm at the foot, leaving a huge open space inside. The basic blocks are subdivided, the sections connected by wooden pegs. The workshop had thus developed a method whereby a statue could be made, transported, and assembled in a distant temple. There is a story that the carts with the packaged pieces of

the Amida left the Kyoto workshop at seven in the morning, and the crew had it assembled in Uji by late afternoon. The distance is about 12 km as the crow flies.

The demand for images had been great as Jodo (Pure Land) and Amida worship reached great heights of popularity, but it was the destructive war that witnessed the end of Fujiwara rule and brought the Hojo to power from 1185 that was the real catalyst for the workshops. The amount of reconstruction and repairs needed was staggering, but the Kyoto shops, now with branches in Nara, took on vast commissions and made large images posed in the most dramatic fashions. Within 20 years they had been able to repair and replace most of the main images of the Hojo-favored damaged and destroyed temples.

Representing the most progressive work was the Kei school, a continuation of the Shichijo Bussho, under three generations of directors: Kokei (d. *ca.* 1196), Unkei (*d.* 1223), and Tankei (1173–1256). The *yosegi-zukuri* technique was now the key to success: small blocks joined inside by wooden pegs or metal clamps formed the flesh of an image; its skin was paint, multicolored, or gold. The Kei style attracted new interest by its extreme realism. Quartz eyes with concave backs were set from the inside of the head, covered by flat pieces of wood and nailed in place. This school's experience and mastery of the production-line system made it possible to produce the two colossal *Nio* (two kings) for the Nandai-mon (South Great Gate) of the Todai-ji in Nara, some 8.4 meters in height, in 72 days.

Under Tankei—at the age of 82—the Kei shop added a large replacement multiarmed Kannon image to the burned Sanjusangen-do (Thirty-three Bay Hall) in Kyoto and replaced hundreds of its 1,000 bodhisattvas in the Fujiwara style to conform with those that had survived the fire.

Some experimenting with mixing woods went on in the 12th century, but unfortunately, both technique and style were so good that later sculptors saw no reason to change, and the dynamic and vigorous nature of the sculptors' art went into a relatively rapid decline. Many temples have later, stereotyped images. The realism of the art of monk portraiture, less the quartz eyes, was passed down by successive generations of sculptors.

J. Edward Kidder, Jr.

See also **Japan; Jocho; Kosho**

Further Reading

Kidder, J. Edward, *The Art of Japan*, London: Guild Publishing, 1985

Kuno, Takeshi, *Nihon no Chokoku* (Sculpture of Japan), Tokyo: Yoshikawa Kobunkan, 1959

Mason, Penelope, *History of Japanese Art*, New York: Abrams, 1993

Moran, Sherwood, "The Statue of Muchaku, Hokuen-do, Kofuku-ji: A Detailed Study," *Arts Asiatiques* 1 (1958)

Nishikawa, Kyotaro, *Ichiboku-zukuri to Yosegi-zukuri* (Making [Images] in Single Blocks and Multiple Blocks of Wood), *Nihon no Bijutsu* 202 (series; Arts of Japan), Tokyo: Shibundo, 1983

Z

OSSIP ZADKINE 1890–1967 *Belorussian, active in France*

Ossip Zadkine is among the most representative sculptors of the École de Paris, a movement of young artists who lived and worked in the neighborhood of Montparnasse in Paris at the beginning of the 20th century. Those artists belonged to a wide variety of artistic movements, such as Surrealism, Cubism, Expressionism, and abstract art, but had in common the will to renew and innovate academic art.

After growing up in Belorussia, Zadkine received his artistic training in London where he enrolled in evening classes at the Art School of Polytechnics and at the Central School of Arts and Crafts. In October 1909 Zadkine moved to Paris where he studied at the École des Beaux-Arts with Antoine Injalbert. It was at this time that Zadkine separated from the tenets of official academic sculpture. In 1910 he returned to Smolensk, the city where he spent his childhood, and participated in the Union of Youth Exhibition in St. Petersburg. In 1911 he exhibited at the Salon des Indépendants and at the Salon d'Automne. Prince Paul Rodocanachi became his first important patron. In 1912, Zadkine moved to an atelier closer to his Montparnasse friends Constantin Brancusi, Pablo Picasso, Max Jacob, and Guillaume Apollinaire.

After joining the Cubists in 1914, Zadkine developed a personal, powerful, original style that was influenced by primitive art, Neoclassicism, and Neo-Baroque styles. He liberated himself from the impact of Cubism by executing his forms in a dynamic geometric structure. Although he was influenced by analytical Cubism in the rhythmic arrangement of his figures into a geometrical system, he was more interested in creating a thematic and formal rearrangement of volume and space As he preferred carving to modeling, he renewed this 19th-century tradition by using all kinds of materials, such as wood, stone, metal, crystal, and glass.

During World War I, Zadkine served as a volunteer in the French army, and his experience from the war was devastating. He expressed his traumatizing wartime experiences in sculptures clearly oriented toward a harsh, geometric style. In 1920 he participated again at the Salon des Indépendants and at the Salon d'Automne. As an artist in exile, he was very sensitive to the notion of the roots, and in 1928 he acquired a new workshop at the rue d'Assas, which is now the Musée Zadkine in Paris.

Zadkine handled ideas on both monumental and modest scales and created more than 500 sculptures throughout his career. He got his inspiration from biblical, mythological, or literary themes, and music, poetry, and suffering during the war. He renewed themes from ancient Greek mythology in order to express contemporary philosophical questions. The attempt to weld poetry with sculpture may be exemplified in one of his most representative works, *Poet: Homage to Eluard*. Zadkine created the sculpture in 1952 as a posthumous homage to his friend, the French poet Paul Eluard. The figure is approximately life-size but otherwise nonrealistic; it was cast in bronze, and its body is almost completely covered with various inscriptions. The ideology of sculptural poetry had special relevance

for Zadkine, who wrote verses and was a friend of poets.

His research for purity in forms made him adhere to the technique of direct carving. In order to treat form and space in a stylized way, he made wood and stone carvings and prized figures from the original forms of a tree trunk or a block of marble.

During World War II, Zadkine lived in the United States, where he taught at the Art Students League in New York City and where important exhibitions of his works were organized. After the war, he returned to France, saw the ruins of Le Havre, and visited bombed-out Rotterdam, the ruins of which inspired his best-known work, the public monument *To a Destroyed City*. Zadkine, who had won the sculpture prize at the 1950 Venice Biennale, got the official commission for the monument in 1951 and conceived it as a memorial to the destruction of a large part of the city during the air raid of 14 May 1940. The monument represents a figure of the exodus with its body torn open and its arms raised in an expression of both despair and hope. In this anguished, expressive work Zadkine combined forms inspired by Cubism with the emotionalism characteristic of the monumental sculpture of social realism in order to create a recognizable image about a culturally shared event. Although some art historians criticized the monument, John Berger regarded it as the "best modern war monument in Europe" (see Berger, 1960).

From 1946 to 1958, Zadkine successfully taught young international sculptors at the Académie de la Grande Chaumière in Paris. The two important retrospectives of his work in Paris and Rotterdam in 1949 consolidated his artistic reputation, and in 1960 he received the Grand Prix of the city of Paris. He wrote an account on how he became a sculptor and published poems with his own illustrations. Zadkine renewed analytical Cubism, restored to sculpture its archaic aura of myth and mystery, and exerted considerable influence upon contemporary sculptors after World War II.

ANNA TAHINCI

Biography

Born in Vitebsk, Russia, 14 July 1890. Attended art school in northern England, 1905; went to London as ornamental woodcarver, 1906; attended night classes in life drawing at Art School of Polytechnics and Central School of Arts and Crafts in London, 1906–09; befriended painter David Bomberg; moved to Paris and studied at École des Beaux-Arts with Antoine Injalbert, 1909; went to Smolensk to participate in Union of Youth exhibition, 1910; returned to Paris and established studio in *La Ruche* complex; worked in the company of Ferdinand Léger, Alexander Archipenko, and

To a Destroyed City
The Conway Library, Courtauld Institute of Art

Maurice Chagall; served as a volunteer in French army, 1915–17; first solo exhibition at Gallerie Le Centaure, Brussels, 1919; became a French citizen, 1921; exhibited internationally and received numerous commissions from 1920s; emigrated to the United States, 1941–45; taught at Art Students League, New York City; returned to France, 1945; taught at Académie de la Grand Chaumière and at own sculpture school; retrospectives, Paris and Rotterdam, 1949, and Venice Biennale, 1950. Died in Paris, France, 25 November 1967.

Selected Works

An important collection of Zadkine's sculptures is at the Musée Zadkine in Paris.

1914 *Job and His Friends*; elm wood; Koninkllijk Museum voor Schone Kunsten, Antwerp, Belgium
1914 *The Prophet*; wood; Musée Grenoble, France

ca.	*Mother and Child (Forms and Lights)*;
1921–22	marble; Hirshhorn Museum and Sculpture Garden, Washington, D.C., United States
1927	*Garden Sculpture*; wood; Maresfield Park, East Sussex, England
1929	*Les Ménades*; bronze; Musée Zadkine, Paris, France
1930	*Laocoön*; bronze; Musée Zadkine, Paris, France
1938–1939	*Diana*; wood; Musée d'Art Moderne, Brussels, Belgium
1950	*Pietà*; terracotta; Aartsbischoppelijk Museum, Utrecht, the Netherlands
1951–53	*To a Destroyed City*; bronze; Schiedamse, Rotterdam, the Netherlands
1952–54	*Poet: Homage to Eluard*; bronze; Musée Nationale d'Art Moderne, Centre Georges Pompidou, Paris, France

Further Reading

Berger, John, "Ossip Zadkine," in *Permanent Red: Essays in Seeing*, London: Methuen, 1960

Jianu, Ionel, *Zadkine*, Paris: Arted, Éditions d'Art, 1964

Prax, Valentine, *Avec Zadkine: Souvenirs de notre vie*, Lausanne, Switzerland: Bibliothèque des Arts, 1973

Zadkine, Ossip, *Comment je suis devenu sculpteur, Medelingen van den Koninklijke Vlaamse Akademie voor Wewtenschapen, Letteren en Schone Kunste van Belgie* no. 2 (1951)

Zadkine, Ossip, "Ma Sculpture," *Civilta delle machine* no. 1 (1963)

Zadkine, Ossip, *Le maillet et le ciseau, souvenirs de ma vie*, Paris: Albin Michel, 1968

ZÜRN FAMILY German (Swabian)

The Zürn family of sculptors was active for three generations in upper Swabia (Lake Constance), Bavaria, Upper Austria, and Moravia. They produced almost exclusively ecclesiastical (Catholic) art works in wood and stone. Their style began around 1600 with the naive offshoots of the Gothic period. In the second generation, the Zürns worked with artistic ideas from the Italo-Flemish Renaissance and developed an independent and vibrant art of expression, which constituted a definitive contribution to southern German Baroque art. In the third generation, Michael Zürn the Younger, probably inspired by activity in Italy and Bohemia, produced an oeuvre that enriched the High Baroque period in southern Germany.

The artistic style of the Zürn family during the first two generations could be characterized as late Renaissance, Mannerist, or Early Baroque. What matters is that they did not follow the international lines of style development, but rather they explored in their own way. Like the contemporaneous southern German sculptors Hans Krumper, Hans Degler, and Bartholomäus Steinle, among others, the Zürns developed out of the offshoots of the Gothic period, the structures of which they retained: a specific figural style with the power of spiritual expression that carried the intensity of medieval ecclesiastical art into the Baroque period. Sacred meaning was expressed by the garment folds, the beard and hair, the stylized faces, and especially the integration of the figures into the composition of the altar. This sort of art became popular in the Swabian and Bavarian ecclesiastical art of the Rococo period in the 18th century; it later achieved an international reception.

The Zürns' orientation has been called traditional in order to distinguish it from the contemporaneous art of the court in Prague, Munich, and Augsburg, which had an international orientation that was based on the Italian style imported by Flemings and the classicist corporeality of the Renaissance. Indeed, the art of the Zürn family belonged in the bourgeois world of the cities and was primarily supported by the social structure of the craft guilds, which adhered to certain traditions.

Hans Zürn the Elder ca. 1555/60–after 1631

Hans Zürn the Elder was born around 1555, probably in Waldsee (upper Swabia); he has been documented as being a master sculptor there from 1582 through 1631. He was also probably the son of the eponymous sculptor Hans Zürn, who is known only through a pietà in Schloss Wolfegg in Hopfenweiler near Waldsee. Hans the Elder was active in Waldsee and at Lake Constance, and he trained all six of his sons in the craft of sculpting. His style was entirely Gothic. Through their delicately contoured bodies and finely individualized faces, his figures maintained a very gentle expression. He stood very much in the tradition of medieval sacred art, and he passed this power of expression to his sons.

Jörg Zürn 1583/84–1635/38

Jörg Zürn was the eldest son of Hans the Elder. He was born around 1583, probably in Waldsee, and was documented as a master sculptor in Überlingen from 1606 to 1635; he died sometime before 1638.

Jörg was the most important Zürn sculptor of his generation. Through Hans Morinck in Constance, he received key inspirations from the Italo-Flemish Renaissance style, which he further developed into a tight plasticity, leaving the Gothic structure almost entirely behind with the exception of a few individual figures. Combined with drastic, individual expressions and en-

ergetic movement, he was able to create dramatic productions that were particularly evident on the middle sections of the high altar in Überlingen, which he carved personally, portraying the annunciation of Mary and the birth of Christ. Following the completion of the high altar, he received no big assignments because of the Thirty Years' War; Jörg then created only a few small format works, among which a few, very solemn crucifixes, stand out.

Hans Zürn the Younger *ca.* 1585–after 1622

Hans Zürn the Younger was the second son of Hans the Elder. He was born around 1585, probably in Waldsee, and was documented as a master sculptor in Buchhorn (now Friedrichshafen on Lake Constance) and worked in Allgäu from 1613 to 1622.

Hans the Younger, who began running his own workshop in Buchhorn early in his career, developed his personal style in small-format sculpture with playfully modeled figures and in large-format sculpture with a very human, lyrical, and delicate expression.

Martin Zürn *ca.* 1585/90–after 1665

Martin Zürn was also a son of Hans the Elder. He was born around 1590, probably in Waldsee, and was documented for the first time in 1615 in Hallendorf near Überlingen as the master sculptor in Braunau am Inn from 1643 to 1665. Martin was active in Überlingen, Waldsee, Wasserburg am Inn, Burghausen, and Braunau am Inn. He worked with his brother Michael (the Elder) until about 1649.

Martin had a hard, sharp-edged style in his detail work, which was reminiscent of beaten metal. His figures were still constructed in a strict Gothic style, but they were animated through Renaissance details. In contrast to the many-storied, parceled altars of the late Renaissance tradition (Überlingen), he developed a single-storied altar structure (with a *predella* [a painted panel, usually small, belonging to a series of panels at the bottom of an altar piece] and copestone) with very large main figures (up to almost 3 meters), which have a monumental effect. This was a step toward the expansiveness of the Baroque period.

Michael Zürn the Elder *ca.* 1590–after 1651

Michael Zürn the Elder was the son of Hans the Elder. He was born *ca.* 1590, probably in Waldsee, and was mentioned for the first time in 1617 in Waldsee. He was active in Überlingen, Waldsee, Wasserburg am Inn, Burghausen, and Braunau am Inn. The final documented mention was in 1651 in Appenzell, Switzerland.

Michael the Elder had a soft modeling style in his detail work, which was reminiscent of kneaded clay. His faces were animated and individualized with great sensitivity. In his late work of 1645–49, he essentially left Gothic composition behind him and turned to strongly emotional scenes, with which he approached the High Baroque style more than any other members of his generation.

Hans Jacob *ca.* 1590–after 1642

Hans Jacob is documented as the son of Hans the Elder. He was born *ca.* 1590, probably in Waldsee, and first mentioned in 1616. From 1622 until 1632, he was documented as master sculptor in Neuötting, Bavaria. The facade and organ in the Church of Neuötting from 1642 may be his work.

David Zürn *ca.* 1598–1666

David Zürn was the youngest son of Hans the Elder. He was probably born in 1598 in Waldsee and was documented for the first time in 1625 in Überlingen. David was a master in Wasserburg am Inn from 1628 on, and he died there in 1666. He was the father of several sculptors, including Michael Zürn the Younger. David adhered in a somewhat rougher form to the strict and monumental style of his brother Martin.

Michael Zürn the Younger 1654–1698

Michael Zürn the Younger was the youngest son of David. Born in 1654 in Wasserburg am Inn, Michael the Younger was active from 1671 to 1681 in Olmütz in Moravia; he became a resident of Gmunden in Upper Austria in 1681, and he lived in Rosenheim in Bavaria from 1692 to 1696. He died in 1698. He probably drew inspiration from his uncles, particularly Michael the Elder, and from Bohemia and Moravia, where his elder brothers were working. However, he developed a completely independent style. It is difficult to imagine when he could have taken a trip to Italy, yet the *Mariensäule* (a column dedicated to Our Lady) in Velehrad, Moravia, and his first marble angels, 1682–86, in Kreuzmünster are scarcely comprehensible without the direct influence of Gianlorenzo Bernini and contemporary Venetian sculpture. The bodies of his figures are overattenuated, stiff, and without spatial depth. The entire attraction of his original Mannerist work lies in the freely composed movement of the garments.

CLAUS ZOEGE VON MANTEUFFEL

Hans Zürn the Elder

Biography
Born probably in Waldsee, Germany, *ca.* 1555–60. Documented as master there, 1582–1631. Probably son of eponymous sculptor Hans Zürn, known only through pietà (from Hopfenweiler near Waldsee, in Schloss Wolfegg). Active in Waldsee and Lake Constance. Died, probably in Waldsee, after 1631.

Selected Works
*ca.*1613 Bust of St. Jacob; polychromed wood; Germanisches Nationalmuseum, Nuremberg, Germany (attributed)

*ca.*1613 Crucifix; polychromed wood; Isnyer Gate, Church of St. Ulrich, Wangen, Germany

1613–16 High altar (with family); wood; Church of St. Nikolaus, Überlingen, Germany (attributed)

1619–20 Figures for high altar, Orsingen parish church, Germany; polychromed wood; Städtisches Museum, Engen in the Hegau, Germany

1624 *Saint Nikolaus* and *Saint Konrad*; polychromed wood; high altar, Frauberg Chapel, Waldsee, Germany

*ca.*1625 *St. Catherine*; polychromed wood; Gebrazhofen near Leutkirch,, Germany

Jörg Zürn

Biography
Born probably in Waldsee, Germany, 1583–84. Eldest son of Hans the Elder. Documented as a master, Überlingen, 1606–35. Died in Überlingen, Germany, 1635–38.

Selected Works
1607/10 Altar of the Virgin; wood, stone; Überlingen Münster, Germany

*ca.*1611 Sacrament House; limestone; Überlingen Münster, Germany

*ca.*1613 Crucifix; wood; Schloss Heiligenberg, near Lake Constance, Germany

1613–16 High altar (with family); wood; Church of St. Nikolaus, Überlingen, Germany

1615 Madonna; (fragment) wood; Rosenkranzaltar, Pfullendorf, Germany

*ca.*1620 Crucifix; polychromed wood; Museum, Mühlheim/Danube, Germany

1620–25 Crucifix; wood; Orsingen parish church, Germany

Hans Zürn the Younger

Biography
Born probably in Waldsee, Germany, *ca.* 1585. Second son of Hans the Elder. Documented as a master in Buchhorn (now Friedrichshafen on Lake Constance) and in Allgäu, 1613–22. Died after 1622.

Selected Works
1608 Statue of a female saint; polychromed wood; Württembergisches Landesmuseum, Stuttgart, Germany

1620–25 Crucifix; polychromed wood; St. Wolfgangkapelle, Wangen im Allgäu, Germany

1620–25 *The Mother of God*; polychromed wood; Church of St. George, Ratzenried, Kreis Ravensburg, Germany

1620–25 *Pietà*; polychromed wood; Church of St. Peter, Deuchelried near Wangen im Allgäu, Germany

1620–25 Statues *Anne and Mary, Jacob the Elder,* and of four angels making music; polychromed wood; St. Wendelinskapelle, Hagnaufurt Kreis Biberach, Germany

1620–25 *Worship of the Kings*; polychromed wood; private collection

1622 Figures and reliefs from the Rosenkranzaltar, Wangen im Allgäu, Germany; polychromed wood; hospital church and God's Acre chapel, Wangen im Allgäu, Germany

Martin Zürn

Biography
Born probably in Waldsee, Germany, 1585–90. Son of Hans the Elder. Documented for the first time, 1615; master in Braunau am Inn, 1643–65; active in Überlingen, Waldsee, Wasserburg am Inn, Burghausen, Braunau am Inn. Died in Braunau am Inn, Germany, after 1665.

Selected Works
1613–16 High altar (with family); wood; Church of St. Nikolaus, Überlingen, Germany

1615 Relief medals; polychromed wood; Rosenkranzaltar, Church of St. Jacob Maior, Pfullendorf, Germany

*ca.*1615 *Christ Bearing the Cross*; wood; private collection

1620–25 *Blessed Betha von Reute*; polychromed wood; Württembergisches Landesmuseum, Stuttgart, Germany

1627–30 Statues of the *Madonna, St. Roch*, and *St. Sebastian*; polychromed wood; Rosenkranzaltar, Church of Saints Peter and Paul, Owingen, Germany

1630–35 *Mother of God*; polychromed wood; private collection

1631, 1634 Crucifix groups; wood; Badisches Landesmuseum, Karlsruhe, Germany; Augustinermuseum, Freiburg, Germany

1637–39 *Mother of God* and *Jacob*; wood; chancel, Church of St. Jacob, Wasserburg am Inn, Germany

1637–39 *St. Florian* and *St. Sebastian*; polychromed wood; from high altar, Church of St. Jacob, Wasserburg am Inn, Germany; Department of Sculpture, Staatliche Museen Berlin, Germany

*ca.*1642 Figures from the high altar; polychromed wood; St. Stephen's Cathedral, Braunau am Inn, Germany

*ca.*1645 Crucifix; polychromed wood; Church of Mariae Himmelfahrt, Eggelsberg, Austria

Michael Zürn the Elder

Biography
Born probably in Waldsee, Germany, *ca.* 1590. Son of Hans the Elder. Mentioned for the first time, 1617; active in Überlingen, Waldsee, Wasserburg am Inn, Burghausen, and Braunau am Inn; worked with brother Martin until *ca.* 1649; mentioned for the last time, Appenzell, Switzerland, 1651. Died after 1651.

Selected Works
1613–16 High altar (with family); wood; Church of St. Nikolaus, Überlingen, Germany

1615–20 *St. Roch*; wood; Städtisches Museum, Überlingen, Germany

1620–25 Statues of the four Evangelists; wood; Städtisches Museum, Überlingen, Germany

*ca.*1625 *St. John the Baptist* and *St. John the Evangelist*; polychromed wood; Church of St. John, Wilhelmskirch near Ravensburg, Germany

1630–35 *St. Bishop*; polychromed wood; Hessisches Landesmuseum, Darmstadt, Germany

ca. 1635–40 Angel from an altar; polychromed wood; private collection

1635–40 *St. Sebastian*; polychromed wood; Badisches Landesmuseum, Karlsruhe, Germany

1635–40 *St. Sebastian* (?); polychromed wood; Bayerisches Nationalmuseum, Munich, Germany

1637–39 Christ and four Evangelists; wood; chancel, Church of St. Jacob, Wasserburg am Inn, Germany

1645–49 Three altars; polychromed wood; St. Georgen an der Mattig near Braunau am Inn, Germany

David Zürn

Biography
Born in Waldsee, Germany, *ca.* 1598. Youngest son of Hans the Elder. Documented for the first time, Überlingen, 1625; master in Wasserburg am Inn from 1628. Died in Wasserburg am Inn, Germany, 1666.

Selected Works
1620–25 *Mother of God*; polychromed wood; Church of St. George, Bermatingen on Lake Constance, Germany

*ca.*1625 *Christ as Savior*; wood; Town Hall, Meersburg on Lake Constance, Germany

1625–30 *Anna Selbdritt*; polychromed wood; Städtisches Museum, Wasserburg am Inn, Germany

1625–30 *St. Catherine*; polychromed wood; Germanisches Nationalmuseum, Nuremberg, Germany

1640–45 Female saint; polychromed wood; Städtisches Museum, Waldsee, Germany

Michael Zürn the Younger

Biography
Born in Wasserburg am Inn, Germany, 1654. Youngest son of David Zürn. Active in Olmütz in Moravia, 1671–81; resident of Gmunden, Upper Austria, from 1681; in Rosenheim in Bavaria, 1692–96. Died in Passau, Bavaria, 1698.

Selected Works
1675–76 Chancel; polychromed wood; Hradisch Monastery, Konice near Olomouc in Moravia, Czech Republic

*ca.*1679–80 Statues of the four Evangelists; white-colored wood; Missionary Church on the Holy Mountain, Olomouc, Moravia, Czech Republic

1680–81? *Mariensäule*; sandstone; outside Cistercian Monastery, Velehrad, Moravia, Czech Republic

1682–86 Sixteen angels; marble; Cloister Church, Kremsmünster, Austria

*ca.*1683 Statue of Mary for a Crucifixion group;

polychromed wood; Barockmuseum, Vienna, Austria

1684–87 Four female figures; polychromed wood; Missionary Church, Frauenberg near Admont in the Steiermark, Austria

ca. 1685 *Beheading of the Apostle Paul*; ivory; Staatliche Museen, Berlin, Germany

Further Reading

Ludig, Günther, *Studien zu einer Monographie über den Barockbildhauer Michael Zürn d. J.*, Frankfurt: s.n., 1970

Theuerkauff, Christian, "Michael Zürn d. J. und Italien: Zu einem Kleinrelief aus der Berliner Kunstkammer," in *Festschrift für Peter Bloch zum 11. Juli 1990*, edited by Peter Bloch, Hartmut Krohm, and Theuerkauff, Mainz, Germany: Von Zabern, 1990

Zoege von Manteuffel, Claus, *Die Bildhauerfamilie Zürn, 1606–1666*, Weissenhorn, Germany: Konrad, 1970

HIGH ALTAR OF ÜBERLINGEN

Jörg Zürn (1583–1635/8) and family

1613–1616

wood

h. 15.29 m; w. 7.15 m

Church of St. Nikolaus, Überlingen, Germany

On 7 December 1614, the city council of Überlingen commissioned the sculptor Jörg Zürn to produce the high altar for the cathedral church. The pictorial program was determined, and Jörg was given two and a half years to complete it; however, he was not able to begin the work before the spring of 1614. He and his workshop of two assistants in Überlingen could not have completed the work by themselves; the 23 large and over 50 small figures, as well as elegant ornamentation, would have been impossible for three men to complete within this time frame. Jörg must have called in the workshop of his father, Hans Zürn the Elder, from Waldsee. Hans's presence in Überlingen was documented in 1614. A stylistic examination has also determined that Jörg's brothers, Martin and Michael Zürn the Elder, worked on the high altar; the style of two assistants whose names are unknown is also evident.

The shrine architecture of the altar was constructed by two master carpenters, Joseph Mutschelenbeck and Hans Georg Ruth, and was erected from June to August 1616. The design sketch for the high altar has been preserved in the museum in Überlingen. In all probability, it was the plan upon which the commission was based. The frame for the shrine was probably designed by a carpenter and not the sculptor, although numerous changes, both in the architecture and the figures, indicate that the artists worked with this design.

On 23 January 1614 the city council decided to contract the painter Wilhelm Baumhauer to polychrome the altar. On 21 July 1614 the painter's proposed commission was rejected for a variety of reasons, the causes of which are unknown and can scarcely be reconstructed. Except for the high altar and the chancel in Wasserburg am Inn (1637/39) by Martin, Jörg's brother, and Michael the Elder, all of the works by the Zürn family are polychromed, and polychromy would have been good for the Überlingen altar, which is backlit. Moreover, giving up polychromy would have encouraged the sculptors to achieve the best possible sculptural quality and the finest carving work.

The archival documentation of Jörg's assignment, the written inscription of the sketch, and the carved signature "GZ" (for Georg [Jörg] Zürn) on the altar below the crucifix show only that he was responsible for the workshop and not which areas of the altar he carved himself. Since he was still relatively young at 30 years old and had been taken on as a master sculptor in Überlingen only six years prior, it may be assumed that he produced some important and central portions of the work himself. On the other hand, he would not have satisfied his father and younger brothers with assignments for peripheral and decorative work but rather would have entrusted them with important figures.

Since there are no notes regarding the division of labor on the high altar, determining the different hands depends entirely on a stylistic critique. If the style of one of the Zürn sculptors can be precisely identified through other works, a similar style evident on the high altar can thus attribute the work to that sculptor's hand.

Jörg's style is characterized by a powerful sculptural form, which is sometimes reminiscent of a bronze cast. The surface appears stretched taut. His intense temperament expressed itself in lively movement and the individualized formation of the faces of his figures. This style is found in all of the figures of the bottom two levels of the high altar; that is, the annunciation of Mary, the adoration of the shepherds, and the Sts. Sylvester and Michael. Thus, as is to be expected, the principal figures, which essentially determine the look of the altar, are ascribed to Jörg.

The style of Hans the Elder can be determined by looking at later works, in particular, a large crucifix from 1613 in Wangen im Allgäu on the Isnyer Bridge (now in the Church of St. Ulrich). This is so similar to the crucifix at the top of the Überlingen altar that it can be attributed to him. We do not find his style elsewhere in Überlingen.

Jörg's brother Martin's later works display a somewhat hard, sterile, formal language with sharp folds and strong, severe faces. His style, which is reminiscent of beaten metal at times, distinguishes itself through its expressive character and monumentality.

This style is found on the high altar in the figure of St. Roch on the top left-hand side and in the crowning of the Virgin Mary in the top center.

Michael the Elder preferred softer, doughy forms that were reminiscent of clay. He modeled the figures to be flatter, more like a relief and not so intensively sculptural as those by Jörg and Martin. Michael the Elder was a master of optical effects. This was to the advantage of the figure of St. Nikolaus (in the top center), which has been attributed to him and was masterfully calculated for the sharp downward angle in which it stands in relation to the viewer. The gently curved figure of St. Sebastian at the top right-hand side could be his work as well.

The figures of Sts. James and Andrew at the top, next to the crowning of the Virgin Mary, cannot be attributed to any of the Zürns. They are somewhat more classicizing than the Zürns' works and display a certain similarity to works by Virgil Moll, Jörg's predecessor in the workshop. Jörg married Moll's widow, and whenever possible he kept Moll's assistants, whose names are unknown. A second assistant of minimal ability carved the supporting figures of the Virgin Mary and John beneath the cross.

Initially, the high altar was not understood primarily as a work of art, but rather as an integral part of the ecclesiastical equipment of the church. It was the retable above the altar, the mensa, the table of the Lord. In the retable, the church's most prized biblical facts and saints were portrayed; that is, they were made visible.

The representational content of the high altar is part of its significance as a work of art. The Überlingen high altar centers on the Virgin Mary. The middle sections display the annunciation of Mary, the adoration of the child, the ascension and the crowning of the Virgin Mary with the Holy Trinity, and the crucifixion of Christ with the Virgin Mary beneath the cross. The life and sacrificial death of Christ are brought into connection with the life of Mary; thus the fundamental doctrine of the Catholic Church is depicted in the high altar.

This fundamental doctrine is accompanied by saints. After Christ and the Virgin Mary, they are venerated as mediators to God. As they stand closer to the people, they also evoke local associations. Seated on a throne below the cross is St. Nikolaus, the cathedral's patron and guardian saint of seafarers. At the time, Überlingen's economy was dependent on fishing. Sts. Sylvester and Michael—next to the veneration—are the patron saints of two villages incorporated into Überlingen. Sts. Roch and Sebastian provided protection from the plague, one of the greatest dangers of that time. There is no known local significance of Sts. James and Andrew.

The overall form of the altar is based on shrine altars of the Middle Ages with a predella (the socle), a center shrine with folding wings or *Schreinwächter* (shrine guards), and a multileveled, tapered top. In the Überlingen high altar, this schemata was translated into the forms of the Renaissance. To achieve this, Jörg used the ornamental prints of Wendel Dietterlin as models. The central portions were constructed like stages with an open back wall, which were modeled on the altars by Hans Degler in the Church of Sts. Ulrich and Afra in Augsburg. The open back wall not only created vibrant light effects from the choir window but also placed the scenes in the real space of the church, and they are thereby brought closer to the congregation. The same is true of the freestanding figures of the saints. In principle, the presentation was the same as it was in the Middle Ages, only in the new, lifelike forms of the Renaissance. Nonetheless, this sculptural work does not correspond to the corporeal sculpture of the Italian Renaissance, but rather has, as before, Gothic structures at its core. This becomes most clear when one notices that the figures are not constructed in *contrapposto* (a natural pose with the weight of one leg, the shoulder, and hips counterbalancing one another), but rather in the Gothic S or C curve. Compared with earlier altars by Degler and Moll, the overall form of the altar appears more harmonious and balanced. The highly attenuated proportions of the entire structure still remain, for which reason the altar is so ideally suited to the Gothic choir of the cathedral.

In the Überlingen high altar, a thoroughly medieval Catholic conception of a Christian subject matter was realized in carved images. The representational principle and the form remain fundamentally medieval; the content is not projected in contemporary images in the style of the Renaissance. The medieval mode of representation is, however, animated through the realistic reproduction of the organic and individualistic elements. This creates a great tension and an immense power of expression that continue to fascinate the modern viewer. This tension is a part of the artistic power of this work, and it is a basis for the further development of southern German Baroque art and its international status.

CLAUS ZOEGE VON MANTEUFFEL

Further Reading

Zoege von Manteuffel, Claus, *Die Bildhauerfamilie Zürn, 1606–1666*, Weissenhorn, Germany: Konrad, 1969

Zoege von Manteuffel, Claus, *Die Waldseer Bildhauer Zürn* (exhib. cat.), Bad Waldsee, Germany: Museums- und Heimatverein Bad Waldsee, 1998

CONTRIBUTORS

Abell, Mary Ellen. Assistant Professor, Visual Arts Department, Dowling College, Oakdale, N.Y. Contributor to *Art New England* (1983), *Provincetown Arts* (1999), *Eye in Hand* (1999), *PART* (1999), and (2002). Articles contributed to *The Encyclopedia of Sculpture*: DAVID SMITH; DAVID SMITH: CUBIS; VLADIMIR YEVGRAFOVICH TATLIN.

Alford, John. Associate Professor, Division of Fine and Performing Arts, Mississippi University for Women. Associate Professor, Art Department, Carson-Newman College, Jefferson City, Tenn. Contributor to *George Cooke: 1793–1849* (1991) and *Art, Experience, and Criticism* (1993). Articles contributed to *The Encyclopedia of Sculpture*: CONTEMPORARY SCULPTURE; ALBERTO GIACOMETTI; ALBERTO GIACOMETTI: *MAN POINTING*.

Allison, Ann Hersey. Independent Scholar, Baltimore, Md. Author of *The Bronzes of Antico* (1993). Contributor to *Mitteilungen des Kunsthistorisches Institut in Florenz* (1976), *Journal of the American Institute of Conservation* (1983), *The Medal* (1986), *Jahrbuch der Kunsthistorischen Sammlungen in Wien* (1993–94), and *Civiltà Mantova* (1995). Articles contributed to *The Encyclopedia of Sculpture*: ANTICO (PIER JACOPO ALARI BONACOLSI); ANTICO (PIER JACOPO ALARI BONACOLSI): *HERCULES AND ANTAEUS*.

Ambrose, Kirk. Assistant Professor, Department of Fine Arts, University of Colorado, Boulder. Contributor to *Traditio* (2000) and *Gazette des Beaux Arts* (2001). Articles contributed to *The Encyclopedia of Sculpture*: GERMANY: ROMANESQUE.

Ambrosini, Lynne D. Independent Art Historian. Author of *Peasants in French Painting, 1815–1848: The Romantic Roots of the Realist Mode* (1989). Coauthor with Michelle Facos of *Rodin: The Cantor Gift to the Brooklyn Museum* (1987). Contributor to *Interpretation at the Minneapolis Institute of Arts: Policy and Practice* (1993), *Made in America: Ten Centuries of American Art* (1995), *La Gazette des Beaux-Arts* (1995, 2000) *Porticus: Journal of the Memorial Art Gallery of the University of Rochester* (1996), *Exu: Atlantic Journal of the Crossroads* (1997), and *Barbizon, Realist, and French Landscape Paintings*, New York (2000). Articles contributed to *The Encyclopedia of Sculpture*: FRÉDÉRIC-AUGUSTE BARTHOLDI; FRÉDÉRIC-AUGUSTE BARTHOLDI: *STATUE OF LIBERTY* (*LIBERTY ENLIGHTENING THE WORLD*); JEAN-ALEXANDRE-JOSEPH FALGUIÈRE; HIRAM POWERS.

Androssov, Sergei. (Adviser.) Professor, Curator, Vice Director, Department of European Art, State Hermitage Museum, St. Petersburg, Russia. Author of *Andrea Verrocchio, 1435–88* (1984), *Donatello* (1986), *Jivopisets Ivan Nikitin* (1998), and *Italianskaia Skul'ptura v sobranii Petre Velikogo* (1999), and *Pietro il Grande collectionista d'arte veneta* (1999). Contributor to *Mitteilungen des Kunsthistorische Institut in Florence* (1980–93), *The Burlington Magazine* (1983, 1991), *Studies in the History of Art* (1990), *Antologia di Belle Arti* (1994), and *Antichità Viva* (1992, 1995). Articles contributed to *The Encyclopedia of Sculpture*: ÉTIENNE-MAURICE FALCONET; ÉTIENNE-MAURICE FALCONET: EQUESTRIAN MONUMENT OF PETER THE GREAT (THE BRONZE HORSEMAN); BARTOLOMEO CARLO RASTRELLI; RUSSIA AND SOVIET UNION.

Angell, Marisa S. Ph.D. Candidate, Department of the History of Art, Yale University, New Haven, Conn. Articles contributed to *The Encyclopedia of Sculpture*: GERMAINE RICHIER.

Arrigo, Jan. Writer. Contributor to *New Orleans: A City Guide* (2002), edited by Todd Berger. Contributor to *The American Art Book* (1999), edited by Megan McFarland. Articles contributed to *The Encyclopedia of Sculpture*: MARK DI SUVERO; JOAN MIRÓ.

Avery, Charles. (Adviser.) Ph.D. Beckenham, U.K. Author of *Florentine and Renaissance Sculpture* (1970), *Giambologna: The Complete Sculpture* (1987), *Donatello: An Introduction* (1995), *Bernini: Genius of the Baroque* (1997), and *Studies in Italian Sculpture* (2001). The Contributor to *The Burlington Magazine* (1983), *British Art Journal* (1999), *Country Life* (1999), *Apollo* (2000), and *The Sculpture Journal* (2001). Articles contributed to *The Encyclopedia of Sculpture*: GIANLORENZO BERNINI; FRANÇOIS DIEUSSART; DONATELLO (DONATO DI BETTO BARDI); DONATELLO (DONATO DI BETTO BARDI): *SANTO ALTAR RELIEFS*; PIETRO FRANCAVILLA; PIETRO FRANCAVILLA:

STATUES FROM VILLA BRACCI; GIAMBOLOGNA; GIAMBOLOGNA: *RAPE OF A SABINE*; HUBERT LE SUEUR; HUBERT LE SUEUR: EQUESTRIAN STATUE OF CHARLES I.

Avery, Victoria. Postdoctoral Research Fellow, Department of History of Art, University of Cambridge, U.K. Contributor to *La bellissima maniera: Alessandro Vittoria e la scultura veneta del Cinquecento* (1999), *Studi Trentini di Scienze Storiche* (1999), and *The Sculpture Journal* (2001). Articles contributed to *The Encyclopedia of Sculpture*: GIROLAMO CAMPAGNA; GIROLAMO CAMPAGNA: ALTARPIECE OF THE *HOLY TRINITY AND EVANGELISTS*; ALESSANDRO VITTORIA; ALESSANDRO VITTORIA: *ST. SEBASTIAN*.

Avery-Quash, Susanna. Ph.D. The Harry E. Weinrebe Assistant Curator, Curatorial Department, The National Gallery, London, U.K. Contributor to *Victorian Society Annual* (1995), *Transactions of the Cambridge Bibliographical Society* (1998), *Journal of the Royal Society of Arts* (1998), *Apollo* (1999), *Seeing Salvation: The Image of Christ* (2000), and *Country Life* (2000). Articles contributed to *The Encyclopedia of Sculpture*: ALBERT MEMORIAL; TINO DI CAMAINO; TINO DI CAMAINO: TOMB OF MARY OF HUNGARY.

Baker, Marilyn. Articles contributed to *The Encyclopedia of Sculpture*: ANTOINE COYSEVOX; CHARLES DESPIAU; LEMOYNE FAMILY; PAUL MANSHIP.

Barnet, Peter. (Adviser.) Michel David-Weill Curator in Charge, Department of Medieval Art and The Cloisters, Metropolitan Museum of Art, New York. Author of *Clothed in Majestry: European Ecclesiastical Textiles from the Detroit Institute of Arts* (1991). Coauthor with Alan P. Darr of *Catalogue of Italian Sculpture in the Detroit Institute of Arts* (2003). Editor of *Images in Ivory* (1997). Contributor to *Apollo* (1986), *Bulletin of the Detroit Institute of Arts* (1988, 1989, 1992), *Hali* (1995), *Romanesque Sculpture in American Collections, II, New York and New Jersey* (1999), edited by W. Cahn, *Sculpture Journal* (2000), and *Encyclopedia of Medieval Germany* (2001), edited by J. Jeep. Articles contributed to *The Encyclopedia of Sculpture*: IVORY SCULPTURE: GOTHIC.

Bassett, Sarah E. (Adviser.) Assistant Professor, Department of Art and Art History, Wayne State University, Detroit, Mich. Contributor to *Dumbarton Oaks Papers* (1992), *American Journal of Archaeology* (1996), and *Art Bulletin* (2000).

Bastante, Maria Cristina. Author of *Eros in the Art of Gustav Vigeland* and *Klimt's Women* (2000). Coeditor of *BTA (Telematic Art Bulletin)* (2000). Contributor to *Exibart* (February 2001) and *Art and Job Magazine* (October 2000). Articles contributed to *The Encyclopedia of Sculpture*: FRANCESCO LAURANA.

Baxter, Denise Amy. Ph.D. Candidate, Department of the History of Art and Architecture, University of California, Santa Barbara. Articles contributed to *The Encyclopedia of Sculpture*: (CLAUDE MICHEL) CLODION; (CLAUDE MICHEL) CLODION: *PAN AND SYRINX* RELIEF; AUGUSTIN PAJOU; AUGUSTIN PAJOU: *PSYCHE ABANDONED*.

Baxter, Ron. Hon. Editor, *Corpus of Romanesque Sculpture in Britain and Ireland*, Courtauld Institute of Art, University of London. Author of *Bestiaries and Their Users in the Middle Ages* (1998). Contributor to the *Journal of the Warburg and Courtauld Institutes* (1987), *The Grove Dictionary of Art* (1996), and *Medieval England: An Encyclopedia* (1998). Articles contributed to *The Encyclopedia of Sculpture*: CHARTRES CATHEDRAL.

Bay, Caterina. Predoctoral Fellow, Department of Art History, University of Pisa, Italy. Contributor to *Mino Maccari* (1999), edited by Sergio Pautasso. Articles contributed to *The Encyclopedia of Sculpture*: ARMAN (FERNANDEZ); JEAN (HANS) ARP; FERNANDO BOTERO; JEAN DUBUFFET; YVES KLEIN; JANNIS KOUNELLIS; PIERO MANZONI; GIACOMO MANZÙ; GIACOMO MANZÙ: *DOOR OF DEATH*; MARIO MERZ; DANIEL SPOERRI.

Bellesi, Sandro. Professor, Department of Art History, Accademia Di Belle Arti, Bologna, Italy. Author of *Cesare Dandini* (1996), *Diavolerie: Magie E Incantesimi Hella Pittura Barocco Florentina* (1997), *Duchi E Granduchi Medicei in Una Serie Di Terrecotta del Primo Settecento* (1997), and *Stephano Della Bella Otto Dipinti so Pietra Paesina* (1998). Contributor to *Il Seicento A Prato* (1998) and *Il Settecento A Prato* (1999). Articles contributed to *The Encyclopedia of Sculpture*: MASSIMILIANO SOLDANI BENZI; ANTONIO SUSINI.

Bentz, Katherine. Ph.D. Candidate, Department of Art History, Pennsylvania State University, Universtiy Park. Contributor to *The Journal of the Walters Art Gallery* (1996–97). Articles contributed to *The Encyclopedia of Sculpture*: CORAL; DISPLAY OF SCULPTURE; PLASTER CAST.

Berger, Ursel. Ph.D. Georg Kolbe Museum, Berlin, Germany. Author of *Palladios Frühwerk* (1978), edited by Böhlau Verlag and *Georg Kolbe, Leben und Werk* (1990, 1994). Coauthor with Volker Krahn of *Bronzen der Renaissance und des Barock* (1994). Coauthor and coeditor with Jörg Zutter of *Aristide Maillol* (1996). Coauthor and coeditor with Josephine Gabler of *August Gaul* (1999). Contributor to *Arte Veneta* (1977), *Pantheon* (1982), *Architectura* (1984), *Museums Journal: Berlin* (1987–99), and *Kunstchronik* (1993). Articles contributed to *The Encyclopedia of Sculpture*: ALEXANDER COLIN; MAX KLINGER; GEORG KOLBE; WILHELM LEHMBRUCK; ARISTIDE MAILLOL; BALTHASAR PERMOSER; BALTHASAR PERMOSER: SCULPTURES FOR THE DRESDEN ZWINGER; GEORG PETEL; JOHANN GREGOR VAN DER SCHARDT.

Berk, Amy. Visual Artist and Writer, San Francisco, Calif. Contributor to *ArtWeek* (1996–), *Art in America* (1999–2000), *Art Papers* (2000), *World Sculpture News* (2000). Member of editorial board for *Stretcher.org* (2000–). Articles contributed to *The Encyclopedia of Sculpture*: ENGLAND AND WALES: ANCIENT; HAGENAUER FAMILY.

Bershad, David L. Professor, Department of Art, University of Calgary, Canada. Coauthor with Carolina Mangone of *The*

Christian Travelers Guide to Italy (2001). Contributor to *Burlington Magazine* (1970–73, 1977), *Arte Illustrata* (1974), *Antologia di Belle Arti* (1978–79, 1984–85), *Scritti di storia dell' arte in onore di Federico Zeri* (1983), *Dictionary of World Art* (1996). Articles contributed to *The Encyclopedia of Sculpture*: ALESSANDRO ALGARDI; ALESSANDRO ALGARDI: *POPE LEO DRIVING ATTILA FROM ROME*; GIANLORENZO BERNINI: TOMB OF URBAN VIII; PIETRO BRACCI; ERCOLE FERRATA; DOMENICO GUIDI; FILIPPO DELLA VALLE.

Bianchi, Robert Steven. Ph.D. Independent Scholar. Author of *Egipto Milenario* (1998). Coauthor of *Faberge: Imperial Craftsman and His World* (2000). Coauthor with J.-E. Empereur of *The Egyptians* (forthcoming). Editor of *From the Collection of Elie Borowski: Ancient Glass* (forthcoming). Coeditor of *Journal of the American Research Center in Egypt* (2001–). Contributor to *Art and Auction* (1997), *Archaeology* (1997), *Gifts of the Nile: Ancient Egyptian Faience* (1998), *Minerva* (1998), and *Journal of the American Oriental Society* (forthcoming). Articles contributed to *The Encyclopedia of Sculpture*: EGYPT, ANCIENT: FIRST INTERMEDIATE PERIOD–MIDDLE KINGDOM (*ca.* 2150–1650 BCE); EGYPT, ANCIENT: SECOND INTERMEDIATE–NEW KINGDOM PRE-AMARNA (*ca.* 1715–1554 BCE); EGYPT, ANCIENT: NEW KINGDOM: AMARNA (*ca.* 1554–1347 BCE); EGYPT, ANCIENT: NEW KINGDOM POST-AMARNA–THIRD INTERMEDIATE PERIOD (*ca.* 1347–720 BCE); EGYPT, ANCIENT: LATE PERIOD–ROMAN PERIOD (*ca.* 720 BCE–CE 395).

Black, Jonathan. Professor, History of Art Department, University College London. Contributor to *CRW Nevinson: The Twentieth Century* (1999). Articles contributed to *The Encyclopedia of Sculpture*: CHARLES SARGEANT JAGGER; CHARLES SARGEANT JAGGER: ROYAL ARTILLERY MEMORIAL.

Bliss, Joseph R. Ph.D. Independent Scholar, New York City. Author of *The GANS Collection of English Silver at the Virginia Museum of Fine Arts* (1992, 1999). Coauthor of *A Renaissance Treasury: The Flagg Collection of European Decorative Arts and Sculpture* (1999). Contributor to *Arts in Virginia* (1986, 1989), *European Decorative Arts, 1400–1600: An Annotated Bibliography* (1989), *Southwestern College Art Conference Review* (1989, 1990), *Antiques* (1990), *Source: Notes in the History of Art* (1990, 1995), *Royal Goldsmith: The Garrard Heritage* (1991), *The Currency of Fame: Portrait Medals of The Renaissance* (1994), and *Studies in the History of Art* (2001). Articles contributed to *The Encyclopedia of Sculpture*: SEVERO DI DOMENICO CALZETTA DA RAVENNA.

Bock, Nicolas. Assistant Lecturer, Department of Art History, University of Lausanne. Articles contributed to *The Encyclopedia of Sculpture*: BUON FAMILY; BUON FAMILY: *MADONNA DELLA MISERICORDIA*; GOLDENES RÖSSL (GOLDEN HORSE) OF ALTÖTTING; JACOPO DELLA QUERCIA; JACOPO DELLA QUERCIA: PORTAL OF S. PETRONIO; NANNI DI BANCO.

Boehm, Barbara Drake. Curator, Department of Medieval Art and The Cloisters, Metropolitan Museum of Art. Author of *The Hours of Jeanne D'Evreux* (2000). Coauthor of *Enamels of Limoges* (1995 exhib. cat.). Contributor to *Painting and Illumina-tion in Early Renaissance Florence* (1994–95, Metropolitan Museum of Art, exhib. cat.), *Bollettino d'Arte* (1997), *Gesta* (1997), *Mirror of the Medieval World* (1999, Metropolitan Museum of Art, exhib. cat.), and *L'Art au temps de rois maudits* (2000, École du Louvre, symposium volume). Articles contributed to *The Encyclopedia of Sculpture*: RELIQUARY SCULPTURE; VIRGIN AND CHILD OF JEANNE D'EVREUX.

Bol, Peter C. Ph.D. Professor, Department of Archaeology, Johann Wolfgang Goethe Universität, Frankfurt, Germany. Author of *Grossplastik aus Bronze* (1978), *Argivische Schilde* (1989), and *Der Antretende Diskobol* (1996). Coeditor with H. Beck and M. *Bückling of Polyklet* (1990). Contributor to *Archaologischer Anzeiger* (1972), *Antike Plasik* (1974), *Staedel Jahrbuch* (1976), *Anthenische Mitteilungen* (1992), and *Antike Welt* (1999). Editor of *Forschungen zür Villa Albani*, volumes 1–4 (1989–98). Articles contributed to *The Encyclopedia of Sculpture*: POLYKLEITOS: *DORYPHOROS* (SPEAR BEARER); SKOPAS.

Bonsanti, Giorgio. Professor, Department of Arts and Music, University of Turin, Italy. Author of *Giotto* (1985), *Antonio Begarelli* (1992), and *Beato Agelico* (1998). Coauthor of *Giotto-Bilancio critico di sessant' anni di studi e ricerche* (2000). Contributor to *Bollettino d'Arte* (1974, 1980, 1996), *Paragone* (1983, 1985), *Arte Cristiana* (1983, 1994), *Il Giornale dell'Arte* (1983–2001), *Michelangelo: The Genius of Sculpture in M.'s Work* (1992), Editor of *OPD Restauro* (1988–2000). Articles contributed to *The Encyclopedia of Sculpture*: ANTONIO BEGARELLI; CONSERVATION: OTHER THAN STONE AND MARBLE; DONATELLO (DONATO DI BETTO BARDI): *ST. GEORGE*; LORENZO GHIBERTI; LORENZO GHIBERTI: *GATE OF PARADISE*.

Boström, Antonia. Ph.D. Assistant Curator, Department of European Sculpture and Decorative Arts, The Detroit Institute of Arts. Editorial board member for *Sculpture Journal* (1996). Contributor to *The Burlington Magazine* (1990, 1995, 1998), *Apollo Magazine* (1991), *The Sculpted Object 1400–1700*, edited by S. Currie and P. Motture (1997), *Sculpture Journal* (1997, 2000). Coauthor with Alan P. Darr and P. Barnett, *Catalogue of Italian Sculpture in the Detroit Institute of Arts* (2003).

Boudon, Marion. Articles contributed to *The Encyclopedia of Sculpture*: FRANÇOIS DU QUESNOY; FRANÇOIS DU QUESNOY: *ST. SUSANNA*.

Bowerman, Eva. Graduate Student, History of Art Department, Yale University, New Haven, Conn. Contributor to *Edward Lear and the Art of Travel* (2000). Articles contributed to *The Encyclopedia of Sculpture*: CHRISTIAN DANIEL RAUCH; JOHAN TOBIAS SERGEL.

Boylan, Alexis L. Ph.D. Candidate, Department of Art History, Rutgers University, New Brunswick, N.J. Editorial board member for the *Rutgers Art Review* (1997). Articles contributed to *The Encyclopedia of Sculpture*: LOUISE BOURGEOIS; HARRIET GOODHUE HOSMER; ELIE NADELMAN.

Brakensiek, Stephan. Ph.D. Department of Art History, Kulturstiftung Ruhr, Villa Hügel, Essen, Germany. Author of *Vom Theatrum mundi zum Cabinet des Estampes: Das Sammeln von*

Druckgraphik in Deutschland 1565–1821 (2001). Contributor to *RISZ: Zeitschrift für Architektur* (1996). *Der Welt Lauf: Allegorische Graphikserien des Manierismus* (1997), and *Weltkunst* (1999). Articles contributed to *The Encyclopedia of Sculpture*: GERHARD GRÖNINGER.

Brook, Anthea. Witt Library, Courtauld Institute of Art, London. Contributed to *Mitteilungen des Kunsthistorischen Insitutes in Florenz* (1985), *Il Seicento Fiorentino* (1986), *Boboli 90* 1989), *La Scultura. Studi in onore di Andrew Ciechanowiecki* (1995), and *Giambologna attraverso l'Italia ed II Nord* 2000). Articles contributed to *The Encyclopedia of Sculpture*: GIOVANNI BATTISTA FOGGINI; GIOVANNI BATTISTA FOGGINI: CAPPELLA FERONI; ITALY: RENAISSANCE–BAROQUE; GIOVAN FRANCESCO SUSINI; TACCA FAMILY; TACCA FAMILY: MONUMENT TO FERDINANDO I DE' MEDICI AT LIVORNO.

Brzyski-Long, Anna. Assistant Professor of Art History, School of Art and Design, Southern Illinois University, Carbondale. Coeditor of *Centropa* (2001) and of special issue of *Centropa* with Peter Chametzky. Contributor to *Chicago Art Journal* (1996) and *Art Criticism* (1997). Articles contributed to *The Encyclopedia of Sculpture*: POLAND.

Budny, Virginia. Research Assistant, Department of European Paintings, the Metropolitan Museum of Art, New York. Contributor to *Cosimo Rosselli: Painter of the Sistine Ceiling* (2001). Contributor to *Weatherspoon Gallery Association Bulletin* (1979, 1980) and *The Art Bulletin* (1983). Articles contributed to *The Encyclopedia of Sculpture*: BENEDETTO DA MAIANO; BENEDETTO DA MAIANO: PULPIT, CHURCH OF SANTA CROCE.

Buller, Rachel Epp. Ph.D. Candidate, Department of Art History, University of Kansas, Lawrence. Contributor to *Oculus: Journal for the History of Art* (1999). Articles contributed to *The Encyclopedia of Sculpture*: CONSTRUCTIVISM; BARRY FLANAGAN; NAUM GABO; NAUM GABO: *LINEAR CONSTRUCTION IN SPACE, No. 1 (VARIATION)* ALEXANDER RODCHENKO.

Burdick, Catherine. Adjunct Instructor, Art History/Liberal Studies Department, Milwaukee Institute of Art and Design. Articles contributed to *The Encyclopedia of Sculpture*: CRETAN SCULPTURE; NEAR EAST, ANCIENT: ANATOLIA.

Burk, Jens Ludwig. Ph.D., Staatliche Hochschule für Gestaltung Karlsruhe, Fachbereich Kunstwissenschaft und Medientheorie. Contributed to *Marburger Jahrbuch für Kunstwissenschaft* (1998). Articles contributed to *The Encyclopedia of Sculpture*: CONRAT MEIT.

Bussers, Helena. Ph.D. Department of Ancient Art, Royal Museums of Fine Arts, Brussels, Belgium. Coauthor of *La sculpture au siècle de Rubens dans les Pays-Bas méridionaux et la principauté de Liège* (1977), edited by Helena Bussers, *De beeldhouwkunst in Antwerpen in de XVIIde eeuw* (1989), edited by Walter Couvreur, *Le musée caché: A la découverte des réserves* (1994), edited by Helena Bussers, *17th and 18th Century Terracottas: The Van Herck Collection* (2000), edited by D. Allard and Frans Baudouin, and *17th- and 18th-Century Drawings: The Van Herck Collection* (2000), edited by D. Allard and Frans Baudouin. Contributor to *Handelingen van de Koninklijke Kring voor Oudheidkunde, Letteren en Kunst van Mechelen* (1983), *Bulletin des Musées royaux d'Art et d'Histoire, Brussels* (1986), *Etudes sur le XVIIIe siècle, Brussels* (1991), *Bulletin des Musées royaux des Beaux-Arts de Belgique, Brussels* (1992), and *Bulleti*. Articles contributed to *The Encyclopedia of Sculpture*: WILLEM (GUILLIELMUS) KERRICX; QUELLINUS (QUELLIN) FAMILY; MICHIEL VAN DER VOORT THE ELDER.

Butzek, Monika. Ph.D., Department of Philosophy, Kunsthistorisches Institut Florence, Italy. Author of *II Duomo di Siena al tempo di Alessandro VII: Carteggio e disegni (1658–67)* (1996). Coauthor with Peter Anselm Riedl and Max Seidel of *Die Kirchen von Siena*, 2 vols. (1985, 1992). Coeditor with Alessandro Angelini and Bernardina Sani of *Alessandro VII Chigi (1599–1667): Il Papa Senese di Roma Moderna* (2000). Contributor to *Mitteilungen des Kunsthistorischen Institutes in Florenz* 24 (1980), *Pantheon* 46 (1988), and *Prospettiva* 61 (1991). Articles contributed to *The Encyclopedia of Sculpture*: GIUSEPPE MAZZUOLI.

Cambareri, Marietta. Assistant Curator of Decorative Arts and Sculpture, Art of Europe, Museum of Fine Arts, Boston, Mass. Coauthor with Peggy Fogelman and Peter Fusco of *Masterpieces of the J. Paul Getty Museum: European Sculpture* (1998). Contributor to *Quaderni dell'Istituto di Storia dell'Architettura* (1990), *Bollettino dell'Istituto Storico-Artistico Orvietano* (1991), *Il Duomo di Orvieto e le Grandi Cattedrali del Duecento: Atti del Convegno Internazionale* (1995), and *Michele Sanmicheli: Architettura, linguaggio e cultura artistica nel Cinquecento* (1995). Articles contributed to *The Encyclopedia of Sculpture*: FRANCESCO MOCHI; FRANCESCO MOCHI: ANNUNCIATION.

Campbell, J. Patricia. Ph.D. Senior Lecturer, Department of History of Art, University of Edinburgh. Author of *Catalogue of the Torrie Collections*, edited by Edinburgh University, with J.D. MacMillan (1980), *Noel Paton*, with M.H. Noel-Paton (1990). Edited the *Proceedings of the International Interdisciplinary Symposium on Instrumentalischer Bettlermantl: An Unpublished 17th Century Music Compendium in the Special Collections* (1997). Contributor to *The Practical and the Pious: Essays on Thomas Chalmers*, edited by Alex Cheyne (1985), *The Cambridge Encyclopedia*, edited by David Crystal (1994), *The Galpin Society Journal* 45 (1995), *The Oxford Companion to Literature in French*, edited by Peter France (1995), and *The Dictionary of Art*, edited by Jane Turner (1996). Articles contributed to *The Encyclopedia of Sculpture*: ACADEMIES AND ASSOCIATIONS; ENGLAND AND WALES: BAROQUE–NEOCLASSICAL (CA. 1625–1800); FRANCE: RENAISSANCE–EARLY 19TH CENTURY; GRINLING GIBBONS; PIERRE PUGET; PIERRE PUGET: *MILO OF CROTON*; LOUIS-FRANÇOIS ROUBILIAC.

Cardone, Lucia. Predoctoral Fellow, Department of Art History, University of Pisa, Italy. Author of *Elio Petri, un regista scomodo* (1999). Coauthor with Lorenzo Carletti of *Sacre passioni: Scultura lignea a Pisa tra XIII e XV secolo* (2000), edited by Mariagiulia Burresi. Contributor to *Critica d'arte* (2001).

Articles contributed to *The Encyclopedia of Sculpture*: ALEXANDER CALDER; ALEXANDER CALDER: *LOBSTER TRAP AND FISH TAIL*; MARINO MARINI; MARINO MARINI: *ANGEL OF THE CITY (RIDER)*; PABLO PICASSO; GEORGE SEGAL.

Carletti, Lorenzo. Predoctoral Fellow, Department of Art History, University of Pisa, Italy. Author of *Testimonianze di fine millennio* (1998), edited by Anika Filandri, and *Guida alla scultura lignea nella provincia di Pisa, dal Medioevo al primo Rinascimento* (2001). Coauthor with Lucia Cardone of *Sacre Passioni: Scultura lignea dal XII al XV secolo* (2000), edited by Mariagiulia Burresi. Contributor to *Die Philologie* (1999) and *Ricerche di Storia dell'Arte* (2001). Author of *Giovanni Pisano, Giovanni di Balduccio, Agostino di Giovanni, Giovanni di Agostino, Lupo di Francesco, Andrea Pisano, Nino Pisano, Tommaso Pisano, Francesco di Valdambrino*, and *Andrea Guardi* for the Cd-Rom *Sacre Passioni: Scultura lignea a Pisa dal XII al XV secolo. I restauri* (2001). Articles contributed to *The Encyclopedia of Sculpture*: CAROLINGIAN SCULPTURE; GUIDO DA COMO; ITALY: ROMANESQUE–GOTHIC; LONGOBARDIC SCULPTURE; LORENZO MAITANI; ANDREA PISANO.

Cast, David. Professor, Department of History of Art, Bryn Mawr College, Pa. Author of *The Calumny of Apelles* (1981). Contributor to *Renaissance Humanism* (1988), *Art Bulletin* (1991), *World and Image* (1993, 2000), *Journal of Society of Architectural Historians* (1993), *The Burlington Magazine* (1996), and *Giorgio Vasari: Art, Literature and History at the Medici Court* (1998). Articles contributed to *The Encyclopedia of Sculpture*: REG BUTLER.

Chapuis, Julien. Associate Curator, Department of Medieval Art and The Cloisters, Metropolitan Museum of Art, New York. Author of *Tilman Riemenschneider, Master Sculptor of the Late Middle Ages* (1999). Contributor to *Van Eyck to Bruegel: Early Netherlandish Painting in The Metropolitan Museum of Art* (1998), *Connaissance des Arts* (2000), and *The Treasury of Basel Cathedral* (2001). Articles contributed to *The Encyclopedia of Sculpture*: TILMAN RIEMENSCHNEIDER.

Checchi, Giovanna. Independent Scholar. Author of *Un comico-drammaturgo dell'Arte: Silvio Fiorillo detto il Capitan Matamoros* (1985), *Momenti dell fortuna goldoniana nell'Ottocento italiano: Practica scenica e editoriale* (1994), *Siena* (1998). Editor of *Silvio Fiorillo in arte Capitan Mattamoros* (1986), *Firenze istruzioni per l'uso* (1997), *Biblioteca Teatrale* (1989–93), *Primafila* (1995–96), *Colpo di scena* (1998–99). Contributor to *Quaderni di teatro* (1984), *La Commedia dell'Arte*, edited by Cesare Molinari (1985), *Medioeve e Rinascimento* (1992), *Studi italiani* (1993), Dizionario biografico degli italiani (1997), *Hysterio* (1997), *Enciclopedia multimediale Rizzoli Larousse* (1998), *ART'o* (2000). Articles contributed to *The Encyclopedia of Sculpture*: CHIMERA; HORSES OF SAN MARCO; LAMENTATION AND DEPOSITION GROUPS; ARTURO MARTINI; SACRED MOUNTS; THEATER SCULPTURE.

Cinelli, Carlo. Author of *Restauri in S. Lucia in Monte* (1991). Coauthor of *Arte e quartierei*, with G. Capecchi (1995). Editorial board member of *Bollettino della Società di Studi Fiorentini* (1997–99). Editor of *La fontana del Nettuno dell'Ammannati*, by J. Myssok (1999) and *Le statue degli Illustri Toscani*, by S. Jacopozzi (1999). Contributor to *Magnificenza all corte dei Medici: Arte a Firenze all fine del Cinquecento*, edited by M. Gregori and D. Heikamp (1997), *Aggiunte all storia della scultura e dell'architettura fiorentina del '500*. Articles contributed to *The Encyclopedia of Sculpture*: LORENZO BARTOLINI; VINCENZO DE' ROSSI.

Cole, Michael. Assistant Professor, Department of Art, University of North Carolina, Chapel Hill. Author of *Cellini and the Principles of Sculpture* (2002). Contributor to *World and Image* (1997), *The Burlington Magazine* (1998), *Art Bulletin* (1999), *Art History* (2001), and *Studies in the History of Art* (2002). Articles contributed to *The Encyclopedia of Sculpture*: BENVENUTO CELLINI; BENVENUTO CELLINI: *PERSEUS AND MEDUSA*; HONORIFIC COLUMN.

Colin, Susi. Ph.D., Assistant Professor, Department of Fine Arts, Montclair State University, Upper Montclair, N.J. Author of *Das Bild des Indianers in der Kunst des 16. Jahrhunderts* (1988) and *The Sculpture of Walt Swales* (1998). Contributor to *Dialogue* (1985), *Indians and Europe* (1987), edited by Christian F. Feest, *Women Artists' News* (1988), *America: Early Maps of the New World* (1992), edited by Hans Wolff. Articles contributed to *The Encyclopedia of Sculpture*: STONE; TOOLS.

Coonin, Arnold Victor. Assistant Professor and Chair, Art Department, Rhodes College. Contributor to *Rutgers Art Review* (1992), *Metropolitan Museum Journal* (1995), *The Burlington Magazine* (1995, 1999), *Memphis Brooks Museum Bulletin* (1996, 1999), *Renaissance Quarterly* (1998). Articles contributed to *The Encyclopedia of Sculpture*: DESIDERIO DA SETTIGNANO; DESIDERIO DA SETTIGNANO: TOMB OF CARLO MARSUPPINI.

Corbet, Christian Cardell. Painter, Sculptor, Curator, Art Historian, Canadian Portrait Academy, Canadian Group of Art Medallists. Author of *Recent Works* (1997), edited by Dustin R. Chandler, *Seventy Year Retrospective* (1998), edited by Dustin R. Chandler, and *Elizabeth Bradford Holbrook: Seven Decades of Art* (2001), edited by Dustin R. Chandler. Coauthor of *History of the Art Medal in Canada* (2002). Contributor to *CPA Journal* (1998, 2000). Articles contributed to *The Encyclopedia of Sculpture*: CARL MILLES; CARL MILLES: ORPHEUS FOUNTAIN.

Corney, Alexandra. Curatorial Assistant, Sculpture Department, Victoria and Albert Museum, London. Articles contributed to *The Encyclopedia of Sculpture*: NIKI DE SAINT PHALLE; NIKI DE SAINT PHALLE: *BLACK VENUS*.

Corso, Antonio. Ph.D. Senior Research Fellow Institute for Advanced Study, Collegium, Budapest, Hungary; Author of *Monumenti Periclei* (1986), *Plinio, Storia Naturale (storia dell'arte)* (1988), *Prassitele, Fonti epigrafiche e letterarie; Vita e Opere* (1988, 1990, 1992), edited by Antonio Giuliano. Coauthor with Elisa Romano of *Vitruvio: De architectura* (1997), edited by Pierre Gros. Assistant Editor of *Quaderni Ticinesi di Numismatica e Antichità Classiche*. Contributor to *Annuario*

Fogelman, Peggy. Senior Project Specialist, Curatorial Administration, The J. Paul Getty Museum, Los Angeles, Calif. Coauthor with Jane Bassett of *Looking at European Sculpture: A Guide to Technical Terms* (1997). Coauthor with Peter Fusco of *Masterpieces of the J. Paul Getty Museum: European Sculpture* (1998) and *Catalogue of European Sculpture, J. Paul Getty Museum*, Vol. 1 (2002). Coeditor of *The Sculpture Journal* (2001). Contributor to *The Burlington Magazine* (1990), *J. Paul Getty Museum Journal* (1994), *Apollo Magazine* (1999), *La Bellissima maniera: Alessandro Vittoria e la scultura veneta del Cinquecento* (1999), *Art In Rome in the Eighteenth Century* (2000), and *The Sculpture Journal* (2000). Articles contributed to *The Encyclopedia of Sculpture*: ANTONIO CANOVA; ANTONIO CANOVA: THE THREE GRACES; JOHN DEARE; VINCENZO GEMITO; JOSEPH NOLLEKENS; JOSEPH WILTON.

Fontein, Jan. (Adviser.) Independent Scholar.

Fort, Ilene Susan. Curator, American Art, Los Angeles County Museum of Art, Calif. Author of *Jacques Schnier: Art Deco and Beyond* (1998). Contributor to *The Figure in American Sculpture: A Question of Modernity* (1995), *American Masters: Sculpture from Brookgreen Gardens* (1997), and *Out of Rushmore's Shadow* (1999). Editor of *The Figure in American Sculpture: A Question of Modernity* (1995). Articles contributed to *The Encyclopedia of Sculpture*: UNITED STATES: 18TH CENTURY–1900; UNITED STATES: 1990–1960.

Foster-Rice, Gregory. Ph.D. Candidate, Department of Art History, Northwestern University, Evanston, Il. Contributor to *The Annals of Scholarship: Art Practices and the Human Sciences in a Global Culture* (2001). Articles contributed to *The Encyclopedia of Sculpture*: MALVINA HOFFMAN; FREDERIC REMINGTON.

Fowler, Cynthia. Assistant Professor, Wentworth Institute of Technology, Boston, Mass. Contributor to *Arts Around Boston*, and *Oculus*, and the *Mid-Atlantic Almanack*. Articles contributed to *The Encyclopedia of Sculpture*: DOROTHY DEHNER.

Gabler, Josephine. Ph.D. Stiftung für Bildhauerei, Berlin, Germany. Author of *Die Neue Wache Unter den Linden* (1992), *Henry Moore: Animals* (1997), *Georg Kolbe 1877–1947* (1997), *Der Tierbildhauer August Gaul* (1999), and *Wilhelm Lehmbruck* (2000). Articles contributed to *The Encyclopedia of Sculpture*: RUDOLF BELLING; KÄTHE KOLLWITZ.

Gahtan, Maia Wellington. University of Pennsylvania, Italian Studies Institute in Florence, Italy. Coauthor with Philip Jacks of *Vasari's Florence: Documents and Drawings* (1994). Contributor to *Journal of the Walters Art Museum* (2001) and *Popolazioni and Storia* (2001). Articles contributed to *The Encyclopedia of Sculpture*: AMBO; BENEDETTO ANTELAMI; PULPIT.

Gale, Amy E. Independent Scholar. Articles contributed to *The Encyclopedia of Sculpture*: FRANZ IGNAZ GÜNTHER; CLÉMENCE SOPHIE DE SERMÉZY.

Galotola, Antoniette. Ph.D. Instructor, Department of Liberal Studies, Parsons School of Design, New York. Contributor to *Parsons School of Design's On-Line Journal* (forthcoming). Articles contributed to *The Encyclopedia of Sculpture*: CLAES OLDENBURG: GIANT HAMBURGER (FLOOR BURGER).

Garcia, Miki. Contributor to *Ultrabaroque: Aspects of Post-Latin American Art* (2000), *St. James Guide to Hispanic Artists* (2002), and *Lateral Thinking: Art from the 1990s* (2002). Articles contributed to *The Encyclopedia of Sculpture*: ANISH KAPOOR; LOUISE NEVELSON.

Garfinkle, Charlene G. Independent Scholar of American Art, Santa Barbara, Calif. Author of "Women at Work: The Design and Decoration of the Woman's Building at the 1893 World's Columbian Exposition—Architecture, Exterior Sculpture, Stained Glass, and Interior Murals" (Ph.D. diss., 1996). Contributor to *American Art* (1993), *CAA: Reviews* (1999), *Stained Glass* (1999), *American National Biography* (1999), *Aurora* (forthcoming), *Historical Dictionary of the Gilded Age*, edited by Leonard Schlup and James G. Ryan (forthcoming), and *Woman's Art Journal* (forthcoming). Articles contributed to *The Encyclopedia of Sculpture*: ANNE SEYMOUR DAMER; SUSAN D. DURANT; ELISABET NEY; WOMEN SCULPTORS.

Getsy, David. Department of Art History, Dartmouth College, Hanover, N.H. Contributor to *Chicago Art Journal* (1997), *Documents* (2001), *Art Journal* (2001–02), *Look, See, Behold: The Spectator's Time* (2001), edited by Antoinette Roesler-Friedenthal and Johannes Nathan, *The Sculpture Journal* (2001), and *Visual Culture in Britain* (2002). Articles contributed to *The Encyclopedia of Sculpture*: ADOLF VON HILDEBRAND; DONALD JUDD; JEFF KOONS; LORD FREDERIC LEIGHTON; RICHARD SERRA; THORNYCROFT FAMILY.

†**Gibson, Katharine.** Ph.D. Art History, Courtauld Institute of Art, London. Contributor to *Master Drawings* (1992), *The Royal Exchange* (1997), edited by Ann Saunders, *Apollo* (1998, 1999), and *British Art Journal* (2000). Articles contributed to *The Encyclopedia of Sculpture*: JOHN BUSHNELL; CAIUS GABRIEL CIBBER; CAIUS GABRIEL CIBBER: RELIEF ON THE MONUMENT TO THE GREAT FIRE OF LONDON.

Gill, Eric. Studio Assistant, Department of Education, the Detroit Institute of Arts. Articles contributed to *The Encyclopedia of Sculpture*: ERIC GILL.

Gimenez, Alejandra. Ph.D. Candidate, Department of Art History, Temple University, Philadelphia, Pa. Articles contributed to *The Encyclopedia of Sculpture*: RENAISSANCE AND MANNERISM.

Giometti, Cristiano. Ph.D. candidate, Department of History of Art, University of Pisa, Italy. Coauthor with Lorenzo Carletti of *Guida alla Scultura Lignea Pisana* (2001), edited by Federico Motta. Contributor to *The Sculpture Journal* (1999), *The Lustrous Trade: Material Culture and the History of Sculpture in England and Italy 1700–1830* (2000), edited by Cinzia Sicca, Alison Yarrington, and *Allgemeines Künstler Lexikon*. Transla-

tor for *Valerio Belli: Un catalogo ragionato dei cristalli di rocca* (2000). Articles contributed to *The Encyclopedia of Sculpture*: CLAY AND TERRACOTTA; GIULIANO FINELLI; NINO PISANO; JOHN MICHAEL RYSBRACK; JOHN MICHAEL RYSBRACK: MONUMENT TO SIR ISAAC NEWTON; RENÉ-MICHEL [MICHEL-ANGE] SLODTZ; STUCCO (LIME PLASTER).

Giusti, Anna Maria. Opificio delle Pietre Dure, Florence, Italy. Articles contributed to *The Encyclopedia of Sculpture*: PIETRA DURA AND OTHER HARD STONE CARVING.

Goossens, Eymert-Jan. Curator, Royal Palace Amsterdam, The Netherlands. Author of *De Fonteyn van Pallas* (1994), *Treasure Wrought by Chisel and Brush: The Town Hall of Amsterdam in the Golden Age* (1996). Coauthor of *1648 War and Peace in Europe* (1998). Editor of *The Royal Palace of Amsterdam in Paintings of the Golden Age* (1997) and *A Distant Court Journey: Dutch Traders Visit the Shoguns of Japan* (2000). Contributor to *The Classical Ideal in the Golden Age* by Jacob van Kampen (1995), *War and Peace in Europe* (1998), and the *Court Historian* (1999). Articles contributed to *The Encyclopedia of Sculpture*: ANDREAS SCHLÜTER.

Grabar, Andrew. Associate Professor, Department of Art, University of Hawaii at Hilo. Author of *Primordial Beginnings* (1984). Articles contributed to *The Encyclopedia of Sculpture*: GYPSUM, ALABASTER, AND "EGYPTIAN" ALABASTER.

Granger, Gina Alexander. Independent Scholar, Grosse Pointe Park, Mich. Emeritus Assistant Curator of Education at the Detroit Institute of Arts. Coauthored (with Alicia Azuela) chapters on provenance and bibliography in *Diego Rivera: A Retrospective* (1986). Articles contributed to *The Encyclopedia of Sculpture*: ALEXANDER PORFIREVICH ARCHIPENKO; MERET OPPENHEIM; ERNST BARLACH; SARAH BERNHARDT.

Grash, Valerie S. Assistant Professor, Department of Fine Arts, University of Pittsburgh, Johnstown, Pa. Articles contributed to *The Encyclopedia of Sculpture*: ARA PACIS (AUGUSTAE); TRIUMPHAL ARCH.

Green, Stratton. Independent Scholar; formerly Hyde Art Museum, Glens Falls, N.Y. Articles contributed to *The Encyclopedia of Sculpture*: PHEIDIAS: *ATHENA PARTHENOS*.

Greenwood, Martin. Freelance Writer and Researcher. Contributor to *The Parian Phenomenon*, edited by Paul Atterbury (1989), *Patronage and Practice: Sculpture on Merseyside*, edited by Penelope Curtis (1989), the *Dictionary of Art*, edited by Jane Turner (1996), *Essays in the Study of Sculpture* (1999), and the *New Dictionary of National Biography* (forthcoming). Articles contributed to *The Encyclopedia of Sculpture*: RAFFAELLE MONTI; ALFRED STEVENS.

Guerriero, Simone. Articles contributed to *The Encyclopedia of Sculpture*: ANTONIO BONAZZA; JOSSE DE (GIUSTO LE COURT) CORTE.

Haag, Sabine. Ph.D., Curator, Kunstkammer, Kunsthistorisches Museum Wien, Vienna, Austria. Author of *Studien zur Elfenbeinskulptur des 17. Jahrhunderts* (1994) and *Masterpieces of the Kunsthistorisches Museum: The Ivory Collection* (2001), edited by Wilfried Seipel. Contributor to *The J. Paul Getty Museum Journal* (1996), *Christoph Daniel Schenck 1633–1691* (1996), *Geschichte der bildenden Kunst in Österreich: Barock* (1999), edited by Hellmut Lorenz, *Religion in Geschichte und Gegenwart* (1999), edited by Hans Dieter Betz et al., and *Bulletin of the Detroit Institute of Arts* (2002). Articles contributed to *The Encyclopedia of Sculpture*: AMBER; IVORY SCULPTURE: RENAISSANCE–MODERN.

Hagans, William. Independent Scholar. Author of *Zorn in America: Saga of a Swedish Artist* (unpublished, 1998). Contributor to *Coins Magazine* (1995, 1997, 1999). Articles contributed to *The Encyclopedia of Sculpture*: AUGUSTUS SAINT-GAUDENS; AUGUSTUS SAINT-GAUDENS: SHAW MONUMENT.

Hall, Marjorie J. Professor of Art History, Arts Program, Wheelock College, Boston, Mass. Contributor to *Arte Medievale* (2001) and *The Meeting of Two Worlds: The Crusades and the Mediterranean Context* (exhib. cat., 1981). Articles contributed to *The Encyclopedia of Sculpture*: FRANCE: ROMANESQUE–GOTHIC; BERNARDUS GELDUINUS.

Hamilton, Jeffrey D. Professor, Department of Art History, Savannah College of Art and Design, Ga. Articles contributed to *The Encyclopedia of Sculpture*: HORATIO GREENOUGH; PAPIER MÂCHÉ; PUBLIC SCULPTURE; REVIVALISM.

Hámori, Katalin. Ph.D. Independent Scholar, Budapest, Hungary. Author of *Collection of Baroque Sculptures, Guide, Museum of Fine Arts, Budapest* (1994). Coauthor of *Reoccupation of Buda in 1686* (1986), *Georg Raphael Donner and Bratislava* (1992), and *Baroque Art in Central-Europe* (1992). Articles contributed to *The Encyclopedia of Sculpture*: FERDINAND MAXIMILIAN BROKOF; CENTRAL EUROPE; GEORG RAPHAEL DONNER; JOHANN MEINRAD GUGGENBICHLER; LEONHARD KERN; FRANZ XAVER MESSERSCHMIDT; FRANZ XAVER MESSERSCHMIDT: *CHARACTER HEADS*.

Hartog, Arie. Curator, Gerhard Marcks-Haus, Bremen, Germany. Author of *Tajiri: Bildhauerei gegen die Langeweile* (2001). Coauthor of *Bernhard Hoetger* (1998), edited by Maria Anczykowski. Coauthor with Veronika Wiegartz of *Von Paradiesen und Infernos, Expressionistische Bildgeschichten* (1999). Contributor to *Henry Moore: Liegende* (1999), edited by Ferdinand Ullrich, and *Wilhelm Lehmbruck* (2000), edited by Martina Rudloff and Dietrich Schubert. Articles contributed to *The Encyclopedia of Sculpture*: GERMANY: 20th CENTURY–CONTEMPORARY; GERHARD MARCKS.

Hay, Jennifer. Curator, Christchurch Art Gallery, New Zealand. Coauthor with Rob Garrett of *Light and Illusion: Diffrench* (2000), edited by Jennifer Hay and Felicity Milburn. Coauthor with Bruce Barber, Blair French, Tony Green, Nick Spill of *Intervention: Post Object and Performance Art in New Zealand* (2000), edited by Jennifer Hay and Felicity Milburn.

Coauthor with Felicity Milburn and Neil Roberts of *150 Years of Art in Canterbury* (2000), edited by Merilynne Evans. Articles contributed to *The Encyclopedia of Sculpture*: PERFORMANCE ART.

Hecker, Sharon. Independent Scholar. Contributor to *Bollettino dell' Accademia degli Euteleti* (1998), *The Burlington Magazine* (1996, 2000), and *Maestri dell'Ottocento e Novecento della Galleria Ricci-Oddi'* (1997), and *1900: Art at the Crossroads* (2000). Articles contributed to *The Encyclopedia of Sculpture*: MEDARDO ROSSO.

Heinrichs-Schreiber, Ulrike. Ph.D. Institute of History of Art, Ruhr-Universität Bochum, Germany. Contributor to *the Allgemeines Künstlerlexikon (AKL)*. Articles contributed to *The Encyclopedia of Sculpture*: PIETÀ.

Henriksson, Linda. Curator, Research Department, Nationalmuseum, Stockholm, Sweden. Articles contributed to *The Encyclopedia of Sculpture*: SCANDINAVIA: SWEDEN.

Holcomb, Melanie. Department of Medieval Art, Metropolitan Museum of Art, New York. Articles contributed to *The Encyclopedia of Sculpture*: IVORY SCULPTURE: EARLY CHRISTIAN–ROMANESQUE.

Hornbrook, Kathleen. Adjunct Faculty, Arts and Humanities Division, Lorain County Community College, Elyria, Ohio. Articles contributed to *The Encyclopedia of Sculpture*: WÄINÖ AALTONEN; NATABORI; FRANCISCO SALZILLO.

Hufschmidt, Tamara. Ph.D. Kunsthistorisches Institut, Florence, Italy. Author of *Adolf von Hildebrand: Architektur und Plastik seiner Brunnen* (1995). Contributor to *Arnold Böcklin e la cultura artistica in Toscana* (1980), *Von Hildebrand bis Kricke* (1985), *Antico Caffè Greco: Storia Ambiente Collezioni* (1991), and *Tadolini Adamo, Scipione, Giulio, Enrico: Quattro generazioni di scultura nei secoli XIX e XX* (1996). Articles contributed to *The Encyclopedia of Sculpture*: LUIGI BIENAIMÉ; ITALY: NEOCLASSICISM–19th CENTURY.

Hughes, Lisa A. Visiting Assistant Professor, Department of Classics, Miami University of Ohio, Oxford, Ohio. Term-Certain Instructor, Greek and Roman Studies, University of Calgary, Alberta, Canada. Contributor to *Classical Outlook* (1998–2001), *Bryn Mawr Electronic Resources Review* (2000), and *Bryn Mawr Classical Review* (2000–01). Articles contributed to *The Encyclopedia of Sculpture*: STELA.

Hunter, John. Associate Dean, College of Arts and Sciences, Cleveland State University, Ohio. Contributor to *Master Drawings* (1988) and *Art Bulletin* (1993). Articles contributed to *The Encyclopedia of Sculpture*: FILARETE (ANTONIO DI PIETRO AVERLINO); ROSSELLINO FAMILY; ANDREA SANSOVINO; ANDREA SANSOVINO: TOMBS OF ASCANIO MARIA SFORZA AND CARDINAL GIROLAMO BASSO DELLA ROVERE.

Huober, Silvia. Scholar and Researcher, Department of Art History, University of Pisa, Florence, Italy. Coauthor of

Castello, campagna medicea, periferia urbana, catalogue of Exhib. (1984). Contributor to *MCM la rivista delle Arti Minori* (1992), *Bollettino Ufficiale del Sacro Romano Impero* (1997), and *Amici dei Musei Fiorentini* (1997). Articles contributed to *The Encyclopedia of Sculpture*: MELCHIORRE CAFFÀ; CARICATURE.

Janoray, Charles. Sculpture Dealer. Coauthor with Jean-Loup Champion and editor of *Antiquity Revisited: The Classical Tradition in Sculpture from Houdon to Guillaume* (2000) and *French Romantic Sculpture from Rude to Préault* (2001). Articles contributed to *The Encyclopedia of Sculpture*: FÉLICIE DE FAUVEAU.

Jones, Jonathan R. Hayward Gallery, London, U.K. Contributor to *Contemporary Visual Arts* (1998–2001), *Modern Painters* (1998–2001), *Art Review* (2001), *Contract Furnishing* (2000–01). Articles contributed to *The Encyclopedia of Sculpture*: STEPHAN BALKENHOL; THOMAS SCHÜTTE.

Jopek, Norbert. (Adviser.) Victoria and Albert Museum, London, U.K.

Jung, Jacqueline E. Professor, Department of History of Art and Architecture, Middlebury College, Middlebury, Vt. Contributor to *Last Things: Death and the Apocalypse in the Middle Ages* (2000), edited by Caroline Walker Bynum and Paul Freedman, and *Art Bulletin* (December 2000). Articles contributed to *The Encyclopedia of Sculpture*: GOTHIC SCULPTURE.

Kachurin, Pamela J. Research Associate, Davis Center for Russian Studies, Harvard University, Cambridge, Mass. Coeditor of *Journal of Cold War Studies* (2001). Contributor to *Drawing* (1996), *Biuletyn Historii Sztuki* (1998), and *Journal of Cold War Studies* (2001). Articles contributed to *The Encyclopedia of Sculpture*: IVAN SHADR.

Kammel, Frank Matthias. Ph.D. Skulpturensammlung, Germanisches Nationalmuseum, Nuremberg, Germany. Author and coeditor of *Mittelalterische Plastik in der Mark Brandenburg* (1990) and *Altdeutsche Tafelmalere auf denn Prüfstand* (2000). Author of *Kunst in Erfurt, 1300–1360* (2000), *Spiegel der Seligkeit: Privates Bild und Frömmigkeit im Spätmittelalter* (2000) and *Kleine Erkstasen: Barocke Meisterwerke aus der Sammlung Dessauer* (2001). Contributor to *Figur und Raum*, edited by Uwe Albrecht (1994), *Meisterwerke Mittelalterlicher Skulptur*, edited by Hartmut Krohm (1996), and *Skulptur in Süddeutschland 1400–1770*, edited by Rainer Kahsnitz (1998). Articles contributed to *The Encyclopedia of Sculpture*: PETER FLÖTNER; ADAM KRAFT; ADAM KRAFT: SCHREYER-LANDAUER MONUMENT; VEIT STOSS; VEIT STOSS: HIGH ALTAR, CHURCH OF ST. MARY.

Karpova, Elena V. Ph.D. Candidate, Head of Department of Sculpture, The State Russian Museum, St. Petersburg, Russia. Author of *Russian Terracotta XVIII–Early XIX* (1995) and *J.D. Rachette: 1774–1809* (1999). Contributor to *Hudozhnik* (1988, 1991), *Palaces of the Russian Museum* (1994), *Gazette des Beaux-Arts* (October/January 1996, May 1997), *Monuments of*

Culture: New Discoveries: Yearbook 1997 (1998), *Monuments of Culture: New Discoveries: Yearbook 1999* (2000). Articles contributed to *The Encyclopedia of Sculpture*: MIKHAIL (IVANOVICH) KOZLOVSKY; IVAN (PETROVICH) MARTOS; FEDOT SHUBIN.

Kennedy, Janet. Professor, Department of History of Art, Indiana University, Bloomington. Author of *The "Mir iskusstva" Group and Russian Art 1898–1912* (1977). Contributor to *Art and Culture in Nineteenth-Century Russia* (1983), edited by Theofanis Stavrou, *Petrushka: Sources and Contexts* (1998), edited by Andrew Wachtel, *Tchaikovsky and His World* (1998), edited by Leslie Kearney, and *Defining Russian Graphic Arts* (1999), edited by Alla Rosenfeld. Articles contributed to *The Encyclopedia of Sculpture*: ANNA GOLUBKINA; SERGEI KONYONKOV.

Kennedy, Trinita. Ph.D. Candidate, Institute of Fine Arts, New York University. Articles contributed to *The Encyclopedia of Sculpture*: FRANCESCO DI GIORGIO MARTINI.

Kidder, J. Edward, Jr. Professor Emeritus, Division of Humanities, International Christian University, Tokyo, Japan. Author of *Japan before Buddhism* (1959, 1966), *Masterpieces of Japanese Sculpture* (1961), *Japanese Temples* (1964), *Early Buddhist Japan* (1972), *The Art of Japan* (1985), *and The Lucky Seventh: The Early Hōryū-Ji and Its Time* (1999). Contributor to *Artibus Asiae* (1952–54), *Archaeology* (1958, 1973), *Transactions of the Asiatic Society of Japan* (1966, 1985, 1991), *Asian Perspectives* (1968), *Orientations* (1972, 1990), *Monumenta Nipponica* (1972, 1987, 1989–90), and the *Japanese Journal of Religious Studies* (1992). Articles contributed to *The Encyclopedia of Sculpture*: KAIKEI; JAPAN; UNKEI; YOSEGI-ZUKURI.

Kirch, Lisa. Articles contributed to *The Encyclopedia of Sculpture*: GREGOR ERHART.

Kitzlinger, Christine. Ph.D. Candidate. Department of Art History, Technische Universität Berlin, Germany. Coauthor with Peter Vignau-Wilberg of *Albert Renger-Patzsch, 1897–1966: Architektur im Blick des Fotografen.* (1997). Articles contributed to *The Encyclopedia of Sculpture*: HANS BRÜGGEMANN.

Klein, Deepanjana Danda. Independent Scholar. New York. Contributor to *Journal of Indian Anthropological Society, Deep Focus*, and *Anandam* (1998). Articles contributed to *The Encyclopedia of Sculpture*: INDIA: INDUS VALLEY CIVILIZATION–GUPTA; INDIA: MODERN.

Klemenčič, Matej. Department of Art History. University of Ljubljana. Author of *Francesco Robba in Beneško Baročno Kiparstvo v Ljubljani* (1998). Contributor to *Gotik in Slowenien*, edited by Janez Höfler (1995), *Zbornik za Umetnostno Zgodovino* (1996), *Acta Historiae Artis Slovenica* (1997), *Arte, Storia, Cultura e Musica in Friuli Nell'Età del Tiepolo*, edited by Caterina Furlan and Giuseppe Pavanello (1998). Articles contributed to *The Encyclopedia of Sculpture*: ANTONIO CORRADINI.

Krohm, Hartmut. Skulpturensammlung und Museum für Byzantinische Kunst, Berlin. Articles contributed to *The Encyclopedia of Sculpture*: NIKOLAUS GERHAERT VON LEIDEN.

Krivdina, Olga A. Ph.D. Candidate. Department of Sculpture. State Russian Museum. St Petersburg, Russia. Author of *Mark Antokolsky Catalog* (1994) and *Ivan Vitali Annals* (2000). Contributor to *Teatrum Machinarum Catalog* (1993), *Revue de l'Art/Sculpture XIX siecle: N 104* (1994), *Artist: N 1* (1998), *Scandinavian Reading 1998* (1999), *Petersburg Reading 1998–99* (1999), *St. Petersburg University: N 20* (2000), *The World of Museum: N 4* (2000), and *Joung Artist: N 10* (2000). Articles contributed to *The Encyclopedia of Sculpture*: MARK MATVEYEVICH ANTOKOL'SKY; IVAN (PETROVICH) VITALI.

Kryza-Gersch, Claudia. Ph.D. Independent Scholar. Andrew W. Mellon Fellow, Department of European Sculpture and Decorative Arts, the Metropolitan Museum of Art, New York. Contributor to *The Burlington Magazine* (1998), *Nuovi Studi* (1998), *La bellissima maniera: Alessandro Vittoria e la scultura veneta del Cinquecento* (1999), edited by Andrea Bacchi, Lia Camerlengo, and Manfred Leithe-Jasper, and *Small Bronzes in the Renaissance* (2001), edited by Debra Pincus. Articles contributed to *The Encyclopedia of Sculpture*: TIZIANO ASPETTI; NICOLÒ ROCCATAGLIATA.

Kuhlemann, Michael. Ph.D. Department of Art History, Mülheim an der Ruhr, Germany. Author of *Michelangelo Naccherino: Skulptur zwischen Florenz und Neapel um 1600* (1999) and *Kunst und Praxis* (2000), edited by Wilhelm Lehmbruck Museum Duisburg. Contributor to *Mittelalterliche Bildwerke aus dem Museum im Roselius-Haus* (1999), *Rodin und die Skulptur im Paris der Jahrhundertwende* (2000) and *Zwischen den Welten: Beiträge zur Kunstgeschichte für Jürg Meyer zur Capellen* (2001), edited by Damian Dombrowski. Articles contributed to *The Encyclopedia of Sculpture*: GERMANY: BAROQUE–NEOCLASSICAL.

Kusch, Britta. Ph.D. Westfälische-Wilhelms Universität, Münster, Westfalen, Germany. Contributor to *Mitteilungen des Kunsthistorischen Instituts in Florenz* (1997). Articles contributed to *The Encyclopedia of Sculpture*: PIERINO DA VINCI.

Lacoss, Don. Articles contributed to *The Encyclopedia of Sculpture*: HANS BELLMER; SURREALIST SCULPTURE.

Lai, Guolong. Society of Fellows in the Humanities, Heyman Center, Columbia University, New York. Coauthor of *A Journey into China's Antiquity* (1997). Contributor to *Journal of Asian Culture* (1995–96) and *Orientations* (1999, 2001). Articles contributed to *The Encyclopedia of Sculpture*: CHINA: NEOLITHIC–SIX DYNASTIES.

Lamia, Stephen. Associate Professor, Department of Visual Arts, Dowling College, Oakdale, N.Y. Coeditor with Elizabeth Valdez del Alamo of *Decorations for the Holy Dead: Visual Embellishment on Tombs and Shrines of Saints* (2001). Contributor to *Encyclopedia of Iconography* (1998), edited by Helene E. Roberts, and *Memory and the Medieval Tomb* (2000), edited

by Elizabeth Valdez del Alamo. Editor of *Mediterranean Perspectives* (1994–). Articles contributed to *The Encyclopedia of Sculpture*: TOMB SCULPTURE.

Langmead, Alison. Ph.D. Candidate. Department of Art History and Archaeology, Columbia University. Contributor to *Timeline of Western Art* (2001). Articles contributed to *The Encyclopedia of Sculpture*: ENGLAND AND WALES: GOTHIC (*ca.* 1150–1500).

Lapatin, Kenneth D.S. Curator, Department of Antiquities, The J. Paul Getty Museum, Los Angeles, Calif. Author of *Chryselephantine Statuary in the Ancient Mediterranean World* (2001) and *Mysteries of the Snake Goddess: Art, Desire, and the Forging of History* (2002). Contributor to *American Journal of Archaeology* (1988, 1996–98), *The Art Bulletin* (1997), *International Journal of the Classical Tradition* (1998, 2000–01), *Archaeology* (1999, 2001), *Antiquity and Its Interpreters* (2000), edited by A. Payne, A. Kuttner, and R. Smick, *Encyclopedia of Greece and the Hellenic Tradition* (2000), edited by Graham Speake, *Oxford Companion to Western Art* (2001), edited by Hugh Brigstocke, and *Journal of Mediterranean Archaeology* (2001). Articles contributed to *The Encyclopedia of Sculpture*: CHRYSELEPHANTINE SCULPTURE; LYSIPPOS; LYSIPPOS: *APOXYOMENOS* (MAN SCRAPING HIMSELF WITH A STRIGIL); PHEIDIAS.

Lee, Cecilia Hae-Jin. Writer. Articles contributed to *The Encyclopedia of Sculpture*: MARCEL DUCHAMP; MARCEL DUCHAMP: *LARGE GLASS* (*THE BRIDE STRIPPED BARE BY HER BACHELORS, EVEN*).

Lefftz, Michel. Professor, Department of Art History and Archeology, Université Catholique de Louvain, Louvain-la-Neuve, Belgium. Author of *Belgian Sculpture* (2001). Coauthor with Muriel Van Rymbeke of *Le maître de Waha* (2000). Contributor to *Revue des archéologues et historiens de l'art de Louvain* (1987), *Annales de la Société archéologique de Namur* (1994), *Piété baroque* (1995), *Revue des historiens de l'art, des archéologues, des musicologues et des orientalistes de l'Ulg* (1996), *L'abbaye de Floreffe, 1121–1996* (1996), *Bulletin de l'Institut archéologique liégeois* (1996), *Bulletin de la Société royale Le vieux Liège* (1998), and *L'ancienne église abbatiale de Saint-Hubert* (2001), Articles contributed to *The Encyclopedia of Sculpture*: JEAN DELCOUR.

Lemny, Doïna. Ph.D. Assistant Curator for Collections and Special Exhibitions, Historical Collections 20th Century, Musée National d'Art Moderne, Centre Georges Pompidou, Paris, France. Coauthor with with Marielle Tabart of *L'Atelier Brancusi: La collection* (1997), *La Colonne sans fin* (1998), *Leda* (1999), *Le Baiser* (1999), and *Brancusi and Duchamp* (2000). Articles contributed to *The Encyclopedia of Sculpture*: TONY CRAGG; JACOB EPSTEIN: *ROCK DRILL*; MAX ERNST; JULIO GONZÁLEZ; ANTOINE PEVSNER.

Lenaghan, Julia. Articles contributed to *The Encyclopedia of Sculpture*: COLUMN OF MARCUS AURELIUS; EQUESTRIAN STATUE OF MARCUS AURELIUS; GREAT ELEUSINIAN RELIEF; PORTRAIT: ANCIENT ROME; SPINARIO; VENUS DE MILO.

Lenaghan, Patrick. Research Assistant, Cast Gallery, Ashmolean Museum, Oxford. Curator, Department of Prints and Photographs, The Hispanic Society of America, New York. Author of *Images for the Spanish Monarchy: Art and the State, 1516–1700* (1998), *From Goya to Picasso: A Century of Spanish Printmaking* (1998), and *Images in Procession: Testimonies to Spanish Faith* (2000), *Commemorating a Real Bastard: The Chapel of the Count of Luna in Memory and the Medieval Tomb* (2000), edited by Elizabeth Valdez del Alamo, and contributor to the *Oxford Companion to Western Art* (2001), edited by Hugh Brigstocke. Contributor to *the Journal of Roman Studies* and *the Sculpture Journal* (1998) and (2000). Editor of *The Hispanic Society of America Tesoros* (2000). Articles contributed to *The Encyclopedia of Sculpture*: ALONSO BERRUGUETE; DOMENICO FANCELLI; GREGORIO FERNÁNDEZ; JUAN DE JUNI; PEDRO DE MENA (Y MEDRANO); BARTOLOMÉ ORDÓÑEZ; SPAIN: RENAISSANCE AND BAROQUE; FELIPE VIGARNY.

Levin, Cecelia. Ph.D. Department of Art of Asia, Oceania and Africa, Museum of Fine Arts, Boston, Mass. Contributor to *Precious Metals in Early South East Asia* (1999), edited by Wilhelmina H. Kal, and *Narrative Sculpture and Literary Traditions in South and Southeast Asia* (2000), edited by Marijke J. Klokke. Articles contributed to *The Encyclopedia of Sculpture*: BOROBUDUR; LORO JONGGRANG TEMPLE COMPLEX.

Levine, Sura. Associate Professor of Art History, Hampshire College, Amherst, Mass. Author of *Hommage à Constantin Meunier* (1998). Coauthor of *Les XX and the Belgian Avant-Garde: Prints, Drawings, and Books ca. 1890* (1992) and *Les Vingt ans de avant-garde in Belgie* (1992). Contributor to *Maximilien Luce, 1858–1941: Peintre anarchiste* (1995), *Minerva. Jenaer Schriften zur Kunstgeschichte* (1996), and *The Stanford University Museum of Art Journal* (1996–97). Member of editorial board for *Nineteenth-Century Art Worldwide* (2001). Articles contributed to *The Encyclopedia of Sculpture*: CONSTANTIN MEUNIER; GEORGE MINNE.

Levkoff, Mary L. Curator of European Sculpture, Department of European Painting and Sculpture, Los Angeles County Museum of Art, Calif. Author of *Rodin in His Time: The Cantor Gifts to the Los Angeles County Museum of Art* (1994, 2000). Contributor to *Bulletin de la Société de l'Histoire de l'Art français* (1989), *The Ahmanson Gifts: European Masterpieces in the Los Angeles County Museum of Art* (1991), *Germain Pilon et les sculpteurs de la Renaissance française* (1993), *The Currency of Fame: The Renaissance Portrait Medal* (1993), *The Sculpture Journal* (2000), and *Rodin: A Magnificent Obsession, the Iris and B. Gerald Cantor Foundation* (2001). Articles contributed to *The Encyclopedia of Sculpture*: PIERRE BONTEMPS; MATHIEU JACQUET (CALLED GRENOBLE); GERMAIN PILON; GERMAIN PILON: TOMB OF HENRI II AND CATHERINE DE' MEDICI; RICCIO (ANDREA BRIOSCO); AUGUSTE RODIN; AUGUSTE RODIN: *GATES OF HELL*; NICHOLAS STONE.

Lewis, Douglas. Curator of Sculpture and Decorative Arts, National Gallery of Art, Washington, D.C. Author of *The Draw-*

ings of Andrea Palladio (1981, 2000), and *National Gallery of Art Systematic Catalogue: Plaquettes* (2002). Editor of *Artibus et Historiae* (1997). Contributor to *Arte Veneta* (1973, 1976), *Studies in the History of Art* (1974, 1987, 1989–90, 1997), *The Burlington Magazine* (1979, 2000), *Mitteilungen des Kunsthistorischen Institutes in Florenz* (1983), *Renaissance Master Bronzes from the Kunsthistorisches Museum, Vienna* (1986), edited by Donald R. McClelland, *Valerio Belli Vicentino, c. 1468–1546* (2000), and *Studies in the History of Art, Symposium Papers: Small Bronzes* (2001), edited by Debra Pincus. Articles contributed to *The Encyclopedia of Sculpture*: PLAQUETTE.

Lieuallen, Rocco. Ph.D. candidate. Department of Fine Art, University of Edinburgh, Scotland. Articles contributed to *The Encyclopedia of Sculpture*: CONSTANTIN BRANCUSI; CONSTANTIN BRANCUSI: *BIRD IN SPACE*; SCOTLAND.

Lock, Léon E. Ph.D. Candidate. History of Art Department, University College London, University of London, U.K. Articles contributed to *The Encyclopedia of Sculpture*: LUCAS FAYDHERBE; NETHERLANDS AND BELGIUM; DE NOLE FAMILY.

Luchs, Alison. Curator of Early European Sculpture, National Gallery of Art, Washington, D.C. Author of *Cestello: A Cistercian Church of the Florentine Renaissance* (1977), *The Convent of Santa Maria Maddalena de' Pazzi and Its Works of Art* (1990), and *Tullio Lombardo and Ideal Portrait Sculpture in Renaissance Venice, 1490–1530* (1995). Coauthor of *Western Decorative Arts, Part I* (1993). Editor of *Italian Plaquettes [Studies in the History of Art]* (1989). Contributor to *The Burlington Magazine* (1975, 1977, 1983, 1990), *Zeitschrift fur Kunstgeschichte* (1985), *The Art Bulletin* (1989), *Apollo* (1999), and *The Sculpture Journal* (2000). Translator of *Martin Wackernagel: The World of the Florentine Renaissance Artist* (1981). Articles contributed to *The Encyclopedia of Sculpture*: LOMBARDO FAMILY; RIMINI MASTER.

†**Luckyj, Natalie.** Articles contributed to *The Encyclopedia of Sculpture*: CANADA.

Machado, John L., Jr. Ph.D. Candidate. Department of Art and Art History, University of Texas at Austin. Articles contributed to *The Encyclopedia of Sculpture*: MELANESIA; NEW GUINEA.

Machmut-Jhashi, Tamara. Assistant Professor of Art History, Department of Art and Art History, Oakland University, Rochester, Minn. Articles contributed to *The Encyclopedia of Sculpture*: ALEKSANDR MATVEYEV; PAOLO TROUBETZKOY.

Maksymowicz, Virginia. Assistant Professor, Department of Art and Art History, Franklin and Marshall College, Lancaster, Pa. Coeditor of *Art and Artists* (1986–89). Contributor to *Art and Artists* (1985–89), *High Peformance* (1987, 1992), *Women Artists News* (1990–98), *The Female Body: Figures, Styles, Speculations* (1991), edited by Laurence Goldstein, *Art and the Public Sphere* (1992), edited by W.J.T. Mitchell, and *Sculpture Magazine* (1997–). Articles contributed to *The Encyclopedia of Sculpture*: ANTONY GORMLEY; INSTALLATION.

Mariaux, Pierre Alain. *Chargé de cours*, Institut d'Histoire de l'Art, Université de Neuchâtel, Switzerland. Author of *La Majolique: La faïence italienne et son décor* (1994). Contributor to *Gazette des Beaux-Arts* (1993), *Apocrypha* (1996), *Revue Suisse d'Art et d'Archéologie* (1996), *Lexikon des Mittelalters* (1997), and *Études de Lettres* (1999). Articles contributed to *The Encyclopedia of Sculpture*: COSMATI; IVORY AND BONE; IVORY SCULPTURE: ANCIENT; LORSCH GOSPEL COVERS; RAINER OF HUY.

Marincola, Michele. Professor of Conservation, New York University. Contributor to *Zeitschrift für Kunsttechnologie und Konservierung* (1997), *Metropolitan Museum of Art Bulletin* (1997–98), *Painted Wood: History and Conservation* (1998), *Tilman Riemenschneider: Master Sculptor of the Later Middle Ages* (1999), *The Sculpture Journal* (2000), and *Journal of the American Institute for Conservation* (2001). Articles contributed to *The Encyclopedia of Sculpture*: POLYCHROMY.

Martin, Frank. Leiter der Arbeitsstelle, Glasmalereiforschung des Corpus Vitrearum Medii Aevi, Berlin-Brandenburgische Akademie der Wissenschaften, Potsdam, Germany. Author of *Die Apsisverglasung der Oberkirche von San Francesco in Assisi* (1993) and *Die Glasmalereien von San Francesco in Assisi* (1997). Contributor to *Gesta* (1996), *Antologia di Belle Arti* (1996), *Zeitschrift für Kunstgeschichte* (1998), *The Sculpture Journal* (2000), and *The Burlington Magazine* (2000). Articles contributed to *The Encyclopedia of Sculpture*: CAMILLO RUSCONI.

Marvick, Andrew. Assistant Professor of Art History, Art Department, Southwestern Oklahoma State University, Weatherforrd, Okla. Contributor to *The Dutch and America* (1982), *The Journal of Pre-Raphaelite Studies* (1997), and *International Review of Modernism* (1998). Articles contributed to *The Encyclopedia of Sculpture*: CÉSAR (BALDACCINI); JEAN-LÉON GÉRÔME; MODERNISM; KURT SCHWITTERS (HERMAN EDWARD KARL JULIUS).

Mason, Miranda. M.A. School of Fine Art, History of Art and Cultural Studies, University of Leeds, U.K. Freelance critic on contemporary art. Articles contributed to *The Encyclopedia of Sculpture*: DUPRÉ FAMILY; MARY EDMONIA LEWIS; ANNE WHITNEY.

Mato, Daniel. Ph.D. Professor, Department of Art History, University of Calgary, Alberta, Canada. Author of *Weaver and Carver* (1979) and *Weber und Schnitzer in Westafrika* (1987). Coauthor with Charles Miller of *Sande, Masks and Statues From Liberia and Sierra Leone* (1990). Contributor to *Mitteilungen aus dem Museum für Volkerkunde Hamburg* (1983), *Glenbow Museum* (1995), and *Chac Mool* (2001). Member of editorial board for *Africa Occasional Papers* (2001) and *Ghana Study Council* (2001). Articles contributed to *The Encyclopedia of Sculpture*: AFRICA: PRE-20th CENTURY.

McBreen, Ellen. Ph.D. Candidate, Institute of Fine Arts, New York University. Contributor to *ArtNet Magazine* (1998–2000)

and *Art Journal* (1998). Articles contributed to *The Encyclopedia of Sculpture*: ÉMILE-ANTOINE BOURDELLE.

McCallum, Donald. (Adviser.) University of California, Los Angeles.

McFadden, Jane. Independent Scholar. Los Angeles, Calif. Articles contributed to *The Encyclopedia of Sculpture*: WALTER DE MARIA; EDWARD AND NANCY REDDIN KIENHOLZ.

McIntyre, Kellen Kee. Assistant Professor of Art History, Department of Art and Art History, University of Texas, San Antonio. Author of *Rio Grande Blankets: Late Nineteenth-Century Textiles in Transition* (1992). Contributor to *La Amplitud del modernismo, 1861–1920* (forthcoming), edited by Stacie Widdifield. Articles contributed to *The Encyclopedia of Sculpture*: LATIN AMERICA.

McManamy, Kevin. Ph.D. Independent Scholar. Visiting Assistant Professor, Art History, University of Wisconsin, Eau Claire, Wis. Translator of *The Cologne Cathedral: A Virtual Tour through 2000 Years of Art, Culture, and History* (1999). Contributor to *Monatshefte* (1998). Articles contributed to *The Encyclopedia of Sculpture*: ALTARPIECE: NORTHERN EUROPE; ANTEPENDIUM; GERMANY: GOTHIC–RENAISSANCE; BAPTISMAL FONT; HANS MULTSCHER; HANS MULTSCHER: *MAN OF SORROWS*; MICHAEL PACHER; JÖRG SYRLIN THE ELDER.

Mesch, Claudia. Assistant Professor, Department of Art, Cleveland State University, Ohio. Contributor to *Dialogue* (1998–2000), *Sculpture* (1998–2000), *M/C: A Journal of Media and Culture* (2000), and *Art History* (2000). Articles contributed to *The Encyclopedia of Sculpture*: JOSEPH BEUYS; JOSEPH BEUYS: *TRAMSTOP*; KATHARINA FRITSCH.

Messer Diehl, Elizabeth R. Assistant Professor, Landscape Architecture, West Virginia University, Morgantown. Editor of *Journal of Therapeutic Horticulture* (1999–). Associate Editor of *Interaction by Design* (2001), edited by Candice Shoemaker. Contributor to *Journal of Therapeutic Horticulture* (1998, 1996), *Journal of Regional Science* (2000), *Encyclopedia of Garden History* (2001), edited by Candice Shoemaker, *Permaculture Activist* (March 2001). Articles contributed to *The Encyclopedia of Sculpture*: GARDEN SCULPTURE/SCULPTURE GARDENS.

Mezzatesta, Michael P. Director, Duke University Museum of Art, Duke University, Durham, N.C. Articles contributed to *The Encyclopedia of Sculpture*: LEONI FAMILY; LEONI FAMILY: *CHARLES V RESTRAINING FURY*.

Miller, Stephanie R. National Gallery of Art, Washington, D.C. Contributor to *Professional Printmaking in the 16th Century Netherlands: Selections from Bloomington Collections* (1994) and *The Studio* (1999). Articles contributed to *The Encyclopedia of Sculpture*: EQUESTRIAN STATUE; DOMENICO GAGGINI; GIOVANNI DI BALDUCCIO.

Mino, Katherine R. Tsiang. Ph.D., Supervisor of East Asian Art Research Materials, Department of Art History, University of Chicago. Contributor to *Between Han and Tang: Religious Art and Archeology in a Transformative Period* (2000), edited by Wu Hung and *Orientations* (2000). Articles contributed to *The Encyclopedia of Sculpture*: CHINA: SUI AND TANG DYNASTIES; CHINA: FIVE DYNASTIES, LIAO, SONG, AND JIN.

Mirabella, Stephen. Sculptor. Contributor to *Sculpture Review* (1997), *National Sculpture Society Newsletter* (1999), and *American Arts Quarterly* (2000). Articles contributed to *The Encyclopedia of Sculpture*: IVAN MEŠTROVIĆ; RELIEF SCULPTURE.

Miss, Stig. (Adviser.) Director of Thorvaldsens Museum, Copenhagen, Denmark. Articles contributed to *The Encyclopedia of Sculpture*: BERTEL THORVALDSEN.

Mitchell, Claudine. Ph.D. Department of Fine Art, University of Leeds, U.K. Author of *Time in Painting* (1985) and *On the Brinck* (1992). Contributor to *Art History* (1987–89, 2002), *Oxford Art Journal* (1987), *Feminist Review* (1989), *Reflections of Revolution: Images of Romanticism* (1993), edited by Alison Yarrington and K. Everent, *Sculpt Age* (1994), *Fitzroy Dearborn's Dictionary of Women Artists* (1996), and *Work in Modern Times II* (2000). Articles contributed to *The Encyclopedia of Sculpture*: CAMILLE CLAUDEL; FRANCE: MID–LATE 19TH CENTURY; FRANCE: 20TH CENTURY–CONTEMPORARY; JANE POUPELET; AUGUSTE RODIN: MOMUMENT TO HONORÉ DE BALZAC.

Moriarty, Catherine. Ph.D. Curator and Research Fellow, Design History Research Centre (Design Council Archive), University of Brighton, U.K. Author of *The Sculpture of Gilbert Ledward* (2003). Contributor to *Transactions of the Ancient Monuments Society* (1995), *War and Memory in the Twentieth Century*, edited by Martin Evans and Ken Lunn (1997), *Journal of Contemporary History* (1999), *Journal of Design History* (2000), and *Evidence, History and the Great War: A Re-Assessment* (2000), edited by Gail Braybon. Articles contributed to *The Encyclopedia of Sculpture*: MEMORIAL: WAR.

Morkot, Robert. (Adviser.) Independent Scholar.

Morrison, Louis E., III. Ph.D. Candidate, Department of Art History, University of Kansas, Lawrence. Articles contributed to *The Encyclopedia of Sculpture*: KOREA.

Morrisroe, Julia. Curator, Department of Art, Central Michigan University, Mount Pleasant, Mich. Articles contributed to *The Encyclopedia of Sculpture*: WOOD.

Morscheck, Charles. Professor, Department of Visual Studies, Drexel University, Philadelphia, Pa. Author of *Relief Sculpture for the Facade of the Certosa di Pavia, 1473–1499* (1977). Contributor to *The Burlington Magazine* and *Arte Lombarda*. Articles contributed to *The Encyclopedia of Sculpture*: GIOVANNI ANTONIO AMADEO; GIOVANNI ANTONIO AMADEO: *TOMB OF BARTOLOMEO COLLEONI*; CERTOSA DI PAVIA; MANTEGAZZA, CRISTOFORO AND ANTONIO.

Motture, Peta. Deputy Curator, Sculpture Department, Victoria and Albert Museum, London. Coeditor of *The Sculpted Object 1400–1700*, with Stuart Currie (1997). Author of *Catalogue of Italian Bronzes in the Victoria and Albert Museum: Bells and Mortars and Related Utensils* (2001). Contributor to *European Sculpture at the Victoria and Albert Museum*, edited by Paul Williamson (1996), and *The Sculpted Object 1400–1700* (1997). Articles contributed to *The Encyclopedia of Sculpture*: RICCIO (ANDREA BRIOSCO): *SHOUTING HORSEMAN*.

Murphy, Paula. Department of History of Art, University College Dublin. Contributor to the *Irish Arts Review* (1994), *Apollo* (1996), *Wilde, the Irishman*, edited by Jerusha McCormack (1998), *When Time Began to Rant and Rage*, edited by James Christen Steward (1998), and *The Sculpture Journal* (1999). Articles contributed to *The Encyclopedia of Sculpture*: IRELAND.

Murray, Chris. Independent Scholar and Writer. Articles contributed to *The Encyclopedia of Sculpture*: NICOLA PISANO; NICOLA PISANO: PULPIT, PISA BAPTISTERY.

Myssok, Johannes. Ph.D. Department of Art History, University of Münster, Germany. Author of *Bildhauerische Konzeption und plastisches Modell in der Skulptur der Renaissance* (1999) and *Bartolomeo Ammanati: La fontana di nettuno* (2001). Contributor to *Zeitschrift für Kunstgeschichte* (1998), *Kunstchronik* (1998), and *Journal für Kunstgeschichte* (2000). Articles contributed to *The Encyclopedia of Sculpture*: VINCENZO DANTI; MICHELOZZO DI BARTOLOMEO; MICHELOZZO DI BARTOLOMEO: TOMB OF BARTOLOMEO ARAGAZZI; OTTONIAN SCULPTURE; WILIGELMO.

Naegel, Barron. Sculptor and Independent Scholar. Articles contributed to *The Encyclopedia of Sculpture*: BERTOLDO DI GIOVANNI; MICHEL ERHART.

Naginski, Erika. Assistant Professor, Department of Architecture, Massachusetts Institute of Technology Cambridge, Mass. Contributor to *Le Progrès des arts réunis*, edited by Daniel Rabreau and Bruno Tollon (1992), *Art Bulletin* (2003), *Representations* (2000), *Yale French Studies* (2001, 2002), and *The Built Surface*, edited by Christy Anderson and Karen Koehler (2001). Articles contributed to *The Encyclopedia of Sculpture*: CAFFIÉRI FAMILY; JEAN-BAPTISTE PIGALLE; JEAN-BAPTISTE PIGALLE: TOMB OF MAURICE, MARECHAL DE SAXE (MAURICE OF SAXONY).

Naylor, Andrew. Sculpture and Conservation Consultant. Articles contributed to *The Encyclopedia of Sculpture*: CHASING AND JOINING CAST METAL SCULPTURE; MODELING; PATINATION AND GILDING.

Nichols, Charlotte. Associate Professor, Seton Hall University, South Orange, N.J. Author of *The Caracciolo di Vico Chapel in Naples and Early Cinquecento Architecture* (1998). Coauthor of *A Documentary History of Naples: The Renaissance 1400–1600*, with James McGregor and John Monfasani (2000). Contributor to *Artistic Centers of the Italian Renaissance 1300–1600: Naples*, edited by A. Beyer and T. Willette (2001). Articles contributed to *The Encyclopedia of Sculpture*: SILOÉ FAMILY; SILOÉ FAMILY: TOMB OF JOHN II OF CASTILE AND ISABELLA OF PORTUGAL.

Nkurumeh, Barthosa. Ph.D. Candidate. Artist and Teacher, School of Visual Arts, Division of Art Education and Art History, University of North Texas, Denton. Author of *The Nkiri* (1991). Contributor to *Nsukka Journal of the Humanities* (1988), *Okike* (1990), *Nsukka Artists and Contemporary Nigerian Art* (forthcoming), edited by Simon Ottenberg, *The Anthill Annual* (1990), *West Africa* (1990), and the *St. James Guide To Black Artists*, edited by Tom Riggs (1997). Articles contributed to *The Encyclopedia of Sculpture*: AFRICA: 20th-CENTURY–CONTEMPORARY.

Noel, Donald Claude. M.F.A., M.A.L.S. Sculptor and Priest. Open Sea Sculpture Studio, Green Bay, Wis. Author of *The First Hundred Years of Contact: De Pere and Green Bay, Wisconsin, 1634–1734* (forthcoming). Articles contributed to *The Encyclopedia of Sculpture*: SCANDINAVIA: DENMARK; SCANDINAVIA: FINLAND; SCANDINAVIA: NORWAY; GUSTAV VIGELAND.

Nolan, Linda Ann. Ph.D. Candidate, Department of Art History, University of Southern California, Los Angeles. Articles contributed to *The Encyclopedia of Sculpture*: BELVEDERE TORSO; ORESTES AND ELECTRA; SKOPAS: HEAD OF HYGIEIA.

O'Grody, Jeannine A. Curator of European Art, Birmingham Museum of Art, Ala. Contributor to *The Bulletin of the Harvard University Art Museums* (1999), *Masterpieces of the Fogg Art Museum* (1996), and *Clay Ennobled: Italian Terracotta Sculpture, 1400–1800* (2001), edited by Bruce Boucher. Editor of *The Kress Collection at the Birmingham Museum of Art* (2002). Articles contributed to *The Encyclopedia of Sculpture*: MICHELANGELO (BUONARROTI): *DAVID*; MICHELANGELO (BUONARROTI): MEDICI CHAPEL; POINTING.

O'Neil, Megan. Ph.D. Candidate, History of Art Department, Yale University, New Haven, Conn. Articles contributed to *The Encyclopedia of Sculpture*: MESOAMERICA.

O'Rourke, Kristin. Assistant Professor, Department of Art and Art History, Vanderbilt University, Nashville, Tenn. Author of *Liberty, Fraternity, Genius: Eugene Delacroix and the Origins of the Modern Artist* (forthcoming). Articles contributed to *The Encyclopedia of Sculpture*: JEAN-ANTOINE HOUDON; JEAN-ANTOINE HOUDON: *VOLTAIRE SEATED*; JOHANN GOTTFRIED SCHADOW.

Olsen Theiding, Kara. Ph.D. Candidate. Department of the History of Art, University of California at Berkeley. Articles contributed to *The Encyclopedia of Sculpture*: ALFRED GILBERT; ALFRED GILBERT: TOMB OF PRINCE ALFRED VICTOR (DUKE OF CLARENCE).

Olson-Rudenko, Jennifer. Ph.D. Candidate. Department of Art History, Pennsylvania State University, State College. Author of *Juana Velazquez: Dictionary of Artists Models* (2001). Contributor to *A Study in Iconography of the Madonna and Child in Glory with Saint Gertrude: The Picker Art Gallery* (1995–96) and *Raymond Han: The Picker Art Gallery Journal*

1997–98 (1997–98). Articles contributed to *The Encyclopedia of Sculpture*: ALONSO CANO; JUAN DE MESA; JUAN MARTÍNEZ MONTAÑÉS; PABLO PICASSO: *THE GOAT*; LUIS SALVADOR CARMONA.

Olszewski, Edward J. Professor of Art History, Case Western Reserve University, Cleveland, Ohio. Author of *Giovanni Battista Armenini: On the True Precepts of the Art of Painting* (1977), *The Draftsman's Eye* (1981), and *Drawings in Midwestern Collections. I. Early Drawings* (1996). Member of the editorial board for *Sixteenth Century Studies Journal* (1979) and editor of *Drawings in Midwestern Collections*. Vol. 1, *Early Drawings* (1996). Contributor to *The Burlington Magazine* (1986), *Journal of the History of Collections* (1989), *International Dictonary of Architecture and Architects*, edited by R. van Vynckt (1993), *Michelangelo: Selected Scholarship in English*. Vol. 2, *The Sistine Chapel*, edited by W. Wallace (1995), *artibus et historiae* (1997), *Storia dell'arte* (1997), *SOURCE: Notes in the History of Art* (1998), and *Life and the Arts in the Baroque Palaces of Rome: Ambiente Barocco*, edited by Stefanie Walker (1999). Articles contributed to *The Encyclopedia of Sculpture*: ARNOLFO DI CAMBIO; ARNOLFO DI CAMBIO: *TOMB OF CARDINAL DE BRAYE*; ANTONIO POLLAIUOLO; ANTONIO POLLAIUOLO: *HERCULES AND ANTAEUS*; GUGLIELMO DELLA PORTA; GUGLIELMO DELLA PORTA: TOMB OF POPE PAUL III FARNESE.

Opacic, Zoë. Ph.D. Courtauld Institute of Art, University of London. Articles contributed to *The Encyclopedia of Sculpture*: PARLER FAMILY; RADOVAN.

Opper, Thorsten. Ashmolean Museum, Oxford. Articles contributed to *The Encyclopedia of Sculpture*: ANTINOUS; *APOLLO BELVEDERE*; ARTEMISION ZEUS (POSEIDON); *CHARIOTEER FROM THE SANCTUARY OF APOLLO AT DELPHI*; ANCIENT GREECE; LUDOVISI THRONE; MARATHON BOY; RIACE BRONZES.

Overhulse-King, Jennifer. Freelance Writer and Principal Owner, St. Nick Media Services. Contributing editor to www.Suite101.com (2000). Contributor to *The Dixie News* (1991–1992), *The Boone County Recorder* (1993), *The Kentucky Manufacturer* (1997), *Minority Business Now Magazine* (1998), *The Bridges Initiatives, Inc.* (1999–2000), and www.ehow.com (1999–2000). Articles contributed to *The Encyclopedia of Sculpture*: SALVADOR DALÍ.

Paraskos, Michael. Associate Lecturer, Fine Art, University of Hull, England. Author of *The Great Wall of Lempa* (2000), *The Yorkshire Art Exhib.* (2000), and *English Expressionism* (2002). Editor of *The Tempest* (1993–94). Contributor to *Herbert Read: A British Vision of World Art* (1993), edited by Benedict Read and David Thistlewood, *Apollo Review* (1999), edited by Chris Murray, *The Yorkshire Journal* (2000), *The Art Book* (2000), *Fifty Great Thinkers on Art* (2001), and *Resurgence* (2002). Articles contributed to *The Encyclopedia of Sculpture*: DIPTYCH AND TRIPTYCH; ENGLAND AND WALES: RENAISSANCE (*ca.* 1510–1625).

Paret, Paul. Ph.D. Independent Scholar, Hartford, Conn. Author of *The Crisis of Sculpture in Weimar Germany: Rudolf*

Belling, the Bauhaus, Naum Gabo (2001). Contributor to *Sculpture and Photography: Envisioning the Third Dimension* (1998), edited by Geraldine Johnson and *Modern Germany: An Encyclopedia of History, People, and Culture* (1998), edited by D. Buse and J. Doerr. Articles contributed to *The Encyclopedia of Sculpture*: OSKAR SCHLEMMER.

Parsons, Sarah Watson. Ph.D. Candidate. Department of the History of Art and Architecture, University of California, Santa Barbara. Contributor to *African Arts* (1999). Articles contributed to *The Encyclopedia of Sculpture*: DAME ELISABETH FRINK; ALLEN JONES.

Pasachnik, Linda. Writer and Independent Research Consultant. Contributor to *Style 1900: The Quarterly Journal of the Arts and Crafts Movement* (2000–01). Articles contributed to *The Encyclopedia of Sculpture*: GASTON LACHAISE.

Patz, Ingolf. Articles contributed to *The Encyclopedia of Sculpture*: JOSEPH ANTON FEUCHTMAYER.

Patz, Kristine. Ph.D. Kunsthistorisches Institut, Freie Universität Berlin, Germany. Coeditor with Hannah Baader, Ulrike Müller Hofstede, and Nicola Suthor of *Diletto e Maraviglia* (1998) and *Ars et scriptura* (2000). Contributor to *Memory and Olivion* (1999), edited by Wessel Reinink and Jeroen Stumpel, and *Künste und Natur in Diskursen der Frühen Neuzeit* (2000), edited by Hartmut Laufhütte. Contributor to *Zeitschrift für Kunstgeschichte* (1986) and *Architektur-Sprache: Buchstäblichkeit, Versprachlichung, Interpretation* (1998), edited by Eduard Führ, Hans Friesen and Anette Sommer. Articles contributed to *The Encyclopedia of Sculpture*: COLOSSAL SCULPTURE.

Pauli, Dorothée E. Ph.D. Media Arts, Department of Art History, Christchurch Polytechnic Institute of Technology, Christchurch, New Zealand. Contributor to *Art New Zealand* (1997–2001), *Paul Dibble-Sculptor* (2001), and *Bulletin of New Zealand Art History* (2001). Articles contributed to *The Encyclopedia of Sculpture*: SOPHIE TAEUBER-ARP.

Pearson, Christopher. Lecturer. Department of Art and Art History, Trinity University, San Antonio, Tex. Visiting Assistant Professor, Department of Art History, University of Oregon, Eugene. Contributor to *Architectura* (1997), *Journal of the Society of Architectural Historians* (1997), *The Sculpture Journal* (2000), and *The Built Surface: Architecture and Pictures from Antiquity to the Millennium*, edited by C. Anderson and K. Koehler (2001). Articles contributed to *The Encyclopedia of Sculpture*: DAME BARBARA HEPWORTH; DAME BARBARA HEPWORTH: *SEA FORM (PORTHMEOR)*; LÁSZLÓ MOHOLY-NAGY; HENRY MOORE; HENRY MOORE: *RECLINING FIGURE*.

Peck, Elsie. (Adviser.) The Detroit Institute of Arts.

Peck, William. (Adviser.) Curator, Ancient Art, The Detroit Institute of Arts. Author of *Drawing from Ancient Egypt* (1978), *The Detroit Institute of Arts: A Brief History* (1991), and *Splendors of Ancient Egypt* (1997). Contributor to *Journal of Egyptian Archaeology* (1971–), *American Journal of Archaeology* (1972–), *Journal of Near Eastern Studies* (1972–), *Ancient*

Egypt: Discovering Its Splendors (1978), *Journal of the American Research Center in Egypt* (1978–), *Mummies, Disease, and Ancient Cultures* (1980, 1998), and *Journal of the Society for the Study of Egyptian Antiquities* (1983–). Articles contributed to *The Encyclopedia of Sculpture*: EGYPT, ANCIENT: INTRODUCTION; PRE-DYNASTIC–OLD KINGDOM (*ca.* 3000–2150 BCE); FORGERIES AND DECEPTIVE RESTORATIONS; OBELISK.

Peers, Juliette. Victoria, Australia. Articles contributed to *The Encyclopedia of Sculpture*: NEOCLASSICISM AND ROMANTICISM.

Pellegrino, Francesca. Ph.D. Candidate. Department of Art History, University of Pisa, Italy. Contributor to *Topoi: Concetti, motivi e figure dell'arte e della letteratura artistica del Rinascimento* (2001), edited by U. Pfisterer, and *Italianistica: Rivista di Studi di Letteratura Italiana* (2001). Articles contributed to *The Encyclopedia of Sculpture*: AGOSTINO DI DUCCIO; NICOLAS CORDIER; COSIMO FANZAGO; GIOVAN ANGELO MONTORSOLI; FILIPPO PARODI; PORTRAIT: INTRODUCTION; PORTRAIT: OTHER THAN ANCIENT ROME.

Penney, David. (Adviser.) Vice President, Exhibitions and Collections Strategy and Curator of Native American Art, The Detroit Institute of Arts. Articles contributed to *The Encyclopedia of Sculpture*: NATIVE NORTH AMERICA.

Perlove, Shelley Karen. Professor of Art History and Humanities, Department of Art History, University of Michigan, Dearborn. Author of *Bernini and the Idealization of Death: The Blessed Ludovica Albertoni and the Altieri Chapel* (1990, 1999). Editor of *Piranesi's Views of Rome* (1986), *Images of Faith: Rembrandt's Biblical Etchings* (1989), and *Renaissance, Reform, Reflections* (1994). Contributor to *Artibus et Historiae* (1989), *Roma Resurgens: Papal Medals from the Age of the Baroque* (1983), *Zeitschrift fur Kunstgeschichte* (1983, 1993), *Gazette des Beaux Arts* (1989, 1995), *Konsthistorisk Tidskrift* (1999), *Il Teatro Italiano del Rinascimento* (1980), *Bulletin of the Detroit Institute of Arts* (1980), *The John Donne Journal* (1998), *The Bulletin of the University of Michigan Museum of Art* (1997), and *The Burlington Magazine* (1989). Articles contributed to *THE ENCYCLOPEDIA OF SCULPTURE*: GIANLORENZO BERNINI: *ECSTASY OF ST. TERESA*.

Peters, Elizabeth. Smithsonian American Art Museum, Smithsonian Institution, Washington, D.C. Articles contributed to *The Encyclopedia of Sculpture*: MAYA LIN; JACOPO SANSOVINO; JACOPO SANSOVINO: *APOLLO*; CLAUS SLUTER; CLAUS SLUTER: *WELL OF MOSES*.

Petzold, Andreas. Ph.D. Adjunct Assistant Professor, Department of History of Art, London Program, University of Notre Dame Indiana. Author of *Romanesque Art*, part of the *Everyman Art Series* (1995). Contributor to the *British Library Journal* (1990), *The Illustrated History of Textiles*, edited by M. Ginsburg (1991), *Arte Medievale* (1992), *Making the Medieval Book: Techniques of Production: Proceedings of the Fourth Conference of the Seminar in the History of the Book to 1500*, edited by L. Brownrigg (1995), and *Image and Belief: Studies in Celebration of the Eightieth Anniversary of the Index of*

Christian Art, edited by C. Hourihane (1999). Articles contributed to *The Encyclopedia of Sculpture*: DOORS: BRONZE; ENGLAND AND WALES: ROMANESQUE (*ca.* 1066–1160); GLOUCESTER CANDLESTICK.

Pfisterer, Ulrich. Kunstgeschichtliches Seminar, University of Hamburg, Germany. Author of *Donatello und die Entdeckung der Stile, 1430–1445* (2001). Contributor to *Römisches Jahrbuch der Bibliotheca Hertziana* (1996) and *Decorations of the Holy Dead* (2001), edited by Elizabeth Del Alamo and Stephen Lamia. Articles contributed to *The Encyclopedia of Sculpture*: ERASMUS GRASSER; NIKLAUS WECKMANN.

Pierre, Caterina Y. Ph.D. Candidate. Department of Art History, City University of New York Graduate School and University Center. Editor of *PART: The On-Line Journal of Art History of the CUNY Graduate Center* (2000). Contributor to *Woman's Art Journal* (2001). Articles contributed to *The Encyclopedia of Sculpture*: MADAME LÉON BERTAUX; LEONARDO BISTOLFI; JEAN-PIERRE-EDOUARD DANTAN; MARCELLO (ADÈLE D'AFFRY); MARIE-CHRISTINE D'ORLEANS; VINCENZO VELA.

Poduval, Jayaram. Art History Department, Maharaja Sayajirao University, Baroda, India. Coauthor with George Michell and Philip Wagner of *Vijayanagara Architectural Inventory of the Sacred Center* (2001), with George Michell of *In and Around Aurangabad* (1993) and Coeditor with Ratan Parimoo, Deepak Kannal, and Shivaji Panikkar of *The Art of Ajanta: New Perspectives* (1991). Contributor to *Journal of Maharaja Sayaji Rao University* (1993), *Nandan* (2000), and *Encyclopedia of Indian Temple Architecture: Lower Dravida Desa*, (2001), edited by George Michell and M.A. Dhaky. Articles contributed to *The Encyclopedia of Sculpture*: INDIA: MEDIEVAL; INDIA: MADURAI TO MODERN; INDIA: BAROQUE AND COLONIAL.

Proctor, Nancy. Ph.D. The Gallery Channel, London, U.K. Contributor to *Prospero* (1995), *Artscene* (1997), *Fitzroy Dearborn's Dictionary of Women Artists* (1997), *CRITS* (1997), *New Oxford Dictionary of National Biography* (1999), *Make: The Magazine of Women's Art* (1996–98), and *Roman Holiday: American Writers and Artists in Nineteenth-Century Italy* (2001), edited by Leland S. Person. Member of editorial board for *TheGalleryChannel.com* (1998–). Articles contributed to *The Encyclopedia of Sculpture*: DUPRÉ FAMILY; MARY EDMONIA LEWIS; ANNE WHITNEY.

Proudfoot, Trevor. Author of *The Conservation of Plaster* (2001). Coauthor with C. Rowell of *The Cleaning of Sculpture* (1996). Contributor to *S.P.A.B. Journal* (1991), *Recent Research into Line Mortars at Corfe Castle* (1995), and *The Dictionary of Art* (1996). Articles contributed to *The Encyclopedia of Sculpture*: CONSERVATION: STONE AND MARBLE.

Pütz, Catherine. Ph.D. Learning and Interpretration Division, Victoria and Albert Museum, London. Contributor to *Jacques Lipchitz: A World of Surprised in Space* (1997), *The Burlington Magazine* (1997), *Essays in the Study of Sculpture* (1999), and *Modernist Art from the Emery Collection* (1999). Editor of *Letters to Lipchitz* (1997). Articles contributed to *The Encyclopedia*

of Sculpture: RAYMOND DUCHAMP-VILLON; HENRI LAURENS; JACQUES LIPCHITZ.

Radcliffe, Anthony. (Adviser.) Independent Scholar.

Ranfft, Erich. Independent Scholar. Auckland, New Zealand. Coeditor of *Sculpture and Its Reproductions*, with Anthony Hughes (1997) and *Die Bildhauerin Milly Steger 1881–1948*, with Birgit Schulte (1998). Contributor to *Expressionism Reassessed*, edited by Shulamith Behr et al. (1993), *Visions of the "Neue Frau": Women and the Visual Arts in Weimar Germany*, edited by Marsha Meskimmon and Shearer West (1995), *The Dictionary of Art*, edited by Jane Shoaf Turner (1996), *Dictionary of Women Artists*, edited by Delia Gaze (1997), and *Bernhard Hoetger*, edited by Maria Anozykowski (1998). Articles contributed to *The Encyclopedia of Sculpture*: JOCHEN GERZ.

Reason, Akela. Ph.D. candidate. Department of Art History, University of Maryland, College Park. Articles contributed to *The Encyclopedia of Sculpture*: THOMAS CRAWFORD; VINNIE REAM; WILLIAM RUSH; WILLIAM WETMORE STORY; TOTEM POLE.

Rich, Paul. Articles contributed to *The Encyclopedia of Sculpture*: GARDEN SCULPTURE/SCULPTURE GARDENS.

Richardson, John J. Sculptor. Assistant Professor of Sculpture, Department of Art and Art History, Wayne State University Detroit, Mich. Articles contributed to *The Encyclopedia of Sculpture*: RICHARD DEACON.

Riedinger, Edward A. Professor and Department Head, Latin American, Spanish, and Portuguese Library Collection, Ohio State University, Columbus. Author of *Como se faz um presidente: a campanha de JK [The Making of the President]* (1955), *Turned-on Advising: A Guide to Video and Computer Sources for Educational Advising* (1995), and *Where in the World to Learn: A Guide to Library and Information Science for International Education* (1995). Editor of *Proceedings of the Brazilian Studies Association (BRASA): First Conference, Atlanta, Georgia, 10–12 March 1994* (1994) and *Proceedings of the Brazilian Studies Association (BRASA): Second Conference, University of Minnesota, Minneapolis, 11–13 May 1995* (1995). Contributor to *The Advising Quarterly* (1992), *Veja* (1992), *College and Research Libraries News* (1993), *Luso-Brazilian Review* (1995), and *Special Libraries* 1995). Articles contributed to *The Encyclopedia of Sculpture*: ALEIJADINHO (ANTÔNIO FRANCISCO LISBOA); VICTOR BRECHERET; BRUNO GIORGI.

Rizk, Mysoon. Assistant Professor, Department of Art, University of Toledo, Ohio. Contributor to *Goodbye!* (1997), *The Passionate Camera: Photography and Bodies of Desire* (1998), edited by Deborah Bright, *Optic Nerve: David Wojnarowicz on CD-ROM* (1999), edited by John Carlin, *Fever: The Art of David Wojnarowicz* (1999), edited by Amy Scholder, and *Reader's Guide to Gay and Lesbian Studies* (2000), edited by Timothy Murphy. Articles contributed to *The Encyclopedia of Sculpture*: TYREE GUYTON.

Robb, Matthew. History of Art Department, Yale University New Haven, Conn. Articles contributed to *The Encyclopedia of Sculpture*: MESOAMERICA.

Roberts, Veronica. Independent Scholar. San Francisco, Calif. Articles contributed to *The Encyclopedia of Sculpture*: SOL LEWITT; ISAMU NOGUCHI; ISAMU NOGUCHI: *KOUROS*.

Roscoe, Ingrid. Ph.D. University of Leeds, Yorkshire, England. Author of *Peter Scheemakers* (1999), edited by Luke Herrmann. Editor of *Gunnis Dictionary of British Sculptors* (2004). Contributor to *Gazette des Beaux-Arts* (1987), *Apollo* (1987, 1995), *Church Monuments Journal* (1994, 1997), *The Political Temples at Stowe*, edited by Patrick Eyres (1997), *The Royal Exchange*, edited by Ann Saunders (1997), and *The Sculpture Journal* (2001). Member of editorial board for *Church Monuments Journal* (1993–) and *Walpole Society* (2000). Articles contributed to *The Encyclopedia of Sculpture*: LAURENT DELVAUX.

Rosenthal, Donald A. Director, Chapel Art Center, Saint Anselm College Manchester, New Hamp. Author of *Orientalism: The Near East in French Painting, 1800–1880* (1982) and *La Grande Maniere: Historical and Religious Painting in France, 1700–1800* (1987). Member of the editorial board for *Porticus: The Journal of the Memorial Art Gallery of the University of Rochester* (1980–1985). Contributor to *Art Bulletin* (1980), *The Burlington Magazine* (1982), *Gazette des Beaux-Arts* (1989), *Art Journal* (1990), and *Art New England* (1996). Articles contributed to *The Encyclopedia of Sculpture*: ANTOINE-DENIS CHAUDET; AUGUSTE (JEAN-BAPTISTE) CLÉSINGER; JAMES (JEAN-JACQUES) PRADIER; FRANÇOIS RUDE.

Rossberg, Marcus. Department of Logic and Metaphysics, University of St. Andrews, Fife, U.K. Articles contributed to *The Encyclopedia of Sculpture*: DOORS: WOODEN.

Salonius, Pippa. Articles contributed to *The Encyclopedia of Sculpture*: LORENZO MAITANI: FACADE RELIEFS, ORVIETO CATHEDRAL; ORCAGNA (ANDREA DI CIONE): TABERNACLE OF ORSANMICHELE; VECCHIETTA (LORENZO DI PIETRO).

Santangelo, Maria L. Independent Scholar; formerly Assistant Curator, European Sculpture and Decorative Arts, Detroit Institute of Arts. Articles contributed to *The Encyclopedia of Sculpture*: JOSEPH CHINARD; JOSEPH CHINARD: *BUST OF MADAME RÉCAMIER*.

Schallert, Regine. Ph.D. Bibliotheca Hertziana (Max-Planck-Institut for Art History), Rome. Author of *Studien zu Vincenzo de'Rossi* (1998). Articles contributed to *The Encyclopedia of Sculpture*: VINCENZO DE' ROSSI: *THESEUS ABDUCTING HELEN*.

Schmandt-Besserat, Denise. Professor, Department of Art, The University of Texas, Austin. Author of *Before Writing* (1992), *How Writing Came About* (1996), and *The History of Counting* (1999). Editor of *The Legacy of Sumer* (1976) and *Ancient Persia* (1980). Contributor to *Scientific American* (1978), *Science* (1981), *Archeomaterials* (1990), *Bulletin of the*

American School of Oriental Research (1998), and *Near Eastern Archaeology* (1998). Articles contributed to *The Encyclopedia of Sculpture*: NEAR EAST, ANCIENT: NEOLITHIC.

Schmidt, Eike D. Research Associate, Center for Advanced Study in the Visual Arts, National Gallery of Art, Washington, D.C. Contributor to *Mitteilungen des Kunsthistorischen Institutes in Florenz* (1996, 1997), *Bulletin van het Rijksmuseum* (1997), *Magnificenza alla corte dei Medici* (1997), *Pantheon* (1997, 1999, 2000), *Nuovi studi* (1998), *Damals* (1998), *Giovinezza di Michelangelo* (1999), edited by Kathleen Weil-Garris Brandt, Cristina Acidini Luchinat, James David Draper, and Nicholas Penny, *Storia delle arti in Toscana: il Cinquecento* (2000), edited by Roberto Paolo Ciardi and Antonio Natali, *Opere e giorni: Studi su mille anni di arte europea dedicati a Max Seidel* (2001), edited by Klaus Bergdolt and Giorgio Bonsanti, and *Il potere, le arti, la guerra: Lo splendore dei Malatesta* (2001), edited by Andrea Emiliani and Antonio Paolucci. Articles contributed to *The Encyclopedia of Sculpture*: GIOVANNI BANDINI (GIOVANNI DELL'OPERA); FRANCESCO FANELLI.

Schmidt, Karin Stella. Ph.D. candidate. Orientalisches Seminar, Albert-Ludwigs-Universität Freiburg, Freiburg im Breisgau, Germany. Articles contributed to *The Encyclopedia of Sculpture*: NEAR EAST, ANCIENT: MESOPOTAMIA; NEAR EAST, ANCIENT: IRAN; NEAR EAST, ANCIENT: SYRIA.

Scholten, Frits. (Adviser.) Rijksmuseum, Amsterdam, Netherlands. Articles contributed to *The Encyclopedia of Sculpture*: FRANCIS VAN BOSSUIT; HENDRICK DE KEYSER; ROMBOUT VERHULST; ADRIAEN DE VRIES; ADRIAEN DE VRIES: BUST OF RUDOLPH II.

Schneider, Claire. Associate Curator, Albright-Knox Art Gallery, Buffalo, N.Y. Author of *Kiki Smith: Reclaiming the Abject* (1997), *New Room of Contemporary Art: Angela Grauerholz: Sententia I to LXII* (1999), *New Room of Contemporary Art: Gerrit Engel: Buffalo Grain Elevators* (1999), *New Room of Contemporary Art: Eugène Leroy* (2000), and *New Room of Contemporary Art: Cathy de Monchaux* (2000). Coauthor of *0044 – Irish Artists in Britain* (1999), edited by Peter Murray. Contributor to *Circa Art Magazine: Contemporary Visual Culture in Ireland* (1998, 1999) and *Circa 1900: From the Genteel Tradition to the Jazz Age* (2001). Articles contributed to *The Encyclopedia of Sculpture*: KIKI SMITH.

Schroll, Savannah. Writer and Editor. Public Information Office, Smithsonian Institution Libraries, Washington, D.C. Articles contributed to *The Encyclopedia of Sculpture*: MAXIMILIAN COLT.

Seelig-Teuwen, Regina. Ph.D. Independent Scholar. Munich, Germany. Contributor to *Pantheon* (1971), *Wittelsbach und Bayern II* (1980), *Weltkunst* (1991), *Avénement D'Henri IV* (1992), *Germain Pilon* (1993), and *The Dictionary of Art* (1996), edited by Jane Turner. Articles contributed to *The Encyclopedia of Sculpture*: PONCE JACQUIO; BARTHÉLEMY PRIEUR.

Seidmann, Gertrud. Research Associate, Institute of Archaeology, University of Oxford, U.K. Contributor to *Jewelry Studies* (1990), *The Virtuoso Tribe of Arts and Sciences* (1992), edited by D.G.C. Allan and J.L. Abbott, *RSA Journal* (1996), *The Dictionary of Art* (1996), edited by Jane Turner, *Gioielli de Museo Archeologico di Padova* (1997), edited by G. Zampieri, *7000 Years of Seals* (1997), edited by D. Collon, *Engraved Gems: Survivals and Revivals* (1997), edited by C.M. Brown (1997), and *Ateneo Veneto* (1998). Articles contributed to *The Encyclopedia of Sculpture*: ENGRAVED GEMS (INTAGLIOS AND CAMEOS).

Silber, Evelyn. Ph.D. Director of the Hunterian Museum and Art Gallery, University of Glasgow, U.K. Author of *The Sculpture of Epstein* (1986) and *Gaudier-Brzeska: Life and Art* (1996). Coauthor with T. Friedman et al. of *Jacob Epstein Sculpture and Drawings* (1987). Contributor to *Journal of the Warburg and Courtauld Institutes, XLIII, 1980*. Articles contributed to *The Encyclopedia of Sculpture*: JACOB EPSTEIN; HENRI GAUDIER-BRZESKA.

Simon, David L. Jetté Professor of Art, Colby College, Waterville, Maine. Coauthor with Domingo J. Buesa Conde of *La condesa Donña Sancha y los orígines de Aragón* (1995), edited by Caja de Ahorros y Monte de Piedad de Zaragoza, Aragón y Rioja. Contributor to *Journal of the British Archaeological Association* (1975), *The Burlington Magazine* (1979), *Cahiers de Saint-Michel de Cuxa* (1979, 1980, 1981), *Gesta* (1984, 1986, 1987) and *Jacetania* (1991). Articles contributed to *The Encyclopedia of Sculpture*: SPAIN: ROMANESQUE.

Siska, Patricia. Associate Cataloguer, Frick Art Reference Library, N.Y. Editor of *ARLIS/NY News* (1997–2000). Articles contributed to *The Encyclopedia of Sculpture*: LORADO TAFT.

Slauson, James. Professor of Art History, Division of Liberal Studies, Milwaukee Institute of Art and Design, Wis. Contributor to *Southeastern College Art Conference Review* (1992), *Shepherd Express* (1996, 1997), and *Proceedings of the 13th Annual National Conference on Liberal Arts and the Education of Artists* (1999). Articles contributed to *The Encyclopedia of Sculpture*: AEGEAN SCULPTURE; ETRUSCAN SCULPTURE.

Sleeman, Alison. Senior Lecturer, History and Theory of Art, Slade School of Fine Art, University College, London, U.K. Author of *More and Less: The Early Work of Richard Long* (1997), edited by Fiona Russell. Coeditor of *The Sculpture Journal* (1999–). Contributor to *Women: A Cultural Review* (1995), *Un Siècle de Sculpture Anglaise* (1996), edited by Françoise Bonnefoy, and *The Sculpture Journal* (1997, 2001). Articles contributed to *The Encyclopedia of Sculpture*: RICHARD LONG; RICHARD LONG: A LINE MADE BY WALKING ENGLAND 1967.

Smith, Nancy Kipp. Assistant Professor, Marywood University, Scranton, Pa. Articles contributed to *The Encyclopedia of Sculpture*: DALLE MASEGNE FAMILY; SCREENS.

Smith, R.R.R. (Adviser.) University of Oxford, U.K.

Smith, Walter. Assistant Professor, Department of Art, Mississippi State University. Independent Scholar, South Canaan,

Pa. Author of *The Muktesvara Temple in Bhubaneswar* (1994). Contributor to *Artibus Asiae* (1984, 1996, 1997), *Smithsonian Studies in American Art* (1990), *Oriental Art* (1996), and *Religion and the Arts* (2000). Articles contributed to *The Encyclopedia of Sculpture*: CHINA: YUAN-CONTEMPORARY; MICHEL COLOMBE; JEAN (HENNEQUIN) DE LIÈGE; DAVID LE MARCHAND; ANTOINE LE MOITURIER.

Smolderen, Luc. *Président, Académie royale d' Archéologie de Belgique* (President of the Royal Archaeology Academy of Belgium). Author of *La Statue Du Duc D'Albe A' Anvers (1571)* (1971), *Jacques Jonghelinck (1530–1606)* (1996), and *Jean De Montfort (1567–1648)* (1996). Contributor to *Jaarboek voor Munt: En Penning Kunde* (1965), *Revue Belge de Numismatique* (1967–68, 1970, 1984, 1986, 1989, 1991, 1998–2000), *Révue des Archéologues et Historiens D'Art de Louvain* (1977, 1999–2000), *Jaarboek Kon: Museum voor Schone Kunsten: Antwerpen* (1980), and *Revue Belge D'Archéologie et D'Histoire de L'Art* (1981, 1995–96, 2001). Articles contributed to *The Encyclopedia of Sculpture*: JACQUES JONGHELINCK (JONGELING).

Snay, Cheryl K. Cataloger and Research Associate, Department of Prints and Drawings, Baltimore Museum of Art, Md. Contributor to *Kresge Art Museum Bulletin* (1992), *Medieval Art in America: Patterns of Collecting 1800–1940*, edited by Elizabeth Bradford Smith (1996), and *Familiar Faces and Places*, edited by Kiichi Usui (1997). Articles contributed to *The Encyclopedia of Sculpture*: ANTOINE-LOUIS BARYE; ANTOINE-LOUIS BARYE: *TIGER DEVOURING A GAVIAL CROCODILE OF THE GANGES*; CHARLES-HENRI-JOSEPH CORDIER; AIMÉ-JULES DALOU.

Somers, Lynn M. Ph.D. Independent Scholar and Assistant Adjunct Professor, New York University. Contributor to *Proteus: A Journal of Ideas* (2002), and *Exposure: Journal for Photographic Education* (forthcoming 2005). Articles contributed to *The Encyclopedia of Sculpture*: ABSTRACT EXPRESSIONISM; ANN HAMILTON; MINIMALISM; POSTMODERNISM.

Sowell, Teri. Ph.D. Lecturer, Department of Art, Design and Art History, San Diego State University. Department of Visual Arts, University of San Diego, Calif. Author of *Worn with Pride: Celebrating Samoan Artistic Heritage* (2000). Contributor to *Selections from the Kinsey Institute*, edited by Joseph Becherer (1990), *Easter Island in Pacific Context. South Seas Symposium. Proceedings of the Fourth International Conference on Easter Island and East Polynesia*, edited by Christopher Stevenson, et al. (1998), and *Proceedings of a Special Session of the Pacific Arts Association*, edited by Robert Welsh (1999). Articles contributed to *The Encyclopedia of Sculpture*: POLYNESIA.

Spagnolo, Maddalena. Ph.D. Candidate. Department of Art History, University of Pisa, Italy. Author of *La Basilica di San Pietro in Vaticano* (2000), edited by Antonio Pinelli. Contributor to *Ricerche di Storia dell'Arte* (1996), *Ricerche di Storia dell'Arte* (1998), and *Polittico* (2000). Articles contributed to *The Encyclopedia of Sculpture*: BAROQUE AND ROCOCO; AGOS-

TINO BUSTI (BAMBAIA); FRANÇOIS GIRARDON; FRANCESCO ("IL BOLOGNA") PRIMATICCIO.

Spencer, Robin. Professor, School of Art History, University of St. Andrews, St. Andrews, Scotland. Author of *The Aesthetic Movement* (1972). Coauthor of *The Paintings of James McNeill Whistler*, 1980. Editor of *Eduardo Paolozzi Writings and Interviews* (2000). Contributor to *Gazette des Beaux-Arts* (1982, 1984) and *The Burlington Magazine* (1992, 1994, 1998). Articles contributed to *The Encyclopedia of Sculpture*: RAYMOND MASON; EDUARDO PAOLOZZI.

Steggles, Mary Ann. Ph.D. Area Chair of Art History, School of Art, University of Manitoba, Winnipeg, Canada. Contributor to *Marg* (1994, 1997), *New Dictionary of National Biography* (forthcoming), edited by Debra Graham, *Revised Dictionary of British Sculpture, 1660–1851* (forthcoming). Articles contributed to *The Encyclopedia of Sculpture*: JOHN BACON; THOMAS BANKS; JOCHO; KOSHO; MEMORIAL: OTHER THAN WAR.

Stevens, Timothy. Articles contributed to *The Encyclopedia of Sculpture*: JOHN GIBSON; GEORGE FRAMPTON.

Stieber, Mary. Assistant Professor, Faculty of Humanities and Social Sciences, The Cooper Union for the Advancement of Science and Art, New York. Contributor to *Transactions of the American Philological Association* (1994), *Boreas* (1996), *Arion* (1998), *Mnemosyne* (1999), and the *Annals of Scholarship* (2000). Articles contributed to *The Encyclopedia of Sculpture*: KRITIOS BOY; PARTHENON; TEMPLE OF ZEUS, OLYMPIA.

Stocker, Mark. Ph.D. Senior Lecturer, School of Fine Arts, University of Canterbury, Christchurch, New Zealand. Articles contributed to *The Encyclopedia of Sculpture*: ART DECO; ENGLAND AND WALES: 19TH CENTURY–CONTEMPORARY; JOHN FLAXMAN; NEW ZEALAND.

Stone, Richard. (Adviser.) The Metropolitan Museum of Art, New York.

Sullivan, Mark. Professor of Art History, History Department, Villanova University, Pa. Author of *James M. and William Hart, American Landscape Painters* (1983) and *The Hudson River School: An Annotated Bibliography* (1991). Contributor to *The Magazine Antiques* (1990), *American Arts Quarterly* (1994), *Choice: Current Reviews for Academic Libraries* (1990–), *Records of the American Catholic Historical Society* (1998), and *Collectanea Augustiniana* (1999). Articles contributed to *The Encyclopedia of Sculpture*: CARL ANDRE; ROBERT SMITHSON; ROBERT SMITHSON: *SPIRAL JETTY*.

Swartz, Anne. Professor of Art History, Savannah College of Art and Design, Ga. Author of *Adrian Piper: Icons of African-American Identity* (1995), *Robert Rauschenberg: Photems, Photographs, and Graphic Works* (1996), *Jasper Johns: The Seasons* (1997), *Andy Warhol's Serial Prints* (1998), and *Christo and Jeanne-Claude: Two Works in Progress* (1999). Contributor to *Mosaic Magazine* (1991–92), *The Cleveland Museum of Art Bulletin* (1993), *Bulletin of the Detroit Institute of Arts*

(1997), and *Woman's Art Journal* (1999). Articles contributed to *The Encyclopedia of Sculpture*: CHRISTO AND JEANNE-CLAUDE; EVA HESSE.

Symmes, Marilyn. Curator, Drawings and Prints, Drue Heinz Study Center, Cooper-Hewitt, National Design Museum, Smithsonian Institution, New York. Author of . . . *other languages, other signs . . .: The Books of Antonio Frasconi* (1992). Coauthor with Elizabeth Glassman of *Cliché-Verre: Hand-Drawn, Light-Printed, A Survey of the Medium from 1839 to the Present* (1980). Coauthor with Dita Amory of *Nature Observed, Nature Interpreted, Nineteenth-Century American Drawings from the National Academy of Design and Cooper-Hewitt, National Design Museum, Smithsonian Institution* (1995). Editor and coauthor of *Fountains: Splash and Spectacle, Water and Design from the Renaissance to the Present* (1998). Contributor to *Print Collector's Newsletter* (1995), *The Dictionary of Art* (1996), *Drawing* (1995–96, 1998), and *The Magazine Antiques* (1998). Articles contributed to *The Encyclopedia of Sculpture*: FOUNTAIN SCULPTURE.

Szalay, Gabriella. University of Calgary, Alberta, Canada. Articles contributed to *The Encyclopedia of Sculpture*: ALESSANDRO ALGARDI; ALESSANDRO ALGARDI: *POPE LEO DRIVING ATTILA FROM ROME*; GIANLORENZO BERNINI: TOMB OF URBAN VIII; PIETRO BRACCI; ERCOLE FERRATA; DOMENICO GUIDI; FILIPPO DELLA VALLE.

Tahinci, Anna. Ph.D. Candidate. Department of History of Art, University of Paris I-Pantheon-Sorbonne. Curatorial Research Assistant, Department of Paintings, Sculpture and Decorative Arts, Fogg Art Museum, Harvard University, Cambridge, Mass. Contributor to *Rodin en 1900: L'exposition de l'Alma* (2001). Contributor to *Sculpture Review* (2000). Articles contributed to *The Encyclopedia of Sculpture*: JEAN-BAPTISTE CARPEAUX; JEAN-BAPTISTE CARPEAUX: *THE DANCE* (*LE GÉNIE DE LA DANSE*; HONORÉ DAUMIER; EDGAR DEGAS; EDGAR DEGAS: *LITTLE DANCER, FOURTEEN YEARS OLD*; PAUL GAUGUIN; HENRI (-EMILE-BENOÎT) MATISSE; OSSIP ZADKINE.

Tait, Leslie Bussis. Ph.D. Queens College of the City University of New York and the Bard Graduate Center for Studies in the Decorative Arts, Design and Culture N.Y. Contributor to *International Medieval Research. Decorations for the Holy Dead*, edited by Stephen Lamia and Elizabeth Valdez del Alamo (2002), *Gothic Sculpture in America: The Museums of the Midwest* (2001), edited by Dorothy Gillerman, and *Sacred Spaces: Building and Commemorating Sites of Worship in the Nineteenth Century* (2002), edited by V.C. Raguin, and *Études Héraultaises* (1995/96). Articles contributed to *The Encyclopedia of Sculpture*: ARCHITECTURAL SCULPTURE IN EUROPE: MIDDLE AGES–19TH CENTURY; CROSS, "BURY ST. EDMONDS" (CLOISTERS); EARLY CHRISTIAN AND BYZANTINE SCULPTURE (4TH–15TH CENTURY); HARBAVILLE TRIPTYCH; MORGAN MADONNA (VIRGIN AND CHILD IN MAJESTY).

Tarasova, Lina. Articles contributed to *The Encyclopedia of Sculpture*: PIOTR KLODT; BORIS IVANOVICH ORLOVSKY (SMIRNOV).

Tchikine, Anatole. Ph.D. Candidate. Postgraduate Research Student and Tutor, Department of the History of Art, Trinity College, Dublin, Ireland. Articles contributed to *The Encyclopedia of Sculpture*: VERA MUKHINA; VLADIMIR YEVGRAFOVICH TATLIN: MODEL FOR *MONUMENT TO THE THIRD INTERNATIONAL*; NICCOLÒ TRIBOLO.

Tekippe, Rita. Ph.D. Department of Art, University of Central Arkansas, Conway, Ark. Coeditor with Sarah Blick of *Art and Architecture of Late Medieval Pilgrimage* (2004). Contributor to *Medieval Germany: An Encyclopedia* (2000), edited by John M. Jeep. Articles contributed to *The Encyclopedia of Sculpture*: GIOVANNI PISANO; GIOVANNI PISANO: PULPIT, S. ANDREA; PORPHYRY.

Tepfer, Ellen. Ph.D. Candidate. Art History, The Graduate Center, N.Y. City University of New York. Lecturer at the Whitney Museum of American Art. Contributor to *Art Nexus* (1996), Performance in Politics and the Arts (1997), and *Women and Performance: A Journal of Feminist Theory* (2001). Articles contributed to *The Encyclopedia of Sculpture*: CLAES OLDENBURG.

Thliveri, Hara. Visiting Fellow, Institute of Classical Studies, Associate Lecturer, Open University, University of London, Milton Keynes, U.K. Author of *Odos Assomaton* (2000). Articles contributed to *The Encyclopedia of Sculpture*: MYRON; MYRON: *DISKOBOLOS* (DISCUS THROWER).

Thomas, Thelma K. Associate Professor, Associate Curator, Department of History of Art, Kelsey Museum of Archaeology, University of Michigan, Ann Arbor. Author of *Late Antique Egyptian Funerary Sculpture: Images for This World and the Next* (2000). Contributor to *Beyond the Pharaohs: Egypt and the Copts in the 2nd to 7th Centuries* (1989), *Bulletin of the American Society of Papyrologists, The Glory of Byzantium: Art and Culture of the Middle Byzantine Era, A.D. 843–1261* (1997), *The Encyclopedia of Late Antiquity* (1999), and *Ars Orientalis*. Articles contributed to *The Encyclopedia of Sculpture*: COPTIC SCULPTURE.

Tripodes, Lucia. Ph.D. Candidate. Institute of Fine Arts, New York University. Contributor to *RES Anthropology and Aesthetics* (Spring 1999). Articles contributed to *The Encyclopedia of Sculpture*: DAVID D'ANGERS; FRANÇOIS RUDE: *DEPARTURE OF THE VOLUNTEERS OF 1792 (LA MARSEILLAISE)*.

Tronchin, Francesca C. Ph.D. Candidate. Teaching Fellow, Department of Art History, Boston University, Mass. Articles contributed to *The Encyclopedia of Sculpture*: KORE AND KOUROS.

Trusted, Marjorie H. (Adviser.) Curator, Sculpture Department, Victoria and Albert Museum, London, U.K. Author of *European Ambers: A Catalogue of the Collection in the Victoria and Albert Museum* (1985), *German Renaissance Medals* (1990), and *Spanish Sculpture* (1996). Editor of *The Sculpture Journal* (1997–2000). Contributor to *The Burlington Magazine* (1986–). Member of editorial board for *The Medal* (1988–).

Turner, Grady T. Articles contributed to *The Encyclopedia of Sculpture*: DUANE HANSON.

Uiyon, Kim. Curator, Museum of Seoul Arts Center in Korea, Art Historian, Correspondent for *Wolgan Misool*, the monthly art magazine of Korea. Articles contributed to *The Encyclopedia of Sculpture*: DAVID SMITH: CUBIS.

Vaccari, Maria Grazia. Assistant Director, Museo Nazionale del Bargello, Florence, Italy. Editor of *La scultura in terracotta: Tecniche e conservazione* (1998), *Mira il tuo popolo: Statue votive del santuario di Santa Maria delle Grazie* (1999), and *Pollaiolo e Verrocchio? Due ritratti fiorentini del Quattrocento* (2001). Contributor to *Quaderni di Palazzo Te* (1986), *Civiltà mantovana* (1987), *OPD Restauro* (1992), *OPD Restauro* (1997), *I Della Robbia (Exibition catalogue)* (1998), edited by Giancarlo Gentilini, and *OPD Restauro* (2000). Articles contributed to *The Encyclopedia of Sculpture*: GUIDO MAZZONI; GUIDO MAZZONI: *LAMENTATION*; WAX.

Valdez del Alamo, Elizabeth. Associate Professor, Department of Fine Arts, Montclair State University, Upper Montclair, N.J. Coeditor with Carol Stamatis Pendergast of *Memory and the Medieval Tomb* (2000), with Stephen Lamia of *Decorations for the Holy Dead* (2001). Contributor to *Gesta* (1990), *Acts of El Románico en Silos: 9°Centenario de la Consagración de la Iglesia y Claustro, 1088–1988* (1990), *Actas: "O Pórtico da Gloria e a Arte do seu Tempo" Santiago de Compostela* (1991), *The Cloisters: Studies in Honor of the Fiftieth Anniversary* (1992), edited by Elizabeth C. Parker, *The Art Bulletin* (1996), *Anuario del Departamento de Historia y Teoría del Arte, Universidad Autónoma de Madrid* (1997–98), and *Les Cahiers de Saint-Michel de Cuxa* (2000). Articles contributed to *The Encyclopedia of Sculpture*: CAPITAL; MISERICORD; PERE OLLER; ROLDÁN FAMILY; ROMANESQUE; SPAIN: GOTHIC.

Van Ausdall, Kristen. Articles contributed to *The Encyclopedia of Sculpture*: ALTARPIECE: SOUTHERN EUROPE.

van Damme, Jan. Articles contributed to *The Encyclopedia of Sculpture*: WILLEM VAN DEN BROECKE (PALUDANUS); JACQUES DU BROEUCQ; CORNELIS II FLORIS DE VRIENDT.

Van Voorhis, Julie. Assistant Professor of Roman Art, Department of History of Art, Indiana University, Bloomington. Contributor to *Journal of Roman Archaeology* (1998). Articles contributed to *The Encyclopedia of Sculpture*: DYING GAUL; *LAOCOÖN AND HIS SONS*; ANCIENT ROME; SPERLONGA SCULPTURES.

Versari, Maria Elena. Ph.D. Candidate. Department of Art History, Scuola Normale Superiore, Pisa, Italy. Contributor to *Dizionario del Futurismo* (2001–02), edited by Ezio Godoli, *I Segni Incrociati: Letteratura Italiana del'900 e Arti Figurative* (1998), edited by Marcello Ciccuto, and *Annali della Scuola Normale Superiore* (1997). Articles contributed to *The Encyclopedia of Sculpture*: UMBERTO BOCCIONI.

Vincenti, Monica De. Università degli Studi di Venezia, Dipartimento di Storia e Critica delle Arti. Editor of *Medioevo*

Canova: dei Musei Civici di Padova dal Trecento all'Ottocento (2000). Contributor to *La Diana* (1995), *Venezia Arti* (1996, 1997, 1998), *La Chiesa di Santa Caterina*, edited by Terribile Wiel and G. Zampieri (1999), and *Francesco Robba e la scultura veneziana del Settecento*, edited by Hofler (2000). Articles contributed to *The Encyclopedia of Sculpture*: FRANCESCO BERTOS; GIOVANNI MARIA MORLAITER.

von Ulmann, Arnulf. Ph.D. Germanisches Nationalmuseum, Institute of Art Technology and Conservation, Nürnberg, Germany. Author of *Bildhauertechnik des Spätmittelalters und der Frührenaissance* (1984), edited by Wissenschaftliche Buchgesellschaft, Darmstadt. Contributor to *Museumskunde* (1994), *Unter der Lupe: Festschrift für Hans Westhoff.* (2000), *Polychrom skulptur og Maleri pa trae.* (1982), *Wiederherstellung der St. Jakobiorgel. Festschrift zur Restaurierung* (1984), *Jahrbuch Hochsauerlandkreis* (1990), *Arbeitsblätter für Restauratoren* (1991), *Maltechnik-Restauro* (1991), *Sculptures médiévales allemandes, conservation et restauration* (1993), *AdR Schriftenreihe zur Restaurierung und Grabungstechnik* (1996). Articles contributed to *The Encyclopedia of Sculpture*: BERNT NOTKE.

Vossilla, Francesco. Author of *La Loggia della Signoria: Una galleria di scultura* (1995). Coauthor of *L'Ercole e Caco di Baccio Bandinelli*, with C. Francini (1999). Member of the editorial board for *Bollettino della Società di Studi Fiorentini* (1997–1999) and editor of *Capolavori di maiolica della Collezione Strozzi Sacrati* (1998). Contributor to *Mitteilungen des Kunsthistorischen Institutes in Florenz* (1994, 1997), *Altari e Committenza*, edited by C. De Benedictis (1996), *Bollettino della Società di Studi Fiorentini* (1997), and *Magnificenza alla corte dei Medici. Arte a Firenze alla fine del Cinquecento*, edited by M. Gregori and D. Heikamp (1997). Articles contributed to *The Encyclopedia of Sculpture*: BARTOLOMEO AMMANATI; BARTOLOMEO AMMANATI: *NEPTUNE FOUNTAIN*; BACCIO BANDINELLI; BACCIO BANDINELLI: *HERCULES AND CACUS*.

Walker, Stefanie. Special Exhibitions Curator, Bard Graduate Center for Studies in the Decorative Arts, Design, and Culture, New York. Coeditor with Frederick Hammond of *Life and the Arts in the Baroque Palaces of Rome: Ambiente Barocco* (1999). Contributor to *Kunst und Antiquitäten* (1991), *Metropolitan Museum of Art Journal* (1991), *Lexikon für Theologie und Kirche* (1992–96), *Journal of the History of Collections* (1994), *Studies in the Decorative Arts* (1997), and *Rome in the Eighteenth Century*, edited by Joseph Rishel and Edgar Peters Bowron (2000). Articles contributed to *The Encyclopedia of Sculpture*: LEGROS II, PIERRE; ST. STANILAS KOSTKA; PIERRE-ÉTIENNE MONNOT.

Wallace, William E. Professor, Department of Art History and Archaeology, Washington University, St. Louis, Mo. Author of *Michelangelo at San Lorenzo: The Genius as Entrepreneur* (1994) and *Michelangelo: The Complete Sculpture, Painting, Architecture* (1998). Editor of *Michelangelo: Selected Scholarship in English* (1995) and *Michelangelo: Selected Readings* (1999). Contributor to *Sixteenth Century Journal* (1979, 1997, 1999), *Source* (1985, 1993, 1995, 1998), *The Burlington Magazine, I Tatti Studies, Renaissance Quarterly* (1994), *Renaissance*

Studies (1997), and *Looking at Italian Renaissance Sculpture*, edited by Sarah Blake McHam (1998). Member of editorial board for *Sixteenth Century Journal* (1991–1999) and *Explorations in Renaissance Sculpture* (1995). Articles contributed to *The Encyclopedia of Sculpture*: MICHELANGELO (BUONARROTI).

Ward-Jackson, Philip. (Adviser.) Courtauld Institute of Art, London, U.K.

Wardropper, Ian. (Adviser.) Curator of European Sculpture and Decorative Arts, The Metropolitan Museum of Art, New York. Coauthor with John Bowlt, Alison Hilton, and Karen Kettering of *News from a Radiant Future: Soviet Propaganda Plates from the Tuber Collection* (1992). Coauthor with Lynn Springer Roberts of *European Decorative Arts in The Art Institute of Chicago* (1991). Coauthor with Fred Licht of *Chiseled with a Brush: Italian Sculpture, 1860–1925, from the Gilgore Collections* (1994). Coauthor with Sergei Androsov and Dean Walker of *From the Sculptor's Hand: Italian Baroque Terracottas from the State Hermitage Museum* (1998). Editor of *Renaissance Jewelry from the Alsdorf Collection* (2000). Contributor to *Museum Studies of The Art Institute of Chicago* (1984, 1989, 1991), *Gazette des Beaux-Arts* (1991), *Revue de l'Art* (1991), *Apollo Magazine* (1987, 1999), and *The Sculpture Journal* (2000). Articles contributed to *The Encyclopedia of Sculpture*: DOMENICO DEL BARBIERE.

Weinshenker, Anne Betty. Professor, Department of Fine Arts, Montclair State University Upper Montclair, N.J. Author of *Falconet: His Writings and His Friend Diderot* (1966). Contributor to *Diderot Studies* (1973), *Art Journal* (1973,1984), *Studies in Eighteenth-Century Culture* (1986), and *Dalhousie French Studies* (1998). Articles contributed to *The Encyclopedia of Sculpture*: EDME BOUCHARDON.

Whiteley, Gillian. Department of Fine Art, University of Leeds, U.K. Author of *George Fullard—A Fastidious Primitive* (1997), *Playing with Paradox: George Fullard 1923–1973* (1998), and *Assembling the Absurd: the Sculpture of George Fullard* (1998). Contributor to *Sculpture Journal* (1997), *Chicago Art Journal* (1999), and *New Dictionary of National Biography* (2001). Articles contributed to *The Encyclopedia of Sculpture*: ASSEMBLAGE; JAMES LEWIS DINE; GEORGE FULLARD.

Wilkins, Ann Thomas. Associate Professor, Department of Classics, Duquesne University, Pittsburgh, Penn. Author of *Villain or Hero: Sallust's Portrayal of Catiline* (1994). Contributor to *Rome and Her Monuments: Essays on the City and Literature of Rome in Honor of Katherine A. Geffcken*, edited by Judith Hallet and Sheila Dickison (2000) and the *International Journal of the Classical Tradition* (2000). Articles contributed to *The Encyclopedia of Sculpture*: APOLLO OF VEII; CAPITOLINE WOLF (LUPA).

Wilkins, David G. Professor and Chair, Henry Clay Frick Department of the History of Art and Architecture, University of Pittsburgh, Penn. Author of *Paintings and Sculpture of the Duquesne Club* (1986). Coauthor with Bonnie A. Bennett of *Donatello* (1984). Coauthor with Kahren J. Arbitman of *Pre-Rem-*

brandt Etchers (of the series, *The Illustrated Bartsch*, 1985). Coauthor with Bernard Schultz and Kathryn M. Linduff of *Art Past/Art Present* (1997). Contributor to *The Role and Images of Women in the Middle Ages and Renaissance*, edited by Douglas Radcliff-Umstead (1975), and *Interpreting Cultural Symbols: St. Anne in Late Medieval Society*, edited by Kathleen M. Ashley and Pamela Sheingorn (1990). Coeditor with Rebecca L. Wilkins of *The Search for a Patron in the Middle Ages and the Renaissance* (1996). Coeditor with Sheryl Reiss of *Beyond Isabella: Secular Women Patrons of Art in Renaissance Italy* (2001). Revising editor *History of Italian Renaissance Art* by Frederick Hartt (1994). Contributor to *The Burlington Magazine* (1969), *American Art Review* (1975), *Art Quarterly* (1978), *American Art Journal* (1981), *Art Bulletin* (1983), *Italian Studies* (1985), the *International Dictionary of Architects and Architecture*, edited by Randall J. van Vynckt (1993), and *The Dictionary of Art*, edited by Jane Turner (1996). Articles contributed to *The Encyclopedia of Sculpture*: NANNI DI BANCO: FOUR CROWNED SAINTS AND NICHE OF THE GUILD OF STONEMASONS AND CARPENTERS; ANDREA PISANO: SOUTH DOORS OF FLORENCE BAPTISTERY.

Wilkinson, MaryAnn. Curator of Modern and Contemporary Art, The Detroit Institute of Arts, Detroit, Mich. Articles contributed to *The Encyclopedia of Sculpture*: KIKI SMITH: LOT'S WIFE.

Williamson, Paul. (Adviser.) Victoria and Albert Museum, London, U.K.

Winkenweder, Brian. Ph.D. Candidate. Visiting Assistant Professor, School of Visual Arts, Division of Art Education and Art History, University of North Texas Denton. Articles contributed to *The Encyclopedia of Sculpture*: MICHAEL HEIZER; ROBERT MORRIS; JAMES TURRELL.

Wong, Dorothy C. (Adviser.) Assistant Professor, Art Department, University of Virginia, Charlottesville, Va. Author of *Intimate Rituals and Personal Devotions: Spiritual Art through the Ages* (2000). Contributor to *Proceedings of the 1987 International Conference on Dunhuang Grottoes* (1990), *Dunhuang Wensu* (1999), edited by Jao Tsung-I, *Between Han and Tang: Religious Art and Archaeology of a Transformative Period* (2000), edited by Wu Hung, and *Archives of Asian Art* (1998–99, 1993). Member of editorial board for *Early Medieval China* since 2001.

Wood, Susan. Professor, Department of Art and Art History, Oakland University, Rochester, Minn. Author of *Roman Portrait Sculpture, A.D. 218–260* (1986) and *Imperial Women: A Study in Public Images, 40 B.C.–A.D. 68* (1999). Contributor to *American Journal of Archaeology* (1978, 1981, 1982, 1983, 1988, 1995), *Ancient Portraits in the J. Paul Getty Museum*, edited by Jiří Frel, Arthur Houghton, and Marion True (1987), *Journal of the American Research Center in Egypt* (1988), *Journal of Roman Archaeology* (1993), *Roman Art in Context*, edited by Eve D'Ambra (1993), *Archaeological News* (1996–97), and *I, Claudia II: Papers from the Colloquium* (2000), edited by

CONTRIBUTORS

Diana E.E. Kleiner and Susan Matheson. Articles contributed to *The Encyclopedia of Sculpture*: Sarcophagus.

York, Karen. Ph.D. Candidate Department of Art History, Indiana University, Bloomington. Articles contributed to *The Encyclopedia of Sculpture*: Émail en ronde bosse; Precious Metals.

Zamudio, Raúl. Ph.D. Candidate. Department of Art History, The Graduate School, City University of New York. Contributor to *Journal of the West*, *TRANS: Arts Cultures Media* (2000), *Art Nexus* (2000–), and *NYARTS* (2000–). Member of editorial board for *PART* 2000–). Curator of "The Parallax Hotel" Independent Art Fair, New York (2000), "Six Feet Under: Bik van der Pol" The White Box Gallery, New York (2001). Articles contributed to *The Encyclopedia of Sculpture*: Lucio Fontana; Damien Hirst; Rebecca Horn; Jesús Rafael Soto.

Zoege von Manteuffel, Claus. Ph.D. Professor, History of Art Department, Württembergisches Landesmuseum und Universität, Stuttgart, Germany. Author of *Die Bildhauerfamilie Zürn 1606–1666* (1969), *E.L. Kirchnen, Zeichnungen* (1979), *Max Klaus, 1891–1972* (1991), and *Die Waldseer Bildhauer Zürn* (1998). Articles contributed to *The Encyclopedia of Sculpture*: Zürn Family; Zürn Family: High Altar of Überlingen.

Index

The Gate of the Kiss (Brancusi), 201
gates, 80–81, 264, 1617
Gates of Hell (Rodin), 455, 603, 1403, 1441, 1442, *1444*, **1444–1445**
 Golubkina compared with, 688
 Modernism and, 1104
Gates of Paradise (Ghiberti), 455, **657–659**, *658*
 Filarete compared with, 557
 influence of, 1403, 1411
 Jacopo compared with, 832
 Michelozzo and, 1081
 Rodin influenced by, 1444–1445
Gattamelata (Donatello), 345, 520, 524, 795, 1343, 1411
Gaudier-Brzeska, Henri, 510, 515, 518, **623–625**
Gaudreaus, Antoine-Robert, 226
Gauguin, Paul, **625–627**, 1272, 1699
Gaul, August, 648
Gaul Killing Himself and His Wife (Susini), 1629
Gaul Killing His Wife, 713
Gaurico, Pomponio, 7, 1312, 1426, 1718
Gauricus, Pomponius, 345–346
Gautier, Théophile, 137, 138
Gazing Head (Giacometti), 659
Gebel, Matthias, 1416
Geefs, Guillaume, 1180
Geel, Jan Frans van, 1179
Geel, Jan-Lodewijk van, 1180
Geesebearer fountain, 581
Geffroy, Gustave, 325, 603
Gefion fountain (Copenhagen, Sweden), 585
Gehry, Frank, 1217
Geierstele (stela of vultures), 1156
Geldinus, Berardus, 1402
Gelduinus, Bernardus, 594, **627–629**, 1452
Gelenius, Aegedius, 651
Gemito, Vincenzo, **629–632**
Gemma Augustea, 512
Gemma Augustea, 1459
Gemma Tiberiana, 512
gems, engraved. *See* engraved gems (intaglios and cameos)
Geneleos group, 710, 711
Geneoels-Elderen diptych, 264
Général Augustin-Daniel Belliard (Geefs), 1180
General Gordon (Thornycroft), 1657
General Jean Rapp (Bartholdi), 130
General Mills Sculpture Garden (Minneapolis, Minnesota), 342
General William Tecumseh Sherman (Saint-Gaudens), 1696
Genesis (Daviervalla), 784
Genesis (Epstein), 515
Genesis Relief (Wiligelmo), 1756–1757, *1757*
Geneviève (Oppenheim), 1223
Genga, Girolamo, 1655
Le Génie de la Danse (Carpeaux). *See Dance (Le Génie de la Danse)* (Carpeaux)
Génie du Christianisme (The Genius of Christianity) (Chateaubriand), 546
Genii of Mankind (Ney), 1193
Genius (Prieur), *1363*
Genius of England (Bacon), 108

The Genius of Eternal Repose (Despiau), 428
Genius of Music (Falconet), 535
Genoa Cathedral, 1333
genre sculpture, 1698–1699
Gentils, Vic, 99, 1183
Gentleman on Horseback (Marini), 1011, 1013
Geoffroy, Gustave, 1447
Geological Museum (London, England), 1910
Geometric Figure Seated (Archipenko), 77
Geometric period, 1604
Geometric Statuette (Archipenko), 76
George Grote (Durant), 475
George III and the River Thames (Bacon), 108
George III (Damer), 395
George III (Wilton), 1758
George of Klasenburg, 275–276
George Washington (Greenough), *715*, 715–716
George Washington (Rush), 1482
Georg Frideric Handel (Roubiliac), 1473
Georgia O'Keeffe (Lachaise), 912
Geremia (Lombardo), 969
Gerhaert von Leiden, Nikolaus, **632–634**
 Grasser influenced by, 704
 Hagenauer and, 731, 732
 Meit and, 1036
 reliquaries, 1407
 Riemenschneider and, 1429
 Weckmann compared with, 1752
Gerhard, Heinrich, 638
Gerhard, Hubert, 279, **634–638**, 1177
 Augustus fountain, **637–638**
 Carlo and, 258
 Cellini influence on, 274
 Giambologna and, 663
 Gras and, 701–703
 influence of, 644
 Krumper and, 908
 Reichle and, 1395, 1398
Gerholt, Jakob, 719
Géricault, Theodore, 1044
German Artists Alliance, 882–883
German Master, 1237
Germany
 altarpieces, 40–41
 baptismal fonts, 120–121
 Baroque–Neoclassical, 126, **644–647**
 émail en ronde bosse in, 500
 Gothic-Renaissance, **641–644**
 ivory sculpture, 820–822, 825–826, 827
 medals, 1034
 Ottonian sculpture, **1235–1238**
 pietàs, 1278–1279, 1280
 plaquettes, 1309
 polychromy, 1321–1322
 relief sculpture, 1402
 Renaissance, 1415–1417
 Romanesque, **638–641**
 rood screens, 1547
 Rosary altars, 1569
 20th century-contemporary, **647–650**

Miroku bodhisattva (Kaikei), 864
mirror-displacements, 1585–1586
Mirrored Cubes (Morris), 1127
mise-en-scène, 605–606
misericords, **1097–1098**
Miss, Mary, 1764, 1767–1768
Mississippian sculpture, 1147–1148
Missouri Botanical Garden, 1085–1086
Mist (Golubkina), 688
Mistry, Dhruv, 784, 785
Mitchell, Charles, memorial to, 588
Mithradates VI of Pontus, collection of, 512
Mitras, Son of Anobazan Slaying Datmus (Bienaimé), 174
Mixtec culture, 1060
Mlle. Pogany (Brancusi), 200
Mobile Object Recommended for Family Use (Ernst), 530
mobiles, 229–232
Moby Dick (Lipton), 4
Mocenigo, Pietro, tomb of, 127, 966, *966*, 968
Mochi, Francesco, 125, 522, 799, **1098–1102**
 Annunciation, **1100–1102**, *1101*
Le Modèle (Whitney), 1755
Model for a Museum (Schütte), 1540
modeling, **1102–1103**
 tools, **1674–1778**
 wax, 1749–1750
Model of a Monastery, 313
Modena Cathedral, 80, 792, 1756
Modernism, **1103–1106**
 Africa, 29–30
 Australia, 102
 Austria, 281
 Canada, 245–246
 China, 314
 Cyclades and, 15
 Czech Republic and Slovakia, 283
 Dalí and, 389–391
 Degas, 414–416
 France, 604–605
 Giorgi, 676–678
 Hepworth, 742–745
 Hildebrand on, 751–752
 Hungary, 278–279
 Latin America, 203–205, 924–925
 Neoclassical style and, 1169, 1172–1173
 Poland, 1314–1315
 Postmodernism compared with, 1346
 Russia, 1486–1487
 Smith, 1578–1579
 U.S., 1698–1699
Modern Tendencies in Sculpture (Taft), 1640
Modesty (tomb for Cecilia Caietani) (Corradini), 370, **371–373**, *372*
Modigliani, Amedeo, 201, 515, 690
Modular Open Cube Pieces (9 x 9 x 9), Floor/Corner 2 (LeWitt), *959*
Modulated Surfaces (Clark), 925
Mogao Caves (China), 303–304, 307, 310
Mognetti, Elisabeth, 927
Mogollon sculpture, 1149

Mogul Empire, **780–782**
Moholy-Nagy, László, 3, 690, 742, **1106–1109**, 1642
Mohs, Friedrich, 1281–1282
Mohs scale, 1281–1282
Moine, Antonin, 1403
Moitte, Jean-Guillaume, 1285
Moiturier, Antoine Le, **944–945**
The Mojave Projects (Heizer), 740
Mola, Gaspare, 1033
Molière (Caffieri), 601
Molière (Injalbert), 603
Molin, Johan Peter, 1529
Molina, Leo da, 454
Moll, Balthasar Ferdinand, 280, 452
Moll, Johann Nikolaus, 280, 452
Moll, Virgil, 1780
Mollinarolo, Jakob Gabriel, 278
Molo of Crotona (Falconet), 535
Momoyama period, 849
Mona Lisa (ivory panel), 1158
Monarque (Puget), 1372
Monastery of S. Lorenzo el Real (Madrid, Spain), 949, 1742–1743
Monastery of San Marcos (Léon, Spain), 859–860
Monastery of St. Benedict (Vallodolid, Spain), 163–164
Monastery of St. George (Balaklavi), 485
Monastery of the Syrians (Wadi, Natrun, Egypt), 484–485
Monastery of Vatopaidi (Mount Athos), 483–484
Mondella, Galeazzo, 1426
Mondragone Head, 68
Mondrian, Piet, 742
Mondsee Abbey, 719
Mone, Jean, 349
Monet, Juan Petit, 1227, 1228
Monk's Mound, 1147
Monnaie du Moulin, 1747
Monnot, Pierre-Étienne, 126, 721, **1109–1111**
Monnoyer, Armide, 945
Monnoyer, J.B., 945
Monolith (Empyrean) (Hepworth), 742
monoliths, 347
Monolith (Vigeland), 1725, *1725*, 1726
Mon people, 1646–1654, 1653
Monreale Cathedral, 793
Monroe, Marilyn, 750
La Montagne Héroique (Lachaise), 912, 913
Montagu, Jennifer, 224
Montañés, Juan Martínez, 247, 919, 921, 1054, **1111–1114**, 1597
Montaperto, Giovanni, funerary monument to, 619
Montefeltro, Federico da, 927
Montelupo, Raffaello da, 1116
Monteverde, Giulio, 808
Montferrand, A., 880
Montfort, Amélie de, 266
Montgomery, Edmund Duncan, 1193, 1194
Monti, Raffaelle, **1114–1116**
Montmorency, Anne de, Prieur tomb scupture, 1362–1363
Montmorency, Henri, duc de, Anguier tomb scupture, 57, 58
Montorsoli, Giovan Angelo, 53, 71, **1116–1118**, 1636

Motoska, Miroslav, 283
Mouhot, Henri, 234
Mould, Jacob Wrey, 585
Moulins a prière (Prayer Mills) (Tinguely), 1661
Mountain (Maillol), 988
Mount Auburn Cemetery (Cambridge, Massachusetts), 1618,
 1693, 1696
Mount of Calvary, 1740–1741
Mountrath monument (Wilton), 1758–1759
Mount Rushmore, 346
Moutiez, Elisa Polycarpe, 397
Movemento spaziale (Spatial Movement), 575–578
The Mower (Thornycroft), 1657
Mr. Arnold (Taft), 1639
Mr. Cruikshank (Paolozzi), 1244–1245
Mrs. Chester Dale (Despiau), 429
Mrs. John Jones Schermerhorn (Crawford), 385
Mteki, Richard, 29
Mubayi, Sylvester, 29
Muche, Georg, 1537
Mudéjar design, 1568–1569
Mukherjee, Meera, 784
Mukhina, Vera, 689, **1128–1130**, 1487, 1562–1563
Mukomberanwa, Nicholas, 29
Muldenfaltenstil, 695, 697, 1197
Müller, Philipp Heinrich, 1033
Müllner, Josef, 281
multimedia art, 653–655, 810, 899–901, 1404. *See also*
 assemblages; installations
Multiplication d'Art Transformable (MAT) (Spoerri), 171,
 1602–1603
Multscher, Hans, 527, 643, **1130–1133**
 deposition groups, 915
 Grasser compared with, 704
 Hungarian influence of, 276
 Man of Sorrows, 1132, **1132–1133**
 Stoss and, 1620
Mulvey, Laura, 854
Mumford, Lewis, 1122
Munby, Arthur, 476
Munch, Edvard, 987, 1527
Munich Ascension plaque, 819
Munnings, Alfred, 220
Munro, Alexander, 510
Münster Cathedral, 717
Mur, Tomás, 924
Murmann, Jakob the Elder, 405
Muromachi period, 849
Murray, John, 669
Murray, Robert, 245, 246
Muschinski, Pat, 1216, 1219
Musée Dantan (Dantan), 397
Musée des Années Trente (Boulogne-Billancourt, France),
 605
Musée d'Orsay (Paris, France), 604
Musée Nationale d'Art Moderne (Paris, France), 605
Musée Secret (Dantan), 397
Musée Sentimentale (Spoerri), 1603
Museo Capitolino (Rome, Italy), 441
Muse of Sculpture (Ceracchi), 394

Museo Pecci di Arte Contemporanea (Prato, Italy), 1053–
 1054
Museum Guard (Hanson), 737
Museum of Folk and Peasant Arts, 1139
Museum Piece (de Maria), 423
museums, 341, 442, 1050. *See also* display of sculpture
musical instruments, 27, 1188
Musical Instruments with a Statuette (Baschenis), 1740
Music-Making Children (Agostino), 31
La Musique (Guillaume), 267
Mutnofret, 492
Mutschelenbeck, Joseph, 1779
Mutt., R. *See* Duchamp, Marcel
Muybridge, Eadward, 470, 959
Mycenaean sculpture, 15, 17–18, 815, 1401–1402
Mycerinus, King of Egypt, *486*, 489
Myers, Ethel, 1699
Myron, 95, 711, **1133–1137**, 1755
 Diskobolos (Discus Thrower), **1135–1137**, *1136*
Myslbek, Josef Václav, 282–283
Mysteriarch (Frampton), 587
Mysteries of the Rosary (Serpotta), 1554

Nabis, the, 987
Naccerino, Michelangelo, 559, 800
Nadelman, Elie, **1139–1141**
Nagappa, M.S., 782–783
Nagesvarasvamy Temple (Kumbhakonam, India), 778–779
Nagle, Isabel, 911
Nájera, Andrés de, 1723
Nakht, 490
Naksana Tample (Korea), 897
Nam June Paik, 360, 787, 897
Nanas (Saint Phalle), 1499, 1500–1501
Nandagopal, S., 784
Nanda period (India), 770–771
Nandi mandapa, 777
Nangua Temple (China), 310
Nanni di Banco, 795, **1141–1144**, 1411, 1433
 four crowned saints and niche of the guild of stonemasons
 and carpenters, *144*, **1143–1444**
Nansen, Fridtjof (Vigeland), 1725
Nanyn, Pierre, 699
Naples Cathedral, 559–560
Napoléon (Angers), 1033
Napoléon as a Roman Emperor (Rude), 1476
Napoléon as Legislator (Chaudet), 294
Napoléon Awakening to Immortality (Rude), 602, 1476
Napoléon Bonaparte
 art acquired by, 250, 802, 1424
 Canova statue, 1370
 Chinard portraits, 315
 Houdon bust of, 766
 Neoclassicism and, 1167–1168
 triumphal arches, 1687
Napoléon Bonaparte as First Consul (Chaudet), 294
Napoléon I's Apotheosis (Davide), 1284
Naqsh-i-Rustam, 1160
Naramsin stela, 1156
Naram-Sin victory stela, 1400

Nara period, 1770
Narasimha, 776
Narcissus (Gibson), 668
Narmer, palette of King, 488
Narni, Erasmo da, 520
Nash, John, 1687
natabori, **1144–1145**
Natambu, Kofi, 727
Nathan Hale (MacMonnies), 1697
National Endowment for the Arts, 1368–1369
nationalism, Neoclassicism and, 1169–1170
National Sculpture Society and American Academy (Rome),
 1698
National Socialism (Germany)
 Barlach, 122
 Belling, 142–143
 Bellmer, 143–144
 Brekker, 1172–1173
 Entartete Kunst (Degenerate Art) exhibition, 122, 142,
 144, 1008, 1537
 Kolbe, 882–883
 Kollwitz, 885
 Marcks, 1007–1008
 Schlemmer, 1537
Native Americans
 Canada, 242–243, 246–247
 kachina dolls, 1149, 1319, 1766
 19th-century depictions, 1697
 totem poles, **1681–1682**, *1682*, 1766
Native North America, **1145–1153**
Nativity (Anguier), 58, *58*
Nativity (Juni), 859
Nativity Scene (Radovan), 1385, 1386
Nature (Francavilla), 592–593
Nature Revealing Herself to Science (Barrias), 367
Nauman, Bruce, 360
Naumburg Cathedral, 697–698
Nautical Fortune (Piamontini), 575
Naval Triumphal Arch (St. Petersburg, Russia), 879
Navarre (Prieur), 1363
Navel-Bottle (Arp), 90
La Navigation (Bertaux), 165
Nayaka period (India), 780
Neapolitan Fisherboy Playing with a Tortoise (Rude), 1476
Near East, ancient
 Anatolia, **1164–1166**
 Iran, **1159–1163**
 Mesopotamia, **1155–1159**
 Neolithic, **1153–1155**
 plaster casts, 1310
 Syria, **1163–1164**
Nectanebo II, 498
Needless Alarms (Leighton), 936
Nefertiti, 494, *494*, 495
Neferure, 493
Nef of St. Ursula, 500
nefs, 499–500
Negative Painting (Heizer), 740
The Negligent Watchboy of the Vineyards, Catching Locusts
 (Durant), 476

Negro in Algerian Costume (Cordier), 366, *366*
Neidhard, Wolfgang, 1399
Nelson, Horatio
 Banks monument, 509
 Damer bust, 395
 Flaxman monument, 565
Nelson Column (Dublin, Ireland), 790
Neocinquecentismo, 369–370
Neoclassical style, **1166–1173**
 ancient Greece and, 707
 architectural decoration, 83
 Art Deco, **92–94**
 Austria, 280–281
 Banks, 116–118
 Canova, 249–253
 caryatids, 270–271
 Chantrey, 286–287
 Chaudet, 293–294
 Chinard, 315–317
 chryselephantine sculpture, 321
 Clodion, 332
 Deare, 412–414
 Denmark, 1523
 display of sculpture, 441–442
 England and Wales, 508–509
 engraved gems, 513–514
 Finland, 1525
 Flaxman, 565–567
 France, 601–602
 German, 646, 647–648
 Hosmer, 763–764
 Houdon, 765–768
 Hungary, 278
 India, 782–783
 Italy, 801–805, **801–809**
 Latin America, 924
 medals, 1033
 Netherlands, 1179–1181
 Ney, 1193–1194
 Pajou, 1241–1242
 Poland, 1314
 portraits, 1344–1345
 Postmodernism, 1346
 Powers, **1350–1353**
 revivalism, 1419–1420
 Scotland, 1544–1545
 stone carving, 1284
 tomb sculpture, 1672
 U.S., 1693, 1694–1695
 women sculptors, 1762
Neo-Conceptualism, 361–362
Neo-Dada, 463–465, 613, 1052–1053
Neo-Expressionism, 888–889
Neo-Hittite period, 1163
neon, 1053
Neo-Sumerian period, 1156
Neo-Syrian period, 1163–1164
nephrite, 1614
Neptune (Adam), 11
Neptune and Galatea (Gibbons), 667

Seregni, Vincenzo, 81
Serenity (Maillol), 988
Sergel, Johan Tobias, 1167, 1529, **1550–1552**
Le Sergent (Dubuffet), *463*
Serial Project #1 (ABCD) (Lewitt), 959
Serious Self-Portrait (Messerschmidt), 1062
Sermézy, Clémence Sophie de, **1552–1554**
Serooskerken, Hieronymus Tuyl van, monument to, 1717
Serov, Valentin, 1641
serpent goddesses, *387*, 388
Serpotta, Giacomo, 129, 801, **1554–1557**
 Charity (La Carità), **1557**
Serra, Richard, 1105, **1557–1559**
 Casting, 423
 Core, 342
 Flanagan and, 561
 Splashing, 423
 Tilted Arc, 361, 1369, 1370
Sesostris I, 491
Sesostris III, *490*, 491
Sesto, Giovanni Battista da, 284
Seti I, 496
Settignano, Desiderio da. *See* Desiderio da Settignano
Settler (Aaltonen), 2
Seuse, Heinrich, 1278
Seven Stations of the Cross (Kraft), 903
7th Man (Jones), 853
Seven Works of Mercy (Santi), 1434
Several (Hesse), 749
Severan portraits, 1340, 1341
Severe Style, 711
 Orestes and Electra, 1230
 Riace bronzes, **1420–1423**, *1421*
Séverine (Carolyne Rémi), 1447
Severin's altar (Cologne Cathedral), 650–652
Severo di Domenico Calzetta da Ravenna, 446, 1424, **1559–1562**
Seville Cathedral, 42, 1111
Sévres porcelain, 268, 1605
Seymour, Charles Jr., 1077
Sforza, Ascanio Maria, Sansovino tomb sculpture, 1507–1508, **1509–1510**
Sforza, Battista, bust of (Laurana), *926*, 927
Sforza, Ludovico, Leonardo monument to, 521
Shabaqo, 497
Shadr, Ivan, 1487, **1562–1563**
Shaka Buddha (Kaikei), 864
Shaka triad (Busshi), 893
Shakespeare: A Midsummer's Night Dream (Whitney), 1755
Shakespeare, William, Scheemakers monument to, 1490
Shalev-Gertz, Esther, 1049, 1370
Shalev-Gertz, Jochen, 1370
shamanism, 1151
Shang dynasty, 298–300
Shaw memorial (Saint-Gaudens), 1495, *1497*, **1497–1498**, 1695
Shchedrin, Feodosy, 1485
Shearer, Alan, 511
shears, 1677
Sheeler, Charles, 563

Sheep Piece (Moore), 1120
Shelah-na-Gigs, 788–789
Shelley, Percy Bysshe, memorial to, 1673
Shells and Flowers (Tauber-Arp), 1638
shell sculpture, 1041–1042, 1361. *See also* engraved gems
 (intaglios and cameos)
Shen Dong Su, 312
Shepherd Boy (Thorvaldsen), 1659
Shepherdess (Ferenczy), 278
The Shepherd of Landes (Richier), 1428
Sheppard, Oliver, 790
Sherman Monument (Saint-Gaudens), 523
She-wolf, 533
Shiba Tasuna, 842
Shichijo (Seventh Block) Bussho, 848, 863–865
Shieldbearer (Bertoldo), 167
Shield of Achilles (Flaxman), 566
The Shining Bed (Dine), 435
Shiva as Lakulisi, 777
Shixia culture, 298
Shnitzaltar, 526, 528, *528*
Shona kingdom, 27, 29
Shöner Brunnen (Beautiful Fountain), 581
shooting paintings (Saint Phalle), 1499, 1500
short-bent chisels, 1676
Shouting Horseman (Riccio), 1424
Shovel, Cloudesley, monument to, 667
Shrine of St. Anno (Nicholas), 1198
Shrine of St. Lanfranco (Amadeo), 44
Shrine of the Magi, 1360–1361
Shrine of the *Virgin* (Nicholas), 1197, 1198
Shubin, Fedot, 1484, **1563–1565**
Shunjobo Chogen, 1767
Siam. *See* Thailand
Sibelius, Jean, 1
Sibilla, Gaspare, 199
Siculus, Diodorus, 477–478
Sidewalk (Zhan), 1370
Siege of Martinengo (Bushnell), 215
Siena Cathedral
 Arnolfo work in, 86
 baptismal font, 120–121
 Beccafumi angels, 607
 Eucharistic tabernacle, 42–43
 Francesco work in, 607
 Jacopo reliefs, 831
 Maitani and, 990–991
 Mazzuoli work in, 1029
 Pisano work in, 1298, 1299, 1303, 1377
 pulpit, 794, 1377
 Stefano work in, 607
 Vecchietta work in, 1710, 1711
Sierck, Jakob, tomb of, 632
Sigismund Chapel (Krakow, Poland), 1415
Sigismund I (Poland), 1415
Signorelli, Luca, 1722
Signpost (Dehner), 418
Sihing type images, 1653
Silence (Saint-Gaudens), 1495
Silence (Verhulst), 1716